A Museum Studies Approach to Heritage

Heritage's revival as a respected academic subject has, in part, resulted from an increased awareness and understanding of indigenous rights and non-Western philosophies and practices, and a growing respect for the intangible. Heritage has, thus far, focused on management, tourism, and the traditionally 'heritage-minded' disciplines, such as archaeology, geography, and social and cultural theory. Widening the scope of international heritage studies, *A Museum Studies Approach to Heritage* explores heritage through new areas of knowledge, including emotion and affect, the politics of dissent, migration, and intercultural and participatory dimensions of heritage.

Drawing on a range of disciplines and the best from established sources, the book includes writing not typically recognised as 'heritage', but which, nevertheless, makes a valuable contribution to the debate about what heritage is, what it can do, and how it works and for whom. Including heritage perspectives from beyond the professional sphere, the book serves as a reminder that heritage is not just an academic concern, but a deeply felt and keenly valued public and private practice. This blending of traditional topics and emerging trends, established theory, and concepts from other disciplines offers readers international views of the past and future of this growing field.

A Museum Studies Approach to Heritage offers a wider, more current, and more inclusive overview of issues and practices in heritage and its intersection with museums. As such, the book will be essential reading for postgraduate students of heritage and museum studies. It will also be of great interest to academics, practitioners, and anyone else who is interested in how we conceptualise and use the past.

Sheila Watson is an Associate Professor and Director of the MA/MSc in Heritage and Interpretation by Distance Learning in the School of Museum Studies at the University of Leicester, UK.

Amy Jane Barnes is a Research Associate in the School of Archaeology and Ancient History at the University of Leicester, UK, a University Teacher at Loughborough University, UK, and an affiliate of King's College London.

Katy Bunning is a Lecturer and Director of Teaching and Learning in the School of Museum Studies at the University of Leicester, UK.

Leicester Readers in Museum Studies
Series Editor: Professor Simon J. Knell

Museum Management and Marketing
Richard Sandell and Robert R. Janes

Museums in the Material World
Simon Knell

Museums and their Communities
Sheila Watson

Museums in a Digital Age
Ross Parry

Preventive Conservation in Museums
Chris Caple

Museum Objects: Experiencing the Properties of Things
Sandra H. Dudley

Museums and Archaeology
Robin Skeates

A Museum Studies Approach to Heritage
Edited by Sheila Watson, Amy Jane Barnes and Katy Bunning

A Museum Studies Approach to Heritage

Edited by
Sheila Watson, Amy Jane Barnes and Katy Bunning

LONDON AND NEW YORK

First published 2019
by Routledge
2 Park Square, Milton Park, Abingdon, Oxon OX14 4RN

and by Routledge
711 Third Avenue, New York, NY 10017

Routledge is an imprint of the Taylor & Francis Group, an informa business

© 2019 selection and editorial matter, Sheila Watson, Amy Jane Barnes and Katy Bunning; individual chapters, the contributors

The right of Sheila Watson, Amy Jane Barnes and Katy Bunning to be identified as the authors of the editorial matter, and of the authors for their individual chapters, has been asserted in accordance with sections 77 and 78 of the Copyright, Designs and Patents Act 1988.

All rights reserved. No part of this book may be reprinted or reproduced or utilised in any form or by any electronic, mechanical, or other means, now known or hereafter invented, including photocopying and recording, or in any information storage or retrieval system, without permission in writing from the publishers.

Trademark notice: Product or corporate names may be trademarks or registered trademarks, and are used only for identification and explanation without intent to infringe.

British Library Cataloguing-in-Publication Data
A catalogue record for this book is available from the British Library

Library of Congress Cataloging-in-Publication Data
Names: Watson, Sheila, editor. | Barnes, Amy (Amy Jane), editor. |
Bunning, Katy, editor.
Title: A museum studies approach to heritage / edited by Sheila Watson,
Amy Jane Barnes, and Katy Bunning.
Description: Abingdon, Oxon ; New York, NY : Routledge, 2018. |
Series: Leicester readers in museum studies | Includes bibliographical references
and index.
Identifiers: LCCN 2018005467| ISBN 9781138950931 (hardback : alk. paper) |
ISBN 9781138950924 (paperback : alk. paper) | ISBN 9781315668505 (Master) |
ISBN 9781317361312 (Web) | ISBN 9781317361305 (epub) |
ISBN 9781317361299 (mobi/kindle)
Subjects: LCSH: Cultural property–Protection. | Museums.
Classification: LCC CC135 .M866 2018 | DDC 069–dc23
LC record available at https://lccn.loc.gov/2018005467

ISBN: 978-1-138-95093-1 (hbk)
ISBN: 978-1-138-95092-4 (pbk)
ISBN: 978-1-315-66850-5 (ebk)

Typeset in Bembo
by Wearset Ltd, Boldon, Tyne and Wear

To all of my colleagues at the School of Museum Studies,
University of Leicester – S.W.

For Oscar and Úna – A.J.B.

To all the staff at the School of Museum Studies for their support,
encouragement and inspiration – K.B.

Contents

Notes on contributors	*xiii*
Series preface	*xxi*
Preface	*xxii*
Acknowledgements	*xxiv*

Introduction 1
Sheila Watson, Amy Jane Barnes and Katy Bunning

PART I
Heritage contexts, past and present 7

Introduction to Part I 9
Amy Jane Barnes

1 Heritage pasts and heritage presents: temporality, meaning and the scope
of heritage studies 14
David C. Harvey

2 Museum studies and heritage: independent museums and the 'heritage
debate' in the UK 29
Anna Woodham

3 People [extracts] 44
Alan Bennett

4 The crisis of cultural authority 56
Tiffany Jenkins

5 Editorials: *History Workshop Journal* 78
Editorial Collective/Raphael Samuel

Contents

6 Hybrids 81
Raphael Samuel

7 Understanding our encounters with heritage: the value of 'historical consciousness' 95
Ceri Jones

8 Weighing up intangible heritage: a view from Ise 113
Simon Richards

9 From monument to cultural patrimony: the concepts and practices of heritage in Mexico 132
Cintia Velázquez Marroni

10 We come from the land of the ice and snow: Icelandic heritage and its usage in present-day society 146
Guðrún D. Whitehead

11 Por la encendida calle antillana: Africanisms and Puerto Rican architecture 169
Arleen Pabón

12 Iconoclash in the age of heritage [extracts] 179
Peter Probst

PART II
Authenticity and tourism **183**

Introduction to Part II 185
Sheila Watson

13 Touring the slave route: inaccurate authenticities in Bénin, West Africa 189
Timothy R. Landry

14 Steampunking heritage: how Steampunk artists reinterpret museum collections 205
Jeanette Atkinson

15 Why fakes? 221
Mark Jones

16 The work of art in the age of mechanical reproduction 226
Walter Benjamin

Contents

17 After authenticity at an American heritage site 244
 Eric Gable and Richard Handler

18 Makeover for Mont-Saint-Michel: a renovation project harnesses the
 power of the sea to preserve one of the world's most iconic islands 259
 Alexander Stille

19 Resonance and wonder 265
 Stephen Greenblatt

20 'Introduction' to *In Search of Authenticity: The Formation of Folklore Studies* 274
 Regina Bendix

PART III
Emotions and materiality **293**

 Introduction to Part III 295
 Sheila Watson

21 Invoking affect 298
 Clare Hemmings

22 The archaeology of mind [extracts] 313
 Jaak Panksepp and Lucy Biven

23 'The trophies of their wars': affect and encounter at the Canadian War
 Museum 329
 Sara Matthews

24 Huddled masses yearning to buy postcards: the politics of producing
 heritage at the Statue of Liberty–Ellis Island National Monument 343
 Joanne Maddern

25 The Holocaust and the museum world in Britain: a study of ethnography 354
 Tony Kushner

26 Senses of place, senses of time and heritage 374
 Gregory John Ashworth and Brian Graham

27 Making heritage pay in the Rainbow Nation 381
 Lynn Meskell

28 The concept and its varieties 404
 Anthony Smith

ix

Contents

29 Materiality matters: experiencing the displayed object 418
Sandra Dudley

30 Concepts of identity and difference 429
Kathryn Woodward

31 Emotional engagement in heritage sites and museums: ghosts of the past
and imagination in the present 441
Sheila Watson

32 The Third World 457
Jeremy Black

33 Turkish delight: Antonio Gala's *La pasión turca* as a vision of Spain's
contested Islamic heritage 474
Nicola Gilmour

34 'The cliffs are not cliffs': the cliffs of Dover and national identities in
Britain, c.1750–c.1950 490
Paul Readman

PART IV
Diversity and identity 511

Introduction to Part IV 513
Katy Bunning

35 Museums as intercultural spaces 517
Simona Bodo

36 Gradients of alterity: museums and the negotiation of cultural difference in
contemporary Norway 527
Marzia Varutti

37 Museums in a global world: a conversation on museums, heritage, nation
and diversity in a transnational age 543
Conal McCarthy, Rhiannon Mason, Christopher Whitehead,
Jakob Ingemann Parby, André Cicalo, Philipp Schorch, Leslie Witz,
Pablo Alonso Gonzalez, Naomi Roux, Eva Ambos and Ciraj Rassool

38 Reflections on the *Confluence Project*: assimilation, sustainability, and the
perils of a shared heritage 559
Jon Daehnke

Contents

39 Ethnic heritage for the nation: debating 'identity museums' on the
National Mall 570
Katy Bunning

40 Heritage interpretation and human rights: documenting diversity,
expressing identity, or establishing universal principles? 587
Neil Silberman

41 Un-placed heritage: making identity through fashion 598
Malika Kraamer and Amy Jane Barnes

PART V
Participatory heritage 619

Introduction to Part V 621
Katy Bunning

42 Research on community heritage: moving from collaborative research
to participatory and co-designed research practice 625
Andrew Flinn and Anna Sexton

43 Beyond the rhetoric: negotiating the politics and realising the potential
of community-driven heritage engagement 640
Corinne Perkin

44 From representation to participation: inclusive practices, co-curating and
the voice of the protagonists in some Italian migration museums 655
Anna Chiara Cimoli

45 Museums, trans youth and institutional change: transforming heritage
institutions through collaborative practice 664
Serena Iervolino

46 Embrace the margins: adventures in archaeology and homelessness 686
Rachael Kiddey and John Schofield

47 Developing dialogue in co-produced exhibitions: between rhetoric,
intentions and realities 700
Nuala Morse, Morag Macpherson and Sophie Robinson

48 Community engagement, curatorial practice, and museum ethos in
Alberta, Canada 714
Bryony Onciul

Contents

PART VI
Contested histories and heritage

731

Introduction to Part VI
Sheila Watson

733

49 Contested townscapes: the walled city as world heritage
Oliver Creighton

736

50 Reassembling Nuremberg, reassembling heritage
Sharon Macdonald

746

51 Can there be a conciliatory heritage?
Erica Lehrer

760

52 Palimpsest memoryscapes: materializing and mediating war and peace in
Sierra Leone
Paul Basu

778

53 Representing the *China Dream*: a case study in revolutionary cultural
heritage
Amy Jane Barnes

797

54 Contested trans-national heritage: the demolition of Changi prison,
Singapore
Joan Beaumont

814

55 The politics of community heritage: motivations, authority and control
Elizabeth Crooke

827

56 "To make the dry bones live": Amédée Forestier's Glastonbury Lake
Village
James E. Phillips

838

57 'Introduction' to *Contested Landscapes: Movement, Exile and Place*
Barbara Bender

850

58 Sensuous (re)collections: the sight and taste of socialism at Grūtas Statue
Park, Lithuania
Gediminas Lankauskas

861

Index

878

xii

Contributors

Eva Ambos is a Research Fellow in the 'Asia and Europe in a Global Context' Research Cluster at the South Asia Institute of the University of Heidelberg. She is working on the Changing Minds and Trauma in Transcultural Perspective projects, and has also been involved in the Religion on Stage project.

Gregory John Ashworth (1941–2016) was a Professor of Heritage Management and Urban Tourism at the University of Groningen. He held this position from 1994 until his retirement in 2006.

Jeanette Atkinson is a Research Network Facilitator in the History Faculty at Oxford University, and an Associate Tutor in the School of Museum Studies at Leicester University. She holds a PhD in Museum Studies from the University of Leicester and has worked in regional and national museums in the United Kingdom and New Zealand.

Amy Jane Barnes is a Research Associate in the School of Archaeology and Ancient History at the University of Leicester, UK, a University Teacher at Loughborough University, UK, and an affiliate of King's College London. She has previously worked in a number of roles in the School of Museum Studies at the University of Leicester. Her monograph *Museum Representations of Maoist China* was published in 2014 (Routledge).

Paul Basu is a Professor of Anthropology at SOAS University of London. His regional specialism is West Africa, in particular Sierra Leone, where he researches landscape, memory and heritage. At present, he is writing up over ten years' worth of research accrued during the Palimpsest Memoryscapes: Historical Consciousness in Sierra Leone project.

Joan Beaumont is a Professor Emerita at the Strategic and Defence Studies Centre, School of International Political and Strategic Studies, College of Asia and the Pacific. She is a historian of Australia during the two world wars, Australian defence and foreign policy, history of prisoners of war, and the memory and heritage of war.

Barbara Bender is an Emeritus Professor of Heritage Anthropology at the Department of Anthropology, University College London. Her publications include *Stone Worlds: Narrative and Reflexivity in Landscape Archaeology*, (with Sue Hamilton and Chris Tilley, Left Coast Press, 2008) and *Contested Landscapes: Movement, Exile and Place* (with Margot Winer, Berg, 2001).

Regina Bendix has been a Professor of Cultural Anthropology/European Ethnology at the University of Göttingen since 2001. Her research focuses on cultural heritage, tourism, and the history of knowledge and science.

Contributors

Walter Benjamin (1892–1940) was a philosopher, and a literary and cultural critic, who had a significant influence on art history and cultural studies. He is widely known for his essay 'The work of art in the age of mechanical reproduction' (1935), which he originally wrote during his exile from Nazi Germany.

Alan Bennett is a British playwright, screenwriter, actor and author. He studied and lectured in history at the University of Oxford before turning to a full-time writing career. His many plays for stage and screen include *Talking Heads, The Lady in the Van, The Madness of King George III* and *The History Boys*. His play *People* opened at the National Theatre in October 2012.

Lucy Biven is a Reader for the Journal of Neuropsychoanalysis. She trained at the Anna Freud Centre in London, and has been the Head of the Department of Child and Adolescent Psychology at the Leicestershire National Health Service.

Jeremy Black is a Professor of History at the University of Exeter and he is working on post-1500 military history, eighteenth century British History, international relations, cartographic history and newspaper history. He joined Exeter University as Established Chair in History in 1996.

Simona Bodo is an Independent Researcher based in Milan. Her expertise lies in museum management, and particularly the social agency of cultural institutions. She has acted as advisor in this capacity to a number of public and private institutions.

Katy Bunning is a Lecturer in the School of Museum Studies, University of Leicester, UK. She teaches on graduate programmes in heritage and museum studies. Her research explores museums, race, and the histories of inclusive and socially engaged practice in museums and heritage.

André Cicalo is an Associate Researcher at the Brazil Institute of Kings College London. His research interests tackle race and racial inequality in Brazil. His book, *Urban Encounters: Affirmative Action and Black Identities in Brazil* (Palgrave, 2012) won the LASA Prize in 2013.

Anna Chiara Cimoli is a Freelance Researcher who has been working in the field of museums and social inclusion for 20 years. Between 2012 and 2015 she was involved in the MeLa: European Museums in an Age of Migrations project.

Oliver Creighton is a Professor of Archaeology at the University of Exeter, focusing primarily on the archaeology of later medieval Britain and Europe, in particular medieval castles.

Elizabeth Crooke is a Professor of Museum and Heritage Studies at Ulster University's School of Creative Arts and Technologies. Her research focuses on cultural, political and identity issues in relation to museums – particularly contested histories in Northern Ireland's museums – and museums and biography.

Jon Daehnke is an Assistant Professor in the Anthropology Department at the University of California Santa Cruz, and is affiliated with the Chicano Latino Research Center. His teaching and research interests lie in cultural heritage stewardship and law, and the archaeology of the North American Pacific Coast.

Sandra Dudley is Director and Head of the School of Museum Studies, University of Leicester. For over 10 years, she worked in a variety of curatorial and collections management capacities at the Pitt Rivers Museum at the University of Oxford.

Andrew Flinn is a Reader in Archival Studies and Oral History at University College London. His research areas include community based archives and memory, diversifying and democratising heritage, oral history, archives and public history, archives and social justice, and widening access to cultural heritage.

Eric Gable is a Professor in the Department of Sociology and Anthropology, University of Mary Washington. He is author of *Anthropology and Egalitarianism* (Indiana University Press, 2011) and co-authored *The New History in an Old Museum: Creating the Past at Colonial Williamsburg* (Duke University Press, 1997).

Nicola Gilmour is a Director of Teaching and Equity at the School of Languages and Cultures, at the Victoria University of Wellington/Te Whare Wānanga o te Ūpoko o te ika a Māui. Her research interests lie in nineteenth and twentieth-century Hispanic literature, Islamic and Jewish communities in Spain, immigration in Spain, and Spanish culture.

Pablo Alonso Gonzalez gained a PhD from the Division of Archaeology at the University of Cambridge, UK. His key interests are heritage, anthropology, archaeology, cultural studies, filmmaking and value theory.

Brian Graham is a Professor at the School of Environmental Sciences, University of Ulster, UK. His books include *In Search of Ireland: A Cultural Geography* (Routledge, 1997) and *A Geography of Heritage: Power, Culture, and Economy* (Oxford University Press, 2000) with Gregory John Ashworth and John Tunbridge.

Stephen Greenblatt is a John Cogan University Professor of the Humanities at Harvard University. He is known for helping to found New Historicism – a set of critical practices that he refers to as 'cultural poetics'. He won the Pulitzer Prize for General Non-Fiction in 2012 for *The Swerve: How the World Became Modern*.

Richard Handler is a Professor and Director of the Global Development Studies Program at the University of Virginia. As a cultural anthropologist, he has research interests in nationalism, ethnicity and the politics of culture.

David C. Harvey is a Historical Cultural Geographer at the University of Exeter. His research addresses themes of heritage, memory-work, oral testimony, lay knowledges, landscapes and communities, and identity politics within both a regional and local context.

Clare Hemmings is a Professor of Feminist Theory at the London School of Economics and Political Science. Her main field of research is transnational gender and sexuality studies.

Serena Iervolino is a Lecturer in Arts and Cultural Management at King's College London. Prior to this, she was a Lecturer at UCL Qatar, Doha. She has also lectured and held research and academic management positions at the Centre for Cultural Policy Studies, University of Warwick and the School of Museum Studies, University of Leicester.

Contributors

Jakob Ingemann Parby was a PhD Fellow at Roskilde University between 2011 and 2015, and has studied history, ethnology and museology at Copenhagen University. His research interests include migration and urban history, history of planning and infrastructure, museology, exhibition practice, and the media.

Tiffany Jenkins is a British Sociologist, Cultural Commentator and Writer. She has authored two books on museums: *Keeping Their Marbles* (Oxford University Press, 2016) and *Contesting Human Remains in Museum Collections: The Crisis of Cultural Authority* (Routledge, 2011). She regularly contributes to the broadsheet press on issues concerning the arts and culture.

Ceri Jones was Research Associate with the Research Centre for Museums and Galleries (RCMG), based in the School of Museum Studies, University of Leicester from 2002–2018. Her research interests include how people engage with museums, galleries and heritage sites, and how we can best, and ethically, capture evidence of that engagement.

Mark Jones is an Art Historian, Numismatist and former Director of the Victoria & Albert Museum, London (2001–2011). In 1992, he was appointed Director of National Museums of Scotland and oversaw the creation of the Museum of Scotland in 1998.

Rachael Kiddey is a Postdoctoral Researcher at the Pitt Rivers Museum, Oxford. She is working on the AHRC/ESRC funded project Architectures of Displacement: The Experiences and Consequences of Emergency Shelter in collaboration with the Refugee Studies Centre at the Oxford Department of International Development.

Malika Kraamer specialises in African and South Asian art, and globalised fashion and textiles. She works as an independent Curator and part-time Lecturer. She is currently Curator of World Cultures at Leicester Arts and Museum Service.

Tony Kushner is a Marcus Sieff Professor of the History of Jewish/non-Jewish Relations at the University of Southampton in the Parkes Institute for the Study of Jewish/non-Jewish Relations and History. Formerly, he was a historian for the Manchester Jewish Museum.

Timothy R. Landry is an Assistant Professor of Anthropology and Religious Studies at Trinity College, Hartford, Connecticut. A socio-cultural anthropologist who works in the Afro-Atlantic world, his research seeks to understand the ways in which autochthonous West African religions and their derivatives move around the globe.

Gediminas Lankauskas is an Associate Professor in Anthropology at the University of Regina. His research focuses on postsocialist Eastern Europe, in particular Lithuania, and how socio-economic and cultural transformations in this region are shaped by a pursuit of Western 'modernity'.

Erica Lehrer holds the Canada Research Chair in Museum and Heritage Studies at the Concordia University's Department of History. Her publications include *Jewish Poland Revisited: Heritage Tourism in Unquiet Places* (University of Indiana Press, 2013), which was a finalist for the American Jewish Book Awards and the Association for Jewish Studies Jordan Schnitzer Book Award.

Conal McCarthy is the Programme Director of the School of Art History, Classics and Religious Studies. He researches in museum history, theory and practice, exhibition history, Māori visual culture and contemporary heritage.

Sharon Macdonald is an Anniversary Professor of Cultural Anthropology at the University of York's Department of Sociology and the Alexander von Humbolt Professor of Social Anthropology at the Humbolt University of Berlin's Institute of European Ethnology, where she is also the Director of the Centre for Anthropological Research on Museums and Heritage.

Morag MacPherson is a Principal Learning and Community Officer at Tyne and Wear Archives and Museums, and is a member of I Object!: Working through Conflict in Museums action learning and research project, which partners University College London, Glasgow, and Tyne and Wear Museums Services.

Joanne Maddern is a Learning and Teaching Development Coordinator at Aberystwyth University's Centre for the Development of Staff and Academic Practice. She has published a number of papers in a variety of fields, including human geography, disability, mobilities, migration, spectrality and academic practice.

Cintia Velázquez Marroni earned her PhD in Museum Studies with the University of Leicester. As a Museum Practitioner, she was Curatorial and Exhibition Design Assistant for the 68' Memorial and later, Head of Education and Community Outreach at Tlatelolco University Cultural Centre (CCUT). Her research is focused on history museums, history in the museum, history as heritage and visitor studies.

Rhiannon Mason is Head of the School of Arts and Cultures at Newcastle University. Her main interest lies in heritage and identity, in particular, how collective and personal identities and memories relate to the museum. She is also interested in museum displays which present histories of place, and how museums are part of the process of building collective pasts, presents and futures.

Sara Matthews is an Associate Professor in Global Studies at Wilfred Laurier University. She researches the dynamics of war and violence in the global context, particularly the relationship between war, memory and nation building.

Lynn Meskell is a Professor in the Department of Anthropology at Stanford University, former Director of the Stanford Archaeology Center and Honorary Professor at the Rock Art Research Institute in the School of Geography, Archaeology and Environmental Studies at the University of the Witwatersrand, Johannesburg, South Africa. She has broad theoretical interests from socio-politics and ethics to feminist theory and embodiment.

Nuala Morse is a Lecturer in Museum Studies at the University of Leicester. Her academic and practice-based ethos is underpinned by participatory action research and her PhD explored the politics of participation in museums.

Bryony Onciul is a Senior Lecturer in Public History at the University of Exeter. Her work focuses, amongst other things, on community engagement, indigenising and decolonising museology and heritage, difficult histories, and understanding place and environment.

Contributors

Arleen Pabón has taught history of architecture, historic preservation, and architectural theory and philosophy at Florida A&M University (FAMU) and at the University of Puerto Rico. She also runs a consultancy in the fields of historic preservation, historical research and cultural interpretation, including work for the Republic of Panama's Office of the President.

Jaak Panksepp (1943–2017) was the Baily Endowed Chair of Animal Well-Being Science for the Department of Veterinary and Comparative Anatomy, Pharmacology, and Physiology at Washington State University, Head of the Chicago Institute for Neurosurgery, and Emeritus Professor of Psychology at Bowling Green State University. He is known for studying the neural mechanisms of emotion and for his research into laughter in non-human animals.

Corinne Perkin has worked at the Museum of Australian Democracy in Canberra, the Yarra Ranges Regional Museum, Bendigo Art Gallery and the Victoria & Albert Museum of Childhood. She is currently a research student in interdisciplinary cross-cultural research at the Australian National University, Canberra.

James E. Phillips is a Senior Research Fellow for Middle Eastern Affairs for the Heritage Foundation, Washington. He has written extensively on international terrorism and the global war against terrorism.

Peter Probst is a Professor and Chair in the Department of Art and Art History at Tufts University in Boston. He teaches African art and visual culture, and critical heritage studies. His publications include *Osogbo and the Art of Heritage: Monuments, Deities, and Money* (Indiana University Press, 2011).

Ciraj Rassool is a Professor at the University of the Western Cape's Faculty of Arts, where he directs the African Programme in Museum and Heritage Studies. His research focuses on public history, visual history and resistance historiography.

Paul Readman is a Professor in Modern British History and Vice-Dean for Research at King's College London. His research interests lie in modern British political and cultural history. He has published articles on electoral and agrarian politics, landscape preservation, the politics of patriotism, foreign policy, historiography and historical methods, and the place of the past in late-Victorian and Edwardian culture.

Simon Richards is a Lecturer at the School of Architecture, Building and Civil Engineering at Loughborough University. He specialises in modern and contemporary architecture theory, taking a special interest in how they are shaped by environmental determinist philosophies, neo-traditionalist aesthetics and discourses of national identity. His books are *Le Corbusier and the Concept of Self* (Yale University Press, 2003) and *Architect Knows Best* (Ashgate, 2012).

Sophie Robinson is a Volunteer and Community Involvement Consultant at the National Trust. Previously, she was the Project Coordinator of Stories of the World at Tyne and Wear Archives and Museums, and Education Manager at the Literary and Philosophical Society, and Mining Institute, Newcastle.

Naomi Roux is a Ray Pahl Fellow in Urban Studies 2016 at the African Centre for Cities. She is an urbanist and visual historian who researches the relationships between memory, public space and urban transformation.

Contributors

Raphael Samuel (1934–1996) was a British Marxist social historian who was best known for his advocacy of 'history from below', his work at Ruskin College in Oxford and his role in establishing the History Workshop, a group of radical historians and students.

John Schofield is a Professor, Head of Department and Director of Studies in Cultural Heritage Management at the University of York's Department of Archaeology. His research focuses on cultural heritage management, landscape, the contemporary past and conflict archaeology.

Philipp Schorch is currently a Marie Curie Research Fellow at the Department of Social and Cultural Anthropology at Ludwig-Maximilians-University in Munich, Germany. His project, Assembling the Transpacific: Indigenous Curatorial Practices, Material Culture and Source Communities, is a collaborative ethnographic investigation of contemporary indigenous curatorial practice.

Anna Sexton is a Research Associate in University College London's Department of Information Studies. Her PhD used action research to explore mental health and life history archives.

Neil Silberman is a Managing Partner of Coherit Associates, an international consultancy specialising in capacity building and participatory public heritage. He has been Director of the Ename Center for Public Archaeology and Heritage Presentation in Belgium, and was one of the founders of the Center for Heritage and Society at the University of Massachusetts Amherst.

Anthony Smith was an Emeritus Professor in Ethnicity and Nationalism at the London School of Economics and Politics Department of Government. His ethno-symbolic approach developed over the course of more than 100 publications, including *Nation and Classical Music: From Handel to Copland* (with Matthew Riley), which was published posthumously, in 2016 (The Boydell Press).

Alexander Stille is the San Paolo Professor of International Journalism at Columbia University in New York. His work focuses on politics and international affairs.

Marzia Varutti is an Associate Professor of Cultural History and Museology at the University of Oslo. Her academic interests include critical museum and heritage studies, museum anthropology and collaborative museology, museums and indigenous peoples, multiculturalism and cultural diversity, cultural heritage and collective memory, and national narratives.

Sheila Watson is an Associate Professor in the School of Museum Studies at the University of Leicester, UK. Prior to joining the School, she worked with the Museum Studies. She worked with deprived communities in Great Yarmouth where she chaired a Heritage Partnership and developed a new museum, Time and Tide, to serve the interests and needs of local people.

Christopher Whitehead is a Professor of Museology at the School of Arts and Cultures, Newcastle University. His research emphasises the cultural politics of memory, display, knowledge construction and interpretation, and at present he is working on the political uses of the past, time and place, and contested heritage.

Guðrún D. Whitehead is a Post-doctoral Fellow and Lecturer in Museum Studies at the University of Iceland. Her research interests include the impact and uses of cultural stereotypes

Contributors

(in particular the Viking myth in Iceland and Britain) in national and personal identities, historical narratives and cultural norms.

Leslie Witz is a Professor in the Faculty of Arts at the University of the Western Cape, South Africa. He researches how different histories are created and represented through memorials, museums, festivals and tourism.

Anna Woodham is a Lecturer in Arts and Cultural Management at King's College London, researching museums, collections and cultural policy. Prior to this, she worked at the Ironbridge International Institute for Cultural Heritage. Before joining the Ironbridge Institute, she worked for the Department for Culture, Media and Sport (DCMS).

Kathryn Woodward is a Visiting Informal Academic Emeritus Professor of the Open University Faculty of Arts and Social Sciences. Her main research interests lie in gender theories, diversity and embodied selves.

Series preface

Leicester Readers in Museum Studies provide students of museums – whether employed in the museum, engaged in a museum studies programme or studying in a cognate area – with a selection of focused readings in core areas of museum thought and practice. Each book has been compiled by a specialist in that field, but all share the Leicester department's belief that the development and effectiveness of museums relies upon informed and creative practice. The series as a whole reflects the core Leicester curriculum which is now visible in programmes around the world and which grew, 40 years ago, from a desire to train working professionals, and students prior to entry into the museum, in the technical aspects of museum practice. In some respects the curriculum taught then looks similar to that which we teach today. The following, for example, was included in the curriculum in 1968: history and development of the museum movement; the purpose of museums; types of museum and their functions; the law as it relates to museums; staff appointments and duties, sources of funding; preparation of estimates; byelaws and regulations; local, regional, etc. bodies; buildings; heating, ventilation and cleaning; lighting; security systems; control of stores and so on. Some of the language and focus here, however, indicates a very different world. A single component of the course, for example, focused on collections and dealt with collection management, conservation and exhibitions. Another component covered 'museum activities'; from enquiry services to lectures, films and so on. There was also training in specialist areas, such as local history, and many practical classes which included making plaster casts and models. Many museum workers around the world will recognise these kinds of curriculum topics; they certainly resonate with my early experiences of working in museums.

While the skeleton of that curriculum in some respects remains, there has been a fundamental shift in the flesh we hang upon it. One cannot help but think that the museum world has grown remarkably sophisticated: practices are now regulated by equal opportunities, child protection, cultural property and wildlife conservation laws; collections are now exposed to material culture analysis, contemporary documentation projects, digital capture and so on; communication is now multi-media, inclusive, evaluated and theorised. The museum has over that time become intellectually fashionable, technologically advanced and developed a new social relevance. *Leicester Readers in Museum Studies* address this change. They deal with practice as it is relevant to the museum today, but they are also about expanding horizons beyond one's own experiences. They reflect a more professionalised world and one that has thought very deeply about this wonderfully interesting and significant institution. Museum studies remains a vocational subject but it is now very different. It is, however, sobering to think that the Leicester course was founded in the year Michel Foucault published *The Order of Things*; a book that greatly influenced the way we think about the museum today. The writing was on the wall even then.

Simon Knell
Series Editor

Preface

This volume is intended to be an introductory reader for all undergraduate and postgraduate students of heritage studies, museum studies and those interested in how we conceptualise and use the past. It widens the scope of heritage studies, drawing on a range of disciplines currently rarely utilised in the relatively recent turn to heritage as well as including the best from more established elements of the field. We have seen heritage's revival as a respected academic subject as a result, in part, of the championship of indigenous rights and a growing respect for the intangible. Heritage has thus focused on management, tourism and the use of traditional 'heritage minded' disciplines such as archaeology and geography, social and cultural theory to support identity and community cohesion as well as championing new approaches to ethics and value, particularly those of indigenous societies and non-Western communities. This edited volume, while retaining some core historic texts and including some of the best new writing in the areas above, also explores heritage through relatively new areas of knowledge which include emotion and affect, the politics of dissent, migration and intercultural, and participatory dimensions of heritage.

The book aims to reproduce papers that are not easily obtainable by those who do not have access to a university library, and papers that are quite simply just not thought of as 'heritage' but nevertheless add something significant to the debate about what heritage is and what it can do, as well as how it works and for whom. We believe there is need for a reader that looks beyond the traditional concerns of this discipline and encourages students and practitioners to engage with more interdisciplinary materials and ideas than is usual in heritage. It also aims to widen the voices of those who care about heritage beyond the professional sphere and serve as a reminder that heritage is not just the concern of the academic but is a deeply felt and keenly valued public and private practice.

Our choice of papers in this volume suggests that while heritage has developed exponentially as more academics take it seriously, it has also lost a degree of flexibility and, perhaps, misses some key concepts to be found in other disciplinary traditions such as cognitive science, migration studies, and in particular, museum studies. Overlapping but arguably distinctive disciplines, museum studies and heritage have grown up with different academic parents, but where has this left us today? While museum studies has historically regarded heritage with a degree of misgiving, heritage has looked upon the museum as but one of the many sites where heritage happens or has ignored it altogether. Is there evidence to suggest that this uneasy relationship has entered a different phase? And what wider implications does this have for how we conceptualise the study of the past and its role in the present?

We thus seek to add to the discussion about heritage a range of observations and theories from museum studies that are rarely encountered within the heritage studies field (which seeks to distance itself from museum studies so that it can be seen as a separate discipline), but

xxii

nevertheless have something significant to say about it. For example, Dudley's paper (2010), though almost entirely focused on the object in the museum, nevertheless raises issues of materiality and affect, that impact upon our understanding of areas of study often labelled as heritage, not museum studies. Matthews's paper (2013, this volume) on the Canadian War Museum, by comparing two affective objects, a car formerly owned by Adolf Hitler and Gertrude Kearns' 1996 painting of a corporal posing next to a tortured Somali teenager, offers methods of analysis of the force of affect, something that has implications not only for cultural studies from which much of the methodology is taken, but also for heritage studies as well as museum studies.

Sheila Watson, Amy Jane Barnes and Katy Bunning
Editors

Acknowledgements

The editors are indebted to many individuals and organisations for making this edited book possible. We would like to thank Professor Simon Knell, Dr Jennifer Walklate, Associate Professor Lisanne Gibson and the staff at Routledge in particular for their advice and support with this project.

We would like to thank the following for their kind permission to reproduce copyrighted material. Acknowledgements for the kind permission to use images appear within the chapters. While every effort has been made to trace copyright holders and obtain permission, this has not been possible in all cases. Any omissions brought to our attention will be remedied in future editions.

Part I

Harvey, D.C. (2001). 'Heritage pasts and heritage presents: temporality, meaning and the scope of heritage studies', *International Journal of Heritage Studies*, 7 (4), pp. 319–338. Reproduced with permission.

Bennett, A. (2012). Extracts from *People*. London: Faber and Faber, pp. v–xvi, 18–21, 25–34. Reproduced with permission.

Jenkins, T. (2011). 'The crisis of cultural authority', *Contesting Human Remains in Museum Collections: The Crisis of Cultural Authority*. London and New York: Routledge, pp. 54–78. Reproduced with permission.

Editorial Collective/Raphael Samuel. (1976). 'Editorials: *History Workshop Journal*', *The History Workshop Journal*, 1, pp. 1–3. Reproduced with permission.

Samuel, R. (2012) [1994]. 'Hybrids', *Theatres of Memory: Past and Present in Contemporary Culture*. London: Verso: pp. 429–447. Reproduced with permission.

Pabón, A. (2003). 'Por la encendida calle antillana: Africanisms and Puerto Rican architecture', *Journal of Heritage Stewardship*, 1 (1), pp. 14–32. Reproduced with permission.

Probst, P. (2012). Extracts from 'Iconoclash in the age of heritage', *African Art*, 45 (3), Autumn. Reproduced with permission.

Part II

Landry, T.R. (2010). 'Touring the slave route: inaccurate authenticities in Bénin, West Africa', in Silverman, H. (ed.) *Contested Cultural Heritage: Religion, Nationalism, Erasure, and Exclusion in a Global World*. New York: Springer, pp. 205–232. Reproduced with permission.

Jones, M. (1990). 'Why fakes?', in Jones, M. (ed.) *Fake? The Art of Deception*. London: British Museum Publications Ltd., pp. 11–16. Reproduced with permission.

Benjamin, W. (1968). 'The work of art in the age of mechanical reproduction', in Arendt, H. (ed.), translated by Zohn, H. *Illuminations*. New York: Schocken, pp. 211–244. Reproduced with permission.

Gable, E. and Handler, R. (1996). 'After authenticity at an American heritage site', *American Anthropologist*, 98 (3), September, pp. 568–578. Reproduced with permission.

Stille, A. (2014). 'Makeover for Mont-Saint-Michel: a renovation project harnesses the power of the sea to preserve one of the world's most iconic islands', *Smithsonian*, June, pp. 77–85, 102–104, 106. Reproduced with permission.

Greenblatt, S. (1991). 'Resonance and wonder', in Karp, I. and Lavine, S.D. (eds) *Exhibiting Cultures: The Poetics and Politics of Museum Display*. Washington and London: Smithsonian Institution Press, pp. 42–56. Reproduced with permission.

Bendix, R. (1997). 'Introduction', *In Search of Authenticity: The Formation of Folklore Studies*. Madison: University of Wisconsin Press, pp. 3–23. Reproduced with permission.

Part III

Hemmings, C. (2005). 'Invoking affect', *Cultural Studies*, 19 (5), pp. 548–567. Reproduced with permission.

Panksepp, J. and Biven, L. (2012). Extracts from *The Archaeology of Mind: Neuroevolutionary Origins of Human Emotions*. New York and London: WW Norton and Company. Extracts from Chapter 1. Reproduced with permission.

Matthews, S. (2013). '"The trophies of their wars": affect and encounter at the Canadian War Museum', *Museum Management and Curatorship*, 28 (3), London and New York: Routledge, pp. 272–287. Reproduced with permission.

Maddern, J. (2004). 'Huddled masses yearning to buy postcards: the politics of producing heritage at the Statue of Liberty–Ellis Island National Monument', *Current Issues in Tourism*, 7 (4–5), pp. 303–314. Reproduced with permission.

Kushner, T. (2002). 'The Holocaust and the museum world in Britain: a study of ethnography', *Immigrants and Minorities*, 21 (1), pp. 12–40. Reproduced with permission.

Ashworth, G.J. and Graham, B. (2005). 'Senses of place, senses of time and heritage', *Senses of Place: Senses of Time*. Aldershot: Ashgate, pp. 3–12. Reproduced with permission.

Meskell, L. (2011). 'Making heritage pay in the Rainbow Nation', *The Nature of Heritage: The New South Africa*. Oxford: Wiley-Blackwell, pp. 37–62. Reproduced with permission.

Smith, A. (2008). 'The concept and its varieties', *The Cultural Foundations of Nations: Hierarchy, Covenant and Republic*. Malden, MA, and Oxford: Blackwell, pp. 12–28. Reproduced with permission.

Acknowledgements

Dudley, S. (2012). 'Materiality matters: experiencing the displayed object', University of Michigan Occasional papers online. Reproduced with permission.

Woodward, K. (1997). 'Concepts of identity and difference', in Woodward, K. (ed.) *Identity and Difference*. London, Thousand Oaks and New Delhi: Sage Publications, in association with The Open University, pp. 2, 8–23, 38. Reproduced with permission.

Black, J. (2005). 'The Third World', *Using History*. London: Hodder Headline Group, pp. 150–174. Reproduced with permission.

Gilmour, N. (2006). 'Turkish delight: Antonio Gala's *La pasión turca* as a vision of Spain's contested Islamic heritage', *Arizona Journal of Hispanic Cultural Studies*, 10, pp. 77–94. Reproduced with permission.

Readman, P. (2014). '"The cliffs are not cliffs": the cliffs of Dover and national identities in Britain, c.1750–c.1950', *The Historian*, 99 (2), No. 335, April [John Wiley and Sons, and the Historical Association]. Reproduced with permission.

Part IV

Bodo, S. (2012). 'Museums as intercultural spaces' in Sandell, R. and Nightingale, E. (eds) *Museums, Equality and Social Justice*. London and New York: Routledge, pp. 181–191. Reproduced with permission.

Varutti, M. (2011). 'Gradients of alterity: museums and the negotiation of cultural difference in contemporary Norway', in Naguib, S. *et al.* (eds) *Patterns of Cultural Valuation: Priorities and Aesthetics in Exhibitions of Identity in Museums* [Special Issue], *ARV. Nordic Yearbook of Folklore*, 67, pp. 13–36. Reproduced with permission.

McCarthy, Conal, Mason, Rhiannon, Whitehead, Christopher, Ingemann Parby, Jakob, Cicalo, André, Schorch, Philipp, Witz, Leslie, Alonso Gonzalez, Pablo, Roux, Naomi, Ambos, Eva and Rassool, Ciraj (2013). 'Museums in a global world: a conversation on museums, heritage, nation and diversity in a transnational age', *Museum Worlds*, 1 (1), pp. 179–194. Reproduced with permission.

Daehnke, J. (2012). 'Reflections on the *Confluence Project*: assimilation, sustainability, and the perils of a shared heritage', *American Indian Quarterly*, 36 (4), pp. 503–524. Reproduced with permission.

Silberman, N. (2011). 'Heritage interpretation and human rights: documenting diversity, expressing identity, or establishing universal principles?', *International Journal of Heritage Studies*, 18 (3), pp. 245–256. Reproduced with permission.

Part V

Flinn, A. and Sexton, A. (2013). 'Research on community heritage: moving from collaborative research to participatory and co-designed research practice', CIRN Prato Community Informatics Conference paper. Reproduced with permission.

Perkin, C. (2010). 'Beyond the rhetoric: negotiating the politics and realising the potential of community-driven heritage engagement', *International Journal of Heritage Studies*, 16 (1–2), pp. 107–122. Reproduced with permission.

Cimoli, A.C. (2014). 'From representation to participation: inclusive practices, co-curating and the voice of the protagonists in some Italian migration museums', *International Journal of the Inclusive Museum*, 6, pp. 111–121. Reproduced with permission.

Kiddey, R. and Schofield, J. (2011). 'Embrace the margins: adventures in archaeology and homelessness', *Public Archaeology*, 10 (1), pp. 4–22. Reproduced with permission.

Morse, N., Macpherson, M. and Robinson, S. (2012). 'Developing dialogue in co-produced exhibitions: between rhetoric, intentions and realities', *Museum Management and Curatorship*, 28 (1), pp. 91–106. Reproduced with permission.

Onciul, B. (2013). 'Community engagement, curatorial practice, and museum ethos in Alberta, Canada', in Golding, V. and Modest, W. (eds) *Museums and Communities: Curators, Collections and Collaboration*. London: Berg Publishers. Reproduced with permission.

Part VI

Creighton, O. (2007). 'Contested townscapes: the walled city as world heritage', *World Archaeology*, 39 (3), pp. 339–354. Reproduced with permission.

Macdonald, S. (2009). 'Reassembling Nuremberg, reassembling heritage', *Journal of Cultural Economy*, 2 (1–2), pp. 117–134. Reproduced with permission.

Lehrer, E. (2010). 'Can there be a conciliatory heritage?', *International Journal of Heritage Studies*, 16 (4–5), pp. 269–288. Reproduced with permission.

Basu, P. (2007). 'Palimpsest memoryscapes: materializing and mediating war and peace in Sierra Leone', in de Jong, F. and Rowlands, M. (eds) *Reclaiming Heritage: Alternative Imaginaries of Memory in West Africa*. Walnut Creek, CA: Left Coast Press, pp. 231–258. Reproduced with permission.

Beaumont, J. (2009). 'Contested trans-national heritage: the demolition of Changi prison, Singapore', *International Journal of Heritage Studies*, 15 (4), pp. 298–316. Reproduced with permission.

Crooke, E. (2010). 'The politics of community heritage: motivations, authority and control', *International Journal of Heritage Studies*, 16 (1–2), pp. 16–29. Reproduced with permission.

Phillips, J.E. (2005). '"To Make the Dry Bones Live": Amédée Forestier's Glastonbury Lake Village', in Smiles, S. and Moser, S. (eds) *Envisioning the Past: Archaeology and the Image*. Oxford: Blackwell, pp. 72–91. Reproduced with permission.

Bender, B. (2001). 'Introduction' in Bender, B. and Winer, M. (eds) *Contested Landscapes: Movement, Exile and Place*. Oxford and New York: Berg, pp. 1–18. Reproduced with permission.

Lankauskas, G. (2006). 'Sensuous (re)collections: the sight and taste of socialism at Grūtas Statue Park, Lithuania', *The Senses and Society*, 1 (1), March, pp. 27–52. Reproduced with permission.

Introduction

Sheila Watson, Amy Jane Barnes and Katy Bunning

What is heritage?

Is there really no such thing as heritage, as Laurajane Smith asserts in her seminal work on the subject (Smith 2005: 11)? Of course Smith was writing, here, about a certain type of material culture, expressed through what she describes as Authorised Heritage Discourse (AHD). This description covers the complex methods by which she asserts Western elites maintain their own versions of the past for their own specific purposes, undermining alternative or subaltern heritage ideas. For Smith and others this monumental and aesthetically pleasing concept of heritage is something imposed on individuals who are less able to manage the professional terminology and qualifications required of those who work in the heritage industry, either because they lack the education or the interest in such matters.

Such an interpretation of the role of heritage, an imposition of an elite culture, may work well as an explanation of some of its practices in former colonial countries, where both indigenous peoples and white settlers seek to establish a set of values and heritage independent of the former rulers. However, such concepts work less well in nations that have a deeper antiquity. There, we would argue, heritage is less imposed than negotiated and there is always a choice as to what should or should not be respected as something of value in the past. Here, heritage is whatever we understand of the past and how we manage that understanding. It is both personal and public, and we all exercise a freedom to take it or discard it as we wish. Andy Wood's study (2013) of the ways English people used memories of the past to create narratives of liberty from serfdom during the later Middle Ages and up to early modern times, and the role of landscape, buildings and family histories in these memories, demonstrate that heritage was not necessarily authorised discourse at this time, as we shall see from some of the papers in this volume, later. In this case it was not imposed from above but managed and cultivated by those who had little power and very little influence in society. Here heritage contributes something useful to museum studies, enabling us to understand that the study of the museum institution, its founders, funders and governors as regulators of the world and the society in which the museum is situated, needs to take account of the visitor experience inside and outside the walls of the museum perhaps more than it has done in the past.

Wood's research illustrates one of the many difficulties we face if we try to establish heritage as a separate discipline from that of history. In a similar manner, museum studies often provides

heritage with considerable insights yet all too often these are omitted from volumes on heritage so we have included some in our first part. However, the whole Reader is an appeal to think about heritage as not being a specialised discipline as such but a study of what we value in the past, and how we remember it and why. Thus, for the purpose of this Reader we understand heritage to be any collective or individual memories, material culture or practices that are valued as a means to make sense of the past for the present. These may well be formal ceremonies, objects in museums and imposing public monuments but often, as we shall see, include a range of informal negotiations which select specific events, ideas and individuals from the past as a means of managing and influencing present day circumstances.

Much has been written in recent years that seek to contextualise the developments in heritage of the 1980s, 1990s and 2000s within its historical trajectory (see Harrison 2013, for instance). In the first part of the book, we update the traditional discourse on the historical development of conceptions of heritage by introducing other voices, including those of new and established writers, some from outside the field. In the current English language literature on heritage, privilege is often given to European and, more broadly, Western histories and understandings of heritage. This volume will include chapters that look at developments in other parts of the world, particularly where notions of heritage have been contested.

Critical heritage

Most recently there has been a movement to create a new type of heritage studies, 'critical heritage', that seeks to distance itself from Western values and disciplines, and embraces a more inclusive perspective of what constitutes heritage. Inevitably this tends to create a binary positioning of heritage – the West versus the rest – which is no doubt unintentional but which is not helpful for various reasons. First, in order to eschew the Western position one must make various assumptions about its ubiquity and influence. Much heritage is hybrid. The West is good at adapting and adopting attitudes and values from other cultures, assimilating and promoting them. In a similar manner, many cultures now adapt and adopt Western concepts of museums and built heritage memorials which to an observer may be very different types of institutions from those found in Europe, North America and Australia. Second, this critical heritage still assumes many of the values of the 'older' heritage, Rodney Harrison points out that in Europe on the whole we do not value the far right's use of heritage and tend to ignore it (Harrison 2013). One might also add that critical heritage tends to value the heritage of the poor, oppressed and marginalised over that of the elite or the 'middle' classes, something traditional heritage practitioners have been doing for several decades. Third, institutions such as universities and many individuals have moved beyond the idea that heritage is just about the built or natural environment and recognise that heritage is performed, internalised and used by all people all of the time, consciously or unconsciously. Critical heritage, with its emphasis on the intangible and the affective forms of heritage, champions this stance but does not say much that is new here. At the third biannual conference of Critical Heritage in Montréal in June 2016 one practitioner, on hearing a debate on critical heritage, stated she had worked in heritage for 25 years and had yet to hear anything new.

Thus this volume, while acknowledging the important role the revival of interest in heritage that the Critical Heritage Movement has engendered and welcoming the forum it has opened up for people of any disciplines to meet and work together, does not subscribe to the view that this is a development that has changed heritage practice and theory in any fundamental manner. Nevertheless, it suggests that we should continue to try and engage more deeply with issues that critical heritage attempts to address such as the nature of the relationships between forms of heritage and contemporary inequalities.

Authenticity and tourism

Authenticity is at the heart of heritage, a concept developed out of the professionalisation of the practice of heritage and its emergence as a discipline. In our second part we consider some key ideas relating to a notion that is as controversial as it is fluid and complex. The power to determine what is and is not authentic remains contested and can be a political tool in the politics of resistance, particularly amongst oppressed minorities and indigenous groups, and this has attracted considerable interest in academia especially from settler societies in the West such as Australia and the United States of America. Authenticity has also attracted the attention of those who write on tourism, who tend to focus on the consumer rather than on those who practice it. In museums the notion of authenticity is part of the magic that gives them and their professionals so much authority and power. Museums are trusted in part because they have the real, authentic thing – that tangible reality that confirms our knowledge. However, museums and heritage studies recognise that authenticity is not tangible. Indeed it rests in the minds of the observer, and creates a form of aura or wonderment that is difficult to define. Moreover, as tourism studies have found, it often resides in experience rather than in material culture. Authenticity is also a key reason for the difficulties experienced by those who curate history. If we move beyond the object to interpretation, at what point does the latter become more authentic in the eyes of the beholder than the object itself and how do we ensure interpretive strategies are transparent, particularly when they involve methods such as re-creations, living history, digital reconstructions or imagined illustrations? Here, immersion tends to overcome critical reasoning and is this ethical? Tourists themselves have a sophisticated way of understanding what is 'real' and 'what is made up', and are comfortable with a mixture of both (Gable and Handler 1997).

Emotional encounters

Following on from authenticity and its intangible nature, we consider the role of emotion in heritage. Over the last two decades increasing attention has been paid to notion of emotion as of crucial importance in human thought and action. This turn has emerged from a range of disciplines, including the fields of cognitive science – psychology, neuroscience, philosophy, anthropology, etc. (Hogan 2011: 1). Similarly more interest has been paid to the idea of affect and the way in which it helps us understand the world (Callard and Papoulias 2010). For example, disciplines such as English (that only infrequently influence heritage studies), have developed ways of deconstructing narrative so that we understand its affect (Hogan 2011). Within the field of museum studies academics such as Sandra Dudley (2010, 2012 this volume) have problematised the nature of the object and its effect upon humans. Emotions are beginning to play a more important role in our understanding of learning and experience in museums and heritage sites. It has long been accepted that emotions are important in the way we relate to the past and to its markers but this has rarely been investigated empirically and is usually understood as a given although there are some indications that this topic is eliciting more attention now (Watson 2013). Part III of the Reader is therefore concerned with the things we often find difficult to articulate but we nevertheless experience every day – emotion and affect.

Diversity

In the fourth part of this book, we explore the links between often complex and sometimes contested perceptions of heritage and how these intersect with ideas about nationhood and identity, in particular, the multi-layered identities created by migration and transnationalism.

The chapters in Part IV look at how heritage is constructed and is used as an expression of national or cultural identity, as an expression of influence over a particular geographical area or community, or in throwing off the legacy of colonialism and the forging of new national identities. They consider how a sense of personal or community heritage is shaped, experienced and made manifest, and how some 'heritages' are legitimised over others to suit narratives of nationhood. These chapters consider: how diverse and multi-vocal expressions of heritage are represented, valued and incorporated into national, often homogenised, narratives of heritage; how theoretical approaches to identity politics underpin conceptions of national heritage; how stereotypes of national identity and heritage are understood and enacted in the imaginings of other nations; and how and why Western conceptions of history and heritage continue to dominate the construction and expression of the heritage narratives of postcolonial nations, despite the existence of rich, indigenous conceptualisations of heritage and identity. The papers included here take a range of international perspectives, and derive from different disciplinary areas of scholarship, including history, literature, tourism, politics, heritage and visual culture.

Participatory heritage

Our fifth part focuses on the ways in which heritage professionals have sought to enhance community involvement and experiment with models of practice which centralise community interpretations. Rather than a defined set of practices, the shift towards participatory processes of heritage-making takes many forms and emanates from different agendas within the cultural, heritage and museum fields. Part V offers a focused look at several experiments in participatory practice, involving the sharing of meaning-making and decision-making processes between heritage professionals and their communities, and drawing on failures as well as successes in engaging participants.

Participatory heritage is an expanding area of practice and research which requires new conceptual tools and frameworks for assessing impact, for both the communities and organisations involved. At stake are issues of expertise and where this lies, the avoidance of tokenism and damaging relations with publics, and the potential for the fundamental transformation of organisational values and processes of heritage and its interpretation towards more audience-centred goals. This part helps to unpack participatory approaches in heritage and museums, particularly around the co-production of exhibitions, and presents some of the ways in which this work is beginning to be more deeply conceptualised and theorised.

Conflicted histories and disputed heritage

Much is contested in heritage and, despite developments in participatory approaches outlined above, there are still many examples of heritage and histories that lead to divisions in society and between different nations. How are difficult and challenging histories interpreted in heritage contexts? And what is the role of memory in mediating the complexity of heritage narratives? What happens when one religious group deems another group's sacred heritage as heretical or idolatrous? As we write this (2016), a Mali extremist has been sent to prison for nine years after being found guilty of the destruction of Timbuktu's mausoleums and the ancient door of the city's Sidi Yahya mosque – the first person to be found guilty of cultural destruction as a war crime at the International Criminal Court at the Hague. Deliberate destruction of material culture deemed to be heritage is all too often part of a war campaign.

Through chapters that explore the use of heritage as a means of controlling, including and excluding populations from heritage narratives; the 'reassembling' (Macdonald 2009) and

reinterpretation of sites associated with contested and difficult histories; the concretisation of time-specific perspectives on heritage; the adoption of an Other within heritage for national and commercial interests; or the multi-layered 'memoryscapes' of post-war contexts (Basu 2007), the final part of this book considers the role of memory in the creation of objects, sites and intangible expressions of heritage, with a particular focus on those histories that are disputed and differently prioritised by diverse, sometimes transnational stakeholders.

Conclusion

Disciplinarity has been a way by which academics order the world. The world is, however, little affected by this mode of thinking. There has come a time when we rethink why we insist on creating artificial barriers between subjects, persisting in regarding academic writing as something which belongs within a framework of an established mode of creativity that often results in a silo like approach to other methodologies and ideas. History, anthropology, geography, cultural studies and archaeology are amongst those disciplines that have begun to embrace a wider notion of what their modes of study have hitherto embraced. We hope this Reader will encourage those who are interested in heritage in all its multiple forms to think creatively, 'outside the box' of its current disciplinary modes, and embrace new ways of thinking about this fascinating subject.

Bibliography

Basu, P. (2007). 'Palimpsest memoryscapes: materializing and mediating war and peace in Sierra Leone', in de Jong, F. and Rowlands, M. (eds) *Reclaiming Heritage: Alternative Imaginaries of Memory in West Africa*. Walnut Creek, CA: Left Coast Press, pp. 231–258 (this volume).

Bodo, S. (2013). 'New paradigms for intercultural work in museums – or intercultural work as a new paradigm for museum practice?', LEM Project Museums and Intercultural Dialogue. www.lemproject.eu/WORKING-GROUPS/Intercultural-dialogue/4rd-report-museums-and-intercultural-dialogue, accessed 16 February 2017.

Callard, F. and Papoulias, C. (2010). 'Affect and embodiment', in Radstone, S. and Schwarz, B. (eds) *Memory: Histories, Theories, Debates*. New York: Fordham University Press, pp. 246–262.

Dudley, S. (2010). *Museum Materialities: Objects, Engagements, Interpretations*. London and New York: Routledge.

Dudley, S. (2012). 'Materiality matters: experiencing the displayed object', University of Michigan Occasional papers online, https://deepblue.lib.umich.edu/bitstream/handle/2027.42/102520/8_dudley_2012.pdf?sequence=1, accessed 16 February 2017 (this volume).

Fairclough, G., Harrison, R., Jameson, J. and Schofield, J. H. (eds) (2008). *The Heritage Reader*. London and New York: Routledge.

Gable, R. and Handler, E. (1997). *The New History in an Old Museum: Creating the Past at Colonial Williamsburg*. Durham: Duke University Press.

Harrison, R. (2013). 'What is heritage?', in Harrison, R. (ed.) *Understanding the Politics of Heritage*. Manchester: Manchester University Press, pp. 5–42.

Hogan, C. (2011). *Affective Narratology: The Emotional Structure of Stories*. Lincoln and London: University of Nebraska Press.

Macdonald, S. (2009). *Difficult Heritage: Negotiating the Nazi Past in Nuremberg and Beyond*. London: Routledge.

Matthews, S. (2013). '"The trophies of their wars": affect and encounter at the Canadian War Museum', *Museum Management and Curatorship*, 28 (3), pp. 272–287 (this volume).

Smith, L. (2005). *Uses of Heritage*. London and New York: Routledge.

Watson, S. (2013). 'Emotions in the history museum', in Witcomb, A. and Message, K. (eds) *Museum Theory: An Expanded Field*. Oxford: Blackwell, pp. 283–301.

Wood, A. (2013). *The Memory of the People: Custom and Popular Senses of the Past in Early Modern England*. Cambridge: Cambridge University Press.

Part I
Heritage contexts, past and present

Introduction to Part I

Amy Jane Barnes

How have understandings of what constitutes heritage and who controls it, shifted over time? In this opening section, we consider contexts of heritage, both past and present. The first half considers conceptions of heritage during a period when Euro-American perspectives came to dominate global discourse on the subject, particularly through the implementation of international conventions in the mid- to late-twentieth century. It explores the conception of heritage, emerging largely from European contexts, and its codification via various national legislation and international conventions.

The part begins with David C. Harvey's 'Heritage pasts and heritage presents: temporality, meaning and the scope of heritage studies', first published at the turn of the millennium. Harvey considers the 'historical scope' of heritage as a discipline of scholarly practice. He argues that understandings of heritage are 'historically contingent and embedded' and considers 'heritage as a cultural process'. Understanding heritage in this way sets up 'debates about the production of identity, power and authority throughout society', with which the authors represented in the second part of this section engage. Harvey's chapter considers the long history of how people have thought about and related to the past beyond the narrow confines of disciplinary perspectives and the so-called 'official heritage' – in particular, Western-centric conceptions of heritage rooted in modernist discourse, spread around the world via the agency of colonialism, and codified in international heritage legislation, most notably by the United Nations Educational, Scientific and Cultural Organisation (UNESCO) World Heritage Convention (1972) in the second half of the twentieth century (see Harrison 2012; Waterton 2010). By his own admission, Harvey 'merely scratches the surface' but prompts us to think about heritage and its practice, in particular, in ways that this volume, similarly, seeks to develop.

In the latter part of the twentieth century, certainly in the UK and North America, an emergent 'heritage industry' (first coined by Robert Hewison in 1987) boomed thanks, in part to increased leisure time and mobility, de-industrialisation and urban regeneration (Harrison 2012: 84–85, 227). As Harvey notes in his chapter, some commentators, Hewison among them, have presented this 'new heritage' as suspect, for its capitalist associations and perceived consequential inauthenticity. The precarious position of independent museums in the UK, often considered to be a manifestation of this commercialised and commodified understanding of heritage, is considered in a new paper, 'Museum studies and heritage: independent museums and the "heritage

debate" in the UK', by Anna Woodham. As a discipline, museum studies is often seen as something distinct from and sometimes at odds with heritage studies. There is no better example from which to challenge this artificial disciplinary distinction than an examination of attitudes shown towards independent museums. The subject offers a means by which to reflect instead on what Woodham argues are the 'entangled' histories of museum studies and heritage studies.

Continuing the debate around commercialisation and heritage, Alan Bennett describes his 'unease' on visiting a National Trust property, in extracts from the introduction to his play *People* (2012); a sense of dissatisfaction with the experience, that prompted his writing of the play (extracts of which are also reproduced here). Bennett highlights, what he perceives to be, a distasteful 'level of marketing' in evidence at many historic homes, which places an emphasis on controversial personalities and prurient stories. In the extract from *People*, Bennett sends this up:

> a series of full chamber pots used by the great and the good of British society, are perceived by Lumsden, the man from the National Trust, as a unique marketing hook for the stately home in which they are housed.

In a provocative chapter, ostensibly about the issues associated with retaining and repatriating human remains, Tiffany Jenkins argues that internalised questioning of the museum as an institution of cultural authority, is leading to an increasingly weakened, destabilised sector. In so doing, Jenkins provides an overview of the key intellectual debates that have influenced the cultural sphere and, by extension, the study and conceptualisation of heritage in post-colonial/post-modern contexts. A critic of the 'new museology', which gained intellectual currency from the late 1980s in the UK and beyond, Jenkins argues that the contestation of museums' cultural authority and efforts to newly justify their value and re-legitimise their societal and cultural role, has largely come from within. And yet, this has failed to influence the ongoing representation of the museum as 'monolithic and resistant to change'. In short, she argues, museology 'is prone to interpreting [itself] primarily as a profession still committed to objectivity, reacting to and defying external challenges to its authority'. Through analysis of interviews carried out with museum professionals, Jenkins reveals a tension between the perceived shortcomings of museums and museum staff in the past (too collections-focused, too intent on retaining cultural authority), the expectations of policy-makers and governmental rulings and of self-reflexive contemporary practice.

The first of the following two papers is credited to the 'Editorial Collective', a group comprised of 'activists' (Taylor 2008) dedicated to the promulgation of non-hegemonic 'history from below'. In this 'manifesto' (Taylor 2008), which appeared in the launch issue of the influential left-leaning *History Workshop Journal* (1976), the 'Collective' makes an impassioned case for 'bring[ing] the boundaries of history closer to people's lives', and for democratising the discipline and working class experience into history. They write of a 'narrowing of the influence of history in our society, and its progressive withdrawal from the battle of ideas', presenting the 'Serious history' of the mid-1970s, as moribund, regressive and 'shrinking'. The *History Workshop Journal*, it is argued, seeks to revitalise the discipline by recognising and loosing itself from the legacy and limitations of so-called 'Whig history', with its emphasis on human progression towards enlightenment, by instead, empowering 'ordinary people', in other words, those from outside the academy, to engage in historical research, interpretation and criticism, and by advising scholars to strive for 'clarity and accessibility' in their own work. The influence of 'history from below' on heritage, at least as it is practiced in the UK, is encapsulated in Robertson's conceptualisation that it is 'about people, collectivity and individuals, and about their sense

of inheritance from the past and the uses to which this inheritance is put. It is about the possibilities that result from that deployment of the past' (2012: 1).

Among the *History Workshop Journal*'s founding 'Editorial Collective' (and most likely a major contributor to the manifesto considered above), was the prominent Marxist historian, Raphael Samuel. In the next chapter, 'Hybrids', first published in 1996, Samuel presents his contention that history is a hybridised narrative contingent on the concerns of the present day and, despite the discipline's claims to truth and authenticity, always has been so: 'However faithfully we document a period and steep ourselves in the sources, we cannot rid ourselves of afterthought. However jealously we protect the integrity of our subject matter, we cannot insulate it from ourselves'. This perspective provides us with additional insight into artificial separations between history (as a discipline) and heritage, particularly the perceived differences between so-called 'national history' and 'cultural heritage' (certainly in dominant Euro-American contexts). He accuses history of 'fetishising' documentary evidence. This, he argues, has roots in the political and administrative needs of medieval society to establish 'fact' and 'right', which gathered influence as 'scientific history' during the nineteenth century and was ultimately codified in the mid-twentieth century in the professionalisation of history as a discrete discipline. This, despite the long-standing, if rather shady practice of 'knowledge-based invention', was employed in order to establish foundation stories, and establish 'fact' after the event. While 'the language of history' gives the impression of 'fixity and definition', all history is an invention of sorts, only masquerading as factual and authentic. 'Rival narratives' – the ever-present legends, fables and stories, the stuff of cultural heritage – challenge this 'record-based history'.

In a section of their manifesto not reproduced here, the Editorial Collective (1976) emphasise the value of examining 'historical consciousness': the 'variety of influences – often contradictory – which go to make [it] up' as a component of 'history from below'. In a new paper, Ceri Jones considers the application of Rüsen's conceptualisation of historical consciousness to '[bridging] the gap between history [the discipline of] and heritage [as an ambiguous and contested concept] to understand both as a way of making sense of the past in the present'. Her analysis and critique of this theoretical approach, considers its usefulness as a 'starting point for thinking about how [the cognitive and cultural ways in which we conceptualise the past] might shape and influence encounters with heritage sites'. Through a discussion of international examples, Jones explores the impact of Rüsen's forms of historical consciousness (traditional, exemplary, critical and genetic) on how visitors conceptualise the past, present and future as 'active meaning-makers', both cognitively and emotionally.

In 'Weighing up intangible heritage: a view from Ise', Simon Richards considers the development, impact and contentious debates surrounding the UNESCO Convention for the Safeguarding of the Intangible Cultural Heritage (2003), introduced as a means of mitigating against the Eurocentric bias of established conceptions of 'heritage' and recognising other ways of performing and understandings of what that constitutes. Through the lens of the Shinto shrine complex at Ise, Japan, Richards explores notions of authenticity and cultural aesthetics in heritage debates, which neatly leads into the second part of this section, which looks at heritage pasts and presents from alternative, often non-dominant perspectives.

In the current English-language literature on heritage, privilege is often given to European and, more broadly, Western understandings of heritage and related practice, which have frequently been criticised as hegemonic (see, for example, Kreps 2005; Smith 2006; Byrne 1991). The chapters in the remainder of this section look at developments in other contexts, particularly where *established* (read: Eurocentric) notions of heritage have been translated, perhaps subverted and contested. This is not to pass judgement on the supposed validity of past/present contexts over one or the other but simply to highlight recent developments in the field and to

bring English-language readers into contact with other understandings and practices of heritage in post-colonial contexts, beyond the dominant debates with which they may well be most familiar.

Cintia Velázquez Marroni considers the concept of patrimony (*patrimonio*), which can be loosely translated from Spanish as 'heritage' but with an additional sense of 'kinship' and 'inheritance'; a notion strongly tied to the sense of national identity in post-colonial, hybrid, culturally diverse Mexico. She considers its origins and its contemporary adaptations vis-à-vis globalised understandings of heritage, most notably via UNESCO and the private sector. Velázquez Marroni analyses these changing definitions present in the cultural sphere – an increasingly inclusive understanding of the concept that encompasses 'living' cultural knowledge, natural landscapes and indigenous culture, as much as it includes monuments, museums and historical sites – but, in contrast with national legislation, which remains focused on archaeological remains and antiquities.

The role of inheritance and kinship in the conceptualisation of heritage is a theme also explored by Guðrún D. Whitehead in the following chapter, in which she looks at constructions and uses of heritage in Iceland, DNA and Viking genealogy. She demonstrates how this 'racial heritage' is asserted in both outward-facing tourism and in ways in which Icelanders perceive themselves, individually and nationally, through case studies as diverse as representations of nature and landscape, saga manuscripts, indigenous religion and Gay Pride.

Arleen Pabón considers understandings of heritage in the Caribbean and, specifically, in Puerto Rico – a country with a rich cultural identity rooted in Africa, but one which is barely visible in the built heritage and largely disregarded by scholars and preservationists. This paper seeks to address this lack by rejecting the dominant norms of Eurocentric interpretation and giving due attention to the cultural and social significance of the subtle 'Africanisms' and resulting adaptations built into Puerto Rican domestic architecture.

Concluding this section are extracts from 'Iconoclash in the age of heritage', first published as an editorial in a special issue of *African Arts* (2012), in which Peter Probst considers heritage in African nations as 'a highly unstable and precarious affair', a consequence of colonialism. Structured around Bruno Latour's notion of 'iconoclash', he muses on the contemporary 'celebration of heritage' in many African nations and asks 'where do images of heritage actually come from?' The common theme in much of this section, that of heritage/inheritance, appears once again here, in Probst's contention that 'heritage is rooted in death' and in remembrance of things past in going forward, and he identifies a paucity of research into African heritage as cultural production, as opposed to the important, but more well-worn 'debates about restitution, representation, and identity/value'.

Bibliography

Bennett, A. (2012). *People*. London: Faber and Faber (see extracts in this volume).

Byrne, D. (1991). 'Western hegemony in archaeological heritage management', *History and Archaeology*, 5, pp. 269–276.

Editorial Collective/Raphael Samuel. (1976). 'Editorials: *History Workshop Journal*', *The History Workshop Journal*, 1, pp. 1–3 (this volume).

Harrison, R. (2012). *Heritage: Critical Approaches*. London: Routledge.

Harvey, D.C. (2001). 'Heritage pasts and heritage presents', *International Journal of Heritage Studies*, 7 (4), pp. 319–338 (this volume).

Hewison, R. (1987). *The Heritage Industry: Britain in a Climate of Decline*. London: Methuen Publishing Ltd.

Jenkins, T. (2011). 'The crisis of cultural authority', *Contesting Human Remains in Museum Collections: The Crisis of Cultural Authority*. London and New York: Routledge, pp. 54–78 (this volume).

Kreps, C. (2005). 'Indigenous curation as intangible cultural heritage: thoughts on the relevance of the 2003 UNESCO Convention', *Theorizing Heritage*, 1 (2), pp. 3–8. www.folklife.si.edu/resources/center/cultural_policy/pdf/ChristinaKrepsfellow.pdf, accessed 2 June 2016.

Pabón, A. (2003). 'Por la encendida calle antillana: Africanisms and Puerto Rican architecture', *Journal of Heritage Stewardship*, 1 (1), pp. 14–32 (this volume).

Probst, P. (2012). Extracts from 'Iconoclash in the age of heritage'. *African Art*, 45 (3), Autumn (this volume).

Robertson, I.J.M. (ed.) (2012). 'Introduction: heritage from below', *Heritage from Below*. Farnham: Ashgate: pp. 1–28.

Samuel, R. (2012) [1994]. 'Hybrids', *Theatres of Memory: Past and Present in Contemporary Culture*. London: Verso: pp. 429–447 (this volume).

Smith, L. (2006). *Uses of Heritage*. Abingdon and New York: Routledge, www.myilibrary.com?ID=56375, accessed 2 June 2016.

Taylor, B. (2008). 'History workshop journal', *Making History: The Changing Face of the Profession in Britain*. The Institute of Historical Research, www.history.ac.uk/makinghistory/resources/articles/HWJ.html, accessed 4 August 2016.

Waterton, E. (2010). 'Heritage in the Wider World', *Politics, Policy and the Discourses of Heritage in Britain*. Basingstoke: Palgrave Macmillan, pp. 36–71.

1

Heritage pasts and heritage presents

Temporality, meaning and the scope of heritage studies

David C. Harvey

In decrying the lack of any full, or even remotely accepted, theorisation of the heritage concept, Larkham questions whether heritage is simply 'all things to all people'.[1] Certainly there seem to be as many definitions of the heritage concept as there are heritage practitioners, while many commentators simply leave the definition as broad and malleable as possible. Johnson & Thomas, for instance, simply note that heritage is 'virtually anything by which some kind of link, however tenuous or false, may be forged with the past', while Lowenthal seems to revel in his claim that 'heritage today all but defies definition'.[2] This in itself raises the question of whether we really need a tight definition at all, let alone a comprehensive 'manifesto' of what heritage studies is all about. However, without wanting to delve into the inconclusiveness (and ultimate aridity) that some of such debates have led us to in the past, we do at least need to consider the 'scope' of heritage studies as a discipline. This is particularly important with regard to the theorisation of temporality that its very 'presentness' seems to imply. In short, many contemporary studies of heritage issues have failed fully to explore the historical scope that the concept really implies, and have rather been too preoccupied with certain manifestations of heritage's recent trajectory. I certainly do not intend to prescribe a narrowly defined heritage manifesto, nor to denigrate any recent heritage work. Rather, I wish to make space for a longer historical analysis of the development of heritage practices. Consequently, by providing a longer historical narrative of 'heritageisation' as a *process*, I am seeking to situate the myriad of multiply-connected interdisciplinary research that makes up the terrain of heritage studies today.

The premise of this paper is that heritage has always been with us and has always been produced by people according to their contemporary concerns and experiences. Consequently, we should explore the history of heritage, not starting at an arbitrary date like 1882, but by producing a context-rich account of heritage as a process or a human condition rather than as a single movement or personal project.[3] This account would place people such as William Morris (or Robert Hewison for that matter) as representative of a particular strand of heritage at a particular moment in time, reflecting the agendas, perceptions and arrangements of that time.[4] Every society has had a relationship with its past, even those which have chosen to ignore it, and it is through understanding the meaning and nature of what people tell each other about their past; about what they forget, remember, memorialise and/or fake, that heritage studies can engage with academic debates beyond the confines of present-centred cultural, leisure or tourism

studies. This short essay seeks to explore the development of the heritage process over the long term. In order to do this, it reviews the contribution of certain published work on such heritage issues that has been produced by people generally working outside the field of heritage studies. A range of scholarly work on early modern and even medieval subject areas will be examined and placed within an understanding of the long-term development of heritage as a social process. In this sense, I will explore processes of 'heritageisation' within a much longer temporal framework than is normally used. For instance, the evolution of a medieval sense of heritage is related to changes in technology and transitions in the experience of place and space, while some more recent developments in the heritage concept are related to the more recent societal changes connected to colonial (and post-colonial) experience. This essay merely scratches the surface of what is implied by this expanded temporal scale. Nevertheless, a deeper understanding of the historically contingent and embedded nature of heritage is vital, both to avoid the trap of producing endless present-centred case studies for little apparent reason, and to enable us to engage with debates about the production of identity, power and authority throughout society.

Firstly, however, we need to examine the nature of this 'present-centredness' that pervades the subject, before quickly exploring the full implications of the heritage definitions that are in current circulation. This will establish a contextual basis within which to place the historical analysis of the heritage concept.

The *Presentness* of Heritage: heritage definitions and the apparent demise of history

A glance at some recent heritage studies texts soon reveals the complexity and wide scope of the subject.[5] In particular, Arnold et al.'s recent collection of essays shows just how broad the blanket term of heritage studies can be, with topics ranging from war memorials in Wales to the media treatment of Princess Diana.[6] This itself has caused some consternation, with Terry-Chandler for instance seeing the 'unsystematized' and 'heterogeneous' nature of heritage studies potentially leaving us with little more than a 'morass of case studies'.[7] Interestingly, the one aspect that appears to unite almost all of these case studies, as well as the wider subject as it is practised today, is the dating of their heritage subjects; almost all commentators place the appearance of the heritage phenomenon in the latter half of the twentieth century, with even the earliest origins often manifested only in the nineteenth century with the Ancient Monuments Act of 1882 and personified by such figures as William Morris.[8] For instance, in the opening pages of their book, McCrone et al. proclaim that 'heritage is a thoroughly modern concept, ... [it] belongs to the final quarter of the twentieth century'.[9] Although McCrone et al. acknowledge a much older origin for heritage in a legal sense, their linking the concept with modernity is complete, claiming heritage to be 'a condition of the later twentieth century'.[10] Continuing this trend of dating the heritage concept within the opening paragraphs of a text, Lowenthal argues that it is only in our time that heritage has 'become a self-conscious creed', while Graham et al. claim that it is only in the last few decades that the word has come to mean more than a legal bequest.[11] Considering the acknowledged complexity of the heritage phenomenon, it is certainly understandable why so many commentators use a purposely vague and malleable definition of the concept. However, in the aforementioned cases at least, it seems that the unexamined assumptions regarding the dating of heritage are let loose before any such definitions are even reached.

It is easy to see why heritage commentators have dated their subject in such a way, what with the increasingly high profile of heritage in the public mind,[12] matching the increasing proliferation of heritage sites; a recent trend that has been much discussed in the literature.[13] The critical

response of Robert Hewison[14] to the recent developments of the so-called 'heritage industry' are well known, and the dating of this rise of 'heritageisation' to the later twentieth century is a central part of his thesis. A simple overview of this debate, however, shows that whether critical or supportive of such recent heritage practices, most authors seem to accept implicitly the recent nature of this general dating framework without question.[15] Perhaps this is not surprising considering the very strong and fertile links that have been established between heritage studies, museum studies and a wide range of professional and amateur heritage practitioners who are working at the 'sharp end' to conserve, present and interpret material in the present. However, this itself raises the question of where the origins for this wider field of professional and amateur heritage practice lie, and, more importantly, what its version, or 'vision', of heritage constitutes.

The origins of this very present-centred professional terrain have been dated to later nineteenth-century heritage initiatives in general and to the 1882 Act in particular.[16] Certainly the founding of such bodies as the Society for the Protection of Ancient Buildings (SPAB), the National Trust, or even *Country Life* magazine appear as seminal moments in the development of the British heritage conservation movement.[17] The continuing legacy of organisations such as SPAB and such individuals as William Morris has been especially noted by Miele,[18] who criticises the continuing implicit sanctification surrounding the memory of these 'founding fathers' and of their practice of preserving 'authentic' physical artefacts in aspic. However viable and laudable the heritage ideals associated with this movement are, they constitute a partial spectrum of the wider potential of the heritage field. The recent dating of such activity, therefore, simply tends to hide a much deeper temporal scope for heritage studies.

This situation is not helped by the strong, yet often simplistic, relation of the heritage concept to conditions of post-modernity and to the post-modern economy.[19] For instance, McCrone et al. relate the rise of heritage to the post-Fordist economic climate that characterises this post-modern era, claiming that 'heritage has its roots in the restructuring of the world economy – a process which began in the 1970s'.[20] This statement sells heritage short on three accounts. First, it seems to imply a definition of heritage completely along commercial lines. A strong and perhaps increasing link between heritage and the marketplace is certainly apparent. However, despite some scholars defining heritage almost completely along the lines of economic commodification,[21] it certainly cannot be claimed that heritage is *only* about the economic practices of exploitation. The second and connected point is that heritage is portrayed almost one-dimensionally, as just another aspect of a burgeoning leisure industry. This has even led some to worry over whether heritage may somehow lose a popularity contest with 'other leisure forms'.[22] As with the economic side of heritage, the relationship with (post)modern forms of leisure seems to be increasingly pervasive in the heritage arena. As with its commercialisation, however, heritage must be allowed a wider scope than simply being portrayed as something that people do to fill their free time, or as a hostage to the whims of leisure fashion. The third, and perhaps most important, point to be made about the relation of the 'rise of heritage' to the changes of the 1970s in the world's economy concerns the conceptual closure that is implied by such dating. Most people would accept that to understand transitions in the world economy requires a much longer and more deeply embedded historical analysis than just identifying changes in the 1970s. The field of heritage studies seems too often to lack such a comparatively rich historical contextualisation beyond the simple tracings of lineage to certain nineteenth-century cult figures as noted above. Just as the present-day economic practices of capitalism were not started on a blank sheet in 1970, then present-day heritage concerns should not be seen as originating completely anew from a similar set of cultural, political and societal transitions, whether they are called 'post-modern' or not.

In order to account for the very recent dating of heritage, we need to explore the implications of the very 'presentness' of heritage processes and practice. Hardy referred to heritage as a

'value-loaded concept', meaning that in whatever form it appears, its very nature relates entirely to present circumstances.[23] Tunbridge & Ashworth, for instance, note that 'the present selects an inheritance from an imagined past for current use and decides what should be passed on to an imagined future'.[24] In other words, the only referent that matters is the present, which some have seen as representing a defeat of history and a closing off of any meaningful relationship with the past.[25] This is comparable to the argument that Hewison used in his attack on the so-called 'heritage industry'; heritage was somehow threatening history, destroying an authentic version of the past and replacing it by simulacra of that past.[26] Since all heritage is produced completely in the present, our relationship with the past is understood in relation to our present temporal and spatial experience.[27]

Some heritage scholars have sought to place this dislocation and rootlessness within wider developments of our post-modern society.[28] What this has meant for the field of heritage studies is that a sort of 'line of temporal closure' has been drawn, which ties the appearance of heritage to the development of post-modernity. Heritage, as practised today, is portrayed as a product of the wider social, cultural, political and economic transitions that have occurred during the later twentieth century. What this itself implies, however, is that, firstly, there is something called 'correct' historical narrative that heritage is busily destroying and, extending from this, that until very recently, all history, historical narrative and other relationships with the past were somehow more genuine and authentic than they have now become. This point requires some discussion of the relationship between history and heritage, and also some thought as to how we define the latter concept.

The extent to which 'traditional' historians ever saw their work as a completely straightforward accounting of 'what happened' is open to question. Certainly during the twentieth century it became more fully recognised that 'the evidence of history cannot be so easily separated from the interpretation built upon it'.[29] A differentiation between historical and heritage narratives based upon issues of objectivity has continued, however, with Plumb, for instance, likening history to a scientific endeavour which, again, is under threat from more frivolous heritage activity.[30] Even Lowenthal contrasts heritage practices with a situation where 'testable truth is history's chief hallmark'.[31] As Johnson further notes, however, this 'distinction between true history and false heritage … may be more illusory than actual'.[32]

Raphael Samuel was very critical of what he saw as 'heritage baiters', accusing them of reifying professional historical narration as an objective practice that recounted a 'real' past, and being hypocritical in their description of the heritage industry.[33] As well as appearing to retain a modernist, scientific version of historical narrative, the heritage baiters' accounts also tend to imply that previous relationships with the past, whether factually correct or not, were somehow more authentic. In this sense, the heritage industry is portrayed as a sort of parasite, exploiting the more genuine and 'ageless' memorial (and largely oral) relationships with the past that people had before the nineteenth century. This idea is related to notions that distinguish between 'modern' and 'traditional' memory, which was best articulated by Nora and discussed by Johnson.[34] Nora draws a distinction between an elite, institutionalised memory preserved in the archives, and the memory of ordinary people, unrecorded, and ingrained in the unspoken traditions and habits of everyday life.[35] Most importantly, however, rather than seeing this 'traditional memory' as something that has ended, and defeated by 'false heritage', Nora sees it as having been transformed (partly through technological and archival development) and democratised. 'In this light, rather than viewing heritage as a false, distorted history imposed on the masses, we can view heritage sites as forming one link in a chain of popular memory.'[36] What this implies for heritage studies is that we should not draw any lines of temporal closure, or view the entire heritage concept as a product of later 19th- and twentieth-century cultural change

David C. Harvey

without origin. Rather, we should supply heritage with a history of its own, not in terms of recounting the story of the development of a particular modernist strand of heritage from a nineteenth-century icon, but in terms of examining the evolution of the heritage process over the longer term. Of course, the narration and practice of both history and heritage involve the subjective interpretation of selective material and issues. This situation is certainly not new, but rather has a long history that needs to be examined.

In addition, although most authors have restricted themselves to talking about the very recent past, there is rarely anything in their definitions of heritage that necessarily supports their dating heritage to this recent past; the temporal restrictions seem to be completely self-imposed. For instance, Lowenthal sees heritage as a practice that 'clarifies pasts so as to infuse them with present purposes', while Hewison has defined heritage as 'that which a past generation has preserved and handed on to the present and which a significant group of population wishes to hand on to the future'.[37] Notwithstanding the very physical and artefactual assumptions in Hewison's definition about what constitutes heritage, neither of these definitions necessarily excludes the practice or *process* of heritage from a pre-twentieth-century context. Rather, through examining a series of case studies, we can explore issues of heritage production and consumption within a pre-modern arena. In this respect, we are making space for heritage studies to explore earlier links in the 'chain of popular memory' of which the present-day heritage industry forms just part of the most recent section.[38] The practice of engaging with these case studies through recourse to heritage concepts will help us to understand heritage as a *process*, or a verb, related to human action and agency, and as an instrument of cultural power in whatever period of time one chooses to examine.[39] In order to investigate these historical case studies, the simple definition of heritage as 'a contemporary product shaped from history' has been used.[40] This concise definition conveys that heritage is subjective and filtered with reference to the present, whenever that 'present' actually is. It is a value-laden concept, related to processes of commodification, but intrinsically reflective of a relationship with the past, however that 'past' is perceived and defined.

Heritage practice in the pre-modern period

A useful place to start this review would seem to be through examining the longevity of the oft-cited relationship between ideas of heritage and those of national identity.[41] A very large body of literature exists that relates these factors, though nearly all of it seems to imply relatively recent origins for this link.[42] Johnson, for instance, focuses on the First World War as a time in which public memory was transformed and institutionalised, while Hobsbawm and Nora concentrate on a longer term transition originating in the political and economic revolutions of the later 18th and early 19th centuries.[43] Indeed, despite no stipulation of a necessary time framework, all of the case studies in Hobsbawm & Ranger's influential collection, for instance, focused on relatively recent events.[44] However, much earlier examples exist of where a particular notion of heritage is used in order to legitimate a 'national consciousness' or a communal memory akin to an early 'nation state'.

A particularly good example of this is found in the support and spread of Bonfire Night in England, celebrated on 5 November each year from the seventeenth century. Cressy argues that during this period, 'England's past became an issue in England's present to a degree unknown elsewhere, ... A deliberately cultivated vision of the past was incorporated into the English calendar, reiterated in sermons, reviewed in almanacs, and given physical form by memorials and monuments.'[45] The act of remembering the Gunpowder Plot was promoted very heavily in the seventeenth century as a device to support notions of communal solidarity, and to legitimise

the Protestant state, its hierarchy and bureaucracy.[46] This seems to be a case of invented tradition in all but name, and one that continues today, with Bonfire celebrations ritualised and ingrained through such devices as the child's rhyme: 'Remember, remember the fifth of November, gunpowder, treason and plot'.

Importantly, although the Bonfire Night example at first sight appears almost as an overt instrument of the state and of a Protestant elite to instil order within the emerging English state, it can perhaps better be viewed as a re-interpretation of a much older tradition. The fire festival of Samain had been held in many parts of Britain in early November since pre-Christian times, and by the seventeenth century the 'unspoken rituals and inherent self-knowledge' that Nora associates with 'true memory' had surely taken root within this custom.[47] Bonfire Night, therefore, can be seen as a product of heritage; represented according to agendas of the present (whether that 'present' is in the seventeenth century or the twentieth), and carried on very largely through oral custom and non-elite practice. Although there were no heritage theme parks related to the seventeenth-century Protestant ascendancy, a cult of Queen Elizabeth I was successfully established within folk memory,[48] while the product of heritage processes surrounding the Restoration of the Monarchy in 1660 can still be seen in the form of countless *Royal Oak* pubs throughout Britain.[49] In other words, 'heritage', even at this time, was non-elite and undoubtedly popular. According to Cressy, even the Fire of London in 1666 was blamed on the Pope, and the 200 foot high Monument built to commemorate London's survival became a venue for anti-Catholic demonstrations, contributing to a new symbolic geography of the city.[50] Although public memory at this time still resided largely within oral tradition, The Monument can be seen as a very material product of a later seventeenth-century 'heritage industry' which sought to inscribe a particular past through re-interpreting relatively recent events according to contemporary agendas.[51]

Some authors have sought the origins of English national identity within an even earlier time period.[52] For instance, one piece of English heritage that still has a very high public profile is that associated with St George and the dragon. Although some modern critics would surely be upset at the way this supposedly 'genuine' piece of legendary folk-heritage has been abused and commodified as part of later twentieth century football rituals, Bengtson has demonstrated how this re-presentation and conscious skewing of the legend in relation to contemporary agendas is not a new practice.[53] Far from contextualising this process of heritageisation within the field of international football during the later twentieth century, Bengtson places the heritage within the field of international conflict in the fourteenth century. Conscious of his family's French origins, Edward III made a particular effort to fuel the cult of St George and to align himself very much with it.[54] What is interesting about this example, from the point of view of heritage studies, is the way that the emergent interpretation of the St George traditions can be seen as a dialogue between the lay traditions, oral heritage and popular memory of ordinary people on the one hand, and the higher agenda of the Monarchy on the other. People were taught to refer to their heritage in a particular way that related to contemporary political aspirations, thereby commodifying the stories so as to create a type of cultural capital that could be used as an instrument of power.[55] Although Shakespeare obviously embroiders actual events in his play *Henry V*, the Agincourt campaign of 1415 really did witness an outpouring of references to St George.[56] The deployment of this particular version of heritage, therefore, helped the Monarchy 'establish an intimacy with the people which they would otherwise have not easily achieved'.[57] The St George stories came to be ingrained and ritualised within ordinary people's psyche, inseparable from the legitimacy of monarchical rule. In this respect, this medieval version of heritageisation and nationalisation of the monarchy is not too dissimilar from Mandler's views on the 'nationalisation' of the stately home in the twentieth century.[58]

Although the examples used so far refer to the heritage of national identity (itself a very modernist preoccupation), medieval versions of heritage were not related solely to emergent national memories. Boholm, for instance, examines how aspects of Roman heritage in the medieval period helped to transform the city of Rome from a decaying backwater into the foremost Christian metropolis.[59] Over several centuries, non-Christian remains came to be placed within an overtly Christian story. Specific heritage stories were mapped onto the cityscape and acted to represent significant sites and landmarks through the subtle re-interpretation of existing popular memories. Rome's pagan heritage was used as a device to enhance the authority of the Pope. In this respect, 'traditions are not static; they modify and change through time as a result both of their internal dynamic and in response to external demands. The present is informed by the past and the past is reconstructed by the present.'[60] Some of the heritage practices commonly associated with the later twentieth century were evidently alive and well in medieval Rome. This statement seems directly to contradict Lowenthal when he noted that the rebuilding of St Peter's showed that in later medieval Rome, 'old stones meant nothing in themselves'.[61] However, as Lowenthal admits,[62] the most important aspect of Roman heritage was found in the significance of the site itself, which had become symbolically charged through re-interpretation over several centuries.

This Roman example suggests that the development of the heritage process from the medieval world to the (post)modern, can be characterised in part by an increasing symbolic value becoming attached to actual physical remains as opposed to the heritage significance of sites themselves. Certainly the early Church always appeared very concerned with maintaining a symbolic link through the re-interpretation of pre-Christian sites.[63] Menuge, for instance, argues that the heritage of the first Christians was always of crucial importance to the medieval church.[64] Certainly, parallels can be drawn between the branching lineages of well-known monastic centres, saints, abbots, or even teachers, and the more narrow and strictly legal definition of heritage as an inheritance within a family line.[65] This idea of continuity, and control over a specifically presented heritage, is echoed in St Gregory the Great's instruction which called for Christian missionaries to 'cleanse heathen shrines and use them as churches'.[66] This active process of re-use and re-interpretation of sites is a crucial and enduring concept. Even where sites fell out of use (as in Rome), they were often re-used, sometimes centuries later, supported by a desire to utilise the religious gravity that was associated with such sites.[67]

In trying to understand the nature of heritage processes in the medieval period, hagiographical accounts comprise a useful source. These saintly legends represented key elements in the legitimisation of Christian belief and its supposedly unquestionable authority.[68] They also represent a strand of heritage, reflecting how cultural power was wielded through the agency of 'heritageisation'. Hagiographies acted to instil a particular popular relationship with the past that would imbue certain sites with particular significance, renew, enlarge and ritualise religious cults, and hopefully generate pilgrimage. Some scholars have successfully portrayed the medieval pilgrimage industry as analogous to that of modern tourism, and Abou-El-Haj, in particular, has animated the popularity and commercialism involved in the medieval pilgrim business.[69] Although a medieval cathedral was obviously a completely different structure from a modern-day heritage theme park, the crowds, enthusiasm and money-spinning generated could be similarly huge, and the popular mediation of memory and identity, similarly genuine.[70] In other words, they both represent 'contemporary products shaped from history' through which people relate to the past. As with the Bonfire Night example, an important element in these cases is the degree to which the identities, memories and temporal experiences of ordinary people are uncovered. Importantly, however, this is not some sort of innate or 'authentic' folk memory that was somehow primordially instilled but, rather, represents a dialogue between folk

experience, elite interests and actions of commodification and commercialism. This reflection of the heritage process is demonstrated particularly well with a close reading of hagiographic legends of local and often obscure saints.

In previous work I have explored how hagiographies of certain saints in medieval Cornwall reflected a particular pedigree of heritage interpretation that stressed continuity with a particular past and a particular landscape.[71] Although very much arranged and presented within a medieval present, these stories forged a genuine link with past events and physical features. In many ways, people learnt how to identify themselves within both a spatial and temporal landscape, through the memory and popular heritage of saintly legends. In the mostly illiterate society of medieval Cornwall, stories of St Samson or St Gwinear, for instance, would have been orally narrated or, particularly on festival days, performed as miracle plays.[72] Henderson even notes that on the occasion of an episcopal visit to the church of St Buryan, a Cornish interpreter was used in order that the local audience could hear the Bishop's solemn recounting of the story of the 'blessed Saint Beriana'.[73] Although presented with contemporary political agendas in mind, such hagiographic accounts expressed the existence of a real popular heritage.

We have no evidence that medieval peasants demonstrated against the demolishing of a physical relic in the way that people are encouraged to do today, and it certainly seems unlikely that a medieval lay movement existed actively concerned with what we might term 'heritage issues'. However, this situation does not mean that people had no concern for certain issues that we would associate with heritage today. People still had a relationship with the past, and they still actively preserved and managed aspects or interpretations of that past; they were just nurtured into a different experience of this heritage.

The development of heritage processes at ancient monuments

With the establishment of a longer temporal framework within which to contextualise concepts of heritage, it becomes possible to explore the long-term evolution of the heritage process. A useful illustration is that of so-called 'ancient monuments'. Much has been written about the present-day commercialism and hidden (or not so hidden) agendas that go hand-in-hand with the presentation of such sites today.[74] The recent re-presentation and issues of exclusion surrounding Stonehenge, in particular, has brought very widespread attention from both academic and non-academic circles,[75] and provides an excellent example which would seem to support the post-modern 'heritage is destroying history' argument of people such as Hewison. However, if we take a longer term temporal perspective of the presentation of such sites, we see that they have always been presented (or intentionally *not* presented) within the context of political agendas and wider conceptions of popular memory contemporary to the time.

As discussed more generally in the examples above, such sites were often utilised and absorbed by the medieval Christian Church, while in the early modern period such sites were interpreted and presented within the context of newer societal structures and arrangements. When William Stukeley described the site of Avebury, he ascribed its origins to British Druids, adding that 'we may make this general reflexion … that the true religion has chiefly since the repeopling [of] mankind after the Flood subsisted in our island: and here we made the best reformation from the universal pollution of Christianity; Popery'.[76] For Stukeley, the heritage of Avebury represented a strand of anti-Catholicism and helped to legitimise both his national identity and the validity of his entrenched religious identity. Again we see the heritageisation of a popular memorial artefact being presented within the context of contemporary agendas.

As agendas changed, so too did the referents for heritage interpretations. In 1699, for instance, Edward Llwyd described the Neolithic remains at Newgrange in Ireland as 'plainly barbarous';

as a 'place of sacrifice used by the old Irish', and far 'too rude for so polite a people' as the Romans.[77] Here we see the heritage process working in respect to both conceptions of Irishness (barbarous), and of Classical Rome (polite), and always reflecting a contemporary terrain of cultural power relationships. Over the following two centuries, various antiquarians and amateur archaeologists visited Newgrange, mostly ascribing it to non-Irish origins; the Irish, after all, were supposedly far too backward to build anything as complex.[78] Thomas Pownall, for instance, even associated Newgrange with ancient Egyptian builders, or at least a lost Phoenician tribe.[79] As can be seen in so many other heritage presentations, Pownall's story says more about him and his time than it does about the object of study. Through such descriptions, the monument is presented as evidence of a previous attempt to bring civilisation to Ireland, and a justification of the system of *improvement* and the wider British colonial project in Ireland.

The example of Newgrange demonstrates how the British domination of Ireland was mirrored by their parallel domination over the representation and interpretation of ancient heritage. The native inhabitants were portrayed as either too stupid or only capable of building such monuments with the help of a civilising influence. This heritage process, therefore, reflects the predilections of a powerful elite, and was used to justify wholesale landscape alteration, plantation and *improvement*. Following Irish independence in 1921, the heritage agenda shifted once more, so as to reflect a new post-colonial perspective. Newgrange became a central part of a new national story; one which is homogeneously Gaelic, powerfully evocative of great antiquity, and engendering ideas of rurality, of continuity, the vernacular, and the local, to become a site which is used unproblematically to express an ancestral connection.[80] In this respect, we should perhaps be a little critical of the revisionist versions of Irish national history.[81] A longer temporal perspective of heritage interpretation reveals that the overtly politicised presentational packages developed in Ireland during the later twentieth century are not new, but are merely (re-)establishing themselves within a heritage landscape that has been interpreted according to contemporary political agendas for centuries.

Concluding thoughts

The above examples have illustrated how concepts of heritage have always developed and changed according to the contemporary societal context of transforming power relationships and emerging nascent national (and other) identities. I would see this relationship very much as a *hand-in-hand* transformation, rather than one of straight *cause and effect*. The paper also demonstrates how heritage processes can be explored within a very long temporal framework, and should not be described simply as a recent product of post-modern economic and social tendencies. Most important here is the notion that heritage is, first and foremost, a process. While not wishing to engage in a semantic and ultimately arid debate about tight definitions, one can argue that, just as historians have been criticised for a perceived 'fetishisation' of the written archive,[82] heritage studies can sometimes come across as fetishising authentic and preserved physical relics and remains.[83] To counter this, we should heed Brett's comments about history being a verb; likewise, heritage is not given, it is made and so is, unavoidably, an ethical enterprise.[84]

This essay, therefore, challenges the popular convention of understanding heritage simply as a physical artefact or record, by advocating an approach that treats heritage as a cultural process. Following Bender's comments on landscape, heritage is 'never inert, people engage with it, rework it, appropriate it and contest it. It is part of the way identities are created and disputed, whether as individual, group or nation state.'[85] Perhaps even more so than the representation of landscape, heritage is a present-centred cultural practice and an instrument of cultural power.

The heritage movement that traces its origins to William Morris and the SPAB of the later nineteenth century represents but one strand of heritage practice, reflecting the perceptions, politics and assumed natural identities of its practitioners. Taking a longer temporal perspective has revealed a complex evolution of heritage, mirroring processes of dialogue and resistance between interested parties. Developments that have occurred should be seen as gradual, tentative and discontinuous, intrinsically linked to changing notions of what heritage should be like, and inseparable from the ingrained ritual associated with practices of everyday life.

An appreciation of heritage as a process that has undergone considerable change over the very long term, leads us to consider the factors that account for such temporal transition. For instance, Lowenthal relates what he sees as a secularising tendency within heritage to a process of democratisation.[86] On the face of it, the involvement of heritage with a mass audience as compared with the nineteenth century seems clear-cut. However, our longer term perspective reveals a large degree of popular involvement in Bonfire celebrations in the seventeenth century and in miracle plays and the like at a much earlier time.[87] Overall, though, it does seem certain that a bigger range and number of people are becoming more involved in a much broader and deeper array of heritage phenomena than ever before. Drawing on the ideas of Dodgshon, this transformation in scale, scope and access to heritage can perhaps be related to a transformation in technology.[88] Dodgshon argues that the technologies associated with modernity have led to a huge discovery of time; 'both deep past time, through physics, geology, archaeology and history – and future time through physics and planetary science'.[89] Accordingly, modern technology has allowed a huge increase in the capacity to store, categorise, interpret and present this broader deposit of time, a carryover, which Dodgshon sees as an essential part of the very being of society.[90] Such technological change, therefore, has led to an increasing bulk and capacity to store, articulate and produce heritage, just as changing leisure practices have allowed greater scope to interpret and 'do' heritage. In this respect, heritage is not seen as a new phenomenon, nor even one particularly or exclusively associated with modernity. Rather, the transformations that are implied by modernity are simply mirrored by an increasing intensification, recycling, depth and scope of heritage activity. In many respects, therefore, the present tendency for nostalgia and finding solace in heritage is just the latest phase of a much longer trajectory.[91]

In parallel with the underdevelopment of a longer temporal perspective on heritage is an underdeveloped sense of heritage history, or what might be termed the 'heritage of heritage'. Lowenthal drew attention to this when he noted that history itself is a heritage.[92] In this respect, conceptions of modernity and even the longing for the future that Lowenthal speaks of are 'contemporary products shaped by the past'.[93] Taking this view, one might therefore see the often-reported and eulogised nineteenth-century development of preservationism and architectural protectionism (along with the entire 'scrape/anti-scrape' debate) as simply an important moment within a much longer trajectory of heritage in Britain. Like all heritage, it is a selective portrayal contingent on present–day requirements, thereby reflecting a sense of nostalgia towards the heritage heroes of yesteryear.

As Lowenthal argues, 'heritage, far from being fatally predetermined or God-given, is in large measure our own marvellously malleable creation'.[94] Heritage is not an innate or primordial phenomenon; people have to be taught it. The view put forward in this paper is that this teaching of heritage has sold the heritage process short by concentrating so heavily on the very recent past, and producing a received wisdom of a heritage that 'began' at a particular date in the nineteenth century. We need to acknowledge, understand and embrace the very long-term temporal trajectory of the heritage phenomenon, otherwise we would not understand it at all. As Lowenthal stresses, understanding heritage is crucial; 'we learn to control it lest it controls us'.[95]

David C. Harvey

Acknowledgements

I would like to thank Catherine Brace for her comments on an earlier draft of this paper. 'Finishing touches' were developed following the excellent 4th Cambridge Heritage Seminar: 'The Condition of Heritage' (28 April 2001) at which this paper was first aired. In particular, comments by Peter Howard and John Carmen were very useful, while continuing discussion with Cornelius Holtorf has been invaluable. This paper has benefited from the financial assistance afforded by a grant from the British Academy (SG-31126) for a project entitled 'Constructions of identity and interpretations of ancient heritage in Britain and Ireland since 1650'. Any errors or misinterpretations are entirely the responsibility of the author.

Notes

1 P.J. Larkham, 'Heritage as planned and conserved', in D.T. Herbert (ed.) *Heritage, tourism and society*, London: Mansell, 1995, p. 85.

2 P. Johnson & B. Thomas, 'Heritage as business', in D.T. Herbert, op. cit. (note 1), p. 170; D. Lowenthal, *The heritage crusade and the spoils of history*, Cambridge: Cambridge University Press, 1998, p. 94.

3 The year 1882 is the date of the Ancient Monuments Act in Great Britain. Other arbitrary dates for the 'start' of heritage include the French Revolution or the establishment of the National Trust in 1895.

4 This idea is strongly resonant of ideas about the *invention of tradition*. See E. Hobsbawm & T. Ranger (eds) *The invention of tradition*, Cambridge: Cambridge University Press, 1983.

5 See, for instance, B.J. Graham, G.J. Ashworth & J.E. Tunbridge, *A geography of heritage: power. culture, economy*, London: Arnold, 2000; Lowenthal, *Heritage crusade*; M. Hunter (ed.) *Preserving the past: the rise of heritage in modern Britain*, Stroud: Sutton, 1996.

6 J. Arnold, K. Davies & S. Ditchfield (eds) *History and heritage: consuming the past in contemporary culture*, Shaftesbury: Donhead, 1998; A. Gaffney, 'Monuments and memory: the Great War', in J. Arnold, K. Davies & S. Ditchfield (eds) *History and heritage: consuming the past in contemporary culture*, Shaftesbury: Donhead, 1998, pp. 79–89; J. Davies, 'The media iconicity of Diana, Princess of Wales', in J. Arnold, K. Davies & S. Ditchfield (eds) *History and heritage: consuming the past in contemporary culture*, Shaftesbury: Donhead, 1998, pp. 39–50.

7 F. Terry-Chandler, 'Heritage and history: a special relationship?', *Midland History*, Vol. 24, 1999, pp. 188–193. Terry-Chandler seems to have faith in the apparent self-evident existence of a 'substantive base' for heritage studies upon which she provides no further comment. This has drawn questions on the Mailbase heritage discussion list, most specifically from Peacock (23 November 1999).

8 Such views were very much to the fore during 'The Idea of Heritage' conference, London Guildhall University (7–9 September 1999), with many delegates using phrases such as 'heritage in Britain started with the 1882 Act'. The sentiments of the present paper were fermented during the attendance of this excellent conference.

9 D. McCrone, A. Morris & R. Kiely, *Scotland the brand. The making of Scottish heritage*, Edinburgh: Polygon, 1995, p. 1.

10 Ibid., p. 1.

11 Lowenthal, *Heritage crusade*, p. 1; Graham et al., *Geography of heritage*, p. 1.

12 Reflecting the thoughts of Tunbridge & Ashworth, 'heritage' is one of those things which everyone possesses, and which everyone will defend, seemingly without thought. J.E. Tunbridge & G.J. Ashworth, *Dissonant heritage: the management of the past as a resource in conflict*, Chichester: Wiley, 1996. More recently, National Lottery funding has added a further cash injection into the public profile of heritage in Britain, raising many questions about the increasingly overt politicisation of heritage management and funding.

13 Robert Hewison is perhaps best known for this. In 1987 his book *The heritage industry: Britain in a climate of decline* formed a cornerstone of a long-running debate about the nature and worth of the recent trajectory of heritage in Britain. This book provides numerous facts that outline the proliferation of 'heritage', such as how the 68 monuments scheduled by the 1882 Act have now risen to more than 12,000, with over 330,000 listed buildings besides.

14 R. Hewison, *The heritage industry: Britain in a climate of decline*, London: Methuen, 1987; R. Hewison, 'Great expectations—hyping heritage', *Tourism Management*, Vol. 9, 1988, pp. 239–240; R. Hewison,

24

'Heritage: an interpretation', in D.L. Uzzell (ed.) *Heritage interpretation*, Vol. 1, London: Belhaven, 1989, pp. 15–23.

15 R. Samuel, *Theatres of memory*, Vol. 1. *Past and present in contemporary culture*, London: Verso, 1994; P. Wright, *On living in an old country: the national past in contemporary Britain*, London: Verso, 1985; D.L. Uzzell, 'Introduction', in D.L. Uzzell (ed.) *Heritage interpretation*, Vol. 1, London: Belhaven, 1989, pp. 1–14.

16 J. Carmen, 'From good citizens to sound economics: the historical trajectory of the archaeological heritage', unpublished conference paper presented at 'The Idea of Heritage' conference, London Guildhall University (7–9 September 1999), p. 15.

17 Lowenthal, *Heritage crusade*, p. 104.

18 C. Miele, 'Conservation and the enemies of progress? William Morris and the myth of authenticity', unpublished conference paper presented at 'The Idea of Heritage' conference, London Guildhall University (7–9 September 1999).

19 See, for instance, K.T. Walsh, *The representation of the past: museums and heritage in the post-modern world*, London: Routledge, 1992; F. Jameson, *Postmodernism, or the cultural logic of late capitalism*, London: Verso, 1991; U. Eco, *Travels in hyper-reality*, London: Picador, 1987; Hewison, 'Heritage: an interpretation'; D. Harvey, *The condition of postmodernity*, Oxford: Blackwell, 1989.

20 McCrone et al., *Scotland the brand*, p. 2.

21 Schouten, for example, defines heritage as 'the past processed through mythology, ideology, nationalism, local pride, romantic ideas, or just plain marketing into a commodity'. F.F.J. Schouten, 'Heritage as historical reality', in D.E. Herbert (ed.) *Heritage, tourism and society*, London: Mansell, 1995, pp. 21–31. Although some more 'cultural' aspects of heritage are recognised in this passage, the central place of commercialism and instrumentalist edge that is implied by Schouten appears to overly limit the scope of the concept.

22 See, for instance, the concerns of Terry-Chandler, 'Heritage and history', p. 192.

23 D. Hardy, 'Historical geography and heritage studies', *Area*, Vol. 20, No. 4, 1988, pp. 333–338.

24 Tunbridge & Ashworth, *Dissonant heritage*, p. 6.

25 F. Jameson, *Postmodernism*; Baudrillard, *The illusion of the end*, Cambridge: Polity Press, 1994; Lowenthal (*The heritage crusade*, p. 3) relates this concept to Fukayama's notion of the 'end of history'.

26 This extreme position was criticised by Samuel (*Theatres of memory*), among others, who sees the practices associated with the so-called 'heritage industry' as valid techniques for exploring one's relationship with the past.

27 This school of thought, which ultimately endeavours to relate notions of time–space compression to ideas that the experience of time itself has now ended, as we are now condemned to live through an endless series of presents, is well discussed in a critical paper by Dodgshon. R.A. Dodgshon, 'Human geography at the end of time? Some thoughts on the notion of time–space compression', *Environment and Planning D: Society and Space*, Vol. 17, No. 5, 1999, pp. 607–620.

28 See, for instance, Walsh, *The representation of the past*.

29 N. Johnson, 'Historical geographies of the present', in B.J. Graham & C. Nash (eds) *Modern historical geographies*, Harlow: Prentice Hall, 2000, pp. 251–272 (p. 252). Johnson cites Collingwood's (1946) work on this point, showing that concerns were being raised about the supposed objectivity of 'proper' history more than 50 years ago.

30 J.H. Plumb, *The death of the past*, Basingstoke: Macmillan, 1969.

31 Lowenthal, *Heritage crusade*, p. 120.

32 Johnson, 'Historical geographies', p. 259.

33 Samuel, *Theatres of memory*, pp. 259–273.

34 P. Nora, 'Between memory and history; les lieux de memoire', *Representations*, Vol. 26, 1989, pp. 10–18; N. Johnson, 'Memory and heritage', in P. Cloke, P. Crang & M. Goodwin (eds) *Introducing human geographies*, London: Arnold, 1999, pp. 170–178.

35 Nora, 'Between memory and history', p. 13. This conception of 'traditional memory' seems closely related to Bourdieu's notion of 'habitus'; P. Bourdieu, *Outline of a theory of practice*, Cambridge: Cambridge University Press, 1977. See also D.C. Harvey 'Continuity, authority and the place of heritage in the medieval world', *Journal of Historical Geography*, Vol. 26, No. 1, 2000, pp. 47–59.

36 Johnson, 'Memory and heritage', p. 171.

37 Lowenthal, *Heritage crusade*, p. xv; Hewison, 'Heritage: an interpretation', p. 16.

38 Albeit an important part, during which time the development of new technologies has transformed the very nature of collective memory and the experience of heritage.

39 In many ways, this newer conception of heritage as a 'way of seeing and being' reflects similar considerations that have transformed the field of landscape studies in recent years. See D. Cosgrove & S. Daniels (eds) *The iconography of landscape*, Cambridge: Cambridge University Press, 1988; S. Daniels, *Fields of vision: landscape imagery and national identity in England and the United States*, Cambridge: Polity Press, 1993; D. Matless, *Landscape and Englishness*, London: Reaction Books, 1999; S. Seymour 'Historical geographies of landscape', in B.J. Graham & C. Nash (eds) *Modern historical geographies*, Harlow: Prentice Hall, 2000, pp. 193–217.

40 Tunbridge & Ashworth, *Dissonant heritage*, p. 20.

41 B.J. Graham, 'The past in place; historical geographies of identity', in B.J. Graham & C. Nash (eds) *Modern historical geographies*, Harlow: Prentice Hall, 2000, pp. 70–99; C. Brace 'Looking back: the Cotswolds and English national identity, *c.* 1890–1950', *Journal of Historical Geography*, Vol. 25, No. 4, 1999, 502–516; J. Taylor, *Shakespeare land: a dream of England*, Manchester: Manchester University Press, 1994.

42 For literature on this subject, see Graham et al., *Geography of heritage*; McCrone et al., *Scotland—the brand*; B. Anderson, *Imagined communities*, London: Verso, 1983; R. Fevre & A. Thompson, 'Social theory and Welsh identities', in R. Fevre & A. Thompson (eds) *Nation, identity and social theory. Perspectives from Wales*, Cardiff: University of Wales Press, 1999, pp. 3–24.

43 Johnson, 'Memory and heritage'; Nora, 'Between memory'; E. Hobsbawm, *Nations and nationalism since 1780*, Cambridge: Cambridge University Press, 1990.

44 Hobsbawm & Ranger, *Invention of tradition*.

45 D. Cressy, 'National memory in early modern England', in J.R. Gillis (ed.) *Commemorations: the politics of national identity*, Princeton: Princeton University Press, 1994, pp. 61–73 (p. 61).

46 The Gunpowder Plot in 1605 sought to blow up the Houses of Parliament in Westminster.

47 A. Ross & D. Robins, *The life and death of a druid prince*, London: Rider, 1989, p. 35; Nora, 'Between memory', p. 13. I do not like Nora's use of the phrase 'true memory', and this Bonfire Night example demonstrates that such 'unspoken rituals' are just as open to re-invention as elite or popular memory is.

48 Some people have argued that this cult of the 'Virgin Queen' should be seen as the Protestant version of the cult of the Virgin Mary.

49 Cressy, 'National memory'. The 'Royal Oak' phenomenon commemorates the oak tree in which the young Prince Charles (later Charles II) apparently hid to escape Parliamentary forces during the latter stages of the second Civil War in 1651; 29 May (Charles II's birthday and the date of Restoration in 1660) became 'Royal Oak Day'.

50 Ibid., p. 70.

51 Ibid., pp. 70–71. Just 15 years after the Great Fire of London, a new inscription was added to The Monument stating that: 'This pillar was set up in perpetual remembrance of the most dreadful burning of this Protestant city begun and carried on by the treachery and malice of the Popish faction.'.

52 See, for instance, Hastings' slightly disappointing account. A. Hastings, *The construction of nationhood*, Cambridge: Cambridge University Press, 1997. In a parallel case, Duby has argued that the origins of French nationhood may be found in (among other things) the heritage associated with the battle of Bouvines in 1214. The mythologising and memorialising of this battle was actively supported by the Capetian Monarchy during the later Middle Ages; G. Duby, *The legend of Bouvines*, Cambridge: Cambridge University Press, 1990, pp. 155–157.

53 J. Bengtson, 'Saint George and the foundation of English nationalism', *Journal of Medieval and Early Modern Studies*, Vol. 27, No. 2, 1997, pp. 317–340.

54 The English king was at war with the French king at this time, and so we see here the attempts by Edward III to transform this clash from an *aristocratic* squabble between overlords, into a *national* struggle between two peoples.

55 Bourdieu, *Theory of practice*, pp. 171–183.

56 Bengtson, 'Saint George', p. 325.

57 Ibid., p. 335.

58 P. Mandler, 'Nationalising the country house', in M. Hunter (ed.) *Preserving the Past*, Stroud: Sutton, 1996, pp. 99–114; P. Mandler, *The fall and rise of the stately home*, Yale: Yale University Press, 1997.

59 A. Boholm, 'Reinvented histories: medieval Rome as memorial landscape', *Ecumene*, Vol. 4, No. 3, 1997, pp. 247–272.

60 Ibid., p. 267.

61 Lowenthal, *Heritage crusade*, p. 13. This statement seems to ignore the hundreds of instances in Rome alone where 'old stones' *did* appear to mean something. Just in Britain, there are many examples of

churches built specifically so as to take into account some former structure, such as a standing stone, or burial mound. In Sweden, the foremost Christian centre in the entire country (at Uppsala) is built within the precinct of a series of pre-Christian mounds.

62 Ibid.

63 Harvey, 'Continuity'.

64 N.J. Menuge, 'The foundation myth: Yorkshire monasteries and the landscape agenda', *Landscapes*, Vol. 1, 2000, pp. 22–37 (p. 25).

65 Many religious 'lineages' may well have been false, but ultimately a Christian establishment would desire to show an unbroken inheritance from the original apostles; with all Popes claiming 'direct descent' (as it were) from St Peter himself, for instance.

66 J. Blair, 'Minster churches in the landscape', in D. Hooke (ed.) *Anglo-Saxon settlements*, Oxford: Blackwell, 1988, pp. 35–58 (p. 50).

67 Harvey, 'Continuity', p. 52.

68 D.C. Harvey 'Landscape organisation, identity and change: territoriality and hagiography in medieval west Cornwall', *Landscape Research*, Vol. 25, No. 2, 2000, pp. 201–212; B. Abou-El-Haj, *The medieval cult of saints. Formations and transformations*, Cambridge: Cambridge University Press, 1997.

69 For relation to the tourism industry, see J.M. Fladmark (ed.) *In search of heritage: as pilgrim or tourist?*, Shaftesbury: Donhead, 1998; Abou-El-Haj, *Cult of saints*, pp. 7–32.

70 Ibid., pp. 22–25 provides an absorbing narrative of the battle between the Abbot of Vézelay, the monastery of Cluny and the Count of Nevers over the tomb of St Mary Magdalene. Following heavy 'lobbying', the Pope proclaimed the tomb genuine, which led to a century of disputes, including military campaigns, assassinations, propaganda and the 'defrocking' and 'dishonouring' of the odd monk!.

71 D.C. Harvey & R.A. Jones, 'Custom and habit(us): the meaning of traditions and legends in early medieval western Britain', *Geografiska Annaler*, Vol. 81B, 1999, pp. 223–233; Harvey, 'Continuity'; Harvey, 'Landscape organisation'.

72 N. Orme, *Nicholas Roscorock's lives of saints: Cornwall and Devon*, Exeter: Devon and Cornwall Record Society, 1992, p. 136; P. Beresford-Ellis, *Celtic inheritance*, London: Muller, 1985.

73 C. Henderson, *Essays in Cornish history*, Oxford: Clarendon Press, 1935, pp. 93–107.

74 Just to name but a few; P.L. Kohl & C. Fawcett (eds) *Nationalism, politics, and the practice of archaeology*, Cambridge: Cambridge University Press, 1995; P.G. Stone & P.G. Planel (eds) *The constructed past: experimental archaeology, education and the public*, London: Routledge, 1999; M. Dietler, 'A tale of three sites: the monumentalisation of Celtic oppida and the politics of collective memory and identity', *World Archaeology*, Vol. 30, No. 1, 1998, pp. 72–89; J. Owen, 'Making histories from archaeology', in G. Kavanagh (ed.) *Making histories in museums*, Leicester: Leicester University Press, 1996, pp. 200–215; G. Cooney, 'Theory and practice in Irish archaeology', in P. Ucko (ed.) *Theory in Archaeology*, London: Routledge, 1995, pp. 263–277.

75 B. Bender, *Stonehenge. Making space*, Oxford: Berg, 1998; T. Cresswell, *In place/out of place: geography, ideology and transgression*, Minneapolis: University of Minnesota Press, 1996; C. Chippindale, P. Devereux, P. Fowler, R. Jones & T. Sebastian, *Who owns Stonehenge?*, London: Batsford, 1990; S. de Bruxelles, 'How restorers "improved" Stonehenge', *The Times*, 9 January 2001, p. 11.

76 W. Stukeley, *Abury: a temple of the British druids with some others described*, London: Innys, Manby, Dod & Brindley, 1743, p. iv.

77 E. Llwyd, unpublished letter to Thomas Molyneux, dated 29 January 1700 (Molyneux MSS), Trinity College, Dublin.

78 M. O'Kelly, *Newgrange: archaeology, art and legend*, London: Thames & Hudson, 1982.

79 T. Pownall, 'A description of the sepulchral monuments at Newgrange', *Archaeologia*, Vol. 2, 1773, pp. 236–275.

80 Cooney, 'Theory and practice'.

81 Such as that demonstrated in R. Foster, 'History and the Irish question', in C. Brady (ed.) *Interpreting Irish history: the debate on historical revisionism*, Dublin: Irish Academic Press, 1994, pp. 122–145.

82 Samuel, *Theatres of memory*.

83 This point is well made by Baker: D. Baker, 'Contexts for collaboration and conflict', in G. Chitty & D. Baker (eds) *Managing historic sites and buildings: reconciling presentation and preservation*, London: Routledge, 1999, pp. 1–21.

84 D. Brett, 'The construction of heritage', in B. O'Connor & M. Cronin (eds) *Tourism in Ireland: a critical analysis*, Cork: Cork University Press, 1993, pp. 183–202 (p. 186).

85 B. Bender, 'Introduction; landscape—meaning and action', in B. Bender (ed.) *Landscape: politics and perspectives*, Oxford: Berg, 1993, pp. 1–18 (p. 3). See also Seymour, 'Historical geographies of landscape', p. 214.
86 D. Lowenthal, 'Stewardship, sanctimony and selfishness—a heritage paradox', in J. Arnold, K. Davies & S. Ditchfield (eds) *History and heritage*, 1998, pp. 169–179 (p. 173).
87 Cressy, 'National memory'; Harvey, 'Landscape organisation'.
88 Dodgshon, 'Human geography'.
89 Ibid., p. 613.
90 Ibid., p. 616.
91 Lowenthal, *Heritage crusade*, p. 5; McCrone et al., *Scotland the brand*, p. 11.
92 Ibid., p. xi. See also the implications of J. Arnold, 'Nasty histories, medievalism and horror', in J. Arnold, K. Davies & S. Ditchfield (eds) *History and heritage*, 1998, pp. 39–50.
93 Lowenthal, *Heritage crusade*, p. 1. These ideas are related to those of Matless (*Landscape and Englishness*) in which a rural nostalgia is fused with a progressive modernism in inter-war England. See M. Andrews' review of Matless's book, *International Journal of Heritage Studies*, Vol. 6, No. 2, 2000, pp. 185–186.
94 Lowenthal, *Heritage crusade*, p. 226.
95 Ibid., p. 3.

2
Museum studies and heritage
Independent museums and the 'heritage debate' in the UK

Anna Woodham

As its central focus, this chapter concerns two main questions: what is a museum? And what is museum studies? Are some 'types' of museum, such as the independent museum, considered outside the scope of museum studies and more aligned with 'heritage', and, if so, does that matter? What is the relationship between museum studies and heritage studies? Are they simply two sides of the same coin? Or are they decidedly different beasts? The following discussion, while not aiming to resolve these questions entirely, concerns the on-going debates around the definitions and distinctions, classifications and boundaries between museums and heritage sites, and the study of museums and the study of heritage.

The chapter takes as its main focus the representation of 'independent museums' via consideration of specific academic, policy and professional literature from the 1980s to the present day. It explores and appraises arguments advanced particularly by Candlin (2012), who suggested that in academic literature, independent museums are the preserve of 'heritage' rather than 'museum studies'.[1] She reasons that independent museums have been relatively neglected as a subject of analysis in traditional museum studies and argues that a failure to understand the contribution of 'heritage orientated' independent museums to the wider academic debate ultimately risks limiting the scope of museum studies as an academic field of enquiry (Candlin 2012). The present chapter agrees with this argument and suggests that the on-going association of independent museums with the domain of heritage rather than museum studies also offers us a useful commentary on the relationship between these two academic subjects as they continue to develop.

The chapter is structured in three main parts: after a brief initial consideration of the definition of an independent museum in the UK context, the discussion moves on to explore the growth of independent museums and their connection to the so-called 'heritage debates' in the UK. This discussion aims to explore why, over the past 30 years, independent museums have been associated more with the domain of 'heritage' rather than museums and the potential issues this has created. The final section of the chapter brings the discussion back to the academic study of museums and heritage, tracing the development of these parallel subjects and arguing that despite a more 'blurred' distinction between independent museums and the 'traditional' museum today, in the academic world the divisions between museum studies and heritage remain.

Defining independent museums

Although this chapter is really about what an independent museum is and how it differs from a 'traditional' museum,[2] it is recognised that in non-western contexts, in particular, the concept of an independent museum, may be less familiar. It is therefore important to briefly set out and problematise what the main characteristics of an independent museum in the UK context are, before embarking on a more in depth analysis of their connection to 'heritage studies' rather than 'museum studies'. The definition supplied by the UK Museums Association (n.d.) emphasises the common distinctions between independent museums and other 'types' of museum. Independent museums are, according to this explanation, 'owned by registered charities and other independent bodies or trusts. They are not usually funded directly by the state but may receive support through government programmes. Some may have funding agreements with local authorities'.[3] This definition considers that independent museums differ from other types of museum because of the ways in which they are governed and funded.

However, this definition raises some grey areas, for example, can we call a museum run by a private family or individual, which is neither a charitable body nor a trust, an independent museum? From the explanation above, the individual or family would need to be considered an 'independent body', which sounds too formal a description for one person or a family group. Candlin (2015) in her analysis of small independent museums also raises questions around the traditional definition of an independent museum. She argues that potentially many hundreds of small 'micromuseums' in the UK, organisations who represent a significant proportion of the independent museum sector, would be excluded from being considered either as an independent museum or, in fact, as a museum at all. Referring to the 1998 Museums Association definition of a museum (see Museums Association n.d.) in which a museum is held to be an institution that holds a collection 'in trust' for the wider public,[4] for an independent museum to be considered a museum, it would need to align itself with this 'in trust' principle, either by attaining charitable status or similar (Candlin 2015). This means that, in effect, any 'museum' and its collection that is owned outright by an individual, or 'for profit' business would be excluded from being considered a museum at all, and could only be regarded as a 'museum-like' organisation (ibid.). It is apparent from this definition that not all institutions have been considered as equally worthy of the term 'museum', and that a proportion of independent museums have existed outside of the standard definition.

Overall, what this brief summary also highlights is the diversity of the independent museum sector in the UK. It is a heterogeneous grouping of museums of different sizes, scales and governance structures, which derive funding from a range of different sources not excluding the state and local authorities. As will become clear later in this chapter, much of the literature referred to in the 'heritage debates' tends to overlook the variety of different institutions that fall within the definition of 'independent museum', instead referring mainly to the first category of large, professionally run organisations. What has not been discussed so far is the rise of this new type of museum, the ways in which it is considered, conceptually at least, to differ from the 'traditional' state or local authority funded museums and the implications of this for the museum sector as a whole. The next section goes on to explore these issues, considering the growth of independent museums from the 1980s to the present day, their association with 'heritage sites', and their uneasy relationship with 'traditional' museums.

Museums or heritage sites? The growth of independent museums in the UK

In the 1980s, at around the same time that the intellectual developments which prompted the new museology were gathering pace in academia,[5] the size and scope of the museum sector in the UK increased dramatically (see Babbidge 2000).[6] During the 1980s, museums were opening at an average of three per week (Boylan 2006) and by the 1990s, the Museums and Galleries Commission (MGC)[7] reported that there were 'upwards of 1,100' independent museums in the UK (1994: 100).[8] These museums were the youngest, most numerous and fastest growing category of museum at the time (Middleton 1990).

Some of the most commonly discussed independent museums in the museums and heritage literature (see note 1) were the result of groups of individuals and enthusiasts coming together to rescue and preserve former industrial sites or rural heritage. Thus, a visit to this type of independent museum was not always focused on looking at displays of objects in glass cases but, instead, on exploring large-scale objects, a building or a series of buildings in a landscape. Interestingly, in order to conserve these objects and structures, and ensure their survival into the future, the introduction of entry fees and other commercial ventures was not uncommon, and some independent museums incorporated profitmaking spaces such as shops and cafés. The physical spaces that many independent museums occupied also often differed from traditional museums, extending beyond the four walls of the museum building, encompassing, large outdoor areas, workshops and mixed indoor–outdoor spaces. It is really these museums in particular (Beamish, Blists Hill, etc.) that questioned the commonly held understanding of what a museum looked like and how it functioned, and raised the issue of whether these museums were in fact more accurately described as heritage sites rather than museums.

However, what we actually mean by a heritage site and how this differs from a museum is far from straightforward. Unlike 'museum', which has been subject to definition by various different organisations, such as the UK Museums Association and International Council of Museums (ICOM),[9] a heritage site has been less formally defined and remains a fluid and complex term.[10] The World Heritage Convention contains a definition of cultural heritage as monuments, groups of buildings and sites (UNESCO 1972, article 1). However, this sets up a false dichotomy, which identifies museums as institutions focusing on artefacts and collections, and heritage sites as structures, landscapes and large-scale objects located outdoors. According to Young (1997: 7), this 'meaningless' and 'counterproductive' distinction is grounded in and sustained by 'traditional and legal views about the value and ownership of places and objects'. However, despite what appears to be a clear distinction between museums and various types of heritage, in reality the separation is far from straightforward. For example, it is arguably just as possible for a 'collection' of buildings to exist in a single location as we may associate with a museum collection, and this can be seen at the Black Country Living Museum or Blists Hill. It is also possible for a museum's collection to be housed in multiple locations, see, for example, the UK Government Art Collection; artworks are housed in government offices and buildings across the globe.[11] Many heritage sites also house a collection of objects such as the vast collection and archive at Beamish.[12] Does this make Beamish, therefore, a museum, a heritage site or both? For the purposes of this chapter, I see the distinction between museums and heritage sites as extremely porous; associating heritage sites solely with outdoor buildings, structures and landscapes, and museums only with a collection of objects and artefacts housed under one roof is too simplistic. Nevertheless, as this chapter argues, this distinction has persisted and is arguably part of the reason why independent museums (as associated more with being heritage sites) have been neglected by museum studies.

We can begin to see quite distinctly how some new independent museums were considered to represent quite a divergence from the established museum mould (Nightingale 2007). As described above, one of the main areas of difference was towards a more market-orientated approach focused on commercial sustainability (see Ross 2004). This was a far less common approach in the traditional state and local authority funded museums at the time, and was considered by some to restrict curatorial freedoms. As most local authority museums were not reliant on visitor income,[13] it meant that museum staff could 'do the kinds of things which may only appeal to a minority' (Ross 2004: 86). However, even though commercial sustainability is important for many independent museums, we should not accept this characteristic as universal, which it is clear some authors do. As described in the last section, there are many independent museums in the UK that would not describe themselves as commercially sustainable, in that they are extremely small in scale, run by enthusiast volunteers, and surviving on private sponsorship and donations. An example of this is The Gissing Centre in Wakefield, Yorkshire.[14] According to a Visit England's (2013) annual survey of visits, the volunteer run childhood home of Victorian novelist George Gissing had 118 visitors in 2013. The museum is open at specific hours by appointment between May and September. It would be difficult to make the case that this independent museum is a commercial enterprise.

As well as a more commercially driven mind-set (taking into consideration the caveats above), many independent museums focused on a diverse range of 'non-academic' subjects such as witchcraft, lawnmowers, straw craft and basketwork (see Candlin 2015). This was another characteristic that tended to set them aside from many publically funded museums at the time, particularly those whose collections pre-dated 1950, and according to Hudson (2014) covered more academic styles of presentation and subject area such as archaeology, ethnography and natural history.

It is not surprising, given what appear to be quite significant deviations from the traditional museum format and ethos, that there was an uneasy consensus around the underlying purpose of these new museums during this period of expansion in the sector (Middleton 1994). Middleton saw the purpose of these new independent museums as '…not synonymous with education, knowledge, leisure or entertainment … [but] a combination of these elements in which a common aim is selective communication of information and experiences' (1994: 112). At the time, this understanding of a museum that placed entertainment and education on an equal footing and recognised that knowledge was selectively communicated, was highly unusual and represented a 'revolution … in museum philosophy' (Hudson 2014: 142).

Responses to the growth of independent museums are indicative of the suspicion that some sections of the museum profession viewed them with. Nightingale (2007: 25), for example, reports that Arthur Drew, the then chairman of the Standing Commission on Museums and Galleries (see note 6) described independent museums as 'Primordial slime from which all museums start'. The Association of Independent Museums (AIM) was quite happy to be associated with 'primordial' as a description, as it reflected them in a positive light by implying that independent museums are the origins from which everything else grows (ibid.). However, some local authority museums preferred the more derogatory interpretation associated with the word 'slime' instead (ibid.). This example is indicative of the belief held by some, that a museum service is something that should only be provided by a local authority. A new independent museum had no business using the word 'museum' to describe what it did, which was considered as an inauthentic and spurious use of the past, an opinion which, as we will see in the next section, was echoed in academic literature.

It has been established so far that the new independent museums exhibited some different characteristics to the more traditional museums even though their diversity makes it hard to

generalise. Certainly for some new independent museums, in particular, the likes of Beamish, Blists Hill and The Black Country Living Museum, it is not hard to see how they appeared so distinct from traditional museums and why they could be considered as something else more akin to heritage sites rather than museums.

Turning now to the academic literature and commentary focusing on the new wave of independent museums, the next section explores how the association of this new breed of museums with the heritage field as opposed to museum studies, prompted an uncomfortable analysis of the role and purpose of museums among academic communities, just as, as we have seen above, it did within the museum profession.

Independent museums and the 'heritage debates'

The growth of heritage sites in the 1980s, including the increasing numbers of independent museums, prompted a range of (mainly academic) commentary. These discussions appear, 30 years later, 'parochial and fixated upon questions of nostalgia, inauthenticity and commercialism' (Candlin 2012: 28). However, the texts that established these arguments, notably David Lowenthal's *The Past is a Foreign Country* (1985), Patrick Wright's, *On Living in an Old Country* ([1985] 2009) and *The Heritage Industry, Britain in a Climate of Decline* by Robert Hewison (1987), are regarded as influential in the development of heritage studies as an academic subject. They are useful to consider here because they position independent museums firmly as belonging to heritage rather than museum studies. The material discussed in this section helps to deepen our understanding of why this might be, focusing in particular on understandings of heritage that are based on nostalgia, false consciousness and a perceived over-commercialisation of the past.

Most introductory books on heritage, particularly those published in and about the UK, are likely to refer to the 'heritage debates' in an opening chapter (see for example, Howard 2003; Sørensen and Carman 2009; Harrison 2010, 2013), and some authors consider that heritage studies as an academic field of study really only began with the debates presented by Lowenthal (1985), Wright ([1985] 2009) and Hewison (1987). Arguably, Lowenthal, Wright and Hewison's main influence on the development of heritage as an academic subject was due to the potential these authors demonstrated for critiquing the contemporary usage of the past at a time when there was limited critical analysis of the 'heritage' phenomenon. All three texts are concerned, to a greater or lesser degree, with the relationship between heritage and issues of false consciousness, nostalgia and, as suggested above, the market-orientated use of the past. Wright and Hewison construct their deliberately provocative arguments around what they perceive as an ever-increasing abundance of heritage, referring to new open-air and industrial museums in particular. Wright's concern was that the growth of heritage-focused museums, an agenda he argues promoted by the government of the time, was actually a distraction from the real social, economic and political issues of the day. His view is that the identification of some forms of heritage as the 'national heritage' was an instrument used to establish a set of social norms, describing this process as re-presenting and deploying 'certain sanctioned sites, events images and conceptions' to meet certain ends ([2009] 1985: 69). Hewison's observations of 'The Way We Were' exhibition at Wigan Pier Heritage Centre show similar concerns.[15] The Centre reused former industrial warehouses and wharfs which had become derelict. Hewison's criticism of the site was that it was an inauthentic, 'rose tinted' stage-set that failed to represent the harsh realities of working class life and instead acted as a 'safe', nostalgic space for the middle classes. The Wigan Pier Heritage Centre was not a museum in Hewison's understanding of the term (1987: 21). For him, traditional museums 'create a focus for ideas of civic or national identity'

but heritage centres represent something far more spurious, their increasing numbers a 'symbol of national decline' rather than 'vitality' (1987: 84). They are, according to this view, used by the state to construct (false) 'stable' narratives at a time of globalisation, migration and transnationalism. That Wright and Hewison were writing at a time of industrial decline in the UK during the Thatcher government is paramount to understanding why they took this particular stance. As Reas and Cosgrove suggest, 'Heritage museums are very much a phenomenon of the '80s, a curious by-product of Margaret Thatcher's free market triumphalism and the desire to make the past directly relevant to the cultural and financial realities of the present' (1993: unpaginated).

Interestingly, an alternative and more recent theorisation of this growth of heritage in the UK has emerged from the European National Museums project (EuNaMus).[16] Knell *et al.* (2012) suggest that the boom in, particularly, industrial and rural heritage sites in the UK, rather than being a state-driven response to the decline of industry, was instead more a reflection of the growing prosperity of the middle classes. At the time, the generation that had been children and teenagers during the Second World War were now retired or nearing retirement. They were in good health, with more leisure time than ever before, and were actively seeking worthy causes to support. The 'sites and instruments of the working classes' (Knell *et al.* 2012: 75), which formed the focus of some of the new independent museums, presented worthy causes for the focus of middle class attention. These sites were initially at least, interpreted in a 'nostalgic mode' with a 'sense of romance' that would appeal to other members of the middle classes (ibid.).

While Hewison and Wright's criticism of the heritage industry found support in the media (Ascherson 1987, 1995), there were authors who provided a counter-argument, notably Raphael Samuel (1999), who argued that the expansion of 'historical culture' through the creation of independent museums and other organisations was not a sign of a sick society. Rather, it was symbolic of the democratisation of the past beyond the domain of the professional historian. We are all now, he argues, 'in some sort, curators or memory keepers' (1995). The variety and scope of the new independent museums was part of this broader more inclusive cultural landscape (Samuel 1999). It is possible to deconstruct the arguments that each of the authors presented in this section (Hewison, Lowenthal, Samuel and Wright) put forward and there was a lively debate between them. For example, for Wright ([2009] 1985: 239), Hewison paints an overly generalised picture and Samuel lacks a more critical understanding of the politics of using the past in the present.

Overall, what most of these authors do, in a predominantly negative sense, is associate independent museums with a disruption of the status quo in terms of traditional uses and representations of the past, and bring to the fore questions around what a museum is and how it should function.[17] For example, Bob West's 1988 critique of Blists Hill echoes Hewison's commentary on the 'heritage debates'. West's argument is based around issues of authenticity, where he is highly critical of the 'Victorian' community constructed at Blists Hill. West suggests that the number of opportunities for visitors to spend money crosses a line between commercialism and academic credibility: 'what we have here is a complete breakdown of the distinction between history-making and money-making' (1988: 57). Similar arguments are put forward by critics of Beamish (Walsh 1992; Bennett 1988; Hall 2006), with the perception that the site is presented as less a museum and more akin to Disneyland: '...a spurious simulacrum' of a heritage site (Walsh 1992: 103).[18]

Walton (2007), and Cross and Walton (2005), however, are rather more defensive of Beamish arguing that: 'This is a world away from Disney' (Walton 2007, unpaginated). They argue that what is presented at Beamish is grounded in scholarship and echo Middleton's suggestion that

the ethos of an independent museum combines aspects that some would find conflicting: 'the public comes for education as well as fresh air, fun, nostalgia and entertainment' (ibid.). Further rebuttals of the harsh critiques of sites like Beamish include the suggestion that the critics do not seem to enquire about the people that work at the sites and what they are trying to achieve, or the context and decision-making behind why they are presented in a certain way (Walton 2007; Cross and Walton 2005). A significant further assumption, which appears to be held by most of the heritage critics discussed here, is the insufficient analysis of audiences. Visitors are primarily regarded as passive and homogenous beings with limited agency, who soak up the 'bogus history' (Hewison 1987: 144) without question. This interpretation, which appears rather out-dated, leaves little room for exploring alternative uses of heritage for individual visitors (see Smith 2006; Howard 2003; Dicks 2000).

One of the main issues with the 'heritage debates' of the 1980s presented here is the extent to which they contributed to the normalisation of nostalgia and sentimentality in discussions of heritage sites in the Western world. This association of heritage with nostalgia and sentimental-ity limits further developments in our understandings of the role that heritage sites play in society. For example, Candlin (2012) considers the interpretation techniques used in a heritage site in Mexico, where activities that would be considered as pure nostalgia in a Western context are interpreted as activities which potentially act to strengthen cultural bonds. This raises the question of how useful it is to persist with such arguments and whether by doing so we are clouding our view of particular kinds of museums in particular contexts. Confronting this idea, Candlin (2012) uses the examples of a range of non-Western museums that are dedicated to different ethnic groups as discussed in Karp *et al.* (2006). Although these museums use similar forms of presentation to, say Beamish or Blists Hill, in contrast, these modes of interpretation are much more favourably received than the presentation of working class cultures in the inde-pendent museums discussed above. For example, the performance of traditional dances may be considered as a deliberate way of promoting and preserving traditional practices in a museum in Mexico. However, a similar performance in Beamish or Blists Hill of folk practices may be criti-cised as sentimental or nostalgic (ibid.). While not claiming to see Beamish as a direct compari-son with non-Western museums, this example helps to illustrate how criticisms of large-scale independent museums, which suggest they present nothing but spurious nostalgia and an inau-thentic interpretation of the past, could be rather limiting.

Before concluding this section and moving on to the final part of this chapter, I now turn briefly to focus on more recent policy and practice-based literature that considers independent museums. It is possible to see that within publications such as the *Museums Journal*,[19] the inde-pendent museum is still perceived as different from other types of museum but with a much more accepted and positive interpretation than it was in the 1980s. As I suggested at the start of this chapter, independent museums in general have always been associated with being forward-thinking; the organisations and their staff have been associated with exhibiting certain heroic and dynamic characteristics indicative of their reputation for 'doing things differently'. For example, Middleton (1994: 115) praises independent museums' 'determination' that they are 'self-reliant', 'Entrepreneurs' and 'innovators of necessity'. Likewise, the MGC (1994: 100) characterised them by their '... innovation, by [their] creative flair and energy', and the *Museums Journal* described them as having a 'pioneering spirit' and a 'can-do attitude' led by heroic-sounding 'young guns' (Nightingale 2007: 24; Wilkinson 2014).

Despite this rhetoric, which implies an unfailing resilience, hard times have hit and continue to affect independent museums. For example, at the 2014 conference of the AIM, the directors of the Black Country Living Museum, Beamish and Avoncroft Museum in Warwickshire each talked about how early successes in their histories were followed by periods of severe decline in

visitor numbers and income (Stephens 2014). However, the practice of associating independent museums with 'leading the way through hard times' was no more apparent than in 2010, when cuts to government spending were biting in the public sector. In a speech at the Museums Association Conference in 2010, independent museums were held up by Culture Minister, Ed Vaizey, as the model for publically funded museums to follow due to their entrepreneurial spirit (Steel 2010b). Vaizey's comments make, yet again the dangerous generalisation that independent museums all act and think the same, which of course they do not. However, his comments also imply that independent museums are still recognised for doing things differently to other types of museum but with fewer negative connotations. For example, Vaizey suggests that local authority museums could explore changes to governance structures to allow them to become charitable trusts, thus, in theory, allowing these organisations greater freedom to become self-supporting and develop commercially (Kendall 2014, 2015).[20] At the level of government policy, there is an emphasis on moving the non-independent museum sector more towards the independent museum model. Local authority museums actually started moving to trust status (or other forms of devolved governance) some years before Vaziey's 2010 speech with, for example, Glasgow's Culture, Leisure and Sport Trust established in 2007 (Kendall 2012), and Coventry Arts and Heritage Service, and Luton Museums Service transferring to trust status in 2008 (Stephens 2010; Heywood 2008).

It is interesting to note that current economic challenges in the UK are having profound effects on the public management of culture,[21] particularly on the mind-sets of organisations that have only ever considered themselves as publicly funded. Many of these are now at least considering that other options may afford benefits. As museum consultant Adrian Babbage states, 'It is not long since the sector believed that it was "beyond the pale" that publicly owned museums should be run by anyone other than a public body' (quoted in Kendall 2012). While this attitude may reflect the resistance towards the idea of privatisation, which the government drive towards devolved governance may signify, it could also hint at the sub-conscious perceptions of independent museums as maintaining a distinctly different mind-set, something which is still hard for some other types of museums to engage with.

In summary, this section highlights the complex representation of independent museums from the 1980s to the present day in academic and professional policy literature. Independent museums present a contradiction that is slowly weakening but has yet to lose its strength entirely. Represented as spurious, primarily by those in local authority museums during the 1980s boom of independent museums, and negatively associated with 'heritage', characterised as a flimsy, inauthentic and nostalgia-driven engagement with the past, independent museums are also held up as being role models for the future of museums, due to their association with entrepreneurialism and innovation.[22] They are arguably still positioned as being different to publicly funded museums, even though it is fair to say that this distinction is no longer framed as derogatorily as it was 30 years ago. We have seen since then, with some former local authority museums moving to trust status, an increasing sense that the distinctions between what may be usually seen as 'public' and 'independent' museums are becoming far less obvious. Does this mean then that the distinction between 'heritage studies' and 'museum studies' is also becoming less polarised? The final section of this chapter explores the relationship between these two areas of study and the implications this has for the future of museum studies.

Heritage and museum studies

Conventionally, in academia, museum studies and heritage are conceived as interlinked disciplines, which stem from different but related disciplinary roots. Both are products of the

twentieth century (see MacLeod 2007 on museums, and Sørensen and Carman 2009 on heritage studies), with museum studies developing more from history, social history, art history and cultural studies, and heritage from archaeology and geography (Biehl 2013). But, as the introduction to this chapter suggested, despite being closely associated with each other in university teaching and research, the two areas of study demonstrate a level of wariness towards one another. Extending beyond this, there is a notable exclusion of independent museums from discussions about key aspects of museum studies, such as what constitutes the idea of the museum as an institution, museum architecture, display and professional practice (Candlin 2012). Independent museums do contribute to discussions around heritage and 'community' (see, for example, Dicks 2000; Watson 2007; Macdonald 2007). 'The assumption is that such organisations are neither technically nor conceptually innovative, or offer any material for further museological study' (Candlin 2012: 37). We know from the last section that, in policy and professional literature, at least, independent museums are associated with innovation and entrepreneurship. But why does this disregard of independent museums, when associated with 'heritage', exist in more theoretical discussions of museums? And where does this bias stem from?

As an area of study, usually defined with a more practical focus (see MacLeod 2007), museum studies can be traced back over 100 years (Speiss 1996). This pre-dates the study of heritage, which, in its present form and in the UK, at least, is a much younger discipline.[23] It was, for example, only in 1994 that Peter Howard wrote in the first issue of the *International Journal of Heritage Studies*, that the study of heritage was rapidly forming into its own distinct discipline. Perhaps the bias in the academic literature therefore is reflective, in part, of the suspicion of heritage as a new area of study?

As a way of emphasising this relatively new growth of heritage and its status as a 'not quite fully matured' area of study, the development of heritage studies is compared to past shifts in museum studies by some. Witcomb and Buckley (2013), for example, suggest that the recent turn towards a 'critical heritage' is not unlike the 'new museology' movement that occurred some 26 years earlier (see note 5). Likewise the critical heritage discourse seeks to challenge the previous political naivety of heritage practice (Witcomb and Buckley 2013), with its manifesto calling for a 'rebuilding [of heritage studies] … from the ground-up' (ACHS 2011).[24]

In Peter Howard's introduction to the first issue of the *International Journal of Heritage Studies* mentioned above, he comments that 'museum studies surely forms the most established taught element within the heritage field' (1994: 4). In a sense, what Howard's description of heritage studies implies is the subsuming of museum studies within a broader area of study. This incorporation of museum studies as a theme within heritage studies would seem to reduce the self-contained identity of museum studies and position heritage as the 'parent'. It could be argued then, that museum studies, a subject which recently experienced a *belle époque*, is now, according to Mairesse (2006), 'going through the Golden Age of "Heritology"' (cited by Lorente 2012: 246). Is this movement towards heritage seen as a potential threat to the subject? Does this then explain why there has been a lack of engagement in museum studies with independent museums associated with heritage?

The available literature on this subject seems to suggest that the influence of heritage on museum studies could be viewed positively rather than negatively. For example, Lorente (2012) suggests that the influence of heritage on museum studies helps to emphasise the relationship of museums to the wider social context, and, in addition, the relationship of museums to the study of different forms of heritage such as intangible and natural heritage. The increasingly interconnected study of heritage and museums also, I argue, continues the association of museum studies with a highly cross-disciplinary area of study (see Macdonald 2010). However, despite the positive impact of heritage on museum studies, Candlin (2012) implies that there is a distinct

polarisation between the two subjects as they try to position themselves as separate from each other.

Just like the argument surrounding whether independent museums can be considered 'museums' at all, critics of heritage question whether it can be considered as a proper field of academic enquiry. They describe the breadth of heritage studies and the heritage phenomena as troubling (see Harvey 2001).[25] With the study of heritage and the methodologies, it uses a product of the very ' "unofficial" history' which is little more than a 'morass of case studies' that needs time to mature (Terry-Chandler 1999: 189, 192; see also concerns raised by Carman 2015). In parallel, perhaps, to discussions earlier in this chapter around the definition of a heritage site, critiques also echo on-going confusion around what heritage is and what the study of 'heritage' refers to, with discussions emphasising the vague, all-encompassing nature of the term (see Lumley 2005; Larkham 1995; Howard 2003). According to a blog post in *HistoryExtra* magazine, which accuses historians of snobbery, the word 'heritage' is guaranteed to have the historian '…foaming at the mouth with rage' (Sandbrook 2009). These criticisms indicate that suspicions of 'heritage' can be found beyond museum studies, and are, I would argue, more vociferously heard from historians, for example, than from within museum studies itself.

It is likely that the distrust of heritage from some 'traditional' areas of academic study is based on a number of different issues including concerns about commonly used methodologies and a lack of understanding that heritage has developed into a subject concerning the critical analysis of the uses of the past in the present. The study of heritage includes striking a balance between theory and practice (i.e. the professional management of heritage), just like museum studies. With such similarities between heritage and museum studies, it is interesting to reflect on why museum studies would exclude the contribution that independent museums, taking the broadest definition, could make to the understanding of the museum as a social and cultural phenomenon. For example, as Candlin (2012: 37) suggests, these institutions could provide insights into a whole range of questions which help us to understand further the museum as an institution, including 'What are the implications of housing a museum in a private residence, temple or pub? What forms of interaction does that location stymie or enable? What are the extents and restrictions of professionalism? How is humour used in exhibitions?' (Candlin 2012: 37).

The context surrounding independent museums has meant that they certainly have been more commonly referred to as part of heritage discourse. This stems from the heritage debates of the 1980s where a view of independent museums developed positioning these organisations as being something entirely different, more aligned to the theme park rather than the public museum, which is, instead, concerned with civic values rather than leisure time and entertainment. These debates reinforced the destabilising impact that independent museums had on public museums, challenging their mission statements, modes of presentation and governance structures. In the present, this perception is no longer negatively perceived, but is, instead, indicative of the entrepreneurial spirit that central government, in particular, wishes to encourage across the museum sector as a whole in order to ensure its survival which may be independent from central government funding. In this chapter, I have argued that, in fact, in the museum world, the division between public and independent museum is becoming less clearly defined. However, the conclusion we arrive at here is that an image of an 'authentic' museum as referred to in the 'heritage debates', as being everything an independent museum is not still persists in the academic world, and while it continues to do so, the full benefits of understanding the heterogeneous group of institutions and organisations that constitute the independent museum sector alongside other types of museums, will remain unknown.

Acknowledgements

I would like to thank each of the reviewers and Dr John Carman for their helpful comments on this chapter in its various iterations.

Notes

1 Particularly the large open-air museums established in the UK in the 1980s such as Blists Hill, part of the Ironbridge Gorge Museum Trust (IGMT) and Beamish, the Living Museum of the North.
2 'Traditional' museum refers here to the classic understanding of the 'modernist' museum as suggested in Hooper-Greenhill (2007) as a nineteenth century European model which still arguably endures today. These institutions are focused on the collection rather than use of objects and privilege the exhibition as a mode of communication. Objects are displayed in particular ways in order to legitimise specific world-views, and are housed in a building readily identifiable as a 'museum'. The modernist museum, 'upholds the values of objectivity, rationality, order and distance' (ibid.: 82).
3 In the UK there are a small group of national and state sponsored museums that are directly funded by central government. A further group of museums are known as 'local authority' museums. According to the UK Museums Association (n.d.), a local authority museum is an institution 'owned and run by town, parish, borough, city, or county councils and other local authority bodies. They generally house collections that reflect local history and heritage'. It is these local authority museums that have been more associated with 'traditional' definitions of museums.
4 'In trust' refers to the notion of public ownership, i.e. that a publically funded museum does not own its collection but rather looks after it 'in trust' or on behalf of the wider public.
5 The new museology was a development in the study of the museums concerned with ideas that are central to cultural theory. The new museology encouraged museums to think critically about themselves and their role in society. See Vergo (1989) and Stam (2005).
6 This growth in museums also extended beyond the UK to Europe and America (Hoelscher 2005).
7 Originally the Standing Commission on Museums and Galleries (1931–1981), the MGC was the national advisory body for museums in the UK (Coles 2000). It existed between 1981 and 2000 and was the predecessor of the now abolished non-departmental public body, the Museums, Libraries and Archives Council (MLA), and prior to this, Re:source. See http://discovery.nationalarchives.gov.uk/details/r/C98 (accessed 29 June 2018).
8 It is unclear what definition of independent museums the MGC used here, which could affect the number of museums it included within this category.
9 See www.museumsassociation.org/about/frequently-asked-questions (accessed 29 June 2018) and http://icom.museum/the-vision/museum-definition/L/ (accessed 29 June 2018).
10 As suggested in note 8, arguably, despite the more readily available definition of a museum, it is also still a highly fluid and complex term that is open to interpretation and that adapts to match societal needs. See Hooper-Greenhill (2007).
11 See www.gac.culture.gov.uk/about/map/ (accessed 29 June 2018).
12 See http://collections.beamish.org.uk/ (accessed 29 June 2018).
13 Although there are exceptions to this such as Norfolk Museums Service, a local authority governed museum service which charges an entry fee to its sites (see former Director Vanessa Trevelyan's comment on Steel (2010a)).
14 See www.wakefieldhistoricalsoc.org.uk/The%20Gissing%20Trust.htm (accessed 29 June 2018).
15 'The Way We Were' exhibition at Wigan Pier closed on 20 December 2008 (Wigan Heritage Service 2008).
16 See www.ep.liu.se/eunamus/for details (accessed 29 June 2018).
17 As previously mentioned, there are a small group of large independent museums which appear to feature most significantly in the 'heritage debates'. Beamish and Blists Hill are two of the more commonly used examples and we must bear in mind that often, these sites are (wrongly) assumed to typify the whole independent museum sector.
18 It is important to note that the large 'open-air' museums such as Beamish are not the only heritage site accused of 'Disney-fying' and dumbing-down as in recent years some country houses have also experienced this criticism. See Adams 2010 and Wallop 2015 on the National Trust, and Alan Bennett's (2012) parody *People*. It can be argued that the majority of country houses could be regarded as 'independent museums' too in the sense that they are not, on the whole, in receipt of direct government

funding. However, certainly in the past, they do not seem to have been framed using quite the same arguments as the open-air museums discussed here, which is symbolic perhaps of what Smith (2006) terms the 'authorised heritage discourse' which privileges monumental, grand heritage.

19 The *Museums Journal* is the periodical of the UK Museums Association, see www.museumsassociation. org/museums-journal (accessed 29 June 2018).

20 However, moving to a devolved governance model has been far from a straightforward process for museums with complex risks and challenges as well as advantages (see MLA 2010 and Babbidge *et al.* 2006).

21 See the recently published DCMS Culture White (March 2016) which encourages 'cultural organisations' to take a more business orientated approach in order to boost their 'resilience'.

22 See also the recently published 'Hallmarks of a prospering museum' published by the AIM (June 2015) available from: www.aim-museums.co.uk/downloads/895c97f1-1e79-11e5-b856-901b0e0dc93a.pdf (accessed 29 June 2018).

23 In countries such as the USA, for example, there is a long tradition of 'public history', which has parallels with 'heritage'.

24 It is important to note here that outside the UK the development of heritage studies can be attributed in part to different reasons. For example, in countries with settler nations, heritage studies has had more overt political aims, being associated with the opposition of perceived museum hegemony over indigenous groups. See for example Onciul (2015), McCarthy (2011), Lonetree (2012) and Sleeper-Smith (2009) among others.

25 Note also that there are parallel criticisms of tourism studies. See for example Butler (2006).

Bibliography

Adams, S., 2010. 'National Trust is "Disney-fying" its country houses, say critics'. *Telegraph*, 29 May 2010.

Ascherson, N., 1995. 'A society that falls back on miming the creation of its wealth is sick'. *Independent*, 19 February 1995.

Ascherson, N., 1987. 'Why "heritage" is right-wing'. *Observer*, 8 November 1987.

Association of Critical Heritage Studies. 2011. *Manifesto*, available from: http://criticalheritagestudies.org/ site-admin/site-content/about-achs (accessed 27 June 2015).

Association of Independent Museums. 2015. 'Hallmarks of a prospering museum', June, available from: www.aim-museums.co.uk/downloads/895c97f1-1e79-11e5-b856-901b0e0dc93a.pdf (accessed 8 March 2016).

Babbidge, A., 2000. 'UK museums: safe and sound?' *Cultural Trends*, 10 (37), 1–35.

Babbidge, A., Ewles, R. and Smith, J., 2006. *Moving to Museum Trusts: Learning from Experience – Advice to Museums in England and Wales.* London: MLA, available from: file:///C:/Users/Anna/Downloads/ Moving_To_Museum_Trusts_Part_1%20(1).pdf (accessed 24 February 2016).

Bennett, A., 2012. *People.* London: Faber and Faber.

Bennett, T., 1988. 'Museums and "the people"'. In R. Lumley (ed.) *The Museum Time Machine.* London: Routledge, 63–85.

Biehl, P.F., 2013. 'Teaching and researching cultural heritage'. In P.F. Biehl and C. Prescott (eds) *Heritage in the Context of Globalization Europe and the Americas.* New York: Springer, 45–50.

Boylan, P., 2006. 'The museum professions'. In S. Macdonald (ed.) *A Companion to Museum Studies.* Oxford: Blackwell, 415–430.

Butler, R., (ed.) 2006. *The Tourism Area Life Cycle, Vol. 2: Conceptual and Theoretical Issues* (Aspects of Tourism). Bristol: Channel View Publications.

Candlin, F., 2015. *Micromuseology: An Analysis of Small Independent Museums.* London: Bloomsbury Academic.

Candlin, F., 2012. 'Independent museums, heritage and the shape of museum studies'. *Museum and Society*, 10 (1), 24–41.

Carman, J., 2015. 'Internationalising heritage: the problem with being both global and local'. *Furnace: The Postgraduate Journal of the Ironbridge International Institute for Cultural Heritage (IIICH)*, 1, 6–12. Available from: http://issuu.com/furnacejournal/docs/furnaceissue1/1 (accessed 28 June 2015).

Coles, A., 2000. 'Influencing and implementing national strategies'. In H. Moffat and V. Woollard (eds) *Museum and Gallery Education: A Manual of Good Practice.* Lanham, MD: Altamira Press, 148–159.

Cross, G.S. and Walton, J., 2005. *The Playful Crowd: Pleasure Places in the Twentieth Century.* New York: Columbia University Press.

Department for Culture, Media and Sport, 2016. 'The Culture White Paper'. London: DCMS, available from: https://assets.publishing.service.gov.uk/government/uploads/system/uploads/attachment_data/file/510798/DCMS_The_Culture_White_Paper__3_.pdf (accessed 12 April 2016).

Dicks, B., 2000. *Heritage, Place and Community*. Cardiff: University of Wales Press.

Hall, M., 2006. 'The reappearance of the authentic'. In Ivan Karp, Corinne A. Kratz, Lynn Szwaja, Tomas Ybarra-Frausto (eds) *Museum Frictions: Public Cultures/Global Transformations*. London: Duke University Press, 70–101.

Harrison, R., 2013. *Heritage: Critical Approaches*. Abingdon: Routledge.

Harrison, R., (ed.) 2010. *Understanding the Politics of Heritage*. Manchester: Manchester University Press.

Harvey, D.C., 2001. 'Heritage pasts and heritage presents: temporality, meaning and the scope of heritage studies'. *International Journal of Heritage Studies*, 7 (4), 319–338.

Hewison, R., 1987. *The Heritage Industry: Britain in a Climate of Decline*. London: Methuen.

Heywood, F., 2008. 'Coventry's arts service switches to trust status'. *Museums Journal*, 108 (4), 4.

Hoelscher, S., 2005. 'Heritage'. In S. Macdonald (ed.) *A Companion to Museum Studies*. Oxford: Blackwell, 199–218.

Hooper-Greenhill, E., 2007. 'Interpretive communities, strategies and repertoires'. In S. Watson (ed.) *Museums and their Communities*. London and New York: Routledge, 76–94.

Howard, P., 2003. *Heritage: Management, Interpretation, Identity*. London: Continuum.

Howard, P., 1994. 'The heritage discipline'. *International Journal of Heritage Studies*, 1 (1), 3–5.

Hudson, K., 2014. 'The museum refuses to stand still'. *Museum International*, 66, 136–143.

Karp, I., Kratz, C.A., Szwaja, L. and Ybarra-Frausto, T., 2006. *Museum Frictions Public Cultures/Global Transformations*. Durham and London: Duke University Press.

Kendall, G., 2015. 'Adapt or die'. *Museums Journal*, 115 (3), 20–25.

Kendall, G., 2014. 'Museums opt to take their futures on trust'. *Museums Journal*, 114 (5), 12–13.

Kendall, G., 2012. 'Benefits are taken on trust'. *Museums Journal*, 112 (2), 15.

Knell, S., Axelsson, B., Eilertsen, L., Myrivili, E., Porciani, I., Sawyer, A. and Watson, S., 2012. 'Crossing borders, connecting European identities in museums and online'. EuNaMus Report, No. 2, Linköping: Linköping University Interdisciplinary Studies, No. 14.

Larkham, P.J., 1995. 'Heritage as planned and conserved'. In D.T. Herbert (ed.) *Heritage, Tourism and Society*. London: Mansell, 85–116.

Lonetree, A., 2012. *Decolonizing Museums, Representing Native America in National and Tribal Museums*. North Carolina: University of North Carolina Press.

Lorente, J.P., 2012. 'The development of museum studies in universities: from technical training to critical museology'. *Museum Management and Curatorship*, 27 (3), 237–252.

Lowenthal, D., 1985. *The Past is a Foreign Country*. Cambridge: Cambridge University Press.

Lumley, R., 2005. 'The debate on heritage reviewed'. In G. Corsane (ed.) *Heritage, Museums and Galleries: An Introductory Reader*. London: Routledge, 15–20.

McCarthy, C., 2011. *Museums and Maori: Heritage Professionals, Indigenous Collections, Current Practice*. Wellington: Te Papa Press. Walnut Creek, California: Left Coast Press.

Macdonald, S., (ed.) 2010. *A Companion to Museum Studies*. Chichester: Wiley-Blackwell.

Macdonald, S., 2007. 'On "Old things": the fetishization of past everyday life'. In L. Smith (ed.) *Cultural Heritage: Critical Concepts in Media and Cultural Studies*. London: Routledge.

MacLeod, S., 2007. 'Making museum studies: training, education, research and practice'. *Museum Management and Curatorship*, 19 (1), 51–61.

Mairesse, F., 2006. 'L'Histoire de la muséologie est-elle finie?' In H.K. Viereg, M. Risnicoff de Gorgas, R. Schiller and M. Troncoso (eds) *Museology: A Field of Knowledge, Museology and History*. ICOFOM Study Series – ISS 35, available from: http://network.icom.museum/fileadmin/user_upload/minisites/icofom/pdf/ISS%2035%202006%20History.pdf (accessed 27 June 2015).

Middleton, V.T.C., 1994. 'Purpose of museums and special characteristics of independents'. In G. Kavanagh (ed.) *Museum Provision and Professionalism*. London: Routledge, 112–115.

Middleton, V.T.C., 1990. *New Visions for Independent Museums*. Chichester: Association of Independent Museums.

Museums and Galleries Commission, 1994. 'The museum scene'. In G. Kavanagh (ed.) *Museum Provision and Professionalism*. London: Routledge, 97–102.

Museums Association, n.d. *About: Frequently Asked Questions*, available from: www.museumsassociation.org/about/frequently-asked-questions (accessed 24 February 2016).

Museums Libraries and Archives Council, 2010. *The Opportunity for Devolved Governance for Museums, libraries and archives*. Birmingham: MLA, available from: www.nationalarchives.gov.uk/documents/information-management/the-opportunity-of-devolution-for-museums-libraries-and-archives.pdf (accessed 24 February 2016).

Nightingale, J., 2007. 'Independence days'. *Museums Journal*, 107 (6), 24–27.

Onciul, B., 2015. *Museums, Heritage and Indigenous Voices, Decolonising Engagement*. London: Routledge.

Reas, P. and Cosgrove, S., 1993. *Flogging a Dead Horse: Heritage Culture and its Role in Post-Industrial Britain*. Manchester: Cornerhouse Publications.

Ross, M., 2004. 'Interpreting the new museology'. *Museum and Society*, 2 (2), 84–103.

Samuel, R., 1999. *Theatres of Memory*. London: Verso.

Samuel, R., 1995. 'Theme Parks – Why Not? History is everybody's'. *Independent*, 12 February 1995.

Sandbrook, D., 2009. 'Many historians dislike the heritage industry out of sheer snobbery', HistoryExtra, 30 September 2009, available from: www.historyextra.com/blog/many-historians-dislike-heritage-industry-out-sheer-snobbery (accessed 3 March 2016).

Sleeper-Smith, S., (ed.) 2009. *Contesting Knowledge: Museums and Indigenous Perspectives*. Lincoln and London: University of Nebraska Press.

Smith, L., 2006. *Uses of Heritage*. London: Routledge.

Sørensen, M.L.S. and Carman, J., 2009. *Heritage Studies: Methods and Approaches*. London: Routledge.

Speiss, P.D., 1996. 'Museum studies: are they doing their job?' *Museum News*, November/December, 32–40.

Stam, D.C., 2005. 'The informed muse: the implications of "The New Museology" for museum practice'. In G. Corsane (ed.) *Heritage, Museums and Galleries: An Introductory Reader*. Abingdon: Routledge, 54–70.

Steel, P., 2010a. 'MA warns of danger of introducing admission charges at free museums'. *Museums Association News*, 24 August 2010, available from: www.museumsassociation.org/news/24082010-danger-of-introducing-admission-charges-at-free-museums (accessed 6 April 2016).

Steel, P., 2010b. 'Vaizey urges museums to be more entrepreneurial'. *Museums Journal*, 110 (11), 9.

Stephens, S., 2014. 'Public benefit'. *Museums Journal Blog*, 25 June 2014, available from: www.museumsassociation.org/museums-journal/museums-journal-blog/25062014-why-lottery-money-is-vital-for-many-independent-museums (accessed 28 June 2015).

Stephens, S., 2010. 'Trust status warning for museums'. *Museums Journal*, 7 October 2010, available from: www.museumsassociation.org/news/07102010-trust-status-conference-session (accessed 21 August 2018).

Terry-Chandler, F., 1999. 'Heritage and history: a special relationship? Review article'. *Midland History*, 24, 188–193.

UNESCO, 1972. *Convention Concerning the Protection of the World Cultural and Natural Heritage*, available from: http://whc.unesco.org/en/conventiontext/ (accessed 6 April 2016).

Vergo, P., (ed.) 1989. *The New Museology*. London: Reaktion Books.

Visit England, 2013. 'Annual survey of visits to visitor attractions', available from: www.visitengland.com/biz/resources/insights-and-statistics/research-topics/attractions-research/annual-survey-visits-visitor-attractions (accessed 24 February 2016).

Wallop, H., 2015. 'Is the National Trust becoming a "bizarre joke"?' *Telegraph*, 10 April 2015.

Walsh, K., 1992. *The Representation of the Past, Museums and Heritage in the Post-modern World*. London: Routledge.

Walton, J., 2007. 'Recovering the popular past: the Beamish open-air museum in its British context'. Paper presented at the 'New Audiences for Old Houses: Building a Future with the Past' Conference, 28 September 2007, Boston, MA, available from: www.bu.edu/ah/files/2011/10/beamishboston.pdf (accessed 28 June 2015).

Watson, S., 2007. 'History museums, community identities and a sense of place'. In S.J. Knell, S. MacLeod and S.E.R. Watson (eds) *Museum Revolutions: How Museums Change and are Changed*. London: Routledge, 160–172.

West, B., 1988. 'The making of the English working past: a critical view of the Ironbridge Gorge Museum'. In R. Lumley (ed.) *The Museum Time Machine*. London: Routledge, 36–62.

Wigan Heritage Service, 2008. 'Last chance to see "The way we were"!' *Past Forward*, 47 (9), December–March 2008, available from: www.wlct.org/heritage-services/pf47.pdf (accessed 6 March 2016).

Wilkinson, H., 2014. 'Negotiating change: curatorial practice in UK museums, 1960–2001', unpublished PhD thesis, Leicester: University of Leicester.

Witcomb, A. and Buckley, K., 2013. 'Engaging with the future of "critical heritage studies": looking back in order to look forward'. *International Journal of Heritage Studies*, 19 (6), 562–578.

Wright, P., [1985] 2009. *On Living in an Old Country*. Oxford: Oxford University Press.

Young, L., 1997. 'Museums, heritage, and things that fall in-between'. *International Journal of Heritage Studies*, 3 (1), 7–16.

3
People [extracts]

Alan Bennett

Introduction

Some plays seem to start with an itch, an irritation, something one can't solve or a feeling one can't locate. With *People* it was a sense of unease when going round a National Trust house and being required to buy into the role of reverential visitor. I knew this irritated me, but, like the hapless visitors whom Dorothy confronts as they are leaving, I still found it hard to say what it was I had expected to find and whether I had found it.

National Trust guides more conventional than Dorothy (and for whom I almost invariably feel slightly sorry) assume that one wishes to be informed about the room or its furniture and pictures, which I don't always. Sometimes I just want to look and occasionally (eighteenth-century porcelain, Chinoiserie and most tapestries) prefer to walk straight through. Sometimes I actively dislike what I'm seeing: yet another table massively laid for a banquet, for instance, or massed ranks of the family photos ranged on top of a grand piano with royal visitors given some prominence. Even when I am interested but want to be left alone with the pictures or whatever. I have learned not to show too much interest as this invariably fetches the guide over, wanting to share his or her expertise. I know this is bad behaviour and it's another reason why I'll often come away as dissatisfied with myself as I am with the house.

The first stately home I can remember visiting was Temple Newsam, a handsome early sixteenth-century house given to Leeds by the earl of Halifax. We often used to go on outings there when I was a child, taking the tram from outside the City Market up through Halton and past the municipal golf course to the terminus at Temple Newsam House. An adjunct of Leeds Art Gallery, it had a good collection of furniture, a long gallery without which no country house was complete, besides housing some of the city's collection of Cotman drawings and watercolours. While aged nine or ten I didn't wholly appreciate its contents, I saw Temple Newsam as a wonderfully ancient and romantic place, which it wasn't really, having been heavily restored and remodelled in the nineteenth century. Still, it gave me a lifelong taste for enfiladed rooms and for Leeds pottery (particularly the horses) neither of which life has enabled me to indulge. As a boy, though, for me its most numinous holding was a large felt hat reputed to be that of Oliver Cromwell with a bullet hole in the crown to prove it.

Visiting Temple Newsam was always a treat, as it still is more than half a century later. Back in 1947, though, with the country in the throes of the post-war economic crisis, the push was on for more coal, and the whole of the park in front of the house was given over to open-cast mining, the excavations for which came right up to the terrace. From the state rooms you looked out on a landscape as bleak and blasted as a view of the Somme, an idyll, as it seemed to me then, irretrievably lost, and young though I was I knew this.

But of course I was wrong. It wasn't irretrievable and to look at the grounds today one would have no idea that such a violation had ever occurred. And it had occurred, too, with even greater devastation at other country houses south of Leeds: Nostell Priory was similarly beleaguered, as was Wentworth Woodhouse, both, like the Stacpooles' house, smack in the middle of coal-bearing country and where the notion as in the play of a country house with a mine in the immediate vicinity is far from far-fetched.

Nostell Priory is full of Adam furniture, and both Nostell and Temple Newsam have Chippendale desks like the one referred to in the play, that at Temple Newsam, bought by Leeds Corporation from the Harewoods at Harewood House – another outing from Leeds, and a mansion, incidentally, that was once on the National Trust's wish list but which happily still remains with the family that built it. It is, though, one of those reprobate mansions cited by June in the play, Harewood having been built from the profits of eighteenth-century sugar and slaves … from one of whom is descended one of the National Theatre's noted actors, David Harewood.

Enjoy (1980) is another play with which *People* has similarities in that both, while ostensibly contemporary in setting, have a slightly fanciful notion of the future. At least I thought of it as fanciful, but what I was writing about in *Enjoy* – the decay and preservation of a working class quarter in a northern town and the last back-to-back in Leeds – all came true much quicker than I could have imagined in the decades that followed. The same threatens to be the case with *People*.

Privacy of at any rate exclusivity is increasingly for hire, instances of which make some of Bevan's proposals in the play not even outlandish. I had written the play when I read that Lichtenstein in its entirety could be hired for the relatively modest sum of £40,000 per night. Around the same time I read that Lancaster Castle, that once housed the County Court and the prison that often went with such institutions, was up for sale. That it had also hosted the execution of condemned prisoners probably increased the estimate. At one point in 2011 the Merchant Navy War Memorial at Tower Hill was to have been hired out for some banker's junket. That a Methodist church in Bourne-mouth has been bought and re-opened as a Tesco is hardly worth mentioning. So what is? Everywhere nowadays has its price and the more inappropriate the setting the better. I scarcely dare suggest that Pentonville or Wormwood Scrubs be marketed as fun venues lest it has already happened.

When it came to giving offence, there too I kept finding that I had been if not timid, at least over-scrupulous. In the management and presentation of their newly acquired property of Stacpole House I imagined the Trust as entirely without inhibition, ready to exploit any aspect of the property's recent history to draw in the public, wholly unembarrassed by the seedy or the disreputable. I envisaged a series of events I took to be wildly implausible, but in the light of recent developments they turn out to be almost tame.

I read for instance that the audio guide to the National Trust house at Hughenden, once lived in by Disraeli, is voiced by Jeffrey Archer, euphemistically described by the Trust as 'a provocative figure'. And in the matter of pornography the Trust has recently sponsored a tape to accompany a tour round London's Soho, the highlights of which are not architectural. It is apparently selling very well.

Alan Bennett

My objections to this level of marketing are not to do with morals but to do with taste. In another connection, though, and nothing to do with the Trust, I found life had outstripped my paltry imagination. I have no reference for this other than what the DNB used to call 'personal knowledge', but talking to someone about what I still thought of as the outrageousness of a country house being made the venue for a porn film, I was told that there was (and maybe still is) an entrepreneur who does just that, arranging similar (and equally chilly) filming in country houses north of the border.

So, writing the play and imagining I was ahead of my times, I then found I was scarcely even abreast of them. Had the play not been produced when it was (in November 2012), in six months' time it might have seemed hopelessly out of date.

As is made plain in the play, Dorothy is not shocked by porn being filmed under her (leaking) roof. As she points out, she is a peeress in her own right. 'The middle class … they're the respectable ones.' Which is a cliché but I'd have thought no less true for all that. But then, what do I know?

My experience of high life is limited, but years ago, I think through George Melly, I used to be invited to parties given by Geoffrey Bennison, the fashionable interior decorator. He lived in Golden Square ('Above Glorex Woollens, dear') and there one would find Geoffrey in full drag, and very convincing drag it was, too, as he made no attempt to seem glamorous, instead coming across as a middle-aged duchess not unlike Lady Montdore in Nancy Mitford's *Love in a Cold Climate*. It would be a very mixed bag of high life and low life – Diana Duff Cooper dancing with a well-known burglar sticks in the mind – respectability and the middle classes nowhere.

'Now that I'm eighty there are two things I no longer have to do,' said another grand lady of my acquaintance. 'Tell the truth and wear knickers.' What Dorothy is or is not wearing under her fur coat I don't like to think.

That said, I have never been entirely confident that the glimpses one is allowed in stately homes of the family's 'real life' always ring true. Years ago I was filming at Penshurst Place, the home of Lord de Lisle and Dudley, and I wrote in my diary (15 December 1984):

> The house is everything one imagines an English country house should be … a hotchpotch of different periods – mediaeval hall, eighteenth-century courtyards, Gothick front, solid green walls of yew and parterres of box. We film in a gallery adjoining the drawing room, part of the private wing, with photographs of Lord D, at Cambridge, in India as a young man and ADC to Wavell and now standing beside Macmillan as he unveils a plaque to Lord Gort. On a coffee table are back numbers of *The Economist, Country Life* and the *TLS* with drinks on the side.
>
> 'Ah,' one thinks. 'A glimpse here of the private life.' But is it? Is this really a private room or just a private room for public consumption? These drinks (and the bottle of vitamin pills beside them), have they been artfully arranged to suggest a private life? Is there somewhere else, another flat which is *more* private? And so on. And so on. The impression is confirmed by the hall table, on which are all the Viscount's hats: his green Guards trilbies, his bowler, his lumberjack's hat that was plainly presented to him on some sort of ceremonial visit. Surely, all this is meant to be *seen*?
>
> *(Writing Home)*

No soiled underwear in the state bedroom at least … but even voicing the thought I can see it coming one day soon. The links between such unworthy musings and what happens in the play are obvious.

Plays have buds, points at which something is mentioned in one play though not dwelt on but which turns up in a later play. Never sure of the significance of what one writes or the

continuity of one's concerns, I find these recurrences reassuring as pointing if nothing else to consistency. They can, though, be shaming.

In *The History Boys* Irwin is a dynamic supply teacher who ends up as a TV historian and government special adviser. Televised in the latrine passage below the reredorter at Rievaulx Abbey, he speculates on those scraps of cloth on which the monks wiped their bums, some of which have been recovered and are in the abbey museum. Could it be shown that one of these fragments had actually been used by St Aelred of Rievaulx, would that scrap of cloth, Irwin wonders, then constitute a sacred relic? It's an unsavoury preoccupation, but unnoticed by me a related concept has smuggled itself into *People*, where the notion of historical and celebrity urine is a branch grown from Irwin's bud.

On a different level the discussion of the Holocaust in *The History Boys* relates to Hector's dismay that Auschwitz has become just another station on the tourist trail, with Hector concerned about the proportion of reverence to prurience among the visitors. This recurs – and to my mind more harshly – in *People*, with Lumsden's comment that there is 'nowhere that is not visitable. That at least the Holocaust has taught us.'

Dorothy's comments about the graffiti done by the Canadian troops billeted in the house during the war echo similar speculations in James Lees-Milne's *Ancestral Voices*:

> **Wednesday 7 January 1942** (At Brocket) I walked across a stile and down a footpath to the James Paine bridge, which the Canadian troops have disfigured by cutting their names, with addresses in Canada, and personal numbers, all complete and inches deep – the vandals. Yet, I thought, what an interesting memorial this will be in years to come and quite traditional, like the German mercenaries' names scrawled in 1530 on the Palazzo Ducale in Urbino.

He might have added the Viking inscriptions cut centuries earlier into the lions outside the Arsenale in Venice.

It was in Lees-Milne, too, that I read about the Jungmann sisters, who in their youth were Bright Young Things and contemporaries of Evelyn Waugh. In later life they turned reclusive, stockpiled the newspaper (the *Telegraph*, I suspect), reading one a day still but years behind the times.

It has been said (by Kathryn Hughes in the *Guardian*) that nowadays 'it is the demotic and the diurnal that matter to us when thinking about the past' and what are generally called 'bygones' make a brief appearance in the play, as they regularly do in the below-stairs rooms of country houses. Fortunate in having had a relatively long life, I have grown used to seeing everyday items from my childhood featuring in folk museums or even as items on the *Antiques Road Show*, a brass and pewter gill measure from a milk pail, for instance (wielded at the Bennett family back door by the milkman, Mr Keen, his horse and trap waiting in the street); a posser for the clothes wash and jelly moulds galore.

Even so I was surprised this summer when going round Blickling to see a young man rapt in contemplation of a perfectly ordinary aluminium pan. Still, he was doubtless a dab hand at the computer, which I'm not, even though to me aluminium pans are commonplace. Other vintage items which were in common use when I was young would be:

A wicker carpet beater.
A wooden clothes horse.
A tidy betty.
A flat iron.

Pottery eggs.
Spats.
Black lead.
Virol.

The danger of making such a list is that one will in due course figure on it.

Curiously it was only when I'd finished the play that I realised I'd managed to avoid giving the house a name. I suppose it ought to be the family name and so Stacpoole, except that one proof of aristocracy is to subtly distinguish the name of the house from the name of its location. Thus in a minor snobbery Harewood, the home of the Lascelles family and their earldom, is pronounced Harwood, whereas the village of Harewood, its location near Leeds, is pronounced as it's spelled, Hare-wood. So on a similar principle I've called the house Stacpole but it's pronounced Stacpool.

In the play Bevan sings the praises of solitude with his slogan 'P-S-T … people spoil things.' While Bevan hardly carries the moral burden of the play he has a point … and some authorial sympathy.

I have tasted the pleasures of singularity myself, having been lucky enough to be in Westminster Abbey at midnight and virtually alone. As an ex-trustee I am permitted to visit the National Gallery after hours, and filming has meant that I have often been in well-loved places like Fountains Abbey almost on my own.

So, while it is to be hoped that such privileged privacies are never marketed in the way Bevan and 'The Concern' would like, the heady delights of exclusion are these days touted commercially more and more and without apology.

The notion that the eighties in England marked a turning point keeps recurring – a time when, as Dorothy is told, we ceased to take things for granted and self-interest and self-servingness took over. Some of this alteration in public life can be put down to the pushing back of the boundaries of the state as begun under Mrs Thatcher and pursued even more disastrously thereafter, though in regretting this (and not being able to be more specific about it) Dorothy in her fur coat and gym shoes is thought by her sister the archdeacon to be pitiably naive as perhaps I am, who feels much the same. The state has never frightened me. Why should it? It gave me my education (and in those days it was a gift); it saved my father's life as it has on occasion saved mine by services we are now told have to be paid for.

What is harder to put one's finger on is the growth of surliness in public behaviour and the sour taste of public life. There has been a diminution of magnanimity in government both central and local, with the public finding itself re-branded as 'customers', supposedly to dignify our requirements but in effect to make us available for easier exploitation. The faith – which like most ideologies has only a tangential connection with reason – is that everything must make a profit and that there is nothing that cannot be bought and sold.

These thoughts are so obvious that I hesitate to put them down, still less make them specific in the play. Dorothy is asking what is different about England, saying how she misses things being taken for granted. We were told in the eighties and pretty constantly since that we can't afford to take anything for granted, whereas to my mind in a truly civilised state the more that can be taken for granted in terms of health, education, employment and welfare the better we are for it. Less and less are we a nation and more and more just a captive market to be exploited. 'I hate it,' says Dorothy, and she doesn't just mean showing people round the house.

Apropos the closet with the ancient chamber pots: having finished the play, we went for a short holiday in Norfolk in the course of which we went round Felbrigg Hall, the family home of R. W. Ketton-Cremer, who willed it to the National Trust on his death in 1969.

Ketton-Cremer was an historian and had a well-stocked Gothick library which, as distinct from other such rooms in country houses, was a place of work, as Ketton-Cremer produced many books. Set in the thickness of the wall behind a pivoting bookcase was a closet with, on a table, a chamber pot. It was, alas, empty.

JUNE: What you don't seem to understand is that if we don't give it to the Trust we'll be compelled to renovate the place ourselves and we do not have the money.
DOROTHY: So sell the Chippendale.
JUNE: No.
 It was made for the house.
 You never used to like the house.
DOROTHY: I don't like it or dislike it. It's home. Plus, there are no people. I spent half my life posing and being looked at. Well, not any more.
JUNE: There are no people now.
DOROTHY: Give it to the National Trust and there would be: in droves.
JUNE: People are unavoidable.
DOROTHY: I thought the clergy were supposed to like people.
JUNE: No, we're supposed to love them. Not the same.
DOROTHY: But you believe in God?
JUNE: This is the Church of England, that's not an issue.
DOROTHY: So do you still say your prayers?
JUNE: You used to say yours with that terrible rosary. Where is that? Where's that got to?
DOROTHY: I don't know, in a drawer somewhere.
JUNE: Because the Trust will want to know. That would be a star attraction, particularly these days?
DOROTHY: It won't be lost. It's got a luggage label on it.
JUNE: Where's Charles I's shirt?
 (Dorothy shrugs.)
 Don't you care?
DOROTHY: Yes, but they've survived because nobody did care. If they'd cared they'd have been sold years ago. I take them for granted. Not caring is what's preserved them.
JUNE: Henry took stuff for granted but his lorry drivers didn't; we lost stuff by the truck load, literally.
DOROTHY: Only at the finish.
JUNE: But wouldn't you like to see the place made presentable? The Adam rooms restored, the rubbish cleared out?
DOROTHY: Not if it means people traipsing round. There was a letter in the paper yesterday saying that the writer had been to York Minster and it was like King's Cross in the rush hour. None of them praying, needless to say. Just looking. And not even looking. Snapping it. Ticking it off. I don't want to be ticked off. And this was in 1983.
JUNE: Is that where you're up to? With the papers?
DOROTHY: There's a war on, near South America somewhere.
IRIS: Those troops. That's why I'm knitting.
JUNE: We won that war.
DOROTHY: You spoilsport. That takes all the fun out of it.
JUNE: It wasn't fun. Besides, there is – and I don't expect you to appreciate this – there is a moral case. We ... our family ...
DOROTHY: Oh, don't.

Alan Bennett

JUNE: We've been here since 1456.

IRIS: 1465.

JUNE: Isn't it time we made amends?

DOROTHY: What for?

JUNE: For the wool that built the house, the tenants turned off their land for sheep. After sheep it was iron and after iron, sugar, and sugar meant slaves. And after slaves, coal. Walk over the hill to where the colliery was and there's the business park. Somewhere ... resited probably ... there's a plaque to the ninety-three miners killed in an explosion just before the First War.

DOROTHY: That wasn't our fault. What has that got to do with us?

JUNE: Ours the colliery, ours the coal. Shawled wives gathered at the colliery gates; the empty cage coming up. All the ancient rituals of loss. Do we not owe for that?

Ralph Lumsden has come in and overhears much of this speech.

LUMSDEN: Forgive me. I eavesdrop. But fascinating stuff. So rich. And the layered landscape. It is England. The history, the tragedy. And today, though one must not say so, the banality. A business park!

No, please, Lady Stacpoole, do not get up. I am after all a suitor, a suppliant. I crawl. Besides I want to envision you enthroned among your treasures. A picture of England. A TABLEAU VIVANT, Ralph Lumsden.

DOROTHY: Yes. This is Iris, my ...

IRIS: Companion.

LUMSDEN: Oh, lady, lady, lady. One has been trying to see this house for so long. It throbs with history.

DOROTHY: Yes, though I think you may be under a misapprehension ...

JUNE: My sister has a few minor reservations, but why don't you finish your tour of the house and then we can talk them through.

LUMSDEN: Quite so. I'll just scoot round upstairs, though having seen the Adam rooms, no doubts, no doubts at all.

JUNE: Have you got a torch?

LUMSDEN: I have. I am all 'tooled up'.

IRIS: Watch the floorboards.

LUMSDEN: Have no fear. À bientôt.

(He goes off.)

(Lumsden returns.)

LUMSDEN: My torch seems to have given up the ghost. And I can't open the shutters. Still, I've seen all that I need. Besides, I have to return to the present. Because it casts a spell. Not on you ... you are part of the spell ... but on those fortunate enough to be given a glimpse of ... all this.

DOROTHY: How kind.

LUMSDEN: Forgive me if I enthuse, but I see this house and your family's continuous occupancy of it as a metaphor. Tell a child the story of England and it is all here.

DOROTHY: Yes. I would be deceiving you, Mr Lumsden, if I said I had not heard such twaddle before.

I particularly abhor metaphor.

Metaphor is fraud.

England with all its faults.

A country house with all its shortcomings.

The one is not the other ... however much the Trust would like us to think so. I will not collaborate in your conceit of country. It is a pretend England.

50

LUMSDEN: Oh. This is a surprise. I must marshal my forces. I suppose I would say that we …
the Trust, its houses, its coastline, its landscape … are, if not the model of England, at least
its mitigation.

DOROTHY: Country houses are window dressing. They mitigate nothing.

LUMSDEN: Does this affect your donation?

JUNE: (Returning with the bottle)
No, of course it doesn't. My sister sits alone in this mouldering house and gets some
cockeyed ideas.

LUMSDEN: Now, Lady Dorothy, we like to debrief our donors. I want you to tell me
everything.

DOROTHY: Nothing to tell. This is not the Cotswolds, Mr Lumsden, and South Yorkshire
is not conducive to anecdote. We lived as we live now, in a fraction of the house. We did
not hunt. The miners had a livelier time than we did, our one excitement when the Festival
Ballet came to Sheffield.

IRIS: And the open-cast mining. That came right up to the terrace.

DOROTHY: But no legends. No idylls. Nothing you could market. And no one the least
larger than life.

LUMSDEN: There is one legend. I've always understood that what is reputed to be here is the
rosary belonging to Henry VIII.

JUNE: It's here somewhere.

DOROTHY: Yes. I saw it when I was a child and indeed used to play with it. Now …
(She shakes her head.)

JUNE: It must be here.

IRIS: Everything is here somewhere.

LUMSDEN: I'm sure, and of course the first thing we would want to do is make an inventory
about what we've … what you've got.
But not aspic. Not aspic at all. Back in the day, yes, red ropes. 'Do not touch'. Every-
thing in its place. Nowadays the scullery and the still room are as important as the drawing
room. And we interact … racks of costumes, frock coats, doublets … Visitors can feel
themselves a part of the house.
But no pretence. I noticed for instance as I went round the ragged footings of the tapes-
tries … gnawed by mice, and wet by centuries of dogs. What we would hope to do is to
have our experts clean them, obviously with a degree of stabilisation but making no attempt
at repair. Or even disguise. Rather we would draw visitors' attention to them, focus on
them as part of the history of the house. They are after all a testament to time and its abra-
sions. And we cannot halt time … but we can put it on hold – while we live in the
present.
I won't, thank you.
(June is offering him a drink.)

JUNE: I don't want to drink on my own.

IRIS: It's never stopped you before.

DOROTHY: Iris.
Mr Lumsden. I have lived in this house all my life.

JUNE: Well, that's not true for a start. There was a long period when you never came near.
You were gallivanting about in London and Paris and New York. So not quite all
your life.

LUMSDEN: Archdeacon.

DOROTHY: I came back here when I was in trouble. It is where I want to die.

51

Alan Bennett

LUMSDEN: If the Trust accepts the property of course you can stay here. You must stay here. Your own little flat furnished with your own favourite pieces plus a chintz of your choice.

DOROTHY: You say, 'If the Trust accepts the property.' My sister implied you had no doubts.

LUMSDEN: I don't. How could I? A soldier returns from the Hundred Years War and builds a house. On the lawns of the same house five centuries later the survivors of Dunkirk are nursed back to health. It's a story and a story the house longs to tell ... I can almost smell it.

IRIS: She won't open the windows.

LUMSDEN: However, we are a large organisation. Top of my wish list though this is, it's only fair to tell you there is a school of thought on my committee that thinks we have enough country houses as it is. Do we need another? Yes, I say. This is special. And it's been so ever since I came across the only photographs of it I've ever seen in an old COUNTRY LIFE when I was a boy.

DOROTHY: It won't look like that now.

LUMSDEN: Well, it does rather. But money is tight and there are other contenders in the field. The childhood home of Cilla Black and ... the past lapping always at the feet of the present ... a pithead baths in Featherstone plus the last functioning children's library in the north-east.

And unlike them what weighs against this house is that it isn't in any sense 'of the people'. And of course it's a big ask.

DOROTHY: A 'big ask' what?

JUNE: A tall order.

LUMSDEN: It will be expensive to restore. Another acquisition under discussion are some surviving cells from the Maze prison in Belfast ... cells which figured in the so-called dirty protest. Do we, how shall I put it, save them? Do we restore the patina? I think we do. I think we must. But you see our dilemma.

DOROTHY: (Cheerfully) Oh, so you're not sure you want is after all?

LUMSDEN: Oh no, dear lady. We do, we do. We must.

DOROTHY: Because one has had interest elsewhere. Someone came to look at the attics only this morning.

LUMSDEN: I don't like the sound of that.

JUNE: It was nothing, Bicycles, croquet mallets ... it was only the junk.

LUMSDEN: Archdeacon, I beg to differ. Bicycles and croquet mallets are not junk. I would go so far as to say they are the very essence of it. Bicycles and croquet mallets are what the Trust is about. A Sheraton side table or an Edwardian mangle ... no comparison. But which gives a livelier sense of the heart of the house and the life lived here? No. I beg you. We must keep the place intact. It's a wonderful house and I long to see it brought back to life. There are some intriguing oddities ... the attic rooms full of old newspapers, for instance.

JUNE: Oh, you could clear those out tomorrow.

DOROTHY: No!

LUMSDEN: Another oddity, in the Adam saloon ...

JUNE: I think I know what's coming. I should have told you about this. I can explain.

LUMSDEN: Please. You sound as if you expect me to be shocked. I wasn't shocked at all. I felt I was perhaps being more nosy at this stage than perhaps I'm entitled to be – this was only a preliminary perambulation after all – but behind the Gothick tracery in the Adam saloon one happened upon a cupboard ...

52

DOROTHY: Not a cupboard. A closet.

JUNE: Oh God.

LUMSDEN: There are ... I may have misunderstood ... but rows and rows ... I should have said about two dozen in all ... of chamber pots. Full chamber pots ...

DOROTHY: Did you take any of them down?

LUMSDEN: I didn't feel it was my place.

DOROTHY: So you didn't look underneath?

LUMSDEN: Hardly. They were quite full. And a touch ... unsavoury.

IRIS: Well, you daft thing, you should have looked underneath.

LUMSDEN: Why? What's inside?

JUNE: Well ... urine, of course. Ancient urine.

DOROTHY: And having with due care and attention looked underneath you'd have found labels. With names.

LUMSDEN: Names?

DOROTHY: Rudyard Kipling, Ramsay MacDonald, George Bernard Shaw, Thomas Hardy ...

IRIS: T. E. Lawrence.

LUMSDEN: Fascinating. To what purpose?

IRIS: Lord Halifax.

DOROTHY: It's always been known as the Adam saloon since the time when Adam designed it. Only in the nineteenth century and after it was used as a billiard room ... and would be still, only we had to take the billiard table upstairs to the attic on account of the roof ... there's a tin bath on it at the moment.

LUMSDEN: I saw.

IRIS: Osbert Sitwell.

DOROTHY: The saloon is a long way from the downstairs lav so when they were playing billiards after dinner they would use individual chamber pots. And if they were at all celebrated ... Shaw, Hardy, Mr Asquith ... they weren't emptied.

JUNE ABSURD: It's worse than absurd: it's embarrassing.

IRIS: Lord Linlithgow.

LUMSDEN: Really? Well ... who was he?

IRIS: I don't know, but his name's on a po so he must have been somebody.

DOROTHY: The one absentee is Henry James, who often stayed here, but he was too fastidious to use the chamber pot, insisted on making the long trek to the loo.

LUMSDEN: Oh dear. What a shame!

IRIS: Yes, and it held the game up.

LUMSDEN: Has anyone ever written about the saloon or done it for TV?

DOROTHY: Certainly not. We don't have any of that. No TV. There's a wireless somewhere just in case.

LUMSDEN: Just in case what?

DOROTHY: War. The last one they had to send down to the kitchen to listen to Mr Chamberlain.

IRIS: He came here once.

LUMSDEN: Any wee?

IRIS: Didn't play billiards.

LUMSDEN: That is fascinating. I am captivated. I was certain as I went round that this house was for us, but I didn't know why, Architecturally it's extraordinary – the pictures, the furniture – but it needed one more feature to make it special.

JUNE: The chamber pots?

LUMSDEN: And the newspapers … They were the clues, and I now begin to see how I can make the case for the house to my people. Thank you. Thank you.

JUNE: Jolly good. I don't altogether understand why, but the house has obviously ticked the right boxes.

LUMSDEN: Some unique boxes. And I'll be in touch very shortly.

DOROTHY: One moment. Flattered though I am that with all its shortcomings you like the house … I have to tell you …

JUNE: Dotty …

DOROTHY: No. I *will* speak. My sister has misled you.

JUNE: We can talk this over. Not now.

DOROTHY: While I would happily hand over the house to be kept up as it is, what I do not want is for the place to be overrun with droves of visitors.

LUMSDEN: People are inductable, Lady Dorothy. They are endemic. They are unavoidable.

While of course as a growth organisation we are concerned to maximise our percentage footfall, do please bear in mind these are not just people. Our membership is made up of self-selecting individuals who appreciate the art and craftsmanship of the past.

DOROTHY: And who just want somewhere to go.

LUMSDEN: But nothing will change.

DOROTHY: The *looking* will change it. Looking always does.

JUNE: How many more times, Dotty, there is no other way. We would like you to have the house.

IRIS: You would. She wouldn't. No 'we' about it.

JUNE: It's the only way.

DOROTHY: It's not the only way. I have other irons in the fire.

JUNE: Dorothy.

DOROTHY: I had a better offer only this morning.

LUMSDEN: A better offer? Are we in competition?

JUNE: No. No.

DOROTHY: I'm currently waiting for them to get back to me.

LUMSDEN: I knew I had to persuade my people, but you assured me your sister had made up her mind.

JUNE: She had. She has.

IRIS: You were always a madam; she hasn't.

LUMSDEN: This is dreadful. I need a decision. I can't go back to the committee with a maybe. It's heartbreaking. This … it's England. You are its custodian. We mustn't lose it.

DOROTHY: No. I'm not England. I just live here. Goodbye, Mr Lumsden.

LUMSDEN: I despair. Sad, sad, sad. (To June.) I will telephone.

JUNE: I'll come out with you.

They are going out, but June lets him get ahead before turning back and saying deliberately:

You – stupid – cow.

(She is going off again when she has another thought, comes back and takes the opened bottle before finally going.)

And don't forget. I've got the Bishop coming.

(Dorothy remains in her chair, catching the occasional moth before dozing off. Iris, seeing she is asleep, gathers up her things and goes.)

DOROTHY: Bloody man.
England is not my problem. I will not be metaphorised.
This is not Allegory House.
England not.
History not.
Bring it on.

4
The crisis of cultural authority

Tiffany Jenkins

In campaigning for repatriation, senior professionals participate in activities that result in the removal of, at times, highly valued material from research collections. They appear keen to highlight the negative historical legacy of colonialism, the deleterious impact on communities, and the role that museums have played in this. But until recently, members of the sector would not advocate the removal of valued material from museum collections, nor would they critically question the role of the institution. They were the gatekeepers of such institutions, guarding the collections. Now, some members appear to be opening the gates. What, then, do these activists achieve by questioning the role of the museum, promoting acts that appear to alter, even undermine, their own role and status? Why do they participate in these activities?

Those examining the construction of problems identify and explore the claims-makers' interests in promoting an issue. Joel Best (1990) observes that activists may stand to acquire more influence, or that there may be indirect symbolic benefits which contribute to explaining their activities. In what follows, we see that the campaigners for repatriation are responding to a crisis of authority, and attempting to secure new legitimacy by distancing themselves from a discredited foundational remit. In the past 40 years, the cultural authority of the museum has undergone considerable scrutiny and a number of criticisms, which have resulted in the destabilization of its legitimacy. A number of overlapping social and intellectual shifts have resulted in significant and widespread questioning of the purpose of the museum, which has weakened its traditional sources of justification. Museum theorist Steven Conn (1998) suggests that museums have always perceived themselves to be in crisis. While the crisis discourse may have been present for some time, and there have been fluctuations in the purpose and credibility of these institutions, my central argument is that the foundational principles of the institution have been consistently and profoundly questioned in the past four decades, and that the extent of this legitimation crisis has not been fully recognized.

Cultural authority

Max Weber's (1968) conceptualization of legitimacy in relation to state authority has provided the analytical framework for most analyses of authority. Weber was interested in legitimate forms of domination. Broadly, he argued that society evolved historically from political orders

based on charismatic and traditional types of legitimation, to a modern state legitimated primarily on legal grounds. Authority demonstrates possession of status or a social position that compels trust or obedience. As part of this ability to demand trust or obedience, authority suggests the potential to use force or to penalize people in some fashion. For example, political authority can threaten imprisonment, which makes people reliant upon such authorities for their freedom. However political authority requires respect and consent, rather than domination. Authority therefore incorporates two sources of control: dependence and legitimacy. Political philosopher Hannah Arendt (1977) is careful to stress these two foundations of authority, identified as crucial by Weber, both of which are equally, concomitantly required. Where and when force is used, Arendt suggests, authority has failed. It has also failed when only argument and persuasion are used, for this presumes equality rather than superiority.

Social theorist Richard Sennett (1980) echoes these observations about the importance of legitimacy, in his discussion of authority in the domain of professional and personal relationships. He asks, what makes an authority? Sennett illustrates his answer with an example of the conductors Toscanini and Pierre Monteux. Both were able to discipline the orchestra, but through very different methods. He concludes: 'Assurance, superior judgment, the ability to impose discipline, the capacity to inspire fear: these are the qualities of an authority' (Sennett 1980: 17–18). Authority, then, can involve more than laws or rules. It can also refer to the imposition of definitions of reality or judgments of value and meaning, where the legitimacy of that or those defining reality or making judgments is crucial. Sociologist Paul Starr (1982) terms the authority that defines and affirms judgments of meaning and reality 'cultural authority'. Social and cultural authority differs in several ways, Starr explains. Social authority controls actions and behavior through law, rules and instructions. Cultural authority involves the construction of reality through definitions of fact and value. Institutions such as the church and the academy make authoritative judgments about the nature of the world, as do museums.

The emergence of the modern museum

Museums hold a cultural authority that frames and affirms the pursuit of truth and defines what is historically and culturally significant. These institutions, which can have varying specialisms; including science, natural history, art and anthropology, play a role in affirming ideas about the pursuit of knowledge and how it is organized, reinforcing ideas about what is considered important and valuable from human civilizations, for reasons that are historically constituted. While aspects of the museum can be traced back to the medieval Schatz, a treasury of goods collected by the Habsburg Monarchy, or private collecting in the Renaissance, it was the development of public collections in the eighteen and nineteenth century that, arguably, rationalized private collections into a specific meaningful public context (Abt 2006). The museum in this period is generally understood as forming in overlapping stages. The first is the move, in the eighteenth century, of the Royal Collections in France into a semi-public context, reconceptualizing the space and the collection from artefacts chosen randomly by private individuals, into a rational organization of artefacts based on ideas of progress (Prior 2002). As museologist Eileen Hooper-Greenhill writes of this period, the French Revolution created 'the conditions of emergence for a new "truth", a new rationality, out of which came a new functionality for a new institution, the public museum' (Hooper-Greenhill 1989: 63). With the Enlightenment, ideas developed about the absolute character of knowledge, discoverable by the methods of rationalism and its universal applicability, which informed the purpose of the museum and the display of artefacts.

Museum theorist Tony Bennett explains that the emergence of the museum coincided with, and presented, new sets of disciplinary knowledge:

> The birth of the museum is coincident with, and supplied a primary institutional condition for, the emergence of a new set of knowledges—geology, biology, archaeology, anthropology, history and art history—each of which, in its museological deployment, arranged objects as parts of evolutionary sequences (the history of the earth, of life, of man, and of civilization) which, in their interrelations, formed a totalizing order of things and peoples that was historicized through and through.
>
> *(Bennett 1995: 96)*

The assemblage of private objects, once categorized as unique artefacts, was transformed into a collection that demonstrated scientific themes and rational principles of classification. This was a significant shift, where museums holding objects became more than displays of eclectic treasures and developed into institutions concerned with the pursuit and display of knowledge within a rational framework.

Tony Bennett posits that during the nineteenth century the museum was informed by the symbolic use of such institutions to the emerging modern state (Bennett 1995). Pointon (1994) describes how the promotion of the European state in the late eighteenth and early nineteenth century developed with the modern national museum, in his analysis of the Louvre in France. The Louvre had been a palace for the King. When the French revolutionary government nationalized the King's art collection it became a symbol of the fall of the old regime and the rise of the new order. For Carol Duncan (1995) too, in her exploration of the development of the discipline of art history, the transformation of this palace into a public space accessible to everyone made the museum a demonstration of the state's commitment to the principle of equality and the idea of national identity. Benedict Anderson's (1983) discussion of nation states as imagined political communities shows that museums were used as repositories and narrators of official nationalism and were symbols of those imagined communities.

While Britain did not have a royal art collection to take over as a national symbol, it is argued that museums did become places of Britishness (Bennett 1988). In his study of museums and modernity in Britain, sociologist Nick Prior (2002) explains that museums in the eighteenth century were not usually owned by the state, but in the nineteenth century, following the emergence of citizenship, governance and democracy, they gradually came to be held by the state on behalf of the people. During this period the state began to 'construct a nineteenth-century state art apparatus.' (Prior 2002: 79) This period, according to Nick Prior, gave clarity and concrete form to the museum project, which was then taken up across Europe.

The organization of the social space of the museum occurred alongside the formation of the bourgeois public sphere. Tony Bennett (1995) suggests that the opening of museum to a wider public in the nineteenth century should be read as a regulating mechanism that aimed to expose the working class to the pedagogic mores of middle class culture, in order to civilize them. Bennett, drawing on theorists Foucault and Gramsci, highlights the ways in which the development of the museum was involved in attempts to transform a populace into a citizenry. Bennett discusses what he terms the 'exhibitionary complex', where the exhibition space was a response to public order and which won heart and minds, while the prison institution disciplined and controlled bodies (p. 335). He concludes that the public museum is a product of an outlook that seeks to civilize and educate the masses to produce a 'self-regulating citizenry' (p. 63).

Theorists have thus argued that museums are institutions of 'overpowering cultural authority [...] [expressing] ambitious and encyclopaedic claims to knowledge' (Karp and Kratz 1991, cited

in Corsane 2005: 39). Crane argues that the authority vested in museums remains 'a fixed aspect of the cultural landscape, so certain does their purpose seem to be' (1997: 46). In line with this analysis, the common sociological understanding of the gallery or museum, as encapsulated by Bourdieu (1984), can be referred to as a dominant ideology approach to state-sponsored cultural institutions, where they are seen to function for the cohesion and reproduction of capitalist society. Museums are taken to contribute to civic ritual, ideals of nationhood, and the promotion of structural inequalities (Fyfe 2006).

A crisis of cultural authority

It is widely recognized that the state and associated institutions, including educational, medical and cultural organizations, are in a condition of a legitimation crisis (Arendt 1977; Gabe, Kelleher and Williams 1994; Owens 1985; Eagleton 1993), although there is considerable debate over the causes, periodization, and institutions affected by this crisis. Broadly, a legitimation deficit arises when older sources of justification for institutions have been undermined and eroded (Habermas 1987). I suggest that a number of overlapping social and intellectual shifts have resulted in significant and widespread questioning of the purpose of the museum. These have weakened its traditional sources of justification and contributed to a crisis of cultural authority. It is this that helps to explain the broader context in which professionals have become key advocates in elevating the problem of human remains.

The social theorist Zygmunt Bauman explains that the late eighteenth and early nineteenth century, the time of the emergence of the modern museum, was a time when men of knowledge—the intellectuals—had authority that could be described as legislative (Bauman 1987; 1992). This intellectual climate underpinned the formation of the modern state and official institutions of culture, including education and the early public museums. In the present period, however, Bauman argues that the role for intellectuals as legislators of meaning has weakened. They no longer securely hold legislative authority or the ability to define meaning and outline judgments. Instead, men of knowledge play a role more akin to that of an interpreter. Bauman traces the changing role of intellectuals, the 'legislators of meaning', in relation to the development of the state and the market over the past 200 years. The state's dependence upon intellectuals for legitimation was superseded in the nineteenth century, Bauman writes, by political technologies of panoptical power, fields within which ranks of experts, and expertise, proliferated. Expertise developed with the creation of techniques of surveillance, medicalization and education. As the state's reliance on culture for the reproduction of its power diminished, market forces rose to challenge the autonomy of intellectuals. Bauman describes a clash of interests between philosophers and aestheticians, and emerging market-orientated intellectuals where the production of culture serves the market:

> It is therefore the mechanism of the market which now takes upon itself the role of the judge, the opinion-maker, the verifier of values. Intellectuals have been expropriated again. They have been displaced even in the area which for several centuries seemed to remain uncontestably their own monopolistic domain of authority—the area of culture in general, 'high culture' in particular.
>
> *(Bauman 1987: 124)*

A role in social reproduction remains for intellectuals, Bauman notes, but it is a weaker role of bureaucratic usefulness rather than of legislative power.

The rise of the market has had a significant impact on the role of the museum. In particular, in relation to this study, British cultural policy underwent a significant change in direction in

the 1980s (Sinclair 1995; Selwood 2001). Theorists argue that the impact of the fiscal crisis of the welfare state led to cuts in public spending including arts subsidy (Quinn 1998; Gray 2000). During this period arts institutions could not rely on the idea of 'art for its own sake' to justify funding and support, but had to find other utilitarian values with which to promote their work. In the context of decreasing state support, and the introduction of admission charges for most nationals, institutions began to conceptualize and promote exhibitions as products to be marketed with the aim of encouraging larger numbers of paying visitors (Macdonald 1998a). Cultural historian Robert Hewison (1991) argues that the influence of the market during this period shifted the values of the institution away from serious scholarship, which has triggered a crisis of purpose. He suggests that scholarship and stewardship have been abandoned due to market forces.

Postmodern thinking

In addition to the constraints and pressures arising from the operations of the market, the central tenets of the Enlightenment, which informed the remit of the museum in the eighteenth and nineteenth centuries, have been called into question (Foster 1985; Bennett, O. 1996; 2001). While the principles of the Enlightenment have always evoked some hostility, a number of intellectual trends since the late 1960s have furthered this stance, thus profoundly challenging claims about truth, and the idea of the museum as a distinct realm removed from social and political forces. In particular, these trends are: postmodernism, cultural theory, and postcolonial theory. These trends are complicated, specific and overlapping, and to give a precise account of them and the relationship of each to the other in a few paragraphs will necessarily truncate and reduce their complexity. However, I will attempt to provide a summary of this process.

Postmodernism is a periodizing concept that describes a break with the aesthetic field of modernism. It has come to be used as a term to describe a rupture, in the last few decades of the twentieth century, from the modern period and modernity (Docherty 1993; Jameson 1993). The aspect of postmodernism thinking that has had a major impact on the role of the museum is a scepticism about modernist ideas. This is a way of thinking that developed out of poststructuralist theory in the 1960s and 1970s, as proposed by theorist Jean François Lyotard (1984). Scholar Terry Eagleton (2003) describes the outlook of postmodern thinking as rejecting concepts of totality, grand historical narratives, universal values, and the very possibility of objective knowledge. Postmodernism is sceptical of truth and progress, and tries to tear down hierarchy, celebrating pluralism and relativism.

> [T]he contemporary movement of thought which rejects totalities, universal values, grand historical narratives, solid foundations to human existence and the possibility of objective knowledge. Postmodernism is sceptical of truth, unity and progress, opposes what it sees as elitism in culture, tends towards cultural relativism, and celebrates pluralism, discontinuity and heterogeneity.
>
> *(Eagleton 2003: 13)*

In relation to intellectual practices, the terms 'modernism' and 'postmodernism' indicate differences in understanding the nature of the social world and the purpose of intellectual work. With the modernist outlook, relativism was to be struggled against and overcome. The postmodern outlook instead holds the view that knowledge is relative. Bauman (1987) makes a helpful distinction between the two, commenting that while it is debatable whether philosophers of the modern era ever established the foundations of objective knowledge, the point is

that they pursued it with 'conviction' (Bauman 1987: 120). Under Postmodernity, he argues, the search for truth was deemed pointless and abandoned.

Cultural relativism, the principle that an individual['s] beliefs and activities should be understood in terms of his or her own culture, was originally developed in anthropological research by Franz Boas, influenced by the thinkers Kant, Herder, and von Humboldt, in the first few decades of the twentieth century (Marcus and Fischer 1986). Frank Furedi (2004) maintains that while these ideas were initially held by the right-wing thinkers, then amongst a small group of artists and intellectuals, they became increasingly influential from the 1960s when they were adopted by left-wing thinkers: the 'New Left'. This is a development described by the American cultural critic Alan Bloom as the 'Nietzscheanisation of the left' (1987: 217), when left-wing thinkers became disillusioned by modernism and embraced particularism and heterogeneity. Cultural relativism has sub-sequently become a prevailing intellectual force.

Cultural theory

Cultural relativism influenced the development of cultural theory. Its central idea is that culture is a signifying practice that is bound up with value judgments (Hall 1992). Milner and Browitt (2002) identify that cultural theory developed within the academy in the late 1960s, although they trace the origins to the ideas of nineteenth-century thinkers. Cultural theory advanced a broad definition of culture beyond the fine arts, to a more anthropological understanding of common meanings and material practices in a whole society. Culture did not exist in reified spheres but was a product of social and material relationships and therefore could be 'ordinary', wrote Raymond Williams in the late 1950s (Williams 2001). The emergence of cultural studies and the work of academics such as Raymond Williams, Richard Hoggart, Tony Bennett and Stuart Hall, popularized a political role for culture in society. These theorists were part of a new institution established to address questions of 'cultural apparatus': the Birmingham Centre for Contemporary Cultural Studies, founded in 1964 (Hewison 1995). Their contribution to academic debate was also reflected in the roles they undertook in the arts world. Williams sat on the board of the Arts Council in the 1970s, and Hall has played a prominent role in artistic networks and cultural institutions.

Broadly there are two strands to cultural studies. One involves theorists who argue that cultural studies are a critique that impartially analyzes cultural products and representations, better to understand structuralist dynamics. This approach is predominant in early cultural studies (see for example Jameson 1998; McGuigan 1996; 1999). It draws on a Gramscian analysis of the hegemony of the state in shaping ideology, and sets out to create strategies of resistance to this through critique. The second strand comes from those who argued that it was impossible to think that cultural studies could be separated into a transcendent space for abstract analysis. Theorists argued that cultural studies could never be free from the agenda of state power. Tony Bennett was an influential advocate of this position, arguing that cultural studies was problematic if it saw itself as a critique, for culture would always be used politically (Bennett 1992; 1998). Reformation rather than revolution was seen as the solution.

Museums, for these theorists, are not able to abstract rational thinking for the public, but instead reinforce the values and position of the elites. Theorists developed a highly critical analysis of culture, and advocated that it should be subject to critical engagement, or consciously used to tackle contemporary political problems. Stuart Hall (2001) argued that the history of modernity in the Western canon needed to be reconsidered—although this would be difficult, because 'museums are still deeply enmeshed in systems of power and privilege' (p. 23). The museum, suggested Hall:

> [H]as to be aware that it is a narrative, a selection, whose purpose is not just to disturb the viewer but to itself be disturbed by what it cannot be, by its necessary exclusions. It must make its own disturbance evident so that the viewer is not trapped into the universalized logic of thinking whereby because something has been there for a long period of time and is well funded, it must be 'true' and of value in some aesthetic sense. Its purpose is to destabilize its own stabilities.
>
> *(Hall 2001: 22)*

For Hall, then, the museum should no longer claim to be the legislator of truth, or to consider itself as benign, as this is not possible. Instead it drew attention to the museum's unreliability. With this approach, permanent and continued questioning is advocated in relation to any idea of truth and value. The authority of the institution, for Hall, must constantly be in doubt.

Tony Bennett (1998) argues that museums should discard the old universalist outlook and become a space to discuss diverse narratives and values. Instead of trying to separate culture from the interests of the powerful, Bennett advises that society should use culture as a positive political tool. The curator, he suggests, should discard their traditional position of the legitimate authority and instead become more of a catalyst for debate. Museums should not aim to establish a singular truth claim or narrative, or universal standards of 'the best', but to show the inherent instabilities of truth claims, and give different individuals and ethnic or social groups the opportunity to present their own versions of the past and of cultural value (Bennett 1998).

The development of cultural theory, and the identification of the political role of culture, coincided with and reflected growing disillusionment with the conventional framework of class politics. Terry Eagleton (2003) explains that this interest in cultural politics replaced declining and failed traditional political concerns. Eagleton (2000) argues that the turn to culture in this way is utopian and that it is a desire to achieve in the realm of the imagination a resolution of the fundamental structural contradictions of capital. For him, the poststructuralist turn to culture attributes historical agency to individuated, culturized strategies of representation in the realm of consumption.

The politics of recognition

The cultural turn was reinforced by ideas generated by the politics of recognition, which became influential in the social sciences in the late 1980s and 1990s, lending the discipline a therapeutic sensibility. Advocates of the politics of recognition argue that culture should be attributed as much weight as political representation because it deals with the psychological aspect of the individual's relationship to society (Honneth 1995). This view suggests that individuals require not just material wealth but the positive affirmation or 'recognition' of their identities by state and institutional bodies (Taylor 1992; Young 1990). Even the political theorist Nancy Fraser (1995), who has criticisms of this approach, suggests that the redistribution of material wealth is not enough and that attention must be paid to cultural exclusion. The therapeutic ethos, that is the need for institutions to recognize and support the emotional needs of citizens, is increasingly a central function of governments today (Nolan 1998), and, it is argued, cultural policy (Silverman 2002; Furedi 2004; Mirza 2005). These trends have contributed to the shift in the purpose of the museum, away from the pursuit of empirical truth to that of playing a role in therapeutic identity work.

The growth of postmodern thinking and cultural studies stimulated post-colonial studies. With the rise of postmodern and postcolonial theories, culture and science came to be viewed, not as universal or objective, but as a damaging reflection of the prejudices of European cultures.

The impact of these ideas stimulated the 'culture wars', 'history wars' and 'science wars' in the 1980s in North America, in which Enlightenment ideas of truth, universalism, judgment, and progress were criticized, defended and debated (Hunter 1991; Gitlin 1994; 1995; Gross and Levitt 1994; Ross 1996). As a consequence of these intellectual shifts, the outlook of the earlier period that informed the role of the museum—to validate the superiority of modern reason, to make judgments, to pursue the truth and to claim to pursue the truth—have been severely attenuated. The previously overriding cultural authority of the institution has been questioned to the point of crisis.

The impact on museology

Until the 1980s, most literature on museums was devoted to reports of exhibitions, discussion about equipment and histories. While there was some examination of the social and educational role of museums, this was marginal (Merriman 1991). This changed dramatically in the 1980s, when a body of work developed criticizing the idea that museums were value-free and arguing that they are inherently and unavoidably political. The debates over objective truth, relativism and the political role for culture, that were present in postmodernism, cultural and postcolonial theory, were rapidly assimilated into museology by theorists and practitioners.

The work of French sociologist Pierre Bourdieu was a catalyst for this approach. In *Distinction: a social critique of the judgement of taste* (1984), Bourdieu explored the social roots and organization of judgment and taste. In this work, and in *The Rules of Art* (1996), Bourdieu developed the idea that cultural discernment was a marker of class position and that visiting galleries was a way to indicate taste and class. Cultural tastes were influenced by primary and secondary socialization processes rather than a response to universal values of truth or beauty. While Bourdieu focused on art galleries in France, his work encouraged a similar analysis of museums. A broad group of museologists and practitioners came to argue that the development of museums in Western societies occurred in specific historical circumstances and actively supported the dominant classes, maintaining the status quo as natural (see for example Duncan and Wallach 1980; Sherman and Rogoff 1994).

Towards the end of the 1980s, a group of British museum professionals and scholars published *The New Museology* (Vergo 1989), a collection of essays that aimed to develop new critical theory on museums and to reconsider the social role of museums. *The New Museology* recommanded that the study of museums and professional work should adopt a greater degree of self-awareness and questioning of the methods employed, as well as the purpose and context of the institutions. The stimulus, wrote the book's editor and Art History professor Peter Vergo, was 'widespread dissatisfaction with the "old museology"', both within and outside the museum profession [...] [I]t is too much about museum methods and too little about the purposes of museums' (Vergo 1989: 3). There were a number of interventions made into the debate by this volume. Firstly the idea was developed that the meanings of objects are contextual rather than inherent, suggesting that the current social and political conditions and context frame the meanings of the object, rather than that they are given by the object itself. Secondly, the argument was advanced that museums were not as isolated from society as had previously been thought, but were far more influenced by the social circumstances. Thirdly, it was advocated that greater attention should be paid to the perceptions of the visitor or others outside of the profession, counterpoised to concentrating on the needs of the elite. This stimulated a series of studies on audiences and the museum visitor. Overall, this approach postulated that the meanings of museums and their contents were more contingent than had been previously considered. While Vergo referred to the new museology as the emergence of theory in the study of museums, it

has come to signify a wider change in thinking and practice in the museum world that has been triggered by this critical approach (Ross 2004). The new museology has been interpreted in different ways in the US, Britain and France, but nonetheless, argues Peter Davis (1999), it can be seen as shorthand for a reassessment of the role of museums in society.

Subsequent to the emergence of the new museology there was, as described by historian Ralph Starn, a 'tidal wave of museum studies' (Starn 2005: 68). The ideological mission, the apparent elitism, and the divisiveness of museum institutions, were critiqued extensively in collections such as that edited by museum theorist Robert Lumley's *The Museum Time Machine: putting cultures on display* (1988) and Sherman and Rogoff's *Museum Culture: histories, discourses, spectacles* (1994), where analysis was focused on the constructions museums have placed on history, difference, class and gender. These edited anthologies developed ideas concerned with and critical of the representation of the past, and assessed how museums reinforce the social divisions in society. There was a developing identification of the role of museums in colonialism and the damaging representation of minorities, influenced by postcolonial theory (see Ames 1992; Barringer and Flynn 1998; Harth 1999; Henare 2005). An example is given by Moira Simpson, theorist and campaigner for the repatriation of human remains, who argues that museums' origins were implicated in colonialism and are still 'inextricably enmeshed' (Simpson 1996: 1). Overall, as the historian Daniel Sherman and the art historian Irit Rogoff describe, 'a broad range of critical analyses have converged on the museum, unmasking the structures, rituals, and procedures by which the relations between objectives, bodies of knowledge and processes of ideological persuasion are enacted' (1994: ix–v).

Sherman and Rogoff also argue that museums have the potential to become a positive force in society. They draw on the work of Tony Bennett and cultural studies scholars, who argue that museums should drop their traditional claims to knowledge and truth and instead become spaces in which diverse values and narratives can be debated. Theorists and practitioners suggest that museums should distance themselves from the traditional justifications of the museum. The institution should embrace pluralism and include the diverse groups traditionally excluded from the museum (Duncan and Wallach 1980; Hooper-Greenhill 1989; Sherman and Rogoff 1994). In Karp and Lavine's *Exhibiting Cultures: the poetics and politics of museum display* (1991) and Karp, Kreamer and Lavine's *Museums and Communities: the politics of public culture* (1992), papers were published from two conferences on the presentation and interpretation of cultural diversity in museums, which took place at the prestigious Smithsonian Institution in Washington. In *Exhibiting Cultures*, contributors argued for museums as political arenas where definitions of identity and culture are asserted and contested. Museums, they suggested, have the power to represent communities more positively. In *Museums and Communities*, contributors explored the changing ways in which museums should manage relations with communities.

For anthropologist James Clifford (1997), historical claims to universalism are, in fact, partial, related to concrete social locations, and contextually located. Clifford proposes that the hierarchy of value should be contested. He suggests that museums should decenter the collection and include more diverse arts, cultures and traditions. Museums should operate instead as a 'contact zone' and be orientated towards cultivating and sustaining relationships with communities and becoming places for dialogue. Clifford argues that this shifts the location of authority away from the traditional sources and positively changes both the role of the object and the institution.

Academics and professionals are enthusiastic about the significance of culture and museums for identity formation (for example, Appadurai and Breckenridge 1992). Here museums are instructed to play a role in the politics of recognition instead of pursuing discredited notions of truth and knowledge. Nancy Fuller (1992), research programme officer of the Office of Museum

Programmes at the Smithsonian, argues that the museum can be a vehicle for community empowerment. Barry Gaither (1992), director of the Museum of the National Centre of Afro-American Artists, suggests that museums can play a role in the reconstruction of society. Laura Peers and Alison Brown (2003) celebrate the way that the relationship between museums and their source communities—the term for those communities considered culturally connected to the artefacts—has changed over the past few decades. As they write: 'No longer able to lay claim to a role as the custodian of a post-Enlightenment "science" or "knowledge", museums nowadays often promote themselves as field sites or "contact zones" ' (Peers and Brown 2003: 2). It is worthy of note that Laura Peers, the co-author of this collection on how to work with source communities, is a curator of the Pitt Rivers Museum in Oxford and was a member of the Working Group on Human Remains, and a campaigner for repatriation who advocated an internal review for the removal from display of uncontested shrunken heads at the museum for which she worked.[1] The problem of human remains, for this professional and anthropologist, is one where the impact of colonization can be reworked and the possibility of equality created (Peers 2007). Similarly, Moira Simpson (1996) argued that by reconfiguring relationships with communities, museums can stimulate profound changes in their lives.

The important observation to be made about these many volumes within the new museology and museum studies, often written by practitioners, is that they have incorporated the intellectual challenges to museum institutions that came from postmodernism, cultural theory and postcolonialism. They are contesting the remit of the institution from the inside. However, what is remarkable about the incorporation and internalization of these challenges is that the process has gone relatively unnoticed. Theorists continue to present museums as monolithic and resistant to change. Most challenges and changes are analyzed as a result of external factors, neglecting an appreciation and analysis of internal influences.

Museums as sites of contestation

During the 1990s, museums in America displaying particular histories became a focus for debates about the construction of national histories, representation and remembrance (Zolberg 1996). The most prominent exhibition sparking controversy was the 1994 exhibit of the Enola Gay. The proposed exhibit, marking the fiftieth anniversary of the end of the Second World War, featured the B-29 bomber airplane Enola Gay in the Smithsonian's National Air and Space Museum. The exhibition aimed to raise critical questions about its use. The exhibition stimulated high-profile debate over how the institution should represent the atomic bombing of Japan. Strong criticism of the planned display was mounted by the American Legion and conservative members of Congress, who argued that curators had ' "hijacked history"; they were "anti-American" ' (Engelhardt and Linenthal 1996: 2).

Theorists have subsequently examined museums as 'sites of contestation' and as influenced by a number of social changes. In *Displays of Power*, Steven Dubin (1999) analyzes a number of controversial exhibitions in American museums, primarily in 1990s but including one that took place in the late 1960s. Museums, Dubin suggests, have become sites of controversy due to three influences: firstly, the legacy of community empowerment that developed in the 1960s; secondly, the emergence of social history, which has destabilized the traditional history once depicted, thus creating problems as groups compete for representation; and thirdly, because cultural issues more generally became controversial in the 1980s and 1990s, displacing the political sphere as a site of debate. As a result, he ventures, museums have become politicized spaces.

Social anthropologist Sharon Macdonald (1998b) tackles the political and contested nature of exhibitions of science and technology in the edited collection *The Politics of Display*. Like Dubin,

Macdonald concentrates on external challenges as crucial, focusing on developments since the 1960s that have contributed to the displacement of the museum's original remit and its emergence as a site of contestation. This, she suggests, has been met with resistance:

> While there has undoubtedly been a proliferation of different, particularly minority, 'voices' speaking in the public arena, the old political and cultural high ground has not simply been relinquished. On the contrary, what we have seen is an escalation of intellectual battles over the legitimacy of different kinds of representation.
>
> *(Macdonald 1998b: 14)*

The controversies over representations of the past are predominantly understood as the results of tension arising from challenges brought by social movements, which make demands regarding the representation of 'their culture'. The institution and profession are characterized as resistant to those challenges (see also Macdonald and Fyfe 1996: 9). In this vein, commenting on controversies over the holding and display of sacred artefacts in museum collections, the sociologist Jan Marontate states: 'Tensions also arise in relations between museums and their "subjects" about ethics and ownership of cultural information or things.' (Marontate 2005: 289) Marontate ventures that museum professionals resist these challenges from their subjects because they still hold on to ideas of truth and objectivity: 'Museum professionals, many of them trained historians, often resist that knowledge is socially constructed [...] This has concrete implications for museum practices. Demands for parity of representation or affirmative action for under-represented cultural groups is a common source of friction.' (Marontate 2005: 289). For Marontate, contestations are created when audiences challenge the representation or ownership of their culture, and professionals withstand these challenges as they still feel their way of understanding the world holds firm: that it has an objective reality discoverable by rational investigation, and that is retains its legitimacy. She remarks in passing that conflict does occur between museum professionals within institutions (p. 288), but overall she sees challenges to representation, and the controversial exhibitions that result from this, as a process that is resisted by professionals: 'Museum professionals may be increasingly aware of the importance of public interaction for meaning-making but they have not necessarily embraced a sense of relativism. Nor have they all relinquished their claims to position of authority' (Marontate 2005: 293).

Although the museum as a site of controversy is commonly interpreted as stimulated by pressure from external groups challenging resisting institutions, in Macdonald's afterward to *The Politics of Display* (1998b), she is careful not to be inflexible in delineating these two sides, explaining that caricatured polarizations do 'symbolic violence' to more complicated positions (Macdonald 1998b: 290). Similarly, her study *Behind the Scenes at the Science Museum* (2002) also acknowledges a more complex interaction. Here Macdonald critiques the frequent assumption within academia that professionals hold strict positivist and celebratory attitudes about science. She explains that this differs from the findings of her ethnographic study of the Science Museum in London, where she observes that staff were involved in debates about social and cultural perspectives on science (Macdonald 2002: 60).

In his analysis of narratives of decline, Oliver Bennett (2001), like Macdonald, points to a more complicated picture than that posited by the common analysis of a bipolar contest between a resistant profession and external challenges. Bennett notes that the relativism that had eroded the defence of high culture was in part felt by those responsible: the directors of cultural institutions and broadcasters who could no longer uphold a status for the arts as value free (Bennett 2001: 132). This departs from Maronate's (2005) assertion that the cultural elite has not taken cultural relativism on board. Similarly, Nick Prior (2006) notes that museums have changed

since the 1960s, and that they have engaged with the critique that they are institutions of dominant ideology. Also acknowledging the role of the profession in these contestations, Dubin (2005) observes that change can come from within due to new curators from diverse backgrounds. And the theorist Max Ross (2004) ventures that influences on the institution, including that from the new museology, have shifted priorities, but concludes that museum professionals are highly resistant to change. In particular, Ross argues that the internal culture of the institution and the traditional subject divisions define and defend professional and social identity. He ultimately maintains the characterization of the changes to museum institutions as one in which social groups challenge and demand representation, against the dominance of an elite that still considers the museum to be orientated towards a legislative project.

However, the issue is not simply that the two positions discussed previously—the challenges from the public and community groups regarding the representation of 'their culture' and resistant professionals—represent a too-simplified analysis of the situation. Rather, this characterization of museums as sites of contestation has not adequately considered the role of the profession in advocating some of the challenges they have been facing. While Macdonald, Dubin, Prior, Ross and Bennett all acknowledge debate and shifting values within the profession, they only acknowledge these trends. What is missing is a substantial exploration of the internal element to these contests; of contestation from and within the profession over the role of the institution. While these theorists refer to the sector becoming more self-reflexive, and integrating critical theories including feminism and postcolonial theory, my central point is that this contribution is more influential than has been previously considered. To date, the literature on contestation in collections has not sufficiently recognized the significance of the extensive internal aspect of the contestation over the role of museum institutions and is prone to interpreting it primarily as a profession still committed to objectivity, reacting to and defying external challenges to its authority.

Reconstituting legitimacy: a temporary resolution

We have seen that professionals are involved in an internal challenge to the role of the institution. This has come about because the foundational purpose of the museum—the pursuit of truth and knowledge—has come under unremitting questioning. In actively questioning this traditional role, campaigners are trying to distance themselves from the museum's discredited foundational purpose. The reorientation of the museum away from the weakened objectives of the pursuit of truth and knowledge is part of an attempt to gain authority via establishing a new purpose for the museum in defining and affirming identities. Professionals' engagement with this process can be seen as an attempt to establish a new basis of legitimacy for the institution as an authoritative voice of therapeutic recognition.

Theorists examining the American and British state have identified the introduction of the therapeutic ethos as an opportunity for the state to develop a role as the authoritative voice of recognition (Rieff 1966; Nolan 1998; Furedi 2003). Sociologist James Nolan interprets this shift towards a therapeutic ethos as an opportunity for the state to address its legitimation crisis, because it offers a 'replacement to traditional moral codes and symbols, worn by the effects of modernization' (Nolan 1998: 17). Refashioning a role for the museum as a place of political struggle and the recognition of identity, then, is a way of establishing the role of the institution as one which affirms and valorizes identities, rather than one that plays a legislative role in the construction and affirmation of knowledge. The former is an important role that currently holds legitimacy. The latter is not. As James Nolan argues in relation to the therapeutic ethos in the American state: 'In Bourdieuian terms, it is a form of "cultural capital" that has, in the contemporary cultural context, a high exchange rate' (Nolan 1998: 17).

Such an attempt to re-legitimize the role of the legislator is anticipated in Bauman's work. While Bauman (1987) argues that legislative authority has shifted away from intellectuals, he suggests that they still aim to retain or refashion their authority. They reposition themselves, he posits, in response to these challenges with the aim of sustaining some form of legitimacy:

> While the postmodern strategy entails the abandonment of the universalistic ambitions of the intellectuals' own tradition, it does not abandon the universalistic ambitions of the intellectuals towards their own tradition; here, they retain their meta-professional author-ity, legislating about the procedural rules which allow them to arbitrate controversies of opinion and make statements intended as binding
>
> *(Bauman 1987: 5)*

For Bauman, intellectuals aim to retain professional authority by putting themselves in the position of an arbitrator of procedure and opinion. The central question raised is whether the attempt to re-legitimize the museum in this way succeeds. Analyzing the continued unfolding of the problem of human remains would suggest that it does not. As we will see, despite attempts to resolve this contestation by defining the institution as moving away from the traditional role and engaging in identity work, professionals have continued to question their own authority. This continued questioning is of particular importance, because it suggests that solutions to the problem of legitimacy are provisional.

An internal battle

Besides studying the claims-makers as a method of examining the diffusion of the problem, Philip Jenkins (1992) outlines that social problems should be understood in terms of those attempting to define them. While any document or policy analysis is a useful method to assess ideas, to explore how they are framed and their institutionalization, this focus has certain limits because texts usually serve a function of rationalising policies. I needed to know how professionals interpreted and understood this problem. Therefore it was important that I analysed how professionals understood the issue. Interviews were particularly helpful to do this, because they explore the world of beliefs and meanings (Arksey and Knight 1999). Through interviewing the actors, I was able to examine why they were involved in different aspects of this debate and assess how they interpreted their involvement in this issue.

The majority of the comments made by interviewees regarding the holding of human remains were situated in a broader discussion about changes within the museum remit, concerning the role and purpose of the institution. Thirty-three interviewees commented, without prompting, that museums are in the process of a number of changes in relation to the role that they play. The prime concern about these changes was that they didn't go far enough, due to fellow professionals who were framed as acting in 'traditional' or 'old fashioned' ways. The word 'traditional' or 'tradition-ally' was often used by actors, to characterize practice and behavior deemed problematic, which needed to be addressed and changed. One curator from a regional museum explained:

> Traditionally the museum community is obsessed with ownership, control and authority … We know now ourselves that it won't do, you know, but it's so ingrained in us we cannot quite kick it, so you know, we are wavering between the two.

This individual welcomed the general changes in museums. He felt the process was positive. Indeed he explained that while change was difficult it was necessary to continue to press for

The crisis of cultural authority

change in other professionals, commenting that there were individuals who were still too controlling.

> We know we should be better at sharing and not controlling but we can't quite kick it. And that is a little bit ... a bit about the type of people who work in museums, without being too crude, um ... there is still a generation of people who work in museums, you know who are ... still in the past, their whole psyche is about control, ownership and authority and not talking and not sharing.

The concern expressed by this curator describes how there are still people in the sector who retain the idea that they are an authority and feel that they control and own the objects. This focus of concern—professionals was held by another interviewee. This senior curator of a regional museum positioned his own advocacy work around human remains in a context of a long-term campaign to change the remit of the museum and those individuals formally termed keepers:

> I've had to battle all my life with people in museums who are, to put it crudely, carers and sharers ... you know keepers is the right name for some of them. Carers are anally retentive ... sharers tend to be the opposite but tend not to have, you know, the scholarly background but are really excited by the museum as a social enterprise ... and that I think what you are seeing in British museums is an agenda which have moved away from the carer to the sharer.

His reference to a 'battle' suggests that the debate about the remit of the museum is significant for him, reinforced by the dramatic use of 'all my life'. That he identifies the 'battle' with 'people in museums' reveals the internal objective of changing the behaviour of professionals, through this issue. His account of the changes in museums echoes Bauman's (1987) articulation of the move from a legislative role, to one of facilitator, when he describes the agenda moving from the carer to the sharer. While this interviewee was 'excited' about changes in museums and a more social role, he was highly critical of those in the sector who tried to 'hang on' both to objects and authority. His reference to carers as 'anally retentive' leaves us in no doubt that he disapproves of this stance.

Another interviewee, a senior archaeologist at a university museum and campaigner also argued that the institution needs to change, suggesting that it should play a different role today which makes a contribution to society.

> Museums have to grow up, which is to be less concerned with where things are, and less concerned with ... maybe issues around control and authority, but just to make sure that ... um ... artefacts or other material over which the museum has responsibility for ... be in a position where they can do most good.

This interviewee opines that the role of the collection should not be object, research or aesthetics orientated. Instead he ventures it should devote itself to a social role and where they can do good. Controlling objects, holding on to them, represents the wrongful assertion of authority to him.

Others were enthusiastic about the contestation over human remains because it suggested museums could change. One archaeologist in a regional museum expressed regret that the repatriation debate had been resolved before she got the job as she would have liked to be

69

involved, even though there were no human remains from overseas communities in the collection. She commented: 'It's a shame as it was so exciting, you know, people were really doing some good and getting things changed.' The issue had symbolic resonance with this individual, despite not being involved in a particular case and even though the museum she worked for held no remains from overseas communities. This curator aged in her twenties had been commissioned to write the museum's general policy on human remains. She was of the view that she was instructed to do so, specifically she was in tune with the wider inclusion agenda in the institution, as indicated when she got the job for this reason. She commented:

> One the reasons I got this job, I've been told, is because of my access experience from the course in Leicester.[2] I was up against two curators with 30 years experience, but they wanted me because they are too collections focused … too much in the backroom.

A recurring motif is the problem of 'control' or 'controlling' professionals and their holding on to collections, which is contrasted to sharing objects and authority with communities. She continued: 'All museum curators today are trying to look at collections differently. You know in the past, it was collect it for yourself, or for collection' sake, not, you know, never for the visitor. Not for the visitor.'

For another curator, at a national museum, the purpose of the collection in contemporary society is to create relationships:

> [W]e certainly feel that the central role of museums in modern society is to broker relationships, relationships between collections and communities, or sometimes between different communities, using the collections in an active way. And you can use the collections in, you can either acquire new collections in order to create relationships, or sometimes you can give back collections to broker relationships. And what we are interested in is in sustainable, respectful and reciprocal relations.

His use of the description 'active' implies that other ways of engaging with the collection, that is using it without communities, is passive and thus negative. For him the collection has a positive purpose when it is orientated towards forging or sustaining a relationship with communities outside the museum. Putting collections to a social use with communities is considered their proper value, for this professional.

Involvement in the campaign to either transfer human remains, or to encourage respectful treatment, was an issue that activists took very seriously and identified with strongly. For one archaeologist and campaigner from a university museum, being involved in the debate was highly important to them; more so than their trained area of expertise:

> I am an archaeologist. My specialism is the Persian period … a big find has just happened and I should go, I am the expert of … in this area, but I would much rather stay and do this, this is more pressing and important for me now.

The intensely personal identification of some individuals around this problem speaks to its symbolic nature. For this individual, being involved in campaigning for, in his case, greater 'respect' for human remains generally, was considered more important than work which involved his trained expertise. It gave him a positive sense of purpose.

Imposing divisions between the past and the present

The dominant theme in my interviews was the problem with traditional museum, and professionals who wanted to retain objects and authority, which interviewees constantly contrasted to their aims and actions. Interviewees repeatedly spoke of 'the traditional museum' in 'the past' as acting in a certain, problematic, fashion, including: keeping or controlling of objects, the pursuit of knowledge, thinking solely about the collection instead of the audience, or only thinking about an elite audience. For example in one interview, a curator at a local museum, explained:

> [...] in the old days museums displayed things associated with faith and belief, but from the point of view of anthropology, archaeology, sociology, fine or decorative art, you know. Traditionally, the objective was appreciation not participation.

Displaying material organized through subject division is seen as promoting 'appreciation' which this interviewee suggests is different to the preferred aim of 'participation.'

There was less detail about current practice than an emphasis on the point that the present practice is unlike the past. For example, when talking about the need to consult with different groups, the emphasis in the following extract is less on the specifics of the groups, their needs or particular concerns, than the actions of the museum and the shifts in what it is to be a curator:

> Generally we are consulting more and more. We will consult on everything in future. It's so completely different to how it used to be done, you know. About a year ago we set up the community consultation panel with different faith groups and other groups. It's about not being so arrogant. Not like, I'm a curator and I know best.

Here we can see the idea that the curator in the past was arrogant and assumed they knew best.

One curator commented that they were not especially concerned about particular treatment of human remains, but that their treatment should be rethought, primarily it would seem because contemporary practice relied on the old way of doing things:

> I do think that there is a need for serious ethical debate about the issue of how all human remains are treated in museums. I don't think they should be just taken off display ... really ... I'm not quite sure, I don't think so. But a lot of what we do just relies on what we used to do, and maybe that needs rethinking.

The talk about the past to justify, even define, contemporary action pervades the discourse. The constant rhetoric that the traditional museum needs to change, or that this is not how it was done in the past, raises the question of how important it is to impose this division position between the old and the new, the traditional and the contemporary. It suggests that present day actions are a strategy to distance professionals from the past.

While most interviewees framed their views regarding human remains and museums in terms of the need for historical changes in institutions, there were 10 individuals who tried to do the opposite. These professionals aimed to contain or avoid any implied wider ramifications to the remit of the institution. These ten had been, or still were, critical of changes to the holding of human remains, and had been critical of the transfer of this material out of collections. One curator who had criticized the transfer of human remains and described it as a serious threat to science, claimed the same material that he had said was valuable, was not, once the law had been passed and remains transferred from the collection. He commented after these developments:

'I see it as a political issue and you know, we weren't working on those skulls. I don't think anyone really wanted to, because they were not useful, and they wanted them.' This professional, over time, down-played the significance of the transfer of this set of remains which he had once identified as important. His use of the term 'political' is a way of diminishing the action and distancing it from general practice. He tried to smooth out divisions in the conception of these changes on the impact of the museum, rather than impose them. Another tried to play down any implication of changes to the institution, suggesting that the transfer of human remains was an act in continuity with the historical remit of the institution, instead of the more frequent presentation of it as a dramatic shift. Firstly, he framed the transfer of human remains as contributing to an idea of public benefit because of the gains to knowledge from Australian aboriginal communities, rather than as a loss to knowledge:

> If we want to expand the work we do across Australia we want to work with representatives of those communities … it's a good thing … and they know stuff we don't, so there is an important public benefit in the return. We will learn from them, so it's to the benefit of the museum. And so then the removal doesn't really entail a loss … In fact, we've always been, museums have always been about public benefit.

The implication is that museums will learn from communities, rather than loose research material. The comment that 'museums have always been about public benefit' suggests that this act is not a significant change in practice, but holds a historical continuity with past practice.

Problematizing the government guidance

By the end of 2005, the major legal change that campaigners were advocating—an amendment to the British Museum Act to permit de-accessioning—was passed in the Human Tissue Act (2004). Significant agreements were reached to transfer Aboriginal human remains out of the British Museum and the Natural History Museum: two important, and previously resistant, national institutions. Furthermore, the *Guidance for the Care of Human Remains in Museums* (DCMS 2005) was published by the Department for Culture, Media and Sport (DCMS), designed to advise institutions on dealing with repatriation requests, and place parameters on actions and treatment concerning human remains. In so doing, the guidance intended to draw the controversy to a close. However, instead of resolving the debate, it was to continue. There was a highly critical response to the document from two groups. One was the newly-formed Pagan organization, Honouring the Ancient Dead, which was formed to make claims on human remains. The other group was formed of members of the museum sector, discussed subsequently. Both groups demonstrate the continued problem of challenges to authority from within the profession.

The main concern expressed by critics of the DCMS guidance was that museum professionals continue to impose their authority, because it is they who are charged with deciding the future of human remains, even if they repatriate them. Indeed, this is explicitly acknowledged by the policy as a problem that should be alleviated over time:

> However, as the current guardians of the remains, the museum will have the responsibility of making the decision over their future and this will make the process one-sided. It is hoped that, through time and a continuing open and constructive dialogue between museums and claimant groups, the process will become equal.

(DCMS 2005: 24)

One member of the committee that drafted the guidance explained to me, in an interview in early 2006, that the committee was concerned about the museum sector continuing as the decision-maker in human remains cases. Hopefully, he said, the one-sided nature of the relationship would change:

> [W]e went through that whole thing of … we went on and on about how this has to be an equitable equal relationship … then someone said … but they are in our collections and we'll be making the final decision. We went, 'oh God', without speaking for five minutes … but we have to accept it. They start off in our care, so we will be the ones that decide. At first … and then we'll see.

Commenting in the *Museums Journal* Tristram Besterman (cited in Heywood 2009: 35) stated: 'The DCMS criteria spring from a western museum mindset that only rubs salt into the wound of the original act of dispossession', arguing that the balance of power is still unequal: the western institution holds all the cards and makes all the rules. The response from the Museums Association was similar. While it welcomed the code of practice, it warned that museums retained too much power to decide the future of the human remains. In a formal response to the DCMS guidance the body stated it was 'disappointed' that there was no 'firm commitment' to the establishment of an advisory panel for museums to seek 'independent advice' in cases involving human remains requests (MA 2005: unpaginated). An advisory panel would have ensured that museums were not able to dominate the decision-making process, the MA argued.

Interviewees often raised this problem, which, in different respects, focused on the authority of the museum institution or professional and the problems of privileging scientific research, or traditional ways of working. Three interviewees cited this particular policy as problematically privileging scientific research. It is worth contrasting this complaint with what the policy says, as while it recognizes the value of science, it also recognizes other different views about the value of human remains. The *Guidance for the Care of Human Remains in Museums* states:

> Requests concerning the appropriate care or return of particular human remains should be resolved by individual museums on a case-by-case basis. This will involve the consideration of possession; the cultural and religious values of the interested individuals or communities and the strength of their relationship to the remains in question; cultural, spiritual and religious significance of the remains; the scientific, education and historical importance of the material.
>
> *(DCMS 2005: 23)*

Despite this recognition of cultural values, two curators and one director whom I interviewed complained that the guidance: 'privileges scientific values'. Similarly, five interviewees were concerned that the claims made on the basis of the document would be evaluated by a 'genealogical model' which, they said, was a problem. Again it is worth looking at what the document does say, as well as the criticism it attracted. The guidance states that claims will be considered both from genealogical descendents as well as those from the cultural community of origin (DCMS 2005: 26), which, it acknowledges, can be difficult to define. Of the cultural community of origin, the guidance states:

> [T]he assumption is that human society is characterized by the creation of communities that individuals feel a part of and which take on a collective set of values, often identified by

particular cultural behaviour [...] For a community to be recognized and their claim considered it would generally be expected that continuity of belief, customs or language could be demonstrated between the claimants and the community from which the remains originate.

(DCMS 2005: 26)

Despite this recognition of cultural community, rather than strict genealogy, for some members of the sector the guidance still problematically favored the genealogical model for assessing claims. One argued that 'the genealogical model is ultimately a colonial model', and that asking claimants to prove they were related at all 'could be seen as an abuse, a continued colonial relationship acted out as a result of this guidance'. For this interviewee, asking claimants to explain their relationship to the human remains they were claiming was repeating the 'abuse' of past colonial domination. Another curator expressed concern about the impact on potential claimants of criteria that asked them to articulate their relationship to the human remains and their meaning to them: 'It's offensive to claimants to have to prove that the remains are significant to them'.

The major issue for 12 interviewees was that the decision about what would happen to the human remains resided with the museum. They expressed concern about the dominance of the museum in these decisions, arguing it was not their place to decide on lineage or affiliation. For example, according to a senior curator of a national museum: 'We are not the people who should decide what a legitimate connection or authority is. We should not be deciding what is a valid link or not'. For one curator, it was essential that professionals learn to remove their authority: 'It's about time we learnt that we do not know everything and there are other ways of understanding the world. We have to cede out authority.'

The continued problem of human remains in museum collections, despite the change in law and the transfer of significant remains out of collections to overseas communities, indicates that there is an underlying dynamic to this problem, which concerns internal questioning of the authority of the museum and the museum professional. The professional body of the sector, and individual professionals, voice the problem that they are retaining too much control in relation to the holding and collection of objects. Such criticism of the guidance indicates that the problem of human remains is partly driven by members of the sector who wish to devolve the authority of the profession and the institution. That some members of the profession appear uncomfortable with their position of decision-maker, and that they continue to try and outsource this role, suggests that despite attempts to resolve the contestation over human remains through legislation, codes of conduct and significant repatriation acts, possible solutions have a provisional and limited quality. The ongoing concern over 'who decides?' indicates that the problem of the authority of the profession and institution is not easily resolved. There is a continued problem of legitimacy.

Notes

1 See the *Oxford Times* (2007), 'Should shrunken heads stay in museum?' February 14.
2 The Museum Studies course at Leicester is known for its endorsement of the new museology and social inclusion agenda.

Bibliography

Abt, J. (2006) 'The Origins of the Public Museum', in Macdonald, S. (ed.) *A Companion to Museum Studies*, Oxford/Victoria: Blackwell: 115–134.

Arksey, H. and Knight, P. (1999) *Interviewing for Social Scientists*, London/Thousand Oaks/New Delhi: Sage.

Ames, M. M. (1992) *Cannibal Tours and Glass Boxes: the anthropology of museums*, Vancouver: UBC Press.

Anderson, B. (1983) *Imagined Communities: reflections on the origins and spread of nationalism*, London: Verso.

Appadurai, A. and Beckenridge, C. A. (1992) 'Museums are Good to Think: heritage on view in India', in Karp, I., Kreamer, C. M. and Lavine, S. D. (eds) *Museums and Communities: the politics of public culture*, Washington DC and London: Smithsonian Institution Press.

Arendt, H. (1977) *Past and Future; eight exercises in political thought*, Harmondsworth: Penguin.

Barringer, T. and Flynn, T. (1998) *Colonialism and the Object: empire, material culture and the museum*, London/New York: Routledge.

Bauman, Z. (1987) *Legislators and Interpreters: on modernity, post-modernity, and intellectuals*, Cambridge: Polity Press.

Bauman, Z. (1992) *Intimations of Postmodernity*, London/New York: Routledge.

Bennett, O. (1996) *Cultural Policy and the Crisis of Legitimacy: entrepreneurial answers in the United Kingdom*, University of Warwick: Centre for the Study of Cultural Policy.

Bennett, O. (2001) *Cultural Pessimism: narratives of decline in the postmodern world*, Edinburgh: Edinburgh University Press.

Bennett, T. (1990) *Threatened Children: rhetoric and concern about child-victims*, Chicago/London: The University of Chicago Press.

Bennett, T. (1992) 'Putting Policy into Cultural Studies', in L. Grossberg, Nelson, C. and Treichler, P. (eds) *Cultural Studies*, New York: Routledge.

Bennett, T. (1995) *The Birth of the Museum: history, theory, politics*, London/New York: Routledge.

Bennett, T. (1998) *Culture: a reformer's science*, London: Sage.

Best, J. (1990) *Threatened Children: rhetoric and concern about child-victims*, Chicago/London: The University of Chicago Press.

Bloom, A. (1987) *The Closing of the American Mind: how higher education has failed democracy and impoverished the souls of today's students*, New York: Simon and Schuster.

Bourdieu, P. (1984) *Distinction: a social critique of the judgement of taste*, London: Routledge & Kegan Paul.

Bourdieu, P. (1996) *The Rules of Art*, Cambridge: Polity Press.

Clifford, J. (1997) *Routes: travel and translation in the late twentieth century*, Cambridge, Massachusetts/London: Harvard University Press.

Conn, S. (1998) *Museums and American Intellectual Life, 1876–1926*, Chicago: Chicago University Press.

Corsane, G. (ed.) (2005) *Heritage, Museums and Galleries: an introductory reader*, London/New York: Routledge.

Davis, P. (1999) *Ecomuseums: a sense of place*, Leicester: Leicester University Press.

DCMS (2005) *Guidance for the Care of Human Remains in Museums*, London: Department of Culture Media and Sport.

Docherty, T., ed. (1993) *Postmodernism: a reader*, New York: Harvester Wheatsheaf.

Dubin, S. C. (1999) *Displays of Power: memory and amnesia in the American museum*, New York/London: New York University Press.

Dubin, S. C. (2005) ' "Culture Wars" in Comparative Perspective', in Macdonald, S. (ed.) *A Companion to Museum Studies*, Malden, Massachusetts/Oxford/Victoria: Blackwell Publishing.

Duncan, C. (1995) *Civilizing Rituals: inside public art museums*, London/New York: Routledge.

Duncan, C. and Wallach, A. (1980) 'The Universal Survey Museum', *Art History*, 3, 4: 448–469.

Eagleton, T. (1993) *The Crisis of Contemporary Culture*, Oxford: Clarendon Press.

Eagleton, T. (2000) *The Idea of Culture*, Oxford: Blackwell Publishers Ltd.

Eagleton, T. (2003). *After Theory*, London/New York: Allen Lane.

Engelhardt, T. and Linenthal, E. T. (1996) *History Wars: the Enola Gay and other battles for the American past*, New York: Metropolitan Books.

Foster, H. (ed.) (1985) *Postmodern Culture*, London/Sydney: Pluto Press.

Fraser, N. (1995) 'From Redistribution to Recognition? Dilemmas of justice in a "post-socialist" age', *New Left Review*, 212: 68–92.

Fuller, N. (1992) 'The Museum as a Vehicle for Community Empowerment: the Ak-Chin Indian community ecomuseum Project', in Karp, I., Kreamer, C. M. and Lavine, S. D. (eds) *Museums and Communities: the politics of public culture* Washington DC and London, Smithsonian Institution Press.

Furedi, F. (2003) *Therapy Culture: cultivating vulnerability in an uncertain age*, London/New York: Routledge.

Furedi, F. (2004) *Where Have All The Intellectuals Gone? Confronting 21st century philistinism*, London: Continuum Publishing.

Fyfe, G. (2006) *Sociology and the Social Aspects of Museums*, in Macdondald, S. (ed.) *A Companion to Museum Studies*, Malden, Massachusetts/Oxford/Victoria: Blackwell Publishing.

Gabe, J., Kelleher, D. and Williams, G. (eds) (1994) *Challenging Medicine*, London: Routledge.

Gaither, E. B. (1992) ' "Hey! That's Mine": thoughts on pluralism and American museums', in Karp, I., Kreamer, C. M. and Lavine, S. D. (eds) *Museums and Communities: the politics of public culture*, Washington DC/London: Smithsonian Institution Press.

Gitlin, T. (1994) 'From Universality to Difference: notes on the fragmentation of the idea of the left', in. Calhoun. C. (ed.) *Social Theory and the Politics of Identity*, Cambridge Massachusetts,/Oxford: Blackwell.

Gitlin, T. (1995) *The Twilight of Common Dreams: why America is wracked by culture wars*, New York: Henry Holt and Company, Inc.

Gray, C. (2000) *The Politics of the Arts in Britain*, Basingstoke: Macmillan.

Gross, P. R. and Levitt, N. (1994) *Higher Superstition: the academic left and its quarrels with science*, Baltimore: Johns Hopkins University Press.

Habermas, J. (1987) *Legitimation Crisis*, trans. Thomas McGarthy, Cambridge/Oxford: Polity Press.

Hall, S. (1992) 'Cultural Studies and its Theoretical Legacies', in Grossberg, L., Nelson, C. and Treichler, P. (eds) *Cultural Studies*, London: Macmillan.

Hall, S. (2001). *Modernity and Difference*, London: Institute of International Visual Arts: 8–23.

Harth, M. (1999) 'Learning from Museums with Indigenous Collections: beyond repatriation', *Curator: the museum journal*, 42, 4: 274–284.

Henare, A. J. M. (1991) 'Commerce and Culture Enterprise and Heritage Crosscurrents of National Culture', in Corner, J. and Harvey, S. (eds) Enterprise and Heritage: crosscurrents of national culture, London: Routledge.

Henare, A. J. M. (1995) *Culture and Consensus: England, art and politics since 1940*, London: Methuen.

Henare, A. J. M. (2005) *Museums, Anthropology and Imperial Exchange*, Cambridge: Cambridge University Press.

Hewison, R. (1991) 'Commerce and Culture Enterprise and Heritage Crosscurrents of National Culture', in Corner, J. and Harvey, S. (eds) Enterprise and Heritage: crosscurrents of national culture, London: Routledge.

Hewison, R. (1995) *Culture and Consensus: England, art and politics since 1940*, London: Methuen.

Heywood, F. (2009) Many Happy Returns? *Museums Journal* 109: 32–35.

Honneth, A. (1995) *The Fragmented World of the Social: essays in social and political philosophy*, Albany, New York: SUNY Press.

Hooper-Greenhill, E. (1989) 'The Museum in the Disciplinary Society', in Pearce, S. (ed.) *Museum Studies in Material Culture*, Leicester: Leicester University Press.

Hunter, J. (1991) *Culture Wars: the struggle to define America*, New York: Basic Books.

Jameson, F. (1993) 'On Cultural Studies', *Social Text*, 11, 29: 17–52.

Jameson, F. (ed.) (1998) *The Cultural Turn: selected writings on the postmodern 1983–1998*, London/New York: Verso Press.

Jenkins, P. (1992) *Intimate Enemies: moral panics in contemporary Great Britain*, New York: Aldine De Grutyer.

Karp, I. and Lavine, D. (eds) (1991) *Exhibiting Cultures: the poetics and politics of museum display*, Washington DC: Smithsonian Institution Press.

Karp, I., Kreamer, C. M. and Lavine, S. D. (eds) (1992) *Museums and Communities: the politics of public culture*, Washington DC/London: Smithsonian Institution Press.

Lumley, R. (1988) *The Museum Time Machine: putting cultures on display*, London: Routledge.

Lyotard, J. (1984) *The Postmodern Condition: a report on knowledge*, trans. Geoff Bennington and Brian Massumi, Manchester: Manchester University Press.

MA (2005) *Response to consultation on the draft code of conduct for the Care of Human Remains in Museums*, London: Museums Association.

Macdonald, S. (1998a) Supermarket Science? Consumers and 'The Public Understanding of Science. In Macdonald, S. (ed) *The Politics of Display: museums, science, culture*, London: Routledge. 118–138.

Macdonald, S. (1998b) *The Politics of Display: museums, science, culture*, London, Routledge: 1–24.

Macdonald, S. (2002) *Behind the Scenes at the Science Museum*, Oxford/New York: Berg.

Macdonald, S. and Fyfe, G. (eds) (1996) *Theorizing Museums: representing identity and diversity in a changing world*. Oxford. Blackwell.

Marcus, George E. and Michael M.J. Fischer (1986) *Anthropology as Cultural Critique: an experimental moment in the human sciences*. Chicago: University of Chicago Press.

Marontate, J. (2005) 'Museums and the Constitution of Culture', in Jacobs, M. D. and Hanrahan, N. W. (eds) *The Blackwell Companion to the Sociology of Culture*, Malden, Massachusetts/Oxford/Victoria: Blackwell Publishing.

McGuigan, J. (1996) *Culture and the Public Sphere*, London/New York: Routledge.

McGuigan, J. (1999) *Modernity and Postmodern Culture*, Buckingham/Philadelphia: Open University Press.

Merriman, N. (1991) *Beyond the Glass Case: the past, the heritage and the public*, Leicester: Leicester University Press.

Milner, A. and Browitt, J. (2002) *Contemporary Cultural Theory: an introduction*, London/New York: Routledge.

Mirza, M. (2005) 'The Therapeutic State: addressing the emotional needs of the citizen through the arts', *International Journal of Cultural Policy*, 11, 3: 261–273.

Nolan, J. L. (1998) *The Therapeutic State: justifying government at century's end*, New York/London: New York University Press.

Owens, C. (1985) 'The Discourse of Others: feminists and postmodernism', in Foster, H. (ed.) *Postmodern Culture*, London/Sydney: Pluto Press.

Peers, L. (2007) 'On the Social, the Biological and the Political', in Parkin, D. and Ulijaszek, S. (eds) *Holistic Anthropology: emergence and convergence*, New York/Oxford: Berghahn Books.

Peers, L. and Brown, A. K. (eds) (2003) *Museums and Source Communities, a Routledge reader*, London: Routledge.

Pointon, M. (1994) *Art Apart: museums in North America and Britain since 1800*, Manchester: Manchester University Press.

Prior, N. (2002) *Museums and Modernity: art galleries and the making of modern culture*, Oxford: Berg.

Prior, N. (2006) 'Postmodern Restructurings', in Macdonald, S. (ed.) *A Companion to Museum Studies*, London: Blackwell.

Quinn, R-B. M. (1998) *Public Policy & the Arts: a comparative study of Great Britain and Ireland*, Aldershot: Ashgate Publishing.

Rieff, P. (1966) *The Triumph of the Therapeutic: uses of faith after Freud*, London: Chatro and Windus.

Ross, A. (ed.) (1996) *Science Wars*, Durham/London: Duke University Press.

Ross, M. (2004) 'Interpreting the New Muscology', *Museums and Society*, 2, 2: 84–103.

Selwood, S. (2001) *The UK Cultural Sector*, London: Policy Studies Institute.

Sennett, R. (1980) *Authority*, London: Secker & Warbury.

Sherman, D. J. and Rogoff, I. (eds) (1994) *Museum Culture: histories, discourses, spectacles*, London: Routledge.

Silverman, L. H. (2002) 'The Therapeutic Potential of Museums as Pathways to Inclusion', in Sandell, R. (ed.) *Museums, Society, Inequality*. London/New York: Routledge.

Simpson, M. (1996) *Making Representations: museums in the Post-Colonial Era*, London: Routledge.

Sinclair, A. (1995) *Arts & Cultures: the history of the 50 years of the Arts Council of Great Britain*, London: Sinclair-Stevenson.

Starn, R. (2005) 'A Historian's Brief Guide to New Museum Studies', *The American Historical Review*, 110, 1: 68–98.

Starr, P. (1982) *The Social Transformation of American Medicine: the rise of a sovereign profession and the making of a vast industry*, New York: Basic Books.

Taylor, C. (1992) *Multiculturalism and 'The Politics of Recognition'*, Princeton, NewJersey: Princeton University Press.

Vergo, P. (ed.) (1989) *The New Museology*, London: Reaktion.

Weber, M. (1968) *Economy and Society: an outline of interpretive sociology*, New York: Bedminster Press.

Williams, R. (2001) 'Culture is Ordinary', in Higgens, J. (ed.) *The Raymond Williams Reader*, Oxford: Blackwell.

Young, I. M. (1990) *Justice and the Politics of Difference*, Princeton, New Jersey/Oxford: Princeton University Press.

Zolberg, V. L. (1996) 'Museums as Contested Sites of Remembrance: the Enola Gay affair', in Macdonald, S. and Fyfe, G. (eds) *Theorizing Museums: representing identity and diversity in a changing world*, Blackwell Publishers/The Sociological Review: 69–82.

5
Editorials
History Workshop Journal

Editorial Collective/Raphael Samuel

This journal comes out of the History Workshops held at Ruskin College, Oxford, over the last ten years. Around these meetings the Workshop developed as a fluid coalition of worker-students (from Ruskin) and other socialist historians. Besides holding meetings it published a number of pamphlets (most of them now out of print); and a series of books based largely on its work have been prepared, of which the first was published in March 1967 and more will appear this year. By setting up this editorial collective to produce the journal we hope to share the work of the Workshop more widely, and to give it more regular and permanent expression. In undertaking it we are setting ourselves a long-term programme of work. Like the Workshops, like the pamphlets, like the books in the Workshop series, the journal will be concerned to bring the boundaries of history closer to people's lives. Like them, it will address itself to the fundamental elements of social life – work and material culture, class relations and politics, sex divisions and marriage, family, school and home. In the journal we shall continue to elaborate these themes, but in a more sustained way, and attempt to coordinate them within an overall view of capitalism as a historical phenomenon, both as a mode of production and as a system of social relations. Like the Workshops, the journal will have a strong grounding in working-class experience, but it will also speak from the start to the internationality of class experience, and will take up theoretical questions in history more explicitly.

We are concerned at the narrowing of the influence of history in our society, and at its progressive withdrawal from the battle of ideas. This shrinking of stature cannot be ascribed to a decline in popular interest. Throughout British society a desire for historical understanding continues to exist; and it is only sometimes fulfilled by the manufacturers of part series, popularizations, television entertainment, and so forth. 'Serious history' has become a subject reserved for the specialist. The restriction is comparatively recent. It can be attributed to the consolidation of the historical profession; to the increasing fragmentation of the subject, especially as it approaches more modern times; and to the narrowness of historians' preoccupations, along with the way that research is organized and shaped. Only academics can be historians, and they have their own territorial rights and pecking orders. The great bulk of historical writing is never intended to be read outside the ranks of the profession, and most is written only for the attention of specialist groups within it. Teaching and research are increasingly divided, and both divorced from wider or explicit social purposes. In the journal we shall try to restore a wider context for

78

Editorials: *History Workshop Journal*

the study of history, both as a counter to the scholastic fragmentation of the subject, and with the aim of making it relevant to ordinary people.

The journal is dedicated to making history a more democratic activity and a more urgent concern. We believe that history is a source of inspiration and understanding, furnishing not only the means of interpreting the past but also the best critical vantage point from which to view the present. So we believe that history should become common property, capable of shaping people's understanding of themselves and the society in which they live. We recognize that an open and democratic scholarship requires more work from the historian, not less: a more complex understanding of historical process, more caution in handling the sources, more bold- ness in extending the boundaries of enquiry, a greater effort to achieve clarity of presentation. Instead of assuming the dutiful interest of the reader, we hope that it can be won by the urgency of what is being said and its relevance to the present. *Women in Nazi Germany*, for example, is a case study of the complex relationships and contradictions between state, ideology, and the sexual division of labour, questions of continuing importance for an understanding of every phase of capitalism, including today's; or again, the account of a peasant museum in Emilia poses a fundamental question about the relationship of dominant and subordinate cultures.

We want the journal to be *Workshop* in character as well as name, to present the workings of historical enquiry not just the results, and to encourage readers in practical criticism, warning them against the automatic acceptance of scholarly findings or text book readings. We hope to bring together working historians of whatever background or experience, and offer them solid- arity and practical help, encouraging a collaborative approach to the problems of research. We would like the journal to be used, not just read, to be a place where difficulties are acknow- ledged, problems defined as well as solved, sources examined for their bias and limitations as well as for the help they may provide, and subjects opened up rather than closed.

The socialism of this journal, neither prophetic nor exclusive, and certainly not sectarian, will inform both the content and how it is presented: we want to be read by people outside the quarantine of formal education, as well as by those who chafe at its limitations and work to change it from within. That is why we shall stress clarity and accessibility in what we publish, both in texts and in footnotes. Our socialism determines our concern with the common people in the past, their life and work and thought and individuality, as well as the context and shaping causes of their class experience. Our socialism will also demand the discussion and development of theoretical issues in history. It will make us attack vigorously those types of historical and sociological enquiries which reinforce the structures of power and inequality in our society, and will bring us into critical and constructive debate with bourgeois scholars. We have come together as editors because our various commitments to the cause of socialism lie at the root of our discontent with the present state of history, and at the root of our belief that a different kind of history is possible. We hope to interest and be useful to people who do not share our political commitments but have felt some of the same discontents; we would like the journal to be of service to the reform of history in polytechnics and colleges, and to the cause of history in the schools.

Democratic scholarship means a two-way relationship between writer and reader, and we hope that in the pages of this journal there will be collaboration and understanding between them. We would prefer an active readership not an armchair one, and we want the journal to be a point of contact, a place where experiences are shared, projects encouraged, theoretical issues broached. In particular we hope the journal will reach the many historians who work on their own, often in their spare time, without acknowledgement because they are outside institu- tions, and we hope that they in turn will write for us. Because this is our first issue there are no letters or contributions from readers. But we want people to write in, not only with critical

79

responses to articles in the journal, but also to reach one another and discuss issues raised by their own work. Our columns (not only in the letter section but also in *Noticeboard* and *Calendar*) can be used to ask for information, to make contacts, to publicize meetings and publications. Far too much research which would be enriched by historical companionship is carried on in conditions of competitive individualism or lonely isolation; too many teachers have to fight an uphill fight unaided. This journal aims to be both critical and supportive, by offering solidarity to the working historian and by exploring the needs of the wider constituency which exists for historical work.

6
Hybrids
Raphael Samuel

The idea that the past is a plaything of the present, or, as postmodernist theory would have it, a 'metafiction', is only now beginning to impinge on the consciousness and disturb the tranquillity of professional historians. But it has been for some twenty years or more a commonplace of epistemological criticism, and a very mainspring of experimental work in literature and the arts. It is also a leitmotiv in commodity marketing and design, where a vast amount of ingenuity is devoted to giving brand-new products a look of instant oldness. In the novel, 'magic realism', intercutting past and present, juxtaposing fact and fantasy, simultaneously using history and calling its authenticity into question, has made time-travelling into an international style, a *lingua franca* as familiar in the samizdat publications and writings of Eastern Europe – and now it seems the Indian subcontinent – as it is in the novels of Márquez and Borges.

These fictions come to us peppered with epigraph and quotation. They criss-cross between historical research and invention; they will sometimes incorporate chunks of what scholars would recognize as original documents, duly footnoted or acknowledged in the afterword. But the purpose is not to establish the real but to make it phantasmagoric, and to suggest that history, like reality, is a chimera. Typically these fictions inhabit a no-man's-land where the rules of time and space, as well as those of narrative, are suspended. Narrators double in the role of Methuselah, taking the action back, it may be, to the earliest times and carrying it forward to such indeterminate times as what one recent fiction calls 'the near future'. Characters pass their hundredth birthday without so much as a nod or a wink, so that a single life can serve as a thread on which to hang a family saga. A sense of period is no sooner established than it is rudely disturbed by authorial intervention or the invasion of some creature from outer space. Chronological sequences are deliberately disrupted; the action takes place in an imaginary space where the normal limitations of time and space are suspended.

The idea of playing with the past – whether by animatronics, dressing up in period costume, or historical re-enactment – is deeply offensive to the historian, while the attempt to abolish or suspend temporality seems to put the historian's vocation into question. Our practice presupposes the existence of an objectively verifiable body of knowledge, while a commonsense realism – showing the past 'as it was' – is not the least of our inheritances from the nineteenth-century revolution in historical scholarship. According to conventional wisdom, historians, if they are to be true to their vocation, should keep their imagination on a tight rein. Ethically

they should be neutral, avoiding the needless utterance of opinion, eschewing value-judgement and cultivating an air of detachment. 'Our scheme requires that nothing shall reveal the country, the religion or the party to which the writers belong', wrote Lord Acton, when outlining his scheme for the *Cambridge Modern History*. 'The disclosure of personal views would lead to such confusion that all unity of design would disappear'.[1] Methodologically, too, historians are told to be self-effacing, allowing documents, so far as possible, to speak for themselves. We are not masters but servants of the evidence. Our first duty is to be objective, making no statement which cannot be verified from the sources; and using sources, ideally, which are free of bias. The integrity of history should be respected, too. Subjects should be studied on their own terms, or, as Bishop Stubbs put it, 'historically',[2] rather than in ways which might be suggested by the language and thought of the present day. Indeed, for the more extreme advocates of a return to the 'traditional' school syllabus, like Sheila Lawlor, the deputy director of the Policy Studies Institute, the merest touch of the contemporary contaminates.

Despite these cautions, we are in fact constantly reinterpreting the past in the light of the present, and indeed, like conservationists and restorationists in other spheres, reinventing it. The angle of vision is inescapably contemporary, however remote the object in view. Even when we reproduce words and phrases verbatim, the resonances are those of our time. However faithfully we document a period and steep ourselves in the sources, we cannot rid ourselves of afterthought. However jealously we protect the integrity of our subject matter, we cannot insulate it from ourselves.

History is an argument about the past, as well as the record of it, and its terms are forever changing, sometimes under the influence of developments in adjacent fields of thought, sometimes – as with the sea-change in attitudes which followed the First World War[3] – as a result of politics. Historical research, in the hands (quite often) of self-proclaimed revisionists, is continually putting old and established markers into question. Explanations, greeted at the time as 'authoritative', now appear as contrived or beside the point. The plot thickens with fresh characters and previously undeveloped motifs. Forgotten episodes are exhumed. Old stories are given a new twist. Attention is drawn to hitherto unnoticed clues. What previously seemed momentous may now appear as no more than a passing interlude. Conversely, apparently trivial events are elevated to the status of precedents and treated as portents and signs.

The immaculate conception of knowledge – with its insistence on keeping inquiry within the boundaries of the discipline, and its refusal to countenance any traffic between the imaginary and the real – is impossible, in practice, to sustain. There are to begin with the silences and gaps in the written record which only inference can fill: the statements to be ventured, if only for the sake of a continuous narrative, which a thousand different instances would not prove. Even when we are immersed in the minutiae of empirical research, we are continually having to abandon the world of hard, verifiable fact for the more pliable one of interpretation and conjecture, 'an unsatisfactory world peopled with rogue elements', as Linda Hannas writes in a fascinating account of her attempt to piece together the underworld of mid-Victorian popular art.[4]

In folk cultures – those which depend on the storyteller for knowledge of the past – the distinction between the ordinary and the fabulous is difficult to maintain. 'The lives of living men turned into legend,' writes Edwin Muir of his Orkney boyhood:

> A man I knew once sailed out in a boat to look for a mermaid, and claimed afterwards that he had talked with her. Fantastic feats of strength were commonly reported. Fairies, or 'fairicks', as they were often called, were encountered dancing on the sands on moonlight nights. From people's talk they were small, graceful creatures about the size of leprechauns,

but pretty, not grotesque. There was no harm in them. All these things have vanished from Orkney in the last fifty years under the pressure of compulsory education.[5]

The earliest historians were forgers – or, to use a less loaded term, inventors. They put words into the mouths of their subjects – as Caesar did with Vercingetorix in *De Bello Gallico*, and Tacitus with Boadicea. Indeed the composition of historic speeches – such as Pericles' oration to the Athenians – was the first of Clio's arts. History, under this optic, was an exercise in rhetoric. It was also regarded as a branch of literature – albeit, according to Aristotle's *Poetics*, an inferior one. What distinguished the historian from the annalist was literary ambition. Where the latter, such as the local historians of Attica,[6] were concerned with collecting genealogical information or topographical facts, the historian constructed a complete narrative.[7] Herodotus, 'the father of history', has always been to his critics, from Thucydides onwards, 'the father of lies', filling his narrative with miraculous and extraordinary stories.[8] But even Thucydides, the historians' historian, who eschews the wondrous and the picturesque and cleaves to what he claims he actually witnessed, had no compunction about imputing motives to the protagonists of his drama, or composing speeches for them to utter. F.M. Cornford in *Thucydides Mythistoricus*[9] (1907) argued that speeches were more prominent in Thucydides than in Herodotus because he was an Athenian; and that they had been dramatically conceived by the author, in line with Aeschylean tragedy, to express character and ideals. Thucydides himself was quite open about his rhetorical strategy: 'As to the accounts given of themselves by the several parties in speeches, either on the eve of the war or when they were already engaged, it would be hard to reproduce the exact language used, whether I heard it myself or it was reported to me by others. The speeches as they stand represent what, in my opinion was most necessary to be said by the several speakers about the matter in question … and I have kept as closely as possible to the general sense of what was said.'

Arguably the true architects of record-based research – and certainly among the first to make a fetish of manuscript sources – were those medieval forgers, who used their writerly skills and their historical knowledge to create ideal pedigrees and produce the documents which ought, by rights, to have been there but which, perhaps because of over-reliance on oral tradition, were not. 'The figment was hardly distinguished from the reality', writes Gurevich. 'What seemed "due" or "fitting" was readily preferred to what was.'[10]

Both lay and clerical institutions had recourse to forgery when their antiquity needed to be established; when their privileges were in question; or when their title to property had to be defended against would-be predators. It seems to have been the monks who practised the most elaborate frauds, though when it came to claims to an impossible antiquity the universities were not far behind.[11] In England, M.T. Clanchy argues in *From Memory to Written Record*, the growth of legal documentation went hand in hand with a multiplication of mythical charters. The years after the Norman conquest, when old titles of every kind were in question, was also the golden age of the forger; and it seems that, so far as monastic charters are concerned, authentic documents may have been the exception rather than the rule.[12] Bede's *Ecclesiastical History of the English People* provided them with a convincing historical background. 'They did not appeal to it to provide specific precedents relevant to the points at issue', writes Antonia Gransden. '… Indeed, had they been able to do so, they might not have considered forgery necessary … rather they borrowed phrases with the intention of making the style of their spurious documents appropriate to the time when they were supposed to have been written.'[13]

One of the most ambitious of these forgeries, and certainly the one with the greatest influence on our own day, because without it the New Age travellers and the eco-freaks would be without their central shrine, was that perpetrated by the monks of Glastonbury. Lacking both a

detailed foundation story and famous relics, they commissioned William of Malmesbury, the finest of the twelfth-century scholars, to provide them with a pedigree. By dint of remarkable quasi-archaeological exploration, he was able to date the foundation of the abbey to the seventh century, and to claim that St Patrick, the patron saint of Ireland, was among its early visitors. The monks, not content with this, set about embellishing the story, first by converting Glastonbury into St Patrick's burial place; then, in 1191, by exhuming the supposed bodies of King Arthur and Queen Guinevere, using them as proof that Glastonbury had been Camelot; finally, and most enduringly, discovering that it had a pre-history in New Testament times, and that in AD 63 it had been visited by Joseph of Arimathea.[14]

Historical illustration is another field in which forgery, or knowledge-based invention, could be said to have set the pace. Francis Haskell in *History and Its Images* pays tribute to the 'remarkable quality of many of those forgeries', in the case of the spuriously Roman coins on which Renaissance numismatists called when initiating the study of classical antiquity. Seventeenth-century historical portraits, sometimes engraved from medals and coins but quite often, it seems, an artist's impression drawn from surviving word pictures, are also (Haskell shows) after their own fashion testimonies to historical knowledge, even if they can be technically classed as fakes. 'In the sixteenth and seventeenth centuries many publishers of grandiose and apparently fanciful portrait collections went out of their way to emphasise the meticulous nature of their researches and to make clear that it was "not without the expense of great labour, trouble and money" that they had explored "seals, monuments, statues, paintings and books" in their determination to reproduce genuine likenesses.'[15]

Historians today don't knowingly forge documents. But by the nature of our trade we are continually having to fabricate contexts. We may not construct imaginary speeches in the manner of Thucydides, but by selective quotation we can make subjects give expression to what we believe to be their innermost being. We make extravagant claims for the importance of our subject, and strain interpretation to secure the maximum effect. Footnotes serve as fetishes and are given as authorities for generalizations which a thousand different instances would not prove. We suppress the authorial 'I' so that the evidence appears to speak for itself. We improve on the original, making connections to cover the gaps in the story, the silences in the evidence. Our pictures, apparently seamless, are so artfully framed and carefully composed, that the historian's gaze imposes itself. We may not go in for hagiography, as our medieval predecessors did, but we are not averse to touching up our portraits; giving a star turn to hitherto unnoticed characters; and crediting our heroes or heroines with genius. Like the Anglo-Norman monks we are adept at simulating antique effects, using the language and idiom of the original documents even though the template of analysis and the descriptive categories are our own – as when a seventeenth-century rhetoric of order and degree is used to illustrate twentieth-century understanding of class.

History is an allegorical as well as – in intention at least – a mimetic art. Where others, such as antiquarians or archaeologists, *collect* facts, we pride ourselves, as our predecessors did, on *arranging* them.[16] The lifelike detail on which we pride ourselves is there not so much as documentary proof but rather as a gauge of authenticity. Real events double in the character of turning points, symbolic moments when all things are made anew. Like allegorists, historians are adept at discovering a hidden or half-hidden order. We find occult meanings in apparently simple truths, revelations in seemingly mundane happenings. We claim the right to treat relics as emblems and thought as paradigmatic. We use numbers in magical ways, to give form and shape to our tale-types, turning dyads into romantic contraries, and triads into totalities.[17] We also exercise the allegorist's freedom in drawing promiscuously on whatever materials come to hand. The historian's reading of the evidence is necessarily an act of interpretation, abstracting

nuggets of information and relocating them in novel surroundings. Often it involves juxtaposing wildly different orders of evidence to establish a problematic, as in those *crises de subsistence* which a Depressionbred generation of historians hypothesized as the progenitor, or catalyst, of phenomena as various as the religious wars of the seventeenth century, the outbreak of the French Revolution, and the fiasco of the 1848 Chartist Demonstration on Kennington Common.[18]

In another way of looking at it, the historian's 'reading' of the evidence could be seen as an essay in make-believe, a way of dressing up fragments to make them look like meaningful wholes – rather as animatronics produces a *tableau vivant* of the museum exhibit. Or it could be seen as an exercise in the story-teller's arts, relying heavily on the expectation of continuity and using a battery of devices to heighten what Roland Barthes calls the 'reality effect'.[19] The art of historical writing is that of making a master narrative out of chaos. The synthesis by which we set such store, when sketching in a background, aims to cover the entire work in the field. Our classifications and taxonomies – the bedrock of the social-science history of the 1960s, as of the economic history which preceded it – are all-inclusive. Our categories make individuals into representative types. We give an ordered sequence, with a beginning, a middle and an end, to events which to the participants themselves may have seemed quite random.

The language of history, so far from being a simple medium for the transmission of fact, intercepts meaning, giving fixity and definition to what in the documents is elliptical or opaque. It animates description, conjuring evocative detail from unpromising sources. It reifies figures of speech. It anthropomorphizes the historian's own categories. Period labels (referring more, in their current usage, to the past of interior decorators than to monarchical reigns) are used to personify eras. Abstractions such as 'the nation' or 'women' masquerade as real-life historical actors and are credited with a mind and will of their own – the historian's equivalent of that pathetic fallacy which John Ruskin identified in mid-Victorian art. Age cohorts, in the hands of historical demographers, also acquire individual characteristics – now wreaking a Malthusian revenge on their straightened conditions of existence by delaying marriage or limiting family size; now breaking out in Dionysiac frenzies, as in that spectacular rise in the bastardy rates in eighteenth-century Europe which so fascinates students of the family.

Economic historians, perhaps to atone for the bleakness of their preoccupations, seem particularly prone to anthropomorphize their subject matter, adopting an 'ages and stages' view of the life-cycle, and picturing a whole series of genetic transformations which carry the economy from a state of childhood innocence to one of world-weary senescence. At one end of the time-scale there is a new attention to the 'birth' of consumerism (variously ascribed to the 1590s, the 1730s and the 1880s), at the other there is a morbid awareness of the symptoms of decay. 'Climacteric', when referring to women a euphemism for menopause, is annexed to the scholarly lexicon, and given the symbolic space which was occupied by 'watersheds' and 'turning points' in the school textbooks of yesteryear. 'Proto-industrialization', the subject of a rich literature in the past twenty years, becomes a kind of adolescent or teenage stage of a nation's life-cycle.[20]

Our time-reckonings, too, though apparently adopted for purposes of expository common-sense, occupy an imaginative as well as a chronological space. Dates, as well as offering mnemonic devices to the teacher, and precise locations to the stickler for accuracy, also serve as choreographic devices; investing events with dramatic and historical pattern; characterizing and ordering what might otherwise seem formless; and creating the space in which notions of linear progression can have free play.[21]

One might think of those three- and four-stage models of human development which from the time of the ancient Greeks have provided narrative history with its symbolic framework[22] and in particular the tripartite division between 'ancient', 'medieval' and 'modern' history which, appearing first in the 1470s, with the term *medium aevum*, has been seemingly untouched

by subsequent development.[23] (Such neologisms as 'early modern', a coinage which is now routinely applied to the entire stretch of history which separates the Renaissance and the French Revolution, have helped to keep it intact.) In another register, where history deals in millennia rather than centuries or decades, geological time, with its story of how man became a giant, inescapably supports the notion of history as a forward march.

Historians may no longer subscribe, as their Evangelical and Catholic forebears did, to a doctrine of the Fall, but a secularized version of it might be thought to underpin a whole series of dualisms which oppose past and present, or before and after, in terms of some prelapsarian social state. The idea of theodicy, of some large design which the individual event illustrates, also enjoys a vigorous after-life. We are continually fastening on symptoms of decline or precocious instances which foreshadow the shape of things to come.[24] Current enthusiasm for the study of the transgressive, and in particular those carnivalesque occasions when the world turns upside down, encourages a quest for moments when the social order is apparently dissolved and, as in the revolutionist's utopia, all things have to be made anew.

Some of history's key terms are theological in origin. The division of historical time into centuries was, it seems, the invention or discovery of some Lutheran pastors of the 1530s.[25] Quite apart from numbers-mysticism – an inescapable component of history's classificatory schema – it might be chastening to monitor the continuing influence of the medieval Christian idea of 'the great chain of being'. Arthur Lovejoy has shown how this influenced the heavenly city of the eighteenth-century philosophers;[26] it might be no less germane to our taken-for-granted notions of trends, patterns and processes.

Residues of Judeo-Christian theology, with its eschatological sense of a final end, could be seen as the ghostly presence in historical notions of destiny and ideas of historically inevitability; and in those unspoken teleologies which see a progress from lower to higher things, or, more pessimistically, a free fall from an originally virtuous state. History may no longer serve expressly prophetic purposes as it did in the Middle Ages,[27] or in early Protestant propaganda,[28] but it does not seem fanciful to see evidence of its continuing imaginative appeal in our liking for portents, albeit retrospective, of the shape of things to come, in our 'idolatry of origins' and in our penchant for discovering eternity in a grain of sand. Thus, to take some examples of prolepsis from recently influential work, a cat massacre in 1730s Paris becomes, in Robert Darnton's extravagant treatment of it, a dress rehearsal for the French Revolution;[29] the 'Machiavellian moment' of Lucrezia Borgia's Florence prefigures the public service ethic and even the coming of the Welfare State;[30] sixteenth-century magic precociously anticipates modern science.

The first history of the English people – Bede's – was an ecclesiastical one, a narrative of missionaries and saints rather than monarchs, and having as its climacteric not some mighty battle or famous conquest but a synod of the Church. In the historical establishment's hiving off of 'Roman Britain' into a subject of separate study – or, in the case of the Oxford history syllabus, its elimination – it is possible to see Bede's original perception at work: the English only became English when they converted to Christianity.[31] In a more Protestant vein one might wonder whether there are not residues of ancient religious battles in the fact that, in all the received versions of the national past, 'modern' Britain begins at the time of the Reformation. Religion has left its mark on apocryphal history too. It seems that one of the most famous incidents in national history – the story of King Canute and the waves – was a monkish parable, designed to prove that kings were made of the common clay; the story of Alfred and the burnt cakes has apparently a similar origin.[32]

Record-based history – with its famous names and dates, causes and effects, and progression from point to point – has always had to compete with rival narratives which attempt to tell the story of the past in different ways. There is to begin with the timeless past of tradition; the 'once

upon a time'; the 'good old days' (or 'hard times') of popular memory. Then there are the legendary histories dramatized in the folk-play, the dressing-up games, the public pageants and rituals. In a no-man's land, epistemologically speaking, are those parables which, by dint of constant repetition, have come to be accepted as true, and which indeed furnish many of the high points in our island story, from fables about the likely burial place of Boadicea to that of Dunkirk, and the alleged rescue of the British army by a flotilla of pleasure-boats. Here are the stories that had graved themselves in the memory of an early-twentieth-century Stockport hat-maker:

> JOHN BARRATT: I know very little of jovial John's career at Canal Street. I know he was here as warehouse boy with my father a short time. If one thinks of a person living or dead of this age or any other, we always fancy some personal appearance and action. Julius Caesar crowned with laurel and his baton in his hand, or else at the head of his Romans, sword in hand just landing on our shores; Wm. Tell has his bow, and is about to shoot at the apple on the head of his son; or else he is leaping from the boat at Altorf; Huss and others are being unpleasantly roasted; Napoleon is standing with folded arms at Helena, or he is on horseback leading his soldiers over the Alps; and lastly John Barratt when at Canal Street always appears to me with a brush in his hand sweeping the old warehouse floor under the very clock which is now hung on J. Fox's room! For years he has now been our head-traveller![33]

It seems likely that notions of the olden days have always been made up of promiscuous elements, with words and things, perhaps, pulling in opposite directions, local traditions and family lore marking their own narrative, and so far as 'our island story' is concerned, a mixture of real-life and apocryphal events. So far as the learning process is concerned, the young Samuel Bamford cannot have been alone in reading the penny history chap-books as though they were true; in believing in 'boggarts' (the Lancashire word for ghosts); and in putting legendary figures on a par with historically recognized ones.[34]

Sacred history, as it was taught in nineteenth-century Bible classes, had the closest affinities, pedagogically speaking, to national history, using mnemonic devices to enable children to learn the Kings of Israel off by heart, much as if they had been Tudors and Plantagenets, making constant reference to maps of the Holy Land (sacred geography), and even – under the influence of nineteenth-century social Romanticism – making a feature of scenes from everyday life. 'Places', 'Customs', 'Arts', 'Antiquities', 'Natural History' and 'Poems on the Subjects of History' figures alongside Holy Writ in Charles Baker's 1860 *Bible Class for Schools, Teachers and Families*, with upwards of a hundred wood-cuts, 'chiefly referring to the manners and customs of the Orientals' to explicate the text. A chronological index preceded the text, and a general index to the notes and poems followed.[35]

Joseph Barker, a sometime Chartist and later an independent minister in the West Riding, has left an autobiographical account of how, as a boy, he negotiated these different histories:

> The first book I remember to have read was the Bible. I read it chiefly as a book of history, and was very greatly delighted with many of its stories. The effect which it had upon my mind at this early period I can scarcely recollect, but one effect was to lead me to regard miracles as nothing improbable, and another was to impress upon my mind the doctrine of one God, the creator, upholder, and governor of all things, the ruler, the judge, and the rewarder of mankind, and to strengthen in my mind the sense of right and duty.
>
> The next book that I remember to have read was Bunyan's Pilgrim's Progress. I regarded that book also as a history. I had no idea that it was a parable or an allegory. My impression

was, that the whole was literal and true, – that there was, somewhere in the world, a real City of Destruction and a New Jerusalem, and that from the one to the other there was a path through some part of the country, just such a pathway as that which Bunyan represents his pilgrim as treading. And, as I have said before, I often used to wish that I could find that way to heaven. One of the next books that I read was a History of Joseph, a work written in a similar style to that of Klopstock's Messiah or Milton's Paradise Lost, being partly fiction and partly truth. But I regarded that also as a true story. I had no idea at that time that people could write and print anything in the form of a history, that was not real matter of fact. I was naturally a firm believer in all that was gravely spoken or printed …

Some time after this I began to be fond of another kind of book. I read with great greediness all the fairy tales I could get hold of, and any kind of wild and foolish romances. I also read the tales of Baron Munchausen, A Thousand Notable Things, The Oddest of all Oddities, and a number of similar productions. I read all, in fact, that came in my way, and that with great greediness. I then got hold of the Life and Adventures of Robin Hood, Blind Jack of Knaresborough, Eugene Aram, Mary Bateman, and some other stories of remarkable persons or great thieves and highwaymen. A little earlier than this, perhaps, I read Robinson Crusoe. But that also I regarded as a true story. I had no idea at the time I read Robinson Crusoe, that there were such things as novels, works of fiction, in existence. I liked Robinson Crusoe very much till I came towards the latter part, and then I began to be weary.[36]

In Elizabethan England, at the dawn of record-based research, there were some half-a-dozen alternative versions of the past on offer. There was to begin with the legendary history of Geoffrey of Monmouth and the *Brut* Chronicles which, until the 1590s and notwithstanding the damaging criticism of Polydore Virgil, remained the received version of the national past.[37] Then there were the ecclesiastical histories, notably Foxe's *Acts and Monuments*, chained to the pulpit alongside the *Book of Common Prayer*, and Knox's *History of the Reformation*, which were at once key texts for Protestant propaganda and also in some sort paradigms for the philosophical histories of the Enlightenment.[38] In a quite different imaginative realm were the 'chorographies', devoted to the descriptions and delineation of place. Those who read them (Helgerson writes) had a much better grounding than those who relied on the chronicle histories. The chronicle was 'almost by definition', the story of kings. The chorographers told of locality. 'In them England is Devonshire, Stafford, and York; Stratton Hundred, Cripplegate Wood, and the Diocese of Rochester … loyalty to England here means loyalty to the land, to its counties, cities, towns, villages, manors, and wards, even to its uninhabited geographical features.'[39] In yet another sphere, there were the chap-book histories, and the 'artisan' novels of Thomas Deloney,[40] which introduced such male Cinderellas as Jack of Newbury, the supposed wool brogger, and Dick Whittington, the apprentice boy who became Lord Mayor of London – a new type of hero, the poor boy made good, to replace the giants and giant-killers of ancient lore. Lastly, reference might be made to history on stage, both the chronicle plays of Shakespeare and Marlowe, and the mummers' plays which, according to some recent scholars, began life as adaptations of the chap-books.[41]

In the nineteenth century there were any number of competing histories on offer, ranging – if war and peace were to be the measure – from such ultra-bellicose, and hugely popular, 'drum-and-trumpet' histories as Edward Creasy's *Fifteen Decisive Battles of the World* (a book which seems to have been continually in print from its publication in the 1850s down to the First World War) to such expressively-named primers as G. Pitt's *History of England with the Wars Left Out*, which reached a third edition in 1893. The cribs themselves were by no means all of

a piece, but might be written in as many as half a dozen voices, with the history of manners and morals serving as some kind of counterweight to that of constitutional developments or genealogical descent.[42] Likewise in the school anthologies and readers, heroic lays, such as those of Lord Macaulay and Mrs Hemans, with their invitation to an epical sense of the past, were printed cheek-by-jowl with word-pictures of old-time country life.

The notion of history as a self-contained 'discipline', or separate subject, is a comparatively recent one, dating perhaps only from the professionalization of writing and research between the wars. Local history – a term which seems only to have entered common usage in the 1920s – was in its nineteenth-century development quite largely in the hands of ecclesiologists studying the fabric of the church, and naturalists monitoring flora and fauna. Likewise the history of everyday things, adopted as a flagship of 'learning by doing' in the progressive pedagogies of the 1970s, was in its earlier phases the province of Jonathan Oldbuck-like antiquarians. When, for instance, William Francis Collier, a prolific author of mid-Victorian school histories, wanted to follow the example of Macaulay's Chapter III and offer passages on *mores*, he drew on the researches of 'eminent antiquarians like Thomas Wright';[43] following this up, in 1865, with a fully-fledged *Tales of Old English Life, or Pictures of the Period*, which combined real-life characters and fictional narratives, using imaginary dialogue but drawing on 'the most recent results of antiquarian research' and making a feature of minuteness of commonplace detail.[44]

In the nineteenth century, history was conventionally regarded as a branch of literature, inferior indeed to poetry, but on a par with oratory and definitely superior to the mere entertainment of the novel or the comedy of manners. Sir Walter Scott, the great architect of historical realism, drew his characters and his leading incidents – even the most melodramatic of them, like the wedding night of *The Bride of Lammermoor* – from living memory and family lore, making a great point, in the prefaces and the annotations, of how they corresponded to oral tradition. His dialogue was no less beholden – even in its archaisms – to living speech.

'Literary' historians – those men of letters, scholar–radicals and Victorian sages who cut such a great figure in the columns of the periodical press – began to come under attack in the 1870s, when history schools established themselves in the ancient universities and the subject as marked out as an apprenticeship in statecraft.[45] The attack was renewed in the 1930s when a generation of hard-nosed professionals look on the 'Whig' interpretation of history and set about waging war on the gentleman-amateur. It was carried to new heights in the postwar turn cliometrics: for the economic historians of the 1950s, virtually any non-quantifiable class of evidence was liable to be given the pejorative label of 'literary' and 'impressionistic'. Yet the 'literary' remains an inescapable component of history's appeal and of its practice. It is not difficult, for instance, to see the influence of modern Gothic in the current scholarly enthusiasm for the study of the marvellous,[46] while the beauties of the horrid may be not the least of the reasons for the vast new historical literature on thanatology, the renewed scholarly (and feminist) interest in witchcraft,[47] and the spate of writing on such saturnalian occasions as public hangings.[48] In another register, micro-history and today's insistence on the small detail of everyday life might be aligned to grainy realism of new-wave writing and photography in the 1960s or to an Audenesque excitement in juxtaposing the epic and the everyday.

When Jean Bodin, in 1566, set out his *Method for the Easy Comprehension of History* – still an attractive read – he distinguished three classes of narration: the first concerned man, the second nature, the third God.[49] history tended to be subsumed in what came to be called natural philosophy' or 'natural theology', and when it entered the schoolroom it was apt to appear under the label of biology – though a minority of county historians, following the example of Robert Plot's *Rural History of Staffordshire* addressed themselves to flora and fauna. The field clubs and natural history societies of the nineteenth century – liberal it seems in outlook, where the

antiquarians were Tory – had a prosperous local following; as did the museums movement, which put natural curiosities on display.[50] But history with a capital 'H', even the social history of J.R. Green and Lord Macaulay, took off in quite other directions.

Today, natural history is a growing point in both archive-based and archaeological research, and it is possible to imagine a state in which the historical study of man and that of nature will once again be, as it was apparently in Bodin's time, coeval. Keith Thomas's *Man and the Natural World* (1983), a book which, from the point of view of history as a specialist discipline, came from nowhere, put the matter on the agenda of scholarly inquiry.[51] Still more pertinent would be the rise of conservationist sentiment, and the new awareness of the natural world as an environment at risk.

As with any new departure in higher research, the turn to natural history – or the return of it – was no doubt over-determined. It owed something to the new arboriculture of the 1960s, and indeed Oliver Rackham, the most widely read of the new ecologically minded historians, has been a leading figure in the campaign to rescue ancient woodland.[52] Animal rights campaigners could claim the credit for creating a climate of opinion in which the study of the horse-drawn society of nineteenth-century Britain,[53] or of the demographic explosion among fourteenth-century rabbits[54] can be accepted as a legitimate, indeed innovative, subject for higher research. Friends of the Earth, and such newly-formed organizations as the Soil Association, are giving a new lease of life to that study of the landscape which professors Hoskins and Beresford established in the 1940s as the very basis for local history. And it is possible – the matter is necessarily speculative – that hunt saboteurs may have been indirectly responsible for that horrified fascination which historians of the British Empire are currently giving to the murderous field-sports of the empire-builders in Africa and British India.[55]

It is arguable that myth, or what F.M. Cornford called 'Mythistoricus' – a history cast in a mould of conception, 'whether artistic or philosophic', which, 'long before the work was contemplated' was already 'inwrought into the very structure of the author's mind'[56] – is immanent in any historical work. Typically we conflate a great mass of evidence to illustrate or to exemplify relatively simple truths – the classical procedure of the allegorist. Our whole effort is to discover a logic or pattern in seemingly quite fortuitous associations; to give meaning and draw lessons from what might otherwise be a quite random sequence of events. In the terms proposed by Vladimir Propp in his morphology of folk-lore, our narratives conform to 'tale-types'.

The nineteenth century, which saw the growth of the idea of 'scientific' history,[57] was also a prolific source of new historical legends. One might refer to the frequency of those two-, three-, four-, or (in Marx's case) five-stage theories of historical development which offered a modernist update of the medieval and pre-medieval Four Ages of Man. Or one might look at nineteenth-century popularizations of apocrypha, such as the story of William Tell, in Sunday School prize books. In France the *mythe celtique* – memorably represented, for radical readers, in Eugène Sue's *Histoire d'une famille prolétaire à travers les ages* – would be worth attending to. In Britain the idea of Merrie England, which appears in the pages of Cobbett and Carlyle as a paradise lost, and in graphic art as a bucolic alternative to the severities of a commercial civilization, has a large documentation waiting to be pieced together in the manner of the cult of chivalry in Mark Girouard's *Return to Camelot*.

Closely related to this one might instance the nineteenth-century discovery of such figures of national myth as Boadicea, who disappeared from the records for a thousand years and who only really came into her own in Victorian times,[58] or (one of Michelet's additions to the democratic pantheon) Joan of Arc.[59] In another sphere, drawing on the word-books of the county dialect societies, or the 'Notes and Queries' corners in the provincial newspapers, one could look at the legends which grew up around place names; the rise of the workplace ghost (the

Victorian coalface seems to have been full of them); and the diffusion of those newly-minted local traditions which arose in the wake of environmental and social change. The popularity of *The Ingoldsby Legends* – a Victorian bestseller, with a strong cult following – might be interesting here, drawing as it did on Kentish lore, and offering a kind of Home Counties version of Sir Walter Scott's *Minstrelsy of the Scottish Borders*, while at the same time laying claim to that rib-tickling space which in the 1840s and 1850s seems to have been reserved for comic histories.[60]

> The World, according to the best geographers, is divided into Europe, Asia, Africa, America and Romney Marsh. In this last named and fifth quarter of the globe, a Witch may still be occasionally discovered in favourable, i.e. stormy, seasons, weathering Dungeness Point in an egg-shell, or careering on her broom-stick over Dymchurch Wall.

History has always been a hybrid form of knowledge, syncretizing past and present, memory and myth, the written record and the spoken word. Its subject matter is promiscuous, as the almanacks printed as a frontispiece to this volume may suggest. In popular memory, if not in high scholarship, the great flood or the freak storm may eclipse wars, battles and the rise and fall of governments. As a form of communication, history finds expression not only in chronicle and commentary but also ballad and song, legends and proverbs, riddles and puzzles. Church liturgies have carried one version of it – sacred history; civic ritual another. A present-day inventory would need to be equally alert to the memory work performed (albeit unintentionally) by the advertisers, and to the influence of tourism, home tourism especially. As a self-conscious art, history begins with monuments and inscriptions, and as the record of the built environment suggests, not the least of the influences changing historical consciousness today is the writing on the walls. The influence of video-games and science-fiction would be no less pertinent in trying to explain why the idea of chronological reversal, or time travelling, has become a normal way of engaging with the idea of the past.

History owes much of its vitality to parallel movements in literature and politics. In Renaissance France, as in Jacobean England, its fortunes were closely bound up with those of jurisprudence and indeed to follow the researches of Donald R. Kelley, it seems that discussion of the origins and nature of feudalism goes back to scholarly debates among sixteenth-century lawyers. In the schools, history has often been associated with what was called, in Edwardian Britain, 'civics'. In the 1920s, when there was a determined attempt in the schools to promote One Worldism, it was closely bound up with League of Nations Union idealism; while in its new-found enthusiasm for the history of everyday things it was no less beholden to a kind of Thames Valley, or Cotswolds, Little Englandism.

Beyond such cultural borrowings, or syncretism, there is the matter of the politics of history which, by a kind of return of the repressed, is now an inescapable element in any discussion of pedagogy or research. The influence of feminism which, in the space of twenty years, has driven a sociology from the field, destabilized, or destroyed, Labour history, and put all our taken-for-granted social categories into question, hardly needs arguing, though in the field of political history it still seems possible for all-male platforms of academics to assemble. Particularly subversive, and particularly fruitful, at the time of writing, is gay history, which takes the whole of the human condition for its province and finds as much sustenance in the Dark Ages as in modern times. Its intuitive feel for, and interest in, the world of appearances, and readiness to take this seriously, makes it peculiarly a scholarship of our time, as does its natural sympathy for the forbidden and the transgressive.

At a time when numbers in higher education are expanding; when whole new constituencies of research are forming outside the academy; and when questions of individual and collective

identity are making history a front-line subject in the schools, it would be absurd for historians to abandon the field of moral and political argument; to attempt to return to history with a capital 'H' – i.e. a single master narrative – or to try to retreat to the cloistered seclusion of a library carrel.

Notes

1 Lord Acton, Letter to Contributors to the Cambridge Modern History, 12 March 1898, in William H. MacNeill, ed., *Essays in the Liberal Interpretations of History*, Chicago 1967, pp. 397–9.
2 W. Stubbs, *Two Lectures on the Present State and Prospects of Historical Study*, Oxford, 1876.
3 There is some discussion of this in my 'Continuous National History' in R. Samuel, ed., *Patriotism*, London 1989, Vol. 1.
4 Linda Hannas, *The English Jigsaw Puzzle: 1760–1890*, London 1972.
5 Edwin Muir, *An Autobiography*, London 1954, p. 14.
6 Lionel Pearson, *The Local Historians of Attica*, American Philological Association, 1981.
7 G.A. Press, *The Development of the Idea of History in Antiquity*, Montreal, 1982, p. 45.
8 M.I. Finley, 'Myth, Memory and History', *History and Theory*, IV, 1964–5, pp. 281–302; John Gould, *Herodotus*, London 1989, is an excellent introduction. J.A.S. Evans, *Herodotus, Explorer of the Past*, Princeton 1991; and Rosalind Thomas, *Oral Tradition and Written Record in Classical Athens*, Cambridge 1990, for the relationship of Herodotus to eye-witness and oral testimony. 'Herodotus and the Invention of History', *Arethusa*, Vol. 20, nos 1 & 2, 1987, for the relation to legend and epic.
9 F.M. Cornford, *Thucydides Mythistoricus*, Oxford 1907. Anthony Grafton, *Forgers and Critics; Creativity and Duplicity in Western Scholarship*, Princeton 1990, pp. 8–15 is a more simple-minded discussion of this phenomenon.
10 A. Gurevich, *Categories of Medieval Thought*, London 1985, p. 179.
11 Oxford claimed King Alfred as its founder; Cambridge the legendary King Arthur. Ibid., pp. 177–8.
12 M.T. Clanchy, *From Memory to Written Record: England, 1066–1307*, London 1979, pp. 248–9.
13 A. Gransden, 'Bede's Reputation as an Historian in Medieval England', in *Legends, Traditions and History in Medieval England*, London 1992, p. 15.
14 A Gransden, 'The Growth of the Glastonbury Traditions and Legends in the Twelfth Century', in ibid., pp. 152–79. William of Malmesbury's *De Antiquitate Glastoniensis Ecclesiae* did come up with some remarkable visual evidence about seventh-century church-building on this site, which twentieth-century excavation has confirmed. Ibid., p. 160, quoting a 1963 paper by Joan and Harold Taylor. See *Glastonbury: Ancient Avalon, New Jerusalem*, ed. Anthony Roberts, London 1978, for a modern zodiac account.
15 Francis Haskell, *History and Its Images: Art and the Interpretation of the Past*, London 1993, pp. 21, 31–5, 46, 53, 59.
16 The distinction and contrast was made by Thomas Hodgkin in an address to the Historical Section of the Archaeological Institute in 1891. Philippa Levine, *The Amateur and the Professional: Historians and Archaeologists in Victorian England, 1838–1886*, Cambridge 1986, p. 91.
17 On numbers mysticism, Umberto Eco, *Art and Beauty in the Middle Ages*, New Haven 1986, p. 35.
18 Originally a medical term, 'crisis' was first adopted as a way of characterizing the social and political order in the aftermath of the 1914–18 war. Winston Churchill, in *World Crisis*, his extended history of the war, used the term as a metaphor for the break-up of the old Empires, and the appearance in the East of an alien force. Lenin, in his prophetic *Imperialism* (1916) saw the war as heralding a 'general crisis' of capitalism. Imperialism was not only the highest stage of capitalism, it was also the last. The Communist International sat out the 'relative stabilization' of the 1920s, waiting for 'the final crisis' to take its bow. The great crash of 1929, the rise of fascism, and the renewed threat of war, seemed to confirm these apocalyptic imaginings. Huizinga's *Waning of the Middle Ages*, published in the very shadow of the Great War – a dazzling account of chivalry in its decadence – was perhaps the first work by a professional historian to take crisis (the 'decay of overripe forms of civilisation') as the theme of its narrative; in the 1930s, his insights were complemented by a new awareness, among economic and social historians, of the Malthusian elements in the population crisis of the fourteenth century; a little later K.B. MacFarlane in England and Edouard Perrory in France related the Hundred Years War to a supposed crisis in seigneurial revenues. By 1946, when Robert Boutruche's *Crise d'une société* was published – a study of the late-medieval Bordelais – all the elements were in place for the historical

discovery of a 'feudal crisis'. It was the work of Ernest Labrousse on the economic collapse which alleg-edly precipitated the downfall of the *ancien régime* which implanted the word 'crisis' in the historian's lexicon. In the 1950s it was adopted by the journal *Past and Present*. Eric Hobsbawm, in the lead article of what proved to be a sustained controversy, argued that there was a 'general crisis' in seventeenth-century Europe, representing for late feudalism an analogous set of contradictions to those which (Marxists believed) were hastening the decay of capitalism. Hobsbawm drew together under a single optic the English Civil War of 1642–49, the French Fronde, and the near contemporaneous Wars of Religion in Germany. The thesis won support from a formidable group of historians, though Hugh Trevor-Roper shifted the emphasis from the economy to religious fanaticism, while East European contributors argued that, east of the Elbe, the seventeenth-century 'crisis' had been followed by a *strengthening* of feudalism. Lawrence Stone's monumental *Crisis of the Aristocracy 1540–1640* – a kind of dance of death over England's *ancien régime* – is perhaps the most enduring English work written in a crisis idiom; Gareth Stedman Jones's much more sophisticated *Outcast London* (1973) – the 'crisis' of unskilled labour in 1889 – is arguably a late echo of it.

19 Roland Barthes, 'The Discourse of History', reprinted and translated in *Comparative Criticism* Vol. 3, Cambridge 1981; 'L'Effet de réel', *Communications*, 2, 1968.

20 E.H. Phelps-Brown, 'The Climacteric of the 1890s; A Study in the Expanding Economy', *Oxford Economic Papers*, N.S., Vol. 4, No. 3, October 1952; L.A. Clarkson, *Proto-Industrialisation, the First Stage of Industrialisation*, Basingstoke 1985, for a summary; Hans Medick, 'The Proto-Industrial Family Economy', in J.A. Chartres, ed., *Pre-Industrial Britain*, Oxford 1944; F. Mendels, 'Proto-industrialisation' in D.R.T. Jenkins, ed., *The Textile Industries*, Oxford 1994.

21 G.J. Whitrow, *Time in History: Views of Time from Prehistory to the Present Day*, Oxford 1990; G.J. Whitrow, *The Natural Philosophy of Time*, Oxford 1980; D.S. Landes, *Revolution in Time*, Cambridge, Mass. 1983; Norbert Elias, *Time: An Essay*, Oxford 1993; Stephen Hawking, *A Brief History of Time*, London 1989; Martin Heidegger, *A History of the Concept of Time*, Indiana 1985; R. Kosellek, *Futures Past: On the Semantics of Historical Time*, Cambridge, Mass. 1985.

22 Ronald Meek, *Social Science and the Ignoble Savage*, Cambridge 1976.

23 G.S. Gordon, *Medium Aevum and the Middle Ages*, Society for Pure English, Tract 19, London 1925, is a splendidly detailed aetiology; see also Peter Burke, *The Renaissance Sense of the Past*; E. Breisach, *Historiography; Ancient, Medieval and Modern*, Chicago 1983.

24 Raphael Samuel, 'Reading the Signs: 2', *History Workshop Journal*, 33, Spring 1992.

25 Denys Hay, *Annalists and Historians, Western Historiography from the VIIIth to the XVIII Century*, London 1977, p. 123.

26 Arthur Lovejoy, *The Great Chain of Being*, Cambridge, Mass. 1972.

27 R.W. Southern, 'Aspects of the European Tradition of Historical Writing: 3. History as Prophecy', *Transactions of the Royal Historical Society*, 5th series, 27, 1971, pp. 159 et seq.

28 *Foxe's Book of Martyrs*, that monument of Elizabethan historical scholarship, and for a century and more afterwards a primary medium of popular education, was, according to William Haller, the first 'Whig' history, picturing England as an 'elect' nation moving towards its appointed destiny, and substituting for medieval (and classical) notions of endless flux an altogether more modern one of progressive development. A similar affinity has recently been suggested between Knox's *History of the Reformation* and the Scottish 'philosophical' historians of the eighteenth century.

29 Robert Darnton, *The Great Cat Massacre*, Harmondsworth 1983; for some critical commentary, Harold Mah, 'Suppressing the Text', *History Workshop Journal*, 31, Spring 1991; Raphael Samuel, 'Reading the Signs. 2', *History Workshop Journal*, 33. Spring 1992; and the articles in *Journal of Modern History*, Vol. 57, 1985, pp. 682–99; Vol. 58, 1986, pp. 218–34; Vol. 60, 1988, pp. 95–112.

30 J.G.A. Pocock, *The Machiavellian Moment: Florentine Political Thought and the Atlantic Republican Tradition*, Princeton 1975, has bred a vast number of epigones.

31 I am grateful to Professor Janet Nelson for this suggestion. Peter Hunter Blair, *The World of Bede*, Cambridge 1991, pp. 11–40, for Bede's view of England.

32 See the interesting discussion of this in Robert Birley, 'The Undergrowth of History', in *History*, 1961.

33 *The Chronicles of Canal Street*, Stockport 1922, pp. 14–15. For a nineteenth-century example, *The Royal Readers*, London 1872, Vol. IV–V.

34 Samuel Bamford, *Early Days*, London 1849.

35 Charles Baker, *The Bible Class Book for Schools, Teachers and Families*, 2nd edn, London 1860.

36 *The Life of Joseph Barker, Written by Himself*, London 1880.

37 F.J. Levy, *Tudor Historical Thought*, San Marino 1967; Denys Hay, *Polydore Vergil*, Oxford 1952; *Annalists and Historians: Western Historiography from the VIIIth to the XVIIIth Century*, London 1977, pp. 118–22.

38 Mary Fearnly-Sander, 'Philosophical History and the Scottish Reformation: William Robertson and the Knoxian Tradition', *Historical Journal*, Vol. XXXIII, No. 2, 1990, pp. 323–38.

39 Richard Helgerson, *Forms of Nationhood: Elizabethan Writing of England*, Chicago 1992.

40 Laura Caroline Stevenson, *Praise and Paradox: Merchants and Craftsmen in Elizabethan Popular Literature*, Cambridge 1984.

41 Ronald Hutton, *The Rise and Fall of Merry England: The Ritual Year, 1400–1700*, Oxford 1994, is a detailed new account.

42 J.C. Curtis, *A School and College History of England*, London 1960; W. Longman, *Lectures on the History of England*, London 1860–61.

43 William Francis Collier, *The History of England with a Sketch of Our Indian and Colonial Expire*, London 1864, p. v.

44 William Francis Collier, *Tales of Old English Life, or Pictures of the Periods*, Edinburgh 1868; Thomas Wright and Richard M. Dorson, *The British Folklorists: A History* London 1968, pp. 61–6; *C. R. Smith's Retrospections*, Vol. I, London 1883, pp. 76–84.

45 Rosemary Jann, *The Art and Science of Victorian History*, Ohio 1986, p. 218.

46 Jacques Le Goff, 'The Marvelous', *The Medieval Imagination*, Chicago 1988. Ed. Joy Kenseth, *The Age of the Marvelous*, Chicago 1992.

47 Lyndal Roper, *Oedipus and the Devil, Witchcraft, Sexuality and Religion in Early Modern Europe*, London 1994.

48 Thomas W. Laqueur, 'Crowds, Carnival and the State in English Executions, 1604–1868', in A.L. Beier et al., eds., *The First Modern Society*, Cambridge 1989. Peter Linebaugh, *The London Hanged: Crime and Civil Society in the Eighteenth Century*, London 1981; V.A.C. Gattrell, *The Hanging Tree: Execution and the English People*, 1770–1868, Oxford 1994.

49 Jean Bodin, *Method for the Easy Comprehension of History*, New York 1945.

50 Philippa Levine, *The Amateur and the Professional*, p.; Lynn Barber, *The Heyday of Natural History, 1820–1870*, London 1980, is an attractive introduction to the subject.

51 Keith Thomas, *Man and the Natural World; Changing Attitudes in England, 1500–1800*, Harmondsworth, 1984.

52 Oliver Rackham, *The History of the Countryside*, London 1986; *Trees and Woodland in the British Landscape*, London 1990.

53 F.M.L. Thompson, *Victorian England, the Horse-Drawn Society*, London 1971.

54 Harry Thompson and Carolyn King, *The European Rabbit; History and Biology of a Successful Coloniser*, Oxford 1994.

55 J.M. Mackenzie, *Empire of Nature; Hunting, Conservation and British Imperialism*, Manchester 1990.

56 F.N. Cornford, *Thucydides*, p. viii.

57 Donald R. Kelley, 'Mythistory in the Age of Ranke', in George C. Iggers, ed., *Leopold von Ranke*, credits Ranke's 'scientific history' with a complete ascendancy and suggests that it is only in contemporary postmodernism that its hegemony has been disturbed.

58 Raphael Samuel, ed., *Patriotism: The Making and Unmaking of National Identity, Vol. III: National Fictions*, London 1989.

59 For Michelet's discovery of Joan of Arc, Gabriel Monod, *La vie et la pensée de Jules Michelel*, Paris 1923; and the delightful essay by Roland Barthes.

60 Richard Harris Barham, *The Ingoldsby Legends*, London 1961. The legends were originally published by Dickens in *Bentley's Magazine*. Illustrated by Cruikshank, Leech and Tenniel, they were constantly reprinted in book form.

7

Understanding our encounters with heritage

The value of 'historical consciousness'

Ceri Jones

If we are to understand how people make sense of their encounters with heritage sites, and how they incorporate those experiences into their everyday lives, we need to piece together evidence from across a range of research fields. Such research and evaluation is shaped by the needs of professionals working in (for example) heritage and culture, museums, leisure, tourism and memory; all with different approaches, methodologies and theories as to how and why people engage with the past. Visitors' voices are often lost within, or absent from, the final analysis, leading to broad theories about the importance of heritage to our sense of identity and place but little actual evidence as to how this translates into everyday living. A more coherent approach is needed to bring together the fragmented evidence, one which seeks to understand how our encounters with heritage become part of our everyday lives and what it means to be 'historically conscious' or aware of having a past, present and future. The theory of 'historical consciousness' is not new but it is one that could be developed to unite the seemingly disparate fields of heritage, history and memory, all of which are concerned about our relationship with the past and how we make sense of that past in the present, individually and collectively, officially and unofficially. It also unites our awareness of the past with a concern for the future, reinforcing the potentially critical social role that heritage sites could play in helping to shape what those future possibilities might be.

The need to understand the role that heritage encounters play in the everyday lives of individuals, is partly driven by the seeming paradox that contemporary societies in the West have become increasingly obsessed with the past – creating more heritage sites, building more museums and increasing the definition of what is counted as heritage. However, at the same time it has been suggested that we lack a collective sense of why the past is meaningful to our lives, a coherent narrative in which to anchor society's memories (Hobsbawm 1994; Hewison 1987; Huyssen 1995; Torpey 2004). Technology has enabled us to preserve, capture, record, store and interpret the past more than ever before (Harvey 2001). Harrison (2013) suggests that this, coupled with a fear of decay and deep uncertainty about the future, has led to a 'crisis of abundance' in heritage, producing 'what appear to be opposing sentiments in the desire to be unshackled from the past, whilst simultaneously fetishizing and conserving fragments of it' (Harrison 2013: 26). Many reasons have been put forward for this ambiguous relationship with the past, including rapid social changes such as urbanisation and globalisation which have changed

the pace of life and utterly revolutionised our perception of the world (Connerton 2009). However, despite claims of 'indiscriminate' preservation of heritage, not all heritage appears to have equal value as the controversies over what is heritage, and whose heritage should be preserved, demonstrate (Smith *et al.* 2011; Logan *et al.* 2010). Sharp academic distinctions between history and heritage add to this confusion. Heritage is accused of being too comfortable and more about the present than the past, as opposed to the more rigorous and objective, but ultimately cold and distant approach of history (Huyssen 1995).

Research carried out in the UK, US and Australia provides evidence of individuals using the past in active, dynamic ways to make sense of their lives in the present – to provide (or reinforce) a sense of belonging, origins and identity (Rosenzweig and Thelan 1998; Ashton and Hamilton 2009; Smith *et al.* 2011). Creating narratives and stories out of our experiences is part of a fundamental human need according to historian Jörn Rüsen (2005), helping to make sense of the world around us and explain why change happens, as well as bringing some certainty to the future. Rüsen's theory of 'historical consciousness', I suggest, could be key to helping us understand more clearly the role of encounters with heritage within people's lives. By exploring our awareness of the past, present and future as a fundamental human trait – existing in time as historical beings – it has the potential to bridge the gap between our individual, everyday experiences of time with collective attempts to create meaningful narratives that explain where we come from, who we are and where we are going. It focuses our attention as professionals and researchers on how heritage sites both carry and create narratives about the past, shape ideas about the present and future, and which are, in turn, shaped by present-day moral values, purpose and rationale. For it is at the point of encounter between the visitor and the heritage site that new meanings may be generated, resisted or challenged, prior meanings may be disrupted, transformed or reinforced, and afterwards revised, revisited or forgotten as visitors take the heritage encounter into their everyday lives.

Writing about museums, Susan Pearce suggests that they are part of the process by which 'we humans understand the world and come to terms with our place in it'; 'It is the crucial act of imagination by which we make sense of our common pasts and presents and project these into the future' (1992: 141). Potentially, heritage sites have the same function but what does this mean in practice? How do our encounters with heritage sites feed into our imagination and help to shape our (common) ideas about the past, present and future? How might our encounters with heritage disrupt and challenge our ideas about the world, as well as support and reinforce them? Is there a role for heritage sites to be more open about this connection between past, present and future, to help audiences imagine a better future? Previously I have explored how 'historical consciousness' can help to understand the way in which young people make sense of the past in museums and historic sites, particularly in relation to history that is far beyond their own life experiences (Jones 2011, 2014). This showed that young people struggled to make sense of the past 'as it was', using their own experiences in the present as a point of comparison but which led to a 'deficit' view of a past that lacked familiar technology and social norms. Developing more complex understandings of how heritage organisations impact on our ideas about the past/present/future, and how these ideas are made manifest and 'meaningful' in everyday life, seems critical if we are to understand the value of heritage sites within contemporary society. There are many potential avenues to explore and this is the beginning of a process of thinking more deeply about the role that 'historical consciousness' has to play in our everyday lives, and how heritage organisations can contribute to 'making sense' (or not) of the world.

Defining heritage

Heritage is a deceptively simple, yet malleable and slippery term that is continually evolving (Harvey 2001; Harrison 2013; Waterton and Watson 2015; Basu and Modest 2015). Heritage can mean many things: a survival from the past, an industry, a process or practice, a symbol, a social phenomenon, a thing of value, at risk or in need of preservation; it can be top-down or grassroots, tangible or intangible, national, international or transnational (Hall 2011; Harrison 2013; Waterton and Watson 2015). Heritage is important because it shows what individuals and groups in the present value from the past (Harvey 2001) and how this can help to imagine our futures (Harrison 2013). Critically, heritage has ethical, moral and political implications because it 'is not given, it is made' (Harvey 2001: 15) and is closely tied to identity, helping to define how people see both themselves and others (Bodo 2012). Over the past 30 years, the focus of heritage study and research has changed from what constitutes heritage to understanding how it is created, consumed and expressed on a global scale (Hall 2011; Waterton and Watson 2015). Harrison suggests that heritage is best seen as an active process 'of assembling a series of objects, places and practices that we choose to hold up as a mirror to the present, associated with a particular set of values that we wish to take with us into the future' (2013: 4). The politics of representation and human rights add another dimension to heritage debates, taking them beyond mere technical or management issues to questions that concern living cultural and natural heritage (Logan *et al.* 2010).

Heritage is used here as a broad term that encompasses 'a set of cultural practices that are concerned with utilising the past for creating cultural meaning for the present' (Smith 2015: 459). This includes tangible remains of the past, museums, memorials, official and unofficial sites, natural and heritage landscapes, intangible traditions and cultural practices, gestures and habits, and ways of thinking and behaviour (Smith *et al.* 2011; Murray 2013; Harrison 2013). Heritage is a contested and loaded term, linked to power and political struggles over what is labelled heritage, whose heritage is valued, and who owns it (Macdonald 2013). The role of heritage in society is therefore ambiguous – it can be a positive force, providing a sense of identity and belonging that promotes social inclusion and empowers marginalised and oppressed communities but it can also be a divisive force contributing to intolerance and conflict (Basu and Modest 2015). Because of the ambiguity of the term, heritage sites are very varied in how they conceive their role in interpreting and representing the past to their audiences. Some heritage sites will see themselves as 'doing history' rather than heritage, taking an objective, even neutral stance that focuses on presenting the past 'as it was'. Some sites take a more political stance, actively using the past to shape the present and the future. Some heritage sites might attempt to 'fossilise' particular ways of thinking and being, for example, in Africa where 'heritage work is an act of consolidation, a means of taming cultural diversity and organising diverse rituals, behaviours, and objects into a regimented routine' (Peterson 2015: 2). What is remembered and what is forgotten may be subject to intense and bitter conflicts, identity emerging from the struggle between the need to recover, but also to suppress, past memories (Murray 2013). Heritage, then, has enormous potential to shape our experience of, and ideas about, the past, present and future, whether this is consciously or subconsciously.

Reconciling history and heritage

'Historical consciousness' is founded on the premise that humans have a fundamental sense of history, the past forming a coherent narrative against which people in the present can make decisions about their future (Zanazanian 2008). History and heritage tend to be seen as very

distinct ways of understanding the past but can the theory of 'historical consciousness' reconcile these two very different approaches? Historians claim that critical distance, which can only come from objectively trying to understand the past as *different* (the focus of empirical history), is fundamental to understanding why change happens, whereas heritage conflates the relationship between past and present, and emphasises *familiarity* (Braudel 1980; Lowenthal 1985; Marwick 2001; Tosh 2008). Heritage focuses on how we understand, think about, talk about and make sense of the past in the present (Harvey 2001), and is more closely associated with 'shared acts of remembering' (Connerton 2009: 67) including living memory and tradition (Nora 1996). Pearce conceptualises the difference between history and heritage as the need for understanding versus the need to feel: 'Heritage is about feeling good in the present, while history is the laborious struggle to come to terms with a past which was serious then and is serious now' (1992: 208). Whilst the ability of historians to avoid contemporary political, social and cultural meanings shaping history has been challenged (White 1973; Southgate 2003; Jenkins 2009), traditional, empirical approaches to history continue to dominate its practice (Moody 2015) whereas heritage is still a relatively new field of study, finding its scope, focus and approach (Waterton and Watson 2015).

The debate over the value of history or heritage for shaping collective ideas about the past, which have the power to shape the present and future, hinges on these notions of familiarity and difference, objectivity and subjectivity, feeling and understanding. The consensus seems to be that empirical history has failed to capture the public's need for a coherent, meaningful narrative that collectively shapes their experience in the present, creating what Huyssen has called a need for 'temporal anchoring' (1995: 7) as well as a 'fundamental crisis in our imagination of alternative futures' (2003: 2). The need for familiarity, for a sense of identity in a changing and uncertain world, has seemingly led to a (re)turn to memory, and a safe, commodified heritage that reflects what we want to be (Macdonald 2013). At the same time, there is, according to Nora, less and less discrimination over what constitutes worth saving from the past, turning everything into 'a "trace," a potential piece of evidence, a taint of history' (1996: 12). If historical memory is what Simon calls a 'constellation of representations' (2003: 34) then the sheer scale of representations that can be made available in the present (particularly since the advent of digital technology) makes it increasingly more difficult to identify meaningful collective understandings of the past;

> The confusion produced by too many memories, and too many people remembering, produces a crisis of memory, expressed as a kind of cacophony of discrepant (and competing) voices laying claim to some 'authentic' reading of the past.
>
> *(Murray 2013: 4)*

This narrative of the 'turn to memory' and heritage can be challenged (Rosenzweig and Thelan 1998; Kean and Ashton 2009), however, at its heart is an important question: what do we, as a society, need in order to make sense of our past, present and future? Are history and heritage as different as is claimed or do we need both? I would argue that, at their root, history and heritage are similar in that both aspire to make sense of the past in the present (Moody 2015) – if heritage is the process of understanding how we make sense of the past in the present, then history could be seen as coming under its broad umbrella. 'Making sense' of the past also seems to be a fundamental human trait – we frame our experiences of the world through explanatory frameworks in which 'people organize and make meaning of their interaction with self, others, and the physical environment' (Polkinghorne 2005: 5). Within our sense-making capacity is a way of conceptualising time into different dimensions, which structures our experience of the world;

'The human mind always mediates ... by working through the experience of change and giving it a meaning by interpretation, which can function as a source and impulse for future perspectives' (Rüsen 2007b: 8). Our sense of change is most commonly connected to our sense of time – the ways in which we make sense of time, of past, present and future – provides us with patterns of significance (narratives, stories, myths) that impose order on an uncertain world (Southgate 2003). This is the basis of the theory of historical consciousness.

History and heritage, therefore, can be reconciled as a similar endeavour to make sense of the past's traces in the present. Both clearly have a role to play within contemporary society, and many historians work with heritage professionals to both create heritage and further our understanding of it (Moody 2015). With that in mind, how can the theory of 'historical consciousness' help to further understand the importance of encounters with heritage and history from the perspective of the (imagined) public?

Historical consciousness: the human experience of change

'Historical consciousness' is a conceptual framework for explaining the complexity of how humans make sense of change over time. As beings *living in time*, we are thought to be inherently 'historically conscious' (Davies 2010: 82), although historians such as Jörn Rüsen have identified different types of historical consciousness where this awareness is more or less developed (Zanazanian 2008). Human beings have demonstrated a remarkable capacity for experiencing time in many diverse ways. For instance, time can be experienced as linear or circular, as a duration or sequence, as a rupture or a standstill, in terms of slowing down or accelerating, as remote or distant (Rüsen 2007b). It can be experienced cognitively, bodily or spatially, through our memories and lived experience, can be shaped by language or cultural practices, in reference to nature, community activity or rituals (Müller 2007). How these experiences of time affect people in the everyday (individually and collectively), how it shapes their actions and ways of thinking, is the concern of 'historical consciousness'.

Critical to the model of historical consciousness is that an individual's innate consciousness is present-orientated but we are conscious of having a distinct and separate 'past as the realm of experiences and future as the realm of projects, projections and predictions' (Rüsen 2007b: 11). This is both a cognitive and a cultural process according to Rüsen, one that assures our species with a sense of longevity (*we are part of history*). The ability to experience time as present, past and future, and the synthesis of our being, values and experiences into a temporal whole (*narrative*) leads to the creation of meaning (*interpretation*): we make decisions about what is important to remember – and what to forget – so that we can progress through life (Rüsen 2005; Zanazanian 2008). 'Historical consciousness' reminds us that we can only ever understand the past in relation to the specific temporal and spatial context in which we inhabit. Our perspective on the past reflects our moral values, forms of reasoning and how we experience the world – it provides a 'stream of knowingness' (Zanazanian 2008: 116) against which to compare the present, 'a mirror of experience within which life in the present is reflected' (Rüsen 2005: 24).

'Historical consciousness' is yet to become a mainstream concept in the UK and is mainly used in relation to academic history (Berger [1997] 2003; Macdonald 2009). In Northern Europe, particularly in Germany, 'historical consciousness' is not only used to describe professional history but an 'everyday' sense of the past, the notion of 'history as life world' [*Geschichte als Lebenswelt*] (Jensen 2009). In particular, German historian Jörn Rüsen's (2005) theory of 'historical consciousness' positions it as a universal process that is familiar to all human societies. Rüsen draws upon 'anthropological universals' of how human beings think about and understand the past to develop a model that suggests the progressive, cognitive development of

historical consciousness from a basic, *innate* or *traditional* type to one of increasing complexity and maturity, the *genetic* type. Although this model is theoretical, Rüsen (2005: 35) contends that there is empirical evidence to support its existence (see Jones 2011 for an extended discussion). It is this potential to bridge both the 'everyday' and professional approaches to history and heritage that suggests Rüsen's theory is, following Macdonald (2013), a useful means to synthesise, and further develop, the idea that our encounters with heritage help us to make sense of the past, present and future – to make sense of our place within time.

Rüsen's theory suggests that there are four primary types of historical consciousness – traditional, exemplary, critical and genetic. Each type is shaped by six elements that can be identified differently across human societies and cultures: content or *experience of time*; patterns of historical significance; a mode of external orientation (*the everyday*); a mode of internal orientation (*historical identity*); relationship to moral values; and relationship to moral reasoning (2005: 28). The basic features of the four types are described briefly here following Rüsen (2004) and Seixas (2005).

The *traditional* type of historical consciousness experiences time as the repetition of a permanent and 'obligatory form of life' (Rüsen 2004: 72). There is no distinction made between past, present and future – the present is effectively continuous, with society experiencing the same social patterns and ways of living over time. Society works towards 'the conservation of sameness over time' (Seixas 2005: 145) and new ideas and ways of thinking are not readily accepted. Moral values, ways of living and ways of being are 'something given' (a priori) – stable ideas that have endured over time.

The *exemplary* type of historical consciousness exploits the past as a source of precedence, timeless rules, examples of conduct and moral values for action and understanding in the present. Historical events only possess significance as a means of comparison with the present, providing a template for ideas about 'temporal change and human conduct' (Rüsen 2004: 73). This type commonly manifests as a linear view of the past that places an emphasis on continuing development or progress (Burke 2001), which is a feature of most history curriculums in the West (Rüsen 2004). This can lead to a *deficit view* of the past where it is viewed (logically) in a negative light because it lacks modern technology, comforts and social norms (Seixas 2005).

The third, *critical* type of 'historical consciousness' rejects conventional and authoritative ways of thinking about the past. It seeks to challenge existing value systems, and disrupt social and cultural norms by identifying counter-narratives, highlighting injustices and attempts to silence or neglect particular peoples and events. Examples include Marxist, feminist, post-colonist and Black histories, which suggest new ways of thinking and being, and new forms of identity that can be projected back into the past as well as taken forward into the future (Rüsen 2004).

Finally, the *genetic* type of historical consciousness understands the relationship between the past, present and future as one of continual change, which opens up the potential for human activity 'to create a new world' (Rüsen 2004: 76). The acceptance and validation of change over time allows many diverse forms of identity and social life to exist, indeed, to stay the same is a greater threat: 'To remain what we are, not to change and evolve, appears to us as a mode of self-loss, a threat to identity. Our identity lies in our ceaseless changing' (Rüsen 2004: 77). This acceptance of change, of *difference*, as a positive notion enables us to be open to ways of living other than our own, to recognise other social realities and historical experiences (Zanazanian 2008).

Rüsen (2005) suggests that these four types are not essentialist and may exist concurrently in various configurations. However, relatively little is known about how the types relate to each other, or the mechanisms or processes which lead to the development from one type to another (Seixas 2005). Application of the theory in history education suggests that the four types can be

identified in how children and young people think about the past (Seixas 1993; Shemilt 2009; Jones 2011). There are also limitations to using Rüsen's model (Billmann-Mahedra and Hausen 2005; Jensen 2009); for instance, despite its claims to be based on 'universal' typologies, the theory is seen as privileging empirical, Western forms of understanding the past (Jensen 2009). Macdonald (2013) also cautions over privileging cognitive ways of engaging with the past over embodied modes, suggesting that an alternative theory of 'past presencing' would allow for the exploration of unconscious and embodied ways of thinking about the past as well as conceptual ones. In response to criticism, Rüsen (2007a) argues that the distancing effect of 'historical consciousness' is essential for understanding the past as something separate from the present and future, this is what creates the special relationship we have with the past. Yet, returning to the use of terms such as history and heritage, might the name 'historical consciousness' also be misleading for what is, really, an orientation in the present?

Other concepts of 'historical consciousness' can be used alongside Rüsen's model. There have been several, large-scale studies carried out in the UK (Merriman 1991), North America (Rosenzweig and Thelan 1998) and Australia (Ashton and Hamilton 2009), in which the authors have developed ways of thinking about how people use and think about the past in their everyday lives. Approaches to 'historical thinking' taken from academic history can also be used as a comparison. For example, Burke (2001) identifies a list of characteristics that seem distinctive to Western ways of thinking about the past, including a *linear view of time*, in which change is accumulative and irreversible; a sense of *distinctiveness* that makes the past very different from the present; an interest in *collective agency*; the importance of *causes* in understanding change; and the need for *objectivity*. The extent to which these characteristics are specific to Western thinking has been questioned (Iggers 2001) but it would be interesting to explore how far these ways of thinking about the past exist in the everyday.

Rüsen's model, then, is not without its issues and challenges. However, as a means of drawing together the cognitive and cultural ways in which we conceptualise the past and future from our perspective in the present, it is a useful starting point for thinking about how this might shape and influence encounters with heritage sites. What broader evidence exists to demonstrate the extent to which encounters with heritage can help to form or shape our ideas about the past, present and future?

How do heritage sites frame 'historical consciousness'?

Returning to the role that the theory of 'historical consciousness' might play in understanding how visitors encounter heritage sites and incorporate their experiences into their everyday understandings of past, present and future, I will begin by exploring how the theory can help us to understand how heritage sites themselves represent and interpret the past. For as part of the heritage encounter, visitors may come across narratives of the past that potentially reflect, or challenge, their own. In *Difficult Heritage: Negotiating the Nazi Past in Nuremberg and Beyond* (2009), Sharon Macdonald highlights the importance of seeking to understand the role of a heritage site from multiple perspectives, using a combination of approaches to 'see how different players, practices and knowledges – local and from further afield – interact and are brought into being, to shape the ways in which the city's past is variously approached and ignored' (2009: 1–2). Only by understanding the political, social, and cultural values and meanings attached to the past by those who develop and run heritage sites, can we fully understand visitor responses.

Heritage sites reflect particular values, ways of thinking, ideologies and practices which shape how the past is put on display (Pearce 1992; Knell 2007). The past does not speak for itself but it is given meaning (Shanks 1992: 138) through a 'human act of authorship' (Knell 2007: 7).

Heritage sites may draw on a wide range of evidence to interpret the past, including historical texts, material remains, oral testimony, folk memory, as well as using a range of modern technologies to make their sites appealing to visitors. The relationship between heritage sites, and how they understand their social role and purpose, will be shaped by different missions, values and aims, and levels of transparency about those elements. For example, some heritage sites have been criticised for presenting versions of the past which rely too much on a strictly defined 'authenticity' that close down the ability of visitors to imagine alternative pasts (Handler and Gable 1997; Gregory and Witcomb 2007). How heritage sites might reflect the different types of 'historical consciousness', and the implications this may have for their interpretation of the past, is explored briefly here.

The *traditional* type of heritage in the UK – the 'authorised heritage discourse' developed by Laurajane Smith (2006) – signifies heritage as 'materialistic, monumental, grand', as representing 'nation', and, above all, 'good' (Smith 2010: 195). It has a close relationship with Mark O'Neill's (2006) *essentialist* model of the museum, which privileges collection, research and preservation, is didactic, and relies on the aura of objective knowledge to give it authority. Wright's claim that heritage sites and museums fossilise the past seems most relevant to the *traditional* type: 'history becomes timeless when it has been frozen solid, closed down and limited to what can be exhibited as a fully accomplished "historical past" which demands only appreciation and protection' (1985: 78). Gregory and Witcomb's description of the historic house museum reflects the tendency of this type of heritage site to create 'mute, static pictures of the past, which do not affectively speak in the present' (2007: 265). The *exemplary* heritage site, on the other hand, does attempt to make connections between the past remains on display and the lives of the audiences that visit. These sites seek to make the past relevant not through 'the objects and sites themselves so much as what they say of us, of national or local identity, what they symbolise or evoke' (Shanks 1992: 106). Such sites may use emotion to engage their audiences (Watson 2010) or make connections with local communities to use the past as a source of (moral) guidance in the present. One example is Beamish, The Living Museum of the North, that, according to Bennett, encourages visitors to identify with the working classes of the North East, to learn from the example of 'a people sufficiently tenacious, inventive, and, above all, canny enough to exploit its natural advantages' (1988: 65).

Heritage sites of the *traditional* and *exemplary* type are common but there are a growing number of heritage sites that aim to support visitors in developing a critical engagement with the past and present, which reflect a combination of the *critical* and *genetic* forms of 'historical consciousness'. For example, the members of the International Coalition of Sites of Conscience – a 'global network of historic sites, museums and memory initiatives connecting past struggles to today's movements for human rights and social justice' (Sites of Conscience 2015) – actively pursue a social agenda that seeks to use the past to improve the present and the future. These sites not only seek to address past wrongs and challenge deeply engrained ways of thinking but to 'promote cross-cultural understanding ... [*and*] foster respect for difference' (Sandell 2007: 2). As one of the founders of Sites of Conscience wrote in 2002, the importance of these sites is 'not because of the stories they tell but rather because implicit in these stories are lessons so powerful that they, if fully understood, could improve our lives' (Abram 2002: 141). In Norway, the Stiftelsen Arkivet, a former Gestapo headquarters during the Second World War, acts as a centre for historical reflection and peace-building, explicitly promoting values such as 'human rights, human dignity and democracy' to its visitors (Rosendahl and Ruhaven 2014: 71). In Cape Town, South Africa, the District Six Museum is a living heritage site which aims to keep alive the memories and histories of the community of District Six (a former inner-city residential area that was declared for 'whites only' in the 1960s) and to 'promote social justice by mobilizing

memory in the interests of contemporary communities' (Murray 2013: 126). Temporary exhibitions may also challenge and disrupt 'authorised' narratives, such as the Bicentenary of the Abolition of the Slave Trade in 2007 which led to an exhibition at Harewood House exploring its connections with slavery, unusual for a historic house museum (Smith 2010). Finding a model for a heritage site that supports the *genetic* type of historical consciousness is more challenging. Rather than learning from the past or desiring to make it relevant for the present, the *genetic* type seeks to understand the past as a process, where change is an inevitable part of the historical landscape, as are multiple voices and perspectives. The aim, described by Collingwood, is 'to imagine the past: not as an object of possible perception, since it does not now exist, but able through this activity to become an object of our thought' ([1946] 1993: 242). An example of a historic site which seems to encourage visitors to make the past an 'object of their thought', is Greenough, an abandoned town in Western Australia. Notable for its 'emptiness and relative isolation' (Gregory and Witcomb 2007: 269), the interpretive methods invite visitors to consider what is not there – the absences and silences in the historical record – and to use their historical imagination to make sense of the space. The initial sense of 'alienation and disorientation' created by the space is, accordingly, 'transformed in the act of interpretation by the visitor into an active critical reading of the past' (Gregory and Witcomb 2007: 269).

Here are some examples, then, of how the way in which heritage sites mobilise and interpret the past can be connected to the four types of historical consciousness. Some, such as the Sites of Conscience, are very explicit about their social role and purpose, others are less transparent. How far these different types reflect the historical understanding of their audiences is the subject of intense debate. For instance, Smith (2010) explores the attempts of many White British visitors to heritage sites in 2007 commemorating the Abolition of the Slave Trade to disengage with the issue, using an 'array of discursive and emotional strategies to avoid the issues raised by the bicentenary and the exhibitions they were visiting' (2010: 193). If the purpose of these exhibitions was to confront visitors with the reality of the past, could this apparent inability to 'change minds' be seen as a failure?

Heritage encounters: the audience's perspective

How visitors encounter, read and respond to the narratives, ideas and concepts carried by heritage sites, and incorporate these (or not) into their lives, is revealed through research. However, we must be sensitive to the way in which research is itself underpinned by assumptions about human behaviour and action. For instance much of the concern over the commodification of heritage betrays a perception of the public as 'passive receptacles for ideological messages' (Merriman 1991: 26) or, even worse, 'unthinking dupes' (Graham *et al.* 2005: 33), which makes it possible to imagine that the public is 'credulous [*towards the*] omissions and fabrications central to heritage reconstructions' (Lowenthal 1998: 249). This can be contrasted with more positive portrayals of visitors as active meaning-makers with frameworks of understanding already in place that are continually (re)shaped, reinforced or transformed in response to heritage encounters (Hein 1998; Hooper-Greenhill 2007). More complex notions of visitor engagement recognise that encounters are not purely cognitive but can be embodied and performative, engaging the emotions as visitors invest in 'certain understandings of the past and what they mean for contemporary identity and sense of place' (Smith 2015: 460). How visitors incorporate their heritage encounters into their everyday lives, however, is not well understood as most research takes place at the point of encounter. It may not also be considered by researchers that visiting a heritage site is out of the ordinary and visitors may act, think or respond differently, particularly as heritage sites provide opportunities to escape from the everyday (Hall 2011).

One of the challenges of disentangling the impact of heritage encounters on audiences is identifying *who* decides what the impact should be. Are heritage sites meant to reinforce our ideas about the past, identity and belonging or challenge and disrupt these notions? The trust that the public place in heritage sites and museums as places to learn about the past (Walsh 1992; Crane 1997; Merriman 1999; Fulbrook 2002; Cameron 2007) puts an important responsibility on heritage sites to represent the past accurately but also to provide meaningful learning experiences. The matter of what, and how, audiences should learn about the past is hotly debated in the public sphere, and often betrays a narrow perception over what learning is, mainly the assimilation of 'correct' facts and information (Wertsch 2000). Laurajane Smith's (2015) research into audience reactions to a series of exhibitions in 2007 to commemorate the Abolition of the Slave Trade encapsulates some of these debates. Smith suggests that rather than showing evidence of learning, visitor responses to the exhibitions revealed the 'enacting of a performance that provides institutional and structured reinforcement of a visitor's sense of self, their ideological positions, and the cultural values that underpin both of these' (2015: 465). In particular, many White British respondents (58 per cent of the sample) were identified as trying to insulate or distance themselves from negative emotions and reflections on identity that were engendered by the exhibition, which, according to Smith, negated or prevented any deep engagement with the content of the exhibition. 'Discursive strategies', such as the use of common platitudes and clichés, were used rather than empathy and imagination in order to explain their response to the experience of slavery.[1] Those who were deeply engaged in the exhibition, however, did use empathy and imagination to 'alter their understandings of the past or present' (Smith 2015: 468) even if they were challenged by the content. What Smith seems to be suggesting here is that some visitors were much better at self-reflection and emotional awareness than others; they were able to confront the difficult emotions that the exhibitions engendered, to work through these emotions *during the visit* and use them to establish an empathetic or imaginative connection with the experience of slaves in the past. As Smith rightly suggests, even if the term learning is used by visitors, it does not 'mean that learning was being done' (2015: 470), but who decides how and when learning has taken place? The visitor, the heritage professional or the researcher? And must learning always be transformational? Smith raises some very interesting issues, in particular, that the visitors' performances and the meanings that are created have 'political and cultural consequences that tend to be obscured in debates about learning' (2015: 479).

Heritage sites can be read by visitors in ways that are not anticipated by professionals or researchers (Kavanagh 1996; Macdonald 2009) and we must be careful not to fall into the trap of the 'good enough visitor' (O'Neill 2002), not to disregard what visitors think because it does not fit with what professionals think they should have learnt or experienced. Waterton and Watson (2015) suggest that we are at an exciting time of 'imaginative encounters' between researchers and audiences at heritage sites, with researchers looking to a range of creative, mainly qualitative, techniques in order to capture visitor voices and experiences more effectively. 'Historical consciousness' could be one way of shaping these imaginative encounters but what do we already know about how heritage encounters shape visitor perceptions of the past, present and future?

A connection with the past through heritage encounters

The idea that heritage sites are vital for educating the public about the past has become deeply engrained in public consciousness (Dodd *et al.* 2012; Hader 2014). Heritage sites are valued for their ability to 'bring the past to life', making it more vivid, immediate and exciting (Fairley 1977; Stone 2004; Trewinnard-Boyle and Tabassi 2007), particularly for children and young

people (Pluckrose 1991; Jackson and Kidd 2011). The best heritage sites can create a sense of connection to a 'real' past that was lived in by 'real' people (Candler 1976; Shanks and Tilley 1987; Hodder and Hutson 2003; Jones 2011). In a US study, for example, respondents that came into contact with the material remains of the past felt that 'they were experiencing a moment from the past almost as it had originally been experienced' (Rosenzweig and Thelan 1998: 106). Research with visitors to the Tower of London revealed that some valued the site as a 'time machine' that allowed them to experience a direct connection with the past. As Zach (not her real name) described: 'I touched the fireplace just with my hand ... I thought my good-ness, the people that stood here' (MacLeod *et al.* 2014: 24). This aura or charisma associated with handling or touching the remains of the past is well documented (Fairley 1977; Jackson and Kidd 2011). Given the opportunity to handle objects that included an Egyptian amulet over 3,000 years old, young people from Leicester Children's Hospital School described how 'awe-inspiring' it was to be able to make a connection with people in the past and to work out the significance these objects held for people who were long gone. Daniel (not his real name) was amazed that he was allowed to touch the 'precious objects, knowing that not many people will have handled these' (Dodd and Jones 2014: 29).

Does the idea that heritage sites offer a direct, unmediated connection with the past show that the public misunderstand the role that heritage professionals play in interpreting and repre-senting the past (Ashton and Hamilton 2009)? Heritage sites of the *traditional* and *exemplary* type have been accused of creating superficial, even trivial, representations of the past, where visitor understanding is 'closed down and limited to ... appreciation and protection' (Wright 1985: 78). It may be that heritage sites that reflect a *critical* or *genetic* type of historical consciousness can help visitors to reflect critically on what they encounter or to use their imagination in recon-structing the past, as Gregory and Witcomb (2007) suggest is the case at Greenough. Witcomb calls for a form of 'historical consciousness' at heritage sites that enables visitors to explore the implications of the past and its remains in the present, a way of understanding history that 'reads against the grain, that looks for gaps in the historical record and is an [*sic*] alert to complexities, tensions, and occlusions' (2013: 256).

Heritage encounters: reinforcing or transforming our perceptions of the present?

The theory of 'historical consciousness' helps to reinforce the importance of the past for shaping our sense of identity and belonging in the present, but also for forming the narratives by which we live our lives in the present. Heritage sites therefore have the potential to reinforce, even transform, our perceptions of the present. *Traditional* and *exemplary* forms of historical con-sciousness are seen as problematic in that these tend to validate elite forms of heritage based on class, nation and birth-right, which are considered to be less appropriate in our globalised and multicultural societies, potentially coming into conflict with the need for intercultural dialogue and understanding (Bodo 2012; Harrison 2013). How visitors use encounters at heritage sites to develop their sense of self and ideas about the world continues, therefore, to be a critical area of research. Research carried out with visitors to national museums in Europe (Dodd *et al.* 2012) showed that historical narratives providing a sense of origins and continuity with the past were important to shaping identity in the present. Many visitors had internalised the importance of using the past to inform the present (the *exemplary* type), including Nektaria (not her real name), a young visitor to the National History Museum in Athens who reflected on the importance of the past as a 'mirror' at a time when Greece was gripped by a difficult political and social climate:

[I]f one looks at their history he will see some mistakes of the past and so won't repeat them. He will see the weaknesses of those people and won't do the same thing. He will try to improve oneself. Not just for himself, as a human being, but for the whole community, his country.

(Dodd et al. 2012: 140)

Three large-scale studies conducted in the UK (Merriman 1991), US (Rosenzweig and Thelan 1998) and Australia (Ashton and Hamilton 2009) reveal that the past is an integral part of everyday life for many people in the West *because* it helps them to understand their life in the present. Age, gender, social class and ethnicity play a role in determining what people are interested in and how active they are in exploring the past, but for many people the past is a source of information, curiosity and guidance. Engaging with the past was a serious pursuit, with people employing a range of skills (including interrogation, cross-examination, analysis and empathy) to shape their own meanings in response to questions about their lives and the world around them. However, whilst some communities or groups were sceptical about official narratives, justifiably in the case of exclusion or misrepresentation, this did not prevent them from using official narratives to develop their own ideas about the past (Rosenzweig and Thelan 1998). Together these three studies reveal that people are equally as interested as historians in understanding what happened in the past but their discoveries are aimed at very different ends. These are personal, directed at developing their own sense of history rather than for society as a whole.

Engaging visitors with difficult, challenging and hidden histories can have an impact on their perceptions of the present, although as Smith's (2015) research shows, visitors might also disengage from the idea that their perceptions *need* to change. Using museum collections to challenge prejudice and discrimination against disabled people is the focus of a series of research projects carried out by the Research Centre for Museums and Galleries (RCMG), based in the School of Museum Studies at the University of Leicester, from 2003 to the present. In *Rethinking Disability Representation in Museums and Galleries* (2006–2008), RCMG worked with nine UK museums to develop a series of interventions that would 'engage audiences in rethinking attitudes towards disability and open up possibilities for engaging with contemporary, disability-related issues and debates' (Dodd *et al.* 2008: 10). Evidence from audience research suggested that the use of the 'social model' of disability (which focuses on the barriers that society creates for disabled people) to frame collections was a powerful way for people to understand the challenges that disabled people experience in the present. This example of a visitor comment from Tyne and Wear Museums' exhibition *One in Four* – which used objects from the museum's collections dating from the 1800s to the present day to explore attitudes towards, and experiences of, disabled people – reflected the thoughts of many when they wrote that it, 'reminds you how far society has come – but also still to go – and that it is society that causes disability i.e. not adapting to individuals' (Dodd *et al.* 2008: 155). In 2012–2014, a live performance created in collaboration by RCMG, artist Mat Fraser and four medical museums, *Cabinet of Curiosities: How Disability was Kept in a Box*, led to positive responses from audiences about the use of historical collections in projects aimed at transforming the present. As one participant said, 'It gives the collections more meaning and allows them to be used to make a change in society' (Fitton and Cowley 2013: 21).

A rich picture emerges, therefore, of how heritage sites can provoke reflection on our sense of identity and belonging in the present, as well as reinforcing, and even transforming, our perceptions of how the world works (although it is not a given that heritage interpretations will always have an impact on visitors, who might disengage from, or avoid, challenges to their ways of thinking). What is less well known is how heritage sites influence visitors' ideas about the future.

Heritage encounters shaping ideas about the future

Using the past to imagine new, and alternative, futures has mostly been discredited, following the collapse of Communism and the 'end of history' (Fukuyama 1989; Torpey 2004). However, how far do these views reflect the reality of everyday life? Does the past have a role to play in shaping ideas about the future? Currently there is very little focus in research on how heritage sites might help to shape their audiences' ideas about the future. Sites of challenging or difficult heritage appear to promote feelings of the need for a better future, as Chia-Li Chen's (2012) exploration of visitor comment books at the Hiroshima Peace Memorial Museum demonstrates. Opening in 1955 to document and preserve the history of the atomic bomb that was detonated above central Hiroshima on 6 August 1945, since 1970 the Museum has maintained a series of visitor comment books. Analysing a selection of comments published by the Museum, Chen has identified a number of themes including visitor reflections on the future. Common visitor responses included the wish for world peace, the desire to live in peace and harmony, and an end to all wars, including this comment from a high school student in 1973; 'I pray for peace. We don't know what war is like. I hope all children in the future will not know a war' (Chen 2012: 385). The need to avoid similar atrocities in the future was another common response and many visitors recognised that the museum had an important role to play in promoting peace, as one US visitor wrote,

> I hope that this Memorial Museum will serve as a warning to future generations not to repeat the mistakes of the past. World peace through education seems to be an effective way to create a new generation that would make peace permanent.
>
> *(Chen 2012: 389)*

This reference to not repeating the mistakes of the past was also used by visitors to national museums in Europe in reference to the present (Dodd *et al.* 2012).

Conclusion: the value of 'historical consciousness' for understanding heritage encounters

There is evidence to show that heritage sites can help to shape visitor perceptions about the present and future, as well as the past. However, there are still many questions about how this happens, when and in what context. Do visitors to heritage sites mostly see the flow of time as linear and inevitable, heading towards a particular outcome in the present and future based on what has happened in the past? Or do they have a much more flexible and dynamic sense of time, with the possibility of many alternative futures depending on the choices that humans make in the present? How do heritage sites support these fundamental ideas about the nature of time and change – are these issues questioned and examined by heritage professionals or are these largely unconscious and taken for granted?

'Historical consciousness' has been presented as a useful framework for understanding how we, as humans, make sense of temporal and spatial change, and how a 'stream of knowingness' that connects past, present and future together, helps to shape our sense of identity and define who we are. Critically, it helps to bridge the gap between history and heritage, to understand both as a way of making sense of the past in the present. By blurring the distinction between the two, it helps to overcome some of the criticisms of heritage, placing it alongside history as part of a spectrum of approaches to dealing with the traces of the past in the present, whether this is on an individual, collective or professional level. All are part of the same impulse, to make sense

of the present in relation to a vanishing past and to an unknown future, the essence of 'historical consciousness' (Rüsen 2004). Being aware of the wider framework of ideas, values and ways of thinking that visitors bring with them to heritage sites would also help (potentially) to challenge the spectre of the 'good enough visitor' (O'Neill 2002), to understand the complex interplay between visitors' prior ideas, knowledge, values and what is presented by the heritage site – and how those might continue to shape visitors' ideas over the course of their life. How can we draw out the unconscious, as well as the conscious, ways in which people think about and attach meanings to, the past, present and future? Qualitative and ethnographic methods of research that allow audience voices to take centre stage will take this forward (Macdonald 2013; Witcomb 2013), getting away from what Watson and Watson describe as 'methodological oppression' and the need to demonstrate audiences knowing the 'right thing' about the past and moving towards a 'more textured concern with description and classification' (2015: 24).

In an increasingly global and multicultural society, where people are potentially coming into contact with people from groups and cultures very different from their own, the need to be aware of, and open to, different experiences of time and space, of different types of 'historical consciousness', becomes more urgent. The *traditional* and *exemplary* types of historical consciousness have come to seem less useful because they emphasise continuity and inevitability over change, encouraging (perhaps) very fixed and stable notions of historical identity that make it difficult to accept the existence of 'others', of difference? Whereas, the *critical* and *genetic* types rupture any sense of continuity, looking for gaps, for differences, for evidence that 'we' (whoever 'we' are) are not the only possible (or desirable) outcome and we exist alongside many other permutations of being. Dealing with multiple voices from the past is part of the heritage professional's work, especially those working in areas of conflict and contradiction, and yet there is an assumption that there is only one 'truthful' narrative that can be told about the past and the attempt to see from different perspectives leads to false or misleading history. As Sandell (2007) and Golding (2009) suggest in the context of museums, the need for intercultural dialogue and understanding in society calls for the need for heritage sites to enable more critical, dialogic and ultimately more meaningful encounters with difference, enabling visitors to explore their histories and traditions against the past, but also to be open to new interpretations and understandings, to new possibilities for how things might be in the future.

Note

1 However, this might be a common strategy in visitor interviews; research carried out at national museums in Europe revealed that visitors often drew on clichés to explain their meaning, see Dodd *et al.* (2012).

Bibliography

Abram, R. J. 2002. 'Harnessing the power of history', in Sandell, R. (ed.) *Museums, Society, Inequality*, Routledge, London and New York, pp. 125–141.

Ashton, P. and Hamilton, P. 2009. 'Connecting with history: Australians and their pasts', in Ashton, P. and Kean, H. (eds) *People and Their Pasts: Public History Today*, Palgrave Macmillan, Basingstoke, pp. 23–41.

Basu, P. and Modest, W. 2015. 'Museums, heritage and international development: a critical conversation', in Basu, P. and Modest, W. (eds) *Museums, Heritage and International Development*, Routledge, New York and London, pp. 1–32.

Bennett, T. 1988. 'Museums and "the People"', in Lumley, R. (ed.) *The Museum Time Machine: Putting Cultures on Display*, Comedia, Routledge, London and New York, pp. 63–85.

Berger, S. [1997] 2003. *The Search for Normality: National Identity and Historical Consciousness in Germany since 1800*, Berghahn Books, New York and Oxford.

Billmann-Mahedra, E. and Hausen, M. 2005. 'Empirical psychological approaches to the historical consciousness of children', in Straub, J. (ed.) *Narration, Identity, and Historical Consciousness*, Berghahn Books, New York and Oxford, pp. 163–186.

Bodo, S. 2012. 'Museums as intercultural spaces', in Sandell, R. and Nightingale, E. (eds) *Museums, Inequality and Social Justice*, Routledge, London and New York, pp. 181–191.

Braudel, F. 1980. *On History*, translated by Matthews, S., The University of Chicago Press, Chicago and London.

Burke, P. 2001. 'Western historical thinking in a global perspective – 10 theses', in Rüsen, J. (ed.) *Western Historical Thinking: An Intercultural Debate*, Berghahn Books, New York and Oxford, pp. 15–30.

Cameron, F. 2007. 'Moral lessons and reforming agendas: history museums, science museums, contentious topics and contemporary societies', in Knell, S. J., Macleod, S. and Watson, S. (eds) *Museum Revolutions: How Museums Change and are Changed*, Routledge, London and New York, pp. 330–342.

Candler, G. M. 1976. 'Museums in education: the changing role of education services in British museums', *The History Teacher*, 9 (2): 183–195.

Chen, C. 2012. 'Representing and interpreting traumatic history: a study of visitor comment books at the Hiroshima Peace Memorial Museum', *Museum Management and Curatorship*, 27 (4): 375–392.

Collingwood, R. G. [1946] 1993. *The Idea of History: Revised Edition with Lectures 1926–1928*, Oxford University Press, Oxford.

Connerton, P. 2009. *How Modernity Forgets*, Cambridge University Press, Cambridge.

Crane, S. A. 1997. 'Memory, distortion, and history in the museum', *History and Theory*, 36 (4): 44–63.

Davies, M. L. 2010. *Imprisoned by History: Aspects of Historicized Life*, Routledge, New York and London.

Dodd, J. and Jones, C. 2014. *Mind, Body, Spirit: How Museums Impact Health and Wellbeing*, Leicester, RCMG.

Dodd, J., Sandell, R., Jolly, D. and Jones, C. (eds) 2008. *Rethinking Disability Representation in Museums and Galleries*, Leicester, RCMG.

Dodd, J., Jones, C., Sawyer, A. and Tseliou, M. 2012. 'Voices from the museum: qualitative research conducted in Europe's national museums', EuNaMus report No. 6, Linköping University, Sweden.

Fairley, J. 1977. *History Teaching Through Museums*, Longman, London.

Fitton, L. and Cowley, D. 2013. 'Cabinet of curiosities: how disability was kept in a box, how did this event change the way people think about disability?' Internal Research report commissioned by RCMG, Leicester from The Audience Agency.

Fukuyama, F. 1989. 'The end of history?' in *The National Interest*, National Affairs, Washington, DC, pp. 3–18.

Fulbrook, M. 2002. *Historical Theory*, Routledge, London and New York.

Golding, V. 2009. *Learning at the Museum Frontiers: Identity, Race and Power*, Ashgate, Farnham and Burlington, VT.

Graham, B., Ashworth, G. J. and Tunbridge, J. E. 2005. 'The uses and abuses of heritage', in Corsane, G. (ed.) *Heritage, Museums and Galleries: An Introductory Reader*, Routledge, London and New York, pp. 26–37.

Gregory, K. and Witcomb, A. 2007. 'Beyond nostalgia: the role of affect in generating historical understanding at heritage sites', in Knell, S. J., Macleod, S. and Watson, S. (eds) *Museum Revolutions: How Museums Change and are Changed*, Routledge, London and New York, pp. 263–275.

Hader, B. K. 2014. 'Concepts of remembrance and commemoration', in Fromm, A. B., Golding, V. and Rekdal, P. B. (eds) *Museums and Truth*, Cambridge Scholars, Newcastle Upon Tyne, pp. 31–50.

Hall, M. 2011. 'Introduction: towards world heritage', in Hall, M. (ed.) *Towards World Heritage: International Origins of the Preservation Movement 1870–1930*, Ashgate, Farnham and Burlington, pp. 1–19.

Handler, R. and Gable, E. 1997. *The New History in an Old Museum: Creating the Past at Colonial Williamsburg*, Duke University Press, Durham and London.

Harrison, R. 2013. *Heritage: Critical Approaches*, Routledge, Abingdon and New York.

Harvey, K. 2001. 'Introduction: practical matters', in Harvey, K. (ed.) *History and Material Culture: A Student's Guide to Approaching Alternative Sources*, Routledge, London and New York, pp. 1–23.

Hein, G. E. 1998. *Learning in the Museum*, Routledge, London and New York.

Hewison, R. 1987. *The Heritage Industry: Britain in a Climate of Decline*, Methuen, London.

Hobsbawm, E. 1994. *The Age of Extremes: The Short Twentieth Century 1914–1991*, Abacus, London.

Hodder, I. and Hutson, S. 2003. *Reading the Past: Current Approaches to Interpretation in Archaeology*, third edition, Cambridge University Press, Cambridge.

Hooper-Greenhill, E. 2007. *Museums and Education: Purpose, Pedagogy, Performance*, Routledge, London and New York.

Huyssen, A. 1995. *Twilight Memories: Marking Time in a Culture of Amnesia*, Routledge, London and New York.

Huyssen, A. 2003. *Present Pasts: Urban Palimpsests and the Politics of Memory*, Stanford University Press, Stanford, California.

Iggers, G. G. 2001. 'What is uniquely Western about the historiography of the West in contrast to that of China?', in Rüsen, J. (ed.) *Western Historical Thinking: An Intercultural Debate*, Berghahn Books, New York and Oxford, pp. 101–110.

Jackson, A. and Kidd, J. 2011. 'Introduction', in Jackson, A. and Kidd, J. (eds) *Performing Heritage: Research Practice and Innovation in Museum Theatre and Live Interpretation*, Manchester University Press, Manchester and New York, pp. 1–8.

Jenkins, K., 2009. *At the Limits of History: Essays on Theory and Practice*, Routledge, London and New York.

Jensen, B. E. 2009. 'Useable pasts: comparing approaches to popular and public history', in Ashton, P. and Kean, H. (eds) *People and Their Pasts: Public History Today*, Palgrave Macmillan, Houndsmill, pp. 42–56.

Jones, C. 2011. 'An illusion that makes the past seem real: the potential of living history for developing the historical consciousness of young people', PhD thesis, Leicester Research Archive, University of Leicester, https://lra.le.ac.uk/handle/2381/10927 (retrieved 15 July 2015).

Jones, C. 2014. 'Frames of meaning: young people, historical consciousness and challenging history at museums and historic sites', in Kidd, J., Cairns, S., Drago, A., Ryall, A. and Stearn, M. (eds) *Challenging History in the Museum: International Perspectives*, Ashgate, Farnham and Burlington, pp. 223–234.

Kavanagh, G. 1996. 'Making histories, making memories', in Kavanagh, G. (ed.) *Making Histories in Museums*, Leicester University Press, London and New York, pp. 1–14.

Kean, H. and Ashton, P. 2009. 'Introduction: people and their pasts and public history today', in Kean, H. and Ashton, P. (eds) *People and their Pasts: Public History Today*, Palgrave Macmillan, Houndsmill, pp. 1–20.

Knell, S. J. 2007. 'Museums, reality and the material world', in Knell, S. J. (ed.) *Museums in the Material World*, Routledge, London and New York, pp. 1–26.

Logan, W., Langfield, M. and Craith, M. N. 2010. 'Intersecting concepts and practices', in Langfield, M., Logan, W. and Craith, M. N. (eds) *Cultural Diversity, Heritage and Human Rights: Intersections in Theory and Practice*, Routledge, London and New York, pp. 3–20.

Lowenthal, D. 1985. *The Past is a Foreign Country*, Cambridge University Press, Cambridge.

Lowenthal, D. 1998. *The Heritage Crusade and the Spoils of History*, Cambridge University Press, Cambridge.

Macdonald, S. 2009. *Difficult Heritage: Negotiating the Nazi Past in Nuremberg and Beyond*, Routledge, London and New York.

Macdonald, S. 2013. *Memorylands: Heritage and Identity in Europe Today*, Routledge, London and New York.

MacLeod, S., Sandell, R., Dodd, J., Duncan, T., Jones, C. and Gaffikin, A. 2014. *Prisoners, Punishment and Torture: Developing New Approaches to Interpretation at the Tower of London*, RCMG, University of Leicester, Leicester, www2.le.ac.uk/departments/museumstudies/rcmg/publications/prisoners-punishment-and-torture (retrieved 15 July 2015).

Marwick, A. 2001. *The New Nature of History: Knowledge, Evidence, Language*, Palgrave, Houndsmill.

Merriman, N. 1991. *Beyond the Glass Case: The Past, the Heritage and the Public*, Leicester University Press, Leicester, London and New York.

Moody, J. 2015. 'Heritage and history', in Waterton, E. and Watson, S. (eds) *The Palgrave Handbook of Contemporary Heritage Research*, Palgrave Macmillan, Houndsmill and New York, pp. 113–129.

Müller, K. E. 2007. 'Concepts of time in traditional cultures', in Rüsen, J. (ed.) *Time and History: The Variety of Cultures*, Berghahn Books, New York and Oxford, pp. 19–34.

Murray, M. J. 2013. *Commemorating and Forgetting: Challenges for the New South Africa*, University of Minnesota Press, Minneapolis.

Nora, P. 1996. 'General introduction: between memory and history', in Nora, P. (ed.) *Realms of Memory: Rethinking the French Past, Volume 1: Conflicts and Divisions*, translated by Goldhammer, A., Columbia University Press, New York and Chichester, pp. 1–20.

O'Neill, M. 2002. 'The good enough visitor', in Sandell, R. (ed.) *Museums, Society, Inequality*, Routledge, London and New York, pp. 24–40.

O'Neill, M. 2006. 'Essentialism, adaptation and justice: towards a new epistemology of museums', *Museum Management and Curatorship*, 21: 95–116.

Pearce, S. M. 1992. *Museums, Objects and Collections: A Cultural Study*, Leicester University Press, London and New York.

Peterson, D. R. 2015. 'Introduction: heritage management in colonial and contemporary Africa', in Peterson, D. K., Gavua, K. and Rassool, C. (eds) *The Politics of Heritage in Africa: Economies, Histories and Infrastructures*, International African Institute, Cambridge University Press, London and New York, pp. 1–36.

Pluckrose, H. 1991. *Children Learning History*, Blackwell, Oxford.

Polkinghorne, D. E. 2005. 'Narrative psychology and historical consciousness: relationships and perspectives', in Straub, J. (ed.) *Narration, Identity and Historical Consciousness*, Berghahn Books, New York and Oxford, pp. 3–22.

Rosendahl, B. T. and Ruhaven, I. 2014. 'The Stiftelsen Arkivet experience: a Second World War Gestapo Regional Headquarters in Norway', in Kidd, J., Cairns, S., Drago, A., Ryall, A. and Stearn, M. (eds) *Challenging History in the Museum: International Perspectives*, Ashgate, Farnham and Burlington, pp. 71–79.

Rosenzweig, R. and Thelan, D. 1998. *The Presence of the Past: Popular Uses of History in American Life*, Columbia University Press, New York.

Rüsen, J. 2004. 'Historical consciousness: narrative structure, moral function and ontogenetic development', in Seixas, P. (ed.) *Theorizing Historical Consciousness*, University of Toronto Press, Toronto, Buffalo and London, pp. 3–85.

Rüsen, J. 2005. *History: Narration – Interpretation – Orientation*, Berghahn Books, New York and Oxford.

Rüsen, J. 2007a. 'Memory, history and the quest for the future', in Cajani, L. and Ross, A. (eds) *History Teaching, Identities, Citizenship*, Trentham Books, Stoke-on-Trent and Sterling, pp. 13–34.

Rüsen, J. 2007b. 'Making sense of time: toward a universal typology of conceptual foundations of historical consciousness', in Rüsen, J. (ed.) *Time and History: The Variety of Cultures*, Berghahn Books, New York and Oxford, pp. 7–18.

Sandell, R. 2007. *Museums, Prejudice and the Reframing of Difference*, Routledge, London and New York.

Seixas, P. 1993. 'Historical understanding among adolescents in a multicultural setting', *Curriculum Inquiry*, 23 (3): 301–327.

Seixas, P. 2005. 'Historical consciousness: the progress of knowledge in a postprogressive age', in Straub, J. (ed.) *Narration, Identity and Historical Consciousness*, Berghahn Books, New York and Oxford, pp. 141–159.

Shanks, M. 1992. *Experiencing the Past: On the Character of Archaeology*, Routledge, London and New York.

Shanks, M. and Tilley, C. 1987. *Social Theory and Archaeology*, Polity Press, Cambridge.

Shemilt, D. 2009. 'Drinking an ocean and pissing a cupful: how adolescents make sense of history', in Symcox, L. and Wilschut, A. (eds) *National History Standards: The Problem of Canon and the Future of History Teaching*, Information Age Publishing, Charlotte, pp. 141–209.

Sites of Conscience www.sitesofconscience.org/ (retrieved 16 July 2015).

Smith, L. 2006. *Uses of Heritage*, Routledge, London and New York.

Smith, L. 2010. '"Man's inhumanity to man" and other platitudes of avoidance and misrecognition: an analysis of visitor responses to exhibitions marking the 1807 bicentenary', *Museum & Society*, 8 (3): 193–214.

Smith, L. 2015. 'Theorizing museum and heritage visiting', in Witcomb, A. and Message, K. (eds) *The International Handbooks of Museum Studies: Museum Theory*, John Wiley & Sons, pp. 459–484.

Smith, L., Shackel, P. A. and Campbell, G. 2011. 'Introduction: class still matters', in Smith, L., Shackel, P. A. and Campbell, G. (eds) *Heritage, Labour and the Working Classes*, Routledge, London and New York, pp. 1–16.

Southgate, B. 2003. *Postmodernism in History: Fear or Freedom?* Routledge, London and New York.

Stone, P. 2004. 'Introduction: education and the historic environment into the twenty-first century', in Henson, D., Stone, P. and Corbishley, M. (eds) *Education and the Historic Environment*, Routledge, London and New York, pp. 1–10.

Torpey, J. 2004. 'The pursuit of the past: a polemical perspective', in Seixas, P. (ed.) *Theorizing Historical Consciousness*, University of Toronto Press, Toronto, Buffalo and London, pp. 240–255.

Tosh, J. 2002. *The Pursuit of History*, Third edition, Pearson, Harlow and London.

Trewinnard-Boyle, T. and Tabassi, E. 2007. 'Learning through touch', in Pye, E. (ed.) *The Power of Touch: Handling Objects in Museum and Heritage Contexts*, Left Coast Press, Walnut Creek, pp. 192–200.

Walsh, K. 1992. *The Representation of the Past: Museums and Heritage in the Post-modern World*, Routledge, London and New York.

Waterton, E. and Watson, S. 2015. 'Heritage as a focus for research: past, present and new directions', in Waterton, E. and Watson, S. (eds) *The Palgrave Handbook of Contemporary Heritage Research*, Palgrave Macmillan, Houndsmill and New York, pp. 1–17.

Watson, S. 2010. 'Myth, memory and the senses in the Churchill Museum', in Dudley, S. H. (ed.) *Museum Materialities: Objects, Engagements, Interpretations*, Routledge, London and New York, pp. 204–223.

Watson, E. and Watson, S. 2015. 'The ontological politics of heritage; or how research can spoil a good story', in Waterton, E. and Watson, S. (eds) *The Palgrave Handbook of Contemporary Heritage Research*, Palgrave Macmillan, Houndsmill and New York, pp. 21–36.

Wertsch, J. V. 2000. 'Is it possible to teach beliefs, as well as knowledge about history?', in Stearns, P. N., Seixas, P. and Wineburg, S. (eds) *Knowing, Teaching and Learning History: National and International Perspectives*, New York University Press, New York and London, pp. 38–50.

White, H. 1973. *Metahistory: The Historical Imagination in Nineteenth-Century Europe*, The John Hopkins University Press, Baltimore and London.

Whitehead, C. and Bozoğlu, G. 2015. 'Constitutive other and the management of difference: museum representations of Turkish identities', in Whitehead, C., Lloyd, K., Eckersley, S. and Mason, R. (eds) *Museum, Migration and Identity in Europe: People, Places and Identities*, Ashgate, Farnham and Burlington, pp. 253–284.

Witcomb, A. 2013. 'Understanding the role of affect in producing a critical pedagogy for history museums', *Museum Management and Curatorship*, 28 (3): 255–271.

Wright, P. 1985. *On Living in an Old Country: The National Past in Contemporary Britain*, Verso, London.

Zanazanian, P. 2008. 'Historical consciousness and the "French–English" divide among Quebec history teachers', *Canadian Ethnic Studies Journal*, 40 (3): 109–130.

8

Weighing up intangible heritage

A view from Ise

Simon Richards

Introduction

Heritage is often contentious but intangible heritage is especially so. UNESCO (United Nations Educational, Scientific and Cultural Organization) recognized the intangible heritage of dance, theatre, storytelling, landscapes, beliefs and many other things in its 'Convention for the Safeguarding of the Intangible Cultural Heritage' of 2003 (UNESCO 2003); a recognition that was spurred on by dissatisfaction among non-western nations with the Euro-centric bias of UNESCO's heritage-listing practices. Subsequent discussions of intangible heritage continue to arraign UNESCO's approach as causing abuses linked to national power, assumed expertise, unwielding bureaucracy, commercial exploitation and an unhealthy fixation on aesthetics. This chapter traces the emergence of intangible heritage into global heritage consciousness and, while acknowledging that much of this is indeed conflicted and problematic, critiques the more well-worn discussions of it. There are two sections, the first on origins and criticisms, the second on experience and aesthetics, both exploring how discussions of the intangible are locked into wider pre-existing arguments about heritage in general. As Japan is a prime mover in the intangible heritage story, Japanese examples feature throughout, especially the Ise Shrine, which is returned to at various points in the chapter as it serves perfectly as a lightning rod for the historical, political, commercial and aesthetic anxieties that shape intangible heritage discourse.

Origins and criticisms

Explanations of UNESCO's adoption of intangible heritage involve a disagreement over whether it was initiated from the grassroots or by UNESCO itself. Noriko Aikawa, former Director of the Intangible Cultural Heritage Section at UNESCO, presents the official story: it came into being through the enlightened progressiveness of UNESCO under the advisement of heritage and government experts. The main driver was a realization that UNESCO evaluations of world heritage had previously prioritized the materiality of tangible artefacts and buildings, and western nations well-provisioned in these, which overlooked nations whose objects were fashioned in less durable materials, and indeed, the non-material heritage of all nations, such as song, dance and folklore. This was pre-empted in the 'World Heritage Convention' adopted by

UNESCO in 1972, which broadened the categories of eligibility for heritage listing from tangible monuments to groups of buildings, sites and natural environments, including geological features, flora and fauna.[1] As groundwork for the 2003 Convention, UNESCO established the 'Proclamation of the Oral and Intangible Heritage of Humanity', and the proclamations of 2001, 2003 and 2005 led to the growth of a 'Masterpiece List' of 90 cultural practices, taking in 3 Japanese theatrical examples (*Bunraku*, *Kabuki* and *Noh*), Vietnamese *Nha Nhac* Court Music, the Sand Drawings of the Vanuatu, and the Vocalizations of the Aka Pygmies in Central Africa.[2] The 2003 Convention further broadened UNESCO definitions to include heritage as 'process and practices rather than end products', as a 'source of identity, creativity, diversity and social cohesion', as well as being 'constantly evolving and creative' (UNESCO 2003, n.p.). Also included was an emphasis on 'practitioners' and 'communities', the 'priority on intergenerational transmission, education and training', and an awareness of the 'interdependence between' intangible and tangible heritage. The focus on changeable heritage, upheld by local people as part of their community identities, and needing 'safeguarding' and cross-generational nurturing rather than straightforward 'preservation', raised questions about what a body like UNESCO might do in concrete terms to make this happen. UNESCO tactically side-stepped this in the 2003 Convention, but there was a stipulation that member states submitting intangible heritage for listing needed to demonstrate their plans to render it sustainable.

Crucially, in 1989 the Japanese government instituted the 'Japan Funds-in-Trust for the Preservation of the World Cultural Heritage', an annual contribution to UNESCO earmarked for protecting endangered monuments and assets in other countries, and this became 'the determining factor for the development of the [intangible heritage] programme'. Indeed Japan had already become the largest contributor to UNESCO by default when the United States withdrew from the organization in 1984 in protest at its giving a platform – allegedly – to anti-American agendas (Aikawa 2004, quotations pp. 139, 146; Ahmad 2006; Bortolotto 2010, esp. pp. 105, 107; Akagawa 2016, p. 15).[3]

Japanese influence was crucial, then, and was galvanized in a culture-focused public-relations campaign led by Takeshita Noboru, who became Prime Minister in 1987. As recompense for its financial contributions, 1992 saw Japan ratified as 'State Party' to the World Heritage Convention, giving it the right to nominate heritage items for listing, and the years immediately following saw a rush of high profile Japanese additions to the World Heritage List, including Himeji Castle.[4] Problematically, however, UNESCO documentation and institutional prejudice considered many Japanese practices inauthentic, including the architectural tradition of *sengu* which involves dismantling and reconstructing important buildings. This happens most famously for the main Shinto shrines at Ise known as the *Naiku* and *Geku*, which house the deities – or *kami* – Amaterasu and Toyouke, and have been rebuilt almost without break every 20 years since the late seventh century AD.[5] Japan's Agency for Cultural Affairs played-up the issue as ongoing UNESCO Euro-centrism and pointed to the Japanese system of 'Living Human Treasures' – state-sponsored individuals who are bearers of traditional knowledge and craft skills – that they instituted as part of domestic intangible heritage protection with the 'Law for the Protection of Cultural Properties' of 1950, extended in 1954 with the addition of 'everyday manners and customs' and again in 1975 with a re-emphasis on folk culture to complement the high arts.[6] Japan sponsored the 'Nara Conference on Authenticity' in 1994 to challenge UNESCO definitions of authenticity, which were then still beholden to the World Heritage Listing 'Operational Guidelines' of 1977, and under which the 'four degrees of authenticity … materials, workmanship, design and setting' maintained the bias towards materialist preservation and minimal interventions. The Japanese used the counter-example of the Ise Shrine as a key part of their strategy at Nara.[7] This agenda was brought to fruition under Koichiro Matsuura,

Director General of UNESCO from 1999 to 2009, the years that saw the establishment of the Intangible Heritage section and of course the 2003 Convention. Western nations that favoured material heritage, however, including some such as Australia, Canada and North America that had indigenous populations invested strongly in intangible traditions, considered the 2003 Convention irrelevant to 'their' interests and abstained from voting (Akagawa and Smith 2009, pp. 2–3; Bortolotto 2010, esp. pp. 101–103, 106–107, quotation p. 102; Labadi 2010, quotations pp. 69–70; Loo 2010, esp. pp. 384–388; Vecco 2010; Alivizatou 2012, esp. pp. 9–10, 12–13; Aikawa-Faure 2014, esp. pp. 38–44, 47–48; Akagawa 2016, pp. 14–16, 20–23).

The irony is that Ise Shrine should have become the exemplar of this heroically pro-Asian, anti-imperialist set of heritage values when it was absolutely central to the Shinto-fuelled imperial expansion of Japan under the Greater East Asia Co-Prosperity Sphere (GEACPS) up through the Second World War. Indeed, Ise was the personal shrine of the Emperor and the national base of Shintoism ever since Emperor Tenmu secured a war of succession with assistance from warlords in the Ise region in the seventh century, an arrangement consolidated with Emperor Kammu's legal mandating of the *sengu* and its Shinto rituals in the eighth century. Although the thatch might need patching there was no real need for rebuilding the complex every 20 years, as planed cypress logs of the dimensions used at Ise could survive for at least twice that duration despite being laid into damp, termite-riddled ground. The 20 year rule was about power, and the emperors asserted this privileged treatment against potential usurpers with their own personal shrines. The shrines of Izumo, Sumiyoshi, Katori and Kashima, for example, were permitted to be rebuilt much less frequently, sometimes only after earthquake or fire, and usually had to make do with running repairs (Coaldrake 1996, pp. 16–51; Adams 1998, p. 49).

The Emperor was side-lined politically by the Shoguns of the Edo-period from the early 1600s onwards, but with the Restoration of 1868 Ise was recruited afresh as a pillar of the modern Japanese state and received state funds directly. In 1869, Emperor Meiji visited the shrine and a new Department of Divinity was established to ensure the populace respected the newly-incorporated 'State Shinto'. By the 1870s, Shinto textbooks were being produced for everyone, from soldiers to schoolchildren, and pilgrimages to Ise were encouraged. Ise also played a key role in Japan's growing military confidence. As well as victory in Russia in 1905, Japan had received Taiwan as spoils for the first Sino-Japanese War in 1895, annexed Korea in 1910, invaded Manchuria in 1931, and spread further through China and Mongolia throughout that decade. This regional expansion gathered momentum from 1940 onwards under the ostensibly benign anti-western protectorate of GEACPS, and Ise was ideologically central to this imperial adventure, receiving 8 million visitors at its peak in 1940 and seeing the sale of 13 million talismans in 1943. Cultural ambassadors deployed by the government's Society for International Cultural Relations, such as the architect Chuta Ito and art historian Jin Harada, often used Ise as a shorthand for Japanese imperial, racial and spiritual superiority, and in 1942 the architect Kenzo Tange won the competition for the Memorial Hall for GEACPS with a design – never built – that copied key features of the *Naiku* and *Geku* (Hardacre 1989, pp. 15–16; Reynolds 2001, pp. 318–320, 322–324; Loo 2010, pp. 377–378; Arichi 2013).

It is little wonder, after Japan surrendered in 1945, that the occupying commander General MacArthur commissioned a 'Shinto Directive'. The Directive decreed that Shinto must henceforth receive no central state funding, must not be taught in public schools, that no one should be required to join a shrine, and that no public official would be permitted to participate in Shinto ceremonies. Ise's financial lifeline was cut and the rebuild scheduled for completion in 1949 was halted. But no sooner had the Americans left Japan in 1952 than Emperor Hirohito travelled to Ise to apologize to Amaterasu for her neglect. The *sengu* was restarted and the buildings were completed in 1953, paid for by donations from the imperial coffers, private business

and general public, a financial arrangement that holds to this day. The imperial associations of Ise were subsequently cleansed away in the formal-aesthetic reinterpretations of Tange, winner of the GEACPS competition, and journalist Noburo Kawazoe, paving the way for its reinvention as a heritage asset (Ono and Woodard 1962, pp. 12–19; Hardacre 1989, pp. 134–137, 167–170; Tankha 2000, pp. 558–561; Fukase-Indergaard and Indergaard 2008, pp. 350–358; Loo 2010, pp. 378–381; Akagawa 2016, pp. 16–20).[8]

Given these machinations, it is understandable that scepticism has developed around UNESCO's recognition of intangible heritage. It has been criticized as a comprehensively state-run monopoly – listing nominations must always come at official diplomatic level from States Parties – rather than being connected to the cultures and interests of the grassroots communities it claims to safeguard. Criticisms point also to the practical difficulties of safeguarding something that is living and changeable, over which the Convention offers no specific guidance. Richard Kurin, writing as Director of the Smithsonian Centre for Folklife and Cultural Heritage shortly after the treaty was brought into full effect in 2006, summarized the conundrum:

> If the tradition is still alive, vital and sustainable in the community, it is safeguarded. If it exists just as a documentary record of a song, a videotape of a celebration, a multi-volume monographic treatment of folk knowledge, or as ritual artifacts in the finest museums in the country, it is not safeguarded.
>
> *(Kurin 2007, p. 12)*

But Kurin remained cautiously optimistic, and he was not alone in this view, that a combination of government, university and museum expertise could achieve effective safeguarding in collaboration with UNESCO while working real grassroots representation into the process (Kurin 2007, pp. 12–18).[9]

Many other commentators, however, saw the 2003 Convention as a continuation of universalizing tendencies long present in UNESCO, including the 1972 World Heritage Convention. That earlier convention, according to Rodney Harrison in his *Heritage: Critical Approaches* (2013), unwittingly compromised the hegemonic intent of UNESCO: 'The Convention's self-definition as a universal convention representing all human heritage meant that these alternative models had to be taken seriously and given equal consideration with existing ways of conceptualising heritage' (p. 126). Consequently the organization could not ignore the lobbying of indigenous groups, including the Aboriginal people of the Uluru-Kata Tjuta National Park in Australia, who highlighted their landscaping techniques, life-practices and beliefs in human–animal symbiosis to influence UNESCO deliberations on landscapes in the early 1990s. Nor, later in the decade, could they ignore the writer Juan Goytisolo, who lobbied on behalf of the oral traditions of the storytellers – or *halaqui* – of Jemaa el Fna, the old market square in Marrakech in Morocco that was threatened by redevelopment. UNESCO responded to these groups in its Global Strategy Meeting in Paris in 1994, and it was as a result of pressure of this kind that in 2008 they re-incorporated the Masterpiece List into a 'Representative List of the Intangible Cultural Heritage of Humanity', hoping to deflect accusations of a western standardization of aesthetic quality (Kaufman 2013).[10] But Harrison (2013) maintains that:

> while this change was motivated by a desire to be more inclusive of human diversity, it must also be seen as a process that expanded and strengthened UNESCO's field of governance by broadening the range of objects, places and practices over which it had expert authority, and the places and circumstances under which it could intervene in the activities of nation-states.
>
> *(pp. 126, 129, 137, 138)*

The 'hegemonic … totalising and universalising mission' was unchanged, as it remained States Parties and not minority groups who nominated. Moreover, the division of intangible from tangible betrayed a deep-seated philosophical bias that cut to the very heart of the west – 'the Cartesian dualism of matter and mind' – while the loosening up of heritage to take in performance made it exceedingly easy for crass commercial interests to move in and capitalize with 'inauthentic' intangible heritage tourism, usually sponsored by States Parties for their commercial interests rather than minority group representation (Smith 2006, pp. 109–111; Harrison and Rose 2010, pp. 238–247; Harrison 2013, pp. 114–139). Thomas Schmitt weighed up the arguments about the controlling, top-down ethos of UNESCO in relation to Jemaa el Fna, concluding that this was a 'decisive external influence', a truly 'local idea … able to change the agenda of an international organisation', and one that 'scarcely matches the cliché of global institutions [working] in accordance with the interests of the most powerful member countries and from deductive ideological considerations' (Schmitt 2008, pp. 97, 102, 108). It is the cliché, however, that enjoys the greatest mileage.

Barbara Kirshenblatt-Gimblett's widely-cited essay on 'Intangible Heritage as Metacultural Production' (2004) is central to this. She excoriates UNESCO's obsession with bureaucratic lists which, however encompassing, are always classificatory and invite jealous comparison, is suspicious of the appearance of high imperial culture such as Japanese *Noh* on the Masterpiece List, and points to the paradox that UNESCO seeks 'vitality' in intangible heritage whereas – and similarly to Kurin's point – 'if it is truly vital, it does not need safeguarding; if it is almost dead, safeguarding will not help'. Better, then, that 'intangibility and evanescence – the condition of all experience' are acknowledged and some traditions left to wither naturally. But Kirshenblatt-Gimblett amplified another concern: commercialization and tourism. UNESCO's intangible heritage initiatives foment the worst 'deculturation integration' practices of the heritage sector, feeding commercial pastiche and touristic opportunism with 'metacultural production'. Heritage is already 'the final resting place for evidence of the success of the missionizing and colonizing efforts [of the West] … which preserve (in the museum) what was wiped out (in the community)', and UNESCO's intangible heritage only accelerates this while pretending 'to reverse course, but there is no way back, only a metacultural way forward' (Kirshenblatt-Gimblett 2004, quotations pp. 56, 60, 61).

To summarize, UNESCO's uptake of intangible heritage is seen as: a means to exert cultural hegemony, whether of UNESCO over the world or nations over their own oppressed groups (Smith 2006, p. 299; Munjeri 2009; Askew 2010); a fetishization of lists according to bankrupt western aesthetics that provoke status-wars among nations, despite UNESCO's encouragement of multinational listing proposals, and serve tawdry commodification, tourism and fundraisers (Brown 2005, esp. pp. 47–49, 53–54; Byrne 2009; Hafstein 2009; Askew 2010; Aykan 2015); a hypocritical substitution of 'bad' globalism with the ostensibly 'good' globalism of UNESCO itself (Askew 2010; Bortolotto 2010, esp. pp. 97–99; Alivizatou 2011, esp. pp. 43–46; Alivizatou 2012 esp. pp. 10–16). These critiques often disregard what UNESCO says and does, however, as in the 'Cartesian dualism' line that the recognition of intangible heritage led to its artificial disconnection from tangible heritage, that UNESCO should better appreciate how both are sustained in ordinary places and the lifestyles, stories and memories that people associate with them, and that these people should in turn keep heritage experts and their aesthetics at a sceptical distance (Smith 2006, pp. 29, 53–57, 107, 299; Kaufman 2013, pp. 22–25; Schofield 2014; Baulch *et al.* 2015). UNESCO cautioned directly against precisely this kind of disconnection in Article 2 of the 2003 Convention, which foregrounds intergenerational transmission of values and identities in 'cultural spaces', created by 'communities and groups in response to their environment, their interaction with nature and their history', and also their being 'constantly

recreated' by ordinary people, which in turn pre-emptively answered the related criticism that documentation and lists alone are not sufficient to 'safeguard' these practices (UNESCO 2003). As of February 2016, only one of the 12 case studies shared by UNESCO for exemplifying 'Best Safeguarding Practices' has involved inventories.[11] Scholars defending UNESCO have noted the replacement of the Masterpiece List with the less exclusive Representative List (Aikawa-Faure 2009) as well as UNESCO's use of NGOs (Non-Governmental Organizations) to assess nominations in order to detect and deflect bias away from national self-interests (Seeger 2009). Moreover, when institutions or governments turn intangible heritage to commercial ends, critics assert that it has been rendered ersatz and inauthentic, but if indigenous people do the same – creating hybridized traditions to appeal to cultural tourists in the performance and retail spaces of international fairs and museums, or through savvy Internet marketing of copyrighted 'intellectual properties' – it is praised as evidence of a living, adaptable culture (Kirshenblatt-Gimblett 2004, pp. 57–58; Brown 2005, pp. 51–53; Alivizatou 2011, pp. 40–43, 46–54, quotations pp. 42, 43). How are these oversights and inconsistencies possible?

They are reminiscent of the blanket critiques of the 'heritage industry' and 'invented tradition' discourses that emerged originally as a response to the commercialization of tradition in 1980s Britain but that have proved highly adaptable, and which characterized tradition as nationalist cultural chauvinism, the subjective enjoyment of heritage tourists as evidence of their being brainwashed, and the professional historian as sole purveyor of historical fact (Hobsbawm 1983/1997; Hewison 1987, esp. p. 32; Hewison 1989, esp. p. 22; Hewison 2012). Stephen Vlastos introduced a volume on *Invented Traditions of Modern Japan* (1998a) by pointing out flaws in the invented tradition critique, especially the questionable assertion that traditions are always invented by political communities seeking to re-institute and capitalize upon unchanging values (1998c, esp. pp. 3–7, 16). Essays in the volume were untroubled by this flaw, however. Examples included Carol Gluck's account of how the heritage of the Edo-period (1603–1868) was re-packaged many times after the Meiji Restoration to serve different agendas. Edo represented: an entrepreneurial, culturally literate urban culture; a repository of pre-proletariat working-class values; the source of Japanese imperial legitimacy; a period of commercial ingenuity and a precursor to 1980s consumer culture. Edo was rendered appealing by and for the competing interests of bohemians, communists, imperialists and capitalists: 'Edo-as-tradition lived its rhetorical life in prefixes to modernity. Edo was un-pre-proto-post-modern, always in teleological relation to what came after it' (Gluck 1998, esp. pp. 264–274, quotation p. 283). Jennifer Robertson characterized old village – or *furusato* – heritage, which incorporates the assumed values of Edo village life, as repressive patriarchal nostalgia. Whether manifested as open-air museums, festivals, restaurants, TV shows, mail-order catalogues or government manifestos, *furusato* produced 'a warm, fuzzy, familial, and ultimately maternal aura' centred around a traditional concept of women as '*ohara*, or "womb-ladies"'. That people seemed to enjoy *furusato* was evidence of their psychological imbalance and brainwashing: 'Commercial ventures pursued under the affective rubric of *furusato*-making work to ensure that nostalgia becomes a natural(ized) frame of mind shaping desires and motivating patterns of consumption'. To be pitied, these were 'unattached individuals … existentially homeless people [who] construct totalities from their disparate experience by linking one tourist attraction to another and/or the nation' (Robertson 1998, quotations pp. 115, 118–119, 124).[12]

That intangible heritage might be inaccurate and possibly even coercive when set to commercial ends is an important criticism to make.[13] But the assertion that it is automatically rendered inauthentic and valueless at this point is questionable, as is the assumption that its consumers are sick. Raphael Samuel had earlier responded that popular heritage mobilized the enthusiasm, self-identity and experiences of ordinary people, that entertainment and fun could be enlightening for

those who did not have the leisure to dedicate a career to historical research, and that the commentators pronouncing against it were hypocritical snobs who themselves were no less in the commercial marketplace than the practices they derided (Samuel 1994/1999, esp. pp. 205–273). The next section introduces some alternative interpretations of intangible heritage indebted to this viewpoint, emphasizing the importance of subjective experience in the determination of cultural value and authenticity.

Experience and aesthetics

The anthropologist Marshall Sahlins wrote bruisingly about what he called 'despondency theory', where the virtues of indigenous cultures are contrasted with the 'defects of their erstwhile colonial masters' and their traditions are lamented as being poisoned into kitsch – 'serviceable humbuggery' – or fabricated outright for commerce. This overlooks local usages and 'the distinctiveness of things' in favour of 'just pointing to them and assigning them plus or minus grades in Hegemony', a score table of 'hegemonic imposition or counter-hegemonic resistance'. It is 'comprehension by subtraction' and renders commentators guilty of the same essentializing crimes they impute to UNESCO. Sahlins believes that 'all cultures are [naturally] hybrid ... [and] have more foreign than domestically invented parts', which means it is essential not to disparage even ostensibly manufactured differences done for commercial and touristic ends, but to be considerate of the way cultures display, enact, market and consume their identities even while instrumentalizing intangible heritage listing (Sahlins 1999, quotations pp. 401–402, 405–406, 409, 411).[14]

Dimitrios Theodossopoulos agreed that many anti-UNESCO critics perpetuate a reductive authenticity–inauthenticity binary, and in denigrating the official half – the half that consults experts about an intangible Masterpiece List – it limits understanding just as arbitrarily, only in a different direction. The attack on commercialized heritage is disrespectful also of the subjective experiences of users and indigenous groups who invest time and effort into these activities (Theodossopoulos 2013, esp. pp. 339, 344, 348). Relatedly, Randolph Starn defended the 'Nara Document on Authenticity' (2002), which vindicated user experience, against the 'finger-wagging High Criticism [and] dismissive all-or-nothing rhetoric of the "heritage wars"' that condemned the document's inclusiveness as opening the floodgates for commercial exploitation; while Dipesh Chakrabarty emphasized the neglect of subjective experience in heritage discourse, especially the confusion of 'nostalgia', which may be open to commercial and political manipulation, with the experience of 'epiphany', a deep, nourishing enjoyment of the past that can be activated through entertainments (ICOMOS 1994; Chakrabarty 1998, esp. pp. 287, 289–291; Starn 2002, quotations pp. 10–11, also esp. pp. 8–9, 13n21).[15]

These arguments enjoy support in tourism studies. Ning Wang classified the different types of authenticity in heritage discourse but advocated the 'existential', which considers authenticity meaningless unless discussed in terms of the user; and any kind of object or experience, no matter how 'inauthentic or contrived', can create 'a sense of existential authenticity'. Some might argue that this experience is mere misrepresentative fantasy, but 'such a fantasy is a real one – it is a fantastic feeling' (Wang 1999, quotations pp. 359–360).[16] For Wang and others, exploring heritage tourism from the monasteries of Mount Athos to the Texas Renaissance Festival, 'authenticity is a very elusive concept which has multiple meanings with both demand and supply side connotations'. The 'ludic' authenticity of patrons becoming 'playtrons' deserves consideration, as 'highly committed tourists gain "self" authenticity despite the fact that they adopt "virtual" or "phantasmagoric" roles' (Kim and Jamal 2007, quotation p. 198; Andriotis 2011, quotation p. 1613). Beyond the objective historical facts of an object or practice there is

Simon Richards

the recreation of 'pastness' for experience in the now, even though this might be stagey, stereotypical and even forged, as in 'deliberately aged' heritage sites:

> What matter are perceptions of pastness, i.e., the past in an audience's imagination rather than in a chronological system … [thus] the more something possesses the quality of being (of the) past, the more it will be in line with certain cultural assumptions of the respective observer's present.
>
> *(Holtorf 2013, quotations pp. 432, 433–434, 437)*

Ahmed Skounti, a Moroccan scholar involved in the Jemaa el Fna campaign and 2003 Convention, discusses something similar with his concept of the 'authentic illusion'. Countering Kirshenblatt-Gimblett's assertion that intangible heritage initiatives uproot and render 'meta-' what they claim to safeguard, Skounti argues that intangible heritage must be frequently refreshed for new audiences in order to keep it in attention for ongoing safeguarding. The illusion of authenticity is sufficient to give a good experience and flexible enough for reinvention. Although representing a 'gradual detachment' from academic historical time and an immersion in 'heritage time', the 'quest is never-ending, giving rise to new hopes and sometimes new illusions' (2009, esp. pp. 75–79, quotations p. 90). Laurajane Smith has also argued in favour of the active, identity-forming aspects of tourism as defence against the widespread accusations of passive, witless consumption, demonstrating convincingly that even the official narratives presented in commercial tourism are not unassailable but often serve usefully as provocations against which people can and do project their 'dissent and challenge': tourism opens up a 'seam of dissonance' (2006, pp. 32–35, 301–308; quotation p. 306).

Returning to Japanese examples, Christoph Brumann and Rupert Cox concede that there are often 'powerful criticisms to be directed at "heritage"', but its performance and commercialization does not necessarily mean that it involves 'ersatz fabrication or a narrowly conceived, politically motivated "invention of tradition"'. They argue for the validity of the 'authentically remade' (Brumann and Cox 2010a, quotations pp. 3–5). Brumann's account of the rehabilitation of the traditional narrow-fronted merchant town houses of Kyoto – the *kyo-machiya* – reveals varied motives at work. This movement began in earnest in the 1990s after the post-Second World War neglect and demolition of many of these houses, and now takes in commercial and touristic ventures dedicated to selling the *kyo-machiya* 'experience', from coffee-table books to papercraft to restaurant design. There is a hardcore of purists, often more advanced in age, who try to keep them as true to origins as possible, even down to upholding religious observances and etiquette from Edo times. But *kyo-machiya* are rehabilitated by a wide demographic, including youngsters who 'should be expected to prefer *sugoi* ("great", "cool", "terrific"), *kawaii* ("cute"), or *kakkoii* ("smart, good-looking") things to *ochitsukeru*-style serenity'. This 'weakly organized' grassroots cooperative is offered *kyo-machiya* construction workshops by the city government but otherwise are left to their own devices. A survey of their reasons for undertaking these refurbishments revealed that the desire to represent national or indeed Kyoto identity was negligible, the main indicators pointed towards the aesthetic appeal of *kyo-machiya* and the fun of the work itself. 'Contrary to what an "invention of tradition" perspective might leads us to expect', Brumann observes, 'participants in the *kyo-machiya* movement do not long so much for community, real or imagined, and for shallow narratives about a better past'. The 'counter-hegemonic unmasking of heritage' is redundant here (Brumann 2010, quotations pp. 160, 166, 168). Peter Siegenthaller defended Japan's open-air architecture and folklore museums on similar terms. Several of these emerged in response to the 1947 Local Autonomy Act and 1951 Museums Law, which facilitated development of local museums to kick-start

tourism and generate taxes, and led to the popular business of staging lifestyle experiences in thatched *gassho-zukuri* farmhouses; an increasingly important anchor for regional economies at a time of chronic migration to the city (Siegenthaler 2010).

The experience of visiting Ise Shrine is certainly touristic. The *Naiku* and *Geku* are inaccessible behind layers of fences but souvenir booths abound with expensive merchandise, as do the shops in the city (see Figures 8.1, 8.2 and 8.3). Tourism and consumer excess, however, are important parts of Ise's history. Pilgrimages represented a sizeable tourist industry throughout the Edo-period and had a colourful reputation. They were provided for with regularly-updated travel guides detailing history, travel practicalities, attractions, local specialities and souvenirs, and administered by a special class of tour-guide Shinto priest known as *oshi*,

> who controlled networks of confraternities that by the end of the period extended nationwide ... Between 80 and 90 percent of the nation maintained a confraternity membership, and thus powerful *oshi* might have as many as four to ten thousand households in their control.
>
> *(Hardacre 1989, pp. 15–16)*

Oshi travelled to their confraternities selling talismans and almanacs – some two million Ise-themed calendars were printed annually – and taking donations, for which they were expected to entertain confraternity members when they arrived at Ise. Pilgrims had to secure official and employer permission to travel to Ise but these were usually granted, and when declined pilgrims often travelled anyway, sneaking around the barrier-gates along the route. They were undertaken by all classes of society: there was a fashion for women travelling in small groups as a holiday away from their husbands, and dogs were popular tourist-pilgrims too, and were usually provided with name and return-address tags as well as money-pouches around their necks by

Figure 8.1 The compound of the new *Geku* shrine at Ise, photographed when still fresh in April 2014, a few months after re-consecration when the *sengu* was completed for the 62nd time in October 2013.

Source: photo credit S. Richards.

Figure 8.2 A party of school children and their teachers file past the disused, dilapidated and rotting compound of the old *Geku* shrine in April 2014, which for a few months before it is dismantled sits miserably adjacent to its new iteration in Figure 8.1.

Source: photo credit S. Richards.

Figure 8.3 The *Naiku* shrine crafted out of pearls in a jewellery shop in Ise city. The shrines themselves cannot be seen, but models such as these are available for purchase throughout the city as well as in the well-stocked souvenir booths scattered around the shrine complexes.

Source: S. Richards.

Weighing up intangible heritage

their owners. People travelling without money would be provided for by almshouses sponsored by the ruling classes who also contributed to the upkeep of road links from Edo. The whole thing, which had a party-like air particularly during the mass thanksgiving pilgrimages – or *okage-mairi* – that occurred every 60 years or so with numbers approaching 4.3 million in 1830, was tolerated by the ruling classes as a kind of safety-valve. The ribald and licentious nature of these pilgrimages, where a trip through the pleasure district of Furuichi that lay directly in-between the main shrines with brothels employing, at their Edo-era peak, over 1,000 prostitutes, was often the highlight of a long itinerary of pleasures. These less sacred aspects of Ise were well-known and satirized in Saikaku Ihara's late seventeenth-century collection *Five Women Who Loved Love* and Ikku Jippensha's novel *Shanks' Mare* in the early nineteenth century (Hardacre 1989, pp. 15–16; Reynolds 2001, pp. 318–320, Arichi 2013).

Under Meiji, attempts were made to clean up the reputation of the pilgrimages and give them an air of respectability appropriate to the incorporation of State Shinto, but they continued to rely on tourism. Accounts and depictions during Meiji's reign from 1868 to 1912 show a rationalization of the physical fabric of the shrines themselves. The 1797 guidebook depicted priests, pilgrims and beggars trampling right across the holy sites, while the 1895 guidebook showed that the fences had by then been erected to keep people off (see Breen 2013). Other changes during Meiji include the location of the treasures houses that accompany the main shrines as well as the eradication of the *oshi* order, their personal wealth and commercial methods seen as an affront to sacredness, which meant that pilgrimages and revenues to Ise plummeted despite state funding. To that end a local organization called *Shin'enkai*, composed of local officials and businessmen as well as Tokyo government bureaucrats, was set up to find methods to reinvigorate Ise revenues. They did so with plans to surround the shrines with examples of the Japanese commitment to progressive western values, science and technologies. A new road – Miyuki Road – was completed by 1894, linking the *Naiku* and *Geku* and cutting out the route through Furuichi, and with the completion of the Ise railway in 1897 pilgrimage numbers began to recover. The second phase of development included plans for a racecourse, zoo, aquarium and museums. A Museum of Agriculture and the Jingu History Museum, the latter in imported neo-classical style, were completed in the early 1900s. So committed were the *Shin'enkai* to these imported entertainments that Kosaburo Ota, the organization's founder, was content to let the brothel he owned in Furuichi to wind down. Guidebook illustrations from this period were just as likely to feature depictions of the railway, and cannons used in the Russo-Japanese War, as they were to feature the shrine buildings and forests (Breen 2013). The donation and tourism funding model that was precipitated by MacArthur's Shinto Directive represented, in fact, a return to the commercial norm of Ise Shrine's Edo history. Appropriately, then, the 1993 *sengu* was marked by the opening of a new Museum of Fine Arts on the Miyuki Road in the elegant *shoin* style of the Edo military aristocracy as well as a new family-friendly pleasure district called Okage Yokocho. Sponsored by the bean-paste confectioners Akafuku it is now packed with busy eateries, bars selling Ise Beer and souvenir shops in Edo-town house style, some brand new and others rebuilt originals from the notorious old pilgrimage routes.[17] The history of Ise is, in large measure, its history of tourism (see Figure 8.4).

Whether or not one agrees with the view that the popular consumption and subjective experience of intangible heritage is valuable, commercialization is not the only thing that the critics discussed earlier considered problematic. Aesthetics was seen as anachronistic, irrelevant and elitist, and largely kept out of discussions save for when commentators welcomed the overthrow of western connoisseurial approaches with the closure of the Masterpiece List. But what of aesthetic practices and values that are purely intangible, built upon a long history that celebrate precisely the *intangibility* of the intangible? The Japanese example is once again central,

Figure 8.4 The Okage Yokocho tourist district just outside the *Naiku* shrine at Ise, opened in 1993 to commemorate and capitalize upon the *sengu* of that year. It represents a restored but cleaned-up pleasure district for Ise pilgrims, seeking to recreate the aesthetic appeal if not the sensual excess of Furuichi in the Edo-period.

Source: photo credit S. Richards.

offering the paradigmatic case where impermanence, suggestion, ambiguity and perishability form the core of many aesthetic traditions. We can note the Heian-era (794–1185) aesthetic category of *aware*, invoking gentle melancholy at the passage of time and loss, captured typically in wistful poetic imagery of the moon hidden behind clouds and falling cherry blossoms; and, several hundred years later, *yugen*, suggesting beautiful gracefulness combined with the intimation of a mysterious, transcendental beyond, an aesthetic associated with classical *Noh* drama. Further examples incorporate the necessary passing of all material things represented in the Zen Buddhist-inspired design aesthetic of *wabi sabi*, where '*sabi* "rust" or *sabireru* "to become desolate"' incorporates solitude also, 'as rust suggests the worn, withered, abandoned, detached, and lonely-but-beautiful-in-its-loneliness' (Keene 1969, quotation p. 302; Pilgrim 1977, quotation p. 297). This was perfected in the sixteenth-century tea-house architecture of Sen-no-Rikyu, where the aestheticization of impermanence, dilapidation and decay combined with the native Shinto fascination for the rhythms of nature. This aesthetic is not one of the distant past, either. The fondness for patina on objects and buildings worn with use was celebrated by the novelist Junichiro Tanizaki in his treatise *In Praise of Shadows* (1933) (Richards 2012). Indeed, the nearest equivalent of 'architecture' or 'design' in Japanese is *madori* or 'grasping space', which denotes an interest less in the buildings themselves than in the intangible experience of the 'intervals' or 'between'-spaces that they articulate (Snodgrass 2011). Add to this vagueness and ambiguity the arts of *ikebana*, literally 'living flowers' that are dead, traditional building elements such as *shoji* and *fusuma* that enclose but do not enclose, *sumie* painting, where the line wanders adrift in space without background or context, and a preference for the suggestiveness of monochromatic palettes rather than the explicitness of naturalistic colour, and it is clear that incompleteness, perishability – indeed, intangibility – lie at the very heart of the traditional Japanese aesthetic experience. 'The Japanese have built for impermanence', Keene concluded (1969, p. 305).[18]

As well as the obvious example of the *sengu* at Ise we find this aesthetic enacted in many other ways, such as in Japanese traditional painting, or *nihonga*. This was re-consolidated – detractors would surely say 'invented' – in the late 1880s at the Tokyo School of Fine Arts in response to the import of western styles and materials for the *yoga* schools of painting. *Nihonga* prioritizes the processes of art-making more than the material end product of the painting. It involves students in material gathering and preparation exercises, collecting rocks and minerals in the mountains and grinding them down for pigment, as well as ritualized forms of teaching through emulating the elegant postures and performative arm and brush movements of the master. This goes against the *yoga* tradition of easily sourcing mass-produced materials, such as oil and watercolours, with the implication that the finished, tangible work takes priority over the intangible processes of preparation and performance (Gelunas 2010). Although other national traditions have noted the qualities of frailty, impermanence and ambiguity they have 'rarely been recognized as the necessary condition of beauty', whereas the Japanese have long 'expressed their preference for varieties of beauty which most conspicuously betrayed their impermanence' (Keene 1969, quotations p. 305). Richard Pilgrim characterizes this mindset in terms of the proto-spiritual 'Way' arts of Japan, where the processes of preparation and making count for more than the finished artwork, and where the aesthetic sensation also counts for more than the artwork that provokes it and survives it as a mere mark – a material leftover. Looking at Motokiyo Zeami's treatises for *Noh* actors and the aesthetic categories of *yugen* (the suggestion of hidden-ness) and *myo* (hiddenness as experienced), Pilgrim detailed the hoped-for shift from the '*ushin* [and] *yojin*' minds of the aspiring young actor, understood as the 'functional, intending, object-oriented mind … attached to its artistic object', towards 'the attainment of no-mind or true Mind (*mushin*) … [the] abiding state of mind/being called Nothingness'. Indeed, Zeami argued that the zenith of the *Noh* actor's skill was the ability to command and sustain moments of '"no action" (*senu tokoro*)' when absolutely nothing is happening. For these and other traditional arts, the artist 'is not caught up in (attached to) the phenomenon of the art'. The goal is to find aesthetic value in everything apart from the object or performance, which exists as a trace or trigger for an intangible experience (Pilgrim 1972, quotations pp. 138–139, 142, 144).

Kirshenblatt-Gimblett objected to the listing of *Noh* as an intangible masterpiece not because of any aesthetic criteria – these being disregarded as inadmissible by the commentators discussed here – but because it was an established, high-imperial rather than a grassroots practice: 'not a minority or indigenous cultural form' (2004, p. 57). Would that be sufficient grounds, even if it were true? As the dramatist Andrew Tsubaki demonstrated, the *yugen* of *Noh* encapsulates neatly 'the inclination in Japanese aesthetics of esteeming the hidden or merely suggested as higher than the obvious or boldly exposed'. But aesthetics are not static and the history of *yugen* is revealing. The term was imported from China and 'originally related to the art of dyeing', implying depth though metaphoric association with dark colours. The gradual folding into *yugen* of the Heian connotations of *aware* was amplified by poets, largely 'fallen aristocrats' indulging 'nostalgia, remembrance, or admiration for things already lost', as the imperial court was challenged by the ascendancy of the samurai class and its ruling Shogunate from the twelfth–seventeenth centuries. Yet the court did not hold a monopoly on taste and through samurai influence the scope of *yugen* was broadened to take in earthy delight in sensual beauty as well as the Buddhist acceptance of material transience, and was no longer restricted to aristocrat laments over loss of power and lifestyle. This aesthetic was extended over the Edo-period as the samurai sought out aesthetes like Sen-no-Rikyu and Zeami. The intangible aesthetics and the related art forms that were consolidated under the samurai, then, were not – indeed, could not be – a straightforward statement of imperial privilege, but instead combined aristocratic, foreign, Buddhist as well as populist and indeed grassroots sources, the samurai hailing, after all, from the

rural peasant classes and being 'representatives of the plebeian' (Tsubaki 1971, quotations pp. 56, 58, 62, 63).

Not surprisingly, the intangible thread in Japanese aesthetics comes right down through the contemporary geek – or *otaku* – culture of manga, anime and cosplay. The term *kawaii*, for example, can be understood straightforwardly as 'pretty' or 'cute', and refers to a broad range of things such as Hello Kitty merchandise, waitress costumes in maid cafés and Harajuku fashion, and the saccharine prettiness of countless doe-eyed manga heroines. Yet it draws an etymological line back via *yugen* to Heian poetics, where *kawayushi* meant a 'combination of pity, adversity, harshness, and loveliness', which mutated into *kawayui* and the more 'negative aspects of pity and regret' and finally into the contemporary *kawaiso* of 'poor, pathetic, repentant'. Today's ostensibly trivial *kawaii*, then, and the consumer arts, fashions and products associated with it, also imply the transience and fragility of life that is central to the intangible aesthetic heritage of Japan (Amit 2012, quotation p. 179).

Conclusion

Many of the specific charges laid against UNESCO for its uptake, conceptualization and implementation of intangible heritage, such as the over-representation of national agendas and the freezing of culture into dead forms, can be answered by UNESCO's own pronouncements, guidelines and practices. As demonstrated earlier, these often do exactly what the critics assert they do not. The question, then, is whether critics are simply unaware of this or whether they believe UNESCO should go further, and usually this is unclear. Another factor that united many of these criticisms was the commitment to block out aesthetics, commerce and tourism from intangible heritage. But aesthetic judgements change over time, are periodically embattled, claimed and shared among different social groups, and the aesthetic history of terms used to describe *Noh* and other intangible art forms in Japan reveals that they confound the stereotype of being elitist, exclusive and statist. The notion of aesthetics as a 'narrow-minded and censorious' game, involving 'connoisseurs, evaluating quality and seeking out masterpieces … a habit already too ingrained among architectural historians', and therefore something that UNESCO should eradicate, is itself narrow-minded and censorious (Kaufman 2013, quotations pp. 22, 26). The related concern about the commercialization of intangible heritage and its enjoyment by tourists appears to descend from the invented tradition and heritage industry discourses, but some recent research is more amenable to the different, creative ways in which authenticity and truth can be experienced by consumers and exposes the elitism – rather ironically – of those who denigrate it. Besides, as Ise and other examples demonstrate, tourism and consumerism are not late twentieth-century inventions; it is sometimes the case that tourism and consumerism represent the long history of a place, its people, practices and artefacts: they *are* the heritage.

Intangible heritage clearly has a complicated history with divergent and conflicted motivations that should not be immune to criticism, and neither should the practical measures outlined by UNESCO for listing and safeguarding in the future. In pursuing this, however, the critiques interrogated in this chapter often slipped into binary stereotypes of elitism and populism, of the disconnected aesthete and the crass consumer, thereby reinforcing the 'comprehension by subtraction' that Sahlins warned about. They plough a politically safe but narrow middle ground, and the field of intangible heritage studies might be historically and aesthetically richer, and more mindful of the heritage experiences of more people, if scholars strayed off it.

Notes

1 A secondary driver involved pressure from smaller nations, most vocally Bolivia in 1973 but picking up others throughout the 1970s and 1980s, to have their intangible heritage brought under international copyright infringement law. Although important in motivating the early stages of the debate, this did not sit well within UNESCO's remit. Early speculative accords such as the 1982 'Model Provisions for National Laws on the Protection of Expressions of Folklore against Illicit and Other Prejudicial Actions', jointly authored by UNESCO and WIPO (World International Property Organization), were over by 2000 when UNESCO withdrew from the copyright issue.

2 Formatting note: non-English words that are not in common usage and which indicate specialist concepts and institutions are presented in italics; this does not apply to well-known words such as 'samurai' or 'manga'. An interactive map of the Masterpiece List is available at: www.unesco.org/culture/intangible-heritage/masterpiece.php?id=39&lg=en. Accessed: 19 February 2016.

3 Yahaya Ahmad (2006) argues that the International Council of Monuments and Sites (ICOMOS) presented cases for the global recognition of intangible heritage often in advance of UNESCO's initiatives.

4 'State Party' and 'States Parties' are the clunky terms UNESCO uses to designate nations signed-up to the World Heritage Convention.

5 Although usually referred to in the singular as 'Ise Shrine', the complex and the *sengu* involve over 80 other buildings such as treasure houses and offering halls, the Uji bridge, as well as some 1,800 treasures, weapons, clothes and playthings for the *kami* to enjoy.

6 Many Japanese folk practitioners have never been convinced of the Living Human Treasures system, however, as the recipient of a grant is required to preserve the tradition 'as found' rather than allow it adapt and change (Aikawa-Faure 2014, pp. 39, 48).

7 The conference involved UNESCO, ICOMOS and ICCROM (International Centre for the Study and Preservation of Cultural Property).

8 See Reynolds 2001 for the definitive analysis of the ideological cleansing of Ise by Tange, Kawazoe and others. See Breen 2010 for a critique of the way NAS (National Association of Shrines) forces the priests of regional shrines to sell Ise amulets to fundraise for the *sengu*. With a national target of 10 million sales a year, this campaign accounts for around 50 per cent of Ise revenues. Inevitably, the pressure to hit targets means regional priests cannot but neglect the finances and upkeep of their own shrines, which – when combined with the haughty disregard from NAS officials – is causing widespread resentment among the priesthood and local worshippers.

9 Museums 'tend to like their culture dead and stuffed', Kurin argued (2007, p. 14), and could not be relied upon to deal with intangible heritage alone. Christina Kreps (2009) responded with examples of innovative museums that have successfully embraced the 2003 Convention and worked with indigenous groups, overcoming 'their traditional role as custodians of tangible, static culture to (become) stewards and curators of intangible, living, dynamic culture' (p. 205). Another optimistic appraisal came from the Australian Aboriginal scholar Henrietta Marrie (2009), a United Nations specialist on biodiversity who cross-referenced the 2003 Convention with many other international human rights, labour rights and agricultural laws and conventions, concluding that it makes excellent provision for safeguarding the living heritage of indigenous peoples. Amanda Kearney (2009) was more circumspect, arguing that indigenous people are often reluctant to make efforts on behalf of intangible heritage when characterized as mere equal 'stakeholders', and often insist that they need to be made de facto legal 'owners' of it first; something which UNESCO refuses to get involved in (see note 1 above).

10 The 'Representative List' (currently 336 items) and a map of their global distribution is available at: www.unesco.org/culture/ich/en/lists. Accessed: 19 February 2016.

11 The current list of 'Best Safeguarding Practices' is available at: www.unesco.org/culture/ich/en/lists. Accessed: 19 February 2016.

12 Harry Harootunian introduced a Freudian twist to the psychoanalytic diagnosis approach by arguing that commercialized heritage represents a sinister 'doubling ... that resulted from repetition compulsion', an 'uncanny' return of 'the same but yet the not-same' (Harootunian 1998, quotation p. 152).

13 See also: Irwin Scheiner, who argues that *furusato* heritage ignores the political divisiveness – and especially the peasant revolts and competing religious beliefs – of Edo history (1998); Stephen Vlastos on the conflicting versions of farming heritage exploited by the early-Meiji elites, by anti-capitalists in the 1920s and imperialists in the 1930s (1998b). On the paternalistic aspects see Voltaire Cang on the grand-master – or *iemoto* – system of arts, craft and performance training, where the *iemoto* has absolute

127

authority over his disciples, often passing it down through primogeniture. This authoritarian, nepotistic business practice has served many schools from the Edo-period onwards as a way of consolidating a kind of brand quality. Cang argues that recently invented or revitalized traditions can get retrospectively configured into an *iemoto* system in order to confer legitimacy upon themselves, as happened with the popular and lucrative *Gujo Odori* dance festival (Cang 2008). Cang believes the legal formulation of Japanese intangible heritage in the 1950s and 1970s gave too much power to stakeholders to invent and dictate value, which aligned with the 'foregone conclusions' of Hobsbawm and Ranger (Cang 2007, quotation p. 53).

14 See Sahlins 1999 pp. 408–409, 411 for examples of traditions, such as Sumo wrestling, that have always been predicated upon commerce.

15 A counter-criticism might be that 'epiphanies' can be amenable to belligerent ideologies. As example, see accounts of the early twentieth-century folklorist Kunio Yanagita, whose non-falsifiable 'visionary' criteria of indigenous values were recruited into the politics of Japanese 'exceptionalism' during the imperial expansion leading up to the Second World War (Harootunian 1998, esp. pp. 145–149, 152–155; Hashimoto 1998, esp. pp. 138, 140–141).

16 Gordon Waitt presented a similarly useful range of tourist authenticity categories in his study of The Rocks heritage waterfront in Sydney, but was not quite so approving of the 'experiential' and more critical than Wang of mis- and under-representation of important groups and narratives (2000, pp. 846–848).

17 The expense for the *sengu* is staggering. In 1993 it cost around 33 billion yen or 320 million dollars, some two-thirds (200 million) coming from Ise Shrine itself, the remaining third (120 million) from donations and tourist revenues (Adams 1998, p. 49). The 2013 *sengu* has been reported as costing somewhere between 55 to 65 billion yen (485 to 585 million dollars). For the 2013 *sengu*, some 13 million visitors passed through by the end of the year, the numbers inflated by grief over the Tohoku earthquake and tsunami in 2011 and anxieties over the crippled Fukushima Daiichi Nuclear Power Plant (Shirayama 2013; Akagawa 2016, p. 19).

18 Even though the qualities of 'flamboyance ... exaggeration, uniformity, profusion and durability' also feature in Japanese aesthetics, these are much less prevalent and seldom seen as 'typical' (Keene 1969, pp. 293–294).

Bibliography

Adams, C., 1998. Japan's Ise Shrine and Its Thirteen-Hundred-Year-Old Reconstruction Tradition. *Journal of Architectural Education*, 52 (1), 49–60.

Aikawa, N., 2004. An Historical Overview of the Preparation of the UNESCO International Convention of the Intangible Cultural Heritage. *Museum International*, 56 (1–2), 137–149.

Aikawa-Faure, N., 2009. From the Proclamation of Masterpieces to the *Convention for the Safeguarding of Intangible Cultural Heritage. In*: N. Akagawa and L. Smith, eds, *Intangible Heritage*. Abingdon, UK and New York: Routledge, 13–45.

Aikawa-Faure, N., 2014. Excellence and Authenticity: 'Living National (Human) Treasures' in Japan and Korea. *International Journal of Intangible Heritage*, 9, 38–51.

Ahmad, Y., 2006. The Scope and Definitions of Heritage: From Tangible to Intangible. *International Journal of Heritage Studies*, 12 (3), 292–300.

Akagawa, N., 2016. Rethinking the Global Heritage Discourse – Overcoming 'East' and 'West'?. *International Journal of Heritage Studies*, 22 (1), 14–25.

Akagawa, N. and Smith, L., eds, 2009. *Intangible Heritage*. Abingdon, UK and New York: Routledge.

Alivizatou, M., 2011. Intangible Heritage and Erasure: Rethinking Cultural Preservation and Contemporary Museum Practice. *International Journal of Cultural Property*, 18 (1), 37–60.

Alivizatou, M., 2012. The Paradoxes of Intangible Heritage. *In*: M. L. Stefano, P. David and G Corsane, eds, *Safeguarding Intangible Cultural Heritage*. Woodbridge, UK: Boydell, 9–21.

Amit, R., 2012. On the Structure of Contemporary Japanese Aesthetics. *Philosophy East and West*, 62 (2), 174–185.

Andriotis, K., 2011. Genres of Heritage Authenticity: Denotations from a Pilgrimage Landscape. *Annals of Tourism Research*, 38 (4), 1613–1633.

Arichi, M., 2013. Sengu and the Pilgrimage to Ise: *Okage Mairi* in the Edo Period. Presented at: *Sengu of the Ise Shrine: Rituals, Myths and Politics*, SOAS Centre for the Study of Japanese Religions, London, 22 November.

Askew, M., 2010. The Magic List of Global Status: UNESCO, World Heritage and the Agendas of States. *In*: S. Labadi and C. Long, eds, *Heritage and Globalisation*. Abingdon, UK and New York: Routledge, 19–44.

Aykan, B., 2015. 'Patenting' Karagöz: UNESCO, Nationalism and Multinational Intangible Heritage. *International Journal of Heritage Studies*, 21 (10), 949–961.

Baulch, L., Collett, D. and Pocock, C., 2015. Assessing Stories before Sites: Identifying the Tangible from the Intangible. *International Journal of Heritage Studies*, 21 (10), 962–982.

Bortolotto, C., 2010. Globalising Intangible Cultural Heritage? Between International Arenas and Local Appropriations. *In*: S. Labadi and C. Long, eds, *Heritage and Globalisation*. Abingdon, UK and New York: Routledge, 97–114.

Breen, J., 2010. Resurrecting the Sacred Land of Japan: The State of Shinto in the Twenty-First Century. *Japanese Journal of Religious Studies*, 37 (2), 295–315.

Breen, J., 2013. Inventing Ise: The Meiji Phase. Presented at: *Sengu of the Ise Shrine: Rituals, Myths and Politics*, SOAS Centre for the Study of Japanese Religions, London, 22 November.

Brown, M. F., 2005. Heritage Trouble: Recent Work on the Protection of Intangible Cultural Property. *International Journal of Cultural Property*, 12 (1), 40–61.

Brumann, C., 2010. Houses in Motion: The Revitalisation of Kyoto's Architectural Heritage. *In*: C. Brumann and R. Cox, eds, *Making Japanese Heritage*. Abingdon, UK: Routledge, 149–170.

Brumann, C. and Cox, R., 2010. Introduction. *In*: C. Brumann and R. Cox, eds, *Making Japanese Heritage*. Abingdon, UK: Routledge, 1–17.

Byrne, D., 2009. A Critique of Unfeeling Heritage. *In*: N. Akagawa and L. Smith, eds, *Intangible Heritage*. Abingdon, UK and New York: Routledge, 229–252.

Cang, V. G., 2007. Defining Intangible Heritage and Its Stakeholders: The Case of Japan. *International Journal of Intangible Heritage*, 2, 46–55.

Cang, V. G., 2008. Preserving Intangible Heritage in Japan: The Role of the *Iemoto* System. *International Journal of Intangible Heritage*, 3, 72–81.

Chakrabarty, D., 1998. Afterword: Revisiting the Tradition/Modernity Binary. *In*: S. Vlastos, ed., *Mirror of Modernity: Invented Traditions of Modern Japan*. Berkeley and Los Angeles: University of California Press, 285–296.

Coaldrake, W., 1996. *Architecture and Authority in Japan*. Routledge: London and New York.

Fukase-Indergaard, F. and Indergaard, M., 2008. Religious Nationalism and the Making of the Modern Japanese State. *Theory and Society*, 37 (4), 2008, 343–374.

Gelunas, A., 2010. Making Art in the Japanese Way: *Nihonga* as Process and Symbolic Action. *In*: C. Brumann and R. Cox, eds, *Making Japanese Heritage*. Abingdon, UK: Routledge, 44–55.

Gluck, C., 1998. The Invention of Edo. *In*: S. Vlastos, ed., *Mirror of Modernity: Invented Traditions of Modern Japan*. Berkeley and Los Angeles: University of California Press, 262–284.

Hafstein, V. Tr., 2009. Intangible Heritage as a List: From Masterpieces to Representation. *In*: N. Akagawa and L. Smith, eds *Intangible Heritage*. Abingdon, UK and New York: Routledge, 93–111.

Hardacre, H., 1989. *Shinto and the State, 1868–1988*. Princeton, NJ: Princeton University Press.

Harootunian, H. D., 1998. Figuring the Folk: History, Poetics and Representation. *In*: S. Vlastos, ed., *Mirror of Modernity: Invented Traditions of Modern Japan*. Berkeley and Los Angeles: University of California Press, 144–159.

Harrison, R., 2013. *Heritage: Critical Approaches*. London and New York: Routledge.

Harrison, R. and Rose, D., 2010. Intangible Heritage. *In*: T. Benton, ed., *Understanding Heritage and Memory*. Manchester and New York: Manchester University Press, 238–276.

Hashimoto, M., 1998. *Chiho*: Yanagita Kunio's 'Japan'. *In*: S. Vlastos, ed., *Mirror of Modernity: Invented Traditions of Modern Japan*. Berkeley and Los Angeles: University of California Press, 133–143.

Hewison, R., 1987. *The Heritage Industry: Britain in a Climate of Decline*. London: Methuen.

Hewison, R., 1989. Heritage: An Interpretation. *In*: David L. Uzzell, ed., *Heritage Interpretation, Volume 1: The Natural and Built Environment*. London and New York: Belhaven Press, 15–23.

Hewison, R., 2012. The Heritage Industry Revisited. The Centre for Urban History Annual Lecture, University of Leicester, Leicester, UK, 30 May.

Hobsbawm, E., 1983/1997. Inventing Traditions. *In*: E. Hobsbawm and T. Ranger, eds, *The Invention of Tradition*. Cambridge: University of Cambridge Press, 1–14.

Holtorf, C., 2013. On Pastness: A Reconsideration of Materiality in Archaeological Object Authenticity. *Anthropological Quarterly*, 86 (2), 427–443.

ICOMOS (International Council of Monuments and Sites), 1994. Nara Document on Authenticity. www.international.icomos.org/charters/nara-e.pdf.

Kaufman, N., 2013. Putting Intangible Heritage in its Place(s): Proposals for Policy and Practice. *International Journal of Intangible Heritage*, 8, 20–36.

Kearney, A., 2009. Intangible Cultural Heritage: Global Awareness and Local Interest. *In*: N. Akagawa and L. Smith, eds, *Intangible Heritage*. Abingdon, UK and New York: Routledge,pp. 209–225.

Keene, D., 1969. Japanese Aesthetics. *Philosophy East and West*, 19 (3), 293–306.

Kim, H. and Jamal, T., 2007. Touristic Quest for Existential Authenticity. *Annals of Tourism Research*, 34 (1), 181–201.

Kirshenblatt-Gimblett, B., 2004. Intangible Heritage as Metacultural Production. *Museum International*, 56 (2), 52–65.

Kreps, C., 2009. Indigenous Curation, Museums, and Intangible Cultural Heritage. *In*: N. Akagawa and L. Smith, eds, *Intangible Heritage*. Abingdon, UK and New York: Routledge, 193–208.

Kurin, R., 2007. Safeguarding Intangible Cultural Heritage: Key Factors in Implementing the 2003 Convention. *International Journal of Intangible Heritage*, 2, 10–19.

Labadi, S., 2010. World Heritage, Authenticity and Post-authenticity: International and National Perspectives. *In*: S. Labadi and C. Long, eds, *Heritage and Globalisation*. Abingdon and New York: Routledge, 66–84.

Loo, T. M., 2010. Escaping Its Past: Recasting the Grand Shrine of Ise. *Inter-Asia Cultural Studies*, 11 (3), 375–392.

Marrie, H., 2009. The UNESCO *Convention for the Safeguarding of the Intangible Cultural Heritage* and the Protection and Maintenance of the Intangible Cultural Heritage of Indigenous Peoples. *In*: N. Akagawa and L. Smith, eds, *Intangible Heritage*. Abingdon, UK and New York: Routledge, 169–192.

Munjeri, D., 2009. Following the Length and Breadth of the Roots: Some Dimensions of Intangible Heritage. *In*: N. Akagawa and L. Smith, eds, *Intangible Heritage*. Abingdon, UK and New York: Routledge, 131–150.

Ono, S. and Woodard, W. P., 1962. *Shinto: The Kami Way*. Rutland, UK and Tokyo: Tuttle.

Pilgrim, R. B., 1972. Zeami and the Way of Noh. *History of Religions*, 12 (2), 136–148.

Pilgrim, R. B., 1977. The Artistic Way and the Religio-Aesthetic Tradition in Japan. *Philosophy East and West*, 27 (3), 285–305.

Reynolds, J. M., 2001. Ise Shrine and a Modernist Construction of Japanese Tradition. *The Art Bulletin*, 83 (2), 316–341.

Richards, S., 2012. 'Shadows in the Farthest Corners': The Pursuit of National Identity in Japanese Architectural Aesthetics. *In*: M. Gamal Abdelmonem and R. Morrow, eds, *Peripheries*. Abingdon, UK and New York: Routledge, 27–39.

Robertson, J., 1998. It Takes a Village: Internationalization and Nostalgia in Postwar Japan. *In*: S. Vlastos, ed., *Mirror of Modernity: Invented Traditions of Modern Japan*. Berkeley and Los Angeles: University of California Press, 110–129.

Sahlins, M., 1999. Two or Three Things That I Know about Culture. *Journal of the Royal Anthropological Institute*, 5 (3), 399–421.

Samuel, R., 1994/1999. *Theatres of Memory, Volume 1: Past and Present in Contemporary Culture*. London and New York: Verso.

Scheiner, I., 1998. The Japanese Village: Imagined, Real, Contested. *In*: S. Vlastos, ed., *Mirror of Modernity: Invented Traditions of Modern Japan*. Berkeley and Los Angeles: University of California Press, 67–78.

Schmitt, T. M., 2008. The UNESCO Concept of Safeguarding Intangible Cultural Heritage: Its Background and Marrakchi Roots. *International Journal of Heritage Studies*, 14 (2), 95–111.

Schofield, J., 2014. Heritage Expertise and the Everyday: Citizens and Authority in the Twenty-first Century. *In*: J. Schofield, ed., *Who Needs Experts? Counter-mapping Cultural Heritage*. Farnham, UK and Burlington, VT: Ashgate, 1–11.

Seeger, A., 2009. Lessons Learned from the ICTM (NGO) Evaluation of Nominations for the UNESCO *Masterpieces of the Oral and Intangible Heritage of Humanity, 2001–5*. *In*: N. Akagawa and L. Smith, eds, *Intangible Heritage*. Abingdon, UK and New York: Routledge, 112–128.

Shirayama, Y., 2013. *Shikinen sengu* of the Ise Shrine: Tradition, Ideology and Politics. Presented at: *Sengu of the Ise Shrine: Rituals, Myths and Politics*, SOAS Centre for the Study of Japanese Religions, London, 21 November.

Siegenthaler, P., 2010. Architecture, Folklore Studies, and Cultural Democracy: Nagakura Saburo and *Hida Minzoku-mura*. *In*: C. Brumann and R. Cox, eds, *Making Japanese Heritage*. Abingdon, UK: Routledge, 59–77.

Skounti, A., 2009. The Authentic Illusion: Humanity's Intangible Cultural Heritage, the Moroccan Experience. *In*: N. Akagawa and L. Smith, eds, *Intangible Heritage*. Abingdon, UK and New York: Routledge, 74–92.

Smith, L., 2006. *Uses of Heritage*. London and New York: Routledge.

Snodgrass, A., 2011. Thinking through the Gap: The Space of Japanese Architecture. *Architectural Theory Review*, 16 (2), 136–156.

Starn, R., 2002. Authenticity and Historic Preservation: Towards an Authentic History. *History of the Human Sciences*, 15 (1), 1–16.

Tankha, B., 2000. Minakata Kumagusu: Fighting Shrine Unification in Meiji Japan. *China Report*, 36 (4), 555–571.

Theodossopoulos, D., 2013. Laying Claim to Authenticity: Five Anthropological Dilemmas. *Anthropological Quarterly*, 86 (2), 337–360.

Tsubaki, A. T., 1971. Zeami and the Transition of the Concept of Yugen: A Note on Japanese Aesthetics. *Journal of Aesthetics and Art Criticism*, 30 (1), 55–67.

UNESCO, 2003. Convention for the Safeguarding of the Intangible Cultural Heritage. www.unesco.org/culture/ich/en/convention.

Vecco, M., 2010. A Definition of Cultural Heritage: From the Tangible to the Intangible. *Journal of Cultural Heritage*, 11 (3), 321–324.

Vlastos, S., ed., 1998a. *Mirror of Modernity: Invented Traditions of Modern Japan*. Berkeley and Los Angeles: University of California Press.

Vlastos, S., 1998b. Agrarianism without Tradition: The Radical Critique of Prewar Japanese Modernity. *In*: S. Vlastos, ed., *Mirror of Modernity: Invented Traditions of Modern Japan*. Berkeley and Los Angeles: University of California Press, 79–94.

Vlastos, S., 1998c. Tradition: Past/Present Culture and Modern Japanese History. *In*: S. Vlastos, ed., *Mirror of Modernity: Invented Traditions of Modern Japan*. Berkeley and Los Angeles: University of California Press, 1–16.

Waitt, G., 2000. Consuming Heritage: Perceived Historical Authenticity. *Annals of Tourism Research*, 27 (4), 835–862.

Wang, N., 1999. Rethinking Authenticity in Tourism Experience. *Annals of Tourism Research*, 26 (2), 349–370.

9

From monument to cultural patrimony

The concepts and practices of heritage in Mexico

Cintia Velázquez Marroni

Introduction

This chapter provides an overview of the patrimonial landscape in Mexico. There is a lack of research on heritage published in English about Latin America, and, more specifically, about Mexico.[1] This is a significant omission in the literature considering the international position Mexico commands on heritage-related matters; for example, it possesses the sixth highest number of World Heritage Sites according to UNESCO (United Nations Educational, Scientific and Cultural Organization) – 33 in total, in comparison with the 50 of Italy, which is ranked first (UNESCO, n.d.) – and it was the tenth most visited country in 2014 (World Tourism Organization – UNWTO, 2014, p. 6). This chapter thus seeks to contribute to published research in English, in order to foster a better knowledge and understanding of this country – and of the Latin American region more broadly.[2]

The chapter considers the rich but complex semantic meaning and practices that *patrimonio* (or patrimony hereafter) has in Mexico, resulting from its particular socio-historical context. This allows an examination of the radical changes that the notion of patrimony has undergone since the nineteenth century, and more significantly in recent decades, when a particular tradition of naming, thinking about, protecting and legislating patrimony is adapting to more international and global trends. Also, it allows an analysis of the ways in which patrimony has been used by the State for nation-building and identity matters. As a country that resulted from the mixing of pre-Hispanic indigenous peoples and the Spanish, the Mexican case is of relevance for those interested in heritage owing to the particular ways in which cultural property, mixed identities, the material past – especially the archaeological one – and the State have interacted.[3] As Ferry points out, Mexico is 'one of the countries with the most extensive legislation concerning cultural properties *and* [*sic*] the strongest connection between the material traces of the past and the nation' (2005, p. 212).

Heritage or patrimony?

Before going any further it is necessary to clarify the use of these terms. The Spanish word *patrimonio* has generally been translated as 'heritage'. However, in recent years, and particularly in a

US context, the word 'patrimony' has gained credence. For example, in his research on the Smithsonian Institution, William Walker writes about 'cultural patrimony' (2013, p. 2). Elizabeth E. Ferry has published a book about 'patrimony, value, and collectivity in Mexico' (2005) and Antonio Azuela has studied national property as patrimony (2011). Ferry provides a compelling argument for using patrimony instead of heritage, cited here in full due to its relevance:

> *Patrimonio* (or hereafter, patrimony) derives from the Latin *patrimonium*, meaning 'paternal estate'. The term can refer literally to property handed down from father to children or from ancestor to descendants, or to the ancestral property of a corporate group or class. It is used much more commonly in Romance languages than in English, and is often translated into English as 'heritage'. In this book I preserve the cognate term 'patrimony' since it contains strongly gendered and kin-inflected associations that are diluted in the word 'heritage'. In current usage patrimony denotes collective, exclusive ownership by a social group, often organized or conceptualized as a patrilineal kin group. To describe something as patrimony places limits on its exchange by classifying it ideally as *inalienable* [*sic*]; such patrimonial possessions are meant to remain within the control of the social group that lays claim to them and usually to be passed down intact from generation to generation.
>
> *(2005, p. 13)*

Sandra Rozental adopts a similar but expanded approach towards the terms *patrimonio* and heritage:

> The Spanish term patrimonio joins its English equivalents 'heritage' and 'inheritance', whilst also indexing the existence of an enduring and deeply hierarchical State – the patria. In Mexico, the underlying premise of patrimonio – understood as a kind of inheritance – is that material possessions [like subsoil resources and ancient artefacts] simultaneously forge and transmit kinship bonds between socially and temporally distinct social beings. At the same time, patrimonio, like 'heritage', makes tangible the ways in which corporate and individual social actors negotiate and lay claims to the past through the material world [...] Nevertheless, patrimonio is a legal property regime and, thus, shapes and mediates relations between people, material possessions, and the State.
>
> *(2014, p. 336)*

In a nutshell, these two authors point towards the cultural specificity contained within the notion of patrimony, which is not present in the notion of heritage. They do so by claiming that patrimony translates the biological link between parents and children to the broader social realm, and as a result societies 'inherit' from what they consider is a 'common ancestry', just as children inherit from their parents. For Ferry, the roots of this are in early medieval and modern familial forms of kinship and inheritance. With the rise of state power, royal property passed down the royal lineage as a 'more generalized category of state property held in the name of the monarch/nation', until eventually 'royal patrimony' became 'national patrimony' (Ferry, 2005, p. 11). This is particularly clear in the case of France after its revolution and can also be seen in Mexico after its independence from Spain in the early nineteenth century. Thus, in these contexts, the intervention of the State is central to understanding the meanings and roles of patrimony (Nivón, 2010, p. 28). Patrimony belongs to the nation, but safeguarding and managing it has been delegated to the State representing the nation. Patrimony performs an essential role in the sustenance of a collective identity; thus, the protection of patrimony is the protection of the modern nation (Smith, 1999, p. 9).

The authors also suggest that patrimony involves a strong relationship between identity and the State. Patrimony is part of the delineation or recognition of a community as it conveys the notion of a 'diachronic kin group' (Ferry, 2005, p. 13) constituted via a series of common inalienable possessions and through the responsibility of maintaining these for future generations. The State is responsible for this patrimony as it is the head of that community and the gatekeeper of 'national identity', and fosterer of nationalism through its control over public property (Vázquez León, 2003, p. 43). Accordingly, debates over the privatization of land, oil and archaeological sites – among others – are vigorously contested because, citing Azuela, 'property issues have a powerful emotional impact on Mexican political discourse' (2011, p. 1922). The loss of these patrimonial possessions is felt to pose a direct threat to Mexico and *mexicanidad* ['Mexicanness'] – the quality of that which is Mexican (Ferry, 2005, p. 199). This might be so, as Graham *et al.* claim, because heritage is also a 'spatial phenomenon'; places and sites can be 'someone's heritage' (2000, p. 4).

The institutional and legal context of Mexican cultural patrimony

As we have seen in the previous section, Mexico is a country in which State formation, identity and patrimony are closely connected. Different patrimony specialists have claimed that Mexico is one of the countries with more state regulation with regard to patrimony than anywhere else (Cottom, 2012; Rojas Delgadillo, 2006; Villareal Escárrega, 2006), and that building this legal framework has been precisely one of the key elements of its nationalism (Cottom, 2012, pp. 174, 175; Vázquez León, 2003, p. 43). In Mexico, patrimony is a constitutional matter because it is considered national property. Dispositions relating to national patrimony are contained in Article 27 of the 1917 Constitution, which states that resources such as land, water and subsoil resources are 'inalienable possessions' of the nation; plus, through secondary legislation, this inalienable character has been expanded to include national parks and archaeological remains (cultural patrimony) (Azuela, 2011, pp. 1915, 1917, 1921).

The 1917 Constitution is the legal document which establishes the general principles that guide national life. This Constitution was produced towards the end of the civil war known as the Revolution, a violent confrontation started in 1910 between different groups with often different claims, but which, on the whole, had a strong popular component and a nationalist stance (Knight, 2015, p. 301). By containing a section that regulates national patrimony, the 1917 Constitution shows that property became fundamental for state formation (Azuela, 2011, pp. 1917, 1918) and for broader social life. It can thus be claimed that patrimony 'emerges out of [both] national juridical structures and the rhetoric of nationalism', and not only out of the notion of inheritance through kinship (Ferry, 2005, pp. 11, 12).

A particular trait of national property dispositions is that there is a strong connection between cultural patrimony and other patrimonies, mainly natural ones, such as land and subsoil resources. The cultural realm was protected by laws in the same way that land or oil were; for example, oil was nationalized in 1938 and one year later a national body for the protection and regulation of cultural property was created (the National Institute for Anthropology and History, or INAH – its acronym in Spanish) (Ferry, 2005, p. 212; Rozental, 2011, p. 347). This shows that both natural resources and culture are perceived to be essential for a collective vision of the nation and its identity (Florescano, 1997b, p. 17). Due to space constraints, however, in this chapter I will only focus on some aspects of cultural patrimony.[4]

INAH was created in 1939 to carry out the following roles: to be responsible for all exploration of archaeological sites; to survey, conserve and restore artistic, historical and archaeological monuments; and to research – and consequently, disseminate knowledge – about these monuments

as well as about indigenous groups (Olivé and Urteaga, 1988, p. 19).[5] The creation of INAH brought to an end what had been up until that date discontinuous bureaus and commissions, and so became 'a capstone to the evolution of an organizational structure for the government-sanctioned presentation of Mexican history and culture' (Saragoza cited in Ferry, 2005, p. 213). From its inception and up until the 1970s, INAH operated with a legislature that was not quite suited for the task to which it had been appointed (Olivé and Urteaga, 1988, p. 25). In 1972, the directorate of INAH finally managed to pass through Congress the 'Federal Law on Archaeological, Artistic and Historical Monuments and Sites', which implemented and specified new regulations in order to better serve its purpose of safeguarding national cultural patrimony as broadly stated in Article 27 of the Constitution. This law was the result both of the practical experience gained from the operation of INAH since 1939 and of the discussion between the different parties involved (Olivé and Urteaga, 1988, p. 34).

Although a key institution in nationalist cultural policies from roughly the second half of the twentieth century, INAH has experienced the impact of broader changes in the economy and politics in the last 20 years or so, owing to the internationalization of the market and to societal change more generally. New actors have emerged on the scene of patrimony management and use, which has forced INAH to renegotiate its power. The clearest case is UNESCO, which through its designation of World Heritage Sites has become a body of both protection and pressure that, at times, exceeds the authority of INAH. Also, in the 1990s and 2000s, several proposals and bids were made in order to both change the competencies of INAH and to encourage the entrance of other bodies, including Non-Governmental Organizations (NGOs), universities and private individuals, in the use and management of patrimony (Cottom, 2012, pp. 178–183; Ferry, 2005, pp. 213–216). The language or terminology of these bids and proposals was often that of 'modernization'. INAH itself was reorganized intensively during this time with the aim of having a more commercially-oriented policy (Olivé Negrete and Cottom, 2003, p. 70).

This same language of modernization was used, as Ferry shows, in 1992 to change some aspects of collective land tenure as it was originally laid out in the 1917 Constitution, which was a cornerstone of the 'social pact' of the Revolution (Azuela, 2011, p. 1915; Ferry, 2005, pp. 205–206). But whilst the bills to foster privatization of land tenure and oil were approved by Congress in 1992 and December 2013 respectively, those relating to cultural property have not yet been passed. From this we can deduce that, among other factors, the realm of cultural patrimony continues to be a highly delicate issue, probably due to its symbolic power. However, the pressure to 'modernize' and 'democratize' INAH, generally seeking the reduction of state intervention as regards cultural property and its opening up to other entities – among them the private sector – has increased in the last decade. In December 2015 a radical change in the cultural sector took place: a Ministry of Culture was created, with the justification of providing this sector with a greater economic and operative strength. However, as has been questioned in the media, there is a risk that in creating this Ministry, INAH will lose power, and that cultural patrimony will become more vulnerable to economic exploitation.[6]

The creation of the Ministry of Culture, and the fact that the bill to change some of INAH's regulations – and thus its legislative power – continues to be present at the negotiating table does show that the 'uses of cultural patrimony are changing in the era of free trade and economic restructuring' (Ferry, 2005, p. 213). Pressure from the private sector, but also from different popular constituencies such as local organizations and NGOs, are pushing to have a greater share in the patrimonial landscape, and in several instances they have managed to impose their views over those of INAH. They do so by claiming their own understandings and ways of using patrimony (Azuela, 2011, p. 1941; Ferry, 2005, p. 216; García Canclini, 1997, pp. 66–70). It seems

Cintia Velázquez Marroni

that there is now a coexistence and intermingling of different idioms about patrimony (Ferry, 2005, p. 216), a situation that demands a more nuanced understanding of the wide array of conceptions as regards patrimony that currently circulate in the public sphere.

The intellectual landscape

Research about cultural patrimony in Mexico has been largely shaped by the institutional and legal context presented above. From the 1940s up until the early 1990s, INAH was the main – and one of the few – institutions that published on the topic. Therefore, on the whole, publications within this time frame were not abundant and had an institutional and technical character (Rosas Mantecón, 2005, p. 60). Research was produced by the State – through INAH – according to official regulations and in relation to public policies. It was aimed more at application and operation than at critiquing the state of things. As a result, some aspects and topics, mainly laws, and the conservation of tangible and built patrimony – especially of an archaeological nature – were better served than others. In particular, patrimonial research was heavily characterized – and still is to date – by an emphasis on legal aspects (Vázquez León, 2003, p. 96).

Some of the key texts of this period are: Julio Olivé and Augusto Urteaga's history of INAH (1988) – which is to date the only book of its kind;[7] Salvador Díaz Berrio's works on the conservation of cultural patrimony (1976, 1986, 1990); and INAH's different compilations of regulations and conferences (1980, 1985a, 1985b, 1985c). Literature devoted to legal issues was also very significant (Gertz Manero, 1976; Litvak King *et al.*, 1980; Lombardo de Ruiz, 1988; Melé, 1995, 1998).[8] It is important to mention that the 1970s and 1980s were not exempt from criticism, but even this came from within INAH, specifically from its Union of Academics, who often opposed the impositions of the federal government and president over INAH (Delegación Sindical de Académicos del INAH, 1983).

Towards the late 1980s and early 1990s, however, there was an increase in the variety and sources of criticism of the idea of cultural patrimony, some of which came from the anthropological domain. In particular, two texts were fundamental: Guillermo Bonfil Batalla's *México Profundo: una civilización negada* [*Deep Mexico: A Denied Civilization*] (1990 [1987]) and Nestor García Canclini's *Hybrid Cultures* (1989). Unlike other texts, these brought the problematic nature of cultural patrimony to the forefront of the discussion, as well as the dynamics of power and domination that exist at its core, and therefore, the unequal conditions of its definition, conservation, use and access.[9] Also, new institutions and entities started to take part in the debate, thus bringing new approaches and views. Finally, there was an expansion of the scope and volume of the research produced in regard to cultural patrimony.

It is in the 1990s that the first and most important compilations on the topic of cultural patrimony in Mexico were produced: *El patrimonio cultural de México* [*Mexico's Cultural Patrimony*] (1993) and *El patrimonio nacional de México* [*Mexico's National Patrimony*] (1997a), both edited by Enrique Florescano. The second edition followed from the success of and high demand for the 1993 version, a result of which was that it was expanded into two volumes, to include the natural realm. The 1997 work featured 23 sections across the 2 volumes, written by different authors, 4 of which were of a more critical nature, and the rest comprising a documentary approach on topics as diverse as flora, fauna, palaeontology, ethnic diversity, language, books, arts, music, popular art, film, museums, archaeological sites, archives, cartography and Mexican cuisine. As we might expect from its comprehensiveness, *Mexico's National Patrimony* sought to encompass, somewhat encyclopaedically, the vastness of patrimony, whilst also attempting to systematize it. Whilst some of the chapters are mostly historical accounts or chronicles lacking in critical spirit, on the whole this compilation became the most important

text about patrimony in Mexico. It constituted the zenith of a previous tradition of research, mainly aimed at conservation and documentation, but that had, so far, remained scattered. However, it also became the basic reference text for both a wider array of topics and for new critical studies.

Published research on cultural patrimony experienced an intense growth in the 2000s. It was evident that publications on patrimony had stopped being 'monopolized' by INAH, the concept now being addressed by other public institutions such as the National University (UNAM), the Metropolitan University (UAM) and regional and local bodies, including several universities from outside Mexico City, to mention a few. There is also, of course, the input from UNESCO, ICOM (International Council of Museums) and even private media companies such as Televisa, who support events and publications relating to patrimony. There has been an increase in the variety and richness of the debated topics as well, including a strong emphasis on intangible patrimony, tourism, cultural industries, popular or local forms of patrimony, contemporary patrimony and even digital patrimony (Arizpe *et al.*, 2004; Ferry, 2005; Nivón and Rosas Mantecón, 2010; Piedras, 2006; Rozental, 2014; Vaca and García, 2012; Voutssás, 2009). Along with this, INAH continues to produce and publish research on the area in its traditional line. As for compilations, a new and more comprehensive work focussing on cultural patrimony was produced: the six volumes resulting from the project entitled *El patrimonio histórico y cultural de México (1810–2010)* [*Mexico's Historical and Cultural Patrimony (1810–2010)*], coordinated by E. Florescano, were published as part of the commemorations for the Bicentenary of Independence (1810) and the Centenary of the Revolution (1910).[10]

In conclusion, it is possible to claim that at present, the study of patrimony is not a homogenous field but rather a complex archipelago of trends, frameworks and traditions. As a result, this field of enquiry has also become richer and more critical. Yet, as anthropologist Bonfil Batalla asserted back in the 1990s, and despite all the research conducted on patrimony, there are two essential things on which there is no agreement even today: what constitutes the cultural patrimony of a society? And, where does the importance of patrimony lie – both for the specialist and for non-specialists (Batalla, 1997, p. 28)?

From monument to patrimony: changing concepts

In this section I will address the first of these two questions, showing the different changes that the concept of patrimony and related terms have undergone. The terminology used to refer to cultural property is constantly adapting and incorporating new elements, in such a way that it seems inappropriate to try to establish a static definition of what it does or does not include. Rather, I will attempt to show the socio-historical conditions that lie behind conceptions of what patrimony and similar terms should encompass. As Nivón claims, tracing the changes in how patrimony is understood remains essential to explain the politics – and practices – that have been followed in this regard (2010, p. 15).

Definitions of patrimony used since the late 1980s and 1990s tend to be broad – vague, even – as this seems to be as far as consensus is possible. For example, Olivé and Urteaga state: 'in the vast set of cultural property there are some with especial historic, social or aesthetic value, which make up the cultural patrimony that should be preserved by the community' (1988, p. 7). About a decade later, definitions continued to be equally broad. Enrique Florescano refers to it as 'social property [*bienes sociales*] and of collective responsibility';[11] that is, 'national property [*bienes nacionales*]' (1997b, p. 9). Bonfil Batalla provided an equally broad definition: 'the collection [*acervo*] of cultural elements that societies have made theirs through time, whether because they created them or because they adapted and adopted them' (1997, p. 31).[12]

The wide and encompassing view of patrimony as shown in the above definitions is the result of a long process of an incorporation of visions and elements into what was originally called *antigüedades* [antiquities]. In Mexico, the earliest notions of patrimony as something socially valuable were associated with the pre-Hispanic world, such as ruins and objects; in other words, with the ancient and the material (Tovar y de Teresa, 1997, pp. 90, 91). This explains why, as several authors show, the literature related to patrimony in Mexico originated in close connection with the archaeological realm (Litvak King *et al.*, 1980; Olivé Negrete, 1980).[13]

This archaeological realm was central in the definition of a 'Mexican identity' towards the first decades of independent life in the early nineteenth century (Florescano, 1997c; López Caballero, 2011). Accordingly, 'Mexican antiquities', as they were called, started to be explicitly preserved and taken care of under the label of 'monuments'. It is during the late nineteenth century that the first institutional and legal infrastructure was created in order to protect patrimony; for example, the *Inspección General de Monumentos* [*General Inspection of Monuments*] (1885) and the *Ley sobre Monumentos Arqueológicos* [*Law for Archaeological Monuments*] (1897) (Tovar y de Teresa, 1997, pp. 91, 92).

From this moment onwards, by looking at the different regulations that were enacted in the twentieth century, it is possible to trace the development of a richer and more specific patrimonial lexicon; for example, there starts to be a recognition of different realms such as 'artistic', 'historic' and 'archaeological'; also, there is a use of other words besides 'monument', such as 'properties', 'beauties' and even 'cultural patrimony' (Díaz Berrio Fernández, 1990, pp. 180, 181; Tovar y de Teresa, 1997, p. 93). Interestingly, the first official law in which the word 'patrimony' is used does not appear until 1970, in the *Federal Law of the Cultural Patrimony of the Nation*. It is possible that this was influenced by the international landscape, where the notion of 'cultural patrimony' started to consolidate around the 1960s at UNESCO conferences (Lombardo de Ruiz, 1997, p. 200).

However, in spite of the consolidation of the notion of cultural patrimony at an international level, Mexican legislation on cultural patrimony returned to its original denomination of 'monument'; the 1972 *Federal Law on Archaeological, Artistic, and Historic Monuments and Sites* is still current. However, the concept of 'monument' has now expanded and incorporated new elements beyond the material and the ancient. As Bolfy Cottom argues, '[T]he concept of monument refers to those sources of historic, anthropological and cultural knowledge, not to the architectural magnificence, as has been often mistakenly said', and thus, it is not opposed to the idea or concept of cultural patrimony (2012, p. 177). All this points to the importance that the particular notion of 'monument' has had and continues to have in the Mexican tradition, at least in legal and official terms, and how it has come to coexist with the widespread term of cultural patrimony, promoted in international conventions by entities such as UNESCO to which Mexico has subscribed (Díaz Berrio Fernández, 1990, p. 407). It is important to note that this subscription can be said to be symbolic and thus of a limited application, as in legal terms most of these charters have neither been officially approved, nor incorporated by existing law.

Precisely because of the strong association in Mexico between archaeology and cultural patrimony, its research, management and conservation has normally been a preserve dominated by archaeologists, conservators and architects. However, since the 1990s there has been an increased involvement of social scientists and historians, and thus a wider consideration of sources and processes (García Canclini, 1997, p. 64; Rosas Mantecón, 2005, pp. 61, 62). The coming together or interaction between the technical and the social science strands, which had so far operated separately (Rosas Mantecón, 2005, p. 62), has resulted in an expansion of the notion of patrimony and of the debates surrounding it. Similarly, from legal (Azuela, 2011, p. 1941) and

anthropological (Vázquez León, 2003) perspectives, there are claims for a greater incorporation of the social sciences into the debate on law and patrimony.

Another of the most important changes in the terminology, and thus conception of what patrimony encompasses, is the consideration of other elements beyond the physical realm. In particular, the notion of 'intangible heritage' has become increasingly significant from the second half of the twentieth century onwards, following an international trend (Arizpe *et al.*, 2004). This interest in the intangible has been both the result and the cause of a new interest in the patrimony of other non-elite and marginal groups that had so far been dominated by notions of 'high culture' (Florescano, 1997b, pp. 18, 19; García Canclini, 1997, p. 58). It has also meant that patrimony is now not only about antiquities (passed or 'dead' cultural property), but also about living property, which is being used by people according to the needs of the present, and in a process of constant re-evaluation (García Canclini, 1997, p. 58; Rozental, 2014, p. 336). Thus, it has also meant that patrimony is not only about preserving the 'authentic' but also about all those cultural objects that a society values as representative or significant (García Canclini, 1997, p. 84).

In brief, it can be said that the notion of patrimony has been expanded in the following ways: (1) it seeks to be representative of diverse social groups; (2) it is now also aware of the intangible; (3) it considers present and contemporary phenomena (what is now the present will become patrimony in the future); (4) it recognizes collective production (and not only that produced by individual or elites); (5) it is sensible to both the local and the regional realms; (6) it takes into consideration the relationship between natural and cultural patrimony; and (7) it aims at increasing social participation (Tovar y de Teresa, 1997, pp. 99–102). To this, we could include two more developments: one, mentioned by Rosas Mantecón, is the realization that the material and social conditions in which patrimony is produced and consumed are as important as heritage itself (2005, p. 64); and the other, mentioned by Nivón, is that the economic, technological and social changes brought about by globalization have intensified the commodification of patrimony – its conception as a commercial asset (2010, p. 28).

Still, the debate about patrimony continues. This is not only because there is a discussion about how current national legislation can adapt to and integrate international trends that have been condensed in charters or agreements, but also, whether this process can be matched in terms of resources (financial, human and material), without compromising the authority of state bodies such as INAH and the National Institute for Fine Arts (or INBA – its acronym in Spanish). At present, although some advancements have been made, authors do agree that the preservation, research and dissemination of patrimony still privileges some areas over others (Cottom, 2012, p. 195; Tovar y de Teresa, 1997, pp. 96, 97). The recent creation of the Ministry of Culture further complicates the landscape, as it is not clear how this will affect the conceptualization and administration of patrimony.

Patrimony and the social construction of national identity

In this last section I will address Bonfil Batalla's second question, which – as mentioned above – has to do with the importance or value of patrimony. One of the key roles of patrimony is its capacity to create and sustain identity. Patrimonial debate in Mexico is of particular importance because the formation of a national patrimony was also the 'foundation' and sustenance of a notion of collective identity (Azuela, 2011, p. 1942; Cottom, 2008, p. 22). However, identity is not a term that lends itself to notions of uniformity or stability. If patrimony is about identity, to which identities does it speak? Is it possible to reconcile or bring together several at once? I will proceed to examine in more detail the problems aroused by the relationship between identity and cultural patrimony in Mexico.

As I briefly referred to in the section 'The intellectual landscape', anthropological critique from the late 1980s used conflict as a central idea in the analysis of patrimony. Unlike previous literature, scholars did not treat patrimony as something 'given' or self-evident, but rather as a social construction that selects according to hierarchies of value that 'which [is] considered *worthy* [sic] of being preserved' (Rosas Mantecón, 2005, p. 64). Therefore, cultural patrimony as a social construction is a 'place of material and symbolic struggle within classes, ethnicities and groups', not a fixed and neutral set of properties (García Canclini, 1997, p. 61). Cultural patrimony is a reflection of this struggle, as it embodies a particular ideological selection of elements that are deemed to represent identity (Lombardo de Ruiz, 1997, p. 208).

For Bonfil Batalla, the hierarchies of value in Mexico have historical roots in the Conquest, when a dominant Western culture imposed its values over those of the indigenous world (1997, pp. 32, 33). During the nineteenth century, a period in which there was intense activity in the consolidation of a national State, both physically and symbolically, debate about patrimony and identity were central, especially in the last two decades (Ferry, 2005, p. 200; Florescano, 1997c, pp. 162, 163; Lomnitz-Adler, 2001, pp. 46–52). Towards the first decade of the twentieth century, this search for a 'common culture' capable of appealing to all the different groups that inhabited Mexico focused on the pre-Hispanic indigenous world (Lombardo de Ruiz, 1997, p. 199) and its archaeological past.

As Smith has argued, archaeological concepts and practices are essential to nationalism, as they support the idea of a 'distinctive, territorial nation' (2001, p. 441). Thus was the case in Mexico: archaeology, as an emerging discipline, was placed in the service of the State in order to 're-discover' the pre-Hispanic past and to make it the source of national unity and identity (Armstrong Fumero, 2010, p. 8). It was a 'political ideologization' of the archaeological past and of pre-Hispanic civilizations (Litvak King and López Varela, 1997, p. 189), and one which allowed the State to legitimate itself on a social scale (López Caballero, 2008). This vindication required the tasks of conservation, study and exhibition of the vestiges (or 'antiquities', as they were called) of that past, which turned them into a sort of 'transcendental aesthetics of the collective identity of Mexico' (Morales Moreno, 2007, p. 57). As mentioned in the previous section, the protection and regulation of antiquities was consolidated precisely towards the end of the nineteenth and beginning of the twentieth centuries.

During the twentieth century, the State intensified the centralization of objects and collections in the main national museums. It was part of a 'State-led [sic] project to move artifacts from all over Mexico to the country's cultural and political centre' (Rozental, 2014, p. 333). Objects that were considered fundamental for the 'display' of national identity were 'patrimonialized' and taken to the capital city, often with an imposition upon or displacement of the original local communities where these objects came from. This concentration of patrimony in the 'heart' of the nation can thus be understood as both a physical and symbolic act of creating a national identity (Rozental, 2011, p. 348).

The colonial realm, and in general its inclusion into a notion of national identity, underwent a very different process of 'patrimonialization'. Unlike the pre-Hispanic domain, interest in the colonial world underwent a much slower process of recognition. Because the independent nation had broken ties with Spain and was defining a new identity, the separation from all that had Spanish influence was seen as necessary, and thus it could not be so easily articulated as something 'worthy' of preserving (patrimony): 'colonial legacy had no legitimacy in the eyes of the anthropologist-ideologues who had been charged with "creating" a national society' (López Caballero, 2008, p. 340). It is only towards the second half of the nineteenth century, but mainly towards the 1930s, when Hispanic roots started to be valued and incorporated into an idea of 'Mexicanness', and accordingly, 'colonial patrimony' became part of the national

patrimony. This was largely due to the development of an idea of 'Mexican identity' based on the hybridization of the indigenous and Spanish worlds (Armstrong Fumero, 2010, pp. 11–13; Lombardo de Ruiz, 1997, pp. 201–206; Lomnitz-Adler, 2001, pp. 53, 54), in such a way that the *mestizo* became the archetype of national identity (Gutiérrez Chong, 1998, p. 88).[14] Yet, the archaeological pre-Hispanic past continues to exert a powerful influence on Mexican national identity.

The current political landscape (second decade of twenty-first century), however, shows that the discourse of a national identity based on a purist and archaeological notion of the indigenous world has been increasingly questioned. This has been the result, among many other factors, of the anthropological critique of the 1980s and 1990s, the change in public policies and new configurations of Mexican society. Nowadays it is possible to see a clash between different understandings of national identity, and its resulting problems in the practical realm of the definition, protection and display of patrimony (Nivón, 2010).

Patrimony has become a much more complex ground, precisely because claims to belonging, to rights and to identity have diversified among many social groups. In the current economic climate, these claims have intensified, as the argument of identity has become a common resource amongst local groups and entities who seek to make patrimony a source of income or even a means of making a living. It is thus possible to argue that as the notion of national identity becomes harder to maintain, there is also a strengthening of private interests over public ones, and thus, 'aspects of patrimony that emphasize individual and family responsibility are at the forefront' (Ferry, 2005, p. 205). Pressure from large international bodies, such as UNESCO, and the private sector, along with an increased recognition of patrimony as a key source of income (a 'commodified product' (Nivón, 2010, p. 15), are indeed altering the way in which patrimony has hitherto been linked to a particular idea of national identity.

Conclusion

In this chapter I have sought to present the particularities of the notion of patrimony in the Mexican context, as well as to examine the socio-historical conditions and context that explain its developmental path. First, I have attempted to show that the term heritage is not appropriate for conveying the particular web of implications that *patrimonio* has. Second, I have also presented how changes in the traditional concepts and terminologies of patrimony – for example, the notion of 'monument' – have taken place as a result of the interaction and intervention of new entities beyond the State and INAH. Finally, I have addressed the intellectual production on the subject and its practice in the specific realm of national identity.

Mexico is a relevant case with which to trace the way in which state-dominated patrimony and national identity are being impacted by international trends; transformations in notions and meanings of national patrimony are being matched by broader societal transformation. As a result of these processes, the landscape of research on patrimony in Mexico has become richer, more varied, but also more vast and complex. Despite this, the knowledge of the Mexican patrimonial context can enhance our understanding of heritage in other countries, whether by similarity – for example, in countries with a strong tradition of State intervention or with a significant archaeological past – or by stark contrast.

Notes

1 Two of these books, for example, are those edited by Fairclough *et al.* (2008) and Graham and Howard (2008).

2 Where possible, the author has sought to provide references in English. The majority of sources about patrimony in Mexico, especially those from the 1990s and earlier, are available only in Spanish. This may have limited the availability of research on the topic at an international level.

3 Before the arrival of the Spanish conquerors and colonizers in the late fifteenth and early sixteenth centuries, the territory that Mexico now occupies was populated by many indigenous nations, several of which had built large urban complexes. Colonial times in what came to be New Spain were characterized by ethnic and cultural intermixing. The War of Independence started in 1810 and was achieved officially in 1821, after which processes of nation-building intensified and eventually the Republic of Mexico came into being.

4 The realm of natural patrimony, whether this comprises land, subsoil, or more recently, the ecosystem, has a complex story of its own. Different authors provide insights on topics such as flora, fauna, biodiversity, palaeontology, mining and land, among others, in the compilations by Escalante (2011) and Florescano (1997a).

5 A similar institution, INBA, which focuses upon artistic patrimony, was founded in 1946. For reasons of space, I will focus on INAH in this particular study. The articles by Villareal Escárrega (2006) and Rojas Delgadillo (2006) provide an explanation of INAH and patrimonial law in Mexico in English. INAH's website has basic information in English about its mission and goals. It is available at www.inah.gob.mx/en/34-inah (accessed on 2 February 2016).

6 Previously, INAH and INBA belonged to the Ministry of Education. The creation of the new Ministry is still very confused and there is public uncertainty about the impact that this will have. The media has covered the debates surrounding the new Ministry of Culture (Aguilar *et al.*, 2015; Amador Tello, 2015; La Jornada, 2015); as of yet there is no academic literature due to the newness of the matter.

7 This book was originally published in 1988, but two later versions followed in 1995 and 2003. The last two versions included updates and additions, mainly in the documentary appendices, but on the whole remain fairly similar to the first edition. There has not been any other attempt to produce a comprehensive history of INAH, a task that would be practically impossible due to the dimensions of this institution. Recently, though, a book specifically about INAH's museums was published (Del Río, 2010).

8 As mentioned, legal research on patrimony continues to be a central topic in the literature; for example, the works by Cottom (2008, 2012) and Rojas Delgadillo (2006).

9 Another anthropological critique of patrimony during this time is furnished by López Aguilar (1991).

10 The six volumes of this work are devoted to geography, anthropology and cultural patrimony, ideas of cultural and historical patrimony and nineteenth- and twentieth-century visual arts, literature and music. For the purposes of this chapter, the volume edited by Pablo Escalante, *La idea de nuestro patrimonio histórico y cultural* [*The Idea of Our Historical and Cultural Patrimony*] (2011) has been particularly useful.

11 The literal translation of the Spanish word *bien* could be 'good' or 'commodity'. However, these two words have a marketplace connotation, which contrasts with the inalienable character of patrimony. This is why I have decided to use 'social' or 'national property' for the translation.

12 *Acervo* is another Spanish word that has no literal translation. The closest related English word is 'collection'.

13 Litvak King (1989) has published an article in English relating to this matter.

14 *Mestizo* is a Spanish word that refers to individuals of mixed indigenous and European ancestry, and as such, it was 'an unmarked ethnoracial category' that defined the majority of the population by differentiating, at the same time, from the 'purely indigenous' (Ferry, 2005, p. 5). *Mestizaje* refers to the process of 'inter-ratial mixing' (López Caballero, 2008, p. 336), and in the Mexican context, it has a positive connotation.

Bibliography

Aguilar, Y., Ventura, A. and Piñón, A., 2015. Intelectuales, a favor y en contra de la Secretaría de Cultura. *El Universal*, 3 September. Available from: www.eluniversal.com.mx/articulo/cultura/patrimonio/2015/09/3/intelectuales-favor-y-en-contra-de-la-secretaria-de-cultura (accessed 31 January 2016).

Amador Tello, J., 2015. La nueva Secretaría de Cultura, en la polémica. *Proceso*, 18 September. Available from: www.proceso.com.mx/?p=415664 (accessed 31 January 2016).

Arizpe, L., Singer, S, Rosas, A., Castro, A. H., Mantecón, A. R., Consejo Nacional para la Cultura y las Artes (México), Instituto Nacional de Antropología e Historia (México), Fundación Televisa and

International Council of Museums (México), eds, 2004. *Patrimonio intangible: resonancia de nuestras tradiciones. Memorias.* México: ICOM México, Fundación Televisa.

Armstrong Fumero, A., 2010. Manuel Gamio and Forjando Patria: Anthropology in the Times of the Revolution. *In:* A. Armstrong Fumero, ed., *Forjando Patria. Pro-nacionalismo (Forging a Nation).* Boulder, CO: University Press of Colorado, pp. 1–20.

Azuela, A., 2011. Property in the Post-post-revolution: Notes on the Crisis of the Constitutional Idea of Property in Contemporary Mexico. *Texas Law Review, 89*(7), 1915–1942.

Bonfil Batalla, G., 1990. *México profundo : una civilización negada.* México: Grijalbo, Consejo Nacional para la Cultura y las Artes.

Bonfil Batalla, G., 1997. Nuestro patrimonio cultural: un laberinto de significados. *In:* E. Florescano, ed., *El patrimonio nacional de México.* México: Consejo Nacional para la Cultura y las Artes, Fondo de Cultura Económica, pp. 27–56.

Cottom, B., 2008. *Nación, patrimonio cultural y legislación: los debates parlamentarios y la construcción del marco jurídico federal sobre monumentos en México, siglo XX.* México: Editorial Miguel Ángel Porrúa.

Cottom, B., 2012. La legislación mexicana del patrimonio cultural nacional. Un panorama incierto. *In: Diagnóstico en defensa del patrimonio: homenaje a Manuel González Galván.* México: Universidad Nacional Autónoma de México, Instituto de Investigaciones Estéticas, pp. 173–196.

Del Río, L., 2010. *Las vitrinas de la nación. Los museos del Instituto Nacional de Antropología e Historia (contexto, desarrollo y gestión). 1939–2006.* México: Instituto Nacional de Antropología e Historia.

Delegación Sindical de Académicos del INAH, 1983. *La Defensa del Patrimonio Cultural. Primer foro.* México: Sindicato Nacional de Trabajadores de la Educación.

Díaz Berrio Fernández, S., 1976. *Conservación de monumentos y zonas monumentales.* México: Secretaría de Educación Pública.

Díaz Berrio Fernández, S., 1986. *Protección del patrimonio cultural urbano.* México: Instituto Nacional de Antropología e Historia.

Díaz Berrio Fernández, S., 1990. *Conservación del patrimonio cultural en México.* México: Instituto Nacional de Antropología e Historia.

Escalante, P., 2011. *La idea de nuestro patrimonio histórico y cultural.* México: Consejo Nacional para la Cultura y las Artes.

Fairclough, G., Harrison, R., Jameson, J. H. and Schofield, J., eds, 2008. *The Heritage Reader.* London: Routledge.

Ferry, E. E., 2005. *Not Ours Alone: Patrimony, Value, and Collectivity in Contemporary Mexico.* New York: Columbia University Press.

Florescano, E., ed., 1993. *El patrimonio cultural de México.* México: Consejo Nacional para la Cultura y las Artes, Fondo de Cultura Económica.

Florescano, E., ed., 1997a. *El patrimonio nacional de México,* 2 vols. México: Consejo Nacional para la Cultura y las Artes, Fondo de Cultura Económica.

Florescano, E., 1997b. El patrimonio nacional. Valores, usos, estudio y difusión. *In:* E. Florescano, ed., *El patrimonio nacional de México.* México: Consejo Nacional para la Cultura y las Artes , Fondo de Cultura Económica, pp. 15–27.

Florescano, E., 1997c. La creación del Museo Nacional de Antropología. *In:* E. Florescano, ed., *El patrimonio nacional de México.* México: Consejo Nacional para la Cultura y las Artes, Fondo de Cultura Económica, pp. 147–171.

García Canclini, N., 1989. *Hybrid Cultures: Strategies for Entering and Leaving Modernity.* Minneapolis: University of Minnesota Press.

García Canclini, N., 1997. El patrimonio cultural de México y la construcción imaginaria de lo nacional. *In:* E. Florescano, ed., *El patrimonio nacional de México.* México: Consejo Nacional para la Cultura y las Artes, Fondo de Cultura Económica, pp. 57–86.

Gertz Manero, A., 1976. *La defensa jurídica y social del patrimonio cultural.* México: Fondo de Cultura Económica.

Graham, B. J., Ashworth, G. J. and Tunbridge, J. E., 2000. *A Geography of Heritage: Power, Culture, and Economy.* Abingdon, UK: Routledge.

Graham, B. J. and Howard, P., eds, 2008. *The Ashgate Research Companion to Heritage and Identity.* Aldershot, UK: Ashgate.

Gutiérrez Chong, N., 1998. Arquetipos y estereotipos en la construcción de la identidad nacional de México. *Revista Mexicana de Sociología, 60*(1), 81–90.

INAH, 1980. *Disposiciones legales del patrimonio cultural*. México: Instituto Nacional de Antropología e Historia.

INAH, 1985a. *Primera Reunión para Definir una Política Nacional de Conservación de Monumentos: las legislaciones sobre la conservación de los monumentos históricos*. México: Instituto Nacional de Antropología e Historia.

INAH, 1985b. *Segunda Reunión para Definir una Política Nacional de Conservación de Monumentos: teorías y técnicas de conservación y restauración en su contexto*. México: Instituto Nacional de Antropología e Historia.

INAH, 1985c. *Tercera Reunión para Definir una Política Nacional de Conservación de Monumentos: zonas y monumentos históricos en el mercado inmobiliario*. México: Instituto Nacional de Antropología.

Knight, A., 2015. History, Heritage, and Revolution: Mexico, *c.*1910–*c.*1940. *Past & Present, 226*(Suppl. 10), 299–325.

La Jornada, 2015. Secretaría de Cultura: nacimiento entre críticas. *La Jornada*, 22 December. Available from: www.jornada.unam.mx/2015/12/22/opinion/002a1edi (accessed 31 January 2016).

Litvak King, J., 1989. Cultural Property and National Sovereignty. *In:* P. M. Messenger, ed., *The Ethics of Collecting Cultural Property: Whose Culture? Whose Property?* Albuquerque: University of New Mexico Press, pp. 199–214.

Litvak King, J., González, L. and González, M. del R., eds, 1980. *Arqueología y derecho en México*. México: Universidad Nacional Autónoma de México.

Litvak King, J. and López Varela, S., 1997. El patrimonio arqueológico. Conceptos y usos. *In:* E. Florescano, ed., *El patrimonio nacional de México*. México: Consejo Nacional para la Cultura y las Artes, Fondo de Cultura Económica, pp. 172–197.

Lombardo de Ruiz, S., 1988. *Antecedentes de las leyes sobre monumentos históricos (1536–1910)*. México: Instituto Nacional de Antropología e Historia.

Lombardo de Ruiz, S., 1997. El patrimonio arquitectónico y urbano (de 1521 a 1900). *In:* E. Florescano, ed., *El patrimonio nacional de México*. México: Consejo Nacional para la Cultura y las Artes, Fondo de Cultura Económica, pp. 198–240.

Lomnitz-Adler, C., 2001. *Deep Mexico, Silent Mexico: An Anthropology of Nationalism*. Minneapolis: University of Minnesota Press.

López Aguilar, F., 1991. Tres discursos sobre el patrimonio cultural y su desconstrucción. *Antropología. Boletín Oficial Del Instituto Nacional de Antropología E Historia, 33*.

López Caballero, P., 2008. Which Heritage for Which Heirs? The Pre-Columbian Past and the Colonial Legacy in the National History of Mexico. *Social Anthropology, 16*(3), 329–345.

López Caballero, P., 2011. De cómo el pasado prehispánico se volvió el pasado de todos los mexicanos. *In:* P. Escalante, ed., *La idea de nuestro patrimonio histórico y cultural*. México: Dirección General de Publicaciones Consejo Nacional para la Cultura y las Artes, pp. 137–151.

Melé, P., 1995. La construccion jurídica de los centros historicos: patrimonio y políticas urbanas en Mexico. *Revista Mexicana de Sociologia, 57*(1), 183–206.

Melé, P., 1998. La proteccion del patrimonio histórico en Mexico: prácticas locales y competencias federales. *Mexican Studies-Estudios Mexicanos, 14*(1), 71–104.

Morales Moreno, L. G., 2007. Museológicas. Problemas y vertientes de investigación en México. *Relaciones: Estudios de Historia Y Sociedad, 28*(111), 31–66.

Nivón, E., 2010. Del patrimonio como producto. La interpretación del patrimonio como espacio de intervención cultural. *In:* E. Nivón and A. Rosas Mantecón, eds, *Gestionar el patrimonio en tiempos de globalización*. México: Universidad Autónoma Metropolitana, Juan Pablos Editor, pp. 15–35.

Nivón, E. and Rosas Mantecón, A., eds, 2010. *Gestionar el patrimonio en tiempos de globalización*. México: Universidad Autónoma Metropolitana, Juan Pablos Editor.

Olivé, J. C. and Urteaga, A., 1988. *INAH, una historia*. México: Instituto Nacional de Antropología e Historia.

Olivé Negrete, J., 1980. Reseña histórica del pensamiento legal sobre arqueología. *In:* J. Litvak King, L. González and M. del R. González, eds, *Arqueología y derecho en México*. México: Universidad Nacional Autónoma de México, pp. 19–46.

Olivé Negrete, J. and Cottom, B., eds, 2003. *INAH: una historia. Vol. 1.* 3rd ed. México: Instituto Nacional de Antropología e Historia.

Piedras, E., 2006. Industrias y patrimonio cultural en el desarrollo económico de México. *Cuicuilco, 13*(38), 29–46.

Rojas Delgadillo, N., 2006. Cultural Property Legislation in Mexico: Past, Present, and Future. *In:* B. Hoffman, ed., *Art and Cultural Heritage: Law, Policy, and Practice.* Cambridge: Cambridge University Press, pp. 114–118.

Rosas Mantecón, A., 2005. Las disputas por el patrimonio. Transformaciones analíticas y contextuales de la problemática patrimonial en México. *In:* N. García Canclini, ed., *La antropología urbana en México.* México: Consejo Nacional para la Cultura y las Artes, Universidad Autónoma Metropolitana, Fondo de Cultura Económica, pp. 60–95.

Rozental, S., 2011. La creación del patrimonio en Coatlinchan. *In:* P. Escalante, ed., *La idea de nuestro patrimonio histórico y cultural.* México: Consejo Nacional para la Cultura y las Artes, pp. 341–361.

Rozental, S., 2014. Stone Replicas: The Iteration and Itinerancy of Mexican Patrimonio. *The Journal of Latin American and Caribbean Anthropology, 19*(2), 331–356.

Smith, A. D., 1999. Introduction. 'Ethno-symbolism' and the Study of Nationalism. *In: Myths and Memories of the Nation.* Oxford: Oxford University Press, pp. 3–27.

Smith, A. D., 2001. Authenticity, Antiquity and Archaeology. *Nations and Nationalism,* 7(4), 441–449.

Tovar y de Teresa, R., 1997. Hacia una nueva política cultural. *In:* E. Florescano, ed., *El patrimonio nacional de México.* México, D.F.: Consejo Nacional para la Cultura y las Artes , Fondo de Cultura Económica, pp. 87–107.

UNESCO, n.d. World Heritage List Statistics. Available from: http://whc.unesco.org/en/list/stat#d2 (accessed 31 January 2016).

UNWTO, 2014. Tourism Highlights. Available from: www.e-unwto.org/doi/pdf/10.18111/9789284416899 (accessed 31 January 2016).

Vaca, A. and García, E., 2012. *Procesos del patrimonio cultural.* Zapopan: El Colegio de Jalisco.

Vázquez León, L., 2003. *El leviatán arqueológico: antropología de una tradición científica en México.* México: CIESAS and M.A. Porrúa.

Villareal Escárrega, M., 2006. The National Institute of Anthropology and History. *In:* B. Hoffman, ed., *Art and Cultural Heritage : Law, Policy, and Practice.* Cambridge: Cambridge University Press, pp. 395–397.

Voutssás M, J., 2009. *Preservación del patrimonio documental digital en México.* México: Universidad Nacional Autónoma de México.

Walker, W., 2013. *A Living Exhibition: The Smithsonian and the Transformation of the Universal Museum.* Amherst: University of Massachusetts Press.

10

We come from the land of the ice and snow[1]

Icelandic heritage and its usage in present-day society

Guðrún D. Whitehead

Introduction

One of the main clichés in the Icelandic tourist industry is describing it as the 'land of ice and fire'. The insinuation here is that Iceland's entire culture and heritage can be summarized in one stereotype, as a land of extremes, whether that be weather, nature, people or history. In this chapter, the image of Iceland within tourism marketing is explored and contrasted with how Icelanders themselves understand and use their culture and heritage. In particular, it explores the changes brought on by the economic crash of 2008–2011 in relation to local understanding of the past and its commercial uses. These changes demonstrate the flexibility and volatility of heritage in society.

Well into the second half of the twentieth century, dominant local views divided Icelandic history into three major periods (Jón Yngvi Jóhannesson *et al.* 2003, pp. 7–8).[2] The first one, 930–1262, is thought of as the cultural Golden Age. It started with the birth of Icelandic nationality, when the first 'Viking' settlers arrived and saw the birth of the Icelandic ancient manuscripts and sagas (Jón Yngvi Jóhannesson *et al.* 2003, pp. 7–8). The second period was a time of Norwegian and Danish domination and cultural decline under foreign rule.[3] The third started with the 'glorious' independence movement of the nineteenth century, which reached its peak when Iceland gained sovereignty in 1918, and ended in 1944 with the establishment of the Republic of Iceland (Jón Yngvi Jóhannesson *et al.* 2003, pp. 7–8). This historical division clearly indicates a primal internal anxiety about foreign influences on Icelandic heritage, the exception being the initial settlers, whose origins have yet to be fully resolved (Agnar Helgason *et al.* 2000). Foreign interference could only result in regression, stagnation or, even worse, the loss of the national character and cultural values. Moreover, progress and modernization were primarily due to Iceland gaining its political independence from Denmark and its unique cultural history, which ensured a positive outcome in the end, despite hardship. This historical three-part division has been dismissed by most scholars of history, culture and society as simplistic, as it disregards many important historical events. Yet this chapter will explore how it still remains influential amongst the general public and continues to dominate external and internal uses of heritage in Icelandic society (Jón Yngvi Jóhannesson *et al.* 2003).

The primary focus of this chapter is on Iceland after the economic crash of 2008–2011. The aim is to explore the varieties and complexities of Icelandic heritage, centring on two main

topics: city and nature. These two terms will guide the reader through two ways in which Icelandic heritage is used in present-day Iceland: as a marketing tool for tourism, and as a means of influencing internal social identities, governmental decision-making and given social norms.

Connecting these different strands of Icelandic heritage is DNA, which was regarded as important even before the general dissemination of information in regards to DNA origins in the rest of the world.[4] In short, Icelandic national identity and society centres, in no small way, on a common racial background, dating back to the original 'Viking' settlers.[5] These early years of Icelandic society are traditionally viewed as the Golden Age by locals. The settlers and their descendants, whose adventures are told in the Icelandic Sagas, are a source of great national pride. Their presence can be felt in all corners of Icelandic heritage and society even today, including within the tourist industry. Icelanders have an extensive knowledge of their genealogical links to the Vikings, due to a long-standing, national obsession with tracing their ancestry. This has resulted in practical source material for medical purposes,[6] as well as modern, 'practical' uses (such as advertisements, exhibitions, branding) in tourist marketing and more. Examples of this modern usage of Icelandic racial heritage will be used in order to demonstrate the constant presence and importance of Viking heritage in present society. As this chapter aims to show, this DNA factor is also what connects the external and internal uses of Icelandic nature, city and Viking heritage. Indeed, what makes the tourist marketing so compelling is the fact that it is rooted within local cultural norms.

Managing heritage

In order to understand Icelandic heritage, some information on heritage laws and policies, official culture and local government is needed. Furthermore, a brief introduction will be given to the events of the economic crash that directly relate to the topic of this chapter. It is not the aim of this chapter to recount this event in detail, but rather to pinpoint and discuss some of its repercussions on the uses and interpretations of Icelandic heritage.

Breaking the chains of pessimism and self-restraint

Nationalism in Iceland has been an important part of governmental policy since the independence movement. As such, various official efforts have been made in order to maintain the purity of Icelandic heritage and culture. This includes the Icelandic Naming Committee (*Mannanafnanefnd*) which must approve names not on the 'Personal Names Register'.[7] The Icelandic Language Institute (*Íslensk málstöð*) and various specialists create Icelandic terms for new technology, aimed at keeping the Icelandic language as pure as possible. The Icelandic Language Committee (*Íslensk málnefnd*) established in 1964 aims at protecting and enhancing the public usage of Icelandic, and composes official spelling and grammar rules taught in schools. The Museum Council of Iceland (*Safnaráð*) obliges all accredited museums to work according to the International Council of Museums (ICOM) Code of Ethics as well as the Museum Act, which dictates that Icelandic museums' primary function is to conserve Icelandic culture, heritage and nature and to guarantee its unspoiled continuation for future generations (Alþingi 2015b). The official governmental culture policy also guarantees governmental participation in cultural events, open public access to Icelandic culture and heritage, with a special emphasis on increasing the participation of children and youths in culture events (Ásta Magnúsdóttir 2013, p. 6). The aim of the policy is to 'reflect the power which defines Icelandic culture' because 'an active cultural life is beneficial to all' (Ásta Magnúsdóttir 2013, p. 6).

Sigurjón Baldur Hafsteinsson (2013) has traced the connection between heritage marketing and the political goals of the Icelandic government in the years 1991–2009. Private enterprise and

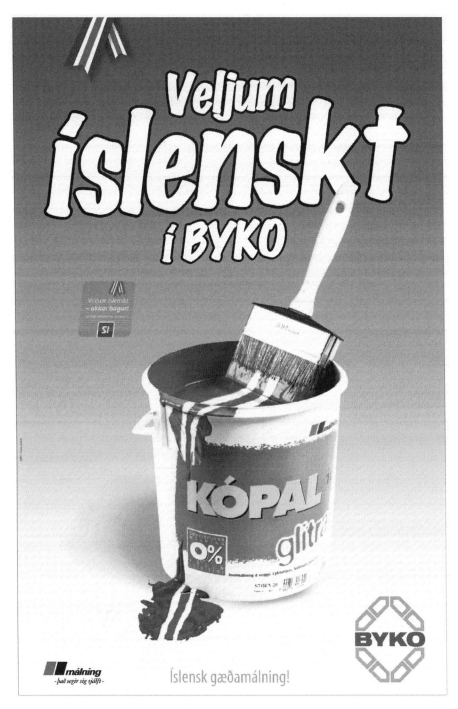

Figure 10.1 Advertisement for Icelandic-made Kópal paint produced by Málning paint manufacturer and sold by Byko construction product store. The headline reads 'Choose Icelandic in Byko', with a message from the Federation of Icelandic Industries which reads 'Choose Icelandic – in our favour'. Printed in: Morgunblaðið, 2009, digital copy available from Timarit.is.

individual initiatives were encouraged at heritage sites and within cultural institutions, which were viewed as job-creating resources (Sigurjón B. Hafsteinsson 2013, p. 91). Sigurjón writes that if Iceland was to compete on the international tourist market, it needed to have a unique product to sell and individuals with the vision to meet tourist demands. In order to see these goals come to fruition, it was important to get the local population on board and to re-evaluate and strengthen local heritage and cultural policies. The privatization and individual initiatives in the cultural sector were merely one part of local government goals, as the politicians of the time believed that a free market, private enterprise and the liberalization of the economy,[8] would be beneficial for the country (Sigríður Benediktsdóttir *et al.* 2011). This development, similar to that of many countries at the time, would transform the local economy as well as the cultural sector.[9] It also served to renew and strengthen local views on Icelandic heritage and identity.

A recent turning point in Icelandic history was the financial crash of 2008. Local advertisements had frequently focused on local anxieties with regards to Icelandic culture and heritage; however, in the wake of the economic crash this became an even more frequent theme in local adverts and media discussions. Food advertisements included the Icelandic flag on each locally-produced item, including paint (Morgunblaðið 2009a), flatbread (Morgunblaðið 2009b), vegetables (Fréttatíminn 2011) and meat (Morgunblaðið 2011).

Icelanders increasingly chose to travel within the country, instead of going abroad. In an interview in the Icelandic paper, *Morgunblaðið* (31 March 2011), Páll, the Chief Executive Officer (CEO) of a chain of hotels, stated his belief that it was important to increase local travel in order to aid the country's economic recovery (Ásgeir Ingvarsson 2011a).[10] In the same edition, there were advertisements from the Federation of Trade and Services (SVTH), encouraging Icelanders to shop from local, Icelandic businesses. Amongst the services specifically mentioned were a watchmaker, Icelandic vegetables, a small handbag and glove shop, and a gym. The CEO of SVTH was also interviewed. He encouraged Icelanders to start thinking positively and locally. The nation as a whole needed to 'break the chains of pessimism and self-restraint' (Ásgeir Ingvarsson 2011b, n.p.). In all areas of consumption, Icelanders were encouraged to consume locally-produced goods and services because the only way upwards was for Iceland to become 'more Icelandic'. The CEO of a potato factory, Þykkvabær, described their 'alíslensk' (completely Icelandic) production practices, which were specifically designed for the needs of Icelandic consumers (Ásgeir Ingvarsson 2011c, n.p.).

On 1 April 2011, Eymundsson, a bookshop chain located in various cities in Iceland, advertised confirmation gifts with the tagline 'Iceland's only hope [aka the young generation] requires good support for the future'. The captions which accompanied products such as globes, travel bags and a book of Icelandic proverbs, alluded to the Icelandic Sagas and other well-known literary heritage. The text accompanying a set of bags concludes that the female settler Auður djúpúðga did not have travel bags, instead she had slaves. Another one mentions a famous quote by Flosi Þórðarson, from Njáls Saga, 'köld eru kvenna ráð' ('women's council is ever cruel'). The sentence is incomplete, indicating that Flosi was unable to finish the sentence under the watchful eye of a fierce Icelandic woman (Eymundsson 2011, p. 7). This advertisement was not merely drawing on classic Icelandic heritage in order to appeal to local consumers, but it was also attempting to instil in the new generation of Icelanders a sense of pride and knowledge of local culture and heritage. A couple of pages later, an article informed readers that Icelandic fashion and design was self-sustainable, ecologically friendly and manufactured under good labour conditions (Bergþóra N. Guðmundsdóttir 2011, p. 10). Here was another clear attempt to demonstrate the superiority of Icelandic products.

In the wake of the 2008 crash, the British and Dutch governments lobbied for the Icelandic government to take responsibility for the foreign debts of *Landsbankinn*, a privately owned

Icelandic bank (Eiríkur Bergmann 2014, pp. 137–140). There were three *Icesave* bills,[11] the second of which the Icelandic government passed in parliament, but the Icelandic president refused to enact the law, leading to a national referendum being held in 2010, where it was rejected (Eiríkur Bergmann 2014). In January 2013, the Court of Justice of the European Free Trade Assocation States Court (EFTA Court) vindicated Iceland of any wrongdoing, refusing the European Union (EU), UK and Dutch governments' claims (Eiríkur Bergmann 2014). During the crash, there were also several advertisements encouraging people to vote for or against the *Icesave* contract, including one showing a forlorn family of five drifting on a small iceberg, underneath which a giant, threatening shark loomed (Áfram-hópurinn 2011). The mother stands proudly waving the Icelandic flag, while the father sat at the edge of the iceberg looking depressed. This might be said to represents the stereotypical image of Icelandic family life and national pride. The fierce and determined Icelandic women were taking charge again and pushing the nation back to 'good old' family values: self-reliance, self-sustainability and most of all, all things *Icelandic*.[12]

An article in *Morgunblaðið* on the 31 December 2008 discussed changing consumer behaviour in Iceland in the wake of the economic crash (Inga R. Sigurðardóttir 2008). The journalist, who verified that the tagline 'choose Icelandic products' had already found its way into local advertising, wrote that this was the dawn of the 'conscious consumer' who was more careful in their choice of consumer goods. There was less demand for cheap items from China, as well as high-brand clothing. Instead, people were choosing classic styles and well-made clothing which were now more practical, rather than a means of displaying or bolstering personal identity. It seemed that true happiness was now to be found in giving and purchasing items which were practical and long-lasting, not cheap and pleasingly impractical. The article concludes that Icelanders will choose locally-produced goods, which are worth much more than 'mass-produced junk' from abroad. Rather than spending a day shopping, parents would find more worthwhile and cheap ways of spending quality time with their children (Inga R. Sigurðardóttir 2008).

The international media discussion regarding the economic crash had a significant and perhaps somewhat unexpected effect on Icelandic heritage. The increase in news reports on Iceland, in combination with other factors, such as the Icelandic currency losing value and making travelling to and within Iceland less costly, led to an increase in tourist activity (Eiríkur Bergmann 2014, p. 165). Local media discussions on tourism increased significantly in 2008 and 2009, increasing the value and importance placed on tourism in the national economy (Gunnar Þór Jóhannesson, 2003, p. 450). Össur Skarphéðinsson, the Minister of Industry, Energy and Tourism in 2008, expressed the view that Iceland was in possession of great treasures, such as nature and culture, which was a strong base upon which to build a growing and increasingly economically beneficial tourism sector in Iceland (Össur Skarphéðinsson 2008). He considered the government's aim in the next few years be to 'attract as many tourists as possible' to Iceland. Currently tourism provides jobs for almost a quarter of the Icelandic workforce; in 2004–2014 the number of people directly working in connection with tourism rose by 66 per cent (Arion Banki 2015). According to the World Travel & Tourism Council (WTTC), the total contribution of travel and tourism to employment was 42,00 jobs in 2014 or 10,500 jobs directly (WTTC 2015).[13,14] I will return to this point later in the chapter, by discussing some of the ways in which this increased tourism has influenced Icelandic society and its self-marketing strategies.

The economic crash also saw the re-emergence of the local romantic image of the self-sufficient farmer living off – and in harmony with – the land. Public debates about the evils of modernity and city life versus the purity and simplicity of nature and turf houses once again appeared as a symbol, this time of the suffering of the country (Sigurjón B. Hafsteinsson 2010,

p. 266).[15] Simultaneously, however, the turf houses were under threat and government-funded initiatives attempted to 'reserve a place for Icelandic turf-house heritage on UNESCO'S World Heritage List' (Sigurjón B. Hafsteinsson 2010, p. 266). This project has met with some difficulty, because one of the requirements of the project is that the initiative for inscription must come from the local population itself, which, in Iceland, has been met with little enthusiasm (Sigurjón B. Hafsteinsson 2010, p. 266).

Profitable, legendary Icelandic heritage and its uses in present society

This section explores the consequences of some of the most important historical and cultural developments in present Icelandic society: the uses and images of heritage, history and nature. Several themes will be explored which relate to or are influenced by the regulations and policies outlined in the previous section, specifically those relating to external and internal images and uses of nature and Vikings. The aim here, as before, is to attempt to explore the significance of Icelandic heritage: who Icelanders *are* and *how* this has come to pass.

Iceland: where nature is diverse and beautiful and always within reach

As is common with any type of heritage marketing, Iceland is marketed to foreign travellers in a way in which its biggest selling points are highlighted: untamed nature, 'quirky' local inhabitants, Viking-related history, and cosmopolitan amenities with deep-rooted connections to small-town living. With ever increasing tourist activity, this outward identity-creation and tourist marketing are visible in all corners of Icelandic society and influence local views and usage of heritage. Icelandic heritage is, in this respect, connected with 'extremes'. Simultaneously, Iceland is the land of the Vikings, heroes and heroines, rebels and undaunted spirit.

The title of this section comes from the official Icelandic tourism site *Visit Iceland*. The marketing strategy on this website is quite clear. Iceland is said to be widely known as 'The Land of Fire and Ice' and '[it] is also the land of light and darkness' (*Visit Iceland* 2015, n.p.). The country where you are never far from nature, not even in the capital, Reykjavík, 'a city of bold contrasts: it is both cosmopolitan and small-town; vibrant and sophisticated; young-at-heart and yet full of history' (*Visit Iceland* 2015, n.p.). This demonstrates a clear attempt at reconciling old and new, city and nature. This is an important task, one that is deeply rooted in the minds of Icelanders. The argument has several layers, yet primarily, it is about recognizing the major selling points of Iceland in relation to its smallness, allowing for a certain 'personal touch'.

This last point is evident in many of the tourist marketing strategies. *Visit Iceland* has introduced a new service for visiting travellers: 'Meet Guðmundur', a human search engine where men named 'Guðmundur' answer questions posed about Iceland. This is a way of personalizing the travel experience and a way to demonstrate what a small, yet helpful group of local inhabitants exist in Iceland. One of the in-flight adverts on *Icelandair* emphasizes this notion, stating that all Icelanders, including important political figures, are registered in the phonebook. This could be interpreted as demonstrating a certain familiarity and trust between Icelanders, a remnant of the old farming society and culture.

Current discussions regarding tourism in Iceland are met with some ambivalence on the part of the locals. It is felt that the country is ill-equipped to handle the number of foreign travellers in the country, which might result in negative experiences for tourists, permanent damage to nature and the disappearance of city landmarks (such as local pubs and restaurants).[16] It has also been pointed out that some of the reasons visitors travel to Iceland are to experience solidarity and peace in nature, and admire archaeological heritage sites (Birna Lárusdóttir 2015,

pp. 17–18). Yet, due to the sheer number of visitors making some of the major tourist attractions very crowded, such an experience is no longer possible,[17] causing an internal image problem. The protective instinct of Icelanders is aroused, who believe that such a massive increase of tourism in nature will result in it disappearing or being vandalized (Landvernd 2015). Certainly, this anxiety is not completely unfounded: reports have shown that tourists are not always equipped to appreciate the delicately balanced natural environment. A recent news report described how three tourists camping in Þingvellir ripped up a large quantity of moss to insulate their tent, causing considerable damage to surrounding vegetation (Iceland Monitor 2015a). Another article reports that the police were searching for tourists involved in off-road driving, who had caused considerable damage in the south (Iceland Monitor 2015b). It was also reported that a 'neighbourhood watch' was in place in the highlands, in order to reduce tourism-related harmful activities, such as off-road driving (Morgunblaðið 2015). This indicates that Icelanders consider themselves to have a sensitive appreciation of the precarious balance of their national wilderness. Therefore, they might feel the need to keep a watchful eye on tourists, who are not used to nature and so do not share that understanding of its value.

'You can't live in this landscape and not believe in a force greater than you'

The image of Icelanders as having a special, almost primeval connection to their country is not new. Nor is it simply an act of simple marketing on the part of the tourist industry. The image of the idealized and romanticized image of the nineteenth-century farming community and their cultural heritage has been a source of debate for a long while. At the beginning of the twentieth century, discussions regarding the future of Iceland were clear. It was to grow from being one of the poorest countries in Europe, to a thriving, western nation-state, with modern governmental ideologies and industry (Sigríður Matthíasdóttir 2004, p. 115). However, people did not agree as to what this modern nation would consist of, i.e. the relatively small group of people residing in the city or the larger group of people living off the land, who were seen as protecting the traditional, romanticized way of life (Sigríður Matthíasdóttir 2004, pp. 115–118). What would the long-term effects of industrialization be on the nation?

During the middle of the twentieth century the image of the farming community changed, by which time it was mostly considered outdated (Sigríður Matthíasdóttir 2004, p. 151). Turf houses, which are now are considered cultural heritage treasures, were at the time identified as national problems that needed to be eliminated and replaced as a symbol of the 'old ways of living' (Sigurjón B. Hafsteinsson 2010, p. 266). In an article written in 1899, Guðmundur Hannesson described them as dark, dirty hovels, a breeding ground for disease and misery, yet it showed the nation's 'superior breeding' that those living in these dismal surroundings were usually healthy in body and mind. This way of thinking, perhaps inevitably, became a popular view as housing improved and the standards of living increased. It was therefore decided that the nation's economy and culture would be supported by fish factories and urban industries. The turf houses became a symbol of the old farming community, more or less obsolete for the new way of life (Sigurjón B. Hafsteinsson 2010).

Nature has long been central to Icelandic identity and society. On 17 July 1944 a great festival was held at Þingvellir, the original site of the national parliament (Alþingi[18]) celebrating the foundation of the Republic of Iceland. The Icelandic bishop at the time, Sigurgeir Sigurðsson likened the nation's struggle to the local rough weather: there may be strong and tough winds that tried to break people down, but the Icelandic spirit and ideology prevailed and the nation's inherited right to freedom and independence was once again restored (Þjóðhátíðarnefnd 1945, pp. 155–158). Furthermore, as this link between nature and the nation was an important

part of the independence movement, it is therefore not surprising that it should resurface on that day (Guðmundur Hálfdánarson 2001, pp. 193–194).

The romantic imagery of nature was not merely connected to sunshine and tame meadows. According to Guðmundur Hálfdánarson (2001, p. 205) it was one of fierceness, cold weathers and strong winds that encouraged and strengthened the nation's citizens in their everyday activities. In recent times, nature has continued to play an important part in Icelandic economic and cultural discussions (Guðmundur Hálfdánarson 2001, p. 208). Most of the twentieth-century debates on hydroelectric power stations were about *ownership*, i.e. whether the profit remained in Iceland or not, rather than environmental pollution. In recent years, this debate has been completely reversed, with discussions now focusing on potential environmental consequences, rather than the nationality of foreign investors (Guðmundur Hálfdánarson 2001, p. 209). Guðmundur (2001, pp. 210–213) has traced this change in focus to several developments in the contemporary Icelandic lifestyle: first, only a small percentage of people earn their livelihood from agriculture or through the direct utilization of natural resources. Furthermore, with a better, more advanced transport system, nature is now more easily accessible to the public. Nature is no longer limited to postcards and TV screens, but can be easily visited by anyone, in person, with a car or a bus, and therefore becomes a more personal experience. Third, Guðmundur (2001) writes that nationalism thrives when there is an important common objective, such as an attempt to overcome economic difficulties originating in the collapse of the banking system. There is a further reason for this connection: an inherited guilt of modernity, which is the anxiety of Iceland losing touch with its unique cultural heritage in the pursuit of economic gain, consumerism, industrial development and modern comforts. Furthermore, there was a fear

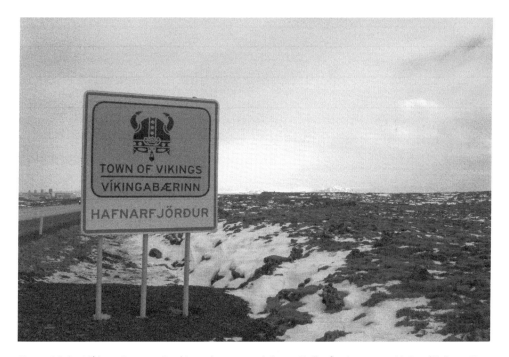

Figure 10.2 Viking sign on Reykjanesbraut road from Keflavík airport to Hafnarfjörður. Sign produced for the town of Hafnarfjörður.

Source: photography by Guðrún D. Whitehead.

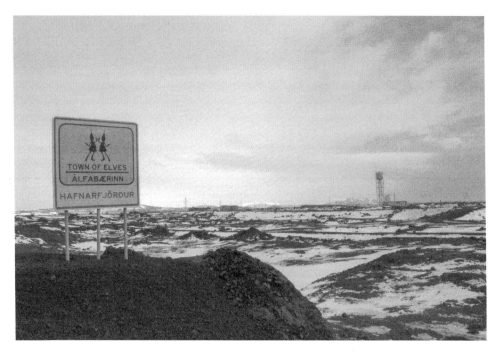

Figure 10.3 Elf sign on Reykjanesbraut road from Keflavík airport to Hafnarfjörður. Sign produced for the town of Hafnarfjörður.
Source: photography by Guðrún D. Whitehead.

that foreign influences would contaminate Iceland beyond recognition. This anxiety is evident in various ways: for example, in 2014, when the international media reported that a new road was delayed because campaigners feared that it would disturb elves living in its path (Kirby 2013). The work could only continue after a local woman talked to the elves, who agreed that the elven chapel could be moved away from the roadworks. This is by no means a unique instance, as Pétur Matthíasson confirmed in his interview with a BBC reporter, stating that while he did not believe in elves, 'we have to respect that belief' (Kirby 2013, n.p.). In the same article, Aðalheiður Guðmundsdóttir, Senior Lecturer in Folklore at the University of Iceland said: 'You can't live in this landscape and not believe in a force greater than you' (Kirby 2013, n.p.). In fact, according to Dr Terry Gunnell (2007), the majority of Icelanders are either unwilling to directly deny the existence of elves, or admit to believing in them. In turn, this belief is then used in heritage tourist marketing, for example, in one of Icelandair's inflight advertisements titled 'The most amazing thing about Iceland…', it is said that 'more than half the nation believes in elves'. Hafnarfjörður, a coastal town south of Reykjavik, also uses this belief in order to create a marketable identity for itself. When travelling on Reykjanesbraut road, from Keflavík airport through Hafnarfjörður, two signs appear, one naming it as the town of Vikings and elves.[19] There is also an 'elf garden' in the city centre, where visitors can have a walking tour of the local elf inhabitants' surroundings and a small 'elf centre' which serves as a souvenir shop and café.

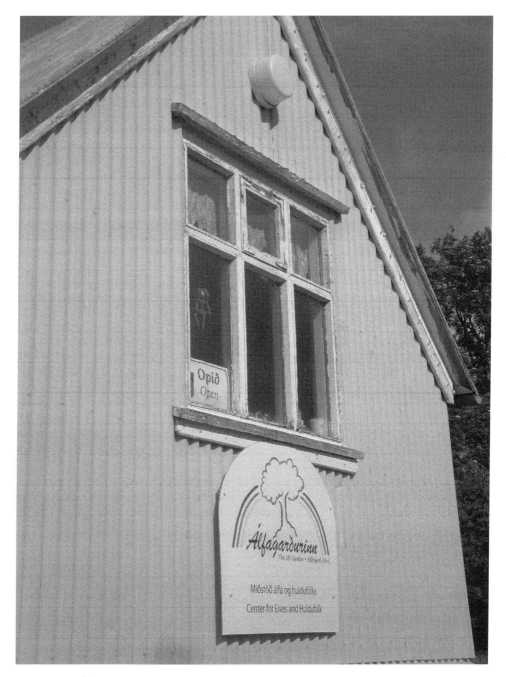

Figure 10.4 Álfagarðurinn, the Elf Garden – Hellisgerði Park, Centre for Elves and Huldufólk.
Source: photography by Julia Petrov.

Guðrún D. Whitehead

Walk among the Vikings

Hafnarfjörður also has the spectacular Viking Hotel, which also has a souvenir shop, Viking-themed rooms, a restaurant and Viking-themed performances, as well as an annual 'Viking festival',[20] which illustrates the second and arguably the more popular aspect of Icelandic heritage – the Viking myth. The stereotypical Viking warrior is firmly established within worldwide popular culture and is also a marketable and profitable part of Icelandic heritage. It can be found everywhere in Reykjavík's city landscape, largely targeted at an external audience. There are statues, museums, advertisements, food and drink brands, and tourist memorabilia (such as magnets, postcards, plastic-horned helmets, shot glasses and t-shirts), all dedicated to Vikings. The Icelandic Settlement Exhibition, a branch of the Reykjavík City Museum – which features archaeological remains excavated on that very location in 2001 – promises that visitors will 'experience Viking Age Reykjavík'. Yet, the word 'Viking' is deliberately omitted from the Icelandic description on the site, where it refers only to 'The Settlement Age'. This indicates that Icelanders with preconceived ideas about their own cultural heritage will understand the exhibition differently from tourists, who are more likely to expect to see Vikings as presented in popular culture as bloodthirsty marauders and adventurers. The Museum also recently opened a temporary exhibition on the twelfth- and thirteenth-century Icelandic Saga manuscripts, including what is deemed to be 'an outstanding treasure of the World's cultural heritage' as described in text on the Museum's window display.

The importance of manuscripts to the Icelandic sense of cultural heritage and identity cannot be underestimated. Following independence from Denmark in 1944, there was only one thing missing: Iceland's national treasures, the very essence of Icelandic heritage, identity and culture. These were the Icelandic medieval manuscripts, which were still in Copenhagen, stored in Danish libraries and manuscript collections (Guðmundur Hálfdánarson 2010). In 1945, after the German forces left Danish soil, a group of Icelandic representatives went to Copenhagen to finalize the political divorce between the two nations and, most importantly, to attempt to reclaim the Icelandic manuscripts, a quest that had started some decades earlier (Guðmundur Hálfdánarson 2010, pp. 54–55).

The manuscripts had been taken to Denmark during the latter half of the seventeenth and early eighteenth centuries as presents to the Danish King from leading Icelandic dignitaries (Guðmundur Hálfdánarson 2010, p. 55). Following independence, Icelandic academics and literati wanted control over their own heritage. The University of Iceland, established in 1911, was to become the new centre of Icelandic studies and the manuscripts were to drive new Icelandic scholarship (Guðmundur Hálfdánarson 2010, p. 55). It was not until 21 April 1971 that those manuscripts, which primarily dealt with Icelandic history and were written in Icelandic, were returned, not without the reluctance of some Danish scholars (Guðmundur Hálfdánarson 2010, pp. 57–58). The headline of a local Icelandic newspaper, *Morgunblaðið* that day, read 'The manuscripts return home' accompanied by a large photograph of the ship that brought them (Handritin heim 1971). Davis (2007) cites Magnús Magnússon who described the scene as follows:

> There were 15,000 Icelanders cramming the quayside; but throughout the rest of Iceland it was as if a plague had struck. No one moved in the streets. Shops and schools were closed. The whole nation, just over 200,000 souls in those days, was listening to the radio or watching television for a live account of the historical event.
>
> (*Magnús Magnússon 1989, p. 1*)

It is not mere coincidence that one of the first acts of independent Iceland was to reclaim these manuscripts. They were at the heart of Icelandic nationalist pride, a symbol of the nation's

greatest history, crucial for the development of Iceland as an independent republic (Guðmundur Hálfdánarson 2010, p. 56).

Both exhibitions at the Icelandic Settlement Museum provide an interesting look at life in the Settlement Age in Reykjavík. It does appear, however, that the manuscript exhibition resonates more with Icelanders, with the Viking exhibition being geared more towards foreign visitors. Both celebrate Icelandic heritage, but in different ways. In the main exhibition hall, Iceland is shown as a land of plenty, and the lives of the settlers and their descendants are told through interactive displays and archaeological artefacts. The manuscript exhibition is far simpler: a dark room, with each manuscript on its own pedestal, the only text being on one wall of the room. This suggests that the Museum assumes that interested visitors will have a certain level of pre-existing knowledge of the manuscripts and their meaning to Icelanders. An alternative interpretation might be that they are, instead, intended to be admired as art or are seen as icons, or as demonstrable proof of Iceland's admirable literary heritage.[21] It is not until guests go into the gift shop that the stereotyped, commercial Viking image reappears, in the form of 'Viking jewellery', books, postcards and more.

Reykjavik's Saga Museum, in contrast, makes little attempt at down-playing the heroism and greatness of the Icelandic forefathers, promising visitors that they can 'walk among the Vikings'. The Museum's brochure is an example of the very essence of Viking age heritage marketing. It states that the aim of the exhibition is to introduce visitors to 'Iceland's most famous heroes and infamous villains portrayed in their defining moments' through wax displays. The exhibition does not only allow people to 'witness the real history of the Vikings' but additionally promises to provide 'an experience as close as you'll ever get to meeting the Vikings in the flesh'. The displays feature beheadings, epic battles, Leif the Lucky's discovery of America and Skalla-Grímur and his son Egill, the main protagonists of *Egilssaga*, who are described as 'true Icelanders' by the Museum.[22] This is presumably due to Egill's 'unruly nature', his bravery, immense physical strength, and skills as a poet (Skalla-Grímur and Egill – True Icelanders? 2015). Finally, visitors have the opportunity to 'become a Viking' when, at the end of the tour, they can try on

Figure 10.5 One of the Saga Museum's brochures.
Source: all rights Saga Museum 2013.

clothes and weapons of the Viking age. The museum shop is described as stocking 'a wide selection of traditional Viking handiwork, souvenirs, clothing and beautiful local design', made primarily from bone, leather and horn.

The Saga Museum cannot easily be dismissed as a 'tourist trap'. This is not merely due to the fact that the shop does indeed have more authentic souvenirs than the majority of memorabilia shops in the city centre, including replica silver jewellery, combs and sewing needles made of bone. The Museum's true strength lies in the exhibition storyline, which tells the history of Iceland from the standpoint of popular local mythology, as was taught in Icelandic schools well into the twentieth century (Jón Yngvi Jóhannesson *et al.* 2003, p. 7). High quality and dramatically posed wax figures show, for example, Hrafna-Flóki, one of the first explorers who attempted to settle in Iceland, setting free one of three ravens, which he brought with him to ensure the 'blessings of the gods', in the hopes they would lead him towards shore (Hrafna Flóki – The exodus from Norway 2015). By re-enacting this creation myth, documented in the thirteenth century *Landnáma* manuscripts, the Museum is underlining their continued relevance in Icelandic society today.

Genealogy: the building block of Icelandic identity

The most basic building block of Icelandic identity and heritage is the Nordic ethnicity of the Viking explorers who first settled on the island. In contemporary Icelandic society, the Icelandic Sagas are regarded as proof of genealogical links between present-day Icelanders and their Viking ancestors. According to an interview in *Morgunblaðið* with Dr Kári Stefánsson, CEO of deCode Genetics, the Icelandic obsession with ancestry has resulted in the preservation of a great deal of valuable genealogical information (Kári Stefánsson 1996b). He adds that most Icelanders prefer to trace their ancestry back to the aforementioned Egill Skallagrímsson, who is regarded as a 'true Icelander'.

Hlín Leifsdóttir, a humanities student who created a mobile app, a game using information from the genealogical database Íslendingabók, to create a personalized quiz about the player's ancestors said in an interview with the Icelandic magazine, *Reykjavík Grapevine*, that her app had a 'positive social purpose' (Kyzer 2013, n.p.). Being aware of 'one's own historical roots can contribute to one's general historical awareness' and increases interest in genealogy among younger generations (Kyzer 2013, n.p.).

The app was created as a part of a competition held by the University of Iceland and deCode in April 2013. The winners caused an international media-storm (Anderson 2013; BBC 2013; Ríkisútvarpið 2013a, 2013b; Sykes 2013) because it included a feature called 'the incest alarm' (*Sifjaspillirinn*) which enabled Icelanders to avoid dating close genetic relatives. The competition aimed at increasing the usability of Íslendingabók, and aimed to demystify the genealogical research conducted by deCode (Gunnar Hersveinn 1998). Responding to public concerns in regards to the use and gathering of genealogical information, Kári Stefánsson (1996a) argued in an interview with *Morgunblaðið* newspaper that the work done in deCode demonstrated the uniqueness of Iceland's genealogical background and history. In later interviews he further concluded that deCode contributed to Icelandic society by advancing local genealogical research, creating job opportunities and a modern biotechnological industry in Iceland (Kári 2013). It could be concluded that the apps created in 2013 signify a way of further normalizing the company's research, making the database, which caused such controversy during its establishment, a part of everyday Icelandic society. Instead of threatening, deCode's use of Iceland's genealogical heritage has become practical and fun.

The link between heritage as a marketing tool and as a building block of Icelandic identity is clear, for example through its usage in museums, by companies such as deCode, official

governmental policies and its appearance in the tourist industry in general. As confirmed by the anthropologist Magnús Einarsson (1996, p. 216), Icelandic heritage, culture and identity are rooted in an ideology of nationalism. By creating and endorsing cultural traditions, genetic links, myth-making and manuscripts, a continuity is created between the past and the present. Magnús Einarsson (1996, p. 216) observes that official historical buildings and cultural institutions, such as museums, attempt to preserve the roots of the nation and serve to confirm and defend nationalistic ideology in society.[23] Museums such as the Saga Museum and other tourist destinations in Iceland are not *creating* a marketable heritage, but rather repackaging it into a more recognizable format. Within the museum, Egill is not merely a recognizable Icelandic 'forefather'; he attains the traits of an internationally popular stereotype, that of the fierce Viking warrior. As such, Icelandic heritage serves a purpose in the tourist industry and simultaneously allows Icelanders to pride themselves on preserving their unique, ancient identity and heritage (Magnús Einarsson 1996, p. 231).

A sense of place

Icelandic identity is naturalized through notions of race, which is then expressed through notions of purity (Niels Einarsson 1996, p. 39). Moreover, various geographical locations are considered important for the Icelandic nation because of their connection with the Settlement Age and the medieval Icelandic commonwealth (Alþingi). Þingvellir, is, for example, protected as a national park and widely regarded as a symbol of the uniqueness of being Icelandic and national unity (Baldur A. Sigurvinsson and Strmiska 2005, p. 172).[24] The independence celebration of 1944 at the park re-enacted that significantly, as did the 1,000 year celebration of the Christianization of the country in 2000, where the aim of demonstrating a unified 'Christian Iceland' was clear throughout the organization of the event (Baldur A. Sigurvinsson and Strmiska 2005).

The Icelandic Pagan Society (Ásatrúarfélagið),[25] also has some claim on Þingvellir, believing it to be their most sacred and solemn location (Baldur A. Sigurvinsson and Strmiska 2005). It is of further interest that as part of the pagan celebration, which took place in 2000 at the same time as the Christian one (Baldur A. Sigurvinsson and Strmiska 2005, p. 173),[26] there was a series of land and fire ceremonies, where fires were lit at the very location where the country had formally been declared Christian. This was to 'make the country whole again' according to pagans (Baldur A. Sigurvinsson and Strmiska 2005, p. 172). Another important milestone for Ásatrúarfélagið will be the completion, in 2018, of a pagan temple (Stefán Á. Pálsson 2015). It will be located in Öskjuhlíð, a hill in central Reykjavík, so that it will be more closely connected with the university and academic community. The fact that 49.2 per cent of Icelanders showed support for the building of such a temple in a recently conducted Marketing and Media Research (MMR) poll, while only 29.7 per cent supported the building of a mosque, demonstrates the continued value placed on Icelandic heritage and the perceived need to protect the nation from foreign influences (Morgunblaðið 2014). Furthermore, that diverse Icelandic social groups (for example, both Christian and Pagan religious groups) have a claim on Þingvellir and are therefore an important part of Icelandic national identity, heritage and society.

Of further interest is the marketing strategy of the Gay Pride celebrations in Iceland. In 2015, advertisements were designed to link Vátryggingafélag Íslands, an insurance company, to Pride in the minds of consumers. It included a photograph of Þingvellir, with the Pride flag fluttering in the wind. The tagline reads 'We know that diversity matters a great deal'. In 2014, on the front of the yearly Pride programme guide, a famous statue of Ingólfur Arnarson (the 'first Icelander') located in front of Hallgrímskirkja Church, was dressed in rainbow colours, and his halberd transformed into the rainbow flag.[27] The aim of that image was to be subversive and

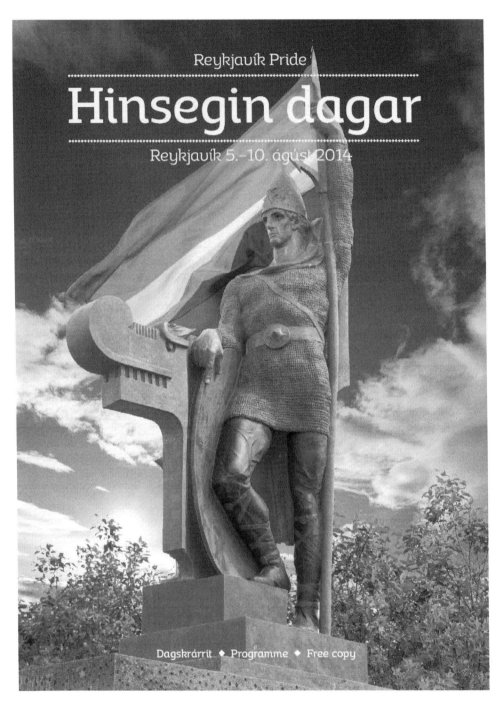

Figure 10.6 Pride programme guide, Ingólfur Arnarson dressed in rainbow colours, his halberd transformed into the rainbow flag. Designed by Guðmundur Davíð Terrezas.

Source: all rights Hinsegindagar, 2014.

We come from the land of the ice and snow

Figure 10.7 Viking ship, Pride float, headed by Icelandic pop icon, Páll Óskar.
Source: photography by Guðrún D. Whitehead.

daring, challenging cultural norms through the use of 'Viking' imagery. Even more spectacularly, in 2015, Icelandic pop icon, Páll Óskar sailed a 12-metre long, pink Viking ship, in order to 'pay respect to all the queens who have been silenced throughout the centuries in Iceland, even since settlement' (Olav V. Davíðsson 2015, n.p.). Clearly, the Icelandic Viking heritage holds as much importance for subcultures in Iceland as it does for the majority. The use of Þingvellir in 2015 further promotes the idea of unity between different social groups in the country. It suggests that despite differences in lifestyle and sexuality, these groups are all proud Icelanders and Vikings.

Conclusion

As the discussions in this chapter indicate, an important part of Icelandic heritage centres on the notion of purity and preservation. It is perceived (and supported by governmental initiatives such as those mentioned above) that by maintaining a certain degree of 'purity', the uniqueness of the national character and society is assured: Iceland will continue to thrive as a modern, independent nation. 'Proof' of this belief has recently been seen during the country's recovery after the economic crash of 2008, which was aided, according to the generally accepted narrative, by the nation's independent mindset, which has been frequently traced back to the original settlers and their ancestors.[28] Official governmental policy directed consumers towards locally-produced goods and services, through advertisements and discussions in the media.[29] Through these media outlets, people were assured that they were aiding the nation's economic recovery. The shame felt due to the events leading to the crash, was thereby turned into a positive: once again, due to the uniqueness of the national character (created by Iceland's history,

Guðrún D. Whitehead

culture and heritage), the nation was saved by its independent mindset and by not giving into foreign demands.[30]

By 2012 the stock market was recovering and in early 2013 inflation dropped below four per cent, wage levels increased and property prices rose (Eiríkur Bergmann 2014, p. 164). International media coverage in the wake of the crash, along with the devaluation of the krona, significantly increased tourist activity in Iceland. The 2010 eruption of the volcano Eyjafjallajökull, which shut down European airspace for a whole week (Eiríkur Bergmann 2014, p. 165), did not have the effect of tarnishing the nation's slowly recovering reputation as had been first feared. It had the opposite effect, increasing tourism even further (Eiríkur Bergmann 2014, p. 165). Tourists in 2015 could buy postcards embedded with a small amount of volcanic ash, soaps, t-shirts and other memorabilia, and could visit the 'Eyjafjallajökull Erupts: Visitor Centre' as well as other volcano-related exhibitions, and go on volcanic walking tours. The Eyjafjallajökull eruption was quickly turned into profit by the heritage tourism market.

The tourism sector – increasingly important for the economy – has recently gained local attention. In July 2015, a local newspaper interviewed several individuals, each specialists in their own fields on the substantial increase in hotel developments in Iceland. With an estimated two million people visiting Iceland in 2018, the article asks 'When are many hotels too many hotels?' (Ólöf Skaftadóttir 2015, n.p.). This was something that locals had themselves been asking, as various city landmarks disappeared in favour of hotels and other tourist-related businesses. Guðmundur Kristján Jónsson, a planning expert and the CEO of Borgarbragur ehf, a planning consultancy, stated that the current developments could potentially disrupt local inhabitants and destroy the very character of Iceland that tourists wish to experience (Ólöf Skaftadóttir 2015). In other words, the wellbeing of both groups is important for the continued economic and social growth of Iceland. In this way, external tourism marketing and internal identity and society are linked through a shared geographical location,[31] where each group – tourists and locals – have a part to play. In this theatrical metaphor, Icelandic heritage is the stage scenery, consisting of the most highly held local cultural and historical components and the locals give the theatre of Iceland its authenticity.

This chapter has highlighted several ways in which Icelandic social norms influence how heritage is marketed for tourists, including Þingvellir, an embodiment of the tension between city and nature. While parliaments are usually based in urban areas, this location was chosen because it was in public ownership, it had the necessary resources for the Alþingi assemblies, and the easiest access from the most populated areas in Iceland (Lugmayr 2002). More recently, Þingvellir has become one of the most popular tourist locations in Iceland, with around 72 per cent of all tourist traffic going through it in the summer (Ferðamálastofa 2014). This development has caused some internal image and identity issues. Þingvellir is not merely the location of important historical events; part of the sacredness is its pure and unspoiled nature, free from any large buildings that might disrupt this peaceful landscape (Baldur A. Sigurvinsson and Striniska 2005, p. 172).[32] The increase of tourism in the area threatens that sacredness in two important ways. First, more people in the area means that the isolation needed to experience nature in its untamed, uncultivated beauty is no longer possible. Taking people through Þingvellir in guided groups increases the problem, as it leads people through the area in an urbanized, overly-organized way (Birna Lárusdóttir 2015, p. 17). Second, this problem speaks to a deep-seated anxiety in Icelandic society: the loss of heritage and identity through foreign influence. Tourists, with little understanding of local conditions, might ruin Þingvellir with their presence as they are not necessarily used to such nature. Icelanders on the other hand, assumedly have an innate understanding of the delicate balance of nature and have an invested interest in its preservation.

There is a second issue related to the tension between city and nature, old and new. Nature is not only an important part of Iceland's heritage marketing and national identity. It is also an economic asset. The national character has traditionally been linked to nature, describing it as one of extreme contrast; underneath the peaceful beauty, active volcanoes bubble fiercely, threatening to erupt at any given moment. However, with the industrialization of Iceland, the nation grew anxious that an irreversible divide was emerging between the nation and its nature. This is well demonstrated when elf-rocks delay local road construction and an intermediary capable of conversing with elves, has to be called for. In turn, this anxiety is used within heritage marketing, such as at Hafnarfjörður in order to increase tourist traffic.[33] Therein lies the true power of good marketing: it has the potential to appeal to both Icelanders and foreign visitors, depending on how it is presented.

Debates around the uses of Icelandic heritage continue. In 2015, ruins of a longhouse dating back to the Settlement Age were discovered in the centre of Reykjavík (Kristján H. Johannessen 2015). According to current estimates, the hall was least 20 metres long and 5.5 metres wide, with one of the largest long-fires ever discovered in Iceland, at 5.29 metres (Kristján H. Johannessen 2015). Archaeologists believe that this was the home of a Viking chieftain, although there are no available sources regarding his identity (Kristján H. Johannessen 2015). The attention to this given by the local media is reminiscent of the longhouse ruins discovered in Aðalstræti in 2001, which are preserved in the Settlement Museum. Both heritage sites were widely discussed as important discoveries and both were excavated in locations intended for hotel developments. While the previous longhouse was allowed to remain where it was found and converted into a museum, there are still uncertainties regarding the fate of the Chieftain's Hall, the outcome of which will be an important indicator of the value and function of heritage in contemporary Icelandic society. It seems likely that the long-hall will be removed, as the excavation site is surrounded by other buildings, and a similar museum-building solution seems unlikely.

The debate on the outcome of the long-house archaeological site demonstrates the rapid changes of heritage, influenced partly by the economic crash in 2008. In the wake of the disastrous economic depression that followed and the social and political unease during that time, the value of Icelandic heritage was reaffirmed and strengthened. Advertisements and news articles focused on the necessity of shopping locally-produced goods, self-sustainability and vacationing within Iceland. This demonstrates the intention of showing an image of the Icelandic nation standing tall and proud, working together to regain economic and social balance. The proud independent Icelandic character, traced back to the original settlers and their ancestors, told through Iceland's unique literary heritage, would again prevail. This influences locally accepted views on the past as well as its use within the rapidly growing tourism industry. According to prevailing indigenous understanding Icelandic heritage is sacred, this includes certain locations, cultural phenomena and norms, including Þingvellir, the Icelandic manuscripts and the Icelandic language. They connect local inhabitants to their surroundings in a way which cannot be fully comprehended or mimicked by outside visitors, who are more likely to damage and disrespect it. Many Icelanders then believe in a collective, communal obligation to maintain its purity and protect it from harm, whether it be due to heavy industry, tourism or otherwise. This view is reflected in some local media discussions and governmental policies. In contrast, within the tourism industry, Iceland's untamed nature and cultural heritage are selling points. Travellers are able to experience a metropolitan capital city, with the beating heart of a small-town; wild untamed nature and modern comforts, history as well as modernity. Iceland's 'Viking' past allows for a perfect marketing tool, branding the country to that effect.

These contradicting views on Icelandic heritage are reflected in the discussion on the long-hall, excavated in Reykjavík city centre. The main conflict is between the urbanization of

Guðrún D. Whitehead

city-centre Reykjavík and rural archaeological heritage. Will the long house be rebuilt at a different location, and if so, will the interpretation and communication of the remains be marketed to tourists under the influence of tropes of Viking history and nature? Will it stand as a landmark, a symbol of unity for the nation to remember its glorious heritage and national, independent character? In the ongoing tug-of-war between nature and city, tourists and locals, the long-house will be a bellwether for changing attitudes towards heritage in Iceland.

Notes

1 Opening line from Led Zeppelin's 'Immigrant Song' (Page and Plant 1970), inspired by their tour in Iceland in the summer of 1970.
2 Icelanders retain the ancient Nordic naming convention whereby a person's first name counts as the principal name. Apart from a few family names, the second name is only a patronymic indicating the father's name with the addition of 'dottir' (daughter) and 'son' (son). In this chapter Icelandic authors will be listed under their full name and alphabetized under their first name (Lynch 2008).
3 A union was made between the Althing and the King of Norway in 1262 and in 1380 with Denmark, when the monarchies of Denmark and Norway were united. It was then during the reformation in the sixteenth century that Iceland became increasingly in decline and was repressed (Þorkell Jóhannesson 1975, pp. 40–46).
4 Racial identities are becoming increasingly complex as DNA research progresses and research in this area reveals more information about people's origins. This is no less true in Iceland, as the latest DNA research shows that while the vast majority of male settlers trace their ancestry back to the Nordic countries, the women's ancestry is more variable. In fact, it has been suggested that the majority of women came from the British Isles (Agnar Helgason *et al.* 2000). The effects of these conclusions have yet to be fully realized as the debates continue.
5 In the context of this chapter, the word 'Viking' is used in the most common understanding of it, i.e. as a man or a woman, from the Nordic countries in the Viking age (and their descendants) regardless of their occupation, unless otherwise stated. A further discussion on this use of the word can be found in Sommerville and McDonald 2010.
6 deCode genetics use this information to research hereditary deceases.
7 One of the naming rules is that new family names are not allowed to be created. Furthermore, a maximum of three first and middle names in total are allowed (Innanríkisráðuneytið 2015). Names have to follow Icelandic spelling and grammar conventions, unless one or both parents are of foreign descent, in which case the child is allowed to be given a foreign name as long as it has at least one Icelandic name (Innanríkisráðuneytið 2015). Until 1996, those who wished to gain Icelandic citizenship had to take up Icelandic names (Alþingi 2015a). Information on the rulings of the Icelandic Naming Committee with regards to names not on the official Personal Names Registry are accessible online at: www.urskurdir.is/DomsOgKirkjumala/Mannanafnaskra/Um_nofn/ (accessed 19 August 2015).
8 Including the privatization of the banking system.
9 This would become fully evident during the financial crisis of 2008–2011.
10 Adverts from tourist companies at the time targeted the same audience, for example Flugfélag Íslands, the domestic flights company, which on the 30 March 2011 advertised 'having fun domestically'.
11 The three *Icesave* bills were named after the foreign branch of *Landsbankinn*.
12 The image of Icelandic women as fierce and in control is frequently connected with the female heroines of the Icelandic Sagas.
13 This accounts for 23.7 per cent of total employment.
14 Which accounts for 5.8 per cent of total employment.
15 The turf house architectural tradition dates back to the settlement in the ninth century. Since that time it has been adapted by local climate and available environmental resources, a.k.a. a timber structure where turf is used to construct walls and cover the roof. Sometimes stones are used as an underlay for the roof. This minimizes the need for wood and firewood, which was scarce in Iceland. Turf houses are long and consist of several smaller houses, joined together by a passage. Many of these houses have been preserved and turned into folk-museums of some sort (UNESCO 2011).
16 See for example the following article discussing the tragedy of local pubs closing down and being substituted with tourist-related businesses: Skemmtistaðir víkja fyrir túristastarfsemi: 'Heimsins versta

hugmynd er fundin' [online]. *Nútíminn*, 6 July 2015. Available from: http://nutiminn.is/skemmtistadir-vikja-fyrir-turistastarfsemi-heimsins-versta-hugmynd-er-fundin/. See also: Benedikt Bóas 2015.

17 In 2014, 969,181 people visited Iceland, their numbers having tripled during summer since 2002. Approximately 59 per cent of summer visitors visited Gullfoss waterfall and Geysir hot springs and 50.4 per cent visited Þingvellir.

18 Alþingi is the oldest parliamentary institution, established in Þingvellir in AD 930. It started as a general assembly of the nation, where the leaders of the country met to decide on legislation and dispense justice. The meetings were the main social events of the year and open to all free men who had not been outlawed (Alþingi 2015c).

19 The signs were part of a two-year, 3 million Icelandic Krona project by town officials, aimed at increasing tourism in the area (Freyr G. Gunnarsson 2013).

20 For further information, see the hotel's official homepage: http://fjorukrain.is/en/ (accessed 21 August 2015).

21 The manuscripts, in this sense, could be viewed as both art and artefact, depending on the viewer's background. For a further discussion on the contrast, connections and exhibition of art and historical objects see, for example: Christopher Whitehead (2012) and Amy J. Barnes (2014).

22 See their website: www.sagamuseum.is/overview/skallagrimur-and-egill (accessed 21 November 2015).

23 See also discussion on this issue in Bennett 1995.

24 See further discussion on Þingvellir in the above section, titled: 'You can't live in this landscape and not believe in a force greater than you'.

25 A religion based on the pre-Christian belief system which has deep-seated roots in Icelandic society because it originates from the original settlers and the nation's Golden Age.

26 Both celebrations being at the same time and place was not without acrimony between the two religious organizations.

27 The programme guide is available online at the following location: http://issuu.com/reykjavikpride/docs/final_net-lq.

28 See for example discussion in Eiríkur Bergmann 2014.

29 See examples in previous section, titled 'Breaking the chains of pessimism and self-restraint'.

30 Ásmundur Einar Daðason, a representative of the 'Progressive Party' at the Icelandic parliament, in a speech in September 2015 said that one of Iceland's greatest strengths was that it was a nation that solved its own problems and would not be controlled by any outside parties (Ásmundur Einar Daðason 2015).

31 Reykjavík city centre, for example.

32 In this context, 'sacredness' is defined within the context of nationalism, as meaning a place holding a significant historical and cultural value, comparable to that of religious artefacts and spaces. This allows communion with something beyond ourselves, such as notions of belonging and nationhood.

33 See section above.

Bibliography

Agnar Helgason, Sigrún Sigurðardóttir, Gulcher, Jeffrey R., Ward, Ryk and Kári Stefánsson, 2000. mtDNA and the origin of Icelanders: Deciphering signals of recent population history. *American Journal of Human Genetics*, 66, 999–1016.

Alþingi, 2015a. Lög um mannanöfn [online]. *Altþingi*. Available from: www.althingi.is/lagas/nuna/1996045.html (accessed 7 July 2015).

Alþingi, 2015b. Safnalög [online]. *Alþingi*. Available from: www.althingi.is/lagas/142/2011141.html (accessed 7 July 2015).

Alþingi, 2015c. Timeline [online]. *Alþingi*. Available from: www.althingi.is/kynningarefni/index_en.html (accessed 30 November 2015).

Anderson, Steve, 2013. Icelandic 'anti-incest' app aims to stop families getting to close [online]. *The Independent*, 18 April. Available from: www.independent.co.uk/news/world/europe/icelandic-antiincest-app-aims-to-stop-families-getting-too-close-8578404.html (accessed 2 August 2015).

Arion Banki, 2015. *Við erum öll í Ferðaþjónustu* [online]. Reykjavík: Arion Banki. Available from: http://arionbanki.is/lisalib/getfile.aspx?itemid=cf0ef672-669f-11e5-84a3-d8d385b75e5c (accessed 16 October 2015).

Áfram-hópurinn, 2011. Óleyst deila er áhætta – og ógn við framtíð okkar [online]. *Morgunblaðið* (MBL), 1 April. Available from: http://timarit.is/view_page_init.jsp?pageId=5365546 (accessed 7 July 2015).

Ásgeir Ingvarsson, 2011a. Íslenskir ferðamenn skipta sköpum. *Morgunblaðið* (MBL), 31 March, p. 14. Available from: http://timarit.is/view_page_init.jsp?pageId=5365497 (accessed 7 July 2015).

Ásgeir Ingvarsson, 2011b. Hvert og eitt okkar getur örvað hjarstlátt atvinnulífsins. *Morgunblaðið* (MBL), 31 March, p. 12. Available from: http://timarit.is/view_page_init.jsp?pageId=5365495 (accessed 7 July 2015).

Ásgeir Ingvarsson, 2011c. Neytendur hafa tekið vel við sér. *Morgunblaðið* (MBL), 31 March, p. 11. Available from: http://timarit.is/view_page_init.jsp?pageId=5365494 (accessed 7 July 2015).

Ásmundur Einar Daðason, 2015. 145. Löggjafarþing – 2. Fundur, 8 September 2015: Stefnuræða forsætisráherra og umræður um hana [online]. *Alþingi*. Available from: www.althingi.is/altext/raeda/145/rad20150908T213835.html (accessed 30 November 2015).

Ásta Magnúsdóttir, 2013. *Menningarstefna* [online]. Reykjavík: Mennta- og menningarmálaráðuneyti. Available from: http://hdl.handle.net/10802/3546 (accessed 27 June 2018).

Baldur A. Sigurvinsson and Strmiska, Michael F., 2005. Asatru: Nordic paganism in Iceland and America. *In:* Michael F. Strmiska, ed., *Modern Paganism in World Cultures: Comparative Perspectives*. California: ABC-CLIO, pp. 126–179.

Barnes, Amy J., 2014. *Museum Representations of Maoist China: From Cultural Revolution to Commie Kitsch*. Surrey, UK and Burlington, VT: Ashgate.

BBC, 2013. Icelandic phone app stops you dating close relatives [online]. *BBC News*, 30 September. Available from: www.bbc.com/news/technology-24304415 (accessed 2 August 2015).

Benedikt Bóas, 2015. Icelanders are not ready for tourism according to tourists. *Morgunblaðið* (MBL), 2 July, pp. 1 and 24–25.

Bennett, Tony, 1995. *The Birth of the Museum: History, Theory, Politics*. London and New York: Routledge.

Bergþóra N. Guðmundsdóttir, 2011. Tíska í takt við umhverfi og samfélag. *Morgunblaðið* (MBL), 1 April, p. 10. Available from: http://timarit.is/view_page_init.jsp?pageId=5365541 (accessed 7 July 2015).

Birna Lárusdóttir, 2015. Nýjir staðir á gömlum grunni. Fornleifar sem áfangastaðir ferðamanna. *In:* Guðrún D. Whitehead, Sólrún I. Traustadóttir and Kristján Mímisson, eds, *Ólafía V: Tími, rými og sýnileiki*. Reykjavík: Félag fornleifafræðinga, pp. 9–21.

Davis, Peter, 2007. Place exploration: museum, identity, community, *In:* Sheila Watson, ed., *Museums and Their Community*. Oxon, UK and New York: Routledge, pp. 53–75.

Eiríkur Bergmann, 2014. *Iceland and the International Financial Crisis: Boom, Bust and Recovery*. Hampshire: Palgrave Macmillan.

Eymundsson, 2011. Íslands eina von þarf góðan stuðning til framtíðar. *Morgunblaðið*, (MBL), 1 April, p. 7. Available from: http://timarit.is/view_page_init.jsp?pageId=5365538 (accessed 7 July 2015).

Ferðamálastofa, 2014. Erlendir ferðamenn: um 72% sumargesta fara Gullna hringinn [online]. *Spyr*, 11 June. Available from: http://spyr.is/grein/ymsar-spurningar/5581 (accessed 3 August 2015).

Fréttatíminn, 2011. Íslenskt grænmeti. *Fréttatíminn*, 30 September, p. 16. Available from: http://timarit.is/view_page_init.jsp?pageId=5805417 (accessed 7 July 2015).

Freyr G. Gunnarsson, 2013. Verja þremur milljónum í skilti og merkingar [online]. *Ríkisútvarpið*, 8 November. Available from: www.ruv.is/frett/verja-thremur-milljonum-i-skilti-og-merki (accessed 7 July 2015).

Guðmundur Hálfdánarson, 2001. *Íslenskt Þjóðríki: uppruni og endimörk*. Reykjavík: Hið Íslenska bókmenntafélag, Reykjavíkur Akademían.

Guðmundur Hálfdánarson, 2010. Interpreting the Nordic past: Icelandic medieval manuscripts and the construction of a modern state. *In:* Robert J. Evans and Guy P. Marchal, eds, *The Uses of the Middle Ages in Modern European States*. New York: Palgrave Macmillan, pp. 52–71.

Guðmundur Hannesson, 1899. Maður horfðu þjer nær – liggur í götunni stein. *Bjarki*. 20 April, pp. 57–58. Available from: http://timarit.is/view_page_init.jsp?issId=51232&pageId=953539&lang=is&q=Gu%F0mundur%20Hannesson (accessed 7 July 2015).

Gunnar Hersveinn, 1998. Hvernig stenst frumvarpið sjálfræðisrökin? *Morgunblaðið* (MBL), 11 October, pp. 20–22. Available from: http://timarit.is/view_page_init.jsp?pageId=1916490 (accessed 29 July 2015).

Gunnar Þór Jóhannesson, 2003. Ferðaþjónusta á krepputímum: Orðræða um ferðaþjónustu á Íslandi. *In:* Ingjaldur Hannibalsson, ed., *Rannsóknir í félagsvísindum X*. Reykjavík: Háskólaútgáfan, pp. 243–253.

Gunnell, Terry, 2007. 'Það er til fleira á himni og jörðu, Hóras …' *In:* Gunnar Þ. Jóhannesson, ed., *Rannsóknir í félagsvísindum VIII*. Reykjavík: Félagsvísindastofnun Háskóla Íslands, pp. 801–812.

Handritin heim, 1971. *Morgunblaðið* (MBL), 21 April, p. 1. Available from: http://timarit.is/view_page_init.jsp?issId=114715 (accessed 7 July 2015).

Hrafna Flóki – The exodus from Norway [online], 2015. *Saga Museum*. Available from: www.sagamuseum.is/overview/hrafna-floki (accessed 7 July 2015) and http://timarit.is/view_page_init.jsp?pageId =1420543 (accessed 7 July 2015).

Iceland Monitor, 2015a. Campers rip up moss to insulate tent [online]. *Iceland Monitor MBL*, 29 July. Available from: http://icelandmonitor.mbl.is/news/nature_and_travel/2015/07/29/campers_rip_up_moss_ to_insulate_tent/ (accessed 7 July 2015).

Iceland Monitor, 2015b. French tourists behind off-road damage [online]. *Iceland Monitor MBL*, 30 July. Available from: http://icelandmonitor.mbl.is/news/nature_and_travel/2015/07/30/french_tourists_ behind_off_road_damage/ (accessed 7 July 2015).

Inga R. Sigurðardóttir, 2008. Ár hugsandi neytandans. *Morgunblaðið* (MBL), 31 December, p. 14. Available from: http://timarit.is/view_page_init.jsp?pageId=5235786 (accessed 7 July 2015).

Innanríkisráðuneytið, 2015. Meginreglur um mannanöfn [online]. *Úrskurðir og álit*. Available from: www.urskurdir.is/DomsOgKirkjumala/Mannanafnaskra/Um_nofn/ (accessed 7 July 2015).

Jón Yngvi Jóhannesson, Kolbeinn Óttar Proppé and Sverrir Jakobsson, eds, 2003. *Þjóðerni í þúsund ár?* Reykjavík: Háskólaútgáfan.

Kári Stefánsson, 1996a. Nýtt íslenskt erfðarannsóknafyrirtæki. *Morgunblaðið* (MBL), 31 May, p. 33. Available from: http://timarit.is/view_page_init.jsp?pageId=1854958 (accessed 29 July 2015).

Kári Stefánsson, 1996b. Lesið í erfðaefnið. *Morgunblaðið* (MBL), 24 November, p. 18. Available from: http://timarit.is/view_page_init.jsp?pageId=1866979 (accessed 29 July 2015).

Kári Stefánsson, 2013. Icelandic geneology app [online]. *BBC Radio*, 24 April. Available from: www.bbc.co.uk/programmes/p0175wbv (accessed 29 July 2015).

Kirby, Emma J., 2013. Why Icelanders are wary of elves living beneath the rocks [online]. *BBC News*, 20 June. Available from: www.bbc.com/news/magazine-27907358 (accessed 7 July 2015).

Kristján H. Johannessen, 2015. Grófu niður á stórbýli. *Morgunblaðið* (MBL), 8 July, pp. 1 and 4.

Kyzer, Larissa, 2013. It's not just an anti-incest app [online]. *Reykjavík Grapevine*, 10 May. Available from: http://grapevine.is/mag/articles/2013/05/10/its-not-just-an-anti-incest-app/ (accessed 3 August 2015).

Landvernd (The Icelandic Environment Association), 2015. Stígum varlega til jarðar – álag ferðamennsku á náttúru Íslands [online]. *Landvernd*, 29 May. Available from: http://landvernd.is/Sidur/ID/6537/ Stigum-varlega-til-jarar-alag-feramennsku-a-natturu-Islands (accessed 7 July 2015).

Lugmayr, Helmut, 2002. *The Althing at Þingvellir*. Reykjavík: Iceland Review.

Lynch, Jack, 2008. *The English Language: A User's Guide*, Indianapolis, IN: Focus Publishing/R. Pullins.

Magnús Einarsson, 1996. The wandering semioticians: tourism and the image of modern Iceland. *In:* Gísli Pálsson and E. Paul Durrenberger, eds, *Images of Contemporary Iceland: Everyday Lives and Global Context*, Iowa City: University of Iowa Press, pp. 215–235.

Magnús Magnússon, 1989. Introduction. *In:* Jeanette Greenfield, ed., *The Return of Cultural Treasures*. Cambridge: Cambridge University Press, pp. 1–9.

Morgunblaðið, 2009a. Veljum Íslenskt í Byko. *Morgunblaðið* (MBL), 2 March, p. 5. Available from: http://timarit.is/view_page_init.jsp?pageId=5248117 (accessed 7 July 2015).

Morgunblaðið, 2009b. Ömmubakstur: gott í dagsins önn. *Morgunblaðið* (MBL), 28 July, p. 13. Available from: http://timarit.is/view_page_init.jsp?pageId=5259694 (accessed 7 July 2015).

Morgunblaðið, 2011. Aðeins íslenskt kjöt í Kjötborði. *Morgunblaðið* (MBL), 8 September, p. 5. Available from: http://timarit.is/view_page_init.jsp?pageId=5377349 (accessed 7 July 2015).

Morgunblaðið, 2014. 42.3% andvíg byggingu moskvu [online]. *Morgunblaðið* (MBL), 8 October. Available from: www.mbl.is/frettir/innlent/2014/10/08/42_3_prosent_andvig_byggingu_mosku/ (accessed 3 August 2015).

Morgunblaðið, 2015. Nágrannavarsla á hálendinu [online]. *Morgunblaðið* (MBL), 15 July. Available from: www.mbl.is/frettir/innlent/2015/07/15/nagrannavarsla_a_halendinu/ (accessed 7 July 2015).

National Museum of Iceland, 2011. *The Turf House Tradition* [online]. Paris: UNESCO. Available from: http://whc.unesco.org/en/tentativelists/5589/ (accessed 16 October 2015).

Niels Einarsson, 1996. Whale-siting: spatiality in Icelandic nationalism. *In:* Gísli Pálsson and E. Paul Durrenberger, eds, *Images of Contemporary Iceland: Everyday Lives and Global Context*. Iowa City: University of Iowa Press, pp. 25–45.

Nútíminn, 2015. Skemmtistaðir víkja fyrir túristastarfsemi: 'Heimsins versta hugmynd er fundin' [online]. *Nútíminn*, 6 July. Available from: http://nutiminn.is/skemmtistadir-vikja-fyrir-turistastarfsemi-heimsins-versta-hugmynd-er-fundin/ (accessed 29 July 2015).

Olav V. Davíðsson, 2015. For the Icelandic settlement queens [online]. *Gayiceland.is*, 24 July. Available from: www.gayiceland.is/2015/for-the-settlement-queens/ (accessed 29 July 2015).

Guðrún D. Whitehead

Ólöf Skaftadóttir, 2015. Hvenær eru mörg hótel of mörg hótel? [online]. *Vísir*, 29 July. Available from: www.visir.is/hversu-morg-hotel-eru-of-morg-hotel-/article/2015707299929 (accessed 29 July 2015).

Page, Jimmy and Plant, Robert, 1970. Immigrant song. New York: Atlantic Records.

Ríkisútvarpið, 2013a. Kimmell gerði kynningu fyrir Íslendingabók [online]. *Ríkisútvarpið* (RÚV), 23 April. Available from: www.ruv.is/frett/kimmell-gerdi-kynningu-fyrir-islendingabok-0 (accessed 2 August 2015).

Ríkisútvarpið, 2013b. Sifjaspellsspillirinn var saklaust grín [online]. *Ríkisútvarpið* (RÚV), 24 April. Available from: www.ruv.is/frett/sifjaspellsspillirinn-var-saklaust-grin (accessed 2 August 2015).

Sigríður Benediktsdottir, Jón Daníelsson and Zoega, Gylfi, 2011. Lessons from a collapse of a financial system. *Economics Policy*, 26(66), 183–231.

Sigríður Matthíasdóttir, 2004. *Hinn sanni Íslendingur: Þjóðerni, kyngervi og vald á Íslandi 1900–1930.* Reykjavík: Háskólaútgáfan.

Sigurjón Baldur Hafsteinsson, 2010. Museum politics and turf-house heritage. *In:* Ingjaldur Hannibalsson, ed., *Þjóðarspegillinn. Rannsóknir í félagsvísindum XI. Erindi flutt á ráðstefnu í október 2010.* Reykjavík: Félagsvísindastofnun Háskóla Íslands, pp. 266–273.

Sigurjón Baldur Hafsteinsson, 2013. Etnógrafísk endurnýjun íslenskra safna. *In:* Birna Lárusdóttir, ed., *Árbók hins íslenzka fornleifafélags.* Reykjavík: Hið Íslenzka fornleifafélag, pp. 91–112.

Skalla-Grímur and Egill – True Icelanders? [online]. *Saga Museum.* Available from: www.sagamuseum.is/overview/skallagrimur-and-egill (accessed 7 July 2015).

Sommerville, Angus and McDonald, Russell A., 2010. Introduction. *In:* Angus Sommerville and Russell A. McDonald, eds, *The Viking Age: A Reader.* Toronto: University of Toronto Press, pp. xiii–xvii.

Stefán Á. Pálsson, 2015. Fyrsta skóflustungan að hofi Ásatrúarfélagsins [online]. *Vísir*, 20 March. Available from: www.visir.is/fyrsta-skoflustungan-ad-hofi-asatruarfelagsins-thetta-mun-breyta-ollu-fyrir-okkur-/article/2015150329942 (accessed 29 July 2015).

Sykes, Tom, 2013. Iceland's incest-prevention app gets people to bump their phones before bumping in bed [online]. *The Daily Beast*, 23 April. Available from: www.thedailybeast.com/articles/2013/04/23/iceland-s-incest-prevention-app-gets-people-to-bump-their-phones-before-bumping-in-bed.html (accessed 2 August 2015).

Visit Iceland [online], 2015. Reykjavík: Icelandic Tourist Board. Available from: www.visiticeland.com/discovericeland (accessed 4 July 2015).

Whitehead, Christopher, 2012. *Interpreting Art in Museums & Galleries.* Oxon, UK: Routledge.

World Travel & Tourism Council (WTTC), 2015. *Travel & Tourism: Economic Impact 2015: Iceland* [online]. London: WTTC. Available from: www.wttc.org/-/media/files/reports/economic%20impact%20research/countries%202015/iceland2015.pdf (accessed 16 October 2015).

Þjóðhátíðarnefnd, 1945. *Lýðveldishátíðin 1944: Þjóðhátíðarnefnd samdi að tilhlutan Alþingis og ríkisstjórnarinnar.* Reykjavík: Leiftur.

Þorkell Jóhannesson, 1975. An outline history. *In:* Jóhannes Nordal and Valdimar Kristinsson, eds, *Iceland 874–1974.* Reykjavík: The Central Bank of Iceland, pp. 33–57.

Össur Skarphéðinsson, 2008. *Ræða ráðherra á ferðamálaþingi* [online]. Atvinnuvega- og Nýsköpunarráðuneytið. Available from: www.atvinnuvegaraduneyti.is/radherra/raedur-greinarOS/nr/595 (accessed 7 July 2015).

11

Por la encendida calle antillana
Africanisms and Puerto Rican architecture[1]

Arleen Pabón

Por la encendida calle antillana
Va Tembandumba de la Quimbamba.
Flor de Tortola, rosa de Uganda,
Por ti crepitan bombas y bámbulas;
Por ti en calendas desenfrenadas
Quema la Antilla su sangre ñáñiga.
Haití te ofrece sus calabazas;
Fogoses rones te da Jamaica;
Cuba te dice: dale mulata¡
Y Puerto Rico melao, melamba¡

Walking down the Antillean street
Goes Tembandumba from Quimbamba.[2]
Flower from Tortola, rose from Uganda,
Dances such as bombas and bámbulas
Crackle in your honor;
For you in uncontrolled calendas
The Antilles burn her ñáñiga blood.
Haiti offers you her pumpkins;
Jamaica gives you her rums;
Cuba directs you: Go on, mulata!
And Puerto Rico: melao, melamba!
<div style="text-align:right">*(Translation by author)*</div>

When Puerto Rican poet Luis Palés Matos wrote these well-known lines of his poem "Majestad Negra" (Black Majesty), he was trying to capture Tembandumba's impact as she walked down an Antillean street.[3] Thanks to his imagery, we can picture the effect of her provocative progress on the population. The alluring street has no name. The poem is about all streets, a metaphor for all Caribbean walks of life illuminated by African presence.

"Majestad Negra," like this paper, deals with intangibles. One of the key components of Puerto Rican culture is its African heritage, particularly in architecture. But, just as Tembandumba lives only in a poem, evidence of African impact on the island's architecture is barely tangible, dimly surfacing only when we interpret some rapidly disappearing ruins or a few old photographs.

This paper is about things that are no more. It deals with absence and tries to dislodge two cherished Western beliefs. First, (to use Nikolaus Pevsner's grand metaphor) only cathedrals and not bicycle sheds deserve academic scrutiny. Second, cultural significance by historic preservation standards is only embodied in physically identifiable artifacts.

Many years ago, when I first tried to understand why historic preservation (or architectural history for that matter) seldom dealt with aspects of *her*story (as opposed to *his*tory), I realized that many academics and preservation practitioners had a narrow vision. Take for example the historical development of Caribbean domestic architecture. Seldom is the topic academically explored; seldom, if ever, is it analyzed as a significant component of the region's cultural heritage. While a few Caribbean dwellings, most always examples of the big house, are presented as transplanted examples of grand European architecture, native and African influences are treated in a perfunctory manner, if at all. Simply put, the issue of architectural diversity has not been analyzed in a holistic fashion.

As a result, society fails to understand how the slave hut was able to breed as many, if not more, important domestic ideas as the big house. More significantly, we fail to consider the role that subordinate groups, such as women and, in this case, Puerto Ricans of African descent, played in the creation of the island's architectural heritage. African influence on Puerto Rican architecture is a nonsubject in part because the following questions have not been addressed: Can an enslaved group contribute to a culture's architectural development? If this is possible, are huts and similarly unassuming structures culturally significant? How are physically absent architectural artifacts to be analyzed? Most importantly, is such analysis relevant in historic preservation?

For decades, only silence answered these questions. Unfortunately, a void in knowledge is construed as nonparticipation. The time has come to follow Tembandumba's lead and walk down the Antillean "street" of architectural knowledge, shedding light upon Africanisms present in Puerto Rican architecture.[4]

The native hut

By all accounts, Caribbean architecture mesmerized Spaniards when they first encountered it. They were surprised by the apparent fragility of the vernacular house, both in terms of form and materials. The climate and nomadic character of the natives dictated informal arrangements of spaces, as well as the use of natural materials.[5] It quickly became obvious that Columbus's enthusiastic description of Puerto Rican houses as "very good" (*muy buenas*) and able to "hold their place in Valencia" was not accurate.[6] The native hut, known throughout the Caribbean as the *bohío*, was a fairly simple arrangement of reeds, grass, bark, and foliage.[7]

Caribbean natives did not construct following Valencian or European architectural ideals; Columbus's lavish interpretation was atypical in the bevy of descriptions generated with time. There were no European-style aesthetic arrangements in the Caribbean native house. Ironically, the native's most common building was very similar to the Vitruvian hut: a makeshift affair, open to nature.[8]

When Europeans first came into contact with the North American continent, pristine spaces exhibited the lightness of the natives' touch. The absence of architectural bravado (a characteristic of European experience) and traditional associational ties created the illusion that the

continent was architecturally mute. European architecture speaks diverse languages that, in turn, allow for multiple interpretations. Since unpretentious structures like the *bohío* are *prima fasciae* devoid of the traditional character that reflects complex architectural language, many leading historians (then and now) believe that such structures lack relevance and significance. While it might not qualify for inclusion in Europe's architectural pantheon, the *bohío* became the basis for the island's most common architectural artifact, the Puerto Rican house.

There exists a well known, deep and complex interaction between building and culture. This is the case with all cultures, even "prehistoric" ones. More than a third of the world's population lives in structures made of mud, and a sizable number still lives in tents.[9] Are we to ignore these expressions or judge them by European standards?

In order to correctly evaluate the architectural significance of nontraditional architectural artifacts, we must abandon traditional Western models of interpretation. We need not follow Columbus's route of exaggeration. Rather, we should analyze how architecture expresses social and experiential diversity. It would be a mistake to consider Puerto Rico's humble abodes, whether erected by the indigenous Taíno or immigrant Africans, to be mere instinctual solutions to the problem of survival. It is paradoxical that even the humblest of these artifacts, in trying to defy dangers implicit in living, is totemic of meaningful existence.

Certainly, some viewed the lack of architectural trappings as cultural inferiority, but not all. During the eighteenth century, Puerto Ricans[10] were described as "An abstraction of all ideas of progress and social obligations ... *Ibaros* [*sic*] without truly understanding their negation of material things are the world's greatest philosophers, recognizing no need for artificial things."[11] Their abodes were then a reflection of a peculiar cultural response to both life and the pursuit of an existence. Labels such as "prehistoric" are secondary in this type of interpretative analysis. The drama of living is common to all humans, whether born millennia ago or centuries from now. The primary stage for this drama, whether located in the Caribbean or the Antipodes, is the artifact we call a house.

The African experience

When slavery began in Puerto Rico in the seventeenth century, many slaves lived in *barracones*, where they experienced a total and degrading lack of privacy.[12] Later, in the nineteenth century when sugar cane production was established in Puerto Rico, some slaves were allowed to have their own huts. In spite of its humble ethos, this hut, a condensation of native and African ideas, is iconic of a momentous cultural transformation. The hut provided something the *barracones* did not: a place where personal roots could be planted.

It is documented that Caribbean islanders followed—and still do—specific rites as they built their houses.[13] From Guadeloupe's ceremony marking the cutting down of the master post of the hut;[14] to the Puerto Rican phrase, *plantar jolcones*, which literally translates into "planting" the wooden structural posts; to Cuban religious ceremonies that took place at the construction site, this rite of passage was important. There was dignity associated with possession of a hut, even the simplest one, for it represented many hopes and dreams. It is paradoxical that so much feeling could go into such an architecturally basic form.

The native *bohío* had much in common with many African house types, enshrined in the memories of those who experienced the African diaspora. However, significant variations on the local prototype can be detected. Africanisms found their way into the native architectural experience partly because slaves were in charge of constructing their abodes.[15] As a result, past experiences and modes of construction were replicated in the new environment. After all, not only were there similarities in terms of climate, as Diego de Torres Vargas pointed out as early

Arleen Pabón

as 1647, but also in construction materials.[16] This approach should not cause surprise, for Europeans, just like Africans, followed the exact same pattern: architectural styling and construction techniques closely mimicked those found in their native land, in spite of climatic differences.

Most archeological findings corroborate historical descriptions of the Amerindian huts: a round or oval floor plan covered with a thatched roof and open-work wooden walls.[17] Consensus is not, however, as widespread regarding the idea that Europeans introduced the square or oblong hut to the island.[18] We do know that the vernacular hut morphology experienced a transformation and that oblong (at times square) floor plans came to be preferred. Since the change was not the result of different construction materials or climatic conditions, the new preference is probably related to diverse experiences: from new construction techniques to religious and cultural ideas imported not from Europe but from Africa. The ideas did not reflect European construction techniques or native architectural expressions. Comparisons can be made with African building traditions, but more research and interpretative activities are needed in order to correlate the *bohío*'s development with architectural traditions present in African countries such as modern-day Nigeria, Congo, and Senegal.[19]

African experience also transformed the minimalist approach that characterized the native*bohío*. Most historical descriptions make a point of emphasizing its "open character," evidenced in most contemporary images. These houses, termed *bohíos* from the very early stages of the Spanish conquest, were described some decades later in the following manner: "Four tree trunks placed into the soil with smaller ones placed across, covered by dried yaguas, [raised] two to three feet from the ground to keep the humidity out and having a small staircase to enter the house." The description further mentions that no nails or other European fasteners were used and that the hut was completely open with only the sleeping area barely protected from the "excessive night air" (*fresco excesivo*). It was here the inhabitants slept, grouped together "like savages." There was no furniture, no table, no bed or crib, only *hamacas* made with "Mayagüez bark" (at a cost of two *reales*). The *ménage*was composed of instruments "provided by Nature," such as palm leaves, which were folded and sewn to make dining plates, wash basins, baskets used as commodes, and even funeral caskets for children.[20]

While in the United States, the slave cabin "recapitulated frontier architecture," in Puerto Rico, African descendants altered the native typology and made possible a new organization, both spatial and contextual.[21] As mentioned before, instead of the round floor plan common to the natives, the square or rectangle was preferred. In addition, the makeshift, nomadic, native ethos was also transformed: as time went on, the *bohío*acquired more substance both in terms of materials and structural components. The most interesting transformation was a switch to a more introverted character. The transformed hut, in most cases, had no windows and only a small door to the interior.

This lack of establishing direct connections with the exterior was a deviation from the native arrangement. Opening interiors to the outdoors is common in a tropical milieu, characterized by its hot, humid weather. Enclosure is probably a most relevant Africanism. Walls define boundaries: within them you have status, personal definition. If you were a slave, outside of the seemingly flimsy boundaries established by the walls of your *bohío*you had nothing and were considered nothing. The more openings present in a hut, the more transparency and lack of privacy experienced within the interior. For the enslaved population (and you were enslaved whether you were a slave, a freed slave, or an *arrimao*) the bright outdoor space was not their space but a cruel stage, a vivid reminder of the unfortunate situation that they experienced.[22] A dark, enclosed interior created a sense of intimacy that protected, to paraphrase Gaston Bachelard, the user's immense intimacy from prying eyes and the real world.[23] Completely enclosed spaces provide respite from the heat as well.

It is recorded that all over the Caribbean, in the few cases where windows do appear, blind shutters closed them, per African tradition, in marked contrast to fancy, more transparent European shutters.[24] When inside the *bohío*, you wanted to shut out the exterior, not to bring it in. This characteristic became an intrinsic part of the traditional Puerto Rican house. To this day, most windows, when shut, allow no light to come in.

As a result of this desire for privacy, the entry point—the place where the conversion between public and private, profane and sacred, took place—was limited to one very small opening. Given that the entrance was considered a "weak" point in the desire for privacy and interior autonomy from the exterior, the access, when the floor was higher than the ground, was a small, roughly conceived wooden ramp or staircase. It was common for the interior space to serve as a living-cum-sleeping place (such generic spaces were called *piezas* or *aposentos* by my grandmother) that either had a dirt floor or a wooden platform on stilts (zocos). Most lived *al fresco* most of the day, working on their labors. The desire to "forget" the reality of their lives could only be exercised at night, when their time was their own. At night they preferred a completely enclosed area in order to reinforce a sense of isolation from the "cruel stage."

The floor had a unique symbolism and, in keeping with its significance, had its own special name, *soberao*, a word of unknown origin.[25] The *soberao* is not just a floor but evidence of a dwelling locus. For a woman her *soberao* proved not only that she had a house but also that she was the lady of that house.[26]

In the United States, slaves at times insisted on a particular type of floor finish as an act of appropriation. Susan Snow, a former slave raised on a plantation in Jasper County, Mississippi, reported that most of the slave cabins had wooden floors, except the one that was assigned to her African-born mother: "My ma never would have no board floor like the rest of 'em, on 'count she was a African—only dirt." By rejecting an apparent material "improvement," this woman recreated in her house an aspect of African domestic life with which she was more comfortable.[27]

The feel and texture of the dirt against bare feet, the smell of packed earth, and the darkness enveloping these sensations were probably a reminder of the long-gone African past. In Puerto Rico, the dirt floor slowly evolved into the raised floor surface, a solution aimed at providing protection against tropical rain and the ever-constant humidity. However, there is evidence that dirt floors were used well into the twentieth century.

A *bohío* was more than just a shelter; it was a womb-like setting that provided comfort by means of privacy. The *bohío* experimented with minimalist architectural ideas and its unique personality was the result of importing the African architectural experience into the domain of the native house.[28] At a later stage, other Africanisms were introduced, such as the emphasis on the long axis and special decorations on the main facade. When these traditions fused with other ideas (such as the Anglo-American grille), the unique Puerto Rican house came to be. Most examples of the hut type are long gone but their architectural influence is still with us in every solidly closed window and in every street used as a *batey* (patio) by children and grownups alike.

On the island, cooking was considered a communal affair and, once again, Africanisms transformed the native experience: the Taíno *batey* became a common area shared by the *bohíos* that help organize it. Contrary to European plaza standards, this iconic space did not follow any particular geometric layout. It was an informal place to work, chat, cook, play, and, on occasions, dance. It is interesting to note that balconies, the paradigmatic European architectural domestic interior/exterior artifact, are not present in the African-Puerto Rican hut. On the island, Europeans used balconies as visual instruments of order and power. In the countryside they acted as a platform from where the activities of the farm (*hacienda*) could be inspected. In the city they

helped maintain the purdah system, being the only exterior place a woman could venture on her own without male escort. In both cases, they represented something foreign, seldom experienced by the group under study: a place to spend time at ease. The communal *batey* was the equivalent of the European balcony: it acted both as architectural signifier and signified.

The lack of interest in formal arrangement evidenced in the *batey* is parallel to the way the group related to the city. Even in the tightly restricted San Juan urban area, the free African-Puerto Rican population chose to express themselves in a different manner. It is interesting to note that the barrio where most lived was distinguished by its own name.[29] In a historic plan of the area, we discover that the individual houses do not follow the rigid grid layout that characterizes the rest of the urban enclave.[30]

As the orthogonal arrangement can still be seen today, the domestic units deconstruct the grid. In fact, some houses in the area still have small front gardens, something unheard of in the rest of the city.[31] This is the only preserved physical evidence we have of an urban Africanism on the island, an example of self-expression by a subordinate class. It is indeed curious how, even in the structured and standardized European grid milieu, the group's identity was preserved.

On things unseen

Not all things are visible like small front gardens or old photographs of *bohíos*. There are things unseen regarding the African impact upon Puerto Rican architecture, things for which we lack physical evidence. Contemporary society is said to be guided by phonocentrism, described as a partiality or a favoring of physicality. As a result, physicality—interpreted, on many occasions, as that which is more common—represents truth and reality. The interpretation that something stands for "reality" just because it is more common, makes possible the construction of many different types of binaries: being/not being, presence/absence, male/female, white/black, among others. As Jacques Derrida and others have explained, such binary oppositions favor the "groundly" term or the construction that supposedly articulates the fundamentals.[32] In this manner, distorted conclusions may be reached.

Unfortunately, architectural phonocentrism affects historic preservation methdologies. We tend to ascribe cultural significance to artifacts that we can see or, at the most intangible, to places directly related to events we define as significant or to sites that we believe physically represent historic events. If we do some soul searching, we realize that we are really in the business of preserving tangibles. Yet tangibles are a trap that cause us to believe that only "real things" (as in physical) matter. This is particularly the case regarding architecture.

On occasion, I define architecture to my students using Martin Heidegger's dwelling concept that, naturally, requires presence. It seems to follow that if architecture requires presence, so do historic preservation activities.[33] Is this true? Is cultural significance exclusively tied to the presence of an object? Most of the time, our answer to this last question is yes. That is one of the reasons why many Underground Railroad resources do not qualify as historic resources: we do not have a string of architectural or archeological "things" we can see that are related to them. Curiously, because of our architectural phonocentrism, even when we see, we fail to understand.

Ruins of *barracones* have a paradigmatic presence in many Puerto Rican *haciendas*. While the various names attributed to these structures should alert us, most specialists miss the point regarding the cultural significance of these structures. These places are more than just ruins of storage areas because, in many cases, slaves also used them as dwelling places. The absence of traditional domestic architectural accoutrements clouds our understanding. Interpreted solely as storage areas, they are perceived as architectural symbols of commercial ventures, as examples of

specific construction techniques … as everything except the homes of slaves. More importantly, understood as mere storage areas and not as slaves' dwellings, no research activities are undertaken on their other possible histories. As a result, no urgent need arises to preserve the half dozen that still remain on the island.

All languages, including architecture, are symbols of a mental experience that consists both of sensory and mental perceptions. Architecture is more than a physical artifact and it follows that its "reality" is constructed of more than just stones and bricks or design ideas. There exist supplemental components, like the intangible "baggage" implicit in cultural diversity to mention just one. As preservationists working with the past for the future we have a cultural exigency: we must question traditional interpretations, dislodge assumed certitudes, and deconstruct undivided points of view. How are we to do this? Let us accept Derrida's recommendation and privilege feelings over physicality.

Conclusion

Buildings are a necessity of the metaphysics of presence. Hence their historical significance: they are physically identifiable. Cultural heritage, however, is formed not only of thoughts expressed physically but also of emotions. Furthermore, absent architectural artifacts might still be audible precisely because of their silence. Regarding Africanisms and Puerto Rican architecture, I believe in privileging absence over presence.

Some structures are more than just *barracones* sitting in the meadows.[34] Some empty fields are more than just old and now abandoned agricultural areas. These places need to be interpreted in a manner similar to historic battlefields. We preserve battlefields because, for a relatively short interval, something important happened there. Ruins and many abandoned fields are landmarks in the same manner as battlefields. In these places—in every sugar, coffee, or cotton row—a battle was fought every hour of every day, every week, every year, for several centuries. The battle was for things sacred: individual dignity and freedom. These sites, including the few known resting places of the enslaved population, are truly battlefields of honor, where blood and sweat were spent. Because of this, they are a significant component of Puerto Rican and Caribbean cultural memory.

Thanks to poetry, Tembandumba's personality and charm are preserved for posterity. The sites and architectural memories that evidence Africanisms present in Puerto Rican architecture are not. We need to preserve them or else risk forgetting one of Puerto Rican culture's most fascinating and elusive histories.

Notes

1 This essay is based on a paper presented at the National Park Service's "Places of Cultural Memory: African Reflections on the American Landscape" conference convened in Atlanta, Georgia, in May 2001. The author wishes to thank Professors Rafael A. Crespo and Andrew Chin, Antoinette J. Lee, Brian D. Joyner, and Frederic Rocafort-Pabón for their help and interest.

2 It is possible that "Quimbamba" refers to Quimbombo, the Congo (from Ganga) word for Gondei. Lydia Cabrera, *Vocabulario Congo (El Bantu que se habla en Cuba)* (Miami: Daytona Press, 1984), 134.

3 Luis Pales Matos, *Tuntun de Pasa y Grifería* (San Juan, Puerto Rico: Biblioteca de Autores, Puertorriqueños, 1950), 65–66. The poem, "Majestad Negra" (Black Majesty) is taught in grade schools throughout Puerto Rico and most school children know it by heart.

4 Joseph Holloway, ed., *Africanisms in American Culture* (Indianapolis: Indiana University Press, 1991), ix, defines Africanisms as, "[E]lements of culture found in the New World traceable to African origin." Quoted in Brian D. Joyner, *African Reflections on the American Landscape: Identifying and Interpreting Africanisms* (Washington, DC: National Park Service, U.S. Department of the Interior, 2003), 2.

Arleen Pabón

5 In prehistoric Puerto Rico, the use of stone as a construction material was limited to carved *menhirs* usually placed around ceremonial areas known as *bateyes* (*parques ceremoniales* or *canchas*). Archeological excavations also show that stone was used in the construction of some roads (*calzadas*).

6 Christopher Columbus's much-contested letter to the Spanish queen and king mentions that the "houses" were decorated with "nets" and surrounded with "fences," as apparently (only to him) was common in the Valencia region.

7 In Cuba, the *bohío* is described as a humble structure made of the different parts of the palm tree. Oswaldo Ramos, *Diccionario popular Cubano* (Madrid: Agualarga Editores S L, 1997), 27. Other construction materials are mentioned in the *Diccionario de la Lengua Española*, 22nd edition (Madrid: Real Academia Española, 2001). According to this second source, the word *bohío* is Taíno in origin and describes a rustic architectural artifact made of wood and branches or reeds that has just one opening. (In contrast, the *caney*, another Taíno word, describes similar structures [*cobertizo*] without walls.) Note that this is a description of the evolved *bohío*. The words *buhío* or *bugío* were also used in the past. Manuel Álvarez Nazario, *El habla campesina del país Orígenes y desarrollo del español en Puerto Rico* (Río Piedras, Puerto Rico: Editorial de la Universidad de Puerto Rico, 1990), 330. In this essay, the word *bohío* is used to both describe the original native and developed forms (which includes Africanisms). The English word "hut" is used interchangeably.

8 Many writers and essayists espouse the idea that the primeval hut is central to the development of architecture. See Vitruvius, *De re architectura libri decem*; Abbé Marc-Antoine Laugier, *Essai sur l'architecture*; Gaston Bachelard, *The Poetics of Space*; Joseph Rykwert, *On Adam's House in Paradise*, among others. Philosophers and theorists follow suit, including Martin Heidegger and Christian Norberg-Schulz. It is my belief that the *bohío* is the Caribbean interpretation of the "primitive hut" or *choza primitiva*. My colleague, Dr. Rafael A. Crespo, refers to the Vitruvian paradigm as the *choza rústica*. (According to the *Diccionario de la Lengua Española*, *cabaña* is synonym for *choza*.)

9 Dora P. Crouch and June G. Johnson, *Traditions in Architecture Africa, America, Asia, and Oceania* (New York: Oxford University Press, 2001), 25.

10 One might question whether or not the full-fledged collective Puerto Rican "personality" had congealed by the eighteenth century. In my opinion and from an architectural point of view, by this time (two centuries plus after initial European and African presence on the island) the personality was identifiable, as the evolution of special domestic types and the use of the word *ibaros* [*sic*] (*jíbaro*) in this quote suggest.

11 Notes taken from an old manuscript on Caribbean islands kept at the General Library of the University of Havana, Cuba, in 1990. Even though I am unable to specifically name the source (it was presented to me as a bunch of pages with a sort of ribbon loosely binding them), I do remember that there were no page numbers or illustrations, as well as no formal title page. The historic character of the document, written in Spanish, however, was obvious. Since the library strives to preserve valuable documents, it is possible that the manuscript was acquired in this incomplete state. I translated the quoted text.

12 Also known on the island as *barracas, cuarteles, cuartelones*, and, at times, *ranchos*.

13 In the Spanish-speaking islands, these structures were known principally as *bohío* but also as *ranchito, casita, mediagua*, and *mediagüita*. Manuel Álvarez Nazario, *El habla campesina del país Orígenes y desarrollo del español en Puerto Rico*, p. 331. Cubans of Congo heritage also used the following terms: *nso, sualo, nusako*, and *kansesa*. (Curiously, tombs were known as *kabalonga* (*casa honda*) or "deep house.") L. Cabrera, *Vocabulario Congo (El Bantu que se habla en Cuba)*, 46.

14 The post is called *pied-bois d'ail*. Jack Berthelot and Martine Gaumé, *Kaz Antiyé Jan Moun Rété* (Paris: Editions Caribéennes, 1982), 85. To "plant" means placing the vertical wooden post (*horcón*) that serves as a column and sustains the main roof beam (*cumbrera* or *cumblera*) and the overhangs (*aleros*). Arleen Pabón de Rocafort, *Dorado: Historia en Contrastes* (Dorado, Puerto Rico: Municipality of Dorado, 1988).

15 The island's construction workforce consisted primarily of slaves and prisoners. An estimated 17 percent of the slave trade was destined for the Spanish territories in America, while an additional 40 percent was directed to European-held islands in the Caribbean, which included Spanish colonies.

16 "Descripción de la Isla y Ciudad de Puerto Rico" sent to the King by Diego de Torres Vargas on April 23, 1647, quoted in Coll y Toste, *Boletín Histórico*, IV, 258. De Torres drew a comparison between the island and Angola. Palm leaves, reeds, *yaguas*, and *guano* are mentioned as local construction materials. (This poses an interesting dilemma for it is well documented that palm trees are not native to the island.) Although some historians mention that mud was used as in Africa, the material as construction material is not associated with Puerto Rico.

Africanisms and Puerto Rican architecture

17 David Buisseret, *Historic Architecture of the Caribbean* (London: Heinemann, 1980), 1. Buisseret's description matches those of Fray Iñigo Abbad y Lasierra, *Historia Geográfica, Civil y Natural de la Isla de San Juan de Puerto Rico*; Pedro Tomás de Córdova, *Memorias Geográficas, Históricas, Económicas y Estadísticas de la Isla de Puerto Rico*; and Obispo Bartolomé de las Casas, *Brevísima relación de la destrucción de las Indias*, among others.

18 Buisseret, *Historic Architecture of the Caribbean*, is one of several that credits Europeans with this idea. A notable exception is presented by J. Berthelot and M. Gaumé, *Kaz Antiyé Jan Moun Rété* since they believe that this morphology is an architectural Africanism. This idea is reinforced by John Michael Vlach, *Back of the Big House: The Architecture of Plantation Slavery* (Chapel Hill: The University of North Carolina Press, 1993). According to Vlach, the shotgun arrangement is an Africanism. While I do not feel that the shotgun interior arrangement is solely an African contribution, the emphasis on rectangular spatial arrangements seems to be something characteristic to the African architectural experience, even if not unique to it.

19 Many Puerto Rican slaves came from these areas.

20 Notes taken from an old manuscript on Caribbean islands kept at the General Library of the University of Havana, Cuba, in 1990. It is interesting to note the specifics mentioned, such as the use of "Mayagüez bark" (Mayagüez is a town located on the west coast of the island). Humble interiors characterized most domestic establishments on the island. As late as 1899, for example, the "big house" was described in the following fashion—Even the finest haciendas are meager and barren in their interior fittings. The floors are always bare. The walls have few pictures, though now and then one is surprised to see a clever painting by one of the masters of the modern French school. The usual wall decoration is a pair of Spanish bas-reliefs, in colored plaster or *papier maché*. Chromos and vilely executed woodcuts often make an appearance, and seem out of place with the oftentimes beautiful architectural finish of the drawing-rooms, whose windows, door less archways are framed in carved woods and relieved of severity by scroll latticework. William Dinwiddie, *Puerto Rico; Its Conditions and Possibilities* (New York: Harper & Brothers, 1899), 147.

21 Henry Louis Gates Jr., *Spencer Crew, and Cynthia Goodman, Unchained Memories: Readings from the Slave Narratives* (Boston: Bulfinch Press, 2002), 67–68.

22 An *arrimao* (from the Spanish *arrimado*) was allowed to work a small plot that belonged to someone else. Payment was part of whatever was produced. Although not considered serfs, their life was extremely harsh as they were subjected to all sorts of uncertainties and economic hardships. It should be noted that in 1899 the institution was still prevalent and described in the following fashion—House-rent is an almost unknown factor in the country, though in towns many people huddle in to one house and live, amid dirt and disease, at the expense to each family of a few pesos a month. It is customary for landed proprietors to grant to their peons small patches, on the steep hillsides, which are of little value for tillage. This meets the end of assuring their services to the plantation-owners upon demand, with no expense to himself, and secures him the *éclat* of being apparently a philanthropist. See Dinwiddie, *Puerto Rico; Its Conditions and Possibilities*, 157.

23 Gaston Bachelard, *The Poetics of Space: The Classic Look at How We Experience Intimate Places* (Boston: Beacon Press, 1994).

24 The most relevant exponents of this theory are Berthelot and Gaumé, *Kaz Antiyé Jan Moun Rété*.

25 There exist all kinds of interpretations about the origins of this word. According to the *Diccionario de la Lengua Española*, in Andalucía and America, *soberado* describes an attic (*desván*). It is possible that some connection was made between an attic-like place and the floor of the house, particularly since many houses were placed on stilts. In 1765, houses on the island were described in the following manner— *Para aquellos días tienen unas casas que parecen palomares, fabricadas sobre pilares de madera con vigas y tablas: estas casas se reducen en un par de cuartos, están de día y noche abiertas, no habiendo en las mas, puertas ni ventanas con que cerrarlas: son tan poco sus muebles que en un instante se mudan: las casas que están en el campo son de la misma construcción, y en poco se aventajan unas a otras.* In these days they have houses that resemble pigeon coops built on top of wooden posts with wooden beams and slats: these houses are minimal and consist of a pair of rooms, they are open night and day, and they do not have doors or windows to close them: their furniture is so limited that they can move in an instant: the houses in the countryside have the same type of construction and they are not much better." (Translation by author.) Appendix II, 1765 "Memoria de Don Alejandro O'Reilly sobre la isla de Puerto Rico," in L. Figueroa, *Breve Historia de Puerto Rico*, Vol. I (Río Piedras: Editorial Edil, Inc., 1979), 463–468. According to Manuel Álvarez Nazario, *El habla campesina del país Orígenes y desarrollo del español en Puerto Rico*, 333, the words originally described the interior generic space and with time came to be associated with the floor surface. There seems to be no

Arleen Pabón

definitive interpretation of whether or not the word was used to describe all floors, including dirt-packed floors. In 1863, a house appearing behind a lady on horseback in the painting *Hacienda de Puerto Nuevo* by Puerto Rican painter José Campeche, was described as having stilts: *Un bohío o casa de campo sobre pilares altos de capá o ausubo. José Campeche 1751–1809* (San Juan: Instituto de Cultura Puertor-riqueña, 1971), 24–26. It is interesting to note that the word *bohío* also was used to describe houses in the countryside belonging to the upper social strata. Curiously, similar structures can be found in the northern part of Spain (Galicia). Called *hórreos*, they are usually used as storage or drying areas.

26 Some years ago, when visiting one of these abodes, I observed that the lady of the house retained her untidy *soberao*, formed of rough wooden planks. At first, I was surprised with her situation. Now, I understand that the *soberao* proves that you have a place of your own (even if you are an *arrimao* and the land belongs to another person). My friend Gloria M. Ortiz, former historical architect for the Puerto Rico State Historic Preservation Office, had a similar experience when visiting the house of a santero artisan.

27 John Michael Vlach, *Back of the Big House: The Architecture of Plantation Slavery*, 165. Susan Snow's quote comes from: Norman R. Yetman, ed., *Life Under the "Peculiar Institution": Selections from the Slave Narrative Collection* (New York: Holt, Rinehart, and Winston, 1970), 61, 144. A former slave described living conditions in the following manner: "Parsons Rogers come to Texas in '63 and bring 'bout 42 slaves and my first work was to tote water in the field. Parsons lived in a good, big frame house, and the niggers lived in log houses what had dirt floors and chimneys, and our bunks has rope slats and grass mattress." Gates Jr., Crew, and Goodman, *Unchained Memories: Readings from the Slave Narratives*, 81. No mention is made in this case whether or not the dirt-packed floor was a personal choice of the cabin's inhabitant.

28 One of the theses of this paper is that the *bohío* had a profound influence on Puerto Rican domestic architecture. During the 1940s they still represented a formidable presence—In sharp contrast to the massive, solid structures of the cities are the *bohíos*, or cabins of the country people, constructed in much the same manner as the aboriginal homes of the Indians which the Spaniards found on their arrival. The real *bohío*, raised a few feet above the ground on stilts, is made from palm thatch, with one or at the most two rooms, and sometimes a lean-to kitchen, where cooking is done over a charcoal fire. Furniture is scant and simple, consisting mostly of hammocks, pallets, or perhaps cot beds with *colchonetas* (quilts) thrown over the springs. Usually the interior walls are brightened by gay pictures from illustrated magazines and newspapers. The crude construction of these humble homes is offset by a profusion of flowers and blossoming vines. Puerto Rico Reconstruction Administration, *Puerto Rico: A Guide to the Island of Boriquen*, 118.

29 Culo Prieto was roughly located to the east of the San Juan urban core, sandwiched between the city and the only land gate. It was roughly located between Sol, Luna, and San Francisco Streets east of de Tanca Street and west of the San Cristóbal fortification.

30 The plan used for this analysis is an 1880 copy of a 1771 document. The copy was prepared by Francisco J. de Zaragosa and dated December 9, 1880. The American administration copied the copy (provided to them by Mr. Morales on tracing paper) dating it to October 16, 1908. The original third copy is housed at the National Archives and Records Administration, Records of the Bureau of Yards and Docks, Record Group 71, "Plano de la Plaza de San Juan de Puerto Rico y sus ymmediaciones [*sic*] ...")

31 In San Juan, street facades typically opened directly onto the street (now sidewalks). During the twentieth century, the streets of the area under scrutiny were formally laid. Since some facades did not directly align, small gardens were inserted between the facades and the street proper. This is how evidence of the former deconstruction of the orthogonal grid is preserved.

32 The concept of the "Other" is amply analyzed in Simone de Beauvoir's *The Other Sex*, Edward Said's *Orientalism*, and Matthew Frye Jacobson's *Whiteness of a Different Color* and *Barbarian Virtues*.

33 Several countries recognize this issue and designate as places worthy of preservation locales that lack definitive presence of artifacts constructed by humans. Unesco recently adopted the International Convention for the Safeguarding of the Intangible Cultural Heritage. In the United States, recent preservation efforts along these lines include the Trail of Tears, a significant symbolic landscape.

34 At the time that I presented this paper in its original form, I was acting as a preservation consultant for a project that was to be located on the ruins of an early nineteenth-century cotton *beneficiado* at Hacienda La Esmeralda in Santa Isabel, Puerto Rico. I collaborated with the architect, Abel Misla, in the creation of a new building that frames the ruins in a compatible and sensitive manner. The archeological ruins of the big house were found next to the *beneficiado* ruins, perhaps reinforcing the idea that the *beneficiado* might have housed slaves. The rehabilitation project won the premio a la Excelencia de Diseño prize from the Colegio de Arquitectos y Arquitectos Paisajistas de Puerto Rico (Puerto Rican Architects Association).

12
Iconoclash in the age of heritage [extracts]

Peter Probst

> We can define an iconoclash as what happens when there is uncertainty about the exact role of the hand at work in the production of a mediator.
>
> *Bruno Latour, What is Iconoclash? (2002)*

In 2002, a number of scholars around the French sociologist Bruno Latour, the American art historian Peter Galison, and the Austrian theorist/artist Peter Weibel curated an influential exhibition, which explored the range of actions and attitudes geared towards images, or "mediators" as Latour called them. By introducing the notion of "iconoclash," the idea was to provide an alternative term to "iconoclasm" that would place less emphasis on the negative breaking (clasm) and suggest the more open possibilities of clash. The exhibit thus focused on "sites, objects, and situations where there is an ambiguity, a hesitation, an iconoclash on how to interpret image-making and image-breaking" (Latour 2002: 22). Following the spirit of open inquiry which informed the exhibition, the articles in this special issue intend to focus on the ambiguity of a certain genre of images: images of heritage.

The topic is timely. From the inauguration of the Festival of the Dhow Countries in Zanzibar and the introduction of a new multicultural independence commemoration in civil-war-torn C6te d'Ivoire, to the tombs of the Buganda kings turned into a UNESCO World Heritage Site, the celebration of heritage has become a major factor in the cultural economies of many African states today. A heritage fever has set in. With the help of supranational agencies like UNESCO, heritage has become a new technology, preserving and safeguarding the present past. As a result, images of the past—all of them endlessly reproduced and remediated on canvas, photographs, and film—have become omnipresent, thus effectively portraying heritage as being first and foremost ruled by an image economy.

Why this fixation on things past? Why images? In the African context, the importance of the question looms large. Postcolonial studies on collective memory have long pointed to the frictions between public and popular memory, how the state instrumentalizes, manipulates, suppresses, and at times even abuses local memories in order to overcome its still fragile and fragmented nature (e.g. Werbner 1998, Mbembe 2001). Lately, the focus has shifted to "alternative imaginaries" and the "reclaiming of heritage" (De Jong and Rowlands 2007) thus opening

179

up the "landscape of memory" (Marschall 2010). We don't dispute the relevance of these debates. In fact, some of the contributions presented here do speak to them directly. Our discussion starts with a different question though: where do images of heritage actually come from?

With respect to Africa, the answer is most often a story about iconoclasm. What we find here is not only the destruction and devaluation of old images through colonialism, religious movements, or periods of civil war, but also the imposition of new images. Indeed, iconoclasm does not only preserve memory, as Ramon Sarro (2008) and others have shown so convincingly. It also triggers new images, in effect iconoclastic icons, images of images, which were once destroyed and abused, as well as images taken over from hegemonic cultures. Resonating with Latour's notion of iconoclash, all too often the result has been a clash of conflicting visual traditions, which might explain why heritage in postcolonial and post-conflict societies is at times perceived as an "ambivalent heritage" (Chadha 2006) loaded with doubt and uncertainty regarding the meaning of its pictorial referents.[1]

Following up on my own work on heritage politics in Nigeria (Probst 2011), the aim here is to come to a more nuanced picture of the role of heritage in the realm of cultural production and the artistic imaginary. What matters to us are issues of production and consumption. In particular, we are interested in the motivations of the image-makers, the roles they give to their works and the effects the works have on those who see and obtain them. What drives and nourishes the clinging to old forms and things past? What kind of values are involved and whose values are they? Last but not least: how do we, mostly in West, study these images without falling into the binary trap of seeing them as either evidence of kitsch or documents of pride?

I

Given the visual prominence of the subject, the lack of African (art) historical research on heritage surprises. So far, research in African art has shown little interest in heritage as a contemporary form of cultural production, i.e., a form that is directed towards the past but is produced in the present (Kirshenblatt-Gimblett 1998). If questions of heritage do arise, they are mostly couched in debates about restitution, representation, and identity/value.

By adopting the notion of iconoclash, our approach aims to take a different route. In doing so, we take the above-mentioned link between heritage and iconoclasm as a starting point. In fact, the word heritage is intimately tied to the (Western) history of iconoclasm. As a collective duty of preservation and conservation, the term "heritage" is said to go back to the year 1795, when the Bishop of Blois, Henri Baptist Gregoire, openly criticized the excesses of the French revolution (Sax 1990). What Gregoire was concerned about was the looting of the Louvre, the former royal palace, which had been transformed into a public art museum by the French revolutionary government (McClellan 1992). The very content of the Louvre, so Gregoire argued, not only belonged to the French nation as a whole, but also constituted the nation's collective memory and identity, something worth preserving as heritage.

Seen in this light, heritage is defined in relation to history and memory, for which it acts as a substitute. During what has become known as the period of modernism, the specific time experience heritage represents (in the West) became a prominent theme of public discourse leading not only to a surge of monuments but also to a series of texts commenting on this development.[2] In view of this tradition, Francois Hartog has reminded us to think of heritage

> less [as] a question of an obvious, assertive identity but [more as] a question of an uneasy identity that risks disappearing or is already forgotten, obliterated, or repressed: an identity in search of itself, to be exhumed, assembled, or even invented. In this way, heritage comes

to define less that which one possesses, what one has, than circumscribing what one is, without having known, or even be capable of knowing. Heritage thus becomes an invitation for collective anamnesis. The "ardent obligation" of heritage, with its requirement for conservation, renovation, and commemoration is added to the "duty" of memory, with its recent public translation of repentance.

(2006: 12)

Surely, the history of heritage as well as Hartog's analysis of it is a European one. This applies also to the specific practices aiming to secure the "duty of memory." For instance, in Western society it is a matter of piety to preserve images of the dead. We don't discard portraits of our forefathers and -mothers. By keeping them we show respect to the deceased. However, this practice differs. Instead of the cult of permanence and monumentality dominating the Western notion of heritage, what we find elsewhere is often an emphasis on the ephemeral and unfinished, something Strother (2002) has aptly termed "iconoclasm by proxy."

II

Does this imply that there are no commonalities? The answer is negative and the reasons for it lie in heritage's embeddedness in feelings of loss and absence. Put simply, heritage is rooted in death. After all, one can inherit only if the owner of the property has passed away. German language makes this quite clear. The two words erben (inherit) and sterben (die) share more than a phonetic proximity. Rather, the two go together. They form a relation. In other words, inheritance is defined by death; the former happens through the latter. In terms of organization, the relationship between the two can be seen as a kind of gift exchange whereby property is exchanged for memory and remembrance. That is to say, the dead leave their work behind for the living. In exchange, the living commit to remember and re-present the dead. Images, mental as well as material ones, thus act as "mediators" to use Latour's term, filling the loss the dead have caused.[3]

Given these ideas, it seems reasonable to reflect upon the forms of exchange under the conditions of the contemporary heritage industry and the flood of images it produces. That is to say, heritage has turned into an image machine. The more popular a site is, the more images it produces. Like in Europe, America, or Asia, the dynamics of "millennial capitalism" (Comaroff and Comaroff 2001, 2009) have left their mark in Africa as well. Here, too, financial excess correlates with a pictorial one. What we can observe is the encroachment of the capitalist market spheres into the spheres of ethnicity. Certainly, the branding and commercialization of cultural heritage is not specific to Africa. What is distinct, however, is the continent's colonial history, which, as I have argued above, made the depiction of heritage a highly unstable and precarious affair.

Notes

1 See the debate about the new Monument of the African Renaissance, in Dakar, Senegal (de Jong and Foucher 2010). With respect to the notion of "ambivalent heritage" see also the special issue of African Arts on "hybrid heritage" I co-edited with de Jong (De Jong and Probst 2009).
2 The respective spectrum is broad-ranging, from Riegl 1903 to Simmel 1911 and Musil 1981.
3 As the reader will have noted, the argument is a hybrid, informed by Marcel Mauss' (2001) famous essay on the gift and Hans Belting's (2011) anthropological take on images.

Bibliography

Belting, Hans. 2011. An Anthropology of Images. Princeton, NJ: Princeton University Press. Originally published 2001.

Chadha, Ashish. 2006. "Ambivalent Heritage: Between Affect and Ideology in a Colonial Cemetery." Journal of Material Culture 11 (3):339–63.

Comaroff, John, and Jean Comaroff. 2001. "Millennial Capitalism: First Thoughts on a Second Coming." Public Culture 12 (2):291–343.

Comaroff, John, and Jean Comaroff. 2009. Ethnicity Inc. Chicago: Chicago University Press.

De Jong, Ferdinand, and Vincent Foucher. 2010. "La tragedie du roi Abdoulaye? Neomodernisme et Renaissance africaine dans le Senegal contemporain." Politique Africaine 118:187–204.

De Jong, Ferdinand, and Peter Probst (eds.). "Hybrid Heritage" (special issue). African Arts 42 (4).

De Jong, Ferdinand, and Michael Rowlands (eds.) 2007. Reclaiming Heritage: Alternative Imaginaries of Memory in West Africa. Walnut Creek, CA: Left Coast Press.

Hartog, Francois. 2006. "Time and Heritage." Museum International 227:7–18.

Kirshenblatt-Gimblett, Barbara. 1998. Destination Culture. Tourism, Museums, and Heritage. Berkeley: University of California Press.

Latour, Bruno. 2002. "What is Iconoclash? Or Is There a World beyond Image Wars?" In Iconoclash, ed. Bruno Latour and Peter Weibel, pp. 14–37. Cambridge, MA: MIT Press.

Mbembe, Achille. 2001. On the Postcolony. Berkeley: University of California Press.

McClellan, Andrew. 1999. Inventing the Louvre: Art, Politics, and the Origins of the Modern Museum in Eighteenth Century Paris. Berkeley: University of California Press.

Marschall, Sabine. 2010. Landscape of Memory: Commemorative Monuments, Memorials, and Public Statuary in Post-Apartheid South Africa. Leiden: Brill.

Mauss, Marcel. 2001. The Gift. New York: Routledge. Originally published 1923/24.

Musil, Robert. 1978. "Denkmale." In Gesammelte Schriften, Vol. 7, pp. 506–509. Frankfurt: Fischer. Originally published 1927.

Probst, Peter. 2011. Osogbo and the Art of Heritage: Monuments, Deities, and Money. Bloomington: Indiana University Press.

Riegl, Alois. 1903. Der Moderne Denkmalkultus: Sein Wesen und seine Entstehung. Vienna: W. Braunmuller.

Sarro, Ramon. 2008. The Politics of Religious Change on the Upper Guinea Coast: Iconoclasm Done and Undone. Edinburgh: Edinburgh University Press.

Sax, William. 1990. "Heritage Preservation as a Public Duty: The Abbe Gregoire and the Origin of an Idea." Michigan Law Review 88 (5): 1144–69.

Simmel, Georg. 1911. "Die Ruine." In Gesarnmelte Essays, pp. 139–48. Leipzig: Klinkhardt.

Strother, Zoe. 2002. "Iconoclasm by Proxy." In Iconoclash, ed. Bruno Latour and Peter Weibel, pp. 458–59. Cambridge MA: MIT Press.

Werbner, Richard, ed. 1998. Memory and the Postcolony: African Anthropology and the Critique of Power. London: Zed Books.

Part II
Authenticity and tourism

Introduction to Part II

Sheila Watson

Imagine the outcry in England if, today, it was decided to rebuild Stonehenge, not as a replica somewhere else, but to put upright the stones where they have fallen, and substitute others for the missing ones. Now it is almost unthinkable, although in the past the stones were rearranged, and what we see today is a remnant of a reimagined monument. In Europe we have, on the whole, established a mode of thinking by which we value the original over the new in heritage. Anything added to an original is in danger of becoming a 'fake', devaluing the values of the thing or site as it is now. It follows the idea promulgated by Walter Benjamin that '[T]the presence of the original is the prerequisite to the concept of authenticity' (1999: 214). Yet, such values are not universal. In some cultures there is an emphasis on the quality of the reproduction. It is better to rebuild or remake than to allow something to fall into disrepair or decay. Moreover, in Europe and the rest of the world reproductions are made if buildings or objects have been destroyed or lost through war or decay with decisions taken on a case-by-case basis. Thus our attitudes to authenticity and its role in heritage are conflicted and contradictory.

With the recapture of Palmyra in 2016, the ancient city vandalised by so called Islamic State (ISIS), there were calls for it to be restored in all its former (albeit somewhat ruined) glory. Yet what some Syrians see as a natural and inevitable process of reclaiming their heritage, others regard with abhorrence.

> Palmyra must not 'rise again', as Syria's director of antiquities has promised. It must not be turned into a fake replica of its former glory. Instead, what remains of this ancient city after its destruction by Isis – and that is mercifully more than many people feared – should be tactfully, sensitively and honestly preserved.
>
> *(Jones 2016: n.p.)*

Here the differences in attitudes are starkly expressed. The Palmyra example raises an interesting question – is it up to each nation to decide how best to preserve and conserve material culture from the past or should there be universally agreed codes of practice? Whether or not such codes will be developed was under discussion by the International Council of Monuments and Sites (ICOMOS) National Committees and International Scientific Committees of the International Council of Museums (ICOM) in 2016. ICOM is:

the global organisation of museums and museum professionals committed to the conservation of the world's natural and cultural heritage. It was created in 1946 and is a non-governmental organisation maintaining formal relations with UNESCO (United Nations Educational, Scientific and Cultural Organization). It also raises awareness of international issues such as combating illicit trade, intangible heritage and restitution.

(ICOM website 2016: n.p.)

However, as you might expect, there is considerable disagreement as to whether or not reconstruction as a means of interpretation is a good thing for the heritage of the world or not. In other words, nations and cultures have different ideas about authenticity and what it means to them.

The authenticity of the object or place may derive from the way in which owners or guardians have stayed true to the purpose, appearance and materials of the original. Moreover these values, this sense of the authentic, change over time. In the UK, Norwich Castle Keep was resurfaced between 1835–1839 to resemble what it might have looked like in its heyday. The Victorians were not above improving on what they found in the way of built heritage. Nowadays it takes months, sometimes years, to obtain permission for small changes to such buildings. A complete rebuild/restoration would be unthinkable. Even now nearly 200 years after its 'rebuild' some people think of it as a fake, although these changes are part of the site's history. What is authentic here? While the Victorians only wanted to improve the look in their opinion of the castle in Norwich, reconstruction can be a political act as it was in parts of Germany after the Second World War (Macdonald 2009, this volume). In Nuremberg, it was also driven by economic necessity. Without it the tourists would not come (ibid.: 123). Does this motive make the process of restoration/rebuilding acceptable?

Authenticity derives its authority from popular perception and also from professional accreditation, whether this is a formal procedure such as a listing of a historic building in the UK, or a set of criteria established by organisations such as UNESCO. What constitutes the authentic is subject to fashion as Creighton demonstrates in his study of contested walled townscapes. All too often a quest for the authentic can result in the stripping away of the accretions of later lives and periods, thus negating their value in the search for the 'original' (Creighton 2007, this volume).

Authenticity does not just reside in the tangibility of the past. It is something used to justify and protect intangible cultural manifestations. For example in Korea, 'living human treasures' are licensed by the government to demonstrate traditional crafts to the people. Such crafts embody a sense of Korean identity and are promoted in heritage sites and museums. The emphasis here is on the unchanged craftsmanship of the living treasure, the process of production, mainly for the Korean people themselves.

Tourists often travel to see and experience something authentic and this sense of authenticity may elicit strong emotional responses to the sites, objects and performances. Landry's account (this volume) of the Slave Route in Benin, created mainly for African-American visitors seeking to experience something of the lives of some of their ancestors and others who suffered slavery, offers an example where historical evidence suggests the tourist trail does not demonstrate strict adherence to the documented past but rather to one that visitors need. Similarly, Atkinson's descriptions of Steampunk artists working in museums of industry in the UK, encouraging visitors to make emotional meanings independent of the traditional narratives that normally surround science objects, suggests that authenticity partly resides in the affective response of an encounter.

The binary opposite of authentic is fake. The latter suggests an intention to deceive and, in so doing, places a value upon the original that copies cannot replicate. However, as Jones (1990)

Introduction to Part II

demonstrates, fakes tell us a great deal about the outlook of those who made and uncovered them. At the same time there is a growing sense that fake objects should be valued as much for what they tell us about changing fashions. Attempts to restore objects to their original state, sometimes seen as faking a vanished form of perfection, add to them a patina of interest (Jones 1990: 14).

When the authentic is understood to be something surviving from a particular period of time, albeit with damage and/or alteration, it can arouse deep feelings in those who encounter it whether it is the place, object, sound or performance. Here the object's historicity gives it something special that a replica apparently cannot. Writing mainly about art objects, Greenblatt (this volume) acknowledges this feeling of 'resonance' and 'wonder', understanding it to come partly from the contextualisation of the object within a historical framework.

Tourism that seeks the authentic often destroys the very thing it seeks. Moreover places of significance, understood to be authentic because events from the past are associated with them or because they have sites of antiquity, are changed by commercial tourist pressures, as Stille's account of his visit to Mont-Saint-Michel in France makes clear (2014, this volume). Other places represent forms of national or local identities and have an authority that depends on a type of historical accuracy that can be challenged, as Handler and Gable point out in their account of the ways in which Colonial Williamsburg in the USA has developed over time (1996, this volume). This former capital of the colony of Virginia in the seventeenth and eighteenth centuries was restored in the 1920s to commemorate and celebrate the colonial era and North America's origins. Here the notion of what is authentic has changed over time with the development of 'new social history' in the 1970s (Handler and Gable 1996: 575; this volume). However, the site adopted a range of techniques to enable visitors to retain some of their romantic attachments to an older form of interpretation that was, with hindsight, understood to have been unauthentic but which nevertheless helped them construct their identities. For Handler and Gable (1996) this construction is about a set of values which tend to go unchallenged. These values, related to patriotism and nostalgia, are those that elicit emotional responses and it is these feelings that help to make authenticity such a contested concept. Such emotional responses are examined by Bendix in her examination of folklore in Germany and the United States (1997). For her, after years of study, the authentic is the 'quality of the' emotional 'experience' (Bendix 1997: 13) that is lost if one spends too much time deconstructing and examining it. For her, any dispassionate examination of the authentic dooms one to present the inauthentic. Thus authenticity is a complex and nuanced idea that rests at the heart of what heritage purports to be and thus deserves serious debate and consideration amongst theorists and practitioners alike.

Bibliography

Bendix, R. (1997). 'Introduction', *In Search of Authenticity: The Formation of Folklore Studies*. Madison, WI: University of Wisconsin Press, pp. 3–23 (this volume).

Benjamin, W. (1999). 'The work of art in the age of mechanical reproduction', in *Illuminations*. London: Pimlico, pp. 211–235 (this volume).

Creighton, O. (2007). 'Contested townscapes: the walled city as world heritage', *World Archaeology*, 39 (3), pp. 339–354 (this volume).

Gable, E. and Handler, R. (1996). 'After authenticity at an American heritage site', *American Anthropologist*, 98 (3), September, pp. 568–578 (this volume).

Greenblatt, S. (1991). 'Resonance and wonder', in Karp, I. and Lavine, S. D. (eds) *Exhibiting Cultures. The Poetics and Politics of Museum Display*. Washington, DC and London: Smithsonian Institution Press, pp. 42–56 (this volume).

ICOM (2016). http://uk.icom.museum/about-us/, accessed 16 August 2016.

Jones, J. (2016). 'Palmyra must not be fixed. History would never forgive us', *Guardian*, Monday 11 April. www.theguardian.com/artanddesign/jonathanjonesblog/2016/apr/11/palmyra-isis-syria-restored-3d-printers-vandalism, accessed 14 April 2016.

Jones, M. (1990). 'Why fakes?', in Jones, M. (ed.) *Fake? The Art of Deception*. London: British Museum Publications, pp. 11–16 (this volume).

Landry, T. (2010). 'Touring the slave route: inaccurate authenticities in Benin, West Africa', in Silverman, H. (ed.) *Contested Cultural Heritage: Religion, Nationalism, Erasure, and Exclusion in a Global World*. New York: Springer, pp. 205–232 (this volume).

Macdonald, S. (2009). 'Reassembling Nuremberg, reassembling heritage', *Journal of Cultural Economy*, 2 (1–2), pp. 117–134 (this volume).

Stille, A. (2014). 'Makeover for Mont-Saint-Michel', *Smithsonian*, June, pp. 77–85, 102–104, 106 (this volume).

13
Touring the slave route
Inaccurate authenticities in Bénin, West Africa

Timothy R. Landry

[The Slave Route] is for everyone. Not just Africans or African-Americans ... the Slave Route is a world heritage—anyone who wants to take the time can come here and learn about our history.

(statement by Béninois tour guide, interviewed July 2008)

Social constructions of memory

French essayist Jean Améry is often quoted as saying, "No one can become what he cannot find in his memories" (1996:84). Indeed, people often find that their *sense of being* is connected to the people and events they recall from their individual and collective pasts. And the numerous, often political ways that memory and cultural heritage are performed on the social landscape can often lead to varying degrees of contestation between social actors. These somewhat messy social exchanges have occupied the careers of many scholars in fields such as anthropology, sociology, and psychology, to name a few. Whether we understand memory and its relationship to cultural heritage to be about shared collective experiences (Halbwachs 1992), embodied performances (Stoller 1995), or the products of habitual action (Bourdieu 1977; Connerton 1989), it is tempting to invoke habitus (Bourdieu 1977) in an effort to explain the ways that collective memory retains its social efficacy over time and across generations. Nevertheless, habitus fails to provide us with the necessary tools to examine the meaning behind processes of creative and embodied remembering. Reacting against habitus as a sufficient model for exploring memory (see Farnell 2000), I find it more useful to interpret processes of meaning-making, especially as it relates to memory and remembered performances, as embodied *action*. For me, memory, like many other aspects of culture, is best appreciated as a creative and dynamically embodied phenomenon that allows for expressive, performative, and active rememberings.

This perspective is aptly illustrated in the context of the "Black Atlantic." As Gilroy (1993) has shown, people on both sides of the Atlantic actively remember the trans-Atlantic slave trade in many innovative ways. Across the former slave coast in West Africa, sites such as the *Maison des Esclaves* of Goreé Island in Sénégal, Elmina Castle in Ghana, and the Slave Route in Bénin have drawn particular attention from scholars interested in Africa's slaving past, as well as from tour agencies that market tours designed for African American tourists who travel to Africa on

a "pilgrimage" to explore their cultural heritage through "roots tourism" (see Bruner 2005a; Ebron 2002).

Unlike Ghana and to a lesser extent Sénégal, slave tourism to Bénin is still in its infancy. This is partly because international tourists were discouraged from traveling to Bénin under the rule (1972–1991) of the Marxist-Leninist dictator Mathew Kérékou. But due to popular discontent surrounding Kérékou's military government, a national conference was established in February 1990, resulting in the formation of a democratic Béninois government. Kérékou peacefully transferred the leadership of Bénin to the new, democratically elected government in 1991. Under the leadership of President Nicéphore Soglo, the new government made it their mission to heighten international attention paid to Bénin. Government officials began creatively mobilizing and invoking the nation's past in ways that appealed to the international community, including the tourism industry. Reflecting this shift in Béninois politics, the peoples of Bénin began marketing their past as one of the largest ex-slaving ports in West Africa.

The government anticipated that African Americans, especially, would be interested in "returning home" to Africa so that they might explore their roots vis-à-vis "heritage tourism." With international support, Bénin began using the trans-Atlantic slave trade as its inspiration to implement a tourism campaign that promised to attract tourists with an interest in Bénin's slaving past. Since the birth of the Slave Route project in 1991, many collective memories that focused on Bénin's role in the trans-Atlantic slave trade have become important to the project's success. In particular, a systematic attempt was made to capitalize on the historical role played by Ouidah, formerly the largest slaving port in West Africa, in the Atlantic slave trade by placing monuments to the slave trade and its victims along the road from Ouidah to the beach where slaves were once forced onto ships bound for the Americas (Law 2004: 2–3).

In addition, to attract tourist monies to Bénin, the government began developing strategies to attract international visitors having an interest in Vodun, a major indigenous religion found in southern Bénin (with versions known as "Vodou" in Haiti and "voodoo" in the Western imagination). Supported by an international awareness of "voodoo," and following the success of Haiti's *négritude* movement that positioned Vodou as both a source of nationalism and an emerging marker of Haitian-ness for Haitians living both in Haiti and in the Haitian diaspora (Largey 2006), Béninois officials saw great potential for Vodun to serve as a catalyst for nationalism. Soglo and his government began working to de-criminalize the practice of Vodun, which had been heavily persecuted by the previous government in an effort to strip local religious leaders of their political power (Joharifard 2005).

Since the development of the Slave Route, many Vodun leaders have become deeply involved in international tourism. Memories of the trans-Atlantic slave trade also have been robustly connected to the development of "National Vodun Day," a national holiday now observed annually on January 10th to celebrate Bénin's indigenous religious diversity. Supporting these governmental ventures, each year the royal palace of Daagbo Hounon, the Supreme Chief of Vodun in Bénin, has become actively involved. Through his involvement, and with the coming of international tourists from around the world, we see multi-layered local and international participation, as well as a blurring of local categories, as contemporary Béninois "Vodun" is elided with and strongly connected to Bénin's slaving past.

When considering complex places of remembering, such as Bénin, it is important to understand that "remembering can use far more than the written word … it can rely on buildings, spaces, monuments, bodies, and patterns of representing self and others" (Birth 2006b: 176). Whereas Ghanaian tour groups and government officials have been able to market their past by appealing to African Americans who wish to learn about the lived experiences of enslaved Africans at Elmina Castle, Bénin's emphasis of historical sites such as the former Portuguese fort

and the family compound of Brazilian slave trader Francisco Felix de Souza constitutes a less marketable telling of the former lives of European buyers and African slave traders.

However, despite the material focus on slave sellers and buyers, international tourists and local scripts tend to spotlight the lives of enslaved Africans. While walking the path of the Slave Route, many tourists stop and pause as they contemplate their individual histories. Indeed, on several occasions I watched African American tourists on the beaches of Ouidah weeping as they considered that they might be standing on the same beach where some of their ancestors might have boarded a slave ship bound for the Americas. While a moving and justifiably profound experience for African American tourists, history tells us that it is also unlikely, since slaves sold to foreign buyers from Ouidah went mainly to the province of Bahia in Brazil. In fact, "Brazil is thought to have taken around 60% of all slave exports from the Ouidah region ... relatively few slaves from Ouidah went to the British Caribbean or North America" (Law 2008: 12). However, it is unlikely that an African American tourist will hear this from a local tour guide or tour agency.

Instead, when African American tourists travel to Bénin to learn about their ancestral roots, they will probably hear stories and accounts that, while historically inaccurate, thrive in the memories created by local, national, and international agencies. Birth aptly reminds us that "any view of the past in the present cannot be limited by an assumption that the past only serves present needs or is only a creation of present interests" (2006b: 180). Such a revisionist model, he argues, "deprives the past of its potentially uncanny, disruptive, and contested presence" (Birth 2006b: 180). In an effort to avoid presentism—a model in which one sees the past as functioning only to meet the needs of the present—I maintain that one's relationship with the past is dynamic. The past's vitality became evident as I watched Béninois actively remember while creatively negotiating the ways in which they wish to mobilize their slaving past to meet the needs of broad local and international audiences. In so doing, Béninois actively mobilize their memories in ways that are both socially fruitful and disrupting. The ways in which Béninois and international tourists envision and consume the past have the potential to vary greatly as re-interpretations of past events simultaneously challenge and change the present.

The slave route project

In 1991, in reaction to the impending 500th anniversary of Columbus' arrival in the Americas, Haitian representatives proposed the development of the Slave Route Project. While under the guidance of a new democratically elected president, Nicéphore Soglo, the people of Bénin began working alongside Haiti, and with the help of the United Nations Educational, Scientific, and Cultural Organization (UNESCO), to develop the Slave Route. In 1993, the General Conference of UNESCO approved the project and agreed to partially fund the construction of tangible monuments in Bénin that would clearly demarcate important "stations" along the Slave Route (UNESCO 2005). Supported by the government of Bénin and UNESCO, the Slave Route Project was officially launched in 1994. As a recent post-Communist country struggling to establish a new identity that was nevertheless rooted in the past, the development of the Slave Route Project and the legitimation of Vodun helped local people attract international tourists from around the globe.

With tourism on the rise from international visitors who desired spiritual experiences, local interest in marketing Vodun grew, and the Slave Route project receded into the background (Araujo 2005). In an effort to save the Slave Route project while still marketing local religion, regional officials and event organizers in Bénin decided to combine the Slave Route project

with national strategies designed to attract tourists interested in Vodun. This merger subsequently led to the creation of National Vodun Day, which celebrates Bénin's indigenous religions while simultaneously paying respect to the millions of Africans who died during the trans-Atlantic slave trade. A shift from commemoration to repentance (see Law 2008) is highlighted annually on the morning of January 10th at the start of National Vodun Day, when His Majesty Daagbo Hounon, the Supreme Chief of Vodun in Bénin, performs the ceremonial Walk of Repentance. On this day, Béninois congregate on the beaches of Ouidah to celebrate the nation's indigenous religions, and to make ceremonial retribution to the millions of Africa souls who were sold into slavery by former Dahomean kings. The ceremonies are repeated annually, similarly to the ways they were performed for "Ouidah '92, The First International Festival of Vodun Arts and Culture".[1] These efforts helped President Soglo increase the influx of tourist monies to Bénin, especially to Ouidah. A growing number of expensive European restaurants and plush beach resort hotels are being built in Ouidah and the surrounding areas, attracting more and more tourists who wish to travel to Ouidah to experience Bénin's slaving past and/or rich local religious practices.

Performing the slave route

For the average visitor, the Slave Route of Ouidah officially begins at *Singbome*, the former residence of the infamous Portuguese slave trader Francisco "Chacha" Felix de Souza.[2] King Gezo, who reigned as king of Dahomey from 1818 to 1858, thanked de Souza by making him his representative in Ouidah for helping Gezo orchestrate a successful coup d'état against his brother, King Adandozan (ruled 1797–1818), that ended with Gezo forcibly taking the throne of Dahomey in 1818. With de Souza as King Gezo's viceroy (*c.* 1820–1840), de Souza met with European slave traders on behalf of the king and negotiated the buying of European goods and selling of African slaves. Drawing on their former glory, the historical value as well as the political and economic presence of the de Souza family is still evident in Ouidah today. Just outside the back gate of Francisco de Souza's former residence and the current de Souza family compound stands a large tree, in a sacred site known locally as *Dantissa*. Today this paved street corner is used as a ceremonial center for the serpent spirit Dagun, the de Souza family's personal spirit, which is said to have originated in Brazil and been brought to Ouidah by Francisco Felix de Souza himself (see Guran 2008). However, according to contemporary oral histories, this same space is also the site from which Francisco de Souza sold slaves to European buyers on behalf of the kingdom of Dahomey.

Imagined as an auction block and labeled in French as "*la place des enchères*" (the place of auction), Dantissa was probably not an auction block in the classic sense. That is to say, the king's representatives, such as de Souza, more than likely sold slaves for prearranged (not auctioned) prices. Ignoring this fact, tour guides often lead tourists to believe that African sellers auctioned off African slaves to European buyers at the southern entrance to the de Souza family compound. Pointing to this matter of history, historian Robin Law reminds us that slaves—at least in Africa—were never sold in open markets (i.e., auctions); instead, they were sold out of the homes of African slave merchants (Law 2004: 132). The "auction block" model that is presented in Ouidah is likely fashioned after American and Caribbean images. Because African American tourists are vividly familiar with grotesque images of slave auctions, "the auction block," regardless of its historical inaccuracy, has the capacity to generate strong emotional and visceral reactions from international tourists who travel to Bénin to understand their pasts, thereby adding to the efficacy of the script that is generated by Bénin's *Slave Route*. Indeed, while not historically "authentic," the Slave Route of Ouidah engages actively with authentic

imaginings of the ways that Westerners, especially, *believe* or *imagine* the past to have been (Delyser 1999).

After visiting the "auction block," visitors continue their 3.5-km walk down a dusty rural road that eventually leads to the beach. In addition to the major stops along the way that dominate the public narrative, small statues that were erected for Ouidah '92 to commemorate the former kings of Dahomey and other important figures (such as Amazonian warriors[3] and Vodun spirits) dot the landscape on the way to the beach.

After passing two such sculptures, visitors find themselves at the next major stop—the *Tree of Forgetting*. While historians have been unable to support local claims (Law 2004; Rush 2001; Singleton 1999), Béninois people adamantly believe the Tree of Forgetting is the former resting place of a sacred tree that was erected by King Agadja of Abomey (ruled 1708–1732). As told by local tour guides, this tree was the first of two major ceremonial centers where enslaved Africans stopped as they made their way from the "auction block" to the beach where they eventually boarded French and Portuguese slave ships bound for the "New World." Local people believe that millions of people—chained together—walked around the Tree of Forgetting (nine times for men and seven times for women) to ensure that their spirits would forget their real identities and the atrocities that were done to them by "their own people," thus making sure that their spirits would not seek retribution from the African kings in the afterlife. Although it is dramatic, this story is unsubstantiated, as scholars are unable to find historical evidence of the existence of a Tree of Forgetting prior to the creation of the Slave Route in 1993 (see Law 2004).

Halfway to the beach, in the village of Zoungbodji, the script that is produced by the Slave Route takes a notable turn, shifting away from Africa's role in the trans-Atlantic slave trade and toward a more common narrative that focuses on the lived experience of African slaves. Zoungbodji houses three important stops in Bénin's Slave Route. The first of these places is the alleged former resting place of Zomaï, one of de Souza's slave confinement barracks, also known as a barracoon. Today, tour guides tell visitors that slaves were ushered into the dark enclosure where they waited until they were finally marched to the beach and loaded onto waiting slave ships. While historic records support the existence of private slave holdings around Ouidah, the Zomaï quarter in Ouidah proper is probably "the location of de Souza's stores of gunpowder" (Law 2004: 137), and the place known as Zomaï in the village of Zoungbodji is probably the product of creative imaginings, since "the location of a barracoon in Zoungbodji is not corroborated in any contemporary source" (Law 2004: 137). Indeed, Law has suggested that the oral histories that surround Zomaï today have "been embellished in the recent quest for 'sites of memory' connected to the slave trade" (2004: 137).

Along with Zomaï, the village of Zoungbodji also houses the *Mass Grave Memorial*, where those Africans who died while waiting to board European slave ships were allegedly buried. As art historian Dana Rush explains, "[T]he monument is constructed upon what is believed to be the ancient common grave for slaves who died in the Zomaï Enclosure" (2001: 43). Marked by a large mosaic depicting bloodied images of African slaves chained together boarding ships bound for the Americas, the monument provides visitors with a tangible place to honor the dead in personally appropriate ways. As with Zomaï, there is no historical evidence to suggest that this is in fact a burial site. Rush writes that "[t]here have been no archaeological excavations to prove or disprove" that the monument serves as a grave marker for hundreds, if not thousands, of slaves who may have died while being housed in the Zomaï enclosure. Although possibly not historically "accurate," both the Zomaï enclosure and the mass grave marker are supported by what one may expect—or imagine—to find in a site designed to remember Africa's slaving past while also attempting to generate the symbolic capital necessary from the international

community, most notably the descendants of African slaves, to ask for forgiveness for past atrocities. Lacking the historic slave castles of Ghana (see Bruner 1996), the designers of the Slave Route undoubtedly have used both historical value and creative license to create spaces for international tourists that will potentially invoke feelings of compassion, empathy, and forgiveness.

Nestled in the village of Zoungbodji, the *Tree of Return* marks the halfway point from Ouidah to the beach. However, unlike the Tree of Forgetting, the tree that stands in Zougbodji is said to be the same tree that was planted by King Agadja. The Tree of Return is marked by a cement sculpture by Béninois artist Cyprien Tokoudagba that depicts the forest spirit Aziza. As told by local tour guides, enslaved Africans—while chained together—would walk around this tree three times to make certain that their spirits would return to Africa after death. Unable to retaliate for wrongs done to them, thanks in part to the ritual potency of the Tree of Forgetting, in a contradictory yet evocative gesture, their spirits are guaranteed safe passage back to their homeland because of the Tree of Return.

While the Tree of Return was probably not used ceremoniously by local officials to ensure the spiritual return of Africans who died as a result of the trans-Atlantic slave trade, the tree "is recorded in contemporary accounts, under the alternative name of 'The Captain's Tree' ... as the place where arriving European slave-traders were met by the ... local authorities of Ouidah" (Law 2004:153). Interestingly, the Tree of Return in its former incarnation as *L'Arbre des Capitaines* (The Captain's Tree) has a great deal of documented historical significance as a rendezvous point for African sellers and European buyers of African slaves. This history, however, is not the one told by local tour guides. Nevertheless, while logistically impossible and historically unproven (see Law 2004; Rush 2001), the story told to tourists provides them (especially African Americans) with exaggerated yet palatable images of Bénin's involvement in its slaving past.

After visiting the village of Zoungbodji, visitors continue the last half of their long walk to the beach. After walking for nearly an hour, one can finally see the *Door of No Return* in the distance, emerging from the horizon on Bénin's sandy shoreline. Bearing UNESCO's seal, the Door of No Return, designed and built by Béninois artist Fortuné Bandeira, is the only official monument associated with the Slave Route Project as established by UNESCO and the government of Bénin. Symbolic of the actual space where millions of Africans boarded European ships, never to return to Africa, this impressive monument has become an icon for Bénin's tourism industry and is rapidly becoming a dominant symbol, invoked by people all over the country as a mark of national pride. Each year on January 10th the Door of No Return becomes the central backdrop for National Vodun Day, as thousands of Béninois and international tourists join to congregate at the beach to pay their respect to local spirits and to the millions of people who died during the Atlantic slave trade.

In December 2006, I walked Ouidah's Slave Route for the first time with a group of American university students. Our tour guide reminded us that the road on which we were walking was the same road that millions of enslaved Africans followed as they made their way to the beach, where they eventually boarded French and Portuguese slave ships bound for the "New World." Perhaps out of some sort of reverence, I felt compelled to walk the sandy road barefooted. With each step, our tour guide told stories of the past—horrific stories of torture and death. The air was almost tangible with pain as we all contemplated our own personal histories. My family's identity as former slave owners in the American south raced to the forefront of my memory as my personal relationship with Bénin's slaving past loomed heavy on my mind. I felt a sense of guilt that grew as my awareness converged with my family's history. Another student in our group, an African American woman, also became overwhelmed at times, albeit for

different reasons. On several occasions she stopped to "breathe it all in" and stand on the soil where, she said, her "ancestors may have once stood."

During that first visit to Bénin I wanted to experience the Slave Route with as few academic biases as possible. Therefore, I made a conscious decision not to read any scholarship about the Slave Route prior to the trip. While walking from the site described as the auction block to the beach, our tour guide told many stories and fielded many questions for other visitors that provided us with emotional rememberings of the past. The experience was moving and generated feelings of sadness, guilt, and anger, sometimes all at the same time. After walking the Slave Route for over 2 h and while talking with other American visitors, it became clear to me that the script provided by our Béninois tour guide, coupled with the terrain that was marked by several purposefully constructed monuments, successfully created a space that felt "authentic." The experience created a type of authenticity that was not measurable by a fact-checker or a history book. Rather, for many of the visitors (including myself), the "authenticity" of the Slave Route was generated through dynamically embodied social action (see Varela 2004), including multi-sensorial social experiences that operated alongside of, and in conjunction with, our pre-conceived imaginings of the trans-Atlantic slave trade.

Zoungbodji—contested heritage in local spaces

When I experienced the Slave Route for the first time in 2006, the village of Zoungbodji had a profound effect on me. As I have already mentioned, the village is home to Zomaï, the alleged former resting place of one of de Souza's barracoons; the Tree of Return, which newly enslaved Africans are said to have circumambulated three times to ensure their spirit's eventual return to Africa; and the Mass Grave Memorial, where hundreds if not thousands of Africans who died while in Zomaï purportedly were buried. For me, as for many of the visitors with whom I spoke, the village of Zoungbodji was the Slave Route's pulsating heart. Housing Zomaï and the Mass Grave, Zoungbodji provided many international visitors with the emotional experience they were seeking.

The Mass Grave Memorial especially generates a defined air of reverence. Demarcated by a cement wall, and protected by a chained gate, the Memorial is protected purposefully by local villagers. Before stepping past the gate, visitors are asked to remove their shoes. As is customary in many parts of Bénin, removing one's shoes shows respect and honor to important people and spirits. In this case, respect is given to the souls of those who died as a result of the trans-Atlantic slave trade, as well as to spirits who animate and elevate the Mass Grave Memorial to a space of profound significance for both local people and international visitors.

Echoing the symbolic potency of removing one's shoes, visitors are also asked by the tour guides to "keep silent" as they reflect on the memorial's significance to local and international peoples alike. As I walked around the memorial, I noticed that other visitors—most of whom were American—were leaving small tokens of their respect behind. While most people left offerings of money at the base of the memorial, I noticed that others had left letters; one African American woman left an article of clothing. Some people walked around in silence; others talked to the memorial as if it were a person or perhaps even a spirit; still others stood or knelt in contemplative tears. Marked with a cement wall and empowered by the removal of shoes and silence, the Mass Grave Memorial has become a "sacred space" where visitors are able to "pay their respects" to the millions of people who lost their lives as a direct result of the trans-Atlantic slave trade (e.g., Sturken 2004; Zertal 2000).

My subsequent visit to the Mass Grave Memorial in 2008 was quite different. As I did in 2006, I had traveled to Bénin the second time to examine the relationships that exist between

international tourism and local religious ideology. This second time, however, I came informed by the literature I had avoided in 2006 and also I was able to travel the Slave Route with a local tour guide who acted as a docent for three separate tour groups that were visiting from the USA. The first group was scheduled to arrive about a week after my landing in Ouidah. I was told about their arrival and invited to join them as they traveled to various "tourist sites" around the city of Ouidah. Upon their arrival in Ouidah, the tour guide, whom I will call "Annette," took the group of 15 to the former site of Ouidah's "auction block" and then to the village of Zoungbodji. Annette stood on the road that led to the village and told the tourists about Zomaï, the Tree of Return, and the Mass Grave Monument. All the stories were the same as what I had heard her tell many times before—but this time, the tour group did not enter the village. I was surprised that Annette avoided the village completely because many visitors with whom I had spoken in the past had found their experiences at Zoungbodji to be one of the most memorable. After finishing our day with the tour group, Annette thanked the tour group and wished them a safe and pleasant stay while they were visiting Bénin.

Once back at her home, I asked Annette, "Why didn't you take the tourists into Zoungbodji? I'm sure they would have loved to have seen those monuments."

She simply responded with a shrug, "Well, I couldn't."

"Why?" I pushed."

She replied, "The visits used to be okay, as you know. Back in 1993 there used to be a guide from the village—I don't know what happened. But when tourists came, they gave him money, you know, a tip. Then people started getting jealous and they didn't want him to be the guide any more because they felt he was making too much money. Since then, there isn't a guide in the village any more, except us, the guides who go there to do our tours. The problem is: The villagers still want money. Tourists will say, 'Make tickets so we can buy them!' But no one is doing that. The problem is, who do you give the money to? I can't remember the year, but I brought tourists there and the villagers were very angry. They even slapped one of the tourists because they wanted to seize his camera. They pretended that they wanted money because he took a picture, but that wasn't the reason… . They told me they wanted money because *I* am making money off *their heritage*."

Past events and present disruptions

Like so many local tour guides, Annette is becoming discouraged because, as she said, "I love sharing the history … but I can't show the tourists everything any more. It's too dangerous for me to tell the entire story. It's frustrating. I don't want to just tell people about our history, I want to *show* them."

Annette's dissatisfaction with the way "things have to be" was also expressed by an African American female tourist in her mid-50s who said, "I spent thousands of dollars to travel to Bénin and I can't see what I came here to see? You've got to be kidding me!" Annette could only apologize and placate the woman by stressing her responsibility to everyone's safety. Of course, Annette later confided to me that she understood why the woman was angry and conceded that if she were in her position, she would have felt the same way.

As tour guides such as Annette continue to work with tourists in countries such as Bénin, where the per capita income is around $1,500 per year, tourist monies—in the form of tips— can make a huge difference in the everyday lives of local peoples. Annette asserts that her proficiency in English, coupled with her genuine interest in the history of "her people," gives her the "power" to continue doing her job regardless of the many difficulties that arise along the way. However, few residents of Ouidah speak English, nor are many educated in local history

or trained to be a tour guide by local agencies. Yet people from varying backgrounds in Bénin are hoping to profit (either economically or socially) from international tourism. The overwhelming interest in international tourism and tourist monies begs the question: How does one determine who is allowed to profit from tourist capital in social spaces such as Zoungbodji that are laden with a great number of social complexities that range from questions of heritage "ownership" to local constructions of entitlement? These are not easy questions to address; in Bénin, local city government and other officials are negotiating with village elders as they search for an amicable solution.

In Bénin as in other parts of the world, local peoples have long been disempowered by international and local governments while also serving as the primary stewards of cultural heritage. In the case of Bénin, where local officials are beginning to work with local villagers and community leaders to ensure inclusive resolutions to heritage issues, I believe that local authorities must work with their communities to develop solutions that meet both the social and economic needs of the residents. However, to make these conversations fruitful in Zoungbodji, where villagers are coping with an ever-increasing number of international tourists, local questions of "heritage ownership," such as those directed to Annette by local villages, must be addressed. What makes these questions exceedingly important, especially in the case of the Slave Route, is their sheer complexity. Who can say they "own" the heritage of the Slave Route? There are many stakeholders—including the government of Bénin, local Béninois (including the descendants of slave traders), African Americans, and, of course, the international community, as Ouidah positions itself to be included as a UNESCO-sanctioned "world heritage" site.[4]

In November 1994, the 45 participants at a conference on "authenticity" held in Nara, Japan, authored "The Nara Document on Authenticity." Supported by UNESCO, the International Centre for the Study of the Preservation and Restoration of Cultural Property (ICCROM) and the International Council on Monuments and Sites (ICOMOS), the authors of the Nara Document suggest that "[r]esponsibility for cultural heritage and management of it belongs, in the first place, to the cultural community that has generated it, and subsequently to that which cares for it." In the case of the Slave Route (as with many other communities looking to market their "cultural heritage"), the obvious question is, which "cultural community" should be seen as its generator? With many stakeholders living on both sides of the Atlantic, it is clear that there is no single vested community. As with so many other heritage sites, the Slave Route has drawn significant attention from people around the globe—all of whom claim a degree of "ownership" over the values expressed in the Slave Route.

The Ename Charter for the Interpretation of Cultural Heritage Sites (2005) right-fully complicates the issue of heritage "ownership" for local and international officials whose aim it is to consider all stakeholders involved in the Slave Route on both sides of the Atlantic by addressing issues of multivocal interpretations. In fact, the authors of the Ename Charter explicitly argue that "the traditional rights, responsibilities, and interests of the *host community, property owners*, and *associated communities* should be respected" (emphasis mine). Following this charter, allowing for, and even encouraging, multiple stakeholders from both Africa and the African Americas will help to position Ouidah firmly on the international stage as it is considered for "world heritage" status.

Inaccurate, maybe. Authentic, definitely

After considering the inclusion of all stakeholders, and tending to the needs and desires of the various local communities involved, questions of "authenticity" still remain. The authors of the Ename Charter acknowledge that "cultural heritage sites can be contentious and should

acknowledge conflicting perspectives." However, they also suggest that "interpretation should be based on a well-researched, multidisciplinary study of the site and its surroundings." What should local and international communities do when these "well-researched" studies (such as Law 2004) find that much of the script produced for a given site such as the Slave Route is based on historically unsupported interpretations provided by institutions such as UNESCO?

Thinking about "authenticity" and its relationship to the Slave Route of Ouidah, one day in July 2008, I was talking to Jean, a Béninois friend, as we walked to the beach from Ouidah to buy coconuts. Although we were not actively participating in the Slave Route, we happened to be traversing the same physical path. We passed all the monuments, briefly greeted tourists, and walked under the Door of No Return. On the way back, each carrying several coconuts that we were going to use to prepare dinner, we overheard a local tour guide talking to a group of American tourists about the Tree of Forgetting. Skeptical about the historical accuracy of the narratives that are maintained and produced by the Slave Route. I asked Jean, "Can you believe that people really think that Africans stopped at that very spot to perform a ceremony that's logistically impossible?".[5] He looked at me and said, "Impossible? What do you mean? It happened. It really happened." While surprised by his assertion, my interest was piqued. MacCannell (1999:93) has argued that "authenticity itself moves to inhabit mystification" and, indeed, many people on both sides of the Atlantic, including Jean, a 21-year-old Béninois university student, believe the script—complete with its historical inaccuracies—which is repeatedly re-established and re-affirmed by the Slave Route.

How does one explain authenticity when the value of "the authentic" is contested? As I have demonstrated, historians have argued that some of the "facts" presented on the Slave Route are either invented fantasies or "imaginative reconstruction[s]" (Law 2008:21). However, many local residents unequivocally believe them to be "authentic." In reference to Appadurai's now seminal work. *The Social Life of Things* (1986), Bruner points out that "authenticity today is becoming a matter of the politics of connoisseurship, of the political economy of taste … [and] a matter of power" (2005a: 163). I would add that a claim to authenticity is often deeply intertwined with Bourdieuian notions of distinction (Bourdieu 1979). The power of social distinction, ownership, or, in the case of heritage sites, stewardship of the "authentic" has the potential to give people important access to a site's social, economic, political, and symbolic capital.

Attending to the many complexities that surround the question of authenticity, anthropologist Edward Bruner has provided us with several ways of examining authenticity that offer insight into the ways we should approach a study focused on discourses of authenticity that may be created and maintained vis-à-vis sites such as the Slave Route of Ouidah. According to Bruner, there are four meanings for authenticity: *verisimilitude, genuineness, originality*, and *authority* (2005a: 151). In the case of the Slave Route, we can use three of Bruner's categories—verisimilitude, originality, and authority—as heuristic devices that will enable us to think less rigidly about experiences or places that some may deem "authentic."

Verisimilitude

Before people even begin packing a suitcase, they begin their trips with preconceived ideas of what they will experience. As tourists, they have undoubtedly been influenced by many factors, including images of their destination spot as purveyed in mass media. In the case of the Slave Route, Americans encounter Bénin's slaving past with pre-formed images that have been partially constructed by childhood textbooks, movies, public discourse, and works of art. Accordingly, most tourists "know" what to expect. And as long as their experiences match those expectations, as long as "Africa" and their predetermined ideas of what slavery in Africa was like

match their imaginations, visitors are likely to see the Slave Route as "authentic"—regardless of the historical inaccuracies.

When considering the "authentic" value of the Slave Route, it is important to keep in mind that the Slave Route was designed by UNESCO and the government of Bénin to fit well into global imaginings of the trans-Atlantic slave trade. People expect to experience Bénin's slaving past in ways that align with their imaginations and preconceptions. Thanks in part to scientific authority and by extension the power of "observation," the West has long privileged visual perception over our other senses when determining "objectively" what is real and what is imagined (see Ingold 2000; Landry 2008; Stoller 1989). Because Bénin lacks impressive monuments relevant to the trans-Atlantic slave trade such as Elmina Castle found in Ghana, the local government has worked closely with UNESCO and local artists to erect visual representations such as sculptures and placards that represent points of interest in Bénin's slaving past. These images have given tourists a point of visual reference to experience places such as the auction block that either no longer exist or may have never existed in Bénin.

Regardless of the historical inaccuracy of many of Bénin's slave monuments, local tour guides actively present them as real representation and remembering of the past. Following in the success of Sénégal (Gorée Island) and Ghana (Elmina Castle), the government of Bénin and UNESCO have together made a calculated decision to develop the Slave Route as a tourist site that focuses on the victims of the slave trade—instead of on the vivid rememberings of the lives of Africa's slave traders that dramatically punctuate Bénin social and religious landscapes. While the Slave Route is, in some instances, historically inaccurate, it has nevertheless become "real" to those people, especially to Africans and African Americans, who embody the realities of the Atlantic slave trade everyday. On one hand, scholars have shown that a site's authenticity is often embedded in its ability to be "credible and convincing"—in the words of Bruner, verisimilitudinous (Bruner 2005a: 149; Delyser 1999). Because the Slave Route plays into salient global imaginings of what people think the trans-Atlantic slave trade was like, its credibility and ability to convince are bolstered not by history but by rich and vivid imaginations.

Originality

At first glance, especially given its historical inaccuracies, one may be tempted to reject the possibility of "originality" in the Slave Route. People who are able to mobilize the proverbial "original" are able to enjoy the social capital it provides. Of course an object or space, whatever it may be, is not inherently better than a copy. But Western cultural actors in particular give "the original" a great deal of social power. Middle-class and elite adventurers travel long distances, and at great expense, to see the "real" Mona Lisa or a "real" Monet, for example. For many people, a photo or a near-as-possible copy just is not enough. However, the copy (or the inauthentic) does not exist in vain. As Geertz (1986) has pointed out, copies serve to authenticate the original, thereby giving it greater value. For many people, "the original" seems to pulsate with what Walter Benjamin (2008) may have called an "aura" or perhaps a magical energy—a mana-like substance that, while intangible, is critical to the tourist experience (Mauss 2001).

As the Slave Route is described by some as a "fiction" (Araujo 2005), and critiqued by scholars for its historical inaccuracies (Law 2004; Rush 2001), it may be difficult to imagine why so many people—locals and internationals alike—believe the Slave Route to be "authentic." Yet a close anthropological reading of the "text" of the tourist experience can provide important clues to how international visitors understand their experiences in Bénin within the framework of "authenticity." Let us consider some discursive strategies.

199

While in Ouidah I heard several tour guides and countless local residents describe the Tree of Return as "the actual tree that was planted by King Agadja." As visitors stand in the presence of this very large tree, many of them comment on its grand size. The size alone seems to provide international tourists with sufficient "evidence" to adequately suggest that the tree is indeed over 200 years old. Seeing the tree as an "original"—as *the tree* that was circumambulated by millions of enslaved Africans performing a ceremony to ensure their spirit's return to Africa— becomes an effortless and convincing exercise in visualization.

Around the Tree of Return, English-speaking tour guides are commonly heard using phrases such as "the actual tree" or "the very place" with their American visitors. In so doing, tour guides are able to emphasize notions of "the original," thus adding to the Slave Route's "authentic" value. The site's authenticity is further heightened by values that are seemingly invariable. While tour guides can forget to emphasize "the original," or grow bored as they repeat the same tired descriptions day after day—thereby diminishing their role in the creation of an authentic experience for tourists—they can never reduce the symbolic capital embodied by Africa itself. Africa's quality as the quintessential "original" is further supported by tour guides as they remind visitors—often multiple times—that they are traversing the "same path" and walking on the "same soil" that enslaved Africans traveled on a little more than 200 years ago. For many tourists, especially African Americans, Africa is considered a "homeland." Referring often to their trip to Africa as going "home" or traveling to the "motherland," their time in Africa is understood as a pilgrimage (Bruner 2005a; Ebron 2002) rather than a simple vacation, as Africa itself becomes, in their imaginations, the ultimate "original." Through a careful and strategic use of language coupled with images of and embodied reactions to "the original," the Slave Route's claims to "authenticity" are strengthened.

Authority

The ability to claim "originality" and transform Ouidah into a space that reflects a visitor's preconceived imagined realities is further supported and sustained by UNESCO's "persona" as an authoritative agency. Bruner (2005a) has accurately speculated that a site's authenticity may be heightened by virtue of authority. When considering authority and thinking about the relationships that exist between "authenticity" and cultural heritage, it is helpful to reflect on UNESCO's symbolic capital in that arena. Because of its position as an international agency that is well positioned on the global stage as a source of cultural authority interested in questions of authenticity, interpretation, and representation, UNESCO—seen as a source of all things "credible" and "truthful"—has the necessary symbolic capital to present, often without question from the laity, certain "truths" about a given site (Bourdieu 1979). In considering these issues, Bruner asks, "[W]ho has the authority to decide which version of history will be accepted as the correct or authentic one?" (2005b: 151). By its very nature, authority is rarely given to the downtrodden or the subaltern. Authority, which is often accorded by virtue of social power and dominance, has the capacity to define what society sees as "true" (Foucault 1980, 1995). While scholars of Bénin have critiqued the historical accuracy of Ouidah's Slave Route, they do not carry the same social capital as UNESCO or the government of Bénin. Simply put, UNESCO and the local government carry the necessary symbolic capital—"a reputation for competence and an image of respectability and honourability" (Bourdieu 1984:291)—that enables them to mobilize the past and create and promote the narrative of their choosing.

While the last "station" on the Slave Route—The Door of No Return—is the only official monument of the Slave Route and the only one that bears UNESCO's seal, several tour guides in Ouidah often tell tourists about UNESCO's involvement in the Slave Route from the

beginning of the tour. For its part, UNESCO is able to position itself as an agent of authenticity because it wraps itself in the language of science. On its official website for the international Slave Route project, UNESCO claims to be "[d]rawing on the expertise of an International Scientific Committee"; it strives to support "scientific research through a network of international institutions and specialists" (UNESCO 2005). At the same time, drawing on a wide range of people from varying backgrounds and with a multitude of perspectives, UNESCO is beginning to support multiple meanings, explanations, and values (see ICOMOS' Ename Charter of 2005).

While the inclusion of multiple interpretations of the past make a site's script more "authentic," many Westerners think of authenticity as an objective concept, one that is somehow measurable and indisputable. To many people, including tourists, an artifact or a site either exudes the "aura" of realness or it does not. UNESCO's authoritative efficacy is directly related to its overt support for "scientific research" and its continuous use of scientific language in public discourse and educational materials. Because of UNESCO's firm position in the realm of scientific ventures and truth-finding, Béninois are able to use UNESCO's claims to authority to present their saleable rendition of the past as unequivocally "true." Just as our collective imaginations affect the way we preview and later internalize our traveling experiences as authentic, our imaginations also affect the ways we understand "science." And UNESCO, perhaps unintentionally, is able to profit from the West's pre-imagined notion of science as a venture in "Truth"-finding.

Concluding remarks

When one thinks about the various qualities that make cultural heritage "authentic," one may be compelled to believe that for something to be authentic it must be positioned in historical Truth. However, as I have shown in this chapter, authenticity is not dependant on accuracy. Instead, authenticity, as it relates to cultural heritage, is measured and experienced through embodied action and performance while also being couched in the politics of capital (i.e., symbolic, political, or economic) and the creative processes of remembering. Just as ritual has the capacity to make religion "really real" for its adherents, sustained symbolic and political capital work to make heritage such as the Slave Route "really authentic" for a wide variety of stakeholders (see Geertz 1973).

Calculated decisions about authentic representation are made as managers of a variety of sites across the west coast of Africa consider the many stakeholders on both sides of the Atlantic. In both Ghana and Bénin, the thematic influence of Gorée Island off the coast of Sénégal is undeniable—despite the controversy surrounding its historic "authenticity," Gorée is touted as "the most powerful visual image of the slave trade" (Law 2008: 11). The imagery of Gorée continues to contribute greatly to the ways we imagine the trans-Atlantic slave trade. Gorée's Porte du Non-Retour has been successfully emulated by other sites such as Cape Coast Castle (Ghana) and the Slave Route (Bénin).

With the memory of the trans-Atlantic slave trade still strong in Ouidah, each time a person actively participates in or reproduces the script created by the Slave Route, local memories of the slave trade are reinforced—and thereby remembered not as replicable historical "facts" but rather as embodied, creative performances. Examination of important historical sites off the western coast of Africa reveals that the trans-Atlantic slave trade is not remembered in the same ways. The *Maison des Esclaves* in Sénégal, for example, provides visitors with a slave-centric script that is heavily vested in the horrific and lived realities of slavery. The Slave Route in Bénin, by contrast, alternates between a historic legacy that the Béninois have "come to terms

Timothy R. Landry

with" (Singleton 1999: 159), focusing on Bénin's tangible monuments such as the former Portuguese fort and the de Souza family compound that highlight Africa's historic role in slave trading, and that of a historical telling that attends to more emotionally sensitive scripts, centered in the village of Zougobodji, which places the horrific lived experiences of enslaved peoples front and center.

Rush criticizes the narrative of The Slave Routs as "both simplified and embelished" (2001:42). Yet, as I have suggested, convenient simplifications and fictive embellishments do not make the narrative any less *authentic*. Instead, in the Slave Route, UNESCO has joined forces with the local government and individual tour guide interpretations to create a narrative that is accepted as "authentic" by both local residents and international tourists.

As I have shown, the Slave Route's authentic value is best explored as a subjective reality, one that takes collective memories and shared cultural realities into account. Unlike positivist notions of measurable and testable "truths," the Slave Route's authenticity is not dependent on historical or scientific "fact." Rather the Slave Route's authenticity is one that is firmly positioned in embodied action, memory, and collective imaginings of the past. International tourists who travel to Bénin to explore Bénin's slaving past experience the authentic through their bodies. I have argued that visitors trust the authentic value of the Slave Route because of its ability to convince. And its ability to convince is further bolstered by the authority embodied by UNESCO, the local government, and local agents as well as the strategic use of "the original." As people of varying nationalities, races, and ethnicities traverse the Slave Route in Ouidah, many have moving and even life-changing experiences that are made possible because of the Slave Route's authentic value. For these people, an authentic experience is not contingent on its historical accuracy. Rather, human experiences, including visiting heritage sites, owning cultural artifacts, or believing the inherent authority of a given person or institution, are dependent on their ability to convince, and on the collective need and/or desire for social actors to perform convincingly. In the end, memories and experiences are real because they must be, not because they just are.

Acknowledgments

This project was made possible thanks to pre-dissertation funding from the West African Research Association (WARA) and the Department of Anthropology at the University of Illinois at Urbana-Champaign. I would like to offer my deepest thanks to Sophia Balakian, Junjie Chen, Angela Glaros, Lance Larkin, Bronwym Mills, Nancy A. Phaup, D. Farchild Ruggles. Bjørn Westguard, and especially Alma Gottlieb and Helaine Silverman for their insightful comments and suggestions on earlier drafts of this chapter. I am forever indebted to Martine de Souza and her lovely family who over the years have become great friends as they have welcomed me into their family. I also would like to offer a special *merci beaucoup* to all my friends in Bénin who opened up their homes and their lives to me, especially to His Majesty Daagbo Hounon Tomadljehoukpon, the Supreme Chief of Vodun in Bénin, and His Majesty Kabiyesi Oba Onikoyi. King of the Ouidah Yoruba community and its vicinities.

Notes

1 Although called "Ouidah '92," the festival was not actually celebrated for the first time until February 8–18, 1993. The festival highlighted Vodun-/Vodou-inspired art from Bénin, Haiti, and Brazil, among other places, and emphasized the dynamic transnational relationships that are still maintained by people in Africa and the African diaspora.

202

2 The word *singbome* roughly translates as "two-story house." According to de Souza family history, the name singbome was adopted to describe the compound because Francisco Félix de Souza was the only resident of Ouidah in the early to mid 1800 s who lived in a multi-story home. Today, the descendants of Francisco Felix de Souza still live there, and de Souza's burial place and various personal effects are housed here, too.

3 Dahomey's Amazon warriors were an all-female army whose members, according to oral history, severed their right breast so as to improve their proficiency with bows and arrows and, later, firearms.

4 Since October 31, 1996, the city of Ouidah has been on UNESCO's "tentative list" for World Heritage consideration because of its historical importance in the trans-Atlantic slave trade.

5 For a lengthy discussion regarding the unlikelihood of the ceremony, see Law (2004) and Rush (2001).

Bibliography

Améry, Jean. 1998. *At the mind's limits: Contemplations by a survivor on Auschwitz and its realities.* (trans: Rosenfeld, Sidney and Rosenfeld, Stella P.). Bloomington, IN: Indiana University Press.

Appadurai, Arjun. 1986. *The social life of things: Commodities in cultural perspective.* Cambridge, MA: Cambridge University Press.

Araujo, Ana Lucia. 2005. Public monuments and private memories: The slaves' route in Ouidah. Talk presented at the Harriet Tubman Center Seminar, York University, Toronto, Canada, 2 November 2005.

Birth, Kevin, ed. 2006a. The immanent past. Themed issue. *Ethos* 34(2).

Birth, Kevin. 2006b. The immanent past: Culture and psyche at the juncture of memory and history. *Ethos* 34(2): 169–191.

Benjamin, Walter. 2008. *The work of art in the age of its technological reproducibility, and other writings on media,* ed. Michael W. Jennings, Brigid Doherty, and Thomas Y. Levin. Cambridge, MA: Harvard University Press (originally 1939).

Bourdieu, Pierre. 1977. *Outline of theory and practice.* Cambridge, MA: Cambridge University Press. (originally 1972).

Bourdieu, Pierre. 1987. *Distinction: A social critique of the judgement of taste.* Cambridge, MA: Harvard University Press.

Bruner, Edward M. 1996. Tourism in Ghana: The representation of slavery and the return of Black diaspora. *American Anthropologist* 98(2): 290–304.

Bruner, Edward M. 2005a. *Culture on tour: Ethnographies of travel.* Chicago, IL: University of Chicago Press.

Bruner, Edward M. 2005b. Abraham Lincoln as authentic reproduction: Critiques of postmodernism. In *Culture on tour: Ethnographies of travel.* Chicago, IL: University of Chicago Press. (originally 1994).

Connerton, Paul. 1989. *How societies remember.* Cambridge, MA: Cambridge University Press.

Delyser, Dydia. 1999. Authenticity on the ground: Engaging the past in a California Ghost Town. *Annals of the association of American geographers* 89(4): 602–632.

Ebron, Paulla A. 2002. *Performing Africa.* Princeton, NJ: Princeton University Press.

Farnell, Brenda. 2000. Getting out of the habitus: An alternative model of dynamically embodied social action. *Journal of the Royal Anthropological Institute* 6(3): 397–418.

Foucault, Michel. 1980. *Power/Knowledge: Selected interviews and other writings, 1972–1977.* ed. Colin Gordon. New York, NY: Pantheon Books.

Foucault, Michel. 1995. *Discipline and punish: The birth of the prison.* New York, NY: Vintage Press. (originally 1979).

Geertz, Clifford. 1986. Making experience. Authoring selves. In *The anthropology of experience,* ed. Victor Turner and Edward M. Bruner, 373–380. Urbana, IL: University of Illinois Press.

Geertz, Clifford. 1973 Religion as a cultural system. In *The interpretation of cultures* ed. Clifford Geertz. New York: Basic Books. (originally 1966).

Gilroy, Paul. 1993. *The Black Atlantic: Modernity and double consciousness.* Cambridge, MA: Harvard University Press.

Guran, Milton. 2008. Le reflux de la traite négrière: les agundas du Bénin. *Gradhiva* 8: 87–96.

Halbwachs, Maurice. 1992. *On collective memory.* Chicago, IL: University of Chicago Press. (originally 1952).

Ingold, Tim. 2000. *The perception of the environment: Essays on livelihood, dwelling and skill.* London: Routledge.

Joharifard, Shahrzad. 2005. *Traditional culture and the problem of dual authority in the People's Republic of Benin*. B.A. Thesis, Department of History, Princeton University.

Landry, Timothy R. 2008. Moving to learn: Performance and learning in Haitian Vodou. *Anthropology and Humanism* 33(1/2): 53–65.

Largey, Michael. 2006. *Vodou nation: Haitian art, music, and cultural nationalism*. Chicago, IL: University of Chicago Press.

Law, Robin. 2004. *Ouidah: The social history of a West African slaving "Port," 1727–1892*. Athens: Ohio University Press.

Law, Robin. 2008. Commemoration of the Atlantic slave trade in Ouidah. *Gradhiva* 8: 10–27.

MacCannell, Dean. 1999. *The tourist: A new theory of the leisure class*. Berkeley, CA: University of California Press.

Mauss, Marcel. 2001. *General theory of magic*. London: Routledge. (originally 1902).

Rush, Dana. 2001. Contemporary vodun arts of Ouidah, Benin. *African Arts* 34(4): 32–47, 94–96.

Singleton, Theresa. 1999. The slave trade remembered on the former gold and slave coasts. *Slavery and Abolition* 20(1): 150–169.

Stoller, Paul. 1989. *Taste of ethnographic things: The senses in anthropology*. Philadelphia. PA: University of Pennsylvania Press.

Stoller, Paul. 1995. *Embodying colonial memories: Spirit possession among the Songhay of Niger*. Chicago Chicago, IL: University of Chicago Press.

Sturken, Marita. 2004. The aesthetics of absence: Rebuilding Ground Zero. *American Ethnologist* 31(3): 311–325.

United Nations Educational, Scientific and Cultural Organization (UNESCO). 2005. The slave route. Electronic document, http://portal.unesco.org/culture/en/ev.php-URL_ID=25659&URL_DO= DO_TOPIC&URL_SECTION=201.html. Accessed 13 February 2009.

Varela, Charles. 2004. Harré and Merleau-Ponty: Beyond the absent body in embodied social theory. *Journal for the Anthropological Study of Human Movement* 13(2): 67–86.

Zertal, Idith. 2000. From the People's Hall to the Wailing Wall: A study of memory, fear and war. *Representations, Special Issue: Grounds for Remembering* 69: 96–126.

14
Steampunking heritage
How Steampunk artists reinterpret museum collections

Jeanette Atkinson

Introduction

In 2009, Steampunk came to Oxford. Strolling past university colleges dating from the thirteenth and sixteenth centuries, gentlemen in top hats with goggles on the brims politely tipped their hats to ladies in corsets and bustles. This contemporary subculture is about reimagining what technology and history could have been (and might be in a potential future) if history had taken a different route. Steampunks inhabit an alternative Victorian and Edwardian world in which industry is still powered by steam and tea is not only a drink, but also a means of duelling. Their destination was the Museum of the History of Science (MHS), part of the University of Oxford and the original site of the Ashmolean Museum, which hosted *Steampunk*, described as the first Steampunk exhibition of art. Inspired by the collections of the MHS, international Steampunk artists offered their interpretation of both science and art. Drawing on Steampunk roots in science fiction literature, together with Victoriana and an emphasis on making and craftsmanship, the objects on display provided an entrée into a new world, one in which steam technology dominates and brass, leather and wood are the materials of choice. Audiences encountered twenty-first century laptops and phones that looked as if they had stepped straight out of the nineteenth century, articulated mechanical spiders, tentacled goggles and brass armatures (MHS 2011). Accompanied by a complementary exhibition of objects from the MHS permanent collections, the museum staff found that *Steampunk* not only offered a reinterpretation of the history of science and scientific instruments, but also a means for visitors to view the museum collection objects with new eyes, a new 'sensibility' (Donovan 2011; Bennett 2012). As a consequence, *Steampunk* proved to be the MHS's most visited exhibition to date.

Between 2010 and 2013, there were four further exhibitions in the UK, in London (at Kew and the Guildhall), Bradford and Leek. These not only expanded on the MHS exhibition, offering more insight into Steampunk art and the identity of the subculture, but also, with the exhibitions at Kew Bridge Steam Museum (now the London Museum of Water and Steam) and Bradford Industrial Museum, placed Steampunk objects in and around steam technology in the case of the former, and juxtaposed them with collection items in the latter. This raised the question, 'what was real and what was Steampunk?' Then, in 2014, Steampunk arrived at the Royal Observatory Greenwich in the form of *Longitude Punk'd*. Three hundred years after the

205

Longitude Act of 1714, Steampunk artists were invited to work collaboratively with curators to reinterpret the Royal Observatory's scientific collections, be inspired by the drama of the original quest for longitude and present their interpretation of history, art and science.

Focusing on the exhibitions *Steampunk* and *Longitude Punk'd*, and using the other exhibitions as comparators, this chapter explores the development of the various exhibitions, their aims and inspirations. It examines the engagement between the museums and the Steampunk artists, how those artists challenge authenticity in a museum context and yet, through the participatory process, how a real synergy and affinity between the museums and this newly included community group has been able to develop which expands interpretive possibilities. Both partners benefit from the terms 'heritage' and 'community' being 'malleable' concepts, which enable 'associations to be made in a myriad of situations' (Crooke 2010: 17).[1] While acknowledging and integrating audiences has become a key part of inclusive museum practice, so facilitating 'the creation of community collections, community exhibitions and community education programmes' (Crooke 2010: 17), Steampunk perhaps offers something different in terms of co-curation – it offers familiarity. As John Naylor (2011), Steampunk artist and chair of the Victorian Steampunk Society (VSS) advocates:

> [Steampunk is] part of the Western psyche, we're brought up with it, we have a literacy based on Steampunk, a visual and technological literacy, that we've grown up with as children and all generations have got that. Its growing in popularity now; I think it's a generational aspect, the people who are now powerful in society remember things like *20,000 Leagues under the Sea*, *The Time Machine* and things like that from their childhood. So, oddly there is a nostalgia for Steampunk.

The chapter first investigates the motivations behind *Steampunk* at the MHS, and then explores in more detail how the exhibitions in London, Bradford and Leek not only introduced Steampunk to a wider UK audience but also demonstrated how Steampunk material culture contributes to contemporary (and alternative) interpretations of both science and art. It was the alternative interpretations that were foregrounded in *Longitude Punk'd*. This section of the chapter investigates the initial motivation for the exhibition and asks what the participatory process tells us about museum engagement with members of the Steampunk community. In conclusion, I determine not only how a subculture like Steampunk is engaging with museums but also, given the way in which Steampunk art plays with authenticity, reinterpreting museum collections to tell an alternative, potentially just as real, story; how subcultures can provide museum audiences with a new way of seeing historical objects. This was an unanticipated outcome of the MHS exhibition; by the time of *Longitude Punk'd*, however, it was one of the curatorial aims in engaging with Steampunk artists, so demonstrating how participatory engagement with this community has developed over the five years since *Steampunk* at the MHS.

The history of science: Steampunked

Steampunk has now moved far beyond its origins in literature. Developing in 1980s America out of futuristic Cyberpunk literature, it epitomises a less dystopian world that looks to the past and steam technology rather than the future. American authors such as K.W. Jeter, Tim Powers, William Gibson and Bruce Sterling exemplify this early phase. The late 1990s saw a resurgence of Steampunk literature and its popularity grew from the mid-2000s onwards (for a graph charting this trend, see Carrott and Johnson 2013: 9–10). Steampunk draws on aspects of science fiction literature, films and television from the 1960s and 1970s (sometimes termed

'proto-Steampunk'), but it has predominantly been influenced by the nineteenth century literature of Jules Verne and H.G. Wells and, to a certain extent, by Charles Dickens and Arthur Conan Doyle. These last two authors are perhaps not so obviously inspirational, but the influence is there, nonetheless, in terms of images of Victorian London with its fog-shrouded buildings, steam trains, hansom cabs, questionable characters, and secret societies and agents.[2] Films are another important element. *Wild Wild West* (Sonnenfeld 1999), *The League of Extraordinary Gentlemen* (Norrington 2003), *The Prestige* (Nolan 2006), *Sherlock Holmes* (Ritchie 2009; 2011) and *Hugo* (Scorsese 2011) all demonstrate influences on, and influences from, both Steampunk literature and the burgeoning subculture. The subculture, perhaps not surprisingly because of the clothes and accessories, draws more media attention than the literature and films. In the UK alone, they can be seen at dozens of social events each year, where clothes – particularly top hats and corsets – are swapped and sold, ray guns, tea cup holsters and cephalopod jewellery are for sale, and tea duelling is an essential pastime. Steam, Victoriana and punk (plus tea) represent the genre's origins and its future aspirations.

It was this community and its artwork that the Museum of the History of Science (MHS) wanted to engage with. The MHS, with its exhibition opening in 2009, was at the vanguard of museum and mainstream interest in Steampunk culture. As Professor Jim Bennett (2012), then director of the MHS explained,

> We were being a bit edgy in bringing in this experimental community into the museum, non-standard, let's say and recognising this movement as something worth paying attention to, when we were the first to do that in a museum context.

It was not all one way, however, as he emphasised,

> They were playing with the idea that this was the University of Oxford and Steampunk had arrived. So they liked the idea of being respectable and we liked the idea of being edgy. Our objectives complemented each other in that respect.

The participatory aspirations therefore can be seen from the beginning and, arguably, subsequent exhibitions in the UK could be said to be riding the wave that the MHS started.

Art Donovan, an American artist and designer, who produces Steampunk lights often inspired by scientific instruments (Donovan n.d.), was the instigator and guest curator of the exhibition. It was his vision that was translated into the final displays. His aim was to showcase the artists and the historic influences they drew on. Many of them had exhibited previously, but not necessarily as Steampunk artists and this was the first time in the UK that work by these artists had been brought together under the banner of 'Steampunk art'. The 'juxtaposition [of Steampunk artwork with the museum's collections] allowed viewers to gain a fuller appreciation for the artists' aesthetic intentions and the historic scientist's practical motivations' and it was this combination that demonstrated how Steampunk was impacting on art and design (Donovan 2011: 28). Donovan engaged with the artists, chose the artworks and considered how they could portray Steampunk within the setting of the MHS. In doing so, he worked in combination with the staff of the MHS. The interpretative process of presenting Steampunk to the public was collaborative and, as a result, Donovan's idea was realised and the Steampunk aesthetic clearly came through in the objects.

Similarly, the exhibition space provided an apposite foil for the Steampunk aesthetic. The MHS is housed within 'the world's oldest surviving purpose-built museum building, the Old Ashmolean' (MHS 2015). The space, with its slightly uneven wooden floors and stairs, and

Figure 14.1 Steampunk exhibition at the Museum of the History of Science.
Source: Museum of the History of Science, University of Oxford.

cabinets of wood and glass, complements the antique globes, astrolabes and other scientific instruments on display. Although it dates from 1683, the building nevertheless proved a suitable match for the materiality of the Steampunk objects in their basement exhibition space, which led to a corresponding exhibition of permanent collection items.

While the artworks displayed at MHS demonstrated some of the fundamental features of Steampunk material culture, the names of the artists incorporated the monikers of their chosen personas (a common practice in Steampunk communities). Through Molly 'Porkshanks' Friedrich's *Mechanical Womb with Clockwork Fetus*, we could see how medical procedures have apparently produced cybernetic humans. Other enhancements were evident in the prosthetic arms developed by Amanda 'Professor Isadora Maelstromme' Scrivener and Thomas 'Lord Archibald "Feathers" Featherstone' Willeford. Richard 'Datamancer' Nagy epitomised Steampunk's alternative history by combining Victorian inspired materials and aesthetics with twenty-first century computer technology. His work, in particular, offered insight into 'what would have happened if twentieth-century techniques had appeared or been invented in the nineteenth century or if technology had halted or taken a different path during the steam age' (Pike 2010: 264). As a consequence, although museum visitors were looking at an alternative version of reality, Nagy's 'Victorian' laptop was displayed as if it was an authentic, historical artefact and, moreover, one that was (still) fully functioning.

Combined with the artworks came the voices of the community, through events such as curatorial talks, films, makers' days, performances and 'Steampunk Live Manikins', which showcased Steampunk fashion, jewellery and goggles in and around the MHS galleries. One of the reasons that *Steampunk* was deemed the most successful exhibition the MHS had ever held was due to the efforts of the Steampunk community in the UK, who worked to engage local shops

and organisations in Oxford and publicise the events more widely on social media. As Jim Bennett (2012) explained,

> When we opened the doors on that very first morning there were a dozen or twenty people, all dressed up in Steampunk gear … We were surprised at how strongly they identified with the exhibition and that worked all the way through; they were always keen to adopt the events that we put on. We had no trouble whatever in putting on events because they just happened, by virtue of my announcing them.

In engaging in this way with the MHS staff, members of the UK Steampunk community helped to ensure the popularity and success of the exhibition. In turn, the exhibition raised awareness of the Steampunk subculture and its artwork not only among the people of Oxford, but also the museum community more generally as can be seen by the various exhibitions discussed in this chapter that were inspired by the MHS's *Steampunk*.

Steampunk artwork provides a means to access the nineteenth century within the twenty-first century. By embracing Victorian industrial mechanisation, Steampunks are not rejecting contemporary technology but its aesthetic, its perceived bland materiality. In combining nineteenth and twenty-first century technologies, they are able to subvert chronological history, both reinventing a timeline and maintaining a more mechanical, more human-sized technology. The notion of technology that is more understandable and so less threatening, is appealing in many ways and this is perhaps one of the charms of the current vogue for vintage and retro (for a discussion on the revival of retro, see Guffey 2006). Many of us can no longer understand the mechanics of a car or how trains are powered, and computers are a far cry from mechanical typewriters. Steampunk takes us back to a time when we had a greater understanding of the industrial world and how it worked. For many people this is one of its attractions..

Another attraction lies in the humour of Steampunk. Here, I want to consider some of the values of the subculture, their effect on identity and on the objects displayed at the MHS and, correspondingly, the effect they had on the museum visitors. The MHS 'preserves the material relics of past science' and includes 'almost all aspects of the history of science, from antiquity to the early twentieth century' (MHS 2015). The Steampunk artists took these 'material relics' and used them as inspiration, so demonstrating some of the core values of the community, as described by John Naylor (2011) of the VSS:

> Imagination and creativity … repurposing, modding [Modding refers to the act of modifying hardware, software, or virtually anything else, to perform a function not originally conceived or intended by the designer], reusing. [Steampunk artists and makers] look at the object, not for what it is, but what it could be.

This ability came across strongly in, but was not confined to, *Steampunk*. Accompanying this, was a complementary exhibition of items from the permanent collection. Scientific objects can be challenging to engage with; the 'material is often very arcane and difficult to understand and place' (Bennett 2012). However, Steampunk can provide a lens through which the objects can be seen. In *Steampunk*, visitors 'didn't have to understand the science', they could

> …just appreciate [the objects], laugh at them, admire them, look at the craftsmanship, whatever it was, be impressed by them. All of the emotional engagements were there; you didn't have to worry if you didn't understand, because frankly they didn't make sense anyway.
>
> *(Bennett 2012)*

Jeanette Atkinson

Although the objects did not make sense, they had facilitated a new way of looking at scientific objects. As Professor Jim Bennett (2012; see also Bennett and Donovan 2011: 19) went on to explain, visitors then walked through into the accompanying exhibition

> …and normally [visitors] wouldn't really engage with them in that way, [but] they carried that sensibility with them … they paused … they looked at them, they thought of them as Steampunk objects, they took in the design, they appreciated their presence, and they didn't worry about how they worked … well they might do, but it wasn't a problem. So we found that people spent much longer in the second room than they would do if they just went straight into it. They looked at the objects more carefully and closely … than just going straight to the exhibition. The Steampunk exhibition … had re-sensitised them, reprogrammed them, had done something to the way they were willing to give time to the objects in the second gallery, which they wouldn't normally do … they spent more time appreciating other qualities of these objects, other than the fact they were scientific instruments.

Steampunk artists, then, were not just displaying their own identities and attitudes to science; they were also influencing perceptions of historical scientific objects. As the V&A's exhibition *Streetstyle: From Sidewalk to Catwalk*, which ran from November 1994 to February 1995, demonstrated, by exhibiting a subculture it does not mean that that culture loses its identity or future (see de la Haye 1996 for a discussion of this). Instead, the process can be a fruitful collaboration, with new insights being gained on and by the culture, and fresh perceptions of historical objects being realised by the museum and its audience. In doing this, Steampunk is not necessarily subverting the message of the museum – its traditional, authorised voice – but is in fact collaborating in the interpretation. Although Steampunk creates, appropriates, manipulates and re-writes history, both of the past and for a potential future, their community heritage is accessible not only to themselves, but also to a wider audience. As such, they are empowering themselves as well as the institution and the museum visitors, so demonstrating the benefits that alternative views can provide (for a discussion of empowerment, see Simon 2010, Chapter 1).

Steam, industry and art

Less than 18 months after the exhibition at the MHS closed in February 2010, *The Greatest Steampunk Exhibition* opened at Kew Bridge Steam Museum, followed at the end of 2011 by *Steampunk* at Bradford Industrial Museum. Foxlowe Arts Centre in Leek, Staffordshire, keen to extend Steampunk into an arts context, was not to be outdone and in late 2012 hosted the *Steampunk and Victoriana Exhibition*. The theme of Victoriana continued in 2013 at the Guildhall Art Gallery, London with *Victoriana: The Art of Revival*, which included various Steampunk objects among their more wide-ranging Victorian inspired exhibits. It appears that Steampunk had arrived. As such, it suggests that Steampunk was no longer, and perhaps never had been, seen as 'deviant other' (Clayton 2004: 147). Despite being classed as a subculture,[3] the aesthetic that we now associate with Steampunk (accurately or otherwise) has been visible in films (for example *The Time Machine* (Pal 1960), as detailed in the quote by John Naylor above) and television (for example, the series *The Wild Wild West* (Moore 1965)) since the 1960s. Consequently, Steampunk may be visually more acceptable – more mainstream – to the public and museums than some other subcultures, leading to the engagement between museums and the community discussed in this chapter. However, it is equally vulnerable to the 'stereotypical representations' discussed by Clayton (2004: 148), as any other subculture. It will be interesting to chart subsequent collaborations between Steampunks and museums. For the moment, though, UK

210

museums do not yet appear to be collecting Steampunk art and material culture (for a discussion of this, see Atkinson 2012; 2013).

In assessing the developing relationship between Steampunks and museums and how the exhibitions discussed here built on that first one at the MHS, in its traditional museum setting, it is interesting to consider the diversity of venues. While there are some similarities between Kew and Bradford, in that they are both industrial museums concerned with preserving and displaying the steam technology of a past era for the public, Foxlowe and the Guildhall focus on the arts. Foxlowe is a community arts centre that opened in 2011 (McCrea 2015), although it is sited in a house that dates from 1777 (Gordon 2012); the Guildhall combines an art gallery, which was originally built in 1885, renovated in the 1980s and 1990s and reopened in 1999, and a Roman Amphitheatre, dating back almost 2,000 years, which opened to the public in 2002 (City of London 2014). The variety in venues demonstrates the versatility of Steampunk and the range of organisations keen to engage with community. It may appear to be steam technology driven geek culture, but it offers both community-produced heritage and precision-made art. As such, it crosses the boundaries of science and art, questions authenticity, and brings together professional artists and popular community culture.

Who are the curators and how much did the impetus for these exhibitions come from the venues compared to the Steampunk community itself? While the artist and designer Art Donovan was the driver behind the MHS exhibition, the venues discussed in this section were the initial instigators of the displays (Foxlowe Arts Centre 2012; Solicari 2013). Reports of the MHS exhibition in the media and in social media suggested that this was a community that was keen to participate, and it was also a subject that had attracted record numbers of visitors for the MHS. There was something beyond this, however, in terms of engaging with museum visitors that Professor Jim Bennett of the MHS had described in terms of Steampunk offering a new 'sensibility'. John Naylor (2011), Steampunk artist and Chair of the VSS, explains further:

> You can't beat the sense of wonder that you see on a viewer's face; there's a lot of particularly young people who go into a museum and they expect it to be stuffy and not engaging with them … With Steampunk you can find someone standing and staring at one piece for 15 minutes or longer, just a single piece … You get people revisiting Steampunk objects in the same visit. That's the biggie, it's a way of engaging with people.

That sense of wonder and engagement was there with all these exhibitions. Kew worked closely with the Victorian Steampunk Society (VSS 2015) on the choice of objects, the installation, interpretation and the events, leading to a very successful exhibition in which the voice and values of the community came through clearly. Steampunk art, clothing, jewellery, and inventive machinery and guns, not to mention an ornate bed, seemed curiously at home in and around the beam engines and permanent collection items. Bradford took this one step further by intermingling Steampunk artworks with original collection items, particularly in the showcases (for a discussion of this, see Atkinson 2013). This juxtaposition, while raising questions regarding what was 'authentic' and what was Steampunk, especially as the style of the labels remained consistent, enabled visitors to reappraise objects from the permanent collections. By placing Victorian dresses or guns next to Steampunk ones, it was possible to assess both 'official' history and the alternative (fictional) history of Steampunk and so see what history and technology might have been, if it had followed a different route.

Foxlowe, inspired by the Bradford exhibition, 'wanted to share some of this wonderful growing movement' with an exhibition that was 'stimulating and intriguing and [brought] something a little different for the audience to consider' (Foxlowe Arts Centre 2012). It also

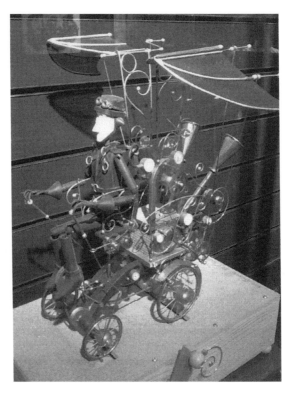

Figure 14.2 Transports of Delight by Keith Newstead. Exhibit at Mechanical Art and Design Museum, Stratford upon Avon, July 2012.

Source: photograph by Jeanette Atkinson.

Figure 14.3 Showcase at Bradford Industrial Museum, with collection objects and Steampunk art combined, March 2012.

Source: photograph by Jeanette Atkinson.

wanted to challenge the context within which Steampunk has previously been exhibited – that of science and industry. Instead, this exhibition combined Victoriana with Steampunk in a community arts centre setting. Although well-known Steampunk artists such as Jema Hewitt and Dr Geof were hosted, the organiser, Georgia Hamilton, was also keen to involve local artists. They created work that extended the range of this exhibition, demonstrating the diversity that Steampunk can encompass, but also confirming that heritage is indeed produced in, and curated by, communities (see West 2010).

The Guildhall built on this diversity with *Victoriana: The Art of Revival*. This exhibition played with the intersection and interconnection between Victoriana, Steampunk and contemporary art and society, apparently producing 'the art of the modern world' (Jones 2013); a phrase that acknowledges how much we currently blend 'vintage' and contemporary influences. Having moved from a traditional museum setting with the MHS into a community arts centre, Steampunk now found itself in a traditional art gallery. In doing so, a different theme – or story – emerged. Again, there was a juxtaposition of objects, this time armchairs containing taxidermy near to prints depicting designer and social pioneer William Morris; photographs reimagining the story of Dr Jekyll and Mr Hyde; sonic ray guns next to space helmets; and a mechanical theatre alongside a feathered hat (for images, see Khan 2013). As such, there was much fun to be had in this exhibition, but there was also a serious side. Many of the objects commented not only on Victorian attitudes to women and children, but also on contemporary ones. The artist Nick Knight demonstrated that women are just as constrained today, in terms of their clothing, what society expects of them and how they should be seen, as their Victorian compatriots. Although I agree that the Steampunk objects on display were not 'concerned with recreating or appropriating nostalgic history, nor with investigating specific Victorian events to give voice to untold stories from the past' (Pearce 2013, p. 81), they did nevertheless challenge contemporary perceptions of history and time, not by giving us untold stories, but by providing alternative stories. As Khan (2013) notes, the work by Herr Doktor hints at what Victorians thought the future might be. Does the work in this exhibition also hint at what we think the future might be or do they, as Jones (2013) suggests, in fact epitomise modern society and the idea that while 'history does not change … what we want from it does' (Guffey 2006: 9)?

In producing this exhibition, the curator, Sonia Solicari sought to include work that reimagines 'the 19th century through the filter of the 20th century' – work that epitomises 'Neo-Victorianism' (Solicari 2013). Yet, as she emphasises, defining 'Neo-Victorianism' is not easy: 'this is not a coherent movement to which artists subscribe – there is no manifesto. Each work has been included for its ability to reimagine the 19th century, rather than recreate it' (Solicari 2013). It is that ability to 'reimagine' that is key to Steampunk. As a movement, it offers not only what might have been, but also what was and what will be – in an alternative future. It is, perhaps, this playing with time, as well as the engagement with vintage and crafting, that intrigues museum audiences. Steampunk not only challenges our perceptions of museum objects, it also encourages us to reappraise the world in which we live.

One of the ways that it does this is through stories – themselves a classic means of engagement. By playing with the 'what if' notion, Steampunk, and the exhibitions under discussion here, explore what might have been, indeed what could be, if we lived in an alternative reality. In the *Victoriana* exhibition, whose story are we seeing through the eyes of Grayson Perry, when he portrays a Victorian woman – the artist's, the woman's or our own? Beyond the humour and alternative concepts of history there are some challenging ideas here and it is at this level that these exhibitions really work; they challenge what we are used to, what we take for granted, showing us a different side to the ordinary and everyday. In this way, they work as all art should, giving us a sense of something other.

Jeanette Atkinson

Punking longitude

Directly inspired by the MHS exhibition, but taking a very specific historical event as the focus, *Longitude Punk'd* was first proposed by curators at the Royal Museums Greenwich (RMG) in March 2011 (Dunn and Higgitt 2011), developed in collaboration with participating artists in March 2013 (RMG 2014a), and ran from 10 April 2014 to 4 January 2015 (see RMG 2014c; 2014b; 2015b). Set in Flamsteed House, part of the Royal Observatory, *Longitude Punk'd* was part of the Longitude season at Royal Museums Greenwich, and complemented the National Maritime Museum's exhibition *Ships, Clocks and Stars: The Quest for Longitude*, which ran from 11 July 2014 to 4 January 2015 (RMG 2014d). Comparably to the exhibitions at Kew and Bradford, *Longitude Punk'd* juxtaposed Steampunk objects with museum objects. The difference this time was the historic house setting. Described as 'the original Observatory building at Greenwich, designed by Sir Christopher Wren in 1675 on the instructions of King Charles II', the building contains 'the apartments where the Astronomers Royal and their families lived and worked' (RMG 2015a). The first of these astronomers was John Flamsteed, who Charles II appointed in 1675 'to draw up a map of the heavens with enough accuracy to be reliable for navigation' (RMG 2015a).

The main aim behind *Longitude Punk'd* was to tell

> ...the tongue-in-cheek story of the Ancient Commodore and his quest to win the Longitude Prize with the help of his obliging kiwi birds. Best-selling author Robert Rankin provides the Commodore's story (in verse!) while eight other UK steampunk artists have filled Sir Christopher Wren's Flamsteed House with drawings, dresses, jewellery, dioramas and a host of bizarre gadgets all purporting to solve the problem of finding longitude at sea.
>
> *(Kukula 2014)*

In producing their artworks, the artists not only considered the challenge of longitude, but also drew on the life and work of Flamsteed, together with Edmond Halley and Nevil Maskelyne, in order to explore aspects of stars, time, space and navigation – all key to the problem of longitude. Each room within the main part of the house contained a single Steampunk object, designed to complement the theme of that room. As a consequence, the experience was akin to that of visiting many historic properties – the belongings of past owners or occupants were on display in order to give a sense of the individuals that had lived in the house. In the case of *Longitude Punk'd*, history and alternative history were melded together in such a way that, although it was clear in most instances which objects were part of the original house and which were Steampunk additions, the objects on display fitted within the context both of the period of the house and, most especially, the scientific aspirations of that time.

Stars and time were clearly the inspiration for Lady Elsie's starlight and constellation-strewn gown, which was dressed with 12 watches showing the time zones around the world. Displayed in the dining room, it also demonstrated the artist's knowledge of early eighteenth century fashion. This was one of the aims of this exhibition – to push the timeframe of Steampunk further back, so that it encompassed the fashion and aesthetic of the eighteenth century (Kukula 2014). As one of the curators, Dr Richard Dunn, explained, there are

> ...a lot of the technologies that Steampunk co-opts, which are essentially clockwork, steam in particular, they are both either invented in the eighteenth century or are already pre-valent in the eighteenth century. So in terms of that kind of aesthetic it didn't seem to me

to be a problem dragging it back, and that's actually what we found when we started talking to the artists.

(Dunn and Finch-Boyer 2014)

The artists also took inspiration from objects within the collections of the RMG. Jema 'Emily Ladybird' Hewitt produced a clockwork chelengk,[4] on display in the Maskelyne's dining room, the stimulus for which may have been a chelengk produced for Vice-Admiral Horatio Nelson (for an image, see RMG n.d.a). Meanwhile, Margaret Maskelyne's rooms housed the uniform of Captain James Cook. Drawing on both navigation and the RMG collections for inspiration, the artist produced a waistcoat that was also a map. Intended to replace paper maps, which can be damaged, the aim was to ensure that Cook would never be lost at sea.

At the top of Flamsteed House is the Octagon Room. Originally 'designed to observe celestial events including eclipses, comets and planetary movements', this was not in fact possible, as 'none of the walls were aligned with a meridian' (RMG 2015a). However, observations of the sky were possible and the room now houses a variety of astronomical instruments and timepieces. Within this room was displayed the Orrery Gown. Suspended from a corset depicting the astronomical bodies were a series of planets in orbit around the wearer. Designed by Jema 'Emily Ladybird' Hewitt, it came complete with a story explaining its origins and place within Lady Flamsteed's life.[5]

Accompanied by the footprints of the Ancient Commodore's kiwis, the exhibition continued downstairs in the modern time galleries. Normally housing the 'Time and Longitude' and 'Time and Greenwich' exhibitions (see RMG 2015d; 2015c), for the purposes of *Longitude Punk'd* they instead contained a myriad of Steampunk and original objects, interpreted through

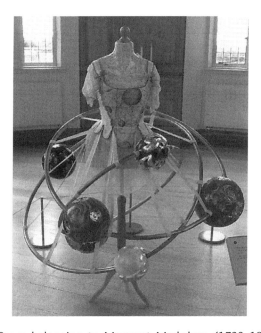

Figure 14.4 Orrery Gown belonging to Margaret Maskelyne (1733–1817), by Jema 'Emily Ladybird' Hewitt, exhibit at Longitude Punk'd, Royal Observatory Greenwich, August 2014.

Source: photograph by Jeanette Atkinson.

a variety of labels. These labels – of different colours, pink for Steampunk and white for original objects – demonstrated that many objects, including the historical ones, had been given a Steampunk interpretation. Nothing was quite what it seemed, which begged the question 'what is real?' Also, why would we think one thing was 'real' and not something else?

The objects displayed behind small doors in a wood panelled section can illustrate the answer to these questions. They provided insight into some of the historical attempts to find a solution to the problem of longitude. These included items developed as a result of people of the time believing in 'the Power of Sympathy'. As one of the *Longitude Punk'd* artists, Yomi Ayeni (2014) explained, this relates to the practice of taking a dog 'and you cut some of the hair, put it into a bowl and stab it and if the dog yelps that means it's one o'clock in London or something like that'. When he told this story to a group of Steampunks in San Diego,

> They thought we created that, even though that's fact, [it happened]. So you're then asking yourself – I mean, the stuff we create wasn't as crazy as that, you know? And I stood there telling – and this gentleman ran off, because there were about 20 of them, rallied them all round and said, 'Have a listen to this', and I told them that that is actually a real piece of history. And at first they didn't believe me. You know, so the stuff we've done is not that mad, we're not that wacky and not that way out.
>
> *(Ayeni 2014)*

The objects on display, then, were all as real as each other, and all potential solutions to the challenge of longitude. In fact, as one of the exhibition labels stated, some of the Steampunk solutions were 'not nearly as ridiculous as the actual scheme submitted to the Board of Longitude'.

Many of the objects in these galleries were arranged in a cabinet of curiosity style, linking back to the early origins of museums (see Bennett 1995). Case after case of objects urged us to question science, longitude, maritime lore and our own history. Even Hogarth's 'A Rake's Progress (plate 8)' came in for a Steampunk reinterpretation, with people apparently trying to solve the longitude problem. This provided an amusing link to the accompanying exhibition *Ships, Clocks and Stars: The Quest for Longitude*, in which Hogarth's print appeared again. This time, the label informed us that the inmates were drawing maritime measurements on the wall (see Tate n.d. for the image).

In addition to telling the story of the Ancient Commodore, Robert Rankin and his wife Rachel contributed various artworks. Notable among these were 'The Kiwi Sanctum', the Commodore's travelling lounge room to house his sacred kiwi birds. The Rankins even provided the origin of the term SAT NAV. Short for SATORI NAVIGATIONAL SYSTEM, and devised by the Commodore, it was suggested that today's sat navs are manned by space-going Kiwi birds. *Longitude Punk'd*, then, provided us with an alternative narrative. Through the eyes of the Commodore, we found that objects that we may have walked past in an ordinary exhibition suddenly had a different story. A portrait of Sir Cloudesley Shovell suddenly became a story about a man who collects, names, and has favourite sticks (see RMG n.d.b for an image). 'Knowing' this, it was possible to see the portrait anew. This was not just an image in a museum, but a person with a real life; and he had been brought to life through the lens of Steampunk. Theirs is a culture that is grounded in history, both real and reimagined. In exploring, pushing and subverting the boundaries between what is real and what is imagined they are challenging the official portrayal of history and providing an alternative. In doing so, they are bringing real history more fully to life. Nothing is seen more clearly than when seen through alternative eyes; it is this that enables us as participants to stand back and also become observers.

Exhibiting a subculture

Steampunk provides us with both an entrée to fictive and imagined science within an alternative history – one that might have happened in the past, or could potentially happen in the future – and also a lens through which to examine our own 'real' history, science and heritage from a different viewpoint. In displaying Steampunk art, museums are collaborating in a revisualisation of the authorised and official version of events. While the end result could be considered an amusing perspective on history or an historical event, the process of negotiation between the museum and the Steampunk artists is somewhat different. Exhibitions such as *Star Trek* (11 October 1995–10 March 1996, Science Museum, London) or *Lord of the Rings* (16 September 2003–11 January 2004, Science Museum, London) envelope the visitor in a world that is totally make-believe. Each of these exhibitions was contained within a particular space and no attempt was made to combine the exhibition items with complementary museum objects. This is one of the key differences with the Steampunk exhibitions and objects discussed here. In the majority of exhibitions, Steampunk inhabited the museum environment, rather than being contained within a small section of it. Even with the MHS, where it had its own gallery, there was a direct link with, and inspiration from, the permanent collections. At the Guildhall, the Steampunk art was set within a neo-Victorian context; the surrounding exhibition objects, and indeed the building itself, were part of the renegotiation of what history is and can be. Steampunk, then, is being portrayed not as a fictional set that an individual steps into, but part of the historical collection of the museum. In this sense, the history that is negotiated between the museum and the Steampunk communities is one that is validated by the exhibition. Steampunk history, in some ways, is as real as any other history.

This was particularly the case at the RMG, and is one of the subtle developments over the five years since the MHS exhibition. Whereas in 2009, the Steampunk art displayed at the MHS was seen as amusing, idiosyncratic and innovative, but many people were not aware of the subculture, now there is much greater knowledge, not least because the aesthetic has influenced the visuals of films and TV and inspired fashion designers. Museums are much more aware of the value of Steampunk, not just what it can do in terms of visitor figures, but also how it can provide a fresh perspective – they learnt this from the MHS exhibition. They are also using Steampunk to tell more of a story. *Steampunk* at the MHS gave us a host of beautiful, strange objects, which made audiences question what science was; they provided the 'tools for visitors to explore their own ideas and to reach their own conclusions' (Perkin 2010: 109). Bradford continued in a similar vein, but also started to play with the notion of what was real – which objects were original and which Steampunk. The *Victoriana* exhibition provided even more questions. Here, we started to see a definite challenging of history, and of societal norms. This is one of the roles of art – to confront what we take for granted and to help us view it through different eyes. *Longitude Punk'd* took this even further. Although initiated by the RMG with the aim of making links 'between the creativity fostered by the work of the Board of Longitude in the late 18th/early 19th centuries and that of artists today working in response to those earlier ideas' (Dunn and Higgitt 2011: 1), what the exhibition ultimately achieved was a series of artworks that did not look out of place among the historical offerings to the Board of Longitude. Steampunk art, therefore, has moved from the clever and quirky, to offering a fictionalised past (and future) history, which can appear as real as the authorised version.

Steampunk has offered us a new lens through which to see history and historical events. One of the reasons the exhibitions have been so successful has been the engagement by the community, whether in the conception and realisation, or in the aftermath of the exhibition opening. As a consequence, their ideas and values – their desire not for visitors 'to suspend belief in a

bizarre way', but 'to liberate [their] minds' (Ayeni 2014) – becomes a part of the museum exhibition. Potentially, Steampunk art engages audiences more because it sidesteps the expert and 'accepted' (and possibly expected) expertise. Museums, though, are learning that 'sharing authority means understanding, and then accommodating to, an often fascinating, sometimes exasperating, competing workview' (Gurian 2006: 201–202). This is at the heart of museum engagement with participatory communities. When communities are collaborators and co-curators of the creative ideas, rather than just consultants, then their values, what they consider important and a part of their culture, can be foregrounded (for a discussion of co-curation, see Lord and Piacente 2014: 174–182). By engaging with, and inhabiting museums, Steampunks are demonstrating their knowledge of how history works, while at the same time they are seeking to rewrite and recreate it. In some ways, this is the ultimate subversion, to engage with the official history, on its own terms in order to get the message across – an unofficial message highlighting an unofficial history. In doing so, they are stating what history is, what it can be. Although we know that it is not the official sanctioned version, for some people it is a more appealing world than the one we currently have.

Acknowledgements

I would like to thank all of my interviewees, specifically Yomi Ayeni, Professor Jim Bennett, Dr Richard Dunn, Dr Heloise Finch-Boyer and John Naylor, for their insights, thought-provoking comments, and contributions to my research.

Notes

1 For a nuanced discussion of the definition of 'community', see Waterton and Smith (2010).
2 For example, British author George Mann is particularly influenced by the work of Conan Doyle. In the Newbury and Hobbes series, the hero/anti-hero Sir Maurice Newbury, peer of the realm, opium addict, occult expert and British Museum academic who moonlights as an agent of Queen Victoria, inhabits a smog-ridden London. With his assistant, Miss Veronica Hobbes, also an agent of the Queen, he battles corrupt industrialists, cannibalistic revenants or zombies, and the secretive Bastion Society, who wish to overthrow the monarchy and return the UK to a mythical Arthurian time (Mann 2008; 2009; 2011; 2013).
3 For a discussion of the definition of subculture, both in the Steampunk context, and in contrast to 'counterculture', see (Carrott and Johnson 2013, p. 8).
4 An Ottoman military decoration, originally made from a bird's feather and then subsequently from jewels, the 'chelengk is a turban ornament consisting of a central flower made up of sixteen petals with leaves and buds. The stalk of the flower is tied by a bow' (RMG n.d.a).
5 Details from exhibition label:

> Silk, cotton, steel, polystyrene, foil This costume was created for the sister of Neville Maskelyne, the Astronomer Royal. It was first worn at a society ball to celebrate the launch of the Board of Longitude. It was at this party that Margaret first caught the eye of Neville's friend Lord Clive, who later commented after their wedding, 'From the moment I laid eyes upon her, in the lady's orbit, I was transfixed.'
>
> *LOA1684*

Bibliography

Atkinson, J., 2013. Steampunk, Bradford Industrial Museum, UK. *Museum Worlds: Advances in Research*, 1, pp. 206–212.
Atkinson, J., 2012. Steampunk's Legacy: Collecting and Exhibiting the Future of Yesterday. In J.A. Taddeo and C.J. Miller (eds) *Steaming into a Victorian Future: A Steampunk Anthology*. Lanham, MD: Scarecrow Press, pp. 273–297.

Ayeni, Y., 2014. Interview between Yomi Ayeni and Jeanette Atkinson at the Royal Museums Greenwich, London.

Bennett, J., 2012. Interview between Jim Bennett and Jeanette Atkinson at the Museum of the History of Science, Oxford.

Bennett, J. and Donovan, A., 2011. Foreword. In *The Art of Steampunk. Extraordinary Devices and Ingenious Contraptions from the Leading Artists of the Steampunk Movement*. East Petersburg, PA: Fox Chapel Publishing, pp. 18–19.

Bennett, T., 1995. *The Birth of the Museum. History, Theory, Politics*, London and New York: Routledge.

Carrott, J.H. and Johnson, B.D., 2013. *Vintage Tomorrows: A Historian and a Futurist Journey Through Steampunk into the Future of Technology*, Sebastopol, CA: O'Reilly Media, Inc.

City of London, 2014. About us – Guildhall Art Gallery and Roman Amphitheatre – City of London. Available at: www.cityoflondon.gov.uk/things-to-do/visiting-the-city/attractions-museums-and-galleries/guildhall-art-gallery-and-roman-amphitheatre/Pages/About-Us.aspx (accessed 24 May, 2015).

Clayton, N., 2004. Folk devils in our midst? Collecting from 'deviant' groups. In S.J. Knell (ed.) *Museums and the Future of Collecting*. Aldershot: Ashgate Publishing Ltd., pp. 146–154.

Crooke, E., 2010. The politics of community heritage: motivations, authority and control. *International Journal of Heritage Studies*, 16(1–2): 16–29.

Donovan, A., n.d. Art Donovan. Steampunk Art and Design. Available at: http://artdonovan.typepad.com/blog/ (accessed 17 July, 2015).

Donovan, A., 2011. *The Art of Steampunk. Extraordinary Devices and Ingenious Contraptions from the Leading Artists of the Steampunk Movement*, East Petersburg, Pa.: Fox Chapel Publishing.

Dunn, R. and Finch-Boyer, H., 2014. Interview between Richard Dunn, Heloise Finch-Boyer and Jeanette Atkinson at the Royal Museums Greenwich, London.

Dunn, R. and Higgitt, R., 2011. NMM Exhibition Proposal: Longitude Punk'd.

Foxlowe Arts Centre, 2012. Steampunk and Victoriana Exhibition, Foxlowe Arts Centre, Leek. Available at: www.foxloweartscentre.org.uk/steampunk-victoriana-exhibition/ (accessed 17 July 2015).

Gordon, J., 2012. Steampunk and Victoriana Exhibition, Foxlowe Arts Centre, Leek. *Forbidden Planet Blog*. Available at: www.forbiddenplanet.co.uk/blog/2012/steampunk-and-victoriana-exhibition-foxlowe-arts-centre-leek/ (accessed 17 July, 2015).

Guffey, E.E., 2006. *Retro: The Culture of Revival*, London: Reaktion.

Gurian, E.H., 2006. Singing and dancing at night: a biographic meaning to working in the spiritual arena, 2004. In *Civilizing the Museum. The Collected Writings of Elaine Heumann Gurian*. London and New York: Routledge, pp. 200–206.

de la Haye, A., 1996. Travellers' boots, body-moulding, rubber fetish clothes: making histories of subcultures. In G. Kavanagh (ed.) *Making Histories in Museums*. London and New York: Leicester University Press, pp. 143–151.

Jones, J., 2013. The empire strikes back: celebrating the Victorians, the first modern masters. *Guardian*. Available at: www.theguardian.com/artanddesign/jonathanjonesblog/2013/aug/26/victoriana-guildhall-art-gallery-exhibition (accessed 25 May, 2015).

Khan, T., 2013. Victoriana Takes Art Back in Time at Guildhall. *Londonist*. Available at: http://londonist.com/2013/09/victoriana-takes-art-back-in-time-at-guildhall.php (accessed 25 May, 2015).

Kukula, M., 2014. Longitude, Steampunk and Satellites – Royal Observatory Greenwich blog. *Royal Observatory Greenwich Blog*. Available at: http://blogs.rmg.co.uk/rog/2014/05/28/longitude-steampunk-satellites/ (accessed 13 July, 2015).

Lord, B. and Piacente, M., 2014. *Manual of Museum Exhibitions*, Lanham, MD: Rowman & Littlefield Publishers.

Mann, G., 2008. *The Affinity Bridge*, London: Snowbooks Ltd.

Mann, G., 2013. *The Executioner's Heart: A Newbury and Hobbes Investigation*, London: Titan Books.

Mann, G., 2011. *The Immorality Engine*, London: Snowbooks Ltd.

Mann, G., 2009. *The Osiris Ritual*, London: Snowbooks Ltd.

McCrea, A., 2015. About us, Foxlowe Arts Centre Leek. *Foxlowe Arts Centre*. Available at: www.foxloweartscentre.org.uk/category/about-us/ (accessed 24 May, 2015).

Moore, I.J., 1965. *The Wild Wild West*, CBS Productions, New York, US.

Museum of the History of Science (MHS), 2015. Museum of the History of Science, Oxford: History. Available at: www.mhs.ox.ac.uk/about/history/ (accessed 17 July, 2015).

Museum of the History of Science (MHS), 2011. Museum of the History of Science, Oxford: Steampunk. Available at: www.mhs.ox.ac.uk/exhibits/steampunk/ (accessed 1 November, 2015).

Naylor, J., 2011. Interview between John Naylor and Jeanette Atkinson, Nottingham Contemporary.

Nolan, C., 2006. *The Prestige*, Touchstone Pictures.

Norrington, S., 2003. *The League of Extraordinary Gentlemen*, Angry Films.

Pal, G., 1960. *The Time Machine*, George Pal Productions, Los Angeles, CA.

Pearce, K., 2013. Steampunk. In S. Solicari (ed.) *Victoriana: A Miscellany*. London: Guildhall Art Gallery, pp. 78–83.

Perkin, C., 2010. Beyond the rhetoric: negotiating the politics and realising the potential of community-driven heritage engagement. *International Journal of Heritage Studies*, 16(1–2): 107–122.

Pike, D.L., 2010. Afterimages of the Victorian City. *Journal of Victorian Culture*, 15(2): 254–267.

Ritchie, G., 2009. *Sherlock Holmes*, Warner Bros., Los Angeles, California.

Ritchie, G., 2011. *Sherlock Holmes: A Game of Shadows*, Warner Bros., Los Angeles, California.

RMG, n.d.a – National Maritime Museum. *Royal Museums Greenwich*. Available at: http://collections.rmg.co.uk/collections/objects/36519.html (accessed 12 July, 2015).

RMG, n.d.b Sir Cloudesley Shovell, 1650–1707 – National Maritime Museum. *Royal Museums Greenwich*. Available at: http://collections.rmg.co.uk/collections/objects/14498.html (accessed 15 July, 2015).

RMG, 2015a. Flamsteed House: Meridian Courtyard and Flamsteed House: Royal Observatory: RMG. *Royal Museums Greenwich*. Available at: www.rmg.co.uk/royal-observatory/flamsteed-house-and-meridian/flamsteed-house (accessed 12 July, 2015).

RMG, 2015b. Goodbye Longitude Punk'd – Board of Longitude project. Available at: http://blogs.rmg.co.uk/longitude/2015/01/08/goodbye-longitude-punkd/ (accessed 31 May, 2015).

RMG, 2015c. Time and Greenwich: Gallery listing: Exhibitions: What's on: RMG. *Royal Museums Greenwich*. Available at: www.rmg.co.uk/whats-on/exhibitions/on-display/time-and-greenwich (accessed 14 July, 2015).

RMG, 2015d. Time and Longitude gallery: Gallery listing: Exhibitions: What's on: RMG. *Royal Museums Greenwich*. Available at: www.rmg.co.uk/whats-on/exhibitions/on-display/time-and-longitude (accessed 14 July, 2015).

RMG, 2014a. Longitude Punk'd: Historical briefing for participating artists.

RMG, 2014b. Longitude Punk'd: Steampunks take over the Royal Observatory Greenwich: Press office and news: About us: RMG. *Royal Museums Greenwich*. Available at: www.rmg.co.uk/about/press/longitude-punkd (accessed 31 May, 2015).

RMG, 2014c. Royal Observatory Greenwich: Longitude Punk'd. *Royal Museums Greenwich*. Available at: www.rmg.co.uk/whats-on/events/longitude-punkd (accessed 1 November, 2015).

RMG, 2014d. Ships, Clocks and Stars: The Quest for Longitude: Events: What's on: RMG. *Royal Museums Greenwich*. Available at: www.rmg.co.uk/whats-on/events/ships-clocks-stars (accessed 31 May, 2015).

Scorsese, M., 2011. *Hugo*, Paramount Pictures.

Simon, N., 2010. Principles of Participation – The Participatory Museum. *The Participatory Museum*. Available at: www.participatorymuseum.org/chapter1/ (accessed 7 January, 2016).

Solicari, S., 2013. First Look: Victoriana at the Guildhall, London. *Apollo Magazine*. Available at: www.apollo-magazine.com/first-look-victoriana-guildhall/ (accessed 25 May, 2015).

Sonnenfeld, B., 1999. *Wild Wild West*, Peters Entertainment.

Tate, n.d. William Hogarth, 'A Rake's Progress (plate 8)' 1735–63. *Tate*. Available at: www.tate.org.uk/art/artworks/hogarth-a-rakes-progress-plate-8-t01794 (accessed 15 July, 2015).

VSS, 2015. British Steampunk, Home of the Victorian Steampunk Society. Available at: www.british-steampunk.org/ (accessed 17 July, 2015).

Waterton, E. and Smith, L., 2010. The recognition and misrecognition of community heritage. *International Journal of Heritage Studies*, 16(1–2): 4–15.

West, S., 2010. Introduction. In S. West (ed.) *Understanding Heritage in Practice*. Understanding Global Heritage. Manchester and Milton Keynes: Manchester University Press in association with the Open University, pp. 1–6.

15
Why fakes?

Mark Jones

Fake? is an exhibition about deception, or rather the material evidence of the myriad deceptions practised by men upon their fellows over three millennia. It is a record of human frailty, of the deceit of those who made fakes and of the gullibility of those who were taken in by them – a curious subject at first sight for exhibition in the British Museum. Yet it can be argued that fakes, scorned or passed over in embarrassed silence by scholar, dealer and collector alike, are unjustly neglected; that they provide unrivalled evidence of the values and perceptions of those who made them, and of those for whom they were made.

Fakes can teach us many things, most obviously perhaps the fallibility of experts. Not a single object has been included here merely because it deceived an untutored layman. Most have been validated thrice over, on initial purchase by an experienced collector, on publication by a leading scholar and on acquisition by a great museum. What is being asserted is not that the less well informed may sometimes make mistakes, though that is evidently true, but that even the most academically and intuitively gifted of individuals, even the most rigorously organised of institutions, can and will occasionally be wrong. And this is not, or not simply, because knowledge and experience can never be complete, but because perception itself is determined by the structure of expectations that underpins it. Present Piltdown Man to a palaeontologist out of the blue and it will be rejected out of hand. Present it to a palaeontologist whose predictions about the 'missing link' have been awaiting just such evidence and it will seem entirely credible. Bring an exceptionally rare Athenian coin to a classical numismatist and he will examine it with careful scepticism. Allow one of the greatest of all classical numismatists, Sir George Hill, a Director of the British Museum, to find such a coin *for himself*, mounted as a jewel around a lady's neck, and he will take its authenticity for granted.

This omnipresent fallibility is of wider significance than might be suggested by a misidentified coin or even a misapprehension about the whole course of human evolution. It can affect our conception of reality itself. One whole section of *Fake?* is devoted to the changing boundaries of belief, boundaries that were often marked and sometimes determined by fakes. The fabricators of the Vegetable Lambs of Tartary that grazed on the surrounding grass while joined to mother earth by an umbilical cord, of the 'Sea Bishop' that visited the King of Poland in 1531, or of the numerous mermen that reached Europe from Japan, altered, for a while at least, the mental universe inhabited by those who saw them. And this is not just a question of

221

medieval credulity. Elsie and Frances Wright's fabricated photographs convinced Conan Doyle, creator of that paradigm of sceptical intelligence Sherlock Holmes, and millions of others, that there really were fairies at the bottom of the garden.

Even those resistant to such beliefs may be vitally affected by fakes. Though the disseminator of the 'Zinoviev letter' may have exaggerated when he claimed that it had lost the British Labour Party the 1924 general election and fundamentally altered the balance of power between the main political parties, there is no denying that smear campaigns based on forgeries, most notoriously the *Protocols of the Elders of Zion* have influenced public opinion – and not only public opinion. A rather earlier forgery, the Donation of Constantine, was the legal basis of the medieval Papacy's claim to temporal power in the West and so, among other things, as Nicolas Barker points out, of Pope Adrian IV's grant of Ireland to Henry VI of England.

Such forgeries were far from being exceptional aberrations. It has recently been estimated that the great monastic houses of England were so busy forging writs in the century after the Norman Conquest that over half the surviving charters of Edward the Confessor may be spurious. No one can be sure, because their forgeries are so clever that it can still be difficult to detect them today. This illustrates the unrivalled potential of fakes as evidence of the sense of history possessed by their creators. In the fakers' work we can see exactly what it was that they believed to characterise the antiquity of the object faked; exactly what was necessary to meet expectations about such objects and so secure their acceptance.

The sense of history revealed by fakes is sometimes remarkable. As John Taylor notes, the ancient Egyptian forgers of the Shabaka Stone, which located the creation of the world in their home town of Memphis, not only claimed that they were copying an ancient, worm-eaten document, but also actually reproduced the layout of just such a document, and introduced archaic spelling and grammatical forms to give it credibility. There could be no better demonstration of the existence of a sophisticated sense of anachronism among the educated élite of Pharaonic Egypt.

Equally surprising is the almost total lack of any such sense demonstrated by some of the fakes surviving from Renaissance Europe. Neither the Constantine and Heraclius medals, nor the severed head of Pompey in the Cabinet des Médailles, Paris, nor the coin portraits of ancient worthies by Valerio Belli look remotely classical to the modern eye. There has therefore been a general tendency among art historians to assume that they could not have been intended to deceive. Andrew Burnett, however, has shown that they were. The earliest books on numismatics were in fact motivated in part by the existence of such fakes and by a desire to help the collector to avoid them.

Just as the fake itself is evidence of the historical sense of its maker and recipients, so its critical history is a gauge of the development, or decline, of such a sense thereafter. The denunciation of the Constantine and Heraclius medals in the early seventeenth century reflects the emergence of a perception of the stylistic norms of late classical and early Byzantine art, and the realisation that such pieces lay outside them. In much the same way the gradual exposure of the *Corpus Hermeticum*, a highly influential collection of religious texts purporting to prefigure many of the central tenets of Christianity, began with the simple observation, in the late sixteenth century, that a letter from Hermes to Aesculapius could hardly be genuine if it included a reference to the sculptor Phidias (since it would have antedated his birth). It continued with Isaac Casaubon's much more sophisticated demonstration, in the early seventeenth century, that the whole collection was written in the Greek of the first century, not that of Heroditus or Hippocrates, let alone that of the much earlier period to which its composition was ascribed.

The development of a critical tradition has thus been intimately connected, in every field, with the exposure and even the production of fakes. As Christopher Ligota demonstrates, it was

in a work purporting to establish the central position of the Etruscans in world history that Annius of Viterbo attacked the unreliability of certain ancient Greek historians and proposed new and highly influential rules for the assessment of historical evidence. This is a world in which poachers act simultaneously as gamekeepers, alerted to others' frauds by their own.

Fakes are, however, only secondarily a source of evidence for the outlook of those who made and uncovered them. They are, before all else, a response to demand, an ever changing portrait of human desires. Each society, each generation, fakes the thing it covets most. For the priests of ancient Memphis this was, as we have seen, the promotion of their cult and of their city. For a nineteenth-century nationalist, like Václav Hanka, it was a medieval tradition of epic poetry that would fire the heart of the Czech nation and lead it to statehood. For medieval monks it was the relics of saints and martyrs that would perform miracles, attract the faithful and ensure the endowment of their foundation. For Renaissance humanists it was relics of a different kind, of that source of all beauty and enlightenment, the ancient world. Succeeding generations added demand for the work of famous artists, for things associated with famous people and, by the late nineteenth century, for almost anything that spoke to them of the calm certainties of the vanished past.

It may be significant then that the great growth area for faking today is not the creation of religious relics, national epics, or works of art, nor even some specifically modern area like the production of spurious scientific data (though that is on the increase), but the massive counterfeiting of brand-named goods. Wherever there is a market for the perfume of Chanel or Dior, the watches of Rolex or Cartier, shirts by Giorgio Armani, luggage by Louis Vuitton or footware by Adidas, the counterfeiter is at work. Most of the purchasers of their work know that at the price they are paying they cannot be buying the real thing. They are buying an illusion – the illusion of status, of belonging, of success, conferred by the fraudulent reproduction of a famous name.

If fakes provide a unique portrait of the changing focuses of human desires, they also delineate the evolution of taste with unrivalled precision. Where there are fakes it is clear that there was a booming market in the things thus imitated: fakers are above all creatures of the market. Unencumbered by the individualism of a great artist or thinker, they move quickly to take advantage of the high prices produced by a new fashion before the development of expertise makes their task more difficult or, worse still, their activities undermine the market altogether (as was the case with the market for classical gems in the mid-nineteenth century). If the market concerned is in antiques, however broadly defined, the fakes produced for it will reflect its demands more accurately than the genuine works traded in it. The former mirror the perceived desires of collectors; the latter may pass unchanged through their hands.

Not all genuine objects remain untouched by their owners, however. Some are rendered more acceptable by restoration, a process that provides the same kind of evidence for the history of taste as fakes themselves. The history of restoration is indeed inextricably linked with that of fakes, as the section of *Fake?* devoted to the collection of classical antiquities in the late eighteenth century demonstrates. At this period the restoration of sculpture was not in itself controversial: no classical figure, however beautiful, was considered worthy of display unless complete. Since classical antiquities were almost always found damaged, restorers were much in demand and their skill lay in the creation of an illusion of completeness, in modifying the old and adding the new in such a way as to create a single unified whole. Faking only came into it when, as was commonly the case, the purchaser was deceived as to the extent of the restoration carried out. In the case of the famous Venus, now at Newby Hall in Yorkshire, the dealer Jenkins created one of the most expensive pieces of classical sculpture ever sold by joining an alien and recut head to a headless body, and selling the result as a complete figure. This is a paradigmatic example of a fake.

Restoration, however, also raises questions of a more complicated kind about the search for authenticity. In the early nineteenth century the crucial decision was taken not to restore the Elgin Marbles. To subsequent generations, reared on the notion that the peak of beauty was to be found in these fragmentary examples of ancient sculpture, previous attitudes to restoration seemed wrong. What had once been seen as returning works of art to their original state, so that they could be seen and appreciated in as near as possible the form that they had had in classical times, was now regarded as deception. So, for example, it was asserted that the restoration of the Aegina marbles by the famous Danish neo-classical sculptor Thorwaldsen amounted to forgery (Schuller 1960, pp. 153–4), and in the 1960s his additions were removed by the Munich Glyptothek, so that the original fragments could once again be seen as they really were. Now a new concept of authenticity is emerging which encourages us to accept that objects have a continuing history, that they are damaged and repaired, cleaned and restored, and that their present state records not only the moment of creation but also a whole subsequent sequence of events. Whether, in the light of this, the pursuit of authenticity requires the restoration of the Thorwaldsen restorations, or whether their removal should be accepted as another significant event in the continuing history of the Aegina marbles, is not yet clear. What is certain is that this controversy has a direct bearing on the treatment of fakes. These have too often been ruthlessly dismantled, victims of a puritanical zeal that would strip away the lie and reveal the truth behind it, even if the truth is a heap of uninteresting fragments and the fake was a construct of historical and aesthetic value.

If *Fake?* poses questions about authenticity, and the problems posed by the application of different concepts of authenticity by different groups of people to different types of object, it also, and most painfully, challenges the authenticity of our responses to them. Why, if what we value from a work of art is the aesthetic pleasure to be gained from it, is a successfully deceptive fake inferior to the real thing? Conscious of this problem, some have attempted to deny the importance, to them, of authorship. The great collector and scholar Richard Payne Knight, when attempting to ascertain the truth about the Flora cameo, which he had purchased as antique but which the contemporary gem-engraver Benedetto Pistrucci claimed to have made himself, told the dealer who had sold it to him that it did not matter whether it was old or new since its beauty was unaffected by its age. Similarly, the purchasers of the supposedly Renaissance bust of Lucrezia Donati expressed their pleasure, on discovering that it was a fake, that an artist of such talent was still alive. But it would be unwise to rely on museums, dealers or private collectors taking that attitude today.

What most of us suspect, that aesthetic appreciation is not the only motor of the art market, becomes evident when a work of art is revealed as a fake. When a 'Monet' turns out not to be, it may not change its appearance but it loses its value as a relic. It no longer provides a direct link with the hand of a painter of genius, and it ceases to promise either spiritual refreshment to its viewer or status to its owner. And even though the work in question remains physically unaltered our aesthetic response to it is profoundly changed. The great art historian Abraham Bredius wrote of Van Meegeren's 'Vermeer' forgery *Christ at Emmaus*:

> It is a wonderful moment in the life of a lover of art when he finds himself suddenly confronted with a hitherto unknown painting by a great master, untouched, on the original canvas, and without any restoration, just as it left the painter's studio! And what a picture! Neither the beautiful signature ... nor the pointillé on the bread which Christ is blessing, is necessary to convince us that what we have here is a – I am inclined to say – *the* masterpiece of Johannes Vermeer of Delft ...

> (*Burlington Magazine, November 1937*)

After Van Meegeren's exposure, however, it became apparent that his forgeries were grotesquely ugly and unpleasant paintings, altogether dissimilar to Vermeer's. His success is, retrospectively, literally incredible. M. Kirby Talley Jr concludes his piece on Van Meegeren with the observation 'had Van Meegeren been a better artist … he might just have succeeded in producing "Vermeers" which would have fooled more people longer than the ones he created'. Yet as he himself tells us, Van Meegeren was exposed not because he ceased to fool people but because he fooled one art lover too many, Hermann Goering, and was forced to prove himself a forger in order to clear himself of the more serious charge of having sold a national treasure to the enemy.

Van Meegeren's success seems incredible. But what is really extraordinary about it is that the pattern revealed by his case is in fact commonplace. The reaction of Bredius and his numerous distinguished colleagues, far from being exceptionally foolish, was normal; fakes are very often greeted with rapture by *cognoscenti* and general public alike. It is generally true that fakers are known to us only because they have revealed themselves, overcoming considerable public and scholarly scepticism to prove the works in question theirs only to find that what was so admired as the work of another is now seen as trite and even maladroit.

From this it is clear that both private and public collections must still contain many works by fakers less boastful, quarrelsome or unlucky than Bastianini, Dossena or Van Meegeren. And they will continue to do so. Some will be exposed by advances in scientific techniques; but many objects cannot be scientifically dated, and even where analysis is appropriate its conclusions must be based on a control group of 'genuine' objects which may itself be contaminated. Others, anchored in their own time, may become 'dated' and expose themselves – as Lord Lee's Botticelli was betrayed by her resemblance to 1920s film stars. But while sensitivity to stylistic anachronism is a powerful tool, it is far from an infallible one. When a group of fakes is accepted into the canon of genuine work all subsequent judgements about the artist or period in question are based on perceptions built in part upon the fakes themselves. Had Bastianini not become enraged by the profits being made from his work we, like Kenneth Clark's art master,[1] might have a conception of Renaissance art formed around his work.

This, finally, is our complaint against fakes. It is not that they cheat their purchasers of money, reprehensible though that is, but that they loosen our hold on reality, deform and falsify our understanding of the past. What makes them dangerous, however, also makes them valuable. The feelings of anger and shame that they arouse among those who have been deceived are understandable, but the consequent tendency to dispose of or destroy fakes, once identified, is misguided. Even if the errors of the past only provided lessons for the future they would be worthy of retention and study. But fakes do far more than that. As keys to understanding the changing nature of our vision of the past, as motors for the development of scholarly and scientific techniques of analysis, as subverters of aesthetic certainties, they deserve our closer attention, while as the most entertaining of monuments to the wayward talents of generations of gifted rogues they claim our reluctant admiration.

Note

1 Kenneth Clark's art master taught him in a room which only contained casts, some of which were by Bastianini (see Clark 1979).

Bibliography

Clark, Kenneth, 'Forgeries', *History Today*, November, 1979, pp. 724–33.
Schuller, Sepp, *Forgers, Dealers, Experts*, London: Arthur Baker, 1960.

16
The work of art in the age of mechanical reproduction

Walter Benjamin

Our fine arts were developed, their types and uses were established, in times very different from the present, by men whose power of action upon things was insignificant in comparison with ours. But the amazing growth of our techniques, the adaptability and precision they have attained, the ideas and habits they are creating, make it a certainty that profound changes are impending in the ancient craft of the Beautiful. In all the arts there is a physical component which can no longer be considered or treated as it used to be, which cannot remain unaffected by our modern knowledge and power. For the last twenty years neither matter nor space nor time has been what it was from time immemorial. We must expect great innovations to transform the entire technique of the arts, thereby affecting artistic invention itself and perhaps even bring about an amazing change in our very notion of art.★

Paul Valéry, *Pièces sur l'art*, *'La Conquête de l'ubiquité,'* Paris

I

… In principle a work of art has always been reproducible. Man-made artifacts could always be imitated by men. Replicas were made by pupils in practice of their craft, by masters for diffusing their works, and, finally, by third parties in the pursuit of gain. Mechanical reproduction of a work of art, however, represents something new. Historically, it advanced intermittently and in leaps at long intervals, but with accelerated intensity. The Greeks knew only two procedures of technically reproducing works of art: founding and stamping. Bronzes, terra cottas, and coins were the only art works which they could produce in quantity. All others were unique and could not be mechanically reproduced. With the woodcut graphic art became mechanically reproducible for the first time, long before script became reproducible by print. The enormous changes which printing, the mechanical reproduction of writing, has brought about in literature are a familiar story. However, within the phenomenon which we are here examining from the perspective of world history, print is merely a special, though particularly important, case. During the Middle Ages engraving and etching were added to the woodcut; at the beginning of the nineteenth century lithography made its appearance.

With lithography the technique of reproduction reached an essentially new stage. This much more direct process was distinguished by the tracing of the design on a stone rather than its

Art in the age of mechanical reproduction

incision on a block of wood or its etching on a copperplate and permitted graphic art for the first time to put its products on the market, not only in large numbers as hitherto, but also in daily changing forms. Lithography enabled graphic art to illustrate everyday life, and it began to keep pace with printing. But only a few decades after its invention, lithography was surpassed by photography. For the first time in the process of pictorial reproduction, photography freed the hand of the most important artistic functions which henceforth devolved only upon the eye looking into a lens. Since the eye perceives more swiftly than the hand can draw, the process of pictorial reproduction was accelerated so enormously that it could keep pace with speech. A film operator shooting a scene in the studio captures the images at the speed of an actor's speech. Just as lithography virtually implied the illustrated newspaper, so did photography foreshadow the sound film. The technical reproduction of sound was tackled at the end of the last century. These convergent endeavours made predictable a situation which Paul Valéry pointed up in this sentence: 'Just as water, gas, and electricity are brought into our houses from far off to satisfy our needs in response to a minimal effort, so we shall be supplied with visual or auditory images, which will appear and disappear at a simple movement of the hand, hardly more than a sign' (*op. cit.*, p. 226). Around 1900 technical reproduction had reached a standard that not only permitted it to reproduce all transmitted works of art and thus to cause the most profound change in their impact upon the public; it also had captured a place of its own among the artistic processes. For the study of this standard nothing is more revealing than the nature of the repercussions that these two different manifestations – the reproduction of works of art and the art of the film – have had on art in its traditional form.

II

Even the most perfect reproduction of a work of art is lacking in one element: its presence in time and space, its unique existence at the place where it happens to be. This unique existence of the work of art determined the history to which it was subject throughout the time of its existence. This includes the changes which it may have suffered in physical condition over the years as well as the various changes in its ownership.[1] The traces of the first can be revealed only by chemical or physical analyses which it is impossible to perform on a reproduction; changes of ownership are subject to a tradition which must be traced from the situation of the original.

The presence of the original is the prerequisite to the concept of authenticity. Chemical analyses of the patina of a bronze can help to establish this, as does the proof that a given manuscript of the Middle Ages stems from an archive of the fifteenth century. The whole sphere of authenticity is outside technical – and, of course, not only technical – reproducibility.[2] Confronted with its manual reproduction, which was usually branded as a forgery, the original preserved all its authority; not so *vis à vis* technical reproduction. The reason is twofold. First, process reproduction is more independent of the original than manual reproduction. For example, in photography, process reproduction can bring out those aspects of the original that are unattainable to the naked eye yet accessible to the lens, which is adjustable and chooses its angle at will. And photographic reproduction, with the aid of certain processes, such as enlargement or slow motion, can capture images which escape natural vision. Secondly, technical reproduction can put the copy of the original into situations which would be out of reach for the original itself. Above all, it enables the original to meet the beholder halfway, be it in the form of a photograph or a phonograph record. The cathedral leaves its locale to be received in the studio of a lover of art; the choral production, performed in an auditorium or in the open air, resounds in the drawing room.

227

The situations into which the product of mechanical reproduction can be brought may not touch the actual work of art, yet the quality of its presence is always depreciated. This holds not only for the art work but also, for instance, for a landscape which passes in review before the spectator in a movie. In the case of the art object, a most sensitive nucleus – namely, its authenticity – is interfered with whereas no natural object is vulnerable on that score. The authenticity of a thing is the essence of all that is transmissible from its beginning, ranging from its substantive duration to its testimony to the history which it has experienced. Since the historical testimony rests on the authenticity, the former, too, is jeopardized by reproduction when substantive duration ceases to matter. And what is really jeopardized when the historical testimony is affected is the authority of the object.[3]

One might subsume the eliminated element in the term 'aura' and go on to say: that which withers in the age of mechanical reproduction is the aura of the work of art. This is a symptomatic process whose significance points beyond the realm of art. One might generalize by saying: the technique of reproduction detaches the reproduced object from the domain of tradition. By making many reproductions it substitutes a plurality of copies for a unique existence. And in permitting the reproduction to meet the beholder or listener in his own particular situation, it reactivates the object reproduced. These two processes lead to a tremendous shattering of tradition which is the obverse of the contemporary crisis and renewal of mankind. Both processes are intimately connected with the contemporary mass movements. Their most powerful agent is the film. Its social significance, particularly in its most positive form, is inconceivable without its destructive, cathartic aspect, that is, the liquidation of the traditional value of the cultural heritage. This phenomenon is most palpable in the great historical films. It extends to ever new positions. In 1927 Abel Gance exclaimed enthusiastically: 'Shakespeare, Rembrandt, Beethoven will make films ... all legends, all mythologies and all myths, all founders of religion, and the very religions ... await their exposed resurrection, and the heroes crowd each other at the gate.'** Presumably without intending it, he issued an invitation to a far-reaching liquidation.

III

During long periods of history, the mode of human sense perception changes with humanity's entire mode of existence. The manner in which human sense perception is organized, the medium in which it is accomplished, is determined not only by nature but by historical circumstances as well. The fifth century, with its great shifts of population, saw the birth of the late Roman art industry and the Vienna Genesis, and there developed not only an art different from that of antiquity but also a new kind of perception. The scholars of the Viennese school, Riegl and Wickhoff, who resisted the weight of classical tradition under which these later art forms had been buried, were the first to draw conclusions from them concerning the organization of perception at the time. However far-reaching their insight, these scholars limited themselves to showing the significant, formal hallmark which characterized perception in late Roman times. They did not attempt – and, perhaps, saw no way – to show the social transformations expressed by these changes of perception. The conditions for an analogous insight are more favourable in the present. And if changes in the medium of contemporary perception can be comprehended as decay of the aura, it is possible to show its social causes.

The concept of aura which was proposed above with reference to historical objects may usefully be illustrated with reference to the aura of natural ones. We define the aura of the latter as the unique phenomenon of a distance, however close it may be. If, while resting on a summer afternoon, you follow with your eyes a mountain range on the horizon or a branch which casts

its shadow over you, you experience the aura of those mountains, of that branch. This image makes it easy to comprehend the social bases of the contemporary decay of the aura. It rests on two circumstances, both of which are related to the increasing significance of the masses in contemporary life. Namely, the desire of contemporary masses to bring things 'closer' spatially and humanly, which is just as ardent as their bent toward overcoming the uniqueness of every reality by accepting its reproduction.[4] Every day the urge grows stronger to get hold of an object at very close range by way of its likeness, its reproduction. Unmistakably, reproduction as offered by picture magazines and newsreels differs from the image seen by the unarmed eye. Uniqueness and permanence are as closely linked in the latter as are transitoriness and reproducibility in the former. To pry an object from its shell, to destroy its aura, is the mark of a perception whose 'sense of the universal equality of things' has increased to such a degree that it extracts it even from a unique object by means of reproduction. Thus is manifested in the field of perception what in the theoretical sphere is noticeable in the increasing importance of statistics. The adjustment of reality to the masses and of the masses to reality is a process of unlimited scope, as much for thinking as for perception.

IV

The uniqueness of a work of art is inseparable from its being imbedded in the fabric of tradition. This tradition itself is thoroughly alive and extremely changeable. An ancient statue of Venus, for example, stood in a different traditional context with the Greeks, who made it an object of veneration, than with the clerics of the Middle Ages, who viewed it as an ominous idol. Both of them, however, were equally confronted with its uniqueness, that is, its aura. Originally the contextual integration of art in tradition found its expression in the cult. We know that the earliest art works originated in the service of a ritual – first the magical, then the religious kind. It is significant that the existence of the work of art with reference to its aura is never entirely separated from its ritual function.[5] In other words, the unique value of the 'authentic' work of art has its basis in ritual, the location of its original use value. This ritualistic basis, however remote, is still recognizable as secularized ritual even in the most profane forms of the cult of beauty.[6] The secular cult of beauty, developed during the Renaissance and prevailing for three centuries, clearly showed that ritualistic basis in its decline and the first deep crisis which befell it. With the advent of the first truly revolutionary means of reproduction, photography, simultaneously with the rise of socialism, art sensed the approaching crisis which has become evident a century later. At the time, art reacted with the doctrine of *l'art pour l'art*, that is, with a theology of art. This gave rise to what might be called a negative theology in the form of the idea of 'pure' art, which not only denied any social function of art but also any categorizing by subject matter. (In poetry, Mallarmé was the first to take this position.)

An analysis of art in the age of mechanical reproduction must do justice to these relationships, for they lead us to an all-important insight: for the first time in world history, mechanical reproduction emancipates the work of art from its parasitical dependence on ritual. To an ever greater degree the work of art reproduced becomes the work of art designed for reproducibility.[7] From a photographic negative, for example, one can make any number of prints; to ask for the 'authentic' print makes no sense. But the instant the criterion of authenticity ceases to be applicable to artistic production, the total function of art is reversed. Instead of being based on ritual, it begins to be based on another practice – politics.

V

Works of art are received and valued on different planes. Two polar types stand out: with one, the accent is on the cult value; with the other, on the exhibition value of the work.[8] Artistic production begins with ceremonial objects destined to serve in a cult. One may assume that what mattered was their existence, not their being on view. The elk portrayed by the man of the Stone Age on the walls of his cave was an instrument of magic. He did expose it to his fellow men, but in the main it was meant for the spirits. Today the cult value would seem to demand that the work of art remain hidden. Certain statues of gods are accessible only to the priest in the cella; certain Madonnas remain covered nearly all year round; certain sculptures on medieval cathedrals are invisible to the spectator on ground level. With the emancipation of the various art practices from ritual go increasing opportunities for the exhibition of their products. It is easier to exhibit a portrait bust that can be sent here and there than to exhibit the statue of a divinity that has its fixed place in the interior of a temple. The same holds for the painting as against the mosaic or fresco that preceded it. And even though the public presentability of a mass originally may have been just as great as that of a symphony, the latter originated at the moment when its public presentability promised to surpass that of the mass.

With the different methods of technical reproduction of a work of art, its fitness for exhibition increased to such an extent that the quantitative shift between its two poles turned into a qualitative transformation of its nature. This is comparable to the situation of the work of art in prehistoric times when, by the absolute emphasis on its cult value, it was, first and foremost, an instrument of magic. Only later did it come to be recognized as a work of art. In the same way today, by the absolute emphasis on its exhibition value the work of art becomes a creation with entirely new functions, among which the one we are conscious of, the artistic function, later may be recognized as incidental.[9] This much is certain: today photography and the film are the most serviceable exemplifications of this new function.

VI

In photography, exhibition value begins to displace cult value all along the line. But cult value does not give way without resistance. It retires into an ultimate retrenchment: the human countenance. It is no accident that the portrait was the focal point of early photography. The cult of remembrance of loved ones, absent or dead, offers a last refuge for the cult value of the picture. For the last time the aura emanates from the early photographs in the fleeting expression of a human face. This is what constitutes their melancholy, incomparable beauty. But as man withdraws from the photographic image, the exhibition value for the first time shows its superiority to the ritual value. To have pinpointed this new stage constitutes the incomparable significance of Atget, who, around 1900, took photographs of deserted Paris streets. It has quite justly been said of him that he photographed them like scenes of crime. The scene of a crime, too, is deserted; it is photographed for the purpose of establishing evidence. With Atget, photographs become standard evidence for historical occurrences, and acquire a hidden political significance. They demand a specific kind of approach; free-floating contemplation is not appropriate to them. They stir the viewer; he feels challenged by them in a new way. At the same time picture magazines begin to put up signposts for him, right ones or wrong ones, no matter. For the first time, captions have become obligatory. And it is clear that they have an altogether different character than the title of a painting. The directives which the captions give to those looking at pictures in illustrated magazines soon become even more explicit and more imperative in the film where the meaning of each single picture appears to be prescribed by the sequence of all preceding ones.

VII

The nineteenth-century dispute as to the artistic value of painting versus photography today seems devious and confused. This does not diminish its importance, however; if anything, it underlines it. The dispute was in fact the symptom of a historical transformation the universal impact of which was not realized by either of the rivals. When the age of mechanical reproduction separated art from its basis in cult, the semblance of its autonomy disappeared forever. The resulting change in the function of art transcended the perspective of the century; for a long time it even escaped that of the twentieth century, which experienced the development of the film.

Earlier much futile thought had been devoted to the question of whether photography is an art. The primary question – whether the very invention of photography had not transformed the entire nature of art – was not raised. Soon the film theoreticians asked the same ill-considered question with regard to the film. But the difficulties which photography caused traditional aesthetics were mere child's play as compared to those raised by the film. Whence the insensitive and forced character of early theories of the film. Abel Gance, for instance, compares the film with hieroglyphs: 'Here, by a remarkable regression, we have come back to the level of expression of the Egyptians … Pictorial language has not yet matured because our eyes have not yet adjusted to it. There is as yet insufficient respect for, insufficient cult of, what it expresses.'[†] Or, in the words of Séverin-Mars: 'What art has been granted a dream more poetical and more real at the same time! Approached in this fashion the film might represent an incomparable means of expression. Only the most high-minded persons, in the most perfect and mysterious moments of their lives, should be allowed to enter its ambience.'[††] Alexandre Arnoux concludes his fantasy about the silent film with the question: 'Do not all the bold descriptions we have given amount to the definition of prayer?'[‡] It is instructive to note how their desire to class the film among the 'arts' forces these theoreticians to read ritual elements into it – with a striking lack of discretion. Yet when these speculations were published, films like *L'Opinion publique* and *The Gold Rush* had already appeared. This, however, did not keep Abel Gance from adducing hieroglyphs for purposes of comparison, nor Séverin-Mars from speaking of the film as one might speak of paintings by Fra Angelico. Characteristically, even today ultrareactionary authors give the film a similar contextual significance – if not an outright sacred one, then at least a supernatural one. Commenting on Max Reinhardt's film version of *A Midsummer Night's Dream*, Werfel states that undoubtedly it was the sterile copying of the exterior world with its streets, interiors, railroad stations, restaurants, motorcars, and beaches which until now had obstructed the elevation of the film to the realm of art. 'The film has not yet realized its true meaning, its real possibilities … these consist in its unique faculty to express by natural means and with incomparable persuasiveness all that is fairylike, marvellous, supernatural.'[§]

VIII

The artistic performance of a stage actor is definitely presented to the public by the actor in person; that of the screen actor, however, is presented by a camera, with a twofold consequence. The camera that presents the performance of the film actor to the public need not respect the performance as an integral whole. Guided by the cameraman, the camera continually changes its position with respect to the performance. The sequence of positional views which the editor composes from the material supplied him constitutes the completed film. It comprises certain factors of movement which are in reality those of the camera, not to mention special camera angles, close-ups, etc. Hence, the performance of the actor is subjected to a series of optical tests.

Walter Benjamin

This is the first consequence of the fact that the actor's performance is presented by means of a camera. Also, the film actor lacks the opportunity of the stage actor to adjust to the audience during his performance, since he does not present his performance to the audience in person. This permits the audience to take the position of a critic, without experiencing any personal contact with the actor. The audience's identification with the actor is really an identification with the camera. Consequently the audience takes the position of the camera; its approach is that of testing.[10] This is not the approach to which cult values may be exposed.

IX

For the film, what matters primarily is that the actor represents himself to the public before the camera, rather than representing someone else. One of the first to sense the actor's metamorphosis by this form of testing was Pirandello. Though his remarks on the subject in his novel *Si Gira* were limited to the negative aspects of the question and to the silent film only, this hardly impairs their validity. For in this respect, the sound film did not change anything essential. What matters is that the part is acted not for an audience but for a mechanical contrivance – in the case of the sound film, for two of them. 'The film actor,' wrote Pirandello, 'feels as if in exile – exiled not only from the stage but also from himself. With a vague sense of discomfort he feels inexplicable emptiness: his body loses its corporeality, it evaporates, it is deprived of reality, life, voice, and the noises caused by his moving about, in order to be changed into a mute image, flickering an instant on the screen, then vanishing into silence … The projector will play with his shadow before the public, and he himself must be content to play before the camera.'[‡‡] This situation might also be characterized as follows: for the first time – and this is the effect of the film – man has to operate with his whole living person, yet forgoing its aura. For aura is tied to his presence; there can be no replica of it. The aura which, on the stage, emanates from Macbeth, cannot be separated for the spectators from that of the actor. However, the singularity of the shot in the studio is that the camera is substituted for the public. Consequently, the aura that envelops the actor vanishes, and with it the aura of the figure he portrays.

It is not surprising that it should be a dramatist such as Pirandello who, in characterizing the film, inadvertently touches on the very crisis in which we see the theatre. Any thorough study proves that there is indeed no greater contrast than that of the stage play to a work of art that is completely subject to or, like the film, founded in mechanical reproduction. Experts have long recognized that in the film 'the greatest effects are almost always obtained by "acting" as little as possible …' In 1932 Rudolf Arnheim saw 'the latest trend … in treating the actor as a stage prop chosen for its characteristics and … inserted at the proper place.'[11] With this idea something else is closely connected. The stage actor identifies himself with the character of his role. The film actor very often is denied this opportunity. His creation is by no means all of a piece; it is composed of many separate performances. Besides certain fortuitous considerations, such as cost of studio, availability of fellow players, décor, etc., there are elementary necessities of equipment that split the actor's work into a series of mountable episodes. In particular, lighting and its installation require the presentation of an event that, on the screen, unfolds as a rapid and unified scene, in a sequence of separate shootings which may take hours at the studio; not to mention more obvious montage. Thus a jump from the window can be shot in the studio as a jump from a scaffold, and the ensuing flight, if need be, can be shot weeks later when outdoor scenes are taken. Far more paradoxical cases can easily be construed. Let us assume that an actor is supposed to be startled by a knock at the door. If his reaction is not satisfactory, the director can resort to an expedient: when the actor happens to be at the studio again he has a shot fired behind him without his being forewarned of it. The frightened reaction can be shot

now and be cut into the screen version. Nothing more strikingly shows that art has left the realm of the 'beautiful semblance' which, so far, had been taken to be the only sphere where art could thrive.

X

The feeling of strangeness that overcomes the actor before the camera, as Pirandello describes it, is basically of the same kind as the estrangement felt before one's own image in the mirror. But now the reflected image has become separable, transportable. And where is it transported? Before the public.[12] Never for a moment does the screen actor cease to be conscious of this fact. While facing the camera he knows that ultimately he will face the public, the consumers who constitute the market. This market, where he offers not only his labour but also his whole self, his heart and soul, is beyond his reach. During the shooting he has as little contact with it as any article made in a factory. This may contribute to that oppression, that new anxiety which, according to Pirandello, grips the actor before the camera. The film responds to the shrivelling of the aura with an artificial build-up of the 'personality' outside the studio. The cult of the movie star, fostered by the money of the film industry, preserves not the unique aura of the person but the 'spell of the personality,' the phony spell of a commodity. So long as the movie-makers' capital sets the fashion, as a rule no other revolutionary merit can be accredited to today's film than the promotion of a revolutionary criticism of traditional concepts of art. We do not deny that in some cases today's films can also promote revolutionary criticism of social conditions, even of the distribution of property. However, our present study is no more specifically concerned with this than is the film production of Western Europe.

It is inherent in the technique of the film as well as that of sports that everybody who witnesses its accomplishments is somewhat of an expert. This is obvious to anyone listening to a group of newspaper boys leaning on their bicycles and discussing the outcome of a bicycle race. It is not for nothing that newspaper publishers arrange races for their delivery boys. These arouse great interest among the participants, for the victor has an opportunity to rise from delivery boy to professional racer. Similarly, the newsreel offers everyone the opportunity to rise from passer by to movie extra. In this way any man might even find himself part of a work of art, as witness Vertoff's *Three Songs About Lenin* or Ivens' *Borinage*. Any man today can lay claim to being filmed. This claim can best be elucidated by a comparative look at the historical situation of contemporary literature.

For centuries a small number of writers were confronted by many thousands of readers. This changed toward the end of the last century. With the increasing extension of the press, which kept placing new political, religious, scientific, professional, and local organs before the readers, an increasing number of readers became writers – at first, occasional ones. It began with the daily press opening to its readers space for 'letters to the editor.' And today there is hardly a gainfully employed European who could not, in principle, find an opportunity to publish somewhere or other comments on his work, grievances, documentary reports, or that sort of thing. Thus, the distinction between author and public is about to lose its basic character. The difference becomes merely functional; it may vary from case to case. At any moment the reader is ready to turn into a writer. As expert, which he had to become willy-nilly in an extremely specialized work process, even if only in some minor respect, the reader gains access to authorship. In the Soviet Union work itself is given a voice. To present it verbally is part of a man's ability to perform the work. Literary licence is now founded on polytechnic rather than specialized training and thus becomes common property.[13]

Walter Benjamin

All this can easily be applied to the film, where transitions that in literature took centuries have come about in a decade. In cinematic practice, particularly in Russia, this change-over has partially become established reality. Some of the players whom we meet in Russian films are not actors in our sense but people who portray *themselves* – and primarily in their own work process. In Western Europe the capitalistic exploitation of the film denies consideration to modern man's legitimate claim to being reproduced. Under these circumstances the film industry is trying hard to spur the interest of the masses through illusion-promoting spectacles and dubious speculations.

XI

The shooting of a film, especially of a sound film, affords a spectacle unimaginable anywhere at any time before this. It presents a process in which it is impossible to assign to a spectator a view-point which would exclude from the actual scene such extraneous accessories as camera equipment, lighting machinery, staff assistants, etc. – unless his eye were on a line parallel with the lens. This circumstance, more than any other, renders superficial and insignificant any possible similarity between a scene in the studio and one on the stage. In the theatre one is well aware of the place from which the play cannot immediately be detected as illusionary. There is no such place for the movie scene that is being shot. Its illusionary nature is that of the second degree, the result of cutting. That is to say, in the studio the mechanical equipment has penetrated so deeply into reality that its pure aspect freed from the foreign substance of equipment is the result of a special procedure, namely, the shooting by the specially adjusted camera and the mounting of the shot together with other similar ones. The equipment-free aspect of reality here has become the height of artifice; the sight of immediate reality has become an orchid in the land of technology.

Even more revealing is the comparison of these circumstances, which differ so much from those of the theatre, with the situation in painting. Here the question is: How does the camera-man compare with the painter? To answer this we take recourse to an analogy with a surgical operation. The surgeon represents the polar opposite of the magician. The magician heals a sick person by the laying on of hands; the surgeon cuts into the patient's body. The magician maintains the natural distance between the patient and himself; though he reduces it very slightly by the laying on of hands, he greatly increases it by virtue of his authority. The surgeon does exactly the reverse; he greatly diminishes the distance between himself and the patient by penetrating into the patient's body, and increases it but little by the caution with which his hand moves among the organs. In short, in contrast to the magician – who is still hidden in the medical practitioner – the surgeon at the decisive moment abstains from facing the patient man to man; rather, it is through the operation that he penetrates into him.

Magician and surgeon compare to painter and cameraman. The painter maintains in his work a natural distance from reality, the cameraman penetrates deeply into its web.[14] There is a tremendous difference between the pictures they obtain. That of the painter is a total one, that of the cameraman consists of multiple fragments which are assembled under a new law. Thus, for contemporary man the representation of reality by the film is incomparably more significant than that of the painter, since it offers, precisely because of the thoroughgoing permeation of reality with mechanical equipment, an aspect of reality which is free of all equipment. And that is what one is entitled to ask from a work of art.

234

XII

Mechanical reproduction of art changes the reaction of the masses toward art. The reactionary attitude toward a Picasso painting changes into the progressive reaction toward a Chaplin movie. The progressive reaction is characterized by the direct, intimate fusion of visual and emotional enjoyment with the orientation of the expert. Such fusion is of great social significance. The greater the decrease in the social significance of an art form, the sharper the distinction between criticism and enjoyment by the public. The conventional is uncritically enjoyed, and the truly new is criticized with aversion. With regard to the screen, the critical and the receptive attitudes of the public coincide. The decisive reason for this is that individual reactions are predetermined by the mass audience response they are about to produce, and this is nowhere more pronounced than in the film. The moment these responses become manifest they control each other. Again, the comparison with painting is fruitful. A painting has always had an excellent chance to be viewed by one person or by a few. The simultaneous contemplation of paintings by a large public, such as developed in the nineteenth century, is an early symptom of the crisis of painting, a crisis which was by no means occasioned exclusively by photography but rather in a relatively independent manner by the appeal of art works to the masses.

Painting simply is in no position to present an object for simultaneous collective experience, as it was possible for architecture at all times, for the epic poem in the past, and for the movie today. Although this circumstance in itself should not lead one to conclusions about the social role of painting, it does constitute a serious threat as soon as painting, under special conditions and, as it were, against its nature, is confronted directly by the masses. In the churches and monasteries of the Middle Ages and at the princely courts up to the end of the eighteenth century, a collective reception of paintings did not occur simultaneously, but by graduated and hierarchized mediation. The change that has come about is an expression of the particular conflict in which painting was implicated by the mechanical reproducibility of paintings. Although paintings began to be publicly exhibited in galleries and salons, there was no way for the masses to organize and control themselves in their reception.[15] Thus the same public which responds in a progressive manner toward a grotesque film is bound to respond in a reactionary manner to surrealism.

XIII

The characteristics of the film lie not only in the manner in which man presents himself to mechanical equipment but also in the manner in which, by means of this apparatus, man can represent his environment. A glance at occupational psychology illustrates the testing capacity of the equipment. Psychoanalysis illustrates it in a different perspective. The film has enriched our field of perception with methods which can be illustrated by those of Freudian theory. Fifty years ago, a slip of the tongue passed more or less unnoticed. Only exceptionally may such a slip have revealed dimensions of depth in a conversation which had seemed to be taking its course on the surface. Since the *Psychopathology of Everyday Life* things have changed. This book isolated and made analyzable things which had heretofore floated along unnoticed in the broad stream of perception. For the entire spectrum of optical, and now also acoustical, perception the film has brought about a similar deepening of apperception. It is only an obverse of this fact that behaviour items shown in a movie can be analyzed much more precisely and from more points of view than those presented on paintings or on the stage. As compared with painting, filmed behaviour lends itself more readily to analysis because of its incomparably more precise statements of the situation. In comparison with the stage scene, the filmed behaviour item lends itself

Walter Benjamin

more readily to analysis because it can be isolated more easily. This circumstance derives its chief importance from its tendency to promote the mutual penetration of art and science. Actually, of a screened behaviour item which is neatly brought out in a certain situation, like a muscle of a body, it is difficult to say which is more fascinating, its artistic value or its value for science. To demonstrate the identity of the artistic and scientific uses of photography which heretofore usually were separated will be one of the revolutionary functions of the film.[16]

By close-ups of the things around us, by focusing on hidden details of familiar objects, by exploring commonplace milieus under the ingenious guidance of the camera, the film, on the one hand, extends our comprehension of the necessities which rule our lives; on the other hand, it manages to assure us of an immense and unexpected field of action. Our taverns and our metropolitan streets, our offices and furnished rooms, our railroad stations and our factories appeared to have us locked up hopelessly. Then came the film and burst this prison-world asunder by the dynamite of the tenth of a second, so that now, in the midst of its far-flung ruins and debris, we calmly and adventurously go travelling. With the close-up, space expands; with slow motion, movement is extended. The enlargement of a snapshot does not simply render more precise what in any case was visible, though unclear: it reveals entirely new structural formations of the subject. So, too, slow motion not only presents familiar qualities of movement but reveals in them entirely unknown ones 'which, far from looking like retarded rapid movements, give the effect of singularly gliding, floating, supernatural motions.'§§ Evidently a different nature opens itself to the camera than opens to the naked eye – if only because an unconsciously penetrated space is substituted for a space consciously explored by man. Even if one has a general knowledge of the way people walk, one knows nothing of a person's posture during the fractional second of a stride. The act of reaching for a lighter or a spoon is familiar routine, yet we hardly know what really goes on between hand and metal, not to mention how this fluctuates with our moods. Here the camera intervenes with the resources of its lowerings and liftings, its interruptions and isolations, its extensions and accelerations, its enlargements and reductions. The camera introduces us to unconscious optics as does psychoanalysis to unconscious impulses.

XIV

One of the foremost tasks of art has always been the creation of a demand which could be fully satisfied only later.[17] The history of every art form shows critical epochs in which a certain art form aspires to effects which could be fully obtained only with a changed technical standard, that is to say, in a new art form. The extravagances and crudities of art which thus appear, particularly in the so-called decadent epochs, actually arise from the nucleus of its richest historical energies. In recent years, such barbarisms were abundant in Dadaism. It is only now that its impulse becomes discernible: Dadaism attempted to create by pictorial – and literary – means the effects which the public today seeks in the film.

Every fundamentally new, pioneering creation of demands will carry beyond its goal. Dadaism did so to the extent that it sacrificed the market values which are so characteristic of the film in favour of higher ambitions – though of course it was not conscious of such intentions as here described. The Dadaists attached much less importance to the sales value of their work than to its uselessness for contemplative immersion. The studied degradation of their material was not the least of their means to achieve this uselessness. Their poems are 'word salad' containing obscenities and every imaginable waste product of language. The same is true of their paintings, on which they mounted buttons and tickets. What they intended and achieved was a relentless destruction of the aura of their creations, which they branded as reproductions with

236

the very means of production. Before a painting of Arp's or a poem by August Stramm it is impossible to take time for contemplation and evaluation as one would before a canvas of Derain's or a poem by Rilke. In the decline of middle-class society, contemplation became a school for asocial behaviour; it was countered by distraction as a variant of social conduct.[18] Dadaistic activities actually assured a rather vehement distraction by making works of art the centre of scandal. One requirement was foremost: to outrage the public.

From an alluring appearance or persuasive structure of sound the work of art of the Dadaists became an instrument of ballistics. It hit the spectator like a bullet, it happened to him, thus acquiring a tactile quality. It promoted a demand for the film, the distracting element of which is also primarily tactile, being based on changes of place and focus which periodically assail the spectator. Let us compare the screen on which a film unfolds with the canvas of a painting. The painting invites the spectator to contemplation; before it the spectator can abandon himself to his associations. Before the movie frame he cannot do so. No sooner has his eye grasped a scene than it is already changed. It cannot be arrested. Duhamel, who detests the film and knows nothing of its significance, though something of its structure, notes this circumstance as follows: 'I can no longer think what I want to think. My thoughts have been replaced by moving images.'[#] The spectator's process of association in view of these images is indeed interrupted by their constant, sudden change. This constitutes the shock effect of the film, which, like all shocks, should be cushioned by heightened presence of mind.[19] By means of its technical structure, the film has taken the physical shock effect out of the wrappers in which Dadaism had, as it were, kept it inside the moral shock effect.[20]

XV

The mass is a matrix from which all traditional behaviour toward works of art issues today in a new form. Quantity has been transmuted into quality. The greatly increased mass of participants has produced a change in the mode of participation. The fact that the new mode of participation first appeared in a disreputable form must not confuse the spectator. Yet some people have launched spirited attacks against precisely this superficial aspect. Among these, Duhamel has expressed himself in the most radical manner. What he objects to most is the kind of participation which the movie elicits from the masses. Duhamel calls the movie 'a pastime for helots, a diversion for uneducated, wretched, worn-out creatures who are consumed by their worries …, a spectacle which requires no concentration and presupposes no intelligence …, which kindles no light in the heart and awakens no hope other than the ridiculous one of someday becoming a "star" in Los Angeles.'[##] Clearly, this is at bottom the same ancient lament that the masses seek distraction whereas art demands concentration from the spectator. That is a commonplace. The question remains whether it provides a platform for the analysis of the film. A closer look is needed here. Distraction and concentration form polar opposites which may be stated as follows: A man who concentrates before a work of art is absorbed by it. He enters into this work of art the way legend tells of the Chinese painter when he viewed his finished painting. In contrast, the distracted mass absorbs the work of art. This is most obvious with regard to buildings. Architecture has always represented the prototype of a work of art the reception of which is consummated by a collectivity in a state of distraction. The laws of its reception are most instructive.

Buildings have been man's companions since primeval times. Many art forms have developed and perished. Tragedy begins with the Greeks, is extinguished with them, and after centuries its 'rules' only are revived. The epic poem, which had its origin in the youth of nations, expires in Europe at the end of the Renaissance. Panel painting is a creation of the Middle Ages, and nothing guarantees its uninterrupted existence. But the human need for shelter is lasting.

Architecture has never been idle. Its history is more ancient than that of any other art, and its claim to being a living force has significance in every attempt to comprehend the relationship of the masses to art. Buildings are appropriated in a twofold manner: by use and by perception – or rather, by touch and sight. Such appropriation cannot be understood in terms of the attentive concentration of a tourist before a famous building. On the tactile side there is no counterpart to contemplation on the optical side. Tactile appropriation is accomplished not so much by attention as by habit. As regards architecture, habit determines to a large extent even optical reception. The latter, too, occurs much less through rapt attention than by noticing the object in incidental fashion. This mode of appropriation, developed with reference to architecture, in certain circumstances acquires canonical value. For the tasks which face the human apparatus of perception at the turning points of history cannot be solved by optical means, that is, by contemplation, alone. They are mastered gradually by habit, under the guidance of tactile appropriation.

The distracted person, too, can form habits. More, the ability to master certain tasks in a state of distraction proves that their solution has become a matter of habit. Distraction as provided by art presents a covert control of the extent to which new tasks have become soluble by apperception. Since, moreover, individuals are tempted to avoid such tasks, art will tackle the most difficult and most important ones where it is able to mobilize the masses. Today it does so in the film. Reception in a state of distraction, which is increasing noticeably in all fields of art and is symptomatic of profound changes in apperception, finds in the film its true means of exercise. The film with its shock effect meets this mode of reception halfway. The film makes the cult value recede into the background not only by putting the public in the position of the critic, but also by the fact that at the movies this position requires no attention. The public is an examiner, but an absent-minded one.

Epilogue

The growing proletarianization of modern man and the increasing formation of masses are two aspects of the same process. Fascism attempts to organize the newly created proletarian masses without affecting the property structure which the masses strive to eliminate. Fascism sees its salvation in giving these masses not their right, but instead a chance to express themselves.[21] The masses have a right to change property relations; Fascism seeks to give them an expression while preserving property. The logical result of Fascism is the introduction of aesthetics into political life. The violation of the masses, whom Fascism, with its *Führer* cult, forces to their knees, has its counterpart in the violation of an apparatus which is pressed into the production of ritual values.

All efforts to render politics aesthetic culminate in one thing: war. War and war only can set a goal for mass movements on the largest scale while respecting the traditional property system. This is the political formula for the situation. The technological formula may be stated as follows: Only war makes it possible to mobilize all of today's technical resources while maintaining the property system. It goes without saying that the Fascist apotheosis of war does not employ such arguments. Still, Marinetti says in his manifesto on the Ethiopian colonial war: 'For twenty-seven years we Futurists have rebelled against the branding of war as antiaesthetic … Accordingly we state: … War is beautiful because it establishes man's dominion over the subjugated machinery by means of gas masks, terrifying megaphones, flame throwers, and small tanks. War is beautiful because it initiates the dreamt-of metallization of the human body. War is beautiful because it enriches a flowering meadow with the fiery orchids of machine guns. War is beautiful because it combines the gunfire, the cannonades, the cease-fire, the scents, and the stench of

putrefaction into a symphony. War is beautiful because it creates new architecture, like that of the big tanks, the geometrical formation flights, the smoke spirals from burning villages, and many others … Poets and artists of Futurism! … remember these principles of an aesthetics of war so that your struggle for a new literature and a new graphic art … may be illumined by them!'

This manifesto has the virtue of clarity. Its formulations deserve to be accepted by dialecticians. To the latter, the aesthetics of today's war appears as follows: If the natural utilization of productive forces is impeded by the property system, the increase in technical devices, in speed, and in the sources of energy will press for an unnatural utilization, and this is found in war. The destructiveness of war furnishes proof that society has not been mature enough to incorporate technology as its organ, that technology has not been sufficiently developed to cope with the elemental forces of society. The horrible features of imperialistic warfare are attributable to the discrepancy between the tremendous means of production and their inadequate utilization in the process of production – in other words, to unemployment and the lack of markets. Imperialistic war is a rebellion of technology which collects, in the form of 'human material,' the claims to which society has denied its natural material. Instead of draining rivers, society directs a human stream into a bed of trenches; instead of dropping seeds from airplanes, it drops incendiary bombs over cities; and through gas warfare the aura is abolished in a new way.

'*Fiat ars – pereal mundus,*' says Fascism, and, as Marinetti admits, expects war to supply the artistic gratification of a sense perception that has been changed by technology. This is evidently the consummation of '*l'art pour l'art.*' Mankind, which in Homer's time was an object of contemplation for the Olympian gods, now is one for itself. Its self-alienation has reached such a degree that it can experience its own destruction as an aesthetic pleasure of the first order. This is the situation of politics which Fascism is rendering aesthetic. Communism responds by politicizing art.

Notes

★ Quoted from Paul Veléry, *Aesthetics*, 'The Conquest of Ubiquity', translated by Ralph Manheim, p. 225. Pantheon Books, Bollingen Series, New York, 1964.

★★ Abel Gance, 'Le Temps de l'image est venu,' *L'Art cinématographique*, Vol. 2, pp. 94 f, Paris, 1927.

† Abel Gance, *op. cit.*, pp. 100–1.

†† Séverin-Mars, quoted by Abel Gance, *op. cit.*, p. 100.

‡ Alexandre Arnoux, *Cinéma pris*, 1929, p. 28.

‡‡ Luigi Pirandello, *Si Gira*, quoted by Léon Pierre-Quint, 'Signification du cinéma,' *L'Art cinématographique, op. cit.*, pp. 14–15.

§ Franz Werfel, 'Ein Sommernachtstraum, Ein Film von Shakespeare und Reinhardt,' *Neues Wiener Journal*, cited in *Lu*, 15 November 1935.

§§ Rudolf Arnheim, *loc cit.*, p. 138.

Georges Duhamel. *Scines de la me future*, Paris, 1930, p. 52.

Duhamel, *op cit.*, p. 58.

1 Of course, the history of a work of art encompasses more than this. The history of the 'Mona Lisa,' for instance, encompasses the kind and number of its copies made in the seventeenth, eighteenth, and nineteenth centuries.

2 Precisely because authenticity is not reproducible, the intensive penetration of certain (mechanical) processes of reproduction was instrumental in differentiating and grading authenticity. To develop such differentiations was an important function of the trade in works of art. The invention of the woodcut may be said to have struck at the root of the quality of authenticity even before its late flowering. To be sure, at the time of its origin a medieval picture of the Madonna could not yet be said to be 'authentic.' It became 'authentic' only during the succeeding centuries and perhaps most strikingly so during the last one.

3 The poorest provincial staging of *Faust* is superior to a Faust film in that, ideally, it competes with the first performance at Weimar. Before the screen it is unprofitable to remember traditional contents which might come to mind before the stage – for instance, that Goethe's friend Johann Heinrich Merck is hidden in Mephisto, and the like.

4 To satisfy the human interest of the masses may mean to have one's social function removed from the field of vision. Nothing guarantees that a portraitist of today, when painting a famous surgeon at the breakfast table in the midst of his family, depicts his social function more precisely than a painter of the seventeenth century who portrayed his medical doctors as representing this profession, like Rembrandt in his 'Anatomy Lesson.'

5 The definition of the aura as a 'unique phenomenon of a distance however close it may be' represents nothing but the formulation of the cult value of the work of art in categories of space and time perception. Distance is the opposite of closeness. The essentially distant object is the unapproachable one. Unapproachability is indeed a major quality of the cult image. True to its nature, it remains 'distant, however close it may be.' The closeness which one may gain from its subject matter does not impair the distance which it retains in its appearance.

6 To the extent to which the cult value of the painting is secularized the ideas of its fundamental uniqueness lose distinctness. In the imagination of the beholder the uniqueness of the phenomena which hold sway in the cult image is more and more displaced by the empirical uniqueness of the creator or of his creative achievement. To be sure, never completely so; the concept of authenticity always transcends mere genuineness. (This is particularly apparent in the collector who always retains some traces of the fetishist and who, by owning the work of art, shares in its ritual power.) Nevertheless, the function of the concept of authenticity remains determinate in the evaluation of art: with the secularization of art, authenticity displaces the cult value of the work.

7 In the case of films, mechanical reproduction is not, as with literature and painting, an external condition for mass distribution. Mechanical reproduction is inherent in the very technique of film production. This technique not only permits in the most direct way but virtually causes mass distribution. It enforces distribution because the production of a film is so expensive that an individual who, for instance, might afford to buy a painting no longer can afford to buy a film. In 1927 it was calculated that a major film, in order to pay its way, had to reach an audience of nine million. With the sound film, to be sure, a setback in its international distribution occurred at first: audiences became limited by language barriers. This coincided with the Fascist emphasis on national interests. It is more important to focus on this connection with Fascism than on this setback, which was soon minimized by synchronization. The simultaneity of both phenomena is attributable to the depression. The same disturbances which, on a larger scale, led to an attempt to maintain the existing property structure by sheer force led the endangered film capital to speed up the development of the sound film. The introduction of the sound film brought about a temporary relief, not only because it again brought the masses into the theatres but also because it merged new capital from the electrical industry with that of the film industry. Thus, viewed from the outside, the sound film promoted national interests, but seen from the inside it helped to internationalize film production even more than previously.

8 This polarity cannot come into its own in the aesthetics of Idealism. Its idea of beauty comprises these polar opposites without differentiating between them and consequently excludes their polarity. Yet in Hegel this polarity announces itself as clearly as possible within the limits of Idealism. We quote from his *Philosophy of History*:

> Images were known of old. Piety at an early time required them for worship, but it could do without *beautiful* images. These might even be disturbing. In every beautiful painting there is also something nonspiritual, merely external, but its spirit speaks to man through its beauty. Worshipping, conversely, is concerned with the work as an object, for it is but a spiritless stupor of the soul … Fine art has arisen … in the church …, although it has already gone beyond its principle as art.

Likewise, the following passage from *The Philosophy of Fine Art* indicates that Hegel sensed a problem here.

> We are beyond the stage of reverence for works of art as divine and objects deserving our worship. The impression they produce is one of a more reflective kind, and the emotions they arouse require a higher test …
>
> *G.W.F. Hegel. The Philosophy of Fine Art, trans., with notes, by F.P.B. Osmaston, Vol. 1, p. 12, London. 1920*

Art in the age of mechanical reproduction

The transition from the first kind of artistic reception to the second characterizes the history of artistic reception in general. Apart from that, a certain oscillation between these two polar modes of reception can be demonstrated for each work of art. Take the Sistine Madonna. Since Hubert Grimme's research it has been known that the Madonna originally was painted for the purpose of exhibition. Grimme's research was inspired by the question: What is the purpose of the moulding in the foreground of the painting which the two cupids lean upon? How, Grimme asked further, did Raphael come to furnish the sky with two draperies? Research proved that the Madonna had been commissioned for the public lying-in-state of Pope Sixtus. The Popes lay in state in a certain side chapel of St Peter's. On that occasion Raphael's picture had been fastened in a nichelike background of the chapel, supported by the coffin. In this picture Raphael portrays the Madonna approaching the papal coffin in clouds from the background of the niche, which was demarcated by green drapes. At the obsequies of Sixtus a pre-eminent exhibition value of Raphael's picture was taken advantage of. Some time later it was placed on the high altar in the church of the Black Friars at Piacenza. The reason for this exile is to be found in the Roman rites which forbid the use of paintings exhibited at obsequies as cult objects on the high altar. This regulation devalued Raphael's picture to some degree. In order to obtain an adequate price nevertheless, the Papal See resolved to add to the bargain the tacit toleration of the picture above the high altar. To avoid attention the picture was given to the monks of the far-off provincial town.

9 Bertolt Brecht, on a different level, engaged in analogous reflections: 'If the concept of "work of art" can no longer be applied to the thing that emerges once the work is transformed into a commodity, we have to eliminate this concept with cautious care but without fear, lest we liquidate the function of the very thing as well. For it has to go through this phase without mental reservation, and not as noncommittal deviation from the straight path; rather, what happens here with the work of art will change it fundamentally and erase its past to such an extent that should the old concept be taken up again – and it will, why not? – it will no longer stir any memory of the thing it once designated.'

10 'The film ... provides – or could provide – useful insight into the details of human actions ... Character is never used as a source of motivation; the inner life of the persons never supplies the principal cause of the plot and seldom is its main result.' (Bertolt Brecht, *Versuche*, 'Der Dreigroschenprozess,' p. 268.) The expansion of the field of the testable which mechanical equipment brings about for the actor corresponds to the extraordinary expansion of the field of the testable brought about for the individual through economic conditions. Thus, vocational aptitude tests become constantly more important. What matters in these tests are segmental performances of the individual. The film shot and the vocational aptitude test are taken before a committee of experts. The camera director in the studio occupies a place identical with that of the examiner during aptitude tests.

11 Rudolf Arnheim, *Film als Kunst*, Berlin, 1932, pp. 176 f. In this context certain seemingly unimportant details in which the film director deviates from stage practices gain in interest. Such is the attempt to let the actor play without make-up, as made among others by Dreyer in his *Jeanne d'Arc*. Dreyer spent months seeking the forty actors who constitute the Inquisitors' tribunal. The search for these actors resembled that for stage properties that are hard to come by. Dreyer made every effort to avoid resemblances of age, build, and physiognomy. If the actor thus becomes a stage property, this latter, on the other hand, frequently functions as actor. At least it is not unusual for the film to assign a role to the stage property. Instead of choosing at random from a great wealth of examples, let us concentrate on a particularly convincing one. A clock that is working will always be a disturbance on the stage. There it cannot be permitted its function of measuring time. Even in a naturalistic play, astronomical time would clash with theatrical time. Under these circumstances it is highly revealing that the film can, whenever appropriate, use time as measured by a clock. From this more than from many other touches it may clearly be recognized that under certain circumstances each and every prop in a film may assume important functions. From here it is but one step to Pudovkin's statement that 'the playing of an actor which is connected with an object and is built around it ... is always one of the strongest methods of cinematic construction.' (W. Pudovkin, *Filmregie und Filmmanuskript*, Berlin, 1928, p. 126.) The film is the first art form capable of demonstrating how matter plays tricks on man. Hence, films can be an excellent means of materialistic representation.

12 The change noted here in the method of exhibition caused by mechanical reproduction applies to politics as well. The present crisis of the bourgeois democracies comprises a crisis of the conditions which determine the public presentation of the rulers. Democracies exhibit a member of government directly and personally before the nation's representatives. Parliament is his public. Since the innovations of camera and recording equipment make it possible for the orator to become audible and visible to an unlimited number of persons, the presentation of the man of politics before camera and recording

equipment becomes paramount. Parliaments, as much as theatres, are deserted. Radio and film not only affect the function of the professional actor but likewise the function of those who also exhibit themselves before this mechanical equipment, those who govern. Though their tasks may be different, the change affects equally the actor and the ruler. The trend is toward establishing controllable and transferable skills under certain social conditions. This results in a new selection, a selection before the equipment from which the star and the dictator emerge victorious.

13 The privileged character of the respective techniques is lost. Aldous Huxley writes:

> 'Advances in technology have led ... to vulgarity ... Process reproduction and the rotary press have made possible the indefinite multiplication of writing and pictures. Universal education and relatively high wages have created an enormous public who know how to read and can afford to buy reading and pictorial matter. A great industry has been called into existence in order to supply these commodities. Now, artistic talent is a very rare phenomenon; whence it follows ... that, at every epoch and in all countries, most art has been bad. But the proportion of trash in this total artistic output is greater now than at any other period. That it must be so is a matter of simple arithmetic. The population of Western Europe has a little more than doubled during the last century. But the amount of reading – and seeing – matter has increased, I should imagine, at least twenty and possibly fifty or even a hundred times. If there were n men of talent in a population of x millions, there will presumably be 2n men of talent among 2x millions. The situation may be summed up thus. For every page of print and pictures published a century ago, twenty or perhaps even a hundred pages are published today. But for every man of talent then living, there are now only two men of talent. It may be of course that, thanks to universal education, many potential talents which in the past would have been stillborn are now enabled to realize themselves. Let us assume, then, that there are now three or even four men of talent to every one of earlier times. It still remains true to say that the consumption of reading – and seeing – matter has far outstripped the natural production of gifted writers and draughtsmen. It is the same with hearing-matter. Prosperity, the gramophone and the radio have created an audience of hearers who consume an amount of hearing-matter that has increased out of all proportion to the increase of population and the consequent natural increase of talented musicians. It follows from all this that in all the arts the output of trash is both absolutely and relatively greater than it was in the past; and that it must remain greater for just so long as the world continues to consume the present inordinate quantities of reading-matter, seeing-matter, and hearing-matter.'
>
> *Aldous Huxley,* Beyond the Mexique Bay. *A Traveller's Journal, London, 1949,*
> *pp. 274 ff. First published in 1934.*

This mode of observation is obviously not progressive.

14 The boldness of the cameraman is indeed comparable to that of the surgeon. Luc Durtain lists among specific technical sleights of hand those

> which are required in surgery in the case of certain difficult operations. I choose as an example a case of oto-rhinolaryngology; ... the so-called endonasal perspective procedure; or I refer to the acrobatic tricks of larynx surgery which have to be performed following the reversed picture in the laryngoscope. I might also speak of ear surgery which suggests the precision work of watchmakers. What range of the most subtle muscular acrobatics is required from the man who wants to repair or save the human body! We have only to think of the couching of a cataract where there is virtually a debate of steel with nearly fluid tissue, or of the major abdominal operations (laparotomy).
>
> *Luc Durtain, op. cit.*

15 This mode of observation may seem crude, but as the great theoretician Leonardo has shown, crude modes of observation may at times be usefully adduced. Leonardo compares painting and music as follows:

> Painting is superior to music because, unlike unfortunate music, it does not have to die as soon as it is born ... Music which is consumed in the very act of its birth is inferior to painting which the use of varnish has rendered eternal.
>
> *(Trattato I, 29)*

16 Renaissance painting offers a revealing analogy to this situation. The incomparable development of this art and its significance rested not least on the integration of a number of new sciences, or at least of new

Art in the age of mechanical reproduction

scientific data. Renaissance painting made use of anatomy and perspective, of mathematics, meteorology, and chromatology. Valéry writes:

> What could be further from us than the strange claim of a Leonardo to whom painting was a supreme goal and the ultimate demonstration of knowledge? Leonardo was convinced that painting demanded universal knowledge, and he did not even shrink from a theoretical analysis which to us is stunning because of its very depth and precision ...
>
> *Paul Valéry,* Pièces sur l'art, *'Autour de Corot,' Paris, p. 191*

17 'The work of art,' says André Breton, 'is valuable only is so far as it is vibrated by the reflexes of the future.' Indeed, every developed art form intersects three lines of development. Technology works toward a certain form of art. Before the advent of the film there were photo booklets with pictures which flitted by the onlooker upon pressure of the thumb, thus portraying a boxing bout or a tennis match. Then there were the slot machines in bazaars; their picture sequences were produced by the turning of a crank.

Secondly, the traditional art forms in certain phases of their development strenuously work toward effects which later are effortlessly attained by the new ones. Before the rise of the movie the Dadaists' performances tried to create an audience reaction which Chaplin later evoked in a more natural way.

Thirdly, unspectacular social changes often promote a change in receptivity which will benefit the new art form. Before the movie had begun to create its public, pictures that were no longer immobile captivated an assembled audience in the so-called *Kaiserpanorama*. Here the public assembled before a screen into which stereoscopes were mounted, one to each beholder. By a mechanical process individual pictures appeared briefly before the stereoscopes, then made way for others. Edison still had to use similar devices in presenting the first movie strip before the film screen and projection were known. This strip was presented to a small public which stared into the apparatus in which the succession of pictures was reeling off. Incidentally, the institution of the *Kaiserpanorama* shows very clearly a dialectic of the development. Shortly before the movie turned the reception of pictures into a collective one, the individual viewing of pictures in these swiftly outmoded establishments came into play once more with an intensity comparable to that of the ancient priest beholding the statue of a divinity in the cella.

18 The theological archetype of this contemplation is the awareness of being alone with one's God. Such awareness, in the heyday of the bourgeoisie, went to strengthen the freedom to shake off clerical rutelage. During the decline of the bourgeoisie this awareness had to take into account the hidden tendency to withdraw from public affairs those forces which the individual draws upon in his communion with God.

19 The film is the art form that is in keeping with the increased threat to his life which modern man has to face. Man's need to expose himself to shock effects is his adjustment to the dangers threatening him. The film corresponds to profound changes in the apperceptive apparatus – changes that are experienced on an individual scale by the man in the street in big-city traffic, on a historical scale by every present-day citizen.

20 As for Dadaism, insights important for Cubism and Futurism are to be gained from the movie. Both appear as deficient attempts of art to accommodate the pervasion of reality by the apparatus. In contrast to the film, these schools did not try to use the apparatus as such for the artistic presentation of reality, but aimed at some sort of alloy in the joint presentation of reality and apparatus. In Cubism, the premonition that this apparatus will be structurally based on optics plays a dominant part; in Futurism, it is the premonition of the effects of this apparatus which are brought out by the rapid sequence of the film strip.

21 One technical feature is significant here, especially with regard to newsreels, the propagandist importance of which can hardly be overestimated. Mass reproduction is aided especially by the reproduction of masses. In big parades and monster rallies, in sports events, and in war, all of which nowadays are captured by camera and sound recording, the masses are brought face to face with themselves.

This process, whose significance need not be stressed, is intimately connected with the development of the techniques of reproduction and photography. Mass movements are usually discerned more clearly by a camera than by the naked eye. A bird's-eye view best captures gatherings of hundreds of thousands. And even though such a view may be as accessible to the human eye as it is to the camera, the image received by the eye cannot be enlarged the way a negative is enlarged. This means that mass movements, including war, constitute a form of human behaviour which particularly favours mechanical equipment.

17

After authenticity at an American heritage site

Eric Gable and Richard Handler

An enduring image of modernist anxiety is that the world we inhabit is no longer authentic—that it has become fake, plastic, a kitschy imitation. Anxiety, so the common wisdom has it, goes hand in hand with desire. We may have lost authenticity, but we want to find it again, and will pay what it costs (within reason) to get it. This image of "authenticity lost" has also been at the center of much "countermodern" cultural critique, and it has given anthropology a kind of romantic aura—a longing for a lost authenticity. Thus it often seems that the scholarly study of late modern or post-modern culture is a study of a reverse alchemy. What was once golden is now plastic.

Lately cultural critics claim to have shed their romanticism. Countermodern romanticism is no longer an unacknowledged scholarly motive, but an object of study, even an object of derision.[1] However, as several scholars have noted, most recently Edward Bruner in an article appearing in 1994, it often seems that cultural critics do not go beyond the assertion that the world is empty, that outward appearances are facades, that everything is somehow constructed. In part, this is because one standard assumption among such critics is that those in power benefit from the prevailing definition of the authentic. They need the authority of authenticity to legitimate their power. Moreover, many of the critics assume that the public at large, the more or less disenfranchised masses of consumers, are co-opted into buying, say, a pedigree or an experience to make up for what they have been taught is the emptiness of their daily lives. The critic's dream is that once already anxious natives are exposed to the constructedness of authenticity, they will stop buying it. As a result, much of current cultural criticism involves exposing the authentic as construction. If the real past is revealed to be a present-day invention, if the natural fact is revealed to be a cultural convention, then the ruling order will topple and the masses will be freed from the yoke of anxious desire.

Museums—and especially heritage museums—play a peculiar role in all of this, for they are perfect topoi upon which to enact such critiques, even as they are also outgrowths of precisely the kind of counter-modern anxiety that is the enduring basis for cultural critique.[2] Heritage is one form of cultural salvage. A "lost world" or a world about to be lost is in need of "preservation," and the museum or heritage site bills itself as the best institution to perform this function. Heritage museums become publicly recognized repositories of the physical remains and, in

244

some senses, the "auras" of the really "real." As such, they are arbiters of a marketable authenticity. They are also objective manifestations of cultural, ethnic, or national identity, which outside the museum is often perceived as threatened by collapse and decay. Yet preservation entails artful fakery. Reconstruction, as it were, is the best evidence for the validity of a constructivist paradigm. Critics of this or that version of authenticity have before them in a heritage site ample evidence from which to build their deconstructive arguments.

In this essay, we would like to explore what happens to a heritage site "after authenticity"—where the pursuit of an elusive authenticity remains a goal even as it generates public statements intended to call into question the epistemology of authenticity.[3] Colonial Williamsburg—a place that fashions itself as one of the most ambitious and extensive reconstruction projects ever undertaken—intends to be experienced as an objective correlate of an American national "identity." Because Colonial Williamsburg makes such claims for itself, it has throughout its history also been subject to critiques of its authenticity by those who wish to undermine its authority to speak as the voice of an all-encompassing America. Moreover, in the past 20 years, the professional historians who ostensibly set the pedagogic agenda at Colonial Williamsburg have become increasingly articulate on-site critics of the epistemological underpinnings of authenticity as they promulgate, at this particular site, a historiography currently popular in history museums at large and in the academy.

The question that frames our essay is, What happens to authenticity when the public are both openly skeptical about the capacity of the powers that be at Colonial Williamsburg to make definitive judgments about authenticity and also openly skeptical about authenticity itself as a foundational value? We will argue that the vernacular concept of authenticity changes very little, that it shows a remarkable resilience, in a sense, because it is under threat. This is because one crucial way that Colonial Williamsburg maintains its authority is by selective or managed admissions of failure to discern what is fact, fancy, real, or fake. This attention to the management of impressions allows for the dream of authenticity to remain viable even in an environment in which all available empirical evidence could easily be perceived as supporting constructivist paradigms or alternatively as undermining authenticity-based claims to truth or value. When constructivist paradigms flourish, as they currently do at sites such as Colonial Williamsburg, they do so not in the service of a critique of the status quo but in defense (to borrow from Durkheim) of what come to be perceived as socially "necessary illusions." While we draw our examples from research we carried out at Colonial Williamsburg from 1990 to 1993, the arguments are applicable to heritage sites in general and ultimately to the way constructivist paradigms are deflected or domesticated in the American vernacular in the "post-authentic" age.[4]

Colonial Williamsburg: the ethnographic setting

Colonial Williamsburg's central district, the Historic Area, which covers 173 acres and includes over 500 buildings, is an inherently ambiguous object of authenticity. Of this collection of buildings, 88 are said to be original and the rest are advertised as reconstructions. These buildings range in size from large public buildings, such as the Governor's Palace and the Capitol, to the dozens of outbuildings dotting the backyards of the stores and residences of the museum-city's streets. Outside the Historic Area are three major museums (devoted to folk art, decorative arts, and archaeology) and a James River plantation called Carter's Grove. The museum was founded in 1926 with the backing of John D. Rockefeller Jr. and is today owned and operated by the nonprofit Colonial Williamsburg Foundation. The foundation has a for-profit subsidiary, Colonial Williamsburg Hotel Properties, Inc., which operates several hotels and restaurants, with the profits used to support the museum. The foundation employs well over 3,000 people,

and about a million people visit it each year. It had an annual budget of close to $130 million and an endowment of close to $200 million in 1989 (Colonial Williamsburg 1989: 21–27).

The history that Colonial Williamsburg teaches has changed over the decades. In the past two decades, a crucial shift has occurred. The museum's patriotic, celebratory story of the American founding has been challenged by a new generation of historians hired at Colonial Williamsburg beginning in the late 1970s. These historians were profoundly influenced by the "new social history" that had developed in academic history departments in response to the social turmoil of the 1960s. When they came to Colonial Williamsburg, they wanted to revive what they saw as a moribund cultural institution by making it tell a new story, one that included the total colonial community. In other words, to the story of the colonial elites, which the museum had always told, the new historians wanted to add stories about the masses, the middle classes, the tradesmen, the lower classes, and, crucially, the African American slaves. They wanted to depict the total social life of the community in order to emphasize inequality, oppression, and exploitation. The new story of the American Revolution was to be one of complicated social, political, and economic motivations and relationships, not simply a glorious triumph of democratic principles.

Moreover, the new historians at Colonial Williamsburg were explicitly constructivists. Not only did they wish to replace a patriotic history with one that was more critical, they wanted to teach the public that history making itself was not simply a matter of facts and truth. It was, instead, a process shot through with hidden cultural assumptions and ideological agendas. Indeed, when we began our research at Colonial Williamsburg, we were particularly interested in the ways that constructivist theory operated and how it fared in the face of an entrenched objectivist historiography that celebrated the authenticity of the site and the truth of the history it embodied. As we shall see, the relationship of authenticity to credibility speaks to a kind of compromise between constructivism and objectivism, a compromise that allows business to continue as usual at mainstream institutions such as Colonial Williamsburg—an institution on the cutting edge of the way heritage is packaged and produced and at the same time typical.

Authenticity, credibility, and the tourist market

Despite the fact that Colonial Williamsburg's historians espouse a constructivist epistemology, the daily discourse that one hears on the site stresses the museum's commitment to total authenticity, that is, to historical truth in every detail.[5] To understand why the institution is willing to live with this contradiction, we need to examine how Colonial Williamsburg tries to position itself in the tourist marketplace. Ironically, but perhaps not surprisingly, Disneyland is a dominant presence, both symbolically and literally, in that market (Kratz and Karp 1993). One of the first things that staff members told us when we began our field study is that Colonial Williamsburg "isn't some historical Disneyland." Instead, they asserted, it was a "serious educational institution." Colonial Williamsburg differs from Disneyland, in the view of the museum's staff, because it presents "the real past" rather than one that is made up. It strives for historical accuracy. In so doing, it is constrained by "documented facts" and by historiographical methods of interpretation and presentation. By contrast, theme parks like Disneyland can make up whatever imaginary past, present, or future they wish, since they purvey amusement and fantasy, not education and history. In sum, Colonial Williamsburg is real, while Disneyland is fake.

Interestingly, the Disney corporation accepts this division of the labor of cultural representation. Late in 1993, Disney announced plans to build an American history theme park in northern Virginia. Though Colonial Williamsburg's administrators must have been worried by the possibility of head-to-head competition with Disney, they put on a brave face, as the headlines

in local newspapers announced, "Williamsburg hopes Disney park will draw interest to the real thing." Moreover, that Disney was clearly distinguished from "the real thing" was taken as a given throughout the "history-based tourism industry." As a spokesperson for Monticello, the "historic house" of Thomas Jefferson, put it, "It will be interesting for people to get the Disney experience and then ... to come here and get the real thing." Disney executives, too, spoke the same language, at least to the press: "Colonial Williamsburg has the same thing the Smithsonian and the Manassas battlefield have: real history. We can do everything we want, but we can't create that."[6]

Despite the fact that the Disney corporation publicly accepts the "reality" of the historical presentations at Colonial Williamsburg, the museum's critics often do not. An example of their critique appeared recently in the *New York Review of Books*, in the form of an attack on contemporary architecture by critic Ada Louise Huxtable. Huxtable's essay opened with a tirade against Colonial Williamsburg, which she saw as "predating and preparing the way for the new world order of Disney Enterprises," an order that systematically fosters "the replacement of reality with selective fantasy." According to Huxtable, Colonial Williamsburg "has perverted the way we think," for it has taught Americans

> to prefer—and believe in—a sanitized and selective version of the past, to deny the diversity and eloquence of change and continuity, to ignore the actual deposits of history and humanity that make our cities vehicles of a special kind of art and experience, the gritty accumulations of the best and worst we have produced. This record has the wonder and distinction of being the real thing.
>
> *(Huxtable 1992:24–25)*

These remarks epitomize an enduring critique of Colonial Williamsburg. Many of the museum's critics have said that it is literally too clean—that it does not include the filth and stench that would have been commonplace in an eighteenth-century colonial town. Many of these critics also find that Colonial Williamsburg is metaphorically too clean; it avoids historical unpleasantness like slavery, disease, and class oppression in favor of a rosy picture of an elegant, harmonious past.[7] This, of course, is exactly what similarly positioned critics say of Disneyland. Indeed, from the perspective of the people who take this critical stance, Colonial Williamsburg is all too much like Disneyland. Both produce the kinds of tidy, oversanitized products they do because they are big, middle-of-the-road "corporate worlds" who sell entertainment rather than education.

Credibility armor

Colonial Williamsburg has suffered the too-clean critique almost from the moment of its founding (Kopper 1986:165). That critique—which labels Colonial Williamsburg a fake like Disneyland instead of an authentic historic site—strikes at the museum's very conception of itself. Indeed, because authenticity is what Colonial Williamsburg sells to its public, the institution's claims to authenticity become a point of vulnerability. This is especially true for the foundation's professional intelligentsia—its historians, curators, and the like—for they are in many respects the peers of Huxtable and the others who snipe at them from the ivory tower. But the too-clean critique extends to the public at large, and so a defense against this critique becomes the business of the institution as a whole, especially on the "front line" where interpreters meet the public.

Every day hundreds of people visit Colonial Williamsburg, an institution whose mission is to show the public what colonial Virginia "was really like." Foundation staff know that in every

crowd there are individuals casting a cold and critical eye on the museum's claim to present that reality. In these circumstances, Colonial Williamsburg staff work hard not only to present an authentic site but to maintain the institution's reputation for authenticity. Moreover, maintaining an image of authenticity means protecting Colonial Williamsburg's chosen institutional identity—that of a serious history museum, not a theme park. As one interpreter put it, "It is important to discuss facts because each facility wants to be accurate and to present to our customers and visitors the best historical interpretation possible and to retain its authentic reputation" (see Bruner 1994:401).[8]

"Reputation" is something that pertains to the self or to the institution as a corporate personality, yet it is made and maintained vis-à-vis others. As Colonial Williamsburg staff see it, the museum's reputation for authenticity is on the line every day, and every one of the myriad historical details it exhibits is both a witness to institutional authenticity and a window of vulnerability. When we asked a manager who was working on increasing the accuracy of the museum's costumes to explain the "educational payoff" of attention to historical detail, he responded by talking about reputation rather than pedagogy:

> The clothing is just as important as creating an accurate interior, creating any sort of accuracy. Any time you have a break in your credibility, then everything that is credible is lost, or it's called into question. If you have someone who comes in, and they happen to see plastic buttons, or someone wearing obvious knee socks, instead of proper hosiery, then to me that's saying, well, that's not accurate. I wonder If the way that tea service is laid out is accurate? I wonder if the fact that that garden's laid out the way it is, I wonder if that's accurate? You start to lose it. That's why it's so important that our interpreters have the ability to take things that are less than accurate and get people to start thinking beyond them. And catching people, anticipating problems of credibility. Now if we can catch them up, by using better tools, better floor arrangements, better costumes, better gardens, then that's one less chink in our credibility armor that we have to worry about.

Colonial Williamsburg defends its credibility every day on the streets of the reconstructed capital, but its defenses are not perfect. Mistakes happen, visitors complain. In Colonial Williamsburg's corporate archives is a revealing record of how such complaints are resolved—files containing letters from disappointed visitors, along with the foundation's responses to them. These files record an ongoing effort to put the best spin it can on these criticisms by invoking Colonial Williamsburg's unwavering fidelity to authenticity.

For example, an elderly couple wrote that their most recent visit had turned into "a long disappointing day" because they "found many things that did not fit the Williamsburg we've known over the past 20 years." They complained that the "lovingly truly preserved past of our America" was being marred by the presence of employees with nail polish, plastic earrings, and tennis shoes. Charles Longsworth, president of the Colonial Williamsburg Foundation, replied:

> You brought a sharp eye with you on your recent visit to Colonial Williamsburg. You caught a few of our interpretive staff with their authenticity and courtesy down. You may be sure that each of the violations you cite of courtesy standards and 18th-century apparel and appearance is being addressed by the supervisors of the violators. Your standards are ours, and we strive to see them honored by all employees. Being human, we sometimes fail, but our efforts to achieve authenticity and friendliness have been and will continue to be unflagging.[9]

Phrases such as "reputation" and "credibility armor," and the image of being caught with one's authenticity (pants?) down, suggest the pervasive insecurity that, apparently, accompanies Colonial Williamsburg's claims to possess the really real. Even the foundation's professional historians, who espouse a relativistic or constructivist philosophy of history, experience this embattled concern for reputation.[10] An architectural historian, for example, told us what he characterized as a humorous story about an encounter he had with a visitor early in his career at Williamsburg. The visitor came up to him and said that Colonial Williamsburg did not have a single padlock on the reconstructed buildings that was genuinely eighteenth-century in design. In response to this criticism, the historian spent a day tracking down all the information he could find on the locks in the reconstruction. Then he went to a museum famous for its collection of early American artifacts "to study the 24 or so 18th-century padlocks they had." He made drawings of those. Next, he told us, he "developed a rough typology—I think there were four recognizable styles of padlock, and the visitor was right, none of ours were like these." As a result, the historian wrote the visitor thanking him and promising that while Colonial Williamsburg could not afford to change all the old locks, "on every subsequent project" they would make more faithful reproductions.

The historian prefaced his humorous story by explaining that he and his colleagues sweat the details so that "you aren't a joke" in the eyes of the public. His humorous portrayal of himself as an insecure ferret let loose on the problem of padlocks—because veracity in every detail is Colonial Williamsburg's hallmark and because he doesn't want to be a joke—reflects an abiding institutional concern, for the visitor who points out flaws in the mimetic portrait of the past Colonial Williamsburg professes to create is a stock character in many stories employees tell about their encounters with the visitors. He is, as one supervisor of frontline interpreters told us, like "a magpie" that weaves odd trinkets—tinfoil, some colored yarn—into its nest. A human magpie at places such as Colonial Williamsburg is someone who collects, indeed is obsessed with, a certain category of obscure historical facts.

Frontline employees are, if anything, more sensitive to the threat of the magpie than are backstage personnel like research historians. To these employees at Colonial Williamsburg, the magpie is an embarrassing nuisance who may be hiding among every flock of tourists, threatening to reveal the guide's ignorance (and knock the guide off his or her storyline) with a pointed query about some object or some theme about which the guide will have no clue.

Magpies threaten individual reputations during brief encounters at particular sites, and they also threaten institutional reputations. When the architectural historian says that it is a point of honor that Colonial Williamsburg get the details right, it is in part to protect his reputation, but also to protect the institution's reputation. Veracity, authenticity, or getting the facts right is a deep value at Colonial Williamsburg and it has a double quality. People like the architectural historian sweat the details, in part, because they too are like magpies. The architectural historian used to tell us how he loved the detective work involved in tracking down just such stray facts. But he and his colleagues also get the facts right so that they won't be exposed as a joke in public. The institution rewards employees for responding to the magpie's trivial or tangential queries because this keeps the credibility armor nicely burnished.

Constructivist ploys in defense of objectivist authenticity

Credibility armor is important because those who work at Colonial Williamsburg assume (and often have such assumptions confirmed) that the public is concerned with authenticity.[11] Every claim to possess or represent the "real" at least implies a claim to possess or represent the knowledge and authority to decide what's real and what isn't. Furthermore, Colonial Williamsburg

employees expect that a significant number of their public are always somewhat skeptical of such claims to authority, especially those made on behalf of large corporate institutions like Colonial Williamsburg. As one of the foundation's historians put it, during a workshop we led concerning historical relativism and African American history,

> I think there are a lot of interpreters who share with many of our visitors this suspicion, that, in fact, there are official histories, and that this institution has been in the past, and may still be … either consciously or unconsciously purveying an official history. Which is simply to say, a history that somebody knows to be wrong, but has good reasons for wanting to promote anyway, either because if we tell the real story we'll turn off visitors, or we'll open up questions of racial antipathy which a well-behaved place—which Americans, good citizens—don't want to [hear]… . So there are lots of reasons why an institution like ours— particularly a slick institution like ours—is likely to have a hidden agenda. Which is only to say that there are probably lots and lots of people who don't know they're relativists, but fear that history is something that is concocted.[12]

People, in sum, are oftentimes predisposed to think (unkindly) of Colonial Williamsburg as a "slick institution" manufacturing facades and cover-ups rather than the authentic truth. Faced with such skepticism, and with the more sophisticated critiques of the intelligentsia, Colonial Williamsburg routinely deploys what might be called a proactive attitude, trying to defuse criticisms by anticipating them. Sometimes this takes the form of teaching visitors about "mistakes" the foundation has made in its depiction of the past. For example, on one tour that we took, the interpreter explained that in an earlier era in the museum's history all the clapboard outbuildings had been kept freshly painted and the woodwork had been of the highest quality. At that time, she explained, "We assumed that every building on the property would be as neat as every other." But now, she continued, researchers know better: "Only the front's important, that's your first impression, so buildings out back are going to be rougher." As a result, outbuildings were being painted less frequently and allowed to wear unevenly. Thus, as we looked at the crisp, white clapboard in front of us, we were asked to imagine more shabbily painted outbuildings elsewhere.

Another proactive ploy is to point out the purposeful artifice of the museum-city, a place meant to recreate an eighteenth-century reality but one that also, of necessity, must negotiate twentieth-century realities. For example, many buildings in the Historic Area are used either as office space or as residences for foundation employees. In such cases, twentieth-century elements must be "disguised." "The rules say you can't show anything 20th-century," one interpreter explained. "No anachronisms! That means no television antennas … no Christmas lights." Other interpreters told us that garages were made to look like stables, central air-conditioning was allowed because it did not have to be visible, and garbage cans could be hidden behind hedges. When we came across these artfully disguised elements, they were duly pointed out to us. As we paused, on one occasion, to marvel at 200-year-old boxwoods, we were reminded that "we also have wonderful things like fire hydrants, trash cans, and soda machines that we try to hide." As we continued our stroll beneath some tall trees, our guide added that "if you look up in trees this time of year you see things that look like an upside-down bucket, and it's a light. You don't find them in the summer because of the leaves."

A third ploy for parrying criticisms entails blaming the visitors for inauthenticities. The best example of this ploy concerns trees (cf. Bruner 1994:402; Gable and Handler 1993a). The streets of the Historic Area are shaded by tall and stately oaks and other deciduous trees. Inevitably, interpreters would call our attention to these beautiful and obviously old trees and remark that

they would not have been there in the colonial era. They would go on to explain that the foundation would never cut down those trees because, despite its commitment to authenticity, it had also to consider visitor comfort. Without the shady trees, the streets in summer ("when most of our visitors come") would be unbearable. In pointing to the trees, our guide on one occasion enjoined us to "keep in mind that many changes have been made to the town itself, things we have done to make it basically more comfortable for … 20th-century people." As on many tours, he advised us to look past or through these anachronisms in order to imagine the real past. It was as if the foundation was trying to shape the visitor's appreciation of the landscape in such a way as to confirm that, yes, the town is artificial, but Colonial Williamsburg could not be as accurate as it wished to be because the visitors' needs precluded it.

These rhetorical tactics might be seen as a kind of "impression management"—constructivism deployed in the defense of objectivism. Interpreters point out repeatedly (and indeed they are trained to do so) that history changes constantly, that what is believed to be true at one moment is discovered to be inauthentic later on, and that the business of history making involves all sorts of compromises. Yet these constructivist confessions, as it were, stem ultimately from a concern for maintaining Colonial Williamsburg's reputation as an arbiter of authenticity. Constructivist caveats shore up the assertion that the foundation aims for authenticity in every detail. As we discovered in interviews with visitors, its public by and large expects that, but some are also inclined to doubt the museum's honesty. Cognizant of that doubt, the museum repeatedly highlights not only the authenticity of its exhibits but the details that fall short of total authenticity. Employed to manage impressions, these admissions of small errors are expected to bolster the public's faith that the institution is diligently working toward its larger goal: to re-create the past in its totality, that is, with complete authenticity.

But Colonial Williamsburg recognizes that there are some elements of its public for whom authenticity—if authenticity is defined as fidelity to objective truth—is anathema. In interviewing them, we occasionally encountered such visitors. An elderly widow stands out, perhaps because she was among the first visitors we talked to. She had been coming to Colonial Williamsburg for over 30 years and always stayed in the Williamsburg Inn, a five-star hotel famous for its slightly rusticated elegance. Explaining to us that she was one of the foundation's regular donors (we never asked her how much she was accustomed to giving), she admitted that she was somewhat chagrined by the "recent," as she put it, preoccupation with refashioning the town as it "really was." Christmas, she told us, was her favorite time to visit, precisely because of the "festive decorations," although, she emphasized, they were not true to the eighteenth century. Would Williamsburg do away with these anachronisms? she worried aloud.

For the widow, the recent move toward greater truth was threatening to ruin what lay at the heart of Williamsburg's appeal. It was a place, she reminded us, where she, an old woman, could still stroll the streets at night. She explained Colonial Williamsburg's appeal by way of a vignette having to do with an early stay at the inn. She had been eating in the luxurious dining room and, desiring sugar for her coffee, was about to dip her spoon into a large pewter cup in front of her when a liveried black waiter quickly bent over, moved the cup, and spooned sugar from a smaller container into her coffee. The first container, she elaborated, was salt. Apparently, in colonial times, she added, they served salt in what today might look like a sugar bowl. But it wasn't the inn's attention to that little piece of authenticity that she wanted us to see through her eyes. Rather, it was the black waiter's silent skill. Ever attentive, waiting unobtrusively but alertly in the background, he'd anticipated her faux pas and resolved her problem without calling attention to her mistake. Skilled waiters like that, she emphasized, could not be reproduced, or faked, or trained. They embodied for her the essence of what Colonial Williamsburg used to stand for before "that new word, 'authenticity,' " had become such a concern.

Visitors such as the widow are not significant characters in the imaginary public Colonial Williamsburg employees created and re-created in daily conversations.[13] Nevertheless, it is entirely plausible that people such as the widow played a larger (if not explicitly recognized) role in the way Williamsburg's higher-ups imagined their *donating* public—a close to 50,000-strong subgroup that Colonial Williamsburg was increasingly relying on for the gifts and grants that would enable the museum to preserve itself.

To this public, the powers that be at Colonial Williamsburg employed what could be characterized as a constructivist historiography, but in the service of the status quo, as celebration, not critique. Consider President Longsworth's annual report for the years 1980 and 1981—a report that introduces Colonial Williamsburg's donating public to the new social history and reassures them that old celebratory history will not be erased as a result.

Longsworth's report is in the form of a history of shifts in the major ideas—couched as consumer preferences—that guided the foundation. In short, it is a constructivist history. It begins with the aesthetic motives of the customers—"visitors came here ... to see buildings and furnishings." Later, in "the days of the cold war ... interpretation was fired by a sense of duty to inspire and encourage patriotism, to imbue visitors with a perception of the preciousness and fragility of personal freedom." In Longsworth's historical sketch, the new social history "reflected the dominant characteristics of the 1960s: suspicion and distrust of leaders and a concomitantly populist view of the world" (1982: 6–7).

Longsworth notes that the new social history "inevitably caused a strong reaction from those whose commitment to the patriots as the source of inspiration was steadfast." And while he avers that it is "the tension of these differences of view that ... creates a lively learning environment," the tenor of his report is to defend the patriots against the new social historians. He does so by embracing a constructivist historiography:

> It would be easy and perhaps popular to embrace social history with passionate abandon and forsake the patriots, retaining their memory as symbolic of an outworn and naive view of America's past. But I know of no one who advocates such a course. One needs to retain always a cautious view of any claim of exclusive access to the true history. I believe one must accept the puzzlement, confusion, ambiguity, and uncertainty that characterizes scholarship—the search for truth.
>
> *(1982: 8)*

Longsworth recognizes that the "reasonable and dispassionate interpretation of evidence" is fogged by "some ideological base." But, given that history cannot escape ideology, Colonial Williamsburg should "maintain an ideological blend rather than develop a pure strain." Ultimately this ideological blend of the "dramatic, inspiring story that never loses its significance" and the new social history is good for Colonial Williamsburg as an institution. It is a strategy that guarantees survival, for it gives the public what it wants, or, at least, what Colonial Williamsburg has gotten them used to: "An organization such as this has by its longevity and its success created certain expectations. They may not be blunted summarily by a generation of scholars or administrators who have discovered the new historiography" (Longsworth 1982: 8–9).

Because the foundation must cater to the desires of a market that it has, in a sense, created, Longsworth concludes that "we shall ... continue to do what we do." As proof he cites the 60 percent increase in the collections budget and the construction of the DeWitt Wallace Decorative Arts Gallery—meant to house a collection of colonial era "masterworks," which, according to the social historians' canons of authenticity, could no longer be displayed in the

well-appointed homes of the reconstructed village because they were neither made nor used in Williamsburg itself (1982: 9–10).

Longsworth (who left the presidency in 1992, remaining at Colonial Williamsburg as chairman of the board) has consistently used constructivist rhetoric to promote the preservation of a certain patriotism linked to a certain aesthetic. In a preface to Philip Kopper's sumptuous coffeetable history of the site, he argues that Colonial Williamsburg makes myths "because of America's need for myth." "It is easy," he writes, "to dismiss Williamsburg as a purveyor of patriotism," but, he argues, "the stimulus provided by patriotic feeling will be a vital tonic to the body politic." He goes on to assert that Colonial Williamsburg "is constantly changing, as it stands its iconographic ground"—that "the recreation of our usable past" is a necessary social process. In concluding, he notes how the old idea

> that Colonial Williamsburg would be "finished" rather than an ongoing enterprise of great vigor and complexity seems naive today. But, I suppose, it also seemed naive, or at least highly unlikely to many, that the dream of a new nation would ever be realized. So, out of our dreams we find reality and in myth our dreams are forged.
>
> *(Longsworth 1986: 6–7)*

Here Longsworth invokes a "usable" past—a self-conscious, ongoing invention of history—in the twin service of national identity and corporate survival.

The uses of constructivism

In his challenging essay (1994) Edward Bruner uses similar observations from his fieldwork at New Salem, Illinois 1984—a site associated with Abraham Lincoln—to suggest that authenticity from the native point of view is evidence of a home-grown cultural constructivism. He shows that authenticity has several meanings for the staff and visitors at New Salem, one of which is "historical verisimilitude." As Bruner puts it, "*authentic* in this sense means credible and convincing, and this is the objective of most museum professionals, to produce a historic site believable to the public, to achieve mimetic credibility" (1994:399). "Some museum professionals go further," Bruner continues, and this entails a second native meaning of authenticity—to "speak as if the 1990s New Salem not only resembles the original but is a complete and immaculate simulation, one that is historically accurate and true to the 1830s" (1994:399). Bruner elaborates upon the distinction between the former and latter senses:

> In the first meaning, based on verisimilitude, a *1990s* person would walk into the village and say, "This looks like the 1830s," as it would conform to what he or she expected the village to be. In the second meaning, based on genuineness, an *1830s* person would say, "This looks like 1830s New Salem," as the village would appear true in substance, or real. I found that museum professionals use *authenticity* primarily in the first sense, but sometimes in the second.
>
> *(1994:399)*

The important point for Bruner is that insiders at the site are well aware that what they are producing is not a perfect copy, but something that is credible to an audience. The implication is that the natives (and here Bruner is referring especially to the professional staff at New Salem) do not confuse the reproduction with the real. Instead, they are aware that what they are

Eric Gable and Richard Handler

creating is "verisimilitude"—something that will convince an audience or be congenial to an audience's sensibilities.

Bruner takes this a step further. Just as professionals are not preoccupied with recreating the real thing, so, too, are visitors to the site less concerned with this kind of absolute authenticity:

> The tourists are seeking in New Salem a discourse that enables them to better reflect on their lives in the 1990s. New Salem and similar sites enact an ideology, recreate an origin myth, keep history alive, attach tourists to a mythical collective consciousness, and commodify the past. The particular pasts that tourists create/imagine at historic sites may never have existed. But historic sites like New Salem do provide visitors with the raw material … to construct a sense of identity, meaning, attachment, and stability.
>
> *(1994:411)*

Bruner concludes his essay by noting that "New Salem can be read in two different ways"—from a pessimistic view or an optimistic one. The pessimists see such sites "as exploitative, as strengthening the ruling classes, as deceit, as false consciousness, as manipulation of the imagination of already alienated beings." Bruner counts himself among the optimists who focus on the ways the site offers "the utopian potential for transformation, offers hope for a better life, says people can take charge of their lives and change themselves and their culture."[14]

According to Bruner, visitors and employees alike "take charge" of the way they consume and produce culture. He emphasizes that visitors and guides "bring their own interests and concerns to the interaction" (1994:410). He describes these interactions as "playful," as "improvisation." The upshot, for Bruner, is that Americans "seeking … a discourse that enables them to better reflect on their lives in the 1990s" (1994:411) can and do find such a discourse at New Salem.

Having made these ethnographic observations, Bruner wishes to link native notions of authenticity to anthropological theories of culture. Bruner is a constructivist. He asserts that the production of authenticity-as-verisimilitude is no more or less than a clear manifestation of what culture everywhere and always is—an invention (in many instances based on an attempt at replication). As such it is a benign fact. It is benign, too, because it allows natives to play with an invented past and revivify certain enduring ideals relevant to their present and future.

What Bruner observed at New Salem and what we observed at Colonial Williamsburg are essentially the same phenomena. Yet we interpret them in almost opposite ways. Let us examine the ways our interpretations differ, and what this implies for theories of cultural production at (what some natives at least like to claim are) "shrines" to an American identity.

Perhaps most significantly, we have different attitudes toward our respective sites. If Bruner celebrates the native preoccupation with authenticity-as-verisimilitude as a benign sign of a universal human tendency to construct culture (and, in the American case, to be aware that they are doing so), then we criticize authenticity-as-impression-management as a symptoms of an ongoing preoccupation in American culture with a certain kind of past. For us, it is bad enough that this kind of authenticity allows an airbrushed past to become exactly the kind of mythological standard middle-class Americans aspire to. What disturbs us just as much is that authenticity-as-impression-management is one of an array of practices (both intentional and unintentional) that effectively enervate constructivist insights at a place whose built environment is living proof, as it were, of the power of constructivist theory as a model for what history, as narrated or embodied or objectified memory, really is.

We, like Bruner, are constructivists. Along with Bruner, we would even go so far as to say that constructivist theory has been the bread and butter of most cultural anthropologists for a long time. For us, the pervasiveness of constructivist theory raises some ethnographic questions

when an anthropologist studies American culture, particularly at sites such as New Salem and Colonial Williamsburg. The first question is whether constructivism is also a native theory in the sense that it is part of the commonsense baggage of people who are not professional anthropologists.[15]

When we began our research at Colonial Williamsburg, we were interested in the ways constructivist theory operated on the ground. At first, it seemed to us that native discussions of authenticity-as-impression-management revealed commonsense understandings of constructivist theories of culture. But authenticity-as-impression-management turned out to have less to do with teaching about constructivist historiography than with protecting or shoring up a threatened reputation. To talk of verisimilitude as credibility armor, to sweat the details so you're not a joke in public in a reconstructed place that was "always changing because new facts are found," but that was nonetheless always being criticized by powerful outsiders for producing a bowdlerized past—this was, we decided, a tactic meant to protect the dream of authenticity as perfect copy.

As we have argued elsewhere (1994), Colonial Williamsburg is a shrine to a "naive objectivism." One of the ways that the priesthood of this shrine protects this cherished paradigm is by judicious legerdemain in the service of public relations. So, one way that we differ from Bruner is that we would argue that a Kuhnian paradigm shift has not occurred at Colonial Williamsburg. The site's authority—its reputation, if you will—depends on the public enactment of fidelity to an essentialist authenticity, not on constructivism.

This does not mean, however, that there are no spaces on Colonial Williamsburg's rhetorical terrain for native versions of constructivist notions as Bruner describes them. Ironically, just as the new social history began to make headway, advocates of the older, more celebratory history were able to use constructivist rhetoric against the new social history in order to repackage celebratory history and reassert its claims to ultimate authority. Longsworth's defense of the status quo reminds us of what philosophers have occasionally pointed out (cf. Hiley 1988), but what we, in the midst of the "culture wars," perhaps overlook. You can be a constructivist and a conservative. Longsworth does this in a speech we quoted above. If all is relative, then why not "continue to do what we do"—while, in effect, relabeling it?

This kind of constructivism has the added benefit of insulating the particular social actors (or institutions) from their own personal skepticism. Longsworth does not have to personally believe in the authenticity of the reconstructed Williamsburg. Instead, he simply has to be convinced that myths, if they contain morally uplifting messages, are salutary. In this way, a conservative constructivism protects an obviously empirically false image of the past, because it is a "necessary illusion" of the same kind Durkheim, personally an atheist, posited for religion. We might add that in America, conservative, constructivism has usually been tinged with a willful optimism. If we all believe, or "think positive" as one euphemism has it, then it will come true. Or more cynically still, if we pretend to believe, or, in our role as leaders, if we ensure that "they," the herd, the mass, believe, then it will come true. It is this kind of constructivism that lends itself to conservatism in its political and cultural sense.

This, then, is a chief way that constructivist notions thrive at Colonial Williamsburg. Authorities such as President Longsworth use constructivist arguments to justify supporting good myths over bad facts, or authenticity as a model for, rather than a model of, a reality. They do so, as often as not, in the name of consumer preference. They do so in order to protect what they take to be universal ideals and values, and, nowadays, they do so against the implied background of a society under siege—a society threatened by postmodern plague. When they lay claim to being the enlightened arbiters of universal values—servants and guides to the public—they import what to us are self-serving visions about how the world should look.

Eric Gable and Richard Handler

This is the reason why we are more pessimistic than Bruner about the ways Americans construct identities for themselves at shrines such as Colonial Williamsburg and New Salem. It is not that we are essentialists—that we see such sites as unreal or inauthentic. Rather, we are ultimately less sanguine than Bruner that what goes on there is a universal form of cultural construction. Natives exhibit what to us is a kind of divided consciousness. On the one hand, they continue to be preoccupied with the past as the last refuge of the really real. On the other hand, some of them, at least, allow for the possibility that the really real is myth. Yet, according to them, it is "myth" that, if institutions such as Colonial Williamsburg and the American nation itself are to survive and prosper, people must believe.

Notes

1 Walter Benjamin's seminal essay "The Work of Art in the Age of Mechanical Reproduction" is the starting point for much of this literature (1969: 217–251). Among many others, see Handler 1986; Orvell 1989; Spooner 1986; and Trilling 1971.
2 This literature grows out of work in a number of areas. On museums, see Karp and Lavine 1991; Pearce 1990; and Vergo 1989. On consumerism, see McCracken 1988 and Miller 1987. On the ethnography of markets and trade goods in a transnational world, see Appadurai 1986; Schildkrout 1992; and Thomas 1991.
3 We borrow the aptly ambivalent framing quality of "after" from the philosopher Gary Shapiro (1995) and from Clifford Geertz (1995).
4 Assisted by Anna Lawson, we carried out fieldwork at Colonial Williamsburg between January 1990 and August 1991. Our research was supported by grants from the Spencer Foundation, the National Endowment for the Humanities, and the University of Virginia. Published results of this research include Gable and Handler 1993a, 1993b, and 1994, and Gable et al. 1992.
5 Carson 1981; Chappell 1989; and Colonial Williamsburg 1985.
6 *Daily Progress* 1993a, 1993b.
7 The critique of Colonial Williamsburg's sanitized history has been elaborated by Leone (1981), Van West and Hoffschwelle (1984), Wallace (1981), and Wells (1993), among others. For an analysis of dirt as a metaphor with respect to history museums, see Gable and Handler 1993b.
8 Quotations from Colonial Williamsburg staff are verbatim, taken from our field notes or, in most cases, from the transcriptions of tape-recorded interviews and tours.
9 Colonial Williamsburg Foundation Archives, file "Colonial Williamsburg Criticisms, 1987," letter dated February 20, response of President Longsworth dated March 9.
10 On historical relativism and constructivism at Colonial Williamsburg and in American history museums in general, see Carson 1981, 1991; Chappell 1989; Gable et al. 1992; and Krugler 1991.
11 For a thoroughly researched study of the way Americans conceptualize authenticity and seek it out in tourism, see Cameron and Gatewood 1994.
12 The workshop in question was a preliminary presentation of material that was eventually published in Gable et al. 1992.
13 This public tended to be populated by history buffs (the magpies), by various versions of the rube from Toledo—the person who asks in all seriousness if the squirrels are mechanical—and by families with obnoxious children.
14 Bruner's optimism scans as a kind of faith in the consumer because, for Bruner, the very "popularity and frequency" of sites such as New Salem is a sign that they do something good for their publics (1994: 411–412).
15 Given that we anthropologists have been spouting a constructivist line for so long, given that other disciplines also have made constructivist theories of culture central to what they teach about the human condition, given that people who work at or visit Colonial Williamsburg and New Salem are "educated," one would expect that such a theory has been incorporated into the commonsense views they bring to such sites. Moreover, given that we are natives, and that we don't manufacture our theories out of thin air but out of the cultural environment in which we live, we would hypothesize that constructivist theory has commonsense analogues.

Bibliography

Appadurai, Arjun, ed. 1986. The Social Life of Things: Commodities in Cultural Perspective. Cambridge: Cambridge University Press.

Benjamin, Walter. 1969. Illuminations: Essays and Reflections. New York: Schocken Books.

Bruner, Edward M. 1994. Abraham Lincoln as Authentic Reproduction: A Critique of Postmodernism. American Anthropologist 96: 397–415.

Cameron, Catherine M., and John B. Gatewood. 1994. The Authentic Interior: Questing *Gemeinschaft* in Post-industrial Society. Human Organization 53(1): 21–32.

Carson, Cary. 1981. Living Museums of Everyman's History. Harvard Magazine 83 (July–August): 22–32.

Carson, Cary. 1991. Front and Center: Local History Comes of Age. *In* Local History, National Heritage: Reflections on the History of AASLH. pp. 67–108. Nashville: American Association for State and Local History.

Chappell, Edward A. 1989. Social Responsibility and the American History Museum. Winterthur Portfolio 24 (Winter): 247–265.

Colonial Williamsburg. 1985. Teaching History at Colonial Williamsburg. Williamsburg: Colonial Williamsburg Foundation.

Colonial Williamsburg. 1989. Annual Report. Williamsburg: Colonial Williamsburg Foundation.

Daily Progress (Charlottesville, VA). 1993a. Disney Magic Will Draw Cash to Area, Officials Say. November 11: A1, A9.

Daily Progress (Charlottesville, VA). 1993b. Williamsburg Hopes Disney Park Will Draw Interest to the Real Thing. November 14: B1–B2.

Gable, Eric, and Richard Handler. 1993a. Colonialist Anthropology at Colonial Williamsburg. Museum Anthropology 17(3): 26–31.

Gable, Eric, and Richard Handler. 1993b. Deep Dirt: Messing Up the Past at Colonial Williamsburg. Social Analysis 34: 3–16.

Gable, Eric, and Richard Handler. 1994. The Authority of Documents at Some American History Museums. Journal of American History 81(1): 119–136.

Gable, Eric, Richard Handler, and Anna Lawson. 1992. On the Uses of Relativism: Fact, Conjecture, and Black and White Histories at Colonial Williamsburg. American Ethnologist 19: 791–805.

Geertz, Clifford. 1995. After the Fact: Two Countries, Four Decades, One Anthropologist. Cambridge, MA: Harvard University Press.

Handler, Richard. 1986. Authenticity. Anthropology Today 2(1):2–4.

Hiley, David R. 1988. Philosophy in Question: Essays on a Pyrrhonian Theme. Chicago: University of Chicago Press.

Huxtable, Ada Louise. 1992. Inventing American Reality. New York Review of Books 39(20): 24–29.

Karp, Ivan, and Steven D. Lavine, eds. 1991. Exhibiting Cultures: The Poetics and Politics of Museum Display. Washington, DC: Smithsonian Institution Press.

Kopper, Philip. 1986. Colonial Williamsburg. New York: Harry N. Abrams.

Kratz, Corinne A., and Ivan Karp. 1993. Wonder and Worth: Disney Museums in World Showcase. Museum Anthropology 17(3): 32–42.

Krugler, John D. 1991. Behind the Public Presentations: Research and Scholarship at Living History Museums of Early America. William and Mary Quarterly 48 (July): 347–385.

Leone, Mark. 1981. Archaeology's Relationship to the Present and the Past. *In* Modern Material Culture. R. A. Gould and M. B. Schiffer, eds. pp. 5–14. New York: Academic Press.

Longsworth, Charles R. 1982. Communicating the Past to the Present. *In* Communicating the Past to the Present: Report on the Colonial Williamsburg Foundation with a Summary of the Years 1980 and 1981. pp. 5–10. Williamsburg: Colonial Williamsburg Foundation.

Longsworth, Charles R. 1986. Foreword to *Colonial Williamsburg*, by Philip Kopper. New York: Harry N. Abrams.

McCracken, Grant. 1988. Culture and Consumption: New Approaches to the Symbolic Character of Consumer Goods and Activities. Bloomington: Indiana University Press.

Miller, Daniel. 1987. Material Culture and Mass Consumption. Oxford: B. Blackwell.

Orvell, Miles. 1989. The Real Thing: Imitation and Authenticity in American Culture, 1880–1940. Chapel Hill: University of North Carolina Press.

Pearce, Susan, ed. 1990. Objects of Knowledge. London: Athlone.

Schildkrout, Enid, ed. 1992. Trade, Ethnicity, and Material Culture. Museum Anthropology 16(3), special issue.
Shapiro, Gary. 1995. Earthwards: Robert Smithson and Art after Babel. Berkeley: University of California Press.
Spooner, Brian. 1986. Weavers and Dealers: The Authenticity of an Oriental Carpet. *In* The Social Life of Things: Commodities in Cultural Perspective. Arjun Appadurai, ed. pp. 195–235. Cambridge: Cambridge University Press.
Thomas, Nicholas. 1991. Entangled Objects: Exchange, Material Culture, and Colonialism in the Pacific. Cambridge, MA: Harvard University Press.
Trilling, Lionel. 1971. Sincerity and Authenticity. Cambridge, MA: Harvard University Press.
Van West, Carroll, and Mary Hoffschwelle. 1984. "Slumbering on Its Old Foundations": Interpretation at Colonial Williamsburg. South Atlantic Quarterly 83(2): 157–175.
Vergo, Peter, ed. 1989. The New Museology. London: Reaktion Books.
Wallace, Michael. 1981. Visiting the Past: History Museums in the United States. Radical History Review 25:63–96.
Wells, Camille. 1993. Interior Designs: Room Furnishings and Historical Interpretations at Colonial Williamsburg. Southern Quarterly 31:89–111.

18
Makeover for Mont-Saint-Michel

A renovation project harnesses the power of the sea to preserve one of the world's most iconic islands

Alexander Stille

"One needs to be eight centuries old to know what this mass of encrusted architecture meant to its builders" wrote Henry Adams in his book Mont–Saint–Michel and Chartres. And that was more than a hundred years ago. Mont–Saint–Michel has gone through several major transformations since Adams' time and is in the midst of another one now that will change its meaning or meanings once again.

Mont–Saint–Michel has been so many different things in the course of its long life, since its founding in the early eighth century, when the Bishop of Avranches built a church dedicated to the archangel Michael on a rock of granite in the sea. It was originally the hopeful assertion of Christianity in a Europe that was still part pagan and vulnerable to Viking raids on the northern coasts of what is now France. Two centuries later, the Duke of Normandy gifted the site to the Benedictine monks, who began building an ambitious abbey church under the patronage of William the Conqueror – the expression of a richer, more confident era as the Normans (former Vikings) were about to set out on not only the conquest of England but also of Sicily and Southern Italy. The abbey atop the Mont became both a major pilgrimage site – there were even souvenirs sold here in the Middle Ages – and a locus of ecclesiastical and political power. It was also a major center of medieval learning, with a rich library and scriptorium. At the time of the Hundred Years' War, the church evolved into a military citadel – an impregnable fortress in the sea – the only spot in Normandy that never fell to the English. During and after this conflict, Mont–Saint–Michel assumed many of its current features – the ramparts that line the handsome stone walls and (much later) the statue of St. Michael, the warrior angel who now stands atop a spire some 300 feet in the air, his sword held aloft and his heel crushing a dragon, representing Satan or sin.

Building on such treacherous ground – on a small rock in a bay that contains some of Europe's strongest currents and most powerful tides – must have seemed like the ultimate act of faith. For the pilgrims flocking to pay homage to the archangel, the trip to reach this heavenly precinct was itself a true test of faith: Centuries ago the shore was a full seven kilometers (4.3 miles) from the island (five kilometers farther than it is today). One had to wait until low tide, when the sea receded and left a flat strand of grayish mud, and get the timing right. The crossing on foot could be dangerous – high tide can rise up to 45 feet and sweep in at some 200 feet per minute. Moreover, at low tide the gray, claylike sand can suddenly give way to pools

259

of quicksand where an inexpert trekker can become trapped. In 1318, eighteen pilgrims drowned in the bay and another dozen died in the quicksand. Now there are organized treks with trained guides; even so, a group of tourists got caught in the sand last year and needed rescuing.

With time, Mont-Saint-Michel has lost more and more of its status as an island. The relentless flow of the tides, bringing in their wake alluvial soil ideal for the growth of vegetation, has left the soil near the shore extremely fertile. And the people of Normandy-like those in Holland – gradually started using dikes and irrigation systems to reclaim land, pushing out the edge of the shore and bringing more of the land by the sea under cultivation. The salty grass that grows on the sandy ground as the sea recedes makes for excellent grazing, and the sheep raised in the area – les agneaux de pres-sales (salty pasture sheep) – are treasured for their flavor. The buildup had pushed its way to within two kilometers of Mont-Saint-Michel by the nineteenth century and might have reached all the way had there not been a movement to stop it and preserve the island nature of the ancient church.

With the French Revolution, the Abbey of Mont-Saint-Michel was closed – like many church buildings – and it was turned into a prison. "What a strange place is this Mont-Saint-Michel!" wrote Victor Hugo, in 1836. "All around us, as far as one can see, infinite space, the blue horizon of the sea, the green horizon of the earth, clouds, air, freedom, birds in full flight, ships with full sails; and then, all of a sudden, there, in the crack of an old wall, above our heads, through a barred window, the pale face of a prisoner." In a poem, he called it the "pyramid" of the seas.

In 2005, the French government, which owns the abbey, began work on a major project to "restore the maritime character" of Mont-Saint-Michel. The buildup of silt was gradually reducing the parts of the bay that filled up with water at high tide, and, according to some studies, if nothing was done, the island would find itself permanently connected to the mainland by 2040. The French central state, together with the regional governments of Normandy and Brittany (Mont-Saint-Michel is technically in Normandy but the Bay of Mont-Saint-Michel is shared by both regions) and the European Union, undertook a massive and expensive renovation project budgeted at nearly $300 million. The main features of the project include: the destruction of the old causeway to allow the sea to move freely around Mont-Saint-Michel and the construction of a light bridge or walkway in its stead; a dam on the Couesnon River to hold water during high tide and then release it when the tide recedes, to push sand away from the island; the destruction of a large parking lot at the foot of the Mont and the construction of a parking area on the mainland with a shuttle bus service to bring tourists and employees to and from the island.

The initial impression of the place as one makes one's way from the shuttle bus is decidedly more commercial than spiritual. The village of Mont-Saint-Michel, which grew up around the church, is tiny, with a full-time population of roughly 50. Its narrow, medieval streets are quickly crowded with tourists, who, shoulder to shoulder, four or five thick, mill about like subway commuters at rush hour along the main street, which is nonstop cafes, hotels, restaurants and shops, selling every kind of souvenir imaginable: key rings, paperweights, potholders, T-shirts, bowls, cups, postcards, caps, pencils, dishes, place mats. The food is mostly bad and overpriced. Almost every other place bears the name La Mere Poulard, the town's most famous restaurant and the flagship business of Eric Vannier, the former mayor (he just stepped down) and the island's biggest businessman. Along with numerous hotels and restaurants, he has started a successful brand of Mere Poulard biscuits, cakes and cookies. The brand is so ubiquitous in Mont-Saint-Michel that Vannier is widely, and usually not affectionately, known as Mayor Poulard, which in French (Maire Poulard) sounds almost exactly like Mere Poulard. The omelettes at La Mere Poulard cost between €24 and €49 ($33 to $68). It must be quite an omelette.

Among its many meanings, Mont-Saint-Michel is the goose that laid the golden egg. Designated a World Heritage site by Unesco, Mont-Saint-Michel has between 2.4 and 2.8 million visitors per year. With each tourist leaving behind about $25, that means an annual flow of some $63 million into a tiny town of 247 acres, about one-third of a square mile. The French state has 99 official national monuments. "Five sites pay for the upkeep of the other 94," explains Jean-Marc Boure, the former administrator of the historic site of the abbey. And yet only 1.2 million of the 2.4 million to 2.8 million visitors actually take the trouble to visit the abbey, which is at the top of Mont-Saint-Michel. The other 1.2 million to 1.6 million are spending their time and money in the shops and restaurants, as well as four "historical museums," cheesy establishments with wax figures emphasizing the more lurid aspects of the local history with a heavy emphasis on the prison and the more brutal forms of torture once practiced there. Three of these museums are owned by the former Mayor Poulard. When Boure proposed allowing tourists to buy tickets to the abbey down at the parking area or at the foot of Mont-Saint-Michel, Vannier helped block the initiative.

In some ways, the trip to the top offers a modern version of the medieval journey through life – a kind of Divine Comedy. The way up is demanding: One must pass through the tourist hell of the town below and make one's way up the increasingly steep ascent to the abbey, where many must pause to catch their breath after one or other of a seemingly infinite set of stairs. As one ascends, the crowd thins, discouraged by the demanding climb, the lack of shops and cafes, or simply held in thrall by the distractions below. Suddenly, as one approaches the top, the views open up – the horizon widens; one can see the immense and gorgeous bay; the sand and water glisten in the sun. There is quiet other than the occasional cries of seabirds.

The climb is well worth the effort. The abbey is one of the great living expressions of European medieval architecture. The builders' genius was called forth by the extreme difficulties of constructing a massive complex on the narrow summit of a jagged piece of granite rock some 260 feet up above the sea. Had the abbey been built on flat ground, it would no doubt have been a large, horizontal complex of buildings with a church, courtyards, cloisters and so forth all on the same level. Instead, there was not enough room for a large church on the top of the mountain. But rather than build a small one, they built into the side of the mountain an ingenious, massive structure on three levels. The church – appropriately – sits atop the whole structure, opening onto a terrace with amazing views. But only about half of it sits solidly on rock; the other half, called the choir, is perched somewhat perilously on top of the two levels of buildings below.

The original building held up for about 400 years, from the time of William the Conqueror in the 1050s until about 1420, when its massive Norman pillars crashed down into the monks' dormitory below, fortunately killing no one. And so, all that is left of the original church is three gorgeous sculpted Norman columns, whose graceful, sober simplicity and strength are the architectural equivalent of the army of 40,000 knights with which its patron, William the Conqueror, crossed the English Channel and conquered England. The choir was rebuilt in the late 1400s in a different style that the French call gothique flamboyant (flamboyant Gothic), with high, slender, delicately carved arches and tall bays of stained glass windows that flood the front of the church with light.

Although separated by nearly half a millennium, the two halves of the church seem remarkably harmonious. It is only after a while, and perhaps a guided tour, that one becomes aware that they are quite different. As Henry Adams wrote: "Although the two structures are some five hundred years apart, they live pleasantly together. … The choir is charming – far more charming than the nave, as the beautiful woman is more charming than the elderly man."

Just beyond the choir is the magnificent thirteenth-century, three-story structure built into the steep northern slope of the Mont known as La Merveille (the Marvel). It contains a gorgeous

cloister with a double row of delicately carved arches and a refectory where the powerful abbots once entertained and where (in Henry Adams' account) jongleurs would have recited The Song of Roland for the entertainment of the assembled company. Underneath is a handsome and well-lit room that served as the abbey's scriptorium, where monks copied manuscripts, for the abbey's famous library. In the cellar is an enormous wooden wheel that served, among other things, as a winch to haul water and other supplies up the north side of the Mont. It is sobering to recall that virtually all of the stone and building materials were brought here by boat, much of it hauled up from the sea by rope. The vast cavernous lower depths of the abbey complex also served as a prison. Even as early as the fifteenth century, the kings of France supposedly sent prisoners here. According to our tour guide, some prisoners spent their days turning the massive wheel to haul goods up to the abbey.

Today, the abbey is shared by something of an Odd Couple pair of occupants: the very secular French state, in the form of the administrator in charge of Mont-Saint-Michel as a national monument, and the Monastic Fraternity of Jerusalem, a French religious order that has occupied the abbey since 2001 and pays a nominal rent to the government. For the most part, the two get along. But the state has an economic interest in getting as many people as possible to take the official tour through the abbey (€9, or $12) as well as use the site for concerts and cultural events; the monks and nuns view the abbey as a religious setting, and no tours are conducted during religious services, which occur three times a day.

The fraternity rents a couple of guesthouses to pilgrims who come on retreat. It was here that I stayed during a weekend spiritual retreat. The demands of the retreat were not especially onerous. I and my fellow participants were free to come and go as we pleased. We were encouraged to attend the three religious services with the brothers and sisters each day and to share a modest meal in their refectory. I skipped the morning service two of the three days but attended the afternoon and evening services and ate with the monks.

Even so, the monastic life seemed a very challenging one. The monks' and nuns' day was long and arduous, getting up at 5:30 for an hour of silent prayer before the morning service at 7 on weekdays – an hour later on weekends. After the service, the two groups ate separately (except on very special occasions), each in their own refectories with a few outside guests. Conversation was strictly forbidden in the dining room and at first it seemed rather lonely to be in this spartan refectory – each eating his humble repast while inside his own world of thoughts or prayers. The monks were friendly and kind in the limited moments when conversation was possible – right after Mass or after we had left the dining room. On Saturday, we took coffee out in a little garden with marvelous views of the bay, and the monks chatted amiably. But conversation is highly circumscribed by the extreme rigor of their lives. When I asked Brother Lauren-Nicholas, the monk who was in charge of the guesthouse, what life path had brought him to the religious order, he politely but firmly rebuffed the question: "Since I have not shared my personal journey even with my brothers here, I am afraid I will have to keep that to myself," he said, but then added with a smile, not wanting to offend: "What matters is the present."

Life at the abbey appears to be entirely divorced from the touristic hubbub of the town below. Brother Lauren-Nicholas half-jokingly refers to the worship of Mammon going on at the bottom of the hill.

The small community of people who live between the abbey and the shops feel angry and betrayed by the changes taking place in and around Mont-Saint-Michel. "This whole project has been driven by the idea of turning Mont-Saint-Michel into a picture postcard – the island with water around it – and not a place where people actually live," says Jean-Yves Lebrec, whose old family home sits halfway up the hill to the abbey. Outside his house is a large banner with the words "Stop the Massacre of the Rock!" It refers to a large concrete platform cut out

of the rock for emergency vehicles. The platform was required as a matter of public safety by the French government, necessitated, somewhat ironically, by another feature of the plan, a ford that will be submerged in water at the very highest tides. The feature was visually appealing but created a potentially dangerous situation: tourists needing medical attention being unable to leave the island. (Amphibious emergency vehicles can still travel between the island and mainland at all times.) "And so," Lebrec continues, "they are actually damaging the thing they are supposed to be preserving: Le Mont!'

"Life here has become impossible," says Geraldine Faguais-Ridel, owner of a small souvenir shop and a member of the municipal council. "We feel as if we have been taken hostage by forces that have not taken our lives into consideration at all." The parking lot that had allowed residents to drive back and forth to fetch groceries or supplies has been eliminated. They are now forced to take shuttle buses, often walking with their bundles in the cold and rain. Weather on the Normandy coast is blustery and wet. The new shuttle bus stop was originally placed nearly a kilometer from the new mainland parking lot, making daily life a mess for people working or living on the island.

It did not escape people's notice that the placement of the shuttle stop forced tourists to walk past establishments owned by Vannier, the businessman and former mayor, and bypassed the shops and restaurants of one of his chief rivals. Vannier was taken to court and fined €30,000 ($41,000). (He is appealing the case.)

The shuttles now drop passengers off closer to the island. At the continent end of the route, the shuttle bus stop was also moved closer to the parking lot. The daily parking fee increased from €8.5 to €12 (about $17), a rather hefty sum for a few hours of parking in rural Normandy. (The workers at the abbey staged a three-week strike last year to protest the rising costs.) Even with the improved shuttle service it still takes a good half-hour to travel the three kilometers from town to the parking lot.

That Mont-Saint-Michel has been transformed from a town into a kind of medieval stage set is demonstrated by one of ex-mayor Vannier's latest commercial strokes of genius: a business that puts on mock Western weddings for Japanese tourists. The former mayor's maitre d'hotel dons the garb of a priest and performs these ceremonies for couples dressed up in Western wedding garb; then they are photographed and filmed feeding each other cake in front of the medieval walls. The idea seemed too preposterous to be true. But there it was – a small office nestled underneath one of Vannier's other businesses in town – Les Terrasses Poulard. No customers were around when I visited in late October – not wedding season – but there was a friendly Japanese office manager, a mannequin of a bride wearing a Western-style wedding dress and a flat-screen TV playing the video of a Japanese couple's "wedding" at Mont-Saint-Michel. The couples are generally not Christian and they are married legally back in Japan, the young woman explained. Holding a wedding ceremony – or having the video of a wedding ceremony – in Mont-Saint-Michel holds real cachet back in Japan, she said. "Japanese have very short vacations, usually a week, and so they have enough time for two things, Paris and Mont-Saint-Michel."

While this might seem to signal the ultimate decline of Mont-Saint-Michel, it is important to remember that the island has had many low moments. According to my official guide, when the prison was in full swing, one man was kept for more than 20 years in a cage too small to allow him either to lie down or stand up. Compared with this, the fake Japanese weddings appear a little less dreadful. And to help put the current local discontent in perspective, Pere Andre, parish priest of the Church of Saint Pierre, said the merchants of Mont-Saint-Michel protested when France closed the prison in 1863. The townsfolk did a lively business in providing food and lodgings for the family members of the prisoners who came to visit their loved ones.

In many ways, to appreciate Mont-Saint-Michel you must leave it. The atmosphere of the town – with its wall-to-wall tourism and fierce internecine political and commercial antagonisms – quickly becomes claustrophobic. What makes Mont-Saint-Michel so extraordinary is not just its architecture: It's the architecture placed in an equally extraordinary natural site. The coming and going of the tide – the constant play of light on the water, on the glistening wet sand – means that Mont-Saint-Michel always looks different. One understands a bit how its spectacular rise from the sea reaching to the sky made Mont-Saint-Michel appear to some pilgrims like the new Jerusalem, a kind of heaven on earth to which they were drawn. Its majestic architectural palimpsest dominates the coastline of this part of Normandy and can be seen at a great distance inland. You can see it already from the highway; it seems to follow you over your shoulder when you drive between Normandy and Brittany.

Perhaps the best part of the current renovation project – and of the few parts that are finished – is a dam built near where the Couesnon River meets the sea just in front of Mont-Saint-Michel. Rather than hold the river water in, the new dam opens up to let the sea water enter at high tide and then releases it again at low tide in order to push water and sand out, relieving the buildup of silt around the Mont. Although the dam has a practical aim, its architect, Luc Weizmann, also used great sensitivity and imagination to create one of the nicest public spaces in and around Mont-Saint-Michel. He built an attractive wooden viewing platform as well. It has a perfect, unobstructed view of Mont-Saint-Michel, and the dramatic moment in which the dam opens and releases a rush of water (usually once or twice a day) has become a popular tourist attraction – about the only free one in Mont-Saint-Michel.

Subtly and poetically, the dam project offers both a mirror and a reading of Mont-Saint-Michel. Harnessing the power of the sea to preserve Mont-Saint-Michel mimics, Weizmann explains, what the original construction of Mont-Saint-Michel did and what the archangel Michael with his foot on the dragon represents: a kind of triumph over the forces of chaos and evil. The enormous steel wheels that open and close the dam were designed to resemble the huge wooden power wheel inside the ancient abbey. Weizmann placed a handsome border of bronze at the front of the viewing platform, which picks up the bronze of the massive bell of Mont-Saint-Michel, and he inscribed letters from Greek, Latin, Hebrew and Arabic alphabets in the bronze. Weizmann took the lettering in part from the rich manuscript collection of the abbey, which is now in the nearby town of Avranches. Weizmann knows there is no such thing as recreating an eighth-century or a fourteenth-century church – only a respectful twenty-first-century reimagining.

Weizmann is also aware that the water coming from his dam is only a tiny factor pushing against the larger forces of nature at work in the bay. Many are skeptical of the work being done now to preserve the Mont's "island character." The buildup of sand, accumulating every day, at Mont-Saint-Michel is the inevitable result of the powerful force of the sea. "The tide coming in is stronger than the tide going out," explains Patrick Desgues, the guide who leads me across the sandy marsh. "As a result, the tide leaves more sand than it carries away. So I don't see how this project can reverse that," he says as we walk across the beautiful claylike desert that forms as the sea recedes. In the background you can see a few pieces of earth-moving equipment – small against the horizon-working to encourage the water to flow back out on either side of Mont-Saint-Michel. Those human efforts seem puny in the face of the wide bay and the roiling sea.

"It's a race against time," admits Audrey Hemon, an engineer who works on the project, as we talk at the dam platform. The grassy patches in the sand have receded somewhat since the dam became operational, but no one knows whether the project will succeed in its ultimate goal: making sure that Mont-Saint-Michel will remain an island over the long term. "But we do know that if we do nothing, the shore will reach Mont-Saint-Michel."

19
Resonance and wonder

Stephen Greenblatt

[...] I propose to examine two distinct models for the exhibition of works of art, one centered on what I shall call resonance and the other on wonder. By *resonance* I mean the power of the displayed object to reach out beyond its formal boundaries to a larger world, to evoke in the viewer the complex, dynamic cultural forces from which it has emerged and for which it may be taken by a viewer to stand. By *wonder* I mean the power of the displayed object to stop the viewer in his or her tracks, to convey an arresting sense of uniqueness, to evoke an exalted attention.

I should say at once that the scholarly practice that I myself represent, a practice known as the new historicism, has distinct affinities with resonance; that is, my concern with literary texts has been to reflect upon the historical circumstances of their original production and consumption and to analyze the relationship between these circumstances and our own. I have tried to understand the intersecting circumstances not as a stable, prefabricated background against which the literary texts can be placed, but as a dense network of evolving and often contradictory social practices. We do not have direct, unmediated access to these practices; they are accessible to us through acts of interpretation not essentially different from those with which we apprehend works of art. If, in consequence, we lose the sense of reassuring solidity that an older historicism seemed to promise, we gain in recompense a far richer sense of the vital and dynamic nature of nonliterary expressions. The idea is not to find outside the work of art some rock onto which interpretation can be securely chained but rather to situate the work in relation to other representational practices operative in the culture at a given moment in both its history and our own. And we can begin to understand something of the dialectical nature of these relations. In Louis Montrose's convenient formulation, the goal has been to grasp simultaneously the historicity of texts and the textuality of history.

Insofar as this approach, developed for the interpretation of texts, is at all applicable to art museums—and this remains to be seen—it would reinforce the attempt to reduce the isolation of individual "masterpieces," to illuminate the conditions of their making, to disclose the history of their appropriation and the circumstances in which they come to be displayed, to restore the tangibility, the openness, the permeability of boundaries that enabled the objects to come into being in the first place. An actual restoration of tangibility is obviously in most cases impossible, and the frames that enclose pictures are only the ultimate formal confirmation of the closing of

Stephen Greenblatt

the borders that marks the finishing of a work of art. But we need not take that finishing so entirely for granted; museums can and on occasion do make it easier imaginatively to recreate the work in its moment of openness.

That openness is linked to a quality of artifacts that museums obviously dread, their precariousness. But though it is perfectly reasonable for museums to protect their objects (and I would not wish it any other way), precariousness is a rich source of resonance. Thomas Greene, who has written a sensitive book on what he calls the "vulnerable text," suggests that the symbolic wounding to which literature is prone may confer upon it power and fecundity. "The vulnerability of poetry," Greene argues, "stems from four basic conditions of language: its historicity, its dialogic function, its referential function, and its dependence on figuration."[1] Three of these conditions are different for the visual arts, in ways that would seem to reduce vulnerability: painting and sculpture may be detached more readily than language from both referentiality and figuration, and the pressures of contextual dialogue are diminished by the absence of an inherent *logos*, a constitutive word. But the fourth condition, historicity, is in the case of material artifacts vastly increased, indeed virtually literalized. Museums function, partly by design and partly in spite of themselves, as monuments to the fragility of cultures, to the fall of sustaining institutions and noble houses, the collapse of rituals, the evacuation of myths, the destructive effects of warfare, neglect, and corrosive doubt.

I am fascinated by the signs of alteration, tampering, and even deliberate damage that many museums try simply to efface: first and most obviously, the act of displacement that is essential for the collection of virtually all older artifacts and most modern ones—pulled out of chapels, peeled off church walls, removed from decayed houses, given as gifts, seized as spoils of war, stolen, or "purchased" more or less fairly by the economically ascendant from the economically naive (the poor, the hard-pressed heirs of fallen dynasties, and impoverished religious orders). Then, too, there are the marks on the artifacts themselves: attempts to scratch out or deface the image of the devil in numerous late-medieval and Renaissance paintings, the concealing of the genitals in sculptured and painted figures, the iconoclastic smashing of human or divine representations, the evidence of cutting or reshaping to fit a new frame or purpose, and the cracks, scorch marks, or broken-off noses that indifferently record the grand disasters of history and the random accidents of trivial incompetence. Even these accidents—the marks of a literal fragility—can have their resonance: the climax of an absurdly hagiographical Proust exhibition several years ago was a display case holding a small, patched, modest vase with a label that read, "This vase broken by Marcel Proust."

As this comical example suggests, wounded artifacts may be compelling not only as witnesses to the violence of history but as signs of use, marks of the human touch, and hence links with the openness to touch that was the condition of their creation. The most familiar way to recreate the openness of aesthetic artifacts without simply renewing their vulnerability is through a skillful deployment of explanatory texts in the catalogue, on the walls of the exhibition, or on cassettes. The texts so deployed introduce and in effect stand in for the context that has been effaced in the process of moving the object into the museum. But insofar as that context is partially, often primarily, visual as well as verbal, textual contextualism has its limits. Hence the mute eloquence of the display of the palette, brushes, and other implements that an artist of a given period would have employed, or of objects that are represented in the exhibited paintings, or of materials and images that in some way parallel or intersect with the works of art.

Among the most resonant moments are those in which the supposedly contextual objects take on a life of their own and make a claim rivaling that of the object that is formally privileged. A table, a chair, a map, often seemingly placed only to provide a decorative setting for a grand work, become oddly expressive, significant not as background but as compelling

representational practices in themselves. These practices may in turn impinge upon the grand work, so that we begin to glimpse a kind of circulation: the cultural practice and social energy implicit in map making are drawn into the aesthetic orbit of a painting that has itself enabled us to register some of the representational significance of the map. Or again, the threadbare fabric on the old chair or the gouges in the wood of a cabinet juxtapose the privileged painting or sculpture with marks not only of time but of use, the imprint of the human body on the artifact, and call attention to the deliberate removal of certain exalted aesthetic objects from the threat of that imprint.

The effect of resonance does not necessarily depend upon a collapse of the distinction between art and nonart; it can be achieved by awakening in the viewer a sense of the cultural and historically contingent construction of art objects, the negotiations, exchanges, swerves, and exclusions by which certain representational practices come to be set apart from other representational practices that they partially resemble. A resonant exhibition often pulls the viewer away from the celebration of isolated objects and toward a series of implied, only half-visible relationships and questions: How did the objects come to be displayed? What is at stake in categorizing them as "museum quality"? How were they originally used? What cultural and material conditions made possible their production? What were the feelings of those who originally held the objects, cherished them, collected them, possessed them? What is the meaning of the viewer's relationship to those same objects when they are displayed in a specific museum on a specific day?

It is time to give a more sustained example. Perhaps the most purely resonant museum I have ever seen is the State Jewish Museum in Prague. This is housed not in a single building but in a cluster of old synagogues scattered through the city's former Jewish town. The oldest of these, known as the Old-New Synagogue, is a twin-nave medieval structure dating to the last third of the thirteenth century; the others are mostly Renaissance and Baroque. In these synagogues are displayed Judaica from 153 Jewish communities throughout Bohemia and Moravia. In one there is a permanent exhibition of synagogue silverwork; in another there are synagogue textiles; in a third there are Torah scrolls, ritual objects, manuscripts, and prints illustrative of Jewish beliefs, traditions, and customs. One of the synagogues shows the work of the physician and artist Karel Fleischmann, principally drawings done in Terezin concentration camp during his months of imprisonment prior to his deportation to Auschwitz. Next door, in the Ceremonial Hall of the Prague Burial Society, there is a wrenching exhibition of children's drawings from Terezin. Finally, one synagogue, closed at the time of my visit to Prague, has simply a wall of names—thousands of them—to commemorate the Jewish victims of Nazi persecution in Czechoslovakia.

"The Museum's rich collections of synagogue art and the historic synagogue buildings of Prague's Jewish town," says the catalogue of the State Jewish Museum, "form a memorial complex that has not been preserved to the same extent anywhere else in Europe." "A memorial complex"—this museum is not so much about artifacts as about memory, and the form the memory takes is a secularized *Kaddish*, a commemorative prayer for the dead. The atmosphere has a peculiar effect on the act of viewing. It is mildly interesting to note the differences between the mordant Grosz-like lithographs of Karel Fleischmann in the prewar years and the tormented style, at once detached and anguished, of the drawings from the camps, but aesthetic discriminations feel weird, out of place. And it seems wholly absurd, even indecent, to worry about the relative artistic merits of the drawings that survive by children who did not survive.

The discordance between viewing and remembering is greatly reduced with the older, less emotionally charged artifacts, but even here the ritual objects in their glass cases convey an odd and desolate impression. The oddity, I suppose, should be no greater than in seeing an image of

a Mayan god or, for that matter, a pyx or a ciborium, but we have become so used to the display of such objects, so accustomed to considering them works of art, that even pious Catholics, as far as I know, do not necessarily feel disconcerted by their transformation from ritual function to aesthetic exhibition. And until very recently the voices of the peoples who might have objected to the display of their religious artifacts have not been heard and certainly not attended to.

The Jewish objects are neither sufficiently distant to be absorbed into the detached ethos of anthropological display nor sufficiently familiar to be framed and encased alongside the altarpieces and reliquaries that fill Western museums. And moving as they are as mnemonic devices, most of the ritual objects in the State Jewish Museum are not, by contrast with Christian liturgical art, particularly remarkable either for their antiquity or their extraordinary beauty. There are significant exceptions—for example, some exquisite seventeenth- and eighteenth-century textiles used as Torah curtains and binders—but on the whole the display cases are filled with the products of a people with a resistance to joining figural representation to religious observance, a strong if by no means absolute anti-iconic bias.[2] The objects have, as it were, little will to be observed; many of them are artifacts—ark curtains, Torah crowns, breastplates, finials, binders, pointers, and the like—the purpose of which was to be drawn back or removed in order to make possible the act that mattered: not viewing but reading.

But the inhibition of viewing in the State Jewish Museum is paradoxically bound up with its resonance. This resonance depends not upon visual stimulation but upon a felt intensity of names, and behind the names, as the very term *resonance* suggests, of voices: the voices of those who chanted, studied, muttered their prayers, wept, and then were forever silenced. And mingled with these voices are others—of those Jews in 1389 who were murdered in the Old-New Synagogue where they were seeking refuge, of the great sixteenth-century Kabbalist Jehuda ben Bezalel (who is known as Rabbi Loew and who is fabled to have created the golem), and of the twentieth century's ironic Kabbalist from Prague, Franz Kafka.

It is Kafka who would be most likely to grasp imaginatively the State Jewish Museum's ultimate source of resonance: the fact that most of the objects are located in the museum—were displaced, preserved, and transformed categorically into works of art—because the Nazis stored the articles they confiscated in the Prague synagogues that they chose to preserve for this very purpose. In 1941 the Nazi Hochschule in Frankfurt had established an Institute for the Exploration of the Jewish Question, which in turn had initiated a massive effort to confiscate Jewish libraries, archives, religious artifacts, and personal property. By the middle of 1942 Heydrich, as Hitler's chief officer in the so-called Protectorate of Bohemia and Moravia, had chosen Prague as the site of the Central Bureau for Dealing with the Jewish Question, and an SS officer, Untersturmführer Karl Rahm, had assumed control of the small existing Jewish museum, founded in 1912, which was renamed the Central Jewish Museum. The new charter of the museum announced that "the numerous, hitherto scattered Jewish possessions of both historical and artistic value, on the territory of the entire Protectorate, must be collected and stored."[3]

During the following months, tens of thousands of confiscated items arrived from Jewish communities in Bohemia and Moravia, the dates of the shipments closely coordinated with the deportation of their "donors" to the concentration camps. The experts formerly employed by the original Jewish museum were compelled to catalogue the items, and the Nazis compounded this immense task by also ordering the wretched, malnourished curators to prepare a collections guide and organize private exhibitions for SS staff. Between September 1942 and October 1943 four major exhibitions were mounted. Since these required far more space than was available in the existing Jewish Museum's modest location, the great old Prague synagogues, made vacant by the Nazi prohibition of Jewish public worship, were partially refurbished for the occasion.

Hence in March 1943, for example, in the seventeenth-century Klaus Synagogue, there was an exhibition of Jewish festival and life-cycle observances; "when Sturmbannführer Günther first toured the collection on April 6, he demanded various changes, including the translation of all Hebrew texts and the addition of an exhibit on kosher butchering."[4] Plans were drawn up for other exhibitions, but the curators—who had given themselves with a strange blend of selfless-ness, irony, helplessness, and heroism to the task—were themselves at this point sent to concen-tration camps and murdered.

After the war, the few survivors of the Czech Jewish community apparently felt they could not sustain the ritual use of the synagogues or maintain the large collections. In 1949 the Jewish Community Council offered as a gift to the Czechoslovak government both the synagogues and their contents. These became the resonant, impure "memorial complex" they are—a cultural machine that generates an uncontrollable oscillation between homage and desecration, longing and hopelessness, the voices of the dead and silence. For resonance, like nostalgia, is impure, a hybrid forged in the barely acknowledged gaps, the caesurae, between words such as *state, Jewish,* and *museum.*

I want to avoid the implication that resonance must be necessarily linked to destruction and absence; it can be found as well in unexpected survival. The key is the intimation of a larger community of voices and skills, an imagined ethnographic thickness. Here another example will serve: in the Yucatan there is an extensive, largely unexcavated late-Classic Mayan site called Coba, the principal surviving feature of which is a high pyramid known as Nahoch Mul. After a day of tramping around the site, I was relaxing in the pool of the nearby Club Med Archae-ological Villa in the company of a genial structural engineer from Little Rock. To make con-versation, I asked my pool-mate what he as a structural engineer thought of Nahoch Mul. "From an engineer's point of view," he replied, "a pyramid is not very interesting—it's just an enormous gravity structure. But," he added, "did you notice that Coca-Cola stand on the way in? That's the most impressive example of contemporary Mayan architecture I've ever seen." I thought it quite possible that my leg was being pulled, but I went back the next day to check; anxious to see the ruins, I had, of course, completely blocked out the Coke stand on my first visit. Sure enough, some enterprising Maya had built a remarkably elegant shelter with a soaring pyramidal roof constructed out of ingeniously intertwined sticks and branches. Places like Coba are thick with what Spenser called the "ruins of time"—a nostalgia for a lost civilization that was in a state of collapse long before Cortés or Montejo cut their violent paths through the jungle. But, despite frequent colonial attempts to drive them or imagine them out of existence, the Maya have not in fact vanished, and a single entrepreneur's architectural improvisation suddenly had more resonance for me than the mounds of the "lost" city.

My immediate thought was that the whole Coca-Cola stand could be shipped to New York and put on display in the Museum of Modern Art. It is that kind of impulse that moves us away from resonance and toward wonder. For MOMA is one of the great contemporary places not for the hearing of intertwining voices, not for historical memory, not for ethnographic thick-ness, but for intense, indeed enchanted looking. Looking may be called enchanted when the act of attention draws a circle around itself from which everything but the object is excluded, when intensity of regard blocks out all circumambient images, stills all murmuring voices. To be sure, the viewer may have purchased a catalogue, read an inscription on the wall, or switched on a cassette player, but in the moment of wonder all of this apparatus seems mere static.

The so-called boutique lighting that has become popular in recent years—a pool of light that has the surreal effect of seeming to emerge from within the object rather than to focus upon it from without—is an attempt to provoke or heighten the experience of wonder, as if modern

museum designers feared that wonder was increasingly difficult to arouse or perhaps that it risked displacement entirely onto the windows of designer dress shops and antiques stores. The association of that kind of lighting with commerce would seem to suggest that wonder is bound up with acquisition and possession, yet the whole experience of most art museums is about *not* touching *not* carrying home, *not* owning the marvelous objects. Modern museums in effect at once evoke the dream of possession and evacuate it.[5] (Alternatively, we could say that they displace that dream onto the museum gift shop, where the boutique lighting once again serves to heighten the desire for acquisition, now of reproductions that stand for the unattainable works of art.)

That evacuation is a historical rather than structural aspect of the museum's regulation of wonder: that is, collections or displacement of objects calculated to arouse wonder arose precisely in the spirit of personal acquisition and were only subsequently displaced from it. In the Middle Ages and the Renaissance we characteristically hear about wonders in the context of those who possessed them (or who gave them away). Hence, for example, in his *Life of Saint Louis*, Joinville writes that "during the king's stay in Saida someone brought him a stone that split into flakes":

> It was the most marvellous stone in the world, for when you lifted one of the flakes you found the form of a sea-fish between the two pieces of stone. This fish was entirely of stone, but there was nothing lacking in its shape, eyes, bones, or colour to make it seem otherwise than if it had been alive. The king gave me one of these stones. I found a tench inside; it was brown in colour, and in every detail exactly as you would expect a tench to be.[6]

The wonder-cabinets of the Renaissance were at least as much about possession as display. The wonder derived not only from what could be seen but from the sense that the shelves and cases were filled with unseen wonders, all the prestigious property of the collector. In this sense, the cult of wonder originated in close conjunction with a certain type of resonance, a resonance bound up with the evocation not of an absent culture but of the great man's superfluity of rare and precious things. Those things were not necessarily admired for their beauty; the marvelous was bound up with the excessive, the surprising, the literally outlandish, the prodigious. They were not necessarily the manifestations of the artistic skill of human makers: technical virtuosity could indeed arouse admiration, but so could nautilus shells, ostrich eggs, uncannily large (or small) bones, stuffed crocodiles, and fossils. And, most important, they were not necessarily objects set out for careful viewing.

The experience of wonder was not initially regarded as essentially or even primarily visual; reports of marvels had a force equal to the seeing of them. Seeing was important and desirable, of course, but precisely in order to make possible reports, which then circulated as virtual equivalents of the marvels themselves. The great medieval collections of marvels are almost entirely textual; Friar Jordanus's *Marvels of the East*, Macro Polo's *Book of Marvels*, Mandeville's *Travels*. Some of the manuscripts, to be sure, were illuminated, but these illuminations were almost always ancillary to the textual record of wonders, just as emblem books were originally textual and only subsequently illustrated. Even in the sixteenth century, when the power of direct visual experience was increasingly valued, the marvelous was principally theorized as a textual phenomenon, as it had been in antiquity. "No one can be called a poet," wrote the influential Italian critic Minturno in the 1550s, "who does not excel in the power of arousing wonder."[7] For Aristotle wonder was associated with pleasure as the end of poetry, and in the *Poetics* he examines the strategies by which tragedians and epic poets employ the marvelous to arouse wonder. For the Platonists, too, wonder was conceived as an essential element in

270

literary art: in the sixteenth century, the Neoplatonist Francesco Patrizi defined the poet as principal "maker of the marvelous," and the marvelous is found, as he put it, when men "are astounded, ravished in ecstasy." Patrizi goes so far as to posit marveling as a special faculty of the mind, a faculty that in effect mediates between the capacity to think and the capacity to feel.[8]

By the later Renaissance these humanistic ideas had begun to influence visual display, so that the ruler's magnificence was increasingly associated with not only possessing but showing wonders. Hence in Prague, in the late sixteenth century, Rudolf II ordered significant reconstruction of the imperial palace in order to provide a suitable setting for his remarkable collections. "The emperor's possession of a *Kunstkammer*, the world in microcosm," writes Thomas Kaufmann, "expressed his symbolic mastery of the world."[9] That mastery would be displayed and reinforced in the wonder experienced by those allowed to enter the specially designed rooms. But as admission was limited to visiting dignitaries and ambassadors, the large-scale cultural power of the marvelous remained even in this instance heavily invested in textual transmission; it was the diplomat's report on the wonder of things seen that would enhance the emperor's prestige.

Modern art museums reflect a profound transformation of the experience: the collector—a Getty or a Mellon—may still be celebrated, and market value is even more intensely registered, but the heart of the mystery lies with the uniqueness, authenticity, and visual power of the masterpiece, ideally displayed in such a way as to heighten its charisma, to compel and reward the intensity of the viewer's gaze, to manifest artistic genius. Museums display works of art in such a way as to imply that no one, not even the nominal owner or donor, can penetrate the zone of light and actually possess the wonderful object. Hence the modern museum paradoxically intensifies both access and exclusion. The treasured object exists not principally to be owned but to be viewed. Even the fantasy of possession is no longer central to the museum gaze, or rather it has been inverted, so that the object in its essence seems not to be a possession but rather to be itself the possessor of what is most valuable and enduring.[10] What the work possesses is the power to arouse wonder, and that power, in the dominant aesthetic ideology of the West, has been infused into it by the creative genius of the artist.

It is beyond the scope of this brief paper to account for the transformation of the experience of wonder from the spectacle of proprietorship to the mystique of the object—an exceedingly complex, over-determined history centering on institutional and economic shifts—but I think it is important to say that this transformation was shaped at least in part by the collective project of Western artists and reflects their vision. Already in the early sixteenth century, when the marvelous was still principally associated with the prodigious, Dürer begins, in a famous journal entry describing Mexican objects sent to Charles V by Cortés, to reconceive it:

> I saw the things which have been brought to the King from the new golden land: a sun all of gold a whole fathom broad, and a moon all of silver of the same size, also two rooms full of the armour of the people there, and all manner of wondrous weapons of theirs, harness and darts, wonderful shields, strange clothing, bedspreads, and all kinds of wonderful objects of various uses, much more beautiful to behold than prodigies. These things were all so precious that they have been valued at one hundred thousand gold florins. All the days of my life I have seen nothing that has gladdened my heart so much as these things, for I saw amongst them wonderful works of art, and I marvelled at the subtle *ingenia* of men in foreign lands [*Dann ich hab darin gesehen wunderliche künstliche ding und hab mich verwundert der subtilen ingenia der meuschen in freinbden landen*]. Indeed, I cannot express all that I thought there.[11]

Stephen Greenblatt

Dürer's description is full of the conventional marks of his period's sense of wonder: he finds it important that the artifacts have been brought as a kind of tribute to the king, that large quantities of precious metals have been used, and that their market value has been reckoned; he notes the strangeness of them, even as he uncritically assimilates that strangeness to his own culture's repertory of objects (which includes harnesses and bedspreads). But he also notes, in perceptions highly unusual for his own time, that these objects are "much more beautiful to behold than prodigies" (*das do viel schöner an zu sehen ist dan wunderding*). Dürer thus relocates the marvelous artifacts from the sphere of the outlandish to the sphere of the beautiful, and, crucially, he understands their beauty as a testimony to the creative genius of their makers: "I saw amongst them wonderful works of art, and I marvelled at the subtle *ingenia* of men in foreign lands."[12]

It would be misleading to strip away the relations of power and wealth that are encoded in the artist's response, but it would be still more misleading, I think, to interpret that response as an unmediated expression of those relations. For Dürer stands at an early stage of the West's evolution of a categorical aesthetic understanding—a form of wondering and admiring and knowing—that is at least partly independent of the structures of politics and the marketplace.

This understanding, by no means autonomous and yet not reducible to the institutional and economic forces by which it is shaped, is centered on a certain kind of looking, the origins of which lie in the cult of the marvelous and hence in the artwork's capacity to generate in the spectator surprise, delight, admiration, and intimations of genius. The knowledge that derives from this kind of looking may not be very useful in the attempt to understand another culture, but it is vitally important in the attempt to understand our own. For it is one of the distinctive achievements of our culture to have fashioned this type of gaze, and one of the most intense pleasures that it has to offer. This pleasure does not have an inherent and necessary politics, either radical or imperialist, but Dürer's remarks suggest that it derives at least in part from respect and admiration for the *ingenia* of others. This respect is a response worth cherishing and enhancing. Hence, for all of my academic affiliations and interests, I am skeptical about the recent attempt to turn our museums from temples of wonder into temples of resonance.

Perhaps the most startling instance of this attempt is the transfer of the paintings in the Jeu de Paume and the Louvre to the new Musée d'Orsay. The Musée d'Orsay is at once a spectacular manifestation of French cultural *dépense* and a highly self-conscious, exceptionally stylish generator of resonance, including the literal resonance of voices in an enormous vaulted railway station. By moving the Impressionist and Post-Impressionist masterpieces into proximity with the work of far less well known painters—Jean Béraud, Guillaume Dubuffe, Paul Sérusier, and so forth—and into proximity as well with the period's sculpture and decorative arts, the museum remakes a remarkable group of highly individuated geniuses into engaged participants in a vital, immensely productive period in French cultural history. The reimagining is guided by many handsomely designed informational boards—cue cards, in effect—along, of course, with the extraordinary building itself.[13]

All of this is intelligently conceived and dazzlingly executed—on a cold winter day in Paris I looked down from one of the high balconies by the old railway clocks and was struck by the evocative power of the swirling pattern formed by the black and gray raincoats of the spectators milling below, passing through the openings in the massive black stone partitions of Gay Aulenti's interior. The pattern seemed spontaneously to animate the period's style—if not Manet, then at least Caillebotte; it was as if a painted scene had recovered the power to move and to echo.

But what has been sacrificed on the altar of cultural resonance is visual wonder centered on the aesthetic masterpiece. Attention is dispersed among a wide range of lesser objects that collectively articulate the impressive creative achievement of French culture in the late nineteenth century, but the experience of the old Jeu de Paume—intense looking at Manet, Monet,

272

Cézanne, and so forth—has been radically reduced. The paintings are there, but they are mediated by the resonant contextualism of the building itself, its myriad objects, and its descriptive and analytical plaques. Moreover, many of the greatest paintings have been demoted, as it were, to small spaces where it is difficult to view them adequately—as if the design of the museum were trying to assure the triumph of resonance over wonder.

But is a triumph of one over the other necessary? For the purposes of this paper, I have obviously exaggerated the extent to which these are alternative models for museums: in fact, almost every exhibition worth viewing has elements of both. I think that the impact of most exhibitions is likely to be enhanced if there is a strong initial appeal to wonder, a wonder that then leads to the desire for resonance, for it is generally easier in our culture to pass from wonder to resonance than from resonance to wonder. In either case, the goal—difficult but not utopian—should be to press beyond the limits of the models, cross boundaries, create strong hybrids. For both the poetics and the politics of representation are most completely fulfilled in the experience of wonderful resonance and resonant wonder.

Notes

1 Thomas Greene, *The Vulnerable Texts Essays on Renaissance Literature* (New York: Columbia University Press, 1986), 100.
2 My view of these Jewish artifacts was eloquently disputed in Washington by Anna R. Cohn, one of the organizers of The Precious Legacy, a traveling museum exhibition of Judaic objects from the State Jewish Museum. I am grateful for Ms Cohn's intervention and wish to emphasize that I am only calling attention to what I regard as a *relative* difference between liturgical art in the Jewish and Christian traditions.
3 Quoted in Linda A. Altshuler and Anna R. Cohn, "The Precious Legacy," in David Altshuler, ed., *The Precious Legacy: Judaic Treasures from the Czechoslovak State Collections* (New York: Summit, 1983), 24. My sketch of the genesis of the State Jewish Museum is largely paraphrased from this important and moving account.
4 Altschuler and Cohn, "Precious Legacy," 36.
5 In effect, that dream of possessing wonder is at once aroused and evacuated in commerce as well, since the minute the object (shoe or dress or soup tureen) is removed from its magical pool of light, it loses its wonder and returns to the status of an ordinary purchase.
6 Jean de Joinville, *Life of Saint Louis*, in *Chronicles of the Crusades*, trans. M.R.B. Shaw (Harmondsworth: Penguin, 1963), 315.
7 Quoted in J. V. Cunningham, *Woe or Wonder: The Emotional Effect of Shakespearian Tragedy* (Denver: Alan Swallow, 1960 [1951]), 82.
8 Baxter Hathaway, *Marvels and Commonplaces: Renaissance Literary Criticism* (New York: Random House, 1968), 66–69.
9 Thomas da Costa Kaufmann, *The School of Prague: Painting at the Court of Rudolf II* (Chicago: University of Chicago Press, 1988), 17.
10 It is a mistake, then, to associate the gaze of the museumgoer with the appropriative male gaze about which so much has been written recently. But then I think that the discourse of the appropriative male gaze is itself in need of considerable qualification.
11 Quoted in Hugh Honour, *The New Golden Land: European Images of America from the Discoveries to the Present Time* (New York: Pantheon, 1975), 28. The German original is in Albrecht Dürer, *Schriftlicher Nachlass*, ed. Hans Rupprich (Berlin: Deutscher Verein für Kunstwissenschaft. 1956), 1:155.
12 Dürer's own words, "*wunderliche künstliche ding*," carefully balance the attribute of wonder and the attribute of artfulness.
13 It could be argued that the resonance evoked by the Musée d'Orsay is too celebratory and narrow. The cue cards tend to exalt French culture at the expense not only of individual genius but of society; that is, while the cards help the reader grasp the vitality of collective genres and styles in this period, they say very little about the conflicts, social divisions, and market forces that figured in the history of the genres and the development of the styles. But even if the cards were "improved" ideologically, the overwhelming meaning of the museum experience would, I think, remain fundamentally the same.

20
'Introduction' to *In Search of Authenticity: The Formation of Folklore Studies*

Regina Bendix

There are certain terms that have a peculiar property. Ostensibly, they mark off specific concepts that lay claim to a rigorously objective validity. In practice, they label vague terrains of thought that shift or narrow or widen with the point of view of whoso makes use of them, embracing within their gamut of significances conceptions that not only do not harmonize but are in part contradictory.

Edward Sapir (1951 [1924]: 308)

[Authenticity] is a reflexive term; its nature is to be deceptive about its nature.

Carl Dahlhaus (1967: 57)

Born originals, how comes it to pass that we die copies?

Edward Young (cited after Boni 1982: 1)

As we approach the year 2000, the world is saturated by things and experiences advertising their authenticity. Dwellings are furnished with certified antiques and clothes made of genuine fabrics. We can dine in restaurants proclaiming the purest culinary heritage or eat canned goods labeled "authentic." Classical concerts distinguish themselves with original instrumentation, while rock idols struggle to maintain the legacy of raw sound and experience. As tourists, we can choose between a cruise to the last real headhunters, a stroll through the back alleys of famous places in search of the hidden authenticities of everyday life, and the opportunity to witness authentic belief experiences among parishioners in Harlem's churches. For all of our senses and all of our experiential cravings, we have created a market of identifiable authenticities.[1]

Recent decades have seen an interest, if not delight, in imitation as well. Museums—traditionally the locus for exhibiting the authentic—have mounted special exhibits of the fake.[2] Popular phenomena, such as Elvis look-alike contests and Karaoke singing, attest to a fascination with achieving the perfect copy, undermining the original in the very effort of striving to be just like it. By submitting to the same processes of representation and commodification those things that were proclaimed to be opposites, the genuine and the spurious are converging, their identities separable only by their narratives (Baudrillard 1994:9). The movie *The Adventures of Priscilla, Queen of the Desert* (1994) shows drag queens in the Australian outback performing as and

'Introduction' to *In Search of Authenticity*

lip-synching the female lead singers of the Swedish band ABBA. In doing so, they realize Clifford Geertz's observation, "it is the copying that originates" (Geertz 1986: 380).

Until recent years the commodification of the authentic so evident in present-day advertising remained outside the orbit of academic disciplines devoted to aspects of culture. Such disciplines originated at the same time as the Western world transformed itself from feudal to democratic, capitalistically driven states. The university was conceptualized as a place where the components of an ideal culture were researched and inculcated into the new economic and political power— the bourgeoisie (Readings 1996: 62–88). Authenticity was a core ingredient of this idealistic project. In formulating the contours of this ideal culture, what lay outside its boundaries had to be inauthentic. At best, the inauthentic held the status of being unworthy of scholarly attention; at worst, it was decried as an agent spoiling or harming the carefully cultivated, noble ideal. The canons of the cultural disciplines, such as literary and language studies, music, art history, and ethnology, thus originated with a strong commitment to understand, restore, and maintain the genuine.

During the past few decades, however, these same fields have increasingly realized the problems inherent in their ideals. Art history has begun to scrutinize its canon and, in dialogue with other fields, is paying attention to the ideologies informing exhibition.[3] Music has come to question its systems of exclusion and authentification in music history and performance.[4] Linguistics remembers the commitment to original language in its foundational scholarship and considers the original's resonance in the current politics of language around the globe.[5] In anthropology, folklore, and history, discoveries of invented traditions, fraudulent tribes, and nationalistic imaginations undermined notions of cultural authenticity while fueling studies devoted to such politics of culture.

To reconcile this tension, scholars have begun to study their own cultures of inquiry, deconstructing the ways their disciplinary subject was constituted historically and examining the mechanisms and strategies through which authoritative knowledge is produced. Not least as a result of the problems gradually surrounding its central concept—culture—anthropology has developed an unusually varied historiography of its field. The project of deconstructing ethnography as idea and method, initiated by Rabinow (1977) and launched fully through the essays assembled in Clifford and Marcus (1986), has profoundly marked American cultural anthropology. George Stocking, through his own research and as editor of the *History of Anthropology*, has provided an unprecedented view into the ways of anthropological knowledge-making (e.g., Stocking 1968; Stocking, ed., 1983, 1985, 1986). The current growth of the history and sociology of science as a discipline of its own is indicative of knowledge-makers' need to develop a sense of the changing nature and legitimation of fields of learning.

This study contributes to such efforts, using folklore studies as one specific example within the burgeoning inquiries that contribute to the study of culture. Using a comparative approach, I examine this field as it evolved in German-speaking Europe and the United States. German *Volkskunde* is arguably the oldest version of folklore studies, while American folkloristics reached disciplinary coherence only in the middle of the twentieth century. Early American institutions of higher learning also modeled themselves to an extent on the German pattern. A number of important individuals within folklore and other fields built intellectual bridges to, or articulated clear departures from, Germanic intellectual practice in the formative stages of their fields. The differences and continuities regarding authenticity between the two cases are instructive, for despite different cultural and chronological contexts, the notion of authenticity legitimated folklore as a discipline in both countries.

Folklore's history and current predicament are revealing beyond disciplinary boundaries. Folklore's broad subject defies definition, but it has continually attracted attention from the

275

entire spectrum of cultural disciplines that are implicated in the very interdisciplinary structure of the field.[6] Despite the field's heterogeneity, the effort to invoke disciplinary contours has been a constant—necessitated in part because clearly defined disciplines are institutionally privileged. This study details why and how facets of culture were isolated and reined in to constitute a disciplinary subject—a process that occurs in all fields claiming parts of culture as their core, from early anthropology and philology to the present plethora of area and ethnic studies. Authenticity, I argue, was variously used as an agent to define this subject, differentiate it from other cultural manifestations, develop methods of analysis, critique competing theories, or create new paradigms. Cultural scholarship and inquiry, furthermore, fueled societal interest in cultural fragments and cultural wholes, becoming one force in the "artifactualization" of facets of culture (Stewart 1991a). In doing so, scholarship prepared the way for the vibrant market and politics in commodified cultural authenticities, which, in turn, are becoming the new disciplinary subject. Dismantling the role of authenticity in this process explains the emergence during recent years of reflexivity in the scholarly habitus.

More than half a century ago Walter Benjamin characterized the contingent, elusive nature of authenticity through an analysis of art in the age of mechanical reproduction: "Precisely because authenticity cannot be reproduced, the arrival of certain techniques of reproduction … has provided the means to differentiate levels of authenticity" (1963: 52, n. 3). Benjamin located art before mechanical reproduction in the realm of cult, irresistible to worshippers through its aura—the appearance of an inaccessible remoteness brought into material proximity. Reproduction reduces aura, and in turn such "secularization affords authenticity the place previously held by cult value" (1963: 53, n. 8).

As secularization reduced the aura and cult status of art, so, too, did knowledge lose its divine status since knowledge was increasingly made by reason and empirical proof and was taught to ever-wider circles of learners. To maintain the linkage to divinity, authenticity in ever-changing guises became at once the goal and cement of cultural knowledge—the origin and essence of being human.

Yet until recent years the word authenticity and the role that the term has played largely escaped critical scrutiny, with the notable exception of Lionel Trilling's *Sincerity and Authenticity* (1972).[7] Fields such as ethnology and anthropology, philology, and disciplines devoted to national literatures and cultural histories emerged and evolved concurrently with political and economic interests in cultural, ethnic, and racial traits, occasioned by Western exploration, by the encounter with heretofore unknown peoples, and by the subsequent desire to colonize them. The rhetoric of authenticity permeated and at times intertwined disciplinary and political constructions. It is the recognition of this entanglement that has made reflexive scholarship of the present so excessively self-aware that disciplinary continuity today is either jeopardized or seems feasible only with ironic distance.

… by laying bare the intertwining of moral and practical dimensions in the uses of authenticity in German *Volkskunde* and American folkloristics, I intend to affirm the responsibility and accountability that scholarship entails. George Stocking observed that anthropology as a system of inquiry was "itself constrained—some might say systematically structured—by the ongoing and cumulative historical experience of encounters and comprehensions between Europeans and 'others.' " His history of anthropology thus encompasses the disciplinary accomplishments "against the backdrop of historical experience and cultural assumption that has provoked and constrained it, and which it in turn has conditioned" (1983: 5–6). A focus on the longing for authenticity filtered through folklore's history demonstrates the contribution of scholarship to the "authored nature of society and of ourselves within it" (Köstlin 1995: 274). Recognizing the mutual authoring of cultural and scholarly processes is not an absolution from continuing to

'Introduction' to *In Search of Authenticity*

contribute to such authoring. If this work assists in removing authenticity—in particular, its deceptive promises of transcendence—from the vocabulary of the emerging global script, its major purpose has been served.

The search for authenticity is fundamentally an emotional and moral quest. But this experiential dimension does not provide lasting satisfaction, and authenticity needs to be augmented with pragmatic and evaluative dimensions. Declaring something authentic legitimated the subject that was declared authentic, and the declaration in turn can legitimate the authenticator, though here such concerns as social standing, education, and the ability to promote one's views also play a role. Processes of authentication bring about material representations by elevating the authenticated into the category of the noteworthy. In the last decades of the twentieth century this process has accelerated exponentially, and so much has been declared authentic that the scarcity value is evaporating: once tomato sauce carries the label "authentic," the designation loses its special significance. The question of internalized authenticity—the authentic human experience, the exuberant search for the "soul of the people," as Herder called it—is a much more complex temptation, an attractive, troubling series of attempts to pinpoint the ineffable.

Folklore has long served as a vehicle in the search for the authentic, satisfying a longing for an escape from modernity. The ideal folk community, envisioned as pure and free from civilization's evils, was a metaphor for everything that was not modern. Equally relevant is folklore's linkage to politics, where authenticity bestows a legitimating sheen, with political change linked to modernity, affirmatively in revolutions, negatively in counterrevolutions. The most powerful modern political movement, nationalism, builds on the essentialist notions inherent in authenticity, and folklore in the guise of native cultural discovery and rediscovery has continually served nationalist movements since the Romantic era.

European nationalism was part of the effort to cast off monarchical government and establish democratic institutions. Yet the notion of national uniqueness harbors a conservative ethos of the past. Because of the insistence on national purity or authenticity inherent in the idea of a unique nation, the notion of authenticity ultimately undermines the liberating and humanitarian tendencies from which it grew. The universalist aspirations implicit in casting out the old order are contradicted by the particularist emphasis that each nation constructs to distinguish itself from all other nations. In emphasizing the authentic, the revolutionary can turn reactionary, a process all too vividly played out in global political movements of the late twentieth century.

The quest for authenticity is a peculiar longing, at once modern and antimodern. It is oriented toward the recovery of an essence whose loss has been realized only through modernity, and whose recovery is feasible only through methods and sentiments created in modernity. As such, it can be understood within the framework of reflexive modernization (Beck, Giddens, and Lash 1994). Coming to terms with the constructed and contingent, if not deceptive, nature of authenticity is the result of cognitive reflexivity; living in a capitalistically driven, mass-mediated world means to be surrounded by the mimetic products and enactments of aesthetic reflexivity (Lash 1994: 135–43).[8] The continued craving for experiences of unmediated genuineness seeks to cut through what Rousseau called "the wound of reflection," a reaction to modernization's demythologization, detraditionalization, and disenchantment.

In the discipline of folklore the idea of authenticity pervades the central terms and the canon of the field. It has contributed a vocabulary that, as the following chapters will demonstrate, has been of amazing durability despite changing theoretical paradigms. The authenticating claim through its subject matter was also a means through which folklorists have staked institutional claims.

The transformation from felt or experienced authenticity to its textual or material representation harbors a basic paradox. Once a cultural good has been declared authentic, the demand for it rises, and it acquires a market value. Unlike an authentic van Gogh, folklore can be endlessly replicated and imitated—any member of the "folk" should be equipped with the skill and spirit to produce some lore. Individuals all over the globe have been sufficiently savvy to alienate themselves far enough from their traditions to market them.

Indeed, alienation itself is a notion alien to anyone not interested in thinking of cultural productions in the dichotomous terms that "authentic" and "spurious" imply. To scholars and ideologues engaged in commenting on culture, however, efforts to promote and market folklore invariably lead to a perceived loss of authenticity, because students of culture until recent years have considered ideological and market forces as outside agents that spoil folklore's authenticity. The transformations of the marketplace also weaken the stranglehold such students have as authenticators of cultural production.

Declaring a particular form of expressive culture as dead or dying limits the number of authentic items, but it promotes the search for not yet discovered and hence authentic folklore. In the mocking words of a German folklorist, it is best not to use the prefix "folk" at all, because as soon as something is presented as genuine folksong or genuine folk architecture, it loses its authenticity (Bausinger 1971: 203). Baudrillard, speaking more polemically, argued that "in order for ethnology to live, its object must die, by dying, the object takes its revenge for being 'discovered' and with its death defies the science that wants to grasp it" (1994: 7). The present study argues that it is not the object that must die—cultures do not die, at best they change, along with those who live in them and thus constitute them. What must change for cultural fields is how workers in those fields conceptualize the object. Removing authenticity and its allied vocabulary is one useful step toward conceptualizing the study of culture in the age of transculturation.

The notion of authenticity implies the existence of its opposite, the fake, and this dichotomous construct is at the heart of what makes authenticity problematic.[9] In religious discourse, identifying something as essential to a particular faith "serves to exclude other concepts, practices, even entire branches of [this religion] as inessential or even illegitimate" (J. Cohen 1988: 136). Similarly, identifying some cultural expressions or artifacts as authentic, genuine, trustworthy, or legitimate simultaneously implies that other manifestations are fake, spurious, and even illegitimate. Disciplinary practice has "nostalgize[d] the homogeneous" (Kapchan 1993: 307) and decried "bastard traditions," thus continually upholding the fallacy that cultural purity rather than hybridity are the norm. It is no wonder, then, that the idea of cultural authenticity has become such convenient fodder for supporting some positions in the political debates on race, ethnicity, gender, and multiculturalism.

Considering how much effort students of expressive culture have wasted with arbitrarily separating the wheat from the chaff, with delineating what is "bona fide" or "legitimate subject matter for the field," and with crusades against fakelore or folklorismus, it seems necessary to document just how empty and at times dangerous the quest for authenticity within and outside folklore ultimately has been.

Behind the assiduous documentation and defense of the authentic lies an unarticulated anxiety of losing the subject. Cultural scholarship in the late twentieth century is plagued by its own anxieties. The nature and place of higher learning is surreptitiously transforming. Modern universities were founded as a part of the project of nation-building. Their role was to teach and research knowledge that would link enlightened individuals in search of self-knowledge to their national cultures. "The German Idealists thought we could find ourselves as an ethnic culture" (Readings 1996: 53), with humanistic scholarship at once interpreting and shaping a cultural

canon for the national polity. In the late twentieth century the idea of homogeneous national culture confronts the reality of multicultural demographics—a reality acknowledged not least by movements within cultural scholarship. Postcolonial and feminist criticism coupled to deconstructionism have exposed the ideologies of disciplines and cultural canons and brought about a sense of lost authority and disciplinary fragmentation.

Simultaneously, "transnational capitalism has eroded the meaning of culture" (Readings 1996: 119), both in the sense of civic (or "bourgeois" or "high") culture and in the sense of ethnographically documented diversity. Culture has become commodity, as has knowledge itself, and an increasingly corporate (rather than communitarian) university is supplanting the hollowed idea of a national or civic culture with the idea of "excellence." Once the language of production enters academia, Marx's dictum "All that is solid melts into air" applies to the institutional structures from which disciplines have drawn their legitimation. Cultural scholarship thus finds itself doubly challenged. Various reflexive moves bring with them the need to examine and understand disciplinary ideology, which is of necessity a divisive undertaking. At the same time, all knowledge-makers are cornered into convincing administrations of the excellence of their intellectual product.

In this unfolding demand to newly articulate the place and nature of cultural disciplines in terms of "excellence" within a market of knowledge, historiography plays an indispensable role. Historiography focuses on the role and goals of fields of learning, on individual researchers, on the discursive practices employed to achieve such goals, and on the interrelationship between learning and the larger web of social and political institutions. Turning knowledge-making itself into an area of investigation forces one to acknowledge the larger contexts empowering and disempowering certain kinds of learning at particular moments in time. Historiography thus forces us to understand what is experienced as momentary crisis on the backdrop of transformations that have been in the making for some time.

George Stocking locates the cause of such introspection in the "more general professional and social concerns centering on issues of knowledge and power" (1983: 3). The Other—once the central preoccupation of variously named fields of cultural inquiry—has begun to challenge Western paradigms and their complicity in colonial domination. Postcolonial native ethnography, history, and linguistics have brought about an interest in unpacking phases of colonial encounters, the role of those encounters in shaping ideas of cultural self and other, and the imprint they left on disciplinary formations.[10] In the process Western structures of cultural inquiry have been increasingly subjected to reflexive examination. Fields concerned with culture thus face internal transformations of legitimacy and external reclassification from a source of empowerment to a transnational consumer good. Holistic, historiographic assessments of disciplinary ideology are vital in coming to terms with these transformations and in regaining a sense, if not of control, then at least of understanding the role of cultural knowledge on the eve of the twenty-first century.

I present this examination of some scholarly efforts to channel the longing for authenticity into a field of study as a case study. Folklore is a particularly poignant example for understanding the ideological currents in cultural scholarship. But what is demonstrated here for one field—which, not least because of its anachronistic name, has survived only in the margins of academia—is not an isolated example. Rather, it displays in microcosm problems inherent to many fields of inquiry.

The linkages between authenticity and folklore are many, covering the yearning for autonomy in the discipline, in politics, and in individual selfhood. It is with my personal linkage to the problem at hand that I begin, for my own "coming of age" as a folklorist coincided with the reflexive turn in social sciences and humanities that has critically examined the scholarly edifice.

A discussion of the authenticity concept, its history, and the philosophical discourse surrounding it serves as the means to frame the historiography of folkloristic authenticities to follow.

There are deeply personal reasons for anyone to study and stay with folkloristics (Camp 1989)—a social commitment, an infatuation with some of expressive culture's beauty, or, conversely, amazement, shock, or outrage at the deep-seated hatred and ugliness packed into some forms of expressive culture. It is in such personal involvements with expressive culture that we may experience an immediate link to our object of study, and the present study lays bare how such commitments have shaped the course of the discipline.

At twenty, I began to study folklore out of an emotional attachment to what I perceived as authentic dances and music of the Balkans—a motivation and personal involvement that has led many into studying folklore. Participating in a folk dance group and listening to exotic music seemed to put me in touch with layers of myself that had been dormant. I was elated when I discovered that there was an academic discipline variously called *Volkskunde*, Folkloristics, or, in many European countries, European Ethnology, and hoped to expand my interests into a profession. The teaching assistant in *Volkskunde* at a Swiss university quickly disillusioned me: such things as I was interested in had little to do with serious European Ethnology; they were but the spurious by-products of sociopolitical processes in Eastern Europe and as such they were not really part of what the discipline studied.

Despite my best efforts to work within the boundaries of what were considered acceptable areas of research, my first fieldwork on a New Year's mumming custom led me to discover that this event, considered ancient if not pagan by natives and folklorists alike, at best began a few centuries ago and only took on its present form after World War II. I remember the discovery as both sobering and exciting. On the one hand, it undermined the generally held assumption of the festival's antiquity and pagan origin, but, on the other hand, it held the promise of interesting new directions for research. During one lengthy interview a primary schoolteacher told me with considerable pride how "degenerate" the festival had been when he began teaching in the area in the 1940s. After consulting with a lay folklorist as well as members of the national association for costume preservation, he embarked on a campaign to "clean up" the event and to "reintroduce" the pagan element in the celebration, using his students as promoters of a new costume type; he also advocated in the local newspaper the "authentic" way to celebrate the event. His campaign was so successful that the majority of the informants in the early 1980s believed the newest costume type to be the oldest (Bendix 1985: 56–58). Although I had intended to study "the real thing," what was real or genuine to the performers obviously differed from the notions of authenticity held in my discipline where (re-) inventions were considered a form of tampering with "genuine" tradition.

In the process of doing the research for that study, I encountered the German literature on *Folklorismus*, catchily defined as "second-hand folklore." The serious problems with both folkloristic history and theoretical concepts raised in the *Folklorismus* discussions gave me the confidence to pursue rather than avoid or exclude what academic folklorists considered fake, spurious, or ideologically perverted, and I have not been able to let go of the question why people, whether scholars or lay people, were so intent on distinguishing (and promoting) "real folklore" from a spurious counterpart.

My own growing obsession fortunately coincided with the increased self-scrutiny within the discipline as well as the growing acceptability of interest in folklore and ideology, be this in the romantic or nationalist, communist or fascist guise. The 1980s saw a profusion of works exploring the invention of social behaviors and artifacts. Works such as Roy Wagner's *The Invention of Culture* (1981), and especially Eric Hobsbawm and Terence Ranger's *The Invention of Tradition*

'Introduction' to *In Search of Authenticity*

(1983), inspired anthropologists, folklorists, and historians to document the modern origins of what were once thought ancient practices. Charting processes of invention and reinvention, often cast in the framework of "the politics and poetics of culture," has become the rule rather than the exception.[11] It has been an unavoidable consequence of this line of inquiry that concepts central to the entire scholarly edifice would also undergo such deconstructionist treatment. Marginalized at first, "the politics of culture" is now at the center of research and theory, and authenticity has become one of the most frequently discussed terms.

The present study is a product of my own need to clarify the "authenticity problem," and its comparative focus on Germany and the United States developed in part from personal circumstances as well. I grew up in Switzerland and made the German-speaking areas of Europe my focus of research, but I received most of my academic training in the United States. Those two areas of study most familiar to me also display the interplay and tensions between European and New World cultures of inquiry.

After listening to my frustrations at reining in the relationship between authenticity and folkloristics, my colleague Ronald Inauen at the University of Basel only half-jokingly uttered the verdict, "The study of culture is the study of the inauthentic." After years of reading and thinking about what, if anything, could still be authentic, I saw authenticity at best as a quality of experience: the chills running down one's spine during musical performances, for instance, moments that may stir one to tears, laughter, elation—which on reflection crystallize into categories and in the process lose the immediacy that characterizes authenticity.

Cultural research, by virtue of being "the study of" but not the "experience of" behaviors, expressions, institutions, and practices, can then not help but present, in this existential sense, the inauthentic. Taking it a step further, authenticity as a criterion should not matter in attempts to appreciate and understand culture. It is hardly possible to get past the very emotional interests that may lead one into a field such as folklore, nor is it always satisfying to shed all romantic visions of oneself in touch with an Other, as such visions are part of the modern sensibility into which we are enculturated. However, some reflexive awareness of how this discipline has been constituted to seek the authentic should at least permit a challenge to the grip that this concept has on our life and work.

Authentic derives from the Greek "authentes," which carries the dual meaning of "one who acts with authority" and "made by one's own hand." Lionel Trilling's recollection of "the violent meanings which are explicit in the Greek ancestry of the word" deepens the meaning and contrasts it with the commodification that the term has undergone in a Western-driven marketplace: "*Authenteo:* to have full power over; also, to commit a murder. *Authentes:* not only a master and a doer, but also a perpetrator, a murderer, even a self-murderer, a suicide" (Trilling 1974: 131). Such etymological layers need not reverberate fully in the present usage of the term, although the violence caused in the name of, say, ethnic or religious authenticity are painful present-day realizations of such old Greek meanings.

Encyclopedias offer historically circumscribed meanings to the term, stemming from religious and legal usage and practice. Among the traceable meanings and contexts are authentic editions of liturgical songs as well as vouchers of authenticity required to prove the authenticity of saints' relics.[12] A seal could endow a document with authenticity, and a series of legal decrees by Frederic I were known as *Authenticae Fridericianae*. Explicating authentic scripture, however, leads one into vague terrain, for authentic scripture refers, in church legal practice, to the canonical writings and their normative and authoritarian claim to contain the revelation. Not surprising, the scholarly efforts on authenticity within biblical studies alone are legion.[13] The literary critics' usage, however, refers to the historical genuineness of a particular scripture.

Current practice expands on meanings such as original, genuine, or unaltered. Trustworthy and guaranteed point to the legal dimension, whereas one of the Greek meanings, "made by one's own hand," can quickly be simplified into "handmade." One definition of authenticity, used in the realm of art and antiques, refers to the clear identifiability of maker or authorship and uniqueness of an artifact, relying on the "made by one's own hand" etymology.

Folklorists, in a peculiar reversal, for a long time located authenticity within the anonymity of entire social groups, or the "folk." Lack of identifiable authorship, multiple existence over time and space, variation of the items, and the social and economic circumstances of the "bearers of tradition" served, instead, as ways of testing folklore's authenticity. Once individual performers or makers of artifacts entered the discussion, the criterion of anonymity or nameless tradition began to unravel, and the problem of authenticity could have rendered itself obsolete. However, the vocabulary of authenticity that permeated disciplinary discourse escaped the paradigmatic changes. Original, genuine, natural, naive, noble and innocent, lively, sensuous, stirring—the string of adjectives could be continued.[14] Folklorists since the eighteenth century have used them to circumscribe the longed-for quality that they saw encapsulated at first in folklore texts and later in folklore performance.

… [T]he language used may be more lasting than the theories developed in trying to transcend this language. Over time, "authenticity" acquired a broad range of meanings, with old usages gaining new connotations as the term was applied by successive generations of scholars, not to speak of the meanings added in fields such as psychology and in the politicization of the Romantic nationalist legacy. Understanding authenticity means understanding the ideological fluctuations of language use and the changing goals of such language use over time and across contexts (Pörksen 1989). Linguists researching language ideology are pointing the way in studies of the ideology of linguistic discourse itself (Woolard and Schieffelin 1994: 67–69). The challenge such inquiry poses toward those who proclaim the possibility of a value-neutral (hence more scientific and worthy) branch of linguistics is substantiated through historiographic research.[15] The present work similarly seeks to find a way around the "vague terrain of thought" mapped by the many concurrent meanings of authenticity in an exploration of the concept's use at different times and places.[16]

There are magisterial accounts of authenticity's emergence in the West that help to prepare the ground for an understanding of the fragmented, multivocal use of the term in the study to follow. "At a certain point in its history," Lionel Trilling wrote, "the moral life of Europe added to itself a new element, the state or quality of the self which we call sincerity" (1974: 2). The imperative of sincerity began "to vex men's minds" in the sixteenth century (p. 12), and the most poignant sources are, not surprisingly, to be found in theater—the domain that is constructed out of pretense and artifice, and hence "insincerity." Actors' ability to move one to tears or anger rousted suspicions in the audience. Drawing on Goffman, Trilling observes how the fascination with theater led to an awareness of role play in life and to the realization that role play compromises sincerity. Yet if the norms of behavior required insincerity, the question arose whether, underneath these demands of civilization, layers of uncorrupted selfhood could be found.

Rousseau's philosophy, formulated in the mid-eighteenth century, contained the most influential formulations of the shift from sincerity to authenticity. "From Rousseau we learned that what destroys our authenticity is society" (Trilling 1974: 92). By contrast, Rousseau's ideal authentic person remains unaffected by opinion and lives in a paradisiacal state of innocence. Rousseau's work "was a program attempting to give dignity to [individuals], liberating [them] from the superstructure of society in order to give [them] back to society pure and uncontaminated"

'Introduction' to *In Search of Authenticity*

(Cocchiara 1981: 116–117). This argument provided a philosophical program for the French revolutionaries who needed to legitimize the democratization of politics. Cleansed of the social superstructure, the original virtue of every human being would emerge, and in that stage all humans would be equal and worthy of liberty.[17] Rousseau's "savage" was the embodiment of authentic existence, and Rousseau found remnants of savages among the humble folk in the country who supposedly lived with their instincts and feelings intact and among whom "neither sentiment nor poetry (was) dead" (Cocchiara 1981: 122).

The call for "authenticity" implied a critical stance against urban manners, artifice in language, behavior, and art, and against aristocratic excesses; it promised the restoration of a pure, unaffected state of being. Such nostalgic visions were clearly fueled by explorers' reports of encounters with "exotic" and "savage" peoples whose existence an enlightened age sought to link to itself.[18] Following the logic of their own philosophy, Rousseau, Herder, and their contemporaries assigned such purity and authenticity to the rural and pastoral way of life in their own countries. Upper-class literati in eighteenth-century Europe, however, did not desire to live like the folk in the manner that Thoreau or the communards later tried to. Herder's gift to his peers was to single out folk poetry as a locus of folkness, inspiring contemporaries and an entire social and literary movement to absorb and imitate the authentic aesthetic of the folk. Herder and the Sturm und Drang Romantics solidified the link between the search for personal, moral authenticity and its artistic expression and communication. To them, the verbal art of the peasantry became a means for humanity at large to get in touch with authenticity.

The "discovery" of the folk and the emergence of a field of study devoted to its culture is intertwined with the fascination for the exotic and the concept of "primitive culture" so formative for cultural anthropology. But while Adam Kuper argues that "the theory of primitive society is about something which does not and never has existed" (1988: 8), the moral of my story is more diffuse. *Authenticity, unlike "primitive society," is generated not from the bounded classification of an Other, but from the probing comparison between self and Other, as well as between external and internal states of being.* Invocations of authenticity are admissions of vulnerability, filtering the self's longings into the shaping of the subject. [My work] deconstructs authenticity as a discursive formation, but such a project cannot simply invalidate the search for authenticity. This search arises out of a profound human longing, be it religious-spiritual or existential, and declaring the object of such longing nonexistent may violate the very core around which people build meaningful lives.

It is not the object, though, but the desire, the process of searching itself, that yields existential meaning. Pilgrimage, and its commodified form, travel, are loci of transcendence, communicated articulately in a slim travel diary chronicling "Travels on the Road." Its author, familiar with the feeling of disappointment on arriving at a longed-for destination, solved the problem by not arriving at all and seeking the authentic instead in the fleeting process of experiencing in passing (Schmidt 1992). Traveling is in many ways a key to the modern "sense of being,"[19] accompanying the transformation of Western societies since the Enlightenment and unfolding as a multidimensional activity of transculturation. Initially scorned as a field of study, tourism scholarship has elaborated articulately on human ways of searching for authenticity within the dynamic of self and Other.[20] "The issue of authenticity runs, like an obbligato, through tourism studies" (Hughes 1995: 781), with interest trained on the marketing and consumption of reified versions of the concept. In contradistinction—perhaps because of their concentration on the self in isolation—existentialist philosophies' theorizing of modern selfhood remains locked in attempts to define authenticity rather than its uses.

The emergence of the authentic self is arguably the central outgrowth of modernity (Taylor 1989), the foundation on which political, social, and economic transformations rest. Striving for

selfhood is intertwined with the attempt to locate or articulate a more authentic existence, and this effort necessitated philosophical articulations that probed the nature of individual existence in the age of mechanical reproduction. Modernity's pace brought forth an anguish, occasioned by the oppositional desires for progress and nostalgia for what is left behind in the invariable transformations caused by progress. Existentialist philosophies can be seen as a twentieth-century attempt to withstand the maelstrom.

Trilling (1974) traced the slow unfolding of the search for authenticity in the Western world since the seventeenth century. The twentieth century has come to endorse the raw and ugly as a truer version of authenticity than the simple and pure.[21] Norman Mailer's gloss, "We are a Faustian age determined to meet the Lord or the Devil before we are done, and the ineluctable ore of the authentic is our only key to the lock," is perhaps the quintessential version of the rawness of the twentieth-century authenticity quest (cited after Berman 1988: 37). Mailer points to the paradoxical pairing of daring and angst engendered by the relentless probing of knowledge and power, the testing of selfhood and autonomy, which characterizes modernity.

Jean-Paul Sartre's version of existentialism updates seventeenth-century travails with role play, reacting against the artifice of the bourgeoisie rather than that of the aristocracy. Denouncing the conventions of respectability governing public behavior as "contaminated by hypocrisy and inauthenticity," he perceived his own struggle to be "civilized" as having "undermined his own inner sense of self" (Charmé 1991: 6–7). Sartre sought redemption in nature—not in the natural purity envisioned by the Romantics, but rather in the physicality of the human body, and in the Otherness of the nonbourgeois.

Martin Heidegger preceded Sartre and was criticized by him.[22] His *Being and Time* (1962 [1927]) strove to be the ultimate formulation on the nature of being in the twentieth century. Heidegger calls the two basic possibilities of existence *Eigentlichkeit* and *Uneigentlichkeit*, translated as "authenticity" and "inauthenticity" (King 1964: 59). He perceived individuals as caught in "everydayness" (*Alltäglichkeit*), preventing them from truly "owning" themselves, for the German *eigen* means "own."[23] To live a Heideggerian authentic existence and reach the "utmost illumination of which [one] is capable," one has to transcend the demands of "everydayness" (King 1964: 58). Inventing the noun *Eigentlichkeit*, and bending the rules of German grammar and vocabulary so as to linguistically represent "being," Heidegger for some has become the inventor of authenticity in modern philosophical terms.[24]

Yet Heidegger's metaphysical lure provides a poor guide for the reflexive revision of the study of culture that has been under way for some years. The current rediscovery of Heidegger is disturbing, for even if one separates the work from the man—a member of the Nazi Party who in 1933 stated, "Not theses and ideas are the laws of your being! The Führer himself and he alone is Germany's reality and law today and in the future"[25]—Heidegger's writing is conditioned by and politically committed to the totalitarian time during which it was generated.

The logical critique of metaphysicians such as Heidegger rests on their use of language, that aspect which made Heidegger appear to be unique and mysterious. Rudolf Carnap in 1931 argued that Heidegger's philosophy relied on "pretend sentences" that suffered from "a scarcity of linguistic logic" (1931: 229). To Carnap, metaphysicians attempted to express authenticity—which he termed "sentiment of living" (*Lebensgefühl*)—through the acts of thinking and writing which did not lend themselves to a task that to him needed to be experiential rather than reflexive.[26]

Writing after World War II, and thus fully aware of the dangers and power inherent in Heidegger's mystifying language, Theodor Adorno put forth a much stronger critique of existentialism. As the title *The Jargon of Authenticity* (1973) indicates, Adorno rejected existentialist thought through an analysis of language and style. The language of existentialists, epitomized in Heidegger's term *Eigentlichkeit*, becomes a dangerous weapon: "The sublime becomes the cover

'Introduction' to *In Search of Authenticity*

for something low. That is how potential victims are kept in line." Heidegger's work "acquired its aura" because it described "the directions of the dark drives of the intelligentsia before 1933—directions which he described as full of insight, and which he revealed to be solidly coercive" (Adorno 1973: xxi, 4–5). The "jargon," the lack of concreteness in the language, made it appear as if the existentialist vision of authenticity "belonged to the essence of man, as inalienable possibility" rather than being "abstracted from generated and transitory situations" (1973: 59). To Adorno and others on the left like Georg Lukács, existentialism in the Heideggerian form is ultimately irresponsible; by reveling in "being," it reflects the existentialists' inability to cope with industrial societies. Withdrawing from society in the search for authentic being in a timeless realm, the individual flees interaction with society and history and his or her place within this relationship. Trilling's argument is similar when he regards the most dangerous manifestation of authenticity to be the exit from human community, "the great refusal of human connection" (1974: 171).

Benefitting from the late-twentieth-century intellectual turn toward examining the social production and ideology of knowledge itself,[27] Bourdieu sees Carnap's critique as missing the point because it remains within the philosophical habitus. Bourdieu insists, instead, on a dual reading, reducing his assessment neither to the realm of "pure text," nor condemning it simply because of the known politics of its author. He engages with Heidegger's texts both within the political culture and the philosophical profession that brought them forth. In examining the "imposition of form that is effected by philosophical discourse," Bourdieu also seeks to go beyond Adorno and to "reveal the alchemical transformation which protects philosophical discourse from direct reduction to the class position of its producer" (Bourdieu 1991: 3). Scrutinizing what Heidegger said and how he said it, Bourdieu also insists on examining Heidegger's "words which are in themselves vague and equivocal, and especially the value judgements or the emotional connotations which their ordinary usage entails" (1991: 104). Bourdieu's conclusion renders Heidegger as deceptive as authenticity itself:

> It is perhaps because he never realized what he was saying that Heidegger was able to say what he did say without really having to say it. And it is perhaps for the same reason that he refused to the very end to discuss his Nazi involvement: to do it properly would have been to admit (to himself as well as to others) that his "essentialist thought" had never consciously formulated its essence.
>
> *(1991: 105)*

A field such as folkloristics, with its emphasis on communal aesthetics, may seem to share few points of convergence with existentialist philosophy. Yet the "jargon of authenticity" and folkloristic vocabulary are related.[28] A very thin line separates the desire for individual authenticity and the calling to convince others of the correctness of a particular rendering or localization of the authentic. The most powerful and lasting example of this double legacy in folklore's disciplinary history is the (ethno-) nationalist project. Textualized expressive culture such as songs and tales can, with the aid of the rhetoric of authenticity, be transformed from an experience of individual transcendence to a symbol of the inevitability of national unity. In Heidegger's time, an ambiguous and vague vocabulary of existential authenticity could legitimate its collectivized corollary of cultural authenticity and serve in the unambiguous exclusion and annihilation of all who could not or would not belong.

[My work] makes no claim to chronicle or theorize authenticity in its entirety. As Barbara Kirshenblatt-Gimblett has noted, it is possible to argue that the concept of authenticity does not

have a history.[29] The crucial questions to be answered are not "what is authenticity?" but "who needs authenticity and why?" and "how has authenticity been used?" There is no single answer to these questions, either in existential terms or within the confines of folkloristic history.[30] Instead, I have drawn together a variety of texts—essays, collections, letters, theoretical works— that allow me to map ways in which authenticity and its allied vocabulary was used in various stages of disciplinary formation.

Expanding on Roger Abrahams's invocation of phantoms in scholarship (1993), I argue that the idea of "authentic folklore," legitimated as a disciplinary subject through ever newly formulated shades of authenticity, has situated the field of folklore at the margins of both society and the academy. The radical, utopian, and antimodern lure of the authentic, all at times made folklore and some of the discipline's ideas sociopolitically attractive, propelling it into momentary and sometimes, in hindsight, regrettable fame. The greatest strength of folklore studies is the perennial finger they hold to the pulse of what human beings, through their expressive culture, crave or fear most deeply.

Charles Briggs, among others, has begun to expose the "metadiscursive practices" employed to ascertain authority by those who draw the boundaries around what is "authentic folklore" (Briggs 1993). This study supports and expands such reflexivity through a historically more extended deconstruction. If I recount the story of Herder and folksong, of the Brothers Grimm and folktales, of fieldworkers and their exuberant discoveries, I do it not simply to repeat key moments, but to point to the role that the search for authenticity played in charting the course of a field of inquiry. But deconstructing how knowledge was constructed is not necessarily liberating. Folklore's "crisis" is not unique; across the academy there is a sense of loss of subject that deconstruction has brought with it.[31] Reflexivity is, however, a first step toward newly conceptualizing inquiry unhampered by concepts that are burdened by the very mode in which they are conceived.

Folklore, if institutionally marginalized, has always been profoundly interdisciplinary. Philologists and linguists, literature scholars, anthropologists and historians, and more recently scholars engaged in area and ethnic studies, all contribute to folklore, even if the number of scholars holding folklore positions is small. In terms of its base of practitioners and its institutional representation, such as it is, folkloristics is thus recognizably metadisciplinary. While the field's subject has been cast in continually changing authenticities, the field's practitioners have relished its escape from more typically positivist, disciplinarian purity of method and theory. Folklore is a small field that embarks on "a passion for the whole" (Köstlin 1995) and a daring that generates a longing of its own among intellectuals strapped into narrow specializations. Consequently, this story is about subjects and the approach to subjects—and much less about the disciplinary boxes into which those who approach subjects fit institutionally. In other words, this is a dual history of ideas and their consequences, not a history of the division of knowledge.

A history of the constructions of authenticity within folklore studies, … is also, hopefully, liberating. Such a history demonstrates that expressive culture is not about to disappear. Once we have overcome the dichotomy within our disciplinary thinking, "authenticity versus inauthenticity" can become an object of study itself. We can study the negotiation of authenticity once we have ceased to be a negotiating party, or once we admit to our participation in the negotiating process. This stance allows us to examine the meanings and the history of "authenticity" from a distance both within and beyond disciplinary discourse.

'Introduction' to *In Search of Authenticity*

Notes

1 Over the past seven years I have collected stacks of advertisements, catalogs, and columns on the arts, politics, and travel documenting this profusion of authenticities. Among the less ephemeral sources alluded to here are Marsh (1995) and Seiler (1991) for musical authenticity and a National Public Radio (NPR) program on foreign tourists in Harlem (NPR 1996).

2 In Milan an exhibit called *Veramente Falso* (truly fake) was shown in 1991; Salerno opened *Il Museo Del Falso* (the museum of the fake) in 1992. *Fake? The Art of Deception* (Jones 1990, Jones 1992) was thus far the most ambitious exhibit of this nature, staged at the British Museum in London. Myers and Harris (1989) also reflect the interest in forgery on the part of a circle of connoisseurs usually preoccupied with authentication.

3 On questioning the art-historical canon, see Belting (1987); on authenticity in the art-culture system, see Clifford (1988: 244), Karp and Lavine (1991), Korff and Roth (1990), Price (1989), and Zacharias (1990).

4 On the "authentic music" movement in the classical music performance traditions, see Kivy (1995); on issues of (anti-) essentializing in popular music, see Lipsitz (1994). Adorno's critical theory still shows traces of a commitment to authenticity (1975, 1984).

5 Olender's *The Languages of Paradise* (1992) provides a useful companion to the early chapters of this book.

6 Among American folklorists, the twenty-one definitions of folklore listed in Leach and Fried (1949) are legendary. Dundes's textbook substituted an enumeration of expressive genres for a concise definition (1965: 3). Ben-Amos defined folklore as "artistic communication in small groups" (1971), which served one camp within the field well, but remained too narrow for those interested in larger communicative matrices. Toelken in the 1996 revision of his introductory text finally demonstrates the profound interdisciplinarity of approaches to the subject: "Indeed, the famous story of the blind men describing the elephant provides a valid analogy for the field of folklore: The historian may see in folklore the common person's version of a sequence of grand events already charted; the anthropologist sees the oral expression of social systems, cultural meaning, and sacred relationships; the literary scholar looks for genres of oral literature, the psychologist for universal imprints, the art historian for primitive art, the linguist for folk speech and worldview, and so on. The field of folklore as we know it today has been formed and defined by the very variety of its approaches" (1996: 1).

7 Lears (1981) and Orvell (1989) have laid further groundwork since then, and in the 1990s a flood of works dealing with authenticity and allied afflictions burst forth.

8 Giddens disagrees with Lash's differentiation of cognitive and aesthetic reflexivity (Beck, Giddens, and Lash 1994: 197). I would argue that for the purposes of understanding transculturation, Lash's perspective is conceptually useful, which is also evident in his coauthored work with John Urry (Lash and Urry 1994).

9 See Haring (1990) for an earlier effort in narrative analysis to problematize dichotomous pairs, including authenticity and its opposite.

10 Among the more widely received works are Greenblatt (1991, responding in part to Todorov [1984]) and Pratt (1992).

11 Consider such examples as Whisnant (1983); Fienup-Riordan (1988); Hanson (1989); and Sollors (1989).

12 On the ramifications of relic authenticity requirements in medieval practice, see Geary (1986).

13 Consider for example Grant (1993), a work containing further bibliographical leads.

14 John Vlach enumerates a similar, longer list of terms specifically for the domain of folk art (Vlach 1986).

15 Newmeyer (1986) delineates the case for an autonomous, value-free linguistics, while the authors in Joseph and Taylor (1990) convincingly argue the contrary.

16 The "history of ideas" approach has been used in folkloristics with greatest effect by Dan Ben-Amos, starting with his revolutionary redefinition of folklore (1971) and continuing through his reflections on the idea of "genre" (1976) and his surveys of "tradition" (1984) and "context" (1993).

17 For a lucid consideration of the pitfalls of Rousseau's philosophy and its political application in France, see Blum (1986).

18 The impact of the "exotic" on Western thought, art, and cultural practice forms a backdrop in much of the present-day discussion on issues of authenticity in cultural studies. Among the recent works on this topic are Bitterli (1976, trans. 1989), Kohl (1986), and Pollig (1987).

19 The German word for this rendering is *Befindlichkeit*, for which a decent translation eludes me.
20 Among the most important works are Cohen (1988) and MacCannell (1989), escalating to theorizing commodified travel destinations, Kirshenblatt-Gimblett (1995c); Hughes (1995: 799–800) arrives at an idea of existential authenticity recoverable from consumable authenticities; on self-reflexivity in heritage, see Gable and Handler (1996) and Handler and Saxton (1988); for surveys, see Bendix (1995) and Kirshenblatt-Gimblett (1989).
21 Marshall Berman in his two major works (1972, 1988) travels a broader intellectual and artistic terrain than Trilling, with a similar focus but perhaps a more utopian lens.
22 For a discussion on the connection between Sartre and Heidegger, see Fell (1979). For a study of how Sartre used the concept of play to get beyond what he considered Heidegger's moralistic notion of authenticity, see Gisi (1979).
23 The English translation of *Eigentlichkeit* as "authenticity" is thus broader than what is denoted by the coinage in German.
24 Influential Christian theologians such as Rudolf Bultmann or Martin Buber certainly held Heidegger in high esteem and sought to apply his philosophy of authenticity in their efforts to create a Christian ethos appropriate for the twentieth century (Boni 1982; Hepburn 1967).
25 This quotation from Heidegger's "Die Selbstbehauptung der deutschen Universität" is cited after Bracher (1970: 268).
26 Robert Minder, a literary critic, examined Heidegger's vocabulary with the assumption that a careful analysis of vocabulary and phrasing can cut through the linguistic shroud of mystery. He argues that Heidegger's insistence on a "radical all-Germanness" in his writing places him in the company, not of the great German poets and thinkers, but of Nazi literature (1968: 234).
27 Bourdieu's essay on Heidegger stands clearly in the French deconstructionist tradition of Derrida (1976) and Foucault (1972).
28 "Origin" is one word within this vocabulary that could yield telling points of convergence and difference between folkloristics and metaphysics. Adorno, who wrote extensively on art and music, considered the question of origin the "false question" to ask. Origin searchers of metaphysical, essentialist, or historical persuasion miss the central characteristic of art he suggested. "Art is a product of becoming" (Adorno 1984: 447). Adorno's views foreshadow insights developed in American performance analyses.
29 Personal communication, May 29, 1995.
30 I am aligning myself here with Handler's resistance to argue for "one objectively bounded or isolable entity or body of discourse" within the study of nationalist ideology (1988: 26).
31 Kirshenblatt-Gimblett's address as president of the American Folklore Society in 1992, detailing her view of folklore's crisis, appeared in various excerpts in Kirshenblatt-Gimblett (1995a, 1995b, and 1995c). For a broader theorizing of science, its nature, and its place in risk society, see Beck (1986: 254–99).

Bibliography

Abrahams, Roger D. 1993. Phantoms of Romantic Nationalism in Folkloristics. *Journal of American Folklore* 106: 3–37.
Adorno, Theodor W. 1975 (1958). *Philosophie der neuen Musik*. Frankfurt: Suhrkamp.
Adorno, Theodor W. 1973. *The Jargon of Authenticity*. Trans. Kurt Tarnowski and Frederic Will. Evanston, Ill.: Northwestern University Press. (Original German ed. 1964.)
Adorno, Theodor W. 1984. *Aesthetic Theory*. Trans. C. Lenhardt. London: Routledge and Kegan Paul. (Original German ed., 1970.)
Baudrillard, Jean. 1994. *Simulacra and Simulation*. Trans. Sheila Faria Glaser. Ann Arbor: University of Michigan Press.
Bausinger, Hermann. 1971. *Volkskunde*. Darmstadt: Carl Habel.
Beck, Ulrich. 1986. *Risikogesellschaft: Auf dem Weg in eine andere Moderne*. Frankfurt: Suhrkamp.
Beck, Ulrich, Anthony Giddens, and Scott Lash. 1994. *Reflexive Modernization, Politics, Tradition and Aesthetics in the Modern Social Order*. Stanford Calif.: Stanford University Press.
Ben-Amos, Dan. 1971. Toward a Definition of Folklore in Context. *Journal of American Folklore* 84: 3–15.
Ben-Amos, Dan. 1973. A History of American Folklore Studies: Why Do We Need It? *Journal of the Folklore Institute* 10: 113–24.

Ben-Amos, Dan. 1976. Analytic Categories and Ethnic Genres. In Ben-Amos, ed., *Folklore Genres*, pp. 215–42. Austin: University of Texas Press.

Ben-Amos, Dan. 1984. The Seven Strands of Tradition: Varieties in Its Meaning in American Folklore Studies. *Journal of Folklore Research* 21: 97–131.

Ben-Amos, Dan. 1993. "Context" in Context. *Western Folklore* 52: 209–26.

Bendix, Regina. 1985. *Progress and Nostalgia*. Berkeley: University of California Press.

Benjamin, Walter. 1963. *Das Kunstwerk im Zeitalter seiner technischen Reproduzierbarkeit*. Frankfurt: Suhrkamp.

Berman, Marshall. 1988 (1972). *All That Is Solid Melts Into Air: The Experience of Modernity*. New York: Penguin.

Bitterli, Urs. 1976. *Die "Wilden" und die "Zivilisierten": Grundzuge einer Geistesund Kulturgeschichte der europaisch-uberseeischen Begegnung*. Munich: Beck.

Blum, Carol. 1986. *Rousseau and the Republic of Virtue: The Language and Politics of the French Revolution*. Ithaca, N.Y.: Cornell University Press.

Boni, Pat. 1982. King Lear and the Real: Religious and Philosophical Dimensions of Authenticity. Ph.D. Dissertation, Temple University.

Bourdieu, Pierre. 1991. *The Political Ontology of Martin Heidegger*. Trans. Peter Collier. Stanford, Calif.: Stanford University Press.

Bracher, Karl Dietrich. 1970. *The German Dictatorship*. Trans. Jean Steinberg. New York: Holt, Rinehart and Winston.

Briggs, Charles. 1993. Metadiscursive Practices and Scholarly Authority in Folkloristics. *Journal of American Folklore* 106: 387–434.

Camp, Charles, ed. 1989. *Time and Temperament: A Centennial Publication of the American Folklore Society*. Washington, D.C.: American Folklore Society.

Carnap, Rudolf. 1931. Überwindung der Metaphysik durch logische Analyse der Sprache. *Erkenntnis* 2: 219–41.

Charmé, Stuart Zane. 1991. *Vulgarity and Authenticity: Dimensions of Otherness in the World of Jean-Paul Sartre*. Amherst: University of Massachusetts Press.

Clifford, James. 1988. *The Predicament of Culture*. Cambridge, Mass.: Harvard University Press.

Clifford, James, and George Marcus, eds. 1986. *Writing Culture*. Berkeley: University of California Press.

Cocchiara, Giuseppe. 1981. *The History of Folklore in Europe*. Trans. John N. McDaniel. Philadelphia: Institute for the Study of Human Issues.

Cohen, Jonathan. 1988. "If Rabbi Akiba were alive today …" or The Authenticity Argument. *American Jewish Congress* 37: 136–42.

Dahlhaus, Carl. 1967. Zur Dialektik von "echt" und "unecht." *Zeitschrift für Vol skunde* 63: 56–57.

Derrida, Jacques. 1976. *Of Grammatology*. Trans. G. C. Spivak. Baltimore: Johns Hopkins University Press.

Dundes, Alan. 1965. *The Study of Folklore*. Englewood Cliffs, N.J.: Prentice-Hall.

Fell, Joseph P. 1979. *Heidegger and Sartre: An Essay on Being and Place*. New York: Columbia University Press.

Fienup-Riordan, Ann. 1988. Robert Redford, Apanuugpak, and the Invention of Tradition. *American Ethnologist* 15: 442–55.

Foucault, Michel. 1972. *The Archeology of Knowledge and the Discourse on Language*. Trans. A. M. Sheridan Smith. New York: Harper and Row.

Gable, Eric, and Richard Handler. 1996. After Authenticity at an American Heritage Site. *American Anthropologist* 98: 568–578.

Geary, Patrick. 1986. Sacred Commodities: The Circulation of Medieval Relics. In Appadurai, ed., *The Social Life of Things*, pp. 169–91.

Geertz, Clifford. 1986. Making Experiences, Authoring Selves. In Turner and Bruner, eds., *The Anthropology of Experience*, pp. 373–80.

Gisi, Martin. 1979. *Der Begriff Spiel im Denken f.-P. Sartres*. Monographien zur Philosophischen Forschung, vol. 176. Konigstein: Forum Academicum.

Grant, Robert M. 1993. *Heresy and Criticism: The Search for Authenticity in Early Christian Literature*. Louisville, Ky.: Westminster/John Knox Press.

Greenblatt, Stephen. 1991. *Marvelous Possessions: The Wonder of the New World*. Chicago: University of Chicago Press.

Handler, Richard. 1988. *Nationalism and the Politics of Culture in Quebec*. Madison: University of Wisconsin Press.

Handler, Richard, and William Saxton. 1988. Dyssimulation: Reflexivity, Narrative, and the Quest for Authenticity in "Living History." *Cultural Anthropology* 3: 242–60.

Haring, Lee. 1990. Variability and Authenticity. In V. Calame-Griaul, ed., *D'Un Conte a tautre: La variabilite dans la culture orale*, pp. 415–16. Paris: Editions du CNRS.

Hepburn, Ronald W. 1967. Bultmann, Rudolf. In P. Edwards, ed., *The Encyclopedia of Philosophy*, pp. 424–26. New York: Macmillan.

Hobsbawm, Eric, and Terence Ranger, eds. 1983. *The Invention of Tradition*. Cambridge: Cambridge University Press.

Hughes, George. 1995. Authenticity in Tourism. *Annals of Tourism Research* 22: 781–803.

Jones, Mark, ed. 1990. *Fake? The Art of Deception*. Berkeley: University of California Press.

Jones, Mark, ed. 1992. *Why Fakes Matter: Essays on Problems of Authenticity*. London: British Museum Press.

Joseph, John E., and Talbot J. Taylor, eds. 1990. *Ideologies of Language*. London: Routledge.

Kapchan, Deborah. 1993. Hybridization and the Marketplace. *Western Folklore* 52: 303–26.

Karp, Ivan, and Steven D. Lavine. 1991. *Exhibiting Cultures: The Poetics and Politics of Museum Display*. Washington, D.C.: Smithsonian Institution Press.

King, Magda. 1964. *Heidegger's Philosophy*. New York: Macmillan.

Kirshenblatt-Gimblett, Barbara. 1989. Tourism. In *Encyclopedia of Communications*, vol. 4, pp. 249–53. Oxford: Oxford University Press.

Kirshenblatt-Gimblett, Barbara. 1995a. Ausblick: Die Krise der Folkloristik. In Bendix, *Amerikanische Folkloristik*, pp. 201–22.

Kirshenblatt-Gimblett, Barbara. 1995b. From the Paperwork Empire to the Paperless Office: Testing the Limits of the "Science of Tradition." In Regina Bendix and Rosemary L. Zumwalt, eds., *Folklore Interpreted: Essays in Honor of Alan Dundes*, pp. 69–92. New York: Garland.

Kirshenblatt-Gimblett, Barbara. 1995c. Theorizing Heritage. *Ethnomusicology* 39: 367–80.

Kivy, Peter. 1995. *Authenticities: Philosophical Reflections on Musical Performance*. Ithaca, N.Y.: Cornell University Press.

Kohl, Karl-Heinz. 1986. *Entzauberter Blick: Das Bild vom Guten Wilden*. Frankfurt: Suhrkamp.

Korff, Gottfried, and Martin Roth. 1990. Einleitung. In Korff and Roth, eds., *Das historische Museum: Labor, Schaubühne, Identitätsfabrik*, pp. 9–37. Frankfurt: Campus.

Köstlin, Konrad. 1995. Lust aufs Ganze: Die gedeutete Moderne oder die Moderne als Deutung—Volkskulturforschung in der Moderne. *Österreichische Zeitschrift für Volkskunde* 49: 255–75.

Kuper, Adam. 1988. *The Invention of Primitive Society: Transformations of an Illusion*. London: Routledge.

Lash, Scott. 1994. Reflexivity and Its Doubles: Structure, Aesthetics, Community. In Beck, Giddens, and Lash, *Reflexive Modernization*, pp. 110–73.

Lash, Scott, and John Urry. 1994. *Economies of Signs and Space*. London: Sage Publications.

Leach, Maria, and Jerome Fried, eds. 1949. *Funk and Wagnalls Standard Dictionary of Folklore, Mythology, and Legend*. New York: Funk and Wagnalls.

Lears, Jackson T. J. 1981. *No Place of Grace: Antimodernism and the Transformation of American Culture, 1880–1920*. New York: Pantheon.

Lipsitz, George. 1994. *Dangerous Crossroads: Popular Music, Postmodernism and the Poetics of Place*. London: Verso.

MacCannell, Dean. 1989 (1976). *The Tourist: A New Theory of the Leisure Class*. New York: Schocken Books.

Marsh, Dave. 1995. Punk Rock 101 Unplugged. *City Pages* (Alternative News and Arts Weekly of the Twin Cities), April 12, pp. 8–13.

Minder, Robert. 1968. Heidegger und Hebel oder die Sprache von Messkirch. In Minder, *Dichter in der Gesellschaft*, pp. 234–94. Frankfurt: Suhrkamp.

Myers, Robin, and Michael Harris, eds. 1989. *Fakes and Frauds: Varieties of Deception in Print and Manuscript*. Detroit: Omnigraphics.

National Public Radio. 1996. Harlem Churches Find Room for Foreign Tourists. *All Things Considered*, August 26, segment 14, transcript 2317.

Newmeyer, Frederick J. 1986. *The Politics of Linguistics*. Chicago: University of Chicago Press.

Olender, Maurice. 1992. *The Languages of Paradise: Race, Religion, and Philology in the Nineteenth Century*. Trans. A. Goldhammer. Cambridge, Mass.: Harvard University Press.

Orvell, Miles. 1989. *The Real Thing: Imitation and Authenticity in American Culture, 1880–1940*. Chapel Hill: University of North Carolina Press.

'Introduction' to *In Search of Authenticity*

Pollig, Hermann, ed. 1987. *Exotische Welten-Europaische Phantasien*. Stuttgart-Bad-Cannstadt: Edition Cantz.

Pörksen, Uwe. 1989. *Plastikwörter: Die Sprache einer internationalen Diktatur*. Stuttgart: Klett.

Pratt, Mary Louise. 1992. *Imperial Eyes: Travel Writing and Transculturation*. New York: Routledge.

Price, Sally. 1989. *Primitive Art in Civilized Places*. Chicago: University of Chicago Press.

Rabinow, Paul. 1977. *Reflections on Fieldwork in Morocco*. Berkeley: University of California Press.

Readings, Bill. 1996. *The University in Ruins*. Cambridge, Mass.: Harvard University Press.

Sapir, Edward. 1951 (1924). Culture, Genuine and Spurious. In D. Mandelbaum, ed., *Selected Writings of Edward Sapir*, pp. 308–31. Berkeley: University of California Press.

Schmidt, Aurel. 1992. *Wege nach unterwegs: Das Ende des Reisens*. Zurich: Benziger.

Seiler, Christian. 1991. Sie spielen auch den Blues. *Die Weltwoche*, March 12, pp. 41–43.

Sollors, Werner, ed. 1989. *The Invention of Ethnicity*. Oxford: Oxford University Press.

Stewart, Susan. 1991a. Notes of Distressed Genres. *Journal of American Folklore* 104: 5–31.

Stocking, George W., Jr. 1968. *Race, Culture, and Evolution: Essays in the History of Anthropology*. New York: Free Press.

Stocking, George W., Jr. 1983. History of Anthropology: Whence/Whither. In Stocking, ed., *Observers Observed: Essays on Ethnographic Fieldwork*, pp. 3–12.

Stocking, George W., Jr. 1986. Anthropology and the Science of the Irrational: Malinowski's Encounter with Freudian Psychoanalysis. In Stocking, ed., *Malinowski, Rivers, Benedict and Others: Essays on Culture and Personality*. History of Anthropology, Vol. 4, pp. 13–49. Madison: University of Wisconsin Press.

Stocking, George W., Jr. 1992. The Ethnographic Sensibility of the 1920s. In Stocking, *The Ethnographer's Magic and Other Essays in the History of Anthropology*, pp. 276–341. Madison: University of Wisconsin Press.

Stocking, George W., Jr., ed. 1983. *Observers Observed: Essays on Ethnographic Fieldwork*. History of Anthropology, Vol. 1. Madison: University of Wisconsin Press.

Stocking, George W., Jr., ed. 1985. *Objects and Others: Essays on Museums and Material Culture*. History of Anthropology, Vol. 3. Madison: University of Wisconsin Press.

Stocking, George W., Jr., ed. 1996. Volksgeist *as Method and Ethic: Essays on Boasian Ethnography and the German Anthropological Tradition*. History of Anthropology, Vol. 8. Madison: University of Wisconsin Press.

Taylor, Charles. 1989. *Sources of the Self: The Making of the Modern Identity*. Cambridge, Mass.: Harvard University Press.

Todorov, Tzvetan. 1984. *The Conquest of America: The Question of the Other*. Trans. Richard Howard. New York: Harper and Row.

Toelken, Barre. 1996. *The Dynamics of Folklore*. Rev. and expanded ed. Logan: University of Utah Press.

Trilling, Lionel. 1974 (1971). *Sincerity and Authenticity*. London: Oxford University Press.

Vlach, John Michael. 1986. "Properly Speaking": The Need for Plain Talk about Folk Art. In Vlach and Bronner, eds., *Folk Art and Art Worlds*, pp. 13–26.

Wagner, Roy. 1981. *The Invention of Culture*. Chicago: University of Chicago Press.

Whisnant, David E. 1979. *Folk Festival Issues: Report from a Seminar*. Los Angeles: John Edwards Memorial Foundation, UCLA.

Woolard, Kathryn A., and Bambi B. Schieffelin. 1994. Language Ideology. *Annual Review of Anthropology* 23: 55–82.

Zacharias, Wolfgang, ed. 1990. *Zeitphänomen Musealisierung: Das Verschwinden der Gegenwart und die Konstruktion der Erinnerung*. Essen: Klartext.

Part III
Emotions and materiality

Introduction to Part III

Sheila Watson

Part III of the book is concerned with the things we often find difficult to articulate but we nevertheless experience every day; emotion, affect, and its relationship to materiality. First we should begin with some definitions. The provision of a definition might tempt us to limit our understanding to the parameters of the definition itself. That is not the intention here. As you read more about these concepts and ideas, you will come to understand more fully how 'slippery' and complex they are. However, without at least a working definition we run the risk of misunderstanding each other.

Much of our thinking about these concepts derives from the Enlightenment, often attributed to Rene Descartes, and called Cartesian philosophy (Panksepp and Biven 2012, this volume). Descartes attempted to show how the mind and body worked and, although he is often interpreted as suggesting a complete separation between emotions and thinking, he recognised they were interlinked. Nevertheless, the concept of the separation of mind (thinking) and body (affect and emotions) has been very influential in Western philosophy, education and politics. Recent developments in science, particularly in brain imaging, have enabled us to look closely at what happens to our brains when we think and make decisions. We now realise such actions are always influenced by how we feel, although we may well be convinced that we are acting in a dispassionate and rational manner. While most research into learning in museums and heritage sites recognises some element of emotional response, such as feelings of excitement or adventure, the time has come to foreground these emotions and affect in the study of the power of heritage. Indeed, without an emotional response, there would be no heritage at all, for without such responses, we would not value sites, objects, events and experiences that constitute our ideas of what heritage is and how it functions.

The notion of affect is very prevalent in cultural studies. Drawing on Hemmings (2005, this volume) Hedges argues that affect 'refers to an amorphous, diffuse and bodily "experience" of stimulation impinging upon and altering the body's physiology, whereas emotions are the various structured, qualified, and recognizable experiential stages of anger, joy and sadness' (Hedges 2010: 247). It is thus understood to be different from emotion, which is understood to be 'a mental phenomenon' (Munro 2014: 45). However, the notion of affect is still a contested one, with Panksepp and Biven arguing that they are 'primarily phenomenal experiences that cannot be adequately explained just in terms of accompanying changes in the body' (2012: 31,

Sheila Watson

this volume). More recently there has been a move in the UK towards a more socially engaged museum profession that values museums not so much for the objects they contain but for the good they can do for society; a form of 'emotion work' and 'affective labour' that involves staff in emotionally engaging and draining work with museum clients, and that contributes to well-being (Munro 2014). Here, affect is understood to be part of that process of the facilitation of well-being. At the same time, the use of affect as a theoretical approach to cultural studies, and to heritage in particular, has allowed us to question some of the hegemonic theories so prevalent 20 years ago. If we accept that affect is the personal body response to heritage that in turn may elicit emotional reactions, we can accept that social structures may play a less important part in regulating people's relationships with heritage than hitherto has been generally accepted, although this is may well be too simple an approach to take (Hemmings 2005, this volume).

The papers in this section all explore the notion of affect and emotion in heritage sites in a variety of ways. Matthews' examination of the Canadian War Museum (2013: Chapter 23) examines the notion of the war trophy and difficult histories. Here, the black Mercedes-Benz car once used by Hitler and a photograph of a Canadian soldier next to a tortured Somalian teenager, are used to deconstruct some visitors' reactions to them, and to ask complex questions about the nature of affect and the use to which material culture can be put by visitors after it has been removed from its original setting. Maddern's examination of the Liberty-Ellis Island National Monument (2004), along with Kushner's deconstruction of the Holocaust Exhibition in the Imperial War Museum London (2002), both look at the political dimensions behind emotionally evocative displays, reminding us that though we may own our own emotions, many heritage sites seek to manipulate our responses for political ends.

Nothing is perhaps more of an emotional topic than nationalism. Its very existence depends upon a sense of belonging (Ashworth and Graham 2007: 9), which in turn needs to elicit feelings of affection, responsibility and pride. Thus we have selected several papers that unpick the notions of identity and, in particular, national identity and nationalism. They come from many disciplines, reminding us that to understand heritage and its nature, we need to be conversant with a wide range of ideas that do not necessarily fall comfortably into one particular form of knowledge or method of enquiry. Much heritage, rather ironically given its obsession with the past, neglects the discipline of history and its attempts to provide dispassionate and scientific authority on topics. Indeed, heritage sometimes is at odds with history, promoting the idea of the significance of events such as Gallipoli to Australian national identity, when history tells us that far more British troops fought and died than Australian ones. Nevertheless, it was out of this debacle in Turkey that a nation's sense of itself was born, so information about the battle in the newly displayed section on Gallipoli in the National War Memorial in Canberra, presents that campaign as a mainly Australian one with a nod to the British commanders who led the Aussie troops.

History, though, is not just about attempting to focus on a more evidenced account of what happened, it can also help those studying heritage to understand why the past is used as it is. Black's chapter on The Third World unpicks how Western ideas of history, politics, geography, theoretical concepts, languages and academic conventions, continue to dominate former colonised countries. Here, we are encouraged to consider how politicians use archaeology and history, in other words create heritage, to establish a new national identity in their postcolonial countries. Such interpretations are not dispassionate, any more than national histories of other nations worldwide. Built with a scaffold of historical convention, they are nevertheless deeply felt emotional constructs that are reproduced in a variety of heritage instruments. Moreover, heritage is not confined to museums and places as Gilmour's paper (2006, this volume) illustrates. Here, Gilmour examines the novel as a way of deconstructing Spain's uneasy relationship

with its Moorish past. Novels, theatre, the arts in general are all means by which national heritage can be expressed. Fictitious and imaginative narratives and characters offer emotional engagements with the nation state. No-one who has seen Laurence Olivier's Henry V in Shakespeare's play of that name, made during the Second World War as a morale raising effort, can doubt how effective such heritage can be in encouraging, developing and re-enforcing emotional connections with the past. Why else do we commemorate centenaries? These are not dry and dispassionate reminders of past times but deeply felt attempts to forge a sense of identity through emotional engagement with what happened before. Without the emotional connections there would be no commemorations of this kind.

Bibliography

Ashworth, G. J. and Graham, B. (2005). 'Senses of place, senses of time and heritage', *Senses of Place: Senses of Time*. Aldershot: Ashgate, pp. 3–12 (this volume).

Gilmour, N. (2006). 'Turkish Delight: Antonio Gala's *La pasión turca* as a Vision of Spain's Contested Islamic Heritage', *Arizona Journal of Hispanic Cultural Studies*, 10: 77–94 (this volume).

Hedges, L. E. (2010). 'Affect and embodiment', in Radstone, S. and Schwarz, B. (eds) *Memory: History, Theories, Debates*. New York: Fordham University Press, pp. 246–262.

Hemmings, C. (2005). 'Invoking affect', *Cultural Studies*, 19 (5), pp. 548–567 (this volume).

Kushner, T. (2002). 'The Holocaust and the Museum World in Britain: a study of ethnography', *Immigrants and Minorities*, 21 (1): 12–40 (this volume).

Maddern, J. (2004). 'Huddled Masses Yearning to Buy Postcards: The Politics of producing Heritage at the Statue of Liberty-Ellis Island National Monument', *Current Issues in Tourism*, 7 (4–5): 303–314 (this volume).

Matthews, S. (2013). '"The trophies of their wars": Affect and encounter at the Canadian War Museum', *Museum Management and Curatorship*, 28 (3), London and New York: Routledge, pp. 272–287 (this volume).

Munro, E. (2014). 'Doing emotion work in museums: Reconceptualising the role of community engagement practitioners', *Museum and Society*, 12 (1): 44–60.

Panksepp, J. and Biven, L. (2012). *The Archaeology of Mind. Neuroevolutionary Origins of Human Emotions*. New York and London: WW Norton and Company (see extracts in this volume).

21
Invoking affect

Clare Hemmings

This chapter interrogates the contemporary emergence of affect as critical object and perspective through which to understand the social world and our place within it. Emphasising the unexpected, the singular or the quirky over the generally applicable, the turn to affect builds on important work in cultural studies on the pitfalls of writing the body out of theory. More importantly for this article, the contemporary interest in affect evidences a dissatisfaction with poststructuralist approaches to power, framed as hegemonic in their negativity and insistence of social structures rather than interpersonal relationships as formative of the subject. The article focuses on the recent contributions of Brain Massumi and Eve Kosofsky Sedgwick in particular, unpacking their celebration of the difference that affect makes. The author's critique of the affective turn focuses on both the illusion of choice that it offers the cultural critic, and its rewriting of the recent history of cultural theory to position affect as 'the new cutting edge'. While affect may constitute a valuable critical focus in context, it frequently emerges through a circular logic designed to persuade 'paranoid theorists' into a more productive frame of mind – for who would not prefer affective freedom to social determinism? Yet it remains unclear what role affect may have once this rhetoric has worked its persuasive magic. In addition, and more worryingly, affective rewriting flattens out poststructuralist inquiry by ignoring the counter-hegemonic contributions of postcolonial and feminist theorists, only thereby positioning affect as 'the answer' to contemporary problems of cultural theory.

> There is no denying, or deferring, affects. They are what make up life, and art ... Affects are ... the stuff that goes on beneath, beyond, even parallel to signification. But what can one say about affects? Indeed, what needs to be said about them? ... You cannot read affects, you can only experience them.
>
> *(O'Sullivan 2001, p. 126)*

Introduction

In the article from which the above quotation is taken, Simon O'Sullivan celebrates affects' capacity to defy deconstruction, and the deconstructionist. O'Sullivan is writing within the context of art history, where which he claims that semiotic and deconstructivist approaches have

become hegemonic, but he is far from alone in embracing affect as offering a new critical trajectory for cultural theory. While not really a school as such, a significant number of disciplinary and interdisciplinary theorists are currently citing affect as the privileged 'way out' of the perceived impasse in cultural studies. The impasse needing to be resolved is by now a familiar one, which the attentions of affect theorists have reshaped into three predominant concerns.

Firstly, post deconstruction we doubt the capacity of constructivist models of the subject to account fully for our place in the world as individuals or groups. In a general sense, this concern is indicated by the intensity of current critical interest in psychoanalytic accounts of the subject, and in particular Judith Butler's development of psychoanalysis through her focus on subjection (1997a). Theorists of affect argue that constructivist models leave out the residue or excess that is not socially produced, and that constitutes the very fabric of our being. Thus Brian Massumi (1996) insists that affect is important to the extent that it is autonomous and outside social signification, and John Bruns (2000) suggests that affect, and in particular laughter, foregrounds the unexpected that throws us off balance, that unsettles us into becoming someone other than who we currently are. Secondly, post deconstruction we doubt the capacity of both quantitative empirical approaches and textual analysis to account for the fullest resonance of the social world we wish to understand. Advocates of affect offer it up as a way of deepening our vision of the terrain we are studying, of allowing for and prioritizing its 'texture', in Eve Sedgwick's words (2003, p. 17). This texture refers to our qualitative experience of the social world, to embodied experience that has the capacity to transform as well as exceed social subjection. Queer theorists in particular have taken up Sedgwick and Adam Frank's (1995) emphasis on the transformative capacities of *shame*, insisting that it should not be something we strive simply to overcome by turning to its dependent opposite, pride. Shame itself, as David Halperin (2002), Sally Munt (2000) and Elspeth Probyn (2000) have all argued, has a resonance well beyond its homophobic generation, enabling queer subjects both to identify the bodily resonances of a heterosexual status quo, and to create community through empathy and shared experience. Thirdly, post deconstruction we doubt that the oppositions of power/resistance or public/private can fully account for the political process. In this context, affective ties have been theorized as offering an alternative model of subject formation. In the work of Adriana Cavarero (2000), for example, how those we are closest to view us is central to our self-narration and therefore our way of being in the world. And Michael Hardt (1999) argues that while affective labour is the hidden centre of capitalist accumulation, since it remains unremunerated yet is what bestows qualitative value, it also produces emotional connections that threaten to disrupt that accumulation. In a similar vein, and following Franz Fanon's (1952) insistence that social relations at both the macro and the micro level are based on *unreasonable* ties, critical race theorists argue that affect plays a role in both cementing sexed and raced relations of domination, and in providing the local investments necessary to counter those relations (e.g. Spivak 1993, Bhabha 1994, Hill Collins 2000).[1]

The approaches I have mentioned share an interest in exploring *analogue* rather than *digital* modes of power and community, which is to say connected and relational over oppositional modes. They emphasize the unexpected, the singular, or indeed the quirky, over the generally applicable, where the latter becomes associated with the pessimism of social determinist perspectives, and the former with the hope of freedom from social constraint. In making this move, affect theorists build on the important work within feminist theory and Sociology on the pitfalls of writing the body out of theory (e.g. Shilling 1993, Grosz 1994), and offer a different worldview than the rather narrow one governed by a repressive/subversive dichotomy. The affective critique is not simply one that highlights omission, however, or one that simply stresses the devaluing of certain practices and experiences in general paradigms. For affect theorists, these

Clare Hemmings

exclusions matter because of their capacity to transform the world we live in, and contemporary critical theorists should ignore them at their peril.

While appreciative of a critical focus on the unusual, which is to say the non-socially-determined, not as a bid for group rights, but a bid for social transformation, I remain sceptical of what is often a theoretical celebration of affect as uniquely situated to achieve this end. This article explores my scepticism of such affective celebration through close engagement with Sedgwick's (2003) and Massumi's (2002) work on the subject. Both authors are well-respected contributors to contemporary cultural theory, and both have recently published monographs invoking affect as *the way forward* within that arena. For both authors it is affect's difference from social structures that means it possesses, in itself, the capacity to restructure social meaning. But both authors are thereby presented with something of a problem. As prominent cultural theorists, they cannot fail to be aware of the myriad ways that affect manifests precisely not as difference, but as a central mechanism of social reproduction in the most glaring ways. The delights of consumerism, feelings of belonging attending fundamentalism or fascism, to suggest just several contexts, are affective responses that strengthen rather than challenge a dominant social order (Berlant 1997). Sedgwick and Massumi do both acknowledge this characteristic of affect in their work, but do not pursue it, interested instead as they both are in that 'other affect', the good affect that undoes the bad. It is difficult to maintain such an affective dichotomy of course, particularly in light of their own professed irritation with cultural theorists' tendency to divide the world up into good and bad, repressive or subversive and so on, as I discuss in more detail below. But unfortunately neither author offers any explanation as to the relationship between these 'two kinds' of affect, which means the relationship remains dyadic.

Instead, both authors negotiate a way out of their own uncomfortable critical position by turning the question of affective freedom back onto the cultural critic, leaving it up to her or him to decide whether the direction they wish to pursue is one of the pessimism of social determinism (including bad affect) or the optimism of affective freedom (good affect). Two points come to mind at this point. Firstly, this question to the critic is hardly an open one. 'Wouldn't you rather be free?' can hardly elicit a negative response in anyone but the most hardened cultural theorist, whose hardness is indeed evidenced by that response. Secondly, as part of persuading the critic that the question is a valid one, both the ills of cultural theory to date and the restorative power of affect need to be overstated. My overarching contention in this article, then, is that while affect may be an interesting and valuable critical focus *in context*, it often emerges as a rhetorical device whose ultimate goal is to persuade 'paranoid theorists' into a more productive frame of mind.

Affective territories

I began research for this article as a result of my frustration at seeing affect mentioned or celebrated but rarely fully explained as either critical tool or object. So I want to spend some time discussing what is actually meant by affect. Affect broadly refers to states of being, rather than to their manifestation or interpretation as emotions. For psychoanalysis affects are 'the qualitative expression of our drives' energy and variations' (Giardini 1999, p. 150), are what enable drives to be satisfied and what tie us to the world. Unlike drives, affects can be transferred to a range of objects in order to be satisfied (love may have many objects, for example), which makes them adaptable in a way that drives are not. So, affect can enable the satisfaction of a drive (excitement might prepare the body for the satisfaction of hunger) or interrupt it (so that disgust might interrupt that satisfaction if you were served a rotten egg to eat). Discontented by the way affects had been theorized only in respect to drives, the influential psychologist Silvan Tomkins (1963) was

300

the first to suggest that they have a singularity that creates its own circuitry. Thus affects may be autotelic (love being its own reward), or insatiable (where jealousy or desire for revenge may last minutes or a lifetime). Tomkins' work suggests that affects have a complex, self-referential life that gives depth to human existence through our relations with others and with ourselves.

In terms of our relations with others, Tomkins asked us to think of the contagious nature of a yawn, smile or blush. It is transferred to others and doubles back, increasing its original intensity. Affect can thus be said to place the individual in a *circuit* of feeling and response, rather than opposition to others. Further, Tomkins argues that we all develop complex *affect theories* as a way of negotiating the social world as unique individuals. An affect theory is all of our affective experiences to date that are remembered (or better, perhaps, registered) in the moment of responding to a new situation, such that we keep 'a trace, within [our] constitution' of those experiences (Al-Saji 2000, p. 56). For Tomkins, then, affect connects us to others, and provides the individual with a way of narrating their own inner life (likes, dislikes, desires and revulsions) to themselves and others. Thus one of the main reasons affect has been taken up as the hopeful alternative to social determinism is its positioning of the individual as possessing a degree of control over their future, rather than as raw material responding rather passively to cognitive or learned phenomena.

Tomkins is joined by Gilles Deleuze to form an unlikely couple dominating the contemporary affective imaginary of cultural theory. Deleuze (1997) proposes affect as distinct from emotion, as bodily meaning that pierces social interpretation, confounding its logic, and scrambling its expectations. In contrast to Tomkins, who breaks down affect into a topography of myriad, distinct parts, Deleuze understands affect as describing the passage from one state to another, as an *intensity* characterized by an increase or decrease in power (1997, p. 181). Deleuze takes two examples from his reading of T. E. Lawrence's experiences in the desert to illustrate the body's capacity to interrupt social logic. In both examples, he paraphrases Lawrence's description of violent events in the desert. The first is the grisly spectacle of 'the gestures of the dying, that attempt at raising their hands that makes all the agonizing Turks ripple together, as if they had practiced the same theatrical gesture, provoking Lawrence's mad laughter' (1997, p. 123). The second is Deleuze's account of Lawrence's experience of being gang raped: 'in the midst of his tortures, an erection; even in the state of sludge, there are convulsions that jolt the body' (1997, p. 123). For Deleuze, both instances index the unpredictable autonomy of the body's encounter with the event, its shattering ability to go its own way. In Deleuze's account, Lawrence does experience shame, but not in alignment with social prohibition, rather as a judgement on his body's response to rape: it is his erection that gives rise to shame. For Deleuze, one cannot do justice to Lawrence's unruly body by reducing it to its social organization. To do so would be to miss the dramatic significance of the body's own asocial trace. Instead, Deleuze proposes a cartographic approach to the body and its affects where the critical focus is on bodily displacement, the movement between bodily states that is its intensity (1997, p. 63), its refrain. For many theorists of affect Deleuze's approach provides insight into thinking through the body in a non-essentialist way that remains faithful to many different levels and modes of bodily experience (e.g. Spinks 2001). As inheritors of this affective legacy, contemporary critical theorists tend to prefer either Tomkins' pragmatism or Deleuze's imaginative flights.

Eve Sedgwick's new work takes up Tomkins' suggestion that a focus on affect sidesteps a myopic attention to structural prohibition. While Tomkins is concerned with differentiating affect from drives, however, Sedgwick is interested in using affect theory to challenge what Probyn calls 'the twinned problematics of discipline or transgression' (2000, p. 13), which anchor poststructuralist critical inquiry. Sedgwick believes that the central problem facing Theory today is its own critical paranoia, where the project of a poststructuralist critical imaginary

has become reduced to the search for, and deadening (re)discovery of, prohibition everywhere: prohibition where it appeared there was freedom, prohibition in a space we had not, until now, thought to look. Sedgwick argues that such paranoia makes cultural investigation protectionist instead of expansive, as theorists ward off other critical imaginaries as duped unless they too come to the same conspiratorial conclusions, unless they too find violence where there had appeared to be possibility (2003, pp. 123–51). For Sedgwick such a 'hermeneutics of suspicion and exposure' that is at once smug and sour, is not merely an unattractive trait in a critical theorist, it also makes her or him ill equipped for analysing contemporary social formations 'in which visibility itself constitutes much of the violence' (2003, p. 140). In current global contexts where violence is anything but hidden, is disconcertingly proud rather than covert, Sedgwick asks 'what use is paranoid theory?' Part of what makes critical theory so uninventive for Sedgwick is its privileging of the epistemological, since a relentless attention to the structures of truth and knowledge obscures our experience of those structures. She advocates instead a reparative return to the ontological and intersubjective, to the surprising and enlivening texture of individuality and community (2003, p. 17). Again following Tomkins, Sedgwick rather provocatively invites us to consider affect as the key to that texture, because of its capacity to link us creatively to others. I say provocatively, because throughout her text, Sedgwick acknowledges that our learned instinct as cultural theorists is to reject Tomkins for his insistence on affect as innate. Indeed, this is precisely Sedgwick's challenge – do cultural theorists shy away from affect *à la* Tomkins for any other reasons than its essentialism? For Sedgwick, if the answer is 'no', as she assumes it is, the rejection of Tomkins' model is itself evidence of paranoid cultural theorists' characteristic disposal of both baby and bathwater.

Brian Massumi similarly intervenes in the contemporary terrain of cultural theory to propose affect as a new way out of the pernicious reign of signification that dominates the field. Mirroring Sedgwick, Massumi's irritation is chiefly reserved for the cultural theorist whose ability for 'critical thinking' has become reduced to identifying points on a stable map of the always already known (Massumi 2002, p. 12). Interpretation through the overlaying of this map can only capture certain moments and certain experiences, which will invariably reflect the framework they are interpreted through. For Massumi, such critical impoverishment means that cultural theorists consistently miss both the matter of bodies and, since his framework is Deleuzian rather than Tomkinsian, the unceasing movement that constitutes the process of becoming. And without this investment in movement between states and bodies, Massumi asks, how do we account for let alone encourage, change (2002, p. 3)? Affect attracts Massumi, then, since it is part of a different order of experience to the epistemological (as defined by Sedgwick): it is 'the unassimilable' (2002, p. 3). His point is that in order to study the unknowable, cultural theorists will have to abandon the certainty that has come to characterize the field.

What is clear then, is that Sedgwick and Massumi emerge as champions of affect in a more general context of the critique of what is usually understood as the 'cultural turn'. The particular form of these arguments is often discipline-specific, but what all critiques share is a lamenting of the turn to language represented by poststructuralism. Within the context I am most familiar with, of feminist debate, this turn to language is usually critiqued for one of two reasons that are somewhat at odds with one another. The first laments the increasing theoretical abstraction of feminist writing, associating it with an increase in professionalization and a concomitant decrease in political accountability (Gubar 1998, Stanley and Wise 2000, Jackson 2001). Poststructuralist feminist writing is often aggressively damned for its inaccessibility, and for its perceived lack of attention to what is often invoked as 'the material'. These arguments have been raging within feminist academic and political contexts for a long time, but cross over into more mainstream critical terrain through the debates between Judith Butler and Nancy Fraser in the late 1990s

(Butler 1997b, Fraser 1997). In the second critique of the 'cultural turn' within feminism, post-structuralism is understood in contrast to have *over-emphasized* power-relations and their framing of both what we do and who we are, to the extent that there appears to be no hope of liberation. We are effectively caught in culture. Critics viewing poststructuralism in this way advocate not a material return but an ontological one, a revaluing of individual difference and capacity for change over time (Prosser 1998, Mitchell 2000). A number of theorists – most notably, perhaps, Rosi Braidotti (2002) – combine these two critiques in their focus on the lived materiality of bodies. Sedgwick and Massumi's interest in affect must therefore be seen within the context of broader challenges to poststructuralist approaches to language, power and subjectivity, and particularly in line with the second trajectory detailed here.

Critical chronologies

The critical narrative laid out above is not simply an abstract one; it takes material form in academic and institutional contexts. In my own institutional context, where I teach graduate students gender studies, the narrative is precisely borne out. Each year it seems students grapple with poststructuralist approaches only to return to the question of how this turn to language is political. As with both critiques presented above, students identify the political in an empirically available real world or in the body. Instead of deconstruction, students are finding themselves drawn to social policy, development theory and practice, or to psychoanalytic or affective approaches that reframe questions of sexual and racial difference. What is of interest here, however, and challenges a simple acceptance of this critical narrative, is that too frequently such material or ontological judgement is made on the basis of secondary reading – that rejects poststructuralism as entirely rarefied and apolitical – not primary reading. This is of course a familiar pattern. As a masters student in women's studies in the early 1990s my secondary reading convinced me of the essentialist ills of early second wave Western feminist texts, most of which I did not read until much later. That lack of direct textual engagement did not stop me writing damning critiques of an 'earlier generation' of feminists, however, and nor did it stop that work being published, because this view was a generally held one. Opinion of what became crudely termed 1970s feminism has begun to shift, in part because of an insistence that a decade of proliferating feminist texts and political action cannot be represented by the handful of theorists most commonly cited as essentialist (Stacey 1997, Graham *et al.* 2002). But my argument here is not that these 'earlier generation' are beyond critique, or innocent of essentialism or abstraction in turn, but that a narrative that posits a contemporary critical break with their characteristics has a vested interest in reading for generality instead of complexity. In my own, and my students' cases, such narratives mitigate against careful critical reading, tend to the dismissive, and celebrate 'the new' as untouched by whatever we find ourselves currently transcending. In the search for 'the new' that bears no resemblance to the past, the identifying features of that past are inevitably overstated, and the claims for that new embellished in ways that must at the very least fall short of rigorous.

In positing affect as the critical new for the noughts, both Sedgwick and Massumi invariably overstate the problems of poststructuralism, as well as and in order to herald affect's unique capacity to resolve contemporary critical dilemmas, much as advocates of poststructuralism overstated the ills of the seventies and early eighties. In *Touching Feeling*, the weight of Sedgwick's dismissal of poststructuralist epistemology is carried by her reading of only two texts: Judith Butler's *Gender Trouble* and D. A. Miller's *The Novel and the Police*. Published in 1990 and 1988 respectively, despite the fact that both arguments are ones that their authors have subsequently developed in different directions. It seems odd to rest the case for needing new

theoretical frameworks on texts that have already prompted just such revisions from their authors, and indeed that are either side of fifteen years old. Surely if the need for affect is so urgently felt, the problem could be found in more contemporary texts? Massumi's dismissal of cultural theory rests on more slender evidence still. At no point in *Parables For the Virtual* does Massumi engage directly with any of the theorists responsible for what he insists is theory's terrible state of critical affairs, although the scattered but persistent references to 'performance' could be taken as similarly implicating Butler. Instead of critical dialogue, Massumi persuades his reader of the need for restorative attention to affect by positioning him or her as a co-conspirator who already knows what the problems of cultural theory are but just needs a little coaxing. Rather than tracing the thinking of particular authors, Massumi objectifies critical thinking, referring to it in the third person throughout. The following passage is typical:

> Critical thinking disavows its own inventiveness as much as possible. Because it sees itself as uncovering something it desires to subtract from the world, it clings to a basically descriptive and justificatory modus operandi. However strenuously it might debunk concepts like 'representation,' it carries on as if it mirrored something outside of itself and with which it had no complicity, no unmediated processual involvement, and thus could justifiably oppose.
>
> *(2002, p. 12)*

'Critical thinking' is unreflexive, childish, stubborn, arrogant and, as suggested, unauthored. Presumably, the reader can be expected to want to be an adult, for who among us would want to 'cling to a … descriptive … modus operandi', let alone 'disavow[… our] own inventiveness'. Our rejection of such juvenile attachment to the theoretical status quo is in the end all just part of growing up. As the wise father, Massumi counsels that this has 'nothing to do with morals or moralizing. [It is] just pragmatic' (2002, p. 13). In both Sedgwick and Massumi, I want to stress that these citation issues are more than simply omission. They construct a critical history at the same time as they dismiss it. Positing affect as a 'way out' *requires* that poststructuralist epistemology have ignored embodiment, investment and emotion, and that the academic reader recognize their own prior complicity and current boredom with Theory's straight-jacketing of thought.

If poststructuralist epistemology is the problem, it is perhaps not enormously surprising that a post-deconstructivist ontology is offered as the solution. Both Sedgwick and Massumi progress from asserting the absolutely flawed nature of epistemology to insisting on the unequivocal good of ontology. For Sedgwick, it is self-evidently horrific that critical thought is dominated by epistemological approaches that consider 'the quality of affect … of [no] more consequence than the color of the airplane used to speed a person to a destination' (2003, p. 18). This horror underwrites her conviction that only a turn to ontology can redress the over-emphasis of truth and knowledge at the expense of individual experience. In Massumi, signification is (passive) death, and ontology is (active) life. Even where theorists stress multiplicity of social location, for Massumi (2002, p. 3) this continues to fix difference: 'The sites, it is true, are multiple. But aren't they still combinatorial permutations on an overarching definitional framework?' While all social meaning is already fully known, already '[nothing] more than a local embodiment *of* ideology' (2002, p. 3), ontology on the other hand heroically carries the very difference that ideology, and cultural theory, would minimize or ignore (2002, p. 5). The epistemological past is grey, flat and predictable, the ontological future is bright, many-faceted and surprising. That future could be ours too (again, who would not want it to be?), if … and only if … we break free of our paranoid attachment to unfreedom and turn

towards the possibilities offered by feeling. It may seem perverse to resist, but as with the issues of citation discussed above, the 'problem of epistemology' only materializes in the moment that it is chronologically and intellectually separated from ontology. Ontology thus resolves the problem its advocates invent.

Both authors' chronologies of the past and future of critical theory need to ignore the range of poststructuralist work that does not follow this pattern; epistemological work that is neither poststructuralist, nor opposed to consideration of ontology. As neither theorist can afford to acknowledge, there is a vast range of epistemological work that attends to emotional investments, political connectivity and the possibility of change. To briefly trace one example, feminist standpoint epistemology might be said to constitute an established body of inquiry into the relationship *between* the ontological, epistemological and transformative. Feminist standpoint is a useful example in considering the turn to affect because its genealogical resonances echo back and forth across the last few decades, countering an affective chronology whose advocates prioritize grand shifts in ways that promote rather than caution against generalization. In standpoint, epistemology and ontology are never separated and opposed, and its key proponents range across Marxist feminism, critical race theory, sexual difference theory, as well as poststructuralism (Harding 1986, Haraway 1991, Braidotti 1994, Hartsock 1999, Hill Collins 2000). In addition, all feminist standpoint work, while enormously divergent, does share the following: firstly, a commitment to political accountability, community and the importance of positive affect for both belonging and change. Secondly, against paranoia, all the feminist standpoint work I can think of posits a different, historical and community validated standard of evidence for the knowledges that it wishes to produce. Or, to take a different tack, postcolonial theorists, among others, have attended to the ways that marginal social location is not simply 'precoded into the ideological master structure' as Massumi (2002, p. 3) suggests. Such theorists have argued that to be marginal in relation to the dominant is to inhabit *ambivalence*, not simply additive or oppositional multiplicity (Fanon 1952, Said 1979, Bhabha 1994, Kandyoti 1994, Spivak 1999). To be 'other' is not only to be the object of another's gaze within the dominant; it also precipitates community that is historically resonant, that draws on and creates alternative signification of the same actions and events. Thus, social difference is not only opposite, but knowing and inflecting, and the social world is always crosscut with fissures that have a social and political history that *signifies otherwise*.

When I first read both Massumi and Sedgwick on affect, I was genuinely confused. Both theorists are of course familiar with the kind of work on epistemology or signification that does not reduce experience to a place on a grid of immutable power relations. Sedgwick herself paradigmatically complicated questions of knowledge and the subject formed by its perverse logics in *Epistemology of the Closet* (1990) and refused to reduce what one could call queer standpoint to a fixed position on a homophobic map. But in fact this failure to attend to the fault lines in a chronology charting cultural theory's progressive myopia is *central* to the positioning of affect as panacea for Theory's hypochondria. Such broad oversights and lack of citational evidence, if not deliberate, are a least necessary to both authors' critical location in their work on affect. Only through these 'oversights' can non-paranoid theory belong to the future rather than to the present and past. A reader could well respond that some oversight and generalization is inevitable in the development of new critical trajectories, and that if Massumi and Sedgwick are wrong in some respects, they are also right in others. But what is overlooked in this particular authorship of history is instructive. It is consistently theory written from the margins (I just mentioned standpoint and postcolonial theory here) that refuses both dominant prescription and simple oppositional location, and values continuity of difference over time. To refuse to cite in order to dismiss, it is politically invested perspectives of difference, rather than abstract

epistemologists who disappear from the critical record. I would argue then that affect theorists' error lies in the evacuation of this theoretical and political complexity from critical theory's development; but this 'error' is precisely what allows complexity to be hijacked for recuperation in the future.

Affective freedoms

As contemporary cultural theorists, both Sedgwick and Massumi know that they cannot simply propose a return to ontological *certainty* in order to alleviate the epistemological myopia they identify. For the critical chronology I have been indicating to remain intact, affect must be both post biological essentialism and post-epistemology. In this vein, Sedgwick and Massumi use the notion of affect as free and autonomous respectively, to persuade cultural theorists of the value of the untrammeled ontological. Sedgwick's 'reparative return' to the singularity of the onto-logical hinges on her argument that affect is free from the constraints of both drives and social meaning. Following Tomkins, Sedgwick (2003, p. 19) asserts that 'affects can be, and are, attached to things, people, ideas, sensations, relations, activities, ambitions, institutions, and any number of other things, including other affects. Thus one can be excited by anger, disgusted by shame, or surprised by joy'. On the one hand, then, attention to affect will always be attention to everyday experience rather than macro abstractions, and even more importantly for Sedg-wick, affective attachments will be *unpredictable*. Since affect is a 'free radical' that can attach itself to anything, and since we create associations between feelings and contexts that are unpredict-able, 'anyone's character … is … a record of the highly individual histories by which … fleeting emotion … has instituted far more durable, structured changes' (2003, p. 62) in the self and in relationships. Sedgwick's conclusion is that to collect these records would be a cure of sorts for critical paranoia, creating both a different archive of experience as well as a different theoretical paradigm. This freedom of affect combines with its contagious nature, resulting in what Sedg-wick understands as its capacity to transform the self in relation to others.

It is certainly true that affect attaches all over the place. As Sedgwick suggests, it is hard to think of an arena of life that is not suffused with affect. However, there is a slippage here, too. Affect's freedom of attachment, its ability to attach to any object, becomes evidence, for Sedg-wick, of *our* critical freedom, should we but attend to its unfolding drama. For affective freedom to equal critical freedom Sedgwick must insist that affect attaches *randomly* to any object, despite the fact that even for her guide, Silvan Tomkins, affective attachment frequently serves to satisfy drives or social norms. Sedgwick's argument (2003, p. 19) is that because affect can be surprising in its attachments, as cultural theorists we have a duty to attend to the patterns and effects of such surprise, rather than to the social frameworks that we already know. The critique of Sedgwick's insistence here takes two directions: firstly, what might still be gained by a (healthy?) critical paranoia in tracing affect; and secondly, which critics are able to turn their location into such celebratory responsibility?

Let us pursue the example of disgust–shame that Sedgwick takes as exemplary of affective freedom. It attaches itself to many different objects, and can arise unexpectedly in relation to an object previously favoured. Yet, it is clear that there are certain things that unquestionably authenticate disgust as response in human beings in the first place. In a scene from *The Negative Affects*, Tomkins suggests that we learn disgust as a primary negative affect when a parent smells our faeces and reacts with the affect disgust – contempt:

> It may be that the anal character, whose primary affect is disgust, is an anal character because humans are innately disgusted by the odor of their feces. If the human feces were

> not innately disgusting, however, it would still be relatively easy to teach the child to be disgusted by his own feces, by identification with the parent who lifted his lip and drew his head away from the child's feces.
>
> *(1963, p. 132)*

Tomkins continues the story: the child realizes that it is *him* that the parent is disgusted with and through identification with the parent, he becomes ashamed of himself. So the child finds other objects to be disgusted of, the better to reduce the likelihood of shame doubling back on him. But the possibility of shit not being recoiled from if it were not innately disgusting, is only imagined momentarily in this passage to be summarily dismissed by the insistence that 'it would still be relatively easy' to teach this disgust anyway. Disgust at shit is thus either innate or inevitable – its randomness resides only in which object its displacement will settle on. The scene is profoundly homosocial in that it is the father's recoil from the son here (all Tomkins' children are little 'heroes') that forms the pedagogic site. A father teaches his son by example that his inevitable recoil from shit is natural. Indeed Tomkins' book of negative affect is bursting with children whose affective responses are bound by the early contexts in which they learn the codes and practices of gender and sexuality. In Tomkins' shame-filled world, boys are instructed specifically not to cry like girls, mumble, gesticulate when speaking, demonstrate enthusiasm in public or eat like birds; in ways that suggest that no matter how expansive our capacity to substitute objects of disgust at a later date, the primary affect these refer to is either learned – or if innate, reinforced – in heteronormative scenes (Berlant 1997). My point here is not that Sedgwick misses the heteronormative regulation of affect, but that her awareness of this inattention is central to how her affective logic functions. This logic is governed by three phrases: a. *Of course shame can be normative, but it can also be transformative*; b. *Shouldn't we attend to those transformative possibilities over and above normative ones?* c. *It is simply churlish to make a fuss*. This grammar only works because of our prior knowledge of Sedgwick's work in a central rather than passing way – we can trust that Sedgwick of all theorists has already factored power into the equation. Thus in our own expectations, as in the critical chronology discussed in the previous section, power belongs to the past, to the already dealt with, allowing the future to emerge as the epoch of individual difference.

Against this teleology of old power versus new freedom of choice I want to continue by suggesting that only for certain subjects can affect be thought of as attaching in an open way; others are so over-associated with affect that they themselves are the object of affective transfer. In this vein, Jennifer Biddle (1997, p. 231) insists that in matters of sexuality it is the woman who carries the shame of gendered impropriety, and marks its limits: 'It is, after all, the prostitute who is shameless, but the gentleman, let us not forget, who is discreet'. Such transferred affective attachments do not only pertain to gender and sexuality, but also suffuse critical accounts of the process of affective racialization. I am thinking here of Franz Fanon and Audre Lorde's often cited descriptions of *other people's* affective response to their blackness. Fanon remembers:

> My body was given to me sprawled out, distorted, recoloured, clad in mourning in that white winter day. The Negro is an animal, the Negro is bad, the Negro is mean, the Negro is ugly; look, a nigger, it's cold, the nigger is shivering, the nigger is shivering because he is cold, the little boy is trembling because he is afraid of the nigger, the nigger is shivering with cold, that cold that goes through your bones, the handsome little boy is trembling because he thinks that the nigger is quivering with rage, the little white boy throws himself into his mother's arms: Mama, the nigger's going to eat me up.
>
> *(1952, p. 80)*

Clare Hemmings

While the white boy's fear, learned within a racist familial and social order, can attach to an unknown black object, Fanon's body is precisely not his own, but is 'sprawled out' and 'distorted', presented to him via the white boy's affective response. Lorde similarly recalls her realization that it is *her body* that is disgusting to a white woman sitting next to her on the bus:

> When I look up the woman is still staring at me, her nose holes and eyes huge. And suddenly I realise that there is nothing crawling up the seat between us; it is me she doesn't want her coat to touch. The fur brushes past my face as she stands with a shudder and holds on to a strap in the speeding train … Something's going on here I do not understand, but I will never forget it. Her eyes. The flared nostrils. The hate.
>
> *(1984, pp. 147–8)*

In discussing the same passage, Sara Ahmed argues that affect thus places bodies in spatial relation along racially defined lines (2000, pp. 85–6). In both of these examples, it is the black body that carries the weight of, and is suffused with, racial affect, as it is the female body that carries the burden of the affects that maintain sexual difference in Biddle's example above.

Biddle, Fanon and Lorde's narratives testify to the argument that some bodies are captured and held by affect's structured precision. Not only, then, is affect itself not random, nor is the ability to choose to imagine affect otherwise. My concerns about the centring of the critic in affective discourse come full circle. In the first instance, the need for a new theory of the ontological requires displacing marginal theory and histories from a chronology of cultural theory. Furthermore, the cultural critic has to evidence their desire to move away from that imagined chronology by choosing choice. Yet, as I have suggested, the autonomy of the critic to make such a choice is dependent upon their being the subject rather than object of affective displacement. The failure of some critics to 'choose choice' paradoxically becomes evidence of their concomitant failure to relinquish an imagined history that they may already have been erased from.

Affective autonomy

Placing affective attachment in the context of social narratives and power relations as I have done above similarly runs counter to Massumi's claim that affect is critically useful because of its autonomy. For Massumi, the moment that we 'make sense' of a state of being, or more properly becoming, we freeze it, evacuating it of the very intensity that offered the capacity for change. Thus:

> Affect is autonomous to the degree to which it escapes confinement in the particular body whose vitality, or potential for interaction, it is. Formed, qualified, situated perceptions and cognitions fulfilling functions of actual connection or blockage, are the capture and closure of affect. Emotion is the intensest (most contracted) expression of that capture and of the fact that something has always and again escaped.
>
> *(1996, p. 228)*

As for Sedgwick, then, affect is interesting insofar as it resists or runs counter to the causal linearity through which we make sense of the world. Yet, where for Sedgwick affective freedom of attachment becomes a mark of the critic's freedom, for Massumi the affective autonomy places it outside the reach of critical interpretation. Affect is thus valuable to the extent that it is not susceptible to the vagaries of theoretical whim. In Simon O'Sullivan's words that I began this article with, 'you cannot read affects, you can only experience them' (2001, p. 126).

Massumi's invocation to cultural critics to open themselves up to something that cannot be read may strike us as odd. While many will concur with Massumi's scepticism of quantitative research in its inability to attend to the particular, we are left with a riddle-like description of affect as something scientists can detect the loss of (in the anomaly), social scientists and cultural critics cannot interpret, but philosophers can imagine (2002, p. 17). How then can we engage affect in light of the critical projects we are engaged in, or are we to abandon the social sciences entirely? In fact, both Massumi and Sedgwick are advocating a new academic attitude rather than a new method, an attitude or faith in something other than the social and cultural, a faith in the wonders that might emerge if we were not so attached to pragmatic negativity. Massumi is thus suggesting not that we *look for* something outside culture, but that we *trust that* there is something outside culture. This is a useful proposition only if one's academic project is to herald the death of the cultural turn, and a return to the rigour of disciplinarity – the visionary sciences, imaginative philosophy, but precisely not the miserable social sciences or defeatist cultural studies.

Much seems to rest on Massumi's understanding of affect as autonomous. As befits his participation in a critical chronology departing from biological essentialism in the first instance, Massumi is careful to note that affect '*includes* social elements, but mixes them with elements according to different logic' (1996, p. 223), taking them up as unfinished '*tendencies* … pastnesses opening onto a future, but with no present to speak of' (1996, p. 224). In making this claim for affect – its movement between past and future, never fixed in the present – Massumi is extending Deleuze's chronology of body and mind in *Essays Critical and Clinical*. Following his description of Lawrence's unexpected bodily response to being raped mentioned earlier, Deleuze suggests that we might therefore conceptualize the relationship between body and mind as follows:

> The mind begins by coldly and curiously regarding what the body does, it is first of all a witness; then it is affected, it becomes an impassioned witness, that is, it experiences for itself affects that are not simply effects of the body, but veritable *critical entities* that hover over the body and judge it.
>
> *(1997, p. 124)*

Body and mind are thus linked but detached, potentially developing in different directions, differently affected. But the mind is the witness to the body, thus needing the body, while the reverse is not the case, and it is in that sense that the body and the affects that it distributes are 'asocial, but not presocial' for Massumi (1996, p. 223).

To conclude this essay on a slightly different note, I want to develop Deleuze's description of the relationship between body and mind here, to argue that extrapolating from its logic that affect is autonomous, as Massumi does, is a misreading. Deleuze is not critiquing linearity per se, but what we understand as the components of linearity. If judgement is always secondary to bodily response, poised above it, but crucially tied to it, the intensity of that response must also presumably be curtailed or extended by that judgement, forming an affective cycle in which each element has the capacity to affect (intensify or diminish) the other. Deleuze has offered us a snapshot of frozen time, a single moment of judgement, but this is a moment only, and one that does in fact take place within a larger passage of time. Judgement links the body and the social and gives both interpretative meaning. The 'maps of intensity' that Deleuze would have us draw up in our desire to understand the individual are the shifts from one component to the next, one affective cycle to the next (1997, p. 64). Thus, 'maps of intensity' are maps of individual life and meaning *in time*, perhaps even constituting time. They are certainly not outside

time. To pursue this interpretation of Deleuze further, these affective cycles form *patterns* that are subject to reflective or political, rather than momentary or arbitrary judgement. Such affective cycles might be described not as a series of repeated moments – body–affect–emotion – a self-contained phrase repeated in time, but as an ongoing, incrementally altering chain – body–affect–emotion–affect–body – doubling back upon the body and influencing the individual's capacity to act in the world. In this context, reflective or political judgment provides an alternative to dominant social norms, but not because of affective autonomy. This reading indicates a return to Tomkins' *affect theory* too, where it is the reinvigoration of previous affective states and their effects, rather than affective freedom, that allow us to make our bodies mean something that we recognize and value.

To return to my discussion of Fanon and Lorde, it is clear that racially marked subject are not simply 'sprawled out' and 'distorted' (Fanon 1952, p. 80), but have a critical and affective life that resonates differently. So that over time, Audre Lorde's critical judgement of the ongoing spiral of smaller cycles of shame in response to her body and to racism is of such intensity that she is able to remake the relationship between her body, affect and judgement to inflect the social world with other meanings. In *The Cancer Journals*, for example, a text that is almost definitional in tracing maps of intensity that fashion the individual other in relation to an other social world (1980), Lorde does not need to think of affect as asocial in order for her investments in survival to provide a different affective trajectory than the one that would deny her subjectivity. Lorde reinvents her body as hers not theirs, a body connected to other bodies by shared judgements of the social. Those judgements constitute a political history that reshapes social meaning, creating recognizable and intelligible alternatives to dominant signification. My critical response to Massumi and Sedgwick's work on affect, then, is not one that rejects the importance of affect for cultural theory. It is one that rejects the contemporary fascination with affect as outside social meaning, as providing a break in both the social and in critics' engagements with the nature of the social. The problems in Massumi and Sedgwick discussed in this article do not require a wholesale rejection of affect's relevance to cultural theory. Instead, affect might in fact be valuable precisely to the extent that it is not autonomous.

Note

1 Richard Langston (2005) takes up this capacity of affect to re-embed or unsettle cultural stereotypes and investments in the context of the foreign language classroom, to illustrate how affect might usefully be pedagogically investigated.

Bibliography

Ahmed, S. (2000) 'Embodying strangers', in *Body Matters: Feminism, Textuality, Corporeality*, eds A. Horner & A. Keane, Manchester University Press, Manchester, pp. 85–96.

Al-Saji, A. (2000) 'The site of affect in Husserl's phenomonology', in 'Philosophy in body, culture and time: selected studies in phenomenology and existential philosophy', eds W. A. Brogan & M. A. Simons, *Philosophy Today*, Vol. 26.

Berlant, L. (1997) *The Queen of America Goes to Washington City: Essays on Sex and Citizenship*, Duke University Press, Durham.

Bhabha, H. K. (1994) *The Location of Culture*, Routledge, London.

Biddle, J. (1997) 'Shame', *Australian Feminist Studies*, Vol. 12, No. 26, pp. 227–239.

Braidotti, R. (1994) *Nomadic Subjects: Embodiment and Sexual Difference in Contemporary Feminist Theory*, Columbia University Press, New York.

Braidotti, R. (2002) *Metamorphoses: Towards a Materialist Theory of Becoming*, Polity Press, Cambridge.

Bruns, J. (2000) 'Laughter in the aisles: affect and power in contemporary theoretical and cultural discourse', *Studies in American Humor*, Vol. 3, No. 7, pp. 5–23.

Butler, J. (1990) *Gender Trouble: Feminism and the Subversion of Identity*, Routledge, New York.

Butler, J. (1997a) *The Psychic Life of Power: Theories in Subjection*, Stanford University Press, Stanford, CA.

Butler, J. (1997b) 'Merely cultural', *Social Text*, vols 52/53, pp. 265–277.

Cavarero, A. (2000) *Relating Narratives: Storytelling and Selfhood*, trans. P. A. Kottman, Routledge, London.

Deleuze, G. (1997) *Essays Critical and Clinical*, trans. D. W. Smith & M. A. Greco, University of Minnesota Press, Minneapolis.

Fanon, F. (1952) 'The fact of blackness', in his (1991) "*Black Skins, White Masks*", Pluto Press, London, pp. 77–99.

Fraser, N. (1997) 'Heterosexism, misrecognition, and capitalism: a response to Judith Butler', *Social Text*, vols 52/3, pp. 279–289.

Giardini, F. (1999) 'Public affects: clues towards a political practice of singularity', *The European Journal of Women's Studies*, Vol. 6, No. 2, pp. 149–160.

Graham, H., Kaloski, A., Neilson, A. and Robertson, E. (eds) (2002) *The Feminist Seventies*, Raw Nerve Books, York.

Grosz, E. (1994) *Volatile Bodies: Toward a Corporeal Feminism*, Indiana University Press, Bloomington, IN.

Gubar, S. (1998) 'What ails feminist criticism?', *Critical Inquiry*, Vol. 24, pp. 878–902.

Halperin, D. (2002) 'Homosexuality's closet', *Michigan Quarterly Review*, Vol. 41, No. 1, pp. 21–54.

Haraway, D. (1991) 'Situated knowledges: the science question in feminism and the privilege of the partial perspective', in her *Simians, Cyborgs and Women: the Reinvention of Nature*, Routledge, New York, pp. 183–201.

Harding, S. (1986) *The Science Question in Feminism*, Cornell University Press, Ithaca, NY.

Hardt, M. (1999) 'Affective labor', *Boundary 2*, Vol. 26, No. 2, pp. 89–100.

Hartsock, N. (1999) *The Feminist Standpoint Revisited and Other Essays*, Westview Press, Boulder, CO.

Hill Collins, P. (2000) *Black Feminist Thought: Knowledge, Consciousness and the Politics of Empowerment*, Routledge, New York.

Jackson, S. (2001) 'Why a materialist feminism is (still) possible and necessary', *Women's Studies International Forum*, Vol. 24, No. 3–4, pp. 283–293.

Kandyoti, D. (1994) 'Identity and its discontents: women and the nation', in *Colonial Discourse and Post-colonial Theory: a Reader*, eds P. Williams & L. Chrisman, Columbia University Press, New York, pp. 376–391.

Langston, R. (2005) 'Feels like teen spirit: affect, gendered bodies, and teaching cross-cultural difference at the millennium', *Women in German Yearbook*, forthcoming.

Lorde, A. (1980) *The Cancer Journals*, Aunt Lute Books, San Francisco.

Lorde, A. (1984) 'Eye to eye: black women, hatred, and anger', in her *Sister Outsider: Essays and Speeches by Audre Lorde*, The Crossing Press, Freedom, CA.

Massumi, B. (1996) 'The autonomy of affect', in *Deleuze: a Critical Reader*, ed. P. Patton, Blackwell, Oxford, pp. 217–239.

Massumi, B. (2002) *Parables for the Virtual: Movement, Affect, Sensation*, Duke University Press, Durham.

Miller, D. A. (1988) *The Novel and the Police*, University of California Press, Berkeley, CA.

Mitchell, J. (2000) *Mad Men and Medusas: Reclaiming Hysteria and the Effects of Sibling Relationship Upon the Human Condition*, Allen Lane, London.

Munt, S. (2000) 'Shame/pride dichotomies in Queer As Folk', *Textual Practice*, Vol. 14, No. 3, pp. 531–546.

O'Sullivan, S. (2001) 'The aesthetics of affect: thinking art beyond representation', *Angelaki*, Vol. 6, No. 3, pp. 125–135.

Probyn, E. (2000) 'Shaming bodies: dynamics of shame and pride', *Body and Society*, Vol. 6, No. 1, pp. 13–28.

Prosser, J. (1998) *Second Skins: the Body Narratives of Transsexuality*, Columbia University Press, New York.

Said, E. (1979) *Orientalism*, Random House, New York.

Sedgwick, E. K. (1990) *Epistemology of the Closet*, University of California Press, Berkeley, CA.

Sedgwick, E. K. (2003) *Touching Feeling: Affect, Pedagogy, Performativity*, Duke University Press, Durham.

Sedgwick, E. K. & Frank, A. (1995) 'Shame in the cybernetic fold: reading Silvan Tomkins', in their (eds) *Shame and Its Sisters: A Silvan Tomkins Reader*, Duke University Press, Durham, pp. 1–28.

Shilling, C. (1993) *The Body and Social Theory*, Sage, London.

Spinks, L. (2001) 'Thinking the post-human: literature, affect and the politics of style', *Textual Practice*, Vol. 15, No. 1, pp. 23–46.

Spivak, G. C. (1993) 'Woman in difference', in her *Outside in the Teaching Machine*, Routledge, New York, pp. 77–95.

Spivak, G. C. (1999) *A Critique of Postcolonial Reason: Toward a History of the Vanishing Present*, Harvard University Press, Cambridge, MA.

Stacey, J. (1997) 'Feminist theory: capital F, capital T', in *Introducing Women's Studies: Feminist Theory and Practice*, eds V. Robinson & D. Richardson, New York University Press, New York, pp. 54–76.

Stanley, E. & Wise, S. (2000) 'But the Empress has no clothes! Some awkward questions about 'the missing revolution' in feminist theory', *Feminist Theory*, Vol. 1, No. 3, pp. 261–288.

Tomkins, S. (1963) *Affect, Imagery, Consciousness – Vol. II: The Negative Affects*, Springer Publishing, New York.

22

The archaeology of mind [extracts]

Jaak Panksepp and Lucy Biven

[…] To the best of our knowledge, the basic biological values of all mammalian brains were built upon the same basic plan, laid out in consciousness-creating affective circuits that are concentrated in subcortical regions, far below the neocortical "thinking cap" that is so highly developed in humans. Mental life would be impossible without this foundation. There, among the ancestral brain networks that we share with other mammals, a few ounces of brain tissue constitute the bedrock of our emotional lives, generating the many primal ways in which we can feel emotionally good or bad within ourselves. As we mature and learn about ourselves, and the world in which we live, these systems provide a solid foundation for further mental developments. These subcortical brain networks are quite similar in all mammals, but they are not identical in all details. This similarity extends even to certain species of birds that, for instance, also have separation-distress PANIC networks—a GRIEF system, as we will often label it here— one of the main sources of psychological pain within their brains and ours.

We mammals and birds share many other basic emotional systems, and some even seem to exist in cold-blooded reptiles, but less is known about them. Thus, across many species of warm-blooded vertebrates, a variety of basic emotional networks are anatomically situated in similar brain regions, and these networks serve remarkably similar functions. We will discuss the nature of these brain systems that are being revealed by research on *other animals* (henceforth just "animals"). This knowledge is beginning to inform us about the deeper aspects of human nature. It provides a scientifically based vision about the origins of mind.

[…] [T]he ancient subcortical regions of mammalian brains contain at least seven emotional, or affective, systems: SEEKING (expectancy), FEAR (anxiety), RAGE (anger), LUST (sexual excitement), CARE (nurturance), PANIC/GRIEF (sadness), and PLAY (social joy). Each of these systems controls distinct but specific types of behaviors associated with many overlapping physiological changes. To the best of our knowledge, these systems also generate distinct types of affective consciousness, and some of the most compelling data for that come from humans (Panksepp, 1985). As we will see, when these systems are stimulated in humans, people always experience intense emotional feelings, and presumably when the systems are normally activated by life events, they generate abundant memories and thoughts for people about what is happening to them.

[…]

[...]

As far as we know right now, primal emotional systems are made up of neuroanatomies and neurochemistries that are remarkably similar across all mammalian species. [...]

[...]

Because of our higher brain expansions, we experience life at cognitive levels that other animals cannot imagine. We can reflect on our options in subtle ways, leading to ever more subtle feelings, constructed largely through learning. Our unique minds, in this world and the cosmos, arise from the cognitive riches of our higher neocortical expansions. But all the while, our higher minds remain rooted in our ancestral past. It is understandable that many wish to envision our affective lives as being completely intertwined with our cognitive abilities, but from a neuro-evolutionary perspective, that is not correct. Although many cognitive scientists and philosophers prefer to only think about our unique cerebral abilities, that does not serve our understanding of the origins of mind at all. But it is fascinating to think about those tertiary aspects of our minds. At that level, we have the full complexity of all the levels interacting, allowing us to even dwell on our mortality, with existential dread, or to have feelings sublime (Hoffman, 2011). It is unlikely that other animals experience their minds with such neuro-affective angst and appreciative depth. But they surely experience their primal emotions, and surely some other levels that are much harder to understand. Here our concern is to go to the deepest roots of the human mind, through an appreciation of the minds of other creatures.

Although neuroscientists have long known much about the ancient emotional circuits of our brains, these circuits have only recently been definitively linked to our emotional feelings. This allows neuroscientists to delve deeply into the neural substrates of affects—the menagerie of our basic internally generated feelings. Which brain systems bring us joy? Why are we sometimes sad? Why, at times, are some people always sad? How do we experience enthusiasm? What fills us with lust, anger, fear, and tenderness? The traditional behavioral and cognitive sciences cannot provide satisfactory answers to such profound issues (and not simply because researchers have failed to ask such questions). [...]

[...] Readers who are interested in pursuing the details of the diverse visions in this field may consult other publications by Jaak Panksepp, who has engaged with these issues many times. An excellent additional reading, highlighting the many views out there, is contained in *The Nature of Emotion* (edited by Ekman & Davidson, 1994).

There is currently a battle in psychology between those who believe we have "*basic*" emotions and those who prefer a "*dimensional*" view of emotional life. For a clear vision of that debate, a [...] collection edited by Zachar & Ellis (2012) may be especially useful: Within the volume is a full-length treatment of the views of Panksepp and those of Professor James Russell of Bostori College, who has championed the *dimensional* view of emotional life. The dimensional view envisions that a unitary bivalent (positive to negative valence, and high and low arousal dimensions) arising from a brain process called the Core Affect is the fundamental grounding of our emotional nature. The debate was supplemented by additional perspectives taken by diverse commentators. This dimensional view has engendered abundant fine research, including recently, subtle animal emotion studies that have evaluated how animals make complex affect-related cognitive choices (Mendl et al. 2010). That approach can now be supplemented by affective neuroscience strategies, by linking findings to neuro-evolutionary levels of control within the BrainMind (see commentary to Mendl and colleagues by Panksepp, 2010a). Such a hybrid approach is essential for making progress in understanding the fuller complexities of the MindBrain.

We use these two terms, mind and brain, double capitalized and in both sequences, to highlight that affective neuroscience is thoroughly monistic, with no remaining dualistic perspectives. The term "BrainMind" is used more often when we take the bottom-up view, and

The archaeology of mind

"MindBrain" when we take the top-down view, both being essential for understanding the "circular causalities" within the evolutionary strata of the brain. The double capitalization, without a space, also highlights the necessity of viewing the brain—"mind-meat" as some enjoy calling it—as a unified organ with no residue of the dualistic perspective that envisions mind and brain as separate entities, an intellectual tradition that has only hindered our understanding. At the same time the two versions of this term highlight (i) that certain aspects of the brain are intrinsic to the types of mental contents we have (BrainMind), while (ii) the other emphasizes that in upper regions of this organ, abundant learning and thought, commonly guided by societal and cultural influences, generate complexities that may not be clarified by animal research.

Thus, we have higher brain functions—commonly envisioned, these days, as a computational-cognitive mind—that need to be distinguished from a more universal affective mind. This distinction between affective and cognitive aspects of mind, although not popular, can be supported in many ways. It is important to ground psychotherapies on a knowledge of affective processes and thereby to understand how to most effectively recruit beneficial cognitive perspectives (Panksepp, 2010b).

The position that brain and mind are separate entities was Rene Descartes' greatest error, to borrow Antonio Damasio's (1994) famous turn of phrase. Another of Descartes' big errors was the idea that animals are without consciousness, without experiences, because they lack the subtle nonmaterial stuff from which the human mind is made. This notion lingers on today in the belief that animals do not think about nor even feel their emotional responses. Most who study animal brains have not yet learned how to discuss and study animal minds, especially their emotional feelings, as systematically and superbly as they study learned behaviors. Animals' primal feelings are best studied ethologically—by monitoring their natural emotional tendencies. Our view is that it is time for us to begin that difficult journey, since it may tell us more about the ancient foundations of our own minds than any other approach that has been tried.

Thus, the detailed knowledge of modern neuroscience, gleaned largely from animal research, has revealed that it is no longer useful to distinguish between the mind and the brain, although we surely must distinguish types of minds and types of brains: Affective feelings, which psychologists and philosophers try to understand largely in terms of ideas are, in fact, functions of the brain. But brain research that can get at neural "mechanisms" (i.e., the details of how a neural system actually works) is quite impossible to do in humans, ethically. Whether it can be done ethically in animals remains a matter of debate. In any event, we believe the evidence is definitive that other animals do have affective experiences, and understanding these systems is very important for biological psychiatry as well as psychotherapeutic practices. Thus, we will feel free to refer to the MindBrain or the BrainMind, depending on which facet of the brain we wish to emphasize, whether it is in humans or animals. But our concern here is largely with the primary-process emotions of the MindBrain, as clarified by animal brain research.

Please consider the following additional terminological clarification before we proceed: we are most concerned with, first, the instinctual emotional responses that generate raw affective feelings that Mother Nature built into our brains; we call them *primary-process* psychological experiences (they are among the evolutionary "givens" of the BrainMind). Second, upon this "instinctual" foundation we have a variety of learning and memory mechanisms, which we here envision as the *secondary processes* of the brain; these have been especially well studied by those who work on fear-conditioning; we believe these intermediate brain processes are deeply unconscious. Third, at the top of the brain, we find a diversity of higher mental processes—the diverse cognitions and thoughts that allow us to reflect on what we have learned from our experiences—and we call them *tertiary processes*. Recognizing such levels of control helps enormously in understanding the fuller complexities of the BrainMind.

Once we begin to seriously consider the evidence that already exists, we believe there can be little question about the existence of many *basic* emotional feelings in the basement of the mind (Panksepp, 1998a). This "basic" vision of emotional life has also long been advocated by those who study the expressions of the human face (Darwin, 1872; Ekman & Davidson, 1994; Izard, 2007). Indeed, the most recent "meta-analysis" of human brain imaging, combining evidence from most of the relevant studies, has recently reached the same conclusion (i.e., Vytal & Hamann, 2010).

Many debates have arisen (e.g., Ekman, 1994; Russell, 1994) because human research really cannot clearly delineate the primary emotional processes of the human mind, since practically all the work with human beings proceeds at the tertiary and secondary levels of analysis. But because of the psychological power of primary-process emotions, those who study our facial expressions have seen the glimmers of basic emotions with sufficient clarity to convince most people that there is something fundamental about our emotional nature. But they have not had the tools to tell us what that is. However, because of animal research, we can be confident that all mammals have many primary-process emotional systems, and other affective ones as well. And the systems are not concentrated in the neocortex, even though they have reciprocal relationships with our higher brain functions.

There are few neuroscientists and even fewer psychologists who are working on how primary-process emotional mechanisms, shared by all mammals, are constituted in the brain. Almost none are working on the feeling (affective) aspects. This helps explain the century-long silence about how affects are actually created within brains. In contrast, many, many scientists are working on perceptual functions such as hearing and vision (for a fine summary of lower-brain perceptual abilities, see Merker, 2007). The almost universal neglect of the primary-process affective networks of the brain leads many scholars of human psychology, not to mention social scientists and philosophers, to neglect issues that their closest interdisciplinary colleagues do not talk about.

In recognizing the evolutionary levels within the BrainMind, one issue regarding brain specializations is of critical importance: At birth, the neocortical "thinking cap" of our MindBrain is largely a blank slate, and experience imprints many abilities and skills up there "naturally." These imprints include what seem to be "hard-wired" brain functions like our sophisticated hearing and visual abilities. At the neocortical level, those abilities are constructed by the process of living in the world and not by any stringent genetic dictates. Among the many critical lines of evidence, the most compelling is as follows: If we eliminate the cortical regions that are "destined" to become visual processing areas *before birth*, perfectly fine visual functions emerge in adjacent areas of the cortex (Sur & Rubinstein, 2005). The subcortical (e.g., thalamic) influences, perhaps directly from the visual projections of the lateral geniculate nucleus (LGN) or perhaps chemical gradients in the cortex itself, are sufficient for the cerebral surface to develop visual competence. Parenthetically, we can be confident that sophisticated hearing is a more ancient process in BrainMind evolution than vision. This is because at the midbrain level, the Grand Central Station of auditory processing—the inferior colliculi that project to the medial geniculate nuclei (MGN) in the thalamus—is lower down (more caudal, implying more ancient) than the hub for midbrain visual processing (the superior colliculi), which project to the LGN. This also may help explain why hearing, which evolutionarily emerged from touch, is a much more emotional sense than vision.

This principle by which we can roughly "date" brain systems is at present just a rule of thumb, and there are exceptions. For instance, more modern downward influences from the neocortex do penetrate through many old layers of the brain. Perhaps the most dramatic example is the longest pathway in the brain, the cortico-thalamic tract. This tract courses all the way from

316

The archaeology of mind

the motor cortex in the frontal regions of the brain far down into the spinal cord, allowing us voluntary control over our fingers and toes, as is needed to play pianos and all other musical instruments with full sophistication, to perform dance routines, and to write books.

Many emotion researchers as well as neuroscience colleagues make a sharp distinction between affect and emotion, seeing emotion as purely behavioral and physiological responses that are devoid of affective experience. They see emotional arousal as merely a set of physiological responses that include emotion-associated behaviors and a variety of visceral (hormonal/autonomic) responses. In their scientific view, animals may show intense behavioral emotional responses, without actually experiencing anything—many researchers believe that other animals may not feel their emotional arousals. We disagree. Some claim that the systems we will talk about are deeply unconscious—without anything happening in the ancestral theater of experience that we call the primary-process BrainMind. We believe the evidence speaks otherwise.

Most neuroscientists are willing to agree that many physiological and emotional behavioral responses are initiated by subcortical structures located deep inside the brain, but they typically deny or ignore that these same structures can generate raw *affective feelings*. According to their view, if an animal is exposed to danger, deep brain structures generate automatic behaviors (like freezing or running away) as well as visceral responses (like increased heart rate and the secretion of cortisol, a universal stress hormone, into the bloodstream). They believe that the response is purely physiological—purely emotional *behavior* without any accompanying affect. Such scholars are all too ready to claim that anthropomorphism—the attribution of human-type psychological processes to other animals—is fundamentally incorrect (for a fine discussion of such issues, see Daston & Mitman, 2005). Many others choose to remain silent about such issues, preferring a more cautious agnostic stance. Our reading of the evidence for all mammals that have been studied in affective neuroscientific ways is that human and animal minds are grounded on genetically homologous—evolutionarily related—affective systems, providing many similar biological "value structures" for higher mental activities. Obviously, some systems will be very comparable, while others, especially the social emotions, will differ more because of selective pressures for evolutionary divergence.

Raw emotions are not everyday occurrences for mature humans, but most can remember clenching their fists and turning red in anger, being incredibly scared, and feeling both deep sadness and joy. Our task here will be to share evidence about such primary-process mechanisms of mental life, much of which comes from the study of animals. Such feelings create an energetic form of consciousness—one that is full of affective intensity—that we will call *affective consciousness*. Primal feelings are not intrinsically bright and intelligent, but they were built into our brains because they are remarkably useful for immediately dealing with the world and learning about its potential. Primal affects are ancestral memories that have helped us to survive. There are many ways these ancient brain networks can make us feel—experiences we sometimes call *core emotional affects* and *raw emotional feelings*. Regardless of which term we use, we are talking about the same thing.

Cognitive scientists who study humans are prone to claim that emotional feelings emerge from some of the highest regions of the human brain. Many scientists who are interested in human psychology, as much as we are, maintain that affects are created when a person or animal is able to make cognitive sense of the changing peripheral physiology of emotion. In other words, affects are defined by and derived from cognitive reflections upon the responses of the body, rather than being intrinsic to the brain itself. On this view, if a person has a churning stomach or clenched fists, the higher cognitive brain (neocortex) interprets these primitive physiological responses as they enter the brain via sensory nerves and label those feelings as emotions. And supposedly it is only then that the person has the subjective experience of feeling

317

anxious or angry. This is the famous James-Lange theory of emotions that was proposed well over a century ago. Now we know that the brain itself typically instigates the bodily arousals that accompany emotions. But despite that, some colleagues go further and assert that affects only come into being when we can actually verbalize them—feelings emerge from our ability to conceptualize the unconscious forces of our minds. Since the neocortex, the outer rind of the brain, is the seat of cognition and language, these cognitive/linguistic theories maintain that affects are created when the neocortex "*reads out*" the physiological controls of emotion that are situated within the brain. For them, the deeper parts of the brain that we will focus on cannot generate any experiences. We believe that the evidence speaks otherwise.

Implicit in read-out theories is the equating of consciousness with cognitions—our self-conscious awareness of our feelings and accompanying thoughts. And if one believes that consciousness is always cognitive, then affects must somehow be cognitive too. According to read-out theories, affective consciousness cannot emerge from the deep brain functions that generate the physiological changes and instinctual behaviors of emotions, because these deep substrates are noncognitive and must therefore be deeply unconscious. Affects can only emerge from the conscious thinking that relies heavily on the very top of the brain, our neocortex, which is essential for all of our higher cognitive activities. However, a vast amount of animal research and many clinical observations oppose this equation of consciousness with cognition. If one accepts affective feelings as a fundamental form of consciousness, there are many ways to distinguish those states of mind from the kind of information processing that constitutes cognitive consciousness, the foundation of human rationality.

Here is one extreme example: Human babies who are born basically without cerebral hemispheres (they are anencephalic) and hence have essentially no neocortex will remain intellectually undeveloped, but they can grow up to be affectively vibrant children if they are raised in nurturing and socially engaging environments (Shewmon et al., 1999; for photos of such a child, see Figure 13.2). As we will see, many decortication experiments have been done on laboratory animals. To the untutored eye, these animals are indistinguishable from normal animals. In fact they are more emotional than normal. Since such children and animals have little neocortex, their affective capabilities must emerge from the other parts of the brain that lie below. This is as close to a proof as one can get in science, where conclusions are more typically constrained by multiple possible interpretations. Revolutionary neurologists and neuropsychologists are now pointing out that even our higher cognitive minds could not work without the low subcortical systems that permit them to do so (e.g., Damasio, 1994; Koziol & Budding, 2009). Our view is also that the ancient affective foundations of mind are essential for many higher mental activities. In short, to understand the whole mind, we must respect the ancestral forms of mind that first emerged in brain evolution.

Needless to say, aphasic stroke victims who have lost the ability to speak or even to think in words (usually due to left neocortical damage) will also retain their affective capacity, which indicates that affective consciousness is independent of language. Thus clinical observation suggests that neither cognitive ability nor the ability to think in words is a necessary condition for affective consciousness. Felt experience can be *anoetic*—an unreflective, unthinking primary-process kind of consciousness that precedes our cognitive understanding of the world, or our so-called *noetic* (learning, knowledge-based) secondary-process consciousness. Continuing in the words of esteemed neuropsychologist, Endel Tulving (2002, 2005), this allows us *autonoetic* tertiary-process thoughtful consciousness—the ability to time travel and to be able to look forward and backward within our minds.

This perspective includes the radical assertion that primary-process core affects are *anoetic* (without external knowledge) but intensely conscious (experienced) in an affective form (which

reflects intrinsic, unreflective brain "knowledge"). As we feel our affective states, we do not need *to know* what we are feeling. In other words, the primary-process emotional feelings are raw affects that automatically make important decisions for us, at times unwise decisions, at least based on the views of our upper cognitive minds. In civilized society, with rules of conduct, emotional acting-out is often unwelcome. Still, the capacity to generate such affective feelings was one critical event in brain evolution that allowed higher forms of consciousness to emerge. Full conscious *awareness* surely had to wait until we had enough cerebral cortex, especially in frontal regions, that allowed us to think, with *autonoetic*, executive, decision-making abilities. But all that fine mental machinery is still heavily influenced by our emotions. The intrinsic evaluations that affective feelings convey to the higher brain enable humans and animals to determine how well or badly they are doing with respect to survival. But at times, they simply get us in trouble. If that keeps happening, psychotherapy is commonly very useful. [...]

[...] Our main goal here is to deal with the nature of those primary emotional processes that are foundational pillars for the brain's mental apparatus. In early life, the primary processes guide what infants do and feel; in maturity, acquired higher brain functions seem to be in complete control—which, as every psychotherapist knows, is rarely the case. We will only tangentially touch on the higher emotional and cognitive processes, but it is clear that those higher brain functions would collapse without the solid affective/evolutionary foundation upon which they are built. This hierarchical scheme readily allows us to handle some traditional paradoxes in the field. For instance, it is often asked why humans like to go to frightening movies. The answer is simple: At the highest tertiary-process levels of mental activity—for instance, autonoetic consciousness—we can be superbly entertained by having our primary-process systems manipulated in situations where we are in fact safe. We can also enjoy a thunderstorm; however, most animals tremble. Without such higher reflective processes, we humans would be unlikely to "voluntarily" expose ourselves to perceptions that can trigger negative affects such as FEAR. We can also be confident that our thoughts often follow our feelings. One of the earliest demonstrations was simple enough: When people were coaxed to be happy or sad, their thoughts tended to follow their feelings (Teasdale et al., 1980). This is a universal observation. But this does not mean that the feelings that characterize happiness and sadness arise from our higher brain. There is no evidence such primitive feelings are "read out" by the neocortex. But such beliefs persist.

[...]

Affects are primary experiences

[...] [W]e will argue that it is now most credible to believe that the varieties of (i) raw emotional feelings, (ii) instinctual emotional behaviors, and (iii) accompanying visceral responses, are all orchestrated by at least seven "relatively" distinct subcortical systems—the systems for SEEKING, FEAR, RAGE, LUST, CARE, PANIC/GRIEF, and PLAY. We say "relatively" since many of these systems have overlapping controls: for instance, general purpose arousal/attention-promoting systems that are mediated by famous transmitters such as acetylcholine, norepinephrine, and serotonin—the cell bodies of which are heavily concentrated deep in the brain stem. [...].

[...] In the normal course of life, especially in childhood, affects become enmeshed with the *development* of higher cognitive abilities. This is due to interaction between the primal affective substrates, which we will focus on, and the maturing neocortex. The neocortex varies dramatically in size and complexity from one mammalian species to another, resulting in rather different levels and types of cognitive abilities and intelligences. As already noted, higher-order emotions

are bound to diverge enormously among different mammalian species. Most of the complex emotions (the cognitively elaborated, socially constructed "mixed emotions" that are so common in humans—think of shame and scorn) have not yet been subjected to any detailed neuroscientific analysis. Realistic laboratory models do not exist for envy and guilt, albeit some progress is being made on feelings like jealousy (Panksepp, 2010c). Because of advances in technology, such as functional Magnetic Resonance Imaging (fMRI) brain scans, we can now image even such subtle higher mental processes within the human MindBrain. And jealousy yields different pictures in male and female brains (Takahashi et al., 2006), with male jealousy arising more from lower emotional brain regions while female jealousy emerges from higher cortical regions. Perhaps this indicates female jealousy is more of a cognitive response, based on the evaluation of how much they have to lose economically. Males are more concerned about sexual matters. Remarkably, when a brain-imaging study of jealousy was done with "lower" primates (rhesus macaques) by having a dominant male view submissive animals having sex with his consorts, the brain arousals resembled those observed in the aforementioned human study (Rilling et al., 2004). It is quite easy to envision male jealousy to be a mixture of feelings of SEEKING, LUST, FEAR, and impending GRIEF (Panksepp, 1982, 2010c), but that is only a theoretical conjecture at the present time. [...]

[...] Because of the intermingling of affects with complex ideas and personal experiences in our forward-looking and backward-reminiscing *autonoetic* consciousness, we humans often have difficulty imagining that affects can exist independently of the higher mental contexts in which they occur. We often find it hard to conceptualize feelings in their purest form. It is much easier to view them in the detailed cognitive contexts of our lives. We think that someone specific has made us feel angry or that a frightening experience causes us to experience fear. (In philosophical terms this means that affects are intentional—they are always "about" something. They are "propositional attitudes" that arise from "emotional appraisals"—issues we will only consider in passing here.) Because of the way the brain is so highly interconnected, we experience ideas and affects as totally intermeshed experiences, and because we are highly cognitive creatures, we tend to see cognition as primary, assuming that affects are created by thoughts or perceptions. There are still some psychologists who assert that life experiences teach us to have affects, and that without these experiences we would not have affective capacities. They claim that people who have never encountered dangerous or painful situations before would not be capable of feeling afraid. For such theorists, emotions are largely learned responses.

But at the primary-process level, emotions are not a matter of individual learning. They were built into the brain by evolution: They are ancestral "memories." To the best of our knowledge, we are born with innate neural capacities for the full complement of seven basic emotions that are hardwired into the subcortical networks of all mammalian brains.[...]

[...] Most basic emotions need not be expressed immediately after birth. Some, including CARE, LUST, and PLAY (more variable across species), come online long after others, such as SEEKING, RAGE, and FEAR. But all of these emotions have genetically hardwired neural substrates. In some mammals, the PANIC/GRIEF response becomes active early in life (as with herbivores that are born remarkably mature or *precocious*); in others, it becomes active later (as with most carnivores that are born very immature or *altricial*). In some others, such as laboratory rats that have been bred in laboratories for many hundreds of generations, certain emotional primes (indeed, perhaps only their behavioral expressions) have become vestigial because of a massive relaxation of natural (evolutionary) selection pressures. For instance, rats and mice do not have a robust separation call like most other mammals, perhaps because of the inadvertent selection of animals that could be housed individually without much distress. Their modest calls may simply be distress calls engendered by bodily stressors such as feeling cold. Because our

genes control primary-process emotions, there can be great variability in the emotional temperaments of different species, as well as different laboratory strains bred for research, such as mice, of which there are thousands of variants, many with distinct personalities, some of them artificially created (Crawley, 2007).

Although the ability to experience affects is built into the brain, at birth humans and animals have unconditional or instinctive affective responses to only a few specific stimuli. Almost all animals are frightened by loud noises and by pain. Human babies cry if they are not held securely or are allowed to fall. And almost all young mammals cry quickly if they are left alone without their mothers, but this response takes some time to mature in many species, including dogs and humans. [...]

[...] Affective responses, along with the explicit emotional behaviors we can see, are among the least well-studied aspects of the brain in all of neuroscience. Affects feel good or bad in a variety of specific ways. Sexual gratification, arising from our capacity for LUST, feels good in a rather different way from the joys of rough-and-tumble PLAY or the tender bliss of caressing, nurturing, and CAREing for one's infant. FEAR is an entirely different kind of emotional "pain" than frustrated RAGE; both differ from the PANICked misery of social isolation. And SEEKING things in the world—whether safety, nuts, or knowledge—has a very special, energized, and, at times, euphoric feel to it but it can also create many negative events.

These diverse pleasant and unpleasant affects provide guidance for living due to the survival-enhancing advantages each of them has conferred over the course of evolution. Affects are ancestral memories of how effectively we play the game of survival and reproduction; these memories are passed down through the collected mindless "wisdom" of our genetic code. Interactions that evoke various pleasant affects—encounters with food, water, a mate, offspring, or playful friends—help animals to survive and reproduce. Life experiences that evoke painful affects—predators, rivals, chaotic weather, and so on—put life and reproductive capacity in jeopardy.

Thus raw affects provide the essential infrastructure for our most basic instinctual behavior patterns—approach and avoidance—without which we could not survive. Humans and other animals approach things that evoke pleasant affects, and they stay away from things that make them feel bad. Hence affective changes can *reinforce* new behavior patterns, although behaviorists never learned much about the brain process of *reinforcement* (a term that may mean, as just noted, little more than how "affects"—and not merely the *basic*, primary-process affects—work in the context of learning). Animals do not necessarily "know" or dwell on these feelings—the feelings may simply be raw *anoetic* experiences in most species. However, humans surely have many thoughts and ruminations about their personal experiences that can further elaborate affects, allowing *noetic* (factual knowing) and *autonoetic* (autobiographical time-travel) forms of emotional experiences (for a summary, see Vandekerckhove & Panksepp, 2009). The extent to which other mammals, even highly intelligent animals like the great apes and most carnivores, have such higher levels of cognitive (thoughtful, reflective) consciousness is surely a more difficult problem than the one we are addressing, which is the existence of raw affective-emotional experiences in all mammals.[...]

[...]

Affects do not feel like anything else

If affects are not cognitive read-outs of the changing physiology of the body, and if they emanate from deep noncognitive parts of the brain, then what do affects feel like? We maintain that affects do not feel like anything else. They are primary phenomenal experiences that cannot be

adequately explained just in terms of accompanying changes in the body, even though there are bound to be many distinct bodily feelings during emotional arousal. Much of the intermingling of emotional feelings and physiological arousal could be because the primary-process emotional systems are situated in the same brain regions that regulate the activities of our viscera, our hormonal secretions, and our capacities for attention and action.

To be sure, bodily responses can also influence emotional arousal. For example, anger is invariably attended by heightened blood pressure. Blood pressure also exerts influence on affect, as any chemical agent that raises blood pressure will make an angered person or animal feel more enraged. This is because pressure receptors in arteries can directly facilitate RAGE circuits in ancient visceral brain regions (i.e., the parts of the brain that represent our internal bodily organs). However, the artificial elevation of blood pressure does not produce anger in a person or animal who is not already irritated. Thus it does not appear that affects simply reflect peripheral emotional physiology. Affects are, as we have already stated, ancient brain processes for encoding value—heuristics of the brain for making snap judgments as to what will enhance or detract from survival.

Those who maintain that language is the hallmark of affect are even further off the mark. Words are best suited for explaining the workings of the world around us. Words can explain that the George Washington Bridge connects New York and New Jersey. Words can tell you how to bake a cake. But words cannot explain primary experiences. Words cannot even explain the primary perceptual experience of seeing the color red. Words like "scarlet," "crimson," or "ruby" do not describe anything. They are mere labels or symbols for the common experience of seeing variations of redness, which is strictly a subjective brain function. One could use any symbol, including a nonverbal one, as a label for the experience of seeing red. "Red" has no intrinsic meaning, but the experience of redness does—it signifies some of the most exciting things about life, from the ripeness of fruit to the passion of sex and of spilled blood. Words cannot describe the experience of seeing the color red to someone who is blind.

Words do not describe affects either. One cannot explain what it feels like to be angry, frightened, lustful, tender, lonely, playful, or excited, except indirectly in metaphors. Words are only labels for affective experiences that we have all had—primary affective experiences that we universally recognize. But because they are hidden in our minds, arising from ancient prelinguistic capacities of our brains, we have found no way to talk about them coherently.

The science of how these systems connect up to the higher conscious abilities of humans is still largely a task for the future. However, because of the importance of these systems for clinical psychiatric phenomena, we will briefly address these higher cognitive aspects in each of the chapters devoted to the "big seven" emotional affects. […]

[…] [Here], we will focus on the substantial empirical and theoretical advances that have been made possible through the identification of the seven emotional brain substrates that reliably evoke distinct emotional behaviors and produce affective experience in all mammals that have been studied. We do not claim that these seven constitute an exhaustive list. More may be discovered. Furthermore there is much to be learned about the different chemicals that regulate these systems or parts of the systems. We also do not yet understand precisely how affects and other mental processes actually arise from the fine intricacies of the brain. Our approach does, however, encourage new ways of considering such difficult neuroscientific and phenomenological issues. This can be pursued because we now do know much about the essential brain regions and processes, especially some of the key neurochemistries. […]

[…] Although words cannot describe these seven basic affects fully, we will do our best, sometimes resorting to physiological correlates in order to literally flesh out their meaning. Here we provide a synopsis of the "big seven".

1 The SEEKING, or expectancy, system is characterized by a persistent exploratory inquisitiveness. This system engenders energetic forward locomotion—approach and engagement with the world—as an animal probes into the nooks and crannies of interesting places, objects, and events in ways that are characteristic of its species. This system holds a special place among emotional systems, because to some extent it plays a dynamic supporting role for all of the other emotions. When in the service of positive emotions, the SEEKING system engenders a sense of purpose, accompanied by feelings of interest ranging to euphoria. For example, when a mother feels the urge to nurture her offspring, the SEEKING system will motivate her to find food and shelter in order to provide this care. The SEEKING system also plays a role in negative emotions, for example, providing part of the impetus that prompts a frightened animal to find safety. It is not clear yet whether this system is merely involved in helping generate some of the behaviors of negative emotions, or whether it also contributes to negative feelings. For the time being, we assume it is largely the former, but that the positive psychological energy it engenders also tends to counteract negative feelings, such as those that occur during FEARful flight and the initial agitation of PANIC/GRIEF. For this reason, animals may actually find fleeing to be in part a positive activity, since it is on the most direct, albeit limited, path to survival.

2 The RAGE system, working in contrast to the SEEKING system, causes animals to propel their bodies toward offending objects, and they bite, scratch, and pound with their extremities. Rage is fundamentally a negative affect, but it can become a positive affect when it interacts with cognitive patterns, such as the experience of victory over one's opponents or the imposition of one's own will on others who one is able to control or subjugate. Pure RAGE itself does not entail such cognitive components, but in the mature multi-layered mammalian brain, it surely does.

3 The FEAR system generates a negative affective state from which all people and animals wish to escape. It engenders tension in the body and a shivery immobility at milder levels of arousal, which can intensify and burst forth into a dynamic flight pattern with chaotic projectile movement to get out of harm's way. If, as we surmised above, the flight is triggered when the FEAR system arouses the SEEKING system, then the aversive qualities of primary-process FEAR may be best studied through immobility "freezing" responses and other forms of behavioral inhibition, and reduced positive-affect, rather than flight.

4 When animals are in the throes of the LUST system, they exhibit abundant "courting" activities and eventually move toward an urgent joining of their bodies with a receptive mate, typically culminating in orgasmic delight—one of the most dramatic and positive affective experiences that life has to offer. In the absence of a mate, organisms in sexual arousal experience a craving tension that can become positive (perhaps because of the concurrent arousal of the SEEKING system) when satisfaction is in the offing. The tension of this craving may serve as an affectively negative stressor when satisfaction is elusive. LUST is one of the sources of love.

5 When people and animals are aroused by the CARE system, they have the impulse to envelop loved ones with gentle caresses and tender ministrations. Without this system, taking care of the young would be a burden. Instead, nurturing can be a profound reward—a positive, relaxed affective state that is treasured. CARE is another source of love.

6 When overwhelmed by the PANIC/GRIEF (also often termed "separation distress") system, one experiences a deep psychic wound—an internal psychological experience of pain that has no obvious physical cause. Behaviorally, this system, especially in young mammals, is characterized by insistent crying and urgent attempts to reunite with

caretakers, usually mothers. If reunion is not achieved, the baby or young child gradually begins to display sorrowful and despairing bodily postures that reflect the brain cascade from panic into a persistent depression. The PANIC/GRIEF system helps to facilitate positive social bonding (a secondary manifestation of this system), because social bonds alleviate this psychic pain and replace it with a sense of comfort and belonging (CARE-filled feelings). For this reason, children value and love the adults who look after them. When people and animals enjoy secure affectionate bonds, they display a relaxed sense of contentment. Fluctuations in these feelings are yet another source of love.

7 The PLAY system is expressed in bouncy and bounding lightness of movement, where participants often poke—or rib—each other in rapidly alternating patterns. At times, PLAY resembles aggression, especially when PLAY takes the form of wrestling. But closer inspection of the behavior reveals that the movements of rough-and-tumble PLAY are different than any form of adult aggression. Furthermore, participants enjoy the activity. When children or animals play, they usually take turns at assuming dominant and submissive roles. In controlled experiments, we found that one animal gradually begins to win over the other (becoming the top dog, so to speak), but the play continues as long as the loser still has a chance to end up on top a certain percentage of the time. When both the top dog and the underdog accept this kind of handicapping, the participants continue to have fun and enjoy this social activity. If the top dog wants to win all the time, the behavior approaches bullying. [...] Even rats clearly indicate where they stand in playful activity with their emotional vocalizations: When they are denied the chance to win, their happy laughter-type sounds cease and emotional complaints begin. The PLAY system is one of the main sources of friendship. [...]

[...]

To summarize, the kinds of layering we envision in BrainMind evolution coaxes one to first focus on the most ancient levels and to use that knowledge to clarify secondary processes, where primal emotional functions are integrated with perceptions, allowing conditioned learning. For example, a rat that begins to fear the sound of a cat's bell is using a secondary emotional process, as are the rudimentary cognitive strategies, such as a rat learning to run to its sequestered home when it hears the cat's bell. This provides animals with factual knowledge of the world—a primitive *noetic* or knowing form of consciousness. But do rats also think about this consciousness? Are they "aware" that they are experiencing something. We simply do not know. And no one has suggested a way to solve that dilemma.

We refer to a tertiary level of processing for higher emotional functions when the first two levels of mind begin to generate more complex cognitive abilities, like the planning that goes into preparation for a weekend hike or planning one's future professional goals. Tertiary processing allows for intelligent reflection about the world and about oneself, considering both past and future frameworks—within *autonoetic* consciousness. That level of mental activity is remarkably hard to study in animals. The tertiary level is strongly linked to functions of the frontal cortex and the parietal cortex—the most recently evolved regions of the neocortex that exist in superabundance in humans and a few other well-cerebrated creatures.

Summary

All of us would like to understand what is happening inside our minds and in the minds of those we know, including the minds of wild creatures and the minds of our various tame domestic and companion animals that bring such richness to our lives. Affective neuroscience provides a

The archaeology of mind

new and unique evidence-based perspective on the nature of emotional Mind Brain functioning, opening a window on the ancestral sources of our deepest affective values.

[...]

Overall, our perspective is that an understanding of affect is of critical importance for an understanding of human nature. Not only are our personality structures rooted in affect (Davis & Lang, 2003; Davis & Panksepp, 2011), but a remarkable number of societally important human issues need to be approached from affective as well as from cognitive perspectives. Insightful modern psychotherapists have known for a long time that the goal of psychotherapy is affect regulation. Even though psychotherapy may appear to focus on thoughts, insofar as patients largely communicate in words, the aim of treatment is to positively change the patient's affective experience. This inevitably entails changes in the way that he or she thinks, but the aim of psychotherapy is not simply to alter cognitive style or content. In contrast, many psychiatric medications modify affects directly, without cognitive interventions, but often with robust cognitive changes following in the footsteps of better regulated affects. Indeed, it is increasingly evident that environmental, interpersonal and medicinal approaches to the treatment of mental problems work better together than any of these approaches by themselves.

Ultimately, affects are the very base of our psychological being. When the affects are satisfying, life is a joy. When they are disturbed, life can be hell. As noted by John Sterling (1806–1844), a poet who lived on the Scottish Isle of Bute, "Emotion turning back on itself, and not leading on to thought or action, is the element of madness."

There is now inferential evidence that a universal core-SELF type structure, essential for organismic coherence, exists deep in ancient regions of the brain where primary-process emotional systems are found. The diverse, evolutionarily "given" emotional tools of our brains may all rely on this extensive substrate for primal body representations for the generation of the many types of raw emotional feelings that all mammals experience, with many nuanced evolutionary differences that we currently know little about.

In contrast, our many higher emotional viewpoints—from blame to shame, and feelings of jealousy to empathy and kindness—are intimately enmeshed with our cognitive apparatus. Our higher cognitive apparatus allows us an enormous number of emotional options, including concurrently distancing ourselves from ruling passions and immersing ourselves in acceptance or "mindfulness."

Cognitive science, still relying almost exclusively on a computational theory of mind, may be turned on its head once academicians realize how profoundly human thoughts are influenced by affective feelings (Davies, 2011). The final picture of how emotions govern our learned viewpoints and the reprocessing of our experiences may turn out to be very different than the provisional visions we currently have. With a better understanding of affects, it is conceivable that the therapeutic enterprise will move toward a more refined, neuroscience-based perspective on how one human being can help another move toward emotional balance, with the synergistic use of psychotherapies and mind-medicines.

An understanding of the primal passions may make it easier for people to aspire toward Aristotelian *phronesis* namely, knowing how to work cognitively with one's own emotions, with wisdom, as opposed to being a hapless victim, living in perpetual conflict, in the unyielding grasp of the ancestral powers of our minds. And it should be recognized that these powers are the same ones that guide the lives of many other animals. The way we will eventually understand our deeper mental nature is by understanding the deeper neural nature of animals. What are we waiting for? Let the conversation begin.

Bibliography

Avena, N. M., Rada, P., & Hoebel, B. G. (2008). Evidence for sugar addiction. Behavioral and neuro-chemical effects of intermittent, excessive sugar intake. *Neuroscience and Biobehavioral Reviews, 32,* 20–39.

Bartz, J., Simeon, D., Hamilton, H., Kim, S., Crystal, S., Braun, A., Vicens, V., & Hollander, E. (2010). Oxytocin can hinder trust and cooperation in borderline personality disorder. *Social Cognitive and Affective Neuroscience.* (Epub ahead of print).

Bennett, M. R., & Hacker, P. M. S. (2003). *Philosophical foundations of neuroscience.* Malden, MA: Blackwell.

Bodkin, J. A., Zornberg, G. L., Lukas, S. E, & Cole, J. O. (1995). Buprenorphine treatment of refractory depression. *Journal of Clinical Psychopharmacology, 1,* 49–57.

Crawley, J. N. (2007). *What's Wrong With My Mouse? Behavioral Phenotyping of Transgenic and Knockout Mice* (2nd ed.). New York, NY: Wiley & Sons.

Damasio, A. R. (1994). *Descartes' error: Emotion, reason, and the human brain.* New York, NY: Avon Books.

Darwin, C. (1872). *The expression of the emotions in man and animals.* London, UK: John Murray.

Daston, L., & Mitman, G. (2005). *Thinking with animals: New perspectives on anthropomorphism.* New York, NY: Columbia University Press.

Davies, P. S. (2011). Ancestral voices in the mammalian mind: Philosophical implications of Jaak Panksepp's affective neuroscience. *Neuroscience and Bio-behavioral Reviews, 35,* 2036–2044.

Davis, K. L., & Panksepp, J. (2011). The brain's emotional foundations of human personality and the Affective Neuroscience Personality Scales. *Neuroscience and Biobehavioral Reviews, 35,* 1946–1958.

Davis, M., & Lang, P. J. (2003). Emotion. In M. Gallagher, R. J. Nelson, & I. B. Welner (Eds.), *Handbook of psychology: Vol. 3. Biological psychology* (pp. 405–440). Hoboken, NJ: John Wiley & Sons.

De Dreu, C. K., Greer, L. L., Handgraaf, M. J., Shalvi, S., Van Kleef, G. A., Baas, M., Ten Velden, F. S., Van Dijk, E., & Feith, S. W. (2010). The neuropeptide oxytocin regulates parochial altruism in inter-group conflict among humans. *Science, 328,* 1408–1411.

Ditzen, B., Schaer, M., Gabriel, B., Bodenmann, G., Ehlert, U., & Heinrichs, M. (2009). Intranasal oxytocin increases positive communication and reduces cortisol levels during couple conflict. *Biological Psychiatry, 65,* 728–731.

Ekman, P. (1994). Strong evidence for universals in facial expressions: A reply to Russell's mistake critique. *Psychological Bulletin, 115,* 263–287.

Ekman, P., & Davidson, R. J. (Eds.). (1994). *The nature of emotion: Fundamental questions.* New York, NY: Oxford University Press.

Ferris, C. F., Kulkarni, P., Sullivan, J. M. Jr., Harder, J. A., Messenger, T. L., & Febo, M. (2005). Pup suckling is more rewarding than cocaine: Evidence from fMRI and 3D computational analysis. *Journal of Neuroscience, 25,* 149–156.

Guastella, A. J., Howard, A. L., Dadds, M. R., Mitchell, P., & Carson, D. S. (2009). A randomized controlled trial of intranasal oxytocin as an adjunct to exposure therapy for social anxiety disorder. *Psychoneuroendocrinology, 34,* 917–923.

Heinrichs, M., & Domes, G. (2008). Neuropeptides and social behaviour: Effects of oxytocin and vasopressin in humans. *Progress in Brain Research, 170,* 337–350.

Hoffman, R. (Ed.). (2011). *The sublime.* New York, NY: Oxford University Press.

Izard, C. E. (2007). Basic emotions, natural kinds, emotion schemas, and a new paradigm. *Perspectives on Psychological Science, 2,* 260–268.

Kendrick, K. M. (2000). Oxytocin, motherhood and bonding. *Experimental Physiology,* 85, 111S–124S.

Knutson, B., & Greer, S. M. (2008). Anticipatory affect: Neural correlates and consequences for choice. *Philosophical Transactions of the Royal Society, London B Biological Sciences, 363,* 3771–3786.

Kovács, G. L., Sarnyai, Z., & Szabó, G. (1998). Oxytocin and addiction: A review, *Psychoneuroendocrinology, 23,* 945–962.

Koziol, L. F., & Budding, D. E. (2009). *Subcortical structures and cognition: Implications for neuropsychological assessment.* New York, NY: Springer.

Mendl, M., Burman, O. H. P., & Paul, E. S. (2010). An integrative and functional framework for the study of animal emotions and mood. *Proceedings of the Royal Society B, 277,* 2895–2904.

Merker, B. (2007). Consciousness without a cerebral cortex: A challenge for neuroscience and medicine. *Behavioral and Brain Sciences, 30,* 63–134.

Meyer-Lindenberg, A. (2008). Impact of prosocial neuropeptides on human brain function. *Progress in Brain Research, 170,* 463–470.

Narvaez, D., Panksepp, J., Schore, A., & Gleason, T. (Eds.). (2012). *Human nature, early experience and the environment of evolutionary adaptedness.* New York, NY: Oxford University Press.

Nathaniel, T. I., Panksepp, J., & Huber, R. (2009). Drug-seeking behavior in an invertebrate system: Evidence of morphine-induce reward, extinction and rein-statement in crayfish. *Behavioural Brain Research, 197,* 331–338.

Nelson, E., & Panksepp, J. (1996). Oxytocin and infant-mother bonding in rats, *Behavioral Neuroscience, 110,* 583–592.

Oldfield, R. G., & Hofmann, H. A. (2011). Neuropeptide regulation of social behavior in a monogamous cichlld fish. *Physiology & Behavior, 102,* 296–303.

Panksepp, J. (1981a). Brain opioids: A neurochemical substrate for narcotic and social dependence. In S. Cooper (Ed.), *Progress in theory in psychopharmacology* (pp. 149–175). London: Academic Press.

Panksepp, J. (1982). Toward a general psychobiological theory of emotions. *Behavioral and Brain Sciences, 5,* 407–467.

Panksepp, J. (1985). Mood changes. In P. J. Vinken, G. W. Bruyn, & H. L. Klawans (Eds.), *Handbook of clinical neurology* (revised series). Vol. 1 (45): *Clinical neuropsychology* (pp. 271–285). Amsterdam: Elsevier Science.

Panksepp, J. (1992). Oxytocin effects on emotional processes: Separation distress, social bonding, and relationships to psychiatric disorders. *Annals of the New York Academy of Sciences, 652,* 243–252.

Panksepp, J. (1998a). *Affective neuroscience: The foundations of human and animal emotions.* New York, NY: Oxford University Press.

Panksepp, J. (2010a). Affective consciousness in animals: Perspectives on dimensional and primary process emotion approaches. *Proceedings of the Royal Society, Biological Sciences, 77,* 2905–2907.

Panksepp, J. (2010b). Affective neuroscience of the emotional BrainMind: Evolutionary perspectives and implications for understanding depression. *Dialogues in Clinical Neuroscience, 12,* 533–545.

Panksepp, J. (2010c). The evolutionary sources of jealousy: Gross-species approaches to fundamental issues. In S. L. Hart & M. Legerstee (Eds.), *Handbook of jealousy: Theories, principles, and multidisciplinary approaches* (pp. 101–120). New York, NY: Wiley-Blackwell.

Panksepp, J. B., & Huber, R. (2004). Ethological analyses of crayfish behavior: A new invertebrate system for measuring the rewarding properties of psychostimulants. *Behavioral Brain Research, 153,* 171–180.

Pincus, D., Kose. S., Arana, A., Johnson, K., Morgan, P. S., Borckardt, J., Herbsmand, T., Hardaway, F., George, M. S., Panksepp, J., & Nahas, Z. (2010). Inverse effects of oxytocin on attributing mental activity to others in depressed and healthy subjects: A double-blind placebo controlled fMRI study, *Frontiers in Psychiatry, 1,* 134. doi:10.3389/fpsyt.2010.00134

Rilling, J. K., Winslow, J. T., & Kilts, C. D. (2004). The neural correlates of male competition in dominant male rhesus macaques. *Biological Psychiatry, 56,* 364–375.

Riters, L. V., & Panksepp, J. (1997). Effects of vasotocin on aggressive behavior in male Japanese quail. *Annals of the New York Academy of Sciences, 807,* 178–180.

Rubin, L. H., Carter, C. S., Drogos, L., Pournajafi-Nazarloo, H., Sweeney, J. A., & Maki, P. M. (2010). Peripheral oxytocin is associated with reduced symptom severity in schizophrenia. *Schizophrenia Research, 124,* 13–21.

Russell, J. S. (1994). Is there universal recognition of emotion from facial expressions? A review of cross-cultural studies. *Psychological Bulletin, 115,* 102–141.

Shamay-Tsoory, S. G., Fischer, M., Dvash, J., Hararl, H., Perach-Bloom, N., & Levkovitz, Y. (2009) Intranasal administration of oxytocin increases envy and schadenfreude (gloating). *Biological Psychiatry, 66,* 864–870.

Shewmon, D. A., Holmes, G. L., & Byrne, P. A. (1999). Consciousness in congenitally decorticate children: Developmental vegetative state as self-fulfilling prophecy. *Developmental Medicine & Child Neurology, 41.* 364–374.

Skrundz, M., Bolten, M., Nast, I., Hellhammer, D. H., & MeinIschmidt, G. (2011). Plasma oxytocin concentration during pregnancy is associated with development of postpartum depression. *Neuropsychopharmacology,* 1–8, advance online publication, 11 May 2011, doi:10.1038/npp.2011.74.

Stutz, R. M., Rossi, R. R., Hastings, L., & Brunner, R. L. (1974). Discriminability of intracranial stimuli: The role of anatomical connectedness. *Physiology & Behavior, 12,* 69–73.

Sur, M., & Rubinstein, J. L. (2005). Patterning and plasticity of the cerebral cortex *Science, 310,* 805–810.

Szalavitz, M. & Perry, B. D. (2010). *Born for love: Why empathy is essential—and endangered.* New York, NY: HarperCollins Publishers.

Takahashi, H., Matsuura, M., Yahata. N., Koeda, M., Suhara, T., & Okubo Y. (2006). Men and women show distinct brain activations during imagery of sexual and emotional infidelity. *Neuroimage, 32,* 1299–1307.

Teasdale, J. D., Taylor, R., & Fogarty, S. J. (1980). Effects of induced elation-depression on the accessibilita of memories of happy and unhappy experiences. *Behavioral Research and Therapy, 18,* 339–346.

Tulving, E. (2002). Episodic memory: From mind to brain. *Annual Review of Psychology, 53,* 1–25.

Tulving, E. (2005). Episodic memory and autonoesis: Uniquely human? In H. S. Terrace & J. Metcalfe (Eds.), *The missing link in cognition: Origins of self-reflective consciousness* (pp. 3–56). New York, NY: Oxford University Press.

Vandekerckhove, M., & Panksepp, J. (2009). The flow of anoetic to noetic and autonoetic consciousness: A vision of unknowing anoetic and knowing noetic consciousness in the remembrance of things past and imagined futures. *Consciousness and Cognition, 18*(4), 1018–1028.

Vul, E., Harris, C., Winkelman, P., & Pashler, H. (2009). Puzzlingly high correcations in fMRI studies of emotion, personality, and social cognition. *Perspectives on Psychological Science, 3,* 274–290.

Vytal, K., & Hamann, S. (2010). Neuroimaging support for discrete neural correlates of basic emotions: A voxel-based meta-analysis. *Journal of Cognitive Neuroscience, 22,* 2864–2885.

Watt, D. F., & Panksepp, J. (2009). Depression: An evolutionarily conserved mechanism to terminate separation-distress? A review of aminergic, peptidergic and neural network perspectives. *Neuropsychoanalysis, 11,* 5–104.

Wiegmann, D. D., Wiegmann, D. A., & Waldron, F. A. (2003). Effects of a reward downshift on the consummatory behavior and flower choices of bumblebee foragers. *Physiology & Behavior, 79,* 561–566.

Zachar, P., & Ellis. R. (Eds.). (2012). *Emotional theories of Jaak Panksepp and Jim Russell.* Amsterdam: John Benjamins.

23

'The trophies of their wars'

Affect and encounter at the Canadian War Museum

Sara Matthews

This paper explores the concept of the war trophy in relation to two exhibits at the Canadian War Museum: a black Mercedes-Benz bulletproof limousine that was once used by Hitler as a parade car and Gertrude Kearns' (1996) painting Somalia Without Conscience, an image that depicts Master Corporal Clayton Matchee posing beside tortured Somali teenager Shidane Arone. A central preoccupation of the paper is how to encounter and think with the affective realm of experience when the narrative encounter at the museum is one that represents difficult histories of social devastation, violence and war. I investigate free association as a method of cultural analysis that can attend to the affective force of the social encounter. To do so, I propose a fictive exhibit that brings the car into conversation with the painting and consider how the embodied subjects of war are constructed in the presence of memorial space. Finally, I comment on how visitor responses to the car and the painting open new questions with regard to the mandate of the museum to remember, to preserve and to educate.

Introduction

Cultural theorist Mieke Bal (1992), in her essay exploring the American Museum of Natural History for its modes of address, asks us to think about what is 'taken in and taken home' (561) by the museum visitor who must navigate the textual, verbal and visual provocations on display. One way to respond to Bal's proposition is to consider how museums enact a form of public pedagogy[1] – whether they are nationalist, colonialist or pluralist, and if they conjure old traumas or encourage new habits of relating. But another aspect might focus how museum exhibits affect us in ways that are profoundly personal. What is 'taken in and taken home' from these encounters penetrates from the outside in – into the privacy of thought, of domestic space, of interiority and of emotional life. This is the domain of affective experience where narrative chases fragments of thought and feeling into tentative forms of meaning; shapes of ideas that we cannot or do not speak, that we utter in hushed tones or through the language of dream life. Pedagogical encounters with the social and the natural world outside, thus brings us close to emotional realities on the inside that demand their own time of telling. These affective responses reply to the sign systems through which museums recruit us to their message, but are often lost from research accounts that rely primarily on a representational analysis of exhibit structure and display.

329

A central preoccupation of this paper is how to encounter and think with the affective realm of experience when the narrative encounter at the museum is one that represents difficult histories of social devastation, violence and war. To do so, I analyze two moments that describe what for me was 'taken in and taken home' (Bal 1992, 561) from my teaching and research at the Canadian War Museum (CWM). Until now, I had considered these experiences anecdotal to my research that primarily focused pedagogical programming for children and youth, and with a project that studied how teacher candidates make sense of adolescents' encounters with the museum (Matthews 2009). The incidents that I will share concern my engagement with two exhibits at the war museum: a black Mercedes-Benz bullet-proof limousine that was once used by Hitler, as a parade car (Figure 10 and Gertrude Kearns' (1996)) painting *Somalia Without Conscience*, an image that depicts Master Corporal Clayton Matchee (of the now disbanded Canadian Forces Airborne Regiment) posing beside tortured Somali teenager Shidane Arone.[2] I explore these accounts for how they carry the force of affect – each tells the story of how someone was aroused or moved into action through their engagement with the car or the painting. I then consider how my own encounter with those provocations led me to ask new questions of the exhibits, itself a turn of thought imbued with affective force. One problem then that this paper investigates is how to think with the force of affect, something that itself must be symbolized. To approach these research questions, I bring the work of cultural analysts (Bal 1992; Butler 2009) together with psychoanalytic thinkers (Britzman 2003; Green 1999) and explore how one's affective engagement with museological objects alter the 'frames of recognition' (Butler 2009) through which we encounter the embodied subjects of war.

Sara Ahmed (2000) raises the question of encounter as a dynamic of being human, where the meeting between the self and the unknown 'stranger' includes the projection of what remains unknowable to us and therefore 'alien' (2). Unknowability is a constitutive feature of the human and yet remains a strange outsider, haunting our very our attempts to understand others and ourselves. 'The term encounter,' she writes, 'suggests a meeting, but a meeting which involves surprise and conflict' (6). Like Ahmed, I am interested to explore how one comes into being as a subject through the surprise and conflict of encounter. In this paper, I discuss two kinds of encounters – that of the museum visitor encountering Hitler's parade car and Kearns' painting, and my own encounter with the museum visitor who encounters these same objects. In both instances, the conflicts of getting to know oneself as human must be negotiated alongside the conflicts of war, social violence and human devastation. Who, or what, is the alien 'other' in these encounters? Is it the civilian, soldier, victim or survivor, the enemy of the state or its protector? Or is it rather those experiences that are 'other' to rational thought – the affective confusions of a destabilized self? 'The encounter,' Ahmed (2000, 7) suggests, 'is ontologically prior to the question of ontology (the question of the being who encounters).' With this formulation, we see that, what is 'taken in and taken home' (Bal 1992, 561) from encounters with representations of violence and war both penetrates from the outside in *and* projects from the inside out. To help me to theorize this relation, I turn to the bridging concept of affect.

Andre Green (1999), in his monograph that surveys the status of affect in psychoanalytic discourse through a reading of Freudian theory, describes affect as having two overlapping dimensions: it is both somatic (of the body) and psychical (of the mind). We might understand affect as the urge to bring a bodily experience that has yet to be named into representation through the work of psychic symbolization (8). A tension seeking discharge or release affect therefore, carries a force that in Green's terms 'snatches the body from silence' (8). This is potent language: to snatch is to seize with haste, a sense that something – or in this case someone – is 'caught between the body and consciousness' (161). 'The body,' writes Green, 'is not the subject of an action, but the object of a passion' (161), an animation encountered *but not yet*

named as emotion. To assign meaning is first to identify with the subject of that experience – an 'I' who is able to 'hear my body speak or my "body-speaking" ' (161). Affect is thus an internal phenomenon through which the self is called into presence in relation to an encounter with the outside world. In the analysis that follows, I consider how Hitler's parade car and Kearns' painting *Somalia Without Conscience* call the museum visitor into the presence of histories of conflicts both external and internal to the self. The body is snatched from silence when conflict as represented in the world outside – in the museum exhibit, for example – meets passion on the inside that knows not yet what it speaks. This unconscious knowledge contests historical claims to truth and returns conflict as a question that presses against one's internal world. But, as researchers, how to read this knowledge? What methods of cultural analysis might we bring to this endeavor?

On cultural analysis: a method

My methodology draws on Bal's (2009) insistence that 'cultural analysis should not be taken literally – or analytically – as meaning the "taking apart" of culture. Rather, cultural analysts interpret the way in which cultures take things, people and themselves "apart" ' (227). In this sense, cultural analysis is an interpretive practice aimed neither at delineating nor deconstructing a 'thing' called culture, but with exploring how cultures implicate and undo us in the course of finding and making a life. Likewise, interpretation seeks to neither unearth nor authorize elusive truths about culture, but instead to disrupt our methods and objects of meaning making and so provoke new questions about what culture can mean. My attempt at cultural analysis therefore resists the lure to cohere narratives about what museological objects represent. Instead, I am interested in modes of understanding and methods of analysis that work with the *not yet* of recognition. In doing so, I seek to explore how museum cultures take us apart and in, when the curriculum contains representations of trauma and war.

There are two concepts/methods that I bring to this analysis: free association and framing. The first borrows from psychoanalytic models of knowledge and interpretation. A strategy fundamental to the analytical dialog, free association is a speculative exercise of being with one's thoughts, feelings and utterances without rhetorical purpose, limitation or direction. A unique narrative practice that breaks with the rules of temporality, free association is, according to Britzman (2003, 28), 'a train of thought, a way of training thought to derail itself' and so to 'give up, however briefly, one's sense of reality in the world, one's sense of actuality and its limits, and one's sense that language can be controlled…'. The method of free association, then, is a practice that symbolizes the tension of feeling undone without reaching too soon toward representation. Thinking with Bal's suggestion that the work of the cultural analyst is to 'interpret the way in which cultures take things, people and themselves "apart" ' (Bal 2009, 227), I turn to free association as a way to symbolize and then interpret how I felt taken apart by my engagement with visitor responses to Hitler's parade car and Kearns' painting. To do so, I propose an imaginary exhibit that brings the car into juxtaposition with the painting. This is an intuitive link that was made as a result of the public encounters I had with these two displays at the museum. As free association is a practice that symbolizes the difficulties of translating affect into thought, my fictive exhibition proposal is a way of framing my interpretation of the encounters provoked by these museological objects. My intent here is to disrupt the 'frames of recognition' (Butler 2009) through which I initially encountered these objects in the course of my official research at the museum. This method makes sense to me in light of Bal's (2002) suggestion that cultural analysis is 'inflected, or tainted, with fictionality' (133) and so is itself a free associative practice that might tolerate the indirect movement between affect and thought.

My proposal for an imaginary exhibit[3] involves replacing the large photo of the Nazi Nuremburg rally currently on display behind Hitler's parade car with Kearns' painting *Somalia Without Conscience*. Entitled, 'The Trophies of Their Wars,' the exhibit is accompanied by the following text:

> Around the Posts hung Helmets, Darts, and Spears; And Captive Chariots, Axes, Shields, and Bars, And broken Beaks of Ships, the Trophies of their Wars.
>
> *(1697 Dryden tr. Virgil Æneis vii, in tr. Virgil Wks. 407)*

Trophy (Oxford English Dictionary)

> A structure erected (originally on the field of battle, later in any public place) as a memorial of a victory in war, consisting of arms or other spoils taken from the enemy, hung upon a tree, pillar, etc. and dedicated to some divinity. Hence applied to similar monuments or memorials in later times.
>
> Anything taken in war, or in hunting, etc.; a spoil, prize: esp. if kept or displayed as a memorial. Anything serving as a token or evidence of victory, valour, power, skill, etc.; a monument, memorial.

To orient this proposal, I draw on the concept of framing from Butler (2009), whose study of war is concerned with the ontological and epistemological frames within which certain lives become recognizable as grievable (lose-able or injurable), and therefore human. Butler's analysis helps me to think through how the two objects in my imaginary exhibit – Hitler's parade car and Kearns' painting – both produce and interrupt the viewer's recognition of the subjects of war in the pedagogical context of the museum. Let us see how this is the case.

Butler (2009) reminds us that sociality, in times of peace, as well as in war is a precarious endeavor because 'one's life is always, in some sense, in the hands of the other' (14). Under the conditions of violence, precarity is minimized for some and maximized for others. This, Butler suggests, is how war does its damage – not only are bodies physically maimed and destroyed – ontologically, war 'seeks to deny the ongoing and irrefutable ways in which we are all subject to one another, vulnerable to destruction by the other' (54). I think of it like this: precarity, as a quality of being human is the very thing that must be minimized by the soldier at the same time that it is maximized for those who are subjugated by war. This is how war dehumanizes. The cost of the denial of precariousness, on an ontological level is the fracturing of social conditions that allow us to live ethically in relation to ourselves and to others. We see this cleavage enacted in trophy photographs, which frame the perpetrator as a subject that 'denies its own constitutive injurability and relocates it in the other' (Butler 2009, 176). Trophies of war are a literal manifestation – a direct symbolic – of the denial of precarity. The passion they celebrate is that of the ontological win – the will to destroy that is a constitutive feature of empire building. These are the dynamics of war that we would rather forget and that are occluded by simplistic representations of war as a battle between victors and the vanquished. Thinking about precariousness as an ethical relation, however, allows us to consider the social consequences of how some lives are constituted in excess of precarity, as well as how it is occluded in others. Awareness of precarity is made within the norms of recognition through which one comes to recognize personhood – in other words, whom one apprehends *as a life*. Butler (2009) calls these discursive regimes 'frames of recognition' (5).

The phrase 'to be framed' carries with it a number of interpretive possibilities; a picture is framed, and so too a person can be framed (Butler 2009, 8). In the first sense, the frame is both

'The trophies of their wars'

containing and embellishing what is enclosed within it. In the second, that one is determined by the action of the frame. In each, however, there remains the possibility that the subject of the frame will exceed the restrictions imposed by it. Interrogating the frame is for Butler a political act that seeks to explore how frames 'can and do break with themselves,' (12) allowing for emergent iterations. Breakage works at the level of apprehension, which she describes as a 'mode of knowing that is not yet recognition' (6), and which I interpret as the affect or impression that registers before thought becomes recognition. This is a crucial point for Butler (2009, 34): 'responsiveness – and thus, ultimately, responsibility – is located in the affective responses to a sustaining and impinging world' (34). Affect therefore sets the stage for the possibility of social critique because it is bound up in the ways in which we apprehend and recognize others.

Returning to my fictive exhibit with Butler's framework in mind, I now engage two analytical tasks. First, I consider how the concept of the war trophy frames our encounter with, and recognition of, the subjects of war with regard to Hitler's parade car and Kearns' painting. Here, I think about precarity as a social relation and contemplate the possibilities for ethical encounter provoked by an engagement with these two exhibits. Second, I take up Butler's (2009) insistence that frames 'can and do break with themselves' (12) producing the conditions for alternate modes of response. To do this, I analyze the exhibits once more, but this time through a reading of visitor responses that, in my estimation, symbolizes the affective register of engagement. It is through this register, I suggest, that we might find new ways of responding to the CWM's call to 'remember, preserve and educate' (www.warmuseum.ca).

The trophies of their wars

The collection of 'trophies' by soldiers during the course of violent conflict – an undertaking which ranges from the appropriation of the personal belongings of dead soldiers and/or civilians to the dismemberment and preservation of body parts, including the apprehension of the subjugated other through the technologies of visual documentation (photography, video) – is not new (Harrison 2006, 2008; Weingartner 1992). Indeed, the practice of collecting skulls, scalps and bones of the conquered enemy, as well as the spectacularization of that behavior through public display and consumption, has characterized wars of colonial expansion since the early eighteenth century (Harrison 2008). As a contemporary example, Weingartner (1992) analyzes the role of the US media in the dehumanization of Japanese nationals during World War II (WWII), demonstrated by the decision of Life magazine to publish a racist image as their 'Picture of the Week' on 22 May 1944. The full-page photograph depicts a young white woman sitting at her writing desk, contemplating the upper half of a human skull that rests to one side of her notepaper. To fully comprehend the photograph one needs the accompanying caption, which reads as follows: 'Arizona war worker writes her Navy boyfriend a thank-you note for the Jap skull he sent her' (in Weingartner, 58). While behaviors such as these are officially disapproved by western military institutions and contravene the tolerated standards for wartime conduct laid out by the various protocols of international humanitarian law (Hague and Geneva Conventions), their prevalence remains, a source of ongoing fascination for the general public and analysis and critique on the part of scholars.

Overlooked by the mainstream news media are discussions of what is at stake, beyond the question of moral turpitude, in the production and circulation of visual images such as these. Nicholas Mirzoeff (2006) takes up this query in his analysis of images of torture from Abu Ghraib prison, which, he argues, spectacularize imperial violence as much as they denote individual responsibility. Critiquing the 'modernist sensibility' (22) of the documentary frame that

333

promises to reveal the truth of war, Mirzoeff asks us to consider images as a system of signs through which we ascertain a particular understanding of war. He puts forward a view of visual culture as that which 'describes and creates networks of visual events in which time and space are questions, not answers' (22), a shift in perspective that demands something quite different from the viewer. If we return to the 'urination video' with this new orientation in mind another set of questions are raised: what does the visual scene want from the viewer and how do we resist and/or comply?[4] What kind of response can be made? How are the subjects of war constructed in time and space and who are we in relation to them? Is the video pedagogical and if so, which lessons of war does it teach? Approaching the video as a question rather than an answer shifts the position of the viewer from dispassionate witness to one who is tied up in the 'politics of bringing the embodied subject into presence in space' (22).

Bringing Mirzoeff's (2006) thinking about visual culture to the context of the CWM, we can query as to how how the museum 'describes and creates networks of visual events' (22) that both produce and disrupt notions of empire. In this sense, the war trophy is a frame of recognition (Butler 2009) through which the embodied subjects of war are brought into the presence of memorial space. How, through the frame of the war trophy, are we led to think differently about the objects of material culture on display at the CWM? For instance, is Hitler's parade car, a popular exhibit housed in the WWII gallery, a *trophy* of war? For the definition to hold, the car must have been 'taken in war,' but by whom, when and how? Here, questions of provenance and preservation come into play. Certainly the car is both 'kept' and 'displayed' by the museum – but as a memorial to what or to whom? Can we consider the car a 'spoil' or 'prize' of war? How does the broader frame of the war trophy alter our perspective on the stated mandate of the museum, which is to 'to remember – to preserve – to educate' and '… to help ensure that the memory and meaning of Canada's military past will never be forgotten' (www. warmuseum.ca)? This phrasing produces the CWM as a particular kind of archive; past wars will be remembered, artifacts will be preserved, and lessons will be learned. My interest lies with exploring how the frame of the war trophy leads us to new ways of understanding the museum as a site of memory, preservation and pedagogy.

While the war trophy symbolizes the spectacle of empire and in turn produces particular notions of the soldier, the citizen and the nation, these constructs are not stable. Rather, the various exhibits on display at the museum function as a set of signifiers in a chain of representation through which the visitor comes to ascribe meaning to what they see. This meaning making is contested work for the viewer. Likewise, extending Mirzoeff's (2006) critique of the documentary frame as a mode of truth telling, one can no longer hold to an innocence that the museum in late modernity will answer the questions of history; on the contrary, what the museum returns to the visitor is the question of history itself. Furthermore, the didactic contents of the museum – the narratives that produce history as legible within the framework of the mandate – rarely reveal the structure of their own production. The consequence is that the task of interpretation falls to the viewer. If, as Mirzoeff suggests, visual culture describes a network of relations that call into question our proximity to cultural objects in time and space, then the problem for museum research is how to capture and understand the ways in which the visitor is brought into presence through an encounter with the artifacts and esthetic objects on display. I am particularly interested in the idea of embodiment and how one's corporeal and affective responses to the CWM become part of one's knowledge of war as a social encounter.

The car

One of the more prominent displays at the CWM is a black Mercedes-Benz bulletproof limousine that was once used by Hitler as a parade car (CBC 2000; Cobb 2000). The Museum acquired the vehicle in 1970 as a donation from a private collector (Pulsifer 1999). Originally thought to be Goering's staff car, historical research revealed the correct provenance; from 1940 to 1943, it was used by Adolf Hitler as a private staff vehicle (Kosche 1982). From 1984 to –2000, the car was exhibited at the war museum's first location on Sussex Drive in Ottawa (Pulsifer 1999). In that context, the car was displayed next to a partial reproduction of what appeared to be the exterior wall of a traditional German post and beam style dwelling. Nazi paraphernalia, including a swastika banner, a bust of Hitler and a mannequin dressed in SS attire, completed the spectacle. According to Pulsifer (1999) the exhibit was intended to bring critical awareness to Nazism as a significant factor in the developments of WWII (74). Despite the curators' attempts to situate the car within a specific circuit of meaning, the critical response for which they had hoped was not forthcoming. Instead, public sentiment expressed exactly the opposite, that glorification of the Nazi regime was the closer result; 'the car and the exhibit did invoke what might be termed the Leni Riefenstahl view of Hitler, with its emphasis on adulating crowds, torchlight parades and Nuremburg rallies, more than on the Hitler of military aggression, racist politics and the Holocaust' (Pulsifer 1999, 75). Though collective criticism of the exhibit led to an attempt, in 1991, to further stabilize meaning by the addition of a series of small photographs depicting the Nazi death camps, the pedagogical and interpretive problems of the exhibit remained unresolved (Pulsifer 1999, 75).

The re-location of the museum in 2005 to its current site at Vimy Place provided an opportunity for curators to revisit the exhibition strategy. While efforts to stabilize the narrative are still apparent, there are significant changes. The dioramic display has been displaced by a minimalist approach in which the car is simply presented on a raised platform that effectively separates it from the viewer. The 'Riefenstahl' association, however, remains; mounted to the wall behind the car is a large iconic photograph of a Nazi Party rally at Nuremburg, reminiscent of Riefenstahl's (1934) film 'Triumph of the Will.' From the perspective of the spectator, one looks forward over the heads of thousands of SS officers, toward a distant central dais flying three Nazi banners. The photograph is black and white, save for the banners, which are photo-tinted red. This display strategy positions the viewer as following the gaze of the soldiers toward the National Socialist insignia. The centering of fascist power conveys a clear vision of empire that resonates with the World War II narrative suggested at the museum, that of Allied victory over evil. The car effectively materializes that evil, celebrating the end of one empire, while securing the centrality of another.

Recalling the definition of a trophy as something 'taken in war' (Trophy, n.d.), details of the car's restoration are key to understanding the relevance of this frame for thinking about the exhibition strategy. When the car was obtained by the museum from the private collector, curators took pains to rectify any inaccurate preservation details, except for the bullet-ridden windows left in place by the original restorer who felt that they 'lent more authenticity to the war action the car had seen' (Pulsifer 1999, 69). Since there is no accurate historical record of exactly what war action the car had seen, this was mere speculation. Though captured from German snipers by American soldiers just north of Salzburg in 1945, it is not clear how the bullet marks on the vehicle were incurred (Pulsifer 1999, 73). These curatorial choices speak of the desire to evoke a particular historical narrative by inviting the projection of phantasy. Reading this phantasy through the frame of the war trophy, it is clear that the car, which invokes the aura of Hitler, serves as a 'token or evidence of victory, valour, power [and] skill'

Sara Matthews

(Trophy n.d.), the victory being the Allied defeat of the Axis powers. In this view, preservation is on the side of the construction of the West as impenetrable, as the ontological winner in the relations of precarity. How does this mean for how the visitor is called into the WWII gallery as a space of remembrance and learning? What of the quality of the human, of the relations of precarity that bind us to each other? The problem is not that historical objects generate phantasmic associations, but rather how our interpretations of these associations preclude or enable our recognition of certain lives as injurable or grievable and thus human. This interplay became clearer to me when I encountered visitor responses to the car posted on the Internet.

I stumbled across unofficial responses to the car during the course of my research exploring how student teachers interpret adolescents' engagements with the exhibit (Matthews 2009). While searching the Internet for images, what I discovered along with photographs of the exhibit itself, were those depicting museum visitors posed next to the car, smiling for the camera. I was struck by the captions and comments that accompanied these images. Here are three:

> March 14, 2007: a teenager is photographed standing beside the car. The photo headline reads, "Hitler's Freakin' Car!" and is subtitled, "Meagan was enthralled with the idea that Hitler had actually ridden in that car."
>
> *(www.flickr.com/photos/30283861@N00/423350338)*

> September 12, 2007: a young woman poses beside the car, smiling. The caption reads, "Em with Hitler's car."
>
> *(www.flickr.com/photos/foxphotoalbum/1367552111)*

> September 17, 2007: a woman and man stand with their arms around each other posed in front of the car. The photo caption reads, "Hitler's Car, of Course."
>
> *(www.flickr.com/photos/pangelingua/1397986251)*

Thinking of the visual image,[5] I find it helpful to return to Mirzoeff's (2006) perspective of the visual event calling into question our location of cultural objects in time and space (22). We might wonder, for example, about the conflicts of learning at stake in the impulse to photograph, and then circulate images of oneself next to an object of material history, such as Hitler's parade car. Moreover, what lessons of history does the car itself teach? Is it of the rise of Nazism and its destructive power? Is it of social fascination with the villains of history? Or is it of war trophies and the details of their capture and display? Reading this image through the frame of the war trophy, the tableau provokes a number of associations; the photographic gaze of the children looking out toward the camera appears in stark contrast to the rows of soldiers in rapt attention of their Führer. What does this image want from the viewer? Certainly the commentary responding to similar photographs provides clues as to the range of possibilities. For example, in the comment noted above, 'Hitler's Freakin' Car!, Meagan was enthralled with the idea that Hitler had actually ridden in that car,' the primary identification is with Hitler's proximity, an uncanny return that provokes her to enthrallment. There is potency here, not only in terms of Meagan's relation to precarity (which is evacuated), but also with regard to the quality of affect expressed. It may be, recalling Green (1999), that what the visual scene enables is not the staging of the body as the subject of an action – in terms of the contract of the photograph – but as the object of a passion expressed by the thrall of identification with the ontological win.

The remarks garnered from the Internet testify to the ways in which one might be called into the presence of the conflicts expressed by a relation to Hitler's parade car. The last statement

'The trophies of their wars'

above is indicative of this summons: 'EVIL car,' the comment proclaims. Is this declaration a complaint against the display of a historical object that embodies, at least in this visitor's estimation, the notion of evil? Or, perhaps it protests the very existence of the car and so of evil itself? The qualifying assertion that the vehicle 'somehow ended up in Ottawa' raises the question of its procurement: why is the car *here*, in this time and place (the nation's capital, the war museum) and how did it come to be so? These queries challenge the exhibit as an exercise of empire. So too does the single remark made in response to an image posted on Flickr on 31 July 2008: 'Idioten,' it simply states. Translated from German into English 'Idiots,' it is unclear if the accusation is directed toward the people in the photograph – as in, 'what an idiots you are for taking this picture of yourselves posing next to Hitler's car' – or toward the museum for staging the exhibit itself. What the variety of responses demonstrates is that, the frame of the war trophy can and does break with itself, offering new ways of relating to the difficult histories that the car represents. This opportunity is missed, however, in responses that deny the precarity of the social relation by siding with history's heroes and/or villains. The question that I have with regard to these found images is, what counts as a grievable life? Can we apprehend the soldiers in the Riefensthal tableau as grievable? What of Hitler? This is a troubling question but gets to the heart of Butler's (2009) appeal to consider precarity as an ethical relation that binds us to what is human in others and ourselves.

Somalia without conscience

Toronto painter Gertrude Kearns' piece *Somalia Without Conscience* (www.ccca.ca) and its companion painting *Somalia With Conscience* respond to the media storm surrounding a violent incident perpetrated against a Somali youth by Canadian peacekeepers in 1993. The titles of the paintings point to the relationship between the soldiers and the acts of violence the images depict. Since 1991 and the Persian Gulf War, Kearns' work has focused primarily on war related themes. In 2005/2006, she spent 31 days in theater with Canadian troops in Afghanistan as part of the Canadian Forces Artists Program (CFAP). CFAP is a government initiative that embeds artists in Canadian military operations for the purposes of documenting, interpreting and representing the day-to-day experiences of military personnel. But even before Kearns joined the program, she sought ways to visually engage with Canada's involvement in war and to explore through her work the difficult and contradictory aspects of military culture. The *Somalia* diptych, which was prominently displayed in the new location of the CWM in 2005 amidst a great deal of contention, is one example of these efforts. As Laura Brandon (2007), curator of the war art collection at the CWM notes in her analysis of the controversy, 'What upset members of those communities that opposed the display of the paintings was learning virtually for the first time that what they regarded as "their" museum (they had, after all, lobbied and fundraised for it) was not only telling the stories of heroism and courage that most of them expected to be told but also stories about failures, disappointments, and human frailty' (12). Indeed, as curator of the exhibit Brandon, along with Kearns, received abusive email directly stemming from the Internet debate that waged on the site www.army.ca for over five months (Brandon 2007).

The paintings depict Canadian Airborne Regiment officers Lieutenant Kyle Brown and Corporal Clayton Matchee in events that transpired on the night of March 1993. Somali teenager Shidane Arone was caught on the Canadian peacekeepers military base and subsequently held on charges of alleged theft, though no evidence was forthcoming. During the evening of March 16, Arone suffered extensive torture and beatings that eventually resulted in his death (Razack 2004). Kyle Brown took 16 photographs of himself and Matchee posed next to the inert body of Shidane Arone, photographs that were later leaked to the Canadian media.

337

Matchee attempted suicide by hanging just days after his court-martial (Department of National Defence 1997). Deemed unfit to stand trial due to the resultant brain injuries, charges against him were dropped. Lieutenant Kyle Brown was charged with torture and second-degree murder, and was dismissed from the Canadian Forces and sentenced to five years in prison for his role in the crime. These and other events implicating Canadian Airborne soldiers in unethical and illegal activities eventually led to the Canadian government's so-called *Somalia Inquiry* (Department of National Defence 1997).

In the context of how the trophy photos taken by Lt. Brown constitute a visual event of empire, Razack (2004) provides one assessment. The photographs, she argues, along with other racist and violent performances of masculinity expressed by Airborne Regiment soldiers (including hazing rituals captured on video and written diaries documenting atrocities in theater), are a symbolization of their desire to 'satisfy their will to wholeness through degradation and containment of Others' (72). Indeed, one cannot understand the visual language of the trophy photograph without its explicit (often racist and sexist) subjugation of one life by another. It is this perspective that is taken by Linfield (2010), who suggests that images of atrocity constitute an event that not only depicts cruelty but actually symbolizes it 'from the very fact that they were made and from the unmistakable happiness of the tormentors they show' (151). Vettel-Becker (2002), in her analysis of World War II Combat photography (notably Edward Steichen's famous 1945 photo exhibition *Power in the Pacific: Battle Photographs of our Navy in Action on the Sea and Sky*), shares this view. Taking up this exhibit, along with Steichen's 1947 diaristic narrative of his experience aboard the aircraft carrier USS Lexington, Vettel-Becker intends to show that the 'photographs enact the play of domination and subjugation through the imagery of impenetrability and rapability, thus contributing to the propagandistic construction of the enemy and extending the voyeuristic pleasures of domination to those not able to experience it firsthand' (80). With regard to the Kyle Browne photographs, the domination of racialized others, a fundamental dynamic of empire, is cast in terms of the performance of hypermasculine violence.[6]

While Vettel-Becker does not address the status of the trophy photo per se, her work contributes to scholarly perspectives that tie the visual event of the subjugated other to the performance of masculinity within military cultures. Also in need of consideration are the ways in which state-sponsored violence nurtures and exploits masculine (and some feminine) bodies in the service of what Georgis (2011) calls the domestic labor of the nation. Georgis' study of the construction of masculinities through nationalist campaigns asks us to consider how male bodies are delivered in servitude to the beloved motherland. In terms of how trophy photographs frame the visual event of empire and embody the subjects of war, we might think about how masculine aggression is cultivated for the purposes of state sanctioned murder at the same time as it is disavowed by the nation. One cost of this disavowal can be understood through Butler's (2009) insistence that social living is a precarious endeavor because we are ontologically and materially bound to each other. Knowledge of this radical relationality, however, is what the soldier (whose job it is to take human life and to take it without compunction) cannot allow. The military phantasy is that precarity might be attenuated by some (the nation's warriors) and amplified in others (the enemy). Indeed, this is not merely phantasy; the weapons wielded by our nation's soldiers can and do maim and kill. The repudiation of precarity, as practiced by the soldier in the context of military service, and as lionized in the performance of trophy photographs is a social violence that must be theorized as part of the ways in which we remember and learn from war.

Let us think about these issues in terms of Kearns' painting. *Somalia Without Conscience* is based on a photographic image and therefore raises the issues of document, representation and interpretation as an explicit concern. Encountering the exhibit, which is situated in the permanent

gallery devoted to contemporary conflicts,[7] little information is available other than a caption stating the title, artist and the explanation that 'an otherwise successful peace enforcement mission was marred by the torture and death of a Somali teenager' (Knoll 2005, 16). No mention of the Canadian Airborne Regiment or the Somalia Inquiry is made. The painting provokes many questions but ultimately the responsibility for answers lies with the viewer. A relatively large piece (approximately 9×4 ft), dominated by a muted color palette punctuated by tones of green and red, the viewer meets Matchee's gaze head-on, creating the sense, according to Brandon (2007), of being identified with the picture taker. In the background is the shadow of a large mechanical saw-like object; Arone's legs poke out from beneath the color field, extending our thoughts to what lies beyond the scope of the frame. There is no doubt, given what we know about the creation and circulation of the original photograph, that the image represents the contract of the trophy, but what of the painting? As a visual event, does it break with this discursive frame and provoke a different relation to empire? The answer, I think, is a complicated one and lies with potential for how the interpretive frame of the painting allows for a different set of questions about what, in times of war, constitutes a grievable life. This new orientation was revealed to me through a personal encounter I had with another visitor to the museum.

During a visit to the CWM, early one morning, I was wandering among the exhibits in the permanent collection. The museum was not particularly busy at that time of day, but I did frequently cross paths with one man as we made our separate ways through the historical galleries. I guessed that he was military because of the attention that he gave to weapons of war, and because his hair was shaved tight to his scalp, his physical bearing upright and trained. Stereotypical, I know, but it gives context to my thinking at the time. We found ourselves together in the final exhibition space, the oval shaped room depicting Canada's relationship to more recent conflicts. I was looking at Kearns' painting, *Somalia Without Conscience*, when I sensed someone standing behind me. And then a voice: 'That painting shouldn't be in the museum,' a man spoke. Turning, I found him there, poised a few feet away. 'Why do you think that?' I replied, though convinced I already knew the reason, being aware of the reaction that many veterans have to the painting: it casts the Canadian military in what many feel is a negative light (CBC 2005; Lofaro 2005). This was his answer: 'Because he raped me.' And then he abruptly walked away.

The affect expressed in this man's outburst is difficult to think with: it testifies to the force of an encounter passed on as an utterance that shocks. What does his admission want? I cannot know the answer to this question. One result was a change in the way that I perceived the histories of violence represented by the painting. It had not occurred to me to connect Matchee with the vicious hazing rituals that I knew had plagued the Airborne Regiment at their training facility in Petawawa (Whitworth 2005), but this man's utterance certainly made that association for me. Certainly I was not thinking about the ways in which sexual violence is deployed in the performance of heteronormative masculinities in the military. Even so, I am wary of psychologizing narratives that elide the racism of the heinous acts perpetrated on Shidane Arone by focusing on war trauma and post-traumatic stress disorder (Razack 2004; Whitworth 2005). More questions are raised than answered by this man's confession; for example, what do instances of torture and sexual domination in the context of military experience express about social relations under the rubric of war and occupation? How does state violence enact itself through the positioning of sovereign subjects (such as soldiers) who deny, as Butler (2009) phrases it, their own 'constitutive injurability' (26) and relocate it in the other? And finally, how does a painting of a devastating photographic image alter the frames of recognition through which we encounter the subjects of war?

Sara Matthews

What I do know is that this museum visitor chose to share his reaction to the painting with me, an anonymous stranger, so that his story now joins with mine in reckoning what is 'taken in and taken home' (Bal 1992, 541) from our common encounter. In this account, interiority is already social. In a sense it was my encounter with *how others encountered* both Kearns' painting and Hitler's parade car that broke the frame of my initial engagement with these visual events. What these two exhibits reveal when they are placed in juxtaposition and framed by the concept of the war trophy are the ways in which we are all subject to relations of dependence and obligation with others; we are all 'precarious lives' (Butler 2009). If precarity is a component of sociality that brings us into contact with the vulnerabilities of being human, to recognize the other is not to decide in advance what a life can or should be, but rather to 'find and support those modes of representation and appearance that allow the claim of life to be made and heard' (48). For the CWM, this means learning to hear in the affective register, to find ways of including the passionate response as part of the rhetoric of remembrance, preservation and learning.

By way of conclusion, I want to return to the method of free association that I originally engaged as a strategy for symbolizing my encounter with public responses to Kearns' painting and Hitler's parade car. My fictive exhibit was an associative experiment that attempted to symbolize and bring into thought my affective response to these encounters. Particularly difficult for me to think within the context of academic inquiry was my meeting with the man who confessed to me, his rape. I can now reflect on how that interaction called each of us into being through the presence of the other. Here, I am returned to Ahmed's (2000) claim that 'encounter … suggests a meeting, but a meeting which involves surprise and conflict' (6). For my part, the man's utterance produced a conflict that called into question my interpretation of Kearns' painting and indeed my understanding of military violence. It was only through our encounter that I was able to think differently about the frames of recognition through which the painting (as well as its display) construct the grievability of human life in the context of imperial violence. More importantly, I thought differently about the man. I was then able to bring this orientation to my analysis of public responses to Hitler's parade car. I wonder, if I were to mount my fictive exhibit as an actual display in the museum, would others be similarly moved? Would the placement of Kearns' painting behind the car encourage an analysis of the broader structures of imperial violence and war? Would people be less inclined to photograph themselves in front of the car? I cannot predict what this juxtaposition might offer in terms of public encounter. What I am more inclined to investigate are how public conversations *about* such exhibits enable the conditions to encounter unknowability as the grounds for relationality. As museum visitors, we might orient ourselves to the space of the CWM as a strange encounter (Ahmed 2000) that provokes a new reading of the self and the other in relation to history.

Notes

1 Public pedagogy is a developing and debated term in the field of educational scholarship (see Sandlin, Schultz, and Burdick 2010). Broadly understood as the critical study of how public spaces, such as museums, memorials, parks, art galleries, etc., are sites of contested power that can be generative of radical or democratic interventions into the social domain, the term draws on a notion of the public as performative, and therefore, an active force in social change and renewal.

2 http://ccca.concordia.ca/artists/work_detail.html?languagePref=fr&mkey=58569&title=Somalia+with+Conscience&artist=Gertrude+Kearns&link_id=6262.

3 It is important to note that my development of this fictive exhibit is a thought experiment and not intended, at least in its current configuration, to be a curatorial project. I make this distinction because the work of advancing a museum exhibit that brings the visitor into the dilemmas or questions raised by the project is quite different from this proposal, which I articulate here as a method for cultural analysis. Following the work of Mieke Bal (1992), who experiments with cultural analysis as an exhibition

strategy, I do explore free association as a practice of curation. My intent here is to use free association as a mode of interpretation that allows moving the analysis along: namely, to think about how the concept of the 'war trophy' reframes Kearns' painting and Hitler's parade car in the context of the CWM.

4 Mitchell's (1996) investigation of how images work in visual culture shifts the emphasis from 'what pictures do to what they want' (74). He suggests that '[l]ike people, pictures don't know what they want; they have to be helped to recollect it through a dialogue with others' (81). I draw from Mitchell's formulation in the sense that I'm interested in how the address of the visual scene calls the viewer into encounter and therefore into being.

5 http://blog.travelpod.com/travel-blog-entries/kann2010/1/1278515749/tpod.html#_.

6 For a full discussion of these complexities in terms of race, masculinities and empire building, see Razack (2004) and Whitworth (2005).

7 At the time of my visit to the museum on 15 May 2012, the painting was no longer on display.

Bibliography

Ahmed, S. 2000. *Strange Encounters: Embodied Others in Post-Coloniality*. London: Routledge.

Bal, M. 1992. "Telling, Showing, Showing off." *Critical Inquiry* 18 (3): 556–594. doi:10.1086/448645.

Bal, M. 2002. *Travelling Concepts in the Humanities: A Rough Guide*. Toronto: University of Toronto Press.

Bal, M. 2009. *Narratology: Introduction to the Theory of Narrative*. 3rd ed. Toronto: University of Toronto Press.

Brandon, L. 2007. "War, Art and the Internet: A Canadian Case Study." *Convergence: The International Journal of Research into New Media Technologies* 13 (1): 9–17. doi:10.1177/1354856507072860.

Britzman, D. P. 2003. "Five Excursions into Free Association, or Just Take the A Train." *Journal of the Canadian Association for Curriculum Studies* 1 (1): 25–37.

Butler, J. 2009. *Frames of War: When is Life Grievable?* London: Verso.

CBC News. 2000. "War Museum Keeps Hitler's Car." February 8. Accessed June 28, 2009 www.cbc.ca/canada/story/2000/02/08/hitler000208.html.

CBC 2005. "Somali 'torture art' re Canadian War Museum." *The National*, May 3.

Cobb, C. 2000. "Hitler's Armored Mercedes Center of Museum Controversy." *The Ottawa Citizen*, February 2. Accessed March 12, 2007 www.ottawacitizen.com/national/000202/3530555.html.

Department of National Defence. 1997. *Report of the Somalia Commission of Inquiry*. www.dnd.ca/somalia/somaliae.htm.

Georgis, D. 2011. "Masculinities and the Aesthetics of Love: Reading Terrorism in *De Niro's Game* and *Paradise Now*." *Studies in Gender and Sexuality* 12 (2): 134–148. doi:10.1080/15240657.2011.559442.

Green, A. 1999. *The Fabric of Affect in the Psychoanalytic Discourse*. London: Routledge.

Harrison, S. 2006. "Skull Trophies of the Pacific War: Transgressive Objects of Remembrance." *Journal of the Royal Anthropological Institute* 12 (4): 817–836. doi:10.1111/j.1467- 9655.2006.00365.x.

Harrison, S. 2008. "Skulls and Scientific Collecting in the Victorian Military: Keeping the Enemy Dead in British Frontier Warfare." *Comparative Studies in Society and History* 50 (1): 285–303. doi:10.1017/S0010417508000133.

Knoll, D. 2005. "New War Museum Faces Criticism." *Esprit De Corps: Canadian Military* 12 (6): 16.

Kosche, L. 1982. "Story of a Car." *After the Battle* 1–13.

Linfield, S. 2010. *The Cruel Radiance: Photography and Political Violence*. Chicago: University of Chicago Press.

Lofaro, T. 2005. "Vet to Boycott Museum Over Somalia-torture Art." Toronto: *The National Post*, May 3.

Matthews, S. 2009. "Hitler's Car as Curriculum Text: Reading Adolescents Reading History." *Journal of the Canadian Association for Curriculum Studies* 7 (2): 49–85.

Mitchell, W. J. T. 1996. What Do Pictures "Really" Want?" *October* 77 (Summer): 71–82. doi:10.2307/778960.

Mirzoeff, N. 2006. "Invisible Empire: Visual Culture, Embodied Spectacle, and Abu Ghraib." *Radical History Review* 2006 (95): 21–44. doi:10.1215/01636545-2006-95-21.

Pulsifer, C. 1999. " 'Hitler's Car' and the Canadian War Museum: Problems of Documentation and Interpretation." *Material History Review* 50: 67–75.

Razack, S. 2004. *Dark Threats and White Knights: The Somalia Affair, Peacekeeping and the New Imperialism*. Toronto: University of Toronto Press.

Sandlin, J. A., B. D. Schultz, and J. Burdick. 2010. *Handbook of Public Pedagogy*. New York: Routledge.

Trophy. (n.d.). *Oxford English Dictionary*. http://dictionary.ocd.com.

Vettel-Becker, P. 2002. "Destruction and Delight: World War II Combat Photography and the Aesthetic Inscription of Masculine Identity." *Men and Masculinities* 5 (1): 80–102. doi:10. 1177/1097184 X02005001004.

Weingartner, J. J. 1992. "Trophies of War: US Troops and the Mutilation of Japanese War Dead, 1941–1945." *Pacific Historical Review* 61 (1): 53–67. doi:10.2307/3640788.

Whitworth, S. 2005. "Militarized Masculinities and the Politics of Peacekeeping." In *Critical Security Studies in World Politics*, edited by K. Booth, 89–106. Boulder, CO: Lynne Rienner Publishers.

24
Huddled masses yearning to buy postcards

The politics of producing heritage at the Statue of Liberty–Ellis Island National Monument*

Joanne Maddern

Located prominently in New York harbour, Ellis Island is part of the Statue of Liberty National Monument, which was inscribed on the World Heritage List in 1984. Formerly an immigration station, Ellis Island is now a powerful commemorative landscape. More than 100 million living Americans can trace their US roots to a man, woman or child who passed through its doors. Because of its popular significance and appeal, hundreds of museum producers endeavoured to create an inclusive, balanced and populist history of the 'peopling of America' within the spaces of the abandoned former immigration station. As part of continuing geographical research this paper draws on in-depth interviews with heritage professionals to explore how complex international immigrant histories have been mobilised by its various producers.

Introduction

> 'Throughout history, peoples have exchanged cultural experience, ideas, values and goods through art, trade and migrations', UNESCO suggests in its statement on Intercultural Dialogue. For UNICEF, 'Human history is the tale of such journeys'.
>
> *(UNESCO, 2004a)*

The title of this paper is a play on a line from the famous poem *The New Colossus*, written in 1883 by Emma Lazarus (Vecoli, 1994: 39) and inscribed on the pedestal at the foot of the Statue of Liberty:

> Give me your tired, your poor
> Your huddled masses yearning to breathe free,
> The wretched refuse of your teeming shore.
> Send these, the homeless, tempest tossed to me.
> I lift my lamp beside the golden door.

Named by Emma Lazarus, *The Mother of Exiles* (Vecoli, 1994: 39) the Statue of Liberty stands in New York Harbour, the major port of entry for the 'great waves' of immigration that

Joanne Maddern

touched the shores of the US in the 19th and 20th centuries. The Statue of Liberty was one of the first sights seen by the shiploads of immigrants and exiles, as many entered Ellis Island immigration station, often referred to as 'the golden gateway', on their way to new lives in a new land. Between 1892 and 1924 an estimated 12 million migrants entered the US through the station and, as a consequence, millions of Americans have an ancestral connection to Ellis Island.

No longer used by the Immigration and Naturalisation Service (INS) for immigration, detention or deportation, Ellis Island is now owned and administered by the United States Department of the Interior's National Park Service as part of the Statue of Liberty–Ellis Island National Monument complex. Collectively these two heritage sites attract around 5,500,000 visitors per year (National Park Service Accountability Report, 2001). Deemed to be of outstanding universal value, they were inscribed on the World Heritage List in 1984.

Ellis Island Immigration Museum contains three floors of self-guided exhibits (covering 200,000 square feet) and is full of audio/visual displays detailing the history of the immigration processing station between 1892 and 1954. Visitors can tour the Great Hall where immigrant legal and medical inspections took place and are confronted with an array of objects and artefacts on display: baggage, immigrant clothing and costumes, passports, steamer and railroad tickets, ship passenger manifests, etc.

Using a case study of the production of an immigration museum at Ellis Island, this paper explores the dialectical tension that often exists between world heritage as a force which may legitimise inclusive multicultural senses of identity and transnational citizenship, and world heritage as vehicle for nation-building (which often excludes histories and knowledge that lay outside national borders: see for instance Hewison, 1987).

Research was carried out between September 2001 and May 2002 and involved extensive archival analysis of National Park Service documents, and textual analysis of around 40 transcribed interviews with key actors involved in the restoration and running of Ellis Island and the Statue of Liberty from the 1960s to the present day. This contribution traces the contestations between differently positioned sets of social actors involved in inscribing the site with meaning and the paper illustrates the problems of representation and legitimacy often faced by World Heritage Sites in an increasingly interconnected world.

Transnational migration histories and world memory

> The world's memory is composed of more than just kings and heroes, battles and conquests, great cathedrals and monumental undertakings.
>
> *(UNESCO, 2004b)*

Immigrant histories are quintessentially transnational histories that involve the popular mass movements across space of millions of people over time. In this sense, they are histories at the forefront of a new social history that has recently encouraged public historians and heritage professionals to *rewrite* the past at heritage sites (cf. Foner, 1997; Handler & Gable, 1997; National Park Service, 2000). The historic adviser to the Statue of Liberty–Ellis Island project has described the new social history and its impact on museum production at Ellis Island as follows:

> [The new social history] is ... the history of the people – bottom up history if you wish. It is the history of the inarticulate ... It's more the history of the people rather than the politicians. [A] ... history of the people in the pew, rather than the priests in the pulpit. You

know it's not popular in the sense of popularisation, it's not popularising, but it's focused on a different class of people: the inarticulate, the immigrants, the people who work, unskilled labourers, the working class. It's influenced labour history, it's influenced religious history, it's influenced immigration history.

(Personal telephone interview with Professor J.P. Dolan, April 2002)

Such an assertion is a rejoinder to cultural institutions which have in the past focused on elite histories to the detriment of more 'popular' versions of the past. Thus, where traditional histories at heritage sites have been 'written from a sedentary point of view' (Deleuze & Guattari, 1987: 23) that stresses 'stability, roots, boundaries and belonging' (Bender, 2001:5), migration histories necessarily emphasise geographical connectivity and rhizomatic networks that transgress the borders of individual nation-states. Indeed, during the production stage of the museum at Ellis Island, incorporating this level of geographical connectivity into the museum narrative caused difficulties for National Park Service interpretive staff, who were used to dealing strictly with *national* (specifically military or political) histories, as Barry Moreno, Ellis Island's librarian emphasises:

The Park Service was confronted in 1965 by a huge challenge, when President Johnson handed Ellis Island over to the Park Service. The Park Service has run mostly natural sites and biological sites, but they also have been in charge of historic sites – mostly presidential sites or military battlefields connected with the Revolution, the Civil War and the Indian Wars … [T]he Park Service knew virtually nothing about immigration. Immigration at Ellis Island is a hugely complicated history and the Park Service was forced to bring in historical experts, historians who know about immigration. Immigration is complicated because it is about the migration from foreign countries of millions of people … So suddenly it's not just US history but it's European history … *it's world history*. So the Park Service … I don't think was capable in the beginning of handling such a complicated museum.

(Personal interview, held at Ellis Island Immigration Museum, March 2002)

The suggestion that the museum professionals were dealing with a 'hugely complicated history' at Ellis Island is borne out by the examples presented below, and the many competing narratives of Ellis Island made the production of the museum particularly problematic. The following section provides a short history of the production of the museum, before moving on to particular episodes of the production process and exploring them in greater detail.

Aestheticising the heritage landscape: a short history

From the original proposal for the museum in 1963 nearly 30 years of work went into deciding how best to commemorate a set of social memories that were illustrative of not just an important chapter in American history, but a defining moment in *world history*. The abandoned buildings on Ellis Island had deteriorated rapidly since 1954 and the federal government was anxious to unload what it saw as a surplus piece of property that no longer served any useful purpose. For over 20 years the decaying buildings became objects of disputation among federal, state and local governments, commercial developers and historic preservationists (see Johnson, 1984). Whilst interest in memorialising Ellis Island had been growing steadily in some quarters, the main obstacle to restoration was a lack funds. With federal funding for historic preservation dwindling rapidly under the Reagan Administration, the National Park Service was forced to devise an

alternative solution: a major cooperative venture between the private sector and the federal government (Holland, 1993). Though such practices are now commonplace at heritage sites in the United States, Ellis Island was one of the first United States National Park Service historical sites to be underwritten primarily by the private sector.

For many people, this public-private initiative raised serious questions about the role of the private and state sectors in collaborating on a project of such significance. It was feared that the combination of private sector funding and state involvement would not bode well for the staging of a relevant and critical presentation of the past. Johnson, for example, was worried that the lines between 'crass commercial replications of the past' and 'formal historical interpretation' would become thoroughly blurred, and felt that in a worst-case scenario, Ellis Island could become 'a Disney-like "Immigrant land" – with smiling, native-garbed workers selling Coca-Cola to strains of "It's a Small World After All" ' (1984: 161).

In 1982, Ronald Reagan appointed Lee Iacocca, (former head of the Chrysler Corporation and an upwardly mobile son of Italian immigrants) as head of the Statue of Liberty–Ellis Island Foundation. With Iacocca lending his corporate celebrity status to the project, this arrangement did nothing to dispel the fears over excessive commercialisation voiced by Johnson. Furthermore, such arrangements fuelled concerns that history museums have often been constructed by members of dominant classes, and have embodied interpretations that supported their privileged positions within the national order (Wallace, 1991, 1996). However, this unease was somewhat tempered by the fact that many others were also involved in the museum, encompassing corporate, voluntary and state organisations. In 1990, after a $150 million dollar restoration, a section of the north side of Ellis Island opened to the public as a new symbol of *America's Immigrant Heritage*.

Visiting Ellis Island Immigration Museum

After a short boat ride today's *recreational migrants* (Kirshenblatt-Gimblett, 1998: 177) arrive at the 27 acre island by ferries named 'Miss Liberty' and 'Miss New York'. The former immigration centre is an ornate and striking redbrick building with turrets, copper domes and scalloped edges faced in white stone. Upon entering the museum the visitor is immediately faced with a large display of imitation immigrant baggage and high piles of luggage:

> Nearly thirty feet long, cordoned off, accompanied by plaques and vintage photographs it virtually blocks the visitor's progress, along the vast arrival hall. The luggage condenses the experience of immigration to a single visual metaphor and produces a concrete borderline for a national culture, to embody the moment of crossing over to America.
>
> *(Rogoff, 2000: 41)*

The museum utilises the original main building to house photographs, texts, models, oral histories, and such artefacts as immigrant possessions and costumes on three floors of 'self-guided' exhibits. The huge *Great Hall* where immigrants were processed has been left largely empty, except for two large American flags – a flamboyant gesture of banal nationalism (Billig, 1995). Outside the main building can be found The *American Immigrant Wall of Honour*, a series of stainless steel plates attached to a large stone circle. For a 'contribution' of 100 dollars families can 'honour their immigrant ancestors' by having their names inscribed alphabetically. Finally, there is a souvenir shop and fast food hall.

Reactions to the museum have varied. Bodnar, for instance, suggests that the museum negates its responsibility to highlight the injustices faced by immigrants in a new country in

favour of a narrative which supposes that immigration was only about progress, both economic and political (1995). In contrast, Ball (1990: 59) argues that the museum was created simply to sustain a heroic image of good immigration, during a time of 'declining global hegemony and increasing ethnic unease'. According to Kirshenblatt-Gimblett, the museum is nothing more than 'a repository of patriotic sentiment' and 'an exemplar of institutional memory under the aegis of corporate sponsorship' (Kirschenblatt-Gimblett, 1998: 177).

The celebratory but selective reading of the American story so readily noted by these authors is certainly evident – nowhere more so, perhaps, than in the promotional material sent to the public by Lee Iacocca, inviting them to inscribe their ancestors' names on the American Immigrant Wall of Honour for posterity:

> Dear Fellow American:
>
> … Parents, Kids and Grandparents alike come to visit [Ellis Island to] learn about the courage of their ancestors, find or register names on the American Immigrant Wall of Honour® and come away with a new appreciation for the freedom and opportunity we enjoy in this country … May I count on you to continue your support of a very worthy cause? A cause which unites Americans and makes us proud. A cause which helps educate our children about sacrifice and freedom and our way of life.
>
> *(Statue of Liberty–Ellis Island Foundation promotional material, 2001)*

In this letter, the figure of the immigrant is used in a heroic manner to portray American identity in terms of social mobility, rugged individualism and manifest destiny (Kouwenhoven, 1988). Narratives focus on the professional or industrial achievements of upwardly mobile pursuers of an American Dream. Most notably, this is a reading of migration which downplays conflict between migrant groups and more established first fleet genealogies (Nash, 2003). It also downplays the harsh social, economic and political structures within which migrants often found themselves trapped. Where hardship and injustice *is* mentioned, it is codified as a kind of 'noble suffering' which immigrants tolerated and eventually transcended through heroic personal efforts (Bodnar, 1995).

Another criticism of this reading of immigration is that complex lives of migrants are simplified, abstracted and connected to ideals of patriotic sacrifice and citizenship:

> This [popular] version of the immigration experience [advocated in the museum by President Reagan and Lee Iacocca] simultaneously flattered now comfortable ethnics by lionising their ancestors as rugged and successful individualists, and legitimised the right-wing's dismantling of the New Deal. It also suggested that contemporary immigrants and African Americans should rely on themselves, and implied their depressed situation was a temporary phenomenon. In time, blacks, Asians and Hispanics, too, would move to the suburbs. And if they did not, the record of prior immigrant success would prove their failure to be a matter of insufficient grit and determination.
>
> *(Wallace, 1996: 57–8)*

Wallace has also argued that the Reagan Administration intervened in public memory at Ellis Island, waging a kind of *symbolic war* on the terrain of history, and attempting to legitimise a number of contemporary political projects at Ellis Island. During the restoration, for example, President Reagan was accused of using a version of immigration history to argue for cuts in public relief, saying that African-Americans and other minorities should 'follow the example of the immigrants and work their way out of poverty' (Bodnar, 1995; Wallace, 1991). Wallace

argues that Reagan also romanticised the lives of migrants in the past while simultaneously calling for an end to high levels of immigration to the US (Wallace, 1996: 58).

However, patriotic narratives are not the only stories about immigration narrated at Ellis Island. The final section of this paper explores how some museum producers have incorporated insights of the new social history into the museum, invoking the complex nomadologies of mass movements of people back and forth across borders (Deleuze & Guattari, 1987: 23).

Island of hope or island of tears?

Interpretive planners at the National Park Service interpretive headquarters in Harper's Ferry, West Virginia, decided that an important element of the museum would be an orientational film to be shown in the on-site cinema at half-hourly intervals to visitors as they first enter the museum on the ground floor. This film, it was suggested, would provide visitors with a sense of historical context and would be an important element of their overall educational experience at the site. A request for proposals was put out, and Charles Guggenheim, an established American filmmaker and his team, were chosen to produce the film. A black and white montage of historical photographs was to be used, along-side actors' voices and real excerpts from the oral history collection, recounting memories of the 1892–1924 period. The film was to be titled, 'Isle of hope, Isle of tears' alluding to the multiple narratives that have been projected onto the site. However, the making of the film was far from unproblematic. When members of the Historians' Advisory Committee were invited to a screening and asked to submit their written comments of a draft version, their dissatisfaction with the film's stereotypical tone was clear:

> The music with which the film begins is the Godfather theme! It touched off a round of giggles among [the historians' committee]. Bad start! The basic flaw however, is the portrayal of immigrant as victim … It is sooo heavy-handed, sooo depressing and sooo inaccurate … There is a strong sentiment among the History Committee members to disassociate ourselves from this film and perhaps to go as far as to lodge a public protest should it be accepted by the National Park Service in its present form. It really is that bad!
>
> *(NPS archival extract, Private Archive, Charleston Navy Yard: Boston National Historical Park, National Park Service)*

These critics argued that the film wrongly presented migrants as passive victims of oppression fleeing persecution and poverty in the Old World. According to them, the emphasis on a benevolent New World and benighted Old World ignored the fact that many immigrants were, in fact, 'sojourners' or 'birds of passage' who made repeated trips back and forth to America to earn money. Their primary loyalty and sense of belonging, however, remained with their country of origin. Indeed it is estimated that during the 1892–1924 time period in question, approximately 40% of migrants eventually left the United States to return to the country of their birth. The academic committee was clearly suspicious of the film's original emphasis on an immigrant population that was unidirectional, and of its focus on immigrant groups who allegedly assimilated dutifully in the land of 'freedom and opportunity', cutting off all channels of communication with, and loyalties to, their place of birth in an act of newly found patriotism towards America.

Another criticism of the film was that it emphasised European migration to the detriment of other types of migrations. In particular, it is alleged that the film neglects processes of Asian migration and the forced migration of African slaves. Although Ellis Island immigrants were primarily Eastern Europeans, Italians and Jews, many other nationalities emigrated in smaller numbers through this portal. Historians argued that because of the diverse visitor base that Ellis

Island was likely to attract, the building should be used not only to articulate what happened at Ellis Island, but also to tell a broader story about the *peopling of America*. They argued that the museum should include the stories of ethnicities that have traditionally been marginalised, if not ignored completely, within predominantly Eurocentric museum narratives, an issue that has also received wider circulation elsewhere (Hooper-Greenhill, 1997). Such a shift in focus would involve thinking about American histories that might be completely at odds with popular histories of migration. Historian Alan Kraut remembers:

> … I remember one morning we were discussing all of … [the museum themes] … and someone in the group … said 'now you know, lets envision a class of New York City public school students coming to Ellis Island, including many little African-American kids, what's here for them? What are they to make of all of this?' And it was a wonderful question well put, because it got us to think about who would be coming to Ellis Island and how could we present this in a way that would be inclusive and accurate and at the same time engaging, and engaging a very broad public.
>
> *(Personal interview with Alan Kraut, Historians Advisory Committee, October 2001)*

From their position as academic experts, the historians were able to create many exhibits within the museum that contest the patriotic images of American identity found in the cinematic narrative. Crucially, displays were constructed which presented *diasporic* histories that were more difficult to appropriate into official versions of national identity. For instance, the section of the museum devoted to immigration history includes displays that attempt to make Ellis Island meaningful to the Native American Indians on the *receiving* end of prejudices from pioneer and settler groups. The displays also provide information about Afro-Americans whose enslaved immigration had less to do with the sentiments espoused by Emma Lazarus in *The New Colossus* (Vecoli, 1994) and more to do with a history of colonial expansionism.

Ellis Island is a world famous tourist site involving a wide range of stakeholders, including numerous and varied social, political and grass-roots institutions, and depicts many diverse ethnic and diasporic populations. As a consequence, it has prompted considerable dispute over the sorts of identities to be represented, including much debate over which stories are deemed *inappropriate* as, for example, arose with temporary exhibits on mass Armenian migration resulting from political turmoil and genocide, and Japanese internment in special 'prison camps' during the enemy alien programme of 1941–1945 (Sengupta, 1997a, 1997b, 1998).

Because of the sheer number of national and ethnic groups claiming Ellis Island as a 'terrain of belonging' (Fortier, 2000: 175) the National Park Service decided not to focus on any one group in particular. They refused such gifts as sculptures and statues for display in the museum offered by ethnic groups which might give this impression. The policy was tested when the Irish American Cultural Institute decided to donate a statue of Annie Moore, the first person to be processed at Ellis Island, to the museum. The offer was rejected on the grounds that accepting it could be perceived as favouritism to Irish-Americans:

> The National Park service seeks to avoid highlighting in a commemorative manner individual nationalities or ethnic groups … The restoration strove to achieve an authentic and balanced telling of the Ellis Island story … We hope you can understand our policy not to add individual statues to this site that is cherished by visitors of all national and ethnic backgrounds …
>
> *(Private letter from the NPS to the Irish-American Cultural Institute)*
> *(National Park Service, 1992)*

A later letter expanded upon the reasons for excluding the statue:

> We believe that it is doubtful that a statue of Annie Moore would be perceived as representing all other immigrants. Indeed, park visitors of other than Irish descent would likely view Annie Moore's statue as implying that their ancestors were somehow of lesser importance. Inevitably there would be requests for statues to commemorate the immigrant experiences of Italians, Germans, Poles and other nationalities ... Her story ... is not inherently more important than the stories of the millions of other immigrants who braved adversity, danger and the unknown to begin a new life in a new country.
>
> *(Rust, 1992)*

Annie Moore's statue was considered by members of the NPS to be 'too Irish' to be easily assimilated into the national creation mythologies embedded in the museum landscape. Though during her lifetime Annie's migration to the USA signified a desire to become an American, and her successful passage through Ellis Island meant that she had officially become a US citizen, in the eyes of US officials her enduring Irish-American links and affiliations precluded her statue from being immediately accepted in a national museum almost a century later.

The battle over the inclusion of the statue continued for several months, involving an ever-widening circle of local, national and international stakeholders. John Walsh, the chairman of the Irish-American Cultural Institute, launched a campaign enlisting the support of prominent political figures both in America and Ireland:

> We ran into difficulty with the National Park Service. They did not want to recognise any immigrant group over another immigrant group ... It was a very difficult time and we had to get former governors, many senators, and many congressmen all to endorse it. It took close to two years to approve it ... I think the political pressure [eventually changed the mind of the NPS] ... Every time they said no, I just got somebody else to write another letter.
>
> *(Telephone interview with John Walsh Chairman of the Irish-American Cultural Institute, March 2002)*

Finally, Jeanne Rynhart's bronze statue of the County Cork emigrant was accepted and in 1993 was unveiled by incumbent Irish president Mary Robinson in a dedication ceremony. Today, many Irish-Americans and Irish tourists make pilgrimages to the island to see it, where it can be found on the second floor of Ellis Island Immigration Museum near the Great Hall.

Though the statue was finally included in the museum, the lengthy battle that preceded its acceptance symbolises the complicated relationship that often exists between the diasporic subjectivities of transnational identities and the official histories adopted at 'national' tourist sites. The statue caused concern because it invoked multiple connections and affiliations which stretched well outside the territory and temporality of the nation-state.

Mobilising history: lessons for World Heritage Sites

> As we cross into the twenty-first century, we ... have embarked on a journey – whose destination holds out the promise of justice, well-being and a peaceful existence for all.
>
> *(UNESCO, 2004a)*

This case study has provided several insights into different the ways in which history is mobilised at World Heritage Sites. It has been argued that memorials can be:

> Heterotopic spaces ... that not only order through difference but through competing readings of that difference. It is the very ambivalence and uncertainty of these spaces that allows many voices to be expressed. Heritage landscapes are also contested spaces, spaces with many actors who all wish to project their ideas about society, their utopias, through its space.
>
> *(Hetherington, 1996: 162)*

These 'utopias' are particularly contested at popular World Heritage Sites, where a wide range of stakeholders from a variety of institutional contexts have a legitimate interest in the sorts of knowledge and identities there inscribed. At Ellis Island Immigration Museum, contestation has revolved around such crucial issues as commercialisation and commoditisation, audience relevance, representation and, most crucially perhaps, battles over the types of ethnic, national and international histories narrated at the museum. As the museum librarian remarks:

> You do have to cope with nationalist feeling or ethnic pride or whatever it may be. Groups become angry sometimes at some of our exhibits ... So we have to deal with some of the ethnic animosity that does come on to Ellis Island brought by these different groups who still have angers or historical grievances against each other and are very sensitive about what is shown at Ellis Island about their history.
>
> *(Personal interview with Barry Moreno at Ellis Island Immigration Museum, March 2002)*

With careful historical interpretation, World Heritage Sites can become arenas for the *working out* of these ethnic differences. However, places designated as relevant to the heritage of all humankind, with the responsibility of acting as receptacles not just of national memory, but of *world memory*, have particular challenges to surmount. Encouragingly, in addressing this problematic, we have seen how some actors at Ellis Island have attempted to construct polysemic versions of history within the museum which challenge exclusionary patriotic versions of history, by stressing instead immigration narratives of the fusion and mixing of different cultural elements over time (Gilroy, 1993; Hall, 1990; Massey, 1993). For instance, the history committee was as much concerned with the lives of the uprooted migrants as their final destination in 'the land of freedom and opportunity' and was instrumental in incorporating more complex stories of migration into the museum displays and orientation film. They initially believed the latter to be excessively nationalistic. Similarly, ethnic organisations such as the Irish-American Cultural Institute were able, through their own campaigning efforts, to become stakeholders in the project and inject new stories and subjectivities. In this regard, immigrant histories are at the forefront of a new social history that highlights most eloquently the spatial interconnections of which we are all a part.

As a former secretary of ICOMOS-UK noted during the 2002 Politics of World Heritage Conference, on which this special issue is based: 'The protection of the world's heritage can reach far beyond technical questions of conservation and site management into the much wider realms of ideology, politics, power and citizenship' (Whitbourne, 2002).

To retain credibility and legitimacy in an age of increasing mobility and spatial interconnectivity, World Heritage Sites must become spaces of *inter-cultural dialogue*, where ethnic animosities can be productively addressed. World Heritage Sites concerned with the narration of the past should aim to promote themselves as transnational rather than national spaces of citizenship, and seek to include rather than *police* ethnically or racially situated 'knowledges' and perspectives within their ideological borders.

Joanne Maddern

Acknowledgements

I should like to thank Luke Desforges and others at the University of Wales for their comments and assistance during the research phase of this project. I would like to register my appreciation to members of the National Park Service, the History Advisory Committee and the Statue of Liberty-Ellis Island Foundation for taking part in interviews that were drawn on in this paper. I should also like to thank members of the National Park Service for their help in locating and copying archival documents. This project was funded by the Economic and Social Research Council (ESRC) and Institute of Geography and Earth Sciences, University of Wales, Aberystwyth.

Bibliography

Ball, E. (1990) Museum of tears. *Village Voice* 35 (37), 59–87.

Bender, B. (2001) Introduction. In B. Bender and M. Winer (eds) *Contested Landscapes: Movement, Exile and Place*. Oxford: Berg.

Billig, M (1995) *Banal Nationalism*. London and Thousand Oaks, CA: Sage.

Bodnar, J. (1995) Remembering the immigrant experience in American culture. *Journal of American Ethnic History* 15, 3–27.

Deleuze, G. and Guattari, F. (1987) *A Thousand Plateaus: Capitalism and Schizophrenia*. Minneapolis: University of Minnesota Press.

Foner, E. (1997) (ed.) *The New American History* (2nd edn). Temple University: Temple University Press.

Fortier, A. (2000) *Migrant Belongings: Memory, Space, Identity*. London: Berg.

Gilroy, P. (1993) *The Black Atlantic: Modernity and Double Consciousness*. Cambridge, MA: Harvard University Press.

Hall, S. (1990) Cultural identity and diaspora. In J. Rutherford (ed.) *Identity: Community, Culture and Difference*. London: Lawrence and Wishart.

Handler, R. and Gable, E. (1997) *The New History in an Old Museum: Creating the Past at Colonial Williamsburg*. Durham, NC: Duke University Press.

Hetherington, K. (1996) The utopics of social ordering: Stonehenge as a museum without walls. In S. Macdonald and G. Fyfe (eds) *Theorizing Museums: Representing Identity and Diversity in a Changing World* (pp. 153–76). Oxford: Blackwell.

Hewison, R (1987) *The Heritage Industry*. London: Methuen.

Holland, R. (1993) *Idealists, Scoundrels and the Lady: An Insider's View of the Statue of Liberty-Ellis Island Project*. Chicago: University of Illinois Press.

Hooper-Greenhill, E. (ed.) (1997) *Cultural Diversity: Developing Museums Audiences in Britain*. Leicester: Leicester University Press.

Johnson, L. (1984) Ellis Island: Historic Preservation from the Supply Side. *Radical History Review* 28–30, 157–68.

Kirshenblatt-Gimblett, B. (1998) *Destination Culture: Tourism, Museums, and Heritage*. Berkeley, CA: University of California Press.

Kouwenhoven, J. (1988) *The Beer Can by the Highway: Essays on What's 'American' about America*. Baltimore and London: Johns Hopkins University Press.

Massey, D. (1993) Power-geometry and a progressive sense of place. In J. Bird, B. Curtis, T. Putnam, G. Robertson and L. Tickner (eds) *Mapping the Futures: Local Cultures, Global Change* (pp. 59–69). London: Routledge.

Nash, C (2003) Genealogical identities. *Environment and Planning D: Society and Space* 20, 27–52.

National Park Service (1982) *Ellis Island Interpretive Prospectus*. Division of Interpretive Planning, Harpers Ferry Centre.

National Park Service (2000) *History at the National Park Service: Themes and Concepts, The National Park Service's Revised Thematic Framework*. Washington: National Park Service.

National Park Service Accountability Report (2001) *Fiscal Year 2001*. Herndon, VA: Accounting Operations Centre, National Park Service, US Department of the Interior.

National Park Service (1992) Private letter from the NPS to the Irish-American Cultural Institute. Internal documentation, Boston National Park Service Archives, Charleston Navy Yard.

Rogoff, I. (2000) *Terra Infirma: Geography's Visual Culture*. London and New York: Routledge.

Rust, M. (1992) Private letter from Marie Rust, National Park Service Acting Regional Director to Richard A. Moore, American Ambassador, 18 May 1992. Boston National Park Service Archives, Charleston Navy Yard.

Sengupta, S. (1997a) At Ellis Island Museum, dispute on Armenia show: Massacre photographs deemed 'too gory'. *New York Times* (11 September), B3, 5.

Sengupta, S. (1997b) Ellis Island, yielding, permits photos of Armenian massacre. *New York Times* (14 October), B2, 5.

Sengupta, S. (1998) What is a concentration camp? Ellis Island exhibit prompts a debate. *New York Times* (8 March) Section 1, p. 35, col. 2.

UNESCO (2004a) Statement on 'intercultural dialogue'. Online at www.unesco.org/culture/dialogue/html_eng/index_en.shtml. Accessed 06.07.04.

UNESCO (2004b) Statement on 'regional histories'. Online at www.unesco.org/culture/history/. Accessed 06.07.04.

Vecoli, R.J. (1994) The lady and the huddled masses; The Statue of Liberty as a symbol of immigration. In W. Dillon and N. Kotler (eds) *The Statue of Liberty Revisited: Making a Universal Symbol* (pp. 39–67). Washington and London: Smithsonian Institution.

Wallace, M. (1987) Hijacking history: Ronald Reagan and the Statue of Liberty. *Radical History Review* 37, 119–30.

Wallace, M. (1991) Exhibition review: Ellis Island. *Journal of American History* 78, 1023–32.

Wallace, M. (1996) *Mickey Mouse History and Other Essays on American Memory*. Philadelphia: Temple University Press.

Whitbourne, P. (2002) The first thirty years. Paper given at the international conference on the Politics of World Heritage, International Institute for Culture, Tourism and Development, London, 2–4 September.

25

The Holocaust and the museum world in Britain

A study of ethnography

Tony Kushner

The Imperial War Museum's (IWM) permanent Holocaust exhibition opened in June 2000 to general acclaim in the media. Subsequently the exhibition, like the United States Holocaust Memorial Museum in Washington, DC, has proved immensely successful in generating visitors (over a quarter of a million in its first twelve months) and it appears to have elicited positive instant responses from them. In contrast to its American counterpart, however, there has been little questioning of the scope of the IWM exhibition or at a more basic level, whether it was appropriate in the first place. This contribution is an attempt to open up dialogue about the nature of the IWM Holocaust exhibition including the validity or otherwise of some of its items of display. It desires to situate the exhibition in wider debates than those focusing more narrowly on Holocaust commemoration. First, it places the exhibition in the context of collective memory and identity in Britain, especially in relation to the outside world and more specifically, Germanness and Jewishness. Second, it examines how other forms of atrocities and racism have been represented in order to provide a comparative framework.

In *Making Representations: Museums in the Post-Colonial Era*, Moira Simpson has suggested that

> In Europe, the tradition of museums as institutions both reflecting and serving a cultural elite has been long established and, in many, is still maintained. The museum, the 'cabinet of curiosities', is the storeroom of a nation's treasures, providing a mirror in which are reflected the views and attitudes of dominant cultures, and the material evidence of the colonial achievements of the European cultures in which museums are rooted. The colonial origins of the museum remain an enduring influence upon these institutions and upon public perceptions of them.[1]

Simpson's work is part of a fast-growing literature on the role of 'collecting' and display in the imperial story and its later legacy.[2] While this new emphasis inside and beyond museum studies is necessary and important, it has potential dangers if it obscures, through the desire to highlight the fundamental dichotomy between the 'west' and its colonial 'others', the construction of hierarchies and the existence of prejudices *within* European society.

The history of anti-Semitism and the representation of the 'Jew' more generally is one obvious subject that would be missed out of accounts focusing solely on the polarisation of

Europe and its colonies. The work of Bryan Cheyette on representation of Jews in imperial British literature in the nineteenth and early twentieth century reveals the limitations of more 'reductive simplicities' in explaining racism solely through a crude understanding of colonialism, especially through Edward Said's narrow use of the concept of orientalism. In a study focusing on the figure of the Jew in the imperial fiction of John Buchan, Rider Haggard and Rudyard Kipling entitled 'Neither Black Nor White', Cheyette 'specifically opposes postcolonial theorists who maintain that there was, historically, a homogenous and dominant white "Western Judeo-Christian" culture'.[3]

The need to compare and connect racisms aimed at Jews and blacks is slowly gaining recognition.[4] There is still, however, a lacuna in respect to the racisms generated within Europe towards various national groupings. In Britain, for example, although Germans in nineteenth-century race science typologies were often constructed on a similar level and indeed with the same roots – as good Aryans/nordics/teutons/Anglo-Saxons (a connection cemented by Royal marriage) – alongside the 'best' of the English population, this did not stop them being perceived and treated as a racial threat throughout the twentieth century. Indeed, anti-Germanism remains one of the most respectable forms of prejudice in modern British politics and society leading to the failure to confront its historical roots.[5]

In April 2002, for example, Leeds United, a football team with a strong reputation for racism among its players as well as supporters, was generally reprimanded for employing a comedian, Stan Boardman, who told a deeply offensive anti-Pakistani/Indian joke at an official dinner. The club spokesman acknowledged that 'booking Boardman had been a mistake'. He added, candidly revealing the hierarchy of acceptability of intolerance in British society, that the club 'had not been aware that Boardman's set contained racist material, other than that directed at "the Germans" '.[6]

It is thus not surprising that the manifestations of the largely uncontested force of anti-Germanism in contemporary British culture remain to be explored. The suggestion made by the commentator Simon Hoggart that the 'British people … are not particularly anti-German these days, but we are just hard-wired to make German jokes' is perhaps reassuring to the national mythology of inherent fairness, tolerance and decency. It is, however, hardly convincing.[7] Linda Colley has argued that national identity was defined in the long eighteenth century in many ways by Francophobia: 'Imagining the French as their vile opposites, as Hyde to to their Jekyll, became a way for Britons … to contrive for themselves a converse and flattering identity.'[8] A similar process has been at work, it will be argued here, in relation to Germany during the twentieth century – a process that is still ongoing.

The journalist and novelist Julie Burchill has acknowledged the depths of her hostility to the Germans. She writes of her exposure, aged nine, to 'a picture of people in a concentration camp staring through barbed wire at the camera. I seem to remember to this day that I literally felt the world shift on its axis as I stared into those hollow eyes, and frankly that was it for me and Fritz.' She adds that 'I nursed my loathing over the years, and it's fair to say that Not Being German – in fact, being The Opposite of German – did in some way define my life.'[9] However disturbing, Burchill's honest self-reflection, in contrast to Hoggart's less convincing denial of prejudice, reveals much of widespread attitudes and responses in post-1945 Britain. Indeed, animosity had much longer roots.

Hatred of the 'Hun' and all things German was intense during the First World War and its immediate aftermath.[10] Not surprisingly, Germanophobia revived during the Second World War,[11] growing towards a genocidal collective mentality after the disclosures from Belsen and Buchenwald in spring 1945. One young man, a scientific researcher, wrote in his diary:

> Now we can really imagine what the German concentration camps were like. The sickening pictures which have now been published proved that they were veritable slaughterhouses. Two men I was speaking to about it argued that the only way to prevent such things happening again would be to exterminate the Germans. 'They're certainly not fit to live', said one.[12]

Such views were not isolated.[13] Whilst declining thereafter, anti-Germanism has never disappeared nor been seriously confronted as a prejudice worth removing. It will be argued that it is the processes by which Germany and Germanness have been constructed and reconstructed that provide the key to understanding the dynamics and the success of the Imperial War Museum's permanent Holocaust exhibition. As will also emerge, it indirectly explains the exhibition's tendency to at best marginalize and at worst objectify the place of the Jew within the European experience.

A recent report suggested that two-thirds of the British population had no language other than English. Checking to find out whether Britain's command of foreign languages was indeed the worst in Europe, a reporter for *The Guardian* newspaper telephoned a range of national bodies and heritage sites using a range of European languages. The call to the Imperial War Museum was in German, enquiring what was showing there. After several transfers and the use of a dictionary, public relations at the Museum, with some embarrassment and hesitation, stumbled a reply that there was an exhibition on the Holocaust.[14]

The Imperial War Museum's Holocaust Exhibition, which cost £5 million, funded by private sponsorship and a Heritage lottery grant of £12 million for the museum as a whole, was officially opened by the Queen in June 2000. Just two years later, it has already become well established within the Museum's displays, yet the creation of the Holocaust exhibition marked a radical departure in the history of the Museum.[15] The Imperial War Museum was founded in 1917 to collect and display material relating to the Great War. Subsequently it has broadened and redefined itself as 'Britain's National Museum of Twentieth Century Conflict', incorporating also 1939–45, the Falklands and other post-1945 wars.[16]

In the absence of a national museum of Britain, it has been suggested that the Imperial War Museum, for all its uneven development in the twentieth century, fulfilled that role. As Sue Malvern has argued, 'The Imperial War Museum displays its collections to tell stories and to represent the nation to "itself" '. She goes further and suggests that with its strange mixture of artefacts, 'The museum was an ethnographic collection whose ethnographic subject was the nation-in-arms'. Malvern highlights how in

> ethnographical museums cultural artefacts are very frequently labelled as anonymous and undated, in contrast to European art collections, where works of art are always assigned an author and a date. European cultures are not represented, unless they can be classified as belonging to folk traditions, as for example at the Pitt Rivers Museum, Oxford. War museums such as the Imperial War Museum, however, which also house extensive collections of artefacts, curios and memorabilia, arguably function as these missing ethnographic collections of European nations... .[17]

From the start, the Imperial War Museum faced criticism for representing items of destruction rather than technology that revealed mankind's ability to improve the world. By including German and Turkish weapons it emphasized a national democratic victory over a defeated enemy and added to the demonization of the common foe. Britishness could be defined by homogeneity, at the exclusion of marginal groups such as women, those of colour, and aliens at

home, but also in opposition to the 'other' in the form of the 'Hun'. Malvern concludes that 'In 1920, the Imperial War Museum became less a museum for the study of war than an ethnographic collection for the display of the British nation-in-arms, a display which defined nationhood by the martial prowess of its citizen army'.[18]

It is not surprising that within this framework there was no consideration of the violence inflicted by Britain on its imperial people. Nor did the Second World War fundamentally change its approach to display – in essence more military hardware was added and the war, as with the parallel genre of 1950s films, novels and memoirs, was represented as a traditional conflict with Britain, of course, as the triumphant victors.[19] That the continent of Europe also represented an epicentre of genocide and ethnic cleansing was hardly mentioned. Again a nationalist approach dominated, with the myth of 'Britain alone' defeating the evils of Nazism to the fore.[20] It was as late as 1991 that the small display 'Belsen 1945' was added to the permanent exhibition on the Second World War in the Imperial War Museum and even then the Anglocentric focus to the overall museum narrative failed, ultimately, to be challenged.[21]

The Museum's 'Belsen 1945' concentrated on the British liberation of this notorious camp and the subsequent relief work carried out there. Most of the photographs and films used displayed the confrontation of British soldiers and then medical workers with the dead and dying of Belsen. These are appalling images, including the huge mounds of bodies and the bulldozing of them into mass graves.[22] They have been used frequently since 1945 and it has been suggested 'most closely define the Holocaust in popular images today',[23] but their meaning at particular points in time and place has been far from static.[24] As Cornelia Brink suggests,

The pictures from 1945 have been and still are viewed as 'icons of extermination' in many countries. Only an analysis of the photographs within the specific contexts in which they have been published will reveal which memories they preserve, which they curtail, what different meanings they assign to the events, what kind of knowledge they transmit and how meanings change over longer periods of time.[25] The rest of this contribution will highlight the use made of these liberation images and others depicting atrocities at the Museum, querying whether the representation of the body of the victims of Nazism can, in essence, humanize the impact of genocide or whether it perpetuates the dehumanization process at the core of the perpetrators' project.

It has been highlighted how while trophy-gathering practices such as scalping and head-hunting have long been regarded by Europeans as the barbaric practices of savage peoples, the gathering of body parts as trophies, along with weapons, clothing and jewellery, was not uncommon among European and American settlers' and others. As Moira Simpson states, 'Examples of such items have found their way into some museum collections'. Regarded now by some as repulsive, there has been pressure for their removal, but that process, as Simpson adds, 'also serves to remove such items of unsavoury history from the public consciousness and the actions of their collectors from the public conscience.'[26] There is clearly a dilemma here when representing man-made horrors that many would prefer not to confront.

In the Pitt Rivers Museum, 'at the request of Maori visitors, the Maori tattooed heads have been taken off display' but 'the "other", the "different", in particular perhaps many of the dark and ghoulish manifestations of humanity, such as shrunken heads and skull racks, remain on display to challenge us'.[27] It is far from clear how these items challenge, for example, young visitors who vote the shrunken heads their 'firm favourite' of all the Museum's exhibits.[28] As we shall see, the aims of curators and the prejudices of museum visitors are often in conflict. It is significant, however, that Simpson does not feel that these dilemmas of representation are

Tony Kushner

applicable to the crimes of the Nazis: 'While such histories [of colonial collecting of body parts] should be told, display is not always the most appropriate method: one would not wish, for example, to see the remains of Jewish holocaust victims of Auschwitz or Belsen displayed for all to see, as they were found in the gas chambers and incinerators.'[29]

The reality is that such remains *have* been displayed and images of them feature regularly in exhibitions and documentaries but with little thought to their impact or self-reflexivity of why they are being employed. As early as December 1945 in Nuremberg, Thomas Dodd, an assistant prosecutor, produced a shrunken head, that of a Pole who had been hanged at Buchenwald as an 'exhibit' to strengthen the moral repugnance against the accused as well as to 'prove' the nature of Nazi crimes against humanity. As Lawrence Douglas writes, 'it signified an understanding and materialized a very particular representation of Nazi atrocities before the Nuremberg Tribunal'. Such items, however, would, as he adds, have been familiar in a different context and with different meaning to Sir Geoffrey Lawrence, chief judge of the Tribunal, who in the early 1930s had acquired two shrunken heads for display at the Pitt Rivers Museum, Oxford.[30]

The newspaper photographs and newsreel footage of Belsen and other liberated western concentration camps, just as the shrunken head at Nuremberg, were used to serve various ends by the British and American state apparatus at the end of the war. First, they were used as 'proof positive', as a contemporary newsreel in Britain put it, of Nazi atrocities.[31] Second, and as a corollary of the first, they showed the absolute moral rectitude of the western Allied war effort. As General Eisenhower stated, after visiting Ohrdruf, a Nazi concentration camp in Germany, 'We are told that the American soldier does not know what he was fighting for. Now, at least he will know what he is fighting against.' Eisenhower's words, alongside a huge photograph of dead inmates at the camp, introduce visitors to the United States Holocaust Memorial Museum's main exhibition, opened in 1993.[32]

For many years after the war, the western camps, especially Belsen for the British, and Buchenwald and Dachau for the Americans, represented the evils of Nazism.[33] All had complex individual histories but none represented the purer type of extermination camp of eastern Europe – that is, centres where the major purpose was mass murder with little or no slave labour or internment function. In fact, only four camps can be said to clearly fit into that category – Chelmno, a mobile killing centre, and the first to be used to gas Jews, and three others which formed the basis of Aktion Reinhard, Sobibor, Treblinka and Belzec, created in 1942 to destroy the three million plus Jews of Poland under Nazi control. Well over two million Jews were gassed in these four camps.[34] Auschwitz, in which it is now estimated 1.1 million Jews were murdered, alongside several hundred thousand Gypsies, non-Jewish Poles, and others, was an enormous and much more complex site, incorporating vast slave labour camps.[35]

When, particularly through the war crimes trials in the later 1940s, awareness of gas chambers became more widespread, it was assumed that these must have operated in the western camps, that is, those such as Belsen, liberated by the western Allies rather than those captured earlier by the Soviet Union such as Majdanek and Auschwitz, a perception that still continues to this day.[36] In fact, those that died in Belsen, for a brief while a camp for privileged Jews, did so due to punishment, disease, starvation and general neglect.[37]

A problem of representation exists. The Reinhard camps were levelled to the ground by the Nazis in 1943 in an attempt to erase all evidence to mass murder. In Auschwitz all the surviving gas chambers were blown up. The speed of the Soviet advance was such that some evidence of mass murder, including the leaving behind of ill survivors such as Primo Levi, was exposed.

For the Soviet liberators in January 1945, the scenes of mass murder were horrific, but partly due to the time of the year, on one level the scenes and smells were less intensive than the

western camps. There was the evidence of medical experiments and the piles of belongings, piles of human hair and so on to show the scale of destruction, which for both reasons of ideology and miscalculation, were overestimated at some four million victims, three times more than the total accepted today. But the revelations from Auschwitz, anticipating the ideological impact of the cold war, received little or no publicity in the west, and it did not become a widely used metaphor until the 1960s for the Holocaust specifically or, more generally, the destructive potential of modernity (for secularists) and evil (for those of a theological bent).[38]

The focus on concentration camps in early memory of what would later become known as the Holocaust, and specifically those liberated by the western allies, not only led to the marginalization of the eastern camps, although the sheer scale and efforts made by the Polish government to make it into an national site of mourning made Auschwitz a partial exception.[39] It also obscured the so-called Einsatzgruppen murders, in which at least two million Jews were shot, or more basically clubbed to death. As Richard Wright has shown, techniques of forensic archaeology have recently proved important in reconstructing the detail of such murders.

Wright was employed by the Australian government to find evidence of war crimes relating to individuals who after the war made Australia their home. He excavated a mass grave in Serniki in the Ukraine which revealed some 550 bodies. The mass murder was carried out in 1942 and the excavation some 50 years later. The archaeology confirmed local testimony:

> An awful scene unfolded. As the eyewitnesses had said, they were mostly women and children. The men were old men. They had been herded down a ramp into the grave. One lot had gone to the left and been shot while lying down within the grave; the others had gone to the right. The majority had entry and exit wounds of bullets in their skulls. Some of them had been clubbed.[40]

In many cases, however, the lack of evidence due to the Nazis burning bodies or the subsequent obscurity of sites has proved too problematic. Indeed, as Richard Wright points out in relation to Serniki, which is on the southern margins of the Pripet marshes, 'The area of the grave is now an ominous-looking dark pine forest, but feelings of that sort are illusory. At the time of the killings this was open country.'[41] Intense skill and luck are required to find the places of mass murder, even in recent cases as with former Yugoslavia where again the talents of Richard Wright have been employed in war crimes trials in the Hague. For the Holocaust, as bystander memory fades, hundreds if not thousands of sites of destruction have been lost to posterity.

In essence, therefore, the extermination of over six million Jews remains largely a crime of mass murder without the presence of the victims' bodies, contrasting, for example, to the Armenian genocide or more recent mass murder in Cambodia and Rwanda. It is for that reason that the images from Belsen became so important as a symbol of what the Nazis had done. An appealing but deceptive symmetry has developed – the enormity of the crime is matched by the sheer horror of the images even if the latter are not generally representative of the former.[42] It is telling, for example, that in Roberto Benigni's Oscar-winning film, *Life is Beautiful* (1998), intended by its director as a fable and 'not a story about the Holocaust. It's a story about a father who is trying to protect a child',[43] the one moment where an attempt is made to allude to the horror of the concentration camp is when the hero glimpses a mountain of corpses, even if they appear through 'a sort of bluish mist'.[44]

It remains that the photographs and films of the liberated western camps were, and continue to be, even with our greater understanding of the detail of the destruction process, potentially problematic both in respect of the perpetrators and the victims. With regard to the perpetrators, the images tend to confirm that the perpetrators must have been monsters, sub-human, in fact

animals, 'the bitch and beast of Belsen',[45] rather than ordinary men and women fully capable of such crimes (or, as Daniel Goldhagen would have it, anti-Semitic sadists who were ordinary Germans).[46]

In respect of the victims, few contemporaries in 1945 were willing to make the effort to find out their background. One small group who did were the army cameramen who created the images for the newsreels of the camps. One of them, Sergeant Oakes, recorded in his notes (or dope sheets) on one part of his film: 'An inmate tells the world. Helen Goldstein, a Pole – Her crime: being born from Jewish extraction. Four years in concentration camps, but was only here two weeks before the British arrived.' Many assumed that those liberated in 1945 would not survive or if they did they would be too damaged to have a meaningful future. For complex reasons, their ethnic-religious identity was downplayed or ignored in their media representation in Britain. Oakes' dope sheet comments, for example, as with similar comments from other cameramen, were 'edited out'. The government was 'concern[ed] about how the story would be received by the British public'.[47]

In short, it did not matter who the victims were, or who they had been. They were a people without a past or a future, used almost solely to illustrate the inhumanity of the Nazis/German people.[48] One image of an individual in Belsen, for instance, taken shortly after liberation, has been and continues to be labelled in different ways – as a dead *or* a dying man. The image was/is used to shock, not to create any sense of empathy.[49] For many survivors, the images of liberation remain highly disturbing. In Boston during the 1980s, the idea of reproducing a form of Nathan Rapoport's statue 'Liberation' from Liberty Park in New York, which features an American GI carrying a tiny survivor, was rejected by the survivors because they feared in the words of James Young that 'a millennium of Jewish civilization would be reduced to the one degrading moment they shared with American liberators'.[50]

These early images of liberation remain, therefore, deeply problematic. How then does the Imperial War Museum's new exhibition, the largest and most expensive in Britain dealing with *any* form of mass murder, deal with Jewish life and culture? Initially the exhibition was to focus on 'man's inhumanity to man' as a history of genocide in the twentieth century.[51] Undoubtedly if this had been carried out then the Jews and other groups would simply have been represented as victims, as people to whom something was done, without any attempt to explain their complex and diverse histories, or for that matter the specific context of each genocide.[52] Due to lobbying, the focus of the proposed exhibition changed, and its finished form represents something of a compromise, allowing for the particular dynamics of the Holocaust to be explored at great length but where the narrative structure is driven by a chronology created by the Nazis rather than their victims.

The overall tendency to focus on Nazi actions is partially countered by the use of powerful video and oral testimony of survivors. Such testimony, however, is frustratingly brief and used ultimately to illustrate what the Nazis did, and even then never on its own as a form of evidence that can be relied upon as 'proof positive' – in this sense, the exhibition follows the example of the post-war trials which marginalized eye-witness accounts in favour of 'hard' written and, as with the shrunken head, physical evidence.[53] In the immediate postwar period the objective was to secure convictions and also to educate for the present and the future. The emphasis on 'proof' over half a century later is driven by somewhat different dynamics. The need to educate is still there, although with a much more focused agenda of meeting the needs of the British national school curriculum in which the Holocaust is now relatively prominent and, as a result, taught widely.[54]

There is also the awareness of the presence of Holocaust deniers and the desire to either counter it or at least not provide them with any ammunition through by ensuring that, as

The Holocaust and the museum world in Britain

Suzanne Bardgett, director of the project, put it, 'irrefutable historical evidence is plac[ed] before the visitor'.[55] Here, the Imperial War Museum was following the example of Washington. Michael Berenbaum, the US Holocaust Memorial Museum's project director, explained before it opened in April 1993, that the transfer and display of a barrack from Birkenau was necessary 'to refute the lies of Holocaust negationists'.[56] Although impressive life story interviews were carried out with the survivors for the Imperial War Museum exhibition, the use of this material is fragmentary and its integrity as a whole is not maintained. Indeed, at the early stages of planning for the exhibition it had not been intended to use such testimony so extensively: the narrative was to be driven almost exclusively by fully authenticated artefacts, documents and photographs.[57]

Throughout discussions when it was suggested that partly following the example of Washington there was a need to explain Jewish life and culture before the Holocaust, the response was firmly that the Imperial War Museum was not and could not become a museum of ethnography. As we have seen, this is not necessarily true – it has functioned from the start implicitly if not explicitly as a, if not *the*, museum attempting to represent the nature of Britishness, or more narrowly, Englishness, to the people of the nation.

In relation to the Second World War, for example, the atrium, at the heart of the building, is known, according to Anne Karpf, 'as the biggest boys' bedroom in London'. Tanks and other military hardware, especially airplanes, including the iconic Spitfire and Hurricane, dominate the physical space. As Karpf adds, their presence is not simply physical but represents an ideological (and one could add, cultural) statement: 'It points to the obsession with technology which, along with triumphalism and the much mythologised spirit of defiant optimism, for so long characterised the war in British popular imagination.'

The presence of many veterans and their families, both individually and collectively in organised reunions in the atrium, attests to the continuing memorial function of the Imperial War Museum and the status of the little ships from Dunkirk and the Spitfire as anthropologically central items in the construction of Englishness. The Museum certainly has not focused centrally on representing the diversity of, and power relations within, the British empire, still commemorated in its title, new or whatever. This lacuna continues to this day. As Malvern points out: 'Representations of black veterans are conspicuous by their absence.'[58]

For the Imperial War Museum to attempt to display the rich, contested lives of the European continents' Jews would have been a remarkable change in approach and direction. Yet under pressure from its historical advisors and, it has to be said, from its funders, the final exhibition, through the life story of survivors, along with some artefacts, does provide something of a history of Jews from central and eastern Europe. But as James Young argues in relation to many Holocaust museums, 'these artifacts ... force us to recall the victims as the Germans have remembered them to us: in the collected debris of a destroyed civilization'.[59] Ultimately, the original anthropological approach of the Imperial War Museum is kept in place. Its Holocaust exhibition is, indirectly, an exhibition on Britishness, one that focuses on what it is not – Nazism/Germanness.

There is a fetishisation of Nazi memorabilia in the exhibition, including a pristine SS uniform, and items, all painstakingly authenticated, relating to the destruction process, including a dissection table from a euthanasia centre and a bonecrusher from Mauthausen concentration camp which was a particularly prized acquisition amongst the exhibition project team.[60] Throughout the exhibition nothing is left to the visitors' imagination: a handcart from the Warsaw ghetto, used to carry the dead from the street, is thus substantiated by a photograph of a similar handcart in action. Likewise, personal testimony, clearly regarded as a 'soft' source on the authentication front, is used alongside 'harder' evidence such an artefact or film so that an experience or object

361

could not have been possibly imagined.[61] Everyday Jewish items are scarce in comparison, and, at the start of the exhibition, bizarrely mixed with anti-Semitica and Nazi material. The first display case thus includes antisemitic propaganda from all over the world alongside Jewish religious items. The visitor is immediately alienated from these strange exotic creatures – Jews on the one hand – and anti-Semites on the other.

The inability to place Jewish culture in a suitable context at the Imperial War Museum as a whole or the Holocaust exhibition in particular is not simply limited because of its specific focus on modern conflict. David Weiss relates finding tefillin at the Pitt Rivers Museum in Oxford:

> They were lying among a rather disordered assortment of tribal philtres, talismans and amulets in a glass-enclosed case bearing the simple legend 'Asian and African Fetishes' ... I wondered how they came to rest here, in the image-choked vaulted hall of the Oxford University Museum's anthropological collection ... Bending over the case, I saw yellowed slips of heavy paper describing each of the fetishes. The one placed at the side of the tefillin explained that these are a representative specimen of the phylacteries ritually worn in the past at worship by males of certain Jewish sects, a phallic archetype of the Israelitic Jehovah cult and ... to ward off the evil eye.[62]

Tefillin in Britain are thus displayed under the glass case as either representing an ancient and 'uncivilized' tribe or alongside propaganda images of Jews which present them as sub-humans. Items which are in fact part of the everyday material culture of ordinary religious (male) Jews both in the past *and* today, are displayed in the British heritage world, with the exception of its marginalized Jewish museums, as utterly alien and 'other' and inevitably confined to the past. Moreover, as James Young puts it: 'That a murdered people remains known in Holocaust museums anywhere by their scattered belongings, and not their spiritual works, that their lives should be recalled primarily through the images of their death, may be the ultimate travesty.'[63]

The exhibition proper ends with a scale model of Auschwitz, some 12 metres long and 2 metres wide. It shows the arrival of a transport at Auschwitz in May 1944 – a time when the gas chambers were working at full capacity – depicting the arrival of some 2,000 Hungarian Jews awaiting selection at the ramp.[64] Alongside it are a few items of clothing and shoes from the stores at Majdanek.[65] The scale model is similar to that at the US Holocaust Museum and again at Yad Vashem and the original such example at Auschwitz itself.[66] These models, including their tiny figures, are totally white. What is the purpose of these representations?

The Chapman Brothers, in their installation 'Hell' in the Royal Academy of Art's Apocalypse exhibition, parody such concentration camp models.[67] Their version of Auschwitz is in colour, and with deliberate and somewhat childish provocation, the Chapmans show SS officers being pushed into the crematoria and thus deliberately attempt to undermine the pious awe that now accompanies the Holocaust. The reverential approach to the Holocaust was illustrated at the opening of the Imperial War Museum exhibition and in media and other responses to it. As Jim Garret, then curator of the Manchester Jewish Museum admonished in the *Museums Journal*, 'This exhibition deserves to be seen – and remembered'.[68]

A sense of duty, among Jewish and non-Jewish visitors has been present. One synagogue group reported back after a day trip to see it, 'No one looks forward to a visit to a Holocaust exhibition as it will not be a bundle of joy, but the Imperial War Museum exhibition *should* [my emphasis] be visited'.[69] As Jake Chapman puts it: 'People become very sincere when you show them this sort of thing. It becomes a kind of moral potty training for adults.' Such overstated sincerity was particularly evident in the official and televised ceremony for the first Holocaust Memorial Day in Britain on 27 January 2001.[70]

The Chapman Brothers also attack the voyeurism that has been constantly connected to Holocaust imagery. Whether the public will deconstruct the images in the Chapman Brothers' diorama is far from certain – postmodern irony is not a familiar genre in Holocaust commemoration – but problematizing the representation of the Jewish and other victims' bodies at the Imperial War Museum and other Holocaust exhibitions is essential if the tendencies towards, at best, sentimentality and, at worst, mawkishness are to be avoided.

But what sort of anthropological function is at work, explaining why it seems no major national Holocaust exhibition can be complete without a death camp model? Is it a matter, in the case of the Imperial War Museum, of boys with toys – a hangover from 'airfix' model plane kits from childhood and a link, however bizarre, with the Museum's atrium? This is undoubtedly an element, especially within the world of military heritage representation where it is normal to represent the battlefield with appropriate scale model soldiers. But beyond this, there is the obsession still with the organized, but still highly marginal, world of Holocaust denial, to *prove* the Holocaust to new generations.

Liberated Auschwitz retained its massive scale and the remains of humans, but not many complete bodies. Somewhat ironically, given their tinyness compared to the original, although they are huge by museum standards, the models are meant to show the vastness as well as the specific function of Auschwitz. Jim Garret has defended the example within the Imperial War Museum: 'To dismiss the 40-foot-long representation of Auschwitz as simply "a model" is to miss its *raison d'être* – that there is an almost total absence of photographs of the arrival at the ramp of such transports. 'This solid representation of an actual event [the selection of Jews from the Berehevo ghetto] enables an appreciation of scale to be imparted'.[71]

The Museum team in the planning stages expressed themselves as 'sensitive to the views of those who claim that the Holocaust cannot be represented'. The model is the only major re-creation in the exhibition, the only point in which the documentary approach is compromised. Ultimately, its colour, size and form highlight artifice. One thinks somewhat cruelly of the Stonehenge model in the spoof rock documentary, *Spinal Tap* (1984), when the replica demanded by the heavy metal band to accompany one of their songs on stage ends up, through a drafting mistake, being 18 inches tall rather than the 18 feet demanded: it is 'dwarfed by dwarfs'. As one of 'Spinal Tap' puts it: the model 'understates the hugeness of the thing'.[72] The human figures of the Imperial War Museum's Auschwitz model in their endless rows, according to the designer, are astonishingly 'clinical and graphic'.[73] In fact, as the Chapman Brothers' alternative version highlights, they are, as the model as a whole, aestheticized and sanitized.

The final image at the museum is that of a British soldier, with neck scarf round his mouth, bulldozing the grotesque and filthy figures in Belsen. Naked and tangled, it is hard to tell when one body starts and another ends, let alone if they are male or female, young or old. This is by far the biggest photograph in the whole exhibition. Are we doomed then to see the dead victims only as piles of corpses, nameless and without any form of identity other than that inflicted on them by the Nazis and their allies?

The Imperial War Museum does not engage in any depth with the place of Britain, as a bystander nation, in the Nazi era.[74] By such absence of discussion, the exhibition sits oddly in the London borough of Lambeth – it is ultimately about the perpetrators, and, in an English/British context, that is, still fundamentally about Germany and in turn 'our', that is the British, glorious role in the Second World War. It does not encourage the British visitor, for example, towards self-reflection – on the importance of place, for example, and the role of the site, formerly Bethlem Royal Hospital (Bedlam), in the incarceration and appalling treatment of those classified as mentally ill, or for that matter of the racial violence, including most notoriously, the murder of black teenager Stephen Lawrence, in an adjacent south London district.

Indeed, the exhibition ends with Belsen, confirming the righteousness of the British war effort. In his *Body Horror: Photojournalism, Catastrophe and War*, John Taylor argues that 'Death is rarely seen in ragged human remains unless they are foreign.' He adds that

> Reports of horrors overseas concentrate on the essential strangeness of victims, whether they invoke revulsion or invite compassion. Even in those stories which spark moral debate, the press uses stereotypes of alien life: they include refugees, corpses and even skeletons in the streets. These pictures contrast with idealised British systems of value, care and order. They imply that outside Britain, chaos is the norm, and life is cheap.[75]

They are, in short, 'unBritish'. Within the Imperial War Museum's Holocaust Exhibition the victims specifically highlight the duality of Britishness/Germanness. Out of this matrix of understanding and representation, can the body of the victim as individual ever be recovered?

The Aktion Reinhard camps today remain largely neglected and unvisited, in stark contrast to Auschwitz and some of the western camps. The physical archaeology remaining is fragmentary, but at Belzec particularly, recent digs have helped build up a more detailed picture of what happened there. Up to a million people were gassed at Belzec, the first purpose-built Nazi death camp. There are no records of the camp, which were destroyed alongside the buildings and any human remains – almost all the bodies were exhumed and burnt by the Nazis.

Recently bodies have been discovered in digs, raising the question of what should be done with them. Orthodox Jewish leaders have refused permission to dig in areas where it is known that the ashes of Jewish victims are present. The digging that has revealed bodies has been near an SS hut. It is not clear who the people were – they could have been Jewish victims, less likely (simply through the numbers of those killed at the camp) Gypsies or indeed the local SS. It has been assumed that they were Jewish and they have been buried according to Jewish orthodox tradition.

Similar issues have emerged at another Aktion Reinhard camp, Sobibor.[76] Whether orthodox Jews have a right to speak for all such victims is far from clear. More locally the same has been true at the York Archaeological Trust dig in the medieval Jewish cemetery.[77] Related issues of ownership of human remains which have found their way into university collections and museums have for groups such as Aborigines and Native Americans proved even more controversial.[78]

There is a tension between the growing sensitivity towards orthodox Jews and their fears of disturbing the mass graves at sites such as Belzec and Sobibor, on the one hand, and the absence of such consideration given to the representation of the victims' bodies in the museum and media world on the other. Archaeology may be able to reveal far more about, for example, Belzec, known only through a handful of documents and post-war testimonies. The excavation carried out on the site has certainly shown it to be much bigger than was previously recognized but beyond that the knowledge gained has been limited, as those involved have been in a constant struggle with the local authorities, Jewish orthodox religious leaders and funding restraints.

A genuine dilemma is posed between the need to know (although the scientific claims of accuracy of modern archaeological techniques should not be accepted without some degree of scepticism) and the need to respect a (mass) burial site. In contrast, the frequent use of graphic images of the victims, naked and without any decency, to show the nature of Nazism, has evoked far too little soul-searching.

Digs such as those carried out by Richard Wright can reveal much about the identity of the individuals. They also connect mass murder to ordinary and easily forgotten local sites. It is

significant, however, that the Einsatzgruppen murders have been portrayed in museums through the tiny amount of surviving film footage and photographs of naked people, especially women, about to be shot. Such images have been shown regardless of the offence caused, especially to orthodox Jews, by images of naked women. More generally, the individuality of the victims is lost sight of in the desire to educate.

In the Mauthausen camp museum there are four poster-sized photographs of a victim of the Nazis, the first in striped prisoner uniform, the second and third naked from front and rear and the fourth as a skeleton. The caption states that prisoner 13992 had been subject to medical experiments. The images also appear in the United States Holocaust Memorial Museum. Prisoner 13992 was the father of Alphons Katan who discovered the photographs by accident when visiting the museum at Mauthausen. Subsequently he has been campaigning for the removal of these photographs from public display. Katan told the Washington museum that 'You are humiliating my father even in his death by presenting his pictures'.[79]

It is possible that Alphons Katan will succeed in his mission to get these images of his father removed and his father's body to be buried. As Cressida Fforde has illustrated in relation to Aboriginal human remains, there is a greater chance of repatriation for burial (and in this case removal of the offensive images) once the body concerned has a name and thus becomes less a 'thing' and more an individual.[80] But, given the intensity of the Nazi murder machine, many victims will never be given a name and the cases in which surviving relatives and friends can identify images of the dead or those about to be killed will be exceptional. That should not, however, be an excuse for those responsible for museum displays and other visual representations of the Holocaust not to examine closely the ethical considerations of showing such images as well as contextualizing (that is, who took the photograph and why) and problematizing such images (making the viewer aware of the dilemmas of such re-production) when they are deemed absolutely necessary.

John Taylor argues that in the name of civility, the horrors of war and atrocity can be disguised, with a potential for public debate, especially national self-criticism, to be avoided or suppressed. He concludes that

> civility sits uneasily with war – unless it is known to be describing official histories, censored reports and popular victories. How would the Holocaust be remembered if it existed only in 'civil' representations – those which were most discreet? What would it mean for knowledge if the images ceased to circulate, or were never seen in the first place? What would it mean for civility if representations of war crimes were always polite? If prurience is ugly, what then is discretion in the face of barbarism?[81]

In the cases of slavery,[82] lynchings,[83] genocide, and the destructive side of imperialism there is still a need to confront the lack of general empathy for the horrors inflicted, and appalling visual imagery makes an *initial* impression. Yet the absence of such representation in regard to 'us', which Taylor himself emphasizes, is not matched by the lack of care in representing the 'other' as victim, and the dichotomy in standards is clearly related.

The Imperial War Museum exhibition, for example, includes a photograph of a semi-naked terrified young Jewish girl who has been subject to sexual abuse through a local 'action' in Lvov. Jim Garret talks of this image and others of naked victims: 'Those who suffered never gave their consent to be looked at over 60 years later.' Surely Garret, now curator of the Pump House in Manchester, a major museum illustrating the lives of ordinary people in Britain, is asking a major question that requires agonizing reflection. His answer, however, like that of the Imperial War Museum project team, is straightforward and lacking any sense of ambiguity. 'But this is

evidence. There is no other way of presenting the realities of a government-led systematic, premeditated persecution and extermination of millions of innocent people.'[84]

In other words, the utter removal of dignity of the victims by the Nazis has to be permanently reproduced in order to 'prove' the scale and horror of humiliation and mass murder. As with such other images of death and nakedness, the Museum is taking the chance that the victims or their relatives did/do not survive and cannot come to the exhibition to object. If they did, is it conceivable that the images would not be removed? In the particular case of the young girl from Lvov, there is also naivety in how such images will be consumed.

Joan Smith has written of William Styron's novel *Sophie's Choice* (1979) and D.M. Thomas's *The White Hotel* (1981) that their success is the juxtaposition of 'sex and the Holocaust ... dressed up as art'. She goes further and suggests that 'The model of female sexuality constructed by Thomas and Styron has nothing to do with real women but exists to legitimize masculine sexual fantasies which are violent, vicious and ultimately lethal'.[85] Alternative readings of the motivation of both writers are possible.[86] Nevertheless, Smith is right to point out that the books' success is at least in part due to their eroticized narratives. 'The rapturous reception of their books, and their status as bestsellers, suggest that a significant proportion of the reading public is receptive to such fevered imaginings.'[87]

From the 1950s at least, Nazi horror has been consumed as a form of pornography to the extent that books such as the salacious *The Scourge of the Swastika* (1954), which featured photographs of naked women being paraded at a concentration camp, as well as standard atrocity material such as the shrunken heads of Buchenwald and the mass open graves of Belsen, were stored in bookshops in the backroom section of 'forbidden' literature.[88] Early forms of printed testimony from survivors published by newly emerging pocket paperback companies such as Digit Books and Badger Books, while often subtle and important in themselves, were also marketed in the form of 'sexploitation'. Their covers featured pictures of vulnerable and often exposed young women in concentration camps with brutal SS thugs in the background.[89]

The crude appeal of sado-masochism in relation to Nazism and its victims extended beyond the sexually repressed 1950s, perhaps most famously played out in Liliana Cavani's *The Night Porter* (1974).[90] The film came out the same year as David Friedman's *Ilsa, She-Wolf of the SS* which is perhaps more typical of the less artistic attempts which fill this ever popular and quite diverse genre. Even serious novels dealing with the Holocaust, such as Sherri Szeman's *The Kommandant's Mistress* (1993), have been marketed by their mainstream publishers with titles and covers to titillate the reader.[91] As Joseph Slade has argued, 'The public is outraged when Nike, the athletic supplier, markets a T-shirt decorated with swastika, but accepts as "normal" the eroticizing of National Socialism.' He concludes that

> It would be nice to think that we are actually trying to defile fascism – to distance ourselves from it – by eroticizing it ... or that we are trying to dramatize Nazi cruelty – to mark it as unmistakably the expression of alien 'others' – as a way of keeping our collective memory of the Holocaust alive ... Neither seems likely ... Unable to comprehend a mass ideological commitment to extermination, we focus on individual acts of psychotic cruelty.[92]

In total contrast to the creators of cheap movies and videos, it was not the intention of those responsible for the Imperial War Museum's Holocaust exhibition to provide titillating material. Indeed, they were aware from the start of the potential danger of voyeurism. Nevertheless, intentions can sometimes lead to the opposite impact of that desired. Catherine MacKinnon has written of media and other coverage of sexual violence in the former Yugoslavia during the

The Holocaust and the museum world in Britain

early 1990s and how it provides a pornographic scripting of rapes. Yet her descriptions are so horrific in their detail that it has been argued by Rose Lindsey that 'the effect is one of voyeuristic hard-core porn, ironically closer in style to the pornography that MacKinnon lambasts, than to an academic text'.[93]

It may at this point be useful to return to John Taylor's statement about atrocity images and what he views as the impossibility of 'discretion in the face of barbarism'. Taylor reproduces a newspaper photograph by Mark Edwards of a man carrying his wife who is dying of cholera in the streets of Calcutta. He suggests that Edwards' photograph 'of the dying woman is remarkable for her nakedness and beauty'.[94] That even academic analyses of the representation of atrocities can lead to their sexualization is an indication of the fundamental instability of such images and the danger of relying on the reader or viewer to distance themselves from the voyeurism inescapably linked to pornography. Discretion *can* have its place. It is, however, largely absent in the Imperial War Museum's Holocaust exhibition because of the overriding and well-intentioned desire to provide evidence.

The exhibition, with its insistence on proof, is unwilling to allow its narrative structure to be in anyway undermined by self-reflexivity. More specifically, in the case of the photograph of the young girl from Lvov, it fails to provide any context whatsoever in which to place sexual violence against the victims of Nazism. As these are underplayed and sometimes even denied in many forms of writing on the Holocaust, the reproduction of the image might possibly have been justified. But without any form of reflection, it, alongside other problematic images of the victims in the exhibition, reflects the lack of progress in Holocaust representation that has occurred since the end of the war.

To conclude, we need to move beyond the need to prove the Holocaust, which almost inevitably belittles the victims, presenting them as humiliated bodies without a past or a future. Sue Malvern's analysis of how the Imperial War Museum 'displays its collections to tell stories and to represent the nation to "itself" ' concluded by pondering how the then to be completed Holocaust exhibition would change its focus. 'It will bring into question again who and what the museum represents and to whom.'[95] For the foreseeable future at least, however, I would argue that the Holocaust exhibition, while being on the surface more inclusive of the small number of survivors and Britain and the greater part of British Jewry, does not, as a whole, shift its overall narrative thrust of 'us' and 'them' or 'here' and 'there'.[96]

James Young has written of the dangers of the United States Holocaust Memorial Museum that it 'will enshrine not just the history of the Holocaust, but American ideals as they counterpoint the Holocaust. By remembering the crimes of another people in another land, Americans will recall their nation's own idealized reason for being.' If in national mythology the USA is the home for the oppressed, within the Museum's representation, those liberated at Buchenwald and Dachau by GIs were 'potential Americans ... the Holocaust was the beginning of their becoming American, making the Holocaust an essentially American experience'.[97]

In a specifically British context where the memory of the Second World War as a reference point of collective identity is so profound,[98] the 'here' and 'there', defined in America as itself against the diseased continent of Europe, is made more geographically specific. In Britain in the short and probably also the medium term, it is almost inevitable that the categories Nazi and German will be blurred through the continuing power of Germanophobia. Instead of opening up self-exploration of national intolerance towards minority groups, it is possible and indeed likely that Holocaust representation that focuses on the 'there' carried out by foreigners will add further ammunition to those who argue for British exceptionalism in a world of many racisms. Furthermore it continues to present the victims as exotic 'others' with little past and certainly no future. Denying its past tradition of immigration, it was hard if not impossible for Britain, in

367

contrast to America, to imagine those liberated from Belsen as future citizens. Indeed, only one or two thousand survivors at most were allowed entry to Britain after the war.[99]

Instead of the reassuring linear narrative chosen by the Imperial War Museum, there has to be much greater awareness of the problems of Holocaust representation and that the well-meaning goal of authenticity, which privileges artefacts, documents, films and photographs over testimony, is misplaced. James Young writes in relation to the sites of Auschwitz and Majdanek,

> In confusing these ruins for the events they now represent, we lose sight of the fact that they are framed for us by curators in particular times and places … we must continue to remind ourselves that the historical meanings we find in museums may not be proven by artifacts, so much as generated by their organization.[100]

Similarly, Marcus Wood critiques the 'Transatlantic Slavery' gallery, by far the largest on its subject matter in Britain, in the Merseyside Maritime Museum in Liverpool and its attempt to 'come to terms' with the past. It displays items of horror, such as branding irons and slave collars, but 'Their patina of age, their elegant forms, the clean stands they are placed upon, the neat labels with their dates and matter of fact descriptions place them comfortably within an aesthetics of museum display which can cover any old object from any culture'. Through objects of torture and destruction, and the re-creations of the middle passage in Liverpool and the Auschwitz model in the Imperial War Museum, both exhibitions fail to recognize the limits of representation.[101] Moreover, they both share a tendency, even though this was not intended, to represent the victims as 'something alien and exotic'. In the case of the Transatlantic Slavery gallery, representations of Africa conform 'to the conventions of anthropological and ethnographic exhibits … There is the peculiar sense that these exhibits are timeless.'[102]

When the anthropological collection of General Pitts Rivers was transferred to the Bethnal Green branch of the South Kensington Museum in 1874 it was arranged into four sections: 'skulls and hair'; 'weapons'; 'miscellaneous arts of modern savages including navigation' and the 'prehistoric series'.[103] In a curious way, the Imperial War Museum, now with the Holocaust exhibition neatly integrated into its whole, replicates these categories.

First, actual skulls and hair may not be, for reasons of taste, included, but the graphic representation of the victims' bodies is reproduced throughout. Second, the means of mass destruction are reproduced through artefacts and images. Third, Nazi civilization is displayed, and within it the images the Nazis made themselves of their victims. Fourth, the victims' own culture is represented as 'prehistory'.

The Pitt Rivers Museum, now in Oxford, is venerated by some as a 'museum of museums'. The Imperial War Museum's history is nearly half a century shorter than Pitt Rivers' but it shares its slowly evolving nature, one in which the Holocaust exhibition, while initially controversial, is, on an ideological and cultural level and taking the long view, not a major new departure.

Is a different approach possible? One counter-strategy would be the embracing of testimony, because of and not in spite of its complex relationship to evidence. It would allow for no obvious narrative structure, but its very absence would point to the diversity, fullness and contested nature of the Jewish experience before the Shoah as well as the chaos caused by the Nazi onslaught. It can enable not a coming to terms with the past but the possibility of greater inclusivity when both history and memory are brought together in a form of constructive tension.[104] Some elements of representation are revealed in the Polish documentary, *Birthplace* and the story of the Grynberg family.

The Holocaust and the museum world in Britain

In 1993, Henryk Grynberg returned to the village in which he and his parents lived before the war and were in hiding during it. His father was murdered by a local farmer. Remarkably some 50 years later the villagers returned to the exact spot where he was buried and exhumed his remains, as well as a milk bottle which he carried around trying to find sustenance for his family. The rootedness as well as the marginality of Grynberg's family as Jews became clear in the short documentary. It is a bleak film, and the only redemption is in the finding of the shallow grave. The body, however, as well as his father's dignity, is regained. The rootedness of his family in Poland before the war, the empathy as well as the antipathy of the local non-Jews during it, the closeness of the family as fugitives within their own village, and how the murder, some 50 years later, was still traumatizing local memory, are all evocatively portrayed. Overall, *Birthplace* showed how the Holocaust, as represented by the killing of one man, continued to problematize individual and group identity in relation to a place called home.[105]

We are a long way here from the piles of dead bodies Belsen and other concentration camps so casually illustrated by the Holocaust museum in Washington and the permanent exhibition in London. We remain, however, intimately connected through life story to the very normalcy of Jewish life in Europe as well as the human impact of the Holocaust. We are also shown the everyday nature of mass murder, whether in the killing fields of colonial massacres or among the better-known genocides of the twentieth century: the Armenians, Cambodians, Bosnians and Rwandans.

Notes

1 Moira Simpson, *Making Representations: Museums in the Post-Colonial Era* (London, 1996), p. 1.
2 For the British case, see, for example, Annie Coombes, *Reinventing Africa: Museums, Material Culture and Popular Imagination* (New Haven, CT, 1994) and more generally George W. Stocking, Jr. (ed.), *Objects and Others: Essays on Museums and Material Culture* (Madison, WI, 1985) and I. Karp and S. Lavine (eds), *Exhibiting Cultures* (Washington, DC, 1991).
3 Bryan Cheyette, 'Neither Black Nor White: The Figure of "the Jew" in Imperial British Literature', in Linda Nochlin and Tamar Garb (eds.), *The Jew in the Text: Modernity and the Construction of Identity* (London, 1995), pp. 31, 41.
4 See, for example, the work of Paul Gilroy, especially his *Between Camps: Race, identity and Nationalism at the End of the Colour Line* (London, 2000). See also Tony Kushner, 'Antisemitism', in David Goldberg and John Solomos (eds), *A Companion to Racial and Ethnic Studies* (Maiden, MA, 2002), pp. 64–72.
5 See, however, the extensive work of Panikos Panayi, especially his *The Enemy in Our Midst: Germans in Britain during the First World War* (Oxford, 1991). On the impact of contemporary anti-Germanism, see the 'Everyman' documentary 'Two World Wars and One World Cup', BBC 1, 25 April 1993.
6 Vikram Dodd, 'Racist Jokes Make Leeds United Sorry', *The Guardian*, 3 May 2002.
7 Simon Hoggart, 'Hard-Wired to be Beastly to the Germans', *The Guardian*, 17 May 2002. More generally on the myth of fairness, see Colin Holmes, *A Tolerant Country: Immigrants, Refugees and Minorities in Britain* (London, 1991).
8 Linda Colley, *Britons: Forging the Nation 1707–1837* (London, 1994 [originally 1992]), p. 368.
9 Julie Burchill, 'Thinking the Wurst', *The Guardian*, 22 September 2001.
10 Panayi, *The Enemy in Our Midst*.
11 See Margaret Kertesz, 'The Enemy: British Images of the German People during the Second World War' (unpublished Ph.D., University of Sussex, 1992), p. 175 which utilizes a November 1944 Mass-Observation directive to reveal 'a continued hardening of opinion' since 1942. The more subjective and detailed Mass-Observation material is confirmed by opinion poll data from September 1943 carried out by Gallup. Answering 'What are your feelings at the present time towards the German people?', 45 per cent expressed 'hatred, bitterness, anger', 14 per cent 'dislike', six per cent that they 'deserve what they are getting', five per cent 'contempt'. Only seven per cent expressed 'friendly' feelings, and even then only for some Germans. In George Gallup (ed.), *The Gallup International Public Opinion Polls: Great Britain 1937–1975*, Vol.1 *1937–1964* (New York, 1976), p. 82.

12 Mass-Observation Archive: Diarist S5205, 20 April 1945, University of Sussex.

13 Mass-Observation Archive: File Report 2248, May 1945 'German Atrocities'. See also Diarist C5270, 21 April 1945.

14 'Can You Say That in English?' *The Guardian*, 21 February 2001.

15 See Imperial War Museum, *The Holocaust: The Holocaust Exhibition at the Imperial War Museum* (London, 2000) and Tony Kushner, 'Oral History at the Extremes of Human Experience: Holocaust Testimony in a Museum Setting', *Oral History*, Vol.29, No.2 (Autumn 2001), pp. 83–94.

16 Imperial War Museum, *The New Imperial War Museum* (London, 1992).

17 Sue Malvern, 'War, Memory and Museums: Art and Artefact in the Imperial War Museum', *History Workshop Journal*, No.49 (2000), pp. 179, 188, 198 note 4.

18 Ibid, p. 188.

19 See Geoff Hurd (ed.), *National Fictions: World War Two in British Films and Television* (London, 1984).

20 Tony Kushner, ' "Wrong War Mate": Fifty Years After the Holocaust and the Second World War', *Patterns of Prejudice*, Vol.29, Nos.2 and 3 (1995), pp. 3–13.

21 Imperial War Museum, *The Relief of Belsen* (London, 1991). See also Joanne Reilly *et al.* (eds.), *Belsen in History and Memory* (London, 1997), pp. 12–13, 197–8 on the background to this exhibition.

22 For the most detailed analysis of the creation of this visual material see Hannah Caven, 'Horror in Our Time: images of the concentration camps in the British media, 1945', *Historical Journal of Film, Radio and Television*, Vol.21, No.3 (2001), pp. 205–53.

23 Ibid., p. 205.

24 Ibid.

25 Cornelia Brink, 'Secular Icons: Looking at Photographs from Nazi Concentration Camps', *History and Memory*, Vol.12, No.1 (Spring/Summer 2000), p. 145.

26 Simpson, *Making Representations*, p. 177.

27 Julia Cousins, *The Pitt Rivers Museum* (Oxford, 1993), p. 28.

28 Simpson, *Making Representations*, p. 174.

29 Simpson, *Making Representations*, p. 177.

30 Lawrence Douglas, 'The Shrunken Head of Buchenwald: Icons of Atrocity at Nuremberg', *Representations*, No.63 (Summmer 1998), pp. 41–3. For the ongoing legacy and appeal of such material see Walter Poller, *Medical Block Buchenwald* (London, 1988 [originally 1960]) which on the cover emphasizes that it is 'illustrated' and not surprisingly the photographic images emphasize torture.

31 Paramount News newsreel available in Imperial War Museum film archive. See more generally Nicholas Pronay, 'Defeated Germany in British Newsreels: 1944–45', in *Hitler's Fall: The Newsreel Witness* (London, 1938), pp. 42–4.

32 See Edward Linenthal, *Preserving Memory: The Struggle to Create America's Holocaust Museum* (New York, 1995), pp. 1–2, 193–4; Michael Berenbaum, *The World Must Know: The History of the Holocaust as Told in the United States Holocaust Memorial Museum* (Boston, MA, 1993), p. 8 and for more critical comment on the use of these images and the Eisenhower quotation, Philip Gourevitch, 'Nightmare on 15th Street', *The Guardian*, 4 December 1999.

33 See Tony Kushner, *The Holocaust and the Liberal Imagination: A Social and Cultural History* (Oxford, 1994), Ch. 7.

34 Yitzhak Arad, *Belzec, Sobibor, Treblinka: The Operation Reinhard Death Camps* (Bloomington, IN, 1987).

35 Robert Jan Van Pelt and Deborah Dwork, *Auschwitz: 1270 to the Present* (New Haven, CT, 1996).

36 See my contribution to the introduction in Reilly *et al., Belsen in History and Memory*, pp. 6–7.

37 Jo Reilly, *Belsen: The Liberation of a Concentration Camp* (London, 1998).

38 On Auschwitz in the immediate post-war trials see Donald Bloxham, *Genocide on Trial: War Crimes Trials and the Formation of Holocaust History and Memory* (Oxford, 2001).

39 Van Pelt and Dwork, *Auschwitz*, Epilogue: 'Owning and Disowning Auschwitz'.

40 Richard Wright, 'Uncovering Genocide: War Crimes: The Archaeological Evidence', *International Network on Holocaust and Genocide*, Vol.11, No.3 (1996), p. 9.

41 Ibid., p. 9.

42 Hannah Arendt, *The Origins of Totalitarianism* (3rd edition, London, 1967 [originally 1951]), p. 446 in a footnote commented:

> It is of some importance to realize that all the pictures of concentration camps are misleading insofar they show the camps in their last stages, at the moment the Allied troops marched in.

The Holocaust and the museum world in Britain

There were no death camps in Germany proper, and at that point all extermination equipment had already been dismantled. On the other hand, what provoked outrage of the Allies most and what gives the films their special horror – namely, the sight of human skeletons – was not at all typical for the German concentration camps; extermination was handled systematically by gas, not by starvation.

43 Melanie Wright, ' "Don't Touch My Holocaust: Responding to *Life is Beautiful*', *Journal of Holocaust Education*, Vol. 9, No. 1 (Summer 2000), pp. 19–32 esp. p. 29.
44 J. Hoberman, 'Dreaming the Unthinkable', *Sight and Sound*, February 1999.
45 Raymond Phillips (ed.), *Trial of Josef Kramer and Forty-Four Others (The Belsen Trial)* (London, 1949), p. xxxix who comments that Kramer was depicted as 'a sadistic beast in human form thirsty for the blood of his tortured victims'. See also Caven, 'Horror in Our Time', pp. 220–22 on representations of Irma Grese and Josef Kramer.
46 Daniel Goldhagen, *Hitler's Willing Executioners: Ordinary Germans and the Holocaust* (Boston, MA, 1996).
47 Caven, 'Horror in Our Time', pp. 209, 225, 227.
48 Kushner, *The Holocaust and the Liberal Imagination, passim.*
49 The image is reproduced in The Imperial War Museum, *The Relief of Belsen*, p. 5 and labelled as 'A man, dying of starvation'. More generally on the sloppy approach in the use of presenting Holocaust-related photographs see Bryan Lewis, 'Documentation or Decoration? Uses and Misuses of Photographs in the Historiography of the Holocaust' (unpublished M.Phil., University of Birmingham, 1999).
50 James Young, *The Texture of Memory: Holocaust Memorials and Meaning* (New Haven, CT, 1993), p. 323.
51 See Suzanne Bardgett, 'Man's Inhumanity to Man: A New Museum within the Imperial War Museum' (unpublished proposal, May 1995).
52 In fact the final stage of the project is a much smaller exhibition on genocide in the twentieth century which employs a video supplemented by interactive educational material which opened in 2002.
53 Douglas, 'The Shrunken Head of Buchenwald', p. 39; Donald Bloxham, *Genocide on Trial: War Crimes Trials and the Formation of Holocaust History and Memory* (Oxford, 2001), pp. 58–63.
54 See Philip Rubinstein and Warren Taylor, 'Teaching about the Holocaust in the National Curriculum', *Journal of Holocaust Education*, Vol.1, No.1 (Summer 1992), pp. 47–54; Anita Ballin, 'The Imperial War Museum as Educator', *Journal of Holocaust Education*, Vol.7, No.3 (Winter 1998), pp. 38–43. The interest of teachers and students as well as the availibility of source material also explain the 'popularity' of the Holocaust in the classroom.
55 Suzanne Bardgett, 'The Imperial War Museum Holocaust Exhibition Project', *Journal of Holocaust Education*, Vol.7, No.3 (Winter 1998), p. 37; Pierre Vidal-Naquet, *Assassins of Memory: Essays on the Denial of the Holocaust* (New York, 1992).
56 Quoted by Young, *The Texture of Memory*, p. 346.
57 Kushner, 'Oral History at the Extremes of Human Experience', pp. 83–94.
58 Malvern, 'War, Memory and Museums', p. 198, note 4.
59 Young, *The Texture of Memory*, p. 132.
60 More generally see David Phillips, *Exhibiting Authenticity* (Manchester, 1997). For an exploration of the use of objects in relation to the United States Holocaust Museum and other museums see Julian Spalding, *The Poetic Museum: Reviving Historic Collections* (London, 2002). Suzanne Bardgett, 'The Holocaust Exhibition at the Imperial War Museum', *News of Museums of History* (forthcoming), talks of the 'ironic situation' of the acquisition of distressing artefacts being 'a source of professional satisfaction'.
61 The Imperial War Museum, *The Holocaust*, p. 2.
62 David Weiss, *The Wings of the Dove* (Washington, DC, 1987), p. 159 quoted by Colin Richmond, 'Parkes, Prejudice and the Middle Ages' in Sian Jones et al (eds), *Cultures of Ambivalence and Contempt* (London, 1998), p. 219.
63 Young, *The Texture of Memory*, p. 133.
64 Stephen Greenberg and Gerry Judah, 'Death in the Detail', *Jewish Chronicle*, 2 June 2000. Judah built the Auschwitz model from a design by Greenberg.
65 Kathy Jones, 'The Shoes of Majdanek Come to London', *Imperial War Museum Holocaust Exhibition Report* (Summer 2000). The shoes are featured in the initial leaflet for the exhibition and on the cover of its catalogue.

66 Linenthal, *Preserving Memory*, p. 205, on the models built in Auschwitz by Mieczyslaw Stobierski.

67 James Hall *et al* (eds), *Apocalypse* (London, 2000).

68 Jim Garret, 'A Hell on Earth', *Museums Journal*, August 2000.

69 The visit was by the Third Age group of Cheshire Reform Congregation See Joan Rose, 'Visit to the Impenal War Museum', *Shofar*, Vol. 29, No. 2 (October 2000), p. 18.

70 Jonathan Jones, 'Shock treatment', *The Guardian*, 7 September 2000 On Holocaust Memonal Day in Britain see Donald Bloxham's contribution in this volume.

71 Garret, 'A Hell on Earth' For a reproduction of detail from the model showing the selection, see The Impenal War Museum, *The Holocaust*, p. 46.

72 Directed by Rob Reiner, released in 1984 and re-released in 2000.

73 Gerry Judah in *Jewish Chronicle*, 2 June 2000.

74 For more general discussion on this point see Tony Kushner, ' "Pissing in the Wind"? The Search for Nuance in the Study of Holocaust "Bystanders" ', in David Cesarani and Paul Levine (eds), *'Bystanders' to the Holocaust A Re-evaluation* (London, 2002), pp. 63–4.

75 John Taylor, *Body Horror Photojournalism, Catastrophe and War* (Manchester, 1998), p. 129.

76 Robin O'Neil, 'Belzec Extermination Camp Report, July 1998' (unpublished typescript), 'Row Over Mass Grave Excavations at Sobibor', *Jewish Chronicle*, 21 December 2001.

77 See Jane Hubert, 'A Proper Place for the Dead A Critical Review of the "Rebunal" Issue', in Robert Layton (ed), *Conflict in the Archaeology of Living Traditions* (London, 1989), pp. 132–3 For the assessment of the evidence, see Jane McComish, 'The Medieval Jewish Cemetery at Jewbury, York', *Jewish Culture and History*, Vol. 3, No. 2 (Winter 2000), pp. 21–30.

78 Simpson, *Making Representations*, Ch. 7.

79 Yehuda Keren, 'In Pursuit of Dignity', *Jewish Chronicle*, 31 August 2001.

80 Cressida Fforde, 'Controlling the Dead an Analysis of the Collecting and Repatriation of Aboriginal Human Remains (unpublished Ph D thesis. University of Southamtpon, 1997), esp. pp. 152–3.

81 Taylor, *Body Horror*, pp. 195–6.

82 See Marcus Wood's superb *Blind Memory Visual Representations of Slavery in England and America 1780–1865* (Manchester, 2000).

83 James Allen *el al, Without Sanctuary Lynching Photography in America* (Santa Fe, NM, 2000).

84 Garret, 'A Hell on Earth'.

85 Joan Smith, *Misogynies Reflections on Myth and Malice* (London, 1989), pp. 127, 137.

86 See, for example, Sue Vice, *Holocaust Fiction* (London, 2000), Ch. 2 and esp. p. 66 on D M Thomas and the claim of pornography.

87 Smith, *Misogynies*, p. 137.

88 Lord Russell of Liverpool, *The Scourge of the Swastika* (London, 1954), photographs opposite pp. 180, 196, 197, 213.

89 See Micheline Maurel, *Ravensbruck* (London, 1958) published by Digit Books with the plug on the cover from a *Sunday Times* review 'a coarse, savage book'. The imagery and approach was even extended to a Badger Books account of the life of Sue Ryder by A J Forrest entitled *But Some There Be* (London, 1957).

90 Annette Insdorf, *Indelible Shadows Film and the Holocaust* (Second Edition, New York, 1989), pp. 136–8.

91 Shern Szeman, *The Kommandant's Mistress* (London, 1994 [originally 1993]), published by Minerva in paperback Szeman was not happy with the title and even less so the cover which has a woman in a Jewish camp uniform with her breasts exposed.

92 Joseph Slade, 'Nazi Imagery in Contemporary Culture The Limits of Representation', *Dimensions*, Vol. 11, No. 2 (1997), pp. 9, 14–15.

93 Catherine MacKinnon, 'Turning Rape into Pornography Postmodern Genocide', in Alexandra Stiglmayer (ed). *Rape The War Against Women in Bosnia-Herzogovina* (London, 1994), pp. 73–81 quoted in Rose Lindsey, 'Nationalism and Gender A Study of War-Related Violence Against Women' (unpublished Ph D, University of Southampton, 2000), pp. 139–40 and idem, 'From Atrocity to Data: Historiographies of Rape in Former Yugoslavia and Their Effects on the Study of the Gendering of Genocide', *Patterns of Prejudice*, Vol. 36, No. 4 (2002), pp. 59–78.

94 Taylor, *Body Horror*, pp. 132–3.

95 Malvern, 'War, Memory and Museums', pp. 179, 197.

96 Most organized survivor groups in Britain, including the Hendon Holocaust Survivor Centre and the '45 Aid Group, have been enthusiastic about the exhibition. Their lack of critical comment in

The Holocaust and the museum world in Britain

contrast to survivors in the USA and Washington museum reflects perhaps their greater marginality and sense of gratitude that a national museum was at last recognizing the Holocaust.

97 Young, *The Texture of Memory*, pp. 337, 345.

98 Paul Gilroy, *There Ain't No Black in the Union Jack: The Cultural Politics of Race and Nation* (London, 1987), pp. 131–5; Patrick White, *On Living in an Old Country: The National Past in Contemporary Britain* (London, 1985); Angus Calder, *The Myth of the Blitz* (London, 1991).

99 Tony Kushner and Katharine Knox, *Refugees in an Age of Genocide: Global, National and Local Perspectives during the Twentieth Century* (London, 1999), Ch. 6.

100 Young, *The Texture of Memory*, p. 128.

101 Wood, *Blind Memory*, pp. 297–9; Anthony Tibbles (ed.), *Transatlantic Slavery: Against Human Dignity* (London, 1994).

102 Wood, *Blind Memory*, p. 299.

103 Cousins, *The Pitt Rivers Museum*, p. 5; David van Kevren, 'Museums and Ideology: Augustus Pitt-Rivers, Anthropological Museums and Social Change in Britain', *Victorian Studies*, Vol. 28, No. 1 (Autumn 1984), pp. 171–89, esp. 175–6 and 183–4 for the early Pitt-Rivers Museum in Bethnal Green and South Kensington and its representation of 'races'.

104 Such an approach was to be adopted by the Manchester Shoah project, set up in the 1990s and which was finally abandoned, largely though not exclusively for reasons of finance, in 2001.

105 'Birthplace' (1993) and shown on BBC 2, Timewatch, 23 March 1994.

26
Senses of place, senses of time and heritage

Gregory John Ashworth and Brian Graham

Introduction

In defining the discourses of inclusion and exclusion that constitute identity, people call upon an affinity with places or, at least, with representations of places, which, in turn, are used to legitimate their claim to those places. By definition, such places are imaginary but they still constitute a powerful part of the individual and social practices which people use consciously to transform the material world into cultural and economic realms of meaning and lived experience. Senses of places are therefore the products of the creative imagination of the individual and of society, while identities are not passively received but are ascribed to places by people. While commonplace, such statements need re-stating here for two reasons. First, as occurs with nationalist ideologies, people do often assume that identities are intrinsic qualities of landscapes and cityscapes. Secondly, it is not enough to conclude that places are imagined entities. Rather, if individuals create place identities, then obviously different people, at different times, for different reasons, create different narratives of belonging. Place images are thus user determined, polysemic and unstable through time.

This raises a number of general issues. First, given this intrinsic variability in time, through space, and between social groups, it may seem perverse to attempt to generalize at all about a phenomenon that relates ultimately to a particular individual person, moment and location. The concept of 'collective identity', like the notions of 'collective memory' or 'collective heritage', with which it is strongly related, does not supersede or replace individual identity. It does, however, allow generalization and the location of ideas of belonging within political and social contexts.

Secondly, if it is axiomatic that place images are created, then someone creates them for some purpose. This leads directly to the formulation and execution of policy. Place images do not simply come into existence. Instead, they are created by and through processes of identification which are both internal to the individual or group and external in the sense that they are imposed by outside agency. This leads to questions such as: who is identifying and for what purpose? Place images are not generally explicable in terms of a single simple dominant ideology projected from definable dominant producers to subordinate passive consumers. The peoples, the identities, the images and the purposes are just all too plural to be reduced simplistically in this way.

Thirdly, senses of place must be related to senses of time if only because places are in a continuous state of becoming (Pred, 1984). The key linkage in this process is heritage. At the outset, it is vital to understand that this concept does not engage directly with the study of the past. Instead heritage is concerned with the ways in which very selective material artefacts, mythologies, memories and traditions become resources for the present. The contents, interpretations and representations of the resource are selected according to the demands of the present; an imagined past provides resources for a heritage that is to be bequeathed to an imagined future. It follows too that the meanings and functions of memory and tradition are defined in the present. Further, heritage is more concerned with meanings than material artefacts. It is the former that give value, either cultural or financial, to the latter and explain why they have been selected from the near infinity of the past. In turn, they may later be discarded as the demands of present societies change, or even, as is presently occurring in the former Eastern Europe, when pasts have to be reinvented to reflect new presents. Thus heritage is as much about forgetting as remembering the past.

Heritage, place and time

It is not the intention here to follow the concept of 'cultural capital' elaborated by Bourdieu (1977). He posits that a ruling élite, upon assuming power, must capture the 'accumulated cultural productivity of society and also the criteria of taste for the selection and valuation of such products' (Ashworth, 1994, p. 20), if it is to legitimate its exercize of power. Thus it can be argued that dominant ideologies create specific place identities, which reinforce support for particular state structures and related political ideologies. However, clearly, this is too constrained a perspective. As we argue, heritage is capable of being interpreted differently within any one culture at any one time, as well as between cultures and through time. Further, while Bourdieu's thesis implies that evocations of official collective memory underpin the quintessential modernist constructs of nationalism and legitimacy, it is also apparent that heritage takes a variety of official (state-sponsored) and unofficial forms, the latter often being subversive of the former.

Thus heritage is seen here as a much more diverse knowledge in the sense that there are many heritages, the contents and meanings of which change through time and across space. Consequently, we create the heritage that we require and manage it for a range of purposes defined by the needs and demands of our present societies. Perhaps the easiest way of conceptualizing this interpretation of heritage is through the idea of representation. Hall (1997) argues that culture is essentially concerned with the production and exchange of meaning and their real, practical effects. 'It is by our use of things, and what we say, think and feel about them – how we represent them – that we give them a meaning' (Hall, 1997, p. 3). Although he is writing specifically of language as one of the media through which meaning is transmitted, heritage can be regarded as an analogous process. Like language, it is one of the mechanisms by which meaning is produced and reproduced. Hall proposes a 'cultural circuit', which can be extended to include heritage. Meaning is marked out by identity, and is produced and exchanged through social interaction in a variety of media; it is also produced through consumption. These meanings further regulate and organize our conduct and practices by helping set rules, norms and conventions:

> It is us – in society, within human culture – who make things mean, who signify. Meanings, consequently, will always change, from one culture or period to another.
>
> *(Hall, 1997, p. 61)*

However the synonymy between language and heritage is not precise because the latter also exists as an economic commodity, which may overlap, conflict with or even deny its cultural role. Heritage is therefore a contested concept and quite inevitably so. Tunbridge and Ashworth's thesis of dissonant heritage (1996) represents the most sustained attempt to conceptualize this facet of heritage and its repercussions. Dissonance is a condition that refers to the discordance or lack of agreement and consistency as to the meaning of heritage. For two sets of reasons, this appears to be intrinsic to the very nature of heritage and should not be regarded as an unforeseen or unfortunate by-product. First, dissonance is implicit in the market segmentation attending heritage as an economic commodity – essentially comprising tangible and intangible place products, which are multi-sold and multi-interpreted by tourist and 'domestic' consumers alike. That landscapes of tourism consumption are simultaneously other people's sacred places is one of the principal causes of heritage contestation on a global scale. Secondly, dissonance arises because of the zero-sum characteristics of heritage, all of which belongs to someone and logically, therefore, not to someone else. The creation of any heritage actively or potentially disinherits or excludes those who do not subscribe to, or are embraced within, the terms of meaning attending that heritage. This quality of heritage is exacerbated because it is often implicated in the same zero-sum definitions of power and territoriality that attend the nation-state and its allegories of exclusive membership. In this sense, dissonance can be regarded as destructive but, paradoxically, it is also a condition of the construction of pluralist, multi-cultural societies based on inclusiveness and variable-sum conceptualizations of power. Whether through indifference, acceptance of difference or, preferably, mutuality (or parity) of esteem, dissonance can be turned round in constructive imaginings of identity that depend on the very lack of consistency embodied in the term.

If heritage is contested along several different axes – the temporal, the spatial, the cultural/economic and the public/private, it also functions at a variety of scales in which the same objects may assume – or be attributed – different meanings (Graham et al., 2000; Graham, 2002). The importance of heritage as a concept is linked directly to that of modernist nationalism and the nation-state and the national scale remains pre-eminent in the definition and management of heritage; United Nations Economic, Social and Cultural Organization (UNESCO) world heritage sites, for example, are nominated by national governments. Nevertheless, even when heritage is defined largely in the national domain, the implementation of policies and their direct management is likely to be conducted at the more local scale of the region or city. Hence heritage is part of the wider debate about the ways in which regions are being seen as the most vital sites within which to convene and capitalize on the flows of knowledge in contemporary globalization. Networking, entrepreneurialism, collaboration, interdependence and a shared vision are all vital prerequisites for regional economic regeneration. Simultaneously, other institutions and agencies are also involved in strategies that 'can serve to circulate and capitalize on existing and other sources of knowledge' (MacLeod, 2000, p. 232), heritage among them. Indeed it may well be a critical factor in that heritage creates representations of places that provide necessary time environments within which more essentially economic processes of wealth generation and marketing can be articulated.

It is a key feature of the post-Fordist capitalist society that knowledge is an input and an output in economic activities. Castells (1996) argues that cultural expressions in what he terms the network society are abstracted from history and geography and become predominantly mediated by electronic communication networks. These latter, which allow labour, firms, regions and nations to produce, circulate and apply knowledge, are fundamental to economic growth and competitiveness. Castells sees a world working in seconds while the 'where' questions – such as environmental sustainability – are in long-term, 'glacial' time. Power, which is diffused in global networks,

lies in the codes of information and in the images of representation around which societies organize their institutions, and people build better lives, and decode their behaviour. The sites of this power are people's minds,

(Castells, 1997, p. 359)

Heritage is one fundamental element in the shaping of these power networks and in elaborating this 'identifiable but diffused' concept of power. It is a medium of communication, a means of transmission of ideas and values and a knowledge that includes the material, the intangible and the virtual. Even, arguably, heritage professionals constitute, as Castells would have it, one of the global networks that produce and distribute cultural codes. Yet at the core of these ideas lies the key assertion that the global network has diminished place. Certainly Castells (1998, p. 357) admits to the re-emergence of local and regional government as being better placed to 'adapt to the endless variation of global flows' but this also points to heritage being a knowledge that is rooted in place and region. Its narratives may communicate the local to the global network, for example through the representations of international tourism and marketing imagery, but critically, they are often far more intensely consumed as inner-directed or internalized, localized mnemonic structures. The rise of the network society does not necessarily lead to the demise of place; rather it points to a redefinition of place at the scale of the local and the regional at the expense of the national.

The uses of heritage

To reiterate, heritage is that part of the past which we select in the present for contemporary purposes, whether they be economic or cultural (including political and social factors) and choose to bequeath to a future. Both past and future are imaginary realms that cannot be experienced in the present. The worth attributed to these artefacts rests less in their intrinsic merit than in a complex array of contemporary values, demands and even moralities. As such, heritage can be visualized as a resource but simultaneously, several times so. Clearly, it is an economic resource, one exploited everywhere as a primary component of strategies to promote tourism, economic development and rural and urban regeneration. But heritage is also a knowledge, a cultural product and a political resource and thus possesses a crucial socio-political function. Thus heritage is accompanied by a complex and often conflicting array of identifications and potential conflicts, not least when heritage places and objects are involved in issues of legitimization of power structures.

The economic uses of heritage

As Sack (1992) states, heritage places are places of consumption and are arranged and managed to encourage consumption; such consumption can create places but is also place altering. 'Landscapes of consumption ... tend to consume their own contexts', not least because of the often assumed 'homogenising effect on places and cultures' of tourism (Sack, 1992, pp. 158–9). Moreover, preservation and restoration freezes artefacts in time whereas previously they had been constantly changing. Heritage is the most important single resource for international tourism. Tourism producers operate in both the public and private sectors. They may be development agencies charged with regional or urban regeneration and employment creation, or they can be private sector firms concerned entirely with their own profit margins. Whichever, tourism producers impose what may well be relatively unconstrained costs on heritage resources. In turn, the relationship between costs and benefits is very indirect. It may well be that the capital from

tourism flows back to heritage resources only indirectly (if at all). It follows, therefore, that heritage tourism planning and management has enthusiastically embraced the idea of sustainable development. If heritage is regarded as a resource, sustainability in this context has four basic conditions. First the rates of use of renewable heritage resources must not exceed their rates of generation: in one sense, all heritage resources are renewable because they can be continuously reinterpreted. Their physical fabric, however, is a finite resource, one factor promoting the immense widening of what might be called the heritage portfolio. Secondly, the rates of use of non-renewable physical heritage resources should not exceed the rate at which sustainable renewable substitutes are developed (for example, the substitution of irreplaceable sites or artefacts with replicas). Thirdly, additional marginal users may displace existing users necessitating prioritization.

Finally, the rates of pollution emission associated with heritage tourism should not exceed the assimilative capacity of the environment (Graham et al., 2000). Heritage management is thus implicated in the belated recognition that the growth in personal mobility in the western world cannot be sustained indefinitely. One outcome is the move towards virtual consumption of place-centred heritage.

The cultural uses of heritage

Heritage is simultaneously knowledge, a cultural product and a political resource. In Livingstone's terms (1992), the nature of such knowledges is always negotiated, set as it is within specific social and intellectual circumstances. Thus key questions include why a particular interpretation of heritage is promoted, whose interests are advanced or retarded, and in what kind of *milieu* was it conceived and communicated? If heritage knowledge is situated in particular social and intellectual circumstances, it is time-specific and thus its meaning(s) can be altered as texts are re-read in changing times, circumstances and constructs of place and scale. Consequently, it is inevitable that such knowledges are also fields of contestation.

As Lowenthal (1985; 1996) has argued, this suggests that the past in general, and its interpretation as history or heritage in particular confers social benefits as well as costs. He notes four traits of the past (which can be taken as synonymous with heritage in this respect) as helping make it beneficial to a people. First, its antiquity conveys the respect and status of antecedence, but more important perhaps, underpins the idea of continuity and its essentially modernist ethos of progressive, evolutionary social development. Secondly, societies create emblematic landscapes – often urban – in which certain artefacts acquire cultural status because they fulfil the need to connect the present to the past in an unbroken trajectory. Thirdly, the past provides a sense of termination in the sense that what happened in it has ended, while, finally, it offers a sequence, allowing us to locate our lives in linear narratives that connect past, present and future.

Although Lowenthal's analysis is couched largely in cultural terms and pays little attention to the past as an economic resource, it is helpful in identifying the cultural – or more specifically – socio-political functions and uses of heritage. Building on these traits which can help make the past beneficial to people, Lowenthal sees it as providing familiarity and guidance, enrichment and escape but also, and more potently, validation or legitimation. This latter trait is particularly associated with identity in which language, religion, ethricity, nationalism and shared interpretations of the past are used to construct narratives of inclusion and exclusion that define communities and the ways in which they are rendered specific and differentiated (Donald and Rattansi, 1992; Guibernau, 1996). Central to the concept of identity is the Saidian idea of the other, groups – both internal and external to a state – with competing – and often conflicting

– beliefs, values and aspirations. These attributes of otherness are fundamental to representations of identity, which are constructed in counter-distinction to them. If yours is the only culture, identity or heritage how do you recognize and demarcate it?

The past validates the present by conveying an idea of timeless values and unbroken narratives that embody what are perceived as timeless values. Thus, for example, there are archetypal national landscapes, both urban and rural, which draw heavily on geographical imagery, memory and myth. Continuously being transformed, these encapsulate distinct home places of 'imagined communities' (Anderson, 1991), comprising people who are bound by cultural – and more explicitly – political networks, all set within a territorial framework that is defined through whichever traditions are currently acceptable, as much as by its geographical boundary. Although many contemporary regions lack this sense of a fixed entity set in history and time, it is apparent that some are evolving as culturally defined bounded spaces in which the 'region-state' aspires to emulate the national state. Both may depend on traditions and narratives that are invented and imposed on space, their legitimacy couched in terms of their relationship to particular representations of the past. In these constructs, the city – particularly the national or regional capital – becomes a landscape that embodies what is defined as official public memory marked by its morphology (the ceremonial axis, the victory arch), monuments, statuary and street names. This urban landscape, in turn, becomes the stage-set for national and regional spectacle, parades and performances.

Implicit within such ideas is the sense of belonging to place that is fundamental to identity. Lowenthal sees the past as being integral both to individual and communal representations of identity and its connotations of providing human existence with meaning, purpose and value. Such is the importance of this process that a people cut off from their past through migration or even by its destruction – deliberate or accidental – in war, often rebuild it, or even 'recreate' what could or should have been there but never actually was. European cities, for instance, contain numerous examples of painstakingly reconstructed buildings that replace earlier urban fabric destroyed in World War II. In the Polish city of Gdansk (formerly Prussian Danzig), for example, the Gothic/Baroque city centre, largely destroyed in World War II, has been reconstructed, not least to link the heritage patrimony of the post-war Polish state to the medieval era before the city became part of the Hanseatic League (Tunbridge, 1998).

Inevitably, therefore, the past as rendered through heritage also promotes the burdens of history, the atrocities, errors and crimes of the past which are called upon to justify the atrocities of the present. Lowenthal (1985) comments that the past can be a burden in the sense that it often involves a dispiriting and negative rejection of the present. Thus the past can constrain the present, one of the persistent themes of the heritage debate being the role of the degenerative representations of nostalgic pastiche, and their intimations of a bucolic and somehow better past that so often characterize the commercial heritage industry with supposed deleterious results to society and economy (see the well known diatribe of Hewison, 1987, on the damage created by the dominance of a backward looking vision).

Bibliography

Anderson, B. (1991), *Imagined Communities: Reflections on the Origins and Spread of Nationalism*, Verso, London.

Ashworth, G.J. (1994), 'From History to Heritage – From Heritage to History', in G.J. Ashworth and P.J. Larkham (eds), *Building a New Heritage: Tourism, Culture and Identity in the New Europe*, Routledge, London, pp. 13–30.

Bourdieu, P. (1977), *Outline of a Theory of Practice*, Cambridge University Press, Cambridge.

Castells, M. (1996), *The Rise of the Network Society*, Blackwell, Oxford.

Castells, M. (1997), *The Power of Identity*, Blackwell, Oxford.

Castells, M. (1998), *End of Millennium*, Blackwell, Oxford.

Donald, J. and Rattansi, A. (eds) (1992), *'Race', Culture and Difference*, Sage/Open University, London.

Graham, B. (2002), 'Heritage as Knowledge: Capital or Culture', *Urban Studies*, 39, pp. 1003–17.

Graham, B., Ashworth, GJ. and Tunbridge, J.E. (2000), *A Geography of Heritage: Power, Culture and Economy*, Arnold, London.

Guibernau, M. (1996), *Nationalisms: The Nation-state and Nationalism in the Twentieth Century*, Polity Press, Oxford.

Hall, S. (ed.) (1997), *Representation: Cultural Representations and Signifying Practices*, Sage/Open University, London.

Hewison, R. (1987), *The Heritage Industry: Britain in a Climate of Decline*, Methuen, London.

Livingstone, D.N. (1992), *The Geographical Tradition*, Blackwell, Oxford.

Lowenthal, D. (1985), *The Past is a Foreign Country*, Cambridge University Press, Cambridge.

Lowenthal, D (1996), *The Heritage Crusade and the Spoils* of History, Cambridge University Press, Cambridge.

MacLeod, G. (2000), 'The Learning Region in an Age of Austerity: Capitalizing on Knowledge, Entrepreneurialism and Reflexive Capitalism', *Geoforum*, 31, pp. 219–36.

Pred, A. (1984), 'Place as a Historically Contingent Process: Structuration and the Time Geography of Becoming Places', *Annals of Association of American Geographers*, 74(2), pp. 279–97.

Sack, R.D. (1992), *Place, Modernity and the Consumer's World*, John Hopkins University Press, Baltimore MD.

Tunbridge, J.E. (1998), 'The Question of Heritage in European Cultural Conflict', in B. Graham (ed.), *Modern Europe: Place, Culture, Identity*, Arnold London, pp. 236–60.

Tunbridge, J.E. and Ashworth, G.J. (1996), *Dissonant Heritage: The Past as a Resource in Conflict*, Wiley, Chichester.

27
Making heritage pay in the Rainbow Nation

Lynn Meskell

Heritage is not an acquisition, a possession that grows and solidifies; rather it is an unstable assemblage of faults, fissures and heterogeneous layers that threaten the fragile inheritor from within and from underneath.

(Michel Foucault, Nietzsche, Genealogy, History, 1977)

Always end your book with Nelson Mandela saying something about rainbows or renaissances. Because you care.

(Binyavanga Wainaina, How to Write About Africa, 2005)

Part of the fascination surrounding heritage in South Africa is the panoply of practices, places, and things that actually constitute it: wild animals, meteor craters, archaeological sites, archives and museums, local crafts, contemporary art, sport, and so on. Everything is someone's heritage in South Africa. Some of that heritage is the stuff of empowerment and capacity building, and some must be considered inherently negative heritage, the type typically jettisoned from the crafting of new nations. Certainly not all new heritage is configured around Africanity or the recovery of black pasts. Some heritage claims have spawned new racisms rather than engendered reconciliation. *Unity in diversity* may have provided a rousing anthem for the birth of a nation, and was leveraged internationally for investment, aid, and tourism, yet it has been tested at home by ethnic prejudice and stark economic realities. With the end of apartheid the ANC inherited an economy that had suffered two decades of stagflation, sanctions, divestment, and public debt of R230 billion (Terreblanche 2008). While economic opportunities have benefitted a new black middle class, between 45 and 50 percent of the population now live in poverty, and the plight of the black poor has notably worsened under the ANC's neoliberal policies (Ferguson 2007). The government's promise of a people-centered society has receded in the face of political denial and unwarranted optimism. Against this backdrop I examine the role of post-apartheid heritage making, comparing the expedient political rhetoric of the 1990s with the subsequent problems of implementation and transformation. Heritage was relentlessly promoted as a socio-economic driver in South Africa, especially for its vulnerable citizens and particularly in the face of dwindling government services and failed delivery. This continues

despite all evidence that such measures offer unrealistic fallbacks (Meskell and Scheermeyer 2008). The challenges of healing the nation while simultaneously providing capital injection to the nation's poorest areas, then, brings us squarely to Kruger National Park, beginning with Mandela's centenary speech setting out his dream for the park's future. The complex issues outlined in this chapter, I argue, were to find full expression in Kruger at the inauguration of the new nation.

South African heritage is called upon to labor, not only in the service of the state but also as a palliative for the nation's poor and historically oppressed and their reintegration into new civic and economic spheres. A person's historical persecution, their traditional knowledge, tribal identity, association with a landscape, use of natural materials, craft production, or their ancestor's graves are potentially all valuable assets that can be harnessed to "capacitate" and develop themselves and their communities. The troubling inheritance of tribalism and its reinvigoration under the promotion of the Rainbow Nation is further entwined with many liberal heritage ventures. Tangible and intangible heritage can all be brought into play (Scheermeyer 2005), ever widening the centrifugal promises of the past to provide for the future. The economic dimension of South Africa's cultural and natural heritages is vital, indeed the point underlies a key argument of this book. Yet I argue that heritage operates as a more complex form of self-compensation or therapy. Capitalizing culture under neoliberal restructuring is too convenient a catchall for these unfolding processes; this mistakenly undercuts the particular historical context of South Africa. Making heritage pay is also more complicatedly about fulfilling the social, spiritual, and therapeutic needs of the majority of South Africans in an era of uncertainty.

Elements of South Africa's liberalized program to "make heritage pay" may be symptomatic of many modern states. Parallels exist in North Africa, where external directives from the World Bank have targeted historic sites and districts for economic growth and social cohesion (Lafrenz Samuels 2009; 2010). While we might identify this as a global trend, I maintain that South Africa represents an extreme example for numerous historical reasons. This is a state-sponsored program, rather than the result of international intervention; South Africa's democracy is little over a decade old; the disempowered constitute the majority not the minority; and the state comprises both first-world and third-world economies. The new nation has also compelled new subjectivities in the shape of active, responsible, entrepreneurial citizens who do not seek to rely on direct state intervention but would heal themselves (Ferguson 2010). Private–public partnerships and NGOs have increasingly replaced state functions that we also see reflected in heritage and conservation management. In terms of expertise there are glaring deficits in the educational system pertaining to heritage and the pre-colonial past. Heritage as a commodity was thus called upon to mitigate state shortfalls in impossible ways. It is for these and other reasons that South Africa provides such a compelling context to investigate the category of heritage and the particular types of work it now performs globally.

The past, observes Wendy Brown (2001: 5), is "less easily reduced to a single set of meanings and effects, as the present is forced to orient itself amid *so much* history and *so many* histories, history itself emerges as both weightier and less deterministic than ever before." Heritage then has come to resemble *muti*, the traditional medicine favored by black South Africans, because both call upon the ancestors in their efforts to heal and transform individuals and society. Invoking the past, performing new rituals, and celebrating diversity are the authentic guarantors of economic and spiritual security. In the burgeoning post-apartheid heritage sphere there are trauma tours conducted by ex-Umkhonto we Sizwe members (Grunebaum and Henri 2003; Grunebaum-Ralph 2001; Meskell 2007b), township tours (Nieves 2008; Witz 2007), cultural villages such as Lesedi and Shakaland (Rassool 2000; Witz, Rassool, and Minkley 2001), living San exhibits (Geldenhuys 2004; Meskell and Weiss 2006), and a multitude of ethnic craft

initiatives. Some of these ventures rely implicitly on familiar Bantustan (apartheid-rule ring-fenced ethnic homelands) identities that many of us imagined would have vanished with the new nation. Indeed, the detailed inventorying of cultural practices, accompanied by public performances, was keenly embraced under apartheid as a necessary constituent of separate development (e.g., Malan and Hattingh 1976) and has long been part of identitarian politics, one way or the other, throughout the nation's history. Inventorying heritage is not simply motivated by private enterprise, but is avidly fostered by the state (Meskell 2005c; Sack 2003), chiefly through programs administered by the Department of Arts and Culture (DAC). Some of these strategies fold back upon themselves, reinforcing apartheid-era stereotypes. Others may indeed create new ethno-futures that supersede reified ethnicities by transforming tribes into corporations (Comaroff and Comaroff 2009: 8). For the Comaroffs (2009: 150), the commodification of ethnicity is an inherently modern practice, imbued with neoliberal expectations and capitalist desires for choice and consumption of cultural identities. One might well cast these South African developments as inherently entrepreneurial, modern – or indeed post-modern – and liberating, especially after repressive decades of apartheid rule. Yet this turn to culture and heritage is not a mere consequence of market forces. It is marked by South Africa's particular colonial history, in which racial and cultural differences were marshaled as the basis for unequal rights and privileges (Garuba and Radithalo 2008: 36), and more lately those same differences fueled the democratic revolution. Since 1994 those diverse cultural heritages, coupled with natural heritages, are being leveraged in order to cultivate new opportunities.

Struggles around culture and difference in South Africa have historically constituted a powerful domain of political resistance, whereby culture or ethnicity was a shorthand for political, social, and economic claims. These claims are increasingly being enacted in the sphere of heritage and are themselves underpinned by state failures over equity, access to resources, and recognition (Garuba and Radithalo 2008: 37). Globally too, recognition politics have been premised on distinctiveness, by appeals to cultural difference in regard to historical injustice and restitution, specific attachments to place and practice, particular lifeways, and so on. The recognition and accommodation of identity-related differences typically provide a route to the realization of human interests and are not simply ends in themselves. Yet South African identity categories resist any simple bifurcation of First Peoples and colonizers as understood in other post-colonial nations. In defiance of all other colonial settler societies, South Africans often reject the appellation "indigenous" to heritage and other forms of tradition and culture. Internal national politics have seen colored, Indian, and other minority heritage sidelined or subsumed by dominant black ANC official memorialization and preservation projects (McGregor and Schumaker 2006; Meskell and Scheermeyer 2008). This has sparked violence in multi-ethnic townships like Kliptown and undermined national solidarity. One notable exception to this trend is the longstanding heritage and memory work around the District Six museum (Hall 2006; McEachern 2002; Rassool 2007; Rassool and Prosalendis 2001). In nations such as Australia or the United States where the majority population is white, liberal attempts at recognizing indigenous alterity have resulted in other ways of constraining and controlling difference (Ivison 2002: 44; Povinelli 2002). In South Africa, issues of identity and "indigeneity" are, unsurprisingly, more multi-dimensional.

This inevitably gives rise to the complex question of who constitutes the nation's indigenous. If "indigenous" is taken to broadly encompass the non-white population, then the term covers the majority of South Africans. San, Khoekhoe, colored and the majority black population were historically victimized under white, colonial occupation and apartheid rule. In that way their subject status under colonialism and apartheid is similar to the experience of native peoples in settler societies of Australia, Canada, New Zealand, and the United States. But if indigenous

refers only to "First Peoples" then it excludes everyone save San and Khoekhoe descendents. Even if we take the category "African" to equate to indigenous status, many white South Africans have hijacked the term asserting that they too are African by birthright. Liberal philosophers argue that "indigenous" can refer to "peoples who lived in that territory before settlers arrived and the process of colonization began. This relativizes the definition to prior occupation rather than first occupation" (Ivison 2007: 614). Finally, self-description as indigenous has recently been cast as a connection to land (Hodgson 2002a: 1038; Sylvain 2002: 1076). However, this definition has been critiqued for the implicitly European belief that true citizenship is a matter of ties of blood and soil (Kuper 2003: 395). Certainly, most of my interviewees who describe themselves as black argue for restitution on the basis of owned and managed lands and settlements that were appropriated by whites, many of which episodes have occurred in living memory. Yet the issue of land and connection can also entrap rural communities in a legacy of primitivism, anti-development and anti-modernization (Sylvain 2002) and pays no heed to urban populations. It is also fraught with historical readings in South Africa since the removal and relocation of peoples were state strategies during colonial and apartheid times. These politicized geographies, premised on scripted tribal identities, had disastrous consequences felt to this day.

The tribal trap

In the desire to make heritage pay, post-apartheid South Africa has unwittingly embraced, if not reinvigorated, much of the same racial and ethnic categorizing that was instrumental in the very logics of minority rule and majority subjugation. *Plus ça change, plus c'est la même chose.* Tribalism, then and now, was both a form of power and a form of revolt against it (Mamdani 1996: 218). Understanding apartheid racialism and its consequences is vital for tracking the progress of the past and the relationship between cultural and natural heritage since 1994.

During apartheid tribes were positioned as nations with their own Bantustans or homelands situated on inferior lands. However, sizable portions of some homelands like Gazankulu, Bophuthatswana and KwaZulu had already been absorbed into protected areas. Independent homelands meant that blacks would be citizens of their own states, rather than the nation, ostensibly denying them South African citizenship. By preserving the trappings of tribalism, the apartheid state essentially prolonged the machinations of colonial indirect rule long after it had been abandoned elsewhere on the continent. South Africa was, after all, the last country to gain independence in Africa. Tribes were embraced as a political technology that fused cultural custom, ethnic identity, and administrative territory (Moore 2005: 14). The Bantu Authorities Act of 1951 was the crucial legislation that established the ethnic reserves and shored up the role of chiefs, who were then responsible for the allocation of land, the welfare and pension system, and development. Apartheid administrators recognized that the greatest threat to racial supremacy came from new class forces engendered by the modern economy that effectively cut across tribal lines, forces that would have been fueled by a racial mode of representation and control (Mamdani 1996: 95). By supplanting "racialism" with "culturalism" the apartheid state could effectively institutionalize separate development, albeit predicated on the tenets of white supremacy. Like other African states before them, South Africans called upon the concept of "culture" to perform the work of "race" in describing difference (Chanock 2000: 18). Rather than talking in outright terms of inferiority, tribes were merely different and, as such, entreated different trajectories. Different cultural groups had separate parliaments with limited self-governance in the tribal homelands, there were traditional authorities and customary law, and some homelands even had their own defense forces. Independent homelands like Venda and

Ciskei had something of their own legal system, whereas non-independent territories such as Gazankulu were strictly subject to apartheid laws (Omond 1985) and were constantly in a state of emergency.

Rediscovered traditions surfaced under apartheid, cultural pasts and military histories were invoked, folklore flourished, and cultural symbols were fabricated and rationalized through the tenets of culturalism. Ethnic branding is by no means new, nor was the idea of unity in diversity. Black communities were encouraged to revive origin myths and ancestral practices, along with traditional ethnic dress, games, cooking, music, and dance (Harries 1991: 108; Ranger 2010). Bantu education promoted craft-based education such as weaving, not mathematics, as Verwoerd famously preached that such subjects would never be of practical use for blacks (Leibhammer 2005: 123). Anthropologists were central to those processes (Dubow 1995; 2006), and later, during the 1980s, the South African Defence Force (SADF) was their largest employer (Gordon 1987). Different languages and customs were stressed in National Party efforts to foster tribal solidarity and cultivate rivalries between groups. Racial mapping further escalated tensions between the Shangaan and Venda around Kruger National Park in the 1960s coupled with forced removals and arbitrary divisions of territory. Some archaeologists also succumbed to the ideology of tribalism and the unchanging Bantu (Hall 1984). Pretoria University's excavation of Mapungubwe during apartheid and their desperate efforts to secure radiocarbon dates that fitted the "late arrival of Bantu" model was politically motivated. Enforcing ethnic identities lay behind the passage of the 1970 Bantu Homeland Citizenship Act that claimed to "develop the spiritual and cultural assets of that national milieu and to help develop a healthy self-respect and pride" (Harries 1991: 106). This has the eerie ring of post-apartheid heritage uplift as well.

Under the new dispensation, the ANC sought to eliminate tribal rivalries, but not tribes themselves. Tribes would remain the centers of culture and community but not the locus of political solidarities (MacDonald 2006: 100). Resurgent nativism can be seen in the establishment of the Native Club by high-profile ANC members (Hamilton 2009; Ndlovu-Gatsheni 2008), illuminating the public scripting of elite ethno-culture. Customary courts and Houses of Traditional Leaders, both holdovers from homelands legislation, have also been welcomed in the new democracy (Oomen 2005: 84). In 2008 the controversial Communal Land Rights Act (No. 11 of 2004) handed control of communally owned land back to traditional leaders for administration. Communities bordering Kruger, including the Dixie and Makuleke, were involved in the protest that claimed that this was taking them back to "apartheid-era tribal units" (Claassens and Cousins 2008; Groenewald 2008). Where the National Party decoupled race and culture as a means of separation and white supremacy, the ANC has held to the same distinction of non-racialism for reasons of national unity and democracy. Advocating non-racialism under the ANC has enabled black and white elites to prosper while the poor have remained marginalized (MacDonald 2006: 127). The old fault lines of inequality and discrimination have simply been papered over by other forms of social injustice and hierarchy, namely those of rich and poor (Daniel, Southall, and Lutchman 2005). One particular remedy that poor black South Africans have been offered is to again "develop" their own "culture." Before and after 1994, the strategy for the disenfranchised requires that they look to the past to forge their future.

The narrative of "progress" from a racist past to a nonracial present and future marks the critical modality in the post-apartheid era. South Africans are effectively living in a "double temporality," with the apartheid past as the constant referent in current understandings and future projections. The public sphere is infused with a "consciousness of the history that preceded and informs the current conjuncture, an awareness of living with the past in the post-apartheid present – and into the foreseeable future, for that matter" (Farred 2004: 593). Like

other purported post-colonial settings, the appellation of *post* is seemingly premature. The new nomos is haunted by the old nomos according to Farred; the old nomos is inescapably part of the new one and that duplicity is laced with concern, regret, anger, or inevitability. Living in double time lays bare the impossibility of remaking the nation without recourse to its multiple pasts, not simply the apartheid years but the long dureé of colonization and repression of indigenous peoples across southern Africa. This particular positioning, some might say impasse, is key for those of us investigating post-apartheid shifts in the cultural productions of history and heritage, museums and tourist locales, as well as constructions of nation, identity, and politics. We are poised at the very moment, this dual orientation, in which South Africans find themselves acknowledging, reconciling, and even re-crafting specific pasts.

Developing heritage

The decade following South Africa's liberation offers a unique window into the discursive creation of a new nation's heritage landscape. Government officials rewrote the dominant, racially motivated historical narratives that the apartheid government's decades of indoctrination imprinted on its citizens. In tandem they launched a campaign of socio-economic initiatives targeting the past as a corrective for redressing the ills of the past regime and simultaneously shoring up African identities in the present. This new suite of public discourses centered on the concepts of the Rainbow Nation and the African Renaissance. Reflected in the wording of the new national heritage legislation, the ANC leadership claimed that heritage "helps us to define our cultural identity and therefore lies at the heart of our spiritual well-being and has the power to build our nation." And further that "our heritage celebrates our achievements and contributes to redressing past inequities. It educates, it deepens our understanding of society and encourages us to empathise with the experience of others. It facilitates healing and material and symbolic restitution and it promotes new and previously neglected research into our rich oral traditions and customs" (Republic of South Africa 1999). As a new apparatus in the ANC arsenal, the past was summoned to serve the democratic state, to have economic, social and therapeutic benefits.

To the government's credit, early efforts were made to incorporate the hurtful histories of white rule. This assimilative strategy often appears under the rubric of the Rainbow Nation and saw full expression in the African Renaissance speeches of former president Thabo Mbeki. The term "Rainbow Nation," coined by Archbishop Desmond Tutu to reflect a new post-apartheid, democratic, multicultural society in South Africa, was quickly taken up by Nelson Mandela in his inaugural address. "Each of us is intimately attached to the soil of this beautiful country as are the famous jacaranda trees of Pretoria and the mimosa trees of the bushveld – a rainbow nation at peace with itself and the world" (Mandela 1994). Rainbow-ness could encompass nature and culture while successfully avoiding all reference to race in any specific terms of color. It was merely symbolic of the diversity of the nation's unspecified racial, ethnic, or cultural groups. Like culturalism before it, the rainbow narrative could be deployed politically and materially, whether for public performances or in the regalia of the state flag. The ANC deployed the rainbow mythos at the famed van Riebeeck celebrations commemorating European arrival in South Africa, previously associated with apartheid rule. Jan van Riebeeck and his wife, Maria de la Quellerie, were imputed as beginning "a 350-year struggle for national unity" in which purportedly everyone fought, and which ultimately led to a multicultural, rainbow-hued South Africa (Witz 2003). The supreme whiteness of van Riebeeck and de la Quellerie shifted to a rainbow color, dressed up in the language of multiculturalism and diversity. In a remarkable display of spin, Nelson Mandela declared that Jan van Riebeeck was one of the founders of the

South African nation. The crafting of such originary myths makes the security of a new South Africa dependent on quasi-fictive narrations of nationhood to which it may not be capable of standing up; its future is perched on a dangerous precipice of fabrication. This is similar to other racist fantasies, like Manifest Destiny, or the fundamental right to appropriate another's country, constituting the very rationale for colonization thereby forcing indigenous constituencies to celebrate their own oppression.

The Rainbow Nation represents a failed decolonization project. Though conceived as a lack it was produced through excess: an excess of history, an overburden of pastness, and inscription of history always onto the present. As Farred (2004: 362 594) would have it, "the past is too constitutive of the present." Tired of the hollow rhetoric and governmental desires to homogenize South African society, one Indian academic explained the dilemma, "in this post-rainbow nation euphoria, we've all become the same color. I don't think it's got to do with color, I think it's got to do with culture, and the culture of mass consumerism." The Rainbow Nation story, like the wider pan-African embrace of the African Renaissance, might have bolstered nation-building fervor during political transition but, more than a decade later, its promise is tired and unfulfilled. Both narratives rested on novel understandings of heritage and past culture, not only black African, as the van Riebeeck celebrations attest. Rainbow Nation-ness is the epitome of an imagined community à la Anderson (Lazarus 2004: 620). Yet it is this very lack of attention to history that fuels repeated ethnic and racial tensions and misunderstandings in post-democratic society. Instead of unraveling and making public the complexities of the deep past, the state would rather revel in the glories of re-enchanted history, on one hand, while simultaneously projecting them forward as exemplary models for progress on the other. South Africans are being educated through various cultural productions about what is best remembered and what it is best to forget. The very recent past of liberation can be underscored, yet the longer, more complex colonial history of the country, and the reasons why apartheid was successfully entrenched in the first instance has been subsequently downplayed.

Building upon the domestic vision of the Rainbow Nation, the African Renaissance demanded a cultural re-engagement with the rest of the continent with South Africa at the helm. At the philosophy's heart is a reliance on a suite of cultural (read archaeological) achievements from Southern Africa and beyond: San art, Great Zimbabwe, and so on link to the monumental efforts of ancient Egypt, Carthage, and Axum (see Mbeki 1996; 1998). Spearheaded by Mandela and promoted vigorously by Mbeki, the theme of an African Renaissance enjoyed regular public and media fanfare. With rousing pan-African zeal Mbeki famously addressed the Constitutional Assembly in 1996:

> I am an African ... I owe my being to the Khoi and the San whose desolate souls haunt the great expanses of the beautiful Cape ... I am formed of the migrants who left Europe to find a new home on our native land ... I am the grandchild of the warrior men and women that Hintsa and Skehukhune led ... My mind and my knowledge of myself is formed by the victories that are the jewels in our African crown, the victories we earned from Isandhlwana to Khartoum, as Ethiopians and as the Ashanti of Ghana, as the Berbers of the desert ... I am the grandchild who lays fresh flowers on the Boer graves at St. Helena.
>
> *(Mbeki 1996)*

This speech also reflects the cultural mythos of rainbow identity, a Rainbow Nation where black can expropriate Khoekhoe, San, and white histories (and presumably visa versa) with the ultimate aim of cultural therapy, thereby healing historic wounds and promoting interracial understanding. Such easy isomorphisms may have emotive appeal yet fail to take seriously

histories of cultural difference, not to mention colonial genocide and apartheid repression, for the sake of a willing amnesia.

President Mbeki's rhetoric around the African Renaissance was a clear example of this strategy to revive, regenerate, and reconstruct the past for the present, showcasing South Africa's achievements for national and international audiences. Like other aspects of early ANC rule, the nation's cultural heritage was primarily connected within Africa, rather than to the West or globally. Yet at the same time it was firmly rooted in a Western capitalist value system with a strong neoliberal agenda. He re-engineered continental institutions like the Organization of African Unity (OAU) and formed new ones, including the Southern African Development Community (SADC) and the New Partnership for Africa's Development (NEPAD) (Kagwanja 2008: xx). Heritage, then, had a dual mandate, to operate within the purview of the African Renaissance but also to be highly consumerist, which was one of the hallmarks of Mbeki's particular style of government. While heritage was easily touted as a wellspring for national pride and for economic growth, the enabling infrastructure and linkages made between resources and outcomes remained tenuous. After the 1994 elections, revitalizing a program of specifically African heritage was a necessity, albeit secondary to the agendas of restitution and civil infrastructure development. This might explain why the desire for making heritage pay continues to be so strong, yet heritage legislation, particularly at the provincial level, has been slow in implementation. Apartheid governments placed greater emphasis and directed far greater capital toward the promotion of natural heritage in the form of national parks and reserves. Mbeki's government was ultimately no different in terms of funding. There remains a general unwillingness to balance support for natural and cultural heritage since environmental tourism proves so lucrative and ensures injections of foreign currency. However [...] the naturalizing of culture and past communities, specifically in an African context, has negative and racist implications for certain communities today.

While politically expedient at the fragile moment of transition, critics have subsequently attacked the candy-coated myth of peace for temporary stability that has prevented real transformation in South Africa (Erasmus 2008). People I interviewed from various backgrounds expressed themselves as "tired" of Rainbow and Renaissance narratives; they felt that changes in social perceptions were being forced rather than developed. Their sentiments were summed up incisively by a young conservator: "I think they can be very empty terms if people don't have water to drink or a place to sleep or get the practical aid and help that they've been promised." Rainbow and Renaissance culture was undoubtedly inflected by the ethos of the Truth and Reconciliation Commission that permeated post-apartheid society. Remembering but also forgetting was deemed a vital therapeutic strategy for forgiveness and recovery during the 1990s (De Kok 1998; Mamdani 1996; Ndebele 1998). Some, like Brink (1998), argued that healing and social transformation can only be achieved after requisite forgetting, that ignorance can be politically expedient when precipitated by the state. Prescriptive state-sanctioned forgetting might ward off the dangers intrinsic to remembering past wrongs and quell fears over the endless chains of vendetta that revenge can unleash (Connerton 2008: 61). Forgetting can also be constitutive in the formation of new identities, which were needed after 1994. But newly crafted memories are frequently accompanied by a set of tacitly shared silences. Cultural critics also see dangers in the conflation and fabrication of historical narratives, arguing that the historicity of the past will be elided and that with forgetting comes the potential for future reprisals. It is perhaps no wonder, then, that the historical details of the South African past, its colonial oppressions and inequities, proved to be challenging for an emergent nation to publicly present, much less celebrate.

Instead of focusing much needed attention on the nation's own deep history, the new government gave substantial funds to Mali to conserve and make available historic, early

Making heritage pay in the Rainbow Nation

manuscripts in Timbuktu in an effort to help cement South Africa's precolonial linkages across Africa (Jeppie and Diagne 2008).[1] When I visited Timbuktu in 2008 the archives were impossible to access and there was no visible acknowledgement of South Africa's financial support. Such gestures sadly have not changed South African's perception of their own history as embedded within this larger frame, nor curbed violent xenophobia toward other Africans (Boonzaier and Spiegel 2008: 202). More seriously, at the time of writing, the government's continued support of Zimbabwean president Robert Mugabe, its recent blocking of UN resolutions against ethnic cleansing and human rights abuses, and its unwillingness to condemn rape and civilian attack in Darfur have led South Africa to be branded a "rogue democracy" (Kagwanja 2008). Emancipatory rhetorics rather than facticity may have been instrumental in forging an ultrademocratic, postcolonial state, yet today the African Renaissance fails to resonate with many South Africans in either spiritual or economic domains.

Neoliberal heritage

The heritage sector is booming in South Africa; there are new heritage agencies, NGOs, UNESCO World Heritage sites, and cultural patrimony is now interwoven with various government ministries and parastatals. Yet the state is attempting to contribute less in way of infrastructure with the expectation that private enterprise, the provincial sector, and international agencies will make up the deficit. Many new national initiatives are expected to be self-sustaining through private partnerships with business, and are based largely on the competitive tender system. As a result, new heritage venues are peculiarly promoted as centers for weddings, receptions, corporate events, and the *indabas* (or workshops) of which South Africans are so fond. New sites of heritage production, including the Origins Center, Maropeng, Didima, and the Cradle of Humankind, advertise widely as corporate or civic venues that are incidentally located in heritage landscapes. This trend is also visible in the parastatal organizations such as SANParks where much of the nation's cultural heritage resides. In 2005 SANParks boasted impressive increases in numbers of black visitors, up from 4 percent to 19.7 percent because of successful transformation. In 2007 it was discovered that the 62.2 percent of black visitors to Mapungubwe National Park (South African National Parks 2006) were attending conferences and workshops.

At the beginning of new dispensation, tourism was targeted as a priority for South Africa's economic development. Developing tourism was premised upon three principles: it would be government led, driven by the private sector, and should be community-based (Republic of South Africa 1996). The precise relationship between the state and private sectors was never specified, nor exactly what would constitute "community-based tourism" (Binns and Nel 2002; Hughes 2007: 273). Speaking during Heritage Month in 2009, the ANC's Chief Whip stressed the yet unfulfilled need to leverage South Africa's cultural and natural heritage for poverty eradication and socio-economic development (Motshekga 2009). Part of the difficulty results from a split portfolio with cultural heritage falling between two ministries, the DAC and the Department of Environment and Tourism (DEAT). More than any other sphere, tourism provides the linchpin. The number of international tourists has risen dramatically since the release of Nelson Mandela and lifting of international sanctions and stands at around seven million annually (Hughes 2007: 270). While domestic tourism is also growing, much of the cultural heritage discussed here remains the purview of the international market for a whole host of social and political factors.

NEPAD and the African Union (AU) effectively treat culture and heritage as integral to sustainable development programs across Africa (Jordan 2006a). NEPAD considers that escalating poverty levels, underdevelopment, and the continued marginalization of Africa require

countries like South Africa (but also countries like Morocco, see Lafrenz Samuels 2009) to harness every economic asset they possess. Influenced by the tenets of the African Renaissance, former minister for Arts and Culture Dr Z. Pallo Jordan expressed great pride in "the fact that Africa is the Cradle of Mankind" and in the "ancient kingdoms of Africa we find the earliest examples of abstract human thought." On the question of sustainable development he warns that "we can no longer rely on traditional methods of conservation and protection. The pressures rooted in under-development and poverty have created serious new threats to heritage sites. One of the challenges of the African Renaissance is empowering Africans to know, and to take pride in their world heritage sites, which are equal to those of other peoples of the world" (Jordan 2006a). While this might be true, it participates in the unwieldy logic that impoverished people are the problem for, and the main beneficiaries of, heritage. Pallo Jordan's personal dedication to the African past ensured the establishment of key initiatives at the Kamberg Rock Art Center, the Origins Center, and Thulamela, as well as in Mapungubwe National Park. Indeed, many fear that the status of archaeology and heritage in South Africa will be further weakened by his loss from the Arts and Culture portfolio in Zuma's new cabinet. Disastrous resignations from the Robben Island World Heritage Site and accusations of homophobia over an exhibit at Constitution Hill immediately plagued the next minister, Lulu Xingwana, herself soon to be replaced (Van Wyk 2010).

Heritage in South Africa has been called upon to fulfill numerous state level agendas: on the domestic front it is to provide social and economic regeneration as well as identitarian politics of nation making. On the international front, national heritage has to connect to the rest of the continent, to constitute a precise Africanity, to contribute to the narrative of origins and achievements that underpins the African Renaissance, and to fulfill globalist fantasies of self-sustainability. This was evidenced during the 2002 World Summit on Sustainable Development when then President Mbeki and Kofi Annan famously visited Sterkfontein Caves. Their imprinted footprints are now on display accompanied by a plaque with Annan's words of caution: "The lives our distant ancestors led here millions of years ago hold a clear lesson for us today: while their footprints on nature were small, ours have become dangerously large. The World Summit on Sustainable Development of 2002 must set humankind on a new path that will ensure the security and survival of the planet for succeeding generations." As Shepherd cleverly notes, Annan's words convey a biblical injunction in regard to salvation of the earth's resources. Salient for the project of this book, it summons the language of "sustainable development" to describe the nation's cultural heritage as well as the historicizing of the African Renaissance. Africa remains central, then, to world affairs, both because of its "originary status" but also the context of its plight today, which implicates the rest of the globe historically (Shepherd 2003: 826).

Taking a closer look at the Cradle of Humankind, a UNESCO World Heritage Site inscribed on the "Cultural Property" list, and specifically its flagship museum, Maropeng (Setswana for *the place where we once lived*), underlines the preoccupations with the rise of public–private enterprises, consultancy culture, and new urgencies around environmental risk, extinction, and resource depletion. Opened in 2005 by Thabo Mbeki and costing some R347 million, the Maropeng Visitor Center at the Cradle of Humankind World Heritage site was developed through a public-private partnership between the Guateng Provincial Government, the University of the Witwatersrand and Maropeng a'Afrika Leisure (Pty) Ltd. Typical of many new government-driven heritage ventures, there is a heavy and overt reliance upon the private sector, market principles, and corporate solutions (Comaroff and Comaroff 2009: 128). The international consultants were a British firm that specializes in theme parks, as can be seen in the proliferation of interactive zones, noisy media displays, and the underground boat ride that is similar to a Disneyland attraction. A plaque at the entrance celebrates a 2005 award by the

British Guild of Travel Writers, and etched in the background is the predictable string of free-floating signifiers: local economy, local community, responsible, sustainable, tourist potential, and education. Other awards include "best marketing campaign" and "best business unusual product or service." The Maropeng complex boasts not only a Visitor Centre with several restaurants and cocktail bar but also a 24-bedroom 4-star hotel and conference facilities for up to 500 delegates. Commercial advertising in brochures and magazines also directs clients to the Cradle Nature Reserve (and Game Reserve), specializing in weddings and conferences and home to the acclaimed Cradle Restaurant.

Maropeng was designed to celebrate South Africa's rich fossil record, which effectively charts our human evolution. Yet rather than promote cultural heritage or human history, the focus remains squarely with a "Commitment to the Environment," as their vision statement demonstrates. The Sustainability Wall explores themes like tool manufacture or fire usage and relates them to contemporary global crises. Instead of exploring the historic or contemporary practices of South Africans, their achievements such as gold smelting and iron working, early international trade or production of art, it jumps ahead to the contemporary focus on environmental catastrophe and degradation. Burning houses, polluted landscapes, shanty towns, unsustainable foods are all showcased with alarmist graffiti asking "will we destroy ourselves" and papered over with posters featuring Mandela, Che Guevara, anti-globalization, anti-animal testing, anti-apartheid, anti-war, AIDS, clean air, and women's rights campaigns. Pressing social issues like education, poverty, migration, unemployment, and hunger, so rife in South Africa, are collapsed in the singular call for environmental sustainability. The social has been replaced by the environmental, the cultural with the natural, and certainly the techniques of archaeology to uncover the fossil record with those of conservation. It is noteworthy that Maropeng is hardly a paragon of sustainability: it uses copious amounts of water internally for a fountain and outside to keep the grass on its tumulus green; it is constructed as a vast concrete and metal bunker; its displays use significant amounts of electricity as well as plastics, metals, glass, and paper. Maropeng's profligate cost has not been matched by visitor numbers, which are largely constituted by school groups, making the center itself unsustainable. Maropeng dramatically evinces the porosity of cultural and natural heritage designations and the tenacity with which environmental discourses permeate all sectors of public life.

Politicians have used Maropeng and other prehistoric sites like Mapungubwe and Thulamela to develop the idea of African civilization in the present, and contrast this with Western empires that are cited as responsible for violence, oppression, and degradation. The majority of speeches begin with the acknowledgement that "humanity first emerged in Africa. Africa is the Mother of humankind … Africa was, indeed, the first civilization, held in the highest esteem in antiquity" (Mancotywa 2007). African qualities like *ubuntu* need to be recouped in order to save the nation morally first, whence other benefits will follow.

> Heritage – not only is it a strategic resource for our country but it is a DNA of our society. The apartheid government created a wrong impression about our heritage, that it was only about buildings, bricks and mortars, hence monumentalising of [*sic*] heritage. In dealing with challenges facing the heritage sector it is important for us to ask ourselves, what is the role of heritage in nation building and national identity?
>
> *(Mancotywa 2007)*

Since 1994, the answers have congealed into a mantra: national cohesion, reconciliation, and regeneration. Resuscitating African civilization, therefore, will ultimately guarantee economic benefits and transformation and halt the moral decay. As Maropeng highlights, the state now

endorses a recombinant neoliberal heritage constituted from national emancipatory rhetoric and commercial production, and in doing so has missed the opportunity to educate its citizens about the complex history of South Africa's past.

By the mid-2000s South Africa's romance with cultural heritage had waned, as was reflected in the shift from impassioned political speeches to those demanding asset delivery. The onus was placed on the past to be self-sustaining. The shift from heritage as an inalienable asset to heritage as an economic driver was outlined in a speech by Pallo Jordan at the Donor's Conference for the African World Heritage Fund, an African-inspired initiative supported by UNESCO.[2]

> The concerns raised by the management of Africa's natural and cultural sites calls for a holistic approach that will make them less of a burden on the fiscus. To attain this we will have to change our attitude to our heritage sites. The manner in which we manage Africa's World Heritage Sites can transform them from fiscal burdens into economic assets. This site, where we are [Maropeng], for example, every weekend receives in excess of 300 guests. On long weekends, that figure escalates to more than 800. During holiday season it rises even higher, and many of those visitors are tourists from abroad who will spend their money here and in the surrounding towns and villages. Innovative management means the sites having a direct impact on the communities that surround them.
>
> *(Jordan 2006b)*

In less than two decades South African heritage was cast as a burden under apartheid and as an asset for the new nation's revivalism, then recast again as a burden on a strained fiscus and before once again being cast as a potential asset. Heritage has been made and unmade since 1994.

We might recall here that South Africa started the European phase of its history not as a colony of some far-flung nation or empire, but as an outpost for an international company. Capitalism was there from the beginning. It was about stockholders not citizens. So there is something oddly circular about the government's restructuring of the nation within a system of global capitalism (Terreblanche 2008: 122). The ANC's version of non-racialism has simply privatized and culturalized race (MacDonald 2006). It has also transformed South African culture, and de facto race, into an international brand (Chanock 2000: 24), in essence capitalizing culture. This assumes that "culture" is permanent and deeply historic, premised upon stable communities with shared structures of behavior and belief. Culture is then conservative rather than dynamic, it can thus be reified, mobilized, and put to work. Like the separation of church and state in a liberal democracy, race is relegated to the private, unofficial sphere (except for Black Economic Empowerment or BEE). This also gives "race" some traction. It can be celebrated under the banner of tradition, but it can also create enclaves and exclusions. The government's financial and commemorative investment in Freedom Park (Baines 2009), Walter Sisulu Square, and Constitution Hill celebrating a largely black, ANC vision of South Africa and its democracy is indicative. As a private, embodied, and cultural asset, "race" can be hived off to create a livelihood as well as remaining an inalienable property. The substitution of race for power/culture has played out since the 1994 elections: Mbeki employed racial nationalism to underpin democratic government during his presidency; he used democratic government to endorse capitalism, and finally turned to capitalism to materialize the importance of racial nationalism (MacDonald 2006: 127). In a country that claims to be non-racial, by which they mean race is not society's organizing principle, race continues to be absolutely inescapable. That race continues to assume the mantle of culture is a reminder of the tenacity and vitality of colonial categories.

Rainbow materialities

Many liberal intellectuals have pointed out that "ethnicity" and tribalism are forms of false consciousness promulgated by the apartheid government's grand plan for homelands and separate development policies (Robins 2001: 837). In the post-apartheid era this has impacted negatively upon certain groups that have claimed special status and recognition, particularly the San and Khoekhoe minorities. In this rather unstable landscape of ethnic making and unmaking, it is still the case that indigenous groups, often territorialized in the ways colonialism and apartheid subdivided the nation (Mamdani 1996; Mbembe 2000; 2001), are being encouraged through government initiatives, development schemes, and private enterprise to present themselves as culturally distinctive through the making and selling of their ethnically respective cultural objects and identities. Such artisanal economies are often supported by neoliberal policies (Colloredo-Mansfeld 2002: 113), often operating under the rubric of development and in South Africa, specifically, they are hitched universal tropes of cultural diversity and potential benefits. The performance of craft making, with all the associations of "primitive" otherness and essential difference, coupled with tourist-oriented "tribal" performances are promoted as recuperating African identities while promoting self help and a sustainable local economy. Some years ago the minister for Arts and Culture outlined:

> poor communities are in many instances, owners of assets – natural and material resources, human resources, cultural assets, indigenous knowledge, traditions and customs that can be the key agents for social and economic development. South Africa is blessed with a rich cultural tradition with artistic individuals and communities living in all corners of the country. Any poverty alleviation programme which aims at creating work opportunities must begin with these assets. We need to invest in people and their ability to make objects and artefacts, production and music.
>
> *(Sack 2003: 4)*

Material culture is one critical component here, particularly the fiction of a specific, ethnically bounded materiality that sediments identity in a pre-modern era and stands as an unchanging hallmark of "black" and "colored" peoples. These contemporary "primitivisms" reflect the earlier, and much critiqued, colonial refications of a simple way of life. Rewriting the past and being attendant to strategic essentialism in the present, we also need consider "both the fixity and fluidity of racial categories" and how people "reworked and contested the boundaries of taxonomic colonial states" (Stoler 1995: 199). Failure to do so simply compounds historical ignorance and allows dangerous prejudices to flare as they did around the 2006 opening of the Origins Center at the University of the Witwatersrand. Radio callers in Johannesburg were angered by the use of the term "First Peoples," and the inference they took from it that San and Khoekhoe arrived prior to black settlement. It was this notion of "Firstness" and primacy that black South Africans found offensive in its reinforcement of old apartheid narratives of their own late arrival. Yet instead of new alliances between San, Khoekhoe, and black constituencies, the flattening of historical processes spawns new discriminations that Rainbow Nation narratives have done little to ameliorate and that appear renewed and multiplied, like the proverbial hydra.

It could be said that South Africa has been a "state looking for a nation" (Appiah 1992: 262). One of the most performative arenas in which that process can unfold is in the heritage sector, replete with material symbolism that can be drawn upon for celebration and legitimation. Attention to archaeology, I would suggest, has been rather overshadowed by the predominance of

Lynn Meskell

human origins within the global fraternity of "cradle of humankind" sites on the one hand and celebration of the liberation movement, what is commonly known as "the struggle," on the other. The latter is reflected in the nine Legacy projects endorsed by Cabinet: the Women's Monument, the Anglo-Boer South/African War, Constitution Hill, the Chief Albert Luthuli Project, the Nelson Mandela and Samora Machel projects, the Ncome/Blood River Projects, the Khoisan Project and Freedom Park (Jordan 2004). McGregor and Schumaker observe that

> state-led commemorations of nationalist achievements and struggle histories have been highly selective, liable to elevate ruling party histories and heroes over others, often ignoring unions, youth or women, and dealing with violence selectively or not at all. It is interesting that the heroes and sites of early colonial revolts have been remarkably absent in public monuments, testimony perhaps to the growing marginalization of rural populations, the lack of local meaning ... or the difficulty of harnessing important living mediums and sacred sites to state projects. Rather than promoting national unity as intended, state heritage projects have often provoked controversy and resistance, particularly when combined with mounting popular disaffection, shifts towards authoritarianism and closure of the public sphere, the pressures of economic decline and gaping inequalities enhanced by neo-liberal adjustment.
>
> *(2006: 8)*

The real problem, I would argue, is the inattention heritage has paid to history. Heritage provides a hollow spectacle that is rarely educational or deeply historical: Freedom Park or Walter Sisulu Square provide pertinent examples (Marschall 2006b; Meskell and Scheermeyer 2008). This fails to address educational deficits perpetrated on South African citizens by decades of apartheid government. School texts and curricula encouraged racial and historical fictions and erased African achievement (see Esterhuysen 2000; Shepherd 2003; 2005). ANC ministers like Kadar Asmal have worked tirelessly with a small group of historians and archaeologists to change the textbooks, but the results are slow and certainly archaeology is yet to attract a new generation of black professionals.

Heritage might indeed be everywhere, but it is often nebulous, celebratory, and frequently without historical substance. Historians, working in conjunction with a younger generation of archaeologists, have begun to produce more detailed accounts of the deep and recent past that are both socially and politically relevant (see Bonner, Esterhuysen, and Jenkins 2007; Bonner, Esterhuysen, and Swanepoel 2009; Delius and Hay 2009). The 500 Year Initiative[3] is one such project that is actively working between history, geography, social anthropology, and archaeology with documentary, material, and oral evidence. Rather than adhering to the hard and fast categories of colonial tribalism, this project more than most has tried to track the emergence of modern South African identities. As we have seen, the attachment to tribalism has remained resilient through apartheid and post-apartheid eras.

Post-apartheid fetishizations of tribal culture are still haunted by the specter of homelands and separate development, taxonomies of primitivism, and often by the de-privileging "First Peoples" like the San and Khoekhoe. Whites, too, have been engaging in forms of cultural promotion and ethnic separatism, as the case of Orania makes clear. The town is a whites-only Afrikaner Volkstaat in the Northern Cape with its own flag and currency, premised upon the cultural preservation of the Afrikaner culture. Afrikaners feel that their special kind of historical persecution under the British, and now their marginalization under black majority rule, justifies their use of language and culture as instruments of identity politics and resistance (Garuba and Radithalo 2008; Kuper 2003; Nasson 2000; Stanley 2005). Yet as many interviewees have

asked me directly, why are there no Afrikaner cultural villages or craft stalls? Afrikaners claim to be African too, some even desire to be considered "indigenous" (see Kuper 2003: 389). Perhaps this inequity resides in the judgment that "Boer" culture is not suitably exotic for tourist spectacle, much less aesthetically appealing, and lacks the necessary historical substrate of continuity and tradition (but see Schutte 2003: 282). Afrikaner culture has visibly changed since the Great Trek; are we to be seduced into believing that Zulu culture has not? Some heritage development in South Africa has clearly been empowering, much of it is targeted towards tourism and reflects global trends, while other dimensions serve to reinforce boundaries and ossify identities. I have witnessed a range of schemes that defy easy determination or judgment, from pragmatic small-scale projects aimed at passing knowledge onto the next generation to desperate development-oriented projects instigated by well-intentioned NGOs that are "built to fail."

Arts funders, craft routes, and glossy art books all neatly divide South Africa into nine provinces with "culture at a glance," a rainbow of "traditional lifestyles" where distinct "tribal" material goods are sold: Tswana pottery, Pedi woodwork, Venda musical instruments, San beadwork, Tsonga weaving, Shangaan textiles, Ndebele murals, Swazi beadwork, Zulu baskets, Basotho blankets, Xhosa pipes, and Pondo woodwork. Communities are thus being branded, commodified, and recuperated though tribe-specific productions (Comaroff and Comaroff 2009: 37; Meskell 2005b). Promoters of these craft routes, like *Due South* (Eskom 2006), argue that regional tourism, particularly in rural areas, will not only benefit communities economically but change the anonymous face of craft production. Funded by Eskom, South Africa's power and electricity giant, and endorsed by the environment and tourism minister, sustainable development and cultural diversity remain the touchstones of this "crafting legacy."

Despite the promises made by governments, NGOs, and corporations alike that heritage promotion has obvious socio-economic benefits, the depressing images of failure and futility are the ones that persist: !Kun and Kwe women sitting on cold floors in tin sheds at Platfontein painting versions of ancient rock art in an assembly line of development (Weiss 2005), women beading jewelry in a deserted movie set that is now Shakaland, men in their eighties from impoverished villages bordering Kruger National Park who want to lead community tours showing how "the blacks live today" and telling stories about their ancestral sites. Franz Fanon (1963: 224–5) is invoked endlessly on this issue, to the point of cliché, yet his observations were undeniably astute: "the artist who has decided to illustrate the truths of the nation turns paradoxically towards the past and away from actual events. What he ultimately intends to embrace are in fact the castoffs of thought, its shells and corpses, a knowledge which has been stabilized once and for all." The material expression of those solidarities implicates archaeologists and anthropologists alike and also calls for critical historical analyses (see Herzfeld 1991; Leibhammer 2005) rather than romantic presumptions. Perhaps the most poignant example of this notion of material culture as uplift and national pride comes from Mbeki's speech on national heritage day:

> We are fortunate that there are still some ordinary men and women of our country who are daily weaving a memory, beading a legacy, cutting a spoor, telling a story and loading into these into bowls of history, a future for all our people ... the weavers of iHulzo and Isilulu, the baskets from Hlabisa woven with care by Reuben Ndwandwe and Beauty Ngxongo, the makers of Ntwana dolls, the Litema of the Basotho women, the iNcwala, the reed dance – these are only some of the traditions that have survived the passage of time.

(2004)

Five years later and the celebration of heritage is downplayed while the harsh realities of implementation are laid bare:

> The greatest challenge for the ANC government is to transform the heritage sector as it is primarily exclusive of the majority of black people in terms of ownership and management of heritage sites. Unless there is collective ownership of the heritage sector in South Africa, the existence and survival of heritage sites will remain threatened as the majority of the black people will perceive these sites as fiefdoms to enrich those unscrupulous individuals who exploit the poor as cheap labor.
>
> *(Motshekga 2009)*

The question remains, would indigenous people choose to perform these pasts if they had other alternatives? The rate of unemployment casts a bleak pall over this issue, especially in rural areas. A landscape littered with endless empty craft stalls and swamped by failed development schemes suggests that there are few options for many South Africans. Easy as the critique may be, few of us have been successful in providing viable alternatives. As decades of research have demonstrated, we would do better to abandon the top-down implementation of participation and development projects for a bottom-up program of capacity building and indigenous management (Cooke and Kothari 2001a; Lafrenz Samuels 2009; van der Waal 2008).

Perhaps this re-enchanted enthnicized landscape is the expected outcome of liberal heritage in countries like South Africa, as it has been in other parts of Africa and elsewhere (Bruner 2005; Bruner and Kirshenblatt-Gimblett 1994; Fontein 2005, Hodgson 2002b; Kirshenblatt-Gimblett 1998; Thomas 1994). Perhaps the Bantustan model has enjoyed such a long history that it too has become "traditional culture" despite black empowerment and mobility being high on the national agenda. Across Southern Africa foreign tourism has encouraged the expansion of "traditional villages" and commodified re-inventions of authentic local life. An entire spectrum of cultural villages now operate in South Africa (more than 40 nationally) from those of single ethnic groups such as the San (Meskell and Weiss 2006; Robins 2001), the Shangaan on the edge of Kruger National Park, or the Zulu at Shakaland, which pays homage to the Hollywood film set rather than a proud history, to the multi-ethnic enclaves like Lesedi Cultural Village. Cultural villages or ethnic villages, while having widespread popularity with tourists, retain a number of troubling aspects over cultural fixity, primitivism, and the reinforcement of ethnic stereotypes and cultural hierarchies, not to mention the repetitive futility of labor for those employed in such enterprises (Adams 2006; Bruner and Kirshenblatt-Gimblett 1994; Edensor 2001, Kirshenblatt-Gimblett 1998; Meskell 2005e; Notar 2006). Naturalizing uneven development in this way has relegated certain groups to a particular stage in the human past, thus extending old ideas about civilization and barbarism (Huggan and Tiffin 2007: 2). Many scholars have pointed to the specter of apartheid ethnic categorizations and segregations in the South African examples that simply resurrect a pre-democratic semblance of the past (Hughes 2007: 266; Rassool 2007). Despite copious deconstructions the desire for ethnic tourism and its more deeply rooted substrate, "the tribe," has been reinvigorated since 1994 with great alacrity.

Lesedi Cultural Village on the outskirts of Johannesburg is a prime example of the congealed ethnicities being performed daily to the delight of many. Visitors to Lesedi begin their tour by being funneled through four segregated villages representing South African culture: Xhosa, Sotho, Zulu, and Pedi. Ironically, there has been so much intermarriage between performers from different "tribes" that Protea Hotel management struggle to keep individuals in their correct tribal locations. When tourists arrive various performers scurry back to their

spatially and socially discrete cultural groups: such separations are impossible to maintain, even at the level of artifice. Brokering tightly bounded and scripted identities clearly has its limits. Lesedi relies upon a heavy materialist focus to inform visitors about cultural types: the Xhosa smoke particular pipes, the Zulu wear certain animal skins, the Sotho make one type of mat, and so on. As with most cultural villages, such didactic renditions are trapped in time, so there can be no modern Zulus or Pedi. Moreover, sexual stereotypes are reinforced and transacted between semi-clad young Zulus and foreign visitors as part of an authentic African experience. The imaginative worlds created by northern tourists in the global south have distinctive material and symbolic features. According to Ebron (2002: 165), they are underpinned by geopolitical fantasies: the smug sense of northern privilege, and the southern dream of opportunity and wealth in the north; the northern search for "something missing" that might be found in the south, and the southern pride in heritage. Such encounters are redolent with nineteenth-century images of pulsating tribes and the performance of ethnographic spectacle that seduces some tourists into imagining that they are partaking in the "real Africa" (Witz, Rassool, and Minkley 2001). This is not to say that cultural and historical traditions cannot be embraced or publicly celebrated, but by performing as "cultural others" many South Africans are inevitably re-living the past in public arenas rather than being presented as members of a new national modernity.

Travelling far south of Johannesburg, Ulundi is an impoverished and increasingly crime-stricken tract of KwaZulu Natal abutting apartheid's industrial wastelands, where Shakaland (like Lesedi) is managed by Protea Hotels. It epitomizes the fascination with tribal exoticism, hyper-masculinity, and Zulu warrior culture, set amidst clashes with colonial forces. Shakaland is its own kind of cultural desert: a depressing wasteland originally built for the Shaka Zulu television series and now branded as a high-end cultural village charging R600 per person per night (Schutte 2003: 481). We are welcomed to the "great Kraal as dedicated in the international TV series Shaka Zulu – now a living museum to the old Zulu order, please tread with respect." Visitors sleep in beehive huts, vividly painted and tackily decorated, amidst an assortment of aloes and cacti as well as goats, cats, and chickens in the sham simulacrum of a Zulu settlement. Trapped by the isolated location and regimented by the daily schedule, my colleague Thembi and I found the experience almost as dispiriting as the live-in workers at Shakaland. The sense of repetitive futility is palpable and workers seemed ground down by the tedium of life under the looking glass. At the tour's end a group of women assembled their beadwork on mats as if preparing for hundreds of tourists instead of two. As we passed through the official Shakaland shop a clichéd repertoire of "African" objects bore the tag "Made in China."

From the vantage of natural and cultural heritage, I suggest that the re-enchantment of South Africa's tribal heritage capitalizes upon various historical and contemporary projects described in this chapter. Many craft initiatives, heritage projects, and cultural villages are reminiscent of ethnic homelands as well as foreign tourist desires for African primitivism. In the new South Africa such productions are sanctioned forms of making heritage, creating jobs, boosting tourism, and celebrating culture and ethnic pride in the Rainbow Nation. They entreat the universal virtues of cultural diversity following on from biological diversity. What is left unquestioned is whether cultural diversity is "naturally" a good thing, why promoting people's difference and maintaining distinctiveness is beneficial or morally worthy. It is another example where overlaying an ecological model onto cultural heritage may be misplaced and have untoward consequences for the people it presumes to protect. Are we more concerned about saving cultural and material differences rather than allowing people to choose from a number of future-oriented lifeways? We may want to preserve a wide range of human conditions because it allows free people the best chance to constitute their own lives, yet this does not entail enforcing diversity

Lynn Meskell

by trapping people within differences they long to escape (Appiah 2006). A more cosmopolitan approach to heritage would not always endorse a preservationist stance (Meskell 2009: 4), nor attempt to congeal people within some preserved ancient authenticity.

Making heritage pay in Kruger

South African scholars have cogently critiqued cultural villages for years (Rassool 2000; Rassool and Witz 1996; Schutte 2003; Witz, Rassool, and Minkley 2001), and I was convinced that researching those forms of heritage making would likely duplicate their findings. Archaeologists are often drawn to representational issues, to the spectacular contortions of our data in the public arena. One of the many reasons Kruger National Park was a captivating field site was the dearth of research into the more mundane parastatal organizations that would promote the African past in their efforts to forge bold new futures. More importantly, there was the complexity of issues around heritage, economics, empowerment, and race that were being juggled by the state, donor agencies, corporations, and park officials. New techniques of government (Ferguson 2010), embedded in an economy of debt and payment, had reconfigured conservation and heritage by welcoming the private sector and community partnerships and engaging in didactic strategies to create new heritage citizens. Kruger was also generally indicative of the South African situation. It occupied the space of double time (Farred 2004), ever-cognizant of its formidable and repressive past, always looking back over its shoulder, and at the same time desperately trying to re-imagine itself, always future perfect. Nelson Mandela captured that particular double temporality during the park's centenary celebrations in 1998. The challenge was neither to "forget those who had to surrender their land to make it possible, often through forcible removal, nor those who for generations were denied access to their heritage except as poorly rewarded labour." His vision for the park's future was rehabilitation via a new liberalization program that would benefit the previously disenfranchised, and indeed all South Africans, who could now enjoy a reconfigured Kruger National Park. He argued that "tourism occupies a strategic place in our overall strategy for reconstruction and development, embracing the spirit of partnership that underlies all our achievements as a newly liberated nation." Specifically, he acknowledged the major role the private sector would play, "whether it be through the promotion of conservation; direct assistance in the upliftment of communities neighbouring on parks; or as business with an interest in the sustainable growth of the industry." Mandela's dream for Kruger importantly included an acknowledgement of the past and pointed to a liberal, developmental future. And as it transpired in the decade following his centenary speech, some economic elements of that dream have largely been realized.

SANParks was effectively realigned with the ANC's policies for corporate liberalization and transformation. This commercialization strategy followed the dominant paradigm of neoliberal economic thinking in South Africa, specifically the policy framework of Growth, Employment and Redistribution (GEAR). That also meant conservation science, for the first time, had to be traded off against the goals of privatization, tourism, black economic empowerment, and the awareness of countless communities and their development. SANParks opened its gates to consultancy culture with McKinseys, private luxury lodges, international foundations, development agencies, and foreign researchers. Apartheid-era branding gave way to an inclusive Africanity captured in the *Xa Mina i Xa Wena* motto ("It's Mine. It's Yours" in Tsonga) coupled with aggressive marketing and commodification. SANParks' mission today is to "develop and manage a system of national parks that represents the biodiversity, landscapes, and associated heritage assets of South Africa for the sustainable use and benefit of all.[4] After much reworking, SANParks' operations are today founded on three pillars: (i) biodiversity conservation;

398

(ii) nature-based tourism; and (iii) constituency building towards a people-centered conservation and tourism. A thoroughly modern park would come in tandem with modern science in the form of biodiversity conservation and new expertise from social ecology, but it was not seen fit to employ trained archaeologists or heritage experts. However, Kruger drew international attention at the moment of democratic transition by claiming the first collaborative archaeological project between blacks and whites of the new nation with the site of Thulamela. And they had struck gold.

In the 1990s the past looked as if it were going to have a real place in crafting a new future for Kruger National Park and its descendant communities. It was already promoted as a font of African pride, but it was promised to leverage economic partnerships, to offer grounds for reconciliation, and to find its niche alongside natural heritage. Liberal heritage was not simply a technique of governmentality but a spiritual resource serving up socio-economic benefits, reconciliation, and African revivalism. For many reasons, historic and contemporary, clusters of things that we call cultural and natural heritage, material culture, archaeology and rock art, indigenous knowledge, and tradition were all harnessed within the project of recovery and restitution. However, the central challenges of education, capacity, racism, and poverty remained. Past legacies and materials were called upon despite the public ambivalence to history, particularly the pre-colonial and colonial past that was largely ignored in the national arena in favor of very recent events (Meskell and Scheermeyer 2008). History offered up a negative reminder of apartheid's shadow and the complicity of Kruger Park: it was political, factional, and racial. It was a wound that might impede transition or breed further conflict, and addressing the past had the potential to tear the park asunder through successful land claims. Cultural heritage, moreover, was in danger of being hijacked by ecological urgencies around diversity, resilience, and risk that over-shadowed people and their histories. The placing of the past and its relationship to natural heritage in Kruger was still unresolved. There was so much history and so many histories, as Brown would say, that history itself seemed more vital and yet ever more fleeting.

Notes

1 www.loc.gov/exhibits/mali (accessed April 13, 2011).
2 www.awhf.net (accessed December 31, 2009).
3 http://web.wits.ac.za/Academic/Science/Geography/Research/500YearInitiative (accessed February 22, 2010).
4 www.sanparks.org/about/vision.php (accessed February 21, 2010).

Bibliography

Adams, K. M. (2006) *Art as Politics: Recrafting Identities, Tourism, and Power in Tana Toraja, Indonesia*. Honolulu: University of Hawaii Press.
Appiah, K. A. (1992) *In My Father's House*. London: Methuen.
Appiah, K. A. (2006) *Cosmopolitanism*. New York: Norton and Company.
Baines, G. (2009) Site of struggle: the Freedom Park fracas and the divisive legacy of South Africa, Border War/Liberation Struggle. *Social Dynamics: A Journal of African Studies* 35: 330–44.
Binns, T. and E. Nel (2002) Tourism as a local development strategy in South Africa. *The Geographical Journal* 168: 235–47.
Bonner, P., A. Esterhuysen, and T. Jenkins (eds) (2007) *A Search for Origins: Science, History and South Africa's 'Cradle of Humankind'*. Johannesburg: Wits University Press.
Bonner, P., A. Esterhuysen, and N. Swanepoel (eds) (2009) *Five Hundred Years Rediscovered: Southern African Precedents and Prospects*. Johannesburg: Wits University Press.
Boonzaier, E. and A. D. Spiegel (2008) Tradition, in N. Shepherd and S. Robins (eds), *South African Keywords*. Johannesburg: Jacana, pp. 195–208.

Brink, A. (1998) Stories of history: Reimagining the past in post-apartheid narrative, in S. Nuttall and C. Coetzee (eds), *Negotiating the Past: The Making of Memory in South Africa*. Cape Town; Oxford University Press, pp. 29–42.

Brown, W. (2001) *Politics out of History*. Princeton: Princeton University Press.

Bruner, E. M. (2005) *Culture on Tour: Ethnographies of Travel*. Chicago: University of Chicago Press.

Bruner, E. M. and B. Kirshenblatt-Gimblett (1994) Maasai on the lawn: Tourist realism in East Africa. *Cultural Anthropology* 9: 435–70.

Chanock, M. (2000) "Culture" and human rights: Orientalising, occidentalising and authenticity, in M. Mamdani (ed.), *Beyond Rights Talk and Culture Talk: Comparative Essays on the Politics of Rights and Culture*. New York: St Martin's Press, pp. 15–36.

Claassens, A. and B. Cousins (2008) *Land, Power and Custom: Coutroversies Generated by South Africa's Communal Land Rights Act*. Cape Town: University of Cape Town Press.

Colloredo-Mansfeld, R. (2002) An ethnography of Neoliberalism: Understanding competition in artisan economies. *Current Anthropology* 43: 113–37.

Comaroff, J. L. and J. Comaroff (2009) *Ethnicity, INC*. Chicago: University of Chicago Press.

Connerton, P. (2008) Seven types of forgetting. *Memory Studies* 1: 59–71.

Cooke, B. and U. Kothari (eds) (2001a) *Participation: The New Tyranny?* New York: Zed Books.

Daniel, J., R. Southall, and J. Lutchman (eds) (2005) *State of the Nation: South Africa 2004–2005*. Cape Town: HSRC Press.

De Kok, A. (1998) Cracked heirlooms: Memory on exhibition, in S. Nuttall and C. Coetzee (eds), *Negotiating the Past: The Making of Memory in South Africa*. Cape Town: Oxford University Press, pp. 57–71.

Delius, P. and M. Hay (2009) *Mpunialanga: An Illustrated History*. Johannesburg: The Highveld Press.

Dubow, S. (1995) *Scientific Racism in Modern South Africa*. Cambridge: Cambridge University Press.

Dubow, S. (2006) *A Commonwealth of Knowledge: Science, Sensibility, and White South Africa 1820–2000*. Oxford: Oxford University Press.

Ebron, P. A. (2002) *Performing Africa*. Princeton: Princeton University Press.

Edensor, T. (2001) Performing tourism, staging tourism. *Tourist Studies* 1: 59–81.

Erasmus, Z. (2008) Race, in N. Shepherd and S. Robins (eds), *South African Keywords*. Johannesburg: Jacana, pp. 169–81.

Eskom. (2006) *Due South: Travel Guide to South African Craft Sites*. Erasmuskloof: Eskom.

Esterhuysen, A. B. (2000) The birth of education archaeology in South Africa. *Antiquity* 74: 159–65.

Fanon, F. (1963) *The Wretched of the Earth*. New York: Grove Press, Inc.

Farred, G. (2004) The not-yet counterpartisan: A new politics of oppositionality. *The South Atlantic Quarterly Special Issue. After the Thrill is Gone: A Decade of Post-Apartheid South Africa* 103: 589–605.

Ferguson, J. (2007) Formalities of poverty: Thinking about social assistance in neoliberal South Africa. *African Studies Review* 50: 71–86.

Ferguson, J. (2010) The uses of neoliberalism. *Antipode* 41: 166–184.

Fontein, J. (2005) *The Silence of Great Zimbabwe: Contested Landscapes and the Power of Heritage*. London: University College London Press.

Foucault, Michel. (1977) Nietzsche, Genealogy and History. In *Language, Counter-Memory, Practice*, ed. D. Bouchard. Ithaca: Cornell University Press, pp. 139–64.

Garuba, H. and S. Radithalo (2008) Culture, in N. Shepherd and S. Robins (eds), *South African Keywords*. Johannesburg: Jacana, pp. 35–46.

Geldenhuys, H. (2004) Shame of San kids on public display. *Sunday Times* (Johannesburg), p. 5.

Gordon, R. B. (1987) Anthropology and apartheid: The rise of military ethnology in South Africa. *Cultural Survival* 11, www.culturalsurvival.org (accessed May 3, 2011).

Groenewald, Y. (2008) New land Act like apartheid. *Mail & Guardian* (Johannesburg). www.mg.co.za/article/2008-10-23-new-land-act-like-apartheid (accessed October 23, 2009).

Grunebaum, H. and Y. Henri (2003) Where the mountain meets its shadow: A conversation on memory, identity, and fragmented belonging in present-day South Africa, in B. Strath and R. Robbins (eds), *Homelands: Poetic power and the Politics of Space*. Brussels: Peter Lang.

Grunebaum-Ralph, H. (2001) Re-Placing Pasts, Forgetting Presents: Narrative, Place, and Memory in the Time of the Truth and Reconciliation Commission. *Research in African Literatures* 32: 198–212.

Hall, M. (1984) The burden of tribalism: The social context of southern African Iron Age Studies. *American Antiquity* 49: 455–67.

Hall, M. (2006) Identity, memory and countermemory: The archaeology of an urban landscape. *Journal of Material Culture* 11: 189–209.

Hamilton, C. (2009) Uncertain citizenship and public deliberation in post-apartheid South Africa. *Social Dynamics: A Journal of African Studies* 35: 355–74.

Harries, P. (1991) Exclusion, classification and internal colonialism: The emergence of ethnicity among the Tsonga-speakers of South Africa, in L. Vail (ed.), *The Creation of Tribalism in Southern Africa*. Berkeley and Los Angeles: University of California Press, pp. 82–117.

Herzfeld, M. (1991) *A Place in History: Social and Monumental Time in a Cretan Town*. Princeton: Princeton University Press.

Hodgson, D. L. (2002a) Introduction: Comparative Perspectives on the Indigenous Rights Movement in Africa and the Americas. *American Anthropologist* 104: 1037–49.

Hodgson, D. L. (2002b) Precarious Alliances. The Cultural Politics and Structural Predicaments of the Indigenous Rights Movement in Tanzania. *American Anthropologist* 104: 1086–97.

Huggan, G. and H. Tiffin (2007) Green postcolonialism, *Interventions: International Journal of Postcolonial Studies* 9: 1–11.

Hughes, H. (2007) Rainbow, renaissance, tribes and townships: Tourism and heritage in South Africa since 1994, *State of the Nation: South Africa 2007*. Cape Town: HSRC Press, pp. 266–88.

Ivison, D. (2002) *Postcolonial Liberalism*. Cambridge: Cambridge University Press.

Ivison, D. (2007) Indigenous rights and the history of colonization, in W. A. Darity (ed.), *International Encyclopedia of the Social Sciences*. Farmington Hills: Macmillan, pp. 614–17.

Jeppie, S. and S. B. Diagne (eds) (2008) *The Meanings of Timbuktu*, Cape Town: Human Sciences Research Council.

Jordan, P. Z. (2004) Keynote address by Minister Z Pallo Jordan, Minister of Arts and Culture, at the Third meeting of the National Heritage Council (NHC), in Mpumalanga, July 31, 2004.

Jordan, P. Z. (2006a) Keynote Address by Minister of Arts and Culture, Z Pallo Jordan at the Launch of the African World Heritage Fund. Maropeng Exhibition Centre, May 5, 2006.

Jordan, P. Z. (2006b) Minister of Arts and Culture, Dr Z. Pallo Jordan, on the Occasion of the Donor's Conference for the African World Heritage Fund. Maropeng, Gradle of Humankind, May 4, 2006.

Kagwanja, P. (2008) Introduction: Uncertain democracy – elite fragmentation and the disintegration of the "nationalist consensus" in South Africa, *State of the Nation South Africa 2008*. Cape Town: HSRC, pp. xv–xlix.

Kirshenblatt-Gimblett, B. (1998) *Destination Culture: Tourism, Museums, and Heritage*. Berkeley: University of California Press.

Kuper, A. (2003) The return of the native. *Current Anthropology* 4: 389–95.

Lafrenz Samuels, K. (2009) Trajectories of development International heritage management of archaeology in the Middle East and North Africa. *Archaeologies* 5: 68–91.

Lafrenz Samuels, K. (2010) Mobilizing heritage in the Maghrib: Rights, development, and transnational archaeologies. PhD thesis. Department of Anthropology, Stanford University, Stanford.

Lazarus, N. (2004) The South African ideology: The myth of exceptionalism, the idea of renaissance. *The South Atlantic Quarterly Special Issue. After the Thrill is Gone: A Decade of Post-Apartheid South Africa* 103: 606–28.

Leibhammer, N. (2005) Technologies and transformations: Baskets, women and change in twentieth-century KwaZulu Natal, in M. Arnold and B. Schmahmann (eds), *Between Union And Liberation: Women Artists In South Africa 1910–1994*. Aldershot: Ashgate, pp. 111–31.

MacDonald, M. (2006) *Why Race Matters in South Africa*. Scottsville: KZN Press.

Malan, T. and P. S. Hattingh (1976) *Black Homelands in South Africa*. Pretoria: Africa Institute of South Africa.

Mamdani, M. (1996) *Citizen and Subject: Contemporary Africa and the Legacy of Late Colonialism*. Princeton: Princeton University Press.

Mancotywa, S. (2007) Renaissance of African civilization challenges facing the heritage sector, Eastern Cape Heritage Indaba. Unpublished report. National heritage Council.

Mandela, N. (1994) Statement of the President of the African National Congress, Nelson Mandela, at his Inauguration as President of the Democratic Republic of South Africa, Union Buildings, Pretoria, May 10 1994. Pretoria, South Africa.

Marschall, S. (2006b) Visualizing memories: The Hector Pieterson Memorial in Soweto. *Visual Anthropology*. 19: 145–69.

Mbeki, T. (1996) Statement of Deputy President Tabo Mbeki, on behalf of the African National Congress, on the occasion of the adoption by the constitutional assembly of "The Republic of South Africa Constitution Bill 1996." Cape Town, May 8, 1996.

Mbeki, T. (1998) The African Renaissance Statement of Deputy President, Thabo Mbeki. SABC, Gallagher Estate, August 13, 1998.

Mbeki, T. (2004) Remarks of the President of South Africa, Thabo Mbeki, on the occasion of the celebration of National Heritage Day. Galeshewe, Kimberly. September 24, 2004.

Mbembe, A. (2000) At the edge of the world: Boundaries, territoriality, and sovereignty in Africa. *Public Culture* 12: 259–84.

Mbembe, A. (2001) *On the Postcolony.* Berkeley: University of California Press.

McEachern, C. (2002) *Narratives of National Media, Memory and Representation in the Making of the New South Africa.* New York: Nova.

McGregor, J. and L. Schumaker (2006) Heritage in Southern Africa: Imagining and marketing public culture and history. *Journal of Southern African Studies* 32: 649–65.

Meskell, L. M. (2005b) Object orientations, in L. M. Meskell (ed.), *Archaeologies of Materiality.* Oxford: Blackwell, pp. 1–17.

Meskell, L. M. (2005c) Objects in the mirror appear closer than they are, in D. Miller (ed.), *Materiality.* Durham: Duke University Press.

Meskell, L. M. (2005e) Sites of violence: Terrorism, tourism and heritage in the archaeological present, in L. M. Meskell and P. Pels (eds), *Embedding Ethics.* Oxford: Berg, pp. 123–46.

Meskell, L. M. (2007b) Living in the past: Historic futures in double time in N. Murray, M. Hall, and N. Shepherd (eds), *Desire Lines: Space Memory and Identity in the Postapartheid City.* London: Routledge, pp. 165–79.

Meskell, L. M. (2009) Cosmopolitan heritage ethics, in L. M. Meskell (ed.), *Cosmopolitan Archaeologies.* Durham: Duke University Press.

Meskell, L. M. and C. Scheermeyer (2008) Heritage as therapy: Set pieces from the new South Africa. *Journal of Material Culture* 13: 153–73.

Meskell, L. M. and L. W. Weiss (2006) Coetzee on South Africa's past: Remembering in the time of forgetting. *American Anthropologist* 108: 88–99.

Moore, D. S. (2005) *Suffering for Territory: Race, Place, and Power in Zimbabwe.* Durham: Duke University Press.

Motshekga, M. (2009) Heritage Month 2009. www.anc.org.za/caucus/docs/notes/2009/nt0925.html (accessed November 13, 2009).

Nasson, B. (2000) Commemorating the Anglo-Boer War in post-apartheid South Africa. *Radical History Review* 2000: 149–65.

Ndebele, N. (1998) Memory, metaphor, and the triumph of narrative, in S. Nuttall and C. Coetzee (eds), *Negotiating the Past: The Making of Memory in South Africa.* Cape Town: Oxford University Press, pp. 19–28.

Ndlovu-Gatsheni, S. J. (2008) Black republican tradition, nativism and populist politics in South Africa. *Transformation* 68: 53–86.

Nieves, A. D. (2008) Places of pain as tools for social justice in the "new" South Africa: Black heritage preservation in the "rainbow" nation's townships, in W. S. Logan and K. Reeves (eds), *Places of Pain and Shame: Dealing with "Difficult Heritage."* London: Routledge, pp. 198–214.

Notar, B. E. (2006) *Displacing Desire: Travel and Popular Culture in China.* Honolulu: University of Hawaii Press.

Omond, R. (1985) *The Apartheid Handbook: A Guide to South Africa's Everyday Racial Policies.* Harmondsworth: Penguin.

Oomen, B. (2005) *Chiefs in South Africa: Law, Power and Culture in the Post-Apartheid Era.* New York: Palgrave.

Povinelli, E. A. (2002) *The Cunning of Recognition.* Durham: Duke University Press.

Ranger, T. (2010) The invention of tradition in colonial Africa, in R. R. Grinker, S. C. Lubkemann, and C. B. Steiner (eds), *Perspectives on Africa: A Reader in Culture, History and Representation.* Oxford: Blackwell, pp. 450–61.

Rassool, C. (2000) The rise of heritage and the reconstitution of history in South Africa. *Kronos: Journal of Cape History* 26: 1–21.

Rassool, C. (2007) Memory and the politics of history in the District Six Museum, in N. Murray, N. Shepherd, and M. Hall (eds), *Desire Lines: Space, Memory and Identity in the Post-Apartheid City.* London: Routledge, pp. 113–27.

Rassool, C. and S. Prosalendis (2001) *Recalling Community in Cape Town: Creating and Curating the District Six Museum.* Cape Town: District Six Museum Foundation.

Rassool, C. and L. Witz (1996) South Africa: A World in One Country; Moments in International Tourist Encounters with Wildlife, the Primitive and the Modern. *Cahiers d'études africaines* 143: 335–71.

Republic of South Africa (1996) White paper on the development and promotion of tourism in South Africa. Pretoria: Government of South Africa, Department of Environmental Affairs and Tourism.

Republic of South Africa (1999) Preamble: National Heritage Resources Act. Pretoria: Government Printer.

Robins, S. (2001) NGOs, "Bushmen" and double vision: The ≠khomani San land claim and the cultural politics of "community" and "development" in the Kalahari. *Journal of South African Studies* 27: 833–53.

Sack, S. (2003) Poverty alleviation, in *Investing in Culture*. Pretoria: Department of Arts and Culture, pp. 4–5.

Scheermeyer, C. (2005) A changing and challenging landscape: Heritage resources management in South Africa. *South African Archaeological Bulletin* 60: 121–3.

Schutte, G. (2003) Tourists and tribes in the "New" South Africa. *Ethnohistory* 50: 473–87.

Shepherd, N. (2003) State of the discipline: Science, culture and identity in South African archaeology, 1870–2003. *Journal of Southern African Studies* 29: 823–44.

Shepherd, N. (2005) Who is doing courses in archaeology at South African universities? And what are they studying? *The South African Archaeological Bulletin* 60: 123–6.

South African National Parks (2006) *Go Wild*. April 2006. Pretoria: SANParks.

Stanley, L. (2005) Aftermaths: Post/memory, commemoration and the concentration camps of the South African War 1899–1902. *European Review of History* 12: 91–119.

Stoler, A. (1995) *Race and the Education of Desire*. Durham: Duke University Press.

Sylvain, R. (2002) Land, Water, and Truth: San identity and global indigenism. *American Anthropologist* 104: 1074–85.

Terreblanche, S. (2008) The developmental state in South Africa: The difficult road ahead, in P. Kagwanja and K. Kondlo (eds), *State of the Nation: South Africa 2008*. Cape Town: HSRC Press, pp. 107–30.

Thomas, N. (1994) *Colonialism's Culture: Anthropology, Travel and Government*. Princeton: Princeton University Press.

van der Waal, K. (2008) Development, in N. Shepherd and S. Robins (eds), *South African Keywords*. Johannesburg: Jacana, pp. 58–68.

Van Wyk, L. (2010) Xingwana: Homophobic claims "baseless, insulting." *Mail & Guardian (Johannesburg)*, March 5. www.mg.co.za/article/2010-03-05-xingwana-homo-phobic-claims-baseless-insulting (accessed May 3, 2011).

Wainaina, B. (2005) How to write about Africa. *Granta* 92: The View from Africa: 92–5.

Weiss, L. M. (2005) The social life of rock art: Materiality, consumption and power in South African heritage, in L. M. Meskell (ed.), *Archaeologies of Materiality*. Oxford: Blackwell, pp. 46–70.

Witz, L. (2003) *Apartheid's Festival: Contesting South Africa's National Pasts*. Bloomingdale: Indiana University Press.

Witz, L. (2007) Museums on Cape Town's township tours, in N. Murray, M. Hall, and N. Shepherd (eds), *Desire Lines: Space Memory and Identity in the Postapartheid City*. London: Routledge, pp. 259–75.

Witz, L., C. Rassool, and G. Minkley (2001) Repackaging the past for South African Tourism. *Daedalus* 130: 277–96.

28
The concept and its varieties

Anthony Smith

Before we can embark on a substantive historical sociology of nations and nationalism, we must have a clear idea of the objects of our enquiry. Second, we need to examine the social processes and cultural resources of the formation and persistence of nations. Third, the question of pre-modern nations requires a deep historical perspective and a cultural genealogy of nations that stretches back to the ancient Near East and the classical world, if we are to gauge the traditions through which different types of national identities were formed in the early modern period.

The modernist conception of the nation sees it as the quintessential political form of modern human association. For most modernists, the nation is characterized by:

1 a well-defined territory, with a fixed center and clearly demarcated and monitored borders;
2 a unified legal system and common legal institutions within a given territory, creating a legal and political community;
3 participation in the social life and politics of the nation by all the members or "citizens";
4 a mass public culture disseminated by means of a public, standardized, mass education system;
5 collective autonomy institutionalized in a sovereign territorial state for a given nation;
6 membership of the nation in an "inter-national" system of the community of nations;
7 legitimation, if not creation, of the nation by and through the ideology of nationalism.

This is, of course, a pure or ideal type of the concept of the nation, to which given instances approximate, and it acts as a touchstone of nationhood in specific cases. As such, it has become almost "taken-for-granted" as *the* definitive standard from which any other conception represents a deviation.[1]

Problems of the modernist conception

But closer inspection reveals that the modernist conception of the nation is historically specific. As such, it pertains to only one of the historical forms of the concept, that of the *modern nation*. This means it is a particular variant of the general concept of the nation, with its own peculiar features, only some of which may be shared by other forms or variants of the general concept.

The concept and its varieties

Can we be more specific about the provenance of the ideal type of the *modern nation*? A glance at its salient features – territoriality, legal standardization, participation, mass culture and education, sovereignty, and so on – places it squarely in the so-called *civic-territorial* tradition of eighteenth- and early nineteenth-century Western Europe and North America. It was in the age of revolutions and the Napoleonic Wars that a conception of nationhood distinguished by the rationalist, civic culture of the Enlightenment, notably its later "Spartan" or "neo-classical" phase associated with Rousseau, Diderot, and David, became prevalent. As Hans Kohn documented many years ago, this conception of the nation flourished mainly in those parts of the world where a powerful bourgeoisie took the lead in overthrowing hereditary monarchy and aristocratic privilege in the name of "the nation." This is not the kind of nation imagined, let alone forged, in many other parts of the world, where these social conditions were less developed or absent.[2]

Now, if the concept of the *modern nation* and its peculiar features derive from eighteenth- and early nineteenth-century conditions in the West, then the modernist ideal type is inevitably a partial one, because it refers to a specific subtype of the generic concept of the nation, the *modern nation*, and only one kind of nationalism, the civic-territorial type. This means that a specific version of a general concept stands in for the whole range of ideas covered by that concept, a version that bears all the hallmarks of the culture of a particular time and place. It also means that the assertion of the modernity of the nation is no more than a tautology, one which rules out any rival definition of the nation, outside of modernity and the West. The Western conception of the *modern* nation has become the measure of our understanding of the concept of the nation *per se*, with the result that all other conceptions become illegitimate.

Methodological grounds apart, there are a number of reasons why such an arbitrary stipulation should be rejected. In the first place, the term "nation," deriving from *natio* and ultimately *nasci* (to be born), has a long, if tortuous, history of meaning, going back to the ancient Greeks and Romans... . [I]ts usage was not confined to geographically defined student bodies in medieval universities or to assembled bishops at Church Councils hailing from different parts of Christendom. It derived from the Vulgate translation of the Old and New Testaments, and from the writings of the Church Fathers, who opposed the Jews and Christians to all other nations, who were termed collectively *ta ethne*. Ancient Greek itself used the term *ethnos* for all kinds of groups sharing similar characteristics (not only human ones); but authors like Herodotus sometimes used the cognate term *genos*. In this, they were not unlike the ancient Jews, who generally used the term *am* for themselves – *am Israel* – and the term *goy* for other peoples, but with no great consistency. The Romans were more consistent, reserving for themselves the appellation *populus Romanus* and the less elevated term *natio* for others, and especially for distant, barbarian tribes. In time, however, *natio* came to stand for all peoples, including one's own. We cannot regard these premodern usages of *natio*/nation as purely "ethnographic," in opposition to the political concept of modern usage, for this does scant justice to the range of cases from the ancient and medieval worlds that combine both usages – starting with ancient Israel. Even though the meanings of terms often undergo considerable change in successive periods, still we cannot so easily dismiss the long history of these usages prior to the onset of modernity.[3]

A second problem concerns the modernist conception of the "mass nation." This has been partly addressed in connection with Walker Connor's thesis of mass participation in the life of the nation as the criterion of its existence, and hence the need, in a democracy, for the enfranchisement of the majority of the population as a condition for designating it a nation. But it goes beyond this particular issue. Modernists like Karl Deutsch, Ernest Gellner, and Michael Mann regard the "mass nation" as the only genuine form of the nation, and as a result treat the nation as a strictly modern phenomenon. Theorists are, of course, perfectly entitled to designate a

405

particular phenomenon – the "mass nation" in this case – as the sole political "reality," and regard every other version as secondary and insubstantial, if not misleading. But if medieval historians can demonstrate the historical basis and importance of these other versions, which is exactly the point at issue for the neo-perennialists, the modernist stance once again becomes arbitrary and unnecessarily restrictive. This applies also to the weaker claim that the mass nation of modernity is the "fully fledged" version of the nation, and all others are lacking in some measure: does this mean that we cannot conceive of other kinds of nation from which the masses were excluded? After all, well into the modern epoch, few recognized nations could be termed "mass nations" – many members of their populations, notably the working class, women, and ethnic minorities, remained in practice excluded from the exercise of civic and political rights. So we should at least be prepared to recognize the possibility of other kinds of "nation," apart from "mass nations."[4]

A further problem stems from the common modernist assertion that nations are the product of nationalisms (with or without help from the state), and since nationalism, the ideological movement, appeared no earlier than the eighteenth century, nations must also be modern. But, even if we accept that, as a systematic ideology, nationalism did not emerge before the eighteenth century, the assumption that only nationalists create nations is questionable; and this is true, even if we define the *ideological* movement of nationalism, along with other ideologies, in relatively "modernist" terms, as I think we must, if only to avoid confusing it with more general concepts like "national sentiment" or "national consciousness."

Now, by nationalism, I mean *an ideological movement for attaining and maintaining autonomy, unity, and identity on behalf of a population, some of whose members deem it to constitute an actual or potential "nation."* And similarly, I think we can designate a "core doctrine" of nationalism, a set of general principles to which nationalists adhere, as follows:

1 the world is divided into nations, each with its own history, destiny, and character;
2 the nation is the sole source of political power;
3 to be free, every individual must belong to and give primary loyalty to the nation;
4 nations must possess maximum autonomy and self-expression;
5 a just and peaceful world must be based on a plurality of free nations.

In this sense, it was only in the later eighteenth and early nineteenth centuries that "nationalist" ideologies were embraced by writers and thinkers in West and Central Europe, from Rousseau and Herder to Fichte and Mazzini. As such, nationalism is a modern doctrine, and the ideological hallmark of that modernity resides in the relatively novel assumptions about political autonomy and authenticity that underlie the doctrine, and in the way these are combined with a political anthropology.[5] But this is not to deny that some elements of the doctrine go back much further. For example, ideas of the nation and a comity of nations were clearly present at the Council of Constance in 1415, and we can find many references to nations and their relations in earlier centuries, going back to antiquity, even if their interpretation poses serious problems. This means that some conceptions of the nation, which may well differ from modern conceptions of the nation, antedate by several centuries the appearance of nationalism and its particular interpretations of the nation; and as a result the concept of the nation cannot be simply derived from the ideology of nationalism. To confine the concept and the practice of the nation to an era of nationalism, and regard them as products of this modern ideology, is again arbitrary and unduly restrictive.[6] But perhaps the most serious defect of the modernist ideal type of the *modern nation* is its inherent ethnocentrism. This has, of course, been recognized by many theorists. Yet, they continue to treat the Western civic-territorial form of the modern nation and its

The concept and its varieties

nationalism as normative, and other forms as deviations. This was the basis of Hans Kohn's celebrated dichotomy of "Western" and "non-Western" nationalisms mentioned earlier. The latter, unlike their rationalist, enlightened, liberal counterparts, tend to be organic, shrill, authoritarian, and often mystical – typical manifestations of a weak and disembedded intelligentsia. Kohn's dichotomy has been followed by John Plamenatz, Hugh Seton-Watson, Michael Ignatieff, and many others for whom the popular distinction between "civic" and "ethnic" nationalisms encapsulates this normative tradition.[7]

Now, while these theorists would concede that "ethnic" nationalisms share with their "civic" counterparts such features as collective attachments to a "homeland," as well as ideals of autonomy and citizenship for "the people," they also highlight the very considerable differences. In the "ethnic" variant of nationalism, the nation is seen to be possessed of:

1 genealogical ties – more specifically, presumed ties of ethnic descent traceable through the generations to one or more common ancestors, and hence membership of the nation in terms of presumed descent;
2 vernacular culture – a culture that is not only public and distinctive, but also indigenous to the land and people in terms of language, customs, religion, and the arts;
3 nativist history – a belief in the virtues of indigenous history and its special interpretation of the history of the nation and its place in the world;
4 popular mobilization – a belief in the authenticity and energy of the "people" and its values, and the need to rouse and activate the people to create a truly national culture and polity.

This implies that, for ethnic nationalists, the "nation" is already in place at the onset of both modernity and nationalism in the form of pre-existing ethnic communities available and ready, as it were, to be propelled into the world of political nations. So, for example, in this "neo-perennialist" view, the Arab nation, descended from Arabic-speaking tribes of the Arabian peninsula, has persisted throughout history, at least from the time of the Prophet, and exhibits the classic features of an "ethnic" nation – presumed genealogical ties of descent, a classic indigenous vernacular culture (notably Qur'anic Arabic), a nativist Arab ethnohistory, and the ideal of "the Arabs" of Islam as the fount of wisdom and virtue who only need to be mobilized to achieve political autonomy. In this and similar cases, we witness the failure of modernism to include this quite different ethnic conception of the nation, which in turn derives from its theoretical rejection of any necessary linkage between ethnicity and nationhood.[8]

Category and description

One of the main problems with the modernist conception is its failure to recognize that the term "nation" is used in two quite different ways. On the one hand, it denotes an analytic category differentiating the nation from other related categories of collective cultural identity; on the other hand, it is used as a descriptive term enumerating the features of a historical type of human community. The problem is compounded by the fact that the historical type of human community denoted by the term "nation" is cultural and/or political, or both: that is, it designates a type of human community that is held to possess a collective cultural identity or a collective political identity, or both.[9]

There is, of course, nothing improper about using terms like "nation" to describe the features of certain kinds of historical community. The problem arises when the description is such as to restrict arbitrarily the range of instances which might be included under the ideal type of

the nation seen as a category of analysis. Of course, the degree to which this constitutes a serious defect is a matter for individual judgment. But my contention is that most modernists, prompted by their theoretical stance, have gone too far in the direction of arbitrary and unnecessary restriction. If they were content to describe a subset of the general category of nation, i.e., the *modern nation*, there would be no problem. But they then go on to assert that this subset stands for the whole, and this is where a descriptive historical term becomes entangled with a general analytic category. This is not to embrace a neo-perennialist approach which would make it difficult for us to distinguish national from other kinds of collective cultural and/or political identity, or to decide which instances of community and identity fell under the "national" rubric. It is exactly these kinds of distinctions that attempting to keep the analytic category of the nation separate from its use as a descriptive term may enable us to make.[10]

Given the complex ramifications of the concept of the nation, it is no easy task to separate the analytic category from the historical descriptions of the nation. The descriptive use of the term will be necessary for enumerating the features of different subtypes of the general category of the nation. But, before we can attempt such historical description, we need a clear understanding of the nation as a general analytic category differentiated from other related categories.

The first step, then, is to define the concept of the nation in ideal-typical terms, and thereby recognize the persistent nature of the analytic category as a transhistorical ideal type. Here the term "nation" represents an analytic category based on general social processes which *could* in principle be exemplified in any period of history. By differentiating the analytic category of the nation from other categories of collective identity, we may avoid designating all kinds of community and identity as "nations." At the same time, this procedure offers some chance of freeing the category of the nation from undue restrictions and offers the possibility of finding instances of the nation outside the modern period and the West, if the evidence so indicates. Thus the concept of the nation, like that of the religious community and the *ethnie*, should in the first instance be treated as a general analytic category, which can in principle be applied to all continents and periods of history. On the other hand, the content of the "nation" as a historical form of human community, exemplified in the specific features of its subtypes, will vary with the historical context. With each epoch we may expect important variations in the features of nations, but they will nevertheless accord with the basic form of the category. As at one and the same time an analytic category based on general social processes and a historical form of human community characterized by a cultural and/or a political collective identity, the ideal type of the nation is inevitably complex and problematic, and its construction is for this reason a fraught and contested task, and one which necessarily involves an element of stipulation.[11]

In this spirit, I propose the following ideal-typical definition of the "nation," as *a named and self-defined human community whose members cultivate shared myths, memories, symbols, values, and traditions, reside in and identify with a historic homeland, create and disseminate a distinctive public culture, and observe shared customs and common laws.* In similar vein, we may also define "national identity" as *the continuous reproduction and reinterpretation of the pattern of values, symbols, memories, myths, and traditions that compose the distinctive heritage of nations, and the identification of individuals with that pattern and heritage.*[12]

Three assumptions have led to the selection of the features of the ideal type. The first is the centrality of social processes and symbolic resources in the formation and persistence of nations, giving them their distinctive but flexible character. The second is that many of the features of the ideal type derive from prior ethnic and ethnoreligious symbols, traditions, myths, and memories among populations deemed to be similar or related. Together, these two assumptions address the question of "who is the nation?," i.e., the unique character of the historic nation.

The third assumption is that these social processes and symbolic resources, though subject to periodic change, may resonate among populations over long periods of time. This means that our analyses of the formation and persistence of nations require, as John Armstrong has so clearly demonstrated, a scrutiny of social and symbolic processes across successive historical epochs over the *longue durée*.[13]

The insistence on analyzing social and cultural elements over the long term implies, first of all, that nations be treated separately from national*ism*, and that the formation of nations needs to be investigated independently of the rise of the ideological movement of nationalism. Second, by bringing together past (history), present time, and future (destiny), the way is opened for long-term analysis of ethnic and national phenomena across different epochs. This in turn may suggest different ways in which the social and cultural features of *ethnies* (ethnic communities) and nations can be linked.

There are three main ways in which such connections are made. The most obvious, and the one sought by most historians of nations and states, is through *continuity* of forms, if not content. Here we are usually speaking about linkages between medieval (rarely ancient) communities and *modern nations*. As we shall see, even historians of medieval and ancient communities tend to measure their degree of "nationness" by the yardstick of the characteristics of the *modern nation*, if only to deny the presence of nations in their period. This entails another form of "retrospective nationalism," in which, as Bruce Routledge puts it, the past is seen as the mirror of the present. Thus, the normal way of claiming continuity for given nations is to trace back the lineages and roots of the modern form of the nation into medieval times, in the manner advocated by Adrian Hastings and the "neo-perennialists" for Western Europe. Alternatively, one can argue that some of these modern nations have drawn on the social and symbolic features and resources of earlier *ethnies* to which they claim some kind of kinship and with which they feel an ancestral relationship – the kind of claim made by Slavophiles and others in late Tsarist Russia when they expressed a deep affinity with Old (pre-Petrine) Muscovy, or by Gaelic revivalists who identified the sources of the modern Irish nation in the Christian monastic culture of early medieval Ireland. In such cases, understandings of an ethnic past frame later conceptions of the present, as much as the latter select aspects of that past; and the task of the analyst is to attempt some kind of assessment of documented historical linkages – and discontinuities.[14]

A second kind of linkage over the *longue durée* looks to the idea of *recurrence* of ethnic and national forms, as well as their basic socio-cultural elements, both at the particular and the general levels. In this perspective, nations as well as *ethnies* along with other types of collective cultural or political identities are recurrent phenomena, i.e., types of cultural community and political organization that can be found in every period and continent, and which are subject to ceaseless ebb and flow, emerging, flourishing, declining, and being submerged again, in some cases only to re-emerge (with or without the help of nationalists). Once again, we have to turn to the pages of John Armstrong's massive volume and his panorama of ethnic identities and their constituent elements in medieval Christendom and Islam to grasp both the persistence and recurrence of ethnic and national identities over the *longue durée*.[15]

Finally, linkages between pasts and presents can be effected through the *discovery and appropriation* of ethnic history. This is a familiar theme in the literature on nationalism, usually to be found in chapters on the "national awakening" or "revival." Intellectuals, as the new priests and scribes of the nation, elaborate the category of the national community, and for this purpose choose symbolic and social features from earlier ethnic cultures that are presumed to be "related" to their own designated communities and populations. This is often done by selecting significant but particular local dialects, customs, folklore, music, or poetry to stand in for the whole of the nation, as occurred in parts of Eastern Europe. The criterion here is the cult of "authenticity,"

in which, in order to reconstruct the community as a pure, original nation, it becomes necessary to discover and use cultural features that are felt to be genuine and strictly indigenous, untainted by foreign accretions or influence, and which represent the community "at its best." Interestingly, such cults had their premodern counterparts. Most of the premodern movements sought to create communities modeled on visions of earlier ethnoreligious cultures – such as Asshurbani-pal's urge to recreate a superior Babylonian culture in the late Assyrian empire, or Chosroes II's harking back to pristine Iranian myth, ritual, and tradition in late Sasanian Persia. But we also find in late Republican Rome a more than nostalgic desire to return to the genuine ways and simple faith of ancestors and earlier generations, to a Cato and Scipio, in order to discover and appropriate a venerated and virtuous ethnic past.[16]

The nation as cultural resource

I turn now to the second main usage of the concept of "nation" – as a descriptive term for a form of historical human community. A significant aspect of the nation as a form of community characterized by a cultural and/or political identity has been its role as a model of sociocultural organization. If at the conceptual level the nation needs to be seen as an analytic category, at the concrete historical level it can also be fruitfully regarded as a social and cultural resource, or better as a set of resources and a model which can be used in different ways and in varying circumstances. Just as the Han empire in China and Akkadian empire in Mesopotamia acted as models and cultural resources for later attempts to build empires in these and other areas, so the kingdoms of Israel and Judah, and the city-states of ancient Athens and Sparta and Republican Rome, provided models and guides for subsequent communities. This is not to prejudge the question of whether, or how far, these societies might themselves be designated as *national* communities, only to say that much later nations looked back to these examples as models of nationhood and drew from them certain resources – ideals, beliefs, and attachments, as well as of social and cultural organization.

Perhaps the best example of what I have in mind is the European reception of the biblical account of ancient Israel – a point that Hastings made, but did not really develop sufficiently. It is not only that Christianity took over the Old Testament model of a polity, the kingdom of ancient Israel, as he claimed, but that medieval rulers and elites of empires, kingdoms, and principalities in Europe from England and France to Bohemia and Muscovy, and also of churches and universities, drew on and made use of the ideas, beliefs, and attachments of the ancient Israelite community which *they* had come to understand as a "national" community. Well before the Reformation, ancient Israel had come to serve as a model and guide for the creation of their chosen communities and historic territories and for the dissemination of their distinctive cultures.[17]

How, in practice, can earlier communities be shown to provide resources and models for later ones? By what mechanisms can such influence be disseminated? The case of ancient Israel suggests the importance of sacred texts, but also of the laws, rituals, ceremonies, and offices described in those texts. Other kinds of cultural resources include customs and mores; symbols such as words and titles, languages and scripts; artifacts, like obelisks and temples, banners and insignia, icons and statues; and more generally artistic styles and motifs, such as those of ancient Greece and Rome, which were revived and renewed in subsequent epochs. Though these general resources could be used for a variety of communities other than nations, the point is that they were readily available, and some of them were associated with communities that appeared, at a distance, to resemble the later aspirant nations of Europe and could act as models for them. The messages associated with these texts, rituals, symbols, and artifacts may not have been those

The concept and its varieties

of their creators and original users, and the memory of them might have been fairly selective. Yet, they continued to resonate among the elites of successive generations as cultural traditions and social elements able to furnish sacred resources for the collective cultural identity of nations.[18]

The nation as "felt community"

My argument so far is that we need to distinguish "nation" as a general category from the historical manifestations of the nation as a human community, one which takes different forms and reveals various features in different epochs, over and above the basic features of the ideal type. In this second usage, that of a form of human community characterized by a cultural and/or political identity, nations can be seen as sets of social and cultural resources on which the members can draw, and which, in varying degrees, enable them to express their interests, needs, and goals. This means that we may also describe the nation as an "imagined, willed, and felt community" of its members.

Such language inevitably raises suspicions of essentialism and reification, even when it is recognized that it represents a shorthand for statements about large numbers of individuals and their normative contexts. Nations, it is argued, are not enduring, homogeneous, substantial communities with fixed traits and essential needs, but simply practical categories imposed by states intent on classifying and designating large numbers of their populations in suitable ways, as was attempted and to some extent realized in early Soviet nationalities policies. In fact, according to the view advanced by Rogers Brubaker, we should not really be analyzing nations at all, only nationalisms, and treat "nations" simply as institutional practices, categories, and contingent events.[19]

But this is to throw out the baby with the bathwater. For, apart from privileging the state (itself just as much a construct), this is to miss out entirely on the understandings, sentiments, and commitments of large numbers of people *vis-à-vis* "their" nations, making it difficult to explain, for example, why so many people were prepared to make great sacrifices (including life itself) on their behalf – except in terms of mass coercion. To try to explain why, in the hearts and minds of so many of their members, their nations and their national identities appear distinctive, binding, and enduring, we do not have to share, much less use, the conceptions and sentiments of the members of nations as categories of our own analyses; nor do we have to assume that nations are homogeneous, much less that they have "substance," "essences," or "fixity." But we do have to recognize that it is these selfsame members of nations who imagine, will, and feel the community, though they do so for the most part within certain social and cultural limits. As Michael Billig has documented, because national institutions, customs, rituals, and discourses persist over generations, many people tend to accept the basic parameters and understandings of their communities from their forebears.[20]

This is not to suggest that historical nations have not been subject to considerable conflict and change, or that their "destinies" have not been the locus of elite rivalries and public contestation. Like all communities and identities, nations and national identities are subject to periodic reinterpretations of their meanings and revolutions of their social structures and boundaries, which in turn may alter the contents of their cultures. Nor should we imagine that national identities are not continually challenged by other kinds of collective identity – of family, region, religion, class, and gender, as well as by supranational associations and religious civilizations. But these caveats do not detract from the historical impact of nations as "lived and felt" communities. Certainly, at the level of the *individual*, nationality is only one of a number of identities, but it is the one that can often be critical and decisive. Individuals may have "multiple

411

identities" and move from one role and identity to another, as the situation appears to require. But *national* identities can also be "pervasive": they can encompass, subsume, and color other roles and identities, particularly in times of crisis. Moreover, with the exception of religion, no other kind of identity and community appears to evoke more passion and commitment, including mass self-sacrifice, than the community of the nation.[21]

At the *collective* level, the role and impact of the nation are even more striking. Here, we may speak of long-term persistence through changes of both *ethnies* and nations – something that cannot be derived simply from the choices and predispositions of their members. For, just as we cannot read off the character of individual members from the political culture of the nation, so the latter cannot be deduced from the sum total of their individual preferences or dispositions, because the political cultures of *ethnies* and nations have their own norms and institutions, symbols and codes of communication. This helps to explain the fact that ethnic communities and nations may persist over long periods, despite the desertion, ethnocide, or even genocide of large numbers of their members; and why cultures can persist even in the absence of most of their practitioners. Long after the final destruction of Carthage in 146 BC and the selling of its inhabitants into slavery, Punic culture persisted in North Africa – till the fifth century AD.[22]

A political community?

We can now return to our starting point, the political conception of the nation proposed by many modernists, and ask: are nations to be regarded as significant only insofar as they are seen as first and foremost forms of political community and identity, or should they be seen as primarily types of cultural community and identity?

For most modernists, as we saw, the nation is a political category *par excellence*, not just in the generic sense of a community of power, but in the more specific sense of an autonomous community institutionalized in sovereign territorial statehood. Here, they draw their inspiration from Max Weber's belief in the primacy of political action and institutions in molding ethnicity and nationhood. For Weber,

> A nation is a community of sentiment which would adequately manifest itself in a state of its own; hence, a nation is a community which normally tends to produce a state of its own.[23]

In the same vein, modernists like John Brcuilly and Michael Mann see national*ism* as primarily a political movement and regard its social and cultural dimensions as secondary. Since, for these modernists, nations are the creation of states and nationalisms, they are inherently political phenomena, and they become significant only to the extent that they are harnessed to states. As for their cultural attributes, these are essentially "pre-political" and of mainly ethnographic interest.[24]

Now, it is true that nations, like other kinds of collective cultural identity, are communities of power and energy, and can attract the allegiance and energies of large numbers of men and women. They may also be seen as conflict groups, united by war against other collectivities, especially other nations and national states. But, this does not mean that all nations seek states of their own, or that sovereign statehood is the focus and goal of all their endeavors. This is not the case, for example, with the Flemish and Bretons, Scots and Catalans, Welsh and Basques, despite the (variable) prominence of parties and movements among them seeking independent statehood for these nations. In each of these cases, a fervent aspiration to attain internal autonomy or "home rule" is accompanied by a commitment to remain part of the wider multinational state

The concept and its varieties

in which they are historically ensconced, whether it be for economic or political reasons. In fact, their aspiration to internal autonomy is in part instrumental. It provides the means for realizing other social, economic, moral, and cultural goals that are valued in and for themselves, even more than is political sovereignty. This is particularly true, as John Hutchinson has documented, of cultural nationalists bent on regenerating their national communities after centuries of lethargy and decline.[25]

Again, it is true that some nations emerged in the crucible of the state, or *pari passu* with its development. This was especially the case in early modern Western Europe, where in both England and France, and to a lesser extent in Spain, we can trace the emergence of national communities alongside the growth of the state's centralizing and bureaucratic powers. Once again, we can see how a peculiar geohistorical context has helped to condition and shape the modernist conception of the nation, to the exclusion of other historical contexts and understandings.[26]

But, equally, we should not overgeneralize from this context and its associated conception of the nation. In other historical contexts – premodern and/or non-Western – the contents of the historical community of the nation, and hence our understandings of it, are very different. There, social, cultural, and religious elements have often had a greater influence and importance than the political dimensions and conceptions favored in the West. To treat these as somehow of lesser significance betrays again that ethnocentrism which was so distinctive a feature of the modernist conception of the nation, and which has proved so detrimental to a wider understanding of nations and national identities.

It is for these reasons that historical nations which belong to different types of the general category of the nation should be seen as forms of human community characterized by a collective cultural *and/or* political identity. In other words, while some nations can be regarded as predominantly forms of political community, aspiring to or conjoined with sovereign states, others are best seen as forms of cultural and territorial community without such political partnership or aspirations, in the specific sense of claims to sovereign statehood. Their drive for internal autonomy tends to focus on social, economic, and cultural goals and aspires to their control within a given territory, without recourse to outright independence and sovereignty. We should take care not to regard such "nations without states" and their nationalisms as of less account than those that possess or aspire to states of their own, for they are often the crucibles of the future politicization of ethnicity.[27]

Notes

1 No modernist spells out this conception in its "pure" form. I have constructed the ideal type of the modern nation from the various conceptions proposed by Deutsch (1966), Nairn (1977), Gellner (1983), Giddens (1984), Hobsbawm (1990), and Mann (1993).

2 On the other hand, outside Europe, in Latin America, and large parts of Africa, where a bourgeoisie was much less in evidence, civic-territorial and republican conceptions of the nation prevailed, with Rousseau's ideals providing the chief inspiration in French West Africa and Mill's writings for British West Africa. On which, see Geiss (1974) and Hodgkin (1964). On the "stoic" phase of the Enlightenment, see Leith (1965).

3 On the ancient Greek usages, see Geary (2001, ch. 2) and Tonkin et al. (1989, Introduction). For the history of the term "*natio,*" see Greenfeld (1992, ch. 1) and Zernatto (1944). On the distinction between "ethnographic" and "political" usages of nation, see the powerful argument in Breuilly (2005a) – though premodern usages often had political dimensions.

4 The mass character of the modern nation is emphasized by Deutsch (1966), Gellner (1983), and Mann (1993), and may be compared with E. H. Carr's (1945) typology, and progression, from monarchical to democratic-Jacobin to social mass nations and nationalism.

413

5 For a highly critical analysis of the core doctrine of nationalism, see Freeden (1998); cf. Miller (1993) and A. D. Smith (1983, ch. 7) for somewhat more sympathetic accounts. More recently, see Hearn (2006, ch. 1).

6 On the language of nations at the Council of Constance, see Loomis (1939) and Toftgaard (2005), which appear to contest the view of John Breuilly (2005b, 81) that at the Church Councils the term "nation" had no ethnic or linguistic connotations. For references to earlier usages, see the essays in Scales and Zimmer (2005), notably those by Reynolds and Scales; also Scales (2000). Reynolds, indeed, argues for the common assumption of "nations" in medieval Europe, albeit as a conception quite different from that of the modern nation.

7 See Plamenatz (1976), Seton-Watson (1977), and Ignatieff (1993). For the uses of this distinction, see Breton (1988) and, on a more philosophical level, Miller (1995). For a critique of "civic" nationalism, see Yack (1999).

8 For this analysis of the Arab national identities, see Suleiman (2003). Other works which link a sense of common ethnicity to modern nations include Hutchinson (1987) on Ireland (and more generally, Hutchinson 2000), Hosking (1993) on ethnic Russianness, and Panossian (2002) on Armenian nationalism. For the historiographical debates, see A. D. Smith (2000a).

9 Other terms like "social class" also possess different uses and meanings; see Ossowski (1962). In fact, cultural and political identities are usually combined in different ways and to varying degrees; and it is difficult, perhaps even futile, to seek to disentangle them and place them in some kind of causal-historical sequence, as Weber (1968) attempted with his suggestion that political action tends to forge ethnic community.

10 On the other hand, perennialists who tended to see nations everywhere generally operate with an analytic category which was defined too imprecisely to discriminate the national from other kinds of community and identity. In this respect, the "neo-perennialist" historians are more circumspect, usually confining themselves to making a case for a few well-chosen examples like England.

11 A purely inductive method of defining the concept of the nation in terms of the ideas of self-styled nationalists – apart from posing the problem of having to define the term "nationalism" in the same manner – relies too much on the variability and self-categorization of its subjects. Hence, in contrast to the method I adopted in A. D. Smith (1983, ch. 7), a large element of stipulation is required for constructing the ideal type and to provide a benchmark for subsequent analysis.

12 For a discussion of competing definitions of the concept of the nation, see Connor (1994, ch. 4) and Uzelac (2002). See also Dieckhoff and Jaffrelot (2005, Introduction and section I) and A. D. Smith (2001, ch. 1). For a critique of the latter, see Guibernau (2004).

13 For Armstrong (1982), these social processes and symbolic resources span much of the medieval epoch in both Christian Europe and the Islamic Middle East. For the links between ethnicity and religion, see Fishman (1980).

14 See Routledge (2003) for his critique of modernist uses of the premodern past as a mirror of the present. The idea of continuity of nations and national sentiment has been most clearly argued for England and its neighbors by Hastings (1997); see also Gillingham (1992) and Lydon (1995). On Slavophilism, see Thaden (1964); and for the Gaelic revival in Ireland, see Lyons (1979) and Hutchinson (1987).

15 For this approach, see Armstrong (1982) and Grosby (2006). Though close at times, this view is to be distinguished from that of both the cultural and the biological "primordialists," on which see Horowitz (2002).

16 For the rediscovery of the past in the "national awakening," particularly in Eastern Europe, see Pearson (1993), Agnew (1993), and Hroch (1985). For a vivid example in Hungary, see Hofer (1980); and for Greece, Herzfeld (1982). On the role of the intellectuals, see, *inter alia*, Breuilly (1993, 46–51), Pinard and Hamilton (1984), and Zubaida (1978). For premodern revivals, see A. D. Smith (1986, chs. 3, 8).

17 Hastings (1997, 186) on the Christian adoption of the polity of the Old Testament. On the European uses of the idea of holy lands in states like England, France, Spain, Bohemia, and Muscovy, see Housley (2000).

18 On the reception of the classical tradition in Europe, see Bolgar (1954); also for the rediscovery of Greek intellectual achievements, Campbell and Sherrard (1968, ch. 1).

19 See Brubaker (1996, ch. 1); cf. A. D. Smith (1998, 77–8).

20 For this tendency to accept national assumptions as ingrained and "enhabited," see Billig (1995).

21 On "situational ethnicity," see especially Okamura (1981), and Wilmsen and McAllister (1995), and for the pervasive quality of national identity, see Connor (1994, esp. ch. 8).

The concept and its varieties

22 See Scheuch (1966) on the methodological problems of analyzing political culture.
23 M. Weber (1948, 176). For an assessment of the political version of modernism in the work of Giddens, Mann, and Breuilly, in particular, see A. D. Smith (1998, ch. 4).
24 See Breuilly (1993; 2005a); Mann (1993, ch. 7; 1995).
25 See Hutchinson (2005, chs. 2–3); for the nations without states, see Guibernau (1999).
26 For general surveys of the growth of the "national state" in Western Europe, see Tilly (1975), Ranum (1975), and A. Marx (2003).
27 See Guibernau (1999); and for Scotland, Ichijo (2004).

Bibliography

Agnew, Hugh (1993): "The Emergence of Czech National Consciousness: A Conceptual Approach," *Ethnic Groups* 10, 1–3, 175–86.
Armstrong, John (1982): *Nations before Nationalism*, Chapel Hill University of North Carolina Press.
Billig, Michael (1995): *Banal Nationalism*, London: Sage.
Bolgar, R. R. (1954): *The Classical Heritage and its Beneficiaries*, Cambridge: Cambridge University Press.
Breton, Raymond (1988): "From Ethnic to Civic Nationalism: English Canada and Quebec," *Ethnic and Racial Studies* 11, 1, 85–102.
Breuilly, John (1993): *Nationalism and the State*, 2nd edition, Manchester: Manchester University Press.
Breuilly, John (2005a): "Dating the Nation: How Old is an Old Nation?," in Ichijo and Uzelac (2005, 15–39).
Breuilly, John (2005b): "Changes in the Political Uses of the Nation: Continuity or Discontinuity?," in Scales and Zimmer (2005, 67–101).
Brubaker, Rogers (1996): *Nationalism Reframed: Nationhood and the National Question in the New Europe*, Cambridge: Cambridge University Press.
Campbell, John and Sherrard, Philip (1968): *Modern Greece*, London: Ernest Benn.
Carr, Edward H. (1945): *Nationalism and After*, London: Macmillan.
Connor, Walker (1994): *Ethno-Nationalism: The Quest for Understanding*, Princeton: Princeton University Press.
Deutsch, Karl (1966): *Nationalism and Social Communication*, 2nd edition, New York: MIT Press.
Dieckhoff, Alain and Jaffrelot, Christophe (eds.) (2005): *Revisiting Nationalism: Theories and Processes*, London: C. Hurst.
Fishman, Joshua (1980): "Social Theory and Ethnography: Neglected Perspectives on Language and Ethnicity in Eastern Europe," in Sugar (1980, 69–99).
Freeden, Michael (1998): "Is Nationalism a Distinct Ideology?," *Political Studies* 46: 748–65.
Geary, Patrick (2001): *The Myth of Nations: The Medieval Origins of Nations*, Princeton: Princeton University Press.
Geiss, Immanuel (1974): *The PanAfrican Movement*, London: Methuen.
Gellner, Ernest (1983): *Nations and Nationalism*, Oxford: Blackwell.
Giddens, Anthony (1984): *The Nation-State and Violence*, Cambridge: Cambridge University Press.
Gillingham, John (1992): "The Beginnings of English Imperialism," *Journal of Historical Sociology* 5, 392–409.
Greenfeld, Liah (1992): *Nationalism: Five Roads to Modernity*, Cambridge, MA: Harvard University Press.
Grosby, Steven (2006): *A Very Short Introduction to Nationalism*, Oxford: Oxford University Press.
Guibernau, Montserrat (1999): *Nations without States*, Cambridge: Polity.
Guibernau, Montserrat (2004): "Anthony D. Smith on Nations and National Identity: A Critical Assessment," in Guibernau and Hutchinson (2004, 125–41).
Hastings, Adrian (1997): *The Construction of Nationhood: Ethnicity, Religion and Nationalism*, Cambridge: Cambridge University Press.
Hearn, Jonathan (2006): *Rethinking Nationalism: A Critical Introduction*, Basingstoke: Palgrave Macmillan.
Herzfeld, Michael (1982): *Ours Once More: Folklore, Ideology and the Making of Modern Greece*, Austin: University of Texas Press.
Hobsbawm, Eric (1990): *Nations and Nationalism since 1780*, Cambridge: Cambridge University Press.
Hodgkin, Thomas (1964): "The Relevance of 'Western' Ideas in the Derivation of African Nationalism," in J. R. Pennock (ed.), *Self-Government in Modernising Societies*, Englewood Cliffs, NJ: Prentice-Hall.

Hofer, Tamas (1980): "The Ethnic Model of Peasant Culture: A Contribution to the Ethnic Symbol Building on Linguistic Foundations by East European Peoples," in Sugar (1980, 101–45).

Horowitz, Donald (2002): "The Primordialists," in Conversi (2002, 72–82).

Hosking, Geoffrey (1993): *Empire and Nation in Russian History*, Baylor University, Waco, TX: Markham University Press.

Housley, Norman (2000): "Holy Land or Holy Lands? Palestine and the Catholic West in the Late Middle Ages and Renaissance," in Swanson (2000, 234–49).

Hroch, Miroslav (1985): *Social Preconditions of National Revival in Europe*, Cambridge: Cambridge University Press.

Hutchinson, John (1987): *The Dynamics of Nationalism: The Gaelic Revival and the Creation of the Modern Irish Nation State*, London: George Allen and Unwin.

Hutchinson, John (2000): "Ethnicity and Modern Nations," *Ethnic and Racial Studies*, 23, 4, 651–69.

Hutchinson, John (2005): *Nations as Zones of Conflict*, London: Sage.

Ichijo, Atsuko (2004): *Scottish Nationalism and the Idea of Europe: Concepts of Europe and the Nation*, London and New York: Routledge.

Ignatieff, Michael (1993): *Blood and Belonging: Journeys into the New Nationalisms*, London: Chatto and Windus.

Leith, James (1965): *The Idea of Art as Propaganda in France, 1750–99: A Study in the History of Ideas*, Toronto: Toronto University Press.

Loomis, Louise (1939): "Nationality at the Council of Constance: An Anglo-French Dispute," *American Historical Review* 44, 3, 508–27.

Lydon, James (1995): "Nation and Race in Medieval Ireland," in Forde et al. (1995, 103–24).

Lyons, F. S. L. (1979): *Culture and Anarchy in Ireland, 1890–1939*, Oxford and New York: Oxford University Press.

Mann, Michael (1993): *The Sources of Social Power*, 2 vols., Cambridge: Cambridge University Press, Vol. 2.

Mann, Michael (1995): "A Political Theory of Nationalism and its Excesses," in Periwal (1995, 44–64).

Marx, Anthony (2003): *Faith in Nation: Exclusionary Origins of Nationalism*, Oxford and New York: Oxford University Press.

Miller, David (1993): "In Defence of Nationality," *Journal of Applied Philosophy* 10, 1, 3–16.

Miller, David (1995): *On Nationality*, Oxford: Oxford University Press.

Nairn, Tom (1977): *The Break-up of Britain: Crisis and Neo-Nationalism*, London: Verso.

Okamura, J. (1981): "Situational Ethnicity," *Ethnic and Racial Studies* 4, 4, 452–65.

Ossowski, Stanislav (1962): *Class Structure in the Social Consciousness*, London: Routledge and Kegan Paul.

Panossian, Razmik (2002): "The Past as Nation: Three Dimensions of Armenian Identity," in *Geopolitics*, 121–46.

Pearson, Raymond (1993): "Fact, Fantasy, Fraud: Perceptions and Projections of National Revival," *Ethnic Groups* 10, 1–3, 43–64.

Pinard, Maurice and Hamilton, Richard (1984): "The Class Bases of the Quebec Independence Movement," *Ethnic and Racial Studies* 7, 1, 19–54.

Plamenatz, John (1976): "Two Types of Nationalism," in Eugene Kamenka (ed.), *Nationalism: The Nature and Evolution of an Idea*, London: Edward Arnold, 22–36.

Ranum, Orest (ed.) (1975): *National Consciousness, History and Political Culture in Early Modern Europe*, Baltimore, MD: Johns Hopkins University Press.

Reynolds, Susan (2005): "The Idea of the Nation as a Political Community," in Scales and Zimmer (2005, 54–66).

Routledge, Bruce (2003): "The Antiquity of Nations? Critical Reflections from the Ancient Near East," *Nations and Nationalism* 9, 2, 213–33.

Scales, Len (2000): "Identifying 'France' and 'Germany': Medieval Nation Making in Some Recent Publications," *Bulletin of International Medieval Research* 6, 23–46.

Scales, Len (2005): "Late Medieval Germany: An Under-Stated Nation?," in Scales and Zimmer (2005, 166–91).

Scales, Len and Zimmer, Oliver (eds.) (2005): *Power and the Nation in European History*, Cambridge: Cambridge University Press.

Scheuch, Erwin (1966): "Cross-National Comparisons with Aggregate Data," in Richard Merritt and Stein Rokkan (eds.), *Comparing Nations: The Use of Quantitative Data in Cross-National Research*, New Haven: Yale University Press.

The concept and its varieties

Seton-Watson, Hugh (1977): *Nations and States*, London: Methuen.

Smith, Anthony D. (1983) [1971]: *Theories of Nationalism*, 2nd edition, London and New York: Duckworth and Holmes and Meier.

Smith, Anthony D. (1986): *The Ethnic Origins of Nations*, Oxford: Blackwell.

Smith, Anthony D. (1998): *Nationalism and Modernism: A Critical Survey of Recent Theories of Nations and Nationalism*, London and New York: Routledge.

Smith, Anthony D. (2000a): *The Nation in History: Historiographical Debates about Ethnicity and Nationalism*, Jerusalem: Historical Society of Israel; Hanover, NH: University Press of New England; and Cambridge: Polity Press.

Smith, Anthony D. (2001). *Nationalism: Theory, Ideology, History*, Cambridge: Polity Press.

Suleiman, Yasir (2003): *The Arabic Language and National Identity*, Edinburgh: Edinburgh University Press.

Thaden, Edward (1964): *Conservative Nationalism in Nineteenth-Century Russia*, Seattle: University of Washington Press.

Tilly, Charles (ed.) (1975): *The Formation of National States in Western Europe*, Princeton: Princeton University Press.

Toftgaard, Anders (2005): "Letters and Arms: Literary Language, Power and Nation in Renaissance Italy and France, 1300–1600," unpublished PhD thesis, University of Copenhagen.

Tonkin, Elisabeth, McDonald, Maryon, and Chapman, Malcolm (eds.) (1989): *History and Ethnicity*, London and New York: Routledge.

Uzelac, Gordana (2002): "When is the Nation? Constituent Elements and Processes," *Geopolitics*, 7, 2, 33–52.

Weber, Max (1948): *From Max Weber: Essays in Sociology*, eds. Hans Gerth and C. Wright Mills, London: Routledge and Kegan Paul.

Weber, Max (1968): *Economy and Society*, 3 vols., eds. G. Roth and C. Wittich, New York: Bedminster Press.

Wilmsen, Edwin and McAllister, Patrick (eds.) (1995): *The Politics of Difference: Ethnic Premises in a World of Power*, Chicago: University of Chicago Press.

Yack, Bernard (1999): "The Myth of the Civic Nation," in Ronald Beiner (ed.), *Theorising Nationalism*, Albany, NY: State University of New York, 103–18.

Zernatto, Guido (1944): "Nation: The History of a Word," *Review of Politics* 6, 351–66.

Zubaida, Sami (1978): "Theories of Nationalism," in G. Littlejohn, B. Smart, J. Wakeford, and N. Yuval-Davis (eds.), *Power and the State*, London: Croom Helm.

29
Materiality matters
Experiencing the displayed object

*Sandra Dudley**

Introduction

This paper is about things and what it means for us to experience them, particularly in a museum setting.[1] It focuses on physical things, although of course museums often hold and interpret many other sorts of things, too. During the first part of the paper. I treat the physical thing as synonymous or at least interchangeable with the 'object;' later, however, I probe the relationship between the two a little further.

We are all part of a material world. We live in, through and with things. We inhabit houses, wear clothes, use crockery, cutlery, laptops, appliances and tools, talk on mobile phones, walk through artefactual landscapes, drive cars, treasure old photographs and appreciate art. Indeed, we interact with animals and other people in ways dependent on our own physicality and sensuality: when we shake hands, embrace, listen, dance or simply avoid intruding on another person's personal space, we do so in ways defined by our own material presence, our physical extendedness in space. Rather than the disembodied minds floating in space that we appear to be in much social theory, we are, and we know, nothing, if not through our physical position in space and our bodily senses. Our experience of the material world is dependent upon our location, our movement and our interpretations of the data we receive from our senses. And of course, the interpretations we make of what we see, hear, smell, touch or taste are strongly influenced by our cultural and personal experiences and by pre-existing knowledge we may have about a particular object.

Academic studies of these engagements with and interpretations of the material world have been strongly resurgent over the past twenty years—more so than at any time since the nineteenth century. Material culture studies in anthropology and other disciplines have significantly deepened our understandings of how people respond to objects and give value and meaning to inanimate things and, in turn, of how objects influence and cement human relationships and societies. Yet much of this scholarship has been so preoccupied with relationships, meanings, values, contexts, representation and communication, that the physical, sensory ways in which we engage with material things, have, more often than not, been overlooked. Overlooked too has been the physicality, the very thingness, of the objects themselves. To read much of the literature in so-called material culture studies, including in the context of museums, you could

be forgiven for wondering where the material objects actually are. Nonetheless it is objects themselves of course that, together with our location, movement and interpretations, determine how we engage with them, what we make of them and how they influence us. The material qualities of objects—their shape, colour, density, weight, texture, surface, size and so on—define our sensory responses to them. I see a green pea differently than I see a children's red ball. This much is obvious, of course. It is pervasive in our everyday life, yet outside sensory culture studies and some areas of aesthetics. It is surprisingly marginal in most studies of how people engage with the material world. Instead, objects are present as merely, to quote Paul Graves-Brown, a "world of surfaces on to which we project significance" (Graves-Brown 2000: 3–4).

So why does this absence of a proper focus on the physicality of objects matter? In scholarship on human culture, it matters because by missing such a fundamental component in what makes objects and our world what they are, we also miss how far the form and materials of objects influence how, in the real world of day-to-day life, we actually engage with objects and attribute meanings and values to them. In museums, I argue that it constitutes a serious missed opportunity. Of course, first impressions could be that, unlike in much material culture scholarship, in museums the object is not missed out or overlooked. After all, we think of museums as places that hold, care for and display things – museums are temples of objects, material institutions par excellence. Yet ironically, the very rationale and modus operandi of museums act to limit the extent to which people can directly, physically, engage with the things on display.

Display

Most obviously, objects in museum spaces are usually physically distanced from museum visitors. We are all familiar with the way in which glass cases, picture frames, ropes and "please do not touch" signs ensure that people and objects are prevented from directly coming into contact with each other in museum spaces. The kinds of interaction an object might have had with person or persons in its pre-museum existence—the mutual, intimate engagement of clothing and body, liquid, lips and cup, or indeed chair and backside—are, once the object has been selected, accessioned, conserved and stored and displayed as a museum object, for most people off limits in perpetuity. Of course, limitations are often imposed on our engagements with objects outside museums, too. Social conventions mean it is usually no more appropriate for me to stroke or smell someone else's clothes when they are wearing them, than when they are adorning a mannequin in a museum. Similarly, I would be no more likely to caress, strike or lick a ceramic bowl in a friend's house than if it were installed in a public institution. Becoming a museum object, however, usually sets something apart from us even more clearly. Yet touching, tapping, smelling and so on is often precisely what one might instinctively like to do if one could—not least because doing so can confirm or contradict the evidence of one's eyes. We have probably all experienced, in real life, that feeling of surprise when picking up something that looked so much lighter than it turns out to be, or indeed of tasting something that we find to be far less sweet than it looked. Indeed, at least some such encounters used to be commonplace in museums long ago, as Constance Classen and David Howes show us by recounting the experience, in 1702, of one Celia Fiennes who, on visiting the Ashmolean Museum in Oxford, noted in her diary her surprise that a cane that looked heavy, was actually so light when she actually picked it up—as was permitted in those days (Fiennes 1949: 33, quoted in Classen and Howes 2006: 201).

In most of our museums today, however, such multi-sensory access is usually unavailable to all but a few fortunate museum workers; visitors must rely on just their vision and the interpretation provided by the museum. Unfortunately, this sense of vision on which museums tend to

Sandra Dudley

expect us to rely, can be both mistaken and limited. Certainly, I can look at something and form an impression of its size, colour, shape, luminosity and so on. But unless I can hold it in my hands I cannot be sure of, let alone appreciate, the weight, density, musicality, coldness and surface texture of an engraved silver cup, just as I cannot know the heaviness of a girdle decorated all over with smooth, glossy cowrie shells and experience the way it ripples when it moves, unless I can touch and flex it. What is more, touching an object is a two-way process: when I hold and stroke or tap something, I not only touch, I am touched, too. My fingertips actively connect with the object before me, and they are simultaneously, passively impacted upon by the object's surface. That two-way interaction allows me an intimacy with the material thing I hold—an intimacy I cannot feel if I only gaze at the thing on a plinth behind a sheet of glass.

However museums choose to present objects, it is, then, inherent in the very nature of the museum that the material things displayed are almost always distanced from the viewer in ways that do not replicate human relationships with things in the outside world. The dominance of vision, and the concern to protect objects from deterioration as a result of handling, prevent me from feeling the undulations and grooves of hand-adzed wood or the emotional charge of holding Henry VIII's seal in my palm just as he did long ago. Such distance makes it harder to imagine and empathize with, to quote Stephen Greenblatt, "the feelings of those who originally held the objects, cherished them, collected them, possessed them" (Greenblatt 1991: 45). Of course, many institutions have explored wider sensory approaches to their objects. Education departments, for example, have long known the value of allowing people to interact physically with 'the real thing,' as have more recent initiatives such as the Victoria and Albert Museum's Touch Me exhibition in 2005.[2] Museums have also used touch in reminiscence and therapeutic outreach work, and others are exploring new, digital technologies that simulate sensory experience beyond the visual—particularly touch.

Nonetheless, unlike the Ashmolean Museum at the time of Celia Fiennes' visit in the eighteenth century, museums have become established as essentially visual, don't-touch places—places where you and I are prevented from touching what others have touched, from physically encountering the past. "[P]reserving artefacts for future view," to quote Constance Classen and David Howes, has become "more important than physically interacting with them in the present" (2006: 216). Yet this object stasis in museums, just like the distance between object and museum visitor, stands in significant contrast to everyday life, in which objects are held and change and decay. In real life, we can interact with objects in ways that allow us to experience their materiality and changes in material states—qualities that themselves have meaning for us and enable us to relate to objects, and their cultural and temporal contexts, in multiple ways (c.f. Ouzman 2006). But when things become museum objects, the object-person engagements in which they can participate shift and become limited. If I cannot stroke my fingertips over the thickened, textured surface of a hand-woven skirt-cloth embellished with supplementary weft in yarn spun from goat's hair, I can neither make a physical connection with the tangible remains of the weaver's productive action nor realise the extra warmth, as well as embellishment, that the technique has given to the garment. If I cannot tap my fingernails, never mind strike a hammer, against a bronze bell. I cannot hear how musical it sounds or intuit something about the thickness and density of the object and material.

Experiencing objects: enhancing stories

If museums seek to reduce this distance between person and thing, if displays and interpretations are constructed in such a way as to facilitate a wider or deeper sensory and emotional engagement with an object, rather than simply to enable intellectual comprehension of a set of facts

presented by the museum and illustrated or punctuated by the object, might visitors actually be enabled to appreciate more aspects of the object and its story? Kirsten Wehner and Martha Sear, curators of the new Australian Journeys gallery at the National Museum of Australia, have recently attempted to facilitate precisely these kinds of bodily, multisensory and emotional—as well as purely cognitive—interactions with the objects they chose for an exhibition which seeks to tell some of the many and diverse stories of migrating to Australia (Wehner and Sear 2010). They sought to connect 'visitors to the richness and detail of others' life worlds," to invite "visitors to engage imaginatively with others' subjective experiences and understandings," to enable objects to "connect people … to their own historical selves" (2010: 143), as well as to the pasts of others. They wanted their exhibition to be 'object-centred,' rather than a largely text-based, story-telling exercise accessorised by objects, which is how they characterise previous exhibitions at their museum and, indeed, how one might characterise many exhibitions at museums around the world. As they explain, in the latter kind of exhibition objects merely illustrate stories; the actual, real work of communication is done mainly by words, not things. Wehner and Sear wanted to change this, to make a less bland exhibition that allowed visitors to rediscover the capacity of objects to "inspire that slightly dislocating delight that comes from recognising that an object was 'there' at another time and … place and is now 'here' in this time and … place and in our own life." They wanted to give objects back their "particularity," their "power to excite and inspire curiosity" (2010: 145).

Choosing objects with particular aesthetic qualities or resonances and drama because of their association with certain events or persons, the curators constructed object biographies for their selected artefacts, focusing especially on how objects participated in the movements of people to and from Australia. What they didn't want to do, however, was then construct a display in which the objects' stories were relayed through large amounts of text. Rather, they wanted to let the objects and their juxtapositions do much of the communicating. They facilitated this by bringing about what they call an "intense, interactive" kind of looking that gets visitors first to focus on the physical qualities of the objects, "to dwell in the process of collecting sensory data," before reflecting on what an object might be, what it could be for, and who might have used it for what, when and where (2010: 153). They wanted to stimulate visitors' empathy for and imagination of other lives, but they were sensible enough too to realise that they still needed to provide context. Their strategy involved dividing the exhibition into 40 smaller exhibits, and centring each of those on one key object with a number of other objects leading off from it in order to evoke different strands of the stories concerned, encouraging visitors to concentrate primarily on objects and the relationships between them. They worked hard to separate necessary text from the objects themselves, in order not to detract from the artefacts and not to distract the visitor from properly and primarily engaging with the physical things before them. Indeed, they tried (though they did not always succeed) to have no interpretive texts in the glass cases at all, placing it instead as a "ribbon" running along only one side of each case. They also installed "sensory stations" to accompany each exhibit, trying to facilitate not just superficial explorations of objects but more lasting, imaginative and empathic engagements through the stimulation of the bodily senses. Visitors can, for example, smell sea cucumbers when looking at cauldrons used by Indonesian fishermen, or trace with their finger the stitches on an embroidered map that is a copy of the original displayed adjacent to it.

What the curators of Australian Journeys have done, is to try to engage visitors with objects more directly and sensually, and through those objects to reach a state of deeper and more subtle engagement with the past people, places and events associated with the artefacts. They have indicated historical uses and significances of the objects they used, but avoided creating clear-cut, singular historical contexts for the objects. They felt that to pin "objects to singular times

and places" would "close down the imaginative possibilities" the objects offered—the chance for visitors simultaneously to attempt to empathise with the sensations of people and in the past, and recognise the subjectivity of their own responses in the present (2010: 159). Instead, through encouraging direct, multi-sensorial engagements with the physical objects and through carefully restricting the extent and position of textual interpretation, they have enabled their visitors to respond to objects in their own way and at the same time to imagine, through those objects, how it felt to be someone in the past. Similarly powerful and empathic connections with objects and the stories associated with them, have been described by others, not necessarily as connections deliberately engineered by the museum and its particular exhibitionary approach, but sometimes simply as enabled by a combination of a powerful object and/or direct sensory interaction with it, and the provision of sufficient knowledge of the object's origin or other contexts. Andrea Witcomb, for example, writes of the affective power she felt when encountering a model of the Treblinka concentration camp—a model now in the Jewish Holocaust Museum and Research Centre in Melbourne, handmade by a man who survived Treblinka but lost his wife and daughter there. The power of the resonance of this object, and its ability to evoke a very strong emotional reaction in Witcomb, for her stands in great contrast to the numbness she felt on encountering other models of concentration camps. Witcomb puts this down not to greater sensory access—this model, like the others, is behind glass—but to its highly personal rendition by its maker and to the fact that it is given enough space to enact its power, "to affect people in a visceral, physical way," in combination with sufficient museum interpretation to allow the viewer to know what the model is of and to place it, and the initial affective response to it, within a framework of cognitive understanding (Witcomb 2010: 51).

Having sufficient information or context to be able not only to 'place' and understand an object but also to experience powerful emotional responses is evocatively described by Nuala Hancock in her narration of encountering Virginia Woolf's spectacles in storage at Charleston, the house in which Woolf lived and which is now a house museum. Having located the storage box and slowly, tentatively unwrapped layers of tissue paper, Hancock encounters a long black spectacle case, lined in purple velvet. Taking the spectacles themselves out of the case, she ponders their physical form, the small area of damage they show, and speculates about the biography of these glasses as a material object. She extends this into a metaphorical reflection on how Woolf saw the world, on the nature of her "poetic vision" (Hancock 2010: 117), and connects her experience of the spectacles with Woolf's understanding of the interconnectivity of sensory experience and, especially, of the visual and the visceral. And lastly, Hancock admits that while Woolf's spectacles "offer us something tangible of her material existence," their status as something that had such an intimate relationship with someone who so hated to be scrutinised leaves us glimpsing, yet somehow uncomfortably intruding into the private world of another's life. Hancock's reflections are evocative and moving, but they and the experiences with which they are concerned only have their power because of the information to which we are already privileged—the fact that these spectacles belonged to a famous and ultimately tragic writer.

Objects or object-information packages?

In different ways, then, the Australian Journeys exhibition and individual encounters with the model of Treblinka or Virginia Woolf's glasses, are concerned with the experiential possibilities of objects that can result from interacting directly—whether physically or emotionally or both—with objects themselves as well as with the context of those objects. The objects in these examples have been engaged with directly, rather than simply encountered along the way as mere illustrators or punctuators of stories communicated by other means.

Materiality matters

Yet it is precisely as mere illustrators or punctuators that objects so often seem to be conceptualised and utilised in museum settings, and this is, I would argue, another way in which museums distance objects from visitors and diminish the possibilities for engagement between the two. There is a dominant view in both the academy and practice that museums are really about information and that the physical object is just a part—and indeed, not always even an essential part—of that information. This is a perspective that is assumed, explicitly or implicitly, in most discussions about museums, whether those discussions are about learning, curation or any other area of museum practice. It is a view in which objects are meaningless, valueless and silent unless they are placed in context, accompanied by information, and used to tell stories identified by the museum as relevant and worth telling (e.g. Kavanagh 1989). The object by itself is, in this view, useless and redundant; it only has significance as part of an object-information package. Indeed, the museum object in such a framework is properly conceived not as a physical thing per se, but as a composite in which the physical thing is but one element in "a molecule of interconnecting [equally important] pieces of information," only one of which is the material object (Parry 2007: 80). That material thing is seen as nothing without information about it, and the 'object' properly defined is a composite of the thing and the information or context that gives it meaning.

This conventional view of museums and objects underpins the idea that what museums do is care for and interpret historically established data-sets comprised of objects and their documentation—data-sets which are available both for reinterpretation by scholars in the future, and for the edification of ordinary visitors in the present. And of course, this is fair enough: I am not trying to claim that the social, cultural, historical and scientific meanings, values and contexts of things are unimportant. We all quite rightly assume, instinctively, that they are, and contemporary and late twentieth century scholarship has well established that they are crucial to interpretive theory and practice in museums and elsewhere. My argument is that, frequently, museums and visitors alike are so concerned with information—with the story overlying the physical thing—that they can inadvertently close off other, perhaps equally significant potentials of things. Specifically, they close off the potential to produce powerful emotional and other personal responses in individual visitors as a result of physical, real-time, sensory engagements. We are sometimes, I suggest, missing a great deal if we ignore the power of the object itself.

Indeed, perhaps we should redefine what we mean by the 'object.' This means understanding that it is more complex than simply the physical thing before us. But it also means not seeing it as a composite of thing plus contextual information. We can instead think of the object as a different sort of composite—one that consists of the interaction between the thing being observed and the human subject doing the perceiving. In the moment in which a material thing is perceived, there is an engagement between an inanimate physical artefact, and a conscious person. For you as the museum visitor, it is only through that engagement that the thing becomes properly manifest to you; in a sense, it is only within that engagement that the object comes to exist at all (c.f. Tilley 2004). For any individual, their perception of and responses to an artefact define or delimit what the object per se is; at the same time, while different people's perceptions and responses vary, they would not be what they are without the influence of the thing and its material, physical, sensible qualities and possibilities. Thus the object in its fullest sense exists not in the artefact nor in our mind, but somewhere in the middle, in the engagements between them. To paraphrase Marilyn Strathern, persons and things alike are actualised in the active relationships that connect them to each other (Strathern 1988, 1999).

So in a museum context, this means that yes, the contemporary paradigms that tell us that interpretation is subjective (i.e. meaning is in the eye of the beholder) are perhaps partially right. Perception and interpretation are indeed subjective: your eyes and mine, your ears and mine, work in the same basic neurological way; but we each bring different sets of expertise and

423

interest, different cultural and personal backgrounds, and indeed different physical and mental states on different days. All of that, all of our personal baggage, determines how we perceive and respond to things and their contexts: how we interpret and react to the limited data our senses are able to collect. It is in the eye of the beholder. Nonetheless, objects too have effects on how we respond; they have agency and power in the process of engagement between them and us in that the sensory data we gather would not be what they are, were objects not as they are.

Object possibilities: transformative experiences

In museums, we can and should exploit this active, two-way engagement between people and things. We should enable that engagement to be as full, as material, and as sensory as possible. And we should do so not only in order to enrich the ways in which visitors are able to connect with the people, stories and emotions of the past, but for another, more radical reason too. Specifically, we need to recognise that the experiential possibilities of objects are important and objects can often 'speak' to us, even when we know nothing about them at all. To even hint at this, of course, contradicts an established view in museum studies and museum practice that objects are mute unless they are enabled to 'speak' through effective interpretation such as exhibition text and design. Indeed, my suggestion that objects can, sometimes at least, have a voice, a significance, a relevance, a meaning, for visitors without the provision of context and interpretation, would be described by many as obfuscation or fetishism, and even risks accusations of elitism (e.g. O'Neill 2006).

My interest is not, however, in Kantian or connoisseurial emphases on "pure, detached, aesthetic" responses to things (O'Neill 2006: 104). In fact I am trying to get at the opposite, at the scope for very personal, very individual, very subjective, very physical and very emotional responses to material things: responses which have the potential to be very powerful indeed, but which are inhibited by so much of what museums do and are expected to do. These are very different sorts of response to those elicited by either the conventional museum foregrounding of things as illustrators of information and stories or by a purist, unemotional aesthetic focus. They are instead potential responses to things that fall into a space somewhere in between these two extremes—a space where, although we recognise that, of course, context matters, the thing must not be lost, things must not "dissolve into meanings" (Hein 2006: 2). The emphasis on context must not, in other words, act to inhibit our opportunities to engage with things, even—and here's the rub—those we know nothing about.

To give you an example from my own experience, I recently visited for the first time the art gallery at Compton Verney in Warwickshire, England. As well as notable collections of Neapolitan. British, northern European and folk art, Compton Verney holds one of the top three Chinese collections in Europe, centred on bronze ritual vessels and other objects.[3] I did not know this as my visit began, and as I walked into the first room of Chinese artefacts. The room was lined with sparsely filled and elegantly lit cases of bronze vessels, and alone, facing the entrance to the room, on a plinth in the middle of the floor and without any glass around it, stood what to me seemed an extraordinarily beautiful and animated bronze figure of a horse. The horse was over a metre high, and stood considerably higher still as a result of its plinth. I was utterly spellbound by its majestic form, its power, and, as I began to look at it closely, its material details: its greenish colour, its textured surface, the small areas of damage. I wanted to touch it, though of course I could not—but that did not stop me imagining how it would feel to stroke it, or how it would sound if I could tap the metal, or how heavy it would be if I could try to pick it up. I was, in other words, sensorially exploring the object, even though I was having to intuit rather than directly experience some of the sensory experiences. There was no

label at all adjacent to the object, only a tiny number which correlated to the interpretive text on the gallery hand guide which I had not yet picked up. I still knew nothing about this artefact, but its three-dimensionality, factility and sheer power had literally moved me to tears. I allowed myself considerable time to reflect on that feeling and the object before I picked up the hand guide. When eventually I did pick up the interpretive text, I read:

Han Dynasty (206 BC–AD 220):

Heavenly Horse, *tian ma*. Bronze.

This large horse would have been a funerary offering for the tomb of an élite Chinese man, the intention being for the owner of the tomb to use the horse to pull his chariot in the afterlife. Such large bronze horses were very rare during the Western Han period, becoming more popular during the Eastern Han. It was extremely difficult to produce such large bronze figures in one mould, therefore this stallion is cast in nine close fitting pieces and joined together, an expensive method in terms of labour and material.

I was left breathless all over again: that this wonderful object was so intimately associated with someone's death, that it was so old, and that it was so rare, further intensified its power over me. I looked for the joins and counted the pieces, and studied the detail of the surface even more intently than I had before.

My initial response to the horse was a fundamental, emotional, sensory—even visceral—one. Had the information about the horse been displayed next to it in the form of a label or text panel, I am certain it would have interfered with, even prevented altogether, the powerful and moving reaction I had to the object for its own sake: I would have been distracted by the text, would have been drawn to read it first, and would not have had the opportunity to experience and sensorially explore the artefact's physicality. So what was the value of that initial encounter? It certainly made a significant difference to how I subsequently reacted to the information I read about the object: I was already emotionally receptive, and I had an empathic as well as purely cognitive response to the artefact's history. Utilising such emotional aspects in the museum environment is of course something that has a value in learning contexts, and is also related to the kinds of strategies Wehner and Sear tried to implement in their Australian Journeys exhibition. But what about the value of a powerful response to an object just for itself, and not because of how it might enhance learning or appreciation of the wider aspects of an exhibition? Is there any such value in a museum environment? My view is that the opportunity to be moved to tears, tickled pink, shocked, or even disgusted to the point of nausea by a museum object is itself a powerful component of what a museum experience can offer—not just as a step on the journey to cognitive understanding of an object's history or indeed of our own, but simply as a potent and sometimes transformative phenomenon in its own right. Many of us would not question this claim if it concerned only art, or perhaps conceptual art at least—we can accept that the role of such art is precisely to move, shock, amuse or puzzle us, or even to stimulate our acquisitiveness, our desire to possess the object. We accept such elemental responses too in the consumption practices that run through our daily lives—and of course, such responses are well understood and manipulated in the commercial sector by advertisers and retailers.

These are not generally understood and used within the world of museums, however. Objects matter within museums, of course—but so often they feature as mere illustrations punctuating the story being told, rather than as powerful items in their own right, too. The effort expended by museums to render objects and interpretation accessible, the work done to enable visitors to identify meaning and context, is laudable and important; yet it can sometimes be the

Sandra Dudley

strategies employed in that very effort which prevent or limit the opportunities for directly encountering and responding to objects in and of themselves, prior to cognitively exploring the stories they have to tell. Textual interpretation in particular can act to dilute, if not remove altogether, the sense of magic and mystery that objects can so often convey. This is not to say that textual interpretation should be absent, of course; but if it is located so as to not stand in the way of an initial engagement with the object, and if access to it is easy but optional, visitors can if they wish concentrate primarily on the artefact itself, the thing in front of them, before they ask what it is, what is was for, who made it and where it came from.

Museums cannot necessarily predict and effectively enable powerful responses to objects— they will not happen for all of us all the time, nor even in response to the same artefacts—but they can seek to place the object once more at the heart of the museum endeavour, and work to avoid the inhibition of emotional and sensory interactions wherever possible. They can think a little more closely about what happens and what might happen when people encounter objects on display. They can ponder what it would be like for visitors to be able properly, bodily, emotionally to engage with an object rather than look at it half-heartedly prior to, or even after, reading a text panel on a wall or a label in a case.

Of course, their duty to conserve objects means that museums cannot in reality allow visitors to pick up, listen to, lick and sniff the objects. But where this cannot be allowed, the museum would do well to remember that visitors can and do still imagine some of the qualities of the objects they see. I can see that the oil painting's surface is three-dimensional, and while I may not be allowed to actually touch it, by drawing on my own sense memories of other textured surfaces I can imagine, even feel in my fingertips, what the sensation would be if I did. Yes, like Celia Fiennes I might get it wrong—but equally I might not. And maybe it does not matter, so long as I am not inhibited from engaging with and responding to an object in some way beyond passively looking at it, reading a label, and moving on, uninspired and unengaged. Yet so often, in reality museums' preference for the informational over the material and for learning over personal experience more broadly and fundamentally defined, may lead to the production of displays that actually inhibit and even preclude emotional and personal responses.

I want to see this change, to return to the materiality of the material, to shift some long overdue attention back to objects themselves, as objects, focusing again on aspects of those objects' apparently trivial and obvious material qualities and the possibilities of directly, physically, emotionally engaging with them. Creative, material-focused, embodied and emotional engagements with objects should be a fundamental building block of the museum visitor's experience. I am not advocating that museums go back to being dusty elitist places that fail to think about multiple audiences and accessibility; but I am saying that in the drive to interpret, to be open to all and to tell stories, something powerful about things themselves has often been lost. Perhaps we should admit that while dusty, elitist museums were often intimidating, dull and not very informative, very occasionally at least they did allow the magic, the mystery of displayed things, to be felt more powerfully than it so often is in the more accessible museums of today. If museums keep open the space that lies between artefacts being either carriers of information or objects of detached contemplation, they keep open the possibility that visitors can reflect creatively, sometimes even transformatively, on things and themselves.

Notes

* I am very grateful to Bradley L. Taylor and Raymond Silverman of the Museum Studies Program at the University of Michigan for inviting me to visit and to give an earlier version of this paper as a lecture.

1 Some parts of this paper appear in earlier forms in Dudley 2010. Some other parts have subsequently appeared in Dudley 2012.
2 www.vam.ac.uk/vastatic/microsites/1376_touch_me/. Last accessed 2 March 2009.
3 www.comptonverney.org.uk/collections/chinese.aspx. Last accessed 12 March 2011.

Bibliography

Arigho, B. (2008) 'Getting a handle on the past: the use of objects in reminiscence work,' in H. Chatterjee (ed.) *Touch in Museums: Policy and Practice in Object Handling*, Oxford: Berg, pp. 205–212.

Classen, C. and D. Howes (2006) 'The museum as sensescape: Western sensibilities and indigenous artifacts,' in E. Edwards, C. Gosden and R. Phillips (eds.) *Sensible Objects: Colonialism, Museums and Material Culture*, Oxford: Berg, pp. 199–222.

Dudley, S. (2010) 'Museum materialities: objects, sense and feeling,' in S. Dudley (ed.), *Museum Materialities: Objects, Engagements, Interpretations*, London and New York: Routledge, pp. 1–17.

Dudley, S. (2012) 'Encountering a Chinese horse: engaging with the thingness of things,' in S. Dudley (ed.), *Museum Objects: Experiencing the Properties of Things*, London and New York: Routledge.

Fiennes, C. (1949) *The Journeys of Celia Fiennes*, London: Cresset Press.

Geary, A. (2007) 'Exploring virtual touch in the creative arts and conservation,' in E. Pye (ed.), *The Power of Touch: Handling Objects in Museum and Heritage Contexts*, Walnut Creek (CA): Left Coast Press, pp. 241–52.

Graves-Brown, P. (2000) 'Introduction,' in P. Graves-Brown (ed.) *Matter, Materiality and Modern Culture*, London: Routledge, pp. 1–9.

Greenblatt, S. (1991) 'Resonance and wonder,' in S. Lavine and I. Karp (eds.), *Exhibiting Cultures: the Poetics and Politics of Museum Display*, Washington, D.C.; Smithsonian Institution Press, pp. 42–56.

Hancock, N. (2010) 'Virginia Woolf's glasses: material encounters in the literary/artistic house museum,' in S. Dudley (ed.) *Museum Materialities: Objects, Engagements, Interpretations*, London: Routledge, pp. 114–127.

Hein, H. (2006) 'Assuming responsibility: lessons from aesthetics,' in H. H. Genoways (ed.) *Museum Philosophy for the Twenty-First Century*, Oxford: AltaMira Press, pp. 1–9.

Jacques, C. (2007) 'Easing the transition: using museum objects with elderly people,' In E. Pye (ed.) *The Power of Touch: Handling Objects in Museum and Heritage Contexts*, Walnut Creek (CA): Left Coast Press, pp. 153–61.

Kavanagh, G. (1989) 'Objects as evidence, or not?,' In S. M. Pearce (ed.) *Museum Studies in Material Culture*, London: Leicester University Press, pp. 125–37.

McLaughlin, M., J. Hespenha and G. Sukhatme (2002) *A Haptic Exhibition of Daguerreotype Cases for USC's Fisher Gallery, Touch in Virtual Environments*, Englewood Cliffs (NJ): Prentice-Hall.

Noble, G. and H. Chatterjee (2008) 'Enrichment programmes in hospitals: using museum loan boxes in University College London Hospital,' in H. Chatterjee (ed.) *Touch in Museums: Policy and Practice in Object Handling*, Oxford: Berg, pp. 215–23.

O'Neill, M. (2006) 'Essentialism, adaptation and justice: towards a new epistemology of museums,' *Museum Management and Curatorship*, 21: 95–116.

O'Sullivan, J. (2008) 'See, touch and enjoy: Newham University Hospital's nostalgia room,' in H. Chatterjee (ed.) *Touch in Museums: Policy and Practice in Object Handling*, Oxford: Berg, pp. 224–30.

Onol, I. (2008) 'Tactual explorations: a tactile interpretation of a museum exhibition through tactile art works and augmented reality,' in H. Chatterjee (ed.) *Touch in Museums: Policy and Practice in Object Handling*, Oxford: Berg, pp. 91–106.

Ouzman, S. (2006) 'The beauty of letting go: fragmentary museums and archaeologies of archive,' in E. Edwards, C. Gosden and R. Phillips (eds.) *Sensible Objects: Colonialism, Museums and Material Culture*, Oxford: Berg, pp. 269–301.

Parry, R. (2007) *Recoding the Museum: Digital Heritage and the Technologies of Change*, London: Routledge.

Phillips, L. (2008) 'Reminiscence: recent work at the British Museum,' in H. Chatterjee (ed.) *Touch in Museums: Policy and Practice in Object Handling*, Oxford: Berg, pp. 199–204.

Prytherch, D. and M. Jefsioutine (2007) 'Touching ghosts: haptic technologies in museums,' in E. Pye (ed.) *The Power of Touch: Handling Objects in Museum and Heritage Contexts*, Walnut Creek (CA): Left Coast Press, pp. 223–40.

Strathern, M. (1988) *The Gender of the Gift*, Berkeley (CA): University of California Press.

Strathern, M. (1999) *Property, Substance and Effect. Anthropological Essays on Persons and Things*, London: Athlone Press.

Tilley, C. (2004) *The Materiality of Stone: Explorations in Landscape Phenomenology*, Oxford: Berg.

Wehner, K. and M. Sear (2010) 'Engaging the material world: object knowledge and Australian Journeys,' in S. Dudley (ed.) *Museum Materialities: Objects, Engagements, Interpretations*, London: Routledge, pp. 143–161.

Witcomb, A. (2010) 'Remembering the dead by affecting the living: the case of a miniature model of Treblinka,' in S. Dudley (ed.) *Museum Materialities: Objects, Engagements, Interpretations*, London: Routledge, pp. 39–52.

30
Concepts of identity and difference

Kathryn Woodward

1 Introduction

The writer and broadcaster Michael Ignatieff tells this story about the wartorn former Yugoslavia in 1993:

> … it's four in the morning. I'm in the command post of the local Serbian militia, in an abandoned farm house, 250 metres from the Croatian front line … not Bosnia but the warzones of central Croatia. The world is no longer watching, but every night Serb and Croat militias exchange small arms fire and the occasional bazooka round.
>
> This is a village war. Everyone knows everyone else: they all went to school together; before the war, some of them worked in the same garage; they dated the same girls. Every night, they call each other up on the CB radio and exchange insults – by name. They go back trying to kill each other.
>
> I'm talking to the Serbian soldiers – tired, middle-aged reservists, who'd much rather be at home in bed. I'm trying to figure out why neighbours should start killing each other. So I say I can't tell Serbs and Croats apart. 'What makes you think you're so different?'
>
> The man I'm talking to takes a cigarette pack out of his khaki jacket. 'See this? These are Serbian cigarettes. Over there they smoke Croatian cigarettes.'
>
> 'But they're both cigarettes, right?'
>
> 'You foreigners don't understand anything', he shrugs and begins cleaning his Zastovo machine pistol.
>
> But the question I've asked bothers him, so a couple of minutes later, he tosses the weapon on the bunk between us and says, 'Look, here's how it is. Those Croats, they think they're better than us. They think they're fancy Europeans and everything. I'll tell you something. We're all just Balkan rubbish.'
>
> *(Ignatieff, 1994, pp. 1–2)*

This is a story about war and conflict set against a background of social and political upheaval. It is also a story about identities. This scenario presents different identities dependent on two separate national positions, those of Serbs and Croats, which are picked out here as two distinctly

identifiable peoples to whom the men involved see themselves as belonging. These identities are given meaning through the language and symbolic systems through which they are represented.

These are people who have shared fifty years of political and economic unity in the nation-state of Yugoslavia under Tito. They share location and myriad aspects of culture in their everyday lives. But the Serb militia man's claim is that Serbs and Croats are totally different, even in the cigarettes that they smoke. At first it appears that there is no common ground between Serbs and Croats and yet within minutes the man is telling Ignatieff that his major grievance against his enemies is that the Croats think themselves to be better than the Serbs, whereas in fact they are the same; there are no differences between them.

Identity is relational here. Serbian identity relies for its existence on something outside itself: namely, another identity (Croatian) which it is not, which both differs from Serbian identity, and yet provides the conditions for it to exist. Serbian identity is distinguished by what it is not. To be a Serb is to be 'not a Croat'. Identity is thus marked out by difference.

This marking of difference is not unproblematic. On the one hand, the assertion of difference between Serbs and Croats involves a denial that there are any similarities between the two groups. The Serb denies what he perceives as the assumed superiority or claims to advantage which he attributes to the Croats, all of whom are lumped together under the umbrella of Croatian national identity which constructs them as alien and 'other'. Difference is underpinned by exclusion: if you are Serb, you cannot be Croat, and vice versa. On the other hand, this claim of difference is also troubling to the Serbian soldier. At a personal level he is adamant that Croats are no better than Serbs; indeed, he says they are the same. Ignatieff points out that this 'sameness' is the product of lived experience and the commonalities of day-to-day life which Serbs and Croats have shared. This disjuncture between the unity of a national identity (which stresses the collective 'we are all Serbs') and daily life creates confusion for the soldier who seems to contradict himself in claiming massive difference between Serbs and Croats *as well as* great similarity – 'We're all just Balkan rubbish'.

Identity is marked out through symbols; for example, the very cigarettes which are smoked by each side. There is an association between the identity of the person and the things a person uses. The cigarette thus functions here as an important signifier of difference and identity and, moreover, one that is often also associated with masculinity (as in the Rolling Stones' song 'Satisfaction': 'Well he can't be a man 'cause he doesn't smoke the same cigarettes as me'). The Serbian militia man is explicit in this reference but less specific about other signifiers of identity, such as the associations with the sophistication of European culture (he speaks of the 'fancy Europeans'), from which *both* Serbs and Croats are excluded, and the inferiority of Balkan culture which is by implication suggested as its antithesis. This sets up another opposition whereby the commonality of Balkan culture is set against other parts of Europe. So the construction of identity is both symbolic *and* social. The struggle to assert different identities has material causes and consequences here, notably in the conflict between warring groups and the social and economic upheaval and distress which war entails.

Note how often the construction of national identity is gendered. The national identities produced here are male identities linked to militaristic notions of masculinity. Women are not included in this scenario, although there are of course other national, ethnic positions which accommodate women. Men tend to construct subject-positions for women in relation to themselves. The only reference to women here is to 'girls' who are 'dated' or rather who have been 'dated' in the past, before the current conflict erupted. Women are signifiers of a past, shared male identity now fragmented and reconstructed into distinct, opposed, national identities. At this specific historical moment the differences between these men are greater than any

Concepts of identity and difference

similarities, because of the focus on conflicting national identities. Identity is marked by difference but it seems that some differences, here between ethnic groups, are seen as more important than others, especially in particular places and at particular times.

In other words, this assertion of national identities is historically specific. Whilst the roots of national identities within the former Yugoslavia might be traced to the history of communities within that location, conflict between them emerges at a particular time. In this sense the emergence of these different identities is historical; it is located at a specific point in time. One way in which identities establish their claims is indeed through the appeal to historical antecedents. Serbs, Bosnians and Croatians seek to reassert lost identities from the past, though in so doing they may actually be producing new identities. For example, the Serbs have resurrected and rediscovered the Serbian culture of the warriors and story-tellers, the Guslars of the Middle Ages, as a significant element in their history which gives weight to current identity claims. As Ignatieff writes elsewhere, 'warlords are celebrities in the Balkans' and outsiders are told 'you have to understand our history ... Twenty minutes later you were still being told about King Lazar, the Turks and the battle of Kosovo' (Ignatieff, 1993, p. 240). The reproduction of this past at this point in time, however, suggests a moment of crisis rather than something settled and fixed in the construction of Serbian identity. What appears to be a point about the past and a restatement of a historical truth may tell us more about the *new* subject-position of the twentieth-century warrior who is trying to defend and assert the separateness and distinctiveness of his national identity in the present. So this recovery of the past is part of the process of *constructing identity* which is taking place at this moment in time and which, it appears, is characterized by conflict, contestation and possible crisis.

This discussion of national identity in the former Yugoslavia raises questions which can be expressed more broadly to encompass wider debates about identity and difference addressed in this volume:

- Why are we looking at the question of identity at this moment? Is there a *crisis of identity* and if so why is this the case?
- If identity is marked by *difference*, how are differences between people manifested and represented? Which sort of differences count? How is difference marked in relation to identity? What are the social and symbolic systems which classify people and mark difference?
- Why do people *invest* in identity positions? How can this investment be explained?

Discussion of these questions, which provide the framework for this chapter, is underpinned by the tension between essentialist and non-essentialist perspectives on identity. An essentialist definition of 'Serbian' identity would suggest that there is one clear, authentic set of characteristics which *all* Serbians share and which do not alter across time. A non-essentialist definition would focus on differences, as well as common or shared characteristics, both between Serbs and also between Serbs and other ethnic groups. It would also pay attention to how the definition of what it means to be a 'Serb' has changed across the centuries. In asserting the primacy of an identity – for example, that of the Serb – it seems necessary, not only to set it in opposition to another identity which is thus devalued, but also to lay claim to some 'true', authentic Serbian identity which has persisted across time. Or is it? Is identity fixed? Can we find a 'true' identity? Does the assertion of identity necessarily involve laying claim to some essential quality, either through establishing that this is inherent in the person or through revealing its authentic source in history? Are there alternatives to the binary opposition of essentialist versus non-essentialist perspectives on identity and difference?

In order to address these questions, we need to look for theoretical explanations which can highlight the key concepts and provide a framework within which we can achieve a fuller understanding of what is involved in the construction of identity. Although it focused on national identities, the discussion of Michael Ignatieff's example has illustrated several of the key aspects of identity and difference in general, and suggested ways in which we can begin to address some of the questions explored in this chapter:

1 We need conceptualizations. We need to conceptualize identity, to break it down into its different dimensions in order to understand how it works.

2 Identity often seems to involve *essentialist* claims about belongingness where, for example, identity is seen as fixed and unchanging.

3 Sometimes these claims are based on nature; for example, 'race' and kinship in some versions of ethnicity. But often the claims are based on an essentialist version of history and of the past, where history is constructed or represented as an unchanging truth.

4 In fact, identity is relational, and difference is established by *symbolic marking* in relation to others (in the assertion of national identities, for example, the representational systems which mark difference could include a uniform, a national flag or even the cigarettes which are smoked).

5 Identity is *also* maintained through *social* and *material* conditions. If a group is symbolically marked as the enemy or as taboo, that will have real effects because the group will be socially excluded and materially disadvantaged. For example, the cigarette marks distinctions which are also present in the social relations between Serbs and Croats.

6 The *social* and the *symbolic* refer to two different processes but each is necessary for the marking and maintaining of identities. Symbolic marking is how we make sense of social relations and practices; for example, regarding who is excluded and who is included. Social differentiation is how these classifications of difference are 'lived out' in social relations.

7 The conceptualization of identity involves looking at *classificatory systems* which show how social relations are organized and divided; for example, into at least two opposing groups – 'us and them', 'Serbs and Croats'.

8 Some differences are marked, but in the process some differences may be obscured; for example, the assertion of national identity may omit class and gender differences.

9 Identities are not unified. There may be contradictions within them which have to be negotiated; for example, the Serb militiaman seems to be involved in a difficult negotiation in saying that Serbs and Croats are both the same *and* fundamentally different. There may be mismatches between the collective and the individual level, such as those that can arise between the collective demands of Serbian national identity and the individual day-to-day experiences of shared culture.

10 We still, also, have to explain why people *take up* their positions and *identify with them*. Why do people invest in the positions which discourses of identity offer? The *psychic level* must also form part of the explanation; this is a dimension, along with the social and the symbolic, which is needed for a complex conceptualization of identity. All of these elements contribute to the explanation of how identities are formed and maintained.

2 Why does the concept of identity matter?

This chapter explores the concepts of identity and difference in more detail ... Different aspects of identity all share some common concerns. Primary among these is an engagement with debates about identity, focusing especially on the tension between essentialism and non-essentialism.

Concepts of identity and difference

Essentialism can base its claims on different foundations; for example, political movements can seek some certainty in the affirmation of identity through appeals either to the fixed truth of a shared past or to biological truths. The physical body is one site which might both set the boundaries of who we are and provide the basis of identity – for example, of sexual identity. However, is it necessary to claim a biological basis for the authenticity of sexual identity? … On the other hand, ethnic or religious or nationalist movements often claim a common culture or history as their basis. Essentialism takes different forms, as has been shown in the discussion of the former Yugoslavia. … Is it possible to confirm ethnic or national identity without claiming a recoverable history which supports a fixed identity? What alternatives are there to cementing identity in essentialist certainty? Are identities fluid and changing and can such an understanding of them sustain political commitment? These questions address the tensions between social constructionist and essentialist conceptions of identity.

In order to address the question of why we are exploring the concept of identity, we need to look at how identity fits into the 'circuit of culture' [A circuit of mutually interdependent concepts of Identity, Representation, Regulation, Consumption and Production] and at how a discussion of identity and difference relates to discussion of representation (see Hall, ed., 1997). To find out what makes identity such a key concept, we also need to focus on contemporary concerns with questions of identity at different levels: in the global arena, for example, there are current concerns with national and ethnic identities; and, in a more 'local' context, there are concerns with personal identity, for example within personal relationships and sexual politics. There is a debate about identity which might suggest that significant changes are taking place in recent decades, even to the extent of producing a 'crisis of identity'. To what extent does what is happening in the world today support the argument that there is a crisis of identity and what does it mean to make such a claim? This involves looking at how identities are formed, at the processes involved, and at the extent to which identities are fixed or, alternatively, fluid and changing. We start the discussion with the place of identity in the 'circuit of culture'.

2.1 Identity and representation

Why are we looking at identity and difference? In examining systems of representation it is necessary to look at the relationship between culture and meaning (for a fuller discussion of representation, see Hall, ed., 1997). Those meanings only make sense if we have some idea of what subject-positions they produce and how we as subjects can be positioned within them. This volume brings us to another moment in the 'circuit of culture', when the focus shifts to the *identities* produced by those representational systems. Representation includes the signifying practices and symbolic systems through which meanings are produced and which position us as subjects. Representations produce meanings through which we can make sense of our experience and of who we are. We could go further and suggest that these symbolic systems create the possibilities of what we are and what we can become. Representation as a cultural process establishes individual and collective identities and symbolic systems provide possible answers to the questions: who am I?; what could I be?; who do I want to be? Discourses and systems of representation construct places from which individuals can position themselves and from which they can speak. For example, the narrative of soap operas and the semiotics of advertising help to construct gendered identities (see Gledhill, 1997; Nixon, 1997). Marketing promotions can construct new identities at particular times – for example, the 'new man' of the 1980s and 1990s – which we can appropriate and reconstruct for ourselves. The media can be seen as providing us with the information which tells us what it feels like to occupy a particular subject-position – the street-wise teenager, the upwardly mobile worker or the caring parent. Advertisements

433

only 'work' in selling us things if they appeal to consumers and provide images with which they can identify. Clearly, then, the production of meaning and the identities positioned within and by representational systems are closely interconnected. It is impossible to separate the two moments in the 'circuit'. The shift here to a focus on identities is one of emphasis – of moving the spotlight from representation to identities. This [...] develops and expands discussion of what identities are produced and the processes whereby identification with them takes place.

The emphasis on representation and the key role of culture in the production of meaning permeating all social relations thus leads to a concern with identification (for a consideration of identification in the context of a discussion of psychoanalysis and subjectivity, see Nixon, 1997). This concept, which describes the process of identifying with others, either through lack of awareness of difference or separation, or as a result of perceived similarities, is drawn from psychoanalysis. Identification was central to Freud's understanding of the child's situation of itself as a sexed subject at the Oedipal stage, and has been taken up within cultural studies, for example in film theory, to explain the powerful actualization of unconscious wishes which can occur in relation to people or images, whereby we attribute qualities to ourselves and transfer associations, making it possible to see ourselves in the image presented. Different meanings are produced by different symbolic systems and these meanings are contested and changing. In [my work], the production of identities and positions from which we can speak and the differences upon which they are based within culture are the main concerns.

Questions can be raised about the power of representation and how and why some meanings are preferred. All signifying practices that produce meaning involve relations of power, including the power to define who is included and who is excluded. Culture shapes identity through giving meaning to experience, making it possible to opt for one mode of subjectivity – such as the cool, blond femininity or the fast-moving, attractive, sophisticated masculinity of advertisements for the Sony Walkman (see du Gay, Hall et al., eds, 1997) – amongst others available. However, we are constrained, not only by the range of possibilities which culture offers – that is, by the variety of symbolic representations – but also by social relations. As Jonathan Rutherford argues, '… identity marks the conjuncture of our past with the social, cultural and economic relations we live in now … [identity] is the intersection of our everyday lives with the economic and political relations of subordination and domination' (Rutherford, 1990, pp. 19–20).

Symbolic systems offer new ways of making sense of the experience of social divisions and inequalities and the means whereby some groups are excluded and stigmatized. Identities are contested. This chapter began with an example of strongly disputed identities, and discussion of identities suggests the emergence of new positions, new identities, produced, for example, in changing economic and social circumstances. This leads us on to another major question. Do the changes mentioned above and highlighted in the opening example of the former Yugoslavia suggest that there might be a *crisis of identity*? What sort of changes might be taking place at global, local and personal levels which might justify the use of the word 'crisis'?

3 Is there a crisis of identity?

> Just now everybody wants to talk about 'identity' … identity only becomes an issue when it is in crisis, when something assumed to be fixed, coherent and stable is displaced by the experience of doubt and uncertainty.
>
> *(Mercer, 1990, p. 4)*

'Identity' and 'identity crisis' are words and ideas much in current use and they are seen by some sociologists and theorists as characterizing contemporary or late-modern societies. We have

already cited the example of an area in the world, the former Yugoslavia, where conflicting ethnic and national identities have re-emerged to break down existing identities. This section will look at a number of different contexts in which questions of identity and identity crisis have become central, including globalization and the processes associated with global change, questions of history, social change and political movements.

Some recent writers argue that 'identity crises' are characteristic of late-modernity and that their prevalence only makes sense when seen in the context of the global transformations which have been defined as characterizing contemporary life (Giddens, 1990). Kevin Robins describes this phenomenon of globalization as involving an extraordinary transformation, where the old structures of national states and communities have been broken up and there is an increasing 'transnationalization of economic and cultural life' (see Robins, 1997). Globalization involves an interaction between economic and cultural factors whereby changes in production and consumption patterns can be seen as producing new shared identities – sometimes caricatured as the Macdonald-eating, Walkman-wearing, 'global' consumers – indistinguishable from one another, which are to be found around the globe. The global development of capitalism is, of course, nothing new, but what characterizes its most recent phase is the 'cultural convergence' of cultures and lifestyles around the world in the societies exposed to its impact (Robins, 1991).

Globalization, however, produces different outcomes for identity. The cultural homogeneity promoted by global marketing could lead to the detachment of identity from community and place. Alternatively, it could also lead to resistance, which could strengthen and reaffirm some national and local identities or lead to the emergence of new identity positions. These debates about globalization which encompass its complexities are developed much more fully in du Gay, ed., 1997, but the phenomenon is cited here to illustrate the scale of transformation and the possible impact this could have on the formation of identities.

Changes in the global economy have produced widely dispersed demands, not only for the same goods and services but also for labour and the structuring of labour markets. The *migration* of labour is, of course, not new, but globalization is closely associated with the acceleration of migration where, largely motivated by economic necessity, people have spread across the globe, so that 'international migration is part of a transnational revolution that is reshaping societies and politics around the globe' (Castles and Miller, 1993, p. 5). Migration has an impact on both the countries of origin and on the country of destination. For example, many European cities offer examples of diverse communities and cultures which result from migration. In Britain there are many such examples, including Asian communities in Bradford and Leicester, and parts of London, such as Brixton, or in St Paul's in Bristol. Migration produces plural identities, but also contested identities, in a process which is characterized by inequalities. Migration is a feature of uneven development, where the 'push' factor of poverty is more likely to promote migration than the 'pull' of the post-industrial, technologically advanced society. The global movement of capital is generally much freer than the mobility of labour.

This dispersal of people across the globe produces identities which are shaped and located in and by different places. These new identities can be both unsettled and unsettling. The concept of *diaspora* ... provides a framework for understanding some of these identities which are not located in one 'home' and cannot be traced back simply to one source.

The notion of 'identity in crisis' also foregrounds the disruption which is manifest in large-scale political upheavals following the break-up of the USSR and the Eastern European bloc, which has given rise to the assertion of new and reclaimed national and ethnic identities and the search for lost identities. The collapse of communism in Eastern Europe and the USSR in 1989 created significant repercussions in the field of political struggles and affiliations. Communism

was no longer there as a point of reference in the definition of political positions. Earlier forms of ethnic, religious and national identification have re-emerged in Eastern Europe and the former Soviet Union to fill the void.

In post-colonial Europe and the United States, both peoples who have been colonized and those who colonized have responded to the diversity of multiculturalism by a renewed search for ethnic certainties. Whether through religious movements or cultural exclusivity, some previously marginalized ethnic groups have resisted their marginalization within the 'host' societies by reasserting vigorously their identities of origin. In some places, these contestations are linked to religious affiliations (such as Islam within Europe and North America and Roman Catholicism and Protestantism in Northern Ireland). On the other hand, amongst dominant groups in these societies, there is also an ongoing search for old ethnic certainties – for example, in the UK, a nostalgia for a more culturally homogeneous 'Englishness' and, in the US, a movement for a return to 'good old American family values'.

Even within the UK, nationalist movements have fought to retain identity through advancing the claims of their own language, as for example in the case of Plaid Cymru in Wales. The reassertion of a new 'European identity' through membership of the European Union is taking place at the same time as struggles for the recognition of ethnic identities within what were nation-states, such as the former Yugoslavia. To cope with the fragmentation of the present, some communities seek a return to a lost past – 'coordinated ... by "legends and landscapes"; by stories of golden ages, enduring traditions, heroic deeds and dramatic destinies located in promised homelands with hallowed sites and scenery ...' (Daniels, 1993, p. 5).

... Past, present and future play a complicated game in these developments. Contestation in the present may seek justification for the forging of new, and future, national identities by bringing up past origins, traditions, mythologies and boundaries. Current conflicts are often focused on these boundaries, where national identity is contested and where the desperate production of – for example – a unified, homogeneous Serb culture involves endeavouring to make culture and national identity correspond to a place which is perceived as the Serb's territory and 'homeland'. Even if it can be argued that there is no fixed, unified Serb or Croat identity dating back to the Middle Ages (Malcolm, 1994), which could now be resurrected, those involved behave as if there was and express a desire for the restored unity of such an imagined community. This is the term used by Benedict Anderson (1983) to describe national culture in his argument that our understanding of national identity must include the idea we have of it. Since it would not be possible to know all those who share our national identity, we must have a shared idea of what it constitutes. The difference between national identities therefore lies in the different ways in which they are imagined.

These 'imagined communities' are being contested and reconstituted in the contemporary world. The idea of a resurgent European identity, for example, which we find expressed in extreme right-wing political parties, has recently been produced against the threat of 'the Other'. This 'Other' often includes workers from North Africa – Morocco, Tunisia and Algeria – who are construed as representing a threat from Islamic fundamentalism. Such an attitude is increasingly to be found in official European Union immigration policies (King, 1995). This could be seen as projecting a new form of what Edward Said (1978) has called Orientalism – western culture producing a set of assumptions and representations about 'the East' which constructs it as a source of fascination and danger, as both exotic and threatening. Said argues that representations of the East produce western knowledge about it – a fact which tells us more about western fears and anxieties than it does about life in the East and in North Africa. Current constructions of the Orient have focused on Islamic fundamentalism, which is construed – even, perhaps, demonized – as the main new threat to western, liberal traditions.

Global changes and shifts in political and economic structures and allegiances in the contemporary world foreground identity questions and the struggle to assert and maintain national and ethnic identities. Even if the past which current identities reconstruct was only ever imagined, it is defined as offering some certainty in a climate of change, fluidity and increasing uncertainty. Conflicting identities are located within the social, political and economic changes to which they contribute. The identities which are constructed by culture are contested in particular ways in the contemporary, post-colonial world, but this is a historical period characterized by the break-up of what are reconstructed as old certainties and the production of new positionalities. What is significant for our purposes here is that the site of struggle and contestation is the cultural construction of identities and that there is evidence of this taking place in a variety of different contexts. Whereas, in the 1970s and 1980s, conflict was explained and discussed in terms of conflicting ideologies, that terrain of contestation is now more likely to be characterized by competing and conflicting identities, which tends to support the argument that there is a crisis of identity in the contemporary world.

3.1 Histories

National and ethnic conflicts seem to be characterized by attempts to recover and rewrite history, as we saw in the example of the former Yugoslavia. The political assertion of identities requires some authentification through reclaiming one's history. This section will focus on the questions this raises. First, is there one such historical truth about identity which can be recovered? Think about the past which the British (or more specifically the English) heritage industry reproduces through the packaging of the stately home, and through media representations such as film versions of Jane Austen's novels. Could there be one, authentic English past which can be used to support and define 'Englishness' as a late-twentieth-century identity? The heritage 'industry' seems to present only one version. Secondly, whose history counts? There can be different histories. If there are different versions of the past, how do we negotiate between them? One version of the past is of Britain as an imperial power, which excludes the experiences and histories of those peoples Britain colonized. An alternative history challenges that account through expressing the diversity of these ethnic groups and the plurality of cultures. In asserting the plurality of positions, which historical inheritance has greater validity? Or does this lead to a relativist position where all are of equal but separate validity? In celebrating difference, however, might there not be a danger of obscuring the shared economic oppression in which all these groups are deeply imbricated? S.P. Mohanty uses the opposition between history and histories to argue that a celebration of difference can ignore the structural nature of oppression:

> Plurality [is] thus a political ideal as much as it [is] a methodological slogan. But ... a nagging question remains. How do we negotiate between my history and yours? How would it be possible for us to recover our commonality, not the humanist myth of our shared human attributes which are meant to distinguish us from animals, but, more significantly, the imbrication of our various pasts and presents, the ineluctable relationships of shared and contested meanings, values and material resources? It is necessary to assert our dense peculiarities, our lived and imagined differences. But could we afford to leave unexamined the question of how our differences are intertwined and indeed hierarchically organized? Could we, in other words, really afford to have entirely different histories, to see ourselves as living – and having lived – in entirely heterogeneous and discrete spaces?
>
> *(Mohanty, 1989, p. 13)*

Histories are contested, not least in the political struggle for recognition of identities. In his article, 'Cultural identity and diaspora' (1990), Stuart Hall explores the different conceptualizations of cultural identity and what is involved in seeking to authenticate identity through seeking out a shared past... .

3.2 Social changes

Changes are not only taking place on global and national scales and in the political arena. Identity formation also occurs at the 'local' and personal levels. Global changes, for example in the economy (such as changing patterns in production, the move away from heavy manufacturing industries and the increase in service sector employment), have local impact. Shifts in social class positioning are a feature of these global and local changes.

The kinds of disruption which can be seen as constituting global crises of identity have involved what Ernesto Laclau has called dislocation. Modern societies, he argues, have no clear core or centre which produces fixed identities, but rather a plurality of centres. One of the centres which it can be argued has been displaced is that of social class. Here, Laclau means not only class as a function of economic organization and of processes of production, but class as a determinant of all the other social relations: class as the 'master' category, which is how it is often deployed in Marxist analyses of social structure. Laclau argues that there is no longer one, overarching, determining force, such as class within the Marxist paradigm, which shapes all social relations, but rather a multiplicity of centres. He suggests that, not only is class struggle not inevitable, but it is no longer possible to argue that social emancipation lies in the hands of one class. Laclau sees this as having positive implications because dislocation offers many, different places from which new identities can emerge and where new subjects can be articulated (Laclau, 1990, p. 40). The benefits of the dislocation of class can be illustrated by the move away from class-based political allegiances, such as the working-class trade union, and the rise of other arenas of social conflict, such as those based on gender, 'race', ethnicity, or sexuality.

Individuals live within a large number of different institutions, or what Pierre Bourdieu calls 'fields', such as families, peer groups, educational settings, work and political groups. We participate in these institutions or 'fields', exercising what we may see as varying degrees of choice and autonomy, but each of them has a material context, in fact a space and a place, as well as a set of symbolic resources. For example, many people live out their familial identities within the 'field' of the home. The home is also one of the places where we are viewers of media representations through which identities are produced – for example, through the narrative of soap operas, through advertisements, and through the marketing of new identities through retailing. Although we may, in common-sense terms, see ourselves as the 'same person' in all our different encounters and interactions, there is also a sense in which we are differently positioned at different times and in different places, according to the different social roles we are playing (see Hall, ed., 1997). The social context can engage us in different social meanings. Consider the different 'identities' involved in different occasions, such as attending a job interview or a parents' evening, going to a party or a football match, or visiting a shopping mall. In all these situations we may feel, literally, like the same person, but we are differently positioned by the social expectations and constraints and we represent ourselves to others differently in each context. In a sense, we are positioned – and we also position ourselves – according to the 'fields' in which we are acting.

Some of [our] ... identities may indeed have changed over time. The ways in which we represent ourselves – as women, as men, as parents, as workers – have been subject to radical change in recent years. As individuals, we may experience fragmentation in relationships and in our working lives, and these experiences are set against historical social changes, such as changes

in the labour market and employment patterns. Political identities and allegiances have shifted, with a move away from traditional, class-based loyalties towards 'lifestyle' choices and the emergence of 'identity politics', where ethnicity and 'race', gender, sexuality, age, disability, social justice and environmental concerns produce new identifications. Relationships within the family have changed, especially with the impact of changing patterns of employment. There have also been changes in working practices and the production and consumption of goods and services, as well as the emergence of new patterns of domestic living, such as increasing numbers of lone-parent households, and higher divorce rates. Sexual identities are also shifting, becoming more contested and ambiguous, suggesting changes and fragmentation which could be described in terms of a crisis of identity.

The complexity of modern life requires us to assume different identities – but these different identities may conflict. In our personal lives we may experience tensions between our different identities when what is required by one may infringe upon the demands of another. One conflict which springs to mind is that between identity as a parent and as a paid worker. The demands of the one impinge upon and often contradict the demands of the other. To be a 'good parent' you should be available to your children, meeting their demands: yet your employer may also require total commitment. Attending a parents' evening at your child's school may conflict with your employer's demands that you work late.

Other conflicts arise out of tensions between social expectations and norms. For example, mothers are expected to be heterosexual. Different identities may be constructed as 'other' or as deviant. Audre Lorde writes: 'As a forty nine year old Black lesbian feminist socialist mother of two including one boy, and a member of an inter-racial couple, I usually find myself part of some group defined as other, deviant, inferior or just plain wrong' (1984, p. 47). Some of these identities may seem to concern the most personal aspects of life, such as sexuality. However, how we live our sexual identities is mediated by the cultural meanings about sexuality produced through dominant systems of representation, which, as Lorde suggests, position some identity categories as the 'other'. However Lorde may have chosen to affirm her identity, for example as a mother, this is constrained by dominant discourses of heterosexuality and by the hostility often experienced by lesbian mothers. Lorde cites a range of different contexts in which her identity – or rather identities – are constructed and negotiated.

Every context or cultural field has its controls and expectations and its 'imaginary'; that is, its promise of pleasure and achievement. As Lorde suggests, assumptions about heterosexuality and racist discourses deny some families access to this 'imaginary'. This illustrates the relationship between the social and the symbolic. Is it possible to be socially excluded in the way Lorde describes – and not be symbolically marked as different? Every social practice is symbolically marked and every social practice has to be understood. Identities are diverse and changing, both in the social contexts in which they are experienced and in the symbolic systems through which we make sense of our own positions. An illustration of this is the development of what have been called 'new social movements', which involved struggles over identity, and which have crossed the boundaries between the personal and the political, to adapt the feminist slogan.

4.3 Summary of section 4

Difference is marked by symbolic representations which give meaning to social relations, but the exploration of difference does not tell us why people invest in the positions they do nor why there is such personal investment in difference. Some of the processes involved in the construction of identity positions have been described, but we have not addressed the question of *why* people take up these identities. [This deserves further consideration...].

Bibliography

Anderson, B. (1983) *Imagined Communities: reflections on the origins and spread of nationalism*, London, Verso.

Bourdieu, P. (1984) *Distinction: a social critique of the judgement of taste* (tr. R. Nice), Cambridge, MA, Harvard University Press.

Castles, S. and Miller, M.J. (1993) *The Age of Migration*, London, Macmillan.

Daniels, S. (1993) *Fields of Vision: landscape, imagery and national identity in England and the US*, Cambridge, Polity Press.

du Gay, P., Hall, S., Janes, L., Mackay, H. and Negus, K. (eds) (1997) *Doing Cultural Studies: the story of the Sony Walkman*, London, Sage/The Open University (Book 1 in this series).

Giddens, A. (1990) *The Consequences of Modernity*, Cambridge, Polity.

Gledhill, C. (1997) 'Genre and gender: the case of soap opera' in Hall, S. (ed.) *Representation: cultural representations and signifying practices*, London, Sage/The Open University (Book 2 in this series).

Hall, S. (1990) 'Cultural identity and diaspora' in Rutherford, J. (ed.) (1990).

Hall, S. (ed.) (1997) *Representation: cultural representations and signifying practices*, London, Sage/The Open University (Book 2 in this series).

Ignatieff, M. (1993) 'The highway of brotherhood and unity', *Granta*, Vol. 45, pp. 225–43.

Ignatieff, M. (1994) *The Narcissism of Minor Differences*, Pavis Centre Inaugural Lecture, Milton Keynes, The Open University.

King, R. (1995) 'Migrations, globalization and place' in Massey, D. and Jess, P. (eds) *A Place in the World*, Oxford, Oxford University Press/The Open University.

Laclau, E. (1990) *New Reflections on the Revolution of Our Time*, London, Verso.

Lorde, A. (1984) *Sister Outsider*, Trumansburg, New York, The Crossing Press.

Malcolm, N. (1994) *Bosnia: a short history*, London, Macmillan.

Mercer, K. (1990) 'Welcome to the jungle' in Rutherford, J. (ed.) (1990).

Mohanty, S.P. (1989) 'Us and them: on the philosophical bases of political criticism', *The Yale Journal of Criticism*, Vol. 21, pp. 1–31.

Nixon, S. (1997) 'Exhibiting masculinity' in Hall, S. (ed.) *Representation: cultural representations and signifying practices*, London, Sage/The Open University (Book 2 in this series).

Robins, K. (1991) 'Tradition and translation: national culture in its global context' in Corner, J. and Harvey, S. (eds) *Enterprise and Heritage: crosscurrents of national culture*, London, Routledge.

Robins, K. (1997) 'Global times: what in the world's going on?' in du Gay, P. (ed.) *Production of Culture/Cultures of Production*, London, Sage/The Open University (Book 4 in this series).

Rutherford, J. (ed.) (1990) *Identity: community, culture, difference*, London, Lawrence and Wishart.

Said, E. (1978) *Orientalism*, London, Random House.

31
Emotional engagement in heritage sites and museums

Ghosts of the past and imagination in the present

Sheila Watson

Certain forms of knowledge along with some types of organisational practices and various cultures prioritise dispassionate appreciation of factual information about the past and this, in turn, masks their potential to elucidate personal and community meanings. Emotions are regulated not only by different cultural attitudes to events, objects, places and commemorative practices, but also by a tacit acceptance by museums and heritage sites that some types of emotions and feelings can be encouraged but not others, as we shall see in the case studies below. Popular feelings about heritage, such as those relating to the supernatural, are rarely taken into consideration when interpretive strategies are formulated by official bodies that tend to adopt a positivist and empirical approach to assessing the significance of historical sites, objects and monuments. Indeed with a few notable exceptions such as the work undertaken by Wells and Baldwin (2012) there has been little qualitative research into how individuals and communities interact on a daily basis with the historic environment. Nevertheless, evidence as to how communities engage with the past is accessible in the form of locally produced histories, folk tales, popular narratives, and types of local associations, and an examination of these suggest that official and private meaning making are sometimes very different from each other. This chapter explores different ways in which emotional responses to material culture, museums and other heritage sites have often been ignored by interpretive strategies that focus on a range of other meanings, directly linked to disciplinary practices and conventions. Here theories about knowledge and professionalism and the ways in which academic discourse is expressed, are all understood to influence the decisions made about what heritage is, and how it is interpreted. Such ideas are based on Foucault (1991) and his theories about the 'role played by various forms of knowledge and expertise in organising differentiated fields of social management in which social conduct is subjected to diverse strategies of regulation' (Bennett 2004: 5). Similarly the work of Bourdieu and his theories of cultural capital which enable elites to accord specific values to heritage in all its manifest forms have been influential here (Bourdieu 1977). Such official heritage is understood not only to ignore much that is popular but to educate the general public about what they should value about the past, privileging the aesthetic and the traditional academic disciplines (Bennett 1995; Harrison 2010). Arising in part from the Enlightenment and its emphasis on science and rationality it becomes a form of Authorised Heritage Discourse (Smith 2006). Such approaches have tended to ignore popular narratives that co-exist alongside such formal and

traditional interpretations and, in so doing, underestimate just how widely such official interpretations can be ignored. This chapter concludes with a brief look at attempts to encourage personal emotional responses in experimental, temporary ways in a museum.

What is affect and what is emotion?

Recent interest in the politics of affect has led to the reconsideration of a range of theoretical concepts that help us understand what happens when we are moved in some way by heritage sites whether they are palaces or landscapes, archaeological sites or traditional forms of transport, reproduced historical sites or original ones, objects, narratives, history or art museums. For some the emotional human response to objects, artistic installations, displays, testimonies, photographs, spaces and interpretive strategies such as living history are difficult to describe and even more difficult to analyse and are understood to be 'poetic' in some way (Spalding 2002; Porter 1986; Kavanagh 2000). The growth in interest in emotion in many disciplines, the so called 'emotional turn' (Bondi 2005: 434; Tarlow 2012: 170), has led to much debate about emotions and affect with little consensus as to their meaning. Despite recent advances in neuroscience there is still much debate as to how they are linked to cognition (Sander 2013; Watson 2013). Within this context the following definition is useful.

According to Stearns and Stearns (1985: 813; after Kleinginna and Kleinginna 1981: 354–359) emotion is engendered by a

> complex set of interactions among subjective and objective factors, mediated through neural and/or hormonal systems, which gives rise to feelings (affective experiences as of pleasure or displeasure) and also general cognitive processes toward appraising the experience; emotions in this sense lead to physiological adjustments to the conditions that aroused response, and often to expressive and adaptive behavior.

It is recognised that emotions clearly matter in heritage sites. Research suggests that once a certain type of mood has been established it will impact upon the cognitive work of the brain for some considerable time afterwards (Reddy 2001: 14). In other words if an exhibition or site, from the outset, makes us feel happy and pleased to be there we are likely to enjoy it more. Conversely a site that interprets difficult, contested or unpleasant history, or confuses us, is likely to engender feelings that will impact upon the ways in which visitors respond to the overall message. However, at present there has been very little research into how and why visitors respond emotionally as they do when they visit such places (with notable exceptions such as Brown and Reavey 2015).

The study of emotions falls into two main approaches – psychological/universal and cultural/contextual (see Tarlow 2012: 171). One approach argues that all humans have access to similar forms of emotions (Izard 2007), which include anger, fear, disgust, happiness, surprise and sadness (Bowen 2014: 116; Ekman 1992; Levenson 2011; Plutchik 1980), while the other posits that emotion is something difficult to define and contextual (Scherer 2005) and culturally regulated within specific historical time periods (Reddy 2001; Voestermans and Verheggen 2013; Rosenwein 1998, 2007). Most people working in this field adopt some kind of compromise between the two attitudes (Bowen 2014). Tarlow argues that popular culture such as historic dramas, tend to assume a universal, nonspecific time based, set of emotions to which current audiences can be drawn. 'Emotional pasts are powerfully attractive but risk presenting modern and Euro-American sensibilities as universal, which has negative political implications' (Tarlow 2012: 171). However, if we accept that emotions are affected by social and cultural

contexts and these, in part, regulate how we respond to stimulus, then we move into the realm of emotionology.

According to Stearns and Stearns, emotionology can be defined as 'the attitudes or standards that a society, or a definable group within a society, maintains toward basic emotions and their appropriate expression' and 'ways that institutions reflect and encourage these attitudes in human conduct' (1985: 813). Thus, at the time of writing (2016) North American citizens express patriotic feelings by flying American flags from their houses and lawns at all times, whereas many British people feel uncomfortable with such overt displays of emotional expressions of loyalty to the nation except on special occasions such as during a sporting occasion or specific royal event. Here the emotions of patriotism are regulated by what is commonly expected of citizens at specific times and in specific locations. When we see the flag of our own nation we may be affected by the sight and, if the flag appears in an emotionally regulated manner, for example, draped over a coffin of a soldier who died in combat, we may feel pride as well as sorrow, and we may also respond physically by crying. In this situation we would find laughter inappropriate. Thus we can refer to 'feeling rules – the recommended norms by which people are supposed to shape their emotional expression and react to the expression of others' (Stearns 1994: 2) and it is these rules that help shape our responses to heritage.

The use of the word *affect* varies from discipline to discipline and from writer to writer. Some writers such as Thrift, in human geography, tend to 'use emotion and affect somewhat interchangeably' (Bondi 2005: 437; see also Thrift 2004, 2007), with affect a popular term to describe non-cognitive bodily experiences. Waterton and Watson (2014: 27) use the language and theory of semiotics to deconstruct certain assumptions made by those writing about heritage sites which do not pay attention to affect. Affect, they argue, is what happens when we encounter something and respond physically and mentally to the encounter. For the purpose of this chapter we can accept that these concepts are fluid, often interchangeable, and made more complex by other descriptors such as *mood* which in turn have several different meanings depending upon the context in which they are used.

Heritage sites and emotions: the context of space

Design and interpretation in heritage sites can also engender emotions. Indeed, heritage sites, places where we encounter the past, have affect which is both cognitive and physical and these affects impact upon the brain to encourage an emotional response as well as a mood. For example, Burgh Castle in Norfolk, England, formerly a Roman Saxon shore fort to defend the estuary against marauding invaders, evokes particular feelings. On a cold day with the East wind and the watery landscape one can feel the sense of isolation, and imagine the anticipation and anxiety that was the lot of the Roman cavalry cohort whose role was to ride hard inland with a message to the Roman town upstream 'the raiders are coming'. With the minimum of interpretation on this site (a few text panels), difficulties of access which creates a sense of remoteness, along with the unforgiving weather of the East coast, the affect is something that can be created without much intervention by those who manage the site. Indeed the emptiness of the fort, its ruined walls and its air of abandonment, all help to promote an affective response.

Of course our response to such sites is individual, framed by our social, cultural and psychological experiences and makeup. It may well depend, if we are English, upon a conflicted response. For those who understand the invading Saxons to be ancestral and the Romans to have been a temporary imposition upon the country then the effect of such a place may be different from someone who greatly admires Roman civilisation. For the latter the site may engender feelings (emotions) of loss and sadness at the decline of Roman power and the coming

Figure 31.1 Burgh Castle Norfolk.
Source: photograph by Sheila Watson.

of the so called 'Dark Ages' or excitement at the survival of the physical evidence of Roman military might. This example illustrates the extent to which knowledge of historical context and cultural norms may affect visitors to sites in different ways and how affect and emotion are interdependent. However, whatever feelings people have on a visit to the Burgh Castle site they are encouraged to engage with it from scientific archaeological and historical perspective without any reference to local associations. Information about the history of the fort is provided which explains clearly and with excellent illustrations. Not once however, is reference made to any feelings or non-academic associations with the site.

The experiences imagined above are intimately related to space and the impact upon the body of its surroundings. Architects have long been interested in the notion of spatial awareness. In 2014 the Royal Academy in London staged an exhibition 'Sensing Spaces: Architecture Reimagined'. Here seven contemporary architects were invited to create spaces 'which set out to awaken and recalibrate our sensibilities to the spaces that surround us' (Gregory 2014:1). The exhibition deliberately sought to educate people into a better understanding of architecture's power to affect our daily lives. It began with a premise, unsupported as far as I know by visitor research, and derived from the work of Bruno Levi (1957; 1948) that 'very few people understood how powerful architecture is or how it can so profoundly affect us', and that 'the "true riches of meaning" in architecture are largely misunderstood, being based on a superficial reading of the art form' (Gregory 2014: 3). Thus the exhibition begins with a deficit view of the visitor, indeed of the majority of people who are not architects, and suggests we need to be educated into the understanding that in the words of Bruno Levi, 'architecture is a personal, enjoyable necessary experience' (Levi cited Gregory 2014: 3). The emphasis, at least in Gregory's education leaflet given out free to schools and to visitors who chose to pick it up, spoke of experience but exhorted intellectual understanding of the affect. In that this was an exhibition about

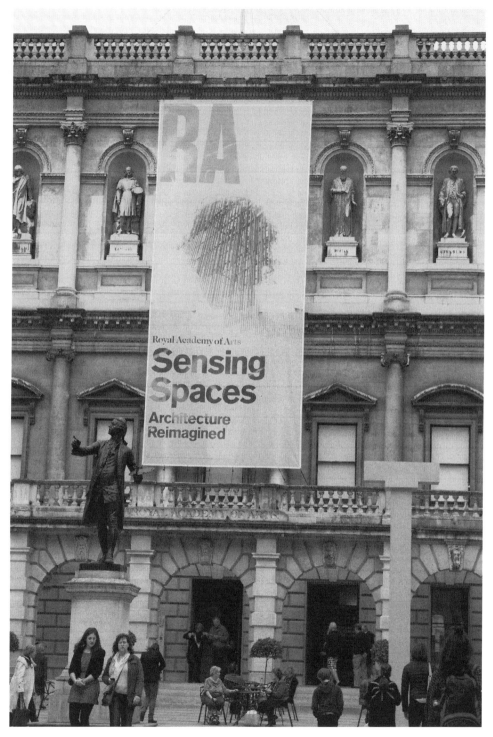

Figure 31.2 The Royal Academy exhibition Sensing Spaces.
Source: photograph by Sheila Watson.

architecture's affective powers this approach was a logical one. However, by encouraging us to explore architectural spaces devoid of context I argue that this exercise allowed us to be aware of only part of place and architecture's great affect upon the human mind.

In life we experience architecture in context, through its location in space and time, and through what is both present and absent within it. Thus we are affected by Burgh Castle by being within its ruined walls and feeling the wind in our faces and smelling the mud flats and tasting the salt from the sea breeze on our lips. Its affect upon us is also influenced by the fact that the site is remote and we have walked some distance along a footpath to find it, However, without the context, the understanding of the role the fort played in the past and how this past has slipped almost beyond memory of most except the locals who still talk of the ghosts around the walls, the experience of space is devoid of some of the meaning that gives it emotional depth.

For many local people their emotional engagement with this site is through stories of its ghosts and through memories of family visits to the place. It is not necessarily through the academic notion of the authenticity of a Roman and post-Roman site. It is this authenticity that motivates many archaeologists and historians to find Burgh Castle and to stand amongst its ruins. As Bendix observes 'The search for authenticity is fundamentally an emotional and moral quest' (1997: 7). For those educated in the formal discourses of archaeology and history, particularly those relating to the end of Roman Britain, these walls are not only original but they legitimate the knowledge of individuals invested in the disciplines of archaeology and history. Recognising the significance of these walls within this historical context allows such visitors to contextualise existing knowledge and to recognise an affinity with something which, for those without this knowledge, may mean little. For Bendix, writing as an anthropologist, what is authentic or authenticity is

> a quality of experience: the chills running down one's spine during musical performances, for instance, moments that may stir one to tears, laughter, elation – which on reflection crystallize into categories and in the process lose the immediacy that characterizes authenticity.
>
> *(1997: 13–4)*

Thus for those who understand the archaeological and historical importance of the site the text panels confirm their knowledge as does the site itself, presenting evidence in the form of bricks, flints and layout. A visit can generate emotions that arise out of a feeling of authenticity. For many local people the site has other significance.

Heritage sites and ghosts of the past

I wrote earlier of ghosts and it is to ghosts I now return for it seems to me that much of our attachment to places and things is located within a human feeling of loss and longing for the old days, along with fear and anxiety about the past generally. While we may feel nostalgia for some things and romanticise others we also suppress stories that disturb us. Above all there is a tension when we come to think about the dead – those people who have gone before whose history we are trying to re-create in our imaginations when we visit historic sites or see an object in a museum. We enjoy both the sense of closeness with objects used or worn by those who have gone before, and we are also uneasy about our relationships with those who have died. Within a Western tradition of ghost hunting and haunting there exist some popular beliefs about our ability to link ourselves in some way to those who went before us, particularly through the materiality of place and object. Thus it is believed by some that certain buildings and places have

been imbued with a form of emotional echo that repeats to the living the feelings of the dead, rather like a recording that cannot be switched off, but is only heard by those with a particular sensitivity (Holloway and Kneale 2008: 299). Such ideas can be attractive to those who enjoy the thrill of the unknown but they may equally be off-putting to others who may find stories of haunting and ghosts unsettling and distressing. Jane Bennett argues that 'despite appearances, modern life contains sites where we may be enchanted, surprised, charmed and disturbed. We can learn to look for these sites and to encourage this response in ourselves...' (Bennett 2001: 4, 12 cited in Holloway and Kneale 2008: 298). In his work on the ghosts of industrial ruins, and the memories they encourage, Edensor meditates on the physical and mental impressions left by derelict sites, where objects and space reveal the lives of those who once worked there. For him this form of haunting, a stimulation of unmediated memories away from formal sites of memory and official interpretation, that enables a form of memory that 'is not located merely in the visible and the narratable but is embodied and affective' (2005: 846). For Edensor this is a form of being haunted that

> draws us, 'always a bit magically, into the structure of feeling of a reality we come to experience, not as cold knowledge, but as transformative recognition' (Benjamin, 1973, page 8). In the ruin 'layers of cultural memory and folds of affect are tangibly inscribed in space' (Bruno, 2003, page 323), in its materialities, obscure signs, and affordances, in its ghosts, and what emerges is not empiricist, didactic, or intellectual knowledge but an empathetic and sensual apprehension, understood at an intuitive and affective level' (Edensor 2005: 846–847) ... 'The objects, spaces, and traces found in ruins highlight the mystery and radical otherness of the past, a past which can haunt the fixed memories of place proffered by the powerful'.
>
> *(ibid)*

Thus ghosts are our memories, or imagined reconstructions of the past, that we feel emotionally rather than cognitively, and experience in a way that can only be described as through magic.

However, what of real ghosts? Not the words used by academics to describe ephemera and personal emotional and affective experiences in old places, or the transient and elusive feelings we have when confronted with some old things that somehow make us feel a personal link to a different time, but the idea of another world intersecting with ours through the experience of visitors from beyond the grave? When we come to try and understand the emotional impact of heritage upon the visitor we should not ignore this particular form of popular encounter, which is more often related by others than experienced oneself. Whether one believes in ghosts or not the Western mind appears inordinately attached to them. In Britain the ghost walk is a popular tourism phenomenon which combines historical narrative with descriptions of paranormal activity (Hanks 2011). Such heritage is popular not only in the West; many cultures accept the existence of ghosts. After the Japanese tsunami in 2011 people reported being haunted by ghosts who were unaware they were dead (Parry 2014). Despite the Enlightenment and the rise of an apparently secular and rational society ghosts are an integral part of many heritage experiences. Indeed museums and heritage sites are often places of 'uncanny encounters' in popular literature and film (Arnold-de Simine 2013: 187) and have been described as places where objects become 'undead' (ibid: 188). Burgh Castle has at least three forms of haunting that persist in popular memory today. Unsurprisingly these stories do not appear in any official form of information about the site[1] but were repeated orally to me by several people during the time I worked in the museums in Great Yarmouth,

near Burgh Castle. Disappointingly perhaps, there are no ghosts of Roman soldiers but stories of a battle that reoccurs once a year between different groups of Saxons who settled there. There is also a story of a ghostly body being thrown from the battlements into the river beyond; though once again there is a consensus that the ghostly body is not Roman. Finally there is the ghost of Black Shuck,[2] the giant black ghost dog of East Anglia, which has been documented over the centuries in various places, but who, according to one legend, returns at dawn to Burgh Castle to rest before beginning his nightly roaming again. Shuck, it is said, is the devil himself. This powerful folk tale, part of the local association of the place, is unmentioned here. None of the ghosts are Roman but are located in communal memories or imaginings of Saxon heritage and later religious anxieties and, as such, do not fit within the formal scientific interpretation of the site.

For many the notion of whether ghosts are real or not is secondary to the emotional impact of imagining they might well be so. Such impact on the public has long been recorded and may well have been encouraged by the development, in the eighteenth century, of the popular entertainment – the Phantasmagoria – that brought 'alive' strange images and experiences through scientific instruments (Arnold-de Simine 2013: 188). While these have been replaced in public entertainment by digital and film media the effect is the same – a manipulation of senses and feeling. Such expressions of attachment, public interest in and fondness for these methods over time are rarely noted within an academic disciplinary context.

If locals are not attached to the site by their ghost stories, then they are engaged to it by personal memories of Old Mother Brown's, an ice-cream hut that dispensed ices to families on Good Friday at the site. For locals Easter meant a visit to Old Mother Brown's, always on Good Friday. Memories of this tradition that continued into the 1960s have now begun to fade but for those who have them Burgh Castle is remembered through an emotional lens of family fun and holiday treats (Taylor 1999).

Despite this rich historical and cultural context the site remains, for the tourist, a formal symbol of Roman power. Without this local interpretation the site is just another Roman ruin. It has been divorced from any emotional meaning except that accessed through academic conventions such as its Roman authenticity.

The disciplining of emotions – or how they are lost and found in historic sites

We have seen that the emotional interpretation of a historical site or object is often bypassed by a desire to position the site or some aspect of material culture within the context of a disciplinary framework that rarely enables individuals to understand the emotional contexts of the past. In this example, textiles at Hardwick Hall, the home built by Elizabeth, Countess of Shrewsbury, (Bess of Hardwick), are displayed very much as examples of craft and design. However, many of them are recycled clerical vestments (Ryan 2014). Now displayed in the Butler's pantry some of them, including the Penelope tapestry, once hung on the walls in the Great Hall in Hardwick and, before that most had been at Chatsworth (another of Bess's houses in which she lived before Hardwick) where 42 tapestries decorated 10 chambers (Durant 1977: 52), By focussing on the ways in which such tapestries depict heroic and famous women from the past (with whom, presumably Bess identified), and the techniques that created such gorgeous materials along with information about conservation, we lose sight of the context in which they were made. These were reworked Roman Catholic vestments, acquired as part of the loot of the Reformation, and re-used in a prominently secular and Protestant manner. They tell us that Bess was a loyal supporter of the Protestant Elizabeth I, that she abjured Rome and openly rejoiced

Emotional engagement in heritage sites and museums

in her Protestant faith – a faith from which she and her second and third husbands had materially benefitted when the monasteries were dissolved in 1536 and 1539. More unusually however, it has been suggested that the designs for these may have been suggested by Bess's prisoner, Mary Queen of Scots, while at Tutbury Castle (Durant 1977: 67) although this is unlikely and this story is refuted in the official guidebook (Girouard 2006: 9). Indeed Mary would have no doubt found this re-use of religious textiles sacrilegious. We are now accustomed to seeing religious material culture as art devoid of a religious imperative (Greenblatt 1991: 46) but this was not the case in the sixteenth century. While we can only imagine how devout Roman Catholics regarded the re-use of clerical vestments, cut up to provide motifs for new wall hangings, we can presume that for some this re-use would be discordant, a painful reminder of the loss of much they held dear. Also on show in the house are other textiles embroidered with references to Bess and her family, their loves and the things they have lost. They bear witness to her emotional engagement with those she loved. Bess moved these items to a place she called home for the last part of her life after her quarrel with her fourth husband, the Earl of Shrewsbury, and her eldest son.

Bess of Hardwick is known as much for her obsession with building as with needlework. Her houses were regularly re-modelled, altered and made more splendid. Bess's early life was the story of insecurity and the lack of a place called home. Her obsession with building can be seen, perhaps, as an attempt to secure somewhere safe for her and her loved ones as well as the outward trappings of a wealthy and influential woman in a man's world. These hangings, which she moved from house to house over time, represent not only the craftsmanship of the time and the outward signs of wealth and power but a complex pattern of emotional associations for Bess and her family, associations that are rarely explored mainly because in the interpretations provided at and of the Hall, techniques and craftsmanship are prioritised over emotional meanings.

Figure 31.3 Penelope Tapestry, The Penelope Tapestry, one of a group of five, created by Bess of Hardwick out of Roman Catholic clerical vestments.

Source: reproduced by kind permission of the National Trust.

This absence of emotional meaning and the focus on professional knowledge is part of the ways in which emotions are regulated by society. In England from which both these examples are drawn, English reticence and embarrassment at the display of emotions in a public space (unless associated with certain activities such as sport or royal ceremonies) in part help to explain this dispassionate form of heritage engagement as well as the idea of disciplinary knowledge and the division of forms of understanding into different compartments or silos where they rarely meet. Here, the absence of interpretation of the emotional contexts of these materials emphasises the power, wealth and state of the woman, not her human attributes.

However, these emotional responses are also regulated by the nature of the organisations that manage heritage sites, in England at Hardwick Hall, the National Trust and in Norfolk at Burgh Castle the Norfolk Archaeological Trust and English Heritage. These bodies adopt specific and centrally managed display practices that are recognised by regular visitors. Those who work for these organisations (indeed any organisation) find that the emotional culture in which they work is regulated by rules both written and generally understood. Many of them derive from academia. Drawing on the work of Bloch (2002) who uses the work of Bourdieu (1975), Flam (1990a, b) and Hochschild (1983) to analyse the ways in which academia manages emotions, we can argue that it is apparent that English heritage organisations generally adopt a policy that is similar to that of peer review in academia. Their employees produce exhibitions and information for consumption by the public, aware that their outputs will be judged by their peers and that each organisation has standards of conservation, presentation and interpretation as well as experts in various fields, all of whom need to be satisfied. As in academia so in these organisations, their peer group 'is a floating sociality, consisting of anything from a specialist network or an invisible college to a wider professional community' (Bloch 2002: 115). For academics negative reviews of one's work, even when phrased constructively, can be an intensely emotional experience which arouses feelings of anger, shame, frustration and despair (Bloch 2002: 124–129). In a similar way work in heritage sites of all types, including museums, is under intense peer scrutiny and can result in the adherence to accepted norms of display and certain traditional methods of working. As in academia, so in some larger heritage organisations, one's standing depends on the affirmation and approval of one's peers. As heritage depends for its validation on the disciplines of archaeology and history, and these are governed by scientific rules of impartiality and emotional detachment (Bourdieu 1991), it is not surprising that sites prioritise facts over feelings.

We should not, however, underestimate the ways in which such official interpretations can sit alongside and accommodate personal, local and less regulated meanings. The English have a long and documented history of maintaining different sometimes contradictory versions of the past, sometimes expressing both simultaneously, and rarely finding such versions problematic. In a seminal work by Andy Wood *The Memory of the People*, Wood returns to Raymond Williams's arguments that many people were able to maintain such contradictory ideas within their own 'mental worlds' which offered alternative personal meanings to those accommodated within mainstream cultural modes of thinking (Williams 1973: 10, cited in Wood 2013: 21, note 74). I would go further and argue that these alternative ways of thinking about historic places, which we have seen in the example of Burgh Castle, are more complex than this. Non specialists in traditional academic disciplines can appreciate and enjoy several different ways of understanding historic sites sometimes attributing different values to the meanings given by the so called experts. Local people in Great Yarmouth love the idea that experts in archaeology consider Burgh Castle to be an important Roman site, not necessarily because they value it as archaeological evidence of late Roman and early Saxon occupation of the area as the archaeologists do.

No, they value it because it gives them and their location a status that is rarely accorded to a run down, deprived seaside town (Watson 2007). When museum staff in 2000 and 2001 undertook consultation to develop for new museum Time and Tide, the Museum of Yarmouth Life, locals did not want their local legends made explicit but the formal archaeological ones. As a result, in the interpretation of local history presented in this museum, we have less of a hegemonic attempt to impose a formal academic interpretation on a site and instead an attempt to provide a more nuanced accommodation of different meanings. It is thus too simplistic in this case to argue that here we can see some form of Authorised Heritage Discourse in play, which excludes or somehow dominates other meanings for it does not take account of the manner in which this formal interpretation and authoritative meaning is transmogrified into something valuable by those for whom the site is local.

Emotional regulation as therapy

Art is often understood through an aesthetic (Robinson 2005; Silvia 2009) which is prioritised as 'wonder' (Greenblatt 1991). However, emotions in art are more readily accepted in the formal context of the art gallery. Recently some museums with art collections have begun to experiment with the idea that they should encourage emotional responses from visitors and acknowledge that traditional ways of seeing and experiencing collections through the aesthetic can be limiting and inaccessible to many visitors. For example, in Malta, MUZA, the project to redevelop the National Gallery of Malta, is using focus groups to ascertain what moves and interests people. Between April and September 2014 the Rijksmuseum hosted an installation called *Art as Therapy* by Alain De Botton and John Armstrong. It was composed of a series of very large yellow post-it notes positioned near certain art works or exhibitions that commentated on them in an unorthodox manner. Occasionally there was a comment on art or the museum itself and it was designed to encourage visitors to respond both emotionally and cognitively within a framework of therapeutic intent.

The Rijksmuseum is not solely a museum about art. It tells the story, through art, of the Dutch people and can be understood as a national history museum. The installations reflected this complex relationship with a mixture of historical context and commentary about emotional responses. De Botton and Armstrong argue that we can use art to help us with emotions and they identify seven 'frailties' which include remembering, hope, sorrow, rebalancing, self-understanding, growth and appreciation (de Botton and Armstrong 2013: 5). The post-it notes helped visitors to understand these 'frailties' and sought to encourage the general public to use art to overcome them for the purpose of self-development.

This was a brave and interesting attempt to develop emotional responses to art while it remained in a classical gallery setting underpinned by its own complex and traditional forms of knowledge. While not subversive, for the interventions complemented the traditional displays and enhanced them, this technique nevertheless questioned, as did my previous examples, the ways in which formal knowledge in the West can work to suppress our natural feelings. Yet at the same time the installations attempted to manage the response of the viewer. The whole concept related to the idea that emotion could be helpful; that we could respond in some ways to certain ideas in art and such responses would help deal with a series of problems, called sicknesses. Each post-it has a 'sickness' at the end which draws the reader's attention to the difficulties that have to be overcome if individuals are to lead rewarding and full lives or, sometimes, understand the art in question as the following example illustrates.

All that follows should be placed within the context of the birth of the Dutch Republic in the seventeenth century, through resistance to Spanish rule, as was made clear in text earlier in

Sheila Watson

Figure 31.4 The explosion of the Spanish Flag Ship during the Battle of Gibraltar. Cornelius Claesz van Wieringen (?–1633).
Source: reproduced by kind permission of the Rijksmuseum Amsterdam.

the gallery. A large post-it note was placed next to the painting of an explosion in a ship. The original text read thus:

> The explosion of the Spanish Flag Ship during the Battle of Gibraltar.
> Cornelius Claesz van Wieringen (?–1633)
> Oil on canvas, *c.* 1621
> On 25 April 1607, 30 Dutch ships took the Spanish fleet by surprise in the Bay of Gibraltar. The Spanish vessels, which posed a threat to Dutch trade, were destroyed. This was the first major Dutch victory at sea. The painter represented victory in this triumphant style, with the Spanish flagship exploding and dozens of crew members flying up into the air.

Next to it the yellow post-it read thus:

> It was a fantastic day; we smashed them to smithereens, we blew them 30 feet into the air; their brains went everywhere. My friend gouged out some guy's eye. We won. We totally owned them.
>
> In its raw, energetic triumphalism, the picture gives a corrective nudge to our present attitudes. We are so conscious that thuggish people must never be encouraged that decent people have learned all too well to suppress their own appetite for a fight, their own desire for a victory. But in a world where conflict is unavoidable, good people need to strengthen their willingness to face down opposition, not always compromise and play it safe, but take

Emotional engagement in heritage sites and museums

risks instead, to relish victory and to be a bit more ruthless in the service of noble and deeply important ends. Sometimes it is not enough to be right, you do need to win.

The picture is frank about pride in achievement. The naval battle which was hideous in reality was crucial to the formation of a free and secure society. It took great courage to face danger, and desperate resolution to win in order to bring about that historic development. Today obviously – the enemy is not a foreign fleet and the battles are not fought with cannonballs and gunpowder. But how many great things have been lost to the world because their originators – while having the requisite insight – lacked the sheer courage and force of character to see them through? Goodness should be strong.

SICKNESS

I couldn't hurt a flea.

The installation certainly draws the eye to the Spanish sailors being thrown into the air and within the context in which it is placed, the exhortation to be prepared to fight for what you believe in, is relatively uncontentious. The first text is the authorised interpretation and illustrates the professional, unemotional and scientific way of describing certain types of historical art. The additional response to the picture appears to offer us insights into imagined Dutch attitudes to this event. However the text raises as many questions as it answers, particularly to a non-Dutch visitor. Who are the 'good' and 'decent' people encouraged to act here? Who decides on decency and goodness? Here the suggestion is that pacifism is a weakness but is it always so? The problem is that both sides in this conflict thought they were right. Both no doubt thought that they were 'good' and both attempted to be strong which led to a long, bitter and destructive conflict and the birth of the Dutch Republic. What has happened here is the transposition of hindsight into a historical situation. We now accept that a prosperous, independent, tolerant and confident Dutch Republic was better for its seventeenth century inhabitants than if it had remained a province of Spain. However, this was not clear at the time. In other words the emotions we are asked to experience here and the justification for them are very much twenty first century ones, managed to supply a homily or improving exhortation. This is very much a political use of emotional responses (Tarlow 2012).

The examples above illustrate how complex and long standing practices militate against the practice of encouraging emotional engagement with heritage unless it is for a particular purpose such as to arouse sympathy for victims or to help visitors recognise and overcome their own problems in a therapeutic manner. Academic and organisational conventions, ironically governed by their own intensive emotional modes of regulating behaviour amongst members, strictly control the ways emotions are studied, interpreted and acknowledged. Such practices can result in certain types of knowledge, such as that of ghosts, being ignored or treated with disdain yet these ways of understanding the past may have deeply felt meanings for local people. Indeed they may co-exist alongside the formal academic interpretation of such sites without tension. At the same time attempts to encourage visitors to appreciate and feel emotional responses to art reveal the same controlling tendency. Many people, on accessing heritage either in the formal setting of a museum or gallery, or on an archaeological site, or with exposure to an object of significance, are required to control their emotional responses and accept the institution's emotional regulation. However, this Authorised Heritage Discourse may be less effective in managing public responses to places, historic houses, archaeological sites and museum objects than is presumed by some authors. Without prior knowledge of heritage individuals may ignore formal interpretations and prefer their own emotional ones. It is suggested here that time has come to think beyond the Foucauldian universe and to explore the irrational and emotional effects that heritage may have on visitors to sites. Without such knowledge interpretation may contain within it the seeds of its own failure.

Sheila Watson

Acknowledgements

I would like to thank Dr Nigel Wright, House and Collections manager at the National Trust's Elizabethan mansion, Hardwick Hall in Derbyshire for his help with my research into Bess of Hardwick's textiles and their histories.

Notes

1 www.english-heritage.org.uk/daysout/properties/burgh-castle/history-and-research and www.nor-farchtrust.org.uk/burghcastle (both accessed 14 May 2014).
2 www.hiddenea.com/shuckland/greatyarmouth.htm and www.castlesandmanorhouses.com/ghosts.php? Sort=Name (both accessed 14 May 2014).

Bibliography

Arnold-de Simine, S. (2013). *Mediating Memory in the Museum: Trauma, Empathy, Nostalgia*. Basingstoke and New York: Palgrave.

Benjamin, W. (1973). *Illuminations*. London: Verso.

Bennett, J. (2001). *The Enchantment of Modern Life: Attachments, Crossings and Ethics*. Princeton and Oxford: Princeton University Press.

Bennett, T. (1995). *The Birth of the Museum: History, Theory, Politics*. London: Routledge.

Bennett, T. (2004). *Pasts Beyond Memory: Evolution, Museums, Colonialism*. London and New York: Routledge.

Bendix, R. (1997). 'Introduction', in *In Search of Authenticity: The Formation of Folklore Studies*. Madison, Wis: University of Wisconsin Press, 3–23.

Bloch, C. (2002). 'Managing the emotions of competition and recognition in Academia', in J. Barbalet (ed.) *Sociological Review Monograph Series: Emotions and Sociology*, 50 (S2), 113–131.

Bondi, L. (2005). 'Making Connections and Thinking through Emotions: Between geography and psycho-therapy', *Transactions of the Institute of British Geographers, New Series*, 30 (4), 433–448.

Bowen, J. (2014). 'Emotion in organizations: Resources for business', *Journal of Management Education*, 38 (1), 114–142.

Bourdieu, P. (1975). 'The peculiar history of scientific reason', *Sociological Forum*, 6 (1), 3–26.

Bourdieu, P. (1977). *Outline of a Theory of Practice*. Cambridge: Cambridge University Press.

Bourdieu, P. (1991). 'The peculiar history of scientific reason', *Sociological Forum*, 6 (1), 3–26.

Brown, S. and Reavey, P. (2015). *Vital Memory and Affect: Living with a Difficult Past*. New York, NY: Routledge.

Bruno, G. (2003). 'Havana: memoirs of material culture', *Journal of Visual Culture* 2 (3), 303–324.

De Botton, A. and Armstrong, J. (2013). *Art as Therapy*. London: Phaidon Press.

Durant, D. (1977). *Bess of Hardwick: Portrait of an Elizabethan Dynast*. London: Weidenfeld and Nicolson.

Edensor, T. (2005). 'The ghosts of industrial ruins: ordering and disordering memory in excessive space', Environment and Planning D, *Society and Space*, 23, 829–849.

Edensor, T. (2013). 'Reconnecting with darkness: gloomy landscapes, lightless places', *Social & Cultural Geography*, 14 (4), 446–465.

Ekman, P. (1992). 'Are there basic emotions?', *Psychological Review*, 99 (3), 550–553.

Flam, H. (1990a). 'Emotional man: I. Man and the problem of collective action', *International Sociology*, 5 (1), 39–56.

Flam, H. (1990b). 'Emotional man: II. Corporate actors as emotion-motivated emotion managers', *International Sociology*, 5 (2), 225–324.

Foucault, M. (1991). 'Governmentality', in G. Burchell, C. Gordon and P. Miller *The Foucault Effect: Studies in Governmentality*, London: Harvester Wheatsheaf.

Girouard, M. (2006). *Hardwick Hall*, Swindon: Hawthornes for National Trust Enterprises (Ltd).

Greenblatt, K (1991). 'Resonance and wonder' in Karp, I and Lavine, S. D. *The Poetics and Politics of Museum Display*, Washington and London: Smithsonian Institution Press, 42–65.

Gregory, R. (2014). *Sensing Spaces: Architecture Reimagined: An Introduction to the Exhibition for Teachers and Students*. London: Royal Academy of Arts.

Hanks, M. M. (2011). 'Re-imagining the national past: negotiating the roles of science, religion, and history in contemporary British ghost tourism', in H. Silverman (ed.) *Contested Cultural Heritage: Religion, Nationalism, Erasure, and Exclusion in a Global World*, New York and London: Springer, 125–139.

Harrison, R. (2010). 'What is heritage?' in R. Harrison (ed.) *Understanding the Politics of Heritage*, Manchester: Manchester University Press, 5–42.

Heath, C. and vom Lehn, D. (2004). Configuring reception: (Dis-)Regarding the 'spectator' in museums and galleries, *Theory Culture & Society*, 21 (6), 43–46.

Hochschild, A. (1983). *The Managed Heart*. Berkeley: University of California Press.

Holloway, J. and Kneale, J. (2008). 'Locating haunting: a ghost-hunter's guide', *Cultural Geographies*, 15 (3), 297–312.

Izard, C. E. (2007). 'Basic emotions, natural kinds, emotion schemas, and a new paradigm', *Perspectives on Psychological Science*, 2, 260–280.

Kleinginna, P. and Kleinginna, A. (1981). 'A categorized list of emotion definitions, with suggestions for a consensual definition', *Motivation and Emotion*, 5, 345–379.

Kavanagh, G. (2000). *Dream Spaces: Memory and the Museum*, New York and London: Routledge.

Levenson, R. (2011). 'Basic emotion questions', *Emotion Review*, 3 (4), 379–386.

Levi, B, (1957). *Architecture as Space: How to Look at Architecture*. Horizon Press, New York, 1948, translated 1957.

Parry, R. L. (2014). 'Ghosts of the Tsunami', *London Review of Books*, 36 (3), 13–17.

Porter, G. (1986). 'Seeing through solidarity: a feminist perspective on museums', in S. Macdonald and G. Fyfe (eds), *Theorizing Museums*. Oxford: Blackwell, 105–126.

Plutchik, R. (1980). 'A general psychoevolutionary theory of emotion', in R. Plutchik and H. Kellerman (eds.) *Emotion: Theory, Research and Experience: Vol. 1. Theories of Emotion* (3–31). New York, NY: Academic Press.

Reddy, W. (2001). *The Navigation of Feeling: A Framework for the History of Emotions*. Cambridge: Cambridge University Press.

Robinson, J. (2005). *Deeper Than Reason: Emotion and its Role in Literature, Music and Art*. New York: Oxford University Press.

Rosenwein, B. (ed.). (1998). *Anger's Past: The Social Uses of an Emotion in the Middle Ages*. Ithaca, NY: Cornell University Press.

Rosenwein, B. (2007). *Emotional Communities in the Middle Ages*. Ithaca and London: Cornell University Press.

Ryan, E.-S, (2014). https://viewfrommyattic.wordpress.com/tag/hardwick-hall/ (accessed 8 July 2014).

Sander, D. (2013). 'Models of emotion: The affective neuroscience approach', in J. Armony and P Vuillemier (eds) *The Cambridge Handbook of Human Affective Neuroscience*, 5–53.

Scherer, K. (2005). 'What are emotions? And how can they be measured?' *Social Science Information*, 44, (4) 695–729. doi:10.1177/0539018405058216.

Silvia, P. (2009). 'Aesthetic emotions (philosophical perspectives)', in D. Sander and K. R Scherer (eds) *The Oxford Companion to Emotion and the Affective Sciences*. New York: Oxford University Press, 9.

Smith, L. (2006). *Uses of Heritage*. New York and London: Routledge.

Spalding, J. (2002). *The Poetic Museum: Reviving Historic Collections*. Munich and London: Prestel-Verlag.

Stearns, P. N. and Stearns, C. Z. (1985). 'Emotionology: Clarifying the History of Emotions and Emotional Standards', *The American Historical Review*, 90 (4), 813–836.

Stearns, P. (1994). *American Cool: Constructing a Twentieth Century Style*. New York and London: New York University Press.

Tarlow, S. (2012). 'The Archaeology of emotion and affect', in *The Annual Review of Anthropology*, 41, 169–185.

Taylor, R. (1999). 'Look out world here I come' www.gtyarmouth.co.uk/Bygones/Brass_Bands_and_Rice_Pudding/html/body_chapter_2_-_lwhc.htm (accessed 8 July 2014).

Thrift, N. (2004). 'Intensities of feeling: towards a spatial politics of affect' *Geografiska Annaler*. 86B 57–78.

Thrift, N. (2007) *Non-Representational Theory: Space/Politics/Affect*. London: Routledge.

Voestermans, P. and Verheggen, T (2013). *Culture as Embodiment: The Social Tuning of Behavior*. Chichester: John Wiley and Sons Ltd.

Watson, S. (2007). 'History museums, community identities and a sense of place: rewriting histories', in Simon Knell, Susanne MacLeod and Sheila Watson (eds) *Museum Revolutions: How Museums Change and have been Changed*. Routledge, 160–172.

Watson, S. (2013). 'Emotions in the history museum', in A. Witcomb and K. Message (eds) *Museum Theory: An Expanded Field*. Oxford, Blackwell, 283–301.

Waterton, E. and Watson, Steve (2014). *The Semiotics of Heritage Tourism*. Bristol, Channel View Publications.

Wells, J. J. and Baldwin, E. D. (2012). 'Historic preservation significance and age value. A Comparative phenomenology of historic Charleston and the nearby new-urbanist community of I'On'. *Journal of Environmental Psychology*, 32 (4), 384–400.

Williams, R. (1973). 'Base and superstructure in Marxist cultural theory', *New Left Review*, 82, 3–1.

Wood, A. (2013). The Memory of the People: Custom and Popular Senses of the Past in Early Modern England. Cambridge: Cambridge University Press.

32
The Third World

Jeremy Black

Confronting the consequences of decolonization in the Third World was an even more abrupt challenge to public history than political transformations in Europe not least because, in contrast to the former Communist states, there was also a racial component to the issues of assessing recent developments and recovering an earlier history. Thinking about history also took place in a post-colonial context in which the need for an explicit rejection of colonial traits of thought was pronounced. At the same time, as was pointed out at the 2003 meeting of the African Studies Association, serious conceptual and methodological problems were posed for scholarly historical work in the Third World by the dominance of theories, methodological categories and analytical conventions and languages, all taken directly from scholars working in the West, or, in reaction, overly uncritically from the Communist world. This situation makes the task of 'decentring' world history (abandoning a Western focus) difficult, although it does not mean that there are not indigenous traditions of history.[1]

There was also the related problem that geographical and political understandings and units derived from the colonial world. This was most obviously true of states and state boundaries, which indeed proved durable despite the end of imperial rule.[2] It was also the case with both regions, such as the Maghreb (French North Africa: Morocco, Algeria, Tunisia), and continents. For example, the Western designation of continents divided what had been zones of demographic, economic and cultural relationships. This was seen with the separation of East Africa from South-West and South Asia, and of North Africa from southern Europe. There was also, thanks to the Western pattern of continents, an emphasis on separation at a larger scale – of Africa from South America, Australia from Asia – that accorded with Western views. The creation of a particular view of the Orient is seen as a culmination of this process.[3]

The dominance of Western concepts was linked to the languages of the colonial powers, such as French in the Maghreb and West Africa, Spanish in Latin America, and English in East and South Africa and South Asia. The role of language helped direct not only academic alignments and borrowings, and educational systems, but also the wider context of popular understandings of history. The continued role of Western publishing houses, such as Longman in the former British Empire, was also important, while school examinations are still controlled in parts of Africa by British examination boards. Another inheritance from the colonial world was

457

The impact of independence struggles

One aspect of decolonization was provided by discussion of the independence struggle. This was generally uncritical in public memorialization, certainly as long as the groups prominent in winning independence retained power. This was seen with the role of the Congress Party in India, of Zanu under Robert Mugabe in Zimbabwe, of the MPLA in Angola, of the FLN in Algeria, and with their many equivalents including, most recently, the PLO in Palestine. In each case, this retention of power gave a particular direction to national history. The role of the now governing party in securing independence was emphasized and efforts were made to establish an exemplary pre-history for independence. This account focused on resistance to the colonial power and on the consequent weakness of the latter. Independence, therefore, in this perspective, was won, not granted by the colonial power. In addition, rival (and unsuccessful) nationalist movements were denounced, such as in Zimbabwe that of Zapu under Joshua Nkomo, and Unita in Angola. In some countries, the creation of an exemplary history for the independence struggle was a continuation of propaganda produced during the struggle itself. An appropriate depiction of actions and actors that were portrayed by hostile critics as terrorist and terrorists was often important.

In the case of India, there was an emphasis on the Congress Party's Quit India campaign of 1942 in leading to the British withdrawal from the subcontinent five years later. There was also discussion, albeit less comfortably, of Subhas Bose and the Indian National Army in which their nationalism was emphasized and their role as a Japanese client force during the Second World War underrated. Such an emphasis was at the expense of the British success (albeit only short-term success) in overcoming the Quit India campaign, and also neglected the large numbers of Indian volunteers who came forward to fight for the King-Emperor during the Second World War, the largest volunteer force in history. This compared directly with the neglect in Ireland of its voluntary contribution as part of the British Empire to the war effort in the First World War, and, indeed, while neutral, in the Second. The presentation of Bose as a nationalist has always been contentious because he split with Congress in 1939 after his quarrel with Gandhi. He is regarded in his home province of Bengal (where Gandhi is unpopular) as a great nationalist leader (and Calcutta airport is named after him), but his status elsewhere in India is much more ambivalent. Discomfort about Bose reflects more the unwillingness after independence to discuss anti-Gandhi/Nehru forces in Congress than his status as a Japanese ally.

The rewriting of India's past also extended further back. The process by which Britain had gained and sustained power was viewed far more critically than had been the case during colonial rule. This entailed a rewriting of Indian atrocities discussed by the British in order to show their greater claim to civilization, such as the Black Hole of Calcutta, in which Siraj-ud-daula, the Nawab of Bengal, had imprisoned British captives with fatal results in 1756, and the treatment of British women and children during the 'Indian Mutiny' of 1857–9. Instead, as far as atrocities were concerned, the emphasis was now on the cruelty of the British treatment of captured sepoys blown to pieces from cannon during the suppression of the 'Mutiny', while the 'Mutiny' itself was reinterpreted, somewhat anachronistically, as India's first war of independence or nationalism (now it is widely referred to as the Rebellion). More generally, empire was presented as an economic burden to India, and a vehicle for British plunder and economic exploitation that had delayed the development of the country. Thus, instead of the British

emphasis on progress towards modernity under colonial rule came a depiction of the latter as a distorting force. The nationalist historians of the 1950s and 1960s emerged in the late colonial period and at the time of India's independence in 1947 they dominated most of the major university history departments. Their major goal was the creation of a 'new' history of India free of British or Western influences. These historians placed great stress on India's past greatness and saw Western intervention as temporary. This was to be a theme taken up in many former colonies.

The presentation of an anti-colonial historiography was not only seen in opposition to Western powers. Japanese rule led to a presentation of Korean history in terms of a lesser people and power, whose weaknesses merited Japanese control. This was countered by an emphasis on past signs of Korean strength and culture and on the capacity of Korea to develop without colonial rule. Early in the century, Korean intellectuals set up a private university to train future intellectuals within the Korean tradition and to lessen the role of the public (Japanese-controlled) university in Seoul. From 1945, in both North and South Korea the impact of Japanese rule was depicted as malign. This matched the emphasis on atrocities during this period, not least enforced prostitution for Japanese troops, and also the erasure from the record of extensive Korean collaboration with Japan. In turn, the bitter and costly Korean War (1950–3) between the Communist North and the non-Communist South left a historical legacy that strengthened the already powerful divisions between the two regimes. In South Korea, the many dead were commemorated thanks to the work of the Korean War Commemoration Commission. The imposing massive façade of the War Memorial in Seoul was matched by the columns of the Gallery of the Honored Dead, with its 100 obsidian plaques listing the casualties. Memorials created their own world of ceremonies. Thus in the DMZ (De-Militarized Zone), the Liberation Bell marked where the South Korean Ninth Division had successfully resisted attack in the battle for White Horse Mountain. Kim Il-Sung, the dictator of North Korea, created an exemplary personal history, claiming a false descent from nationalists and inaccurately saying that he had been born on a sacred mountain. Kim also alleged that North Korea had descended from an ancient Korean kingdom that includes much of Manchuria and part of Russia's Pacific province. Also seeking longevity, South Korea claimed descent from a different kingdom.

A parallel to the overthrow of colonial perspectives, although not one that was welcome to the governments involved, was provided by the challenge mounted to the role of long-standing governing parties in states that had already gained independence. This was seen in both Japan and Mexico. In the latter, the Institutional Revolutionary Party, which had governed for seven decades, was ousted after elections in 2000 while, in 1993, Japan's Liberal Democrats lost overall power for the first time in nearly 40 years. In the former case, there was a definite consequence for public history and academic scholarship, with a greater degree of freedom in discussing recent history. At the same time, challenges to the governing groups that had seized the mantle of independence, for example to the FLN by the Islamic nationalists of the FIS in Algeria in the 1990s, and to Congress by Hindu nationalists in India, led to a criticism of these groups' presentations of the past. The Bharatiya Janata Party (BJP), which evolved from a nationalist Hindu body, Rashtriya Swayamsevak Sangh, drew on long-standing Hindu notions of India as a Hindu nation and civilization and on Hindu revivalism. The party was a response to the strong sense of communal identities in India, and to Hindu concern about the assertiveness of minority groups under Congress rule. Congress presented itself as deliberately non-sectarian and as concerned to give voice to minorities such as Muslims.

Thus, the volatility of Indian politics and society led, on the part of the BJP, to the reiteration of a historicist account of identity and continuity as an aspect of a concern that produced calls for national renewal as defined by and in the interests of those expressing the concern. At the

political level, the tension between Congress and BJP views of India past, present and future had greater weight than the earlier challenge to Indian nationalist historiography from Communist and left-leaning historians who saw the nationalists as sharing in Western notions of elitist history and attempting to create similar obsolete lines of historical research. This theme was carried further from the 1970s by the group known as subalterns who emphasized the role in Indian history of the poor and the marginals (such as tribes), specifically in opposing the power of the colonial state. The first volume of what became a long series of *Subaltern Studies* was published in 1982.[4] In emphasizing the role of those outside the elite, for example in the Rebellion of 1857–9, a clear comment on modern India was offered:

> They were not mere adjuncts to a linear tradition that was to culminate in the appropriation of power by the elite in a post-colonial state. Nor were they mere toys manipulated by the latter in a historical project in which they played no part ... To seek after and restore the specific subjectivity of the rebels must be a major task of the new historiography.[5]

Far from being unconcerned about Hindu revivalism, the BJP 'Saffron wave' and associated communal tensions, Indian historians sought to provide a historical perspective on the latter.[6] Under the BJP government from 1998 until 2004 historical and educational institutions, including the Indian Council for Historical Research and the National Council for Educational Research and Training, were used to support the sectarian Hindu perspective. This was seen in the replacement of school textbooks by those that matched BJP views. In turn, resistance to the adoption of textbooks was mounted by the Indian History Congress on behalf of a largely critical scholarly community that had been left out of the production of the textbooks,[7] and the government elected in 2004 sought to reverse the BJP's impact.

Over a longer timespan, there are signs in Latin America of challenges to the governing groups that seized the mantle of independence gained in the 1810s and 1820s, dominating the continent before and after independence. This challenge has come from the descendants of the indigenous population and has been particularly strong along the Andean chain in Ecuador, Peru and Bolivia, although it is also seen elsewhere, for example in Central America, where Mayan consciousness is in part an aspect of the rejection of control by the government of Mexico. Along the Andean chain, a sense of history played a role in the challenge, not only by channelling an awareness of separateness and oppression but also in terms of sites of defiance. Thus, in 2004, the mayor of Ayo Ayo in Bolivia was hanged from a lamp-post in the shadow of a large bronze statue of Tupaj Katari, who in 1781 had led an uprising of the Aymara against Spanish colonial role.

More generally, decolonization entailed a process of rethinking pre-colonial, colonial and post-colonial history, as well as relations with the outer world. It also involved widespread renaming, as a conscious aspect of the rejection of what was seen as the imperial legacy. Whereas what had been European settlement colonies, such as Australia, Canada and New Zealand, retained imperial names, such as Sydney, Vancouver, and Wellington, these were widely rejected in newly-independent states where such settlement had been limited. The renaming of states was an important break in continuity although, as an aspect of the theme of post-apartheid reconciliation, as yet this has not happened to a major extent in South Africa. On independence in 1964 Nyasaland was renamed Malawi, while Upper Volta became Burkina Faso in 1984, and Burma became Myanmar (the name of the country in Burmese) in 1989. With the end of White-minority rule, Southern Rhodesia became Zimbabwe. Cities were also renamed. The capital of Southern Rhodesia, Salisbury, became Harare, while in India Bombay became Mumbai in 1995 and in 1996 Madras became Chennai. The rejection of colonial boundaries

was a related process. Syria, which became independent in 1946, rejected the French acceptance in 1939 of Turkish claims to the Alexandretta region.

Renaming was an aspect not only of the rejection of colonialism but also of defining a new identity. While this was presented as a throwing off of the imperial yoke, it was also an aspect of the struggle for influence and control among indigenous groups, which could be seen generally in post-colonial and post-Communist societies. In Nigeria, the rejection of the colonial legacy included the movement of the capital in 1991 from Lagos to a new city, Abuja. This in part was an attempt to limit the influence of the Yoruba, who dominated the area round Lagos. Abuja is inland, in the centre of the country, and far closer to northern Nigeria which is the homeland of much of the military leadership. The army has dominated Nigeria in recent decades, and their conception of its identity is not served by a focus on Lagos.

Consideration of the pre-colonial period helped provide people with a history that had been slighted, and also directed attention to powerful civilizations and states, for example medieval Mali. Earlier attempts to explain such African civilizations as the work of Mediterranean peoples moving south, the theory advanced in Harry Johnston's *History of the Colonisation of Africa by Alien Races* (1899) and C.G. Seligman's *Races of Africa* (1930), were rejected. This was in accord with academic arguments, but also fitted the new political mood with its stress on African achievement and thus on the absence of need for European intervention. Furthermore, the historical consciousness of pre-colonial societies, to an extent, was recovered, as in work on African oral history, an approach that encourages interdisciplinarity. At times, this emphasis on African achievement was stronger on rhetoric than reality but, whether the period in question was pre-colonial, colonial, or postcolonial, the publication of books for national audiences and by native authors was central to the process of reconsidering the past.

There are important issues facing the attempt to recover the precolonial history of the Third World, not least the availability of information. Thus, for the millennium prior to European colonization, the information available for African history is limited and there are also specific problems with the use of oral evidence. Yet, it offers more than traditional Western historiography allowed. In the opening chapter of his *The History of England* (1754–62), David Hume reflected the values of his age when he explained why he was slighting England's pre-Roman history:

> Ingenious men, possessed of leisure, are apt to push their researches beyond the period, in which literary monuments are framed or preserved; without reflecting, that the history of past events is immediately lost or disfigured, when intrusted to memory and oral tradition, and that the adventures of barbarous nations, even if they were recorded, could afford little or no entertainment to men born in a more cultivated age.

Thus, methodological issues relating to sources were linked to a ranking of relevance reflecting the norms of fashionable Western opinion, an approach still overly influential today. Hume continued:

> The convulsions of a civilized state usually compose the most instructive and most interesting part of its history; but the sudden, violent, and unprepared revolutions, incident to Barbarians, are so much guided by caprice, and terminate so often in cruelty that they disgust us by the uniformity of their appearance; and it is rather fortunate for letters that they are buried in silence and oblivion.[8]

While modern scholars would be wary of such views, it is instructive to note how many treatments of historiography and historical method never mention Africa.

The depiction of pre-colonial Africa has greatly changed since the 1960s with research indicating that the notion of tribes advanced in works such as Samuel Johnson's *History of the Yorubas* (1921) was in large part an aspect of Western classification that was designed to aid comprehension, if not control, and, due to the pejorative connotations of tribalism, to demean African society. Instead, a more complex account of ethnogenesis was offered.[9] The extent to which the territorial scope and thus ethnic composition of many states is the work of Western conquerors, and therefore relatively recent, creates problems for the presentation of history. Western territorialization and concepts of identity and political authority have themselves been used to particular ends by African nationalists.

The post-independence rethinking of the colonial period in Africa and elsewhere has led to a greater emphasis on resistance to colonial rule, and on the historiography of resistance, although these tend to involve a misleading 'appropriation' of resistance for the cause of nationalism. Resistance was linked to later anti-colonialism. This was particularly politically useful in Guinea where the first prime minister (from 1958 to 1972) and first president (from 1961 to 1984) of the independent state, Ahmed Sékou Touré, was the grandson of Samori Touré, the leader of the Mandinke people and the 'Napoleon of the Sudan' according to his eventually successful French opponents, whom he fought in the 1870s and 1880s. Reference to him ignored the extent to which he had been a tyrant, particularly to other tribes.

Consideration of the colonial period in Africa and elsewhere was itself politically problematic, as it posed a question mark against the success of post-colonial governments in improving living standards and maintaining stability. Such consideration also directed attention to current relations with the former colonial power. Thus, in Senegal there is contention over links between the government and France, which indeed subsidizes the Ministry of Education and Culture. This contention affects the depiction of West African soldiers that served France between 1857 and independence in 1960: the government presents them as saviours of France in the two world wars and as heroes fighting for the cause of progress, the opposition as both victims and accomplices of a damaging colonialism.[10] Growing interest in former colonies in pre- and post-colonial history has ensured, however, that the colonial period can be presented as part of a longer-term process, rather than as the key episode in history. The former approach encourages interest in the continuity of issues, institutions and identities and thus displaces Europeans from the centre of attention.

Interest in pre-colonial history led to efforts to repatriate monuments and other material from that period that had been acquired by Western powers, sometimes as part of a process of post-conquest looting. The theme of apology focused not only on monetary reparations but also on the return of objects that had been seized. These had, or it is argued have, symbolic value, and their return is also designed for economic gain in the shape of reviving sites worthy of tourism. Much of the Third World has lost objects, either through seizure or purchase. Western powers became increasingly sympathetic to this pressure. In the case of Ethiopia, a state with a long history of independence, the consequences of two Western invasions are at issue. In 1868, a British force successfully sent to rescue imprisoned hostages stormed the fortress of Magdala and seized both secular and religious treasures there. The loot included crowns, shields, crosses, and manuscripts, as well as tabots, sacred carved blocks of wood or marble. The 11 tabots in the British Museum have, now, been moved aside for special treatment, and are kept in a room where only priests can visit them, but the museum insists that under its charter it is not allowed to yield to calls to return them to Ethiopia. The Italian conquest of Ethiopia in 1935–6 also led to the seizure of treasure, including a granite obelisk at Aksum. When taken in 1937 it was already broken into five parts, but the Italians shipped it to Rome and erected it at a road junction. In 1947, as part of the post-war peace settlement, Italy promised to return its wartime loot,

but the obelisk was still in Rome in 2002 when another agreement was signed. At present, the obelisk is dismantled in Rome awaiting shipment.

The return of seized monuments and other material was an aspect of reversing the memorialization of colonial conquest. In addition, the statues of colonial generals were often removed and, in their place, came a recognition of the role of the resistance. In 2004, the 125th anniversary of the Zulu victory over the British at the battle of Isandlhwana led to an appropriate memorialization of the Zulu casualties. This fulfilled a goal long sought by prominent Zulu politicians, such as Chief Mangosuthu Buthelezi of the Inkatha Freedom Party, and thus underlined their role as well as serving to emphasize Zulu distinctiveness, a cause at odds with the governing African National Congress's emphasis on South African inclusiveness.

The issue of memorialization was not restricted to warfare. Under colonial rule, a life-sized bronze statue of the British explorer David Livingstone was erected overlooking Victoria Falls. Less welcome in Zimbabwe after its independence in 1980, indeed seen as a symbol of British imperialism, the statue was defaced in 2002. In contrast, Zambia, on the other side of the Falls, in 2004 expressed interest in acquiring the statue. Siloka Mukuni, the chief of the Leya people, the major ethnic group around the town of Livingstone, stated: 'The Zambians have a great deal of affection for Livingstone's memory, unlike the Zimbabweans. We have changed a great many of our colonial place names since independence, but we have kept the name of Livingstone out of a deep respect.' Nomenclature was also an issue with the Falls. They still record the name of the ruler of Britain from 1837 until 1901, when, in European eyes, they were 'discovered' by Livingstone in 1855, not their native name when Livingstone became the first European to see Mosi-oa-Tunya, 'the smoke that thunders'.

Albeit through the very partial spectrum of the August–September 2004 issue of the London-based magazine *New African*, it was possible to probe the distinctiveness of African perspectives on historical importance. Asked to nominate the top 100 influential Africans or people of African descent, the voters emphasized heroes from independence movements. The leading figures were, first, Nelson Mandela and, second, Kwame Nkrumah, the key figure in winning Ghanaian independence in 1957 and in producing the 1961 Charter of African States. Patrice Lumumba, the founder of the Congolese National Movement and, in 1960, its first prime minister, also figured prominently. American Civil Rights leaders played a role, with Martin Luther King placed sixth and Malcolm X ninth, suggesting a historical consciousness that linked the struggle for independence in Africa and that for African-American civil rights.

The African-American quest for apparent African antecedents, especially the notion that the civilization of ancient Egypt was in fact a black African one, was probably responsible for the inclusion of Queen Nefertiti, a fourteenth-century BCE queen consort at 81st. Ironically, she is supposed by some commentators to have been an Asian princess from Motanni. The debate on origins was focused and encouraged by Martin Bernal's *Black Athena: The Afroasiatic Roots of Classical Civilization: The Archaeological and Documentary Evidence* (1992), which argued that Greek culture derived largely from Egypt which, in turn, was a black African culture. Furthermore, Bernal claimed that this had been deliberately suppressed by white Western historians who instead sought, in what he termed the 'Aryan Model', to argue that European culture derived from non-black, specifically Indo-European sources. This approach was heavily challenged by specialists, such as Mary Lefkowitz in her *Not Out of Africa* (1996) and in the collection *Black Athena Revisited* (1996) edited by Lefkowitz and Guy Rogers. Critics of Bernal have argued that his approach is a matter of assertion rather than scholarship but, nevertheless, it clearly has had an impact, particularly in some African-American circles. The African scholar V.Y. Mudimbe presented Roman writers who came from Roman North Africa as African.[11] African and African-American scholars are also prone to treat slavery and the slave

trade in terms of the European Atlantic and to ignore or underrate the Ottoman and Indian Ocean dimensions.

The shadow of colonial rule lay heavy over the public history of most states that had experienced it. It could also lead to competing drives for restitution, a theme taken up in an interview by Jean-Bertrand Aristide, the deposed president of Haiti (president 1990–1, 1994–5, 2000–4). Arguing with reference to his removal from office in 2004, 'It is important to set what happened in the wider context of Haiti's history', Aristide claimed that France had played a role in his removal partly because it was the bicentennial of Haiti's success in winning independence from France. Aristide also claimed to want to set the record straight about his period in office: 'My responsibility now is to tell the truth', as a result of which he wrote a book.[12]

Israel

A particular instance of post-colonial history is provided by the historical myth associated with Israel, with the post-biblical dispersion of the Jews apparently for some an equivalent to colonial rule, and the creation of the state of Israel in 1948, in a way a return to the biblical past, at least in the sense of national independence. The creation of Israeli identity faced serious challenges, as the different sources of Jewish immigrants had very varied experiences and cultures. Furthermore, there were important contrasts between them and longer-established Jewish communities. These variations continue to be the case today, not least as the consequence of more recent large-scale immigration from the former Soviet Union. Like the use of Gaelic in Ireland, the use of Hebrew as the language of the state (rather than Yiddish, the language of most of the refugees, but a European language) was a deliberate act of identification with the biblical past, as was the nomen-clature of the state. Episodes from a distant, heroic past, such as the defence of Masada against the Romans in 73 CE, were used to provide an exemplary national history, and were considered alongside the travails of the Jews in the recent past. The theme of Jews as fighting back linked Masada with the Warsaw ghetto in 1943 and sought to counter the feeling that due to passive acquiescence not enough had been done to resist the Holocaust. The Holocaust played a central role in Israeli self-identification, not least with the establishment of Yad Vashem as a Holocaust Memorial, museum and archive in 1953, and the seizure and trial of Adolf Eichmann, a major Nazi war criminal, in 1961–2.

The use of the Holocaust in order to justify the establishment of the state of Israel was particularly effective in winning support in the USA both from Jews and, even more significantly, from non-Jews. Binyamin Netanyahu, the Israeli prime minister, declared in 1998 that 'if the state of Israel had not been founded after the Holocaust, the Jewish future would have been imperilled', because it would have been more difficult to win American support. This emphasis on the Holocaust was accompanied by a slanted account of Israeli history that in some respects was similar to that of Arab nationalists. In the former account, the emphasis on the sufferings and endurance of the Jews was not matched by adequate consideration of the plight of the Palestinian refugees nor of the extent to which they had been forcibly driven out of their homes in what is now Israel. Furthermore, the reasons offered for Israel's stance in the West Bank and Gaza were given a questionable historical foundation.[13] As a related point, the Israeli position both in these territories and in Israel itself was defended by the association of progress with Zionism, specifically the argument that Jewish settlers had rendered fertile land that had been neglected and mishandled by the Palestinians.

Inventing nationality

The extrapolation of the Western model of the nation state had, and has, immediate value for African and other non-Western nationalists, but it may be very misleading. It is possible that the states and, especially, the political identities, particularly across much of Africa, that were first charted in any detail in the nineteenth century have had their longevity exaggerated by our own assumptions and by the agendas of ethnogenesis which lie at the heart of proximate cultural nationalism. Not simply has tradition been invented, but even possibly states, for some revisionist archaeologists have thrown doubt on the extent and even existence of certain pre-colonial states. Furthermore, modern concepts of nationality have been employed misleadingly to interpret the polities and politics of the past. Indeed, there appears to have been considerable migration for centuries in almost every sphere of human activity across what have since been constructed as national borders. There were also multiple civil and sacred identities, and it would be misleading to ignore the complexity of African thought on these matters.[14] Thus, and more generally, modern Western thinking about what we are, and what we belong to, yields something very far short of a universal taxonomy. Similar points can be made about identities elsewhere, for example in Oceania.

Given these academic problems with issues of identity, it is scarcely surprising that governments seeking to frame a public history have charted paths that suit their political purpose. In this process, nationalism and ethnicity have played major roles. In so far as they can be differentiated as factors, ideological factors have also been important in framing public histories. This is obviously significant for recent history, with the rejection of the colonial legacy presented in terms of a unifying and uplifting account of national liberation. At the same time, the decision by the Organization of African Unity to support the maintenance of colonial frontiers chimed with that of African states. The threat to governments from ethnically/regionally-based opposition, even separatism, with its own distinctive memorialization,[15] also encourages an account of the recent past in which the emphasis is on unity. Thus, the public history of Nigeria supports federalism and is very hostile to separatism, and this provides the context within which the civil war of 1967–70 that stemmed from Biafran separatism is considered. In Mauritania in 1986 three history lecturers were imprisoned for being part of a group that had alleged discrimination by the ruling Arab-Berber military government against the southern black population. In neighbouring Morocco, the Berber issue, a cause of anti-authoritarian if not separatist attitudes, is presented historically in terms of the interest of the state, which has scant sympathy for any distinctive Berber agenda. Territorial claims are also important in helping to set the agenda. The Moroccan annexation of the former Spanish Sahara in 1975 played a role in directing writing in Morocco.

Nationalism, ethnicity and ideological factors are not simply matters of the content of public histories. The use of national languages for the history of formerly discrete areas which had their own oral and often written language is an aspect of the agglomerative character of official history as well as of scholarly work. In Indonesia, the national language was used for official histories of areas such as Bali. Conversely, those seeking to resist state control are keen to publish histories in their own languages. In Spain, Basque nationalist historiography appears in the Basque language, Euskera, while in 1967 Croatian nationalists issued a declaration stating that Croatian was a language distinct from the Serbo-Croat recognized by Tito's government.

The linkage between the state and national history was demonstrated even more clearly in countries where those who wrote the latter could serve in senior public office. For example, Jorge Basadre (1903–80), whose *Historia de la República del Perú* (1939, frequently revised) was

Jeremy Black

the basic work for the history of Peru from independence, was also director of the Biblioteca Nacional and Minister of Public Education. His positive, inclusive account of national history was exactly what the state required.[16]

Indonesia

The same was true of Indonesia. 'Glorious past; dark present; glittering future.' This was the view advanced by Achmail Sukarno, the prominent Indonesian nationalist who became president after independence, which had been declared in 1945, was finally won from the Dutch in 1949. Sukarno, who had spent part of his youth teaching the subject, was certain that history had a key role to play in the assertion of Indonesian identity. Indeed, since the state was the product of a brief period of Dutch imperialism, and the word Indonesia was only coined in the nineteenth century – from the Greek *Indos* (Indians) and *nesos* (island) – there was clearly a need for a unifying ideology when that imperial control was removed. In search of an exemplary national past, Muhammad Yamin, a politician as well as a historian, sought to demonstrate the longevity of the concept of Indonesia. He probed this well before the period of Dutch imperialism, discussing for example the role of the fourteenth-century Javanese empire of Majapahit.

Determining that history was to be an important aspect of this unifying ideology did not provide the content for that history but, as with India, much stemmed from the nature of the independence struggle. It was obvious that opponents to the spread of Dutch rule in the nineteenth century and earlier should be eulogized. In particular, it was important that the potential encouragement to separatism represented by their individual interests should be overlaid by an emphasis on their role as proto-Indonesians. This was more necessary for Aceh, in northern Sumatra, an Islamic state that had very much followed its own path, than for Java, the island that was the kernel of modern Indonesian nationalism.[17]

Under Sukarno, the national versus regional dimension was crucial in determining the content of public history, but other disputes also relating to the protean and contested nature of Indonesian nationhood played an important role. In particular, the extent to which the new state should have a Muslim, a Communist or a liberal identity was related to the presentation of its history. Muslims emphasized the Islamic, and not the Hindu-Buddhist, past, while Communists and liberals offered different accounts of the interests and development of the state.

This was resolved in 1965–6 when the Communists were bloodily crushed by the military. General Suharto, who became president in 1968, sought to establish a self-styled New Order designed to replace ethnic and religious divisions and to ensure economic growth, and created a party, Golkar, to rally support for his army-based regime. Anti-Communist, this regime also suppressed Islamic opposition and its public history matched the content of its nationalism. This was explicitly designed to foster support for the nation and for the nationalist Pancasila ideology. Education was carefully organized to this end. This was a matter primarily of the formal education of the young through schools and universities, not least the compulsory subject 'History of National Struggle' added to the school curriculum in 1985. An authorized national history designed for schools was published in 1977. The key figure in this work, Nugroho Notosusanto, was head of the military history section of the armed forces (and a brigadier general as a result), and became minister of education in the 1980s.

Formal education in Indonesia was not only a matter of the young. The remainder of the population was also educated, or rather indoctrinated. Officials were sent on courses in the Pancasila ideology, museums and monuments were carefully used to this end, and the celebration of Heroes' Day carried forward an exemplary view of the past. This cult developed from 1957 and was continued after Suharto replaced Sukarno. The heroes were very much drawn

466

from those who had resisted the Dutch, either the conquest or what was presented as the occupation.[18] Given this presentation of the past, it is easy to see why separatism was opposed, irrespective of the popular backing it enjoyed. This response played a major role in the crisis over East Timor in the 1990s, and does so at present over Aceh and West Irian.

Ethiopia

Ideological accounts of the past can also look far back. The left-wing Mengistu regime that ruled Ethiopia from 1974 to 1991 emphasized the historical integrity of Ethiopia and presented it as under threat from neighbouring and rival Somalia and from Western imperialism. Thus, the threat from the Somalis was seen as a continuation of earlier Islamic invasions going back to the Sultan of Adal and the Ottoman Turks in the sixteenth century. This threat was also linked to Western pressure. British imperialists were blamed for inventing the notion of a Greater Somalia, which was seen as continued by the contemporary Somalis. Thus, the leading modern rival was allegedly following an agenda laid down by an imperialist manipulator. The Italian conquest of Ethiopia in 1935–6 was bitterly criticized. In line with this, past Western links with Ethiopia were minimized or denigrated. The Portuguese, who had provided assistance against Adal in the sixteenth century, were referred to as pirates.

The 'defensive' tone to the presentation of Ethiopian history – the sense of a country under threat – was matched by an 'offensive' reality. Eritrea was seen as part of Ethiopia. Reference was made to the 'liberation' and reunion of Eritrea with the Motherland in September 1952, a view that made little sense of, or to, the eventually successful separatist movement launched there the following year. 'Reunion' remained a theme until the counter-insurgency conflict ended in failure for Ethiopia with the overthrow of Mengistu, although subsequent conflict between Eritrea and Ethiopia has ensured that a history emphasizing hostility appears pertinent.

Iran

A similar sense of continuity in accounts of the past was seen in Iran, with, again, historical rivalries being viewed through current ideological perspectives. Under both the Pahlavi dynasty, rulers from 1921 to 1979, and the Islamic republic that replaced it in 1978–9, there was an emphasis on territorial pretensions and, in particular, a tendency to stress control over the Persian Gulf. There was also an emphasis on long-standing rivalry with whatever state had ruled Iraq, which, from the early sixteenth to the early twentieth centuries, meant the Ottoman Turks. There was, however, also a major contrast between the presentation of history under the very different governmental systems.

Under the Pahlavi dynasty the emphasis was on the positive role of past monarchs, both in terms of domestic policies and with reference to foreign challenges. In 1971, Mohammed Reza Shah allegedly spent $100 million on celebrating 2,500 years of the Persian monarchy, drawing prestige for the relatively recently established Pahlavi dynasty from a continuity stretching back to Cyrus the Great (c. 590–529 BCE). The dramatic ruins at Persepolis became a setting for the celebrations, which included parading large numbers of troops in uniforms allegedly based on those of Cyrus's forces. The treatment of Iranian history reflected the image the Pahlavis were trying to create. The Buwayhids (932–1062), a Persian dynasty that at the time had inspired a revival of national identity, were seen as playing a major role in supporting Islamic civilization and the welfare of their subjects, and were therefore praised. A far bleaker view of the Seljuk Turks (1038–1194), the empire of the Khwarizm Shah the Mongol Il-Khanate (c. 1260–1353)

and Temur (Tamerlane), who conquered Persia in 1380–94, the most prominent rulers until the early sixteenth century, was then offered. They were presented as damaging aliens who, in turn, were replaced by the Safavids (1501–1722), a dynasty that seemed an apt prefigurement of the Pahlavis, not least with their regional power. Indeed, the Pahlavis emphasized and exaggerated the territorial sway of the Safavids, particularly in the Persian Gulf, which was unwelcome to the independent states on its southern shore, such as Bahrain.

The Islamic republic offered a very different historical perspective to that of the Pahlavis although, again, with a strong emphasis on ethnic identities. The emphasis was on Iran and the Iranians, and not on royal dynasties that were presented as non-Iranian. Downplaying the role of dynasties stemmed inevitably from the foundation of the republic in the overthrow of the Pahlavis. The relationship between the fundamentalist (and thus historicist) religious consciousness of the religious leaders crucial to the new republic, and the pressures of secular change, for example rapidly rising population, created, however, a serious challenge to stability.

China

In China, the Communist regime that ruled from 1949 faced the dual problems of providing a consistent account of its own activities with that of trying to make useful sense of what was now seen as a long pre-history. Ideological considerations played a role under both heads, but nationalist interests were also reflected in the attempt to provide historical backing to Chinese claims over areas for which there were territorial disputes with neighbouring powers, such as Turkestan and the Amur valley, as well as in the clash with neighbouring Vietnam, and in maritime power-projection in neighbouring seas. The emphasis was on a far-flung China, and the extent of past Chinese empires was exaggerated, not only to lend weight to specific territorial pretensions but also to provide a general sense of potency. International tensions affected public history in the region, while the complexities of past relations with China's neighbours were ignored. In Inner Mongolia (part of China), the impact of Chinese ideological control was sharpened as a result of the rift between China and the Soviet Union from the 1960s, as neighbouring Mongolia (the People's Republic of Mongolia) was a Soviet satellite. While history emanating from the latter focused on rivalry between China and the Mongols, the Chinese encouraged a different account in Inner Mongolia.

Within China, the perspectives of non-Han Chinese peoples, in particular the Tibetans and the Uighurs, was ignored. As a result, their past resistance to Chinese governments was neglected. The Uighur historian Turgin Almas was placed under house arrest from 1989 because his book on the history of the Uighurs was accused of supporting separatism in Xinjiang. The historical consciousness of non-Han Chinese peoples was also attacked. Thus, during the Cultural Revolution religious statues and religious scroll paintings in Tibet were destroyed. At the same time, the Han Chinese Red Guards also attacked their own (Han) cultural heritage during this period. Temples and cultural relics all over China were smashed and destroyed; in this regard the 'national minorities' were not singled out for special treatment.

The Chinese treatment of the history of twentieth-century China emphasized the strength of radicalism, just as accounts of earlier periods in Chinese history stressed peasant risings, which were seen as a form of class struggle. The extent of support for the 1911 republican rising was exaggerated, as was radical and anti-imperialist sentiment in the 1920s. The role of the Communists in opposition to the Japanese conquest and occupation of 1931–45 was emphasized, while that of the rival Kuomintang Nationalists was minimized, as indeed was that of Communists who fought at a distance from Mao Zedong's zone of control. Because the focus was on continuing rivalry with the alternative (Nationalist) China still in Taiwan, there was far more

emphasis on the Civil War of 1946–9 than on the Sino-Japanese conflict. The Civil War was presented as a liberation war, while the role of the Communist Party in defending China against supposed American threats was given historical resonance by stressing the earlier damage supposedly done to China in the nineteenth and early twentieth centuries by Western imperialism: the resulting contrast in effectiveness served to make the Communist Party appear more successful.[19]

At the same time, events and ideas of the past were reinterpreted by the Communist government to suit different political needs. This was particularly true of the ideas of the 4 May 1919 movement, which served both the Cultural Revolution of the 1960s and the far less radical Communism of the 2000s. In 2002, a museum of the New Culture Movement opened in Beijing, with a memorial to the patriotic students of 1919 nearby.[20] As reform gathered pace in the 1980s so it became acceptable, indeed desirable, to treat the radical aspects of the recent past, especially the Great Leap Forward and the Cultural Revolution, as mistakes. The official change of position was the product of a party conclave. The Sixth Plenum of the Eleventh Central Committee of the Chinese Communist Party met on 27–29 June 1981 and adopted a 'Resolution on Certain Questions in the History of Our Party Since the Founding of the People's Republic of China'. With regard to Chairman Mao, the resolution admitted error for the first time but also declared, 'His merit is primary and his errors are secondary.' The formula that Mao was 70 per cent right and 30 per cent wrong soon became standard, but is not found in the resolution itself.[21] The role of Mao is now largely ignored and, although Marxism is still the official line in economic history, there is now far less emphasis on peasant risings.[22]

Instead, there was an emphasis on a new nationalism designed to help counter the strains created by economic and social transformation as well as the political challenge posed by American-led pressure on human rights. Commemoration of the Sino-Japanese War, as an acute form of the imperialist pressure that was condemned, played a major role in this nationalism, not least in response to Japan's alliance with the USA and to greater conservative nationalist activism in Japan from the 1970s. This has led to greater attention to the Nanjing Massacre of 1937.[23] The wooing of Taiwan also played a role, not least in encouraging a more favourable portrayal of the Nationalist war effort. The anti-Japanese struggle looms larger than the Civil War in Chinese consciousness today.

A very different account of the twentieth century was offered by Taiwan: the rejection of Communist ideology led to a strikingly contrasting historiography, although this became more diverse from the ending of military law in 1987 and the subsequent democratization. As a result, accounts of recent Taiwanese history that do not adopt the Kuomintang Nationalist approach have developed, dealing in particular with two constituencies that had been marginalized: ethnically-Chinese native Taiwanese (i.e. descendants of immigrants centuries ago), and the indigenous aboriginal population. The former are the majority of the island's population and now dominate its democratically elected government. Since the late 1980s, they have not been marginalized. The recovery of their view has led, in response to the brutality of Kuomintang rule from 1945, to a relatively sympathetic account of Japanese rule from 1895 to 1945. In November 2004, Beijing issued an outraged statement against the declaration of the Taiwan education minister that Japan should be given credit for having modernized Taiwan's industry and education. In contrast, although the identity and history of the indigenous aboriginal population (a tiny percentage of the population) have now been noted with the establishment of a Ministry of Aboriginal Affairs, they still play only a minor role in Taiwanese history.[24]

Tibetan exiles also challenged Chinese accounts[25] while, in addition, the Chinese approach to history presented a challenge to its neighbours, not least because of the stress on Chinese

hegemony and territorial interests. This led to acute sensitivity and to critical responses, as in South Korea in 2004 when China was accused of appropriating the historical legacy of ancient Korean states.

Japan

A very different ideological legacy to that of Communist China was at stake in Japan, and its public history can more fairly be located in the First World, not only because, compared to that of Communist China, there was no long-lasting legacy of foreign occupation or control but also because there was an acceptance of debate to a degree unusual in most of the Third World. Thus, Marxists, nationalists and liberals were able to define different interpretations of the Japanese national past. At the same time, there was a clear public myth, well represented in the treatment of the imperial family. This was readily apparent during the Meiji centenary celebrations of 1968, but was also clear at other times.

Japanese left-wing scholars, silenced during the war years of the 1930s and early 1940s, were very influential thereafter. Their approach was broadly Marxist in terms of seeing a conspiracy, prior to 1945, between the military and big business, supported by conservative governments and the newly created urban bourgeoisie, both to repress the masses at home and to exploit surrounding nations. The most common terms in this historiography were *gunkoku-shugi* (militarism, though taken to mean a mix of Fascism and militarism) and *tennō-sei* (the emperor system, that is, a system of repression using the symbol of the monarchy to keep the masses docile). From the late 1960s, the now dogmatic Marxist critiques were accompanied by a greater range of scholarly writing. The extent to which Japan's economy was already producing a mass middle class defined by an affluent consumerist life-style may have assisted this rethinking.

The role of states

Most Third World states lacked the longevity of Ethiopia, Iran, China and Japan and, for them, pre-colonial forms of history, such as the Burmese or Asante royal genealogies (in Myanmar and Ghana respectively), were no longer relevant when independence was regained. From whatever source, the definition of exemplary national story became the prime goal of national history.

A common fault, from the academic perspective, was the focus in national histories on states, especially powerful states. This ignores the more complex and varied political nature of much history and the extent to which powerful states had only a limited role in history. Instead, there was frequently a proliferation of localized areas of authority, often as an aspect of shared sovereignty. As these entailed multiple identities, it was not what most of the makers of public history sought: the context, and goal, of their activity were far different from that of the founders of the European Union who, as already indicated, were indeed seeking to create just such a state, and a tradition to match it. Linked to this political complexity was a lack of clarity in the past across much of the world about frontiers that does not match modern assumptions. In particular, there were border zones, rather than frontier lines. As a consequence of this, much of the modern public history with its focus on frontiers, a major theme of nationalist myths with their sense of clear sovereignty, is seriously ahistorical, while this focus is also generally a cause of international tension, if not dispute.

The attempt to ensure a favourable public history is neither new nor unexpected. The following description comes from an account of pre-modern Islamic historiography, but is also relevant today:

states had a stake in learning in general and historiography in particular. Nearly all patronized representations of the past that legitimized their exercise of power (strong and weak states alike sought to translate the power to coerce into the ability to persuade), and large-scale learning (such as sophisticated historiography) depended on urban networks of knowledge that states cultivated and defended.[26]

A common characteristic of public history after decolonization was its nationalist character with, in particular, an emphasis on national identity, character and destiny expressed through statehood. This very much matched political developments. In 1960, the United Nations stated that all 'peoples' had the right to self-determination. Yet, the principle and practice of national self-determination confronted the inchoate and controverted nature of nationhood across much of the world, for example in Nigeria, or involved the suppression of signs of alternative nationhood. Turkey provides a good instance of the latter, as the Armenian Massacres of the 1890s and, even more, the Armenian Genocide of 1915, the latter a well-planned operation that possibly led to the slaughter of more than a million Armenians, is ignored in Turkish public history or, erroneously, treated as the consequence of treasonable Armenian separatism.

Precisely because during and after decolonization it was not clear how 'peoples' were to be defined, there was an emphasis on the national character of states and proto-states. This cut across the recent Western academic emphasis on the artificiality of nations, the extent to which they were constructs, and the importance for identity and classification of other groupings, especially class, gender and culture.[27] The artificial character of states is particularly apparent in Africa, the Middle East and South Asia. Yet, public history not only asserts the identity of states in the face of divisive, if not fissiparous, tendencies, but is also a counterpoint to international pressures, not least the intense intrusion presented by what is summed up by Westernization or globalization.

Globalization

Alongside a new public history after independence came a rethinking of the economic history of Third World countries. As an aspect of the independence struggle and of decolonization, this involved in particular a critique of capitalism which was seen as a cause of imperialism and also as a distorting consequence of colonial rule. This approach remained potent as many newly independent states, such as India and Tanzania, turned to Communist or socialist models, but became less credible as Marxist economic planning produced successive crises in the Communist and Third Worlds, especially from the 1970s. From the 1990s, however, the critique of globalization came to provide a new iteration of this approach, not least because it appeared to offer a long-term explanation of relative economic failure.

Although historiographies and historical writing are still largely structured along national lines,[28] globalization has been ably studied by academics, especially in the developing field of world history.[29] Yet, globalization lacks a popular public history, a contrast also seen with comparative history.[30] In part the lack of a popular public history for globalization is due to it being largely a matter of economic forces, but more than that is at stake. Internationalism has failed to win a mass support or define a populist ideology. This is due to the failure of the United Nations to gain widespread popular backing as a key way to organize the world, and the absence of any other institution capable of generating an international public myth.

In contrast, at the level of global regions, there have been attempts to create such a myth. This is readily apparent in the European Union with support for educational and other initiatives that can be related to federalist goals. This extends, in the European University based in

Florence, to an attempt to mould a key group of future educators. History is one of the biggest programmes at the university, which focuses on the training of postgraduates.

Pan-Arabism represents not an equivalent but at least a parallel. There are, however, few others. It is striking, for example, that the academic anti-Westernism represented by the critique of Orientalism by Edward Said[31] and others is not matched by a successful public discourse other than at the national level. As a result, at the international level, anti-Westernism is shot through by the consequences of particular state interests, while the statist perspective, 'historiography powered by statehood', has marginalized other ways of looking at historical experience.[32]

Globalization is represented as a negative force from both national and regional perspectives. This is part of a widely anti-economic character to popular history, a pervasive distrust of entrepreneurs and a view of economic change as destructive, that is widely expressed. At the same time, many states publicly endorse economic development as a means to enhance national strength and well-being, and as a crucial adjunct to political independence. This, however, is compatible with popular suspicion of (national) entrepreneurs and (international) globalization, because state support for economic development generally focuses on governmental control and direction. This was definitely the case during the Cold War, as Third World states, such as India, found the model of state socialism particularly attractive.

In the 1990s this situation altered as the collapse of the Soviet Union, and the reaction against state control of the economy in parts of the West, helped lead to an abandonment of Marxist ideology and state socialism. The impact of this on public history, however, was less marked. Even in states that took a conservative direction politically, there was a lack of comparable movement in public history about economic issues. This situation is likely to continue, and poses a problem for politicians seeking to foster economic growth through the liberalization that is linked to international investment and globalization.

Notes

1 For different emphases, V.Y. Mudimbe. *The Idea of Africa* (Bloomington, Ind., 1994); R. Guha, *History of the Limit of World-History* (New York, 2002). V.N. Rao, D. Shulman and S. Subrahmanyam, *Textures of Time: Writing History in South India, 1600–1800* (London, 2003), and S. Subrahmanyam, 'Europe and the People without Historiography; or. Reflections on a Self-Inflicted Wound', *Historically Speaking*, Vol. 5, No. 4 (March 2004), 36–40.

2 A.I. Asiwaju (ed.), *Partitioned Africans: Ethnic Relations Across Africa's International Boundaries, 1884–1984* (London, 1985): W.S. Miles, *Hausaland Divided: Colonialism and Independence in Nigeria and Niger* (Ithaca. NY, 1994); A.I. Asiwaju and P. Nugent (eds), *African Boundaries: Barriers, Conduits and Opportunities* (London, 1996).

3 E. Said, *Orientalism* (London, 1978); R. Inden. *Imagining India* (Oxford, 1990).

4 R. Guha (ed.), *Subaltem Studies: Writings on South Asian History and Society* (Delhi. 1982); R. O'Hanlon, 'Recovering the Subject: *Subaltem Studies* and Histories of Resistance in Colonial South Asia', *Modern Asian Studies*, 22 (1988), 189–224.

5 G. Bhadra, 'Four Rebels of Eighteen-Fifty-Seven', in R. Guha and G.C. Spivak (eds), *Selected Subaltem Studies* (Oxford, 1988), p. 175.

6 G. Pandey, *The Construction of Communalism in Colonial North India* (Delhi, 1990); K.N. Panikkar (ed.), *Communalism in India: History, Politics and Culture* (Delhi, 1991).

7 L. Menon, 'Coming to Terms with the Past: India', *History Today*, 54 No. 8 (August 2004), 28–30.

8 D. Hume, *The History of England from the Invasion of Julius Caesar to The Revolution in 1688* (6 vols, Indianapolis, 1983), 1, 3–4.

9 T. Ranger, 'The Invention of Tradition in Colonial Africa', in E. Hobsbawm and T. Ranger (eds), *The Invention of Tradition* (Cambridge, 1983), pp. 211–62; L Vail, *The Creation of Tribalism in Southern Africa* (London, 1989); P. Yeros (ed.), *Ethnicity and Nationalism In Africa: Constructive Reflections and Contemporary Politics* (Basingstoke, 1999); C. Lentz and P. Nugent (eds), *Ethnicity in Ghana: The Limits of*

Invention (Basingstoke, 2000); J.D.Y. Peel, *Religious Encounter and the Making of the Yoruba* (Bloomington, Ind., 2000).

10 I have benefited from listening to a paper on this subject by Ruth Ginio.

11 V.Y. Mudimbe, *Idea of Africa* (Bloomington, Ind., 1994); A Mazrui, *The Africans: A Triple Heritage* (London, 1986); CA. Di'op, *Civilization and Barbarism: An Authentic Anthropology* (Westport, Conn., 1990).

12 *Times*, 8 October 2004.

13 T. Seqev, *The Seventh Million: The Israelis and the Holocaust* (New York, 1993); R. Wistrich and D. Ohana (eds), *The Shoping of Israeli Identity: Myth, Memory and Trauma* (London. 1995); N. Lochery, 'Scholarship or Propaganda: Works on Israel and the Arab-Israeli Conflict, 2001', *Middle East Studies*. 37 (2001), 219–36; R. Ovendale, *The Origins of the Arab-Israeli Wars* (4th edn, London, 2004), p. 277.

14 B. Jewsiewicki and D. Newbury (eds), *African Historiographies: What History for Which Africa?* (Beverly Hills, CA, 1986); B. Davidson, *The Black Man's Burden: Africa and the Curse of the Nation State* (London, 1992); T. Falola. *African Historiography: Essays in Honour of J.F. Ade Ajayi* (London, 1993).

15 J. Alexander, J. McGregor and T. Ranger, *Violence and Memory: One Hundred Years in the 'Dark Forests' of Matabeleland* (Portsmouth, NH, 2000).

16 T.M. Davies, 'Jorge Basadre, 1903–1980', *Hispanic American Historical Review*, 61 (1981), 84–6.

17 For an attempt to place Java in a wider context. D. Lombard, *Le Carrefour javanais: Essai d'histoire globale* (3 vols, Paris, 1990).

18 A. Reid and D. Marr (eds), *Perceptions of the Past in Southeast Asia* (Singapore, 1979).

19 A. Feuerwerker (ed.), *History in Communist China* (Cambridge, 1968).

20 R. Mitter, *A Bitter Revolution: China's Struggle with the Modern World* (Oxford, 2004), especially pp. 230–3, 309–11, 44.

21 An English translation of the full text can be found in *Beijing Review*, 6 July 1981, 10–39.

22 J. Unger (ed.), *Using the Past to Serve the Present: Historiography and Politics in Contemporary China* (Armonk, NY, 1993).

23 Y. Daqing. 'Convergence or Divergence?: Recent Historical Writings on the Rape of Nanjing', *American Historical Review*, 104 (1999), 842–65.

24 R. Mitter, 'Old Ghosts, New Memories: China's Changing War History in the Era of Post-Mao Politics', *Journal of Contemporary History*, 38 (2003), 117–31.

25 J. Powers, *History As Propaganda: Tibetan Exiles Versus the People's Republic of China* (Oxford, 2004).

26 C.F. Robinson, *Islamic Historiography* (Cambridge, 2003), p. 189.

27 R. Samuel (ed.), *Patriotism: The Making and Unmaking of British National Identity* (London, 1989); E.J. Hobsbawm, *Nations and Nationalism since 1780: Programme, Myth, Reality.* (Cambridge, 1990); B. Anderson, *Imagined Communities: Reflections on the Origins and Spread of Nationalism* (2nd edn, London, 1991); R. Porter (ed.), *Myths of the English* (Cambridge, 1992); J. Breuilly (ed.), *The State of Germany. The National Idea In the Making, Unmaking and Remaking of a Modern Nation-State* (London, 1992).

28 S. Berger, 'Representations of the Past. The Writing of National Histories in Europe', *Debate: A Review of Contemporary German Affairs*, 12 (2004), 91.

29 E.g. W.H. McNeill, *The Rise of the West: A History of Human Community* (Chicago, 1963); J.H. Bentley, *Shapes of World History in Twentieth-Century Scholarship* (Washington, DC, 1996).

30 On academic developments, see S. Berger, 'Comparative History', in S. Berger, H. Feldner and K. Passmore (eds), *Writing History: Theory and Practice* (London, 2003), 161–79.

31 E. Said. *Orientalism* (London, 1978).

32 Guha, *History at the Limit of World-History*, quote, p. 73.

33
Turkish delight

Antonio Gala's *La pasión turca* as a vision of Spain's contested Islamic heritage[1]

Nicola Gilmour

The exact nature of the role played by Spain's Islamic/Moorish heritage in the development of its national identity has long been polemic amongst Spanish writers, cultural historians, sociologists, and philosophers.[2] Whether viewed as a toxic influence on Spanish culture, an essential part of a unique national identity or an irrelevant historical parenthesis of no lasting impact, the Moorish/*morisco* presence and its perceived contribution to contemporary Spanish identity is curiously versatile. Its apparently endless capacity for reinterpretation by generation after generation of writers and commentators for purposes more relevant to the present than to the past has been noted by Miguel Ángel de Blunes in his introduction to Mercedes García Arenal's study *Los moriscos*:

> [E]ste colectivo humano ha sido moneda de trueque para reflexiones que se alejan de los planteamientos y de las conclusiones propias de un historiador para vindicar colonialismos, supremacías o problemas propios del siglo presente y no del quinientos y del seiscientos.[3]
>
> *(x)*

Although he is referring specifically to the *moriscos*, I would argue that the same can be said for the Islamic presence in Spain in general.

Interest in the Muslims of Spain, past and present, has increased dramatically over the last twenty-five years due to the confluence of many factors, both domestic and international, which have raised the stakes considerably, making this area of study one of greater urgency in recent times than the purely historical debate of the past.[4] Serafín Fanjul, in *Al-Andalus contra España*, cites statistics which suggest an exponential increase in publications in the field: between 1970 and 1990 some 822 books were published on the topic, 35% of them in the last five years of the period in question, and he goes on to predict a continuation of this trend (86).[5] This trend has been further encouraged since 1990 by recent world events related to Islam in general, as well as events specific to Spain's history, such as the commemorations of 1492 and the increase in Muslim immigration into Spain with the preoccupations that this generates. An additional stimulus appears to be a growing interest in exploring Spain's past and its impact on the present. Not surprisingly, this interest has filtered through into the world of literature, both in more literary works as well as in middle-brow and popular fiction. As Eduardo Subirats notes in "Moros

y judíos, y el problema de España," "la literatura española contemporánea se ha planteado de nuevo la pregunta por los significados de las culturas árabe y judía en España" (201).[6]

In this article, I will examine the ambivalence of Spain's relationship to its Islamic past through the analysis of Antonio Gala's *La pasión turca*, which participates in a prevalent fetishizing discourse with respect to that element of Spain's history. While the novel, published in 1993, predates by over a decade some of the dramatic events that have contributed to the latest upsurge in interest in Spain's connection with Islam, it is an early fictional manifestation of this interest, whose publication can be linked to the debate surrounding the commemorations of 1492 and Spain's political positioning as a European nation within the European Union. I argue that this narrative constitutes an example of the way in which Orientalist fantasies about Turkey, standing in for the Moorish elements in Spain's history, are deployed to express anxiety about Spain's present. The narrator's sexual obsession with the figure of Yamam in *La pasión turca*, I will argue, can also be read as an example of the way in which fantasies about the past can resurface in popular contemporary literature, reflecting in this instance a dissenting but ultimately flawed vision of Spain's current construction of its national identity as a thoroughly Europeanized nation.[7]

Gala (1936-), poet, dramatist, essayist and novelist, is one of the authors most associated with a particular interest in Spain's Islamic past.[8] As their titles indicate, his first two prose works, *El manuscrito carmesí* (Premio Planeta 1990), and *Granada de los nazaríes* (1992), centre specifically on the culture of al-Andalus.[9] With *La pasión turca*, his third work in prose, Gala's focus ostensibly shifts from Arabic Spain to the sentimental and existential problems of middle-class life in modern Spain. However, as we shall see, Spain's Moorish heritage continues to play an important role in respect to this novel.

While arguably not an important novel in terms of its literary significance,[10] *La pasión turca* was an extremely successful one, reaching twenty-eight editions in its first few years of publication, a popularity which reflects the novel's tapping into a particular vein of public interest. It recounts the tragic passion of a Spanish woman, Desideria Oliván. On a package holiday in Turkey, she falls tempestuously and obsessively in love with her Turkish tour guide, Yamam, with whom she discovers an overwhelming sexual fulfillment. Seeking happiness with Yamam, Desideria abandons her husband, family, friends and country, and travels to Turkey. However, Yamam is not all he seems and, enslaved by her passion, Desideria is forced to undergo two back-street abortions, suffers abuse of various kinds and is prostituted by Yamam to further his illegal business interests (drug-trafficking), before finally committing suicide when he abandons her for another woman. The text is presented as Desideria's diary written during her time in Turkey. This diary, a series of notebooks symbolically contained in an empty box of Turkish Delight sweets, passes through various hands, until reaching an "editor" who publishes it.

By virtue of the novel's title, one might expect *La pasión turca* to abound in sizzling sexual encounters in exotic locations. However there are relatively few of either in the novel. Instead, the reader is confronted with page after page of intense emotional self-analysis and abstract philosophizing on the subject of love and obsession, as Desideria writes of her emotions. Underscoring the novel's overt theme of feminine desire run rampant is the protagonist's unusual name. Derived from the Latin word *desiderium*, Desideria is grammatically neuter and in the plural, translated explicitly in the text as longings, yearnings, or desires (256); a plurality which hints at the presence of levels of desire in the text other than the overwhelming sexual desire of the protagonist.

One of those levels of desire, I will argue, is a desire for Spain's lost "difference" from the rest of Europe, its Islamic heritage, a difference that is associated in the novel with virility and embodied in the figure of Yamam. It is my contention that the presentation of Yamam as

Nicola Gilmour

representing the lost potency of Spain's Islamic heritage has its echo outside the novel in political and media discourses produced around the same time in relation to Islamic Spain, in both the past and present. Examining these discourses in conjunction with the novel will prove fruitful in revealing some of the problems inherent in the prevalent use of the image of al-Andalus in this way, as "una moneda de trueque" (x) as Blunes puts it.

In addition to the international events of obvious importance, the growth in the interest of the Spanish public in matters pertaining to Islam has a more historical and nationally specific component. Debate centres on what modern Spain might owe to the Muslim inhabitants of al-Andalus and what that heritage (if it exists)[11] might mean in a Spain whose identity and sights have long been firmly fixed on a full participation in the European Union.[12] One factor which stimulated this renewed interest was the official commemorative focus on 1992, the 500th anniversary of Columbus's voyage to the Americas. 1992 also saw Spain host a number of significant cultural events which were read by Helen Graham and Antonio Sánchez as a celebration of "Spain's coming of age as a modern, democratic European nation-state" (406).[13] One consequence of such an intense focus on 1492 was a recognition on the part of some that 1992 also marked the 500th anniversary of what Juan Goytisolo refers to in *Crónicas sarracinas* as "la amputación del legado musulmán y judío hispano" (185): the conquest of the last Islamic kingdom in Spain and the end of al-Andalus, as well as the expulsion of the Jews from the newly united Catholic Spain. The predominant official concentration on Columbus's voyage and the subsequent colonization of America, it was argued, indicated an insufficient recognition of the "other cultures" of the Iberian peninsular and of the impact of Christian Spain's actions on these minorities.[14]

The question, which continues to be hotly debated, becomes one of exactly what Spain should be commemorating and how Spaniards should feel about this. On the one hand, Subirats, in "La península multicultural," argues that:

> [d]esde su fundación histórica en 1492, hasta el día de hoy, la identidad nacional se ha configurado a fuerza de desechar, muchas veces con virulenta violencia, cualquier forma de reflexión sobre la destrucción de las lenguas históricas, y los cultos y culturas que poblaron la Península ibérica. Se ha configurado también a fuerza de desechar sus memorias.
>
> *(39)*

Viewing the matter in this way, some kind of recognition and understanding of the wrongs of the past is essential to creating a Spanish identity that is not based on empty imperialist rhetoric.

Others, like Fanjul, would argue that Américo Castro (and those who support his arguments) suffer from an obsessive political correctness:

> un enfermizo y obsesivo complejo de culpabilidad, de interiorización colectiva de *nuestro* pecado original frente a moroso y judíos, con el includible corolario de la expiación de *nuestras* culpas.
>
> *(Al-Andalus contra España 106)*

For Fanjul, all talk of an Arab heritage is mythologizing, a product of a desire to justify "una nacionalidad recientemente inventada" (*Al-Andalus* xxi).[15] As far as he is concerned, modern Spaniards did not participate in those decisions and therefore have no need to feel guilty about them or to revisit them. For Fanjul and others, modern Spain owes little or nothing to those historical minorities expelled in the past.

One final twist is given to Spain's problematic relationship with its Islamic past by the upsurge of *magrebí* immigration into Spain in recent years. The influx of these and other immigrants into Spain has lead to a continuing media focus on issues of racism, xenophobia, tolerance, assimilation versus integration, as well as the role of the government in regard to these immigrants and the challenges presented by their presence in Spanish society.[16] Although there may or may not be any unsettled accounts with the historical Islamic presence in Spain, there are certainly matters pending in relation to a current one, with the same vocabulary being used to talk about it. The frequent use of the word *convivencia* in such a context inevitably calls to mind the hotly debated period when three religions coexisted in the Iberian peninsula, whether it is perceived as a golden age of tolerance or a period of more problematic coexistence.

Links are drawn between the presence of this particular group of immigrants and a threat to Spain's national integrity, which in turn lend themselves to further parallels being established with the situation of the Moors/*moriscos* in Spain over five hundred years ago. In newspaper articles related to issues of immigration, there is a notable tendency to draw a connection between these immigrants and the inhabitants of Al-Andalus. References are made to the "reconquest of al-Andalus,"[17] with the increased immigration (legal or otherwise, although particularly the latter) even being adduced as "evidence" of a supposed conspiracy on the part of Morocco to re-establish al-Andalus or as part of a larger plan on the part of Osama bin Laden to "izar la bandera del islam tanto en la infiel Londres como en Sicilia o en al-Andalus" (Canales and Montánchez 163).[18] References in the press to the Islamic affection and nostalgia for al-Andalus, their own version of Paradise lost, feed into the fear that Spain is in danger of being invaded by their historical enemy. As Leopoldo García García emphasizes, Spanish hostility towards Arabs is directly related to the internalization on a national level of the past experiences of Spain: "La Edad Media ha dejado en el consciente colectivo de los españoles la imagen del musulmán como el 'enemigo' por excelencia" (13).[19] Thus, Spain's relationship with the Islamic immigrant in the twenty-first century is inevitably linked to the presence of those "others" who were so brutally dealt with in 1492 and later in 1614 with the final expulsion of the *moriscos*. Perceptions relating to Spain's past, then, are being used to justify or demand changes in the approaches taken in the present, despite the very different historical contexts.[20]

The way in which Spain perceives its historical links with the Islamic world tinges even its modern international relations feeding into the debate as to the role modern Spain should play with regard to both Europe and the Arab world. In 1990, Miguel Ángel Moratinos (now Minister for Foreign Affairs in President Zapatero's government) advocated a role for Spain in relation to the Southern Mediterranean based on "nuestro común pasado histórico cultural," asserting that "España, sin caer en falsas retóricas, es quizá el país que mejor comprende al mundo árabe" ("Política española" 61). In a different speech around that time, Moratinos further stated:

> Nuestro país no puede ni debe renunciar a su vocación mediterránea. Su europeidad—cada día más consolidada—debería permitirle prestar un mayor interés a un área vecina con la que mantiene estrechos lazos de historia y cuya evolución afectará muy directamente a su propio futuro.
>
> *("El Mediterráneo" 46)[21]*

These speeches appear to present the notion that Spain can gain prominence within the EU by acting as a bridge between the Islamic Orient and European Occident because of its unique Islamic heritage (however vaguely or euphemistically that may be defined), glossing over the issue of the forced conversions and subsequent expulsion of the *moriscos*. This sense that Spain is

unique in its Islamic connection is reflected in a different way in Gala's *La pasión turca* which is published around the same time as the events of 1992 and at the same time as Spain commits itself fully to the European Union (1992). However, a close study of the way in which such issues are played out within the novel reveals the problematic and ambivalent nature of the assumptions upon which such statements are based. *La pasión turca*, I will argue, responds to these two realities, past and present, in a very ambivalent way, fetishizing the protagonist of the novel, Yamam (the Turk/*el moro*) as a response to the threatening homogeneity of Europe.

One of the layers underpinning this best-selling tale of sexual obsession is a representation of Spain caught up in a crisis of identity and differentiation as it is incorporated into the larger body of the European Union. The relationship of the protagonists in the novel can be read as an attempt to construct a Spanish national identity via what is ultimately a fetishistic, Orientalist fantasy.[22] Such a fantasy is linked to perceptions of Spain's lost Moorish heritage and the adoption of popular myths of al-Andalus and what Spain owes to it, or wants to find in it. The novel also highlights the ambivalence and violence attached to this relationship of desire. In order to clarify my reading the text in this way, it is necessary to outline briefly the nature of the crisis suffered by the protagonist, Desideria, and relate it to my assertion that the novel fetishizes the figure of Yamam. Taking her as representing Spain, I propose to show how the story of her sexual enslavement can also be viewed as a cultural fantasy deployed as a response to contemporary events. Finally, I will tie these observations into the ongoing debate surrounding the significance of Spain's Islamic past and present.

As I will show, Desideria's narrative reflects parallel perversions:[23] her obsession with Yamam on the level of plot appears to present a textbook case of the perversion of sexual enslavement, as described by Louise Kaplan in *Female Perversions* (1993), while on another level the representation of Yamam read as a symbolic figure presents strong indications of functioning as a fetish object in the narrative. It is essential to my argument to state that I am viewing fetishism as a narcissistic mechanism that creates a split in the subject who both denies what he perceives as the castration of his mother and, at the same time, highlights it by the symbolic nature of his fetishistic fixation. For the fetishist, the fetish object (in this instance, Yamam) both is and is not what it appears to be. The unconscious aim of fetishism is disavowal of loss (or castration) and the fetishist is seen to be oscillating between two poles, holding two opposing views at the same time, that of identity and difference.[24]

Desideria is driven by a crisis specifically radicated in the area of desire and physical passion. A bored, middle-class housewife, trapped in a sexually unfulfilling relationship with her husband Ramiro, she imagines love and fulfillment awaiting her "somewhere else" in an unknown location (85–86). From the outside, Desideria and Ramiro's marriage seems fairly typical: a bourgeois union not dissimilar to their friends' relationships. However, the lack of sexual contact between the couple, due to Ramiro's impotence, reduces their relationship to one of shared economic interests alone. Ramiro's sexual coldness, it is implied, is due to his immersion in an emasculating social environment which restricts and stifles the expression of desire.

This is not just a personal affliction specific to one character; all Spanish men in the novel are shown to be lacking in one way or another.[25] This lack of virility is also present in European men in general and seems to be attributed to a loss of sexual difference or contact with the sexed, and therefore sexual, body. Because sexuality is repeatedly constructed within the narrative in opposition to civilization, the inhibited, provincial, middle-class community of Huesca is presented as a place where sexual difference, and therefore virility/potency, is reduced. This lack of difference extends to all aspects of life, resulting in the bland mediocrity of a Spain (and a Europe) where everyone is the same. This can be seen, for example, in Desideria's description of one of Yamam's business associates, portrayed as embodying a rather unattractive series of half

Turkish delight

measures: "Era un francés típico: medio rubio, medio calvo, medio gordo; engreído y completamente seguro de su *charme* y su *glamour*" (226).

Desideria's boredom and her desire for something or someone "different" has its echo on the national level, for social analysts in the 1990s frequently conceptualize modern Spain's post-Franco, post-transition development as a movement towards homogeneity, or loss of difference. Francesc Mercadé describes Spain as being in a process of homogenization:

> España sigue siendo una mezcla apasionante de tradición y modernidad. Las nuevas tecnologías conviven con los bueyes y el arado, las grandes ciudades sumidas en el individualismo y el anonimato se sitúan frente a pueblos recónditos en los que persisten las tradiciones más antiguas. Tal como veremos, los cambios culturales y los medios de comunicación acabarán—en algún momento no lejano—con estas diferencias [...].
>
> *(572)*

He also characterizes modern Spanish society, in terms not dissimilar from those in *La pasión turca*, as being dominated by "el desencanto, la atonía y quizá el aburrimiento" (579). Similarly, in regard to literary trends, Paul Ilie refers to the period from 1975–1990 as "la época amorfa" (38), a formlessness perceived as a crisis of identity, imagination and creativity at a national and cultural level (Mercadé 579).

What, then, is the solution proposed in the novel for Desideria's dissatisfaction and Spain's crisis of sameness and difference? Within the narrative, Western European civilization is placed in direct opposition to the animal forces of the body, sexual potency and fertility. In one telling quotation the narrator explicitly associates sexuality (and the sexual body) with non-European cultures, and specifically with Africa:

> Yo conozco mejor que otras mujeres la incompatibilidad de una vida regulada, modelo, o al menos razonable, con la violencia del reclamo del sexo, con *su vorágine africana, irracional y sudorosa*.
>
> *(emphasis added 131)*

Exotic lands, perceived as less civilized and therefore closer to animal nature and the body, provide a space to rediscover sexual desire. Hence, when Desideria and her friends travel first to Egypt, then to Syria and finally to Turkey, they discover that these "Eastern" lands serve as aphrodisiacs. On all three occasions these countries are presented as older, wiser, more sensual and embodied than the provincial Spain with which the couples are familiar.

In her visits to these countries, Desideria feels a racial or genetic affinity with their peoples, accompanied by an increasing consciousness of her own body. It is almost as if contact with the Orient and, more specifically, the Islamic Orient, causes her body to materialize.[26] The fact that this bond is linked to Spain's Moorish heritage is stated explicitly in the text:

> Yo notaba algo decisivamente fraternal en aquel viaje. Como si los árabes andaluces murmuraran dentro de mis venas incomprensibles oraciones. Nada muere del todo; el olvido no existe. Creí entonces, y hoy, lo sigo creyendo, que *estamos hechos de lo que en apariencia olvidamos* [...].
>
> *(emphasis added 77)*

Through her travels in these countries, Desideria reestablishes a connection with a lost, forgotten or repressed part of herself: her "Moorish"/sexual body.

479

Nicola Gilmour

On a symbolic level, Spain too connects with that lost or apparently forgotten part of itself. Just as Desideria sees the "family resemblance" between herself and the peoples of the Middle East, so too is the Spanish nation mirrored at the Eastern end of the Mediterranean, as is made evident in the following comment regarding Syria:

> Desde un extremo del Mediterráneo volábamos al otro extremo. Desde una tierra que es el rabo sin desollar de Europa y que tiene tanto de África, volábamos […] a otra tierra, también al borde de Europa y en el dintel de Asia. De nuestras mezquitas transformadas en catedrales volábamos a sus catedrales transformadas en mezquitas. De nuestro amontonamiento de culturas, al suyo.
>
> *(75)*

In this passage, emphasis is explicitly placed on the geographical, historical, and cultural similarities between Spain and Syria: both in liminal positions between continents, both with a history of religious conversion (albeit in mirror image) and cultural layering. Spain is also described as "el rabo sin desollar de Europa," implying that, despite its connection with Europe, Spain is not yet skinned for consumption by that continent due to its continued strong links with Africa.[27] This passage hints in a veiled fashion at Spain's difference from Europe, to suggest that Spain too has, or has had, the capacity to access the power of the body, just as Desideria does. This residual potency is explicitly attributed in the text to the repressed traces of its Arab past.

However, it is neither Egypt nor Syria that provides Desideria's definitive contact with the sexual body of the Other, Yamam, but rather Turkey. Also on the border between Europe and Asia,[28] Turkey is constructed as a place where Western European sensual and sexual fantasies are fulfilled, fantasies explicitly fostered by Yamam, the tour guide:

> El café, el sorbete, la otomana, el diván y las pasas son inventos turcos. ¿Y quién no ha oído nombrar, o no ha probado, las delicias turcas? Nuestros baños, señores, son famosos en el mundo entero […]. Cuando ustedes aún estaban en la oscuridad de la Edad Media, nosotros vivíamos en un mundo de placeres y voluptuosidades […].
>
> *(97–98)*

Yamam will not only lead the tourists through the exotic landscapes of Turkey but will also guide Desideria to the discovery of the exalted sexual capacity of her own body, given that he is an expert in the arts of erotic pleasure. In this way the meeting of the two characters and two countries or cultures becomes a union of mind and body, of self and other, a fantasy of total completion for the Western partner.[29]

Desideria falls in love with Yamam, as the very incarnation of virility who magically endows her new-found body with meaning:

> Hay un valle cerca de Cavusin en que lo obligado es ver *chimeneas de las hadas*, y yo sólo vi falos […]. Avanzaba por un mundo en estado de gracia, que era bello, recién estrenado y mágico porque surgía bajo la vara de prestidigitador de Yamam […].
>
> *(110)*

Yamam's phallic power—his "magic wand"—is such that he, unlike Ramiro, can impregnate Desideria, although he will not allow her to carry a pregnancy to full term.[30] A fetishized figure of masculine potency, he is uniquely virile and irreplaceable in her eyes. In fact, it is emphasized that his very name, Yamam, means "el único."

Such an obsession is in line with Louise Kaplan's description of the woman afflicted with *Horigkeit* (sexual bondage) who lives only for her moments of ecstatic sexual union in which the man's mighty phallus confirms the outlines of her feminine self. The woman can only find pleasure in a fantasy of being part of a more powerful personality, that is, when she is encircled by her lover's phallic aura (Kaplan 215–16). The idea of being completely penetrated by her lover is clearly present in Desideria's narrative, as for example in the following quotation:

> Y de arriba abajo mi cuerpo está traspasado por él; mis orejas, mis rodillas, mis párpados, mis muslos, mis nalgas, mis poros, todos los orificios, por pequeños que sean, lo reciben y lo acogen.
>
> *(313)*[31]

Examples of such dramatic assertions abound throughout the novel, reflecting the degree of obsession that the narrator feels.

Having shown how Desideria's narrative reflects the perverse scenario of sexual bondage, I now wish to turn to examine in what way the figure of Yamam can be considered to be a fetish and by what process of displacement he (and Turkey) comes to stand for this lost part of Spanish culture. The fact that Turkey itself is so physically absent from the narrative suggests, perhaps, that Turkey is a symbolic narrative space, a placeholder representing something else.[32] The symbolic choice of Yamam and Turkey as the fetish object can be attributed to a number of factors. As Goytisolo states, from 1453 on—around the same time the Moors of Spain are eliminated as a threat to Christian culture—the Turks, Istanbul and the Ottoman empire become particular sources of fascination for Europe, replacing the Moors as the embodiment of the Islamic Other in European eyes (*Estambul* 9).[33] Turkey's historical development runs in parallel to that of Spain, constituting the centre of an Islamic empire at the other end of the Mediterranean, mirroring imperial Spain and also the lost Arab kingdom in Spain. The evidence for reading modern Turkey as a placeholder for Moorish Spain in the novel is underscored by the fact that Yamam's name is not Turkish but Arab. As fetish object, Yamam both is and is not what he seems.

In short, then, the power of masculine sexual difference that the Europeanized Desideria perceives as lost but desires so ardently is associated specifically with the Islamic culture of Turkey and her ability to connect with it and become powerful comes, as has been shown, from her hidden Arab/Moorish heritage. Thus, by extension, the text seems to suggest that the "masculine" (African) vigor and difference or uniqueness that modern Spain lacks may hinge upon the recuperation of that part of Spain's cultural identity repudiated in 1492. On this level, then, *La pasión turca* acts out a disavowal of that repudiation. In addition, in the context of the imagery deployed in the novel, it attempts to reinforce the connection between Spain and its Islamic past to maintain its difference and stave off the threat of "skinning" by Europe referred to earlier.

However, as the novel progresses, it is clear that there is no happy ending and that the relationship between the protagonists is driven by a dynamic of conquest and power, of desire and hostility on both sides. For Desideria, now fully connected with the body, Yamam is a fleshly terrain to explore and conquer. She observes that her efforts to dominate and absorb him through sexual union threaten Yamam's virile difference, feminizing him:[34]

> Comprendo que Yamam haya llegado a sentir por mí [...] cierta antipatía, en el sentido liberal de la palabra. Él ha de verse, por turco y por machista, como si fuese la mujer de la pareja.
>
> *(249)*

Nicola Gilmour

This leads him to push her away. As a result, Desideria fights harder to recover her lost territory, a struggle narrated in terms of a violent reconquest:

> Tengo que reconquistar a sangre y fuego; emplear la máquina de placer que es el cuerpo de Yamam hasta sus últimos engranajes. [...]. Yo era la agente, la invasora, la mantis religiosa, es decir, la devoradora.
>
> *(334)*

While such language has a strong cultural resonance in the context, recalling Catholic Spain's *reconquista*, here it is played out in terms of the interplay of dominance and submission of sexual bondage.

That Desideria's desire to dominate Yamam is linked to the convergence of modern Europe can be seen in Yamam's comment with regard to a Europe that both attracts and threatens:

> Europa es una advenediza que engulle todo lo que se le acerca: una boa constrictor. Ya verás tú dónde acaba la esencia de lo español dentro de nada. Cuando todos allí seáis iguales, te juro que todos seréis mucho peores.
>
> *(174–75)*

In *La pasión turca*, then, both Europe and Desideria are cast as desirable but insatiable women, wanting to absorb the virile East into their sameness.

However, while Europe threatens that part of Spain which is different (its Eastern component), the Orient too threatens the West. Turkey's vision of the West is described to Desideria in a manner that emphasizes the threat and hostility of the Other:

> Sentimos fascinación por Occidente, pero no re fíes, porque es mayor nuestra aversión hacia él [...]. De ambigüedades estamos hechos, no lo olvides.
>
> *(145–46)*

As can be seen in his abusive behavior towards her, Yamam does indeed constitute a threat to Desideria's physical and emotional integrity. Desiring each other's difference, the protagonists's relationship also threatens them and the novel offers no sense of a possible peaceful coexistence between the two.

The dynamic of the relationship between Desideria and Yamam—one of "feminine" insatiability pitted against masculine phallic independence in a struggle for dominance—has its parallel in the relationship between Europe and Spain, between Occident and Orient, with Spain in a sense occupying both sides on different occasions.[35] In relation to Yamam, Desideria is the West, representing the threat of Christian Spain to Islamic Spain in historical terms, and also the engulfing threat of a homogeneous Europe. As Spain in relation to an increasingly homogeneous Europe, however, she represents a connection with that Eastern element, "the uniqueness" of Spain which is in its turn threatened by absorption into Europe. This struggle is played out in the novel as one of life and death, of historical and economic presence and absence, of sameness and difference.[36]

The narrative conflict between the protagonists is resolved by the arrival of the Authorities, in the figure of Pablo Acosta, an Interpol agent and childhood friend of Desideria. As a member of the pan-European police force, Acosta confronts Desideria with evidence of Yamam's criminal activity and offers to take her back to Spain with him. She postpones her response for one day and there her narrative ends. The epilogue of the novel, based on Acosta's testimony,

informs us that Desideria has committed suicide for reasons that he assumes to be related to Yamam's rejection of her. Desideria is relegated to a feminized position of silence, losing her narrative voice to the point where even her last words in her suicide note are illegible. The only way of restoring order within the narrative is to give Desideria what she desired: loss of self, which equals death. What Desideria sought in love—a complete fusion of self and other—is revealed as only feasible in annihilation of the self. Thus, the novel ends in a permanent separation between the figures representing East and West, the conservatism of the ending implying that the forces unleashed with the contact between Orient and Occident have proved too dangerous for Europeans. Despite being presented so unappetizingly at the beginning of the novel, the work ethic and economic convenience of middle-class marriage and the bland sameness of Europe now seem to serve as a safeguard, protecting Western civilization from the threatening allure of the "different" Eastern other.

At first, *La pasión turca* seems to offer a dissenting view to that which endorses Spain's entry into Europe, suggesting that "real" wholeness for Spain may not lie in the arms of an emasculating, insatiable Europe where economic power comes at the price of national individuality. Running throughout the text there is a discernable anxiety articulated about the price being paid for Spain's modernity: the elimination of its "residual" difference, as symbolized by Spain's Moorish past. Such a difference, Goytisolo (and others) have suggested, is key to Spanish identity,[37] giving it a supposedly unique role in the modern world and in Europe, as seen in the passages previously cited from Spain's foreign policy reports. At the same time, a determinedly European focus on the part of the government threatens to cut Spain off from those Eastern/African roots, emasculating it even further. Through the figure of Desideria, Spain can be read as fantasizing about rediscovering its identity in the fetishized East, the repository of lost national difference, enacting a fantasy of disavowal of what is implied to be a national castration.[38] As *La pasión turca* moves towards its conclusion, however, it is clear that union with the Eastern other is a very ambivalent and ultimately unsustainable fantasy. It is not possible to recuperate this always-already lost element of national identity in any other form than a fetish image (which both covers and marks the original loss). By killing off the protagonist, resolving the extreme confusion of gender boundaries in the only way possible, the ending of *La pasión turca*, I suggest, unconsciously highlights the fundamentally conservative and destructive nature of such perverse scenarios.

In addition to being a best-selling novel of erotic obsession, *La pasión turca* also clearly taps into concerns with the issue of how Spain's modern identity is constituted. Is Spain part of the East through its Moorish heritage or of the West through its connection with Europe? More to the point, what is the nature of Spain's Moorish heritage, presented in the novel as a fantasy of sexual difference and empowerment? Is the Islamic past (whatever it be) a threat to Spanish identity or an advantage to be used as a springboard to a new position of world importance? *La pasión turca* reflects an ambivalence readily visible in contemporary Spanish discourse related to the Islamic world, both past and present, embodying many issues that are still being debated over a decade later, with even greater reason.

Spain's relationship to al-Andalus, then, is not merely historical nor simply a fascination with the exotic. There seems to be a general sense that Spain's current relationship with the Islamic world, both inside and outside its borders, cannot be separated from its past relationship with the Islamic world in the form of the Moors of al-Andalus, whether they be perceived as purveyors of culture and brilliance or as brutal aggressors who destroyed the most glorious culture in medieval Europe.[39] It is no coincidence that such a focus on Spain's Moorish past is coming to the fore at the same time as the increasing integration into Europe and constitutes, I argue, at least a partial contestation of this vision of Spain's identity.

Nicola Gilmour

The Spanish government, by reclaiming the nation's supposed Islamic heritage and, thus, a cultural commonality with Islamic nations because of this shared past, justifies Spain's assumption of a greater role in the Southern Mediterranean, presenting itself as a bridge between the other European nations and the Islamic nations of the region. Thus politicians would seem to be asserting political agency via a particular vision of Spain's past. Where Desideria acquires sexual power through her obsession with Yamam, Spain, as a nation, seeks to acquire new protagonism and agency through recognition of these historical links with Islam. Represented within the text by Eastern/North African countries, Spain's Moorish heritage is posited, at least initially, as providing the answer to this crisis of desire and identity, both for Desideria and the nation. Media and political discourses deploy a similar concept of Oriental "difference" to that which gives Desideria access to sexual difference and the body in Gala's novel. However, as my analysis of the novel has revealed, this "difference" is based on a highly dubious Orientalist fantasy of domination and power. Nevertheless, these questions and the tensions they raise unconsciously subtend Gala's *La pasión turca*, making it a fascinating example of the ways in which best-selling fiction can tune into and reflect broader socio-historical issues.

Arizona Journal of Hispanic Cultural Studies
Volume 10, 2006

Notes

1 I wish to thank the *Ministerio de Asuntos Exteriores* of Spain and the *Agencia Española de Cooperación Internacional* for awarding me a Beca para Hispanistas MAE-AECI in 2004. This scholarship was instrumental in permitting me to carry out much of the research for this article and for my on-going project. I am also grateful for the assistance of Dr. Christine Arkinstall of the University of Auckland, Auckland, New Zealand for her invaluable advice and encouragement.

2 Opinions have ranged from those espoused by Américo Castro, the Generation of '98, Claudio Sánchez Albornoz (a poisoning of the essence of Spain's true nature), Juan Goytisolo (an essential part of Spain's identity), and Serafín Fanjul (a cataclysmic social and political event), to cite but a few. Equally vigorously debated is the role of the Hispanic Jewish Community.

3 Examples of how the *moriscos* are seen to be relevant to present-day political issues include the way in which Juan Goytisolo, in the prologue to Francisco Márquez Villanueva's *El problema morisco (desde otras laderas)* (1998) creates a direct link between the expulsion of the *moriscos* in the early Seventeenth century and the first Gulf War with its "mecanismos exculpatorios del recurso a la violencia" (xv–xvi, xvii). Seven years later, José Miranda in his 1998 introduction to *La expulsión de los moriscos* states that "el planteamiento del problema morisco no es un simple ejercicio de nostalgia: ofrece, al revés, una candente actualidad," relating it to "[l]a ola de xenofobia que recorre Europa" (9).

4 The most recent events of international impact are the first Gulf War in 1991, the *coup d'état* in Algeria in 1992 (fending off the possibility of a Islamic fundamentalist victory in the polls), the world-wide rise of Islamic fundamentalism and the Al-Qaeda terrorist attacks on the World Trade Center in New York on September 11, 2001, with the subsequent discovery of the Spanish Al-Qaeda connection. Spain's subsequent participation in the Bush administration's "war on terror," the Aznar government's political and military support for the invasion of Iraq, subject of massive public protests throughout Spain, and, of course, the more recent bomb attacks in Madrid on March 11, 2004 have all contributed to raising the profile of Islam-related issues, both past and present, in the public domain.

5 Fanjul stresses that this figure does not include professional academic studies. The figures he cites come from María J. Viguera's "Arabismo y valoración de al-Andalus," *Actas I Simposio de la Sociedad Espaõla de Estudios Árabes* (Salamanca 1994), Madrid 1995. Fanjul himself has contributed two books to this trend in the last four years: the first is *Al-Andalus contra España. La forja de un mito*, first published in 2000 and into its fifth edition by 2004 (an indication of the topicality of its subject matter), and the second is *La quimera de Al-Andalus*, published in 2004.

6 Subirats refers specifically to the more literary works of Juan Goytisolo and Carme Riera. However my own investigations have uncovered a long list of historical novels which deal specifically with issues of the place and role of these cultures in Spanish history. These include works by Pedro Jesús Fernández,

José Luis Corral Lafuente, Jesús Sánchez Adalid, Marilde Asensi and Magdalena Lasala, amongst others.

7 I first came to study *La pasión turca* in the context of research into what I call transvestite narratives, that is to say narratives written from perspective of a first-person narrator of the opposite sex to the author. For reasons of space, it is impossible to detail my thesis here; however, in brief, I argue that such narratives represent a transvestite-like dressing up in the words of the opposite sex and as such often embody a similar oscillation between sameness and difference as that observed in the psychological perversion of fetishism. Additionally such narratives frequently feature depictions of psychosexual perversions, as is the case with *La pasión turca*. For more on this link between fetishistic transvestism and narrative, see my article on Cristina Peri Rossi's masculine first-person narration: "Mothers, Muses and Male Narrators: Narrative Transvestism and Metafiction in Cristina Peri Rossi's *Solitario de amor*."

8 Such is Gala's public association with *andalusí* culture that he is singled out by Fanjul (along with Juan Goytisolo) for especially virulent criticism for being "andaluz de profesión" (*Al-Andalus* 108).

9 Although *Granada de los Nazaríes* is a non-fiction description of the city in question under the rule of the Nazarí dynasty, I include it as it reflects an obvious interest in things "andaluz."

10 Miguel García Posada, in a critical review in 1993, refers to the novel rather scathingly as "un best-seller culto" (8) and suggests that the novel is deliberately positioned in such a way. In fact, *La pasión turca* constitutes an interesting example of what Bridger Fowler calls the "middle brow" romance. Such texts, while featuring representations of an unsubordinated female sexuality and thus serving to rupture the patriarchal order, are placed within wider controlling narratives that normalise their deviance (97). As such, she argues, they can present a more complex and ambiguous vision of the reality they describe than is usually thought (89).

11 In his prologue to *La quimera de al-Andalus*, Miguel Ángel Ladero Quesada commends Fanjul for debunking what he calls:

> los tópicos, falsedades y supercherías de diverso género con que hoy se nos pretende convencer sobre las herencias islámicas de España y la antigua 'convivencia' entre musulmanes y cristianos en suelo peninsular.
>
> *(xi)*

12 According to some observers, "[t]he aspiration to identify with Europe and the EC became a central element of the political culture and discourse of democratization" and they refer to EU membership as being "the Spanish national project" (Closa and Heywood 15, 245).

13 I refer, of course, to Barcelona's hosting of the Games of the XXV Olympiad, the Expo 92 in Seville and Madrid being named the European City of Culture.

14 Graham and Sánchez view this lack of recognition as a failure to confront the realities of genocide and racism, both then and now (416).

15 The "nacionalismo" Fanjul refers to here is that of Andalucía. It can thus be seen that in fact Fanjul is using his work on the Islamic heritage of Spain as a means of attacking the growing autonomy of Spain's autonomous regions.

16 > Javier Jordán Enamorado states that, [l]a correcta integración de las comunidades e individuos en nuestra sociedad, que respete al mismo tiempo su especificidad propia, constituye un decisivo ejercicio de multiculturalidad y de convivencia" and is "un desafío todavía no resuelto.
>
> *(137)*

The failure to address issues related to immigration satisfactorily has been perceived as having catastrophic consequences. According to Pedro Canales and Enrique Montánchez, writing even before the Madrid bombing of March 11, 2004,

> la inmigración magrebí en toda Europa se ha convertido en el caldo de cuitivo ideal para el reclutamiento de combatientes islámicos. España no escapa a esta regla, con el agravante de la precariedad de estructuras de acogida y de inexperiencia por parte de la integración cultural de los inmigrantes.
>
> *(64)*

17 For example, an article published in *El País* in September 1992 reporting the election of an Arab mayor in a town in Seville apparently warranted the headline "La reconquista de Al-Andalus" (Carrasco). Marco Kunz also critiques in his survey of representations of immigration and immigrants in contemporary Spanish literature, "[el] anacronismo inherente a las comparaciones de la inmigración

Africana actual con la 'invasión' árabe de 711" (127) and shows that even works sympathetic to the plight of the immigrant, such as Andrés Sorel's *Las voces del Estrecho* (2000) can fall into that trap (117).

18 Canales and Montánchez refer to a theory that:

> Marruecos acosa a España, por ejemplo en el caso de las ciudades de Ceura y Melilla en una primera fase, del Levante español y el antiguo territorio de al-Andalus en una segunda, con intención deliberada. Este acoso está destinado a reconquistar las ciudades españolas situadas en el norte de Marruecos, a reislamizar España y Europa, a enriquecer los claries que dominan el poder marroquí por medio del control y la perennidad del tráfico de hachís.
>
> *(64)*

19 This aversion is well documented: Juan Goytisolo refers to the "[r]echazo atávico al moro" ("Américo Castro" 30), while Irene Andrés-Suárez also presents the view that it is the *magrebí* immigrants, and particularly the Moroccans, who "suscita[n] mayor rechazo entre los españoles" (15).

20 César Vidal, for example, presents Islam as a threat to "nuestra supervivencia como cultura" (17). His text seems to be aimed at justifying a hostile attitude towards the Islamic world of the twenty-first century and he makes repeated comments to the effect that:

> la mezcla de debilidad y apaciguamiento frente al islam se ha traducido siempre en feroces ofensivas musulmanas de trágicas, y no pocas veces irre-versibles, consecuencias para la civilización occidental. El gobierno de Almanzor sólo iba a ser una manifestación más de tan dramático aserto.
>
> *(140)*

Indeed, the whole of Vidal's book seemed designed to justify the policies of the Aznar government towards the Islamic world.

21 Closa and Heywood confirm this focus of Spanish foreign policy: "Spain has been Europe's most committed proponent of an EU policy of political, social and economic cooperation with the Mediterranean" (225).

22 In this analysis I am primarily dealing with fetishism as a purely psychosexual phenomenon. However, as Anne McClintock stresses in *Imperial Leather*, this definition has been superimposed upon other definitions of the fetish as a religious term and as an economic one (commodity fetishism) (Ch. 4). For discussions of these aspects of fetishism, see Lorraine Gamman and Merja Makinen's *Female Fetishism* or Emily Apter and William Pietz's *Fetishism as Cultural Discourse*.

23 In psychoanalytic theory a "perversion" is clinically defined as the deferral or deviance of the sexual instinct, either in its object or its aim, from the norm of reproductive sexuality (Freud, *Introductory Lectures* 392). Teresa de Lauretis states that:

> Freud's theory contains or implies, if by negation and ambiguity, a notion of perverse desire, where perverse means not pathological but rather non-heterosexual or non-normatively heterosexual.
>
> *(xiii)*

Thus, perversions also include homosexuality, exhibitionism, voyeurism, narcissism, sadism, masochism and paedophilia (Rycroft 116). Other texts specifically on the issue of female perversions also include in the list kleptomania, self-mutilation, sexual bondage (Kaplan) as well as the several kinds of food fetishism (Gamman and Makinen).

24 A full elaboration of the way in which I have developed my view of the theory of fetishism is not feasible in this context, however for more on this topic see Freud's essay "Fetishism," (1927), Jacques Lacan's further development of the concept of primary castration (Ragland-Sullivan "Primary Castration"), Luce Irigaray's expansion on Lacan's work (Bronfen 34), Teresa de Lauretis's work on lesbian fetishism in *The Practice of Love. Lesbian Sexuality and Perverse Desire*, and Kaplan's *Female Perversions*, amongst many other works. For a fuller treatment of fetishisn in relation to narrative see my forthcoming book to be published with Edwin Mellen.

25 Desideria's father is represented to be an ineffectual man in the dying profession of candlemaking (40); her former history teacher is a broken man who did not have the nerve to follow his heart when he had the opportunity (60); Pablo Acosta, the bold Interpol agent, fails to save the woman he loves (344); Arturo, a paediatrician, fails to save Desideria's dying baby (162); even Ivan, Desideria's one-night stand in Madrid, turns a casual sexual encounter into hard work (232–33). Nor is Desideria's French lover, Denis, especially virile.

Turkish delight

26 The close link between this bond with the Arab world and the body is made explicit when Desideria looks in the mirror and ponders the origin of her facial features, as if seeing them for the first time:

> Antes de acostarme me miraba en el espejo del baño en los hoteles, y me interrogaba: ¿de dónde vienen estos ojos oscuros, este pliegue tan singular de los párpados, esra boca tan voraz, este pelo negrísimo, este furor por seguir viva a pesar de todos los pesares?
>
> *(77)*

27 The image of skinning graphically conveys a sense of the formlessness resulting from the removal of the boundaries which separate the body and the world, self and other. Loss of borders (skin) equates to vulnerability and the loss of difference that entry into Europe would entail. However, Spain is not yet completely skinned. The phallic nature of the image is also worthy of note.

28 The positioning of Turkey as a threshold is emphasized in the text when Desideria, finding herself on the harbour facing the city of Istambul, cites the well-known verses from José de Espronceda's "Canción del pirata": "Y ve el capitán pirata,/cantando alegre en la popa,/Asia a un lado, al otro Europa/y allá a su frente Estambul" (283).

29 There is, of course, little new in this representation of Turkey (or any other Eastern country) as Europe's exotic other. As Edward Said maintains, the East is, to European eyes, "the source of its civilizations and languages, its cultural contestant, and one of its deepest and most recurring images of the Other" (1). The Orient, he argues, also suggests sexual promise (and threat), untiring sensuality, unlimited desire and deep regenerative energies (188), and is conceived of as a source of sexual experience unobtainable in Europe. While Said is here referring to the attitudes of past centuries, it is clear from Gala's text that such images are still powerful ones in the European sexual and socio-cultural imaginary. Such views are also expressed repeatedly in the historical novels set in the period of the Arab presence in Spain. These novels feature almost obligatory descriptions of sumptuous banquets, sensual luxury, and hedonistic delights. See, for example, the novels of Magdalena Lasala, José Corral Lafuente, and others. Fanjul, in *La quimera de al-Andalus* dedicates a chapter to the historical novel set in al-Andalus, arguing that they are:

> un pastiche donde se mezclan sistemas de valores, ideologías y hasta formas de expresión lingüística de nuestra contemporaneidad con una superestructura de nombres exóticos y un cauce argumental que sigue, más o menos, el hilo de los sucesos históricos.
>
> *(119)*

30 There can be no real offspring from this relationship for it is ultimately sterile and a dead end.

31 In Kaplan's view, it is not the sexual pleasure that binds such a woman to her lover but the lover's ingenuity in creating a situation of submission and dominance (216). The feminine submissiveness covers up for other hidden powerful drives and ambitions perceived as property of the masculine and, at the same time, serves to appease the punishing Other for those ambitions. Indeed, as Kaplan argues, the woman's pride in her enslavement to her lover makes everyone else impotent and in this way the woman attains a castrating power over others (231).

32 With the exception of two passages, related almost as snapshot images (138), Turkey itself fades into the background. The principal setting of the text is the interior of Yamam's flat in Istanbul, where Desideria writes in harem-like seclusion.

33 Indeed, the contact between the *moriscos* of Spain and the Ottoman authorities is one of the principal reasons given by commentators for the final expulsion of the *moriscos* from Spain in 1614.

34 It is characteristic of the dynamics of fetishism that gender boundaries (markers of difference) are blurred, as they are continually throughout the novel. Desideria, although corresponding in some of her characteristics to misogynist stereotypes of woman (her sexual insatiability, her vanity and her passive acquiescence in the face of male abuse), is also paradoxically positioned in the traditional place of the masculine. Active in her desiring—if not in her own self-interest—she symbolises Western European civilization, possessing the analytical skills, education and narrative rationality the novel presents as being characteristic of the masculine. The same blurring of gender roles and characteristics is evident in the portrayal of Yamam. Although represented as the hypermasculine phallus of the East, Yamam is consistently placed in a hierarchically inferior position and "feminized" according to the patriarchal logic that dominates the text. As a European, Desideria sees herself as being of higher social and racial status and, therefore, in a position of dominance in terms of class and education, as is evident in the way she delights in tripping Yamam up in his arguments (173).

35 Again, Spain/Desideria is placed in alternately masculine and feminine roles.

487

36 Appropriately, the vehemence and violence of the struggle between the protagonists in the novel has a parallel in the increasingly heated debate around the issue of Spain's Moorish and *morisco* past. It also reflects the tensions of the debate as to where Spain belongs and the nature of its identity.

37 "[L]a originalidad de la cultura española estriba precisamente en el hecho de ser producto de un vasto crisol de aportaciones e influencias romano-visigóticas y semitas" ("Américo Castro" 33). This is also contested territory however, as others argue that Spain is not in fact unique in this respect and that the same mix of cultures and religions has been documented in other places and at other times. These critics perceive the desire for uniqueness as obsessive navel-gazing on the part of Spanish cultural commentators (Fanjul, *Quimera* 3).

38 It is debatable as to whether this symbolic use of Turkey could be continued past Turkey's own entry into the European Union, which, in the logic of the narrative, would constitute its own emasculation.

39 For José Vicente Niclós Albarracín, los árabes se perciben hoy como gentes que dotan a sus ciudades de España de una existencia brillantes e intensa, aúna el modo de vida del guerrero con la mentalidad del filósofo.

(16)

Conversely, for Vidal, they were the destroyers of:

una cultura floreciente, pujante y fecunda que se sustentaba en un sistema educativo ya en vigor desde el siglo V y que, a la sazón, carecía de paralelos en el Occidente que antaños había sido romano.

(73)

Bibliography

Andrés-Suárez, Irene. Introducción. Andrés-Suárez, Kunz, and D'Ors 9–20.
Andrés-Suárez, Irene, Marco Kunz, and Inés D'Ors. *La inmigración en la literatura española contemporánea.* Madrid: Verbum, 2002.
Apter, Emily, and William Pietz, eds. *Fetishism as Cultural Discourse.* Ithaca: Cornell UP, 1993.
Blunes, Miguel Ángel de. Introducción. *Los moriscos.* By Mercedes García Arenal. Granada: Universidad de Granada, 1997 (1974). ix–xxvii
Bronfen, Elizabeth. *Over Her Dead Body: Death, Femininity and the Aesthetic.* Manchester: Manchester UP, 1992.
Canales, Pedro, and Enrique Montánchez. *En el nombre de Alá, La red secreta del terrorismo islamista en España.* Barcelona: Planeta, 2002.
Carrasco, María José. "La reconquista de Al-Andalus." *El País.* 11 September 1992, sec. Andalucía: 5.
Closa, Carlos, and Paul M. Heywood. *Spain and the European Union.* London: Palgrave Macmillan, 2004.
De Lauretis, Teresa. *The Practice of Love. Lesbian Sexuality and Perverse Desire.* Bloomington: Indiana UP, 1994.
Fanjul, Serafín. *Al-Andalus contra España. La forja de un mito.* (2000). 5th ed. Madrid: Siglo XXI de España, 2004.
Fanjul, Serafín. *La quimera de al-Andalus.* Madrid: Siglo XXI de España, 2004.
Fowler, Bridget. "Literature Beyond Modernism: Middlebrow and Popular Romance." *Romance Revisited.* Ed. Lynn Pearce and Jackie Stacey. London: Lawrence and Wishart, 1995. 89–99.
Freud, Sigmund. "Fetishism." Trans. James Strachey. *The Standard Edition of the Complete Psychological Works of Sigmund Freud.* Vol. 21. London: Hogarth Press, 1953–74. 152–57.
Freud, Sigmund. *Introductory Lectures on Psycho-Analysis.* Trans. James Strachey. New York: Norton, 1989.
Gala, Antonio. *Granada de los nazaríes.* 1992. Barcelona: Planeta, 1996.
Gala, Antonio. *El manuscrito carmesí.* 1990. Barcelona: Planeta, 1997.
Gala, Antonio. *La pasión turca.* Barcelona: Planeta, 1993.
Gamman, Lorraine, and Merja Makinen. *Female Fetishism. A New Look.* London: Lawrence and Wishart, 1994.
García García, Leopoldo. Introduccíon. *La convivencia en el Mediterráneo occidental en el siglo XXI.* Madrid: CESED, 2001. 11–23.
García Posada, Miguel. "Historia de la pasión: La novela de una relación trágica en el corazón de Turquía." *Babelia/El País.* 5 June 1993: 8.

Gilmour, Nicola. "Mothers, Muses and Male Narrators: Narrative Transvestism and Metafiction in Cristina Peri Rossi's *Solitario de amor*." *Confluencia*. Spring (2000): 122–36.

Goytisolo, Juan. "Américo Castro en la España actual." *América Castro y la revisión de la memoria. El Islam en España*. Ed. Eduardo Subirats. Madrid: Libertarias, 2003. 23–37.

Goytisolo, Juan. *Crónicas sarracinas*. 2nd ed. Barcelona: Ruedo Ibérico, 1982.

Goytisolo, Juan. *Estambul otomano*. 2nd ed. Barcelona: Planeta, 1991.

Goytisolo, Juan. Presentación. *El problema morisco (desde otras laderas)*. Ed. Francisco Márquez Villanueva. Madrid: Libertarias, 1998. xi–xvii.

Graham, Helen, and Antonio Sánchez. "The Politics of 1992." *Spanish Cultural Studies. An Introduction. The Struggle for Modernity*. Ed. Helen Graham and Jo Labanyi. New York: Oxford UP, 1995. 406–18.

Ilie, Paul. "La cultura posfranquista, 1975–1990: la continuidad dentro de la discontinuidad." *Del franquismo a la posmodernidad*. Ed. José B. Monleón. Madrid: AKAL, 1995. 21–39.

Jordán Enamorado, Javier. "El factor cultural." *La convivencia en el Mediterráneo occidental en el siglo XXI*. Madrid: CESED, 2001. 125–55.

Kaplan, Louise J. *Female Perversions. The Temptations of Madame Bovary*. London: Penguin, 1993.

Kunz, Marco. "La inmigración en al literatura española contemporánea: un panorama crítico." Andrés-Suárez, Kunz and D'Ors, YEAR?????????. 109–256.

Ladero Quesada, Miguel Ángel. Presentación. *Al-Andalus contra España. La forja de un mito*. By Serafín Fanjul. 5th ed. Madrid: Siglo XXI, 2000. xi–xiv.

McClintock, Anne. *Imperial Leather: Race, Gender and Sexuality in the Colonial Context*. New York: Routledge, 1995.

Mercadé, Francesc. "Vida cotidiana, valores culturales e identidad en España." *España*. Ed. Salvador Giner. Vol. 1. Sociedad y política. Madrid: Espasa Calpe, 1990. 569–92.

Mitanda, José. Introducción. *La expulsión de los moriscos*. Ed. José María Perceval, Mikel de Espalza, and Leonard P. Harvey. Madrid: Bancaja, 1998. 9–12.

Moratinos, Miguel Ángel. "El Mediterráneo, un mar olvidado." *El Mediteráneo y Oriente Medio. Reflexiones en torno a dos escenarios prioritarios de la Política Exterior Española (1989–1995)*. Ed. Miguel Ángel Moratinos. Madrid: Ministerio de Asuntos Exteriores, 1996. 43–49.

Moratinos, Miguel Ángel. "La política española en el Magreb." *El Mediterráneo y Oriente Medio. Reflexiones en torno a dos escenarios prioritarios de la política exterior española (1989–1995)*. Ed. Miguel Ángel Moratinos. Madrid: Ministerio de Asuntos Exteriores, 1996. 51–67.

Niclós Albarracín, José Vicente. *Tres culturas, tres religiones: Convivencia y diálogo entre judíos, cristianos y musulmanes en la península ibérica*. Salamanca: San Esteban, 2001.

Ragland-Sullivan, Ellie. "Primary Castration." *Feminism and Psychoanalysis. A Critical Dictionary*. Ed. Elizabeth Wright. Oxford: Blackwell, 1992. 349–52.

Rycroft, Charles. "Sexual Perversion." *A Critical Dictionary of Psychoanalysis*. London: Nelson, 1968. 116–17.

Said, Edward W. *Orientalism*. London: Penguin, 1987.

Sorel, Andrés. *Las voces del Estrecho*. Madrid: Muchnik, 2000.

Subirats, Eduardo. "Moros, judíos, y el problema de España." *La expulsion de los moriscos*. Ed. José María Perceval, Mikel de Espalza and Leonard P. Harvey. Madrid: Bancaja, 1998. 189–205.

Subirats, Eduardo. "La península multicultural." *América Castro y la revisión de la memoria. El Islam en España*. Ed. Eduardo Subirats. Madrid: Libertarias, 2003. 39–49.

Vidal, César. *España frente al Islam. De Mahoma a Ben Laden*. Madrid: Esfera de los libros, 2004.

34
'The cliffs are not cliffs'
The cliffs of Dover and national identities in Britain, c.1750–c.1950

Paul Readman

This article examines the relationship between landscape and British national identities by means of a case study of the white cliffs of Dover in Kent, England. The cliffs were important symbols of island-nationhood across the modern period, and demonstrate that even in the age of empire British as well as English national identities could be conceptualized in distinctly insular ways. In particular, the cliffs were seen to be associated with the national homeland, its heritage and historical continuity over hundreds of years, as well as with national defence and a defiant self-asserted separateness from the rest of Europe. The article has implications for the (still relatively neglected) role played by specific landscapes in the construction of national identities, not just in Britain but generally. In functioning as markers of national difference the physical distinctiveness of these landscapes was important, but their associational value mattered more.

Since the publication of Hugh Cunningham's landmark *History Workshop* article on the language of patriotism, which first appeared in 1981, the study of national identity – or rather identities – has loomed very large in scholarship on modern British history.[1] Discourses of national identity have been discovered in a bewildering range of contexts, from the red benches of the House of Lords to followers of the red flag of socialism, from the great national galleries to the music hall stage, from Cotswold villages to far-flung corners of the empire.[2] National identity seems to be present everywhere and a point of reference for the study of almost anything: gender relations, warfare, politics, social experiences, colonial encounters, cultural productions, and so on. One area of study where national identity might be expected to figure strongly is that of landscape: all nation-states occupy physical territories and all nations claim homelands, the particular landscape features of which have often functioned as powerful markers of identity. The interconnections between landscape and national identity are arguably strongest of all in the case of islands, where territorial integrity and national separateness can seem almost divinely ordained. Such was the case in Britain, whose inhabitants have long celebrated the felicitous insularity of the sceptred isle, made safe from continental contaminations by the English Channel, that 'wise dispensation of Providence' as British prime minister William Gladstone described it in 1870.[3]

Cut off by the Channel, Britain and British identities were inextricably connected to the sea. Late nineteenth-century historians such as J. A. Froude and E. A. Freeman had no compunction in describing the inhabitants of the British Isles as 'folk of the sea' for whom the sea was their

490

'natural home', while the Scottish writer Robert Louis Stevenson described the sea as 'our approach and bulwark … the scene of our greatest triumphs and dangers; and we are accustomed in lyrical strains to claim it as our own'.[4] The sea, then, was British: it carried the trade that sustained the workshop of the world, it helped provide the means of exploration and colonial expansion; it was seen as the happy hunting-ground of the Royal Navy and nursery of the national character. Yet while it might have promoted outward-looking sensibilities in some – not least in relation to imperialism – there was another side to Britain's maritime identity, and this was arguably more important. Britain's relationship with the sea promoted what might be termed a discrete sense of islandhood, a constellation of patriotic sentiments that focused on the homeland.

Witnesses to this insularity are not hard to find. In 1961, Mervyn Morris returned home to Jamaica after spending three years as an undergraduate at Oxford University. While Morris was at Oxford, two English sociologists had sent him a questionnaire inviting foreign students to write articles about their experiences in England. Morris produced one of these articles, a version of which appeared in the *Caribbean Quarterly* for December 1962. In his narrative, Morris suggested that his encounter with England taught him 'the fundamental lesson of nationalism', a lesson imparted before he had even set foot on English soil:

> I learnt this half an hour away from England, approaching the cliffs of Dover. There was excitement among the English on board; I looked, but the cliffs seemed very ordinary to me. And then I realized that of course the cliffs are not cliffs: to the Englishmen they are a symbol of something greater, of the return from a land of strangers, of the return home. Nothing is more important in nationalism than the feeling of ownership.[5]

Morris's observation testifies to the important role played by landscape in providing a focus for national feeling; landscape, and distinctive landscapes in particular, have functioned as powerful symbols of national identity. The Rhine, the Swiss Alps and the Norwegian fjords are obvious examples here. Yet, it is striking that relatively little attention has been paid to the relationship between landscape and nation by historians.[6] This is despite the extensive discussion of this relationship in theoretical writings on nations and nationalism, and the more focused empirical research within other disciplines, geography most notably.[7] In the British context, historical geographers such as Denis Cosgrove, Stephen Daniels, David Lowenthal, David Matless and Catherine Brace have done a good deal to extend understanding of the relationship between landscape and national identities, yet historians have not on the whole followed their lead.[8] Historians have not been shy of exploring the interconnectedness of English identity, the rural and the natural environment generally, with Martin Wiener's *English Culture and the Decline of the Industrial Spirit* stimulating much work – and no little debate – on the prevalence and influence of rural-nostalgic versions of Englishness.[9] But their treatments typically lack locational specificity. Types of landscape are identified and their cultural purchase analysed (as Alun Howkins did in an important essay on the 'south country'),[10] yet particular landscape features are given much less attention by historians, being dealt with in passing as part of a more general treatment, rather than subjected to thorough study.[11]. As a consequence, the British historical understanding of the relationship between place and national identities is underdeveloped, and more historical work on the capacity of particular landscapes to encapsulate national sentiment and identities is needed. What follows will explore the ways in which the cliffs of Dover formed one such landscape, coming to stand for insular, sea-girt ideas of nationhood – ideas significantly disconnected from imperial ties of belonging. Understood as historical witnesses to past time, they represented the continuity of the national homeland, acting as powerful symbols of defence,

defiance and difference across the modern period. More generally, the article also seeks to show how and why certain valued landscapes – like the white cliffs – operated on men and women with the patriotic force that Morris observed.

Different landscapes, of course, are valued for different reasons and are interpreted by different people in different ways. This is a function of the fact that landscape is not objectively 'out there'; it is, as D. W. Meinig has put it, 'defined by our vision and interpreted by our minds', with any given landscape being 'composed not of what lies before our eyes but what lies within our heads'.[12] It is for this reason that the same natural features can be seen quite differently by two people: Morris looked at the same block of chalk as his English travelling companions (in terms of physical substance it was identical), yet their experiences varied markedly – they were each looking at a different landscape. It follows that all perceptions of landscape are essentially subjective, a point suggested by Theodor Adorno some time ago in the context of his discussion of natural beauty, which he described as necessarily indeterminate and 'undefinable' by any formal set of criteria.[13] But this is not to say that no generalizations can safely be made about why certain landscapes are valued by certain people: from the historical evidence, patterns of collective agreement can readily be discerned. Landscapes valued by members of any given national or social group are valued because they have particular attributes: that members of the group deem valuable. Beauty is one of these attributes: landscapes have often been prized on account of their perceived scenic appeal, and especially their distinctiveness, in Britain as elsewhere in the world. Indeed, it could be argued that such considerations play a particularly important role in the construction of landscapes seen as national symbols, their claimed uniqueness helping to reify national identities.

Yet any judgements concerning the value of any landscape – including its scenic value – are not merely functions of (perceived) physical characteristics; because landscape is a human construct, exogenous factors inevitably come into play. One of the most important of these is authenticity – an observation which has featured in theoretical writing on aesthetics for many years, indeed centuries.[14] Like forged art, nature known to be 'fake' – to use the environmental philosopher Robert Elliot's term – does not exert the same appeal as nature deemed 'original'. In judgements of the value of any given natural landscape, genealogy matters.[15] This line of thinking can be extended beyond the realm of philosophical theory, however; for present purposes, the point it suggests is that appreciation of the value of a landscape depends on factors other than physical properties in and of themselves. Crucial here is what may be termed the associational value of landscape, the connections made between landscape and human culture (art, literature, music, etc.), science (geology, for example), and – perhaps most important of all – history. In short, judgements about the value of any landscape are powerfully affected by knowledge, perfect or imperfect, relating to the landscape in question. As the geographer Yi-Fu Tuan has remarked, appreciation of landscape is 'fleeting unless one's eyes are kept to it for some other reason, either the recall of historical events that hallowed the scene or the recall of its underlying reality in geology and structure'.[16] It will be argued here that in the British context associational value is vital to any understanding of the relationship between landscape and national identity between the eighteenth and the twentieth centuries. It was not so much the physical appearance of the cliffs of Dover – although this was certainly important – that bound them so tightly to discourses of nationhood, but the associations they triggered in the minds of the British. After all, in terms of natural physical properties, there were – and are – many similarities between the white cliffs of Cap Blanc Nez in north-east France and their similarly white if somewhat more famous counterparts in south-east Kent, on the other side of the Channel. For all that they looked quite like those of England, the white cliffs of France have been of relatively minor cultural significance to the inhabitants of that country.

492

I

The cliffs of Dover attracted relatively scant attention in contemporary discourse before the middle of the eighteenth century. That they were an important landmark was beyond doubt, as is evident from the map of Britain produced in Italy in 1546. This, the first engraved map of the British Isles apart from those in editions of Ptolemy's *Geographia*, featured a naturalistic depiction of the white cliffs, in miniature, integrated into its overall design.[17] But in the written record, fleeting allusion was the norm even in works that otherwise had much to say about the town of Dover or the county of Kent. In his famous *Britannia*, a 'chorographicall description' of Britain published in English in 1610, William Camden alluded to 'a mighty ridge of steepe high Cliffs, *Cicero* termeth them *moles magnificas*, that is, *Stately* Cliffs, bringing forth *Sampier* in great plenty', but said little more.[18] It appears likely that while the cliffs certainly made a powerful visual impression, they did not attract much in the way of positive value judgements. Writing in the 1720s, Daniel Defoe felt the Dover 'coast affords nothing of note'.[19]

By Defoe's time, however, attitudes were changing. Previously, most cultivated commentators had found the sea and its shores disagreeable, with sea cliffs – like mountains – much more likely to provoke sentiments of horror than pleasure: landscapes of danger, they were to be avoided rather than sought out, let alone celebrated. The mid-eighteenth century onwards, however, saw increased cultural interest in coastal landscapes, particularly those wild or rocky in character. Topographical and travelogue accounts lauded the 'striking appearance' of the 'lofty white cliffs' at Dover.[20] Ann Radcliffe's description of her journey to Holland and Germany in 1794 featured admiration for the prominent landmark of Shakespeare's Cliff, just to the south-west of Dover town, which she thought as 'sublime as the name it bears',[21] By 1818, the view of the Dover coast from the direction of Walmer had become 'one of the most striking prospects that imagination can conceive'.[22]

The effect of this shift in attitudes, uneven at first but decisive by the turn of the nineteenth century, grew stronger and was more widely disseminated as time passed. In the Victorian and Edwardian eras improved communication, combined with the expansion of popular tourism, dramatically increased the number of British men and women who actually saw the white cliffs with their own eyes. Although Dover enjoyed a rather fleeting early-to-mid-nineteenth-century popularity as a tourist destination in its own right (*The Lady's Newspaper* commended its 'stupendous perpendicular cliffs' in 1847),[23] the expansion of cross-channel traffic was the crucial factor here.[24] (Not the least reason for this was the perception that the cliffs were shown to their best advantage when viewed from the seaward side: 'Dover can only be seen aright by one who comes to it from the sea', as Byron's Don Juan did as he was blown towards 'Albion's earliest beauties, | Thy cliffs, *dear* Dover!')[25] But aside from the effects of transport and tourism, these years also saw hugely important developments in technologies of image production, which also served to embed the cliffs in the emergent discourse of national heritage.[26] Innovations in engraving techniques made the mass production of lithographic prints possible from the 1830s on. As a consequence, artistic depictions of landscapes such as the white cliffs became much more available – and affordable – than previously, with J. M. W. Turner's work in particular reaching a wide audience in this way. Later in the nineteenth century, photographs and other means of image reproduction furthered the process of commodification and dissemination. In December 1881, for example, the Kensington Fine Art Association offered an oleograph reproduction of a painting by H. Hillier. Entitled 'Dover Pier and Harbour by Moonlight', it depicted the port at night, sheltered by the white cliffs. Advertised in newspapers around the country, not only those of southern counties, but also in publications such as the *Manchester Times*, it was billed as a picture 'that will commend itself to all Englishmen, on account of the interest that is

felt in the historic old town, watched as it is by the famous castle and the cliff which Shakespeare has described in language that will endure for all time'.[27]

The nineteenth-century popularization – and nationalization – of the image of Dover cliffs could simply be read as reflecting changing aesthetic tastes in landscape. But while it may be that the cliffs came to be seen as compatible with mainstream Victorian ideas of the picturesque – as popularized by Turner and others – this was not sufficient on its own. In order to explain the appeal and significance of the white cliffs over the course of the 200 years or so after the middle of the eighteenth century, it is necessary to consider additional factors. Beneath the adulatory descriptions of the cliffs' appearance as 'striking' (a word very frequently used) lurked influences other than the narrowly aesthetic, especially those connected to the associational value of landscape. It is this associational value to which we now turn.

To begin with, the white cliffs were associated with the nation, or rather nations – England in particular, but also Britain (the two often being conflated). This alone did much to account for the esteem in which the cliffs were held. The association was not new, of course. 'Albion' had been used as a synonym for Britain or England for many centuries (not least in Camden's *Britannia*),[28] the word deriving from the Latin 'albus', meaning white: in a real sense, the white cliffs of the south coast had already defined the nation. That said, the nineteenth and early twentieth centuries saw a marked strengthening of this association. Descanting on the 'fascination' of Dover cliffs, one guidebook remarked how 'in the white walls of this part of the coast the popular fancy sees something indefinable, indicative of Albion's glory, emblematic of British pride'; while another claimed 'these strange white cliffs … stand for England' perhaps even more than 'the very lion upon her standard' because ' "Albion" was a name, at least in Europe, centuries before any national banner waved upon her shores'.[29] In 1908, the art historian and collector W. G. Rawlinson offered the opinion that Turner's *Straits of Dover*, which had appeared in the artist's still enormously-popular *Picturesque Views in England and Wales*, was a 'scene … so *English*, so exactly what one sees on landing at Dover on a sunny, windy day'.[30]

As reflected in this reading of Turner's picture, the developing association between the cliffs, the sea and nationality was congruent with the strengthening of the (curiously understudied) conceptualization of Britain as an 'island nation' in contemporary cultural discourse.[31] The final surrender of Calais to France in 1558 had laid the foundations of the view that the Channel was Britain's frontier, and this view was further bolstered by the spread of Enlightenment-generated ideas that nation-statehood was properly defined by natural boundaries such as seas, rivers and mountains. By the nineteenth century, with the strength and successes of the Royal Navy increasingly a source of self-congratulation for the British, the connections between the sea, insularity and national greatness were axiomatic.[32] Notoriously, Britain's geographical separateness from the continent was a matter of celebration, and in combination with increasingly secure geological knowledge helped reinforce the longstanding idea that British nationhood was naturally (or providentially) ordained. In 1801, Charles Dibdin 'rejoiced' in the thought that Britain had been separated from the continent 'either by an earthquake or a partial deluge' as 'it is self-evident that whatever gave us our insular situation laid the foundation of our glory'.[33] It was a message that was much repeated over the course of the century and beyond, not least in educational books aimed at the young.[34] Indeed, its strength and persistence does much to explain why proposals to construct a tunnel under the English Channel met with the hostility they did. Early efforts in the 1880s and 1890s foundered on the objection, in the words of E. A. Freeman, a prominent opponent of the tunnel, that it would make Britons 'cease to be islanders, and become continentals'.[35] (It was the same story with later attempts made in the inter-war period, and even in 1975 the Labour cabinet minister Barbara Castle could confess her relief that Tony Crosland had shelved the plans then

being considered, her sentiments being founded on 'a kind of earthy feeling that an island is an island and should not be violated'.)[36]

This patriotic solicitude for Britain remaining *virgo intacta* – as Lord Randolph Churchill had phrased it in opposing Channel Tunnel legislation in June 1888 – was of course sharpened by the fact that the proposals for a tunnel envisaged it beginning at or near the white cliffs. (Indeed, Sir Edward Watkin's schemes of the 1880s and 1890s called for the submarine link to begin at Shakespeare's Cliff, the promontory just outside Dover so called on account of its associations with *King Lear* – of which more later.)[37] In the context of the prevailing 'Rule Britannia' discourses of nationality the cliffs had emerged as a powerful emblem of an insular national identity, one shaped less by the expanding overseas empire than by Britain's place in Europe, particularly as affected by historical rivalries with continental powers, especially France. It was this identity that the tunnel threatened to subvert. To a significant extent, from the nineteenth century onwards the cliffs came to stand as a synecdoche of British separateness from the continent, of Britain's status as an island apart from the rest of Europe, functioning as a landscape of difference for the inhabitants of an island kingdom. Dover's cliffs thus became a marker of Britishness as well as Englishness. This was important, as in contrast to the arguably more 'cultural' identities of England, Scotland, Wales and Ireland, Britishness has not generally been associated with landscape features, being linked rather to the state, government and civic life, or perhaps empire and the economy.[38] As a unique landscape of British identity, the cliffs did important ideological work, helping to territorialize meanings of Britishness, so supporting sentiments of belonging not just to one of the component nations of the British Isles, but to the British nation-state as a whole.

II

The nationalistic deployment of the white cliffs reflected their continuing association not only with British insularity, but with the defence of the British Isles against foreign military threats, particularly invasion. The association between Dover and defence was of long standing, with Matthew Paris's description of the town as 'the lock and key' of the kingdom being much quoted over the centuries.[39] Dover's great castle, and its antiquity as a fortified site, did much to contribute to this, of course. But as powerful a symbol of defence and defiance as the castle undoubtedly was, it was rarely considered in isolation from the cliffs upon which it perched, and from which it derived much of its iconographic force. Turner's *Dover from Shakespeare's Cliff* (1826) is a classic rendition of the scene, showing the guns of the modern fortifications engaged in practice firing (in the direction of France), with the medieval castle prominent in the background.

In fact, the cliffs of Dover were themselves potent emblems of national defence, with or without the castle: metaphorically as well as physically, they functioned as ramparts. In nineteenth- and early twentieth-century publications, they were described as 'white walls', as 'natural defences of the most impregnable character'.[40] A great deal was made of the story that when Julius Caesar arrived at the Kentish coast, the sight of heavily armed Britons thronging the white cliffs had encouraged him to seek a landing place elsewhere, but they were as much natural fortifications of the mind than anything else. In 1878 *Black's Guide* to Kent commended Dover 'with its walls of glittering chalk, majestic and impregnable', as 'a fitting symbol of English Power'.[41]

The symbolic significance of the cliffs in this regard is borne out by the fact that artistic depictions often exaggerated their height, so emphasizing their status as bulwarks or battlements. Those of Turner provide a good case in point. The artist first visited Dover in 1792, and returned on several occasions in later years, the town and its environs being a frequent subject

for his later topographical watercolours.[42] Featuring the fortifications of the Western Heights in the foreground, along with a soldier looking out to sea and the practice firing of guns, *Dover from Shakespeare's Cliff* presents one example, representing the cliffs as being significantly higher than they were in reality, as does the artist's less militaristic *Dover Castle* (1822).[43] And in *Dover* (*c.* 1825), so great was Turner's artistic licence that John Ruskin was moved to object that he had 'lost the real character of Dover Cliffs by making the town at their feet three times lower in proportionate height than it really is'.[44]

The representation of the cliffs as towering natural battlements reflected perceptions of their military significance, the heights around the town having been extensively fortified in the late eighteenth and early nineteenth centuries (William Cobbett famously complained of the expense incurred in making 'a great chalk-hill a honey-comb' in which to hide British soldiers from Frenchmen).[45] But it also reflected more generalized anxieties about the threat of invasion, with the experience of the Napoleonic Wars being an important factor here. Yet the fears persisted long after 1815, deep into the Victorian period and beyond. Louis Napoleon's *coup d'état* in 1851 was followed by a slew of invasion scares. Concerns about the designs of a resurgent France led to the further fortification of England's southern coastline and in 1859 the creation of the Volunteer Force – a locally organized precursor to the twentieth-century Territorial Army and home guard. France's defeat by Prussia in 1870–1 did not end such anxieties, partly because distrust of the French was so deep-seated (witness the controversies surrounding the early Channel tunnel proposals), but mainly because an assertive imperial Germany promoted renewed fears of invasion – as manifested in the outcry provoked by publications such as G. T. Chesney's *Battle of Dorking* (1871), to give an early example, and William Le Queux's *Daily Mail*-serialized *Invasion of 1910*, to give a rather later one.[46]

For all their xenophobia and sensationalism, these Victorian and Edwardian scare stories were not entirely irrational, nor were they dismissed as such by contemporary opinion. Advances in technology had made invasion seem all the more possible. Steam power meant ships could operate at much higher speeds than previously, making the threat of a surprise attack – or 'bolt from the blue' – loom larger. It also meant they could operate independently of tides and winds: the unpredictability of the weather could no longer thwart a determined enemy, as arguably it had done in 1588 with the Spanish Armada. In 1845, Lord Palmerston told the House of Commons that 'the Channel is no longer a barrier. Steam navigation has rendered that which was before impassable by a military force nothing more than a river passable by a steam bridge.'[47] This was hyperbole, certainly, but the fear was strongly felt, and it intensified as ships became still faster and more manoeuvrable as the century wore on.

Advances in aviation made matters worse. The 1783 balloon ascent by the Montgolfier brothers may have triggered some prognostications of airborne assault, but the slow speed and ready combustibility of hydrogen balloons ensured that such speculations remained on the wilder fringes of alarmist discourse for the next hundred years or so.[48] Winged and motor-powered flight changed things dramatically, however, as it soon became apparent that these were technologies with far more military potential. In his *War in the Air* of 1908, H. G. Wells observed that 'with the flying machine war alters its character: it ceases to be an affair of "fronts" and becomes an affair of "areas"; neither side, victor or loser, remains immune from the gravest injuries'.[49] The following year, a dramatic demonstration of Wells's prescience was given by Louis Blériot, who succeeded in flying his monoplane across the English Channel, landing on the cliffs of Dover on 25 July 1909 – a feat which the *Daily Express* greeted with the headline that 'Britain is no longer an island'.[50]

In the event, the experience of the First World War did relatively little to blur the boundaries of the battlefield, notwithstanding the German air raids on southern and eastern England (which

in the event caused relatively few casualties). At war's end, Field Marshal Sir Douglas Haig was welcomed home in an elaborately choreographed ceremony at Dover, the iconographic significance of his landing site being readily apparent to contemporary commentators as well as the commander-in-chief himself, who in his speech on disembarkation described the town as 'keeper of the eastern gate of England' and 'guardian of the Narrow Seas'.[51] But in the 1920s and 1930s, as technology advanced, Britons had no doubt that air power had radical implications for national defence, notwithstanding the long associations between Dover, the Channel and the protection of the homeland from the ravages of war. In Virginia Woolf's novel *Between the Acts*, a village pageant is interrupted by the noise of twelve aeroplanes flying overhead, an incident which prompts one audience member to ask, 'what's the channel, come to think of it, if they mean to invade us?'[52] And even in the world of politics, such questions were being posed as well, being more or less explicit in defence policy. Speaking in support of his government's proposals for rearmament in July 1934, Stanley Baldwin told parliament that 'since the days of the air, the old frontiers are gone. When you think of the defence of England you no longer think of the chalk cliffs of Dover; you think of the Rhine. [Hon. Members: "Hear, Hear".] That is where our frontier lies.'[53]

Yet despite the transformative potential of technology, the cliffs of Dover retained their associations with defence, as the ramparts of Britain's island identity in a wider European context. In 1940, the fall of France re-emphasized the significance of insularity, and for all that the Blitz did to undermine the effectiveness of the Channel as a barrier against deadly attack on the civilian population of the homeland, the white cliffs remained a potent emblem of national resistance to foreign threats. Indeed, if anything their power in this respect grew stronger. With Britain standing alone, the cliffs' long-established symbolic connections with national identity fused with the reality of their being in the war zone, on the front line. Heavily shelled by German guns at Calais, and inaccessible to the public without a special permit, the Dover coastline acquired the reputation of 'hell-fire corner', its landscape featuring in the work of war artists like Paul Nash and Charles Pears, as well as film propaganda such as the GPO Film Unit's *Britain at Bay*. Dover cliffs' associations with island defence were further emphasized by the sensational success of Alice Duer Miller's prose poem, *The White Cliffs*.[54] First published in New York in August 1940 with a view to encouraging residents of the United States to support the British war effort, the book told the story of a young American woman who had visited Britain before the Great War and ended up making her home there, as the wife (and widow) of an Englishman who was killed in that war, and with whom she had a son. It sold several hundred thousand copies on both sides of the Atlantic, was dramatized for BBC radio and turned into a 1944 Hollywood film. It also provided the inspiration for Nat Burton's wartime hit, 'There'll be bluebirds over the white cliffs of Dover', which was famously immortalized by Vera Lynn's version of it.[55]

The association between the white cliffs and British resilience during the Second World War took a strong hold on the popular imagination, being especially connected with the Battle of Britain (upon which the press corps had reported from the vantage point of Shakespeare's Cliff, the aircraft of the RAF and Luftwaffe wheeling in combat overhead).[56] After the war, the cliffs would be remembered as a landscape of defiant resistance, a mnemonic for the time when Britons stood alone yet unconquered. In 1965, at the death of Sir Winston Churchill, who had visited Dover on a number of occasions during the war and had a home at Chartwell in Kent, the former prime minister Sir Alec Douglas-Home remembered him as an 'indomitable figure – four-square on the cliffs of Dover'.[57] In later years, images of RAF fighters framed against a backdrop of white chalk suffused the material culture of popular memory, from the sleeve illustrations for records and compact discs to the ephemera of commemoration, the *Daily Mirror*

marking the sixtieth anniversary of the Battle of Britain with a double-page photograph of a Spitfire flying alongside Dover cliffs.[58] That war in the air should be linked in this way to the cliffs provides a striking illustration of the ideological power of landscapes of maritime identity; the sea and the coast, as much as the sky, provided the backdrop to victory.

III

If the white cliffs have functioned as an emblem of national security and defiance, and as a marker of difference projected against continental adversaries of various kinds, from invasion armadas to sporting rivals, then they have also functioned as a symbol of the national home and homecoming. This is significant not least because of the importance of the idea of home in the construction of British national identities: as the author of one elementary school textbook saw fit to declare, the 'chief characteristic of English men and women is their love of "home" '.[59] Guarding the historical 'gateway to England', the cliffs framed the port which for many centuries was the main route in and out of the country, a town which in the sixteenth century Camden had judged to be 'a place of passage of all other most haunted', of which 'it was provided in old time by a speciall Statute, that no man going forth of the realme in pilgrimage, should els where embark and take sea'.[60] The traffic handled by Dover port increased steadily from the mid-eighteenth century on, with the introduction of a regular steam packet service to Calais in 1818 and the arrival of the railway at Dover in 1844 greatly facilitating access to and from the continent. These developments, combined with the growth of international trade and tourism, meant that by the 1890s the number of travellers on the Dover-Calais route totalled around 300,000 per year – a figure that would increase still further in the twentieth century.

As more people gained first-hand experience of the white cliffs through journeying to and from Dover, the landscape's association with home gained greater strength. It is of course the case that 'home' has had wildly varying meanings for Britons, not least because in the English language the word can stand for so many different things – house, neighbourhood, village, county, town, city, country, nation.[61] In all cases, however, the concept of home is inseparable from the idea of travelling, or – speaking more abstractly – movement in space. Implicitly or explicitly, all individuals define their relationship to their personal homes (however imagined) in spatial terms: one is at home, away from home, near home, and so on.[62] Following from this, it can readily be seen how the white cliffs of Dover, as a much-viewed and physically distinctive marker of homecoming for people whose more particular homes were inevitably scattered all over Britain, came to function as a powerful symbol of a larger national homeland, and specifically a homeland conceptualized as an island, as inextricably linked to the sea. In doing so, it acted as the externally orientated complement to the ruralized, more inwardly focused idealizations of home, centred in large part on the idyllic country village and its cottages.[63]

Unsurprisingly, therefore, references to the white cliffs as emblems of 'The sever'd land of home'[64] saturated nineteenth- and twentieth-century cultural discourse, with many poems and novels making much of the connection. Well before Vera Lynn's time, popular songs frequently deployed the image of the cliffs as an idealized embodiment of 'old England' for emigrants, sailors, soldiers fighting overseas, and returning travellers.[65] It was also a staple of tourist guidebooks. The 1931 'official guide' to Dover commended the view of the cliffs and castle as a vivid 'home-coming picture' which 'remains long in the minds of countless thousands of Britons on leaving or returning to their native shores', and reported the words of the Bishop of London who having returned from a world tour declared that 'Nothing has given me the same thrill as the lovely Dover cliffs as we came within sight of home.'[66] To the weary traveller coming back from abroad, the cliffs were presented as standing for the nation as a whole. In the final scene of

the 1934 film *The Scarlet Pimpernel*, Sir Percy Blakeney (played by Leslie Howard) is shown on board ship heading away from revolution-ravaged France; gazing out at the white cliffs of Dover as they approach, he turns to his French wife and delivers with great emphasis the last line of the film: 'Look Marguerite … England!' Used in this way as an emblem of home, the white cliffs were felicitously capacious. They were an idealized image – *pace* Vera Lynn, no 'bluebirds' had ever flown over them (bluebird species not being native to the British Isles) – and this allowed the cliffs to complement and sometimes encompass more specific and personal *patriae*. In the words for a song of 1904, W. A. Mackenzie described how for the homecoming traveller, the image of the mother or wife waiting in the 'little English nook, where a nestling village sleeps' are recalled 'In the fairest and the rarest sight that glads our eyes. In the tall white cliffs of England, glimm'ring o'er the Channel foam.'[67]

Embedded in the collective national consciousness, the cliffs were carried about the world by the British. Voyaging down the Congo river in the 1870s, Henry Stanley came upon a riparian swelling 2,500 yards wide – he named it Stanley Pool – on the right of which 'towered a long row of cliffs, white and glistening, so like the cliffs of Dover that Frank [Francis John Pocock] at once exclaimed that it was a bit of England'. The explorers then named the cliffs 'Dover Cliffs' in an attempt, replicated *mutatis mutandis* by Europeans elsewhere, to domesticate the otherwise alienating landscape of the colonized, transforming it into the landscape of empire.[68] Years later, the white cliffs would be carried to foreign parts by the soldiers of two world wars, the second in particular. The recollections of ex-servicemen from all over Britain are revealing in this regard, demonstrating the strengthening association between white cliffs and nation in the mid-twentieth century. Testimonies recalling the British Expeditionary Force's evacuation from Dunkirk in northern France mention the relief and joy soldiers felt at sighting the cliffs,[69] as do those describing the experiences of men returning home at war's end. Sailing back from Bombay via Gibraltar, George Lapsley, who was from Northern Ireland, remembered how he 'got home, and the first sign I saw of England was the white cliffs of Dover. You hear an awful lot of stories about the white cliffs of Dover, but my heart turned over when I saw them.'[70] Those arriving by air had similar experiences. On board a bomber bound for Britain in 1945, one former prisoner of war remembered how 'the best moment of all' came 'when the pilot asked if anyone wishe[d] to see the white cliffs of Dover', a question apparently asked of other aerial returnees.[71] Undoubtedly the popularity of Vera Lynn's rendition of 'There'll be bluebirds over the white cliffs of Dover' was important in reinforcing the landscape's association with home, not least because Lynn – with her status as the 'forces' sweetheart' – was herself a reminder of civilian Britain for those living the predominantly homosocial lives of servicemen overseas.[72] For the soldiers, the combination of an idealized personification of the women they had left behind with the quintessential landscape of home was a potent one.

As important symbols of home and homecoming the white cliffs had particularly strong resonances for the English, but they also stood for a larger British homeland. This was because of their associations with national history. As Anthony D. Smith has argued, homelands are imagined as historic territories, their landscapes those of national ancestors and national heritage.[73] As a potent symbol of the homeland, the cliffs of Dover were particularly well connected to the national past, its vicissitudes and worthies. This is borne out particularly well by the white cliffs' relationship with William Shakespeare. In Act IV of *King Lear* the blinded Gloucester asks Edgar to lead him the edge of 'a cliff whose high and bending head | Looks fearfully in the confined deep'.[74] Gloucester's intended place of suicide – to which Edgar does not in the end lead him – was evidently a well-known landmark in Tudor and Stuart England; identified as the prominent headland to the south-west of Dover town, it was subsequently named 'Shakespeare's Cliff' in honour of the connection. It had lost a good deal of height due to landslips over the

years, which only served to increase the propensity of literal-minded commentators to remark on how much lower in altitude and precipitousness it seemed in comparison to the Bard's description.[75] Yet in truth, the physical character of Shakespeare's Cliff was only a small part of its appeal; although Edgar did not take Gloucester there, it was the literary association with *King Lear* that mattered. This provided a means by which the educated of the metropolis could claim ownership of the landscape and its meaning, even from the inhabitants of Dover itself, who could not necessarily be counted upon to appreciate great literature. In 1848, the year of revolutions, one contributor to the *London Journal* wrote of the contrast between the 'dull and ignorant' coastguard posted on the summit of the eponymous cliff, 'who neither thinks nor knows any thing of Shakespeare', and the earnest 'strangers … every day bending their steps, recalling at each some line of the tragic scene while labouring up the steep ascent, in the expectation of the extensive and glorious view they are to enjoy from the dizzy height, with some nervous apprehension that they may "topple down headlong" '. Such sentiments can be read as defensive reactions, being a function of the increasing hold of Shakespeare over not just the educated elite, but the public at large – including the proletarian public.[76] And with the ripening and broadening of the cult of Shakespeare from the mid-nineteenth century on, few British guidebooks or commentaries on Dover and its environs failed to draw attention to the associations with *King Lear*.[77] For the ordinary visitor as much as the connoisseur, it was associations such as these, not the visual impact of the landscape, that counted for most:

> However fine, as an object, the Shakspeare [*sic*] Cliff may be, there is nothing about it so remarkable as to exercise the particular interest of the topographer and the tourist, in an island like this, which, on its western shores especially, is so famous for rock-scenery were it not for the halo which the genius of Shakspeare has shed over it.[78]

But the Shakespearean associations of the white cliffs were just one dimension of a wider relationship with national history and heritage. The associations with defence and specifically Britain's history of resistance to invasion have already been noted. Yet the cliffs were also seen to bear more general witness to the story of the nation. Crowned by their ancient castle, in whose precincts stood a Roman watchtower (widely believed to be the oldest building in the country), the cliffs brought to life 'a series of vivid pictures that have made European history'.[79] These included the ceremonial comings and goings of various monarchs, from Edward I to Victoria, the defeat of the French under Eustace the Monk in 1295, the Spanish Armada, and much else besides: 'On what grand historic scenes – on what memorable festivals – have yonder cliffs looked down!', asked one guidebook in the 1870s.[80] Lapidary statements signalling how the cliffs were 'grandly associated with nearly every page of British history' loomed large in the discourse throughout.[81] As one belletrist publication from the 1950s put it, 'The noble rampart of the chalk between Shakespeare's Cliff and the South Foreland bear[s], more perhaps than any other stretch of our coast, the burden of legendary England and of two thousand years of memory.'[82]

Perceived as witnesses to British history, the cliffs were also seen as ancient, constituent parts of the national heritage and comforting markers of continuity. Perhaps ignorant of the fact that the man-made Admiralty Pier at Dover had done much to limit the effects of erosion, tourist guide-books pointed to how the 'chalky heights' of the white cliffs, 'strong in their natural strength, seem to defy both age, decay, and the fiercest onslaughts of Father Time'[83] – this claimed rocky asperity also reinforcing their quondam associations with resistance to foreign threats. The cliffs were a bright and unchanging marker of national identity – and national persistence – down through the centuries. White when the Romans came, and still white today,

'The cliffs are not cliffs'

they functioned as powerful symbols of the continuity of the homeland across more than 1,000 years:

> In history's dawn we see the ancient Britons in battle array on the Dover cliffs, differing greatly in many respects from Dovorians of to-day, yet as true and patriotic as those of the Twentieth Century … Dover, from the earliest times, margined a charming bay, and although Saxons, Normans and English have slightly modified its features, the Town and Port still nestles between the tall, white cliffs, the addition of forty thousand more people to the population having altered but little the physical features.[84]

Whatever the ebb and flow of human history, the cliffs were imagined as continuing to testify to the persistence of the nation.

In this way, the cliffs of Dover played a significant role in what Smith has called 'the territorialisation of memory', acting as witnesses to the survival of the British people over time, being associated with key events in national history from the Roman invasion to the Second World War, and symbolizing the continuity of the national home.[85] The cliffs' function in this respect grew more important from the late nineteenth century on, in the context of the accelerating pace of urbanization and technological change, and the speeding-up of life generally that was experienced across European societies at this time.[86] While these developments generated great excitement and conferred palpable benefits, they could also stimulate fears of degeneration and national decline, and impose new pressures and anxieties on individuals. Against this back-drop, the continuity represented by the cliffs – as with other historic landscapes – served to bolster national identity, the underpinnings of which seemed increasingly assailed by the dislocating effects of urban-industrial modernity.[87] As Adorno, Raymond Williams and other commentators have pointed out, the cultural value a society typically places on the natural environment and natural landscapes is directly related to the urban-industrial development of that society: increased idealization of land, landscape and the rural was a function of the experience of nineteenth- and twentieth-century modernity, not its antithesis.[88] Britain was no exception. In the context of the (real and perceived) rapidity of economic, social and cultural change from the mid-eighteenth century, natural landscapes provided reassurance that despite the changes and challenges of the contemporary world, the homeland persisted still. This homeland – as figured and limned by the cliffs – was insular; it was defined by its being surrounded by the sea. As such, it was British as well as English. Despite Blériot and what he portended, insularity remained a crucial component of British national identity, and the imagining of the white cliffs as national landscape provides compelling evidence of this. Finally, although this national landscape was inextricably linked to the sea, and one might say the Britishness of the sea, it was focused on the island homeland rather than on the empire across the seas. Indeed, it may be that historians have exaggerated the connections between the sea, the empire and British identities[89] – at any rate for the people of the British Isles (for some of the inhabitants of the empire, it may have been a different story).[90] Throughout the modern period, the bulk of the Royal Navy was stationed in home waters. Ironically, the progressively heated late Victorian and Edwardian clamour about the Navy being essential for imperial defence correlated almost perfectly with its progressive concentration in Europe.[91] The continued valorization of the white cliffs as marker of an identity based on discrete insularity was the cultural counterpart to this.

Various idealized and generalized views of the English countryside also provided reassurance that an island homeland persisted amid the transformations of modernity. One prominent example was the powerful symbolism of the English 'south country' and its signature landscape

501

Paul Readman

of tranquil villages, verdant fields and rolling downland.[92] But it is important to emphasize the role played by particular, individual landscapes in doing this cultural work: as in other European countries, national identities in Britain were importantly predicated on local identities, local and national patriotisms being in a symbiotic and mutually supportive relationship across most of the modern period.[93] Particularity, of course, could be a source of local pride: in Dover's case, the town was jealous of its cliffs, and fully conscious of their symbolic importance. It was for this reason that the turn-of-the-century town council, prompted by a local petition, took steps to remove a large advertisement for Quaker Oats which had been affixed to the cliff face above the harbour. Local opinion condemned the prominently placed hoarding, all too visible from the sea, as an affront to 'the welfare and reputation and picturesqueness of Dover', the 'traditions' and 'ancient features' of the place.[94] But the offence to locality was also, and primarily, an offence to nationality: the local patriotism of Doverians was based on outrage that 'the historic front of "Old Albion" ' had been 'disfigured only to proclaim the virtues of Yankee Oats'.[95] In the case of the white cliffs (unlike some other valued landscapes), the national was prior, dominating the local. Perhaps the quintessential national landscape, the cliffs figured and limned the homeland, emphasizing its insular character.

To an extent the nation represented by the cliffs was distinctively English: although difficult to demonstrate conclusively, it is almost certainly the case that the cliffs were more meaningful markers of home for inhabitants of England, particularly southern England, than for the Welsh or the Scots. This was in part a simple function of physical geography. The white cliffs were located in the south-east corner of England, and fronted the English Channel. They were also composed of chalk, which carried very strong associations with the English land-scape, especially the downlands of the south. One book on the Kent coast published in 1914 even asseverated – quite incorrectly – that 'we in England have a world-monopoly of chalk.'[96] But despite these felt connections between the white cliffs and Englishness, their importance as markers of a larger British homeland should not be underestimated. The port of Dover's long-established position as the key place of passage to and from continental Europe played a key role here. From the eighteenth century on, people from all parts of the British Isles could identify the cliffs with the British national home. In 1772, one Yorkshire man described how catching just a glimpse of the cliffs of Dover from Calais town walls 'gave me such satisfactory sensations as are only to be felt by such who have been absent from their native land, and on the point of returning to it'.[97] Fifty years later, another north countryman – son of the proprietor of the *Leeds Mercury* – described the cliffs as 'giant ramparts to our happy land', welcoming to the returning traveller; and 100 years later again the Nottinghamshire-born Arthur Mee thought the white cliffs 'the gladdest sight the Englishman [away] from home can wish to see'.[98] And for all that inhabitants of Scotland had recourse to alternative national landscapes, which exerted a far stronger appeal at least as far as Scottishness was concerned, it would seem that the white cliffs could even exert a patriotic pull on them as Britons. Arriving in Boulogne in 1765 after two years of continental travel, the writer Tobias Smollett – a British as well as a Scottish patriot, though certainly no lover of the town of Dover – nevertheless experienced intense pleasure on seeing the white cliffs, the sight reminding him of all the reasons why he was so 'attached to his country'.[99] Later on, the daughter of the duke of Argyll – having just departed Dover for France in July 1814 – recorded in her diary how the view of the cliffs 'recall a sensation of pride to every British heart'.[100] Later still, as we have seen, the Scottish explorer Stanley drew on the memory of the cliffs in naming features of the river Congo; and after the carnage of the Great War, the Scottish general Haig lauded their significance as a marker of homecoming, going so far as to call them 'a most inspiring spectacle' [which] in itself repays us for all that we have been privileged to do in the discharge of our duty to King and country'.[101]

Such personal views of the cliffs were bound up with the dissemination and consumption of their image – across the British Isles – in artworks, lithographic prints, photography and film. This helped further entrench their position as fixtures in British national topographies, and aided in the imagining of these topographies and in the territorialization of British national memories. Their capacity to do this cultural work was inescapably connected with their association with insularity: while England, Scotland and Wales were parts of a larger island nation-state, Britain was an island nation-state. To a degree previously underappreciated by scholars, insularity – as referenced by the cliffs – could support cultural Britishness as well as cultural Englishness. While the inland landscape of Kent was emphatically and exclusively an English landscape, being celebrated as the 'garden of England' and the natural habitat of that archetypal rural patriot, the sturdy yeoman, its coastline was invested with rather different national meanings. Moreover, as these meanings demonstrate, the cliffs did not support any banal, emptily assertive nationalism, but were associated with specific elements of an insular national identity.[102] This insular British-ness proved surprisingly robust and enduring. Its beginnings correlated with the late eighteenth- and early nineteenth-century beginnings of Britishness more generally, and as with this wider phenomenon, the conflict with Revolutionary and Napoleonic France was the crucial cata-lyst.[103] In the context of war with an enemy directly across the Channel, and one which pre-sented a real threat of invasion, the cliffs proved a very effective delineator of the British homeland against the menace of the continental Other. As technologies of communication and dissemination developed in later years, the cliffs' symbolic power in popular imaginings of the British national community grew still stronger, reaching its apogee in the middle of the twen-tieth century, when the enemy was Germany rather than France but the fear of catastrophic defeat was at least as potent.

That this was so might seem odd. For Gillian Beer, 'the technology of the airplane' acted as a solvent of 'the concept of nationhood which relies upon the cultural idea of the island', and thus undermined the historically insular foundations of British identity.[104] Yet the nationalistic associations attaching to the white cliffs deep into the twentieth century suggest otherwise. The strength of these associations was such that it could be argued that the national border was the object of more celebration in Britain than in other modern nation-states. Certainly, it is difficult to identify equivalent landscape features in other countries that did the quality and quantity of cultural work done by the white cliffs (perhaps the nearest comparator is the Statue of Liberty, but this is almost entirely part of the built environment, has a generalized and global as much as a specific and nationalistic appeal, and is in any case less landscape than landmark – or icon).[105] While particular natural landscapes certainly played key roles in the construction and symboliza-tion of other countries' national identities, few of these landscapes were located on the geo-graphical edge of their corresponding nation states (the Norwegian coastline might be seen as a possible exception, but it is too large and various to have any pronounced quality of particular-ity). Typically, indeed, they are located deep within the heart of the national territory: the river Volga and Mount Fuji are two possible examples.[106] This helps support a conclusion that insu-larity was – and perhaps remains – a crucial component of modern British national identity; certainly, the place of the white cliffs in the national landscape imaginary provides suggestive evidence in this regard. Although this is somewhat beyond the scope of this article, it is worth noting that distinctive and evocative markers of difference are still very important in con-temporary Britain. In thanking donors for their contribution to the National Trust's 2012 fund-raising campaign for the purchase of more chalk coastline near Dover, the organization's outgoing Director-General Dame Fiona Reynolds remarked that 'nothing symbolises island nation as much as the White Cliffs', sentiments with which many who had given money doubt-less concurred.[107] (For Sally Bybee, they were an 'historic symbol of Britain and represent[ed]

our heritage and status as an island nation'; for William Hird, they were 'the bastion of England … raising echoes all through our island story'; and for Francis Wright and Stephen Foot, they 'symbolise[d] the beauty and strength of this island, and the steadfastness of its people'.)[108]

Finally, the white cliffs also provide evidence of the strength – in the age of empire – of conceptualizations of national identity centred on the historic island homeland rather than more recently acquired territories outside Europe. For inhabitants of Britain, at any rate, the cliffs were only indirectly connected with Britain's imperial mission as it was variously conceived between the eighteenth and twentieth centuries. That said, however, the island-focused patriotic charge carried by the cliffs was not incompatible with the imperialist project, nor was it uncongenial to the agents of this project. We have seen how memories of the white cliffs and what they signified were carried to colonial borderlands in the imaginations of explorers, servicemen and emigrants. Their image could also be valorized by Dominion imperialists who had never previously set foot in Britain, one inter-war example being the young R. G. Menzies, future prime minister of Australia (who in later life took great pride in being invested, at Dover Castle, in the ceremonial office of Lord Warden of the Cinque Ports).[109] But typically, the connotations of the white cliffs were insular in character; the associations they triggered were inward, rather than outward-facing in orientation. At most – as in the case of Menzies – the cliffs could be made to stand for the island heart of a larger empire, and even here the accent was on their relationship to a specifically insular rather than more widely drawn imperial homeland. In 1935, on sighting the white cliffs for the first time, Menzies felt great emotion at finally coming 'home'; yet as he said on another occasion, 'the boundaries of Great Britain are not on the Kentish coast but at Cape York and Invercargill.'[110]

IV

Visually, the cliffs of Dover are relatively unusual landscape features, and high-flown claims of their distinctiveness resounded down through the centuries. Writing in 1914, Charles G. Harper felt confident that there was 'nothing in the rest of the whole wide world in the least resembling' the 'bastioned chalky heights' of 'the "white cliffs of Albion" '.[111] Unsurprisingly enough, claims of their aesthetic superiority to the landscape on the other side of the Channel were often heard, one ultra-patriotic writer of the 1820s reckoning that the 'beauty' and 'power' of the Dover coastline, with its 'romantic and lofty' cliffs, was such that a 'stranger … who lands in Dover for the first time, and compares the delightful Picturesque scenery before him with the opposite shore near Calais, will naturally imagine that he is treading on enchanted Ground'.[112] Other eyes saw things rather differently. Commissioned by the Swedish government to travel to North America on a botanical fact-finding mission, the eighteenth-century Linnaean naturalist Pehr Kalm provides one early example. On his voyage out to the New World, Kalm had an opportunity to view both the French and British sides of the Pas de Calais in 1748, when the boat on which he was travelling was buffeted from coast to coast in high seas. '[T]he land on both sides has the same *facies* and appearance', he remarked, 'so that if one who had seen the coast of England should get to see the coast of France here, and did not know it was such, he would certainly believe that it was the English coast … and English hills'.[113]

The reason why so many British men and women saw things differently over the course of the next two centuries is bound up with the associational value of landscape. It is worth repeating that judgements about the value of any landscape – even aesthetic judgements – are never reliant on physical characteristics alone. For the British the physical appearance of the white cliffs may have made more plausible claims of distinctiveness, but they alone could not support the weight of the patriotic load carried by the landscape. Had it been otherwise, the chalk cliffs

of the Seven Sisters on the Sussex coast – which, it could be argued, are visually more impressive than those at Dover – would have played a more prominent role in constructions of national identity. In explaining the nationalistic significance of the white cliffs of Dover, exogenous factors are crucial. The cliffs' associations with national defence, homecoming and homeland, national culture and history mattered more than their physical characteristics taken in isolation. That this was so suggests a more general conclusion: it is only through considering the associational value of landscape that full appreciation of landscape's role in the construction of national identities can be gained. Indeed, as can be demonstrated by the experience of those excluded from or unmoved by the nationalistic associations of landscapes like the cliffs of Dover, the visual was not enough. Unbuttressed by associations of patriotism and belonging, the visual could disappoint, even alienate. When he first saw the white cliffs Menzies confided to his diary that: 'Our journey to Mecca has ended, and our minds abandoned to those reflections which can so strangely … move the souls of those who go "home" to a land they have never seen.'[114] Yet England was at the centre of Menzies's world and sense of identity; things could be very different for others. As a girl growing up in Antigua, the writer Jamaica Kincaid was given an English education, instructed to revere England, value its customs and respect the royal family. Yet when later in life she travelled to England for the first time, she did not feel as Menzies did, like a pilgrim returning to her spiritual home. Rather, she discovered that: 'The moment I wished every sentence, everything I knew, that began with England would end with "and then it all died, we don't know how, it just all died" was when I saw the white cliffs of Dover.' As a schoolgirl Kincaid had been taught to sing hymns and poems 'about a longing to see the white cliffs of Dover again', despite never having seen them herself. Years later, when she did, 'they were not that pearly majestic thing I used to sing about … The white cliffs of Dover, when finally I saw them, were cliffs, but they were not white … they were dirty and they were steep.'[115] For Mervyn Morris and Jamaica Kincaid, the cliffs were cliffs, seeming 'very ordinary', 'dirty' and 'steep'. For the British men and women who travelled to Dover with them, and for British people generally throughout the modern period, the cliffs were not cliffs; they signified rather more. This would remain the case into the twenty-first century. As comments appended to National Trust donations put it in 2012, 'These are more than cliffs, they're history, they're habitat, they're Britain … Historical defiant defensive known world-wide immortalised in song bastion of strength part of my home'.[116]

Notes

Some of the research for this article has been presented in lectures and seminars at the University of North Carolina at Chapel Hill (2009), Georgetown University (2009), Capital Normal University (2010), the University of Exeter (2010), Nanjing University (2011), Southeast University (2011), and the University of Leicester (2012); I am grateful to my audiences for their comments. I should also like to thank Arthur Burns for his thoughts on an earlier draft, Martha Vandrei for advice on part of the argument, and King's College London for the award of a period of study leave which facilitated the article's completion. The submitted version was much improved by the helpful suggestions of the three anonymous reviewers.

1 Hugh Cunningham, 'The language of patriotism 1750–1914', *History Workshop Journal*, 12 (1981), pp. 8–33.
2 For a useful survey, see Peter Mandler, 'What is national identity? Definitions and applications in modern British historiography'. *Modern Intellectual History*, 3 (2006), pp. 271–97.
3 [William E. Gladstone], 'Germany, France, and England', *Edinburgh Review*, 132 (1870), pp. 554–93, at p. 588.
4 J. A. Froude, *Oceana*, new edn (London, 1886), p. 16; E. A. Freeman, 'Latest theories on the origin of the English', *Contemporary Review*, 57 (1890), pp. 36–51, at p. 45; Robert Louis Stevenson, 'The English Admirals'. *Virginibus Puerisque and other papers* (London, 1881), pp. 191–218, at p. 193.

5 Mervyn Morris, 'A West Indian student in England', *Caribbean Quarterly*, 8 (1962), pp. 17–29, at p. 28.

6 A point made by Eric Kaufmann and Oliver Zimmer, 'In search of the authentic nation: landscape and national identity in Canada and Switzerland', *Nations and Nationalism*, 4 (1998), pp. 483–510. at pp. 484–5.

7 See, for example, David Hooson (ed.), *Geography and National Identity* (Oxford, 1994).

8 Denis Cosgrove and Stephen Daniels (eds), *The Iconography of Landscape* (Cambridge, 1988): David Matless, *Landscape and Englishness* (London, 1998); David Lowenthal, 'British national identity and the English landscape', *Rural History*, 2 (1991), pp. 205–30; Catherine Brace, 'Looking back: the Cotswolds and English national identity, c.1890–1950', *Journal of Historical Geography*, 25 (1999), pp. 502–16, and 'Finding England everywhere: regional identity and the construction of national identity, 1890–1940', *Ecumene*, 6 (1999). pp. 90–109.

9 Martin J. Wiener, *English Culture and the Decline of the Industrial Spirit 1850–1980* (Cambridge, 1981). Cf. Peter Mandler, 'Against "Englishness": English culture and the limits to rural nostalgia, 1850–1940', *Transactions of the Royal Historical Society*, 6th ser., 7 (1997), pp. 155–75; Paul Readman, 'Preserving the English landscape, *c.* 1870–1914', *Cultural and Social History*, 5 (2008), pp. 197–218.

10 Alun Howkins, 'The discovery of rural England', in Robert Colls and Philip Dodd (eds), *Englishness, Politics and Culture 1880–1920* (London, 1986), pp. 62–88.

11 Though Robert Colls's work on Northumbria is an important exception; see Robert Colls (ed.), *Northumbria: History and Identity 547–2000* (Chichester, 2007).

12 D. W. Meinig (ed.), *The Interpretation of Ordinary Landscapes* (Oxford, 1979), pp. 3, 33–4.

13 'The essential indeterminacy of natural beauty manifests itself in the fact that *any* fragment of nature … can become beautiful … And this has little or nothing to do with formal proportions and the like' (T. W. Adorno,'The beauty of nature', in his *Aesthetic Theory* (London, 1984 [1970]), pp. 91–115, at p. 104).

14 As Immanuel Kant hypothesized in his *Critique of Judgement*, 'were we to play a trick on our lover of the beautiful, and plant in the ground artificial flowers …, and perch artfully carved birds on the branches of trees, and were he to find out how he had been deceived, the immediate interest which these things previously had for him would at once vanish … The fact is that our intuition and reflection must have as their concomitant the thought that the beauty in question is nature's handwork: and this is the sole basis of the immediate interest that is taken in it' (Immanuel Kant, *Critique of Judgement* (Oxford, 2007), pp. 128–9).

15 Robert Elliot, 'Faking nature', *Inquiry*, 25 (1982), pp. 81–93. Elliot's arguments are extended further in his *Faking Nature* (London, 1997).

16 Yi-Fu Tuan, *Topophilia: A Study of Environmental Perception, Attitudes, and Values* (Englewood Cliffs, NJ, 1974), pp. 93–4.

17 Edward Lynam, *The Map of the British Isles of 1546* (Jenkintown, PA, 1934), pp. 1–3.

18 William Camden, *Britain, or a Chorographicall Description of the most Flourishing Kingdomes, England, Scotland, and Ireland, and the Hands Adjoyning, out of the Depth of Antiquitie* (London, 1610 [1586]), p. 344.

19 Daniel Defoe, *A Tour through the Whole Island of Great Britain* (2 vols; London, 1962 [1724–6]). I, p. 122.

20 John Alken, *England Delineated*, 2nd edn (London, 1790), p. 268.

21 Ann Radcliffe, *A Journey Made in the Summer of 1794* (Dublin, 1795), p. 369.

22 L. Fussell, *A Journey Round the Coast of Kent* (London, 1818), pp. 142–3.

23 *The Lady's Newspaper*. 28 August 1847, p. 207.

24 In 1863, the number of passengers on the Dover–Calais route was 123.025; in the 1890s the annual total reached 300,000; in 1910 the combined total number of travellers carried by the Dover-Calais and Dover-Ostend routes was over 590,000: J. B. Jones, *Annals of Dover* (Dover, 1916), pp. 159–60, 167.

25 Arthur D. Lewis, *The Kent Coast* (London, 1911), pp. 266–7.

26 For these technologies, see David Brett, *The Construction of Heritage* (Cork, 1996), esp. pp. 65–8.

27 *Manchester Times*, 31 December 1881.

28 Camden, *Britain*, p. 1.

29 *A Guide-Book and Itinerary of Dover* (Dover, 1896), p. 30; A. G. Bradley, *England's Outpast* (London, 1921), pp. 317–18.

30 W. G. Rawlinson. *The Engraved Work of J. M. W. Turner* (2 vols, 1908), I, pp. 125–6.

31 The comparative scholarly neglect of this phenomenon is worth remarking upon. While the connections between pastoral landscapes and Englishness have been extensively discussed, it remains the case – as Jan Rüger has recently pointed out – that relatively little attention has been given to the relationship between coastal landscapes and discourses of national identity. Jan Rüger. *The Great Naval Game: Britain and Germany in the Age of Empire* (Cambridge, 2007). pp. 170–4. The discussion that does exist tends to be rather fleeting, or very general: see, for example, R. Colls, *Identity of England* (Oxford, 2002), pp. 237–42; Ken Lunn and Ann Day, 'Britain as island: national identity and the sea', in Helen Brocklehurst and Robert Phillips (eds), *History, Nationhood and the Question of Britain* (Basingstoke, 2004), pp. 124–36; Robert Shannan Peckham, 'The uncertain state of islands: national identity and the discourse of islands in nineteenth-century Britain and Greece', *J. Hist. Geo.*, 29 (2003), pp. 499–515.

32 Cynthia F. Behrman, *Victorian myths of the sea* (Athens, OH, 1977). See also Geoff Quilley, ' "All ocean is her own"; the image of the sea and the identity of the maritime nation in eighteenth-century British art', in Geoffrey Cubitt (ed.), *Imagining Nations* (Manchester, 1998), pp. 132–52.

33 Charles Dibdin, *Observations on a Tour through Almost the Whole of England* (2 vols; London, 1801), I, p. 21.

34 One children's publication of 1858 celebrated the day 'when the sea broke through with a roar and a bound' as one which had given Britain 'a distinct place among the nations of the world': Ida Wilson, *Our Native Land* (London. 1858), p. 72.

35 E. A. Freeman, 'Alter Orbis', *Contemp. Rev.*, 41 (1882). pp. 1041–60, at p. 1042.

36 Keith Wilson, *Channel Tunnel Visions 1850–1945* (London, 1994), pp. 188–92; Barbara Castle, *The Castle Diaries 1964–1976* (London, 1990), p. 545.

37 Lord Randolph Churchill: *Hansard*, 327 (27 June 1888), col. 1500. For the history of the Channel Tunnel, see Wilson, *Channel Tunnel.*

38 See e.g. Marjorie Morgan. *National Identities and Travel in Victorian Britain* (Basingstoke, 2001), esp. pp. 196ff.

39 See, for example, Camden, *Britain*, p. 344; *Handbook for Travellers in Kent*, 5th edn (London, 1892), p. 50; Ford Madox Hueffer [Ford], *The Cinque Ports* (Edinburgh, 1900), p. 242; *The Dover Official Guide and Souvenir* (Dover, 1930), p. 13.

40 *Dover: The Gateway to England* (Dover, 1931), p. 6: *A Guide-Book and Itinerary of Dover* (Dover 1896), p. 30; *A Pictorial and Descriptive Guide to Dover*, 6th edn (London, 1924–5), p. ix: Samuel T. Davies, *Dover* (London, 1869), p. 3.

41 *Black's Guide to Kent* (Edinburgh, 1878), p. 213.

42 E. Joll, M. Butlin and L. Herrmann (eds), *The Oxford Companion to J. M. W. Turner* (Oxford, 2001), p. 79.

43 Eric Shanes, *Turner's Rivers. Harbours and Coasts* (London, 1981). pp. 28–9, 33–4 and pls 46, 67.

44 John Ruskin. *The Harbours of England* (Orpington, 1895). pp. 63–4.

45 William Cobbett, *Rural Rides*, ed. G. D. H. Cole and M. Cole (2 vols; London, 1930), I, pp. 227–30.

46 For invasion scare literature, see I. F. Clarke, *Voices Prophesying War 1763–1984* (London, 1966).

47 *Hansard*, 82 (30 July 1845), cols 1223–4.

48 Perhaps significantly, in January 1785 a French government-funded attempt to cross the Channel from France to England by balloon ended in disaster. The prevailing winds blew the craft back over French soil, where it caught fire and fell to earth, killing the two pilots. See L. T. C. Rolt, *The Balloonists: The History of the First Aeronauts* (Stroud, 2006), pp. 90–3.

49 Cited in Clarke, *Voices*, pp. 100–1.

50 Brian A. Elliot, *Blériot* (Stroud, 2000), pp. 125–6.

51 *Manchester Guardian*, 20 December 1918, p. 7; J. B. Firth. *Dover and the Great War* (Dover, n.d.), pp. 118–21.

52 G. Beer, 'The island and the aeroplane', in H. K. Bhabha (ed.), *Nation and Narration* (London, 1990), pp. 265–90, at pp. 273, 286–7.

53 *Hansard*, Commons, 5th ser., 292 (30 July 1934), col. 2339.

54 Alice Duer Miller, *The White Cliffs* (London, 1941). The poem began, 'I have loved England, dearly and deeply, | Since that first morning, shining and pure, | The white cliffs of Dover I saw rising steeply | Out of the sea that once made her secure'.

55 K. R. M. Short, ' "The white cliffs of Dover": promoting the Anglo-American alliance in World War II', *Historical Journal of Film, Radio and Television*, 2 (1982), pp. 13–25; F. M. Leventhal, 'British writers, American readers: women's voices in wartime', *Albion*, 32 (2000), pp. 1–18.

56 Reginald Foster, *Dover Front* (London, 1941), p. 7: Ben Robertson, *I Saw England* (London, 1941). p. 85; A. M. Sperber, *Murrow* (London. 1986), p. 161.

57 *The Mirror*, 25 January 1965, p. 8.

58 *Daily Mirror*, 15 September 2000. pp. 12–13.

59 Stephen Heathorn, *For Home, Country, and Race: Constructing Gender, Class and Englishness in the Elementary School, 1880–1914* (Toronto, 2000), p. 151.

60 Camden, *Britain*, p. 344.

61 In the Romance languages, by contrast, 'home' is more typically used simply as a synonym for 'house'. See David E, Sopher, 'The landscape of home: myth, experience, social meaning', in D. W. Meinig (ed.), *The Interpretation of Ordinary Landscapes: Geographical Essays* (New York and Oxford, 1979), pp. 129–49, at pp. 130–1.

62 As one geographer has put it, 'Home … cannot be understood except in terms of journey': J. D. Porteous, 'Home: the territorial core', *Geographical Review*, 66 (1976), pp. 383–90, at p. 387.

63 Heathorn, *For Home*, pp. 141–51.

64 *Bow Bells*, 25 (November 1876), 490.

65 Examples of scores held in the British Library include George Linley and W. Neuland, *The White Cliffs of England* (London, 1833); John F. Duke, *Farewell White Cliffs of Old England* (London, 1899); Anthony Johnstone and W. A. Mackenzie, *The White Cliffs of England* (London, 1904); Percy Edgar and Henry E. Pether, *The White Cliffs of England (are the White Cliffs of Home)* (London, 1916); Max Kester and Max Saunders, *The White Cliffs of Dover* (London, 1935): Harry Leon and Leo Towers, *The White Cliffs of Dover: A Song of Old England* (London. 1936).

66 *Dover: Gateway*, p. 7.

67 'In some little English nook, where a nestling village sleeps, | There's a mother sits and waits, or a wife that weeps, or a wife that weeps. | Ah! we hear their loving call, and we see them one and all | In the fairest and the rarest sight that glads our eyes, | In the tall white cliffs of England, glimm'ring o'er the Channel foam, | From our dear ones sending welcome to the wandr'rers nearing home': Johnstone and Mackenzie, *White Cliffs*.

68 Henry M. Stanley, *Through the Dark Continent* (2 vols; New York, 1988 [London, 1878]), II, pp. 254–5.

69 For example, W. L. McWilliam, an orderly with the Royal Army Medical Corps, from Devon: 'Civil and Military Medical Services of World War II', Typescript Imperial War Museum, 73/58/1, p. 73; Tommy Ward, army officer: www.bbc.co.uk/print/ww2peopleswar/stories/12/a4654712.shtml (accessed 29 August 2008).

70 www.bbc.co.uk/print/ww2peopleswar/stories/39/a4111039.shtml (accessed 29 August 2008).

71 www.bbc.co.uk/print/ww2peopleswar/stories/91/a4644191.shtml (accessed 29 August 2008).

72 For Vera Lynn's appeal as 'the perfect reminder of home', see Zoe Jane Varnals, 'The Entertainments National Service Association 1939–1946', unpublished PhD dissertation. King's College London (2009), p. 230.

73 Anthony D. Smith, *Myths and Memories of the Nation* (Oxford, 1999), pp. 149–59.

74 William Shakespeare, *The Tragedy of King Lear*, in William Shakespeare, *The Complete Works: Compact edition*, ed. Stanley Wells and Gary Taylor (Oxford, 1988), act IV, scene 1, p. 964, and act IV, scene 5. pp. 966–7.

75 See for example, Alken, *England Delineated*, p. 276.

76 For radical bardolatry, see Antony Taylor, 'Shakespeare and radicalism: the uses and abuses of Shakespeare in nineteenth-century popular politics', *Historical Journal*, 45 (2002), pp. 357–79.

77 For good examples, see *Black's Guide*, pp. 207–9; Mackenzie Walcott, *A Guide to the Coast of Kent* (London, 1859), pp. 14, 88; *John Heywood's Illustrated Guide to Dover* (London, 1894), pp. 7–9.

78 *Saturday Magazine*, 10 (April 1837), p. 138.

79 *The Dover Official Guide and Souvenir* (Dover, 1930), p. 9.

80 *Black's Guide*, p. 213.

81 *Heywood's Illustrated Guide*, pp. 6–7, 10–12, at p. 10.

82 Aubrey de Selincourt, *The Channel Shore* (London, 1953), p. 10.

83 Samuel T. David, *Dover* (London, 1869), p. 2.

84 Jones, *Annals*, pp. 430–1, and see also *Heywood's Illustrated Guide*, pp. 5–6.

85 Anthony D. Smith, *Chosen Peoples: Sacred Sources of National Identity* (Oxford, 2003), pp. 134ff, and Smith, *Myths*, esp. pp. 150–2.

86 For this context, see Stephen Kern, *The Culture of Time and Space, 1880–1918*, 2nd edn (Cambridge, MA, 2003).

87 See Paul Readman, 'The place of the past in English culture, *c.* 1890–1914', *Past & Present*, 186 (2005), pp. 147–99.

88 'there is no room for natural beauty in periods when nature has an overwhelming presence for man, as seems to be the case with peasant populations which are known to be insensitive to the aesthetic qualities of natural scenery because to them nature is merely an immediate object to be acted upon' (Adorno, 'Beauty of nature', p. 96). See also Raymond Williams, *The Country and the City* (London, 1985 [1973]): 'there is almost an inverse proportion, in the twentieth century, between the relative importance of the working rural economy and the cultural importance of rural ideas' (p. 248).

89 For some suggestive remarks on this, see Stephen Conway, 'Empire, Europe and British naval power', in David Cannadine (ed.), *Empire, the Sea and Global History* (Basingstoke, 2007), pp. 22–40.

90 The Australian politician and post-war prime minister R. G. Menzies provides one example. Menzies 'idealised England' and its landscape, culture and institutions – not least the white cliffs–combining this with an understanding that 'Australians were simply Britons in another part of the world', and as such were integral to a larger imperial unity. See Judith Brett, *Robert Menzies' Forgotten People*, 2nd edn (Carlton, 2007), pp. 114–23, 190–2, at pp. 190 and 192.

91 P. P. O'Brien, 'The Titan refreshed: imperial overstretch and the British Navy before the First World War', *Past & Present*, 172 (2001), pp. 146–69.

92 Howkins, 'Discovery of rural England'.

93 Readman, 'Place of the past', pp. 176–9. Germany provides perhaps the most useful comparator: see esp. A. Confino, *The Nation as a Local Metaphor: Württemburg, Imperial Germany, and National Memory. 1871–1918* (Chapel Hill, NC, 1997).

94 *A Beautiful World*, 9 (1900–3), pp. 9–10, 18; *Dover Observer*, 24 August 1901, p. 7.

95 *Dover Observer*, 7 September 1901, p. 7; *Dover and County Chronicle*, 12 October 1901, p. 3.

96 Charles G. Harper, *The Kentish Coast* (London, 1914), pp. 271–2.

97 Cornelius Cayley, *A Tour thorough [sic] Holland, Flanders, and part of France, In the Year 1772* (Leeds, 1773), p. 104.

98 Edward Baines, jun., 'Letters from the Continent (No. 1)', *Leeds Mercury*, 5 January 1833; Arthur Mee, *Kent* (London, 1936), p. 144.

99 Letter XLI from Boulogne, 13 June 1765, in Tobias Smollett, *Travels through France and Italy* (Oxford, 1981 [1766]), p. 327. For Smollett's views of Dover, see ibid., pp. 4–6; for his 'sympathetic British-ness', see Evan Gottlieb, *Feeling British: Sympathy and National Identity in Scottish and English Writing, 1707–1832* (Lewisburg, PA, 2007), pp. 61–98.

100 'Diary of Lady Charlotte Susan Maria Campbell Bury, July 1814', in *Diary Illustrative of the Times of George the Fourth Interspersed with Original Letters from … Queen Caroline* (2 vols; Philadelphia, PA, 1838), II, p. 18.

101 *Manchester Guardian*, 20 December 1918, p. 7. Even in the twenty-first century, the cliffs retain strong associations with Britain and Britishness in the popular mindset. This is nicely illustrated by the enormously enthusiastic and patriotic public response to the National Trust's 2012 'White Cliffs of Dover Appeal', which – in the teeth of a global recession – raised £1.2 million from over 16,500 people in just 133 days, the money going towards the purchase of 0.8 miles of coastline. Examination of the hundreds of messages of support posted by donors on the appeal's webpage suggests that about as many described the cliffs as a British as they did an English landmark. 'Leanne, Mark and Aldan' donated 'Because we're proud to be British and the White Cliffs just say "British"!'; Stella Wood gave because they were 'an iconic feature of Great Britain', while Karen White's generosity sprang from their being 'A true Great British treasure'. For another donor ('GE'), 'This is one area that … everyone associates with the UK'. www.nationaltrust.org.uk/get-involved/donate/current-appeals/white-cliffs-of-dover-appeal/?id=298; www.nationaltrust.org.uk/get-involved/donate/current-appeals/white-cliffs-of-dover-appeal/?id=318; www.nationaltrust.org.uk/get-involved/donate/current-appeals/white-cliffs-of-dover-appeal/?id=253; www.nationaltrust.org.uk/get-involved/donate/how-youve-helped/white-cliffs-of-dover-appeal/ (all accessed 14 December 2012).

102 Cf. Michael Billig, *Banal Nationalism* (London, 1995).

103 See Linda Colley, *Britons: Forging the Nation, 1707–1837* (New Haven, 1992).

104 Gillian Beer, 'Discourses of the island', in F. Amrine (ed.), *Literature and Science as Modes of Expression* (Dordrecht, 1989), pp. 1–27, at p. 21.

105 Marina Warner, *Monuments and Maidens* (London, 1985), pp. 3–17, esp. pp. 11–17.

106 This is also true for less location-specific national landscapes, like the Canadian prairies and the Russian steppes, both of which played important roles in their respective nation's nationalist imaginaries. See, for example, Christopher Ely, *This Meager Nature: Landscape and National Identity in Imperial Russia* (Dekalb, IL, 2002).

107 www.nationaltrust.org.uk/get-involved/donate/how-youve-helped/white-cliffs-of-dover-appeal/supporters/view-page/item1017114/ (accessed 14 December 2012).

108 www.nationaltrust.org.uk/get-involved/donate/current-appeals/white-cliffs-of-dover-appeal/?id=395; www.nationaltrust.org.uk/get-involved/donate/current-appeals/white-cliffs-of-dover-appeal/?id=743; www.nationaltrust.org.uk/get-involved/donate/current-appeals/white-cliffs-of-dover-appeal/?id=811 (all accessed 14 December 2012).

109 Brett, *Menzies' Forgotten People*, pp. 190–1.

110 Ibid., pp. 114–15, 122.

111 Harper, *Kentish Coast*, pp. 271–2.

112 Thomas Lowndes, *Tracts in Poems and Verse* (Dover, 1825), pp. 14–15.

113 *Kalm's Account of his Visit to England on his Way to America in 1748* (London and New York, 1892), p. 455.

114 Brett, *Menzies' Forgotten People*, p. 115.

115 Jamaica Kincaid, 'On seeing England for the first time', *Transition*, 51 (1991), pp. 32–40, at p. 40.

116 [*sic*]; Fiona Whitworth (www.nationaltrust.org.uk/get-involved/donate/current-appeals/white-cliffs-of-dover-appeal/?id=37> (accessed 14 December 2012)), and Paul Andrews (www.nationaltrust.org.uk/get-involved/donate/current-appeals/white-cliffs-of-dover-appeal/?id=306 (accessed 14 December 2012)).

Part IV
Diversity and identity

Introduction to Part IV

Katy Bunning

This section draws together some important contributions to understandings of heritage through the lenses of diversity, nationhood, and identity, in particular, the multi-layered identities created by migrations and transnationalism. Diversity is often seen, at least in general terms, as a positive, 'uplifting' (Hartmann 2015), and modern notion (McCarthy *et al.* 2013, this volume). It has been a key concept in the strategic direction of much museum and heritage practice for several decades for a range of reasons. Not only addressing an ethical and moral stance calling for the pursuit of greater inclusivity and participation in national heritage narratives, a commitment to diversity may also serve processes of governance and the creation of citizenship (Bennett, Grossberg and Morris 2005: 86; Message 2007), as well as reflecting advances in disciplinary knowledge of the social world. In practice, however, experiments in addressing diversity through curating and programming all too often fall short of anticipated expectations of meaningful change, both in levels of diverse cultural representation within the heritage sector, and in terms of broader social conditions of prejudice and marginalisation that they proclaim to address. Such experiments sometimes also escape a critical gaze because, by just existing, they appear to solve the need for 'inclusion'. As Modest suggested in a recent international conference on museums at the University of Leicester, professionals might do well to refrain from being too optimistic about how far the sector has come in such work (Modest 2016).

If we accept Hall's (1999) observation, that 'heritage' is 'one of the ways in which the nation slowly constructs for itself a sort of collective social memory', then, perhaps in some respects, this makes a relatively rapid shift towards representing diverse narratives in heritage contexts difficult to achieve. Although a strategy of celebrating diversity and pursuing 'multiculturalism' may serve the political centre, the shift towards diversity is often articulated and made manifest through rights-based, often liberal discourse and practice, which can feel provocative or even threatening to some sections of society who decry what they perceive as the unacceptable politicisation of the past (Jenkins 2011; Rothstein 2010). At the same time, well-meaning attempts to contribute to issues of injustice and inequality through inclusive heritage practices can inadvertently work to reproduce the biases and inaccuracies that such work seeks to challenge (Lynch and Alberti 2009; Lagerkvist 2006).

The chapters in this section highlight a range of experiments of diversifying the national narrative and, taken together, begin to reveal some of the underlying reasons for these issues.

For example, diversity is still most often *pursued* through a corrective mode, rather than something that emerges organically through, for example, an embedded, participatory approach to heritage making. As such, core and recognisable heritage narratives and processes may remain less accessible and adaptable for new participants. Moreover, while heritage of all kinds – both 'official' and 'unofficial' to use Harrison's definitions (Harrison 2012: 14–15) – has been identified as being complicit in sustaining or reinforcing inequalities, the sector's response to this – through efforts of public reconciliation and 'de-colonisation', for example – have not always been positive or successful developments, as several chapters in this section show.

The first chapter, by Simona Bodo, frames these issues by appealing to the importance of a dialogical and participatory approach to heritage. She analyses a number of contrasting examples of approaches to intercultural dialogue in museums in Europe, showing how they share a problematic tendency to present heritage as fixed and given, and intercultural communication as a goal rather than a process. In all of this, diversity is viewed as a 'richness' rather than, as Bodo insightfully claims, something pertaining to unresolved tensions or divisions in society. This severely limits the social impact of such work. Marzia Varutti's chapter illustrates this tendency towards relatively uncontroversial narratives in practice, as she considers a range of approaches to displaying 'other' cultures across Oslo's museological landscape. In particular, Varutti charts the evolution towards presenting contemporary aspects of culture and experiments in more dynamic experience-based 'displays' of diversity at the Intercultural Museum, and dwells on the significance of this alternative approach.

Bodo and Varutti's chapters are placed in a broader context by a conversation that took place in 2012 at a conference on critical heritage studies in Gothenburg, Sweden. At this event, museologist Conal McCarthy led a discussion on the tensions between national conceptions of diversity and local identity in heritage practice. The conversation that ensued acted as a 'taking stock' moment, where participants raised a number of compelling questions on the future of diversity in heritage from a range of international perspectives. Here, McCarthy points to the difficulties of presenting the difficult histories of the nation, while Mason responds with her observations of the inadequacies of the 'core-plus' model of inclusion; the adding in of 'other' cultures into mainstream narratives. Mason muses on alternative models for framing diversity and fostering inclusion in ways which avoid essentialising identities, such as those framed in geographic terms or through cross-community issues. Later in this discussion, Chris Whitehead considers migration and the particular relationship this has with concepts of inclusion and exclusion at the level of nation and citizenship. He notes that displays of migration above all prioritise positive stories of assimilation, despite widespread anxieties in relation to immigration and its perceived impact on local identities and resources. Such observations have a significant resonance at the time of writing, in both Europe and the United States, as political and public debates around immigration in the context of mass displacement continue to rage. To this, Witz draws attention to the disconnect between local heritage and communities in a post-apartheid South African context where local identities are laced with xenophobia and intolerance, offering further insights into expressions of local heritage which are less acceptable in the context of professional heritage practice.

Ambos' insightful contribution to McCarthy's discussion shifts our attention to how identities and ethnicities can be essentialised within heritage practices in the context of increased migration and transnationalism. This is taken forward with a new chapter for this volume written by Kraamer and Barnes, which productively rethinks existing ways of framing diversity through ethnicity and place in the context of transnational experiences. In their focused look at expressions of identity in fashion, textiles and dress within both East African Asian communities in the UK and within collaborative museum project work, Kraamer and Barnes suggest how key

514

framing notions in both heritage and identity such as an emphasis on place may be inadequate in the processes of diversifying local narratives.

In a personal account, Daehnke (2012) offers an analysis of heritage programming around the Bicentennial of Lewis and Clark's 'Corps of Discovery' and specifically Maya Lin's 'Confluence Project', a series of art installations along the banks of the Columbia River, which sought to emphasise a plurality of voices on the present day meanings of the historic expedition. The Project explicitly sought to reimagine the impact of the expedition on Native peoples in terms of a 'shared heritage' in order to contribute to positive movements towards environmentalism and sustainability in the present day. For Daehnke, the notion of a shared heritage across communities with very different historical and social experiences is deeply problematic, providing an 'ahistorical story of shared environmental concerns' to suit a present day desire for cohesion. This stands as one of many examples that, in the words of Elizabeth Cook-Lynn, fail to address the 'doctrinal hatred' of Native Americans, which many feel needs to be acknowledged in such work (Atalay 2008). Crucial here, in a post-colonial context, is the continued relevance of the histories and legacies of prejudice that sit beneath heritage work that explicitly aims to brings communities together, and the difficulties this can place on the positive expressions of community that some feel are very important to moving forward. We might look to Lehrer (this volume), who cautions us to approach such work ethically and yet with due optimism that embodied encounters have the power to generate empathy. As he writes, ' "reconciliation", if it is to be meaningful, is not achieved in one fell swoop; it is an organic process that unfolds in daily life, within and between aggrieved communities' (Lehrer 2010, this volume).

The preference for using heritage to express unity and celebrate a positive notion of diversity is a theme expanded upon by my chapter (Bunning, this volume) in the context of museum developments at the Smithsonian Institution. Here, I analyse a number of critiques around perceived overplaying of 'identity politics' that accompanied the somewhat controversial shift in museum practice towards culturally-specific narratives, and draw attention to the centrality of notions of race and the emergence of post-racial discourses in this context. This is a discussion which intends to open up questions of museums' roles in identity representation through expressing cultural distinctiveness, racial experience and, at the same time and somewhat problematically, notions of shared heritage.

In the penultimate chapter of this section, Silberman places a discussion of diversity into the context of rights-based heritage management, identifying three distinct interpretive approaches in such work. Rather than approaching these as operating separately, Silberman points to the opportunities of bringing together this range of interpretive approaches, which express cultural identity, focus on the accurate documentation of heritage, and promote universal values. While addressing the particular context of World Heritage Sites, Silberman nevertheless speaks to the range of problematic issues raised in this section, such the frameworks of essentialised identities, the difficulties of expressing unity, understandings of nation, and the need for participatory approaches in the production of heritage, a theme expanded upon in Part V of this volume.

Questions of diversity – how it should be acknowledged, interpreted, made visible, and how it should shape heritage practice and participation – remain vital to pursue today, as nations and communities continue to fragment over different ideals and values. Additionally, we need to question the role that heritage professionals can play in this work with a clear-eyed view of the opportunities and limitations of current practice.

Bibliography

Atalay, S. (2008). 'No sense of the struggle: Creating a context for survivance at the National Museum of the American Indian', in Lonetree, A. and Cobb, A. (eds.) *The National Museum of the American Indian: Critical Conversations*. Lincoln: University of Nebraska Press, pp. 267–289.

Bennett, T., Grossberg, L. and Morris, M. (2005). *New Keywords: A Revised Vocabulary of Culture and Society*. Hoboken: Blackwell.

Bodo, S. (2012). 'Museums as intercultural spaces', in Sandell, R. and Nightingale, E. (eds.) *Museums, Equality and Social Justice*. London and New York: Routledge, pp. 181–191 (this volume).

Daehnke, J. (2012). 'Reflections on the Confluence Project: Assimilation, sustainability, and the perils of a shared heritage', *The American Indian Quarterly*, 36 (4): 503 (this volume).

Hall, S. (1999). 'Whose heritage?: Un-settling "the heritage", re-imagining the Post-nation', *Third Text*, 13 (49): 3–13.

Harrison, R. (2012). *Heritage: Critical Approaches*. Abingdon and New York: Routledge.

Hartmann, D. (2015). 'Reflections on race, diversity, and the crossroads of multiculturalism', *The Sociological Quarterly*, 56 (4): 623–639.

Jenkins, T. (2011). 'Turning museums into cultural ghettos'. *Spiked!*, 22 June, www.spiked-online.com/newsite/article/10621#.WZiZSiiGNPY, accessed 18 February 2013.

Lagerkvist, C. (2006). 'Empowerment and anger: Learning how to share ownership of the museum', *Museum and Society*, 4 (2): 52–68.

Lehrer, E. (2010). 'Can there be a conciliatory heritage?', *International Journal of Heritage Studies*, 16 (4–5): 269–288 (this volume).

Lynch, B. and Alberti, S. (2010). 'Legacies of prejudice: Racism, co-production and radical trust in the museum', *Museum Management and Curatorship*, 25 (1): 13–35.

McCarthy, C. *et al.* (2013). 'Museums in a global world: A conversation on museums, heritage, nation and diversity in a transnational age', *Museum Worlds*, 1 (1): 179–194 (this volume).

Message, K. (2007). 'Museums and the utility of culture: The politics of liberal democracy and cultural well-being', *Social Identities: Journal for the Study of Race, Nation and Culture*, 13 (2): 235–256.

Modest, W. (2016). 'On the Nowness of Now, or Museums in the Age of the Global Contemporary', Keynote conference paper at 'Museums in the Global Contemporary', 20–22 April. School of Museum Studies, University of Leicester, Leicester, UK.

Rothstein, E. (2010). 'To each his own museum, as identity goes on display', *New York Times*, 28 December, www.nytimes.com/2010/12/29/arts/design/29identity.html, accessed 27 April 2014.

Silberman, N. (2011). 'Heritage interpretation and human rights: documenting diversity, expressing identity, or establishing universal principles?', *International Journal of Heritage Studies*, 18 (3): 245–256 (this volume).

Varutti, M. (2011). 'Gradients of Alterity: Museums and the Negotiation of Cultural Difference in Contemporary Norway', in Naguib, S. *et al.* (eds.). *Patterns of Cultural Valuation. Priorities and Aesthetics in Exhibitions of Identity in Museums*, Special Issue, *ARV: Nordic Yearbook of Folklore*, 67: 13–36 (this volume).

35

Museums as intercultural spaces

Simona Bodo

Many museums were founded in order to represent and validate national, local or group identities and have been understood to function as spaces which have tended to work against contemporary social and political concerns for cultural diversity and inclusion. Increasingly, however, museums are being perceived as places which might nurture respect for cultural differences and foster dialogue between groups (Bodo *et al.* 2009; Sandell 2007). This chapter draws on recent European research to examine this trend in museological thinking and practice and, in particular, looks at contemporary, experimental initiatives from Italy to consider the role that museums might play in promoting equality and mutual understanding between communities in multicultural societies.

Heritage, museums and intercultural dialogue: a problematic relationship

The very notion of 'heritage' can be problematic when we begin to consider these issues. For many it can seem to refer to something that is attained 'once and for all' by birthright, rather than developed by an individual throughout their lifetime (Matarasso 2006); a perception that has informed the views of many policy-makers and museum professionals but also underpinned broader public understandings of heritage. As Matarasso has highlighted, it is commonly assumed that:

> one can become a cultured person; one can learn to understand and appreciate art, music, or ballet … one can accumulate cultural capital … But one cannot acquire a heritage: it is given, fixed at birth. Heritage claims an essential, and ineradicable, difference between someone born in a village, or a country, or a faith, and someone who has chosen to make their life within that social and cultural framework; and that distinction, paradoxically, disadvantages the person who has freely chosen an identity, making a conscious commitment to a place, a group or a set of values. In this world, a migrant can only ever be an honorary member, an affiliate whose status, whether welcomed or merely tolerated, is always at risk of revocation.

(2006: 53–4)

Simona Bodo

For Matarasso, however, heritage should not be 'mistaken for the neutral remains of the past, as most heritage bodies imply … Rather, it is how people interpret evidence of the past for present use; and one of those uses is to define themselves' (ibid.: 53). Building on this understanding of the constructed nature of heritage, it is possible to determine two main interpretive paradigms (Besozzi 2007) with radically different implications for museums. The 'essentialist paradigm' sees heritage as the 'neutral remains of the past': static, consolidated, 'of outstanding universal value'[1] and, as such, something to be 'transmitted' through a linear communication process from the curator (as the only reliable source of authority and expertise) to the cognitively passive visitor. The 'dialogical paradigm', on the other hand, understands heritage as a set of cultural objects – both material and immaterial – that should not only be preserved and transmitted, but also renegotiated, reconstructed in their meanings and made available for all to share in a common space of social interaction.[2]

In the real world, both paradigms represent legitimate concerns and interests and, in fact, need not be understood to be entirely in conflict with each other. Whilst in the former, decisions are made on what is worth preserving and transmitting to future generations, in the latter, this heritage is constantly questioned and rediscovered by individuals who breathe new life into it. As museum mediator Rita Catarama observes, 'heritage is not something separate from life' (Pecci 2009a: 129).

Tensions emerge, however, since the essentialist paradigm has dominated most institutional policy and practice thereby constraining dialogical notions of heritage, compromising the accessibility of museums and excluding those who do not possess an 'adequate' level of cultural literacy, let alone a sense of belonging.

In light of this tension between a more traditional, self-referential, and a more inclusive, participatory way of conceiving heritage, how are museums responding to a political agenda which is increasingly urging them to play a role in the promotion of intercultural dialogue? I began to address this question in 2007, through my involvement in a study on European Union member states' approaches to intercultural dialogue in different policy domains (culture, education, youth and sport), carried out by the European Institute for Comparative Cultural Research (ERICarts Institute) on behalf of the European Commission Directorate General for Education and Culture (Bodo 2008). My brief within this project was to investigate the different understandings of intercultural dialogue and the resulting policy approaches to its promotion in museums across Europe.[3] In this chapter I provide an indicative selection of the approaches found in the study and focus on whether and how museums have been successful in encouraging interaction between different cultural groups.

Understandings of intercultural dialogue

One of the prevailing understandings of a museum's responsibility to promote intercultural dialogue has been to encourage increased knowledge and greater recognition and appreciation of 'other' cultures. Although this approach may take very different forms (for example, by showcasing difference as an educational strategy to inform audiences about cultures which have traditionally been misrepresented or made invisible in museum spaces; or by exposing and challenging past and present stereotypes concerning certain cultural traditions), what often distinguishes these initiatives is not so much a will to encourage attendance and participation on the part of migrant communities, as to promote a 'knowledge-oriented multiculturalism' directed principally at an autochthonous public. Here, the 'other' is conceived as an object of knowledge – rather than an individual with whom we engage in a relationship – and is constructed from the point of view of a dominant culture; one 'unmarked by ethnicity in relation

to which the differences of other cultures are to be registered, assessed and tolerated' (Bennett 2006: 24).

At the opposite end of the spectrum, the promotion of intercultural dialogue has often been associated with the integration of 'new citizens' within mainstream culture, by helping migrant communities to become familiar with a country's history, values and traditions. In the best of cases, these initiatives are rooted in communities' needs and expectations, rather than driven by curatorial and institutional interests, or transitory political and social agendas (Bodo 2009b). For example, some museums are actively supporting groups of recent arrivals and helping them settle into the new country by assisting them with language learning. Others are encouraging an inclusive mediation of the local heritage by experimenting with a participatory approach to the interpretation of collections. However, some initiatives, typically including guided tours to museums and heritage sites targeted at specific groups, have turned out to be rather more problematic due not only to a lack of consistent outreach policies and limited direct involvement of participants but, in some cases, to a patronising attitude,[4] intended 'to make it easier for those who are not yet believers to learn to appreciate what they are missing' (Matarasso 2004: 493).

A further option which is being increasingly explored by museums across Europe is 'culturally specific programming', for example the development of exhibitions and events drawing on collections that might hold particular significance for an immigrant community. Along-side these initiatives, intended to redress the under- or misrepresentation of specific minority groups, there has been a growing interest in collections or programmes that reflect the cultural heterogeneity of a region or city's population and those which explore topics (such as the history of immigration, colonialism and slavery) that enable diverse cultures to be represented.[5] Some communities are actively involved by museums in the interpretation of collections or assisted with preserving and presenting their own cultural heritage (whether it be material or immaterial), while other communities are attempting to establish their own museums or community archives.

The ERICarts survey found that these approaches, as different as they may be, often have some key features in common (Bodo 2008). First, they tend to utilise a static, essentialist notion of heritage, which is primarily seen as a 'received patrimony' to safeguard and transmit. Second, they generally target communities exclusively in relation to their own cultures and collections, while cross-cultural interaction across all audiences is generally avoided. Third, by keeping 'majority' and 'minority' cultures and communities apart – and by generally treating the latter as 'unified, traditional, unchanging and thereby exotic' (Bloomfield and Bianchini 2004: 98) – they sometimes operate to reinforce rather than to challenge stereotypes. Fourth, they are inclined to embrace the rhetoric of 'diversity as a richness', rather than acknowledging and confronting tensions and frictions between communities. Lastly, these approaches are generally based on an understanding of 'intercultural dialogue' as a *goal* to be attained rather than as a *process*, ingrained in a museum's practice, through which it might promote 'multiple visions and interpretations' (Veini and Kistemaker 2003: 20). In other words, the concept of multiple and shifting identities – which is so central to intercultural dialogue as it permits a move beyond the prevailing rationale of cultural representation (including diverse communities in museum narratives) – may well be widely accepted in theory but, in reality, is very seldom placed at the heart of a museum's work.

By highlighting these common features, however, I am not suggesting that these approaches are to be discredited or abandoned. Indeed they all have an important role to play – not least, in supporting diverse communities and helping individuals and groups to maintain a vital link with their cultural traditions – and provide the basis for the promotion of museums as inter-cultural spaces (Bodo 2009a). Rather, what I wish to contend is the need to work towards what Young

Simona Bodo

refers to as 'a more integrative model of diversity, rather than the current model with its tendency to reify difference and put people into discrete categories without interaction or overlap' (Young 2005).

This approach will demand an honest, open and comprehensive rethinking on the part of museums around what it really means to carry out intercultural work. Does such work involve enhancing the cultural literacy of immigrant communities through familiarity with a country's history, art and culture, or 'compensating' for the misrepresentation of minorities in cultural narratives, as many museums and heritage institutions have understood it? Or, might intercultural work be conceived more productively as a bi-directional, dialogical process which is transformative of all parties (majority as well as minority representatives; those from host as well as immigrant backgrounds) and in which all are equal participants?

Museums as 'intercultural spaces': exploring new paradigms

Based on an overview of the most recent developments in Italian museums' thinking and working practices,[6] I wish to argue here that alongside the more established policy responses to the growing diversity of museum audiences – and ideally as their culmination – there is a pressing need for strategies and programmes aimed at creating 'third spaces', where individuals are permitted to cross the boundaries of belonging (Bodo 2008) and are offered genuine opportunities for self-representation.

To explore the ways in which Italian museums are responding to this need for 'third spaces' I wish to highlight three significant strands of experimental practice. First, some museums are taking on the training of immigrant cultural mediators[7] with a view to exploring a more dialogical, multi-vocal interpretation of collections. Second, some institutions are actively engaging mixed groups in the development of new, shared narratives around collections through storytelling, theatre techniques and other mediation methodologies, starting from the premise that project participants can provide a significant contribution to the knowledge, understanding and interpretation of museum objects. Third, some museums are facilitating interaction with contemporary artists in order to develop new perspectives on the notions of heritage or identity, and to experiment with unconventional communication and relational methodologies, mediated through contemporary art languages.[8]

The potential of the first area of experimentation – cultural mediators as 'new interpreters' of the museum's heritage – is evident in a project called *Tongue to Tongue: A Collaborative Exhibition*, jointly promoted by the Museum of Anthropology and Ethnography of the University of Turin and the Centre for African Studies (Pecci and Mangiapane 2010; Pecci 2009b; Bodo *et al.* 2009).

Tongue to Tongue was based on a participatory approach to the interpretation and display of collections, involving mediators,[9] the museum's staff and an architect/exhibition planner (playing the threefold role of exhibition designer, facilitator and 'translator' of the mediators' knowledge and expertise) in the planning and mounting of a multi-vocal exhibition. The voice or 'tongue' of the museum – institutional, scientific, didactic – engaged in dialogue with the mediators' voices – autobiographical, evocative, emotional – hence the title of the exhibition. At the heart of the project was a training course primarily conceived as a process of cultural empowerment, providing 'first and second generation migrants and cultural mediators with genuine opportunities for self-representation and cultural re-appropriation of tangible and intangible heritages' (Pecci 2009b).

During the course – which developed participants' skills in a range of areas from the use of storytelling as a heritage mediation tool to youth engagement – each mediator freely selected

from the museum's ethnographic collections one or more objects, not necessarily directly related to their own cultural backgrounds, but nevertheless 'holding a particular significance for them, as they revealed sometimes unexpected links with their personal history, past and present, or with their knowledge systems and memories' (Bodo *et al.* 2009: 36). The selection of objects from the collection was followed by the planning of 'narrative routes' for visitors, developed in close cooperation with the museum's staff. Finally, the objects were displayed in showcases alongside the 'subjective heritage' of mediators (souvenirs, pictures, books, clothes and so on), thereby creating an impressive range of autobiographical installations. Through this project: 'Museum objects … revealed their capacity to evade the classifications and narratives into which they had been institutionally inscribed and to be re-presented into a new, more connective display' (Pecci and Mangiapane 2010: 149).

The visit to the exhibition, mainly addressed to local students attending the last two years of secondary school, but also to the general public of the Museum and to under-represented audiences (in particular, young people and immigrant communities), consisted of dialogical 'narrative routes' resulting from the interaction and exchange of knowledge and perspectives between a museum educator and a mediator.

> The [museum educator] gave an account of the 'journeys', both geographical and museological, of the displayed object; through storytelling, the [mediator] helped the educator and the audience put the objects in context, by highlighting their history, their functions and interpretations, and sometimes their ideological use. The autobiographical approach also allowed mediators to incorporate their individual (and migratory) stories in the displayed objects and exhibition spaces.
>
> *(Pecci 2009b)*

A key achievement of *Tongue to Tongue* is the reciprocity it encouraged between the museum and mediators, by bringing into dialogue their different perspectives, experiences and knowledge bases, and incorporating them not only in interpretation (the development of the 'narrative routes'), but also in display (the planning and mounting of a multi-vocal exhibition). Overall, the project demonstrates that:

> the potential role of museums as agents of social change lies in their contribution to the recognition as well as to the reflective deconstruction of the cultural identity of individuals and groups. But in order for this to be achieved, the museum's areas of work must be conceived as *processes*, rather than as tightly defined 'mechanical' functions such as conservation, exhibition and education.
>
> *(Pecci 2009a: 15)*

The second strand of experimental practice I would like to explore – the engagement of mixed groups in the development of new, shared narratives around collections – found an ideal testing ground in the Guatelli Museum. The history of this most peculiar museum is closely connected with the personal story of its creator, Ettore Guatelli, a primary school teacher born in 1921. Interested in objects as evidence of the history of mankind, Guatelli was particularly fascinated by the narratives they embody and unfold. The collection reflects daily life through the poetry of objects (utensils from rural culture and everyday objects such as boxes, toys, shoes and pottery), evocatively displayed on the museum walls. In trying to initiate intercultural dynamics and participation patterns in the local community's life, the project *Plural Stories* (Turci 2009; Bodo *et al.* 2009) drew inspiration from the museum founder's vision, in that it aimed at

collecting histories and experiences of participants in some way connected with the collections. As Mario Turci, director of the Guatelli Museum, observes, 'women became part of a "provisional community" interested in developing new interpretations of the relationship between personal biographies and the biographies of objects' (Turci 2009: 65).

Project participants (ten native and migrant women, aged between 18 and 60) were identified outside formal learning contexts through contacts with local associations and with the support of two neighbouring local authorities. One of the key aims of *Plural Stories* was to help participants 'recognise, interpret and conceptualise tangible and intangible elements acquiring a heritage value with respect to both their original culture and the culture of the place where they have settled' (Bodo *et al.* 2009: 52).

The initial intention to invite participants to describe objects in written form was subsequently revised due to significant differences in literacy levels amongst the women. The project team opted instead for a theatre workshop (run by FestinaLente Teatro, one of the museum's partners in this project), where women were free to express themselves through verbal and non-verbal language. In fact, the use of theatre techniques helped overcome linguistic barriers and enabled a strong interaction between project participants. This was achieved through the shared recovery of 'gestural memories' drawing inspiration from the museum's spaces and objects (for example, the gesture of washing clothes, of lighting a fire and so on), as well as through storytelling and the exchange of narratives triggered by the participants' own objects (a sort of 'personal museum'), and connected with their respective life experiences and contexts of origin. Through *Plural Stories*, 'The past embodied in objects was conceived and explored as a "foreign country", which helped define a "third space" where participants could share the development of new knowledge systems, skills and experiences' (Bodo *et al.* 2009: 53).

The project ended with an itinerant theatre performance held across the museum's spaces, in which women gave life to their stories through spoken and body language. The title of the performance, *Plural Stories: From Hand to Hand*, reflects the belief that heritage, conceived in its dialogical dimension, is constantly re-created and enriched by being passed on from one individual to the other, from one generation to another.

A third strand of practice with which Italian museums are increasingly engaging is the interaction with artists with a view to visualising intercultural dynamics through contemporary art languages.

The *City Telling* project, launched by the Sandretto Re Rebaudengo Foundation in Turin (Bodo *et al.* 2009; Pereira *et al.* 2010), offers an interesting example of how this can be achieved. The underlying goal of the project was to increase the opportunities for cultural participation of young immigrants (students of a local centre for adult education and training), as well as to build a common ground of cultural, linguistic and aesthetic interaction, by helping participants to 'develop a critical understanding of the reality surrounding them; increase their ability to analyse and communicate their own experience of the world; acquire the necessary skills to carry out personal inquiry and re-discover the urban territory where they live' (Bodo *et al.* 2009: 34).

City Telling started with the setting up of a team composed by the education staff of the Foundation, teachers from the Drovetti Centre for Adult Education and Training, artist-director Gianluca De Serio and photographer Anna Largaiolli, who exchanged views and expertise with respect to the methodological approach as well as to their respective knowledge of the territory to explore during the project. For six months, the group of young students were actively involved in discovering their local urban space. The project began by enabling the students to share their geo-cultural origins through storytelling and the use of objects, photographs, postcards and web technologies. In the following phase of the project, De Serio and Largaiolli guided the students in two parallel itineraries respectively devoted to video and photographic

storytelling, a methodology with which the education staff of the Foundation was very familiar. The two working groups developed a personal route across urban space, by identifying significant spots in the city (schools, museums, libraries, private homes, gardens, places of worship, urban installations, services and meeting spaces) and collecting their manifold impressions in a journal made of photographs, observations and audiovisual creations. A key strength of the project was the chance for participants to work at leisure in the Foundation's exhibition spaces, where the artworks provided opportunities for reflection, writing and the production of audiovisual materials.[10]

One of the photographic series produced by *City Telling* project participants drew inspiration from an artwork in the Sandretto Re Rebaudengo Foundation's permanent collections – *A-Z Living Unit*, by Californian artist Andrea Zittel – which is concerned with travelling through different cultural contexts and discovering what is essential for living. Dina and Belen, the two young participants who produced their own photography inspired by this piece, spent a lot of time in the room where *A-Z Living Unit* was exhibited, as they knew the idea of 'being here and somewhere else at the same time' was central to their own story. The series opens with the parallel awakening of Dina and Belen in two different parts of the city; both feel an initial sense of being *at home*, before their dreaming gives way to reality. Walking around Turin, across different kinds of spaces (changing spaces, empty spaces, spaces full of memory, spaces of desire), Dina and Belen talk about their past, present and future, how they see and don't see themselves, the trace they want to leave in the city.

Conclusions

Whilst these three projects involved different groups, heritage institutions and working practices, they can nevertheless be understood to have grown out of a shared assumption: that the rethinking of heritage from a participatory, dialogical, intercultural perspective is an important pursuit, one which holds the potential to impact all citizens. Museums as intercultural spaces can function to not only promote the cultural rights of migrant communities but also to nurture in *all* individuals ('natives' and 'migrants'), those attitudes, behaviours and skills (including cognitive mobility; the ability to question one's own points of view and to challenge stereotypes; the awareness of one's own multiple identities) which are indispensable in a world of increasing contact and interaction between culturally different groups.

The exploratory and experimental projects discussed in this chapter show a willingness on the part of some museum professionals to go beyond policies targeting individuals and groups according to their racial origin and ethnicity; initiatives which are often based on the over-simplistic assumption that a 'community' will be interested exclusively in objects and issues that are specifically and directly related to its cultural background. As Pecci and Mangiapane (2010: 147) argue, 'Migrants are not representatives of the cultures they come from, but interpreters or witnesses who, instead of wearing the uniform of culture, creatively escape from its essentialist definition of a bounded and confined unity'. In other words, these projects work on identity as 'the start rather than the end of the conversation' (Khan 2010), and work with a notion of the museum as a space for generating new (inclusive and liberatory) meanings (Pecci and Mangiapane 2010; Sandell 2007). Moreover, they highlight methodological issues which are key to the development of 'third spaces'. In such spaces, the use of a thematic approach to the presentation of collections is not simply an alternative way of transmitting content or specialist knowledge but rather it is aimed at helping participants develop a critical understanding of the reality surrounding them and increasing their ability to analyse and communicate their own experience of the world. Similarly, autobiographical storytelling is explored, not simply as a one-off chance for

self-expression but instead as an opportunity to facilitate an ongoing reflection on the role of the museum and to lay down foundations for continued dialogue and cooperation. Finally, such spaces emphasise the evocative and emotional power of objects, not only to strengthen group allegiances but also to disengage objects and audiences from the prevailing rationale of cultural representation (Bodo 2009b).

Museums' increasing concern to function as spaces for intercultural dialogue represents a significant international trend in museological thinking and practice. Underpinning such efforts is the recognition that this work can promote more diverse and less stereotypical images of communities by providing participants with the opportunity for self-representation; it can create shared spaces where meaningful, interactive communication takes place and all participants are recognised as being equal. At the same time, the experiences of museums working in this field highlight how hard it still is, even for the most forward-looking institutions, to break the dichotomy between curatorship as a core function (carried out by museum experts) and education, outreach and community engagement as an activity which takes place in the margins, where project ownership and the active involvement of participants are more easily tolerated, precisely because they do not seem to threaten the authority and expertise of curators and scientific staff.

Further challenges for the museum sector, therefore, lie in ensuring that the outcomes of programmes and activities aimed at promoting cross-cultural interaction between different audiences are more clearly visible and easily retrievable, whether in the museum's collections documentation system or permanent displays; and, perhaps most importantly, in a rethinking of all the fundamental functions of a museum (from collections management and conservation to exhibition strategies) through an intercultural perspective, so that this is built into its institutional fabric. As the museum anthropologist Christina Kreps observes, 'achieving interculturality is a step by step process that may help, with every project and every action, to not only transform our societies, but also our museums and the nature of public culture' (2009: 4).

Notes

1 See article 1 of the UNESCO World Heritage Convention (1972: 2).
2 See article 2 of the UNESCO *Convention for the Safeguarding of the Intangible Cultural Heritage* (2003: 2), which acknowledges heritage as being 'constantly recreated by communities and groups in response to their environment, their interaction with nature and their history'.
3 A growing body of research around good practice in intercultural dialogue in museums across Europe and beyond is available, arising from a number of surveys and action-research projects: see for example Bodo *et al.* (2009); Gibbs *et al.* (2007); CLMG – Campaign for Learning through Museums and Galleries (2006).
4 In Italy, this attitude is best exemplified by initiatives aimed at 'explaining Italian art to non-EU citizens'.
5 Sandell (2004) offers a useful categorisation of museum initiatives such as these and their underpinning motivations and potential social effects and consequences.
6 In 2007, Milan-based Fondazione Ismu (Initiatives and Studies on Multiethnicity) launched *Patrimonio e Intercultura* (http://fondazione.ismu.org/patrimonioeintercultura, English version available), an online resource exclusively devoted to heritage education in an intercultural perspective, which regularly monitors projects carried out in Italian museums. For an overview of the Italian museum sector in terms of cultural diversity and intercultural policies see also Bodo and Mascheroni (2009).
7 As the term 'mediator' is interpreted differently across the museum sector in Europe, it is worth clarifying that, in the Italian context, the expression 'cultural/linguistic mediator' is mainly used to describe professionals with an immigrant background acting as 'bridges' with their respective communities in sectors such as formal education and the healthcare system. Only recently has this profession started to be developed in a museum/heritage context.

Museums as intercultural spaces

8 The three case studies presented in this section of the chapter were all carried out in the framework of the European project, *MAP for ID – Museums as Places for Intercultural Dialogue* (www.mapforid.it; see also Bodo *et al.* 2009), funded by the European Commission as part of the Grundtvig Lifelong Learning Programme.

9 Trained mediators' countries of origin ranged from Chad, Congo and Senegal to Italy, Morocco and Romania.

10 The short films and photographic series produced through this project can be viewed in the 'Videos' section of the website *Patrimonio e Intercultura.*

Bibliography

Bennett, T. (2006) 'Cultura e differenza: teorie e pratiche politiche', in S. Bodo and M. R. Cifarelli (eds) *Quando la Cultura Fa la Differenza. Patrimonio, Arti e Media nella Società Multiculturale*, Roma: Meltemi: 21–37.

Besozzi, E. (2007) 'Culture in gioco e patrimoni culturali', in S. Bodo, S. Cantù and S. Mascheroni (eds) *Progettare Insieme per un Patrimonio Interculturale*, Quaderni Ismu 1/2007, Milan: Fondazione Ismu: 19–28.

Bloomfield, J. and Bianchini, F. (2004) *Planning for the Intercultural City*, Stroud: Comedia.

Bodo, S. (2008) 'From "heritage education with intercultural goals" to "intercultural heritage education": conceptual framework and policy approaches in museums across Europe', in ERICarts Institute (ed.) *Sharing Diversity. National Approaches to Intercultural Dialogue in Europe*, final report of a study carried out on behalf of the European Commission – Directorate General for Education and Culture. Online. Available at: www.interculturaldialogue.eu (accessed 25 August 2011).

Bodo, S. (2009a), 'The challenge of creating "third spaces": guidelines for MAP for ID pilot projects', in S. Bodo, K. Gibbs and M. Sani (eds) *Museums as Places for Intercultural Dialogue: Selected Practices from Europe*, Dublin: MAP for ID Group: 22–4.

Bodo, S. (2009b) 'Introduction to pilot projects', in S. Bodo, K. Gibbs and M. Sani (eds) *Museums as Places for Intercultural Dialogue: Selected Practices from Europe*, Dublin: MAP for ID Group: 26–30.

Bodo, S. and Mascheroni, S. (2009) 'Il patrimonio culturale, nuova frontiera per l'integrazione', in Fondazione Ismu, *Quattordicesimo Rapporto sulle Migrazioni 2008*, Milan: FrancoAngeli: 253–61.

Bodo, S., Gibbs, K. and Sani, M. (eds) (2009) *Museums as Places for Intercultural Dialogue: Selected Practices from Europe*, Dublin: MAP for ID Group.

Campaign for Learning through Museums and Galleries (2006) *Culture Shock: Tolerance, Respect, Understanding … and Museums*, London: Home Office.

Fondazione Ismu (Initiatives and Studies on Multiethnicity) (2007) *Patrimonio e Intercultura*. Online. Available at: http://fondazione.ismu.org/patrimonioeintercultura (accessed 25 August 2011).

Gibbs, K., Sani, M. and Thompson, J. (eds) (2007) *Lifelong Learning in Museums. A European Handbook*, Ferrara: Edisai.

Khan, N. (2010) *The Artist as Translator*, paper delivered at the seminar 'Super Diversity – Who Participates Now? Discussion on the Phenomenon of "Super Diversity" in the Visual Arts', Institute of International Visual Arts, London, 2 February.

Kreps, C. (2009) 'Foreword', in S. Bodo, K. Gibbs and M. Sani (eds) *Museums as Places for Intercultural Dialogue: Selected Practices from Europe*, Dublin: MAP for ID Group: 4–5.

Matarasso, F. (2004) '*L'Etat, c'est nous*: arte, sussidi e stato nei regimi democratici', *Economia della Cultura*, Journal of the Italian Association for Cultural Economics (themed issue edited by S. Bodo and C. Da Milano on Culture and Social Inclusion), 4: 491–8.

Matarasso, F. (2006) 'La storia sfigurata: la creazione del patrimonio culturale nell'Europa contemporanea', in S. Bodo and M. R. Cifarelli (eds) *Quando la Cultura Fa la Differenza. Patrimonio, Arti e Media nella Società Multiculturale*, Rome: Meltemi: 50–62.

Pecci, A. M. (ed.) (2009a) *Patrimoni in Migrazione. Accessibilità, Partecipazione, Mediazione nei Musei*, Milan: FrancoAngeli.

Pecci, A. M. (2009b) 'Tongue to Tongue', in 'Projects', *Patrimonio e Intercultura*. Online. Available at: http://fondazione.ismu.org/patrimonioeintercultura/index.php (accessed 24 August 2011).

Pecci, A. M. and Mangiapane, G. (2010) 'Expographic storytelling: the Museum of Anthropology and Ethnography of the University of Turin as a field of dialogic representation', *The International Journal of the Inclusive Museum*, 3 (1): 141–53.

Pereira, M., Salvi, A., Sani, M. and Villa, L. (2010) *MAP for ID. Esperienze, Sviluppi e Riflessioni*, Bologna: Istituto per i Beni Artistici Culturali e Naturali della Regione Emilia-Romagna.

Sandell, R. (2004) 'Strategie espositive nei musei e promozione dell'uguaglianza', *Economia della Cultura*, Journal of the Italian Association for Cultural Economics (themed issue edited by S. Bodo and C. Da Milano on Culture and Social Inclusion), 4: 539–46.

Sandell, R. (2007) *Museums, Prejudice and the Reframing of Difference*, London and New York: Routledge.

Turci, M. (2009) 'Dell'impossibilità che il dialogo possa essere interculturale', in *Antropologia Museale*, Journal of the Italian Society for Demoethnoanthropologic Heritage and Museography (themed issue edited by V. Lattanzi on Heritage, Museums and Collaborative Practices), 20/21: 64–5.

UNESCO (1972) *Convention Concerning the Protection of the World Cultural and Natural Heritage: Adopted by the General Conference at its Seventeenth Session, Paris, 16 November 1972*, Paris: United Nations Educational, Scientific and Cultural Organization.

UNESCO (2003) *Convention for the Safeguarding of the Intangible Cultural Heritage*, Paris: United Nations Educational, Scientific and Cultural Organization.

Veini, E. and Kistemaker, R. (2003) 'Dancing with diversity', *Muse*, XXI (4), Canada Museums Association: 20–3.

Young, L. (2005) *Our Lives, Our Histories, Our Collections*, paper commissioned by the Museum of London. Online. Available at: www.museumoflondon.org.uk/Collections-Research/Research/Your-Research/RWWC/Essays/Essay2 (accessed 25 August 2011).

36

Gradients of alterity

Museums and the negotiation of cultural difference in contemporary Norway

Marzia Varutti

Part of the charm of museums as objects of study resides in their propensity to reflect and inform social and cultural change. As platforms for intercultural communication, museums are ideal sites for the investigation of how collective values and attitudes coalesce and evolve over time. The analysis of these processes is all the more relevant in a country such as Norway, whose population is becoming increasingly multicultural (Goodnow & Akman 2008). In Oslo alone, a quarter of the population are immigrants, mostly of non-Western origin (Council of Europe 2008:2). How are museums responding to these changes in Norwegian society?

This article endeavours to provide an answer to this question through an analysis of museum displays of non-ethnic Norwegian cultures in a sample of museums in Oslo.[1] These include the Intercultural Museum (IKM) and specifically the exhibition *Our Sacred Spaces*; the Kon-Tiki Museum; the ethnographic galleries of the Museum of Cultural History of the University of Oslo; and the Norwegian Museum of Cultural History (specifically, the galleries devoted to the Sami and the display of the Pakistani apartment). The study also draws on examples from other museums, such as the Glomdal Museum in Elverum (specifically the permanent exhibition *Latjo Drom* devoted to the Travellers minority). These museums were selected since they are the main sites in which the visitor may encounter non-ethnic Norwegian cultures, given their location in the capital and their prominence in the national museumscape.

The analysis of museums of non-ethnic Norwegian cultures is based on discourse analysis of displays, analysis of relevant literature and interviews with museum curators and academics. The investigation yielded two main interrelated insights. Firstly, the various modalities in which other cultures are represented in museums point to a range of different articulations of discursive and representational practices which I call "regimes of representation". Secondly, different "regimes of representation" reveal different kinds of assumptions and perceptions of cultural alterity, suggesting that not all Others are equal, but there are different categories of Others, as well as *gradients* of cultural alterity. In the conclusions, I use these findings to question the role that museums can play, in Norway and beyond, in the making of more inclusive societies.

527

Marzia Varutti

Museum displays as regimes of representation

The reader might legitimately question my use of the concepts of "Other" and "cultural differ-ence" as analytical categories. These concepts are problematic because they imply a self-centred stance in relation to which *other* cultures are viewed and commented upon. Indeed, it might be objected that the use of these concepts actually helps to reinstate and formalize the very system of assumptions about other cultures that this article is trying to debunk. Aware of this risk, I resolved to retain the term "Other" (hyphenated) for the sake of brevity and clarity to signify "non-ethnic Norwegian". The concept of cultural difference is used in the definition provided by Homi Bhabha (1988:18):

> [cultural difference] is the process of the *enunciation* of culture as "knowledge*able*", authoritative, adequate to the construction of systems of cultural identification. [...] [*it*] is a process of signification through which statements of culture or on culture differentiate, discriminate, and authorize the production of fields of force, reference, applicability, and capacity.

Understood as a construct, cultural difference is a useful concept for the analysis of cultural phenomena, especially when contrasted with the more descriptive notion of cultural diversity (e.g. Bhabha 1988; Eriksen 2006). Explorations of how cultural difference is created, expressed, negotiated or reinvented in museums gain saliency when framed through the perspective of material culture, that is, considering how museum objects are used for the above-mentioned purposes. As Christopher Tilley (2006:61) notes, "material forms do not simply mirror pre-existing social distinctions, sets of ideas or symbolic systems. They are instead the very medium through which these values, ideas and social distinctions are constantly reproduced and legiti-mized, or transformed." It might be added that in order for material forms to become such media – in Alfred Gell's (1998) words, to carry agency – some kind of human intervention is needed (see also Keane 2001:75; Steiner 2001:210). In museums such agency becomes visible in the work of curators: the writing of texts and labels, the selection and juxtaposition of objects, the choice of images, photos and references that complement the display. Moreover, displays always entail processes of displacement and re-interpretation which I argue, following James Clifford (1997:3), are constitutive of cultural meanings and therefore deserve scholarly attention.

In order to analyse these processes, I draw on Arjun Appadurai's (1986) theory on the social life of things. Appadurai's main argument entails that during their social life, objects move across different regimes of value and as they do so, they take up different meanings. Building on Appa-durai's concept of regime of value, I argue that different combinations of display techniques and narratives constitute different regimes of representation in museums. It follows that – applying Appadurai's theory – museum objects can be made to evoke different meanings according to the museological regime of representation through which they are framed.

The concept of regime of representation can be fruitfully juxtaposed with the concept of regime of visibility. As in the case of Appadurai's regimes of value, the term "regime" indicates that a system of control of what is being represented and seen is in place. The emphasis on regu-lation is also central to the anthropologist Stephan Feuchtwang's (2011:65) conceptualization of regimes of visibility as "a disposition of political authority, in a narrow sense, and more broadly, an habitual ordering of the world into what can and what cannot be seen, a regime which also entails ways of making the invisible apparent, of imagining it. Behind visualization is an invisible authority that makes it possible, an authority that reveals hidden principles and forces, of good

or of malice, of truth or of error." In Feuchtwang's approach, the regime of visibility is firmly inscribed in (and indeed made possible by) the combined deployment of political authority and scientific authentication, which legitimate and validate what is on view.

In the context of a museum display, such political authority and scientific authentication are manifested in the work of curators. The regime of representation can then be understood as the result of curatorial choices and professional knowledge; these, to paraphrase Feuchtwang, constitute the invisible authority behind visualization. The regime of representation is then a concept that facilitates the analysis of processes of exhibition making by giving a name to the set of interrelated display techniques and narrative lines that constitute a given museological genre.

The concept of regime of representation enables and invites a closer examination of its constitutive elements and of the dynamics through which a given regime is manifested. Among these, framing is one of the most analytically relevant. As Saphinaz-Amal Naguib (in this volume) aptly shows, framing is a useful tool to analyse museum representations.

Framing can be understood as a perspective, a specific angle of interpretation of objects and texts, a given way to organize the elements of an exhibition so that they convey a specific world-view, a mood, or an idea. In short, framing is a museological device through which a regime of representation is instantiated. A regime of representation can be translated through different kinds of framing, and conversely, the same kind of framing device can be deployed in the context of different regimes of representation.

Taken together, these concepts assist scholars in analysing museum displays by providing analytical tools to decode the museological "genre" of a display (that is, its regime of representation) and to examine how, within a given museological genre, a specific perspective or world-view is being put forward (that is, how the exhibition is "framed"). For a discussion of framing as museological device, the reader can refer to Naguib's article in this volume. In the following, I will focus on regimes of representation.

The displays in the museums considered in this paper can be "read" through the lenses of the regime of representation deployed for the depiction of cultural difference.

The "Other" within – the Norwegian Museum of Cultural History

The Norwegian Museum of Cultural History (Norsk Folkemuseum) is a prominent site for the display of Norwegian cultural identity. Albeit historically linked to Norwegian folk, peasant and rural traditions, the Museum has been sensitive to the changes affecting the population of Norway and has reformulated its institutional mission to reflect these changes. As a result, today the Museum aims to represent not only Norwegians, but all the people inhabiting the space of Norway, including the Sami indigenous group, ethnic minorities and migrant communities.[2]

At the Norwegian Museum of Cultural History, the visitor can walk among rural and urban buildings including housing units, churches, schools, banks, pharmacies of diverse historical periods and geographic locations. One of the most distinctive features of the Norwegian Museum of Cultural History lies in its propensity to let the visitor *experience* the built, artistic, cultural and natural heritage of Norway. The homogeneity of the Norwegian heritage is challenged and problematized historically and culturally. So for instance, over the last decade the museum has devoted a number of temporary displays to non-ethnic Norwegian communities. In the permanent exhibition areas, the most prominent of such displays are those devoted to the Sami and to the Pakistani communities living in Norway.

The gallery displaying Sami indigenous cultures is composed of two segments: the first opened in 1990, the second in 2007. The first section is mostly informed by an ethnological

approach framed by an historical perspective: the display aims to show features of daily life in Sami communities during the period when the Sami collection was created (roughly mid-1800s to mid-1900s). The historical perspective is important in the display, since key historical events contribute to illuminate the cultural, social, economic and political trajectories of development of Sami communities in Norway. For instance, visitors learn about the 1826 Border Treaty with Russia, which illustrates how small-scale Sami communities became victims of political decisions made far outside their reach, or the burning of Samiland during World War II and the deep impact on Sami social life of the ensuing process of reconstruction.[3]

The display makes a conspicuous use of black and white historical photos portraying Sami people, dwellings and landscapes. Special attention is devoted to Sami historical figures such as the reindeer herder, artist and writer Johan Turi, referenced here to illustrate the debate on the "origins" of Sami peoples. Panels provide information on the distribution of Sami communities in the landscape and their seasonal migratory paths, thus helping to historicize (through panel titles such as "The East Sami maintained old ways") and territorialize the Sami. A display style inspired by an ethnographic perspective is detectable in the use of mannequins to show Sami "traditional" costumes, and of dioramas portraying living conditions, hunting practices, fishing methods, etc. The exhibition approach in this gallery might be described as an ethnographic display style centred not so much on the present as on the past.

The section of the Sami gallery added in 2007 presents the visitor with a strong contrast. The display opens with a powerful political statement: "We are Sami and we want to be Sami." The tone – assertive and authoritative – provides a sharp contrast to the distant, analytical and didactic tone of museum texts in the older section of the gallery. Even more visually striking is the contrast between the collages of black and white historical photos depicting Sami herders in the old gallery segment, and the life-size frontal picture of a young Sami in a punk rock dress style smiling at the camera in the new gallery addition. This picture is a powerful challenge to received definitions of Sami culture, and resonates strongly with the opening statement of the gallery section. There are no mannequins or life-size dioramas of rural dwellings on display in this section. Rather, exhibits include newspaper articles and posters about Sami rights and political independence movements, the Sami flag, photos of the Sami Parliament, books, design items, and the reproduction of a contemporary Sami flat – recognizable as Sami only from details such as Sami "traditional" symbols on clothes or objects. In short, this new section of the gallery aims to acknowledge and celebrate the achievements of the Sami political movement and intellectual scene (including literature, theatre and the arts).

The layering of narratives, display techniques, museological and cultural approaches to the displays of Sami cultures deployed in the two sections of the permanent gallery at the Norwegian Museum of Cultural History encapsulate the complexity of the historical relationships between the Norwegian majority and Sami indigenous communities. It also casts light on the tensions between curatorial expertise and indigenous knowledge, and between established museological traditions and new modes of display shaped by the balancing of different political and cultural agendas, and by an acute concern with contemporary issues.

The other area within the Norwegian Museum of Cultural History devoted to non-ethnic Norwegian cultures is included in the permanent display *Apartment building. Wessels Gate 15.* As the name suggests, the display is a detailed reconstruction of an apartment building originally located in central Oslo. The apartments reconstructed include a flat inhabited by a Pakistani family. The Pakistani flat presents an intriguing combination of Norwegian old-style furniture and exotic spices, Asian food and Norwegian décor.

The flat is replete with marks of cultural hybridity. This is mostly the result of cultural syncretism whereby Pakistani migrant communities to Oslo reformulated over time their cultural

identities by mixing Pakistani and Norwegian elements. Whilst the smallest items could be carried in the migration process, the most bulky and thus the most visible items, such as furniture, are Norwegian. The inclusion of the Pakistani flat in a "traditional" (architecture-wise) Norwegian building, inhabited by "traditional" (ethnicity-wise) Norwegian families, together with the emphasis put on the hybridity of the material culture on display, indicate an effort to re-define the very notion of Norwegian identity.

Globally considered, with its intensive use of photographic documentation, dioramas, mannequins and contextualizing texts, the regime of representation deployed in the Norwegian Museum of Cultural History is a compelling combination of historical and ethnographic-folkloric approaches. In particular, this regime of representation is characterized by an emphasis on "witness-objects", that is, objects that can be considered as both historical and cultural tokens. Only a few categories of "Others" are displayed at the Norwegian Museum of Cultural History: for the time being, only the Sami and Pakistani communities have been included in the Museum's permanent exhibitions. Yet their presence in this particular museum bears a strong symbolic weight: these "Others" have been formally included in the Norwegian ethnoscape.

Experiencing difference – the Intercultural Museum (IKM)

Loosely inspired by the St Mungo Museum of Religious Life and Art opened in Glasgow in 1993, the Intercultural Museum (IKM) started to take shape in the late 1980s as an initiative of Bente Guro Møller (Møller & Einarsen 2008:141). The IKM is currently a section of the umbrella institution Oslo Museum, also including the City Museum and the Theatre Museum. The Intercultural Museum is not easily placed in established museum categories: it is not a museum of art though it hosts art installations, it is not an ethnographic nor an historical museum properly speaking, but rather a combination of these museum genres. The words of Bente Møller (2008:143) on this point are illuminating: "When we work towards changing attitudes, it is important to talk to the whole person, not just their rationality. [...] Art opens cognitive rooms in us other than those opened by theoretical knowledge. That is why we always have art exhibitions in addition to cultural history exhibitions."

The temporary[4] exhibition *Our Sacred Space* introduces six religious communities in Norway: Buddhism, Hinduism, Islam, Judaism, Christianity and Sikhism. By showing "religious diversity in Norway today" the exhibition aims to "encourage dialogue between people with different religious practices". At the IKM performativity is very important. The visitor is part of the *mise en scène*, s-he is invited to take up temporarily the role of a visitor to a religious space, for instance taking off shoes, washing hands, wearing a headscarf and so on.

The architectural structure of the IKM is intriguing. The building was formerly a prison, thus the exhibition space is composed of a series of small cells and niches, linked by corridors. In the context of the exhibition *Our Sacred Space*, corridors are liminal spaces where the visitor briefly reappropriates his or her identity before entering another religious context and taking up another role. This enactment is made all the more meaningful by the sequence and juxtaposition of different faiths as visitors literally "divest" a faith to "wear" another.

The objects on display are not labelled, they can be freely touched, smelled, acted upon – a bell can be rung, a candle can be lit, incense can be burned. Objects are not presented in a way that draws attention to their materiality and uniqueness, nor to their aesthetic, historical or scientific value. Rather, they contribute to creating a background, a canvas for the deployment of personal feelings, memories, emotions and personal understandings of the sacred. There is no judgemental connotation in the panel descriptions of the different religious practices. The equanimity deployed in the display of the different religious spaces (resulting for instance from the

equal exhibition space allotted to each group and the factual, non-discriminating texts) helps to create an effect of homogeneity. The six religious spaces ultimately elide each other transforming the display, quite paradoxically, into an eminently secular space. One might wonder whether there is a risk of over-simplifying the complexity of these religious spaces, and of giving the visitors the comfortable feeling to have "understood" the different religious communities, to have somehow appropriated them, and later simply divested them.

In museological terms, it could be argued that the IKM presents the items on display as ethnographic specimens, that is, as objects that tell us something about our own, and/or other cultures. But *Our Sacred Space* does more than this. The ideas underlying the exhibition and its museological approach are compelling because they challenge the basic notions of museum and museum object, and subvert established museum practices. Yet, this is a museum. Despite the efforts to accurately reconstitute six sacred spaces, these are ultimately artificial set-ups. As such, the IKM offers a "safe" environment to explore spaces that many visitors might hardly have the chance or the interest to visit. In this sense, the IKM offers a non-threatening venture in spaces often closed to non-adepts, and conversely, it enables the maintenance of a certain distance from the *real* sacred spaces of these communities, made fictionally available through the museum's panoptical gaze.

Crystallizing difference – the Museum of Cultural History, UiO

The Museum of Cultural History of the University of Oslo was formally established in 1999 through the merging of three formerly independent University museums (Archaeology, Numismatics and Ethnography – which was founded in 1857).[5] After having been repeatedly incorporated and disincorporated from the University, today the Museum is part of a constituency regrouping all the University Museums of Oslo, and enjoys the double status of museum and university department.[6] The Museum includes ethnographic galleries devoted to the Circumpolar regions, Africa, Asia, and the Americas. The galleries differ not only in geographic focus, but also in conceptual approach, museological formats and display techniques. In short, it could be said that the Museum of Cultural History conflates several museums in one.

The gallery devoted to the Circumpolar regions for instance, presents a mostly ethnographic approach, evidenced by the intense use of mannequins and life-size dioramas. The way in which objects, historical black and white photos, and text are juxtaposed in the glass cases exudes a concern with pedagogy.

In a similar vein, in the African gallery, objects are also framed through ethnographic lenses. One can find again mannequins and dioramas (though less prominent than in the Arctic section) as well as a wealth of photos providing visually evocative backgrounds for objects. Texts are relatively limited and fall short of providing adequate contextualization for artefacts, whose functions, meanings and values might remain obscure to most visitors. Enlarged background photos reproduce stereotyped images of the continent: Tuareg in the desert, women carrying water containers on their heads, straw huts, Masai warriors dancing, dark and thick forests. Similarly, the coffee-table books available for browsing – bearing titles such as *The Vanishing Traditions of Berber Women, Africa Dances, Africa Adorned, The Masai* etc. – do little in the way of challenging received ideas and providing information about contemporary African communities. Display techniques emphasize the exotic and aesthetic character of African cultures.

The Asian Gallery includes items from China, Korea and Japan. This gallery combines a plurality of exhibition approaches. A hint of exoticism characterizes the display of curiosity and iconic artefacts such as the shoes for women with bound feet, fingernail covers, or the magnificently embroidered capes and garments dating back to the Qing dynasty. In line with the

important tradition of ceramic connoisseurship in China, ceramics and tea implements are among the most prominent items on display. Ceramics are exhibited in purpose-built cabinets made to resemble those in use in China in private houses or tea-rooms. This mode of display also recalls the way ceramics are displayed in private collections, thus suggesting an approach to these artefacts based on aesthetic appreciation. In other areas, the exhibition style takes a more ethnographic approach, as for instance in the choice to display a selection of traditional musical instruments, and traditional Korean and Japanese clothing items complemented by panels explaining the patterns, and a miniature weaving loom. Aside from these instances, most of the objects selected for display in the Asian gallery lend themselves to be appreciated as aesthetic items, and indeed are the object of collecting and connoisseurship traditions. The display methods used in the gallery present the material culture of Asian countries as fine art, inviting an aesthetic and historical, more than an ethnographic gaze. This approach is corroborated by the choice not to illustrate objects with panels and texts, but rather to limit captions to the minimum and provide limited information through an object list hanging from each exhibition shelf.

In the American galleries the exhibition style can be described as ethnographic. In contrast with the other galleries, here a panel provides a title for the exhibition ("Americas, contemporary and past identity"), the opening date (November 2008), and the names of the curators and the professionals involved, thus indicating the "authorship" of the display. The ethnographic approach is visible in the re-creation of specific settings such as the religious practice of Santeria in Cuba, or the reproduction of ritual offerings for the Day of the Dead in Mexico. Artefacts are organized around specific topics – such as "shamanism" and "global links and urban centres" – and contextualized through rich panel texts and contemporary photos.

In parallel to the four permanent galleries examined, the Museum of Cultural History also hosts temporary exhibitions bringing into focus specific topics and/or contemporary issues. The engaging museological approaches deployed in the temporary exhibitions offer a stark contrast to the inertial character of the permanent galleries.

A good illustration is provided by the exhibition *We Paint the Stories of Our Culture*, held at the Museum in spring 2011, and presenting a selection of contemporary artworks (paintings, sculptures and artefacts) from Australian Aborigine artists.[7] Collected during anthropological research in Australia by the curator Maria Øien, the works aim at providing an overview of the cultural diversity and heterogeneity of styles expressed in the arts of Australian Aborigines.[8] The display unfolds on several levels. On a most immediate level, it is a sensory and aesthetically powerful experience. Artefacts are displayed in an art-gallery mode, skilfully hung against a white background, powerfully illuminated by spotlights, surrounded by minimal design. This approach brings to the fore the materiality of the exhibits: the large, brightly coloured, pigment-saturated involute patterns exert an almost hypnotic effect on the viewer. It is simply not possible to walk absent-mindedly past these exhibits. But the exhibition strives to reach beyond the aesthetic impact, to offer an intellectually engaging experience. The visitor gets to learn about the cultural significance of the works, and the specific symbolic meanings embedded in their materiality (referring to Aboriginal myths, songs, story-telling). Artworks are prefaced by panels providing contextualizing information. Exhibition texts draw on anthropological insights and critical reflection on such topics as religion and the relationship between the land, the ancestors and living communities, notions of tradition and innovation, the cultural significance of designs, the ties between Aborigines and Australian national identity. In addition, each artwork is accompanied by an interpretative text provided by the artist. The cultural meanings of the objects on display further invite critical reflection to the extent that they challenge lingering divides between art and ethnography, and tangible and intangible cultural categories. This

exhibition provides an example of the possibility (and efficacy) of museological approaches combining visual impact and cultural contextualization, artistic sensitivity and anthropological depth of (cross-)cultural understanding: the display is visually engaging, appealing, accessible, yet faithful to the inherent epistemological and cultural complexity of the exhibits. Regrettably, however, this kind of critical, research-driven reflection that should be the benchmark of a university museum, has hitherto been only to a limited extent incorporated and reflected in the Museum's permanent galleries.

The four permanent galleries considered – Arctic, African, Asian and American – share one feature: the authenticity of objects is of pivotal importance. Objects are made to be iconic, to represent a culture, but at the same time, their individual potency and singularity cannot be left in the background: these are unique artefacts bearing considerable historic, artistic, technical and cultural value. These objects do not need to be interpolated by a strong narrative. Rather they act as brush strokes that, taken together, collectively contribute to forming the big picture of a distant "Other".[9] Because they do not have to support other narratives than their own unique-ness and authenticity, they can afford to be aestheticized. Aesthetics becomes here a mode of apprehension of distant cultures (see Naguib 2004, 2007); this is not incompatible with other approaches, such as the ethnographic and historical. Indeed, at the Museum of Cultural History exhibits are presented both as items to be admired in themselves, and as culturally and histor-ically salient, to be understood as part of a specific cultural system. Objects are historicized through the extensive use of black and white historical photos as contextualization material. With the exception of the Americas gallery, there are few references in the displays, texts or pictures to contemporary living societies; when the display does tackle cultural features that might be considered as "contemporary" or "modern", as in the case of market exchanges in the African gallery, these are framed as a Western import, as if to imply that these societies are "modern" only in those spheres of social life that are influenced by the West.

All things considered, the displays at the Museum of Cultural History do not succeed in displacing stereotypical images of Other cultures. In the African gallery for instance, the earth-enware, ivory horns, Benin bronzes, masks and wooden sculptures strongly resonate with col-lective imagery about the African Other, as do the Amazonian feather headdresses, Mesoamerican basketry and Plains Indian leather items in the Americas Galleries, or the igloo in the Circum-polar gallery. The object-stereotype (the mask, the basket, the feathers) is used as a prop, a tool to invite visitors to learn more about the cultures on display, yet without really challenging previously held and received understandings about them. Conversely, displays at the Museum of Cultural History essentially reassure the visitors in their assumptions about Other cultures. To an external viewer, this situation might seem somewhat paradoxical in a museum employing several professional anthropologists. It is only by exploring the process of exhibition set-up, rather than just analysing its final result, that other relevant analytical elements emerge, for instance the fact that anthropologists have no direct responsibility for exhibitions, which are managed by a separate exhibitions department, currently headed by an archaeologist.[10] This problematic division of responsibilities within the Museum encroaches upon the disciplinary expertise of social anthropology (understood as the science devoted to the study of cultural phenomena and their interpretation in a cross-cultural perspective) and curtails the potentially significant role that social anthropologists might play in reshaping the ethnographic galleries. Whilst these organizational issues help to explain the poor conditions of the ethnographic gal-leries, they do not provide a satisfactory response to visitors' expectations of more accurate and updated cultural representations.

The Kon-Tiki Museum: the aesthetics of the exotic

The privately owned Kon-Tiki Museum is devoted to the life and achievements of the Norwegian explorer Thor Heyerdahl and his lifetime expeditions across the Pacific, Indian and Atlantic oceans. The fulcrum of displays at the Kon-Tiki Museum are the vessels used by Heyerdahl and his crew members, as well as detailed photographic and textual material documenting the expeditions; these are complemented by ethnographic artefacts, archaeological finds and botanical specimen. The local communities encountered during the expeditions appear as secondary characters in narratives focusing on Thor's persona and endeavours. The ethos of the intrepid, solitary explorer connecting with the natural environment is here celebrated as a properly "Norwegian" archetype.

The general emphasis on Thor's persona rather than on artefacts was reversed in the special exhibition *Tiki Pop Culture*, held at the Museum in 2009. The exhibition was devoted to the spread of images, objects, food and drinks associated with the Pacific which occurred upon the return of American soldiers after the end of the Second World War, and which was revived by the interest generated by Thor Heyerdahl's expeditions. The display cast a critical eye on the development of Pacific-inspired paraphernalia and pop culture around the world, and specifically in Norway, where Tiki restaurants and bars revived the flavours of the "South Seas". The exhibition included contemporary art (sculptures and textiles reproducing and re-interpreting Pacific "traditional" patterns), exotica and a vast array of gadgets (including small sculptures, mugs, shell bracelets and Hawaiian-style flower necklaces) collected by Norwegian enthusiasts. On display was also a reconstructed corner of a Tiki-inspired bar, complete with Pacific wooden carved poles, flowered textiles, and a Pacific-themed menu with exotic drinks and food.

The exhibition *Tiki Pop Culture* is particularly interesting for the ironic, self-reflexive view on the appropriation and commodification of the Tiki accoutrements as emblems of the exotic Pacific Other. The exhibition reflected on the aesthetizing gaze directed at Pacific objects. In so doing, it projected the image of a distant, exotic Other reactualized in today's tourist and consumerist enactments. The display recalled Susan Stewart's (1984:146, 148) comment on exoticism: "the exotic object represents distance appropriated [...] To have a souvenir of the exotic is to possess both a specimen and a trophy [...] [the souvenir's] otherness speaks to the possessor's capacity for otherness: it is the possessor, not the souvenir, which is ultimately the curiosity." The Kon-Tiki Museum develops an aesthetics of the exotic that resonates strongly not only in an historical dimension (the events of World War II and Thor's expeditions) but also in its contemporary implications. The exhibition *Tiki Pop Culture* in particular played with the ideas of exoticism and consumerism, casting a disenchanted gaze on Western practices of construction and consumption of cultural difference. By drawing the visitor's attention to cultural distinctiveness and on cultural difference, displays accentuate the dichotomy between an implicit Norwegian "us" and the Other, but interestingly, they do so in a self-reflective way. The "Other" encountered in the Kon-Tiki Museum is not threatening but appealing, not present but distant in place and time, not real but imagined. These features ultimately facilitate and encourage its consumption.

Hybrid regimes of representation

The analysis of displays in the museums considered in this study evinces three main regimes of representation: aesthetic, ethnographic and historical.

The Museum of Cultural History (especially the African gallery) and the Kon-Tiki (especially the *Tiki Pop Culture* exhibition) offer instances of aesthetic regimes of representation. This

kind of regimes of representation emphasize the aesthetics of artefacts through a range of *ad hoc* display techniques. These tend to singularize the object and to draw attention to its material properties, for instance through precise, powerful lighting and the use of individual glass cases. The exhibit is presented as a work of art. Consistently, texts and captions are limited, as they are not perceived to be essential to the full appreciation of the exhibit. Exhibition approaches of this kind ease cross-cultural comparisons, and often lead to generalizations and the establishment of a canon, such as "African Style" or "Nordic aesthetics" (Varutti 2010).

Examples of ethnographic regimes of representation can be found at the Museum of Cultural History, and in the Norwegian Museum of Cultural History, especially the section of the Sami gallery dating to 1990. Ethnographic regimes of representation focus on the cultural significance of objects and their contexts of production, use and consumption. In line with this aim, ethnographic style displays make a significant use of contextualizing material such as dioramas, mannequins, texts, diagrams and photos. Ethnographic regimes of representation are centred on cultural features; for instance, prominence is given to craft traditions, religious practices, dwelling customs, strategies of climatic adaptation, lifestyles, and so on. Cultural context, and its spatio-temporal variations, are the lenses through which the objects on display are interpreted here.

The Museum of Cultural History (especially the Arctic galleries), the Norwegian Museum of Cultural History (in the old section of the Sami gallery) and the Kon-Tiki (in the permanent galleries) instantiate the category of historical regimes of representation. Historical regimes of representation are primarily concerned with providing historical context for the events, peoples and cultures on display. This notion might recall the concept of "regimes of historicity" developed by the French historian François Hartog (2003). In Hartog's view, a regime of historicity may be understood as the way a society deals with its past, and in more detail, the ways in which historicity is lived, conceptualized, deployed, and the way the past, the present and the future are articulated (2003:19, 35, my translation). It follows that discussions of regimes of historicity imply a self-reflexive concern with the way temporalities are conceived and perceived within and across societies – a concern that is more appropriately defined as historiographical, rather than historical. The concept of historical regimes of representation deployed here differs from Hartog's regimes of historicity since it does not aim to explain the different ways in which societies relate to their past (and to time more broadly). Rather, more coarsely, it aims to define the internal consistency of a set of display techniques, approaches and narratives that create an historical backdrop for the events or cultures displayed. In this sense, in the notion of historical regimes of representation the emphasis is put on *regimes* and the systemic, coherent qualities it suggests, whilst in Hartog's concept, the analytical focus is on the notion of historicity. Thus, historical regimes of representation are characterized by a conspicuous use of historical photographic material (especially black and white photos), and by the deployment of narratives of "progress" and of progressive "civilization". This implies that historical regimes of representation are not necessarily exclusively concerned with the past, but also characterize exhibitions engaging with contemporary issues such as climate change and environmental pollution. Historical and ethnographic regimes of representation can be intimately entangled in the context of a display, yet it is still useful to distinguish them for analytical purposes (see below). Whilst an historical perspective may be present in ethnographic regimes, their main focus is kept on cultural features, and social change is usually explained through reference to cultural elements. Similarly, in historical regimes of representation we may find that cultural details and ethnographic analyses greatly enrich an historical analysis, yet the main concern of the historical regime is communicating the chronological sequence of events, and setting events one in relation to the other, usually on the basis of a cause-effect logic.

The identification of these three regimes of representation – aesthetic, ethnographic and historical – serves here analytical, rather than descriptive purposes. This also implies that these ideal types are not exhaustive, one might identify many other regimes of representation defined by various combinations, approaches and emphasis in display techniques and narratives. Defining, however approximatively, these three ideal-types of regimes of representation – aesthetic, ethnographic and historical – allows me to locate, by way of inference, another open, hybrid category which combines features of the three ideal-types described. In the same way as with Appadurai's regimes of value, in fact, regimes of representation are not discrete, closed systems, but open and fluid: their borders are blurred, they can merge, overlap, dissolve. Indeed, it is *hybrids* of these regimes of representation that are most interesting to explore.

Among the museums considered, examples of hybrid regimes of representation can be found at the Glomdal Museum (notably the *Latjo Drom* exhibition on Travellers), the IKM, the new section of the Sami gallery and the Pakistani flat, both at the Norwegian Museum of Cultural History, and the temporary exhibition "We Paint the Stories of Our Culture" at the Museum of Cultural History of the University of Oslo. Hybrid regimes of representation, however, cannot be reduced to a set of arbitrary choices of museum curators. On closer examination, they reveal an internal logic and consistency. Interestingly, these are all relatively recent displays, indicating that this regime of representation has crystallized over the last five or six years. Moreover, these museums chime with Anthony Alan Shelton's (2006:492) description of "new" museums as "threshold institutions constructed between major intellectual, historical and social fault zones, at the intersections and between the interstices of conflicting, contradictory and paradoxical, pluri-cultural cross-currents".

In such hybrid regimes of representation, the centrality of the object-masterpiece constructed as an icon of authenticity is displaced to the benefit of more evocative approaches using objects as springboards for narratives that appeal to personal experience, emotions, memories and imagination. This is also suggested by the generalized emphasis put on the creation of detailed, thematic contexts that engender a mood and a background enabling an immersive museum experience. Displays are characterized by open, multiple narrative lines making room for a plurality of points of view. The narrative mode often adopts a documentary style, using meta-narratives, real-life stories, individual accounts, personal life-trajectories, belongings and memory boxes. These display techniques tend to conceal curatorial agency in order to convey the sense of a more direct relationship between audiences and the communities represented. This exhibition approach is less concerned with providing an accurate, comprehensive representation of a group than with establishing cross-cultural links that contribute to locating that group within a broader national or global arena. This effect is also achieved through a thematic focus on universal topics and issues which are then explored in a cross-cultural perspective.

Gradients of alterity

In a report for the Norwegian government, the museum professional Per Bjorn Rekdal (1999:15) wrote: "one expected result of increased museum activity connected to our cultural diversity is that this can contribute to the integration of new groups in Norwegian society." Whilst it is beyond the purpose of this paper to discuss the degree to which this objective is being successfully pursued, this statement confirms the concern among museum academics and professionals for the potential role that museums can play in the development of a more inclusive and cohesive society. Less debated are the implications of a range of concrete modes of cultural representation adopted by museums in the pursuit of this goal. The analysis of museums developed in this paper helps to shed light on this issue.

When juxtaposed, the analyses of the different regimes of representation in the museums examined project different kinds of assumptions and perceptions about the various "Others". This suggests that not all non-ethnic Norwegian enjoy the same museological status, but there are in museums different categories of Others, as well as *gradients* of cultural alterity.

This might be a surprising finding in a country that identifies egalitarian individualism as one of its main values (Gullestad 1992), but Norwegian society might not be as egalitarian as imagined. The historian Einar Niemi (2008:5) explains that since the 1990s, a minority policy hierarchy has gradually taken shape, whereby the Sami are the most prominent group, followed by national minorities, and lastly immigrant communities (see footnote 1). In the same vein, the anthropologist Thomas Hylland Eriksen talks of a "hierarchy of Norwegian Others" (2002:232), and Elisabeth Eide (n.d.) of "scales of Norwegian-ness".

That there are different kinds of non-ethnic Norwegian communities might not be a novelty *per se*. What deserves attention, however, is the role of museums in reproducing such hierarchies and subtly communicating them to audiences. I would argue that through the deployment of different regimes of representation, the museums analysed in this study implicitly communicate such hierarchies. In more detail, in the museums considered there are to my mind at least four different categories of Others: the Sami; the mostly integrated national minorities (such as the Travellers); the partially integrated immigrant communities (such as the Pakistanis); and more distant "Others", culturally and geographically far from Norway. Whilst this is an oversimplified interpretation of cultural complexity in contemporary Norway, museums do not appear to engage in a critical rethinking of such gross categorization.

In general, one can notice that the less the ethnic group is statistically, socially, economically or culturally relevant in Norway (thus unlikely to play any role in the (re)definition of Norwegian national identity), the more its museum representation is characterized by essentialism, objectification, generalizations and exoticism. For instance, a group that has been inhabiting what is today the Norwegian territory for a very long time – this is obviously the case for the Sami indigenous group, but also for the Travellers, officially recognized as an ethnic minority since inhabiting Norway for more than 100 years – enjoys dedicated museums and/or display space, and the possibility to play an active role in the set-up of their museum representation. This is the case for the Sami at the Norwegian Museum of Cultural History, and the Travellers at the Glomdal Museum.

Gradually, this kind of opportunities are being extended to groups of more recent settlement in Norway, such as immigrants, refugees, asylum seekers, and so on. Migrant cultures are often presented in the context of collective displays conflating the diverse groups in an allegedly unifiable "immigrant culture" (as for instance at the IKM). However, museums are slowly developing a sharper focus on migrant communities. This is attained either through exhibitions devoted to a specific group – for instance the Pakistani flat at the Norwegian Museum of Cultural History, or *Fotspor Somalia–Norge/Footprints Somalia–Norway*, which was an exhibition devoted to Somali culture held at the Glomdal Museum from June 2006 to June 2008 – or through a thematic approach – for instance the temporary exhibition *innSYN=INNsikt* held at the IKM in Autumn 2010 focused on migration and the role of language as bridge or barrier among cultures; in a similar vein the exhibition *Hijab og hodeplagg – med rett til å velge/Hijab and head wear – with a right to choose* held at the Museum of the City of Oslo in Spring 2009, explored the use of the hijab as a fashion item.

The preference accorded to hybrid regimes of representation in these exhibitions can be interpreted as a heightened recognition of the visibility of non-ethnic Norwegian communities in Norwegian society, and of the need to represent cultural difference in "politically correct" manners as a way to foster intercultural dialogue and social cohesion. Increasingly, such politically

correct representations serve to negotiate the gradual introduction of "foreign" cultures in the domestic ethnoscape. In fact, in most instances, "politically correct" representations of other cultures focus not so much on the "Other" and its cultural difference, as on its relation with the Norwegian majority. This results in an implicit, gradual redefinition of Norwegian national identity and citizenship.

To illustrate this point, I will use the example of the Sami. The display of Sami culture in the new gallery section at the Norwegian Museum of Cultural History emphasizes the *similarities* between Sami and ethnic Norwegians. The punk girl in the opening photo is not recognisable as a Sami, her cultural belonging is overridden by her statement as an individual – in contrast to the anonymity of the featureless Sami mannequins used in the old section of the same gallery. The photo of the young Sami punk signifies rebellion, including rebellion against previously fixed definitions of "Saminess". It is also an image of modernity as it redefines the image of the Sami by locating Sami culture in the hybrid space of a subculture – punk rock – that transcends cultural borders. Precisely because Sami culture is defined here in non-culturally specific terms, it is easier to link it to Norwegian culture. This point chimes with Eriksen's (2002:223) analysis of the understanding of cultural difference in Norway as a lack of Norwegian features: the Other is such precisely because it is not culturally similar. The invisibility of Sami as a visually distinctive group in today's Norwegian society is perhaps the most patent indication of their degree of integration. The "naturalization" of Sami also appears in museum texts such as "Sami are now to be found in all walks of life…", or "daily life becomes more and more similar to that of other people in the country" (Norwegian Museum of Cultural History). The core message of the displays of Sami culture at the Norwegian Museum of Cultural History appears to be: "we are all ultimately similar".

Another instance showing the centrality of the equation "similarity-equality" for the integration of non-ethnic Norwegian cultures is provided by the permanent exhibition *Latjo Drom*, at the Glomdal Museum, illustrating the culture of Travellers' communities. The display is interspersed with references to Norwegian history, cultural elements and collective imagery. For instance, a Traveller witness points out that hygiene has always been very important for her and that she used Lano soap for her children. The Travellers' own reference to an item so firmly inscribed in Norwegian collective imagination such as Lano soap (the most widespread brand of soap in Norway since the 1930s) might not, at first glance, seem noteworthy. Yet, the fact that this information was retained by the curator and by the Traveller communities as relevant suggests the existence of a shared set of references and values associated with "Norwegianness" in relation to which other cultures are located, and locate themselves. Conversely, the curator of the permanent exhibition reported[11] that on some occasions visitors claimed that the display is not objective since it does not account for Travellers' involvement in knife fights, misappropriations and so on. In response to such claims, the curator usually points out that museum displays of Norwegian peasant culture do not either display fights, drinking habits and so on, and questions possible double standards for Travellers. What the curator is aiming at with this answer – and what some visitors are resistant to accept – is the extension of the regime of representation of the Norwegian majority to non-Norwegian cultural components. In other words, the permanent exhibition *Latjo Drom* is negotiating the transition and the acceptance of Travellers into the Norwegian nation. It is doing so by striving to present Travellers' culture as both unique and distinctive, and situated within the framework of Norwegian history and culture. The core message of the display, mediated by the Museum authority, could be crudely synthesized as "they [*the Travellers*] are like us". Yet the very creation in 2004 of this dedicated permanent exhibition is evidence that this statement is not obvious, but needs to be enforced – and museums are precisely contributing to this end.

539

Marzia Varutti

Conclusions

In this paper, I proposed to extend Arjun Appadurai's concept of "regime of value" to museum displays by means of its reformulation as "regime of representation". I used this as an analytical concept in a study of the way Norwegian museums tackle cultural difference.

In general terms, the construction or depiction of cultural difference in museums (as in other media) has mostly followed two main lines: the temporal or the spatial. Art and history museums have traditionally centred on the chronological development of cultures, essentially locating the roots of cultural difference in a different historical trajectory, whilst anthropology museums have worked with notions of cultural difference as linked to a different spatial or geographical location. Based on this study of museums in Norway, the last generation of museums displaying other cultures seems to aim to transcend this dichotomy, striving to open up an in-between space where cultural identities are neither past nor faraway, but rather multiple, fluid, ever-changing identities that are here and in the present. Perceptions of cultural and territorial belonging overlap and intersect, creating new co-ordinates of identity where ethnic communities can both maintain strong links with their cultures of origin, and be fully part of the multicultural society in which they live. Crucially, there is a growing awareness of these processes among museum professionals, the political body and Norwegian society at large (Norwegian Ministry of Labour and Social Inclusion 2010; Rekdal 2001).

If Victorian museums, according to Tony Bennett (2006) educated masses to "civic seeing", that is, to becoming the "modern" citizens of "civilized nations", the last generation of museums and displays of cultural difference in Norway appear to operate as sites for a "multicultural seeing", educating audiences to become citizens of a multicultural, open-minded, cosmopolitan and globalized world. In this sense, the hierarchization of cultural difference that surfaces in museum displays is not necessarily negative: it can be understood as part of a long-term process of acceptance and integration of different cultural communities, and ultimately as a way to gradually negotiate the multi-ethnic profile of the Norwegian nation.

Although museum representations do not really challenge received understandings about different categories of Others, but rather work within such schemata, their efforts to break through established regimes of representation and to explore new visual and narrative ways to present other cultures are important and deserve to be encouraged. Museums will have to cope with the challenge, but also the extraordinary opportunities, to work with ethnic communities to better translate the complex, imaginative processes through which Norwegian and non-Norwegian cultural elements are being constantly re-articulated and reinterpreted in the formulation of collective (ethnic) identities. This direction bears the potential to transform museums from sites of superficial showcasing of cultural diversity, into laboratories for the development and expression of the inspirational cultural vibrancy of a truly multicultural country.

Notes

1 Since this article is mostly concerned with the ethnic dimensions of cultural difference, the analysis focuses on indigenous groups, ethnic minorities and migrant communities, rather than on religious or linguistic minorities. It should also be noted that, in addition to the Sami indigenous people, Norway officially recognizes five national minority groups: Kven, Forest Finns, Jews, Roma (Gypsies) and Romany (Travellers).

2 Thomas Walle, curator, Norwegian Museum of Cultural History. Personal communication, 25 November 2009.

3 I am grateful to Dr Leif Pareli, curator at the Norwegian Museum of Cultural History, for these insights. Personal communication, 6 May 2011.

4 The exhibition *Our Sacred Space* opened at the IKM in Spring 2007 and was extended until the end of 2010.

5 Dr Leif Pareli, curator at the Norwegian Museum of Cultural History. Personal communication, 6 May 2011.

6 The complex institutional history of the Museum of Cultural History and its collections have been extensively discussed by other authors (see Bouquet 1996; Naguib 2007).

7 The exhibition is correlated to web pages (in Norwegian and English) reproducing all the exhibition texts organized in thematic sections, high-quality photographs of the art-works on display, profiles of the exhibiting artists, a video interview with Aborigine women demonstrating the making of a traditional handbag, and photo galleries offering a glimpse of the exhibition making process.

8 Maria Øien, exhibition curator. Personal communication, 14 April 2011.

9 For a discussion of the concept of "culturally distant" (*fjernkulturell*) see Gullestad 2001: 52.

10 Professor Øivind Fuglerud, Department of Ethnography. Museum of Cultural History, University of Oslo. Personal communication, 4 February 2011.

11 Mary Møystad, curator of the *Latjo Drom* exhibition, Glomdal Museum, Elverum. Personal communication, 3 November 2009.

Bibliography

Appadurai, Arjun. 1986: *The Social Life of Things: Commodities in Cultural Perspective*. Cambridge: Cambridge University Press.

Bennett, T. 2006: Civic Seeing. Museums and the organization of vision. *A Companion to Museum Studies*, ed. S. Macdonald. Oxford: Wiley-Blackwell.

Bhabha, H. 1988: The Commitment to Theory. *New Formations* 5, pp. 5–24.

Bouquet, M. 1996: *Sans og samling – hos Universitete[t]s etnografiske museum*. Oslo: Universitetets etnografiske museum.

Clifford, J. 1997: *Routes. Travel and Translation in the Late Twentieth Century*. Cambridge, Mass.: Harvard University Press.

Council of Europe 2008: *City of Oslo. Intercultural Profile*. Online: www.coe.int/t/dg4/cultureheritage/culture/cities/osloprofile.pdf (accessed September 2010)

Eide, E. (undated): The Long Distance Runner and Discourses on "Europe's Others". Ethnic Minority Representation in Norwegian Feature Stories. Online: http://home.hio.no/~elisabe/Tufte.htm (accessed 30 December 2009).

Eriksen, T. H. 2002: The Colonial and the Postcolonial. A View from Scandinavia on Italian Minority Issues. *The Politics of Recognizing Difference*, ed. R. Grillo & J. Pratt. London: Ashgate.

Eriksen, T. H. 2006: Diversity versus Difference. Neo-liberalism in the Minority Debate. *The Making and Unmaking of Difference*, ed. Richard Rottenburg *et al*. Bielefeld: Transaction. Online http://folk.uio.no/geirthe/Diversity.html (accessed 1 December 2009).

Feuchtwang, Stephen. 2011: Exhibition and Awe: Regimes of Visibility in the Presentation of an Emperor. *Journal of Material Culture*, 16 (1), pp. 64–79.

Gell, Alfred. 1998: *Art and Agency: An Anthropological Theory*, Oxford: Clarendon Press.

Goodnow, K. J. & Akman, H. (eds.) 2008: *Scandinavian Museums and Cultural Diversity*. New York: Berghahn Books.

Gullestad M. 1992: *The Art of Social Relations. Essays on Culture, Social Action and Everyday Life in Modern Norway*, Oslo: Scandinavian University Press.

Gullestad M. 2001: Imagined Sameness. Shifting Notions of "Us" and "Them" in Norway. *Forestillinger om "den Andre"/Images of Otherness*, ed. Line Alice Ytrehus Kristiansand: Hoyskoleforlaget.

Hartog, F. 2003: *Régimes d'historicité. Présentisme et expériences du temps*. Paris: Seuil.

Keane, W. 2001: Money Is No Object. Materiality, Desire and Modernity in an Indonesian Society. *The Empire of Things. Regimes of Value and Material Culture*, ed. F. Myers. Oxford: James Currey.

Norwegian Ministry of Labour and Social Inclusion 2010: *[Documentation on] Integration and social inclusion policy*. Online: www.regjeringen.no/en/dep/aid/Topics/Integration-and-diversity/midt- spalte/integrerings—og-inkluderingspolitikk.html?id=86693 (accessed October 2010).

Møller, B. G. & Einarsen, H. P. 2008: As in a Mirror. *Scandinavian Museums and Cultural Diversity*, ed. K. J. Goodnow & H. Akman. New York: Berghahn Books.

Naguib, S. A. 2004: The Aesthetics of Otherness in Museums of Cultural History. *Tidskrift for kulturforskning* 3/4, pp. 5–21.

Naguib, S. A. 2007: Autres temps, autres regards. Représentations de l'altérité au musée d'Histoire culturelle de l'Université d'Oslo. *Histoire de l'Art* 60, pp. 149–160.

Niemi, E. 2008: Indigenous Peoples and National Minorities in Norway. Categorisation and Minority Politics. *Scandinavian Museums and Cultural Diversity*, ed. K. J. Goodnow & H. Akman. New York: Berghahn Books.

Rekdal, P. 2001: *Norwegian Museums and the Multicultural Challenge. Principles and Practices in Exhibition and Education*, Oslo: Norwegian Museum Authority. Online: www.abm-utvikling.no/publisert/tidligere-utgivelser/nmu (accessed September 2010).

Shelton, A. 2006: Museums and Museum Displays. *Handbook of Material Culture*, ed. C. Tilley *et al.* London: Sage.

Steiner, C. 2001: Rights of Passage. On the Liminal Identity of Art in the Border Zone. *The Empire of Things. Regimes of Value and Material Culture*, ed. F. Myers. Oxford: James Currey.

Stewart, S. 1984: *On Longing. Narratives of the Miniature, the Gigantic, the Souvenir, the Collection*. Baltimore: Johns Hopkins University Press.

Tilley, C. 2006: Objectification. *Handbook of Material Culture*, ed. C. Tilley *et al.* London: Sage.

Varutti, M. 2010: The Aesthetics and Narratives of National Museums in China. *National Museums. New Studies from Around the World*, ed. S. J. Knell *et al.* London: Routledge.

37

Museums in a global world

A conversation on museums, heritage, nation and diversity in a transnational age

Conal McCarthy, Rhiannon Mason, Christopher Whitehead, Jakob Ingemann Parby, André Cicalo, Philipp Schorch, Leslie Witz, Pablo Alonso Gonzalez, Naomi Roux, Eva Ambos and Ciraj Rassool

The following conversation took place during the Critical Heritage Studies conference in Gothenburg, Sweden, on 6 June 2012. The initial idea and topic was suggested by Kylie Message, the session was chaired by Conal McCarthy, and the recording was transcribed by Jennifer Walklate and edited by Conal McCarthy and Jennifer Walklate.

Chair:
Conal McCarthy, Victoria University of Wellington, New Zealand

Participants, in initial order of speech:
Rhiannon Mason, Newcastle University, UK
Christopher Whitehead, Newcastle University, UK
Jakob Ingemann Parby, PhD, Fellow, Roskilde University, Denmark; Curator, Museum of Copenhagen, Denmark
André Cicalo, Postdoctoral Researcher, desiguALdades Research Network, Freie Universität, Berlin, Germany
Philipp Schorch, Research Fellow, Cultural Heritage Centre for Asia and the Pacific (CHCAP), Deakin University, Melbourne, Australia
Leslie Witz, University of the Western Cape, South Africa
Pablo Alonso Gonzalez, PhD Candidate, University of Cambridge, UK; Researcher, University of León, Spain
Naomi Roux, PhD Candidate, Birkbeck College, University of London, UK
Eva Ambos, PhD Candidate, Cluster of Excellence, "Asia and Europe in a Global Context", South Asia Institute, University of Heidelberg, Germany

Respondent:
Ciraj Rassool, University of the Western Cape, South Africa

Question:
How, in an increasingly transnational and global world are the challenges of nation and diversity being squared with ideas about local and community identity? How are the tensions around these themes being articulated by museums, heritage, and cultural policy?

543

McCarthy:

In 2009, Ciraj and I went to a conference in Prato, Italy, called National Museums in a Transnational Age. There were people from all over the world talking about national museums, national identity, and nationalism. The very title seemed to imply that national museums were an anachronism in a transnational world and that they would naturally disappear, along with other elements of the nineteenth-century nation-state, in the face of the Internet, global trade, and multiculturalism. What struck me was that, despite the postnation thesis and the grim prognosis for the national museum, if anything, nations, national identity, and national museums were not only persisting and surviving, but in fact flourishing.

In the Pacific, there are lots of relatively new national museums, in New Zealand, Australia, Canada, New Caledonia, which are very much institutions forging a sense of national identity, both settler identity and indigenous identity. They have been referred to as 'civic laboratories' where 'experiments in culture' are carried out (Healy and Witcomb 2006). Whether it is called postcolonial or decolonizing these nations are facing the challenges of their colonial legacy and also dealing with contemporary issues. But as Kylie Message pointed out in her book *New Museums and the Making of Culture* (Message 2006), the newness of these museums often effaces the past and the tensions and complexities of the national past are oft en not shown. So this is a very fruitful area of debate where there's been a lot of writing, but it seems a good time now to really take stock of where the thinking is going.

Certainly at this conference on critical heritage studies there's been a lot of discussion about new tools, new theories, and new methodologies for looking at museums and heritage, and for thinking about these kinds of issues. I've heard a lot about moving beyond representation to object-centered philosophy, Latourian sociology, and a whole range of other ideas, which may equip us to analyze these questions related to museums, globalization, and identity in more complex ways.

Mason:

I'm similarly very interested in this postnational thesis and where it has some traction and where I think it doesn't. I will just say that when I was thinking about this last night, it occurred to me that I have to start with the fact that the UK is a multinational unitary state. Great Britain is the state that is the umbrella at the top level, but underneath that we have, obviously, Scotland, Wales, Northern Ireland, and England. So really what you see when you're thinking about nation is actually a renewed interest in pursuing articulations of the nation, particularly in Scotland and Wales, which I'm more familiar with than Northern Ireland since political devolution. So 'nation' hasn't gone away in any sense; it's got stronger as a frame of reference. In the UK we've got a referendum on Scottish independence scheduled for 2014, which would be a *huge* thing for the UK in terms of reconfiguring political relationships. In the UK then I would say that the national paradigm is still strong in museums.

As for diversity and transnational identities, in thinking through these issues brought up by the migration of different populations to the UK I think you could say that this pattern has been treated as a core-plus model—we've got these nations *within* the UK and then we're going to add these others onto it. I would say that that's being reflected in museums and their approaches. For a long while what I was seeing in museums was a 'main narrative' and integrated into it were these different groups, which we identify by 'ethnicities'—the Chinese in Liverpool, the Pakistanis in London, and so on. But talking to people in city museums—and of course there's a big difference between a city museum somewhere like London, which is a world city, and a city museum perhaps in the northeast of England, where nonwhite populations are very small— you can see parallels where they're saying this kind of core-plus, this adding on of ethnicities,

leads us into what I'm coming to think of as an identity trap; that you can never satisfy. You know, you always miss out someone: the Kurdish group or the Irish trannies in Liverpool, or some community who, once they see the representation couched in a particular way, a bounded identity group, understandably feel that they have been missed out.

There seems to be a bit of dissatisfaction with that and an intent to do it in different ways and I was just thinking through a couple of these. One would be to integrate stories of different diversities throughout the narrative. For example, if you're telling a story of Liverpool you run the community stories through it and you pick certain ones that are emblematic of a significant story *but* you don't pick them all in terms of a politics of recognition. Another approach is more *issues* based, looking at issues that can be seen across communities. Another one you can see is this idea of belonging to the city. What does it mean to be a Londoner? Chris and I have been traveling a bit and I think we can see this in other museums. In Amsterdam, what does it mean to be an Amsterdamer? What about a Copenhagener, a Berliner? That kind of place-based frame of reference seems to be another strong impetus.

There are lots of pros and cons. Talking to curators in museums where these approaches have been tried, it seems that oft en some communities will say: 'You've missed *us* out! Where are *we*?' There is an interesting question there. Are people so used to seeing displays framed in this way that they're at a loss to read them in a new frame?

Whitehead:

What I want to talk about is a particular transnational experience: what 'nation', 'diversity', 'local communities', 'local identities' do in relation to that transnational experience of migration. I'm talking from the European Union perspective, in relation to the European Commission-funded MeLa project that Rhiannon and I are working on. Migration is obviously not a new transnational process and one of my colleagues, Iain Chambers, holds that it is actually a central experience of modernity. But I think that it's inflected in quite specific ways in contemporary discourses in relation to issues of inclusion within, and exclusion from, and movement to and through, geopolitical entities like nations, or multinational affiliations like the European Union, not to mention the bordering of entities like this.

Migrants can be seen as a heterogeneous group of people ranging from refugees to economic migrants to the transnational rich. They can be relatively invisible like the Australians in London, and they can interact very little with the host culture really—if there can ever be said to be only one host culture. The very rich and privileged and the very poor and disadvantaged can end up living in quite different kinds of gated communities and their presence can go largely unnoticed or it can cause complex tensions. So what then does migration actually *do* to the nation and to communities and localities? Obviously this can be thought of in relation both to emigration *and* immigration, which each have different problematics.

Emigration can constitute a forced displacement or a brain drain, whereas immigration can be seen on the one hand as bringing vitality, skilled labor, and new cultural capital to a locality or it can be seen by some as an alien threat to entrenched local values, a drain on the economy, and risk to monocultural and monoethnic communities. Thinking about emigration, it's rarely represented in Europe as a historical phenomenon; for example, at the Deutsches Auswander-erhaus Bremerhaven or the Emigration Museum in Genoa, where there's a focus on early twentieth-century and mid-twentieth-century emigration, to the Americas for example. One of the notable findings of our MeLa research has been a lack of relationality between representations of immigrant groups in Western Europe and the 'homelands' from which they come. So in the Netherlands and Germany there are various representations of Turkish migrant groups and experiences, but if you go to Turkish museums there is no account of Turkish emigration

Conal McCarthy *et al.*

to Western Europe, even though there are some three million people of Turkish origin living in Germany alone.

Now with immigration, in the context of Western European museums, for example, this is a locus for very complex representations, bearing as much on the identity of the so-called receiving state as on the individual migrant whose experience is narrated—it's usually an individual who stands for the plurality of migrant experiences and also for new pluralities within society. In terms of themes we see stories of positive assimilation above all. So, for example, in the Amsterdam Museum we see stories of integration, assimilation, and adoption, adoption both of the people by the place and adoption of the place by the people. We see historicized stories of struggle where particular groups have struggled to integrate. An example is the Turkish community in Amsterdam, a historicized story that ends in the 1980s with the closing of the shipyards, where many of the Turks were guest workers. We see topics like leaving the homeland, the migration itself, the actual sense of the travel, and the new home, and these create different sorts of emphases within the actual representations. We also see the idea of the museum as a corrective or reforming instrument in the sense suggested by Tony Bennett. For example, at the immigration museum in Genoa we see videos of migrants explaining the hardships that they undergo on their way to Italy and we see curators, with whom you can have a virtual dialogue, actually reworking people's assumptions about the disadvantages of hosting migrants, such as overturning the idea that migrants take jobs away from Italians. In general, the immigrant experience is one that ruptures the fixity of the local, bringing into focus questions of diversity, tolerance, and notions of communities as groups of people who are known to each other, and with shared ideals, bringing into focus issues of hybridization and resistance to that hybridization. Migration catalyzes extreme nationalisms sometimes, but it also fuels the cosmopolitan dream. It makes local places themselves transnational, and requires a form of reflexive recognition in the museum that historicizes it in the now and grasps problematics relating to its politics and its persistence, and the mythologies that surround migration as a transnational practice.

Parby:
In my work as a museum professional and a historian I think this topic of migration and diversity we are discussing is one of the greatest challenges to European societies, particularly societies like Denmark, which has a self-image of being very homogeneous. The easy way to go is to say, 'Now we have these *added* communities', as you describe them, Rhiannon, and then we probably recognize them or try to integrate them. We construct this quite heightened and clear dichotomy between the core nation and the rest of the communities in the nation, even in the second or third generation, so that these identities are imposed upon the newcomers for quite some time. The other issue is that, rather than postnationalizing the nation or denaturalizing notions of national identity, you find that a lot of the discourse on migration actually formulates and reformulates what Danishness is—a very strong claiming of particular positions. You could argue that the experience of migration reinforces and allows the reclamation of national identity as a really bounded and clearly formed identity.

If we move from this general discussion to a more specific perspective, what can museums do about this situation? What is their role in all this? In the Danish national scene I would say that the approach of most museums has been multiculturalist; museums have strived to show newcomers that as museums they really accept them, respect them, and want to include them. Oft en, however, that creates the problem of Othering, because you direct specific projects to the Turkish community or to the Somali community or whatever. I think there's a lot of staging and compartmentalization in this approach, which does not really promote integration or cohesion in society, but rather petrifies a discourse into cultural heritage. One of the ways to move

beyond that is to situate and historicize national identity constructions in order to show that they are part of a distinct development. Stable national or ethnic identities (those that have always been there or are going to be there forever) do not exist. On the contrary, they are continually constructed and reconstructed through human interactions. As a historian, I operate by applying these theories of the postnational to the period *before* the nation-state, investigating how [other kinds of] transnational and cosmopolitan loyalties informed the relationship between individuals and groups in that era.

Because I work in a city museum another strategy is to look at a unit that's *not* the nation. The history of the city reveals a certain fluidity—you never have a sort of bounded, sedentary state of living, because transition and the constant influx and outflux of citizens has historically been the norm rather than the exception. It's been really helpful in my own work to think about migration and identity in this way. But obviously such an approach may have drawbacks in that perhaps you seem to dissolve ethnicities as particular identities. Even though you can criticize, and claim that 'postnational identities are better' or that that idea has greater potential in creating meaningful communities in today's societies, museums cannot altogether dismiss the individuals and groups still attached to national and ethnic affiliations. What the museum can do, however, is stimulate reflexivity about it.

Cicalo:

My research topic is about the construction of slave heritage in Brazil, so I am not talking about migrants as such, but forced migrants who have been brought into the nation. But although they were and are considered part of the nation, there has been a lack of recognition of people like the Afro-Brazilian and the indigenous community. So although there is not a problem of recognizing individuals and groups depending on whether they were migrant or not, there is a problem regarding the position that those migrants occupied in the construction of the national narrative. Now this situation is changing quite a lot through affirmative action, which is actually an effect of globalization, along with other things like multiculturalism, the World Conference against Racism in Durban in 2001, and the favorable position of UNESCO for the promotion of slave heritage. As a result, a new perspective is emerging toward slave heritage. My research is in Rio de Janeiro, where there is currently a huge debate about the building of a slave memorial and the development of an urban itinerary tracing and signposting places that are relevant to Afro-Brazilian history and culture in the port area of Rio de Janeiro, a part of the city that received millions of slaves during the trafficking period. Where previously elements of the history of slavery were completely absent in the city center, this subchapter of Brazilian history is coming out again through a social movement that is starting to organize and explore how to reconfigure the state and the nation with respect to its Afro-Brazilian identity. My ethnography of this process deals with the reconstruction of national identity not just in terms of rhetorically recognizing the nation as the historical sum of different and separate groups, but also in ways that actively confer more value to each one of these groups, questioning what place they occupy in the nation, and giving them their rightful place in the national culture as well as in society.

Schorch:

Both Christopher and André touched on two really important issues, and those are history and experience. Chris alluded to the fact that migration is not just a contemporary but a modern phenomenon, and, as we clearly see in the case of Brazil, actually a premodern phenomenon. My research sits at the intersection between globalization, museums, and meaning. Appadurai and Breckenridge (1999) said once, "Museums are good to think with." For me they are places

and spaces to understand globalization and how the actual meanings of globalization are performed and constituted. In order to do that one needs to pay attention to the fact that globalization is not a modern or contemporary invention; it is just a historical process that now gains different manifestations, especially through travel and technology. Southern Spain has always had influences from northern Africa and Islam, the Silk Route has always connected different worlds. A lot of sociological perspectives that dominate the literature don't pay sufficient attention to this longer historical context.

On that note, let us get back to the Pacific. Polynesian people migrated through the South Pacific well before any modern understanding of migration. In Australia the debate about migration relates mainly to policy and ideology after the Second World War, whereas British settlement in settler colonies is not seen as migration. It should also be remembered that nationality as a concept does not have purchase in all societies and that identity is understood in many complex ways across the world. For instance, the Maori in New Zealand have always performed multiple identities. They refer to *Hawaiki* (the homeland), to *iwi* (tribe), *whanau* (family), and different forms of identity in real-life situations. It's not so much an either/or separation, or tension, either national or local. It has been performed on a both/and level over centuries.

Museum studies as a field actually offers us tools to better understand those processes and shed light on them, and thereby create better-informed theories and policies, rather than constructing another dichotomous vocabulary or grammar of identity. The concept of place and space is very useful for my own research because, on the one hand, like any identity, it links a spatial concept to a physical place, and on the other, it always embodies a discursive space. Museums have *always* depended upon the travel of objects and of people. The objects in museums have been moved over centuries from one place to another, and if one considers the experience of the people who visit museums then there is the same shifting perspective. So although there might be a break, like in the 'New Museology', as Kylie's book points out (Message 2006), this newness covers up a historical dimension.

In that sense there's no such thing as a purely national museum or place if one considers that museums do not just embody meaning, but produce and construct it. To articulate and further this, I'm trying to work with ideas like methodological cosmopolitanism, which Ulrich Beck (2006) came up with. To achieve that distinction it is important to take into account the national or the local because you are dealing with a building, a specific place that gains meaning in those very particular settings. However, it is always linked to the discursive dynamics of an interconnected world and that has *always* been the case—it's just heightened now through travel and technology. To sum it up, the global always gains meaning in the local, and the local is always embedded in the global. Museums offer a perfect place to understand this.

Witz:

It is very interesting to listen to these discussions, but I'm not sure whether we can skirt around issues of ethnicity, identity, and diversity in the same sorts of ways in a postcolonial climate, especially when one of the major features of the apartheid state in South Africa was to reclaim diversity—you *had* to belong to an ethnic identity. One of the major aims of the postapartheid state was to do away with this notion of ethnicity and diversity in some ways, to reclaim a nation that does away with these borders. The museum sector in South Africa has flourished since the end of apartheid, but frankly I don't know why this is the case. I can see why people want to reclaim histories and all that sort of thing, but what does the museum do? Not many people visit museums. They don't make any money and don't really create jobs. So I'm still struggling with what, as an institution, the museum *does* as opposed to a book or school or something like that—it's a very important question.

548

But out of nearly all of these museums, whether the older type or the newer museums, there's only one that will claim an *ethnicity*, and that is the Berlin Jewish Museum. The rest all make claims around communities or nation or some national narrative—so you have the Robben Island story, there's Freedom Park, there's District Six. It's very interesting to see the ways in which community has been claimed in those instances, more as a locality and a memory in some ways.

I'm involved in a museum called the Lwandle Migrant Labour Museum, which is about forced labor and apartheid, about people coming to Cape Town and living in hostel-type compound accommodation. Really the museum is a museum that should *not* be there. It's a sort of independent initiative of one or two people, but it is there and it's got government recognition recently. The point is: what sort of history do we put in there? I'm chair of the board of this museum and it's interesting that the narrative we employ is a narrative that relates to the historiography of the 1980s and the social history movements, you know, 'history from below'. That becomes a national story in some ways; so, crudely put, we try and find little bits that fit into the national story of migrant labor in South Africa. We create a local past out of a national past.

I want to finish with two more points in connection with this migrant labor museum. The first is tourism, which we haven't spoken much about. What imperatives are created in the tourist context of South Africa, where ethnicity is proclaimed and people come to South Africa to see 'tribes' in action? One of the major pressures on this museum was to make it a 'tribal' place, almost like a cultural village, rather than as a social history place. What do the tourists want? Do they want to see Lwandle as a form of cultural village?

The second thing is about xenophobia. The community I am talking about has a history of migrant labor, and in more recent years people from all over Africa are living in Lwandle: there are Somalis, Nigerians, people from Zimbabwe, Malawi, and elsewhere coming to live there. Now the museum has to deal with this situation. There are people who are xenophobic. They say, 'Who are these people? They should not be here.' So the museum has to somehow talk about this xenophobia and relate it to the story of a migrant labor past under apartheid that it has focused on. Yet for many residents of Lwandle there seems to be a disconnection—the present xenophobia is disconnected from the area's history of oppression through migrant labor.

Gonzalez:

My research focuses on local museums in Spain in a really peripheral, marginal area, and in Cuba I look at national stories—which in some cases overlap with Brazilian national stories. I'm going to try to frame a bigger picture, rather than just stick to my research. Basically I consider the Spanish case to be somewhat unique, because Spain is always going in different directions than the rest of Europe. I would argue the Hispanic world and the Anglo world are very different, with different traditions, ethnologies, and epistemologies.

In Spain we have this French idea of a museum, which is bureaucratic and quite different to the Anglo tradition of museum management and interpretation. Museum directors are always people from the world of culture and work within a broader framework. All of this explains why identity politics is not fundamentally important. Spain, Italy, and Greece are essentially emigrant countries, and consider themselves to be so. In the 1990s and 2000s, Spain received six to seven million immigrants, more than anywhere in the world, more even than the United States. However, there was never an identity politics associated with this phenomenon. No one ever spoke of multiculturalism, or integration, because we think of ourselves as immigrants.

So what *are* museums doing in Spain? Identity politics is professed at a traditional regional level. This is because of the new reorganization of the state after the Franco regime fell, which divided the country into regions; so we have Catalonia, the Basque region, Galicia, and so on. Some regions considered themselves to be nations within the nation, so they used museums to construct these national stories. Then there are older regions that consider themselves to be historic areas, and they also are engaged in this building of their stories through museums. But this precedent of building identity happens at all levels in Spain. We also have provinces. My province, León, has its own museum that somewhat legitimates the struggle to gain independence from the autonomous region of Castile-León.

So it is clear that everyone is trying to create a different identity without looking at what's going on in the world, which makes us quite provincial in terms of museum management, I suppose. This can be clearly seen in the local places and marginal areas where, say in the case study I presented here at the conference yesterday, there is a small village, Val de San Lorenzo, where half of the population emigrated to South America, Buenos Aires, Cuba, Mexico. But they don't talk about the immigration that comes in today, so how can they talk about emigration when they don't consider that topic to be the stuff of museums? Museums are places where beautiful objects are displayed and that's how they are mainly regarded in Spain. However, we also have quite postmodern stuff, like, you know, the Guggenheim museum in Bilbao or in Valencia, because in Spain tourism is about 15 percent of the GDP.

It seems to me that we have to consider museums within new theoretical frameworks. It is useful to talk about 'assemblages' of museums, cultural industries, cultural offers. In Barcelona, for example, there is a national history museum that counters museum narratives at the Spanish national level, but at the same time comes into an assemblage with museums from all over the world. It all comes together to create an offer to the tourist that is not only ideological, but that is also productive of businesses and many other things.

It's important to connect Spain with South America in many cases because UNESCO meetings have workshops in which people from Spain meet with people from South America, make common programs, and share experiences. In Cuba, Mexico, and other Latin American countries there is a mixture of Spanish-style museums, stemming from the local politics of the newborn states of the nineteenth century. Many people consider that nationalism began in South America. These museums, like the National Museum in Mexico City, legitimate the modern nation in the Aztec world. But this is a process of inclusion through exclusion, because in reality these communities are excluded, so what they are basing their identities on is an abstract idea of the Aztec, without really engaging with these contemporary marginalized communities. However, in South America you get a lot of projects that engage with local politics, and indigenous communities, so there is this complex relationship going on in both directions.

Roux:

Like Leslie, I work in the context of South African heritage and museums, and I would agree that perhaps we *do* have a different take on ideas of nationhood, 'multiculturalism', and diversity because of that history. An example that comes to mind from my own research is quite a small, very locally based community museum in Port Elizabeth in the Eastern Cape, called the South End Museum, which deals with a similar kind of narrative to that of the District Six Museum in Cape Town. It commemorates a neighborhood in Port Elizabeth, quite a cosmopolitan, diverse, mixed community that was ripped apart when people were separated by race into different parts of city in the 1960s under the Group Areas Act. The approach the museum's management has taken in the exhibitions has been to represent South End's diversity via a series of separate

narratives and exhibitions that are culturally defined: so, for example, there's a display about the Chinese 'community' of South End, a separate one on the Cape Malay 'community', and one on the Indian 'community'.

This is arguably problematic, because of course these all fall into the same kind of categorizations that were used by the apartheid state in order to disperse people. But the museum's management sees this approach as the best way to represent South End as a 'melting pot', or as a space where diverse cultures existed alongside each other. I think in the South African museum context, given the history of how ideas of culture and ethnicity have been used, addressing questions of 'multiculturalism' requires one to quite directly confront these complications and the baggage that comes with ideas of nationhood, ethnicity, and culture. Something that's also worth thinking about is the question of audience, which is related to the question of tourism, whether international, local, or national. That's something worth bringing into the discussion— the fact that a museum and an exhibition is addressed to someone. Is the museum addressing 'the nation', or is it addressing foreign visitors, or domestic tourists? Who is the public who is meant to be consuming this material, and what does that mean for the way that ideas about culture and ethnicity are being approached?

Ambos:
I'm an anthropologist and my research is not directly related to museums, but I study Sri Lankan healing traditions, which are put on a national stage as 'heritage'. These healing traditions were 'museumized' in the sense of being considered to be in need of revitalization and preservation, which entails a kind of freezing of these practices. I would like to pick up on what Philipp said with the intersection of different scales—the national, the global, and the local, for instance. I think it is very important we acknowledge this intersection to avoid the trap of creating new binaries or dichotomies. My research is concerned with how the translation from the local scale to the national scale works, what the shift from a local village healing ritual to a 'national heritage' means. I am looking where the ruptures occur in this process and where the translation breaks down, because this translation can never be smooth.

There's another topic that came up in several of the statements, namely, the acknowledgment that when we talk about globalization, transnationalism, and so on, we have to speak of winners *and* losers. For some groups these processes mean the opening of borders, crossing and transcending of boundaries, and increased mobility, but for others this implies confinement. The low-caste performers I study are not necessarily profiting or taking advantage of their local practices as they're elevated onto the national stage, but rather they are kind of confined in a corset of tradition, confined by notions of nationalism, of 'pure' Sinhalese Buddhist culture in the Sri Lankan context.

Another important aspect, which was mentioned by Jakob, points to the danger of abandoning the notion of ethnicity. As an anthropologist, I look at globalization from a locally anchored perspective. For people in Sri Lanka, ethnicity plays a vital role, because it is a lived reality. It is dangerous to deconstruct everything as that [reality] plays a very important role in negotiations of identity in these local contexts. And yet at the same time I want to suggest that this increased cultural exchange in the context of globalization has the paradoxical effect of increasing or enhancing the essentialization of identity, of trying to pin down identities and closing ethnic boundaries.

When I speak about heritage, that heritage is very much a normative discourse—a normative discourse in the sense that it imposes a very strict corset on a very plural and multiple articulation of reality. In the Sri Lankan context I found a shift in cultural policy from an emphasis on multiculturalism to transculturality. Transculturality in a double sense: the sense of transcending

culture, that is, how a nation-state presents itself as something naturally grown, something acultural or culture neutral, something based on equal rights, democracy, and so on; and in the second sense transculturality as an engulfing of the Other, other heritages, other cultures, by a dominant nationalist ideology. What you have in Sri Lanka, especially after the official end of the civil war in May 2009, is, for example, a redefinition of Tamil Hindu religious practices and elements as Sinhalese Buddhist heritage, or their assimilation within it. This kind of heritage politics is expressed in a museumization of cultural practices, an objectification of culture that always leads to asymmetrical power relations in which some groups become more visible and others remain invisible within the nation-state. Therefore, we have to think of heritage and museums as something *performative* that allow us to talk about contestations and dynamics, but on the other hand we also should acknowledge the *normative* aspects that cultural policy and heritage discourse bring with them.

Rassool:
This has been an absolutely fascinating discussion. Let me start with Conal's point of departure, and go back to our discussions at the Prato conference about museums in a transnational world and the possibilities of museums beyond the nation. That conference was also about the relationship between museums and historians and about the place of the discipline of history in the museum. Let me first give you my conclusion. We are living at a very interesting, complicated time in the world, characterized by such unevenness, such extraordinary change, in which we are witnessing the *end* of the museum as we know it. It's not just the end of the national museum; it's the end of the collecting museum. The authority of the museum as the collecting institution is called into question in a postcolonial world.

That argument does not arise in every society, because, as we are witnessing the end of the museum as we know it, we are still seeing the persistence of the national museum. Here, the contests over immigration and immigrant communities, and attempts to understand processes of globalization, are precisely some of the different ways in which the modern nineteenth-century museum tries to reproduce itself. All of the instruments of the modern museum through the international institutions that service the museum and heritage sector, the ethical frameworks, and definitions and committees of ICOM and so forth, all service the existing relationships within and between museums.

I'm speaking from the vantage point of being intimately involved right at the moment in the return of human remains from Austria to South Africa. In the middle of the negotiations, the key question was the authority of Austrian institutions to continue to hold these collections. Quite frankly, the deeper epistemic questions underlying these seeming transactions over individuated things are fundamental questions about the future of the museum. Because while the museum is the institution of the discipline of history, it is also the institution of a classificatory system in which the world was divided into societies of people with history and people without history. When you have postcolonial nations emerging and claiming to be nations they do that through the discipline of history and that calls into question the authority of older colonial disciplines.

Now we have many different kinds of institutions that are emerging that are calling themselves museums. In the District Six Museum in Cape Town we work with Museu do Maré in Rio de Janeiro and we've had a couple of exchanges. We participated in an IBRAM [Brazilian Museums Association] conference in Belém de Pará where we engaged in discussions about the ways in which ecomuseums, community museums, cultural centers, heritage projects, keeping places are precisely *not* about the collection. The museums are about something else, and it might be about a different way of telling a history of something. Those of us who are studying

these processes examine it through engaged forms of historical practice outside the academy. Leslie Witz and I and our colleagues have begun to refer to this as the 'practice of public history'. The other important museum forms that are emerging that might call itself 'museum' and that might call itself 'heritage' and that might call itself 'memory project' merge postconflict healing and transitional justice processes through which museums become places of historical narration. I don't know if they're postmuseums, if they are 'new museologies', or if they are museums beyond the collection. But the one thing that is becoming certain is that the future of the museum lies precisely in the source community relationship. This future lies in their transactions and in the connections between museum institutions in one society and communities and people in other societies.

Rethinking the relationship of the museum and the community is necessary because the nineteenth-century museum was not only about the nation, not only about particular modern disciplines and disciplinary institutions; it was also about the formation of citizens. So immigration and all of that are locked into the processes of citizen formation as regulation. Immigration museums tell the story of the extension of the boundaries of the citizenry, and how you come to know who you are through your national story, and who gets named as an immigrant and who does not get named as an immigrant. Really everyone's an immigrant when it comes down to it. But we are living at a time of tension. If the museum does not engage with that debate, then the museum has no future as an institution.

McCarthy:

Now we're able to open the conversation up. I'll kick off by mentioning another part of the world where these debates are echoed. Rhiannon and I were at a conference six weeks ago in Athens that was exploring how European national museums can create social cohesion within the EU: the Eunamus project. The Europeans at the conference were really struck by the fascinating presentations from Asia—which are not so well represented in museum studies. In Singapore the National Museum and Asian Civilization Museum present an idealized picture of the polyglot racialist state, with Malays and Chinese and Indians coming together in national harmony. As we learned here at this conference from the stream on China, there are nine thousand museums in the PRC now, and a new museum opens every day—the newly reopened National Museum in Beijing is now the largest museum in the world! These museums are very much about the majority Han Chinese civilization, which makes up 85 percent of the population, rather than the eighty or so minorities around the country. In northeast Asia, impressive new museums are symbols of the modern industrialized state. Taiwan, for example, where I lived for a while, boasts huge museum buildings that are obviously symbols of nationhood. But there are more people outside flying their kites on the lawn than inside.

Different parts of the world have really different situations, and scholarly perspectives have been limited to a few countries and writers have generalized about many things—settler colonies, for example. The literature on postcolonialism, nationalism, and museums oft en comes from places like Canada, Australia, and New Zealand, but the settler indigenous relations in new nation-states are not typical of other parts of the world. The other important thing for me, I think, which came out of our conversation, was the historical dimension mentioned by several of the people here. One of the problems with the scholarship on museums at the moment is modernity. Everyone talks about modernity, which is supposedly everywhere and nowhere, which is everything and nothing. So many things are ascribed to it and yet we can see premodern entities going right through this late modern period we are living in.

For example, in the Pacific a lot of Polynesian people think of themselves in all sorts of different kinds of ways. In nineteenth-century New Zealand, which became part of the British

Empire, settlers saw themselves as British and only later as New Zealanders, whereas a lot of Maori people saw themselves as 'brown Britains', because of the Aryanism that was a feature of the British Empire in the colonial period. At the same time they saw themselves as Maori, but in a number of ways simultaneously: there were subtribes, and increasingly tribes (itself, some argue, a colonial invention), but also a pantribal sense of indigenous nationalism, different to the kind of settler nationalism that appeared in the late twentieth century. This is a much more complex mix than is suggested by postcolonial theory today, which looks at contemporary society with its nationalism and identity politics, and tends to back-project that onto the past when those things didn't really exist.

Schorch:

To me it feels as if scholarship in general comes up with new categories like 'modern' or 'post-colonial' museums, imposing something that has been constructed in the present on a process or situation in the past. So all of a sudden we talk here at this conference about affect and emotions and so forth but it's just another intellectual abstract construction to make sense of something that has always been a unified whole. If you consider the human experience in all its complexity, people have always managed multiple identities just as we do all the time. You've got to focus on holistic complexity rather than dichotomous vocabulary.

At the same time we can definitely point out similarities: colonial migration, forced removal, in Australia there is the example of the 'Stolen Generation'. So there are always similarities and differences that allow us to communicate with the Other by creating this common sphere that is possible among human beings. Again it's not a monolithic understanding of a supposedly national framework—you have a difference within and you have the similarities between different states. What Conal said about modernity is likewise with 'hegemony', 'discourse', 'capitalism', 'state'—these categories are used as if they are self-enclosed totalities working at the bottom of society, whereas they are inherently contested terrains. Scholarship should open up the moments and processes when they are contested and really interrogate the complexity, rather than taking it as a self-evident point of departure.

Mason:

Yes—rather than looking at polarities and dichotomies, trying to see how the local and global are always interconnected shows how they are produced through the museum space. But I wanted to just pick up on this idea you were talking about Philipp, this looking back at the longer history of migration in museums, because it's exactly what they tell you, isn't it, when you go there and look at them: it's all about that, if you get past the ways it has been compart-mentalized. But I *don't* think in the UK that that kind of cultural historians' understanding of the long trajectory of globalization is reflected in the way museum policy operates, because diversity is bracketed off as a post-Second World War thing, which is really problematic in the national narratives that circulate.

I started off looking at Wales, and you only have to scratch the surface of the history of South Wales, an industrialized area in the late nineteenth century, and you discover that it is full of stories of migration. But those stories were forgotten, they were pushed away in the processes of nationalism that sought to tell a unified story. Now I'm thinking about the longer history of migration that opens up the possibility of deconstructing the national narrative as it exists in Europe, and I still think there is a very important job to be done there because that isn't the way that the public discourses frame it. But on the other hand I suppose there is the problem that if you say we're all migrants, we have always been migrants, how do we do that on the one hand, but not downplay the very *different* experiences, the very structural inequalities for certain

groups. I mean, look at the history of slavery—the migration that we're talking about there is radically different from what I'm talking about in an industrial area of Britain.

So I guess there are different political strategies in museums: one is about taking the core story and deconstructing that and the things that can flow from it and the possibilities it can open up for debates around citizenship and who belongs and so on; and the other is the kind of 'politics of recognition' that I think still has important things to do in certain places, because it still offers people a place to speak from and it draws attention to perhaps what is different and makes a very powerful political statement.

I'll just end by coming back to your question Leslie. You asked why are people interested in museums? What do they do that books don't do? It's tied into what I was just saying; people recognize them as an opportunity to make a move or a statement in the public sphere. In a sense, the question of *who* visits is a different part of the equation and it is very, very important. Who are migration museums for? Are they for migrants? Are they for the nonmigrant? Are they insulting for nonmigrants? Different political things are tied into these questions of the moves that are made in the public sphere in a national narrative, and these relate absolutely to these questions of who can be a citizen, who does the state acknowledge as a citizen, and do the different communities want to see themselves as citizens?

Parby:
I'd like to pick up on that one, specifically from a policy perspective. You need to realize how much political involvement and even self-censorship is at work in the museum sector, compared to, I guess, many intellectual traditions and different ways of critiquing modernity, which have really been common since the 1960s. There seems to be an apparent lack of the same critique in many museum and heritage practices, which leads to academic criticism. But what I often find is that, particularly with an issue that is so politically debated like migration, that any new initiatives are subject to a lot of political attention from the outside, but also create self-censorship among the people involved in doing them within the institutions. I think that's one of the main reasons why you oft en end up finding museums just reconstructing the nation in new ways and trying to pull in new groups within this unit of the national narrative.

The classification of cultures in museums is another important reason why museums have such a hard time trying to employ more relational ideas about identities or portray people and nations as constructed and negotiated. It is a complicated process to move in this direction, when a lot of the objects contained in most museums are collected and described in a way that is oft en closely connected to and embedded in the national narrative. It takes a lot of institutional and individual transformation to move beyond that mode of thinking.

Ambos:
Well, I'd like to comment on what Philipp said about the nation-state being contested and subverted. What I encountered in my research when I visited the homes of these performers, is that they have their own private family museums—their living rooms are backed with photos, newspaper articles, postcards, souvenirs. This material is ordered in a certain way, chronologically and in other ways. We should acknowledge what we might call these 'subaltern' articulations of the idea of the museum, of preserving something.

Cicalo:
Usually when we go to museums we think of a narrative. There is a narrative in the museum, even when the museum wants to be inclusive, a narrative about inclusion. I'm thinking maybe

Conal McCarthy *et al.*

the museum could be much more interesting if it was self-critical. I don't know if this is possible, but it would be a real challenge to have a museum where there is self-reflection about what this representation means and that conveys this kind of debate that we're having today, showing different opinions, different narratives.

Witz:

But I still don't understand this response to the notion of the museum as a public sphere. Why that institution? I mean a movie can do exactly that, can't it? What is the specific institutional role the museum has performed that makes it different?

Mason:

It's a truth claim…

Witz:

Yes, ok, it's a truth claim, but movies have also got truth claims, books have got truth claims—lots of things have got truth claims. But Ciraj has put on the table 'The End of the Museum'. I wonder if you are really talking about the destruction of that institution and its very foundational concepts of presenting facts and artifacts.

McCarthy:

You know you're doing Jakob out of a job (laughter).

Mason:

One thing that interests me is in this question about whether the museum as we have known it is moving into new territory. Could we look beyond the museum for a moment and just look at other things, like film, like television, literature, and so on, and expand our horizons a bit? Sometimes in museum studies we treat museums so independently, but of course people visit and engage with culture *across* a spectrum. The reason I think broadcasting, particularly TV, is interesting is that's it's a platform for different views, it's a *political* space. On the BBC you hear all sorts of political views that the BBC is not necessarily supporting, but there's some interesting questions there about authorship, about who is speaking, the debates you can have in a civil society, which might be interesting to play out against the museum, because I think a lot of these debates are about the voice with which the museum is speaking in a multicultural society.

Whitehead:

Moving on from the issues of the self-reflective museum, the end of the museum, and the issue of truth claims, I think one of the issues here is about the ostensible authorlessness of the traditional museum, if you like, and this is how its truth claim works in a sense. There is generally no name of the curator/writer under the label, not in the same way as there is with the director of a film or the author of a book. That authorlessness, a bit like with maps in some way, works to present a 'reality' that can't be questioned easily because there appears to be no one to question. The issue of self-reflection is a very interesting one. But then, of course, the issue is how to reconcile that with existing display technologies and existing expectations on the part of visitors about what they expect really, about the different codes of display and information delivery that we work with.

Then there's also another issue about conflict and how to frame that. If you get into a topic like migration you can historicize migration flow and hybridity in the deep past, or even in the

relatively recent but still closed past, relatively easily. But to historicize contemporary migration is difficult because it's such a matter of contention and conflict and difference of opinion. How do you actually do that? That also bears upon issues of neutrality and pluralism within the museum. Does a museum pretend to a morally neutral role? Can it continue to do so? Is that part of the end of a museum as we know it? Or does the museum have to take a position and propose a certain kind of pluralism, a certain kind of hybridization, as something to which society should aspire? What happens when you talk about admitting oppositional voices into the museum? In our project we've been looking recently at migration displays in museums in different countries where far-right political parties drop off leaflets that counteract or counter-mand the positive representations of immigration as a social good as seen in the museums. What do we do with those voices and how do we marshal them, how do we police that particular debate?

The last thing is the question of who museum representations are for. Is the museum the right place for a migrant to represent her- or himself, or to recognize themselves? Outside the Museum of Migration on the docks in Genoa are dozens of migrants selling goods on the path-ways. The migrant community is very visible *outside* the museum rather than *within* it, so there is this disjunction between who we are speaking *about* and who we are speaking *to*. And this is also connected to this issue of the museum as a representation of globalization, as an outward gesture not as an inward one. So the museum, different from the film and the book, is a matter of international relations. It's a claiming of a geopolitical identity. What is different about the museum in this sense is its emblematism in this context.

Gonzalez:
Now I want to make some general claims about the analysis of museums and society that reflect my difficulty in this conference. I feel that our tools are already too outdated to deal with museums, because we are working within a postmodern frame in which there are really quick and internally complex assemblages and politics of things, museums, and political economy. And yet we keep on thinking as if museums are public institutions within public experiences and have a massive stake in dialogue and truth. But they are not. The museum cannot help with this, because there are always people, psychological authors, who are going to invest desire and money to push some strands forward—by that I mean nationalism, money, tourism, work, and so on.

It's still important to discuss the concepts of scale—global, regional, and local—because even my local museum in my city is connected to global flows. But I really don't think it's interesting any more to talk about, or to compare, 'national' and 'local' museums, because they are engag-ing in the same flows. The main thing is what they are doing specifically, in specific places. In Spain, 99 percent of museums are not national museums. Are they local museums, regional museums, or widespread museums? There's no barrier, totally the contrary. Obviously we look, first, at the national museum because it provides us with that narration we can deconstruct and criticize. But museums don't care about that, they are constructing and deconstructing some-thing new all the time, and we are already lagging behind them. There's all these people con-stantly investing time, energy, identity, and money and creating symbolic capital and new identities, just as you said, Leslie.

Lastly, it's important not to split economy from culture because in our countries, the coun-tries that have a lot of their GDP percentage in tourism, we cannot afford to create narrations, as in Britain or Sweden, that are a representational view of our identity, of making a claim. Rather, our identities are the by-product of these complex networks and assemblages. Art, tourism, and so on are our by-products, and we cannot only deal with the by-products, but

Conal McCarthy *et al.*

must analyze what's going with that identity to be constructed. So I think our analytical tools should grow from discourse and deconstruction to an analysis of what's going on behind and what spreads about in this 98, 99 percent that we are leaving behind.

Rassool:
As I've been listening to the second round of discussion, what comes out most powerfully is that we should stop using museum as a *noun*, and that we should start thinking about museum as a *verb*. We are living in a time of multiple, contested museumifications and museumizations, in which identities are continuing to be rendered as a museum display, through tourist gazes and the reproduction of cultural images that are limited. South Africa continues to be seen as animal and tribal as a tourist destination, which poses severe limitations on its capacity to be democratic and postracial, as if its Africanness is forever ethnic. And so the kinds of museum institutions that emerge around Cultural Villagization represent one of the contested museumifications. At the same time, some of the important processes of museumification involve taking issue, in quite an activist way, with those kinds of images and framings, in which museums become social projects of intervention about the way we understand the world. If we try to understand the processes of museumification and museumization at the center of what we are doing, understanding the knowledge transactions through which the museum project occurs, then every process of museumification involves a set of knowledge relations in which expertise is wielded, in which community knowledge is appropriated, in which authenticity is claimed. We need to really take the idea of the museum as verb in much the same way that it is better to think of *identification* as a verb as opposed to *identity*. Then we have more interesting ways of understanding the processes that are unfolding so we can continue to intervene in those processes.

Whitehead:
But is it a passive or an active verb?

[With lots of laughter, the conversation came to an end.]

Websites

EUNAMUS: European National Museums: Identity Politics, the Uses of the Past and the European Citizen. http://eunamus.eu (accessed 8 October 2012).
MeLa: European Museums in an Age of Migrations. www.mela-project.eu/ (accessed 9 October 2012).
National Museums in a Transnational Age: A Conversation Between Historians and Museum Professionals. 1–4 November 2009. www.globalmovements.monash.edu.au/events/2009events.php (accessed 10 October 2012).

Bibliography

Appadurai, Arjun, and Carol A. Breckenridge. 1999. "Museums are Good to Think With: Heritage on View in India." pp. 404–420 in *Representing the Nation: A Reader: Histories, Heritage and Museums*, ed. David Boswell and Jessica Evans. London: Routledge; New York: Open University.
Beck, Ulrich. 2006. *Cosmopolitan Vision*. Trans. C. Corin. Cambridge: Polity Press.
Healy, Chris, and Andrea Witcomb, eds. 2006. *South Pacific museums: Experiments in culture*. Melbourne: Monash University ePress.
Message, Kylie. 2006. *New Museums and the Making of Culture*. Oxford: Berg.

38
Reflections on the *Confluence Project*

Assimilation, sustainability, and the perils of a shared heritage

Jon Daehnke

The recent bicentennial of Lewis and Clark's "Corps of Discovery" created increased interest in commemorations of this event along the entire course of the expedition's travels. In advance of the bicentennial, a number of states established Lewis and Clark commemorative commissions, museums at both national and local levels planned exhibits on the Corps of Discovery, and leaders of local communities along the trail deliberated on the best ways to use the bicentennial to attract tourist dollars to their communities. A group of Lewis and Clark reenactors—including some descendants of William Clark—even set out to retrace the entire course of the journey during the bicentennial years.[1]

The desire to commemorate the bicentennial was certainly felt along the Columbia River, along which the Corps of Discovery traveled in 1805 and 1806. A centerpiece of Columbia River commemorations of Lewis and Clark—and the one that might have the most long-lasting presence—is the *Confluence Project*, a series of seven permanent and public art installations located at specific spots on the banks of the river. The *Confluence Project* art installations were principally designed by artist Maya Lin and further developed and constructed with the assistance of a number of architects and partners.[2] The *Confluence Project* was initiated in 2000 as a collaborative effort between various civic groups from Oregon and Washington, a number of Pacific Northwest Native American tribes, artists, and landscape designers. The stated goal of the *Confluence Project* is to "reclaim, transform, and reimagine," through the creation of public artworks, seven places along a roughly three-hundred-mile stretch from the mouth of the Columbia River to near the border of Washington and Idaho.[3] All seven of the chosen sites were stopping points for the Corps of Discovery. Ultimately, the *Confluence Project* was "designed to rethink what a commemoration of the Lewis and Clark Northwest Expedition could be," especially by providing greater space for Native American voices and framing the history of the Corps of Discovery as part of a larger shared heritage.[4]

Explicit in the *Confluence Project*, and promoted as part of a shared heritage, is a message of environmentalism and sustainability. The seven sites that were chosen for the *Confluence Project* were chosen in part because they were points of intersection between environment, culture, and history, places of "encounter between the natural world and the built environment, the past and the present, for people of all backgrounds."[5] The art installations located at each site were designed by Maya Lin to interpret the area's ecology and history and to

559

Jon Daehnke

integrate environmental concerns and history with an awareness of and sensitivity to the tremendous changes the journey of Lewis and Clark effected on Native Americans and their homelands. The *Confluence Project* has a strong, positive emphasis on a future where we begin to preserve and sustain our natural and cultural resources.[6]

Messages of shared heritage, especially when placed in the context of long-term environmental sustainability, seem reasonable and, in fact, even relatively mainstream. My argument in this article, however, is that these messages, while on the surface seemingly agreeable, are not entirely benign. I suggest that the messages of shared heritage and sustainability found in the *Confluence Project*, rather than transforming and reimagining the story of Lewis and Clark, serve to further assimilate the Native American story as one more component of the American master narrative, create a false equation of Indigenous and settler experiences on the landscape, distance and erase the tragedies of colonialism, and perpetuate stereotypes of pristine nonanthropogenic landscapes. In effect, the *Confluence Project* hides what is a very real and specific history of colonial violence and dispossession and turns it instead into an ahistorical story of shared environmental concerns.

My arguments in this article are drawn from multiple visits to two of the *Confluence Project* artworks; the Vancouver Land Bridge in Vancouver, Washington, which connects the Columbia River with historic Fort Vancouver, and the bird blind at the Sandy River Delta east of Portland, Oregon, where the Sandy River flows into the Columbia River. My analysis is also shaped by my observation of the First Walk celebration and dedication of the Vancouver Land Bridge held on the morning of August 23, 2008. While my thoughts on both the artworks and dedication ceremony are certainly informed by the theoretical literature on memory and public history, this article is not meant to be principally theoretical in nature and therefore will not contain any extended discussions of that sort.[7] Mostly, this article is meant to be reflective and representative of my initial impressions of the artworks and dedication ceremony and is perhaps best read as a form of travel reflection or meditation.[8] I should also note that I do have a previous attachment to the heritage issues of the region, having conducted archaeological work in the nearby Ridgefield National Wildlife Refuge since 1999 and researching some of the concerns related to public representations of history that affect the region.[9] What this means is that the ideas that appear in this article did not just appear out of the blue. Rather, some are only the most recent manifestations of concerns over which I have been ruminating for some time.

First walk: the celebration and dedication of the Vancouver Land Bridge

The Vancouver Land Bridge is the second of the seven *Confluence Project* sites to be completed. The Land Bridge is a roughly forty-foot-wide earth-covered pedestrian bridge that arcs over Washington State Route 14 and connects the Columbia River waterfront (an area with restaurants, parks, and condominium development) with historic Fort Vancouver (the location of the first European trading post in the Pacific Northwest and now run by the National Park Service). The pedestrian bridge, which was designed by Maya Lin and architect John Paul Jones (Cherokee-Choctaw), includes a number of sculptures and paintings (which will be discussed more directly in the next section), and its pathway is lined with plants that were once native to the area. Small signs are placed by many of the plants, and the signs typically include a quotation from either Lewis or Clark about how Native Americans used that particular plant. The southern entrance to the site is framed by the Welcome Gate, a sculpture made from two basalt blocks and two large cedar canoe paddles, each embedded with glass sculptures of the face of a Chinook woman. The bridge is located near one of Lewis and Clark's campsites, and overall the design

560

Reflections on the *Confluence Project*

of the bridge is meant to "evoke the site's role as a historic tribal crossroads as well as a point of contact between European and Native people."[10]

The Vancouver Land Bridge was dedicated on the morning of August 23, 2008, at a well-attended public ceremony. The dedication began with the ceremonial First Walk, which consisted of a procession from the Fort Vancouver side of the pedestrian bridge to the Columbia River side. The processional was led by a group of Scottish bagpipers (perhaps in honor of the part-Scottish John McLoughlin, the chief factor of Fort Vancouver from 1825 to 1845—although this connection was never explicitly stated), followed by three twenty-foot-tall puppets, and then followed by members of the public. The procession crossed the bridge and ended at the Old Apple Tree Park on the south side of the project, where the bulk of the dedication ceremony took place.[11]

Jane Jacobsen, executive director of the *Confluence Project* and emcee of the dedication ceremony, began the event with a brief welcome statement and introduction of the ceremony participants, which included local and state government officials, the superintendent of the Fort Vancouver National Historic Site, architect John Paul Jones, and artist Maya Lin. Jacobsen then led participants and attendees in recitation of the Pledge of Allegiance. After introductory statements by Royce Pollard, mayor of Vancouver, Washington, and Tracy Fortmann, superintendent of the Fort Vancouver National Historic Site, the audience joined in the singing of all five verses of "America the Beautiful." The remainder of the dedication ceremony consisted of comments by John Paul Jones and Maya Lin and the recitation of a poem about Lewis and Clark entitled "What We Carry on the Trail" by Sam Green, poet laureate of the state of Washington.[12]

That this was an "official" event was evident from the beginning of the dedication ceremony. Its official nature was reflected not only in the recitation of the Pledge of Allegiance and the singing of "America the Beautiful" but also in the involvement—and in fact the centrality—of government officials. Primary participants in the ceremony included Royce Pollard (mayor of Vancouver), Brian Baird (at the time the US representative for Washington's Third District), and Mike Gregoire (husband of Christine Gregoire, governor of Washington). Although the *Confluence Project* may have begun as a coalition of various civic groups, Northwest Native American tribes, artists, and landscape architects, the dedication ceremony felt dominated by government actors. Additionally, despite the *Confluence Project*'s goal to provide more voice for Native Americans in the Lewis and Clark story, the presence of Native Americans at the dedication ceremony was muted. The principal visible Native American presence at the dedication was the Northwest Indian Veterans Association, which served as the dedication's color guard, carrying the flag of the United States. Cliff Schneider, a citizen of the Chinook Nation, did offer a blessing at the end of the dedication ceremony. It's important to note, however, that Schneider offered this blessing as an individual, not as an official representative of the Chinook Nation.[13] In fact, if any of the regional tribal nations attended the dedication in an official capacity, it was not made apparent to attendees.

Two of the principal messages of the dedication were "celebration" and "shared history." The First Walk was officially labeled as "a celebration and dedication," and Jacobsen began the event by stating that "we've got some celebrating to do!" The message of "shared history" was expressed clearly in an official letter from Washington governor Christine Gregoire (read on her behalf by her husband, Mike Gregoire) that stated the following: "Lewis & Clark's epic journey is part of our national heritage, and I am deeply grateful for your dedication to the preservation and thoughtful examination of our shared history."[14]

The messages of "celebration" and "shared history" may not, however, have been the most appropriate given the location of the Vancouver Land Bridge and the historical specifics of the

region. For instance, Fort Vancouver was built shortly after the Hudson's Bay Company decided to move its Columbia River headquarters from Fort George (located near the mouth of the Columbia River) to a spot that was located directly across from the mouth of the Willamette River in July 1824. A new fort was established at this location, and on March 19, 1825, Fort Vancouver was officially dedicated, and Dr. John McLoughlin was appointed chief factor.[15] Only a few years earlier, the Hudson's Bay Company, through a forced merger, had absorbed its primary economic rival, the North West Company, and the consolidation of these two companies left the HBC as the primary economic power in the region. While business ventures were certainly a component of the HBC, its principal role was to assert and reaffirm British imperial claims to the region. The ultimate "ownership" of the Pacific Northwest and the boundaries between British Canada and America were still fluid and contested at this point. Under the guidance of McLoughlin, British imperial claims to the region were pushed northward up the Pacific coast, eastward into Snake River country and southwest Oregon, and southward toward northern California.[16]

In addition to its central role in British and American imperial competitions, Fort Vancouver was embroiled in problems relating to colonial settlement of the region, especially in the context of conflicts caused by European American settler encroachment on Native American lands. While McLoughlin's goal was to calm tensions in an "unsettled" area, his methods often relied on violent retributive attacks on Native Americans directed from Fort Vancouver.[17] Although McLoughlin resigned in 1846 and the Oregon Treaty of that year placed the Canadian–American American boundary well north of Fort Vancouver, the fort remained the headquarters for colonial control of Native American populations fighting to stay within their lands. At times the fort even served as an internment site for Native Americans, including documented internments of Cowlitz and Nez Perce populations.[18]

While Fort Vancouver was serving as a headquarters for imperial and colonial actions against Native Americans, disease was devastating regional Native American populations. The Columbia River, which had served so well as a highway for trade, unfortunately served equally as well as a highway for disease. Smallpox may have reached the Northwest as early as the 1500s, and well-documented smallpox epidemics occurred in 1775, 1801, 1836–38, 1853, and 1862. One of the worst epidemics to hit the Columbia River, however, began in the summer of 1830. Called the "fever and ague" by the Americans and the "intermittent fever" by the British, this epidemic—most likely malaria—raged through the lower Columbia and Willamette river valleys for several summers. The epidemic had a devastating effect on Native populations. Both the Hudson's Bay Company and Lewis and Clark estimated a regional Native population of somewhere near 15,500 in the early decades of the 1800s. By 1841 this number had been reduced to 1,932, a decline of nearly 90 percent. While the effects of the epidemic were felt throughout the lower Columbia and Willamette valleys, as well as river valleys as far south as the San Joaquin valley in northern California, the greatest devastation was inflicted on the Middle Chinookan populations of the Portland Basin. Sauvie and Deer Islands, large Middle Chinookan population centers that are in close proximity to Fort Vancouver, were entirely depopulated by 1835.[19]

Such large-scale abandonment of villages led some white observers, including McLoughlin at Fort Vancouver, to suggest that the Native populations of the region were now extinct. Although the rate of mortality was extremely high, Middle Chinookan populations had not gone extinct. Some survived, and those who did joined villages within their kinship networks, moved to the seacoast, or fled into the mountains.[20] Some of the survivors even fled to what they thought would be the safety of McLoughlin's own Fort Vancouver. But employees of the company felt "obliged to drive the Indians away instead of affording them the assistance they

implored of us by our having as many of our people on the sick list as we could possibly attend to."[21] By 1850 the overall population of the region had rebounded to pre-1830 levels. Its composition, however, had undergone a radical transformation: English-speaking Americans had almost totally supplanted Native Americans. The few Natives that remained came under intense pressure and competition from white squatters. Furthermore, the passage of the Donation Land Law of 1850—which granted land to Americans after four years' "occupancy"—gave official sanction to the formerly illegal activities of white settlers.[22]

The First Walk dedication ceremony at the Vancouver Land Bridge included no mention that Fort Vancouver served as the headquarters of imperial expansion and colonial control of Native American populations. Nor was there discussion of the high levels of disease historically present in the Portland Basin that resulted in a death rate of perhaps 90 percent among Indigenous populations and that in conjunction with colonial settlement and government policy resulted in the displacement of Native American populations. In this sense the history of the site where the Vancouver Land Bridge now sits is neither celebratory nor shared.

Jeffrey Hantman has sounded a note of caution about choosing benign words for public "events of unbalanced cultural encounters and colonial control," ones that are steeped "in conflicting cultural memories of events that are as much about violence and tragedy as they are about a place of humble beginnings or unambiguous victories."[23] The history of the Portland Basin and Fort Vancouver is one of "unbalanced cultural encounters and colonial control," and the use of the words "celebration" and "shared history" to describe the land bridge dedication serves to distance and erase this violent and starkly unequal colonial history. The failure to address this history perhaps reflects an unwillingness to acknowledge the long-term entanglements of colonialism, the loss and displacement for Indigenous populations that have accompanied it, and the fact that the legacies of colonialism continue today.[24] The failure to directly acknowledge this history in a public event results in a celebratory image of a shared history that is, in reality, ahistorical.

Symbolic assimilation and equation at the Vancouver Land Bridge

I'll now turn my attention from the First Walk celebration and dedication to a few observations on the Vancouver Land Bridge itself. In specific, my comments focus on the illustrations that are prominent on the Columbia River side of the bridge. The Columbia River entrance to the land bridge contains a series of five illustrations that line a gently inclining walkway that leads to the top of the bridge. The first illustration is labeled "Columbia River 1845" and shows a picture of a "Chinook Traveling Lodge" painted by Paul Kane.[25] The second illustration is titled "Hudson Bay Company and U.S. Military Post" and shows the fort in the mid-1800s. The third image is a photograph of the fort as a military post circa 1860. The fourth is a photograph of Fort Vancouver as the home of the army's Spruce Production division in World War I, and the fifth shows its use as a shipyard during World War II. Other than the text that labels the illustrations, there is no additional text to provide historical context.

My initial reaction to this series of illustrations was that, whether intended or not, they represent a fairly overt message of American progress and Manifest Destiny. All the standard tropes of the frontier myth are present: the inevitable replacement of Indigenous populations by an advancing—and more advanced—settler population (perhaps even reinforced by the physical incline of the walkway itself), the eventual settlement of the United States all the way west to the Oregon Territory, and the central role of the region in the important events of the broader American story.[26] In this series of illustrations Native American presence on the Columbia River seemingly disappears after 1845 or is at the very least assimilated into the American story

to such an extent that it has become invisible. Native Americans have undergone a form of symbolic annihilation.[27]

My secondary reaction to the series of illustrations is related to duration. The last four illustrations in the series—those representing post-contact periods along the Columbia River—offer snapshots that are at most a few decades long. They also suggest that the area went through a relatively rapid series of transformations that mirror the overall trajectory of the United States. The first illustration, the "Chinook Travelling Lodge" painted by Paul Kane, presumably represents Indigenous presence on the landscape before contact and into the early contact period. Unlike the decades-long periods represented in the other illustrations, however, Native American presence on the landscape in reality spanned multiple generations and thousands of years. The symbolic effect of this is that a relatively short period of settler occupation (as demonstrated by the last four illustrations) is given more visual weight than a significantly longer (although the image suggests more static) Indigenous occupation. Indigenous and settler temporal experiences on the landscape are, in effect, symbolically flattened. As a result, what were in reality dramatically different experiences on the landscape falsely become equated through a series of illustrations.

Finally, I find it interesting that the Paul Kane painting chosen to represent the Chinookan presence on the landscape shows a traveling hut, a small, temporary, and quickly constructed shelter utilized during the warmer parts of the year. The painting does not depict the larger, permanent, and often richly decorated cedar plankhouses that were located up and down the Columbia River and that are so illustrative of the wealth of many Chinookan villages and their central role in mediating wide-scale trade.[28] I can't help but think that an image demonstrating such wealth and permanence would give visitors an impression of the bridge different from that left by the image of the traveling hut. Furthermore, Paul Kane traveled along the Columbia River in the mid-1840s, after Indigenous populations and lifeways in the Portland Basin had already been devastated by disease. Kane's painting, therefore, depicts a landscape already tragically altered by disease and the widespread accompanying change in lifestyle.

Taken together, these illustrations show a series of snapshots, the first of which shows an Indigenous presence on the landscape (albeit a landscape already devastated by disease) and the latter of which shows no Indigenous presence at all. What they fail to show collectively is the continued entanglements, the continued displacement, and the continued loss that Native Americans of the Columbia River suffer as part of an ongoing process of colonization. Although Indigenous populations were devastated by disease and colonial policies, they did not disappear, as suggested by the illustrations, nor did they assimilate seamlessly into American society. They continue to fight to have their sovereignty recognized, to have their rights to fish and hunt protected, and to tell their histories as they see fit.

Narratives of nature and sustainability

As already noted, narratives of nature and sustainability reoccur throughout *Confluence Project* documents, were present during the First Walk dedication ceremony, and are embedded in the *Confluence Project* artworks themselves. For instance, Maya Lin's speech at the First Walk ceremony lamented the loss of animal and plant life since the time of Lewis and Clark and the overall degradation of the landscape, but she tempered that sorrow with the hope for a future of preservation and sustainability. This sense of sorrow and nostalgia for the Lewis and Clark landscape is clearly expressed in the poem "What We Carry on the Trail," written for the First Walk dedication by Sam Green.[29] The poem begins with a celebration of the observational and record-keeping skills of Meriwether Lewis:

Reflections on the *Confluence Project*

We know that Lewis saw the hoary aster. He left
a sketch & kept a sample pressed & dried
like something in a card sent back
from holy lands by some devoted uncle.

We know how well he kept his watch.
No doubt he heard the hiss of water
over sand, of fur sliding through an ocean
of grass, & knew the difference. All day he cast
the heavy net of his attention & sorted the catch
at night: the size and shape of a grizzly's track,
the raucous calls of geese & ducks. He ground
ink, mixed colors, & left his mark. At times
his notebooks seem to fear
the awful abundance of things.

The final stanzas of the poem, however, transition into a narration of environmental loss, our
place within that loss, and a glimmer of optimism about our collective ability to move in a
positive direction:

He could not have known how rare
that lupine would become,
how trained dogs would come
to hunt it by scent, how every year it blooms
more near the abrupt cliff
of absence. If wild bees hummed
prayers, they might contain the names of flowers
in trouble. Air doesn't recall the shape
of a bird's song. Water can't remember
the weight of a swimming frog.

Like Lewis, like Clark, we have set our feet
on a bridge into the future, intending to arrive
with everything we've come to love—including
the brown pelican, Kincaid's lupine,
Fender's blue butterfly. We teach our children
each step is a name that matters.

We have travelled a long, long way & are travelling
still. We carry the cost of failure, the lengthening list
of what is gone already, of all that might be lost, knowing
what we have to do, believing that we will.

The same sorrow over environmental loss and optimistic hope of sustainability seen in this
poem are present in both word and structure at the Sandy River Delta Bird Blind. The bird
blind is an elliptical structure made of thin slats of black locust wood located in a forested area
near the confluence of the Sandy and Columbia Rivers. The site was chosen partly because it
was already a component of a National Forest Service riparian reforestation program, and the

restored ecosystem fit nicely into the "Confluence Project's commitment to sustainability and ecologically aware artistry." Engraved into each slat of the bird blind is information about one of the animal species noted by Lewis and Clark on their travels westward. The information listed on the slats includes the following: date the animal was noted by Lewis and Clark, Lewis and Clark's name for the animal, common name, scientific name, and current status (species of concern, endangered, extinct, recovered, flourishing). The goal of the artwork is to provide a quiet spot where the visitor can view some of the wildlife living in the area today while learning about animals living two hundred years ago and to serve "as a lasting reminder of the impact humans have had on the environment and a model for a new way to envision the connection between people and the natural world."[30]

Messages of sustainability are not inherently problematic, and it is clear that as a society we have a number of environmental issues that we must face. This doesn't mean, however, that these messages should be treated uncritically. For instance, there is the potential that in this context messages of sustainability are framed within familiar and shallow stereotypes of ecological Indians treading lightly on a pristine untouched wilderness.[31] The reality is, of course, much more complicated than this. The landscape was not an untouched *terra nullius* but was instead actively managed and shaped by generations of Native Americans. While hints of ecological Indians and pristine landscapes are present in the *Confluence Project*, my concerns lie with what I see as two larger issues: first, the question of who is authorized to mediate environmental knowledge, and second, the lack of presentation of the links between "sustainability" and present-day issues of tribal politics, sovereignty, and cultural reclamation.

At both the Vancouver Land Bridge and the Sandy River Delta Bird Blind—as well as at the First Walk dedication ceremony—the principal mediators of environmental knowledge appear to be Lewis and Clark. Maya Lin's talk at the First Walk ceremony stressed the need for a greener future—in this case, the future is a return to the green landscape of two hundred years ago—and Lewis and Clark were touted as authorities on that green landscape. At the Vancouver Land Bridge, Native plants and their uses by Indigenous populations are mediated through the words of Lewis and Clark posted on signs by the plants themselves. Lewis and Clark also serve as the official recorders of wildlife at the Sandy River Delta Bird Blind. The *Confluence Project* presents Lewis and Clark, rather than the local Indigenous groups, as the stewards of the landscape at contact. Furthermore, while the *Confluence Project* laments the degradation that has occurred to the landscape since the time of Lewis and Clark in a form of "modernist discourse of nostalgia and loss,"[32] it does not frame them as a central component of the cause of that loss. In fact, by turning them into stewards and pre-green movement environmentalists, it distances them from this environmental tragedy: in effect, Lewis and Clark, as well as the rest of us, are just as much victims of the environmental degradation that occurred after their visit as are Native Americans.

The *Confluence Project*, at least at the Vancouver Land Bridge and the Sandy River Delta Bird Blind, also fails to present the more complicated interconnections between "sustainability" and broader present-day Indigenous concerns regarding sovereignty, culture, and survival. For instance, while the engravings in the bird blind document the tremendous "natural" damage that has occurred, and continues to occur, to animals since the time of Lewis and Clark, it does not document the cultural damage that has occurred, and continues to occur, to tribes indigenous to the area. Nature, in fact, seems to be a separate issue that is not directly related to these other concerns. Noel Sturgeon reminds us, however, that "environmentalism for indigenous activists is part of an interlocking set of concerns involving sovereignty, economic independence, community health, and cultural preservation."[33] These "interlocking concerns" are not stressed in the *Confluence Project*, and the larger political aspects of environmental concerns for

tribal populations are mostly ignored. The sovereign right of Indigenous nations in the region to determine the management of these lands—lands from which they have been dispossessed—and to define what constitutes environmental stewardship outside of the context of Lewis and Clark is neither discussed nor offered within the context of the project. Nor is it noted that some tribal nations in the region remain unrecognized by the federal government and thus have reduced capacity for tribally based environmental stewardship.

Lynn Meskell argues that this type of focus on nature and environmental sustainability—rather than a focus on the broader and more interconnected suite of cultural and political issues connected to environmentalism—is readily embraced because nature is neutral, supraracial, immediately legible, and modern, and it presents an image of shared humanity and a community-wide call to action. The broader cultural and political aspects connected to nature, on the other hand, are too specific to identity and group, too local, and in colonial situations fraught with reminders of inequality, displacement, land claims, and the reality of very different experiences between Indigenous populations and settlers.[34] The *Confluence Project* seems to have followed this more neutral, apolitical, and ahistorical focus on sustainability, and as a result it fails to present to the public a broader suite of concerns that Indigenous communities hold regarding environmentalism.

Conclusion

Elizabeth Cook-Lynn, in her discussion of the challenges of telling tribal histories within the context of American master narrative histories like Lewis and Clark, states the following:

> What is unforgivable about all of this literary history is the failure to admit to the doctrinal hatred for Native Americans that was evident in American life then and now, in legislation and modernity. Without that cruel and distasteful, yet real, acknowledgement, there is no explanation for the genocidal treatment of Indians that continues even today—the theft of lands, unjust laws, and enforced subjugation.[35]

Her concern is that these types of American stories uncouple history from the violence and specificity of colonialism and fail to make the linkages to continuing violence against tribal populations.

Cook-Lynn's concerns seem also to be appropriate to the *Confluence Project*. The *Confluence Project* is, without question, an ambitious endeavor that brought together a number of voices, created aesthetically beautiful permanent and public artworks, and likely resulted in a greater awareness of and interest in history along the Columbia River. And the project certainly deserves praise for its efforts to reimagine the Lewis and Clark journey, especially by providing greater space for Native American voices in this story. This does not, however, mean that the project should be viewed uncritically or that good intentions automatically lead to uniformly positive results. My analysis of both the Vancouver Land Bridge and the Sandy River Delta Bird Blind, as well as the First Walk dedication ceremony, suggests that the project's efforts to reimagine Lewis and Clark are hindered by a decoupling of history from the violent specifics of colonialism and by presenting a picture of a "shared heritage" that falsely equates indigenous and settler experiences on the landscape. Images that reinforce standard narratives of American progress and Manifest Destiny (and the role of Native Americans in that story) and messages of a shallow version of sustainability that relies on stereotypes, places Lewis and Clark rather than tribal nations at the center of environmental knowledge, makes us all equal victims of environmental degradation, and ignores the larger political aspects of the interconnections between tribal sovereignty and environmentalism also serve to obstruct an accurate public representation of the

history of the region. The story of Lewis and Clark on the Columbia River is located within a history of unequally shared violence and dispossession. Unless we are willing to first tell the truths of this unequal history publicly, it's difficult to imagine the type of shared optimistic future that the *Confluence Project* presents.

Notes

1 National Geographic ran a series of articles on the Lewis and Clark reenactors, "Reliving Lewis and Clark: Surviving Winter Camp," http://news.nationalgeographic.com/news/2004/02/0203_040203_lewisclark1.html (accessed December 16, 2011). The reenactment of the Corps was not without its moments of controversy, including protests (see "Dakota-Lakota-Nakota Human Rights Advocacy Coalition," www.dlncoalition.org/dln_coalition/2004landc.htm (accessed December 11, 2012) and rumors of schisms within the group ("Willamette Week's Guide to Lewis and Clark Re-enactors," www.wweek.com/portland/article-5040-willamette_weeks_guide_to_lewis_and_clark_re_enactors.html (accessed December 11, 2012).

2 At the time of this writing, four of the seven art installations are completed. Two of the remaining three were scheduled to be completed by the fall of 2012, but they are not yet finished. The completion date for the seventh is yet to be determined. Information on the installation and timelines can be found at www.confluenceproject.org.

3 *Confluence Project: places reclaimed, transformed, reimagined*, brochure in possession of the author.

4 "Confluence Project Journey Book," http://journeybook.confluenceproject.org/#/engagement/cis/creating-bonds/last (accessed December 27, 2010).

5 *Confluence Project* brochure.

6 *Confluence Project* brochure.

7 My thoughts on this project have certainly been shaped by the writings of John Bodnar, *Remaking America: Public Memory, Commemoration, and Patriotism in the Twentieth Century* (Princeton: Princeton University Press, 1992); Edward Casey, "Public Memory in Place and Time," in *Framing Public Memory*, ed. Kendall R. Phillips (Tuscaloosa: University of Alabama Press, 2004), 17–44; Michael Kammen, *Mystic Chords of Memory: The Transformation of Tradition in American Culture* (New York: Alfred A. Knopf, 1991); Edward Linenthal, *The Unfinished Bombing: Oklahoma City in American Memory* (Oxford: Oxford University Press, 2003); and Cathy Stanton, *The Lowell Experiment: Public History in a Postindustrial City* (Amherst: University of Massachusetts Press, 2006), to name a few.

8 See James Clifford, *Routes: Travel and Translation in the Late Twentieth Century* (Cambridge: Harvard University Press, 1997), especially the chapters titled "Four Northwest Coast Museums: Travel Reflections" and "Fort Ross Meditation."

9 See Jon Dachnke, "Utilization of Space and the Politics of Place: Tidy Footprints, Changing Pathways, Persistent Places and Contested Memory in the Portland Basin" (PhD diss., University of California, Berkeley, 2007); Jon Daehnke, "A 'Strange Multiplicity' of Voices: Heritage Stewardship, Contested Sites and Colonial Legacies on the Columbia River," *Journal of Social Archaeology* (2007): 250–75; and Jon Daehnke, " 'We Honor the House': Lived Heritage, Memory and Ambiguity at the Cathlapotle Plankhouse," *Wicazo Sa Review*, forthcoming (2013).

10 See Vancouver Land Bridge, www.confluenceproject.org/project-sites/vancouver-land-bridge/ (accessed December 11, 2012) for a description of the Vancouver Land Bridge.

11 A brief story and photos of the First Walk are available at "Confluence Project land bridge is link to history," http://seattletimes.nwsource.com/html/localnews/2008135107_confluence24m.html (accessed December 11, 2012).

12 The poem was commissioned and written specifically for the dedication ceremony. The full text of the poem is available at ArtsWA, www.arts.wa.gov/news/archive/september-2008-enews.shtml (accessed December 11, 2012).

13 During the afternoon of August 23 I attended a joint Chinook Nation and Shoalwater Tribe canoe event held in Bay Center, Washington. I spoke with a few citizens of the Chinook Nation about the land bridge dedication ceremony, which had occurred earlier in the day. Most were aware of the event, but none had any interest in attending and felt that it held little relevance.

14 A copy of the letter from the Governor's Office is in my possession.

15 Robert Boyd, *Cathlapotle and Its Inhabitants, 1792–1860*, Cultural Resources Series 15 (Sherwood OR: US Fish and Wildlife Service, 2011), 60.

16 Gray H. Whaley, *Oregon and the Collapse of the Illahee: U.S. Empire and the Transformation of an Indigenous World, 1792–1859* (Chapel Hill: University of North Carolina Press, 2010), 74–83.

17 Whaley, *Oregon*, 83–91.

18 See Nathan Reynolds, " 'More Dangerous Dead than Living': The Killing of Chief Umtuch," paper available through the Cowlitz Indian Tribe, Longview WA, 2007.

19 Robert Boyd, *The Coming of the Spirit of Pestilence: Introduced Infectious Diseases and Population Decline among Northwest Coast Indians, 1774–1874* (Seattle: University of Washington Press, 1999); Boyd, *Cathlapotle*, 71–83; Whaley, *Oregon*, 91–98; William Wuerch, "History of the Middle Chinooks to the Reservation Era" (MA thesis, University of Oregon), 89–95.

20 Boyd, *The Coming*, 91; Wuerch, "History," 95.

21 Burt Baker, ed., *Letters of Dr. John McLoughlin, Written at Fort Vancouver, 1829–1832* (Portland: Binfords and Mort, 1948), 175; Boyd, *The Coming*, 91.

22 Boyd, *The Coming*, 84; Wuerch, "History," 119.

23 Jeffrey L. Hantman, "Jamestown's 400th Anniversary: Old Themes, New Words, New Meanings for Virginia Indians," in *Archaeologies of Placemaking: Monuments, Memories, and Engagement in Native North America*, ed. Patricia E. Rubertone (Walnut Creek: Left Coast Press, 2008), 227.

24 Patricia Rubertone, "Engaging Monuments, Memories, and Archaeology," in Rubertone, *Archaeologies of Placemaking*, 21. See also Stephen Silliman, "Culture Contact or Colonialism? Challenges in the Archaeology of Native North America," *American Antiquity* 70 (2005): 55–74.

25 Paul Kane was an Irish-born Canadian painter who traveled around the Oregon Territory, including the Columbia River, in 1846 and 1847 (the "1845" label on the land bridge is a slight error). He completed numerous paintings and sketches of Native Americans during his travels. See J. Harper Russell, ed., *Paul Kane's Frontier* (Austin: University of Texas Press, 1971); Paul Kane, *Wanderings of an Artist among the Indians of North America* (Edmonton: Hurtig Publishers. 1968); and Thomas Vaughan, ed., *Paul Kane: The Columbia Wanderer* (Portland: Oregon Historical Society, 1971).

26 For discussion of the centrality of the frontier myth in American nationalism and the central role that Native Americans play in that myth, see Richard Slotkin, *Regeneration through Violence: The Mythology of the American Frontier, 1600–1860* (Middletown CT: Wesleyan University Press, 1973); Slotkin, *The Fatal Environment: The Myth of the Frontier in the Age of Industrialization, 1800–1890* (New York: Macmillan, 1985); and Slotkin, *Gunfighter Nation: The Myth of the Frontier in Twentieth Century America* (Boston: Atheneum, 1992).

27 I borrow this term from the work of Jennifer L. Eichstedt and Stephen Small, *Representations of Slavery: Race and Ideology in Southern Plantation Museums* (Washington DC: Smithsonian Institution Press, 2002). They use the term "symbolic annihilation" to describe the way that many southern plantation museums use rhetorical and representational strategies to erase or obscure the historical reality of the institution of slavery.

28 As an example, one of the cedar plankhouses at the Chinookan village of Cathlapotle, located only a few miles from Fort Vancouver, measured roughly 40 feet wide by 200 feet long, and a second house was roughly 40 feet wide by 150 feet long. Yvonne Hajda notes that one of the plankhouses in the Portland area reached 471 feet ("Notes on Indian Houses of the Wappato Valley," *Northwest Anthropological Research Notes* 28 [1994]: 184).

29 Lines from "What We Carry on the Trail," are reprinted with the author's permission from *First Up: Barnstorming for Poetry* (Bellingham WA: Village Books, 2012), copyright © 2012 by Samuel Green.

30 See Sandy River Delta, www.confluenceproject.org/project-sites/sandy-river-delta/ (accessed December 11, 2012).

31 For discussion of these stereotypes, see Noel Sturgeon, *Environmentalism in Popular Culture: Gender, Race, Sexuality and the Politics of the Natural* (Tucson: University of Arizona Press, 2009), 53–79.

32 Cori Hayden, *When Nature Goes Public: The Making and Unmaking of Bioprospecting in Mexico* (Princeton: Princeton University Press, 2003), 35.

33 Sturgeon, *Environmentalism*, 77. See also Beth Rose Middleton, *Trust in the Land: New Directions in Tribal Conservation* (Tucson: University of Arizona Press, 2011).

34 Lynn Meskell, "The Nature of Culture in Kruger National Park," in *Cosmopolitan Archaeologies*, ed. Lynn Meskell (Durham: Duke University Press, 2009), 94–95.

35 Elizabeth Cook-Lynn, *New Indians, Old Wars* (Urbana: University of Illinois Press, 2007), 93–94.

39
Ethnic heritage for the nation
Debating 'identity museums' on the National Mall

Katy Bunning

Introduction

Since the early 1960s in the United States of America, cultural museums that centre on ethni-cally- or racially-defined group experiences have opened in significant numbers. Museums of African American historical and cultural experience, for example, have emerged alongside new scholarship and bolder articulations of African American public history and culture during the last six decades (Burns 2013). As a 'movement' that has taken hold across the United States, this landscape of new museums has provided multiple sites of interplay between different articula-tions of the American experience (Burns 2013: 7). The prospect of community-focused museums on the National Mall in Washington D.C., as part of the Smithsonian Institution's family of national museums, has prompted significant national-level debate into questions of national and ethnic identity and the role of national museums in forging shared narratives of the past. In this chapter, I briefly explore some of the critical responses to the proposals for new museums of this kind at the Smithsonian Institution, particularly since the early 1990s, to highlight the relation-ship between museum development, racial justice and political ideas of national heritage. These responses shed light onto the narratives of race and the notion of a 'post-racial' society that, I argue, have been central to the changing nature of many responses over time. I end this discus-sion with a series of further questions about heritage, museums and race that have been raised by more recent events. Namely, the long-awaited opening of the National Museum of African American History and Culture (NMAAHC) on the Mall in 2016; the electoral campaign of Donald J. Trump; and the continued prominence of the nationwide Black Lives Matter move-ment have each brought matters of race to the fore of the Nation's consciousness.

Museums that focus on a particular 'ethnic' or 'racially-defined' community group in the United States have been collectively termed in different ways within different contexts. As a short-hand, news media and cultural critics have often favoured the terms 'ethnic museums' and 'identity museums' while professionals within the museum and cultural sector have used terms like 'community museums' and 'culturally specific museums' (Farrell and Medvedeva 2010: 20). In line with the fluidity and impreciseness of the terminology to describe these museums as a type, my choice of term varies in this chapter. My focus is on museum developments that have been articulated as part of a process of dismantling 'Eurocentric' representations of the American

past, and bringing other, largely absent, historical experiences and perspectives to the fore (Gaither 1992; Karp and Lavine 1991). The Smithsonian Institution is a major research and cultural complex of 19 national museums, research centres and a zoo, located primarily in Washington D.C., the nation's capital, and overseen and funded by the federal government. The Institution is a highly visible, political and symbolic site for new museum developments of all kinds, and the emergence of 'culturally specific' narratives and museums within the Smithsonian has provided a platform for discussions about the positioning of different perspectives and cultural narratives in relation to the nation as a whole.

To trace the responses to, and debates around, culturally specific museums over time, I focus on a number of key moments in the development of several such museums at the Smithsonian Institution: the National Museum of the American Indian (NMAI) which was founded in 1989 and opened its Mall site to the public in 2004; the National Museum of African American History and Culture (NMAAHC) that was established in 2003 and opened in 2016; and the proposed National Museum of the American Latino (NMAL) in the early 2010s which gained significant support in Congress and within the Smithsonian itself. I begin with the so-called 'culture wars' of the 1990s, which saw public and professional debates ensue in relation to the newly established NMAI, as well as contemporaneous responses to advancing proposals for a national African American museum on the Mall. Some years later, the prospect of a national Latino museum, in what Savage has called Washington D.C.'s 'monumental core', re-ignited debates across the cultural and political spheres in the early 2010s about the continued use of such museums as correctives to existing national museum narratives (Savage 2009). Looking across these key moments, and focusing on the debates and discussions within and beyond the Smithsonian helps to highlight both shifts and continuities in how such museums are perceived.

In his book on critical approaches to heritage, Harrison traces what he calls the 'discursive turn' in heritage studies and argues for the rebalancing of such work with a focus on the meanings and implications presented by the *materiality* of heritage (Harrison 2012: 9). While this would afford a broader lens of analysis, for a number of reasons, my focus here remains largely on the discursive aspects of culturally specific museum developments. In the context of protests around contemporary racial inequality, I argue that this discursive turn in heritage studies can assist a deeper reflection on the expectations that society has of its national museums beyond their institutional and material realities. This serves as the focus of the chapter. Additionally, the focus on discourse responds to the historical conditions of the emergence of national, culturally specific museums at the Smithsonian. The critical reception of such museums is often centred at the points at which new museums are announced or reach key milestones in their development. Debates arise and play out long before such museums are constructed in the physical landscape, helping to both shape and make visible a broader changing discourse around the issue of race in the context of national heritage; from the need for new national narratives, to accusations of excessive 'identity politics' and expressions of 'post-racial' aspirations. As Dyson has suggested, national museums have historically 'played a central role in defining a hegemonic version of the nation and have therefore been sites of struggle over competing definitions of national culture' (Dyson 2005: 119). Tracing the discourse of 'identity museums' at the national level over key decades, I demonstrate that 'culturally specific' national museums are sites of contestation that have acted as platforms for competing ideas about the continued persistence of racial injustice.

Broadly speaking, museums of this kind have been a distinctly United States phenomenon, related as they are to unique historical experiences, rights movements, forms of heritage expression, and identity construction within this particular national and historical context. Indeed, the Smithsonian itself provides a unique focus for research into discourses around identity politics and cultural representation. Yet insights here potentially relate to international culturally specific

projects and programming concerning racial histories and racial justice, and may prompt a deeper consideration of the role of aspirational post-race discourses in respect to national institutions and more inclusive practices elsewhere.

In contrast to the preoccupations of heritage studies, Littler observes a greater focus within museum studies on issues of race, most notably referring to the body of literature on the politics of cultural display exposing ongoing legacies of imperialism and colonialism (Littler, 2005: 5). While ethnographic museums have been scrutinised in terms of racial meanings, particularly in terms of their institutional and collection histories, and their modes of representation, it has been claimed that heritage, as a process that can materialise in broader ways, and is theorised as more fluid than museums as institutional forms, (linked closely to senses of self and notions of belonging), has evaded this level of scrutiny (Littler 2005: 5). Despite this assertion, I would argue that the relatively advanced focus on issues of race in museums has done little to position race as significant to questions of the interpretation of the past in processes of national identity creation and belonging, in the context of what can be described as a liberal multicultural and neoliberal agenda (Message 2007). Acknowledging the inherent 'presentism' in historical research (Gunn and Faire 2012: 208–209), I aim to support the fields of museum studies and heritage studies by situating studies of museum developments over time within contemporary, urgent political and social questions about how to account for the racial past in a society that remains racially-shaped, divided, complex and unequal.

Culturally specific museums and the Smithsonian's 'culture wars'

During the 1980s and 1990s, constructionist approaches to the study of museums and heritage brought a new critical turn to museum thinking, which drew attention to the idea that museums are inherently political (Karp and Lavine 1991; Karp, Kreamer and Lavine 1992). Inspired by at least 20 years of feminist and post-colonial activism and scholarship, the arrival in mainstream museum studies discourse of what Macdonald has called 'representational critique', spurred the professional sector to attend to questions of the politics of representation or 'how meanings come to be inscribed and by whom, and how some come to be regarded as "right" or taken as given' (Macdonald 2006: 3). Such questions around the politics of knowledge construction and representation were deemed crucial to explore, for the extent to which they might point to the reproduction of inequalities and 'particular regimes of power' beyond the academy and the museum (2006: 3).

In his essay 'Museums in Late Democracies', historian Chakrabarty characterises the museological shift towards the politics of identity – which he succinctly defines as 'the question of who can speak for whom' – as marking 'liberal democracies' attempts at multiculturalism' (Chakrabarty 2002: 9). He explains this shift as one of moving away from the oppressive agency of colonial-era knowledge systems and opening-up to 'the politics of experience', and an acceptance of the validity of embodied knowledge and lived experience (2002: 9). Yet he notes that the 'politics of identity' is often used as a disparaging term (2002: 10). Indeed, during the 1980s and 1990s, museums across the United States, but particularly at the Smithsonian Institution, found themselves at the centre of what became known as the 'culture wars'; a term most often used to denote the unwelcome interference of political positions in matters of presenting an 'unbiased' account of the past (Dubin 1999; Dubin 2006: 477). Central to the debates around controversial museum programming that presented new so-called 'revisionist' narratives of culture and history were questions of objectivity, and 'whether it was or was not possible or permissible to see some cultural products and forms of knowledge as in any sense more valuable or valid than others' (Macdonald 2006: 4). Although many of the 'culture wars' encircling the

Smithsonian were fought in relation to exhibition projects within existing museums, such as the controversial redisplay of the Enola Gay at the National Air and Space Museum, and the critique of colonial expansion in *The West as America: Reinterpreting Images of the Frontier* at the Smithsonian American Art Museum in 1991, the conceptualisation of new ethnic museums at that time elicited similar critiques (Luke 2007; Trachtenberg 2007). Central to much of the criticism was the sense that particular cultural group experiences were being prioritised over others at the expense of (ostensibly) unbiased scholarship and a holistic and diverse representation of the nation's history.

With its research programmes and focus on scholarship, the Smithsonian had long been a place for experiment and innovation in cultural display (Walker 2013). A social and educational remit was at the forefront of the Institution under Smithsonian Secretary S. Dillon Ripley, who served in this executive role between 1964 and 1984. In the late 1960s, an innovative 'storefront' museum was founded under Ripley as part of the Smithsonian Institution in the nearby Anacostia region to better serve underrepresented communities (Ripley 1969: 105–106). This museum quickly became an African American community-focused museum, arguably the first ethnic museum within the Smithsonian, although ultimately, it was viewed as insufficient in terms of scope and location for those who were pushing for greater visibility of African American histories and experiences at the Smithsonian (James 2005; Burns 2013: 167). Meanwhile, the rights movements of the late 1960s were making their mark on collecting and curatorial activities in small pockets of the Institution demonstrating a shift to more inclusive, socially responsive practice at an institutional and professional level (Message 2013). During the 1970s and 1980s, efforts were made to be more inclusive of diverse cultures through major events such as the Smithsonian Folklife Festival, and culturally specific programming and research and collecting initiatives that worked across the Institution (Walker 2013). In this climate, ethnic-specific narratives were increasingly recognised and articulated as part of the national experience, and in particular, American Indian activism resulted in significant shifts in the politics of representation (Lonetree 2012: 17). But ethnic museums were not yet a feature on the landscape of the National Mall.

Towards the end of the 1980s, under the leadership of Robert McCormick Adams, the Smithsonian Institution faced an ethical and media crisis when it emerged that the Smithsonian was holding skeletal remains of tens of thousands of individuals of Native descent (Erikson 2008). After much negotiation, the Smithsonian agreed to a repatriation programme for these remains to be brought in alongside the creation of a National Museum of the American Indian, a museum envisaged to prioritise Native peoples' agency, voice, and knowledge structures in its work (Molotsky 1989; Swisher 1989). The prospect of a new museum, however, spurred criticism from some of the Smithsonian Institution's long-time public supporters who felt that the creation of a designated museum as a platform for Native voice would threaten the Institution's scholarship. One short letter in response to this controversy said: 'I am opposed to the National Museum of the American Indian. [...] The skeletal remains of Indians should be retained for research and not be reburied' (Letter to Senator Bentsen 1989). Such letters of complaint, questioning the apparent pursuit of identity politics at the expense of accurate and authoritative knowledge (based on approved forms of scientific evidence) were received in some number to the office of Secretary Adams over the years to follow. 'Throughout its long and illustrious history', wrote one complainant, 'the Smithsonian has been apolitical. When did you change this policy?' (Letter to Adams 1991a). Indeed, it was felt by many complainants that the Smithsonian should strive to be apolitical in its approach to interpreting the past.

In the early 1990s, the notion of a new culturally specific museum on the Mall sparked further considerable controversy, this time around the potential implications of a culturally

specific approach within the context of national constructions of heritage. In May 1991, news of the unanimous support of the Smithsonian Board of Regents for a proposed 'National Black Museum' reached the Press (Gamarekian 1991). While many greeted the news as a sign of progress, it touched a nerve for other members of the American public. There was a deep concern that the development of a culturally specific museum on the Mall would be socially divisive, even racially suspect, for a Nation that imagined itself as representing both equality and unity. One Florida resident wrote to the Smithsonian Secretary to express his outrage:

> This is an insult to every other race and nationality that has made America the greatest country in the world. Nobody objects to recognizing the creativity and accomplishments of persons of African descent but to single out that group with a museum for that purpose is an outrageous discrimination not worthy of sponsorship by any institution. You can achieve the same objective (and promote peace and harmony) by creating a unique American National Museum that celebrates the creativity and accomplishments of all persons that have contributed to American history. Why are you trying to divide us??
>
> *(Anon 1991)*

Insinuations of racism and 'political correctness' came flooding into the Smithsonian in response to the news of its support for a national African American museum on the Mall, and these critiques came from those with both liberal and conservative leanings. A mocking segment in the editorial page of the *Richmond Times Dispatch* read 'We anxiously await the opening of this and future taxpayer-funded historical museums dedicated to Aleut-Americans, Asian-Americans, Hispanic Americans, Gay and Lesbian Americans, Dead White Male European Americans, Non-Communist Academics (which would be a very small museum), *ad nauseam*' (Cited in Letter to Adams 1991b). A clipping of this piece was sent to the Smithsonian Secretary by a member of the public with a note saying that this 'expresses very concisely the opinion of millions of U.S. taxpayers in regards to another African American Art Museum' (Letter to Adams 1991b). Others felt that this move would 'interject race' in to the Institution, 'by emphasizing one culture and race while ignoring the contributions of other ethnic groups and races to the development of the United States' (Letter to Board of Regents 1991). Indeed, some wrote to the Smithsonian to withdraw their financial support of the institution, with one individual adding 'Why can't we just be Americans?' (Letter to Adams 1991c). While some were offended by a perceived bias towards a particular group, others emphasised the loss of unity and cohesion that such an approach could, in their opinion, foster. While inclusive narratives were broadly seen to be desirable, the separation and highlighting of one particular cultural group within the Smithsonian, presumably at the expense of others, was an uncomfortable concept for some.

During the early 1990s, the Smithsonian Council – an advisory board of museum professionals, distinguished academics, artists and writers set up to 'review and debate topics embracing the entire Institution' (Heyman 1998) – was heavily focused on issues of cultural diversity and cultural pluralism. Despite the increasing representation of a diversity of perspectives being an institutional priority under the leadership of Secretary Adams (Adams 1990), a number of senior curatorial staff and programme directors had raised key concerns with the implementation of this agenda, pertaining to views held by both professional staff and audience stakeholders. A series of recommendations collated ahead of the Smithsonian Council's 1990 meeting by James Early, Assistant Secretary for Public Programs, indicated these concerns: 'culturally-diverse perspectives will indeed challenge the reigning mythology of national values and […] this initiative will, no doubt, raise the anxiety level of those who believe in myths and inaccuracies propagated in American culture and history'. Moreover:

> The Smithsonian Council should question the professionalism and quality in judgement of staff in high positions [...] regarding issues of cultural diversity and cultural equity. Criticism that some of these individuals are not responding to cultural diversity priorities of the Institution, are countered with statements that they are protecting higher standards and will not lower them. The same argument is raised at management committee when the Institution says it is prepared to protect 'core' (unicultural) programs and release 'peripheral' (multicultural) programs.
>
> *(Early 1990)*

As well as funding concerns, these remarks signalled both a strong commitment, and a degree of internal philosophical resistance to the Smithsonian's cultural diversity agenda which was seen to be driven by identity politics at the expense of the 'accepted' standards of scholarship.

In response to the climate of increasing internal and external debates around the political uses of museums, the agenda for the two-day Smithsonian Council Meeting of 1991 was revised to facilitate a '[d]iscussion of the role of the Smithsonian in presenting new scholarship and varied contemporary perspectives in programs for the public' (Smithsonian Council 1991; Young 1991). Scholarship was a key concern across both discussions of cultural diversity programming and the newly established NMAI at this meeting. Discussions around cultural diversity focused on 'the role of the curator', with Council members reportedly agreeing that staff should demonstrate 'a willingness to revisit and to rethink personal, cultural, intellectual, social, and political reference points' and 'to reshape exhibitions that appear skewed, one-sided and out-dated' (Harris 1991). There was also agreement that:

> [T]the curator, in fostering cultural diversity, must keep paramount the goal of striving for historical accuracy, being fair to materials, using all the available skills to ensure that the most accurate views prevail, while acknowledging any inadequacies of information and seeking ways to address such deficiencies.
>
> *(Harris 1991)*

As Council Chair Neil Harris noted in his summary of the meeting, however, there was 'division and debate [...] reflecting different opinions about the best ways of achieving diversity' (Harris 1991). Questions were also raised during the Council Meeting of 1991 in relation to scholarship and 'accuracy' within the newly established NMAI. Participants queried the 'larger philosophy' of the museum, asking '[w]ill it be celebratory? If so, is there a danger that new romantic myths about Indian peoples might be created concerning, for example, their harmonious relationship with nature or their universally peaceful value systems?' (Harris 1991). Citing the NMAI's collections which include both items of 'anthropological value' and 'acclaimed fine art', questions were raised about whether there was enough art history expertise within the Indian community to successfully curate this material (Harris 1991). Talking of this as an innovation for the Smithsonian, Adams responded:

> This is the first time, Indian people will become the principal agents of, and partners in, an enterprise that depicts, interprets and displays their own culture, history, and art. For this reason, the first-person voice of the American Indian will be given emphasis in the process. NMAI staff are highly cognizant of the aesthetic and artistic aspects of the collections, no less than the anthropological, cultural, and historical dimensions. Each of these facts of the new museum is being weighed carefully in the ongoing process of consultation, planning, and development.
>
> *(Adams 1992)*

Having made his point about the importance of self-definition as well as traditional disciplinary concerns in the process, Secretary Adams then voiced a note of caution on the nature of culturally specific interventions and programmes. While a coherent, national viewpoint, 'albeit a pluralistic and diverse one', was expected and sought, Adams felt this should be obtained 'not simply by stacking up separate interests, but rather melding, fusing, synthesizing, and even transcending the ideas, symbols, and subcultures of the constituent parts' (Adams 1992). Indeed, Adams pointed towards the need for a more embedded approach to cultural diversity, indicating something of a criticism in the current 'culturally specific' approaches being taken. Adams' aspirational vision for the national museums under his leadership appeared to emphasise shared heritage and a unifying narrative that would go beyond notions of distinctiveness and separation.

A perceived 'stacking up' of separate narratives and a potential lack of integration within existing narratives was a concern for Smithsonian staff and external advisors who were working at the heart of culturally specific museum projects in the 1990s. Yet, for many of these individuals, the importance of providing a space for new 'voices' and self-definition remained paramount. The concern among ethnic museum proponents was that the emergence of a culturally specific museum might work to excuse existing Smithsonian museums from presenting more diverse narratives, thus problematically 'containing' diversity into separate and new facilities. Moreover, existing projects and programmes focusing on African American history within the National Museum of American History, and on Native cultures at the National Museum of Natural History, might be threatened with the opening of a culturally specific museum which overlapped with their objectives.

Tensions in the relationship between culturally specific museum projects and other museums on the Mall were addressed in the 'Life' supplement of the *Washington Times* in October 1991. In this article, Claudine Brown, a key figure in the initial planning stages and feasibility study of a national African American museum, was reported to say:

> We think a national African American Museum whose exhibits refer to other museums on the Mall will give visitors a chance to figure out that they fit into all of the museums. But there is some question whether this new museum will create more, not less, segregation. The National African American Museum could result in a kind of reverse discrimination by freeing other Mall museums from the responsibility to feature black exhibits.
>
> *(Colp 1991)*

This predicament was addressed during internal discussions led by the National African American Museum's Institutional Study Advisory Board a year before, which was set up to explore the need for and potential location of this museum. Rick Hill, who had worked closely with the NMAI, was invited to speak at the second meeting of the Board, and was asked by a member in attendance: 'How will the existence of [culturally specific] museums affect the fact that mainstream institutions are also charged with representing Native Americans, African Americans, Hispanics etc. in their institutions?' (African American Institutional Study Advisory Board 1990b: 8). Referring to the NMAI, Hill responded: 'While it is important that the host institution have an overall commitment to multicultural representation, it is also important that a space be created so that Indian culture can be presented specifically from an Indian perspective' (African American Institutional Study Advisory Board 1990b: 8). During the discussion that followed, members agreed that there was a risk that other ethnic programming throughout the Smithsonian may be cut or transferred over. For Hill, however, the role of such museums was to allow for the processes of self-definition, and this was vital. Cornell West, Director of

Princeton University's Afro-American Programme and a member of the Advisory Board also touched on questions of the relationship between the proposed museum and the Institution as a whole when he highlighted a tension 'between insisting on a strong representation of people of color throughout the Smithsonian, and also arguing for a distinct and separate museum' (African American Institutional Study Advisory Board 1990a: 38). For West,

> ... [i]t was important not to convey the impression that the new museum was a form of 'ghetto-izing', or the product of a narrow black nationalist perspective which presumed that the African American experience can be separated out from the larger context of U.S. history.

On the other hand, he continued, it was important not to

> fall into the 'faceless integrationist trap', which assumes that African Americans are no different than any other immigrant group. The question is one of 'walking that tightrope' so that the distinct space can be created while insisting on the presence of people of color in all other Smithsonian programs and activities.
>
> *(African American Institutional Study Advisory Board 1990a: 38)*

In the early 1990s, then, culturally specific museum developments at the Smithsonian were providing a platform not only for the inclusion of alternative histories and experiences within institutions of national heritage but also for broader debates about processes of group integration and separatism within the United States. While some articulated the need for culturally specific narratives in addition to national narratives of ethnic experience, other commentators saw these as only supplanting the national story. Moreover, among many commentators, there was a lack of direct reference to racial histories or contemporary racial injustice in relation to these museums. Rather, these museums were primarily discussed as manifestations of the Institution's commitment to 'cultural diversity' and its perceived unpalatable shift towards identity politics. Indeed, during the 1980s and 1990s, race was a difficult concept to address directly and, for many institutions, a 'colourblind' approach to addressing perceived differences or divisions in society was preferred. This approach extended to internal discourse within the Smithsonian (Yeingst and Bunch 1997: 154).

As the 1990s progressed, the notion of museums as inherently political and non-neutral institutions became increasingly widespread among museologists (Macdonald 1998). Some years later, as the 2010s began to unfold, ethnic museums, faced a new philosophical challenge. Concerns that such museums inherently essentialise complex cultural identities in ways that unhelpfully accent rather than challenge racial ideas began to surface, echoing new articulations about the increasingly complex nature of diversity and identity within the nation.

Outmoded identity politics and 'post-race' museology

By the 2010s, notions of culturally specific museums as conceptually 'lagging behind' in their presentation of an unsophisticated 'identity politics' began to be publicly voiced. While many of these critiques emanated from longstanding critics of identity politics, new conceptualisations of identity amidst fast-paced demographic and generational changes popularised a wariness of institutions that claimed to be about a particular cultural group (Kennicott 2010). Meanwhile, a tantalising suggestion that the nation might somehow have lurched further towards a post-race status in the wake of the election of President Barack Obama in 2009 had begun to creep into

professional, as well as public and political spheres. Although a post-racial society was rarely articulated as having been achieved, questions were raised in public discourses about this possibility that harked back to earlier expressions of a 'colourblind' society (Teasley and Ikard 2009).

The increasing visibility in the media of a proposed new National Museum of the American Latino that was envisaged as a likely new Smithsonian museum to be sited on or close to the National Mall, helped to spark new responses to these museums. Writing in the *Washington Post*, journalist and cultural critic Phillip Kennicott called into question the continued relevance of culturally specific museums:

> [T]he entire concept of a Latino American Museum seems almost retro. […] There's resistance to [ethnic-specific museums] among people who don't identify as minorities, and while much of that resistance is based in racial and ethnic animus, some of it represents legitimate concern that history won't be well served by an infinite fracturing into sub-narratives, each under the control of a different cultural group. […] It seems likely that within a generation, the Mall could have a large collection of very quiet and not terribly relevant museums. Not because the stories they have to tell are irrelevant or uninteresting, but because the game changed. The appetite for history will be for complicated master narratives that cross lines between ethnic groups, that dip into technology and economics and art, and can't easily be told in an old-fashioned, balkanized museum of ethnic identity. The big danger is that the National Museum of the American Latino will arrive just as the heyday of ethnic museums is passing.
>
> *(Kennicott 2010)*

It was not only critics in the media who were voicing concerns about the future relevance of culturally specific museums in the face of new and emerging articulations of identity. The museum profession was also asking new questions about demographic changes that lay ahead within the American population. For the American Association of Museums' Center for the Future of Museums, the very notion of a 'minority' group was a problematic one (Farrell and Medvedeva, 2010). Querying whether such groups 'actually form a coherent whole', the report asked if, in the future, such groups will 'find common ground in experiences, perceptions, motivations and tastes that museums can use to develop strategies for community engagement? Or', it continued, 'will Latinos, African Americans, Asian Pacific Americans, Native Americans and others continue to be separate groups with more differences than commonalities—all of them remaining minorities by virtue of their size—who will need to be reached through different kinds of museum strategies and programs?' The Center's report picked up on what was a promising new concept that America might, in light of this achievement, finally become a 'post-race' society:

> Do the conventional categories of race and ethnicity reflect intractable social divisions in the U.S.? Or do changing attitudes from one generation to the next mean we are on the cusp of some new post-racial, multiethnic, global era in which the old divisions are destined to fade in the face of new realities?
>
> *(Farrell and Medvedeva 2010)*

Once again, an image of a new, more complex, less divided American population was to call into question the relevance of ethnic-specific approaches in favour of universal approaches that might foster cohesiveness and transcend racial boundaries.

The prospect of a new Smithsonian Latino Museum reignited criticisms on the philosophical and moral aspects of creating ethnic-specific museums in a perceived diverse and multicultural

America. Democratic Congressman Jim Moran made the headlines in 2011 with his critique of the continued development of federally supported ethnic museums. Calling them 'un-American', Moran argued:

> Every indigenous immigrant community, particularly those brought here enslaved, have a story to tell and it should be told and part of our history. The problem is that much as we would like to think that all Americans are going to go to the African American Museum, I'm afraid it's not going to happen [...] The Museum of American History is where all the white folks are going to go, and the American Indian Museum is where Indians are going to feel at home. And African Americans are going to go to their own museum. And Latinos are going to go their own museum. And that's not what America is all about [...]
>
> *(Bedard and Huey-Burns 2011)*

Spurred on by funding concerns, Moran's speech insisted that the creation of distinct museum spaces for different ethnic communities would amount to an unwelcome segregation of audiences and histories. Underpinning his critiques, however, was his support for a proposition for a new 'National Museum of the American People', a museum that would celebrate all ethnic groups in the making of America (Reiner 2012). The concept of such a museum was posed in direct opposition to the growing trend towards culturally specific museums and closely echoed sentiments of unity expressed by critics of such museums some 20 years earlier (Reiner 2012).

In response to the resurgence of criticism following movements in Congress for the National Museum of the American Latino, the Smithsonian sponsored a public debate on the issue of culturally specific museums. Taking place in 2012, the format was a day-long symposium that invited museum directors from 'culturally specific' museums across the country to form a panel. Entitled '(Re)Presenting America: The Evolution of Culturally Specific Museums', the day began by locating the emergence of such museums within the disciplinary changes in anthropology scholarship and critical race studies. While some panellists drew on experiences of ethnic museums and community engagement around the country, the symposium unpacked the issue of separatism and the problematic notion of essentialising identities that had dominated public discourse around culturally specific museums at the Smithsonian. For panellist Clement Price, a scholar at Rutgers University, the issue at hand was that separation had been a necessity for rights movements and progress among groups. Those who have been 'plagued by race', he explained, 'have sought to redefine their status in the nation by reinventing themselves racially' (Price 2012). Price drew on W. E. B. Dubois' insights into the complexities of both trying to shift away from being defined by race, to the need for some separateness in rights movements, necessitating the use of racial categories. There is a 'strong undertow of voluntary group separateness that defines the ethnic experience and sustains it over time'. Moreover, Price continued, those who impose 'consensus or unity' do so 'in the face of two generations of scholarship' that has shown the nation to be 'fractured, contentious, insecure and ambivalent' (Price 2012). Yet, he continued, 'there is an implicit need for the Smithsonian to tease out a national consensus amidst our messy democracy, a shared national narrative [...], a coming together of seemingly disparate threads during the early decades of the 21st Century' (Price 2012). Price's statements highlighted what he saw as an inevitable key tension posed by a culturally specific museum in a national museum context, while making the point that the Smithsonian must attend to both positions simultaneously.

In contrast to Price's call for both a national and a culturally specific depiction of ethnic experiences, *Washington Post* critic Kennicott, who was a member of the panel at the 2012 Symposium, was keen to highlight the role of identity politics in shaping museums over time. In the

context of the Smithsonian-hosted Symposium, his chief concerns were, for the most part, 'practical' ones around the sustainability of such institutions in a fast-changing Nation. The so-called 'balkanisation' of histories no longer concerned him, as the 'master narrative' was still in need of un-doing (Kennicott 2012). However, looking towards the future, he said:

> I think that in fifteen or twenty years, we may not think about ethnic identity in the same way that we think about it today, that, as we build museums that are dedicated to particular groups, we also have to remember that we are becoming an amazingly hybridic society in the way that we identify and so are the buildings and museums that we create today … are they still going to be adaptable enough to essentially carry that narrative of identity forward into places that we can't even anticipate yet?
>
> *(Kennicott 2012)*

Kennicott's critique demonstrates an assumption that museums of this kind struggle to change, and may operate primarily through fixed narratives of identity, drawn from the rights movements that underpinned their development. Here, and elsewhere in the critiques, there is an emphasis on the politics and changing nature of identity rather than on the museums' potential role in addressing matters of institutional marginalisation or broader racial injustice. Such critiques, I would argue, also appear to essentialise museums themselves as simplistic vehicles for culturally-determined political interests rather than as places for complex intercultural connections.

The extent of the possibilities for ethnic museums to be agents of change in society has been a recurring theme in commentaries, both supportive and otherwise, of ethnic museum developments. This, I would argue, suggests that debates about the relevance of ethnic museums appear to hinge on differing ideas of the nature of identity itself, as well as expectations of museums themselves as cultural forms. Writing about identity museums, UK-based cultural critic Jenkins has objected to the politicisation of identity in the telling of the past (Jenkins 2011). While agreeing with the logic that specialist institutions are needed, particularly those that focus on the issue of race, Jenkins posits that a lack of rigorous scholarship, and an emphasis on self-definition and self-affirmation, makes culturally specific museums like the NMAI, highly problematic in their prioritisation of identity over objectivity. 'This isn't scholarship' Jenkins claims: 'It is a therapeutic fantasy designed to make people feel better, and its consequence is the affirmation of the status quo.' She continues: 'One effect of the predominance of cultural politics is that lower standards of scholarship are accepted, with ethnically determined points of view considered acceptable bases for accounts of the past. […] In the politics of recognition, identity is understood differently to how it was when it inspired the civil-rights movement and the fight for equality. Here peoples' differences are not something to be overcome, they are central to who we are' (Jenkins 2011). For Jenkins, the emphasis on difference and distinctiveness in articulations of ethnic identity implies stasis, pointing to the assumption of a desired progression towards sameness and away from the perceived threat of frictions caused by separatist positions.

Ironically, the political role of museums as sites for the pursuit of national identity and cohesion is underscored across many critiques spanning the 1990s to the 2010s, despite the frequently articulated distaste for museums as sites of identity and politics. Writing in 2012, Pearlstein, a columnist for the *Washington Post*, said: 'My concern has less to do with the [African American] museum but with its location on the Mall. The Mall is, and ought to be, a symbol of national unity and shared experience, a place where we celebrate our collective history, culture and achievements' (Pearlstein 2012). Making an impassioned plea for a museum

of industry, Pearlstein continued, 'If anything deserves to be recognized and celebrated on the great national commons – if anything can pull us back together as a country – surely it is the goal of rekindling that national spirit and a national commitment to industrial ingenuity' (Pearlstein, 2012). Media commentators such as Rothstein (2010) and Jenkins (2011), suggest that so called 'identity museums' are a product of an overly inflated identity politics that result in museum work that is devoid of scholarship and attendant rigour, and favours identity at the expense of accurate history. At the same time, however, these critics typically agree on the importance of inclusive and diverse narratives within national museums of the United States. Their leaning is nevertheless towards an assimilative presentation of identity that could show 'an identity that emphasizes not its distinctions from the American mainstream, but its connections to it' (Rothstein 2010). In these positions, expressions of diversity seem only important for their role in serving the idea of a tolerant mainstream that proceeds to de-emphasise difference in favour of commonality.

In the context of contemporary activism around combating racial inequalities and injustices, positions of unity and commonality have been rejected and reified. In 2014, not long after the publication of Pearlstein's plea for unity, the fatal shooting of Michael Brown, an unarmed 18-year-old in Ferguson, Missouri prompted a new wave of protests across the Nation into racialised police violence. How museums should respond to this heightened moment of protest was a key concern for activists and socially engaged practitioners within the museum profession, prompting more direct questions about the role of museums not only in acknowledging the racial past but also an ongoing racial present (Incluseum 2014). Museums of all kinds were challenged to respond to issues of race in the wake of new cases of police violence and renewed protests across the Nation (Brown 2014). By this time, Black Lives Matter, a social movement begun in response to the acquittal of George Zimmerman following the killing of Trayvon Martin, had achieved considerable visibility worldwide. Banners displaying the 'Black Lives Matter' slogan were used across the United States to show solidarity and support for what had become for many the most important new movement for social justice since the 1960s in the United States (Demby 2014). Some responses to the movement, however, challenged the central message of the campaign, and rejected its central slogan by using the alternative 'All Lives Matter' or simply 'Lives Matter' (Samuel 2016). Although responding to a widespread social justice movement, these responses appear to mirror those against museums that are perceived to highlight specific groups over others in ways that are seen to overly emphasise racial experiences. Many have argued that such universalising assertions, in their rejection of specificity, work to frustrates processes of change and can be 'disabling' for rights movements (Goldberg 2016; Clifford 2000: 95).

Within a professional and public discourse of diversity and inclusion, museums of ethnic heritage have been challenged as sites that unhelpfully separate and essentialise ethnic experiences. Ideologically, ethnic museums are seen to challenge the pursuit of cohesion in society and to disregard the perceived realities of shared and complex heritage. Indeed, various responses to ethnic museums point to a wariness of museums of identity as overly politicised and relatively fixed organisations in that they are seen to predominantly serve a particular political and cultural community, rather than society as a whole. Yet this critical position might be read as one that itself distances distinct ethnic experiences from the national heritage, because of a rejection in the way in which the articulation of this experience is itself demarcated under the banner of an ethnic group. This reading may relate to Mukherjee's observation of a new kind of marginalisation, which casts out positions that appear to 'overly' emphasise race (2014). Drawing attention to the role of supporting diversity and inclusion in serving mainstream agendas of stability and economic growth, Mukherjee points to the marginalisation of more radical approaches of

race-conscious citizens, which sits less comfortably within the commercial, national, neoliberal agenda:

> Recognizing some racial differences while disavowing others [the emergence of post-race] confers privileges on some racial subjects (the white liberal, the multicultural American, the fully assimilable black, the racial entrepreneur) while stigmatizing others (the 'born again' racist, the overly race-conscious, the racial grievant, the terrorist, the illegal).
>
> *(Mukherjee 2014: 51)*

As suggested by Mukherjee, expressions of identity and culture, which are seen to prioritise and emphasis the legacies and contemporary issues of race, may be met with greater hostility than those that emphasise cultural diversity amidst accusations of being 'overly' race-conscious. Critiques of ethnic museum developments at the Smithsonian appear to follow this 'logic', whereby culturally specific narratives and museums are broadly accommodated in terms of diversity, but are occasionally viewed as exclusionary and outmoded in their apparent emphasis on racial identities.

Differing views about the perceived relevance and centrality of race, together with anxieties and desires for separateness in cultural terms within US society as a whole, are being directly addressed by the arrival of the National Museum of African American History and Culture (NMAAHC) which opened in 2016. This museum takes the position that racial histories and African American cultures are of relevance to all Americans, with race articulated as a defining feature of the national experience (Bunch 2014). The need for this strong narrative of national relevance suggests that the NMAAHC is working to create a closer relationship between national and African American experiences in a museum context where this relationship has previously only rarely been acknowledged. Questions emerge as to what response an explicitly race-conscious institution will have on discourses around national museums and their roles, and what expressions of identity and contemporary racial experience will be tolerated, respected, and (to use a loaded term) assimilated by those who subscribe to particular views of the Nation. Furthermore, what new articulations of heritage might we see in the age of Trump and the Black Lives Matter movement, which have each propelled debates around a still-racial present to the heart of national public discourse? These emerging questions around race and heritage in relation to ethnic museum developments and their initial critical reception, will undoubtedly shift as debates about race continue and as existing museums within the Smithsonian develop and change. While there continue to be impassioned pleas for presenting identity within museums in ways that 'unite' rather than 'divide' (Henderson 2014), pressing questions remain on the implications of articulating unity for movements that seek to challenge prejudice, and these questions may increasingly feature in public museum-focused debate as the professional sector in emboldened in pursuing inclusive and activist practice.

Conclusion

This chapter has examined only briefly the nature of key critiques of culturally specific museums, yet it raises critical questions of national heritage and race in relation to museum developments over time. Provocative as a symbol of a particular approach to inclusion, and symptomatic of, in the opinion of some, an unwelcome historical 'revisionism', the emergence of culturally specific museums under the umbrella of the Smithsonian Institution on the National Mall has prompted arguments against representing cultures separately in a spatial sense, drawing on notions of a desired unity within the nation. These questions are set against long-standing museological

debates around the political role of museums as sites of perceived objectivity and truth, but, as I have begun to show, they also point more directly to differing notions of identity, heritage, national experience, and the continued relevance of the racial past.

Typically polemical, the public responses to ethnic museums appeared to shift in nature between the 1990s and the early 2010s in line with a change in popular notions of race more broadly. During much of the 1990s, for example, issues of race were perceived to be solvable by way of an active rejection of the concept of race, while more recently, a post-race discourse has enabled race-based identity and racial experiences to be acknowledged but in terms of the past rather than the present. In sum, this chapter has shown that national ethnic museum developments offer a distinct lens for tracing complex ideas about race and heritage within the United States. Discourses around such museums interlink and align with discourses more broadly, and national museums, I would argue, both respond to and at times help to shape ideas about the position of race within the Nation.

With increasingly direct and urgent conversations about race and museums taking place among professionals, there may be a significant shift towards positions that highlight the continued presence of racial thinking, and a move away from problematic ideas of a post-racial society. This in turn may serve to move critiques of culturally specific museums away from the disparaging framework of outmoded identity politics (Kennicott 2010), and into the centre of debates about the nature of the racial past, present and indeed future of the United States. Key to these new conversations may be a greater focus on the possibilities for culturally specific and more universalistic narratives to co-exist without threat of censorship. Further interrogation might explore in greater depth what forms of empowerment and possibilities for change may be gained or lost in these processes of representation.

Bibliography

Adams, R. McC. (1990). 'Cultural Pluralism: A Smithsonian Commitment' address at the 1990 Festival of American Folklife, Smithsonian Institution/National Park Service, http://archive.org/stream/1990festivalofam00fest/1990festivalofam00fest_djvu.txt, accessed 7 November 2014.

Adams, R. McC. (1992). Letter to Professor Neil Harris from Robert McCormick Adams, 10 January. 'Smithsonian Institution Council' folder, Smithsonian Institution Archives, Accession 94-110-004, Smithsonian Institution, Deputy Assistant Secretary for the Arts and Humanities, Records.

African American Institutional Study Advisory Board (1990a). 'Meeting Summary African American Institutional Study Advisory Board' [Draft], 18 June. 'African American Institutional Study Advisory Board' folder, Smithsonian Institution Archives, Accession 93-066-007, Smithsonian Institution, Office of the Secretary, Administrative Records.

African American Institutional Study Advisory Board (1990b). 'Meeting Summary African American Institutional Study Advisory Board (Second Meeting)', 24 September. 'African American Institutional Study Advisory Board' folder, Smithsonian Institution Archives, Accession 93-066-007, Smithsonian Institution, Office of the Secretary, Administrative Records.

Anon. (1991). Letter to Adams, 20 September. 'Afro American Museum' folder, Smithsonian Institution Archives, Accession 94-052-001, Smithsonian Institution, Office of the Secretary, Administrative Records.

Bedard, P. and Huey-Burns, C. (2011). 'Dem congressman: ethnic museums on National Mall are un-American', U.S. News, 12 May, www.usnews.com/news/blogs/washington-whispers/2011/05/12/dem-congressman-ethnic-museums-on-national-mall-are-un-american, accessed 10 May 2014.

Brown, A. (2014). '#Museumsrespondtoferguson' [Storify], https://storify.com/aleiabrown/museumsrespondtoferguson, accessed 19 June 2016.

Bunch, L. (2014). 'America's moral debt to African Americans', Smithsonian, 6 June, www.smithsonianmag.com/history/americas-moral-debt-african-americans-180951675/, accessed 19 June 2016.

Burns, A. (2013). From Storefront to Monument: Tracing the Public History of the Black Museum Movement. Amherst and Boston: University of Massachusetts Press.

Chakrabarty, D. (2002). 'Museums in late democracies', *Humanities Research*, IX (1): 5–12.

Clifford, J. (2000). 'Taking identity politics seriously: "The contradictory, stony ground…"', in Gilroy, P. Grossberg, L. and McRobbie, A., (eds) *Without Guarantees: In Honour of Stuart Hall*. London and New York: Verso, pp. 94–112.

Colp, J. (1991). 'African American Museum: putting the past on review', *The Washington Times*, 23 October. 'Afro American Museum' folder, Smithsonian Institution Archives, Accession 94-052-001, Smithsonian Institution, Office of the Secretary, Administrative Records.

Demby, G. (2014). 'The birth of a new civil rights movement', *Politico*, 31 December, www.politico.com/magazine/story/2014/12/ferguson-new-civil-rights-movement-113906, accessed 19 August 2017.

Dubin, S. C. (1999). *Displays of Power Memory and Amnesia in the American Museum*. New York and London: New York University Press.

Dubin, S. C. (2006). 'Incivilities in civil(-ized) places: "Culture Wars" in comparative perspective', in Macdonald, S. (ed.) *A Companion to Museum Studies*. Oxford: Blackwell, pp. 477–493.

Dyson, L. (2005). 'Reinventing the nation: British heritage and the bicultural settlement in New Zealand', in Littler, J. and Naidoo, R. (eds) *The Politics of Heritage: The Legacies of 'Race'*. London and New York: Routledge, pp. 115–130.

Early, J. (1990). 'Memorandum to Mike Young from James Early', 12 April. 'SI Council Committee on Cultural Diversity' folder, Smithsonian Institution Archives, Accession 94-110-004, Smithsonian Institution, Deputy Assistant Secretary for the Arts and Humanities, Records.

Erikson, P. P. (2008). 'Decolonizing the "nation's attic": the National Museum of the American Indian and the politics of knowledge-making in a national space', in Lonetree, A. and Cobb, A. (eds) *The National Museum of the American Indian: Critical Conversations*. Lincoln: University of Nebraska Press, pp. 43–83.

Farrell, B. and Medvedeva, M. (2010). *Demographic Transformation and the Future of Museums*. Center for the Future of Museums, www.aam-us.org/docs/center-for-the-future-of-museums/demotransaam2010.pdf, accessed 19 June 2016.

Gaither, E. B. (1992). '"Hey! That's mine": thoughts on pluralism and American museums', in Karp, I. *et al.* (eds) *Museums and Communities: The Politics of Public Culture*. Washington: Smithsonian Institution Press, pp. 56–64.

Gamarekian, B. (1991). 'Smithsonian National Black Museum', *New York Times*, 7 May, www.nytimes.com/1991/05/07/arts/smithsonian-board-backs-national-black-museum.html, accessed 19 August 2017.

Goldberg, D. T. (2016). 'Why "Black Lives Matter" because all lives don't matter in America', *The Huffington Post*, 25 September, www.huffingtonpost.com/david-theo-goldberg/why-black-lives-matter_b_8191424.html, accessed 19 August 2017.

Gunn, S. and Faire, L. (2012). *Research Methods for History*. Edinburgh: Edinburgh University Press.

Harris, N. (1991). Letter to Robert McCormick Adams, 29 November. 'Smithsonian Institution Council' folder, Smithsonian Institution Archives, Accession 94-110-004, Smithsonian Institution, Deputy Assistant Secretary for the Arts and Humanities, Records.

Harrison, R. (2012). *Heritage: Critical Approaches*. Abingdon and New York: Routledge.

Henderson, A. (2014). 'How museums and the arts are presenting identity so that it unites, not divides', *Smithsonian*, 29 May, www.smithsonianmag.com/smithsonian-institution/how-museums-arts-are-presenting-identity-so-it-unites-not-divides-180951560/, accessed 19 June 2016.

Heyman, I. M. (1998). 'Museums and marketing: as philanthropy ebbs, the Smithsonian Council advises prudence in our search for corporate sponsorship', *Smithsonian*, January, p. 11. *Expanded Academic ASAP*, go.galegroup.com.ezproxy3.lib.le.ac.uk/ps/i.do?p=EAIM&sw=w&u=leicester&v=2.1&it=r&id=GALE%7CA20316780&asid=9257ca939f153c8fc0660f041fd6f2ae, accessed 19 July 2017.

Incluseum (2014). 'Joint statement from museum bloggers and colleagues on Ferguson and related events', 22 December, https://incluseum.com/2014/12/22/joint-statement-from-museum-bloggers-colleagues-on-ferguson-related-events/, accessed 19 July 2017.

James, P. (2005). 'Building a community-based identity at Anacostia Museum', in Corsane, G. (ed.) *Heritage, Museums and Galleries: An Introductory Reader*. London: Routledge, pp. 339–356.

Jenkins, T. (2011). 'Turning museums into cultural ghettos', *Spiked!*, 22 June, www.spiked-online.com/newsite/article/10621#.WZiZSiiGNPY, accessed 18 February 2013.

Karp, I., Kreamer, C. and Lavine, S. (1992). *Museums and Communities: The Politics of Public Culture*. Washington D.C. and London: Smithsonian Institution Press.

Karp, I. and Lavine, S. (eds) (1991). *Exhibiting Cultures: The Poetics and Politics of Museum Display*. Washington D.C.: Smithsonian Institution Press.

Kennicott, P. (2010). 'How can the American Latino Museum best answer the call of the Mall?' *Washington Post*, 25 July, www.washingtonpost.com/wp-dyn/content/article/2010/07/22/AR2010072206713.html, accessed 20 June 2016.

Kennicott, P. (2012). Remarks made during panel 'The Role of Ethnic/Culturally Specific American Museums', at '(Re)Presenting America: The Evolution of Culturally Specific Museums', Smithsonian Institution Special Symposium, 25 April, www.youtube.com/watch?v=dcVHMeb12MI, accessed 20 June 2016.

Letter to Adams (1991a). 1 April. 'Japanese American Internment' folder, Smithsonian Institution Archives, Accession 94-052-001, Smithsonian Institution, Office of the Secretary, Administrative Records.

Letter to Adams (1991b). 5 May. 'Afro American Museum' folder, Smithsonian Institution Archives, Accession 94-052-001, Smithsonian Institution, Office of the Secretary, Administrative Records.

Letter to Adams (1991c). 22 May. 'Afro American Museum' folder, Smithsonian Institution Archives, Accession 94-052-001, Smithsonian Institution, Office of the Secretary, Administrative Records.

Letter to Board of Regents (1991). 8 May. 'Afro American Museum' folder, Smithsonian Institution Archives, Accession 94-052-001, Smithsonian Institution, Office of the Secretary, Administrative Records.

Letter to Senator Bentsen (1989). 'National Museum of the American Indian' folder VI, Smithsonian Institution Archives, Accession 93-066-002, Smithsonian Institution, Office of the Secretary, Administrative Records.

Littler, J. (2005). 'Introduction: British heritage and the legacies of "race"', in Littler, J. and Naidoo, R. (eds) *The Politics of Heritage: The Legacies of 'Race'*. London and New York: Routledge, pp. 1–19.

Lonetree, A. (2012). *Decolonizing Museums: Representing Native America in National and Tribal Museums*. Chapel Hill: The University of North Carolina Press.

Luke, T. (2007). 'Nuclear reactions: The (re)presentation of Hiroshima at the National Air and Space Museum', in Watson, S. (ed.) *Museums and their Communities*. London and New York: Routledge, pp. 197–212.

Macdonald, S. (1998). *The Politics of Display: Museums, Science, Culture*. London: Routledge.

Macdonald, S. (2006). 'Expanding museum studies: An introduction', in Macdonald, S. (ed.) *A Companion to Museum Studies*. Oxford: Blackwell, pp. 1–12.

Message, K. (2007). 'Museums and the utility of culture: the politics of liberal democracy and cultural well-being', *Social Identities*, 13 (2), pp. 235–256.

Message, K. (2013). *Museums and Social Activism: Engaged Protest*. London and New York: Routledge.

Molotsky, I. (1989). 'Smithsonian to give up Indian remains', *New York Times*, 13 September, www.nytimes.com/1989/09/13/us/smithsonian-to-give-up-indian-remains.html, accessed 1 August 2016.

Mukherjee, R. (2014). 'Antiracism Limited: A pre-history of post-race', *Cultural Studies*, 8 July, pp. 1–31.

Pearlstein, S. (2012). 'A museum for American ingenuity?' *Washington Post*, 18 February, www.washingtonpost.com/business/steven-pearlstein-a-museum-for-american-ingenuity/2012/02/12/gIQAvsCPMR_story.html?utm_term=.30686e8a9c4a, accessed 20 June 2016.

Price, C. (2012). 'Race, identity, and American museums'. Paper presented at '(Re)Presenting America: The Evolution of Culturally Specific Museums', Smithsonian Institution Special Symposium, 25 April, www.youtube.com/watch?v=dcVHMeb12MI, accessed 20 June 2016.

Reiner, N. (2012). 'Melting pot on the Mall?: Race, identity, and the National Museum Complex', *International Journal of the Inclusive Museum*, 5 (2), pp. 33–41. Available from: Art Full Text (H. W. Wilson), Ipswich, MA, accessed 20 August 2017.

Ripley, S. D. (1969). *The Sacred Grove: Essays on Museums*. New York: Simon and Schuster.

Rothstein, E. (2010). 'To each his own museum, as identity goes on display', *New York Times*, 28 December, www.nytimes.com/2010/12/29/arts/design/29identity.html, accessed 27 April 2014.

Samuel, E. (2016). 'Seahawks cornerback Richard Sherman explains why he stands by that All Lives Matter', *New York Daily News*, www.nydailynews.com/sports/football/richard-sherman-explains-stands-lives-matter-article-1.2728272, accessed 19 August 2017.

Savage, K. (2009). *Monument Wars: Washington D.C., the National Mall, and the Transformation of the Memorial Landscape*. Berkeley and Los Angeles: University of California Press.

Smithsonian Council (1991). Draft agenda '25th Anniversary Smithsonian Council Meeting, 25–27 October 1991', 19 July. 'SI Council, 25–26 October 1991' folder. Smithsonian Institution Archives, Accession 94-110-004, Smithsonian Institution, Deputy Assistant Secretary for the Arts and Humanities, Records.

Swisher, K. (1989). 'Smithsonian to surrender Indian bones', *Washington Post*, 12 September, www.washingtonpost.com/archive/politics/1989/09/12/smithsonian-to-surrender-indian-bones/16d52b37-75f1-48b2-b6b3-811c3a6942c4/?utm_term=.1083c5eedddd, accessed 19 June 2016.

Teasley, M. and Ikard, D. (2009). 'Barack Obama and the politics of race: The myth of postracism in America', *Journal of Black Studies*, 40 (3): 411–425, www.jstor.org.ezproxy4.lib.le.ac.uk/journal/jblackstudies, accessed 20 August 2017.

Trachtenberg, A. (2007). 'Contesting the West', in Knell, S. (ed.) *Museums in the Material World*. London and New York: Routledge, pp. 292–300.

Walker, W. (2013). *A Living Exhibition: The Smithsonian and the Transformation of the Universal Museum*. Amherst and Boston: University of Massachusetts Press.

Yeingst, W. and Bunch, L. (1997). 'Curating the recent past: The Woolworth Lunch Counter, Greensboro, North Carolina', in Henderson, A. and Kaeppler, A. L. (eds), *Exhibiting Dilemmas: Issues of Representation at the Smithsonian*. Washington DC: Smithsonian Institution Press, pp. 143–155.

Young, M. (1991). Memorandum from Mike Young to Management Committee '1991 Smithsonian Council Meeting (25–26 October) – Changes in Agenda', 30 July. 'SI Council, 25–26 October 1991' folder. Smithsonian Institution Archives, Accession 94-110-004, Smithsonian Institution, Deputy Assistant Secretary for the Arts and Humanities, Records.

40

Heritage interpretation and human rights

Documenting diversity, expressing identity, or establishing universal principles?

Neil Silberman

Introduction

On the face of it, no quest could be nobler: to enrich and highlight the 'outstanding universal value' of World Heritage sites (Cleere 1996) with what the United Nations (UN) has recognised from its founding as the outstanding universal value of human rights (Schwelb 1964). In recent years, political scientists, legal scholars and social philosophers have separately and extensively discussed the complexity of the human rights concept, from the distinct standpoints of its historical evolution (Hunt 2008, Moyn 2010, Lauren 2011), judicial definition and significance (Blake 2000, Alston and Goodman 2007), and the perennially contentious question of its universality (Cerna 1994, Good 2010). Heritage studies scholars have discussed the dimensions of 'rights-based' heritage in both general terms and in (often negative) case studies from around the world (Silverman and Ruggles 2007). Anthropologists and archaeologists have tackled the problem of human rights through the lens of their own disciplines, envisioning these disciplines to be agents of social activism (Goodale 2009, Meskell 2009, Hodder 2010). A considerable body of theoretical work has therefore been assembled on the subject of human rights and their relevance to cultural heritage. However, the body of academic theory is yet to be effectively integrated into the implementation of existing international conventions, charters and the various national conservation laws and practices that are derived from them.

United Nations Educational, Scientific, and Cultural Organization (UNESCO) has long been recognised as an influential force shaping international heritage practice (Turtinen 2000, Giovine 2009). The ratification of the *World Heritage Convention* (UNESCO 1972) gave historical, archaeological and ecological form to the UN' shared belief in the idea of a common patrimony of the community of nations. The subsequent *Convention on the Safeguarding of the Intangible Cultural Heritage* (UNESCO 2003) expanded the normative understanding of global cultural heritage with a concern for ideas, beliefs, practices and traditions as expressions of the cultural identity of a wide variety of state-level and sub-state groups. Still later, the preamble to the *Convention on the Protection and Promotion of the Diversity of Cultural Expressions* identified the very principle of cultural diversity as 'a defining characteristic of humanity' and acknowledged its connection to 'the full realisation of human rights and fundamental freedoms proclaimed in the Universal Declaration of Human Rights and other universally recognised instruments'

(UNESCO 2005). Yet the successive Conventions were vague in identifying the precise human rights and fundamental freedoms that were to be insured by the national overseers and administrators of culture and cultural heritage. This imprecision – and the growing number of international and interethnic disputes over cultural rights and cultural destruction led the UN Human Rights Council (UNHRC) in 2009 to appoint the Pakistani Sociologist Farida Shaheed as an independent expert to compile an official report on 'the relationship between cultural rights, cultural diversity, and the universality of human rights' (Office of the United Nations High Commissioner for Human Rights 2009). Indeed, the choice of a sociologist, rather than a heritage professional or academic specialist in one of the historiographical disciplines, highlighted UNESCO's focus on the contemporary social aspects of her assignment. Her challenge was to survey existing human rights principles relevant to the governmental treatment of culture and cultural heritage – and to highlight the extent to which they were – or should be – observed.

The goal of this paper is to highlight some ways in which public heritage interpretation can serve as a meaningful tool to integrate the theme of Human Rights into the existing processes and procedures of international heritage, as exemplified by the UNESCO's World Heritage list. This most visible programme of the World Heritage Convention of 1972 has served as a global model for procedures of site assessment, evaluation, management and conservation, yet its *Operational Guidelines* (UNESCO 2008) lack specific criteria or standards for the public communication of a World Heritage site's value or significance. Indeed the terms 'interpretation' and 'presentation', often used interchangeably to denote the public display and explanation of heritage sites, have long been viewed as secondary to the core tasks of research and physical conservation. The instrumental purposes of interpretation have thus long been the effective transmission of authoritative facts and authorised narratives (Smith 2006, Ablett and Dyer 2009) and to cultivate public appreciation and support for the heritage enterprise itself (Tilden 1957, Ham 2007). With the growth of economic motivations for heritage development in tourist revenues, interpretation has also been conscripted to serve as 'edu-tainment' in the Experience Economy (Silberman 2007).

At the same time, the increasing use of digital and online applications, community-based and specialised educational programming has made heritage interpretation an increasingly powerful medium for encouraging dialogue and communicating heritage values. The participation of individuals and communities in the *process* of interpretation (rather than its finished project) has become increasingly visible in public contributions to local heritage websites, online exhibitions and archives (Giaccardi 2006, Labrador and Chilton 2009), and in the creation of new online memory communities through social media networks (Silberman and Purser in press). Indeed this kind of participatory heritage interpretation goes beyond the transfer of information between individuals; it creates various, overlapping memory communities.

Yet integration of human rights issues into the interpretation of a cultural landscape, historic city, heritage site or museum is not simply a matter of utilising new interpretive technologies or adding an additional theme. The terms 'human rights' and 'culture' have both undergone repeated redefinition within the UN system. To make them more than a mere slogan in interpretive texts and scripts requires an understanding their performative as well as linguistic function. In the following pages, I will briefly review the evolving meaning and significance of these central terms for communicating the value of heritage. After describing recent theoretical developments in the field of heritage interpretation, I will propose a heuristic model for rights-based heritage interpretation. This model may offer a practical way of balancing three integral modes of interpretation: the transmission of empirical facts, the expression of collective identity and the encouragement of individual reactions to and associations with the past. I will suggest that striving for this interpretive balance will not simply *communicate* human rights values but also help more effectively to *embody* them.

Evolving policy perspectives

The changing conceptions of human rights and culture within the UN system have been extensively discussed in legal, anthropological and the heritage studies literature (Marks 1977, Symonides 1998, Logan 2007, 2008, 2009, Silverman and Ruggles 2007, Langfield *et al.* 2010). In contrast to the sweeping, legal, political and economic rights of the individual articulated in the Universal Declaration of Human Rights (United Nations General Assembly 1948), the only explicit *cultural* right mentioned is 'the right freely to participate in the cultural life of the community' (Article 27). Most scholarly discussion about this formulation has focused on its problematic conception of culture (Eriksen 2001). However, the performative aspect – the participation in culture – is of particular importance to assessing interpretive activities. What exactly does 'participate' mean when it comes to culture, and how does one gauge if it is 'freely' done?

This narrowly and imprecisely defined 'human right' became even more ambiguous in the decades that followed the drafting of the Universal Declaration of Human Rights (UDHR) in 1948 as the very concept of 'culture' passed through three distinct stages in UN policy that had a profound influence on how the right to culture should be presented or performed. As Logan (2007) has pointed out, the 'cultural life' of the community was initially interpreted unquestioningly as of the 'arts and literature' category, a rarefied concentration of highbrow aesthetic creativity and self-evident social value that needed to be carefully protected and 'presented' to the public as a kind of cultural vitamin. This required the expertise of recognised scholars and connoisseurs to set explicit standards and values of culture and create specialised institutions to display or perform them. Indeed that expert-driven concept of culture was at the original core of the 1972 World Heritage Convention. Its central criterion of 'Outstanding Universal Value' is a notoriously subjective and contested concept that needed – and indeed still needs – expert scholarly and technical opinion even to be identified, and even more so, to be expressed effectively in the required World Heritage nomination dossiers (Jokilehto 2008).

The second major stage in the UNESCO definition of 'culture' came as a result of the political and social upheavals of the 1970s onwards that entwined the process of decolonisation with movements for civil, racial, ethnic and Indigenous rights (Stamatopoulou 1994, Xanthaki 2007). Often termed the 'anthropological' understanding of culture in UN circles, it was ironically far less nuanced than the intense questioning of the culture concept underway among anthropologists and sociologists (Yengoyan 1986). The focus now shifted from selected aesthetic and historical criteria to collective expressions of identity. Here interpretation became truly performative; the boundary between authoritative voice and passive listener began to fade (Yúdice 2003). This kind of interpretation is what Connerton (1989) has called 'performative memory'. Identification with – and conspicuous enactment of – distinctive customs, rituals and ceremonies performed at traditional sacred places, and revitalisation of endangered linguistic, craft and artistic traditions underpinned political claims not only by established nation-states (Gillis 1996), but by sub-state religious and ethnic minorities as well (Ucko 2001). Culture was now seen as a distinctive way of life, interpreted and performed with greatest authenticity by the bearers of each culture. The scholarly documenters and evaluators who had heretofore been the exclusive judges of cultural values gave way to interpreters and practitioners of 'intangible cultural heritage' as codified in the 2003 UNESCO Convention (Aikawa 2004). Indeed, this second, 'anthropological' conception of culture – whether used as a tool of resistance by sub-state minorities or as a tool of homogenisation by nation-states – represented a decided turn to an active, collective expression of culture, rather than static, musealised products of human creativity.

In retrospect, however, the rise of state-sanctioned, identity-based culture created as many conflicts as it resolved, for each 'official' or state-supported roster of monuments and cultural icons tended to be contested by other states, be they regional rivals, as in the cases of Israel and Palestine, Armenia and Azerbaijan, or Cambodia and Thailand – or by sub-state groups such as Catalans and Basques in Spain, Muslims in the Balkans and Uighurs and Tibetans in China (Harrison 2004). This danger of cultural fragmentation and conflict at a time of increasing global interconnection eventually gave rise to a third conception of culture within the UN system: as a medium of global toleration, not just the exercise of a particular identity. The clearest expression of this is the 2005 UNESCO Convention on the Protection and Promotion of the Diversity of Cultural Expressions, which identified Cultural Diversity as 'a common heritage of humanity [that] should be cherished and preserved for the benefit of all' (UNESCO 2005, preamble).

The three approaches to culture outlined above are linked with quite specific modes of interpretive practice. The 'high culture' approach is dependent on scholarship and authoritative discourse; the 'collective identity' approach is dependent on public participation; and the 'cultural diversity' approach is dependent on both individual autonomy and the acceptance of universal principles. Thus, through these various modes of public heritage interpretation the acknowledged human right 'to participate in the cultural life of the community' has multiple meanings and actions, not a single, unambiguous way to participate. Yet my argument here is that the three approaches to culture are not exclusive, nor did one replace the next over time. They coexist as complementary triad that together embody the human right to culture and cultural heritage. In the following sections, I will explain how a recognition and careful balance of all three approaches are the keys to the effective development of rights-based World Heritage.

Three interpretive alternatives

As described above there are three distinct UNESCO understandings of culture and three distinct avenues for interpretive action. Since the only acknowledged human right in the UN system relevant to heritage is 'the right freely to participate in the cultural life of the community', it is of crucial importance to understand how public heritage interpretation facilitates, hinders or subtly directs the way that rights-based participation might take place.

The first mode of interpretation, linked to the 'high culture' approach, is the meticulously documented, empirically verified description of specific sites, objects, or practices deemed to be of cultural or historical significance. This mode of presentation can be communicated by a live site interpreter with emotion and drama (e.g. Tilden 1957), by text panels and exhibits, or by a variety of new technologies (e.g. Kalay et al. 2007). Based on systematic empirical study and academic authority, it offers a primarily one-way stream of communication from an authoritative source to the visitors touring a heritage site. It draws its epistemology from the Enlightenment positivism of factual accuracy and historical objectivity that is expected largely to be accepted and passively consumed by site visitors and the public at large. It is by nature accretionary, building on the faith that the never-ending accumulation of data will provide an ever more accurate vision of the past. In regard to the principle of cultural diversity, its many specific site interpretations likewise assume that the more data that are collected and transmitted about the world's many cultures, the more accurate our shared understanding of the world's cultural diversity will be. Yet documented facts, dates and figures do not always safeguard values and can, in some cases, become a means of political evasion by insisting on scholarly impartiality. Fact- and expert-based interpretation may facilitate the transfer of empirically obtained data, but does not

necessarily enhance public engagement in the cultural life of the contemporary – whichever community one identifies with.

The second avenue of interpretation is performative – in line with the cultural 'identity politics' of the second stage. Here I do not refer to the performance of 'costumed interpreters' at outdoor and house museums, or historical re-enactors at weekend gatherings and battlefields. I refer rather to the enactment of contemporary identity by members of a particular ethnic group, religion or people as an act of collective allegiance, drawing on traditional visual motifs, places and objects to assert contemporary legitimacy. This type of interpretation is not primarily aimed at the transmission of information (though of course it may include it), but rather as a demonstration of the vitality of a particular cultural community. It is not an objectifying representation by outsiders or experts, but rather an act of *translation*, from the past to the present and from within the group to the outside. Claims for repatriation of cultural objects and human remains (Daes 1994); the identity visibility derived from items inscribed on the UNESCO representative list of intangible cultural heritage (Lenzerini 2011); and even campaigns to restrict access to or reinterpret World Heritage sites, such as Uluru in Australia (Sullivan 2005), are examples of participatory heritage that 'is constantly recreated by communities and groups in response to their environment, their interaction with nature and their history, and provides them with a sense of identity and continuity' (UNESCO 2003, Definition 1).

However, this process of utilising heritage as an expression of collective identity has its limits within the framework of the UNESCO conventions that serve as global models for heritage practice. Only member-states have the authority and standing to make nominations to both the Intangible Cultural Heritage Representative List and the World Heritage list and this a priori gives the authorised representatives of those nation-states the power to determine what is its citizens' legitimate 'cultural life' and which are its legitimate cultural communities. Refugees, immigrants and members of Indigenous peoples or ethnic minorities that a particular state views with hostility or suspicion are not accorded the same rights of participation in the cultural life of the community they choose. It is clear that in recent years the selection of World Heritage sites has become increasingly subject to political pressures and less dependent on expert evaluation of nomination dossiers (for clear quantitative indices, see Jokilehto 2011). Thus the performances and sites connected with powerless or marginalised sub-state communities are quite regularly excluded from even the narrow UN definition of cultural human rights; it is an issue that is only now beginning to be formally addressed within UNESCO policy (Labadi 2007). Performativity in itself is thus no automatic advance in furthering the 'right freely to participate in the cultural life of the community' if it is not universal or equally applied.

The last mode of heritage interpretation to be mentioned is one of self-definition, intercultural dialogue and toleration – seeing the mosaic of global human cultural diversity as a medium for the public discussion of the great triumphs and tragic *violations* of human rights over the centuries (Tunbridge and Ashworth 1996). This method of heritage interpretation has been developed and disseminated by the members and supporters of colonised, marginalised and stereotyped Indigenous peoples (Battiste 2000) and by such organisations as the International Coalition of Sites of Conscience at heritage locales all over the world (Hamber *et al.* 2010). This trend in heritage interpretation has so far gravitated towards sites of suffering, cruelty, tyranny or violence, but it could just as easily be focused on sites where human rights were established, practised or preserved. Its emphasis on the somewhat paradoxical universality of diversity and its insistence on the moral autonomy of each individual to weigh the ethical dimensions of human heritage offer a direct and open linkage between cultural heritage and human rights.

From the right to culture to a heritage of human rights

In March 2011, the final report of the UNHRC Independent Expert Farida Shaheed offered a wide-ranging list of suggestions and recommendations about the linkage between human rights and cultural heritage, which still clung closely to the right of 'access' and 'enjoyment' of cultural heritage as the primary human rights concern (Shaheed 2011). The report stressed the importance of recognising the sheer number of cultures whose importance all member-states should acknowledge. In addition to the need for greater diversity in officially recognised cultures, Shaheed made additional important observations that significantly expanded the linkage between cultural heritage and human rights. She stressed that heritage need not always be a positive expression and could represent tragedy and human cruelty as well (2011, II–8). She noted the dangers of commercialisation and commodification of heritage sites and objects in not only devaluing community culture, but also in physical displacement and exclusion from full participation in its development possibilities (2011, III–12–14). Her recommendations included a call for greater involvement of local and associated communities in the conservation and presentation of cultural heritage sites of special concern. In that sense she emphasised that 'access' or 'participation' should not be construed merely as a passive activity to take part in an already existing heritage infrastructure, but the full diversity of cultural communities within member-states be empowered at all stages of cultural heritage planning and development.

However, how shall that participation be achieved despite the existence of top-down, expert-driven heritage laws and frameworks that encourage visitors and residents to be passive consumers of pre-packaged experiences and authorised narratives and facts? Multivocal, participatory interpretation can help us reconceptualise World Heritage, and indeed all cultural heritage as a contemporary intellectual, social and personally reflective activity, not just a fossil of the past. Through it, we may be able to recognise the character of heritage not only as 'inheritance' and something to be 'passed on to future generations' but also a dialogic medium for promoting discussions about social justice and cultural creativity in the present (Ablett and Dyer 2009). In that sense, heritage interpretation should be seen as deliberative public discourse, necessitating a regard for facts, common interests and individual moral autonomy (Bohman 2000). As such, a heritage site or museum can also be seen as a site of deliberative discourse. Heritage interpretation involving both visitors and experts can become a medium for that type of discussion. And in transforming interpretation from a monologue to a public conversation, none of the three successive UN definitions of culture can be accepted as authoritative, for all of them – the didactic, the performative and the individually reflective – have a positive discursive value only when they are carefully juxtaposed. To achieve a truly rights-based approach to culture and public interpretation, the strengths of all three approaches must be integrated and carefully balanced (see Figure 40.1). Without a conscious combination of reliable data, collective identity and individual freedom of autonomous reflection, heritage interpretation can all too easily be diverted to ends that actively work against – not for – the principles of human rights.

An approach that relies entirely on empirically gathered data and expert opinion can sometimes miss the forest for the factual trees. On the other hand, the interpretive voice that cares nothing for evidence and relies only on tradition, or dogma or intuition can never allow itself to question its seeming self-evident truth (Fagan 2006). Likewise, the conspicuous, obsessive display and celebration of a shared culture can cultivate an atmosphere of xenophobia and ethnic tension. Yet when culture is not seen as a deeply felt personal bond but a collection of art, ancient custom and artisanship, it can easily be exploited or trivialised as a market commodity. Finally, when one sees every expression of cultural heritage as a deconstructable totem for hegemony, no action or participation in heritage can ever be undertaken without expressing

Heritage interpretation and human rights

Figure 40.1 Balancing cultural understandings for rights-based heritage.

constant critique. And conversely, if the individual has no autonomy to judge for himself or herself the value of the tradition or to choose freely one's own cultural identity, the 'right to participate in the cultural life of the community' can become an obligation, not a right at all.

The goals and various methodologies of heritage interpretation are largely overlooked in the *Operational Guidelines* of the World Heritage Convention, where communication with the public is consistently termed 'presentation' and implicitly recognised only the expert-driven authoritative mode (UNESCO 2008, e.g. Ib5, Ib7, Ic15a, Ic15d, Ic15g, VIb213). The Burra Charter (ICOMOS Australia 1999) and 'values-based' heritage policy (Torre 2005) widened the determination of values and significance to local stakeholders as well as experts. Specifically in the area of site interpretation, the ICOMOS Charter for the Interpretation and Presentation of Cultural Sites (ICOMOS International Scientific Committee on Interpretation and Presentation 2008) offered some generalised guidelines to balance the three different types of interpretive activity to create a means of public communication that integrates information, collective significance and inclusivity:

Interpretation as reliable documentation of historical research and collective memory

This refers to the empirically verifiable documentation of specific tangible and intangible cultural heritage objects and memories. A key element of rights-based interpretation, as stressed in Principle 1 of the ICOMOS Charter, is the breadth of information sources – not as a mere popularisation of scientific or scholarly information but as an enhancement of social context. Whether the interpretation relates to an ancient site beyond the living memory of any

Neil Silberman

contemporary community or a monument for which the oral and written testimony is rich, *empirical evidence* and *accurate representation* of collective traditions are essential for informed public participation in the cultural heritage life of the community.

Interpretation as the exercise of the right to identity with dignity

The enactment and intergenerational transmission of intangible cultural heritage are clear exercises of 'performative' collective memory. If World Heritage sites and other protected monuments were to be seen as meaningful and evolving embodiments of place, communities and traditions – if they were to become the focus of educational and interpretive programmes aimed and managed by members of the local or associated communities, the element of identity and social cohesion might be more strongly felt. The role that members of the local or associated communities play in a site's interpretation is crucial to its significance in the flow of their contemporary lives.

Interpretation as an exercise of individual cultural creativity and rights

It should by now be clear to the administrators of the World Heritage Convention (as it is presumably already clear to those working with intangible heritage) that heritage significance evolves with time. The interpretation of World Heritage Sites must leave room for continuous reinterpretation, not only based on the accumulation of new knowledge, but on the right of individuals to challenge orthodox, homogenising or dogmatic interpretations. The interpreter's race, gender, language, religion, opinions, national or social origin, property, birth or other status (all mentioned in the Declaration) should not involuntarily condemn him or her to a certain imposed cultural relationship to the site or to an imposed, essentialised identity.

If, as according to Article 13 of the UDHR, 'Everyone has the right to freedom of movement and residence within the borders of each State' and 'the right to leave any country, including his own, and to return to his country', does such a freedom extend to the right of identification with any of the diverse cultural traditions of humanity? In addition, if this kind of cultural hybridisation is to be encouraged from a human rights standpoint, how does that affect heritage practice? The focus has long been on the involvement of local communities and ethnic communities within the member-state's borders, but diasporic and associated communities and individuals – living far from a particular heritage site but still with strong attachments – may justifiably also claim rights to participate in the interpretation of this heritage.

Conclusion

This paper has attempted to offer a theoretical model for balancing the distinct interpretive values of heritage sites in a way that more clearly defines a means of actualising the UDHR's 'right to participate in the cultural life of the community'. It is in the integration of approaches, rather than in an evaluation of their individual validity, that participation is widened and the community becomes coterminous with the interlocking groups of professionals, community groups and individuals for whom it holds some significance. We live in a time of movement, diaspora, cultural displacement, and the creation of new cultural forms that profoundly alter the traditional heritage concepts of coherent national narratives (Labadi and Long 2010). Old monuments take on new meanings; new monuments become heritage. Today cultural identities are fluid and old ideas of national or universal identity to be drawn from a particular World Heritage site are the object of constant negotiation and political debate.

594

As I have tried to suggest in this paper a carefully balanced strategy of interpretation, which seeks to expand and widen its role from 'monologic' to 'dialogic' (Ablett and Dyer 2009) offers a new approach to 'rights-based' heritage. The principle enshrined in the central definition of the Intangible Cultural Heritage Convention that intangible cultural heritage is that which is 'transmitted from generation to generation, is constantly recreated by communities and groups in response to their environment, their interaction with nature and their history, and provides them with a sense of identity and continuity …' is the kind of dynamic conception of cultural heritage rights and social significance that is applicable to the human dignity of evolving and culturally diverse individuals and communities in the twenty-first century. An ongoing process of interpretation aimed at creating a sense of engagement and belonging – in Grenville's (2007) use of the term 'ontological security' – can become a useful component of a new approach to the human rights value of World Heritage Sites.

Bibliography

Ablett, P.G. and Dyer, P.K., 2009. Heritage and hermeneutics: towards a broader interpretation of inter-pretation. *Current Issues in Tourism*, 12, 209–233.

Aikawa, N., 2004. An historical overview of the preparation of the UNESCO International Convention for the Safeguarding of the Intangible Cultural Heritage. *Museum International*, 56 (1–2), 137–149.

Alston, P. and Goodman, R., 2007. *International human rights in context: law, politics, morals*. New York, NY: Oxford University Press, USA.

Battiste, M., 2000. *Reclaiming indigenous voice and vision*. Vancouver: UBC Press.

Blake, J., 2000. On defining the cultural heritage. *International and Comparative Law Quarterly*, 49 (1), 61–85.

Bohman, J., 2000. *Public deliberation: pluralism, complexity, and democracy*. Cambridge, MA: The MIT Press.

Cerna, C.M., 1994. Universality of human rights and cultural diversity: implementation of human rights in different socio-cultural contexts. *Human Rights Quarterly*, 16 (4), 740–752.

Cleere, H., 1996. The concept of outstanding universal value in the World Heritage convention. *Conservation and Management of Archaeological Sites*, 1 (4), 227–233.

Connerton, P., 1989. *How societies remember*. Cambridge: Cambridge University Press.

Daes, E.I.A., 1994. Equality of indigenous peoples under the auspicies of the United Nations – Draft Declaration on the Rights of Indigenous Peoples. *St. Thomas Law Review*, 7, 493.

Eriksen, T.H., 2001. Between universalism and relativism: a critique of the UNESCO concept of culture. *In*: J. Cowan, M.B. Dembour, and R. Wilson, eds. *Culture and rights: anthropological perspectives*. Cambridge: Cambridge University Press, 127–148.

Fagan, G.G., 2006. *Archaeological fantasies: how pseudoarchaeology misrepresents the past and misleads the public*. London: Routledge.

Giaccardi, E., 2006. Collective storytelling and social creativity in the virtual museum: a case study. *Design Issues*, 22 (3), 29–41.

Gillis, J.R., 1996. *Commemorations: the politics of national identity*. Princeton, NJ: Princeton University Press.

Giovine, M.A.D., 2009. *The heritage-scape: UNESCO, world heritage, and tourism*. Plymouth: Lexington Books.

Good, C., 2010. Human rights and relativism. *Macalester Journal of Philosophy*, 19 (1), 27–52.

Goodale, M., 2009. *Surrendering to Utopia: an anthropology of human rights*. Stanford, CA: Stanford University Press.

Grenville, J., 2007. Conservation as psychology: ontological security and the built environment. *International Journal of Heritage Studies*, 13 (6), 447–461.

Ham, S.H., 2007. Can interpretation really make a difference? Answers to four questions from cognitive and behavioral psychology. *In*: Fort Collins, ed. *Proceedings of the Interpreting World Heritage Conference*. Fort Collins, CO: National Association for Interpretation, 25–29.

Hamber, B., Ševčenko, L., and Naidu, E., 2010. Utopian dreams or practical possibilities? The challenges of evaluating the impact of memorialization in societies in transition. *International Journal of Transitional Justice*, 4 (3), 397–420.

Harrison, D., 2004. Contested narratives in the domain of world heritage. *Current Issues in Tourism*, 7 (4/5), 281–290.

Hodder, I., 2010. Cultural heritage rights: from ownership and descent to justice and wellbeing. *Anthropological Quarterly*, 83 (4), 861–882.

Hunt, L., 2008. *Inventing human rights: a history*. New York, NY: W.W. Norton.

ICOMOS Australia, 1999. *The Burra charter*. Burwood: ICOMOS Australia.

ICOMOS International Scientific Committee on Interpretation and Presentation (ICIP), 2008. *The ICOMOS charter for the interpretation and presentation of cultural heritage sites*. Available from: www.international.icomos.org/charters/interpretation_e.pdf (accessed 28 June 2011).

Jokilehto, J., 2008. *What is OUV?* Paris: ICOMOS. Available from: www.international.icomos.org/publications/monuments_and_sites/16/pdf/Monuments_and_Sites_16_What_is_OUV.pdf (accessed 12 August 2011).

Jokilehto, J., 2011. World heritage: observations on decisions related to cultural heritage. *Journal of Cultural Heritage Management and Sustainable Development*, 1 (1), 61–74.

Kalay, Y.E., Kvan, T., and Affleck, J., 2007. *New heritage: new media and cultural heritage*. London: Routledge.

Labadi, S., 2007. Representations of the nation and cultural diversity in discourses on World Heritage. *Journal of Social Archaeology*, 7 (2), 147–170.

Labadi, S. and Long, C., 2010. *Heritage and globalisation*. London: Routledge.

Labrador, A.M., and Chilton, E.S., 2009. Re-locating meaning in heritage archives: a call for participatory heritage databases. *In Making history interactive*. CAA 2009. Williamsburg, Virginia. Available from: www.caa2009.org/articles/Labrador_Contribution386_c%20(1).pdf (accessed October 22, 2011).

Langfield, M., Logan, W., and Craith, M.N., 2010. *Cultural diversity, heritage and human rights: intersections in theory and practice*. London: Routledge.

Lauren, P.G., 2011. *The evolution of international human rights*. Philadelphia, PA: University of Pennsylvania Press.

Lenzerini, F., 2011. Intangible cultural heritage: the living culture of peoples. *European Journal of International Law*, 22 (1), 101–120.

Logan, W.S., 2007. Closing Pandora's box: human rights conundrums in cultural heritage protection. *In*: H. Silverman and D.F. Ruggles, eds. *Cultural heritage and human rights*. New York, NY: Springer New York, 33–52.

Logan, W.S., 2008. Cultural diversity, heritage, and human rights. *In*: Brian J. Graham and Peter Howard, eds. *The Ashgate research companion to heritage and identity*. Farnham: Ashgate, 439–454.

Logan, W.S., 2009. Playing the devil's advocate: protecting intangible cultural heritage and the infringement of human rights'. *Historic Environment*, 22 (3), 14–18.

Marks, S., 1977. UNESCO and human rights: the implementation of rights relating to education, science, culture, and communication. Texas International Law Journal, 13, 35.

Meskell, L., 2009. Talking of human rights: histories, heritages, and human remains. *Reviews in Anthropology*, 38, 308–326.

Moyn, S., 2010. *The last Utopia: human rights in history*. Cambridge, MA: Belknap Press of Harvard University Press.

Office of the United Nations High Commissioner for Human Rights, 2009. *Independent expert in the field of cultural rights*. Available from: www2.ohchr.org/english/issues/cultural_rights/index.htm.

Schwelb, E., 1964. *Human rights and the international community: the roots and growth of the Universal declaration of human rights, 1948–1963*. Chicago, IL: Quadrangle Books.

Shaheed, F., 2011. *Report of the independent expert in the field of cultural rights*, Human Rights Council, UN General Assembly. Available from: http://indigenouspeoplesissues.com/attachments/article/10227/A-HRC-17-38.doc.

Silberman, N.A., 2007. Sustainable heritage? Public archaeological interpretation and the marketed past. *In*: Y. Hamilakis and P. Duke, eds. *Archaeology and capitalism: from ethics to politics*. Walnut Creek, CA: Left Coast Press, 179–193.

Silberman, N.A. and Purser, M., in press. Collective memory as affirmation: people-centered cultural heritage in a digital age. *In*: E. Giaccardi, ed. *Heritage and social media: understanding and experiencing heritage in a participatory culture*. London: Routledge.

Silverman, H. and Ruggles, D.F., 2007. Cultural heritage and human rights. *In*: H. Silverman and D.F. Ruggles, eds. *Cultural heritage and human rights*. New York, NY: Springer New York, 3–29.

Smith, L., 2006. *Uses of heritage*. London: Routledge.

Stamatopoulou, E., 1994. Indigenous peoples and the United Nations: human rights as a developing dynamic. *Human Rights Quarterly*, 16 (1), 58–81.

Sullivan, S., 2005. Local involvement and traditional practices in the world heritage system. *Linking Universal and Local Values, World Heritage Papers*, 13, 49–55.

Symonides, J., 1998. Cultural rights: a neglected category of human rights. *International Social Science Journal*, 50 (158), 559–572.

Tilden, F., 1957. *Interpreting our heritage: principles and practices for visitor services in parks, museums, and historic places.* Durham, NC: University of North Carolina Press.

Torre, M.D.la, 2005. *Heritage values in site management: four case studies.* Malibu, CA: Getty.

Tunbridge, J.E. and Ashworth, G.J., 1996. *Dissonant heritage: the management of the past as a resource in conflict.* Chichester: Wiley.

Turtinen, J., 2000. *Globalising heritage: on UNESCO and the transnational construction of a world heritage.* Stockholm: Stockholm Center for Organizational Research.

Ucko, P.J., 2001. 'Heritage' and 'Indigenous Peoples' in the 21st century. *Public Archaeology*, 1 (4), 227–238.

United Nations Educational, Scientific, and Cultural Organization (UNESCO), 1972. *Convention concerning the protection of the world cultural and natural heritage.* Available from: http://whc.unesco.org/en/conventiontext (accessed 23 June 2011).

United Nations Educational, Scientific, and Cultural Organization (UNESCO), 2003. *Convention for the safeguarding of the intangible cultural heritage.* Available from: http://unesdoc.unesco.org/images/0013/001325/132540e.pdf.

United Nations Educational, Scientific, and Cultural Organization (UNESCO), 2005. *Convention on the protection and promotion of the diversity of cultural expressions.* Available from: http://unesdoc.unesco.org/images/0014/001429/142919e.pdf.

United Nations Educational, Scientific, and Cultural Organization (UNESCO), 2008. *Operational guidelines for the implementation of the world heritage convention.* Paris: UNESCO, World Heritage Committee.

United Nations General Assembly, UNG, 1948. Universal declaration of human rights. *Resolution Adopted by the General Assembly*, 10, 12.

Xanthaki, A., 2007. *Indigenous rights and United Nations standards: self-determination.* Cambridge: Cambridge University Press.

Yengoyan, A.A., 1986. Theory in anthropology: on the demise of the concept of culture. *Comparative Studies in Society and History*, 28 (2), 368–374.

Yúdice, G., 2003. *The expediency of culture: uses of culture in the global era.* Durham, NC: Duke University Press.

41
Un-placed heritage
Making identity through fashion

Malika Kraamer and Amy Jane Barnes

Introduction

Leicester in England is a city of multiple migrants and transnational people. Goods and people have been moving in and out of Leicester since Roman times and people from different parts of the world have made it their home. With an industrial manufacturing base focused on hosiery and footwear manufacture, Leicester was a prosperous town (and city from 1919) during the nineteenth century and for much of the twentieth century. The city's industry was driven by a migrant workforce – first Jewish refugees from Russia, and later Czechs, Lithuanians and Poles and after the Second World War, workers from India and the West Indies (see Runnymede 2012). From the 1960s, Leicester became home to a steadily increasing migrant population of South Asians and East African Asians, which 'helped to mitigate the post-war labour shortage' (Harijan 1990; Barnes and Kraamer 2015: 178) and contributed to increasing diversity. Since the turn of the twenty-first century, the city can be properly understood as a super-diverse place,[1] a term coined by Vertovec to address the changing nature of global migration in the last 30 years with regards to the increasing complexities of the movement of people and 'a multiplication of significant variables that affect where, how and with whom people live' (2007: 1025). Vertovec continues, explaining that:

> ...it is not enough to see diversity only in terms of ethnicity, as is regularly the case both in social science and the wider public sphere. Such additional variables include differential immigration statuses and their concomitant entitlements and restrictions of rights, divergent labour market experiences, discrete gender and age profiles, patterns of spatial distribution, and mixed local area responses by service providers and residents. Rarely are these factors described side by side. The interplay of these factors is what is meant here, in summary fashion, by the notion of 'super-diversity'.
>
> *(Vertovec 2007: 1025)[2]*

A growing number of people are becoming part of transnational networks, including family, leisure and business links, within which they both physically and virtually move around. They not only experience forms of self-identified cultural heritage but they also shape these heritages through remembered-inherited and lived-through experiences.

In this chapter we explore the active making of heritage in the process of (multiple) migration with a particular focus on Leicester from the late 1960s to the 1980s; a time before Internet and cheap flights, before the increased conflation of time and space that these developments have facilitated. Although an explosion of studies considering the interplay between migration and heritage can be seen in the recent literature (see for example Graham and Howard 2008; Anheimer and Isar 2011; Daugbjerg and Fibiger 2011; Jones and Garde-Hansen 2012; Harrison 2012; Macdonald 2013; Meskell 2015; Waterton and Watson 2015; Grasmuck and Hinze 2016) this interplay – let alone the relationship between multiple migrants and heritage – has been under-researched for this time period. In this chapter, we look at ways of shaping and experiencing heritage, in particular in relation to material cultures of fashion, dress and textiles.

We argue that essentialising notions of geographical place in the construction of cultural and material heritage are problematic despite the prominence given to it in the literature on heritage. Place is not necessarily the key agent; other factors might play a much more significant role. Through the example of the so-called Japanese sari – manufactured in and prominently marked 'Made in Japan', often designed in Britain, and targeted at fashion-forward women of the South Asian diaspora – and in comparison with a similar phenomenon related to the use of African wax cloth, we demonstrate that people actively 'show-off' the other place of production of their clothes; places of origin far removed from the part of the world with which they may otherwise identify. These items of dress play a key role in identity-processes, manifest in material culture. We argue that the paradox that this apparently poses can only be described as such if assumptions about heritage and identity are so bound to place; it is clearly not a paradox for those who are actively involved in using these clothes as 'part of their heritage' and manifestation of their British East African Asian, South Asian or West African identities. Furthermore, we argue that this new way of conceptualising 'un-placed' heritage is of key importance in the context of exhibition and collection work. We consider how the multiple migrations and transnational identities of Leicester people with South Asian and East African Asian connections – having current and/or historical family networks in these regions of the world – were explored in the 2012 Cultural Olympiad exhibition *Suits and Saris*, at New Walk Museum and Art Gallery between March and October 2012, and argue that community advisory groups may not always help museums to grasp complex fluid, generation-specific, and memory-shaped migration histories.

This chapter problematises, thus, the central role of place given by academics when analysing the making of heritage. It considers specifically the implications of multiple migrations and the lived experience of multiple migrants on the concept of cultural heritage itself. This focus allows us to give attention to what we call global forms of moveable heritage constructed through peoples' experiences, rather than just facilitated by the conflation of place due to modern technologies.

Suits and Saris was an intergenerational participatory exhibition that sat between social history and fashion, with young people as its main target audience. One of the key aims was to give visitors the opportunity to reflect on the diversity of communities, while at the same time, to think about the similarities in experience and practice between individuals and across groups often considered as belonging to different communities. Rather than being didactic, the exhibition invited visitors to ask questions and discover shared experiences below the surface of perceived difference. The exhibition was thus structured around stories, two of which are explored in this chapter.[3] The first looks at the fascinating story of the aforementioned Japanese sari – a phenomenon more or less absent from the scholarly record,[4] and which exemplifies the transnational and globalised character of South Asian fashion. The second considers a collection of Gujarati

clothing, collected in the field on behalf of Leicester Arts and Museum Service (LAMS) in the 1980s, a selection from which was displayed in the exhibition in a section entitled 'Building a Collection'. This component of the exhibition looked at the implications of collecting, interpreting and displaying a group of objects perceived to represent the cultural heritage of South Asian and East African Asian communities in Leicester.

In Leicester, it has been understood that it is important to foster the celebration of identity (however fluid and multi-faceted), cultural heritage and senses of belonging in order to promote social cohesion.[5] Grass root initiatives and local government policies have changed emphasis since the first multi-cultural initiatives in the 1980s, but museums have always played an important role. Those policies, translated into many forms such as community projects, collection policies and exhibitions, have often been developed on the assumption that cultural heritage is un-problematically bound to migrants' 'place of origin'. We argue, however, that even when people identify themselves principally with a particular region of the world, for instance the Indian state of Gujarat, museums need to take into account the complex mixture of cultural memories in relation to individual and collective experiences, including migration routes as well as the contextual and fluid nature of identities when making displays or choosing what to collect. Especially in the case of multiple migrants, the active shaping of cultural heritage needs to be fully understood as happening within a transnational space. Jackson, Crang and Dwyer (2004) argue that 'transnational processes, including economic networks, political movements and cultural forms both reflect and produce transformations of social space' (Barnes and Kraamer 2015: 171). Space itself is 'constitutive of transnationality in all its different forms' (Jackson *et al.* 2004: 1). It is 'complex, multidimensional and multiply inhabited' (Jackson *et al.* 2004: 3) and 'different transnational formations can, themselves, be distinguished by their different geographies, their particular spatialities' (Jackson *et al.* 2004: 2).

This chapter does not only aim to contribute to wider theoretical debates and general understandings of heritage, but also to provide heritage professionals with examples of working with, and representing, British people with multiple heritages, and ways of collecting and displaying heritages of (super) diverse communities as part of mainstream culture. To set the context, the chapter begins with an exploration of theoretical perspectives on concepts of heritage and place, and on fashion and dress, and their connections with multiple migration and transnationalism, before moving on to an exploration of the case studies outlined above.

Heritage, place, fashion and multiple migrants

Since the 1990s, public interest in, and scholarly discussions of heritage have grown significantly, as mentioned above, as has the literature on dress, fashion and globalisation (e.g. Niessen, Leshkowich and Rabine 2002; Jones 2003; Hansen 2004; Goodrum 2005; Paulicelli and Clark 2008), and on multiple migrants (e.g. DeVoretz 2001; Castles 2002; Bhachu 2004a; Jackson *et al.* 2004; Collyer 2007; Paul 2011; Ossman 2013; Ahrens *et al.* 2014). Heritage is always a social construction of the past. It can be created in discourse, but also in material, in musical and performative ways (Corsane 2005). The debate on heritage is a complex network of often 'loosely articulated understandings, ideas, issues and ways of perceiving things' (Corsane 2005: 1). Still, many hold the view that concepts of heritage originated in Europe, emerging from The Enlightenment and romanticism. These concepts were exported around the world as a consequence of colonialism and taken up in many postcolonial states (see the work, for example, of Lowenthal 1998; Graham *et al.* 2000; Peckham 2003; Van der Laarse 2005; Corsane 2005, especially Part I; Hess 2005; Lumley 2005). Others challenge this narrative by highlighting 'indigenous models of heritage' (e.g. Mead 1983; Kreps 2003). However, this reifies a binary thinking between

Western and non-Western practices, when instead, people typically draw on ideas and practices from different parts of the globe (see, for example, Appiah 1992; Barber 1997; Meyer 1999; Piot 1999).

Many postcolonial writers have tried to destabilise grand narratives that centre the West and deny agency to other (subaltern) groups (e.g. Mudimbe 1988; Bhabha 1994; Piot 1999), by acknowledging two-way processes of transcultural influences and transformations (cf. Comaroff and Comaroff 1997). However, only a few scholars have applied these insights in studies of heritage (see, for example, McLeod 1999; Piot 1999). However, as Harrison notes, there still 'remains an important task of documenting non-Western discussions around heritage' (2012: 10). In more recent scholarly work, the concept of heritage has been explored as much more dynamic, with an examination of the politics of cultural heritage-making, itself in close relationship to identity politics on an individual, local national and global level.[6] Attention has also been given to how material culture-as-heritage plays a dynamic role in creating and transforming social and cultural identities, rather than merely reflecting such identities (Labadi and Long 2010). Heritage scholars are now also much more concerned with memory, identity and representation; they have started

> to concern themselves with processes of engagement and the construction of meaning, so that *post*-post-structural, or more-than-representational, labyrinth of individuated, affective, experiential and embodied themes has started to emerge. [...] 'Authenticity', 'memory', 'place', 'representation', 'dissonance' and 'identity', examples of the sorts of concepts that have been challenged or refreshed as new modes of thinking, drawn and applied from the wider social sciences, have started to stimulate new theoretical speculation
>
> *(Waterton and Watson 2015: 1)*

The precise relationship between identity and heritage, both considered as plural, is crucial to understand in order to avoid referring to heritage as 'the totality of the inheritance of the past' (Graham and Howard 2008: 2), and to support our main argument on the understanding of place within the nexus of identity and heritage. Heritage is about 'the meanings placed upon them and the representations which are created from them' (Graham and Howard 2008: 2). We agree with Graham and Howard that 'heritage in its broadest sense is among the most important means' of articulating identity, of 'vague feelings and senses of belonging' (Graham and Howard 2008: 1). Dress, art, music and language are not 'axiomatically heritage although they may become so ... as markers of nationalism or ethnicity' (Graham and Howard 2008: 7). The Japanese sari, African wax cloth and the LAMS Gujarati textile collection, operate for many as markers of ethnicity – however formulated – and are, therefore, considered to be 'heritage'. MacDonald, writing on what she calls transnational heritage, points out further complexities in this relationship when she contemplates 'whether heritage is capable of accommodating others kinds of identities, especially those that might be considered, variously, 'hybrid', 'open' or 'transcultural' (MacDonald 2013: 162). However, in all these new directions that consider the relationship between heritages and identities, it is assumed that the 'places' in which people primarily locate these identities are the same as the 'places' where those heritages that accommodate these identities are produced. Moreover, that this is of key importance to those constructing these identities, including those who are 'hybrid', 'open' or 'transcultural'. Geographers in particular have addressed how memory plays a key role in 'addressing how our spatial relations are not merely relations between current body and current space, but a hyper-complex entanglement of past/present spatial relations' (Jones and Garde-Hansen 2012: 10). They tend, however, as Atkinson (2007) has argued, to focus on fixed, bounded places and sites of memory,

but 'a place-fixated nexus of heritage and identity risks fetishising place and space too much and obscures the wider production of social memory throughout society' (Graham and Howard 2008: 7).

Although place is therefore problematic to some extent, Graham and Howard, amongst others, do assume that place identity remains important, even in hybrid and transnational societies, 'in that migrants "fix" identities in their homelands' (2008: 8). This resonates with the extensive literature on the concept of diaspora which (almost all academics agree) entails the existence of a collective – often idealised – memory of the homeland, grounded in a strong sense of ethnic identity (Cohen 1997). Not surprisingly, the literature on the 'Indian or South Asian diaspora', focuses mainly on the reproduction of culture and relationships with the homeland.[7] However, as Oonk (2014) and Mattausch (2014) have recently pointed out, this focus on connections with the homeland is not necessarily prominent or unproblematic, especially in the case of 'twice' migrants, such as East African British Asians or Surinamese Hindustanis in the Netherlands. We argue not only that the importance of memory and 'fixing' identities in the homeland is complex, but believe that the means of doing so is less place-bound than has, so far, been analysed.

A focus on dress, as a 'means' of heritage, in relation to multiple migrants in the two case studies we present in this chapter, demonstrates this position. In the growing literature on dress, fashion and globalisation there has been a lack of focused research on the significance of specific migration routes on the clothing choices of multiple migrants except in the work of Bhachu (2004) and our own recent publication (Barnes and Kraamer 2015).[8] The literature on the phenomenon of individuals migrating more than once in their life, and identity groups migrating twice or more within a relatively short period of one or two generations critiques the unproblematised use of the word transnational (Jackson *et al.* 2003, 2004). The phenomenon itself is referred to in different ways, such as onward migration (Ahrens *et al.* 2014), transit migration (e.g. Collyer 2007), twice migration (e.g. Bhachu 2004), secondary migration (e.g. Weine *et al.* 2011), serial migration (e.g Ossman 2013) and stepwise migration (e.g. DeVoretz 2001, Paul 2011).[9] While in the 1990s clear distinctions were still being made between first, return and onward migrants, the growing literature on transnationalism has blurred and problematised these distinctions. Studies in transnationalism focus on the embeddedness of migrants in more than one country (Castles 2002: 1146), in the multi-layered and multi-sited elements of transnational identities (Portes *et al.*, 1997; Levitt and Jwaworsky 2007), and how they contribute to this new social condition of 'super diversity' that characterises countries like Britain.

British South Asian and East African Asians in Leicester

To understand how (descendants of) multiple migrants have played an important role in the making of particular heritages in a city like Leicester related to South Asian identities, we need to focus our attention on the history of these South Asian diasporas and their specific migration routes; in particular on those groups who are often referred to as East African Asians. This heterogeneous community – in terms of social, economic and religious backgrounds and in terms of motivations and migration routes of individuals and generational groups – has a large presence in Leicester, London, Gujarat and East Africa at the time of writing (2016).

The migration histories of the East African Asian communities need to be understood within the close relationships between British imperialism and industrialisation. In the nineteenth century, large groups of South Asians migrated to East Africa and other parts of the British Empire. Between 1870 and 1914 (Nayyar 2002), India was at the heart of the relationship between British colonialism and a new world economic order, as India was a destination for

capital, a source of labour for other parts of the Empire and a source of raw materials (Brown 2006). Unlike many in other parts of the Empire (Trinidad, Guyana, Mauritius and South Africa, for example), those who moved to East Africa in this period, mainly from Gujarat, were not indentured labourers (Brown 2006). Many people from Western India travelled to East Africa as free migrants, finding work within the colonial civil service, or as servants and shop-keepers. Many of them settled long-term or permanently, bringing their families over and establishing homes and businesses (Brown 2006). The Asian community prospered and close economic and social contact with South Asia remained until the 1940s (Anon. 2003).

In 1972, Idi Amin, President of Uganda, forcibly expelled Asians from the country. This was the culmination of a period of 'Africanisation', during which resentment against the economic-ally successful Asian community had steadily grown within the context of the newly inde-pendent state. Similarly, many other South Asian diaspora communities in East Africa and beyond, also chose or were coerced into migration. A significant number of the estimated 28,000 Ugandan Asians who migrated to Britain ultimately settled in the city of Leicester, largely in the Belgrave Road area (Marett 1993).

Many found work in the city's manufacturing sector. For the first time, many migrant women were required to work in order to support their families financially (MORI 1993), finding employment in clothing factories, where they felt 'comfortable', could converse 'in their own language', and utilise pre-existing sewing skills (MORI 1993: 2). Several East African Asians also set up or found work in shops, mainly on Belgrave Road, selling saris and *salwar kameez* ('Punjabi suits') These businesses were only established after the arrival of East African Asians, not when the first wave of migrants directly from India arrived in Leicester after Indian independence (Barnes and Kraamer 2015: 178).

Suits and Saris

Suits and Saris explored global connections between South Asian and British historical and con-temporary fashions and clothing traditions, including the role of East African Asians in these connections. The exhibition attempted to present a set of eye-opening, vibrant, dynamic stories based on research undertaken in Leicester and Nairobi, rather than to attempt to present a big narrative. Interaction was its focus. It was developed in collaboration with South Asian clothing businesses and volunteer curators. *Suits and Saris* could be thought of as an exhibition that enabled visitors to explore interrelated stories that presented multiple voices. In this section we explore two case studies based on themes around which we structured the exhibition, and which exemplify the issues surrounding transnationalism and globalisation discussed in the first half of this chapter. The first of these is the 'Japanese sari' and the second is 'Building a Collection'.

Japanese saris

The case of the Japanese sari allows us to explore the role of place in the nexus of identity and heritage. It poses fundamental questions about the concept of heritage in the making, unmaking and re-imagining of diaspora cultures and

> opens the possibility of starting to examine heritage as transnational and globalised in itself, shifting the focus from a particular place – the homeland – to a transnational space, which might also help researchers understand what makes and constitutes a diaspora community.
>
> *(Barnes and Kraamer 2015: 183)*

An analysis of how these saris, produced in and, in particular, stamped 'Made in Japan', have been used and 'performed' in transnational spaces also allows us to examine the ways in which multiple migrants conceptualise this material as cultural heritage through their lived experiences. This space is truly transnational, as defined by Jackson *et al.* (2004), as these saris have been produced, distributed and used not just in 'the geographies inhabited by this particular "global diaspora" of largely (multiple migrant) East African Asians – a group that in itself has a multiplicity of transnational experiences and relations – but also incorporates places beyond these geographies, such as Japan' (Barnes and Kraamer 2015: 171).

In the 1960s, and especially the 1970s and early 1980s, synthetic but high-quality, fashionable and practical (easy to launder and care for) Japanese-made saris were a cultural phenomenon within the South Asian diaspora. Emerging from primary research undertaken in Leicester and Nairobi for *Suits and Saris*, it was one of the least expected but, potentially, richest outcome of the exhibition's development.[10] During the course of our research with East African Asian communities in Leicester, before and after the exhibition, more or less every first generation migrant we spoke to mentioned or showed us examples of Japanese saris, as did many of the owners of sari shop businesses along Belgrave Road, several of whom had played integral roles in the development of and innovations in the design of the saris (see Barnes and Kraamer 2015; Shah, personal communication, 2015; Saheli Women's Group, personal communication, 2016).[11] Undoubtedly, the phenomenon of the Japanese sari would not have occurred without the global outlook of Japanese textile production, and the transnational and multiple migrant nature of the South Asian diaspora.

Japan was established as a manufacturer and exporter of high quality synthetic fabrics in the 1950s and 1960s, and it was not much later that Japanese mills began to manufacture and export synthetic fabrics worldwide. South Asian women in the diaspora, but not in India due to the import ban on these fabrics until 1975, bought these fabrics to turn into saris,[12] but Japanese mills also produced synthetic cloth with the specific intention that they would become sari lengths (J. and K. Chauhan, personal communication, 2010; Gutka, personal communication, 2010; Mattani, personal communication, 2010; Barnes and Kraamer 2015: 174).[13] These saris were practical and appreciated for being of a 'nice and soft material' (Saheli Women group, personal communication, 2016).[14] They were quick and easy to launder, fade resistant, and hard-wearing (see Barnes and Kraamer 2015: 174). And they were contemporary; colours and motifs were inspired by Western fashion trends and the design of the saris themselves – all-over patterns and no *pallu*[15] – lent themselves to being worn in the figure-hugging and glamorous pan-Indian national *nivi*-style (see Barnes and Kraamer 2015: 176). Indeed, several sari shop businesses in Leicester commissioned designs to be manufactured in Japan, specifically with their own customer-base in mind, taking inspiration from trade magazines, global fashion trends and seasonal trends (Barnes and Kraamer 2015: 180–181).

However, by the late 1960s, Japan was not the only producer and exporter of synthetic materials or, indeed, saris,[16] and yet Japanese-made saris continued to be valorised by diaspora communities and increasingly in India as well. We have heard anecdotes from consumers and sellers alike that prior to the lifting of import restrictions in the mid-1970s, people from the South Asian diaspora would often take Japanese-made synthetic saris to India as gifts for friends and family members. 'It was specifically because of their [perceived] superior quality, fashionable designs and restricted availability in India, that Japanese saris became very desirable – those prominently stamped "Made in Japan" on the selvedge particularly so' (Barnes and Kraamer 2015: 179). Some women went as far as making sure that the stamp 'Made in Japan' or '6.4.4.',[17] another indicator of Japanese manufacture, was clearly visible when wearing the sari. Showing the stamp was important, as it authenticated the sari as Japanese and indicated its quality over

cheaper versions produced in India. From at least as early as the 1980s, 'imitation' Japanese saris – saris produced in Surat with a stamp 'Made in Japan' – were made in India (A. Mistry, personal communication, 2015; D. Mistry, personal communication, 2016),[18] another indicator of the perceived correlation between quality and Japanese-produced fabric.

This practice of actively showing off the origin of production can also be seen in a different part of the world: the use of African wax prints. These factory-printed textiles, made by printing designs on both faces of the cloth, have their origin in the nineteenth century when European manufacturers found cheaper ways of replicating Indonesian wax prints. An improved version of these imitation fabrics was too expensive for the Indonesian market as it was perceived as being too close to real batik, but proved to be popular in West Africa.[19] Even though the cloth was produced and designed outside West Africa, it was used until the 1980s predominantly in West Africa but also in Central and East Africa. The design process was guided by West African tastes and patronage (Kraamer 2013: 160–161), which allowed these fabrics to enter a highly competitive textile market (Sylvanus 2007: 207). In the 1960s, part of the production of wax prints relocated to different places in Africa, and Asian centres of production have, since then, provided the market with imitations of European patterns. Today, less than 10 per cent is produced in Europe (Sylvanus 2007: 211), either by Vlisco in the Netherlands or, until 2007, by ABC near Manchester, after which ABC moved their entire production to Ghana. In this long history of African wax-prints, the Dutch-produced wax prints have always been the most valorised fabric. On the seam of the cloth, like on the Japanese sari, its origin of production is printed: 'veritable Dutch wax' and especially within West Africa, but also in the diaspora, the clothes are sewn in such a way that this stamp is clearly visible. Sylvanus argues that 'the fabric simultaneously loses and integrates its twofold foreign "origins" – Javanese and European – as a result of the transformation processes through which initial signifiers are reconfigured into new signifiers, thereby transcending the notion of origins' (2007: 211–212). However, we would rather argue that these notions of origin are not transcended but form an integral part of their authenticity as signifying a South Asian or (West) African heritage. The Japanese sari is actively called a Japanese sari, and within an Indian context, the proof of its origin is actively shown off in wearing. In the same way, the mark 'veritable Dutch wax' is prominently displayed in the African diaspora and in West Africa itself.[20] Beatrice Gapta, for instance, born in Ghana but living for the last ten years in Leicester, commented; 'I am showing it to others to identify that it is a quality fabric … the textile is a sign of wealth … It shows my heritage [and] I have a pride in it' (Gakpa, personal communication 2016).[21] Our argument seems to echo Raghuram's argument that in diasporic fashion

> … the place of production may not only hold meaning but may also be valorized, since a second-order meaning of 'authenticity' may be ascribed to the product precisely because of its production and producers … Thus production tales become central to consumption tales.
>
> *(2003: 78)*

But Raghuram refers to the manufacturing in India of British-designed cloth for consumption in Europe, a history that correlates more closely with the 'homeland' idea of heritage studies. Instead, we suggest that while this often is the case, production tales within a transnational space of production, distribution and consumption, do not necessarily operate like this. The role place plays within these processes needs to be examined much more critically. We agree with Sylvanus that the 'Africanity of the wax lies neither in the fabric, nor in its material usages, but in the signifiers which the fabric conveys and that are produced in the context of local consumption'

(2007: 212). This is also true for the Japanese sari, but we can only truly understand the processes of identity and heritage formation when we consider the importance of 'place' in a different way to that which is currently common in debates surrounding heritage and identity. In both examples it is clear that these textiles have been produced and used in a transnational space that is not just confined to diaspora fashion. In the case of the Japanese sari, it is also clear that the particular migration routes of the users and producers play a significant role and in both cases, especially within diaspora communities, the cloth is performed as indicative of 'Indian' or 'West African' heritage, even though the most valued of these saris or wax cloths were neither produced nor designed in India or West Africa. It is clear that this is in no way experienced as problematic, as one would expect based on the literature on heritage and identity. On the contrary, the fact that this material is produced in Japan, The Netherlands or Britain is conceptualised as part of the wearer's heritage; the production and design within a transnational space is actively celebrated.

Building a collection

'Building a Collection' offered visitors the opportunity to think about what museums do and how they represent their audiences. It revisited the LAMS collection of Gujarati textiles, the majority of which had been collected in the 1980s. It also presented the museum team with the opportunity to gather local perspectives, experiences and knowledge about the collection and to reflect on the extent to which and the multiple ways in which first, second and consequent generations of Leicester residents, who identify themselves as East African Asian and/or South Asian, related to it, some 25 years after its creation.

Origins of the collection

In the 1980s, Julia Nicholson, the Assistant Keeper of Indian Arts and Crafts, had travelled to the rural Kachchh region in Gujarat to collect examples of Gujarati textiles in the field, in response to community concerns that young people of South Asian heritage in Leicester were losing touch with, what was for many, their Gujarati heritage (Nicholson, personal communication, 2011).[22] The goal was to collect material objects that would permit younger generations access to 'their heritage' (Nicholson 1988). But who decided what that 'heritage' actually encompassed?

Julia and her community advisory panel, which comprised 12 members of the Gujarati community in the city, felt that it was important to collect items and objects that were similar to those that had been used and worn within living memory (Nicholson, personal communication, 2011); not just to address local concerns about heritage education, but also because no other museum in the UK, at that time, had a particularly strong collection of material culture from this region (Nicholson personal communication, 2011).

In 1985, Nicholson undertook three months of field research and collecting in the Kachchh region of Gujarat, acquiring objects for the permanent collection. Kachchh was chosen because many in the Leicester Gujarati community had ancestral links with the region (Nicholson, personal communication, 2011) – indeed she stayed with local families, including the extended families and contacts of members of the advisory panel, in liaison with the Gujarat State Handloom and Handicrafts Development Corporation (Nicholson 1988). The focus of collecting was on textiles, with the goal of augmenting existing Gujarati collections in the UK, rather than replicating them.[23] Julia documented techniques and skills, and purchased examples of the textiles and embroideries directly from producers rather than dealers (Nicholson 1988: 1). She

made a particular effort to collect items that resonated with and had particular relevance for the Gujarati community in Leicester, 'for example *traditional* costumes [authors' italics] from Lohana and Patidar (Patel) communities', 'both of which are represented in Leicester' (Nicholson 1988: 1). This was a conscious decision that made it possible, in her opinion, 'to collect material with a greater awareness of its cultural context of daily life and belief', and that would 'enable the wider public [of Leicester] to have a greater understanding of the Indian communities they live alongside' (Nicholson 1988: 1–2).

And yet, it is interesting to note that while it was acknowledged in the catalogue of the resulting exhibition *Traditional Indian Arts of Gujarat* (see below), that many members of the Gujarati communities in Leicester had never lived in Gujarat (or India for that matter) and had only an ancestral link to the state, it was still felt at that time (in the early 1980s) that 'In Leicester, as in East Africa, Gujarati traditions remain strong [at least amongst members of the older generation], particularly with regard to cuisine, language, dress and religion' (Nicholson 1988: 1). Members of the community were recalling the cultural heritage of their parents and grandparents.

Tanman Patel, a member of the advisory panel, who *had* lived in Gujarat before East Africa and ultimately Britain, when asked in 2011 if there had been any discussion about collecting in East Africa in addition to or instead of Gujarat, said that there had not. She felt that Gujarat was the ultimate source of East African Asian culture: '... if you want to learn anything from the Gujarati, you can't go to Africa, you have to go to [Gujarat]' (Patel, personal communication, 2011).[24] Similarly, another interviewee and fellow member of the advisory panel, Nilima Devi, argued that although people had migrated from India to East Africa and East Africa to Europe, their roots were in India; while they may have assimilated some African influences (she noted similarities between some South Asian and African textiles – wax resist techniques, for example), they were proud of their Gujarati roots (Devi, personal communication, 2011).[25] When asked, why Kachchh? Tanman Patel argued that many of the original Gujarati migrants to East Africa did so via Kachchh and spoke the Kachchhi language (Patel, personal communication, 2011). Additionally, she speculated that Kachchh was selected for collecting in the field because the area was largely unindustrialised and the people there had to make things, like clothing and embroidery, in order to make a living. There would be a ready supply of the type of items that the Museum and Advisory Panel wished to collect and that they were 'not that much' different from the garments and textiles women had sewn and embroidered in East Africa prior to migration to Britain (Patel, personal communication, 2011). One might also speculate that the experience of migration was still very raw for many in Leicester's East African Asian community and it was too soon, politically and emotionally to confront traumatic memories head-on by engaging directly with the countries from which, less than two decades before, they had either chosen to leave in the face of increasingly discriminatory policies, as was the situation in Kenya and Tanzania, or had been forcibly expelled from, as in the case of Ugandan Asian refugees. The cultural heritage of the South Asian diaspora was, inevitably, disrupted as a consequence of 'Africanisation' policies and mass, enforced migration.

When these items were collected in Gujarat in the mid-1980s, one was just as likely to see young urban women wearing saris, *salwar kameez* and Western-style clothing (skirts, t-shirts, sometimes jeans) or, most likely a mix and match combination thereof (Tarlo 1996: 335). As in Leicester at that time, certain types of often heavily embroidered, 'glamorously ethnic' (Tarlo 1996: 335) clothing – for example, *chaniya choli* (a cropped blouse and long skirt combination) or *ghaghara* (a very full, gathered skirt with a drawstring waist) – were increasingly only worn on special occasions. It is these types of clothing that largely comprise the LAMS Gujarati textile collection.

A selection of these objects was displayed for the first and only time prior to *Suits and Saris*, in 1988 (25 June 1988–5 March 1989), in an exhibition entitled *Traditional Indian Arts of Gujarat* at New Walk Museum and Art Gallery, Leicester. After the exhibition closed, several of the items of clothing were occasionally used in community handling sessions and, in 2006, a small selection of the Gujarati textiles, mainly hand embroidered and block-printed fabrics from Kachchh, were put on permanent display in the new World Arts Gallery at New Walk Museum and Art Gallery.

Revisiting the collection

On revisiting the collection in preparation for *Suits and Saris*, it became clear that, on accession, the collection had been classified in a very particular way that followed museological conventions: each accession number is prefixed by a 'C' for costume. Tarlo advocates against using the term 'costume' as it 'analytically separate[s] clothes from the people who wear them' (Tarlo 1996: 1). In the development of *Suits and Saris* we consciously referred to the collection instead as 'clothing' or 'dress', as we do in this chapter, 'as reminders that the central theme … [was] the significance of clothes as people wear them, not [as Tarlo states] as they are arranged in museums and catalogues' (Tarlo 1996: 2). The collection is sub-classified by originating community – as if these had developed in isolation – and very much in accordance with established (older) ethnographic approaches, which, as Tarlo drawing on Miller asserts, orders cultures by 'the multifarious "types" of peoples that made up [in this case] the Indian population' (Tarlo 1996: 2–3). But this is also a system of classification that owes much to mid-twentieth century anthropology, with its emphasis on social structures and, in the case of India, on its caste system (Tarlo 1996: 3–4).

With respect to the Gujarati 'costume' collection, sensitivities associated with the caste system were taken into account by the use of certain descriptors which superficially obfuscated the caste of the originating community. Each item within the collection 'belongs' to one of four sub-groups, based on family name (e.g. the Patel costume collection, Patel wedding collection or Lohana costume collection), or the village from which it was collected (e.g. the Horka village collection). And yet, those in possession of appropriate cultural knowledge, would be able to identify caste/class from these names, as family names are indicative of a caste background. The Patel collections were collected in Dudhai and Bhavnagar and comprise items including a man's wedding outfit of smock, turban and baggy trousers, women's backless blouses and tie-dyed shawls; the Lohana costume collection, acquired from Khavda village, in Kachchh, featuring gathered, embroidered skirts and a bridal outfit; and the Horka village collection, which includes long backless blouses and printed shawls. We will return to the problematic nature of these classifications later in this section.

In the introductory text panel, the attention of visitors was drawn to the processes of collecting for museums. This provided the opportunity to critique the effects of museum practice on, for example, fixing identities in place and time through displays of cultural dress (cf. Tarlo 1996). We highlighted that the historical development of such a collection, the motivations for its creation and its use and changing meanings over time within exhibitionary contexts is a 'behind the scenes' aspect of museum work that visitors are not often made aware of. We cast light on 'the museum effect' (Kirshenblatt-Gimblett 1991: 410–413): how an object on entering a collection is classified (for example, clothes become 'costume') and ordered, and that these processes inadvertently divorce the object from its multiple cultural meanings and everyday uses (Barnes 2014: 209; Tarlo 1996). We introduced audiences to the implications of curatorial authority, that collections are selectively chosen from a whole and that the decision to accession

an object is often influenced by the preferences of the responsible curator, contemporary priorities (based on institutional collecting policies) and socially, politically and culturally contingent values ascribed to particular aspects and understandings of cultural heritage. We argued that selections of objects for exhibition (aside from practical considerations such as condition and conservation) are made in order to best present a particular narrative and that existing collections influence the ways in which museums 'speak' about individuals, groups of people and different cultural heritages. Particularly in the case of objects pertaining to non-Western, non-dominant heritages, the effects resulting from museum accession, may set them apart from their context and place in time, with the consequence that they may, erroneously perhaps, come to be presented as being representative of the originating culture (which itself may have been essentialised) (Lidchi 1997: 172). In so doing we wanted to encourage visitors to think about how, while 'it may seem that clothes show precisely who you are and where you are from … Identities and cultural traditions are constantly changing and adapting to new ideas and influences' (LAMS 2012a). The rationale was to show the outcome of providing alternatives for standard curatorial practice with regards to collecting new fashion items, as well as documenting, displaying and making accessible collections inherited from the past in such a way as to make them more relevant to people in super-diverse cities like Leicester. This approach sought to challenge the perception, deconstructed by the new museology of the last three decades but still widely held by the general public,[26] that museums and museum texts are neutral and objective bearers of knowledge.

We addressed head-on the problematic way in which the collection had been classified. While the museum had, in the past, chosen to mitigate the potential for emotive caste/class-based responses to the collection, by euphemistically describing the collection of items collected from a Harijan community – considered the lowest caste – by the name of their village, instead we explored the language used in museum documentation in the exhibition text:

> Horka village collection
> The Horka village collection is the only major section of the collection referred to by its place of origin, instead of a community, or caste, of people. This is interesting, because the objects from Horka village originated with the Dalit community. Although Dalit has today come to mean 'oppressed', in the past it was translated as 'untouchable'.
>
> Mahatma Gandhi preferred the term Harijan ('children of God') and this was how the museum referred to this community in the catalogue of the 1988 exhibition. The caste system can be a difficult and challenging aspect of Indian society to discuss. Perhaps this is why this group of objects were classified by the museum as 'Horka village', to avoid causing offence.

We also sought to contextually place the collection within the period of time it was acquired (the mid-1980s), challenging the de-historicising and de-contextualising effects of museum display mentioned above. For example, with respect to the Lohana collection, while subtly noting that these garments were acquired as 'representative' of their originating culture, they, and items like them, were not necessarily universally worn by women that would identify themselves or be identified as 'Lohana': 'At the time, these Lohana women often wore gathered, embroidered skirts, sometimes made from striped mashru fabric' (LAMS 2012c).

During the development of the exhibition, the curatorial team undertook a series of conversations with different individuals and groups from the East African Asian and South Asian communities in Leicester. We sought to explore the Gujarati textile collection with them, what it meant to them, and how the museum had and continues to classify, describe and use objects

from it. Some of these comments were put next to the clothes they commented about, such as the next two examples:

Q. How do you relate to this Gujarati textile collection?
A. These textiles do not say anything about me, but they might relate to people of an older generation. I researched the Amreli blouse for the museum as part of my extended project. Knowing more about these textiles did not really changed [*sic*] the way I relate to them. (Anisha Patel, 19, born in Leicester. Anisha researched two garments of the Gujarati textile collection as part of her course at Regent College.)

Q. What do you think about this Gujarati textile collection?
A. My grandparents were wearing these kind of clothes all their lives but I have only worn shoes like these, which I find still very trendy and fashionable. (Shailesh Dandiya, 38, moved from Gujarat in 2000.)

This aspect was further explored in the exhibition itself, with gallery text asking visitors to think about the collection, if and how they related to it. The responses varied greatly, as we had foreseen.[27] Some stressed the influence that the Kachchh style has on the clothes on sale in Asian clothes shops in Leicester today, or commented that although older generations were wearing these clothes, they did not wear them themselves. Others perceived that the influence was much greater, stressing that the Kachchh style of embroidery had very recently been in fashion in Mumbai (Bombay),[28] or stressed that these textiles are part of the younger generation's heritage and should be taught to them (often without specifying which heritage for whom exactly).[29] Some young people clearly stated that these clothes had nothing to do with them (see the above comment),[30] while others were intrigued by them without feeling a too strong connection.[31] Some were highly critical about the way the museum had been classifying this collection[32] and some brought suggestions how to improve it.[33] Others did feel they were part of their identity[34] and enjoyed the freedom to intermingle clothing traditions.[35]

It is clear that the way in which South Asian migrants and their offspring in Leicester relate to heritage, including to the memory of heritage, has had an important role in the way that younger generations relate to their multiple heritages, and in the way that heritage has been performed, displayed and collected in the city since at least the early 1980s. At the same time, these collections and their displays in museums do not do justice to the varied ways people with connections to Gujarat experience and relate to those objects as part of their heritage.

So how can museums collect and interpret objects in such a way that does not fix people's identities, nor allow others to perceive the identities of other people as fixed and mainly related to homeland? The way in which the museum had collected and classified the 'Gujarati collections', a common way among many museums in the UK and elsewhere, does influence how audiences think about their own, and the heritages of others. Collections such as those related to Gujarat when on display become 'representative' for much wider groups, in this case Gujarati or even South Asian, in the ways different audiences perceive them, but those to whom the heritage supposedly directly refers clearly experience, relate and, in the process of making connections, shape what they perceive as their heritage in much more varied and complex ways.

How does a museum collect without implicitly extrapolating the material culture gathered from a particular place and at a particular time to become representative for people with different connections to an entire region in the world? And how might a museum display objects allowing people to use material culture as part of identification processes, for themselves or for others, and

also highlight how these items might play a role as part of an amalgamation of items, memories, and stories within a transnational space in which place not necessarily is the most important part of experiencing and performing heritage? It is not just problematic that heritage and place are completely intertwined both in the literature and in museum practice, but the entire discourse about heritage and migration often homogenises and essentialises the notion of place. And in doing so it directs people in using a vocabulary to frame their experiences through place. Museums and their collection policies can make a difference by paying much more attention to the different migration routes of people and the multiple ways in which people relate to material culture as heritage. The *Suits and Saris* exhibition not only made it clear how extensively diverse any group of (multiple) migrants is, which influenced the collection and display strategies in the museum to some extent, but also how the position and experience of multiple migrants can play a pivotal role in the shaping of heritage, as is the case with the 'Japanese saris'.

Conclusion

Leicester is a super-diverse place with a long history of multiple migrants. It is an ideal place to examine the constructions of cultural and material heritage within transnational spaces and the ways museums and other heritage organisations might incorporate these insights in their collection policies and participatory approach to exhibition making.

The chapter has shown, through the example of the Japanese sari and African wax prints, the problematic notion of place and homeland in current heritage debates even when global or transnational heritage is discussed. This focus on the perceived homeland in the reproduction of culture of diaspora communities, and in particular in the case of multiple migrants is problematic as it actually distracts, we would argue, from an understanding of the concept of heritage in the making, unmaking and re-imagining of diaspora cultures.

The case of the Japanese sari helps to conceptualise heritage beyond geographical boundaries, even beyond a space of an imagined community; like the African wax prints, it helps to move, on different levels, to a proper transnational and global understanding of heritage. The making of globalised heritage is often only possible because of the global and multiple migrations of people and goods to different parts of the world and it is therefore of crucial importance to consider the migration routes of people, memories, goods and the ways people themselves actively articulate this whether in the ways they speak, perform or use what they consider to be their heritage. The global outlook of the Japanese textile production and the transnational South Asian communities, in and beyond India, were pivotal in the making of the Japanese sari as a part of South Asian twentieth century clothing culture (Barnes and Kraamer 2015: 188). Japan's role in an emerging fashion industry for a global diaspora created not only the conditions and context, but also made it, as a result, an active participant in the making of this heritage. Moreover, the name given to these saris, in common parlance among South Asian diaspora groups – 'Japanese saris' – acknowledges the clear multiple cultural and transnational aspects of this heritage, while at the same time their complete acceptance, at the core of what is part of their identity and more bluntly put, their wardrobe. The wardrobes of the many of the older women that we worked with in Leicester were over 80 per cent full of Japanese saris.[36]

Furthermore, the uncritical acceptance of using place as the key agent in the construction of heritage even proves problematic when considering the role of material culture in heritage constructions by people within the 'homeland' itself. The use of the Japanese sari and African wax cloth in India and West Africa shows how important it is to always look critically at the role of geographical place. These two examples also point out that transnational spaces in which formations of heritage take place are not something just of the recent past.

We give so much importance to re-thinking the role of place and conceptualising 'unplaced' heritage as it helps not only to augment our understanding of heritage-making itself, but it also suggests new ways of participatory working within museum and heritage contexts. In the collection of cultural products, the possible transnational processes involved need to be explored; 'not only the multiple dimensions and multiple inhabitants of the transnational space in which these processes take place ... but also the particular migration routes of key participants or those (previous) generations they identify with' (Barnes and Kraamer 2015: 188). We clearly believe that working with communities in exhibition and collection work is desirable, but if carried out uncritically it might not always help museums to grasp fully the complexities of heritage, including the complex fluid, generation-specific and memory-shaped migration histories. The selection of participants needs to be done in such a way that it not only allows for reflection on current concerns, but also that it incorporates a wide variety of voices as well as considering the importance of memory, place, homeland – even when not understood as such or not explicitly discussed – in identity-formations and heritage-making, before taking final decisions on what and where to collect, and how to display and interpret these collections.

Thus, conceptualising heritage as transnational and global helps to shift the focus away from a particular place – the homeland – and addresses issues surrounding the understanding of what makes and constitutes a diaspora community. Thinking of heritage as fundamentally transnational and global, beyond an academic exercise in deconstructing different elements that constitute a particular material heritage, but also including the ways in which people imagine, feel, understand and use their heritage, might further a more complete knowledge of the actual making of heritage in the process of (multiple) migration. It might be that it is – especially in this context of multiple migration and global transnationalism – the production of global heritage, although framed, used and conceptualised as specifically Indian culture, can develop, precisely as the concept of culture is much less understood in geographically bound ways.

Notes

1 After the arrival of Ugandan Asians in the early 1970s,

> subsequent events of note include the secondary migration of Somalis to the UK since 2000, and the migration seen over the last decade due in part to the accession of 10 countries, including Poland, Slovakia, Latvia and Lithuania, into the EU in 2004. Over this same period, there has also been inward migration of third country nationals, mainly from Africa, who have come to the UK either as students or as the result of government recruitment of professionals, such as nurses, to address labour shortages. Many of these people are originally from Zimbabwe, Nigeria and Ghana, with other people from the Philippines and southern India.
>
> *(Leicester City Council 2012: 4)*

2 The concept 'super-diversity' has, since 2007, taken on a life of its own with a wide usage of interpretations and usages, as Vertovec has himself examined (Vertovec 2014).
3 Malika Kraamer worked as lead curator on this complex conceptual and organisational project and Amy Jane Barnes as freelance curator, in collaboration with youth and community curators and contributors. The research that underpins this chapter would not have been possible without the invaluable contributions of all of these people, and in terms of research, we thank in particular, Anjani Ghelani, Jaina Mistry, Linda Amess, and Natalie Roberts.
4 We have begun to address this lack. A previous publication sets out our initial findings with regards to the design, manufacture and consumption of so-called 'Japanese saris' (see Barnes and Kraamer 2015).
5 This multiculturalist approach is not without its critics. See the recent BBC Radio 4 programme, *Multiculturalism: Newham v Leicester* (Sodha 2016).
6 Several recently published heritage readers give an overview of recent debates in heritage studies (e.g. Meskell 2015; Waterton and Watson 2015; Harrison 2012; and Graham and Howard 2008).
7 See, for instance, Cohen (1997); Safran (1998); and Raghuram (2008).

8 In this article, we also questioned the validity of the whole notion of 'Western dress' itself in the twenty-first century in addition to the deconstruction of dichotomies between costume on the one hand and fashion on the other, and between so-called traditional dress outside the Western world and Western styles (Barnes and Kraamer 2015).

9 We have benefitted from the presentation of Jill Ahrens at the African Studies Association UK 2014 at the University of Brighton in which she gave an overview of different terms and concepts used in discussions of transnationalism.

10 Barnes and Kraamer (2015) provide an in-depth discussion of the background to and manufacture of the 'Japanese sari'.

11 Interview with Saheli Women's Group, East-West Centre, Leicester, 2 March 2016 and interviews with Mrs. S. Shah, Leicester, 22 September 2015.

12 In Leicester, people bought the material from department stores in lengths of six or ten yards, depending the type of sari – a practice that continues today for different type of fabrics (Saheli Women's Group, personal communication 2016).

13 Interviews with Mr Gutka, Nairoi, Kenya, 18 March 2010; Priti Mattani, Leicester, 1 October 2010; Jyoti and Kishor Chauhan, Leicester, 3 March 2010; Mrs S. Shah, Leicester, 22 September 2015.

14 East African British Asian members of the Saheli Women's Group remember wearing Japanese saris in East Africa before migrating to Britain. However, those members who migrated directly from India only came across them after moving to Leicester (personal communication 2016).

15 The *pallu* is 'the end-piece of a tied sari, which was an especially important design feature when worn loose in front (Gujarati style)' (Barnes and Kraamer 2015: 176). Incidentally, the absent *pallu* was less a conscious design innovation and more the result of Japanese mills lacking the necessary technologies to print *pallu* designs (see Barnes and Kraamer 2015: 180).

16 For example, synthetic saris may have been produced as early as the inter-war years, in Japan and Korea (Barnes and Kraamer 2015: 175), and in India by the late 1960s (often using Japanese threads). But it was not until the late 1970s, that these could begin to compete with the quality fabrics produced by Japanese mills (Priti and Hemant Mattani, Leicester, personal communication, 4 March 2016; Barnes and Kraamer 2015: 176, 179; K. and J. Chauhan, personal communication 2010; Banerjee and Miller 2003: 196–198).

17 The '6.4.4' was the stamp mainly found on textiles imported from Japan to East Africa in the 1950s and 1960s (P. and H. Mattani, personal communication, 2016).

18 Telephone interview with Dipak Mistry, 12 January, 2016; Interview with Ashok Mistry, Leicester, 19 January 2016.

19 There is much debate on how these fabrics made a successful transfer to the West African market somewhere in the second half of the nineteenth century (Kraamer 2013: 160; Sylvanus 2007: 207; Picton 1995: 25).

20 We do not argue that the social place of Japanese saris and African wax cloth is the same; as African wax cloth is much more expensive and the highest perceived quality cloth is only available to elite groups, while the Japanese sari has been accessible to middle and lower income groups and was only popular for a short period in the 1970s. However, their production and use within a transnational space and the role of place have commonalities.

21 Interview with Beatrice Gakpa, Leicester, 28 February 2016.

22 Telephone interview with Julia Nicholson, 18 January, 2011.

23 As well as clothes and textiles, Nicholson collected printing tools, brass vessels and other objects for LAMS.

24 Interview with Tanman Patel, Leicester, 9 May 2011.

25 Interview with Nilima Devi, Leicester, 20 May 2011.

26 For example, in their 2013 analysis of public attitudes towards museums, the UK Museums Association concluded that museums are 'trusted to provide accurate and reliable information in a national conversation increasingly dominated by bias and vested interest' (Museum Association, n.d.). This statement implies that the modernist concept of the museum as the bearer of 'unassailable logic and authority' (Knell 2011: 4) persists strongly in the public imagination.

27 As part of the exhibition development, the exhibition team conducted several group and individual interviews with in total over 30 people of different ages, backgrounds and migration routes, on which these observations are based.

28 A member of the Shali group in Leicester (68 and living in Leicester in 2012, moved from Mumbai to Leicester in 2000) explained: 'All this kind of embroidery is in fashion now. It is popular now in Bombay.'

29 Nilima (born in Baroda, living in Leicester in 2012) said, for example: 'Parents should educate the younger generation about their cultural heritage. Museums have an important role to play in this.'

30 Kavika (29 in 2016, and living in Leicester) mentioned, for instance: 'I don't think that I have a personal connection to any traditional Indian clothing styles.'

31 Kaajal (19 in 2012, born in Leicester) commented: 'They would be great in my wardrobe. They would represent originality and uniqueness. I would certainly wear some of these items today.'

32 Jaina (born in Bradford, 27 and living in Leicester in 2012), for instance, articulated: 'I don't think the museum should continue to refer to it as "the Gujarat Collection", because it is misleading. Gujarat is a very large state and the collection is gathered from a specific area and particular communities. There are many Gujarati communities in Leicester and this collection is not diverse enough to represent them all.'

33 Sudha (born in Delhi, 49 and living in Leicester in 2012) suggested: 'The information on the museum collection database seems relevant. However new additions need to be added to show that the traditions keep going. It would bring the history into the collection.'

34 Vasu (born in Tavdi, Gujarat; 54 and living in Leicester in 2012) said, for instance: 'I come from Gujarat so it is very relevant. I like to incorporate these styles in my everyday clothes to brighten up my image and show my Indian roots.'

35 Saroj (54, born in Fiji, now living in Leicester) stated, for instance: 'I personally have been wearing these clothes and they remind me of my relatives in the family in India. They designs are coming back in fashion and people are eager to keep these traditions going.' Trusha (19 in 2012 and living in Leicester) commented: 'Being born in England but brought up in an Indian culture allows an interconnection and intermingling of clothing and traditions. This allows me – or my generation – to be represented by an Indo-Western dress sense.'

36 We explored this within another theme in the *Suits and Saris* exhibition called 'Wardrobe Stories'. Although outfits ranging from casual home-wear to special occasion wear were selected for display and only comprised a small number of Japanese saris, the total amount of saris that Tara Patel, the photos of whose wardrobe we were given permission to put partially on display, showed us and told about were predominantly Japanese saris.

Bibliography

Ahrens, J., M. Kelly and I. Van Liempt. 2014. Free movement? The onward migration of EU citizens born in Somalia, Iran, and Nigeria. *Population, Space and Place* 22(1), 84–98.

Anheimer, H.K and Y.R. Isar (eds). 2011. *Heritage, Memory and Identity*. The Culture and Globalisation Series 4. London: Sage Publications.

Anon. 2003. IIS co-sponsors conference on 'Literature and South Asian Communities of East Africa'. The Institute of Ismaili Studies (April 2003). www.iis.ac.uk/view_article.asp?ContentID=101578. Accessed 23 August 2013.

Appiah, K.A. 1992. *In My Father's House: Africa in the Philosophy of Culture*. New York: Oxford University Press.

Atkinson, D. 2007. Kitsch Geographies and the Everyday Spaces of Social Memory. In *Environment and Planning A: Economy and Space*. 39: 521-540.

Banerjee, M. and D. Miller. 2003. *The Sari*, Oxford and New York: Berg.

Barber, K. 1997. *Readings in African Popular Culture*. Bloomington: International African Institute in association with Indiana University Press.

Barnes, A.J. 2014. *Museum Representations of Maoist China: From Cultural Revolution to Commie Kitsch*. Farnham: Ashgate.

Barnes, A.J. and M. Kraamer. 2015. Japanese saris: dress, globalisation and multiple migrants. *Textile History* 46(2), 169–188.

Bhabha, H. 1994. *The Location of Culture*. London: Routledge.

Bhachu, P. 2004a, *Dangerous Designs: Asian Women Fashion the Diaspora Economics*. New York and London: Routledge.

Bhachu, P. 2004b. It's hip to be Asian: the local and global networks of Asian fashion entrepreneurs in London. In C. Dwyer, P. Jackson and P. Crang (eds) *Transnational Spaces*. Oxford and New York: Routledge, pp. 40–59.

Breward, C., R. Crill and P. Crang (eds). 2010. *British Asian Style: Fashion and Textiles/Past and Present*. London: V&A.

Brown, J.M. 2006. *Global South Asians: Introducing the Modern Diaspora*. Cambridge: Cambridge University Press.

Castles, S. 2002. Migration and community formation under conditions of globalisation. *The International Migration Review* 36(4): 1143–1168.

Chand, M. 2012. *House of the Sun*. London: Faber Finds.

Clifford, J. 1997. *Routes: Travel and Translation in the Late Twentieth Century*. Cambridge, MA: Harvard University Press.

Cohen, R. 1997. *Global Disaporas: An Introduction*. Taylor & Francis.

Collyer, M. 2007. In-between places: trans-Saharan transit migrants in Morocco and the fragmented journey to Europe. *Antipode* 39: 620–635.

Comaroff, J.L. and J. Comaroff. 1997. *Of Revelation and Revolution, Volume 2: The Dialectics of Modernity on a South African Frontier*. Chicago: University of Chicago Press.

Corsane, G. (ed.) 2005. *Heritage, Museums and Galleries: An Introductory Reader*. London: Routledge.

Daugbjerg, M. and T. Fibiger. 2011. Introduction: heritage gone global. Investigating the production and problematics of globalized pasts. *History and Anthropology*, 22(2): 135–147.

DeVoretz, D. 2001. Canadian immigration: economic winners and losers. In S. Diajic (ed.) *International Migration: Trends, Policies and Economic Impacts*. London: Routledge.

Divakaruni, C. Bannerjee. 1997. *Arranged Marriage*. London: Black Swan.

Dwyer, C. 2004. Tracing transnationalities through commodity culture: a case study of British–South Asian fashion. In C. Dwyer, P. Jackson and P. Crang (eds) *Transnational Spaces*. London: Routledge, 60–77.

Falzon, M.A. 2004. *Cosmopolitan Connections: The Sindhi Diaspora, 1860–2000*. Leiden: Koninklijke Brill NV.

Goodrum, A. 2005. *The National Fabric: Fashion, Britishness, Globalization*. Oxford and New York: Berg.

Graham, B., G. Ashworth and J. Tunbridge. 2000. *A Geography of Heritage: Power, Culture and Economy*. London: Arnold.

Graham, B.J. and P. Howard. 2008. *Ashgate Research Companion to Heritage and Identity*. Aldershot: Ashgate.

Grasmuck, S. and A.M. Hinze. 2016. Transnational heritage migrants in Istanbul: second-generation Turk-American and Turk-German 'Returnees' in their parents' homeland. *Journal of Ethnic and Migration Studies*. Published online 18 February 2016.

Hansen, K.T. 2004. The world in dress: anthropological perspectives on clothing, fashion, and culture. *Annual Review of Anthropology*, XXXII: 369–392.

Harijan, L. 1990. New Technology, Management Strategies and Shopfloor Workers: a study of textile and clothing industries in Leicester with special reference to the position of ethnic minorities. University of Leicester (unpublished thesis).

Harrison, R. 2012. *Heritage: Critical Approaches*. London: Routledge.

Hess, J.B. 2005. *Art and Architecture in Postcolonial Africa*. Jefferson, N.C.: McFarland & Co.

Jackson, P., P. Crang and C. Dwyer. 2004. Introduction: the spaces of transnationality. In Dwyer, Jackson and Crang (eds) *Transnational Spaces*. London: Routledge, pp. 1–23.

Jones, O. and J. Garde-Hansen. 2012. *Geography and memory: explorations in identity, place and becoming*. Palgrave Macmillan memory studies. London: Palgrave Macmillan.

Kirshenblatt-Gimblett, B. 1991. Objects of ethnography. In I. Karp and S. Levine (eds) *Exhibiting Cultures: The Poetics and Politics of Display*. Washington D.C.: Smithsonian Institution, pp. 386–443.

Knell, S. 2011. National museums and the national imagination. In S. Knell, P. Aronsson, A. Bugge Amundsen *et al.* (eds) *National Museums: New Studies from Around the World*. Abingdon: Routledge, pp. 3–28.

Kraamer, M. 2013. African wax and fancy prints. In Fogg, M. (ed.) *Fashion: The Whole Story*. London: Thames and Hudson, pp. 134–137.

Kreps, C.F. 2003. *Liberating Culture: Cross-cultural Perspectives on Museums, Curation and Heritage Preservation*. London: Routledge.

Labadi, S. and C. Long (eds). 2010. *Heritage and Globalisation*. London: Routledge.

Leicester Arts and Museum Service (LAMS). 2012a. Introductory text panel. *Suits and Saris*. 31 March–7 October 2012. Leicester: New Walk Museum and Art Gallery.

Leicester Arts and Museum Service (LAMS). 2012b. Text panel: 'Building a Collection'. *Suits and Saris*. 31 March–7 October 2012. Leicester: New Walk Museum and Art Gallery.

Leicester Arts and Museum Service (LAMS). 2012c. Text panel: 'Lohana Collection'. *Suits and Saris*. 31 March–7 October 2012. Leicester: New Walk Museum and Art Gallery.

Leicester City Council. 2012. *Diversity and migration* [online]. www.leicester.gov.uk/media/177367/2011-census-findings-diversity-and-migration.pdf. Accessed 9 March 2016.

Levitt, P. and B.N. Jaworsky. Transnational Migration Studies: Past Developments and Future Trends, In *Annual Review of Sociology*, 33: 129–156.

Lewis, R. (ed.) 2013. *Modest Fashion: Styling Bodies, Mediating Faith*. London and New York: I.B. Tauris.

Lidchi, H. 1997. The poetics and the politics of exhibiting other cultures. In S. Hall (ed.) *Representation: Cultural Representations and Signifying Practices*. London: Sage: 151–222.

Lowenthal, D. 1998. *The Heritage Crusade and the Spoils of History*. Cambridge; New York: Cambridge University Press.

Lumley, R. 2005. The debate on heritage reviewed. In G. Corsane (ed.) *Heritage, Museums and Galleries: An Introductory Reader*. London: Routledge: 15–25.

Marett, V. 1993. 'Resettlement of Ugandan Asians in Leicester', Journal of Refugee Studies, 6(3), 248–259.

Macdonald, S. 2013. *Memorylands: Heritage and Identity in Europe Today*. London: Routledge.

McLeod, M. 1999. Museums without collections: museum philosophy in West Africa. In: S. J. Knell. (ed.) *Museums and the Future of Collecting*. Aldershot: Ashgate: 22–29.

Mattausch, J. 2014. A chance diaspora: British Gujarati Hindus. In Oonk (ed.) *Global Indian Diasporas*. Amsterdam: Amsterdam University Press.

Mead, S.M. 1983. Indigenous models of museums in Oceania. *Museum: A Quarterly Review* 35(139): 98–101.

Meskell, L. (ed.). 2015. *Global Heritage: A Reader*. Chicester: Wiley Blackwell.

Meyer, B. 1999. *Translating the Devil: Religion and Modernity Among the Ewe in Ghana*. Trenton, NJ: Africa World Press.

MORI. 1993. *Asian Women Workers in the Hosiery, Knitwear and Clothing Industries*.

Mudimbe, V.Y. 1988. *The Invention of Africa: Gnosis, Philosophy, and the Order of Knowledge, African Systems of Thought*. Bloomington: Indiana University Press.

Museums Association. n.d., What the Public Thinks: Museums 2020 [online]. www.museumsassociation. org/campaigns/museums2020/11122012-what-the-public-thinks. Accessed 6 June 2015.

Nayyar, D. 2002. *Governing Globalisation: Issues and Insitutions*. Oxford: Oxford University Press.

Nicholson, J. 1988. *Traditional Indian Arts of Gujarat*. Leicester: Leicestershire Museums, Art Galleries and Records Service.

Niessen, S., A.M. Leshkowich and C. Jones (eds). 2003. *The Globalization of Asian Dress: Re-Orienting Fashion*. Oxford and New York: Berg.

Oonk, G. 2014. Global Indian diasporas: exploring trajectories of migration and theory. In G. Oonk (ed.) *Global Indian Diasporas*. Amsterdam: Amsterdam University Press.

Ossman, S. 2013. *Moving Matters. Paths of Serial Migration*. Stanford: Stanford University Press.

Paul, A.M. 2011. Stepwise international migration: a multistage migration pattern for the aspiring migrant. *American Journal of Sociology* 116: 1842–1886.

Paulicelli, E. and H. Clark (eds.). 2008. *The Fabric of Cultures: Fashion, Identity and Globalization*. Abingdon: Routledge.

Peckham, R.S. 2003. Introduction. The politics of heritage and public culture. In R.S. Peckham (ed.) *Rethinking Heritage: Cultures and Politics in Europe*. London; New York: I.B. Tauris: 1–13.

Picton, J. 1995. Technology, Tradition and Lurex: The Art of Textiles in Africa. In J. Picton (ed.) *The Art of African Textiles. Technology, Tradition and Lurex*. London: Barbican Art Gallery: 6–30.

Piot, C. 1999. *Remotely Global: Village Modernity in West Africa*. Chicago: University of Chicago Press.

Poros, M.V. 2011. *Modern Migrations: Gujarati Indian Networks in New York and London*. Stanford: Stanford University Press.

Portes, A. 1997. *Globalization from Below. The Rise of Transnational Communities*. Oxford: University of Oxford.

Pradhan, S. 2014. *Dancing with Shadows*. Bloomington, IN: Partridge India.

Pratt, M.L. 1992. *Imperial Eyes: Travel Writing and Transculturation*. London; New York: Routledge.

Rabine, L.W. 2002. *The Global Circulation of African Fashion*. Oxford and New York: Berg, 2002.

Raghuram, P. 2003. Fashioning the South Asian diaspora: production and consumption tales. In N. Puwar and P. Raghuram (eds), South Asian Women in the Diaspora, Oxford: Berg; 67–86.

Raghuram, P. 2008. Migrant Women in Male-Dominated Sectors of the Labour Market: A Research Agenda. In *Population, Space, and Place*, 14(1): 43-57.

Runnymede. 2012. *Leicester Migration Stories*. London: Runnymede.

Safran, W. 1998. Introduction: Nation, Ethnie, Region, and Religion as Markers of Identity. In William Safran (ed). Nationalism and Ethnoregional Identities in China. Portland: Frank Cass: 1–7.

Sodha, S. 2016. *Analysis – Multiculturalism: Newham v Leicester.* [Radio broadcast]. BBC Radio 4, 28 January. Available from www.bbc.co.uk/programmes/b071459c. Accessed 29 January 2016.

Sylvanus, N. 2007. The fabric of Africanity. Tracing the global threads of authenticity. *Anthropological Theory* 7(2): 201–216.

Tarlo, E. 1996. *Clothing Matters: Dress and Identity in India.* London: C. Hurst & Co.

Tarlo, E. 2010. *Visibly Muslim: Fashion, Politics, Faith.* Oxford and New York: Berg Publishers.

Van der Laarse, R. 2005. Erfgoed en de constructie van vroeger. In R. van der Laarse (ed.) Bezeten van vroeger. Erfgoed, identiteit en musealisering. Amsterdam: Het Spinhuis: 1–28. (In Dutch).

Vertovec, S. 2007. Super-diversity and its implications. *Ethnic and Racial Studies* 30(6): 1024–1054.

Vertovec, S. 2014. Reading 'Super-diversity'. In Anderson, B and Keith, M. (eds) Migration: A COMPAS Anthology. Oxford: COMPAS.

Waterton, E. and S. Watson (eds). 2015. *Palgrave Handbook of Contemporary Heritage Research.* London: Palgrave Macmillan.

Weine, S.M., Y. Hoffman, N. Ware, T. Tugenberg, L. Hakizimana, G. Dahnweigh, M. Currie, and M. Wagner. 2011. Secondary migration and relocation among African refugee families in the United States. *Fam Process* 50(1): 27–46.

Part V
Participatory heritage

Introduction to Part V

Katy Bunning

Over the last few decades, a new emphasis on publics within professional discourse has ushered in 'participatory' ways of working, in which heritage organisations seek to involve their audiences and stakeholders more deeply in the processes of creating, managing and interpreting 'their' heritage. Such work has taken various forms, and has generated a broad nomenclature: consultation; collaboration; co-curation; co-production; co-creation; community engagement; and 'sharing authority' to capture different approaches (Bunning *et al.* 2015; Duclos-Orsello 2013; Lynch 2011). Participatory practices have been developed in many parts of the world in alignment with broader cultural shifts, which have focused on issues of indigenous rights, social justice, and widening access to culture, education and the arts (Flinn and Sexton 2013; Giaccardi 2012).

Participatory ways of working and their impact on the heritage profession have been the subject of significant interest among scholars and practitioners since the mid-2000s, giving rise to a sense that participatory approaches are new. Yet, far from being a recent development, collaborative approaches have, rather, been newly *centralised* within practice and discourse. For some museums and community heritage organisations, a participatory approach has long formed the core ethos of everyday practice. Community-focused museums such as the Japanese American National Museum and the Smithsonian's Anacostia Community Museum have provided inspirational models of practice for building agency within communities in heritage work (James 2005; Kikumura-Yano, Hirabayashi and Hirabayashi 2005). More recently, the Science Museum in London, like other major museum institutions worldwide, has been exploring ways of embedding participatory approaches within their exhibitions and programming as part of a strategic priority towards public engagement (Boon, van der Vaart and Price 2014; Bunning *et al.* 2015). Despite the widespread appeal of involving communities in heritage processes and decision-making, and expectations among various funders to do so, there are still many heritage organisations that do not pursue or value such approaches, and many that struggle to involve their communities and publics in their work.

While there have been several sustained efforts to more fully comprehend the boundaries, tensions and novel aspects of participatory approaches and provide models of practice as a field of research (Watson 2007; Simon 2010; Lynch 2011; Golding and Modest 2013, Beinkowski 2014), participatory heritage practices remain under-researched and critical appraisals of

participatory practices are still not widely shared among organisations (Lynch 2011). When such practice is critically assessed and shared, the sector has benefitted from new insights not only into the processes of building deeper relationships with audiences and the benefits of community engagement but also into gaps, tensions and limitations of heritage programming and the narratives of the past they embody. At the centre of many debates, particularly within the museum sector, are issues of trust, professionalism, quality, and charges of tokenism (Fouseki 2010; Hollows 2013), and indeed the role of heritage organisations and professionals themselves within community relationships (Peers and Brown 2003; Iacovino 2010). There are also questions around the need for balance between audience-led practice and the leadership of organisations to generate change within society, particularly in contexts of social justice work (Sandell and Nightingale 2012). Meanwhile, increased availability and use of digital applications among publics and within organisations has opened up new ways of collaborating and co-producing (Adair, Filene and Koloski 2012; Giaccardi 2012). Nevertheless, digital forms of participatory practice can spark similar tensions among participants around knowledge, trust, expertise, genuineness, and impact (Simon 2010).

There remain deep gaps in both knowledge and theory relating to participatory approaches. Key publications tend to focus on particular cases, personal experiences of practitioners (rarely of non-professional 'participants'), or strategies and tools for engaging communities, while theoretical or conceptual frameworks for locating aspects of participatory practice such as engagement, dialogue, sharing expertise, the embedding of practices, the sustaining of community relationships, as well as the impact of participatory projects on visitors and broader non-participating publics, are in short supply. The chapters in this section offer a range of critical reflections on current shifts towards more participatory and dialogical approaches to museum and heritage work, in the context of museums and heritage projects, and offer a number of conceptual frameworks for locating this work within broader contexts.

The first chapter of this section, drawing on University College London's (UCL's) review of practice of collaborative research efforts between universities and community heritage organisations, offers a useful framework for understanding this complexity of emerging practice and research of participatory practice. Flinn and Sexton (2013, this volume) offer a summary of the broad turn to participatory approaches to history and heritage-making, including self-representation and shifts in institutional authority, and help to locate the particular agendas and drivers of such practices across different international contexts, including indigenous rights frameworks.

Written by an exhibition curator, Perkin (2010, this volume), seeks to draw out a number of tensions within community-driven heritage projects and identifies an alternative community-driven model for heritage in the context of Bendigo, Australia. Through this case study, Perkin discusses the role of key individuals within this work and reflects on the dangers of an 'institution-led' approach to community engagement.

Next in this section, Cimoli (2014, this volume) reflects on emerging practices in Italy, and in particular the role of migrants in the practices of various museums of migration. She refers to a 'debate zone' in which museum mediators and community members can come together to share and enrich knowledge of migration thus contributing towards the goals of the institution. Cimoli offers a review of practice in Italy, identifying different models and sites of community participation within and beyond the galleries, and juxtaposes the dialogical programming of some art and ethnography museums with the more curatorial-led approaches found within the migration museums she has studied.

The focus on dialogue with community participants towards a final 'product' is explored in a new paper for this volume by Iervolino, in which she discusses recent participatory approaches

in the making of trans-heritage at the Science Museum in London. Drawing on her experiences of collaborative projects around gender identity and the development of a permanent exhibit, Iervolino reflects on the role of participatory approaches in bringing new narratives to the fore of museum practice and the transformative potential this holds.

Kiddey and Schofield (2011, this volume) presents the initial findings of a socially engaged archaeology project in Bristol which focused on material culture and notions of place among people who have experienced homelessness. In this project, the community participants were seen as equal partners, rather than just 'informers', and the project helped to reveal much about the significance of local sites, the importance of history and heritage, and the culture of homeless people within the city. The experience of being involved, recognised and valued was seen to be transforming for some of those involved. This chapter shows the potential for impact at a personal level for participants, and mutual benefits of the projects for other participants, but also highlights the difficult ethical terrain of working with marginalised communities.

Morse, Macpherson and Robinson (2013, this volume) focus on the process and ethical implications of exhibition making and co-production through Tyne and Wear Museums' *Stories of the World* project between 2009 and 2012 in the North East of England. The authors tease out some of the challenges of dialogic practice and participatory approaches and questions the extent to which projects are pre-determined in significant ways in their early conception. This chapter offers reflections on where this ambitious participatory project may have been flawed and what role the museum might play as a facilitator of dialogue.

Onciul (2013, this volume) presents the notion of an 'engagement zone' to express the complex, physical and conceptual space of interaction and negotiation between museums and communities. She focuses on the context of Blackfoot First Nations communities and interpretive projects, and shows how the products of such engagement zones can be anything from indigenised curatorial practice to co-produced exhibitions. Onciul draws attention to radically different forms of participatory practice and how these depend on cultural contexts and the longevity of engagement beyond the confines of a particular project.

Within the heritage sector, participatory approaches have long been seen as the antidote to issues of exclusion, unequal access to cultural assets, and the production of top-down 'official' narratives of the past. The have also been pursued as ways of expanding the footfall and use of heritage resources, contributing to the sustainability of established heritage institutions and processes (Onciul 2013, this volume). Yet research is beginning to show that such approaches can often fail to benefit communities or substantively combat exclusion in the ways intended (Lynch 2011). While new models of practice are being developed, which help to recognise and more deeply acknowledge the notions of heritage and forms of expertise that are found within communities, there is still much more to be learned about how the professional heritage sector can effectively embed such approaches at their core.

Bibliography

Adair, B. Filene, B. and Koloski, L. (2012). *Letting Go? Sharing Historical Authority in a User Generated World*. London and New York: Routledge.

Beinkowski, P. (2014). *Communities and Museums as Active Partners: Emerging Learning from the Our Museum Initiative*. London: Paul Hamlyn Foundation. http://ourmuseum.org.uk/wp-content/uploads/Our-Museum-emerging-learning.pdf, accessed 25 February 2017.

Boon, T., van der Vaart, M. and Price, K. (2014). 'Oramics to electronica: investigating lay understandings of the history of technology through a participatory project', *Science Museum Group Journal*, 2, Autumn.

Bunning, K., Kavanagh, J., McSweeney, K. and Sandell, R. (2015). 'Embedding plurality: Exploring participatory practice in the development of a new permanent gallery', *Science Museum Group Journal*, Spring, http://dx.doi.org/10.15180/150305, accessed 28 February 2017.

Cimoli, A.C. (2014). 'From representation to participation: Inclusive practices, co-curating and the voice of the protagonists in some Italian migration museums', *International Journal of the Inclusive Museum*, 6: 111–121 (this volume).

Duclos-Orsello, E. (2013). 'Shared authority: The key to museum education as social change', *Journal of Museum Education*, 38 (2): 121–128.

Flinn, A. and Sexton, A. (2013). 'Research on community heritage: Moving from collaborative research to participatory and co-designed research practice', paper presented at CIRN Prato Community Informatics Conference, www.ccnr.infotech.monash.edu.au/assets/docs/prato2013_papers/flinn_secton.pdf, accessed 25 February 2017 (this volume).

Fouseki, K. (2010). '"Community voices, curatorial choices": community consultation for the 1807 exhibitions', *Museum and Society*, 8 (3): 180–192.

Giaccardi, E. (ed.) (2012). *Heritage and Social Media: Understanding Heritage in a Participatory Culture*. London and New York: Routledge.

Golding, V. and Modest, W. (eds) (2013). *Museums and Communities: Curators, Collections and Collaboration*. London, New Delhi, New York and Sydney: Bloomsbury.

Hollows, V. (2013). 'The performance of internal conflict and the art of activism', *Museum Management and Curatorship*, 28 (1): 35–53.

Iacovino, L. (2010). 'Rethinking archival, ethical and legal frameworks for records of indigenous Australian communities: A participant relationship model of rights and responsibilities', *Archival Science*, 10: 353–372.

James, P. (2005). 'Building a community-based identity at Anacostia Museum', in Corsane, G. (ed.), *Heritage, Museums and Galleries: An Introductory Reader*. London: Routledge, pp. 339–356.

Kiddey, R. and Schofield, J. (2011). 'Embrace the margins: Adventures in archaeology and homelessness', *Public Archaeology*, 10 (1), February, pp. 4–22 (this volume).

Kikumura-Yano, A., Hirabayashi, L.R. and Hirabayashi, J.A. (2005). *Common Ground: The Japanese American National Museum and the Culture of Collaborations*. Boulder: University Press of Colorado.

Lynch, B. (2011). *Whose Cake is it Anyway? A Collaborative Investigation into Engagement and Participation in 12 Museums and Galleries in the UK*, Summary Report (Paul Hamlyn Foundation).

Morse, N., Macpherson, M. and Robinson, S. (2013). 'Developing dialogue in co-produced exhibitions: Between rhetoric, intentions and realities', *Museum Management and Curatorship*, 28 (1): 91–106 (this volume).

Onciul, B. (2013). 'Community engagement, curatorial practice and museum ethos in Alberta, Canada', in Golding V, Modest W (eds) *Museums and Communities: Curators, Collections and Collaboration*. London: Berg Publishers (this volume).

Peers, L. and Brown, A. (2003). *Museums and Source Communities: A Routledge Reader*. London and New York: Routledge.

Perkin, C. (2010). 'Beyond the rhetoric: Negotiating the politics and realising the potential of community-driven heritage engagement', *International Journal of Heritage Studies*, 16 (1–2): 107–122 (this volume).

Sandell, R. and Nightingale, E. (eds) (2012). *Museums, Equality and Social Justice*. London and New York: Routledge.

Simon, N. (2010). *The Participatory Museum*, Museum 2.0, www.participatorymuseum.org/, accessed 25 February 2017.

Watson, S. (ed.) (2007). *Museums and their Communities*. London and New York: Routledge.

42
Research on community heritage
Moving from collaborative research to participatory and co-designed research practice

Andrew Flinn and Anna Sexton

Introduction: community-based heritage practice

This paper arises out of our shared interest in collaborative, participatory and community-based research practice and the current fashion internationally for the promotion of collaborative and participatory practices within heritage thinking and practice, including public history, community archaeology and community-based archival activities as well as the specific stress in UK academic research with engagement, impact, participative approaches, co-creation, co-development and co-production of knowledge and of community-led and community-based activities. We will do this by looking at some of literature and context in which this practice takes place as well as drawing on our own experiences seeking to work in this fashion (successfully and unsuccessfully) as heritage practitioners, researchers and academics. Whilst acknowledging the many different (and often contradictory) bases for these practices, we wish for the purposes of this paper to foreground the approaches to community engagement advocated by universities and heritage organisations alongside the autonomous, transformatory and counter-hegemonic motivations of some community-based activists. We will examine whether the current interest in public engagement, impact and participation in the universities and the cultural heritage sector in the UK has really resulted in the promotion of more collaborative and equitable research relations with those outside those institutions. To do so we will reflect on our experiences as researchers, archivists, and collaborators with a specific focus on the multi-disciplinary Arts and Humanities Research Council (AHRC) funded heritage teams at UCL (Dig Where We Stand (2012) and Continuing to Dig (2013)) which sought to develop collaborative relationships with various community heritage projects all supported by a Heritage Lottery Fund (HLF) stream of funding called 'All Our Stories'. This was not a process without problems and challenges, but nonetheless there have been positive results and interesting lessons for anyone involved in public history, community-based archives and participatory heritage practice in general who is seeking to develop sustainable, equitable and even transformative relations between heritage researchers inside and outside institutional and mainstream frameworks.

Archival context for collaborative/participatory practice

As writers from other fields have commented 'participation' is itself 'a warmly persuasive word' which seems 'never to be used unfavourably' (Hildyard et al., 2001: 58). This is generally applicable to our own use of the term in the heritage sector where there is an implicit general consensus within our literature that participation is a positive attribute, something to be aspired to and encouraged. Despite this positive framing, it remains difficult to firmly articulate exactly what being 'participatory' actually means. Writers from other fields openly acknowledge that being 'participatory' is an 'infinitely malleable concept that can be used to describe almost anything involving people' (Cornwall, 2008: 69).

Despite the slippery nature of the concept it is possible to draw out distinctions around the use of the term within the archival and heritage field. Therefore, we will briefly outline three different ways in which we see the term 'participatory' being framed when the lens is narrowed to a focus on academic and professional discourse. These three frames are not exhaustive and by that we mean there are possibly other ways in which archivists and heritage workers frame being 'participatory', they are also *by no means mutually exclusive*. The three frames presented here merge in and out of each other and can even be found overlapping. Nevertheless, each has a distinct emphasis through which to create the boundaries around the concept.

The first way in which archivists have set about defining what being 'participatory' is has been to examine it from a relational perspective, framing a 'participatory approach' in terms of a renegotiation of roles. In this context a 'participatory approach' is seen as one which changes the traditional boundary between the 'professional archivist' and 'other stakeholders'. In this framing being 'participatory' is about allowing 'others' to move into spaces that have been traditionally seen as the responsibility of the professional (Theimer, 2013). In framing 'being participatory' primarily around the relationship between 'professional' and 'other' there is the hope of a 'democratization' that will dissolve the professional distinction. 'Shared authority' becomes one of the driving aspirations; a shared authority *between* 'professional' and 'other'.

The second frame focuses on the nature of the content and products that the participatory approach can generate. Here, the participatory approach is tied into a commitment to use participation as a *creative process* to reveal and explore multiple pathways, understandings and contextualities. Here participatory approaches are foregrounded as processes that enable 'multiplicity' and 'diversity' to flourish. This ties in neatly with constructivist theories on knowledge generation and production which champion a non-deterministic approach; seeking to understand and make explicit the subjective meanings that individuals, communities and societies place on their experiences with an understanding that these meanings are varied, multiple and complex. Here, the participatory archive becomes the process and the space in which a constructivist archive can shift and evolve.

The third way of framing the 'participatory' focuses in on the *transformatory* potential of the approach. It is different to the other two ways of framing the 'participatory' because it begins with defining an injustice or social problem that 'participation' is specifically designed to address and change and as such has the de-stabilization of existing power dynamics as its core and explicit central aim. This framing of the 'participatory archive' is illustrated in Shilton and Srinivasan's exploration of 'Participatory Appraisal and Arrangement for Multicultural Archival Collections' (2007) when the uneven balance of power and control between mainstream and marginalized is the injustice in which the 'participatory approach' locates itself and which it seeks to transform. Similarly, participatory models specifically rooted in challenging injustice are being articulated out of work to address concerns around archival issues and indigenous human rights in the United States, Canada, New Zealand and Australia where there is a recognition that

Western archival and legal frameworks that assert who has the ability to control, disclose, access and use these records restrict the self determination and freedom of the Indigenous communities that these records are about. It is in direct recognition and response to these issues, that an advocacy position has been articulated by McKemmish et al. (2010; 2011) to establish an alternative approach to negotiating rights. This is articulated as a participant relationship model which acknowledges all parties to a transaction as immediate parties with negotiated rights and responsibilities (Iacovino, 2010). Acceptance and use of such a model represents a landmark transformation in archival frameworks of control.

This rooting of a 'participatory' approach by some archivists into a specified injustice with the intention that the approach will transform the status quo meshes with much discussion within other fields and other discourses where research is undertaken within a framework of social justice. Many parallels can be drawn between emerging praxis in an archival context and work undertaken using methodologies such as Participatory Action Research (Whyte, 1991), Participatory Community Research (Denison and Stillman, 2012), Community-Based Participatory Research (O'Toole et al., 2003) Anti-Oppressive Practice (Moosa-Mitha, 2005), and the many forms of action research that are rooted or influenced by critical and emancipatory theories (Strega, 2005).

Collaborative/participatory practice and history making

In the practice of history-making, heritage and archiving, radical participatory approaches which embrace the transformational power of representing oneself or community, of assuming the authority for your own histories or the histories of your community have a long and influential lineage, often making the same connections between the radical participative approaches discussed above and social movements rooted in civil rights and social justice perspectives. Many of the activities are driven by a shared recognition that community-based knowledge-production, including history-making, is socially-constituted, invariably contestatory and a valuable process and resource which aims to transform not only the lives and understanding of those who engage in the process but also may contribute to the transformation of the political, social, economic and cultural realities in which they find themselves. The emphasis here is on a 'public history' which stresses the 'making' and the engagement with the process of meaning making as opposed to a passive consumption of official, professionally mediated history and heritage (Kean and Martin 2013).

Community-based archival, archaeological and historical research activities whether they reflect class, national, gender, regional, ethnic, faith or other identities or a combination of such, invariably seek to unsettle established and dominant heritage narratives by asserting the community's authority to represent itself (Hall 2001; 2005). Whether it be the Jewish Historical Societies of the late nineteenth and early twentieth centuries in the US and the UK seeking to use communal history to deflect anti-semitism; the archives relating histories of those of African background as tools for supporting education, positive identifications and self-confidence; labour and working-class movement museums offering narratives of past struggle to inform and mobilise around contemporary campaigns for social, economic and political justice; women's, gay and lesbian archives and resource centres offering safe spaces for the articulation of emotional responses to frequently traumatic individual and community histories; all place understanding and engaging with the past firmly in the collective present whilst looking to transform future realities. Research into Palestinian archive and heritage 'fever' in Gaza, the West Bank and the refugee camps encapsulates this simultaneous look to the past (the exiled home), the present reality (disenfranchised exile) and future aspirations (not only return (to the past) but also a transformed future society) (Butler 2010; Doumani 2009).

The acknowledgement of the value of the meaning-making of the past and the socially-constructed nature of that 'work ... of a thousand different hands' (Samuel, 1994) has led to many attempts by professional heritage workers and academics, often motivated by political and social justice sympathies to support, participate and collaborate in these endeavours. In the UK, radical and democratic History Workshop approaches, history from below movements, the sharing of authority in oral history and the community archive and archaeology movements have all combined to seek to dissolve the boundaries between the 'professional' and others engaged in history-making by collaborating, facilitating and sharing expertise and skills (Kean and Martin 2013, xxiii–xxv).

A famous, influential and, for us inspirational framework for this collaborative approach and facilitation was provided by the Swedish writer Sven Lindqvist. *Gräv där du står* (*Dig Where You Stand*, 1978) and an English article of the same title in Oral History (1979) made the case for the distorted and biased nature of industrial and business history and argued that instead 'factory history could and should be written from a fresh point of view, by workers investigating their own workplaces'. Lindqvist wrote that history was dangerous and important 'because the results of history are still with us' and while it was crucial that workers (and others) should carry out their own research, it was essential for someone to facilitate that processes by providing guidance on the techniques and methods of historical research. He thus produced Dig Where You Stand, '... a handbook which would help others, especially workers to write these factory histories in their own neighbourhoods and their own places of work' and toured Sweden (and later the UK) addressing factory groups and Workers' Educational Association meetings on the workers doing factory community-based research. The advantage of the skill sharing and facilitating approach advocated and practised by Lindqvist and Samuel (Kean and Martin 2013: xxiv) was that the subject matter of the research and the control and ownership of the research remained with workers (in this case), that is, it remained a participatory approach that was closer to a community-led model than it was to a more collaborative, partnership model of co-development and co-production advanced elsewhere by History Workshop and regional (labour) history societies where activists from inside and outside the academy sought to work together on historical research and publication.

Relationships between community historians, and academics and professionals to produce community-based heritage research and community archaeology were relatively common in the UK in the 1980s but declined in the early 1990s as academics and community-based researchers drifted apart. The oral historian Alistair Thomson (2008) has outlined the reasons for the growing estrangement of academics from community history and community oral history in terms of an increasingly specialised and academy-focussed research culture in the universities, the decline of adult and continuing education departments within higher education institutions, and a growing divergence of practices which were characterised as 'overly theoretical' or 'popular' and 'uncritical' respectively which contributed to community and academic practitioners moving in different directions.

The 2000s however have seen a renewed interest in community-based activities and an increased willingness to explore partnership and collaboration, including exploring the possibilities of co-development and co-production in ways that seek to empower rather than falling into previously identified traps of tokenism and exploitation (Arnstein 1969). Despite welcoming these developments, we would also wish to guard against complacency and ignoring practices which in fact reinforce 'abiding and inequitable imbalances between professionals and communities in relation to the control of resources and narratives' (Watson and Waterton 2010: 2).

The facilitating model advocated by Lindqvist has important benefits, not least in leaving the ownership of the project with community, but it did (does) tend to reinforce top-down notions

of where expertise lies between the academic or heritage professionals and those they are working with and can result in financial and physical resources remaining in those institutions which are deemed to be the centres of expertise. The provision of such skills may not only facilitate history-making but may also give the community access to the tools to continue to make meaning of the past. However on the other hand, a more bottom-up, collaborative approach aiming at the co-development and co-production of research might be 'more complex and challenging' to establish and to implement but the results might also have 'greater success and sustainability' in the longer term (Perkin 2010: 120).

UK funding context for collaborative/participatory research

Funding is another critical factor for understanding the context in which these community-based participatory heritage research collaborations happen. In some contexts those engaged in community-based heritage research or archival activity may be doing so without recourse to external funding (relying on individual or community resources owing to the small-scale, grass-roots nature of the activity or perhaps out of an explicit decision to remain autonomous and self-reliant and avoid the contradictory aims, restrictions and strings that might be attached to external funding). However in the UK much of this community-based heritage activity and participatory academic/community collaborations has been facilitated by public funding either directly from government or from arm's length bodies such as the Manpower Services Commission (MSC), the Heritage Lottery Fund (HLF) and academic research councils such as the Arts and Humanities Research Council (AHRC). All these funding bodies have their own aims and objectives and whilst much of the recent community-based history-making would not have happened without their funding, it does raise questions regarding the coincidence between the aims of community-based researchers (particularly radically minded or identity-focussed activists) and the funding body. MSC's community focussed funding in the 1970s, 1980s and early 1990s supported a huge amount of community heritage, community archaeology and oral history work but the funding resulted in tensions and pressures over the priority of training over research, the aims of more politically engaged projects, and the scale of institutional resources needed (Thomson, 2008: 102, Moshenska and Dhanjal, 2012: 2). HLF and latterly AHRC funding has, along with developments in technology and social media, been absolutely central to the revival of participatory community-based archive and history practice, a second-wave of community archaeology in the late 1990s and 2000s and the beginnings of the re-engagement of university-based researchers and heritage professionals with this community-based heritage activity (Isherwood 2012: 7–8). Certainly very little of the activities that we as researchers have been involved in has happened without support from these external funders. The consequences of the reliance on these funding streams for participatory practice and for collaboration and co-production of history-making is one of the issues which underpins the prospects for future growth of this kind of activity.

Of particular significance in this regard is the central focus in government driven funding and research on the problematic notion of community. A notoriously slippery and ill-defined term with dangerous implications for being a language of othering and marginalisation, 'community', community cohesion, community well-being has been at the centre of government (local and central) rhetoric and policy for much of the last 15 to 20 years in the UK (Alleyne 2002, Crooke 2007, Waterton and Smith, 2010). The HLF's focus on the benefits that engaging and participating in heritage activities might bring to communities has been firmly in line with these broader concerns, and has ensured that community heritage and community archives have been given a prominent role in delivering the social impacts of participatory heritage

practices. The funding of research in UK universities has addressed similar priorities in recent years.

This renewed interest in participatory approaches to knowledge creation and community-based participatory research has been accompanied by public policy and research council focus on impact, engagement and the notion of community as an important (and largely beneficial) construct. This has led to a number of funding streams and research opportunities which encourage collaboration between academic departments/institutions and individuals and groups outside the academy. This has included sponsorship of community-based participatory research for community heritage.

Since 2010 the UK Research Councils (RCUK) have been funding a large cross-council multidisciplinary programme entitled Connected Communities 'designed to help us understand the changing nature of communities in their historical and cultural contexts and the role of communities in sustaining and enhancing our quality of life'. Connected Communities funded research:

> …seeks not only to connect research on communities, but to connect communities with research, bring together community-engaged research across a number of core themes, including community health and wellbeing, community creativity, prosperity and regeneration, community values and participation, sustainable community environments, places and spaces, and community cultures, diversity, cohesion, exclusion and conflict.

Connected Communities research not only has communities as its focus but also stresses the engagement of the community in all stages of the research process as a key feature. The programme seeks to connect research expertise, so that Connected Communities is not (or not just) research on communities, but research for and with communities. Of particular relevance here is a particular funding strand, led by the AHRC which is entitled Research for Community Heritage ('research with communities, not on communities') which between 2011 and 2013 funded a number of multidisciplinary heritage research teams including at UCL. This strand, in which both authors were engaged in 2012 and 2013 sought by:

> Working closely with the Heritage Lottery Fund … to catalyse and develop sustainable links between expertise in research organisations in the area of community histories and heritage and relevant community groups. It is expected that this will lead to the development of innovative collaborative or co-produced community heritage research projects led by community groups.

Some early-stage evaluations of this initiative, the partnerships and collaborations it stimulated and in particular the extent to which the programme successfully enabled the 'innovative collaborative or co-produced community heritage research' it aimed for will be the major focus of the rest of this paper.

Dig Where We Stand[1]

The UCL Dig Where We Stand (DWWS): Developing and Sustaining Community Heritage (and Continuing to Dig: supporting and sustaining innovative community heritage projects in London and the South East) project (2011–2013) was established as part of the AHRC's Connected Communities Research for Community Heritage programme. DWWS was one of a number of multidisciplinary teams funded by the AHRC in universities across the UK to work

with and support the community heritage research activities of groups funded by the AHRC's partner in the scheme, the HLF. In a specially designed stream of funding ('All Our Stories' grants worth £3000-£10,000), the HLF funded some 500 community-based groups to conduct heritage research. DWWS was comprised of UCL-based researchers from archaeology, archives, history, oral history, cultural heritage, digital humanities, public geography, film studies and museum studies, united by an interest in community-based heritage and in engaging our disciplines and our research with people outside the university. As previously noted one of the stated objectives of the Research for Community Heritage strand was the development of sustainable partnerships between heritage researchers inside and outside the university, and ultimately 'innovative collaborative or co-produced community heritage research projects led by community groups'. Taking our cue from Sven Lindqvist and Dig Where You Stand, DWWS sought to work with groups to enable them to develop and implement their research ideas, offering training in particular research skills where necessary, and encouraging a more holistic approach to community-based heritage research by bringing together the different elements (eg archaeology, archive research, oral history and digital technology). Lindqvist's work and slogan was inspirational and appropriate for us not only because it linked the use of archaeology and other historical methods to understand the history of where communities stood but also because it emphasised the significance of history, the importance of people participating in the telling of their own histories, and the fact that the tools used by the academic historian required for rigorous community or factory based historical research could be made available to all via handbooks, workshops and as web resources.

Over the two years (2012–2013) we worked with a number of groups prior to the submission of their funding ideas to the HLF, held one to one surgeries and delivered workshops on heritage research techniques with grant holders and then worked in a more sustained fashion with ten to fifteen groups on the delivery of their projects. The overall scheme (the partnership between the two funders the HLF and AHRC) had its problems and frustrations as we will discuss later in this paper but it was still overwhelmingly an exciting and constantly challenging experience for all those involved. For various reasons (to be explored later) we may have been more often offering access to skills and expertise rather than truly engaging in the co-development of new and innovative community-based heritage research, but in some cases (such as with Mental Fight Club) that process did begin and we have been able to develop our relationships with some of the groups which if sustained further may lead to new and more innovative community heritage research. In any event many of the groups were able to use the techniques, equipment and good practice guidance that we were able to offer to produce heritage research and final products considerably enhanced from what they had originally intended. To give one example, one project (Hoxton Hall) declared that they had 'greatly benefited' from the guidance and conversations with us on oral history techniques and particularly on the ethics of recording and display, and this had resulted in 'a project that is of real relevance to the community of Shoreditch and our organisation' and that this learning was now embedded in the organisation and was contributing to their other large heritage projects.

Instigating participatory practices – an evaluation and a framework

In 'Interrupting Positions' (2005), Herising develops a concept of 'thresholds' to critically explore and open up discussion around the stances that academic researchers take when working with and in marginal communities. Herising's concepts of 'positioning' in relation to 'thresholds' and the building of 'passageways' through which collaborative research can traverse are useful in articulating some of the substantive questions facing the DWWS team in considering

how to develop collaborative relationships between ourselves and the communities we were seeking to work with. Within the overarching question of what we mean when we say we are aspiring to 'co-production' with our communities there are a multiplicity of other questions relating to position, space and boundaries: Is there a chasm to negotiate between ourselves as academic researchers, the gatekeepers in the community projects we were working with, and the wider community that each project engages with or represents? What are the challenges of negotiating the spaces between these relational thresholds? What are the frictions and dissonances within and between these spaces? What aspects of our positioning need to alter to enable us to traverse with our partners? What aspects of our beliefs, values, identities, and knowledges do we need to disinherit, disavow, decentre, disrupt, claim, reinsert or centre in order to work with our various communities (Herising, 2005, p. 128)? What other relational thresholds impinge or have an influence on how we traverse? Are we as a team of cross-disciplinary academics in a cohesive relational space or are there chasms to traverse between us too and to what extent can this question also be asked of the gatekeepers and their wider communities?

Reflecting on these questions should of course be an iteratively embedded part of the research process itself. In keeping with Herising (2005: 128), in exploring thresholds and passageways it is not to seek an arrival at a fixed and certain ground but rather ways of dwelling within "the realm of questioning, experiment and adventure" (Heilbrun, 1999: 98). However, we can perhaps begin to suggest a narrative of the reflexive journey we are on by exploring our initial (as the academic partner's) stance on 'co-production'. How has our idealised view on how we will traverse with our community partners been shaped and then challenged? What 'best-practice' assumptions did we initially bringing with us? First and foremost we aspired to develop ways of working that can be seen as community and not academy led. This stance is in recognition of the broader socio-historical framework in which we are working in. The imbalances of power that have existed (and still exist) between institutionally led and/or academic heritage production on the one hand; and grass-roots community led heritage production on the other sets the tone for wanting to establish the community itself as the core around which we work. This is in response to the fact that institutional and academy led versions of heritage are still ingrained as the accepted meta-narratives for people, communities, societies, and nations while community produced versions still struggle for broader recognition.

Reflecting on the balance of control running through the positioning of stakeholders in a partnership and the way relationships are developed and infrastructures are maintained is vital to understanding who ultimately pushes and pulls in the co-production of heritage. In relation to DWWS, our stance has been to articulate an over-arching recognition of the value inherent in the community owning their projects and controlling the production of their heritage. In doing this there is perhaps an overwhelming desire to avoid enacting the role of "the appropriator", particularly for those of us who can reflect back on ways of working where we have been blinkered to our own complicity in systems of domination and subordination and have missed the opportunity to re-draw the power relations between 'researcher' and 'researched' (Strega, 2005: 229). In seeking to avoid appropriation, we are articulating an affinity with the tenets of many published typologies on Participatory Action Research which, while differing in emphasis and perspective, generally echo the idealisation of 'citizen control' in Arnstein's 'ladder of participation' (1969). But what ramifications has this overarching stance had on how we further articulate the relational positioning between us, as members of the academy and supporters of community produced heritage on the one hand, and our community partners on the other? In our commitment to see the community as the primary controllers, do we see ourselves as "facilitators" and what can this mean when we know we can never facilitate neutrally, passively or objectively? Do we draw on a "consultant" "client" metaphor where we as academics, are cast

as the specialists while the community partners are cast as the recipients of our expertise? Do we draw on different models depending on situation, need and circumstance? Where possible, should we see our overarching aim as being one that seeks to move away from one-way exchanges of knowledge and skills towards two-way processes which have the potential to invoke co-authority, co-control, and co-production, at least over some activities within the overall community owned project? Critically, if co-production is our aspiration, how can we open up as "much space for discovery, intellectual adventure, and close exploration [as possible] … without the mandate of conquest"? (Morrison, 1992, p. 3 in Herising, 2005: 132)

A significant challenge to our aspiration towards 'co-production' and the 'with' not 'on' philosophy we wanted to adopt, came from the size and scope of the 'All our Stories' funding stream which limited grants to between £3000 and £10000 pounds with an expectation that the project would be operational for around 6 months. The funding was aimed at encouraging community participants who were new to exploring and producing community history, as well as supporting more experienced community participants to explore their shared history from new perspectives. In both cases, the emphasis in the grant documentation was more towards process rather than product, with the development of learning outcomes for participants being stressed within the grant criteria to a much greater extent than the development of sustainable heritage resources. Crucially for the DWWS teams, the comparatively small nature of the 'All our Stories' grants meant that there was not the necessary scope to develop an involved research process with co-production between DWWS, the grant holder, and the wider communities that the grant holder sought to involve and represent. Infra-structures for co-production need to be flexible and fluid to build in the space for project goals and boundaries to shift and change, such infra-structures are simply too time and resource intensive to be possible within the scope of the 'All our Stories' funding.

This barrier to co-production was further compounded by mis-matched timelines between when funding became available to DWWS through the AHRC and when 'All our Stories' partners received money from the HLF. The lack of dovetailing between the funding bodies meant that we were meeting some of the projects after they had submitted and been awarded their grants. The benefit of this was that the projects were therefore very much community-led from the outset, with ideas and ways of working already established by the community representatives, but this also meant that opportunities to develop innovative co-produced research as opposed to skills exchange were limited.

There was also an issue with the numbers of groups that actually received 'All our Stories' funding and our capacity to support them effectively. Due to the number of applications the HLF received from community groups there was a decision to increase funding from £1 million to £4.5 million to fund an extra 400 projects. This meant that there were now over 75 'All our Stories' funded projects in London alone which might want to collaborate with us. We ended up working in a sustained capacity with 10 projects, but even this number of projects constrained the depth of interaction that our team could give to each one. For example, as a researcher working one day a week on the project, Anna had sustained input into three projects and briefer bespoke input into one further project over her six month contract and we found that developing a single point of contact was important for the groups in establishing trust and a personal relationship. However, to move to genuine 'co-production', Anna felt she could have done this better if she could have focused on one group. Therefore, there was an issue of breadth at the expense of depth, even though the number of groups we worked with was small compared to the numbers of potential collaborators.

The result of timings and parameters around the projects meant that the Dig team ended up providing a lot of workshops training and skills sessions (like Lindquist's handbook) rather than

co-developing new research. How far we managed to move away from the academics as 'experts' model will become clearer though our more in-depth evaluation but initial feedback speaks of our input both in terms such as 'specialist competence', advisors on 'best practice' and providers of 'expertise' and 'guidance' as well as terms that suggest that there was on occasion a more reflexive, two-way exchange involved with the creation of 'meaningful connections'.

Our provision of 'expert-led' training not only falls into a model that we were seeking to avoid but actually risked causing real upset. In offering 'free' (actually subsidised by the AHRC) training in oral history for instance we diverted potential income streams from established community providers. Here is how one established community heritage group manager described the situation:

> So for example, UCL is now doing some of the work that we could sometimes generate income from, in terms of supporting other grass roots initiatives. So for example, I had a community group come to me recently looking for advice which took my time, and we offered training that we would have been able to charge about £250 for, but they got back to me and said they don't need our training because UCL is helping. There is a danger that UCL is taking a valuable funding stream away from us. Which is a shame. It's something I want to talk to Andrew about.

The danger is of course that the relationship between universities and community heritage groups is already unbalanced and can become more problematic. The community heritage group leader continues:

> We are working with another university at the moment, and they are adamant that they are going to put in a bid on our behalf even though the project was our idea. Academics work in a different way, I want to see more discussion around how academics work with the community heritage sector. I think that discussion is needed.

Clearly this is right, we do as academics seeking to engage in this territory need to discuss and negotiate with those already well-established and perhaps dependent on this territory to support their own history-making activities. In reality we have never had any long-term interest in setting up UCL as an alternative skills provider, we are more interested in establishing longer-term relationships in which we can move on from skills exchange into co-development and co-production of new research but this response reminds us even more forcibly of the need to take account of all the impacts of our interventions.

Continuing with our reflections on the tensions and challenges around moving from one-way 'skill exchange' towards 'co-production', we have also found that the relationship between the community project and its wider community was significant. Some of the projects we worked with were being run by existing and established community groups who had the production of community heritage already firmly embedded in their working practices; some were well established community groups but were new to community heritage or at least seeking to undertake a heritage activity that was new to them; others were groups who were seeking to engage or establish new relationships within their community and were new to community heritage. The complexity of starting positions means that a 'one size fits all' approach by us would be completely inappropriate and our responses to the projects needed to be localised and specific to each one. In some cases, skills exchange was perhaps an appropriate and useful response where the groups were exploring the use of a new heritage approach in which we have experience.

However, reflecting back on what 'skills exchange' and 'training' we pro-actively suggested we could offer to the groups, we were perhaps taking a blinkered approach which missed an opportunity for us to input more effectively into the community projects. We focused our offers of training both in terms of workshops held at UCL that the community projects could attend; and bespoke training tailored to specific groups around 'heritage activity'. For example, how to do … oral history, archival research, exhibitions, or managing archaeological finds. However, what we could have offered to the community groups was skill exchange in 'co-production' and 'participatory approaches'. At the time we lacked a wider vision that the heritage activities are of course embedded in broader relational structures and processes of working; and that we have something to offer the groups (and the groups have something to offer us and each other) in terms of how to embed participatory approaches into their own work. Where a project itself was more committed to taking a participatory approach with its own community; then we found we were often asked by the gatekeepers to deliver activity based training directly to the community itself as an embedded part of the project. This was the case with Catch 22's 'Stories of Becontree' project which sought to engage and connect disadvantaged young people to the history of their housing estate through archival research, oral history, and film making. Here we delivered training in oral history and archival research directly to the young people who were then empowered to take control over the project and shape its outcomes. By embedding us directly into the project process the potential for 'co-production' became possible from there.

It became apparent as we worked alongside some of the groups that, in some cases, the gate-keepers themselves were taking a 'top down' approach in how they were structuring their project and their interactions with community. There was in some cases, a careful controlling of heritage activities by the gatekeepers and a desire to engage a chosen audience within the community with those activities but not perhaps to share control of the project with those communities. In hindsight, where we became aware of a project taking a 'top down' approach it was more likely connected to a lack of awareness around the benefits of (and ways of taking) a more participatory approach rather than a desire for control. It was a reinforcement to us that a project can carry the label of 'community' but we need to be careful about our own assumptions around what that label implies in terms of relationships and processes and that of course projects can be community-placed without being community-based (O'Toole: 1526).

Another example where 'skills exchange' transitioned into something more collaborative was with Mental Fight Club (MFC). Reflecting back on what made this transition possible there is again a connection between the broader established ways of working within this group which are inherently 'participatory'; and our ability to become embedded (at least for a pocket of time) within these frameworks that are already conducive to 'co-production'. Our relationship with Mental Fight Club was inspired by a connection of interest around 'heritage and well being' that was shared between this group and several members of the DWWS team. In establishing this common ground, we were asked by the community to develop a series of talks which we called 'Archaeologies of the Mind' which would explore some of the ways which we as academic researchers see the connection between heritage and well being. Over the course of three weeks we delivered talks which were developed in collaborative discussion with MFC's founder, Sarah Wheeler, and which led to broader collaborative discussions with the members of the wider MFC community around our shared interest. From the starting point of these talks flourished exchanges around meanings, frames, labels, concepts and ways of seeing and knowing. There was a sense in which these sessions (although small in number) became iterative with the participants response to the previous session shaping, changing and influencing the development of the next set of talks. While we can reflect further on the extent to which we as academics took a directing role and how we could have worked in an even more co-operative way, our

Andrew Flinn and Anna Sexton

commitment to active listening and learning and the group's underlying culture of creative and shared exploration made the process feel genuine. To collaboratively question and push around issues that are fundamental to our academic research was hugely beneficial for several of the DWWS team and the response from the community participants suggested that these benefits were shared and reciprocal.

Standing back from our reflections, constraints relating to mis-matched timelines prevented us from creating starting points with our community partners and embed co-production throughout the 'All our Stories' project processes. This was further compounded by short project turn-around times, and needs outweighing resource. However, within the structures and frames established by the communities, where the community itself had an existing culture of co-production which aligned with a participatory approach, we found spaces opened up for us to be positioned within these frameworks and our input could align with these existing tenets. Here the thresholds between what we aspired to and what was already in place were easily traversed. A one-way exchange became two-way and three-way (with relationships developing not just with gatekeepers but with the wider community in which the projects were embedded). In these cases there was a reciprocity which allowed both the authority and the benefits to be more equally shared. The challenge is perhaps to consider our role in supporting projects without these embedded ways of working, how we can be transformative as well as supportive in these instances. Similarly, where a culture of co-production already exists how can timing and resource be dovetailed to enable co-production between us, our community partners and their wider communities to be established in more than just pockets or bursts of activity? How can we develop and foster future frameworks that enable co-production from the outset, throughout and even beyond the strict boundaries of the 'project'? And how can we do this in a way that does not encroach either on the relationship the project wants to establish with its community; or on existing frameworks of support between community groups who rely on exchanging skills and developing partnerships with each other as valuable income streams. Here we need a broader awareness not just of the benefits of our attempts but of the potential damage that we might do – a reminder to critically question who stands to loose out as well as gain from our actions.

Conclusions: cycles of engagement?

An interesting and useful initial outcome of the Connected Communities programme is the publication of a series of different cross-disciplinary scoping studies and literature reviews about research on communities and with communities. The fact that interest in community-based research and participatory approaches are common to many disciplines and occupations of course underpins the logic of RCUK's Connected Communities programme and such multi-disciplinary sensibilities inform our own research approaches. Nevertheless it is still revealing and useful to compare our experience of engaging in community-based research with those from different fields and to find similarities in practice and reflection. One such scoping study produced by researchers from the University of Exeter (Robin Durie, Craig Lundy and Katrina Wyatt, Researching with Communities, AHRC Connected Communities Scoping Studies) draws on complexity theory to propose a 'cycle of engagement' which in seeking to model the actions or circumstances needed to achieve successful community-based participatory research includes many factors which we as a team have found to be essential both within the structures of the Dig programme and in other less structured collaborations.

At the core of what we have learnt from Dig Where We Stand is a reinforcement of the importance of infusing all of our interactions with community partners with critical reflection

that looks inwards on our actions within the boundaries of the project and outwards on the potential consequences of those actions beyond the project itself. Our critical reflections need to consciously examine how our relationships are developing; the structures that sit around what we are doing (and how those structures enable and hinder); the extent to which assumptions are shared or conflict; and how authority and control is perpetuated through the complex relational exchanges that occur within and between us. We must pay attention to space and positioning and the distances that exist between us both as individuals and as we come together in different incarnations of 'community'. This critical reflection needs to go hand in hand with our actions and we should look for opportunities to make the reflective process itself more equitably shared.

Durie et al. encapsulate this need for critical reflection within their engagement cycle model which looks at the different stages within a project, and how reflective and flexible phases need to occur before, after and during the key period of co-production. Durie et al. argue that this should be recognised by funding bodies and built into the process of designing and supporting collaborative and participatory practice. They also highlight the difficulty yet significance of aligning rhythms and structures across academic and community settings. The broader structural scaffolding that sits around these formal and to some extent artificial collaborative and participatory approaches inevitably creates constraints that limits the fluidity, creativity and flexibility within the co-production. This can lead to frustration and tension for all concerned. The top-down nature of research management structures in academic institutions need to be scrutinised in relation to compatibility with the ethos of co-production that seeks to reach beyond the academy. In cases where external funding bodies also play a part in supporting collaborative practice by academics with communities, the rigidity of the system is often a stumbling block. The Connected Communities programme is a progressive and enabling environment for collaborative and participatory practice but in order for it to better support this work there is refinement needed. In relation to DWWS, the lack of dovetailing between the two funding bodies involved (AHRC to support the academic partners and HLF to support the community partners) added an extra layer of constraint as it was difficult to tie together when we were able to be involved and when they were working on their project. We were never working alongside each other from start to finish; it is almost impossible for co-production to flourish successfully if the partners' timeframes do not sufficiently overlap. Something as simple as the mutual identification of desired outcomes and benefits at the beginning of the project was not possible. The reality is that the scale and timeframes of these projects meant that the development of co-produced research was unlikely; but what the scheme did was allow us to support those groups that required or desired our help and whose own work may have been transformatory and life – changing in different ways for some of those who participated. The dangers of the skills exchange and facilitation model remain (not least in the allocation of resources and the potential for harming other providers), but engagement with community projects in this fashion also introduced us to each other and allowed us to begin the conversations which might result in the future (within timeframes which are less circumscribed and more synchronised), in something more sustained and co-produced.

The notion of 'cycles of engagement' suggested by Durie et al. is useful when considering how to approach each individual project that we as academics committed to co-production might be involved in. But it is also useful in thinking more broadly about how time and resource bounded projects can be seen on a macro level as one 'engagement' in a broader cycle. If we have any aspiration towards sustainability we must view our work within individual projects like DWWS as a small part of a broader holistic process; as a vehicle for adding to and building on sustainable and long lasting relationships. We have had some success at this as some of the

community partners we engaged with already had established relationships with members of the DWWS team but there is a challenge that sits around how best to sustain relationships beyond the boundaries set by individual initiatives. DWWS has opened the door on relationships and enabled us to take some established relationships in new directions; our next steps need to further those relationships.

Note

1 This research was funded by grants from the AHRC's Research for Community Heritage fund. The UCL Dig Where We Stand team comprised Principal Investigator (Andrew Flinn), Co-Investigators (Gabriel Moshenska, Kris Lockyear, Beverley Butler,), researchers (Sarah Dhanjal, Tina Paphitis, Anna Sexton) and other UCL team members Ego Ahaiwe, Caroline Bressey, Debbie Challis, Lee Grieveson, James Hales, Louise Martin, Gemma Romain, Chris O'Rourke and Melissa Terras.

Bibliography

Alleyne, B. (2002). "An idea of community and its discontents: towards a more reflexive sense of belonging in multicultural Britain." *Ethnic and Racial Studies* 25 (4): 607–727.

Arnstein, S. (1969). "A Ladder of Citizen Participation." *Journal of the American Institute of Planners (JAIP)* 35 (4): 216–224.

Butler, B. (2010). "Palestinian Heritage 'To the Moment': Archival Memory and the Representation of Heritage in Conflict", in (eds), D, Perring et al., *Journal of Conservation and Management of Archaeological Sites*.

Catch 22 (2013). "Stories of Becontree project" Available at www.storiesofbecontree.com. Accessed 30 January 2014.

Cornwall, A. (2008). "Unpacking Participation: Models, Meanings and Practices." *Community Development Journal* 43 (3): 269–283.

Crooke, E. (2007). *Museums and community: ideas, issues and challenges*. London, Routledge.

Denison, T. and Stillman, L. (2012). "Academic and Ethical Challenges in Participatory Models of Community Research." *Information, Communication and Society* 15 (7): 1037–1054.

Doumani, B. (2009). "Archiving Palestine and the Palestinians: The Patrimony of Ihsan Nimr." *The Jerusalem Quarterly*, 36:3–12.

Durie, R. Lundy, C. and Wyatt, K. et al. "Connected Communities: Researching with Communities." www.ahrc.ac.uk/Funding-Opportunities/Research-funding/Connected-Communities/Scoping-studies-and-reviews/Documents/Researching%20with%20Communities.pdf. Accessed 30 January 2014.

Hall, S. (2001). "Constituting an archive." *Third Text* 54: 89–92.

Hall, S. (2005). "Whose heritage? Un-settling 'the heritage', re-imagining the post-nation." In J. Littler and R. Naidoo (eds.), *The politics of heritage: the legacies of 'race'*. London, Routledge: 23–35.

Heilbrun, C. (1999). *Women's Lives: The View from the Threshold*. Toronto: University of Toronto Press.

Herising, F. (2005). "Interrupting Positions: Critical Thresholds and Queer Pro/Positions." In J. Brown, and S. Strega (eds.), *Research as Resistance: Critical Indigenous and Anti-Oppressive Approaches*. Toronto, Canadian Scholars' Press: 127–152.

Hildyard, N. et al. (2001). "Pluralism, Participation, and Power: Joint Forest Management in India." In U. Kothari and B. Cooke (eds.), *Participation: The New Tyranny?* London: Zed Books: 56–71.

Huvila, I. (2008). "Participatory Archive: towards decentralised curation, radical user orientation, and broader contextualisation of records management." *Archival Science* 8 (1): 15–36.

Iacovino, L. (2010). "Rethinking archival, ethical and legal frameworks for records of Indigenous Australian communities: a participant relationship model of rights and responsibilities." *Archival Science* 10: 353–372.

Isherwood, R. (2012). "Community Archaeology: conceptual and political issues" in G. Moshenska and S. Dhanjal (eds.), *Community Archaeology: Themes, Methods and Practices* Oxford, Oxbrow Books: 6–17.

Kean, H. and Martin, P. (2013). *Public History Reader*, London, Routledge.

Lindqvist, S. (1979). "Dig Where You Stand." *Oral History* 7–2: 24–30.

McKemmish, S. et al. (2010). "Australian Indigenous knowledge and the archives: Embracing multiple ways of knowing and keeping." *Archives and Manuscripts* 38 (1): 27–50.

McKemmish, S. et al. (2011). "Resetting relationships: archives and Indigenous human rights in Australia." *Archives and Manuscripts* 39 (1): 107–144.

Maher, W. J. (1998). "Archives, archivists, and society." *American Archivist*, 61(2): 252–265.

Mental Fight Club, http://mentalfightclub.com. Accessed 30 January 2014.

Moosa-Mitha, M. (2005). "Situating Anti-Oppressive Theories within Critical and Difference-Centred Perspectives." In J. Brown and S. Strega (eds.), *Research as Resistance: Critical Indigenous and Anti-Oppressive Approaches*. Toronto, Canadian Scholars' Press: 37–72.

Moshenska, G. and Dhanjal, S. (eds.) (2012). *Community Archaeology: Themes, Methods and Practices*. Oxford, Oxbrow Books.

O'Toole, T. et al. (2003). "Community-based Participatory Research: Opportunities, challenges and the need for a common language." *Journal of Internal Medicine* 18 (7): 592–594.

Perkin, C. (2010). "Beyond the rhetoric: negotiating the politics and realising the potential of community-driven heritage engagement." *International Journal of Heritage Studies* 16(1–2): 4–15.

RCUK (n.d.). Connected Communities. Available at www.ahrc.ac.uk/Funding-Opportunities/Research-funding/Connected-Communities/Pages/Connected-Communities.aspx. Accessed 30 January 2014.

Reason, P. and Bradbury, H. (2008). *Handbook of Action Research: Participative inquiry and practice*. 2nd edn. London: Sage.

Rutman, D, et al. (2005). "Supporting young people's transitions from care: Reflections on doing Participatory Action Research with youth from care." In J. Brown and S. Strega (eds.), *Research as Resistance: Critical Indigenous and Anti-Oppressive Approaches*. Toronto, Canadian Scholars' Press: 153–180.

Samuel, R. (1994). *Theatres of memory*. London, Verso.

Shilton, K. and Srinivasan, R. "Participatory Appraisal and Arrangement for Multicultural Archival Collections." *Archivaria* 63: 87–101.

Strega, S. (2005). "The view from the Poststructural Margins: Epistemology and Methodology Reconsidered." In J. Brown and S. Strega (eds.), *Research as Resistance: Critical Indigenous and Anti-Oppressive Approaches*. Toronto, Canadian Scholars' Press: 199–236.

Theimer, K. (2013). *ArchivesNext Blog > Participatory Archives: Something Old, Something New*. Available at www.archivesnext.com/?p=3463. Accessed 30 January 2014.

Thomson, A. (2008). "Oral history and community history in Britain: Personal and critical reflections on twenty-five years of continuity and change." *Oral History*, Spring, 95–104.

Waterton, E. and Smith, L. (2010). "The recognition and misrecognition of community heritage." *International Journal of Heritage Studies* 16(1–2): 4–15.

Watson, S. and Waterton, E. (2010). "Heritage and community engagement." *International Journal of Heritage Studies* 16(1–2): 1–3.

Whyte, William F. (1991). *Participatory Action Research*. London: Sage.

Yakel, E. (2011). "Credibility in Participatory Archives." Presentation at Society of American Archivists Conference (unpublished).

43
Beyond the rhetoric
Negotiating the politics and realising the potential of community-driven heritage engagement

Corinne Perkin

Introduction

In many countries, community engagement has become a popular sentiment for a range of local councils, governments, arts and heritage organisations, prompting the development of strategies and mission statements that emphasise the importance of community consultation and involvement (Sandell 2002, Witcomb 2003, Newman et al. 2005, Crooke 2007, Message 2007, Watson 2007). In response, organisations often develop and direct community-based projects to fulfil their own prescribed ideals for engagement. Such models of engagement can be highly successful but without caution can also result in tokenistic and unsustainable projects which erode the trust of communities and result in a lack of support for future initiatives.

Alternatively, community engagement projects may also develop in response to grass-roots campaigning from the community groups that larger organisations may seek to engage. Such projects often evolve from an identified need or area of importance, and often have established participants and community support. This form of community-driven engagement has the potential to move beyond the ambitions of a council or collecting institution to create meaningful ongoing collaborations between organisations and local communities. However, whilst potentially rewarding and beneficial if successful, community-driven engagement projects are not the panacea approach some may envisage. Such projects are potentially rife with politics, differing agendas and visions for the future. Those wishing to embark on a community-driven engagement project must understand the motivations and needs of the groups involved, mediate between groups where necessary and accomplish results of mutual benefit for all involved as part of the project management process.

In Bendigo, Australia, a community-driven engagement project has developed, resulting in an evolving partnership between Bendigo Art Gallery, a range of local heritage groups and the local council. The project continues to work towards raising the status and accessibility of local heritage organisations and collections, supporting the work of local heritage groups and encouraging community engagement with local history. With reference to the Bendigo experience, this paper will explore: the politics of the local heritage sector; the role of the project manager in effecting change amongst community groups and the partner organisation; the pitfalls and limitations of community-driven engagement projects and, therefore, potential avenues for

ensuring success and sustainability. A greater understanding of the politics and potential of community-driven engagement may expedite more meaningful project outcomes of mutual benefit and community relevance, thus generating a more effective model of community engagement.

Museums and community engagement

The complex multi-faceted role of museums is often evolving to respond to, and encourage, changing viewpoints or knowledge and shifting political sentiment or government policy. As centres of research, museums potentially can, and at times do, initiate critical thinking and respond with their own self-driven evolution and policy shifts. However, as recipients of public money they can be required to respond to the demands of government as a means of ensuring ongoing funding. The increased drive to demonstrate economic accountability and efficiency since the 1980s in countries such as the United Kingdom and Australia is one such example. In response, museums have been required to demonstrate their annual economic effectiveness through blunt measurements such as visitor numbers (Selwood 2004, Scott 2006). Such figures, however, fail to encapsulate the complexity of the museum's role and function in society and serve to perpetuate the need for the next blockbuster exhibition or popular programme to maintain visitor numbers and funding. Through an evaluation that included both qualitative and quantitative research methods, as well as the inclusion of museum professionals, visitors and non-visitors, Scott (2006) has demonstrated that the important impacts of museums tend to be the intangible elements such as: personal learning in a visual, hands-on, free-choice environment; the development of perspective and insight; and the important experience of linking with the past. This type of value and experience is impossible to express in visitor figures alone.

Whilst economic efficiency remains central to public funding agreements, more recently there has been increased emphasis on social policy. Government policy in countries such as the United Kingdom (and, more recently, Australia) has come to reflect the view that cultural institutions have a role to play in building social cohesion, reducing social exclusion, improving individual self-esteem and encouraging 'life-long learning'. As such, these institutions must now strive to overcome the established real and perceived barriers preventing potential visitors and participants from engaging (Jenson 2002, Sandell 2003, Newman et al. 2005). In turn, organisations such as museums and galleries may increase their value once they can consistently demonstrate their ability to implement and achieve worthwhile goals that make a noticeable positive difference within their communities (Weill 2002). In the United Kingdom, government policy has been reflecting these sentiments by 'encouraging' museums to transcend their traditional role as educators and act as conduits for tackling social exclusion – influencing complex issues of disadvantage, poverty and inequality through a range of public programmes, exhibitions and events aimed at reaching a variety of audiences. This political encouragement is frequently closely tied to funding provisions and becomes, therefore, inherently mandatory. There is a danger here for institutions undertaking community engagement or social inclusion programmes to do so in an effort to obtain funding or meet political expectations and agendas. Does this really differ from an approach that looks only to visitor numbers? Sufficient time and resources must be invested to allow for development and delivery of community programming ensuring relevance, effectiveness and sustainability and optimum programme benefits.

There has been much recent debate about the instrumentalisation of cultural institutions and their programmes resulting from government policies around museums and social inclusion (Belfiore 2002, Belfiore and Bennett 2007, Gray 2007, 2008). However, as Gibson (2008) asserts, public museums in Britain and Australia have, since their inception, been 'constitutively

instrumental' and funded with a dual intention for potentially improving public health, economic development, community cohesion, education and municipal development. Whilst many museums were initially established and frequented by the privileged, from the 1830s onwards there was a push for museums to be made more accessible and take on an educative role, encouraging learning amongst the broader public (Kavanagh 1994, Sandell 1998). Despite these benevolent intentions, museums and galleries have historically tended to exclude groups that, for example, come from different cultural or non-English-speaking backgrounds, have access issues, differing education levels or socio-economic status, and who fall outside the traditional white, middle class audience (Bennett 1995, Littler and Naidoo 2005). This model for engagement has tended to assume the ignorance of the masses, which, in turn, requires the assistance, goodwill and guidance of the more educated elite. Such a model inevitably led to a rather patronising, top-down approach, with the museum or gallery determining what communities needed, how programmes should develop and what should be accomplished. This did not encourage the collecting or interpreting of alternate or diverse histories, nor empower communities to contribute to their own development or celebrate their unique identities. It has perhaps also contributed to a perception of museums as traditionally elitist institutions, insular in their scope and outlook.

When considering the complex role of museums in their communities, it is also crucial to note the privileged position museums continue to hold as perceived centres of knowledge and authority. Recent findings have suggested that audiences respect the position held by museums, yet also wish to have a greater role in what they are allowed to know and the opinions and views they are able to express (Cameron 2006, Kelly 2006). Scholarship on museum learning is emerging that validates these concerns and suggests that institutions need to consider themselves as mediators and advocates for knowledge, rather than suppliers of information, and thus should position themselves to provide tools for visitors to explore their own ideas and to reach their own conclusions (Cameron 2006, Kelly 2006). This research is also extremely pertinent to community engagement strategies and programming. It is crucial to overcome the inherent power imbalances that may exist as a result of the real or perceived position of authority that museums hold and to develop, instead, collaborative, transparent relationships with audiences based on a concept of shared authority (Archibald 2002). The approach taken to develop or implement a community engagement or social inclusion project will therefore be critical to its success, impact and sustainability. It is vital for museums to offer and participate in more effective programmes if they wish to move beyond simply meeting criteria to fulfil financial or political demands.

Just as current politicking about museums and social inclusion echoes nineteenth century notions of museums as instruments for positive social change, there is a potential danger that with the resurgent focus on the social responsibility of museums there will be a return to previous institution-led or top-down approaches when developing projects. To ensure that present community engagement strategies do not serve to further isolate audiences, it is imperative that collaborative approaches be explored which allow institutions and communities to work on an increasingly even footing and to augment the leadership role played by community groups when establishing partnerships. This should increase the capacity for sustainable and influential programming and better realise the potential for collecting institutions as relevant community contributors and facilitators of social change.

Policy and programming that encourages different levels of Australian government to work in partnership with communities is growing. Community engagement work covers a diverse range of project areas including public health, environmental issues and town planning and is gradually moving into the heritage and arts sectors (Reddel and Woolcock 2004, Cuthill and

Fein 2005, Lane 2007). From a strategic viewpoint, these initiatives aim to encourage engagement, create a shift towards more participatory forms of governance and build the capacity of communities to implement a variety of projects. Common to this work, however, is the tendency for an institution-led approach. Whilst this has benefits such as harnessing an organisation's capacity to mobilise and share its resources and expertise, participate in knowledge transfer and facilitate the capacity-building process, there are also problems of implementation. In researching citizen participation in local governance, Cuthill and Fein (2005) note that while participation and collaboration imply a level of equity between citizens and local government, realistically achieving this is difficult. When a commitment to sharing decision-making processes is expressed, implementing such community engagement rhetoric is complex. Reddel and Woolcock (2004) highlight the need for engagement strategies to go beyond linear approaches, such as partnership-building, which reinforce passive models of decision-making. They propose a focus on diplomacy, negotiation, problem-solving and stakeholder analysis as a way of creatively approaching engagement. For the institution looking to embark on effective community projects within the heritage sector, creative approaches are imperative.

In Australia, much of the engagement work in the heritage sector has primarily been in the field of cultural heritage management and archaeology. Amongst archaeologists, broader dialogue with communities is beginning to challenge the practice and analysis of archaeology in Australia. Previously, the level of community involvement in traditional archaeological practice tended to focus around archaeologists and heritage organisations 'getting consent' to undertake projects. There is increasing recognition of the value attributed to material traces of the past by communities and the complex identities and histories they encompass. The heritage sector and communities benefit from more collaborative approaches that combine archaeological and heritage expertise with local knowledge and collective memory. Such partnerships may contribute to a richer and more vibrant understanding of Australian history and culture (Greer et al. 2002). In cultural heritage management, research, conservation and development of specific sites, especially those with significance for Indigenous communities, has led to broader definitions of heritage; re-evaluating the role of experts or professionals in managing such projects and the ongoing management of heritage sites (Field et al. 2000, Smith et al. 2003).

Across Australia, it is widely acknowledged that community heritage groups (many of whom operate community museums) are responsible for the care, display and interpretation of a vast portion of the nation's tangible and intangible heritage. As such, there is an increasing trend for larger museums to assist such groups. Partnerships aim to improve the capacity for smaller groups to care for and manage their collections, while encouraging larger museums to promote and integrate local stories and more diverse histories into displays, programming and collections. Such projects have mutual benefits for both the organisations involved and for wider audiences. There is, however, still a natural tendency for museum outreach work to become skewed towards a top-down model rather than encouraging true collaboration between volunteer-run and larger, government-funded heritage organisations. With such an approach, the ideas, knowledge base and specific local and cultural features of community heritage groups may be overlooked or overridden, leading to decreased community ownership, identity and, ultimately, engagement.

It was against this backdrop that a community engagement project was undertaken in Bendigo, a large regional centre in central Victoria (Australia) with a population of over 100,000 people. The city has a rich and complex past including thousands of years of traditional Indigenous ownership, pastoralism since the 1830s and mining stemming from the 1850s goldrush. Bendigo proved to be one of the world's most profitable goldfields, attracting thousands of migrants from around the globe. This rich and intense period of migration has contributed

heavily to the area's physical development, industry and its social, cultural and environmental history. A variety of dedicated, largely volunteer-run, and sometimes politically vocal, heritage groups have, over the past century, developed to conserve and promote various local histories. Some of these groups have even developed out of migrant organisations established during the goldrush period and can trace their history back to this time. Over the past few decades recurring and often heated local debate has arisen, frequently occurring in the media, council meetings, election campaigns, public forums and within and between residents regarding the establishment of a centralised regional museum for Bendigo. This debate has raised challenging questions for local heritage groups, council and the wider community such as: how viable is such a museum; whose responsibility is it; and whose history should it display. Concurrently, whilst local groups work hard to preserve local heritage, the historical diversity this dedication uncovers has often remained within small circles, with limited resources to engage with the wider local community and tourists.

In response to community demands, in 2007 Bendigo Art Gallery, with the support of the local council and Arts Victoria, embarked on a heritage engagement project. The project aimed to foster support for local heritage and initiate an overall growth in its status and accessibility by first developing collaborative working relationships with and between disparate local heritage groups. The Bendigo-based community-driven engagement project resulted in the development of a representative heritage group who meet regularly, organise successful exhibitions and programming and contribute to securing financial support for a permanent, centrally located heritage gallery space (currently under development) (Table 43.1). The project has had a positive impact on the local community, in particular the 28 groups who make up the Bendigo Heritage Representative Group (Table 43.2).

The opening of the permanent heritage gallery space will be important for tourism but also for the wider Bendigo community who will be able to see changing exhibitions and programmes reflecting, informing and challenging local history. The exhibition content will be representative of a diverse range of local history groups, collections and research areas and encourage visitors to access and support these groups. This project is currently expanding to further improve and secure relationships with and between heritage groups and foster new links with communities and audiences outside the heritage enclave. Local history and the work of heritage groups continue to be supported and promoted through collaborative exhibitions, programmes and capacity-building work.

When considering the model used for this project, some parallels can be drawn from museum development work occurring across cultures, particularly in developing nations. Such projects have had to incorporate community involvement to engender long-term success and encourage increased local engagement with museums. Ideally, such development work encourages a participatory approach that values the contributions, knowledge and perspectives of local people and integrates these into professional museum practices. Termed *appropriate museology*, this approach advocates adapting museum practices and strategies for cultural heritage preservation to specific local contexts and conditions. This is a bottom-up community-based participatory approach that combines local knowledge and resources with those of professional museum work. In this way, professionals and community members may work collaboratively to more adequately meet the needs and interest of a particular museum and its community and generate greater interest, ownership and engagement amongst community members (Kreps 2008). Such approaches have applicability to museum and heritage development work and community engagement projects in developed nations; in most communities top-down approaches are not always conducive to building sustainable collaborative partnerships. However, appropriate museology and bottom-up engagement work is not a problem-free approach. It is therefore

Table 43.1 Selected exhibitions and programmes associated with the Bendigo Community Heritage Engagement Project

Exhibition/programme	Description	Date and place	Groups involved
Snapshots & Stories	Exhibition.	February to April 2008, Bendigo Art Gallery.	Bendigo Cemeteries; Bendigo Health; Bendigo Historical Society; Bendigo Irish Association; Bendigo RSL Military Museum; Bendigo Tramways; Bendigo and District Caledonian Society; Bendigo and District Cornish Association; Campaspe Run; Central Deborah Goldmine; Eaglehawk Heritage Society; Elmore Progress Association Museum; German Heritage Association; Golden Dragon Museum and Chinese Association; Heathcote McIvor Historical Society; Huntly and District Historical Society; La Trobe University and Jaara Songline Cultural Tours; National Trust (Bendigo).
Snapshots & Stories	Local history talks.	February to April 2008, Bendigo Art Gallery.	As above.
Deco on View	Exhibition.	September 2008 Dudley House, Bendigo.	Bendigo Art Gallery; Bendigo Historical Society; Campaspe Run; Eaglehawk Heritage Association; Elmore Progress Association Museum; Bendigo Veteran, Vintage and Classic Car Club; along with four individual community members.
Deco on View	Film – In a Lifetime.	September 2008 Dudley House, Bendigo.	Campaspe Run; Elmore Progress Association Museum; Eaglehawk Heritage Association.
Young Curators	Seven-week museum skills and local history program for 25 Year 10 students resulting in an exhibition 'Life on the Goldfields' displayed at the Golden Dragon Museum.	March to May 2009, Golden Dragon Museum.	Bendigo Health; Bendigo Historical Society; Bendigo and District Cornish Association; Eaglehawk Heritage Association; Golden Dragon Museum and Chinese Association; Catholic College Bendigo.

continued

Table 43.1 Continued

Exhibition/programme	Description	Date and place	Groups involved
Young Curators	Ten-week local history program for 300 Year 9 students incorporating object handling and intergenerational oral history interviews.	April to June 2009, Catholic College – La Valla.	Bendigo Cemeteries; Bendigo Historical Society; Bendigo and District Cornish Association; Bendigo RSL Military Museum; Campaspe Run; Dutch Australian Friends; Eaglehawk Heritage Association; Elmore Progress Association Museum; Northern District School of Nursing Graduates' Association; Catholic College Bendigo; Catholic College Bendigo Archives; Bendigo Veteran, Vintage and Classic Car Club.
A Camera on the Somme	Exhibition.	June to August 2009, Bendigo Art Gallery (touring to other Australian venues 2009–2011).	Bendigo RSL Military Museum; Eaglehawk Heritage Association; Bendigo Art Gallery and individual community members.

Table 43.2 Members of the Bendigo Community Heritage Representative Group

Bendigo Cemeteries Trust Volunteer Committee	Central Deborah Goldmine
Bendigo Family History Group	Eaglehawk Heritage Society
Bendigo Health	Elmore Progress Association Museum
Bendigo Historical Society	German Heritage Association Bendigo
Bendigo Irish Association	Golden Dragon Museum & Chinese Association
Bendigo Regional Archives Centre	Heathcote McIvor Historical Society
Bendigo Regional Genealogical Society	Huntly and District Historical Society
Bendigo RSL Military Museum	La Trobe University & Jaara Songline Cultural Tours
Bendigo Tramways	Long Gully History Group
Bendigo and District Caledonian Society	National Trust (Bendigo)
Bendigo and District Cornish Association	Passchendaele Barracks Historical Society
Campaspe Run	St Josephs Primary School Archives
Catholic Church Archives	Dutch Australian Friends
Catholic College Archives	Northern District School of Nursing Graduates' Association

important to explore such approaches in greater depth to consider issues arising from an Australian example of community-driven heritage work and explore strategies to improve project success. The Bendigo project is showing signs of success in achieving its proposed objectives and a positive example of community-driven engagement but this project also provides a focal point for exploring a range of potential issues arising from such work. Developing a deeper understanding of the potential problems and implications of such an approach can aid in the development and planning of future projects and ensure increased success and sustainability.

Deconstructing community-driven heritage engagement projects

Politics within the local heritage sector

Community heritage projects inevitably involve a variety of different groups, organisations and individuals. Even the smallest project will require negotiation of the goals, interests and agendas of those involved. Issues between smaller heritage groups and larger organisations, such as a local council, can arise from: a lack of or uneven distribution of funding; poor facility or service provision; maintenance and lease arrangements for buildings; and a perceived lack of support for the work of heritage groups, for example, through insufficient tourism promotion or responsiveness to group needs. In Bendigo, heritage groups felt a long-standing sense of neglect from the local council. The focal point for this anger became the city's lack of a regional museum. The council was seen to superficially utilise Bendigo's heritage when it suited them, for example, in tourism advertising, but in reality did little to contribute to preserving or promoting heritage on a deeper level. What was interesting, however, was the lack of unity between Bendigo's various heritage groups on these issues. The local Bendigo groups did not band together in support of a regional museum or to petition the council or state and federal governments regarding local heritage issues.

Feeling disenfranchised regarding larger organisations resulted in a range of responses from heritage groups – some becoming increasingly political and vocal in the media in an attempt to effect change, others in contrast becoming increasingly insular and disengaged. The only commonality amongst the groups was their lack of solidarity with each other and a focus on achieving the ambitions, aims or goals of their own group in isolation. This independent outlook of

heritage groups in Bendigo resulted in the establishment of quite distinct group identities as well as a vast number of active heritage organisations, in this way the quantity and diversity of heritage organisations was strengthened. However, for many years the lack of unity demonstrated between these organisations served to discourage successive councils from investigating or supporting any large heritage projects, such as a centralised museum. The differing reactions of groups to the perceived lack of council support and the lack of unity amongst heritage organisations points to inherent differences and issues within and between these groups.

In order to develop partnerships with heritage groups it is important to identify individual group characteristics and points of differentiation. Whilst differing in size and funding allocation, collecting organisations can also vary in their collections, facilities, membership base, purpose and mission, level of motivation, political acumen, wider community involvement and public exposure. Competitiveness and disagreements can arise between groups as a result of these differences but also due to other factors such as personality clashes, past or current events, entrenched community rivalries (for example, between towns, cultural groups or sporting clubs) and perceived favouritism from funding or supporting organisations such as a local council. Membership to a community heritage organisation can have tremendous individual and societal benefits, improving personal well-being and community involvement. However, politics within individual groups, as in any organisation, arise and can result in decreased member involvement and productivity within the group. Such difficulties may result from the competing agendas, interests and motivations of individual members, differing understanding of the purpose and mission of the group and its priorities. Within communities, external issues arising from outside the group, for example in workplaces, in external community organisations and problems amongst families, neighbours and friends, can also have repercussions for the cohesiveness of a community heritage group. Every organisation is unique and it is crucial to understand the often subtle dynamics involved in any community project. Community-driven engagement will not succeed without a strong sense of the different and sometimes competing interests, needs and motivations of the partner organisations. Identifying and understanding the individuality of groups and the political history and issues that have or may arise is an important part of the project design, development and ongoing management. Without a good grasp of these issues, community-driven engagement work may be undermined or unsuccessful.

Pitfalls and limitations of community-driven engagement projects

A community-driven engagement project can involve a range of stakeholders and partner organisations. As these projects result from an identified need or request from community groups it is often not up to the museum, gallery or larger organisation to be too restrictive about which groups will be involved. To alienate or disregard a group of people who feel they should be involved in the project as it is of importance to them can be counter-productive. Such a project will not truly be community-driven as it will not accurately reflect the diversity and depth within that community. The Bendigo engagement project developed in response to the disappointment and anger expressed by community groups over many years where there were strong feelings that heritage was being undervalued and unsupported in Bendigo. Bendigo Art Gallery and the City of Greater Bendigo, with the support of Arts Victoria, employed a Professional in Residence to respond to these issues and manage the heritage engagement project.

For this project to be effective, all Bendigo groups with an interest and identity based in local heritage were potential partners. As such, the first step for the newly employed project manager was to meet and learn about the scope and diversity of these groups and understand the issues from their perspective. Whilst the project manager may inevitably be a professional from a larger

Beyond the rhetoric

funded organisation, the project must develop based on close consultation with community groups. Their needs and vision for the future must be given equal priority with those of larger organisations. When there are many community groups involved they each inevitably bring increased diversity and politics. As such, involving and representing the interests of all identified stakeholders is challenging. These interests must also be balanced against the demands and needs of the supporting organisations and funding providers.

Community-driven engagement work such as the Bendigo heritage project develops in response to community groups but does not necessarily involve the entire community from the outset. However, to have relevance and be sustainable in the future it is imperative that such projects consider their impact on the broader community and the needs of potential or future stakeholders who may become involved as the project develops. In the Bendigo example, it was vital that heritage groups be given support and be promoted. However, any work undertaken had to benefit the groups involved but also the wider Bendigo community. Heritage can play a key role in communities, for example by encouraging civic pride and in shaping identity. In order to interpret and preserve local history effectively it must be contributed to, contested and explored by the wider community and not kept within an enclave of heritage enthusiasts. Many of the heritage groups involved in this project identified a lack of interest from the local public or difficulties in securing new volunteers as major issues. For some groups their intense politicking or disengagement had led to their dislocation from the general public, for others a lack of resources or public awareness was the contributing factor. To overcome some of these issues, planning for increased positive involvement between heritage groups and the wider community was essential to secure the projects success. Planning to meet the needs of not only partner organisations but also the wider community can better ensure increased uptake and support for the project and secure its future sustainability.

When a community-driven engagement project develops in response to a community-identified need or issue, ideally the approaches for addressing these issues are developed collaboratively by all involved partner organisations. However, just as all the groups involved bring with them a diverse range of characteristics, the way they may want the project approached or an issue solved may differ and be derived from their own vision for the future. Groups may have an established concept of what the correct approach is and this is often based on the individual needs and viewpoints of a particular group rather than considering the partner organisations or the wider community. The solutions presented by community groups may be viable, inclusive and the best solution for the community and the project. In some cases, proposed solutions may be ideal but then unachievable due to funding or other constraints and as such alternatives or compromises must be reached. Alternatively, groups could be advocating a solution that is not in the best interest of other groups or the success of the overall project. The larger partner organisation has a mediatory role to play in providing professional advice and guidance to groups as part of the decision-making process while minimising the potential for the project morphing into an expert-driven top-down approach. There is a delicate balance to strike; often it is the larger organisation that has ultimate responsibility for the project and its success due to the positional power the organisation holds in terms of managing or providing funding, staff and resources. However, ultimately the project will not have long-term success if the community groups involved feel they have been pushed towards project outcomes they are dissatisfied with. The project outcomes may be a compromise but must still meet the overall needs of the groups involved and fulfil the project aims.

The groups involved in the Bendigo heritage project brought with them a variety of solutions or outcomes they saw as important or correct. The most often talked about and publicised was the establishment of a regional museum for Bendigo. This solution was seen as potentially

addressing the storage issues faced by one or two groups, demonstrating council support for heritage and promoting the history of the city. The groups that supported this solution were the most politically active in the collective and were initially unable or unwilling to consider alternate views. A museum could have many benefits for Bendigo but at this stage could also create many problems. Due to the large number of heritage organisations and collections now operating, it would be difficult to decide whose collection or research should be included, how it would be displayed and who would manage or have a say in the running of the museum. Such a project would require a significant local and state government investment that would then require the museum to be professionally staffed and operated. Centralising Bendigo's heritage in such a dramatic way could ultimately result in some groups losing control or access to their collections, other groups being disregarded entirely and a decrease in the number of heritage groups operating in Bendigo. The closure of heritage groups could reduce the scope and diversity of heritage preservation and research in Bendigo and damage the fabric of communities for which the heritage group is a source of local identity, a social network and an outlet for contributing to society.

Rather than focusing on the obvious solution of opening a centralised museum, the role of this project was to understand the needs and aspirations of local heritage groups, encourage communication and collaboration between the groups and propose projects and avenues through which the needs of all the groups could to some degree be met. Rather than the project manager dictating a compromise solution to the groups from the outset, encouraging collaboration and communication between heritage groups was key. The establishment of the Bendigo Heritage Representative Group and the implementation of joint projects such as exhibitions and public programmes slowly began to overcome long-established barriers between groups and allow them to learn from and about each other. An increased shared understanding of the needs of all heritage groups, combined with the success of joint projects such as the 2008 *Snapshots and Stories* exhibition at Bendigo Art Gallery encouraged even the most politically minded to consider the collective needs of heritage rather than focus on individual group perspectives. It was then possible for all those involved to look beyond traditional models for regional museums to a purpose-designed heritage gallery space. This gallery can draw on local collections and research and enhance collaborations with local groups to present a professionally curated schedule of temporary exhibitions. The model is designed to augment and support the work of local groups and encourage them to continue to work collaboratively while developing their individual group identities and foci. The successful way in which the groups have learned to co-operate and the community response to the exhibitions and additional project outputs has also encouraged local government to fund the development of the new gallery space ensuring the life of the project into the future.

Role of the project manager

The project manager of a community-driven engagement project has an important role to play in balancing the interests and needs of partner organisations and objectively ensuring positive outcomes for all involved, the overall project and the wider community. The larger the project or the more groups that become involved, the more complex this can become. Regardless of this, there are some key priorities (see Table 43.3).

For community-driven projects to be successful, the project manager must address and counter the inherent power imbalances between partner organisations. A project manager involved in a community-driven engagement project will often be a paid professional employed by a larger partner organisation. The project manager and the larger partner organisation bring

Table 43.3 Lessons learned from the Bendigo Heritage Engagement Project

- Treat all groups equally;
- Where possible, take an objective stance – be aware of, but remain neutral on, political issues;
- Demonstrate strong communication and listening skills;
- Be available and approachable to all groups;
- Build trust with the groups and between groups;
- Provide a regular forum for discussing and contributing to project development as well as an opportunity for partner organisations to listen to and share with each other;
- Creative problem-solving, particularly if solutions or funding is limited or if the needs of a range of stakeholders must be considered and ideally met;
- Advocate on behalf of community groups with larger partner organisations or funding providers for example local government;
- Take both macro and micro views on the project. For example, develop an understanding of how the project partners collectively function and can work collaboratively and also identify, understand and address issues or challenges which may hinder this co-operation on an individual or group level;
- Service and information provision based on needs identified by community groups. Assisting to build capacity amongst community groups by sharing professional expertise and opportunities where requested;
- A demonstrated enthusiasm for and a positive approach to the project, encouraging and supporting efforts and contributions of groups and celebrating group and individual achievements and successes;
- Encouraging regular feedback and suggestions from all partner organisations to ensure the project continues to meet the needs of the groups involved and identify areas requiring further development. In order for this feedback to be utilised to strengthen the project, it must be received and examined as objectively as possible;
- Identify and decrease impediments to the projects development. This could be something simple such as ensuring all groups are informed of meeting times or training opportunities despite differing levels of access to the internet. It could also involve more complex issues such as conflict management within and between groups.

with them professional training, industry experience, money and authority – attributes which can assign them power. The most powerful asset that community groups bring to the project is their passion and commitment for the volunteer work they dedicate themselves to. Project managers must ensure power imbalances do not develop as these have the potential to unhinge the project and undermine the community-driven approach. Concurrently, the project manager can strengthen a project by harnessing the passion and motivation exhibited by community groups. It is crucial that the project manager develop strong self-awareness and an ability to recognise that although they have heritage or community development expertise a community-driven project relies heavily on the valuable contributions of community groups. Local heritage groups have a more intimate knowledge of their collections, history, problems or communities than the project manager may ever be able to possess. Their experience as volunteers within their various organisations is specific and complex and as such they are experts in their own right. In this type of project work, the expertise and experience of these volunteers is as valid as that of the professional project manager. The Bendigo experience has demonstrated that only with a partnership of expertise and experience that allows power to be equally shared will a project have the best chance of success. The skill-set and approaches mentioned above must be employed to ensure the project does not develop power imbalances and drift towards a top-down approach but instead draws on the collective expertise of all partner organisations.

The project manager can also act as a conduit between the larger and smaller partner organisations. Community-driven projects strive to avoid reverting to top-down partnership models. As such the larger partner organisations must also undergo change or development. The project manager has a role to play in educating the larger project partners (such as the gallery, museum or local council) by challenging preconceptions held about community groups and crystallising a less elitist more community-minded approach to engagement work. In the development of the Bendigo Heritage Gallery, the local council assumed that climate control systems may not be required as the collections of local heritage groups were not as significant or sensitive as those held in larger state-operated museums. In this instance, the project manager was essential in educating and challenging these perceptions to ensure suitable display standards for collection material and therefore secure the usability and success of the new gallery. More accurate perceptions of community groups and collections will allow larger organisations to further recognise the value and potential of engagement work and potentially secure future funding or support. Promotion of community groups and the community-driven project can also identify future project partners that can open potential avenues for promotion, tourism, special events and sponsorship. If people and other organisations are not aware of the project or the groups involved, then opportunities for development and support may be missed. As such, the project manager has an important promotional or marketing role that extends beyond their advocacy position. The community groups involved in the project will importantly feel that their interests and viewpoints are being conveyed to hierarchically higher organisations and to groups and individuals with the power to effect change or decisions in the project's favour. These factors will help to cement the long-term support for and sustainability and growth of a community-driven engagement project.

Conclusion

Government bodies and publicly funded organisations across a range of sectors have a responsibility to actively engage with and add value to communities in a meaningful way. Such initiatives plan to benefit all those involved including the participating organisation. However, amongst organisations that effectively realise community engagement strategic goals as tangible programmes, an organisation-led or top-down approach is often taken. This approach may be seen by larger organisations or funding providers as simpler to manage and deliver as the power, leadership and direction is more within their control from the outset. The issue for such an approach is, however, the depth of its success, the relevance to local communities and the long-term sustainability of the project. An alternative community-driven model is also available and can result in successful engagement and partnerships between community groups and larger organisations. Whilst more complex and challenging to develop and implement in the short term, the indications are that the projects have greater success and sustainability, therefore securing a life beyond the project funding. This approach may result in more effective use of public funds and more relevant community engagement between larger organisations such as museums and galleries and local community groups.

This approach has its own limitations and pitfalls such as politics within and between groups which, if not managed as part of the project development, can potentially undermine its success. The Bendigo heritage engagement project has involved collaboration between Bendigo Art Gallery, City of Greater Bendigo and 28 local heritage groups. The project will soon also involve a number of local schools and additional community-based stakeholders. The number and range of partners involved in the Bendigo example highlights the wide range of issues that do or could arise and potentially affect the success of any engagement work, regardless of its scope. In such a project the role of the project manager is complex and requires a range of skills

Beyond the rhetoric

and techniques to retain the authenticity of the community-driven model whilst enabling project success. Identifying and understanding the issues and politics arising within community-driven engagement projects will allow organisations such as galleries and museums to move beyond the rhetoric of community engagement towards sustainable and relevant projects which positively impact local communities.

Bibliography

Archibald, R., 2002. Introduction. *In: Mastering civic engagement: a challenge for museums*, Washington, DC: American Association of Museums, 1–6.

Belfiore, E., 2002. Art as a means of alleviating social exclusion: does it really work? A critique of instrumental cultural policies and social impact studies in the UK. *International Journal of Cultural Policy*, 8 (1), 91–106.

Belfiore, E. and Bennett, O., 2007. Rethinking the social impact of the arts. *International Journal of Cultural Policy*, 13 (2), 135–151.

Bennett, T., 1995. *The birth of the museum: history, theory and politics*. London: Routledge.

Cameron, F., 2006. Beyond surface representations: museums, edgy topics, civic responsibilities and modes of engagement. *Open Museum Journal* [online], 8. Available from: http://archive.amol.org.au/omj/volume8/volume8_index.asp (accessed June 2009).

Cuthill, M. and Fein, J., 2005. Capacity building: facilitating citizen participation in local governance. *Australian Journal of Public Administration*, 64 (4), 63–80.

Crooke, E., 2007. *Museums and community: ideas, issues and challenges*. London: Routledge.

Field, J., et al., 2000. 'Coming back': Aborigines and archaeologists at Cuddie Springs. *Public Archaeology*, 1 (1), 35–48.

Gibson, L., 2008. In defence of instrumentality. *Cultural Trends*, 17(4), 247–257.

Gray, C., 2007. Commodification and instrumentality in cultural policy. *International Journal of Cultural Policy*, 13, 201–215.

Gray, C., 2008. Instrumental cultural policies: causes, consequences, museums and galleries. *Cultural Trends*, 17 (4), 209–222.

Greer, S., Harrison, R., and McIntyre-Tamwoy, S., 2002. Community-based archaeology in Australia. *World Archaeology*, 34 (2), 265–87.

Jenson, J., 2002. Identifying the links: social cohesion and culture. *Canadian Journal of Communication*, 27, 141–151.

Kavanagh, G., 1994. *Museums and the First World War*. London: Leicester University Press.

Kelly, L., 2006. Museums as sources of information and learning: the decision making process. *Open Museum Journal* [online], 8. Available from: http://archive.amol.org.au/omj/volume8/volume8_index.asp (accessed June 2009).

Kreps, C., 2008. Appropriate museology in theory and practice. *Museum Management and Curatorship*, 23 (1), 23–41.

Lane, R., 2007. Museum outreach programs to promote community engagement in local environmental issues. *The Australian Journal of Public Administration*, 66 (2), 159–174 (accessed 16 August 2017).

Littler, J. and Naidoo, R., 2005. *The politics of heritage: the legacies of 'race'*. New York: Routledge.

Message, K., 2007. Meeting the challenges of the future? Museums and the public good. *reCollections: The Journal of the National Museum of Australia*, 2 (1), 71–93.

Newman, A., McLean, F., and Urquhart, G., 2005. Tackling problems of social inclusion. *Citizenship Studies*, 9 (1), 41–57.

Reddel, T. and Woolcock, G., 2004. From consultation to participatory governance? A critical review of citizen engagement strategies in Queensland. *Australian Journal of Public Administration*, 63 (3), 75–87.

Sandell, R., 1998. Museums as agents of social inclusion. *Museum Management and Curatorship*, 17 (4), 401–418.

Sandell, R., ed., 2002. *Museums, society, inequality*. London: Routledge.

Sandell, R., 2003. Social inclusion, the museum and the dynamics of sectoral change. *Museum and Society*, 1 (1), 45–62.

Scott, C., 2006. Museums: impact and value. *Cultural Trends*, 15, 45–75.

Selwood, S., 2004. The politics of data collection: gathering, analysing and using data about the subsidised cultural sector in England. *Cultural Trends*, 46, 13–97.

Smith, L., Morgan, A. and van der Meer, A., 2003. Community-driven research in cultural heritage management: the Waanyi women's history project. *International Journal of Heritage Studies*, 9 (1), 65–80.
Watson, S., ed., 2007. *Museums and their communities*. London: Routledge.
Weill, S., 2002. *Making museums matter*. Washington: Smithsonian Books.
Witcomb, A., ed., 2003. *Re-Imagining the museum: beyond the mausoleum*. London: Routledge.

44

From representation to participation

Inclusive practices, co-curating and the voice of the protagonists in some Italian migration museums

Anna Chiara Cimoli

Dynamizing the heritage

The focus of this article is primarily on the pioneering role of anthropology and art museums in Italy in the production of participative practices directed towards the inclusion of migrants. The second part consists of a reflection on how these practices are expressed, or may be expressed, in museums dedicated to migration.[1]

By 'inclusion of migrants' I refer to the development of tools designed to invite, consult and collaborate with the so-called 'new citizens', regardless of any curatorial outcome from this collaboration. These tools can include interpretation of the collections, negotiation of their meanings, and actualization of the museum heritage through comparison, narration, and evaluation conducted in partnership with the migrants.

In a broad sense. I refer to a debate zone where educators, curators, museum mediators, and migrants – individuals or groups – can meet and share thoughts, memories and interpretations, therefore enriching the complexity of the knowledge built through the museum experience. This very open and flexible definition of 'migrant inclusion' becomes useful and meaningful practice only when it stems from clear determination and conviction on the part of the museum, when it goes hand in hand with rigorous evaluation methods and when it translates into a new cultural attitude towards the migrant audiences.

From a methodological point of view, both as a museum educator and as a scholar, I follow the lead of Simona Bodo and Silvia Mascheroni (2012), who define heritage as a set of goods to be "put back into circulation" (in terms of a procedural, dialogical and circular vision). They consider the museum as "a place of encounters and relationships" which should welcome, and indeed encourage, multiple viewpoints and interpretations, and heritage education in an intercultural context as a transformative practice. In this regard, "what makes a museum's educational process inter-cultural […] is the development in the public, in all kinds of public, of those skills and competences that are increasingly necessary in a world of growing contact and exchange between different cultural practices, such as cognitive mobility, cultural decentralization, the problematization of one's own point of view, and the recognition of the multiple identities which each of us carries within" (Bodo and Mascheroni, 2012: 16. Other relevant references

The inclusion of immigrants: some examples from Italian anthropology and art museums

Reflection on the inclusion of immigrants in museums began, in Italy as in most European museums, in ethnographic and anthropology museums, particularly from the late 1980s. Only more recently this endeavor has affected art museums. Without attempting to present an overview of all the numerous practices and case studies in the field,[2] I will briefly present some recent and, I believe, effective examples, chosen in virtue of their exemplary nature under the methodological point of view.

These include the exhibition *Soggetti migranti. People behind the things*, designed within the framework of READ-ME2, Reseau Européen des Associations de Diaspora et des Musées d'Ethnographie, at the Museo Luigi Pigorini in Rome (2012–13). The project has been shared by the curators of the museum and representatives of some diaspora associations from a variety of countries (Associna, Buudu Africa, Kel'Lam non-profit organization, Mexican Catholic Community in Rome, Peruvian Community in Rome). The working team initially has identified a group of objects from the museum's collections, chosen because of their cultural significance. Secondly, the team has reflected on the layout of the exhibit display in which the associations involved could choose to 'adopt' objects.

The adoption method was also chosen in the case of *TAMTAM*, an intercultural collaborative practice which took place in the PIME Museum in Milan in 2011–12, in collaboration with the ISMU Foundation. The PIME Museum displays objects brought by missionaries from all over the world. Here the migrants – both experienced museum mediators and 'simple' individuals mainly from Latin America, Africa, the Philippines and Eastern Europe – were involved by the project staff in a storytelling experience which started from their own personal history and converged on an object adopted not only because of its aesthetic quality, but also because of its meaning and the resonance it had with the individual's memory.

Among the many other intercultural projects aimed at involving the migrants developed in recent years, I would like to cite *The Art of Making Difference* (Museum of Anthropology and Ethnography of the University of Turin with Associazione Arteco); *Tongue to Tongue. A collaborative exhibition* (University Museum of Anthropology and Ethnography with the Centre for African Studies in Turin); *Choose the Piece* (City of Modena Museum of Archaeology and Ethnology); *Plural Stories* (Ettore Guatelli Museum Foundation, Ozzano Taro di Collecchio), as well as the professional courses for museum mediators developed in Turin, Milan, Bergamo and other cities.[3]

In the last decade, the input and stimuli nurtured in museums of ethnography and anthropology were developed by art museums, and the dialogue between the two types of institutions became more and more fruitful. In Milan, an interesting case is that of *Brera: tutta un'altra storia* (Brera: another story), developed in the neoclassical galleries of the State Pinacotheque. Here, museum mediators with a foreign background tell a somewhat 'new story' of the history of art, leading the visitors through a path they have designed themselves, starting from an autobiographical reflection, and the ability of creating connections between different eras and artistic movements through personal associations.

Some Italian museums of contemporary art, in particular those of Turin, Bergamo, Milan, have been able to take a step further, shifting the focus from collections to practices of producing meanings, not wishing to transform anyone into an artist, but rather working with various tools of contemporary art – such as new technologies – in a collaborative way. In some cases, the

work with immigrant audiences has not entered the museum at all. On the contrary, it has been the museum which has ventured out into the local area, with its own methodology and specificities, and learned a great deal.

Turin has been a pioneering city from this point of view. The Castello di Rivoli and the Fondazione Sandretto Re Rebaudengo – the first a city museum, the second a private one – together with many other institutions, have set the standard for an open dialogue with the local community, the schools, the educators and the university. (Bodo et al. 2009; Pecci 2009; Pironti and Zanini 2010).

For many years, the Castello di Rivoli, among its many other activities, has operated a permanent project known as *Flying Carpet*, set up in the San Salvario neighborhood, one of the largest immigration areas of the city (mainly from northern Africa) and which has, over time, become a powerful vehicle for transformation. The Fondazione Sandretto Re Rebaudengo has developed several projects of an inter-cultural nature with adolescents and young adults, in partnership with other organizations in the area, which have had very positive effects in terms of approach to the museum, a growing sense of citizenship, and the acquisition of skills. The GAMeC-Gallery of Modern and Contemporary Art in Bergamo is also very active in this field and has been playing a pioneering role.

Up to this time, to simplify slightly, we have encountered the following methodological approaches: the *adoption* of the object (very common in museums of anthropology); *venturing out into the local area* (often used by museums of contemporary art), and *autobiography* (transversal). Another case is that of the Museo del Novecento in Milan. The subject here is *translation* from the native language into Italian, and from visual to verbal language.

The Museo del Novecento, dedicated to the art of the twentieth century, opened in 2010 in Piazza Duomo, in the historic center of the city. Along with a group of freelance colleagues of the ABCittà cooperative[4], we proposed several inter-cultural educational projects, which are now routinely offered to the public. The workshops share a common methodology. First and foremost, there is no 'making of art': no coloring, cutting, or assembling. Rather there is group debate, as per the methodology of peer education (consequently, having identified this methodology as the most appropriate for working with migrants, we cater only to adolescent and adult visitors, not children). Secondly, all the workshops take place in the museum's galleries, in the presence of the exhibits. Lastly, since we refer to an inter-cultural methodology, we do not exclusively address an audience of migrants, but rather a mixed, inter-ethnic audience consisting of high school classes and adults.[5]

Among the workshops offered to the public, the one called *The Words to Say It*, a language teaching workshop in the museum, in my opinion displays the most innovative features, and has attracted people to the museum who, otherwise, by their own admission, would never have visited. I refer to students of Italian language schools for migrants, among them refugees and asylum seekers, specifically those in Italy as a result of the Libyan crisis.

The route through the museum starts in the room dedicated to Lucio Fontana. Here, without too much preamble, participants are invited to lie down and look at a work from 1951 on the ceiling, and to encourage the evocation of images drawn from their own memories, or via free association. This first task, which is a kind of 'ice-breaker', often provides the opportunity to say something about oneself, and for the guide to 'weigh up' the linguistic level of the group.

In the next room, dedicated to the works of the 1950s and 1960s, the focus is on the use of materials such as glue, sand, lint, graphite dust, iron, cement and pumice. The comparison with the works of art allows associations with one's experience of those materials (cement is used by construction workers, glue is used by children in their homework, and some materials are often used in local handicrafts …).

The final activity is dedicated to a map by Alighiero Boetti, 1989, which is part of a series dedicated to the geopolitical representation of the world over the years. Here the activity can be manifold. It goes from identifying one's country of origin and reflecting on the symbol representing each nation (in this case it is the national flag but, according to the group, it may be the colors of the football team, the food, the most representative monument, etc.), to an observation on the technique used. For advanced level groups, a reflection on the concept of 'authorship' is also possible, often crossing over into a consideration of the role of new media.

Finally, the group takes a few minutes to discuss what was most interesting and what the participant will take away from the experience. This is always very useful in designing and organizing subsequent meetings. We also ask group leaders to send feedback to help us further improve future meetings.

Other museums, such as the British Museum, the V&A, the Smithsonian and the Getty, offer language courses for adults. However, the emergency surrounding the landings in Sicily and the arrival of many asylum seekers of all nationalities without, among other things, a common language, presents us with the need to communicate with people (who are sometimes illiterate) as soon as they arrive. It would appear that, in this case, the museum has been able to seize the urgency in real time, showing itself to be a true antenna at the service of society.[6] It would be important, in the future, to collect the output of these workshops (all participants are given little notebooks, where they can write or draw following some written suggestions) and to 'return' them to the audiences. The richness of the interpretations, the coming-and-going of memories between a 'here' and a 'there', and the openness towards the works of art constitute a precious gift to the museum and the city.

The migrants' voice in migration museums

I would like to focus now on the practices of inclusion of migrants in Italian migration museums. How do these museums deal with the migrants living in their local area? What tools do they use to take into account their experiences, opinions and challenges? Can we apply the 'nothing about us without us' rule here? I would think not.

In Italy, there are about thirty migration museums, for the most part rather small and local, usually focused on emigration from the country. Only recently have some institutions decided to switch from a static, historical narrative of the past to a more dynamic, multifaceted and contemporary approach (Tirabassi 2007a, Tirabassi 2007b).

The paradox is that, in a land so affected in the past by emigration to the 'new world', the museology of migration is still very immature, and struggles to see the phenomenon of migration as a permanent condition, innate to humanity itself (Livi Bacci 2010; Steiner et al. 2012). There are thus many museums dedicated to emigration, but there is still no wide-ranging treatment which balances both emigration and immigration, and which has the power to express both in an inclusive way and effectively address the tasks of inter-cultural training, education towards dialogue, and the prevention of prejudice.

However, leaving aside the many missed opportunities, I would like to cite three cases which I consider to be examples of a more dynamic and a more inclusive process. The first is that of the Galata-Museo del Mare e delle Migrazioni in Genoa, a maritime museum which in 2010 decided to dedicate a permanent section to the theme of migration (Cimoli and Buonasorte 2012, Cimoli 2013).

The museum design is highly immersive, multimedia-oriented, and based on environmental reconstructions, somewhat reminiscent of the examples of Bremerhaven German Emigration Center and Hamburg BallinStadt. The section dedicated to immigration differs from that dealing

with emigration, but is adjacent to it. The link between the two is very clearly explained. It starts in the year 1973, when the migration balance became positive, and is arranged by topic: travel, school, food and work, with a section dedicated to the landings in Lampedusa. At the end of the exhibition, the 'niches of reflection' offer the possibility to consolidate the information gathered by responding to a series of quizzes, with an ironic nod to the reality shows.

Notwithstanding the occasional invitations to speak at the museum, no form of 'live' mediation in the museum has been activated by the migrants thus far. This is planned for the future, depending on the economic resources available. The migrants were interviewed, however, during the process of creating the collection. The museum has established a privileged relationship with an Italian language school run by a non-profit organization, often asking for assistance from students in the form of borrowing materials, or even asking them to play the role of narrator/actor. Two students, for example, have become protagonists in the interactive exhibit 'Travel postcards', while the young people who appear in the reconstruction of a high school were chosen from those schools where a voluntary association carries out projects on the theme of multiculturalism.

As for the display case where objects related to faith and cultural belonging is concerned, the museum curators have asked friends and acquaintances of various communities to identify which ones were essential to them, what they brought with them on their journey, etc. In some cases they have requested objects on loan and, in other cases, they have purchased replicas. An important issue, therefore, is that of the relationship with active associations and the tertiary sector, and the ability to work in partnership with them. The aim of the current project is to create an archive of oral histories.

The Museo Narrante Nave della Sila (Sila Ship Narrative Museum), in Calabria, is another interesting case study. Located in the inner part of the region, it is situated within a literary park dedicated to Norman Douglas and travelers on the Grand Tour. Open only in summer, and in winter by appointment for school visits, the museum tells a story of Italian emigration in an area which, over the last decade, has been marked by intense immigration, by continual arrivals and the presence of temporary accommodation centers. In addition, the violent riots in Rosarno in 2010, motivated by exploited and underpaid migrant agricultural workers, convinced the association which manages the museum to devote more attention to the theme of immigration. For this reason, a new wing was designed and inaugurated in July 2013.

While the section on emigration was curated by a journalist, Gian Antonio Stella, retracing the steps of his book *The Horde*, the new wing refers to the world of film and new media, in order to create an immersive environment devoted to the theme of travel. After passing through a black curtain, designed to represent detachment from all previous experience, the visitor enters the spyglass of the container. Here, images of the sea are projected onto the floor, taken from a bird's eye view, in both calm and stormy conditions. The projection is amplified by the presence of mirrors along the lower parts of the walls. Above the mirrors a row of monitors shows images of travel recounted in both subjective and objective mode. These are provided by the Coast Guard, the Archivio Memorie Migranti and the ZaLab film production company. A carpet of amplified surround sound accompanies the images, intensifying the illusion of being on water.

To quote from the project: "The idea is to propose a reading of the journey of hope which gathers together all the stories of immigration from an unusual point of view which, at times, leads to a kind of reversal of perspective. Via the projection, the floor will be transformed into an expanse of continually shifting sea (alternating between calm and stormy) through which the visitors will have to make their way" (project by Ernani Paterra, WPS).

Moving further south and reaching the foothills of Italy, we arrive at the project for the Migration Museum on the island of Lampedusa. Despite the continual 'stops-and-starts' and

problems related to political upheavals and even (more or less explicit) outright sabotage, through Herculean effort the museum received final administrative approval in February 2013, with the signing of an agreement between the municipality and the promoters, for the creation of a subsidiary foundation. The collection consists of sacred texts, cards, personal items and photographs which have, in part, been re-read and reinterpreted by Giacomo Sferlazzo, a musician and visual artist who is the principal mover behind the Askavusa association. Also participating in the project are the Fondazione Migrantes, Legambiente, the Archivio Memorie Migranti and the Associazione Isole, non-profit organizations which are very active in safeguarding migrant heritage. The plan is for the objects, which are being catalogued, to be housed in the Town Hall. The Port Authority has also offered an area to the museum, while the Porta d'Europa by artist Mimmo Paladino will be another branch of the museum. Other important locations on the island will be identified by the organizers in partnership with the migrants.

In this peculiar case, working with the migrants is a necessity rather than a choice, and the flavor of the initiative is not only cultural but also highly political. It represents a manifestation of human and civil resistance which sees some Lampedusa locals working with, and for, the migrants on a daily basis. It is encouraging to notice that this work, which arose from an anti-institutional and strongly oppositional attitude, has resulted in a form of collaboration with the municipality, in the hope of giving life to this important place of civilization.

The opening of the museum is a few years away, but this collaboration is already expressed in its links with the LampedusaInFestival, which includes the active participation of the immigrant community.[7] According to Sferlazzo, the festival represents a "technical rehearsal" for everything the museum could be (interview of 12 April 2013). The starting point is self-narrative. The report that the migrant gives of him/herself is placed at the center, whether in the form of visual art, fiction, music and more. Only in this way, according to the organizers, can we build a new culture, a new language, and open new fields of study to read our present time according to categories which are less 'worn out' than the current ones. The project also invites migrants who have passed through the island to return to tell their story. A call to contemporary artists to interpret the heritage of the museum is also on the drawing board.

Learning from the others: suggestions for more dynamic and inclusive migration museums

Some of the practices mentioned earlier in relation to the museums of anthropology and contemporary art, such as storytelling, translation and interpretation based on personal experiences, as well as in-the-field workshops, may assist the migration museums in overcoming the risk of growing old too quickly, of being a one-off visit, or of having an overly local dimension. The only way to continue to speak a contemporary language is to communicate equally to 'old' and 'new' citizens, which is to consider everybody as an in-progress citizen, seeing ourselves as both players and spectators within the universal migratory experience and, whether directly or indirectly, touched by it.

Echoing the methods mentioned before, I would summarize by suggesting several lines of action which may be borrowed from other types of museum, and which could also be adopted by migration museums in order to develop an attitude of dialogue with the migrant public and promote inter-cultural education for all types of audiences.

Adoption: Migration heritage evolves with the passage of time, but some elements remain unchanged and common to different generations of migrants, as well as present in the experience of all. I refer, for example, to objects of affection, letters (physical or digital), pictures, presents, the entire vast field of self-representation through time. Updating this heritage, telling

its story and evolution over time, therefore 'adopting' it in a very personal way, implies reflecting on the history of migration, the concept of hospitality, citizenship, identity, etc. Visitors, whether or not they are immigrant, may help update the heritage by developing narrations (in written, filmed or digital form, also in real time during their visit) regarding their own luggage, their own way of keeping in touch with family through new media or their own objects of affection which help maintain a relationship with what we call home.

Venturing out into the local area: As several contemporary art museums have shown, the opportunity to work in the field is of great importance both for the museum and for its local community. Collecting stories, building archives, reflecting on shared modes of representation form the basis of a relationship of trust between the museum and its local area. Migration museums should be able to build a constant dialogue with the immigrants living in their territory, based on real, first-hand knowledge of life conditions, mutual trust and a genuine will to interact.

Autobiography and storytelling: These are tools which, although simple, are by no means trivial: on the contrary, they are always highly effective, precisely for their ability to excite and stir profound emotions. In this way one can construct a much more realistic story of migration within the museums, revealing both the dark side of disillusion and the brighter side of achievement, satisfaction and results.

Translation: This is translating from one language to another, but also from one culture to another or from one form of representation to another. Reflecting on this translation is in itself a huge exercise in meeting and listening. It is not only about offering language courses in the museum, but rather about a more subtle reflection on the translation from one language to another (for example, photography, music, theatre, dance …), from one's culture to another's. It is about designing tools for sharing experiences with or without words, in a material or immaterial way.

All of these routes seem to represent stimulating and yet-to-be-explored avenues of work. Despite the economic crisis which has greatly affected the cultural sector, many Italian museums are reflecting on ways to attract new audiences, being more inclusive and fully articulating their education potential. The adoption of an inter-cultural methodology represents a first step in this direction.

Notes

1 This article ensued from the Research Project *MeLa★ – European Museums in an age of migrations*, funded within the European Union's Seventh Framework Programme (SSH-2010-5.2.2) under Grant Agreement No. 266757.

2 In this context, it is worth highlighting the importance of Italian participation in research programmes funded by the European Union, such as "Museums Tell Man Stories" (2006–07). "Map for Id" (2007–09) and the LEM-Learning Museum (2010–13), which have represented a significant driving force for Italian museums.

3 Up-to-date information regarding all these projects can be found at http://fondazione.ismu.org/patrimoniocintercultura/index.php?lang=2 (accessed 23 May 2013).

4 www.abcitta.org; http://museodelnovecento.org/didattica/edu900-scuola, last accessed 21 May 2013.

5 In Lombardy, the percentage of non-Italian students in compulsory education is 13.2%, amounting to about 70,000 students. In high school, this decreases to 9.5% – a total of 35,000. Source: Dossier Statistico Immigrazione Caritas Migrantes 2012.

6 Simona Bodo includes the practice of teaching in the museum in inter-cultural actions to "integrate new citizens into the dominant culture," and is aware of its limitations; this practice would tend to strengthen "a static, substantialist notion of heritage, which is seen primarily as a bequeathed inheritance to be safeguarded and transmitted" (in Pecci 2009: 78). This would be true if we limited ourselves to teaching the language simply by naming the objects, without creating any kind of dynamic or interchange within the group, or elicit any feedback from the students and their group leaders.

Anna Chiara Cimoli

The premise, however, is that the canvas on which a painting is produced can become, metaphorically, a round table – a place for discussion, expression and therefore of learning. I agree with Bodo, however, when she says that if these practices are conceived as an end rather than a means, they are doomed to failure or, at best, become merely isolated episodes.

7 Dagmawi Yimer, a Somali citizen, who arrived in Italy via Lampedusa, later to become a filmmaker and star of the film 'Like a Man on Earth.' is working on the organization of the 2013 edition of the festival. The archive of materials collected in recent years constitutes a significant part of the heritage belonging to the museum.

Bibliography

Basso Peressut, Luca, and Clelia Pozzi, eds. 2012. *Museums in an Age of Migrations*. Milan: Politecnico di Milano DPA.

Baur, Joachim. 2010. "Il museo dell'immigrazione." *Nuova museologia* 22: 2–8. ["The Immigration Museum"]

Baur, Joachim. 2009. *Die Musealisierung der Migration. Einwanderungsmuseen und die Inszenierung der multikulturellen Nation*. Bielefeld: Transcript. [*The Musealization of Migration. Immigration Museums and the Staging of the Multicultural Nation*]

Bodo, Simona et al. 2007. *A Brera anch'io. Il museo come terreno di dialogo interculturale*. Milan: Electa. [*At Brera, Me Too. The Museum as a Vehicle of Intercultural Dialogue*]

Bodo, Simona, and Silvia Mascheroni. 2012. *Educare al patrimonio in chiave interculturale*. Milan: Fondazione ISMU. [*Educating to Heritage through an Intercultural Methodology*]

Bodo, Simona, Kirsten Gibbs, and Margherita Sani. 2009. *Museums as Places for Intercultural Dialogue*. Dublin: MAPforID Group.

Bolla, Margherita, and Angela Roncaccioli, eds. 2007. *Il museo come promotore di integrazione sociale e di scambi culturali*. Verona: Comune di Verona. [*The Museum as a Promoter of Social Integration and of Cultural Exchanges*]

Cimoli, Anna Chiara. "Migration Museums." In *European Museums in the 21st Century: setting the framework*, edited by Luca Basso Peressut, Francesca Lanz and Gennaro Postiglione, Vol. 2, 9–107. Milan: Politecnico di Milano DPA, 2013.

Cimoli, Anna Chiara, and Nicla Buonasorte. 2012. "Le Musée de la Mer à Gênes. Le nouveau pavillon « Mémoire et Migrations »." *Hommes et Migrations* 1299: 123–27. ["The Sea Museum in Genoa. The new 'Memory and Migration' Wing"]

De Angelis, Alessandra. "A Museum on the Margins of the Mediterranean. Between Caring for Memories and the Future". In *Cultural Memory, Migrating Modernities and Museum Practices*, edited by Beatrice Ferrara, 35–44. Milan: Politecnico di Milano DPA, 2012.

Golding, Viv. 2009. *Learning at the Museum Frontiers. Identity, Race and Power*. Farnham: Ashgate.

Golding, Viv. and Wayne Modest (eds.). 2013. *Museums and Communities: Curators, Collections and Collaboration*. London: Bloomsbury Academic.

Iervolino, Serena. 2013. "Museums, Migrant Communities and Intercultural Dialogue in Italy". In *Museums and Communities. Curators, Collections and Collaboration*, edited by Golding, Viv, and Wayne Modest, 113–29. London: Bloomsbury Academic.

Karp, Ivan, Corinne A. Kratz, Lynn Szwaja, and Tomas Ybarra-Frausto, eds. 2006. *Museum Frictions*. Durham and London: Duke University Press.

Keith, Kimberly F. 2012. "Moving beyond the mainstream: insight into the relationship between community-based heritage organizations and the museum." In *Museums, Equality and Social Justice*, edited by Richard Sandell, and Eithne Nightingale, 45–58. London–New York: Routledge, 2012.

Livi Bacci, Massimo. 2012. *A Short History of Migrations*. Cambridge: Polity Press (*In cammino. Breve storia delle migrazioni*. Bologna: il Mulino, 2010).

Pecci, Anna Maria, ed. 2009. *Patrimoni in migrazione*. Milan: Franco Angeli. [*Migrating Heritage*]

Pecci, Anna Maria, and Gianluigi Mangiapane. 2010. " 'Expographic Storytelling': The Museum of Anthropology and Ethnography of the University of Turin as a Field of Dialogic Representation." *The International Journal of the Inclusive Museum* 1: 141–54.

Pironti, Anna, and Paola Zanini. 2010. *Tappeto Volante. L'arte contemporanea nella valorizzazione del contesto sociale*. Turin: Ananke. [*On the Flying Carpet. Contemporary Art and the Empowering of Local Contexts*]

Sandell, Richard. 2007. *Museums, Prejudice, and the Reframing of Difference*. London–New York: Routledge.

Sandell, Richard, ed. 2002. *Museums, Society, Inequality*. London–New York: Routledge.

Sandell, Richard, and Eithne Nightingale, eds. 2012. *Museums, Equality and Social Justice*. London–New York: Routledge.

Steiner, Niklaus, Robert Mason and Anna Hayes, eds. 2012. *Migration and Insecurity: Citizenship and Social Inclusion in a Transnational Era*. London–New York: Routledge.

Szekeres, Viv. 2002. "Representing Diversity and Challenging Racism: the Migration Museum." In *Museums, Society, Inequality*, edited by Richard Sandell, 42–52. London-New York: Routledge.

Teulières, Laure, and Sylvie Toux, eds. 2008. *Migrations, mémoires, musées*. Toulouse: CNRS-Université de Toulouse-Le Mirail. [*Migrations, Memories, Museums*]

Tirabassi, Maddalena. 2007a. "Musei reali e virtuali sulle migrazioni." *Studi Emigrazione* 44: 754–61. ["Real and Virtual Migration Museums"]

Tirabassi, Maddalena. 2007b. "I luoghi della memoria delle migrazioni." In *Storia d'Italia. Annali 24. Migrazioni*, edited by Paola Corti and Matteo Sanfilippo, 709–23. Turin: Einaudi, ["The Sites of Migration Memory"]

45

Museums, trans youth and institutional change

Transforming heritage institutions through collaborative practice

Serena Iervolino

Introduction

How are Lesbian, Gay, Bisexual, Transgender and Intersex (LGBTI), particularly Transgender, histories and identities represented in museums and similar heritage sites, and in which ways are heritage institutions contributing to debates around trans issues? Museums are particularly interesting sites of investigation in this context. As mainstream organisations that claim cultural authority (Karp and Kratz 2000: 207) and are often considered 'as one of the last vestiges of trust' (Museum Association 2013), museums 'wield the power to perpetuate or disrupt the ways in which we experience sex, gender, and sexuality' (Levin 2010: 10). This chapter seeks to address this question through focusing on an empirical case study, a collaborative initiative between the Science Museum, London,[1] and Gendered Intelligence (hereafter GI), a London-based, not-for-profit organisation whose mission is 'to increase understandings of gender diversity through creative ways'[2] (2013–2014). GI works primarily with the trans community, offering support particularly to trans young people and their families and running arts programmes, creative workshops and trans youth sessions for trans people (under 25). More specifically, this chapter explores the process of co-designing the display case 'What Makes your Gender' (February–June 2014) for the Science Museum's *Who Am I?* gallery (hereafter *WAI*) (2010–), which was one of the tangible outcomes of this collaboration.

The author was recruited by the Science Museum to work on this participatory project, as well as on the larger project, funded by the UK's Arts and Humanities Research Council (AHRC), in the context of which the GI and Science Museum's collaboration emerged. The chapter presents the author's *grounded* analysis of this collaborative project to which she contributed as a participant observer. The author's active involvement in the project should be emphasised as, with a few notable exceptions (Dodd *et al.* 2008; Lynch and Alberti 2010), scholars have in fact typically presented collaborative projects to which they have not contributed personally, resulting in a focus on the 'output', often specific exhibitions which are 'read off' after the opening. Alternatively, accounts have been authored by museum staff highly invested in these projects, who therefore lack the essential distance and time[3] to reflect on those processes that, more or less explicitly, challenge traditional organisational structures and force museums to alter their established practices. This has produced a gap in the literature where

grounded, and often dispassionate, analyses of these power-sharing processes between museums and their 'communities', particularly LGBTI groups, have been rare.[4] This chapter aims to begin to alter this trend through presenting a detailed, grounded research of collaborative museum practice. This type of research approach is essential, as will become evident later, to better understand the dynamics of participatory heritage processes.[5]

The Science Museum's *WAI*, where the co-designed display was presented to the museum's diverse audiences, is a permanent gallery that comprises fifteen display cases, fourteen of which are (mostly) unchanging, whilst one – known as the Update Case – is temporary, being periodically 'updated' (hence its name) by the Contemporary Science Team.[6] By presenting 'What Makes your Gender' in the *WAI*'s Update Case, the Science Museum took the somewhat bold step to represent transgender identities in one of its permanent galleries, which explores the connections between human identities and science – particularly discoveries in genetics, brain sciences and advancements in medicine. Drawing on data generated during the process of co-design, as well as on semi-structured interviews conducted with key contributors to the process, a critical account of this collaborative initiative is provided. More specifically, this chapter seeks to highlight the impact that this approach to museum practice can have on *both* museums and their partners, whilst emphasising the significance of initiating community projects that present a strong alignment of interests within museums – amongst all their staff contributing to the projects. In addition, the chapter explores how a collaborative approach to exhibition-making allows this traditionally marginalised group to gain control over *their* representation in mainstream cultural institutions, thus actively contributing to shifting public attitudes towards non-normative gendered identities. More broadly, the chapter reflects upon museums' collaborative endeavours in the area of exhibition making and beyond, seeking to answer the following questions. Can museums effectively share their knowledge with non-experts, thus reconfiguring processes of knowledge production in more democratic ways? To what extent do participatory approaches facilitate long-term change in museums? What is uniquely transformative of collaborations with trans young people? And, lastly, what can heritage sites learn from the experience of museums such as the Science Museum?

As a major, national science museum in the UK whose mission is 'to make sense of the science that shapes our lives, help create a scientifically literate society and inspire the next generation',[7] the London's Science Museum represents a particularly compelling locus to address the questions above. This is because the relationship between the world of science and transgender experiences has been always complex, as repeatedly highlighted by GI and its youth group during the project. Whilst seemingly specific to the Science Museum and its (historical) medical collection, however, several of the challenges outlined hereafter resonate with those that heritage sites typically face. Heritage sites have often been more reluctant than museums to acknowledge and critically engage with LGBTI issues, even when these were enmeshed in their history. With few exceptions,[8] heritage sites have rarely employed interpretative strategies seeking to break the silence surrounding the lives of famous historical figures who did not conform to conventional norms about sexuality or gender, and would be called LGBTI people today.[9] Both museums and heritage sites, however, confront considerable dilemmas when interpreting past events and stories which inevitably requires longer historical perspective than that offered by the more recent past – particularly those that inherently reflect past, presently outdated, value systems and positions.

Before delving into the case study, the chapter briefly introduces recent debates around trans representation in mainstream media. Following this, a brief discussion of recent trends in museum trans representation and museum collaborative practices, particularly with disenfranchised groups, is necessary.

Museum collaborative practice

In recent years, transgender issues have received growing attention in Euro-American societies, becoming 'a subject of increasing social, cultural and legal interest' (Hines 2010a: 11). Trans issues have obtained increasing visibility in the media, particularly after the 2014 Eurovision Song Contest victory of the activist artist Conchita Wurst (Tzanelli 2014), who however openly stated to be a drag queen artist, not a trans woman.[10] Following this, in 2015 some influential trans people were represented in mainstream media, featuring on the covers of prominent magazines such as *Time* (Laverne Cox) and *Vanity Fair* (Caitlyn Jenner). These events mark an extraordinary shift as, up until recently, trans identities and histories have been marginalised within both the wider society and the LGBTI movement (Clarke and Peel 2007: 24; Lombardi 2007: 638).

It should be noted, however, that transgender people still suffer discrimination and hate crimes in many parts of the world, including in those societies where public attitudes are slowly changing and policies supporting LGBTI people are being introduced.[11] Whilst ignorance around transgender issue remains pervasive and inequality and discrimination continue to be persistent, transgender stories and issues are increasingly been told not only in mainstream media but also in museums. Indeed museums have started to *gradually* play an active role, seeking to address transgender issues and unveil transgender histories.

The recent increase in the number of exhibitions addressing LGBTI, and more specifically trans issues, has resulted from close collaborations between museums and trans groups. The application of a collaborative approach is becoming a prevailing trend in museum practice (Golding and Modest 2013; Simon 2010). Over the last two decades or so, the number of museums that, particularly across the Western world, have sought to initiate collaborations with individuals or groups outside their traditional audience profile has increased (Iervolino 2013). Through collaborative initiatives museums have provided marginalised 'communities', often defined according to categories such as ethnicity, 'race', disability, sexuality and religion, with concrete opportunities to inform museum exhibitions and shape *their* representation. LGBTI groups have received increasing attention and exhibitions exploring LGBTI issues have opened in several western museums.[12] As Sandell (2007: 191) and Mills (2010: 82) acknowledge, however, representations of transgender people have been largely omitted. Their heritage and histories have been rarely presented, let alone preserved, in museums (Mills 2008), even more rarely working collaboratively with trans individuals or groups. In recent years, a number of momentous, collaborative exhibitions presenting trans histories and identities have opened in the UK. The Museum of Liverpool, for instance, produced in collaboration with Homotopia – the international festival of queer arts and culture – the exhibition *April Ashley: Portrait of a Lady* (September 2013–March 2015) (Sandell 2017: 111). Birmingham Museum and Art Gallery held, in its Community Gallery, the exhibition *Mapping My Journey*, organised by the charity Gender Matters (January–March 2014).

The theme of community collaboration, with LGBTI and other communities, has attracted growing professional and scholarly attention, being described as 'an important and growing trend in professional practice' (Nightingale and Sandell 2012: 4). This has stemmed from several internal or external drivers for change urging museums to alter their relationship with their societies and more responsibly reflect their diversity. External or endogenous factors of change include the sectorial shift from an 'old' to the 'new museology' (Vergo 1989), a growing attention to museums' potential to act as agents of social change (Nightingale and Sandell 2012; Sandell 2002, 2007), an increasing concern towards ethical issues in museum theory and practice (Marstine 2005, 2011), and policy and political factors of pressure, including funding streams.[13]

With recent extraordinary cuts to public funding across the sector in the aftermath of the global economic downturn of 2007–2008 (Museum Association 2014; Siegal 2013), including to those specifically devoted to community work, museums have had to be creative and find alternative avenues to conduct collaborative work and create more inclusive representations. Recent research suggests that, in the UK, museums have in fact strengthened their ties with communities and empowered them in a way unlikely before the cuts. Based on research conducted at nine museums across the UK, Crossley (2016a) concludes that 'museum's work with vulnerable groups is thriving' as museum professionals consider this type of work pivotal, and are striving to identify new ways to continue to serve, and work closely with, vulnerable groups.[14] In addition, some institutions have even sought, and have been supported, to 'embed community participation in every aspects of their work' (Bienkowski 2016: 6).

In recent decades the increasing attention to participatory museum practices has generated a plethora of publications mostly focusing on specific case studies, mainly temporary exhibitions (for instance, Bodo, Gibbs and Sani 2010; Clifford 1997; Crooke 2006, 2007; Golding and Modest 2013; Iervolino 2013; Karp, Kreamer and Lavine 1992; Levin 2010; Marzio 1991; Nightingale 2010; Sandell, Dodd and Garland-Thomson 2010; Sandell and Nightingale 2012; Shatanawi 2012; Simon 2010; Watson 2007a). Scholarly attention has lately focused on issues of power, control and sharing of authority associated to museum participatory or co-creative practices (Lynch 2011a, 2011b, 2011c, 2013, 2014; Lynch and Alberti 2010). More recently, participatory approaches seeking to engage different communities in the development of major *permanent* galleries in large, national museums have been also investigated (Bunning *et al.* 2015). This chapter contributes to the debate surrounding heritage collaborative practice through moving the focus from the 'output' of a collaborative process to the process itself.

Reshaping collaborative practice

As explained above, the display 'What Makes your Gender?' was the main outcome of a collaborative project between the Science Museum and GI seeking to explore transgender heritage and its relation to the world of medical science. This collaboration took place in the context of *All Our Stories*, a Science Museum's AHRC-funded research project (April 2013–March 2014). The project resulted from a joint initiative between the AHRC and the UK's Heritage Lottery Fund (HLF).[15]

In the summer of 2012, several community and heritage groups across the UK received funding through the HLF *All Our Stories* (AoS) programme which offered 'everyone', more specifically local groups and communities, an opportunity to conduct independent community heritage projects, researching their past and producing several outcomes for public access. The AoS programme understood community heritage as the heritage that is of relevance to specific communities and local groups. As a result of the programme 542 community and heritage groups were awarded funding for projects aiming to explore different heritages. To support these groups, in close liaison with the HFL, the AHRC successively awarded eighteen research institutions across the UK, including the Science Museum, matching funding through the *Research for Community Heritage* grant (phase 2), part of the 'Connected Communities' programme. This funding enabled research institutions to provide the HLF AoS grantees with professional skills and knowledge that could inform their somewhat amateurish but often passionate efforts to conduct, interpret and further disseminate *their* heritage research (AHRC 2013). In this context, the Science Museum was awarded funding by the AHRC for its *All Our Stories* project, named after the HFL programme which it sought to support.

The Science Museum's *All Our Stories* team responsible for the design and delivery of the project was formed by Kayte McSweeney, then *All Our Stories* Research Coordinator and

Audience Advocate, and two especially recruited Postdoctoral Fellows – Sarah Chaney and the author of this chapter. The team offered guidance and research support, as well as access to the museum's resources and expertise, to several HLF's AoS grantees through delivering three, day-long seminars – two at the Science Museum and one at the National Railway Museum, York. Moreover, we worked closely with five of HLF's London-based AoS grantees (specifically GI, CoolTan Arts, Clapham Film Unit, British Wireless for the Blind Fund, Muslim Women's Welfare Association, Grove Park Heritage), whose projects explored themes of science and medicine, and were therefore intimately connected to the museum's collections and expertise. The Science Museum had in fact flagged up the HLF funding opportunity to two of those five HLF grantees, specifically CoolTan Arts and GI, which had previously voiced their interest in conducing projects critically exploring the Science Museum's collection. The HLF funding provided the two organisations with the financial resources to concretise this ambition.

The museum's selection of two civil society organisations with which to work closely, one having at its heart trans young people (GI), the other focusing on people with mental health experiences (CoolTan Arts), shows the museum's desire, more specifically of its Audience Research/Advocacy and Research and Public History departments that had initiated the AHRC grant application, to collaborate with two 'hard to engage' groups, whilst also seeking to impact the wider public and facilitate change in the entire institution. This was, however, an underlying but undeclared goal of the project (Joy, personal communication, 13 December 2013). The AHRC matching funding enabled the Museum to support more closely the two HLF grantees through facilitating their research process and helping them produce two museum 'outputs' to be presented on the institution's premises.

GI's HLF project 'Who Am I? Hacking into the Science Museum' (hereafter 'Hacking') was envisaged as a collaborative endeavour from the very outset. The museum and GI held a strong reciprocal interest, which was pivotal to success of 'Hacking'. But, why were these two distinctive organisations so interested in one another? 'Hacking' was not the first instance of a close collaboration between the museum and GI, as they had already worked together in 2012 on the project 'I-Trans: Constructing Identities through Technology', which explored how science and technology shape our gender identities. The trans young people contributing to 'I-Trans' strongly criticised how gender is represented in the museum's permanent *WAI* gallery (2010-), considering its representation of gender issues unsophisticated (Steward, personal communication, 12 December 2013). The young people had, as Steward explains (personal communication, 12 December 2013), 'strong opinions about that gallery and about how simplistic and problematic it was in terms of gender'. They lamented that the gallery implicitly replicated a binary, male versus female, idea of gender, for instance through the display 'Boy or Girl?' (Figure 45.1), whilst largely omitting transgender identities and the stories of trans people like themselves.

Their criticism provided the initial impetus for 'Hacking'. The museum and (some of) its staff were eager to take on board the young people's criticism, thus demonstrating that community work can effectively raise new questions about collections, approaches to heritage interpretation, and issues of representation, which may be unnoted and therefore under-researched by museum professionals, thus opening up new research avenues. 'Hacking' sought to explore broader issues of gender embodied in the museum's collections and displays.

The lead applicant of the GI's HLF grant application was Jay Steward, one of the co-founders of Gender Intelligence and an influential LGBTI person in the UK. He was recently awarded an MBE (Member of the Order of the British Empire) for his services to the trans community.[16] Steward (personal communication, 12 December 2013) explains that both institutions saw their partnership as a way to pursue their independent, yet interrelated goals. 'In a way they've got

Museums, trans youth and institutional change

Figure 45.1 The display 'Boy or girl?' in the 'Who am I?' gallery, Science Museum.
Soruce: © Serena Iervolino.

the massive audience that we can influence, and we've got the tiny set of niche people that they have a vested interest in. So it's a two-way street, definitely.' Specifically, GI could pursue its project of making the 'world more intelligent about gender', whilst the museum could continue its strategic queries around audience participation and collaborative practices.

The Science Museum, particularly the AHRC project's principal investigator, Annika Joy, saw in this collaboration a rare opportunity to conduct scholarly research on community collaboration, so as to inform the institution's future trajectories in this area of work. The grant enabled the museum, for the first time, to study critically how it could support community, heritage, interest or other groups, such as GI, wishing to conduct their *self-determining* research into the museum's collections, whilst actively controlling how *their* heritage is researched and communicated and *their* identities are represented. In so doing, GI could fulfil their own interests in the Science Museum, which clearly go beyond being addressed only as a potential target audience of the museum. Karp (1992: 11) argues, 'It is one thing for museums to try to broaden their audiences, and another for the public to claim the museum.' It is something even different for the museum to support *actively* these claims, which was the intention of the *All Our Stories* project. But, how can a *national* museum facilitate collection-based community research, and to what extent can this contribute to expand the institution's knowledge? These were the questions that the broader AHRC project sought to address. Ultimately the aim was to investigate the challenges and benefits of supporting more or less independent community heritage projects and initiatives, and explore whether 'research' could be included in the institution's permanent public engagement offer and how (Joy, personal communication, 13 December 2013). Joy also hoped to achieve another goal, however, that is, to *queer* the museum's narratives and collections.[17] This aim was in line with, and actively responded to, GI trans youth's condemnation of the museum's heteronormative discourse, as outlined above.

Serena Iervolino

The 'trans eye': queering museum collections and narratives

To elaborate on the museum's desire to bring to the surface and examine critically the heteronormative gender narratives that make up the Science Museum's discourse, it is imperative to briefly introduce the notions of transgender and gender identity, which were central to the 'Hacking' project but cannot be discussed in detail herein due to space limitations.

Hines (2010a: 1) explains that 'The term "transgender" denotes a range of gender experiences, subjectivities and presentations that fall across, between or beyond stable categories of "man" and "woman"'. It is an umbrella term that refers to people who feel that their sex assigned at birth does not match or sit easily with their gender identity. 'Gender identity' refers to a person's inner sense of self – as female, male or something else (American Psychological Association 2011). People who were assigned female but identify as male and (wish to) alter their bodies are also known as transmen or Female-to-Male (FtM); those who were assigned male but identify as female and (wish to) alter their bodies are called transwomen or Male-to-Fale (MtF).

What happens, Joy (personal communication, 13 December 2013) wondered, if a group of trans identifying young people – FtM, MtF, or queer – closely scrutinise, drawing on their knowledge and lived experience of gender issues, how the museum talks about gender through the objects it displays and the stories it tells? What other stories – which may question dominant, both historical and contemporary, sociocultural norms – come from the collection? By placing the museum's collections, displays or programmes under the 'trans' or 'queer' eye, the intention was to understand whether the institution's heteronormative[18] 'gaze' could be disrupted, with the long term aim of creating a more inclusive (gender) narrative.

Heteronormativity can be found virtually everywhere, in our knowledge systems and cultural institutions (Yep 2003: 11), including museums and similar heritage sites that perpetuate heteronormative ideologies. With the expression 'trans' or 'queer eye' Joy refers to trans youth's proclivity to detect instinctively and vigorously question the museum's heteronormative gaze by also applying elements of queer theory. Recently, queer theory has been applied to museum theory and practice to critique and disrupt traditional approaches to museum display and interpretation (Gabriel 2010; Levin 2010: 51–52; Mills 2008: 201). Through co-designing the display 'What Makes your Your Gender?', it was hoped that the young trans people could recommend non-normative, or even subversive, narratives. It would be misleading to claim that this act of disruption can only be enacted by someone who identifies as LGB or T or by a queer theorist. Nonetheless, 'there is something about consciously applying a mental search process for something that's not the normative narrative' as Joy (personal communication, 13 December 2013) maintains. Indeed, trans young people's acute sensitivity towards and understanding of gender issues became palpable during the display co-production. It was obvious that, as Steward (personal communication, 12 December 2013) stated, 'Young transgender people are very intelligent when it comes to gender, and they've got a lot to offer society.' Hereafter the discussion focuses on the workshops, through which we sought to facilitate the young people's conscious investigation.

Co-producing trans representation

Whilst the project included several steps and activities, it was during six day-long collaborative workshops with ten trans young people members of GI (September–November 2013) when the project's core was developed.[19] Then the Update Case's core message was defined, and objects and stories and overall interpretation strategies were selected. The workshops (Figure 45.2) were

670

Figure 45.2 One of the collaborative workshops during which the group was engaged in the development of the case's content.
Source: © Jason Elvis Barker.

facilitated by the AoS team, together with Jay Stewart and another GI facilitator, Jason Elvis Barker. Stewart and Barker brought in-depth knowledge of 'what language is appropriate to use or what those [trans] experiences look like or how kind of socially awkward a young trans person might be, and how best to work with that' (Stewart, personal communication, 12 December 2013). In addition, Katie Dabin, Curator of Clinical and Research Medicine, and Ling Lee, Content Developer, contributed to some workshops, respectively facilitating access to the collections and supporting the content development.

The workshops were emotionally challenging for all the participants, requiring the young people to engage instinctively with a theme closely linked to their lived experiences, and to verbalise and share anecdotes and feelings that were often personal and sensitive. The GI facilitators ensured that the workshops ran smoothly, in respect of GI's procedures and the needs of the vulnerable young people. Whilst sensitive and emotionally aware, the AoS team – all non-trans or cisgender persons[20] – were relatively unfamiliar with trans experiences, having worked before with vulnerable young people, but never with trans youth.

The AoS team's limited familiarity with trans issues mirrored the museum's paucity of knowledge of the subject. Indeed, if the Science Museum had already worked with GI in the context of the project *I-Trans*, this had facilitated only a limited interaction between the young trans people and the Museum's staff – primarily with the then Head of Science Museum Arts Programme, Hannah Redler. As a result, the long-term impacts on the museum of the *I-Trans* project were limited. When the Science Museum and GI started working closely on the co-design of 'What Makes your Gender?', none of the staff working on the project could be considered an 'expert' in trans issues or even medical interventions. If, in the project, someone could be regarded as an

'expert', this was GI and the trans youth group. This was in line with the AoS project's aims however, and was somewhat unavoidable due to the specificity of Hacking's theme.

As a group, we struggled with several 'dilemmas', including how to develop a simple, but intelligible concept for one display case only (Iervolino 2013) through which the group could obviously present – what Lee (personal communication, December 2013) describes as – only a 'snapshot', that is, a specific viewpoint on the subject. The question of how to present – within the Science Museum – the role that science and medicine have played, and still play, in trans people's lives and experiences was a rather difficult one to answer. Referring to this dilemma it is worth quoting Stewart at length.

> As you know, we had a long conversation … that ran through the project: 'is medicine our friend or our foe?' And it was very binary in terms of either being one thing or the other; and we were very clear we didn't want it to be so black and white. But, that's the crux of the argument. How, as trans-people, do we value advancements made through medical science and technology? Of course, we value that! We wouldn't … be able to do the things we do to our bodies, had it not been for medical advancement. So, of course, we've got that invested interest and can celebrate new technologies. At the same though, historically and still currently really, being trans comes from a pathological framework. That it's bad to be trans, that it's weird to be trans and that it's not ok, and it should either be cured or it should be made taboo and invisible in the wider public. Science has got a lot to answer for that … But if you're kind of slating science in the Science Museum in a display case, what would that look like and how productive would that be? I think, for me, it's about what do you want to achieve? What's the end point? If it's for people to engage in these discussions, for me that's going to make the world richer; rather than simplistically kind of 'pooh-poohing' science, which would come up against some criticism, if you did do that.

Stewart's statement clearly demonstrates GI's control of the case's message and objectives, as well as the organisation's determination to deploy *instrumentally* museums' cultural authority to reach its political goals; that is, to engage visitors in discussions about gender issues and to alter public attitudes towards trans individuals and communities, thus advancing trans political agendas and facilitating social change. The AoS team and other museum staff played an advisory and supportive role, providing the groups with knowledge and expertise in the area of exhibition production in which GI was lacking. Stewart acknowledges GI's inexperience in using the exhibition medium, which he describes as 'a different language' that can be employed to communicate a clear but powerful message, whilst openly acknowledging the need of its organisation to draw on the museum's specialist knowledge in this area (Stewart, personal communication, 12 December 2013).

In the end, the group settled for the concept 'gender is a spectrum', an idea supported by some feminist and trans scholars that challenge the gender binary, that is, the system that dichotomously distinguishes people between female and male, whilst advocating that *everybody*, not only trans and queer people, 'does gender' in a variety of ways along the gender spectrum. The display was imagined as presenting a (gender) 'toolkit' or a 'closet' where to present – as the concept document (produced after the last workshop) reads:

> … a range of objects which we use (but are often particularly important to Trans people) to help us express our gender identity so we can be ourselves. These will be everyday objects as well as more Trans specific e.g. binders and packers,[21] hormone pills etc.

Below a picture of the final display can be seen (Figure 45.3).

672

Figure 45.3 The display 'What makes your gender?' in the 'Who am I?' gallery, Science Museum, London.

Source: © Serena Iervolino.

Through presenting a trans perspective on gender identities and expressions, 'What Makes Our Gender?' enabled the two partner organisations to offer a more inclusive representation of human diversity in terms of gender to the museum's visitors. Rather than being relegated to a temporary exhibition – where previously neglected communities are often represented, thus running the risk of being marginalised as 'others' (Merriman and Poovaya-Smith 1996: 183), the display enabled representation and gave visibility to a trans group within a *permanent* (and, importantly, free entry) gallery of the Science Museum, a large national museum that welcomes 'every year over three million visitors'.[22] As the Update Case was utilised for the project, nonetheless, 'What Makes your Gender' had only temporary life in the *WAI* gallery. Yet its prominent location in a permanent gallery ensured that it was encountered, and could be viewed, by the Science Museum's large visiting public, both trans and non-trans (cisgender) people. As McSweeney (2014) states, effectively the display '…brought new voices and new perspectives into the museum', making trans (transitorily) part of the 'establishment', being viewed by the museum's wider public.

All the young people interviewed expressed a strong belief that the display's inclusion within a prominent gallery could have a profound impact on the museum's visiting public by shifting their negative attitudes towards trans and changing 'their minds and hearts', as one young person stated. 'It is things like that, normalising trans, not sensationalising trans – like putting it in a gallery where kids and family are, and trans are – I think that's so important', they added. Furthermore, the young people expressed a sense of *personal* and *collective* recognition – both as trans individuals and as members of the trans community – because a science museum, and not a different type of museum, had worked with them to present trans experiences.

> The fact that the Science Museum is hosting this project gives validation to trans as scientific notion. I don't know if this is the right world. It kind of verifies your identity. Because a lot of people think it is a psychological illness or something. It is really a nice thing that such a prestigious institution, probably the best 'sciency' one in the world, to actually recognize and teach people … It kind of validates it, which is really nice.

Whilst the display '…proved engaging to and welcomed by visitors', as McSweeney (2014) states, the actual extent to which the case did 'change hearts and minds' cannot be assessed. Drawing on the data generated, it is instead possible to elaborate on how this project – through which community members who are non-museum professionals participated as *partners* in the museum's professional business – impacted on the museum.

Community engagement as a motor for institutional change

As Lynch suggests (2011a: 14), in engagement projects communities are often placed in the role of passive 'beneficiaries' or 'supplicants', whilst museums normally take on the role of patriarchal, generous 'benefactors'. 'Hacking' instead strived to facilitate a more equalitarian relationship between two equal parties, enabling them to operate in a bespoke, intimate way and mutually benefit from the collaboration. If the museum benefitted 'in multiple ways, some more intangible than others' (Dabin, personal communication, 12 December 2013), the two areas below deserve particular attention as, it is believed, they impacted more directly on the institution's core functions, specifically curatorial/collection, thus embedding change in the organisation.

Museums, trans youth and institutional change

New collections

Collaborations with community groups may enable museums to acquire in their permanent custody objects and their stories, thus expanding their collection in a more inclusive manner.[23] Whilst this outcome was not anticipated or actively pursued by the museum, a degree of object accessioning became part of 'Hacking', almost naturally. When the group began to actively engage with the museum, the lack of trans materials was noticed and several spontaneous offers of donations were made by the young people. In general, they did not particularly engage with the objects pre-selected by Dabin as potentially relevant to the project, such as objects held in the museum's medical collection used in the past to 'test' gender-variant, and possibly transgender, children for gender identity (Figure 45.4). The young people regarded those objects as not effective in telling *their* stories.

As a result, a larger acquisition drive was set in motion as the group sought to acquire, within their community, relevant objects for the display. Ultimately their efforts enriched the museum's medical collection (McSweeney 2014), thus potentially facilitating the production of more inclusive (gender) narratives that challenge heteronormative assumptions in the future. To ensure that new acquisitions have a long-standing legacy, however, appropriate resources should be invested in objects' archival documentation (Iervolino 2014b).

Building staff knowledge and confidence

Hacking demonstrates that collaborations with interest groups have the potential to generate new knowledge, 'which would greatly influence and enrich the work that the Science Museum

Figure 45.4 Some of the objects that were shown to the young people during a visit to the Blythe House, where the Science Museum's collections are stored.
Source: © Jason Elvis Barker.

675

does' (McSweeney 2014). Importantly, partnerships can equip museum staff with both the knowledge and confidence to engage with different stories.

'Hacking' generated new knowledge around the theme of transgender, both medical and non-medical, heritage. The project enabled Dabin to reflect upon the gender dilemmas embedded in the collection she looks after, while acquiring knowledge about trans issues and 'a more sophisticated perspective that you can then feed back and start enriching the collections' (Dabin, personal communication, 12 December 2013). She further explains: 'The project made me realise how much non-medical interventions are important in terms of people's identity ... I mean changing gender can be a medical story but a lot of that isn't.' The more nuanced understanding of trans heritage that Dabin developed was palpable when reflecting upon new possible areas of research and collecting. The materiality and history of medical interventions and objects such as packers, which 'traditionally ... have not been seen as medical, in terms of how the collections have developed' (Dabin, personal communication, 12 December 2013), were cited as those she would be interested in collecting. She also referred to materials related to trans' disparate journeys of transition and those linked to their complex encounters and negotiations with the medical world, particularly with doctors, on the road to transition (for instance, medical records). She mentioned stories associated to these negotiations, both trans people's stories and clinicians' memoirs, so as to better understand the 'other' perspective, and how decisions are played out. It was apparent that Dabin had been 'positively provoked to consider her collection in light of trans identities and how she might display trans identities in the future Medical Gallery redevelopments' (Joy 2013). She talked passionately about how she had benefitted from the project, particularly in her capacity as leader of the new Medicine Galleries (to be completed in 2019). 'I had not actually realised how we could better include [these stories], but they are so important. My working practices have been definitively transformed. It was just really great!'

Importantly, the project had made her feel more confident of engaging with trans stories and helped her start thinking in non-normative ways. Such a confidence is essential when ensuring that the legacy of collaborative projects is long-lasting. But what are the benefits and challenges of this 'role reversal' between community members and the museum, where community members take on the role of subject specialists, which is ordinarily a curatorial privilege?

Reverting roles: benefits and challenges

The project demonstrates that, through working closely with community or interest groups, museums can gain greater insights into non-specialist knowledges of academic subjects, including STEMM subjects (science, technology, engineering, mathematics, and medicine). If well thought-out, community collaborations can enable museums and similar heritage sites to acquire understandings in niche subjects in which community members hold more knowledge than the museum's specialist staff. This results from the reality of the museum world where niche interests of the type held by GI can be rarely, if ever, covered by a collection specialist, or where heritage sites tend to focus on more mainstream stories and omit or ignore trans ones. Comprehensibly this 'role reversal' can cause some apprehension in the museum's curatorial staff who may experience a feeling of being unhelpful to, or even unprepared for community projects, as well as a sense of frustration for not making a particularly strong contribution to collaborative projects.

> ... I enable access to collections but sometimes I feel I don't have the right skills or knowledge to support some projects. Because there is a general assumptions that curators just know everything, and I think it's more complex than that ... Just knowing what to look for in the first place was difficult. I have been scared, well, there was a slight fear to pull out objects that were really clichéd.
>
> *(Dabin, personal communication, 12 December 2013)*

Here Dabin does *not* refer to her lack of previous experience and training to work with marginalised community members, and of necessary skills such as empathy, active listening, compassionate attitude, social perceptiveness, and other communication and interpersonal skills, which this work demands. These skills are not typically required in curatorial positions, but rather in social work roles. Interestingly, however, the two appositely recruited Postdoctoral Fellows were selected for the project due to both their research interests and their professional and life experiences, including in the field of social work. For instance, the writer's previous experience as a youth worker in a disadvantaged council estate in Leicester, UK, was regarded as valuable. It could be suggested that the lack of relevant training, experiences and skills can make curators feel unfit for community work. In the quote above, however, Dabin instead refers specifically to her anxiety deriving from her limited knowledge about trans. She elaborates on the point further.

> I don't have any detailed knowledge of any transgender issue ... I felt like I was only digging into the surface because I do not know enough, therefore I was only able to pick up clichéd objects or objects that would have come up under very obvious searches, such as gender, or things I just knew about like James Barry's picture ...

Dr Barry's picture (Figure 45.5), who was born as Margaret Ann Bulk and wanted to become a doctor at a time when such a profession was not open to women, was the *only* collection piece the young people engaged with. Whether or not Barry was a trans person, as this is debatable, the young people connected to his story, thus establishing a person-centred connection with a collection piece. The other objects did not attract the young people or challenge them with a significant story, being often predictable or even stereotypical (Dabin, personal communication, 12 December 2013). One trans young woman, for instance, lamented that the breast implants we showed them were rather stereotypical – as trans women rarely opt for breast augmentation, we learnt.

Drawing on this evidence it can be suggested that, if the aim is to facilitate collection-based engagements and to critically assess museums' – particularly historical – collections, detecting their embodied heteronormative and patriarchal assumptions, curators should be involved in community projects from their inception. 'Hacking' could have started with an in-depth process of collection research drawing on the group's knowledge. If an interdisciplinary collection research process with 'experts' from related fields, such as trans history – as envisaged by Dabin (personal communication, 12 December 2013), could be helpful, stronger efforts should be also made to facilitate community-led collection research *within* collaborative projects. A more active involvement of several museum departments, apart from the learning/audience research, seems fundamental to ensure that the transformative potential of museum collaborative work is fully exploited.

Figure 45.5 1980–550 Dr James Barry MD (1785–1865)/[c.1850]. Drawing, pencil and wash, col.; 31 × 22 cm.

Source: © The Board of Trustees of the Science Museum, London.

Conclusion

Whilst acknowledging museums' increasing interest in issues of diversity and equality, Nightingale and Sandell (2012: 1) point to the growing perplexity in the field that such an interest has 'brought about real change in institutions – their values, policies and practices with regards to all areas of activity'. The *All Our Stories* project was pioneering in its effort to critically examine the extent to which the Science Museum's collaboration with community groups – including trans (young) people, a conventionally marginalised and excluded group – could bring about real change in the organisation. Importantly, the project enabled the museum to conduct 'research for research's sake', which is unattainable in a practice-based museum environment that typically focuses on the production of museum outputs (Joy, personal communication, 13 December 2013). If the specific partnership produced a museum output, that is, the Update Case 'What Makes your Gender?', this was considered by the museum as a 'means to an end', whilst the research component was deemed central. The project was conceived as a little research incubator and its team was asked to study by doing.

This chapter shows that museums can be transformed from heritage institutions that carry out and disseminate research conducted in seclusion towards some that work collaboratively with communities, or even allow for the knowledge, passion, and interests of these external groups to guide museum work. If GI and its youth group led the process of co-designing 'What Makes your Gender?', the project only tangentially facilitated original collection research. In order to accommodate participants' (unsurprising) needs, however – specifically, to have their identities represented and validated in a mainstream cultural institution – the Science Museum embraced a familiar role, by supporting GI in the process of translating its knowledge into a display and assisting in the creation of a professional museum output.

If museums and heritage institutions want to ensure that the outcomes of collaborative work are embedded in the organisation's fabric, it is essential that collaborative work moves from the margins to the core (Nightingale 2009) – from the organisations' 'soft end', that is, the learning or audience departments, towards its 'hard end', that is, the curatorial and collection departments, as described by Joy (personal communication, 13 December 2013). For this to happen, however, a more active contribution of the museum's and heritage institution's 'hard end' to the entire participatory project – from funding application to its completion – is required. The minimal contribution of the Science Museum's curatorial department to the development of the AHRC bid resulted in several opportunities to be missed during 'Hacking'. The research shows, however, that engagement projects such as 'Hacking' can facilitate long-term change by providing curators with an opportunity to experience first-hand the positive impacts that community collaborations can have on their curatorial work. This awareness may transform them into enthusiastic facilitators, if not champions, of community collaborations.

Linked to this, the issue of funding requires careful consideration. It seems that at the Science Museum, as in many other museums and heritage institutions, funding opportunities for community projects are often identified and pursued (by learning and audience departments) without a deep interrogation of how they can be practically delivered or an adequate consultation of all the relevant departments/staff members; and certainly with only a partial understanding of how the institution can benefit from them. This is suggested by Dabin (personal communication, 12 December 2013):

> Maybe opportunities are taken first rather than really interrogated … It is not necessary bad, because I think something is better than nothing … You are slightly drawn into it and

people say 'it's not gonna take much of your time'.... So what's the point of involving us? I think there should be more thought heading into it, but often the practicalities of the project compress a lot of the thinking.

Practicalities have an important role to play, particularly in the face of the increasing competition for funding and the limited resources that museums can invest in the uncertain funding application phase. Not having been involved in its intellectual development, and therefore not feeling a sense of ownership of the project and sometimes considering it as not particularly relevant to their interests and work, however, curators might just offer a token participation – as Dabin suggests she might have done, had she not been genuinely interested in 'Hacking' and how it could feed into the new Medical Gallery development. This suggests that the significance of developing collaborative projects with community groups that present a strong alignment of interests not only between the museum and the external group, but also internally between the staff contributing to the process.

It should be noted that the specific, matching nature funding structure of the project played an important part in 'Hacking', which was funded by both GI and the Science Museum – through the HLF and AHRC grants. This facilitated the creation of a more equal relationship between the two partner institutions, thus counteracting the museum's tendency to play the role of a patriarchal, generous benefactor. It appears that the control of the budget has important implications, contributing to the definition of the degree of equality characterising relationships of different kinds, including in the context of community collaborations, and providing the material footing on which a more bespoke, equal relationship of collaboration can be established.

The Science Museum's eagerness to study collaborative practices and its interest (in those 'quarters' where the project had been initiated) in moving away from 'employing' community groups as a 'tool' in projects initiated and controlled by museum professionals and on which community groups have little or no say (Lynch 2011a: 6) to turning the museum and its collections into a resource on which community groups can draw when conducting their heritage research, make this project and its findings distinctive in the field of collaborative heritage practices. This shift could be mistaken for a trivial one by neophytes in the field of community museology. This should be in fact described as a sea change seeking to 'turn the museum around' and transform it from an institution disseminating internally generated knowledge to 'lay' audiences (sometimes drawing on the insights of specific communities), to an organisation supporting communities in conducting rigorous research in areas of their interest and disseminating knowledge to a broad audience. This transformation, if effectively steered, can facilitate the creation of a relationship 'of full reciprocity' (Hoerig 2010: 63) between museums and their communities, including trans groups. More research-based evidence such as those presented in this chapter are necessary, however, as Joy (personal communication, 13 December 2013) acknowledges, before a case can be made for *each* staff member's time, curatorial or otherwise, to be invested in community work.

The picture that emerges from this study is a complex and multifaceted one, which sees museums intersecting with power, inequalities, and identity politics, and contributing to sociopolitical and cultural change, whilst reconfiguring conventional processes of knowledge production and being internally transformed in the process. The author wishes to conclude by inviting museums, including the same London's Science Museum, to embrace *fully* the subversive, sometimes troubling, but potentially transformative changes that 'community' collaborations can engender. Drawing on the evidence presented in this chapter, it can be argued that working with communities, including trans communities, can make for museums' productive

Museums, trans youth and institutional change

(gender and other) trouble (Butler 1990), which can effectively alter museums' internal, often hierarchical, structures and their firm regimes of 'expert's' power/knowledge, whilst unveiling, if not challenging, their patriarchal, typically unconscious, heteronormative tendencies. The author's research strives to critically examine, and combat, such embedded cultural norms. Nonetheless, it is apparent that patience is needed for museums to really grasp the long-term impacts of engagement projects on their internal structures and established practices. It seems appropriate to end with Joy's (personal communication, 13 December 2013) statement:

> The machine of an institution of this size [Science Museum] is so slow that it will be years before the conversations that the curator has had with the young people from GI begins to take form in the museum. Long-term. … It's like there's another ten years work to do here and each time we're doing something it's slowly coming together into like 'rolls of bread'. Eventually we'll sort of put it all back together and re-mould it into something and see what the whole form is.

We shall see which shape a truly participative museum or heritage institution will actually take in the decades to come.

Notes

1 The Science Museum is part of the Science Museum Group, a family of museums that also includes the National Railway Museum (York), Museum of Science and Industry (Manchester), and the National Media Museum (Bradford).
2 See http://genderedintelligence.co.uk/ (accessed 15 October 2015).
3 See Macdonald (2001: 87) on the implication of the lack of distance and time for critical analyses of exhibitions.
4 Excellent examples of scholarly publications that discuss museum collaborative practice and examine its impact on both museum staff and communities work exist, including Watson (2007b), Dodd *et al.* (2008), and Golding and Modest (2013). Hardly any literature can be found, however, investigating community-led projects (such as the initiative discussed in this chapter) conducted in major national museums, and closely examined as part of a rigorous research project.
5 As demonstrated by a few seminal studies (O'Hanlon 1993; Macdonald 1997, 2001, 2002, Katriel 1997. See also Bouquet 2012), an ethnographic approach can offer unique insights into museum practice.
6 The Contemporary Science Team normally designs the update case working collaboratively with external groups. Whilst conducting curatorial research, Antenna differs from the curatorial departments for its focus on active engagement with the public (Lin, personal communication, 12 December 2013).
7 See http://goo.gl/PrrGbX (accessed 2 March 2016).
8 An exception is the Eltham Palace and Gardens, an English Heritage site, where a public event – *Queens Of Eltham Palace* – was organised as part of the UK's eighth LGBT History Month. The event sought to tell the rich 'LGBT history' (Vincent 2014: 144) of Eltham Palace and its historical inhabitants.
9 In this context, an example is Berkeley Castle (UK), a heritage site where King Edward II of England is thought to have been murdered in 1327 by forces loyal to his wife, Queen Isabella of France. Whilst, today, it is generally acknowledged that Edward was homosexual or possibly bisexual, being considered by some a 'gay icon' (Mortimer 2008), this aspect of his identity and how it shaped his life and, ultimately, caused his death have been overlooked at the Castle. Whilst the history of King Edward is contentious, as evidence conflict with one another, the Castle's reticence to address his sexuality suggests that his homosexuality or bisexuality is still received with disapproval by some.
10 See www.youtube.com/watch?v=l798BATHy4U&feature=youtu.be (accessed 15 October 2015).
11 See, for instance, www.huffingtonpost.com/news/transgender-hate-crimes/ (accessed 2 March 2016).
12 Prominent exhibitions exploring themes related to LGBTI culture and heritage include *Pride and Prejudice: Lesbian and Gay London* (1999) and *Queer is Here* (2006) at the Museum of London (Mills 2010; Sandell and Frost 2010), *The Warren Cup: Sex and Society in Ancient Greece and Rome* (2006) at the

British Museum (Frost 2010; Sandell and Frost 2010), *Hidden Histories* (New Art Gallery in Walsall, 2004) (Petry 2004, 2010), *Hello Sailor! Gay life on the ocean wave* (Merseyside Maritime Museum in Liverpool, 2006) (Tseliou 2014), *Gay Icons* (National Portrait Gallery, 2009), *David Hockney 1960–1968: A Marriage of Styles* (Nottingham Contemporary, 2009), Family Album (Grace Gallery, Sheffield, 2009) (Sandell and Frost 2010); *Queering the Museum* (2010–11) at Birmingham Museum and Art Gallery (Frost 2010; Tseliou 2014), *Hitched, Wedding Clothes and Customs* (Sudley House in Liverpool, 2010) (Tseliou 2014), *sh[OUT]: Contemporary art and human rights* (Gallery of Modern Art in Glasgow, 2009) (Sandell *et al.* 2010).

13 Particularly so-called social inclusive policies, such as those adopted in the UK by New Labour after 1997, have been considered as 'instrumental' policy forms by some commentators (Belfiore 2002; Gray 2008). It has been suggested that these *forced* museums to operate outside of the 'core' elements of museum practice traditionally considered as related to heritage preservation and presentation undertaken by trained 'experts'.

14 See also Crossley 2016b.

15 The HLF is an executive, non-departmental public body that gives grants to support the heritage sector, drawing on money raised through the National Lottery.

16 An MBE is awarded 'for a significant achievement or outstanding service to the community', as well as '…for local "hands-on" service which stands out as an example to other people'. (https://goo.gl/n1kUAb accessed 21 November 2015).

17 In *A Critical Introduction to Queer Theory*, Nikki Sullivan (2003) takes issues with queer theorists' typical refusal to define 'queer' and how it functions in specific contexts. After reviewing the ways in which the term has been used, she argues: 'it may be more productive to think of queer as a verb (a set of actions), rather than as a noun (an identity, or even a nameable positionality formed in and through the practice of particular actions' (Sullivan 2003: 50). She (2003: vi) further explains that her aim is 'to queer – to make strange, to frustrate, to counter, to delegitimize, to camp up – heteronormative knowledges and institutions, and the subjectivities and socialites that are (in)formed by them or that (in) form them'. In the interview Joy employed the verb 'to queer' in a similar fashion, which is in line with the author's understanding of the term.

18 Heteronormativity is an ideology that refers to the naturalised and unquestioned presumption of heterosexuality, the promotion of gender conventionality and family traditionalism (Jackson 2006).

19 The project also included an oral history component which will not be discussed herein, however.

20 Recently added to the Oxford English Dictionary, the word 'cisgender' refers to 'a person whose sense of personal identity corresponds to the sex and gender assigned to him or her at birth' (Green 2015).

21 Packers are worn by some trans women to give the appearance of having a penis, whilst binders are used by trans men to flatten breast tissue and create a male-appearing chest.

22 See www.sciencemuseum.org.uk/about_us/history/facts_and_figures.aspx (accessed 11 November 2015).

23 See also Kuceyeski 2008.

Bibliography

American Psychological Association. 2011. *Answers to your questions about transgender people, gender identity, and gender expression*. Available at www.apa.org/topics/lgbt/transgender.pdf (accessed 5 November 2015).

Arts & Humanities Research Council (AHRC). 2013. *Research for Community Heritage*. Swindon, Wiltshire: AHRC.

Belfiore, E. 2002. 'Art as a means of alleviating social exclusion: does it really work? A critique of instrumental cultural policies and social impact studies in the UK'. In *International Journal of Cultural Policies*, 8(1): 91–106.

Bienkowski, P. 2016. *No longer Us and Them. How to change into a participatory museum and gallery. Learning from the Our Museum programme*. London: Paul Hamilton Foundation.

Bodo, S., Gibbs, K. and Sani, M. (eds) 2010. *Museums as places for intercultural dialogue: selected practices from Europe*. MAP for ID Group.

Bouquet, M. 2012. *Museums. A Visual Anthropology*. London and New York: Berg.

Bunning, K., Kanavagh, J., McSweeney, K. and Sandell, R. 2015. 'Embedding plurality: exploring participatory practice in the development of a new permanent gallery'. In *Science Museum Group Journal*, Issue 3 (Spring 2015).

Butler, J. 1990. *Gender Trouble: Feminism and the subversion of identity*. New York; London: Routledge.

Clifford, J. 1997. *Routes. Travel and Translation in the Late Twentieth Century*. Cambridge, Mass.; London: Harvard University Press.

Clarke, V. and Peel, E. 2007. 'From lesbian and gay psychology to LGBTQ psychologies: a journey into the unknown'. In Clarke, V. and Peel, E. (eds) *Out in Psychology: Lesbian, Gay, Bisexual, Trans and Queer Perspectives*. Chichester, West Sussex: John Wiley & Son Ltd, pp. 11–35.

Crooke, E. 2006. 'Museums and community'. In MacDonald, S. (ed.) *A Companion to Museum Studies*. Malden, MA and Oxford: Blackwell, pp. 170–185.

Crooke, E. 2007. *Museums and Community: Ideas, Issues and Challenges*. London: Routledge.

Crossley, L. 2016a. *Feeling the squeeze and doing it anyway: how museums are changing lives during the age of austerity*. 2016 Festival of Postgraduate Research. Leicester University. 7 July 2016. Available at www2.le.ac.uk/research/festival-2016/meet/2016-posters/laura-crossley-poster-1 (accessed 13 October 2016).

Crossley, L. 2016b. *Heritage changes lives: how partnerships between museums and community organisations are making positive differences to people's lives*. Conference paper. Association of Critical Heritage Studies. Third Biennial Conference. 4 June 2016.

Dodd, J., Sandell, R., Jolly, D. and Jones, C. 2008. *Rethinking Disability Representation in Museums and Galleries*. Leicester: RCMG, University of Leicester.

Frost, S. 2010. *Queering the Museum. Birmingham Museum and Art Gallery*. Exhibition Review. Available at http://mattjsmith.com/wp-content/uploads/2014/12/Journal_035-61.pdf (accessed 12 September 2016).

Gabriel, P. 2010. 'Why grapple with queer when you can fondle it?' In Levin, A. K. (ed.) *Gender, Sexuality, and Museums. A Routledge Reader*. London and New York: Routledge, pp. 71–79.

Golding, V. and Modest, W. (eds) 2013. *Museums and Communites: Curators, Collections and Collaboration*. London: Bloomsbury Academic, pp. 113–129.

Gray, C. 2008. 'Instrumental policies: causes, consequences, museums and galleries'. In *International Journal of Cultural Policies*, 17(4): 209–222.

Green, C. 2015. '"Cisgender" has been added to the Oxford English Dictionary'. In *Independent*. Thursday 25 June. Available at www.independent.co.uk/incoming/cisgender-has-been-added-to-the-oxford-english-dictionary-10343354.html (accessed 19 March 2016).

Hines, S. 2010a. 'Introduction'. In Hines, S. and Sanger, T. (eds) *Transgender Identities: Towards a Social Analysis of Gender Diversity*. New York and London: Routledge, pp. 1–22.

Hines, S. 2010b. 'Recognising diversity? The Gender Recognition Act and Transgender Citizenship'. In Hines, S. and Sanger, T. (eds) *Transgender Identities: Towards a Social Analysis of Gender Diversity*. New York and London: Routledge, pp. 87–105.

Hoerig, K. A. 2010. 'From third person to first: a call for reciprocity among non-native and native museums'. In *Museum Anthropology*. 33(1): 62–74.

Iervolino, S. 2013. 'Museums, migrant communities and intercultural dialogue in Italy'. In Golding, V. and Modest, W. (eds) *Museums and Communites: Curators, Collections and Collaboration*. London: Bloomsbury Academic, pp. 113–129.

Iervolino, S. 2014a. *Project Report: 'Who Am I? Hacking into the Science Museum': A Gendered Intelligence Project with the Science Museum*. Report commissioned within the AHRC-funded 'All Our Stories' Project. London: Science Museum.

Iervolino, S. 2014b. *Learning to Change for the Better: Museums and Collaborative Practices*. Internal report commissioned within the AHRC-funded 'All Our Stories' Project. London: Science Museum.

Jackson, S. 2006. 'Gender, sexuality and heterosexuality: the complexity (and limits) of heteronormativity'. In *Feminist Theory*. 7(1): 105–121.

Karp, I. 1992. 'Introduction: museums and communities: the politics of public culture'. In Karp, I., Kreamer, C. M. and Lavine, S. (eds) *Museums and Communities: The Politics of Public Culture*. Washington, D.C. London: Smithsonian Institution Press, pp. 1–17.

Karp, I. and Kratz, C. A. 2000. 'Reflections on the fate of Tippoo's Tiger'. In Hallam, E. and Street, B. V. (eds) *Cultural Encounters. Representing 'Otherness'*. London and New York: Routledge, pp. 194–228.

Karp, I., Kreamer, C. M. and Lavine, S. (eds) 1992. *Museums and Communities: The Politics of Public Culture*. Washington, D.C. London: Smithsonian Institution Press.

Kuceyeski, S. 2008. 'The Gay Ohio History Initiative as a model for collecting institutions'. In *Museums & Social Issues*. 3(1): 125–132.

Levin, A. K. (eds) 2010. *Gender, Sexuality, and Museums. A Routledge Reader*. London and New York: Routledge.

Lombardi, E. 2007. 'Public health and trans-people: barriers to care and strategies to improve treatment'. In Meyer, I. H. and Northridge, M. E. (eds) *The Health of Sexual Minorities. Public Health Perspectives on Lesbian, Gay, Bisexual and Transgender Populations.* New York: Springer.

Lynch, B. T. 2011a. *Whose cake is it anyway? A collaborative investigation into engagement and participation in 12 museums and galleries in the UK.* Report commissioned by the Paul Hamlyn Foundation. London: Paul Hamlyn Foundation. Available at http://issuu.com/paulhamlynfoundation/docs/phf_museums_galleries (accessed 18 September 2012).

Lynch, B. T. 2011b. 'Collaboration, contestation and creative conflict. On the efficacy of museum/community partnerships'. In Marstine, J. (ed.) *The Routledge Companion to Museum Ethics: Redefining Ethics for the Twenty-first Century Museum.* London: Routledge, pp. 146–163.

Lynch, B. T. 2011c. 'Custom-made reflective practice: can museums realise their capabilities in helping others realise theirs?' In *Museum Management and Curatorship.* 26(5): 441–458.

Lynch, B. T. 2013. 'Reflective debate, radical transparency and trust in the museum'. In *Museum Management and Curatorship,* 28(1): 1–13.

Lynch, B. T. 2014. 'Generally dissatisfied: hidden pedagogy in the postcolonial museum'. In *Thelma. La revue des Musées de la civilisation* (Inaugural Issue), pp. 1–17.

Lynch, B. T. and Alberti, S. J. M. M. 2010. 'Legacies of prejudice: racism, co-production and radical trust in the museum'. In *Museum Management and Curatorship,* 25(1): 13–35.

Macdonald, S. 1997. 'The museum as the mirror. Ethnographic reflections'. In James, A., Hockey, J. and Dawson, J. (eds) *After Writing Culture: Epistemology and Praxis in Contemporary Anthropology.* London: Routledge, p. 161.

Macdonald, S. 2001. 'Ethnography in the Science Museum, London'. In Gellner, D. N. and Hirsch, E. (eds) *Inside Organizations: Anthropologists at Work.* Oxford and New York: Berg, pp. 77–96.

Macdonald, S. 2002. *Behind the Scenes at the Science Museum.* Oxford and New York: Berg.

Marstine, J. 2005. *New Museum Theory and Practice: An Introduction.* Malden, USA, Oxford, and Victoria: Blackwell Publishing.

Marstine, J. (ed.) 2011. *The Routledge Companion to Museum Ethics: Redefining Ethics for the Twenty-first Century Museum.* London: Routledge.

Marzio, P. C. 1991. 'Minorities and fine-arts museums in the United States'. In Karp, I. and Lavine, S., (eds) *Exhibiting Cultures. The Poetics and Politics of Museum Display.* Washington, D.C., London: Smithsonian Institution, pp. 121–127.

McSweeney, K. 2014. *Connected Communities: All Our Stories at the Science Museum.* Grant Reference: AH/K007793. Report submitted to the ARHC. London: Science Museum.

Merriman, N. and Poovaya-Smith, N. 1996. 'Making culturally diverse histories'. In Kavanagh, G. (ed.) *Making Histories in Museums.* London and New York: Leicester University Press, pp. 176–187.

Mills. R. 2008. 'Theorizing the queer museum'. In *Museums & Social Issues,* 3(1): 41–52.

Mills, R. 2010. 'Queer is here? Lesbian, Gay, Bisexual and Transgender histories and public culture'. In Levin, A. K. (ed.) *Gender, Sexuality, and Museums. A Routledge Reader.* London and New York: Routledge, pp. 80–88.

Mortimer, I. 2008. 'A note on the deaths of Edward II'. Available at www.ianmortimer.com/EdwardII/death.htm (accessed 18 March 2016).

Museum Association. 2013. *Public perceptions of – and attitudes to – the purposes of museums in society.* A report prepared by BritainThinks for Museums Association. March 2013. London: Museum Association Available at www.museumsassociation.org/download?id=954916 (accessed 17 October 2015).

Museum Association. 2014. *Cuts Survey 2014.* November 2014. London: Museum Association. Available at www.museumsassociation.org/download?id=1123548 (accessed 24 October 2015).

Nightingale, E. (ed.) 2010. *Capacity Building and Cultural Ownership – Working with Culturally Diverse Communities.* London: V&A.

Nightingale, E. 2009. 'From the Margins to the Core'. In *Journal of Museum Education,* 34(3): 255–269.

Nightingale, E. and Sandell, R. 2012. 'Introduction'. In Sandell, R. and Nightingale, E. (eds) *Museums, Equality, and Social Justice.* Abingdon, Oxon; New York: Routledge.

O'Hanlon, M. 1993. *Paradise. Portraying the New Guinea Highlands.* London: British University Press.

Petry, M. 2004. *Hidden Histories – 20th Century Males Same Sex Lovers in the Visual Arts.* London: Art Media Press.

Petry, M. 2010. 'Hidden histories: The experience of curating a male same sex exhibition and the problems encountered'. In Levin, A. K. (ed.) *Gender, Sexuality, and Museums. A Routledge Reader.* London and New York: Routledge, pp. 151–162.

Sandell, R. (ed.) 2002. *Museum, Society, Inequality*. London: Routledge.

Sandell, R. 2007. *Museums, Prejudice and the Reframing of Difference*. London and New York: Routledge.

Sandell, R. 2017. *Museums, Moralities and Human Rights*. Abingdon, Oxon and New York: Routledge.

Sandell, R., Dodd, J. and Jones, C. 2010. *An evaluation of sh[OUT] – The social justice programme of the Gallery of Modern Art, Glasgow 2009–2010*. Leicester: University of Leicester.

Sandell, R., Dodd, R., Garland-Thomson, R. (eds) 2010. *Re-presenting Disability: Activism and Agency in the Museum*. London: Routledge.

Sandell, R. and Frost, S., 2010. 'A persistent prejudice'. In Cameron, F. and Kelly, L. (eds) *Hot Topics, Public Culture, Museums*. Newcastle upon Tyne: Cambridge Scholars Publishing, pp. 151–174.

Sandell, R. and Nightingale, E. (eds) 2012. *Museums, Equality, and Social Justice*. Abingdon, Oxon; New York: Routledge.

Shatanawi, M., 2012. 'Engaging Islam: working with museum communities in a Multicultural Society'. In *Curator. The Museum Journal,* 55(1): 65–79.

Siegal, N. 2013. 'Euro crisis hits museums'. In *Art in America*. Issue. 3 May 2013. Available at www.artinamericamagazine.com/news-features/magazine/euro-crisis-hits-museums/ (accessed 24 October 2015).

Simon, N. 2010. *The Participatory Museum*. Santa Cruz, California: Museum 2.0.

Sullivan, N. 2003. *A Critical Introduction to Queer Theory*. Edinburgh: Edinburgh University Press.

Tseliou, M-A. 2014. *Museums and heteronormativity: exploring the effects of inclusive interpretive strategies*. PhD thesis. Leicester: University of Leicester.

Tzanelli, R. 2014. 'Conchita's Euro-vision: on aesthetic standard and transphobia battles'. In *OpenDemocracy*. 26 May 2014. Available at https://goo.gl/NmFYio (accessed 15 October 2015).

Vergo, P. (ed.) 1989. *The New Museology*. London: Reaktion Books.

Vincent, J. 2014. *LGBT People and the UK Cultural Sector: The Response of Libraries, Museums since 1950*. Farnham (UK) and Burlington (USA): Ashgate.

Watson, S. (ed.) 2007a. *Museums and their Communities*. Abingdon: Routledge.

Watson, S. 2007b. 'History museums, community identities and a sense of place'. In Knell, S., Macleod, S. and Watson, S. (eds) *Museum Revolutions. How Museums Change and are Changed*. Abingdon and New York: Routledge, pp. 160–172.

Yep G. A. 2003. 'The Violence of Heteronormativity in Communication Studies'. In *Journal of Homosexuality*, 45: 2–4, 11–59.

46
Embrace the margins
Adventures in archaeology and homelessness

Rachael Kiddey and John Schofield

Part 1: introduction

Background

In his 'archaeological critique of universalistic reason', Gonzales-Ruibal notes how the vocabulary of some archaeologists engaged in what might be termed humanitarian activities, 'unwittingly resonates with the (neo)colonial rhetoric of development' (2009: 114). He cites Žižck (2004: 178–79) who describes how many Western academics 'cling to some humanitarian ritual … as proof that, at the core of their being, they are not just cynical career-oriented individuals but human beings naively and sincerely trying to help others'. Equally, during this project, we repeatedly heard homeless people criticizing 'do-gooders' who set out to help them, people usually connected to the Church. There was thus only a narrow margin for getting this project right, for doing good without patronizing; for creating a project that was genuinely helpful to its participants and to promote a heritage discourse that increasingly seeks to challenge the authoritative view (e.g. Smith, 2006). We understood the potential pitfalls and challenges of working with vulnerable people, but also the likely benefits for those participants who chose to get involved. Ultimately, we wanted to conduct an archaeological study of contemporary homelessness that broke new ground in several ways: we wanted to truly engage the homeless community (or at least those who wanted to participate) in constructing an archaeology of themselves; we wanted to understand the material culture and the landscape of homelessness; and we wanted to somehow connect this study of homelessness with more official views of heritage (e.g. Smith, 2006). Put simply, we wanted to know what the connections were between heritage policy and practice and excluded or minority groups, and whether participation in the archaeological project offered genuine and tangible benefits for the communities and individuals concerned.

At the risk of appearing self-congratulatory, we have enjoyed conducting this study, and our homeless colleagues have clearly enjoyed it too, seeing it as a distraction from the mundane and predictable routines of life on the street. They have learnt about themselves and they have learnt about us. They now know that heritage is not (or should not be) elitist, but rather that everyone's views and places count – 'history rocks!', as one of our colleagues (Whistler) said recently. They welcome our interest, as we shall see. In this essay we describe three aspects of the project:

first, we examine changes to the way cultural heritage is perceived and understood, by practitioners and society at large; second, we review some ethical issues that studies of this kind introduce; and finally, we describe some results from our study and some of their implications. The project is not complete. A self-contained pilot phase (described here) has now been replaced by a larger, broader project, also based in Bristol, which forms the subject of Rachael Kiddey's (RK) Ph.D. research under the supervision of John Schofield (JS) at the University of York. But, at the completion of the pilot phase, it seems timely and appropriate to take stock, review progress, and gauge reaction to the project thus far.

Archaeology, heritage, and the public

Archaeology has a broad base, and offers a range of intellectual possibilities. Its close attention to material culture and place, and to interpreting traces of evidence for past human behaviour, embraces the full range of human experiences, from the deep past to the very latest depositions, and is inclusive of everyone in society. Archaeology also provides a range of possibilities for public participation and engagement, not only with the archaeological process but also with intellectual content. During our wanderings in Bristol we often discussed archaeology, and one recurring theme was the similarities between survival strategies of contemporary homeless and earlier hunter-gatherer societies, in terms of food gathering, social cohesion and compassion, and in the locations chosen for settlement. Statements from recent literature refer to archaeologies of the contemporary past 'challenging the taken-for-granteds of modern life' (Buchli & Lucas, 2001) and 'making the familiar unfamiliar' (Graves-Brown, 2000; Harrison & Schofield, 2010). Homelessness is deeply unfamiliar to almost everybody who is not now and never has been homeless. It is another world, with different rules and priorities, yet there are clear and interesting comparisons that can be drawn with earlier periods, comparisons that many of our homeless colleagues find fascinating.

Ultimately though, the project is driven by heritage agendas which are ever changing. Thomas (2004), for example, describes how the influence of the state is declining, in heritage practice as in life, while the recognition of multiple interpretations of heritage, and different heritage priorities, is becoming overwhelmingly obvious. Nowhere is this more evident than in the 2005 Faro Convention, the Council of Europe Framework Convention on the Value of Cultural Heritage for Society (Council of Europe, 2009). This recognizes the need to 'put people and human values at the centre of an enlarged and cross-disciplinary concept of cultural heritage'; it recognizes that '*every person* has a right to engage with the cultural heritage of their choice', and is 'convinced of the need to involve *everyone* in society in the ongoing process of defining and managing cultural heritage' (our emphases). The Council of Europe's Director of Culture and Cultural and Natural Heritage noted how,

> heritage is not simply about the past; it is vitally about the present and the future. A heritage that is disjoined from ongoing life has limited value. Heritage involves continual creation and transformation. We can make heritage by adding new ideas to old ideas. Heritage is never merely something to be conserved or protected, but rather to be modified and enhanced... . This is why heritage processes must move beyond the preoccupations of the experts in government ministries and the managers of public institutions, and include the different publics who inhabit our cities, towns and villages (Palmer, 2009: 8).

These contemporary archaeology and heritage agendas are entangled in interesting and challenging ways. Archaeology has always been more about the ordinary and the everyday, while

heritage is increasingly coming around to that perspective. Our work with homelessness is interesting because in a way it is ordinary and everyday, but it is also about those 'different publics', the extraordinary and the very unfamiliar.

Sociologists and anthropologists have increasingly sought to explore the culture of homelessness (Anderson, 1926; Hopper, 2003; Caplan, 2003) and its impact (Sebastian, 1985), while homelessness has also started to receive archaeological attention (e.g. Zimmerman et al., 2010). However, this project was always going to be different in that it sought specifically to engage homeless people directly in fieldwork and in the presentation of findings. We wanted to present this investigation not only through our voices and our perspectives, but more so through the rarely heard views of our homeless colleagues. We wanted to facilitate their ability, and their willingness, to speak out, through the related opportunities of heritage discourse and traditional approaches to field archaeology. Archaeology in particular presented a rare, if not unique, opportunity that was accepted with great enthusiasm. But this opportunity also introduced some complications and challenges which require further comment.

Methodology: challenges and opportunity

RK has lived and worked in Bristol since 2003. From 2006, she spent time working in and walking through Stokes Croft, central Bristol. Stokes Croft is widely associated with homelessness and has been over many years. The local area is the site of several hostels, services for people with drink and drug problems, free food venues and *The Big Issue* office. Passing through Stokes Croft, she came to know several homeless people – Punk Paul, Disco Dave, Jane, Smiler, Rich, Ratty (female), Ratty (male), Little Tom, Gary, Lorraine, Michael, Tia, Pops, Whistler, and Tony Tap, to name a few.

Initially, we arranged a pilot phase of fieldwork in June 2009. Our aim was to meet a different homeless person each day and map their routine in as much detail as they were prepared to share. Central to this week were the contacts RK had already made. Throughout the fieldwork in June 2009, we found that Punk Paul, Smiler, Ratty (female), and Little Tom were the most keen to take part and show us 'their' Bristol. Others were involved intermittently, or joined us for an hour or so.

Mapping routines included the journey, places along the way, people we met, items picked up and discarded, and conversations between us and with others, some of which we recorded using radio recording equipment. Each day we started on Turbo Island, a tract of private land on Stokes Croft, now occupied by an advertising hoarding and identified by homeless people as a meeting place. The routes we followed varied considerably, but by the end of the week, patterns and regular sites began to emerge within these different personal landscapes.

Being homeless is chaotic and fraught with unpredictability. In some cases, people arranged to work with us and then something happened that meant they could not; they were hurt or became ill in the intervening time, or they consumed a volume of alcohol or drugs which put them out of action for a while. We were flexible and open to the possibility that our plans might need to change at a moment's notice. This, to us, was part of the pattern of contemporary homelessness and therefore something we needed to include in our approach to fieldwork. If we do genuinely want *everyone* to engage with the heritage of their choice, then the onus is on us as practitioners to develop methods for working with vulnerable and marginalized people. It is up to us to make the methods correspond to people's particular requirements, rather than expecting people to conform to age-old practices and conventions. After all, if it was easy for everyone to arrive 'on site' at a given time and begin working a regular routine, they might not be considered 'socially excluded'.

For the same reason, we did not exclude people from engaging in the project if they were under the influence of alcohol or drugs. Our fieldwork predominantly involved walking, drawing, speaking into a tape recorder, and writing on maps – none of which are particularly dangerous under the influence of drugs or alcohol. In our opinion it is better to be inclusive of all people, in all states, and develop working methods that ensure that fieldwork and the data collected are not compromised, than to exclude people. Many of the people we worked with for this project were either drunk or had used heroin; some of them also used crack cocaine but none worked with us under its influence. One man explained that 'crack makes your head fizz – you couldn't do archaeology on crack. It wouldn't make sense and you wouldn't be bothered' (Punk Paul pers. comm.). We did not witness anyone taking illegal drugs but we were shown plenty of material evidence for drug-taking and many of the material remains included drug paraphernalia (although their significance often had to be explained to us).

In fact, drug-taking generated some interesting discussion and presented surprising insight. In several cases, people described developing addictions through a sense of hopelessness and boredom, or through needing to feel warmer – both alcohol and heroin make a person feel warmer, despite decreasing body heat. One man (Whistler) described how he had been introduced to heroin when he was first homeless in Bristol, aged seventeen. He said his first impression of the drug was that it was 'a nice warm, fluffy place to go where nothing matters'. For Whistler, taking heroin was about perceiving a change in his material, physical surroundings. For archaeologists this is a fascinating perspective on place – the fact that drugs create 'places' that hold a particular significance for vulnerable addicts.

Trust was a significant consideration for us, and we quickly noticed how hard it was for many homeless people to trust us. For example, when we first began asking homeless people to show us the places they used in the city and to describe how they used them, they wanted to be sure we weren't 'pigs' or 'undercover', and needed reassuring that we were not trying to set them up and that we were telling the truth when we said we were archaeologists. The fact that RK had spent two years prior to the project developing relationships with homeless people from Bristol was invaluable as word spread quickly that 'the archaeologists are alright'. Trust also works by association. Because RK was alright, then so was JS whom she introduced. We also introduced two other archaeologists to our homeless team, both of whom were instantly accepted on the same basis.

We were aware of criminal behaviour at times. For example, people spoke a lot about drugs – their quality, availability, and who was 'doing' what; fenced and stolen goods also came up in conversation (e.g. bicycles, mobile phones, and iPods). We took the view that providing we did not witness a crime taking place, we could legitimately observe and record what we saw. We had to be careful also not to 'hustle' for information (Venkatesh, 2008), or to unwittingly 'gossip' or pass on information gleaned from one person or situation that might be used 'against' another homeless person, potentially putting them in danger. For example, the fact that we had 'just seen Joe Bloggs in the Post Office on a certain day (Giro day)' is the kind of information that could lead to them being followed and mugged for their benefit money. The threat of serious physical harm from people wanting to steal benefit money is prevalent and real, and an everyday fear for many homeless people.

Money – lack of it, sourcing it, and holding on to it – is significant for homeless people, particularly those with addiction problems. How we would reimburse people for their time was a subject we discussed from the outset. We decided that we would offer people lunch and non-alcoholic drinks by way of payment for working with us. It is interesting to note that there is a plethora of 'free food' places in Bristol so we were not actually offering anything that homeless people could not already access for free, but several people opted to take up our offer even so.

We intended to be clear with everyone that we would not pay money for joining in the project – in fact, no one enquired about being paid. It seemed important that people engaged with the project because they were interested in it, not because it led to 'rewards'.

Our own safety was something we were careful to ensure. We worked with people who wanted to work with us and on their terms, in overwhelmingly public places, always together, and often with RK's two dogs. And we trusted our instincts. We found most homeless people to be pleasant, polite, and no more likely to cause us harm than anyone else. Those people who were anxious, angry or agitated tended to pass us by, not wanting to engage with the project. We also listened to the advice of one of our recently ex-homeless colleagues, Smiler: 'he's trouble', or 'don't go anywhere on your own with him', was advice we took without question, for example.

In summary, it was important to recognize that we were working with vulnerable people, whose mental states were often fragile and whose histories often included being victims of severe mental, emotional, physical, and sexual abuse. It was therefore vital to manage expectations well, to explain the point of our project, to ask people whether they minded having their photograph taken, to make clear that we intended to publish our findings, and such like. We made it clear from the beginning that we were archaeologists working on a project to 'map' homelessness and that we wanted to work alongside homeless people; that they were members of the team in the same way that we were. We did not want them to think of themselves merely as our 'helpers', and as the project progressed it became increasingly obvious that they did not see themselves in that role.

We can now move on from methodological issues to describe some of the project's findings.

Part 2: places, themes, and implications

Places

The discovery of new types of site, or behaviours, has always inspired archaeologists, and it is a revelation that transcends periods of study. Even for the supposedly familiar past, new site types can emerge through field investigation and ethnographic enquiry. In studying contemporary homelessness such discoveries were made routinely, initially through dialogue and followed through with detailed field inspection and recording. Some examples of these 'homeless places' follow.

The bear pit – a hub for homeless people

A site that featured as part of everyone's homeless landscape was a series of underpasses beneath a city centre roundabout, known colloquially as the Bear Pit, described by one homeless colleague, Punk Paul, as 'a hub for homeless people, one of the first places you get to know about when you get here'. It is a familiar 1960s' construction of grey, grimy pedestrian subways with shrubs, wild flowers, and a few trees in the middle. It is an inherently public place and renowned citywide for looking dishevelled (see Dixon, 2009).

On our first day in the Bear Pit, we met two homeless people who had constructed a shelter in which they had slept the night before. The shelter, in common with several sleeping places we were shown, was elevated and under a tree that felt roof-like. It was a neat construction of four placard sticks with layers of woollen blankets and duvets. Foliage was loosely strewn on top for camouflage, which screened the shelter from a nearby security camera. Sleeping places are

often sited within the sweep of these cameras, as homeless people are less likely to be attacked there at night. Sleeping places are also often elevated, with views out, and enclosed or demarcated, perhaps by a fence or railing.

The occupants of this shelter described how it was constructed and designed to be easily transportable. They explained how they could dismantle the shelter and fit it into a rucksack if asked to move on. We asked how long they expected to stay there and were told it could be minutes or days. On the fourth morning of fieldwork, the shelter had gone. We photographed and sketched the traces left behind. Half a placard stick protruded from the ground. It was snapped and suggested the people had left in haste. There were three postholes where the other sticks had been. Artefacts and the foliage used to cover the shelter were strewn around.

This was one of many 'skippers' we looked at, the term used by homeless people to describe rough sleeping places and also the act of rough sleeping – 'a skipper', 'to skipper'. The term has historic roots and features, with the same meaning, in George Orwell's *Down and Out in Paris and London* (1933). It is interesting how some elements of the language of the streets have persisted as a form of intangible heritage.

Two phone boxes – crack cocaine consumption

On our third day we met up with Little Tom. Tom explained during our journey with him how blue clingfilm 'contains your blue, your B, your brown' (heroin), and clear film, 'that contains your white, your powder, your crack' (crack cocaine). He showed us the large number of cigarette ends on the floor of a phone box in St Paul's, and explained how these, along with screwed up pieces of 'white' clingfilm, told him that crack cocaine was regularly consumed there. There were no cigarette ends in the second phone box. Tom said that this was probably due to the fact that the first phone box was pasted with posters advertising free parties and that these provided some privacy, allowing illegal actions to go unnoticed from outside. It is of note that, after giving a talk on this project to a community audience in September 2009, which a local police officer attended, the doors of both phone boxes were removed. We have no proof there is a connection but it is possible.

St Mary le port – a 'homely dungeon'

Heritage and historic fabric, to our surprise, featured heavily in the homeless experience. Frequently we were introduced to places used for rough sleeping or just relaxing, or for drinking and drug-taking, which are historic and identified as such by homeless people. Historic buildings were variously described as 'nice places', or places where people felt more comfortable, or even safer, though there is no evidence to suggest that these places are in fact safer, especially given the lack of cameras at most of them.

One such site is Castle Park, in amongst the ruins of St Mary le Port, a church excavated by Philip Rahtz in 1962–63. Here the ruins, under tree cover, elevated, and with good outward views to the river, are a focus for activities associated with homelessness: rough sleeping, drinking, drug-taking, and also – it would appear – prostitution. Conversations with homeless women since this visit have revealed that this site is specifically for 'sex with other drug users', that is, not ordinary punters. The prostitution that occurs here is between female addicts who have no money for drugs and male addicts who either have drugs (which they share in return for sex) or are willing to pay a small amount, maybe £10, which is enough for a small bag of heroin. Of course, homeless people, like the rest of the population, have sex for fun so evidence of condoms at homeless places is not always evidence of prostitution.

Visiting this site with Smiler, a former occupant, we were told how he had slept in the crypt ('vaults') which he reached by lifting and then lowering and locking a metal grille. This is now welded into position making the site inaccessible. Smiler described how the site had been a 'safe' and 'good' place to sleep when he had used it a few years previously, because it was possible to tuck himself away with the grille acting as a kind of intruder alarm. Smiler said 'the abbey' (his name for the church) was used a lot in the summer when the leaves offered privacy and some shelter; it was less heavily used in winter when the tree was bare. Jane had also slept here and referred to this site as her 'homely dungeon'.

Castle park – camp of thieves

On the northern side of Castle Park we were shown into bushes which Smiler described as a 'notorious place for rough sleeping'. There were clearly worn footpaths that led down towards the walls of Castle Park and the ground was heavily littered with artefacts – condoms, syringes, strong lager cans with the bottoms ripped off, and ubiquitous blue plastic lids from two-litre bottles of White Ace cider. Smiler explained that people rip the bottoms from drink cans and use the concave hollows to 'cook' heroin before drawing the liquid form into a syringe. In some cities, services for drug users supply steri-cups for this purpose but Bristol does not, perhaps due to the number of heroin addicts there are in Bristol and the cost implications.

As we journeyed further into the bushes, 'bedrooms' and 'social spaces' were more clearly defined – we found several sleeping bags, tent poles, and a duvet wrapped in a bin liner along with two men's jackets hanging from branches and an Iron Maiden poster. The 'sleeping place' was again elevated and clearly uphill of a worn circular patch of ground, scattered liberally around which were drink cans, tobacco smoking paraphernalia including plastic lighters, a Rizla packet, and the cellophane from a packer of cigarettes, along with a blue and yellow 'sin bin' (for the safe disposal of syringes), several discarded needles, and unattached orange safety caps. Smiler warned us to be extra vigilant because the proliferation of orange needle caps suggested to him there would be unguarded used syringes lying around.

Closer to the 'entrance' (a gap in the bushes) on the Broadmead (shopping centre) side of the park, we found several empty handbags and a purse containing a driving licence and store cards, along with a handwritten note showing a sort code and bank account number. Smiler explained that people using the space probably stole handbags in the adjacent shopping centre from where they could quickly escape through the gap in the bushes and 'disappear'. Smiler was very disapproving of the people who used this site. He told us that when he was addicted to heroin, he 'worked' for money to buy drugs and 'these sort of people' give all addicts a reputation for being 'scumbags' which, in the end, makes reintegration into society for those who undergo rehabilitation that much harder. To fund his habit Smiler 'did scrap' which involved taking valuable metal from commercial premises (usually copper) and churches (usually lead). For Smiler, there is a clear distinction between stealing from individuals, of which he greatly disapproves, and stealing from companies or the establishment. It is interesting how Smiler cites history as the reason why it is OK to steal from, for example, the Church. In his view the Church stole land from 'ordinary people' and that this rationalizes 'stealing it back'. He concluded – from the volume of handbags, purses, security tags and personal items, and the presence of two jackets hanging up suggesting they were ready to be used again – that people using the site were street robbers, plain thieves. Smiler said that people changed their coat as soon as possible after a robbery to avoid being easily recognized by CCTV cameras. Smiler suggested we called this site the 'Camp of Thieves'. Punk Paul said he knew two people who had been sleeping at the site recently, 'two Welsh lads … mucky bastards. There are some people who are just lost. They live

in bushes and they don't comb their hair or have a wash or nothing. They're just on it [heroin]'. We noted that the site was obviously different from that at St Mary le Port, a short walk across the park – it felt 'active' and unsafe. Smiler agreed that it was a 'negative place'. Paul added that this 'might be because we're so close to Newgate Prison. God knows, this could have been a graveyard part of Newgate'.

Pilkington glass factory – a huge squat

Another site we were shown was the Pilkington Glass Factory on Redcliff Street. Smiler and Punk Paul said it had been a huge squat, part of which was a crack den for a while when they had lived there in 2003. Paul said he had slept in the squat for a while and that part of it functioned as brothel space during this time. Prostitutes could work from the glass factory in the knowledge that others were close by, a security measure that demonstrates a community spirit within the homeless population.

Smiler fondly remembered raves or illegal parties at the site and explained how he entered the building initially, over a ten-foot metal gate with anti-burglar spikes. It was evident that Smiler's idea of 'hopping over a wall' was very different from ours! Smiler showed us where he put his feet in the gate to avoid the spikes, and how he was then able to walk along the top of the wall a few feet and jump down inside the factory grounds. On his first visit, he told us he went into the building to see whether it was worth 'tatting' for scrap materials. Finding the building still contained a lot of copper in the form of pipework and cables which could be stripped of their copper, Smiler broke the lock from the gate and moved his vehicle inside. He managed to strip the building of copper before the squatters were evicted.

Turbo Island – a meeting place, and a contested place

Turbo Island featured in the daily lives of almost every homeless person we spoke with, either as a meeting place or somewhere to drink. All of our journeys began and ended there during the week of fieldwork in June 2009. Each day we were invited to sit awhile. It was during these periods that we became aware of the significance of Turbo Island to the homeless community in Bristol.

We were told variously that the island had been a 'place where pirates were hanged' (Clifford), it was 'a kind of Speaker's Corner' (Punk Paul), and that beneath it there was a 'vault or passageway that leads to the biggest crack den in Bristol' (Smiler). Several people told us there had 'always been homeless people here', and that it has 'always been a place where you don't get told to move on' (Jane, Muggy, Gary, Ratty, female). On one occasion the discussion about the history of the site became quite animated. We suggested that one way to learn more about its past was to excavate it – together, as archaeologists. This suggestion was met with enthusiasm, and that is how we came to arrange an archaeological dig on Turbo Island in December 2009.

Enlisting the help of University of Bristol staff and students and community police officers, we arranged to run the dig for three days. We wanted to involve homeless people directly in the excavation, and specifically to run the excavation in winter when homeless people are at their lowest ebb. But we had failed to understand one important thing: homeless people have nowhere to clean up, and are therefore less likely to want to get covered in mud and soaking wet. This meant fewer homeless people took part in the physical side of our winter excavation than we had hoped. Some homeless people rolled up their sleeves and got muddy, but more watched the digging, commented on finds, and hung around for the duration.

With homeless diggers, students, and local police, we first conducted surface collection followed by the excavation of three trenches, the location for the first being chosen by Smiler.

Finds from the surface and the dig included bottle glass, blue plastic tops from White Ace bottles, money, and pharmaceutical drug packaging, including hay fever tablets, anti-psychotic medication, zopiclone (sleeping pill), and diazepam. There were also ring pulls, sherry bottle lids, lighters, bits of mobile phones and sunglasses, sweet wrappers, and tobacco and smoking paraphernalia. We also collected pieces of posters and flyers and a latex fake wound! The homeless diggers were especially interested in the everyday items which are found on most excavations: notably clay pipe stems and ceramic vessel fragments, some of which came from seventeenth-century drinking mugs. To them these were clear evidence that people had been smoking and drinking on Turbo Island for over 400 years, and called into question the legitimacy of the present ban on street drinking.

Themes

Alongside types of places, there were recurring themes, some of which were confined to particular types of place, and some of which were ubiquitous. A few examples of these recurring themes follow.

Homeless heritage and local history

Among the homeless people we have worked with in Bristol, the English Civil War is a topic that is often referred to. This might be explained by the fact that there are numerous Civil War sites in and around Bristol and, by extension, library books and information about the period are available and easily accessible. There also exists an appetite for romantic and maritime history, possibly inspired by Bristol's continued role as a maritime city. Pirates and smugglers often feature in stories told by homeless people in Bristol. Punk Paul told us that pirates were hanged beneath Victoria Street Bridge; he also said that various doors at the waterline along the stretch of river opposite Castle Park are where smugglers kept their wares 'close to the city, so they could sell it easily'. Also in this area, Paul invited us to consider a very particular view, across the river to the then derelict Courage Brewery building. Immediately in front of us in Castle Park Paul pointed out a small memorial related to D-Day 1944. 'The Destruction of Courage' Paul said.

This and his comment at the Camp of Thieves about Newgate Prison reflect an intrinsic interest in the past and ordinary people's stories about it. When we asked Paul where he had learned these histories, he said there were panels and plaques all over the city telling you what things were. Paul reads these, and added that you have a lot of time to wander about looking at things and thinking about them when you're homeless, and you meet a lot of interesting people who tell you things. Someone who is begging is in a way duty bound to listen to the ramblings of those who decide to donate. This exchange – you give me money, I'll listen to your story – is accepted as part of the 'job' by people who beg.

Belonging

For Paul, spirit and the past play an important role in how places develop character and this perception bears agency on his behaviour in certain places. For example, at Turbo Island, Paul thinks very little of leaving his can or bottle on the grass; in Temple Church (another derelict church we were shown as a homeless place), he insisted we left no rubbish because 'there are people resting here. You have to respect that.'

Attachment to a place can also create a desire to maintain it voluntarily. Smiler explained how he regularly clears rubbish from Turbo Island and puts it in a public bin. He said he does

so 'to keep the place looking nice'. For Smiler, it is important to preserve and enhance Turbo Island as one of the few green spaces within Stokes Croft. This resonates with findings made by Sheehan (2010) in observations of homeless people in Jackson Square, New Orleans. Homeless people were recorded sweeping, 'asserting a sense of residence' with Jackson Square, while one man, Boss, regularly swept and maintained an area of 'his' Square. One might argue that by caring for a place – or being facilitated to help care for it as part of a community – a person is rewarded with a greater sense of self-respect, vital for happiness and self-esteem.

Memory: remembering Tibor Tarr

On one journey with Little Tom, Punk Paul, and Smiler, we stopped by a signpost in the city centre. On the post was a memorial to Tibor Tarr, a *Big Issue* seller who died the previous winter (2008/09). The memorial was small, and gave his name and a photograph. We talked about this and photographed it. It provoked a conversation about how homeless people are invisible when they are alive, but even more so when they die: when there is no trace whatsoever, no records, and perhaps in some cases virtually no memory. We were struck how, in this case, there was a tangible witness to someone who had meant a great deal to the homeless man responsible for the memorial. As we walked through the town we asked Smiler to use the places we passed to recall the homeless people who had died or vanished and whom he associated with these places. They came thick and fast. On returning through town an hour or two later we were shocked and saddened to find the memorial had gone from the post. We contacted Bristol City Council and were told that it was council policy to remove such items after a short period of time. Nearby was a memorial to a non-homeless teenager killed when he was hit by a car. Flowers and cards tied to the railings in his memory had not been removed. This is an example of how homeless people are treated differently from the rest of society; their existence and materiality erased by a local authority as though 'attachment' to a place felt by homeless people is not sufficiently 'real' or important to preserve or acknowledge.

Fitness

There is a commonly held view that homeless people are 'lazy', that if only they stopped lying around 'doing nothing' they would be able to help themselves – our fieldwork revealed this could not be further from the truth. For example, during the day we spent with Little Tom we walked more than six miles in a couple of hours, at a pace that JS and RK (both reasonably fit) struggled to maintain. Similarly, when Gary offered to show us his sleeping place we had to scale a five-foot wall, walk approximately a quarter of a mile over loose gravel alongside a railway, and jump down from another high wall just to enter the wooded area where the sleeping place was sited! Smiler's description of 'hopping over a wall' and 'tatting' a warehouse of all electrical cables and pipes reiterated to us just how fit many homeless people are or have to be to survive.

Surveillance

Whether a person can or cannot be seen is arguably more significant to homeless people than to the rest of society. The majority of our homeless colleagues described the significance of CCTV cameras and overwhelmingly we were told that it is 'good' to sleep in view of a camera 'because then, when you get kicked in the head for fun or set fire to in your sleeping bag by piss heads, you've at least got proof of what happened … even if the police don't listen to you. You know

it's on tape and … it makes you *feel* a bit safer' (Jane, pers. comm.). However, there are times when homeless people specifically avoid the gaze of CCTV. 'Like, if you're scoring or hitting up [injecting heroin], then you want to make sure you know where they [cameras] are so that they *don't* see you!' (anonymous, pers. comm.).

Little Tom explained how CCTV cameras are destroyed in those parts of Bristol where crime happens regularly – 'someone pays a kid to climb up and smash it off or spray [paint] the lens so it can't work'. We were told that children under the age of twelve are recruited because they receive more lenient sentences if caught. Interestingly, on a more recent journey through Bristol, RK asked Tom to explain how he knew where cameras were located. RK explained that it wasn't always clear what a CCTV camera looked like. Tom was genuinely shocked: 'I can't believe they're letting you do a Ph.D. if you don't even know what a camera looks like!' he said. To Tom and many other homeless people, CCTV cameras are distinct landmarks, material concerns to be navigated, and typically referred to in descriptions of where others are 'living'.

Implications

> If [homeless] people can gain [the police's] trust then there's going to be a lot less hassle. Having [local police] here digging with homeless people, helping to find out the past of the local area together, that's good. (Smiler, on bringing together homeless people and local police in the excavation of Turbo Island)

Without homeless people, we would not have found most of the homeless sites we were introduced to and much of the meaning behind the finds from the Turbo Island excavation would also have escaped us, remaining unrecorded or overlooked. For example, in the case of finds from Turbo Island, a cigarette lighter with a rubber band secured around one end became more interesting after we found another exactly the same (to add to the ones we had found at skippers and other homeless sites during the survey). It was explained that this probably belonged to a homeless crack cocaine user. They need a rubber band when making a crack pipe and tend to keep one around their lighter so they know where it is. Similarly, the discovery of hay fever tablets at surface level at Turbo Island in December intrigued us because hay fever is not a winter condition. Consultation with homeless people revealed that an active ingredient of hay fever medication, when mixed with crack cocaine, expands the drug, making a dose go further.

Taking an archaeological and a participatory approach to homelessness in Bristol, and specifically the excavation, provided a rare opportunity for the local community to engage with homelessness and homeless people – an integral part of their everyday landscape – on a neutral basis. The project increased community awareness of homeless people as individuals and, locally, enhanced compassion for them causing some homeless people to re-evaluate how they behave towards local residents and their property, including public spaces. For example, since the excavation of Turbo Island, some homeless people have taken it upon themselves to keep the area tidy. During the backfilling of the excavation, Smiler planted thirty daffodil bulbs in the topsoil of Trench One, remarking that when they bloomed 'everyone can enjoy them'. In short, the project allowed bridge-building to occur between groups of people who previously were disconnected and unable or unwilling to find common ground. Using archaeology as a starting point, we have engaged in 'social action' (Byrne, 2008) and enhanced an inclusive sense of local identity. Contextualizing the way in which homelessness fits into the wider story of how Bristol developed has been instrumental in forging links between homeless and non-homeless people,

links that can be strengthened and perhaps act as the necessary spark for beginning the process of rehabilitation, at least for some people.

In July 2010, Punk Paul and Smiler co-presented with RK a lecture about our initial findings to a conference session at the University of the West of England (UWE) ('A Second City Remembered: Rethinking Bristol's History'). Within the presentation was an analysis of why Smiler had opted to sleep rough rather than in Victoria Street homeless hostel where he had been housed by the council. Smiler talked about the conditions at the hostel and explained why it was preferable to sleep outside where he had some agency over his surroundings rather than in the hostel which he described as squalid and dangerous. He explained that in choosing to do this he had made himself 'intentionally homeless', a housing category that results in a person going to the bottom of the housing list. Amongst the discussants was MP for Bristol, Stephen Williams. Williams approached Smiler and Punk Paul after the talk and, after a short conversation, established that the hostel was still in operation and that conditions had not improved, despite recent assurances from Bristol City Council that the facility would be closed down. A week after this conversation, Victoria Street hostel was evacuated and closed down. It has not been established whether the exchange between Smiler and the MP was the catalyst for this closure but it would seem a timely coincidence.

Critics (including those calling for a return to 'sensible archaeology') might argue that what we discovered as archaeologists could just as easily be revealed through sociology, psychology, or by the council's 'sex and drug litter team'. From reading stories about archaeology in free and discarded newspapers, and seeing archaeologists working in Bristol, archaeology has become something vaguely familiar to homeless people. Some find it interesting, exotic, romantic even. It is also something that appears (and is?) alternative, which also appeals to them. This is why we believe they are so enthusiastic about participating. With due respect, if we had approached them saying, 'We are sociologists – would you like to come and work with us?', we know what they would have said. Homeless people have told us variously that they enjoy the project and that it is refreshing to be acknowledged and also invited to participate in a project that does not seek to judge or change them in any way. As one homeless man put it:

> Before you started asking me about where I keep my blankets and why I go to the Bear Pit of a morning, I sometimes used to think I may as well rob a bank because I must be invisible or something! No one ever sees you when you sell *The Big Issue*! It's nice to know that you noticed me! It's not like you're not human, just because you're on your arse like. (Whistler, pers. comm., June 2010)

Conclusion

Since the Turbo Island excavation and the publication of two co-authored essays on the pilot project (Kiddey & Schofield, 2009, 2010), we have received invitations from heritage groups, councils, academic institutions, and local community groups keen to hear about our methods, our approach, and the results so far. The project has attracted attention from heritage professionals interested in looking at ways of conducting public and community archaeology, and the local police are keen to talk with us about organizing a further community project like the Turbo Island excavation.

But some of the most interesting responses have come from the homeless community itself. Since the publication of the *British Archaeology* piece, Rich has started to describe himself as 'the homeless archaeologist' and has confessed to being recognized as a minor celebrity in the street!

Punk Paul and Disco Dave have regularly expressed their desire to continue the project and help curate an exhibition about it.

The project directly affected Smiler, who has since begun to use his proper name, Andy. Andy told us that taking part in the project helped him to realize that he is no longer the person who slept rough, did scrap, and had to feed a drug habit, and whose traces we have been following around Bristol. Becoming an archaeologist and seeing his own past in this way has enabled him to move on. Coming to terms with his reintegration in mainstream society was made easier by taking part in this project, which has also increased his social circle and enabled him to feel a sense of belonging and identity necessary to 'stay clean' and feel happy.

The opportunity to share their expertise – knowledge about the city, understanding about drug culture and associated crime – and the chance to remember friends and communities for whom homeless people feel the same level of 'attachment' or 'nostalgia' as anyone else, is refreshing, as is the fact that the project is having an effect on the people and on the place. Two men who engaged with the project and claim that it contributed to increased self-esteem have since gone on to take up voluntary positions at a local art group where they are learning life skills and extending their social circles to include people who have never experienced homelessness or addiction.

By including homeless people and by truly engaging with the culture of homelessness – the undesirable, uncomfortable, illegal parts of it, as well as the survivalist and witty elements – we hope to learn as much about 'us' as 'them', and as much about what causes homelessness as homelessness itself, including institutionalism, prison, care, the military, and the way we approach mental health difficulties, for example.

This project allows us to map places that traditionally are ignored and overlooked. For example, in most interpretations of Stokes Croft, Turbo Island is described as a 'gap site' – a non-place where 'nothing' exists. Throughout our excavation and working in partnership with socially excluded, marginalized people we learnt about rituals and patterns of behaviour of which we previously knew very little. The processes of archaeological survey and excavation uniquely afford the opportunity to explore non-conformist culture, and to understand the perspectives and rituals of homeless people, through collaboration and partnership and – crucially – without judgement. Throughout this project archaeology has contributed to understanding a community felt by many, even within the professions engaged to work with homeless people, to be 'unreachable'. It was also an experience which our homeless co-workers greatly enjoyed and appreciated.

But Punk Paul described in his own words why this project really matters and it seems fitting to end with his perceptive remarks:

> Hopefully constructing an insightful view on things and implementing change in society, making order of our modern times, seeing us as no different from the Egyptians or the Romans. I love you for being interested. The truth is if you dig deep enough you uncover the truth… . The week we spent together was power, truth and hope. You have this big heart in a bigger community and it was good to think that we might actually change the world we live in. Inshallah.

Acknowledgements

We are grateful to the Council for British Archaeology for agreeing to fund this fieldwork through their Challenge Fund, and to English Heritage for supporting JS's participation. Cassie Newland took time out from her Ph.D. research to act as Field Director of the Turbo Island dig,

while finds from the excavation have been examined by Gillian Smith in partial fulfilment of her MA in Historical Archaeology at the University of Bristol. But our greatest debt, of course, is to our many homeless, previously homeless, and vulnerably housed friends who agreed to conduct this study with us, and did so with such good humour, enthusiasm, and intelligence. We won't name them all again, as all are identified by name in this paper, but given the subject matter it is no exaggeration to say that without them this work would not have been possible.

Bibliography

Anderson, N. [1926] 1998. *On Hobos and Homelessness*. Reprint edited by Raffaacle Rauty. London: University of Chicago Press.

Buchli, V. & Lucas, G. eds. 2001. *Archaeologies of the Contemporary Past*. London and New York: Routledge.

Byrne, D. 2008. Heritage as Social Action. In: G. Fairclough, R. Harrison, J. Jameson Jnr., & J. Schofield, eds. *The Heritage Reader*. London and New York: Routledge, pp. 149–73.

Caplan, P. ed. 2003. *The Ethics of Anthropology; Debates and Dilemmas*. London: Routledge.

Council of Europe, 2009. *Heritage and Beyond*. Strasbourg: Council of Europe.

Dixon, J. 2009. Shopping and Digging. *British Archaeology*, 105 (March/April): 32–37.

Gonzales-Ruibal, A. 2009. Vernacular Cosmopolitanism: An Archaeological Critique of Universalistic Reason. In: L. Meskell, ed. *Cosmopolitan Archaeologies*. London: Duke University Press, pp. 113–39.

Graves-Brown, P. ed. 2000. *Matter, Materiality and Modern Culture*. London and New York: Routledge.

Harrison. R. & Schofield, J. 2010. *After Modernity: Archaeological Approaches to the Contemporary Past*. Oxford: Oxford University Press.

Hopper, K. 2003. *Reckoning with Homelessness*. Ithaca, NY: Cornell University Press.

Kiddey, R. & Schofield, J. 2009. Rough Guide. *The Big Issue*, 874 (23–29 November), 14–15.

Kiddey, R. & Schofield, J. 2010. Digging for (Invisible) People. *British Archaeology*, 113 (July/August): 18–23.

Orwell, G. 1933. *Down and Out in Paris and London*. London: Victor Gollancz Ltd.

Palmer, R. 2009. Preface. In: Council of Europe, *Heritage and Beyond*. Strasbourg: Council of Europe, pp. 8–9.

Sebastian. 1985. Homelessness: A State of Vulnerability. *Family & Community Health*, 8(3): 11–24.

Sheehan, R. 2010. 'I'm Protective of this Yard': Long-term Homeless Persons' Construction of Home Place and Workplace in a Historical Public Space. *Social & Cultural Geography*, 11(6): 539–58.

Smith, L. 2006. *Uses of Heritage*. London and New York: Routledge.

Thomas, R.M. 2004. Archaeology and Authority in the Twenty-First Century. In: N. Merriman, ed. *Public Archaeology*. London and New York: Routledge, pp. 191–201.

Venkatesh, S. 2008. *Gang Leader for a Day*. New York and London: Penguin Press.

Zimmerman, L., Singleton, C. and Welch, J. 2010. Activism and Creating a Translational Archaeology of Homelessness. *World Archaeology*, 42(3): 443–54.

Žižck, S. 2004. *Organs without Bodies: Deleuze and Consequences*. New York: Routledge.

47
Developing dialogue in co-produced exhibitions
Between rhetoric, intentions and realities

Nuala Morse, Morag Macpherson and Sophie Robinson

Introduction

Stories of the World was the museum strand of the London 2012 Olympic and Paralympic Games: the Cultural Olympiad. As a national government initiative of London and regional museum partnerships, it aimed to engage young people, 14–24 years old, working with curators and originating communities, to explore and reinterpret world cultures collections. Beginning in 2009, the three-year programme culminated in a series of youth-led, co-produced exhibitions across UK museums in 2012. Each regional partnership was based on a broad theme relating to the region's collections. The North East of England programme was called *Journeys of Discovery* after the voyages of Captain Cook (born in the region). One of the exhibitions was delivered by Tyne & Wear Archives & Museums (TWAM).

Reflecting on the TWAM experience, this paper examines the social relations that are created when museums are charged with 'producing' participation, dialogue and co-production between multiple parties, in this case, young people and originating communities. We approach this by examining the gaps between the project rhetoric, the museum intentions and the realities of a project as it unfolded during the development of the exhibition. In many ways, *Stories of the World* is typical of a set of contexts in which UK museums operate: a national government-led initiative, setting external agendas, timescales and deadlines, all of which shape the participation work of museums from the onset by predefining the terms of involvement and the forms of the outcome (Lynch 2011b). The particularity of the three-way participation of *Stories of the World*, however, brings into sharper focus the tensions within participatory work, and can be set within wider discourses of participation in museums.

In the last two decades, in the UK and beyond, there has been a growing interest in museum co-production and the idea of dialogue as a means of developing multi-voiced exhibitions, working with originating communities (Bennett 2006; Peers and Brown 2003; Watson 2007) and including community and visitor voices (McLean and Pollock 2007; Nightingale 2008). Part of this context is the re-articulation of museum ethics in relation to the rights of diverse groups, foremost originating communities, in claiming authority and ownership of museum objects (Harrison 2005; Marstine 2011). In terms of young people and museums, much of literature has focussed on museum learning and education (Bellamy and Oppenhiem 2009), with

recognition that outside of educational settings, teenagers are underrepresented as a visitor group and generally feel excluded from museums (Mason and McCarthy 2006). In the UK, there is a wider commitment to breaking down traditional barriers for access. This has been enacted in policy through the notion of social inclusion, through targeted initiatives for groups with diverse access requirements and an underlying principle of access for all, both physical and intellectual, to all buildings and collections (Sandell 2003). We situate this article within these overlapping contexts to examine some of their consequences for the aspiration to 'participation for all' and the ways in which such claims have framed active participation in museums.

Recent discussions have questioned the limits of participatory practice in museums, in particular, its failures to overcome institutional power (Crooke 2007; Lynch and Alberti 2010; Peers and Brown 2003). Such accounts reveal that despite well meaning intentions, participation is not always the democratic process it sets out to be; rather, it more frequently reflects the agendas of the institution where the processes, such as the final right to edit content, are tightly controlled by the museum (Fouseki 2010; Lynch 2011a). Although the case we go on to describe attempted to share authority with participants through the approach to co-production, much was already preset within the national and institutional framing of the project and its outcome. As Lynch and Alberti (2010, 30) have discussed, when collaboration and dialogue are already implicitly aimed towards a pre-determined output – 'whether justice, rationality or a preset notion of an exhibition' – the possibilities are always limited, and certain outcomes are always favoured.

Developing dialogic practice should reflect the museum's attempt to 'destabilize its own stabilities' (Hall 2001, 22) and expose the unreliability of its own authority through multiple dialogues with communities. Dialogue is not a means to an end; it is defined as open-ended possibilities. It involves listening, making meaning together and developing understanding on an issue or situation from multiple perspectives. It implies risk, uncertainty, conflict and empathy. However, in project work, by its short-term nature, dialogue is often reinterpreted implicitly by the museum in a limited form as an ideal for dyadic communication or a tool for decision-making (Harris 2011).[1] Within the context of co-producing exhibitions, attempting to embrace uncertainty is often in direct conflict with the need for certainty built into the operating values of museums. Functions such as conservation, design and technical construction are squeezed, as in most exhibition planning processes, to the very end. The people who carry out these functions typically do so across a number of programmes, and current practice dictates that clear deadlines are a mantra they must invoke to remain in control of their workload. The processes through which the practicalities of creating an exhibition are managed all mitigate against accommodating the uncertainty and the revealing moments of dialogue.

In this paper, we do not aim to analyse the success of the exhibition itself but rather to examine where the requirements of a dialogic process were mediated by the three-way collaboration and processes of co-producing an exhibition; how our own assumptions might have impacted this mediation; and what this might mean for our own future practice in relation to exhibitions which are intended to develop dialogue with, between and across communities.

Typically, dialogic museum practice for co-production involves a two-way relationship with museums working directly with specific originating communities (see Peers and Brown 2003; Phillips 2003). In *Stories of the World*, the particular aim of the project was to establish not just dialogue, but effectively a 'trialogue' between three distinct parties, with young people mediating the conversations with originating communities, with support from the museum. The key aspects of *Stories of the World* were the ideas of dialogue, participation, co-production and youth empowerment which were assumed to be mutually productive processes. This paper seeks to unpack such assumptions by reconsidering the relations and ethics of such processes. A focus on ethics and

relations provides an alternative to critiques of co-production that have mainly focussed on a discourse of control. The particular three-way collaboration of *Stories of the World* recasts an enduring ethical question within museum practice: who has the right to exercise voice and on what basis? As Yuval-Davis (1999, 7) reminds us, there is a need for 'dialogues that give recognition to the specific positionings of those who participate in them' as well as the 'unfinished knowledge' (Collins 1990, 236) that each such positioning can offer. Power relations always occur between dialogue participants and diverse views often clash. Bernadette Lynch (2011a, 2011b) argues that conflict is an essential part of democratic dialogue in museums, however in our experience of the project there was no specific experience of conflict, even though the process was open to (and anticipated) contestation and debate. Rather, we consider how the young people became co-opted into perceived professional attitudes and consensual ways of working. As such, we aim to reconsider how the 'field of possibilities' was already structured (Chakrabarty 2002) in the very framing of the project and its institutional setting (Lynch and Alberti 2010).

In our experience of three-way collaboration, many difficult questions are raised: What happens when young people are asked to mediate the dialogue on behalf of the museum and its (contested) collections? In such collaborations, who has the right to produce knowledge and displays? What ethical considerations come into play when institutions are charged with 'producing' dialogue, and how should members of staff deal with these ethical questions? As its focus is limited to only one particular project, this paper does not provide firm answers, nor does it claim to present a particular case to study the application of theories of dialogue; but rather it provides a context in which to consider relations and ethics in participatory museum practice.

By tracing the connections of intention, planning, mediation and emergent consequences as they unfolded in the project, we expect to expose some institutional weaknesses in our design and approach. However, we also believe that such inherited assumptions embedded in the programme initiation, circumstantial compromises and mid-programme renegotiations are not atypical of the realities of working in a UK local government museum service with ambitions to contributing to wider social objectives, and may well have resonance in other national and international settings. Our account reveals how some of the problems were specific to the project and the institution while others may be part of the framework of participatory practice in museums more generally, and highlights wider epistemological problems of participatory knowledge production. This paper records the museum strategies and the development of a particular project that aimed to develop dialogic practice, and in doing so reveals much more about the dissonance between the different terms, stakes and purposes of participation at both the national project level and in the museum's adaptation of the programme.

Contexts

> In the spirit of the London 2012 Games, Stories of the World welcomes the world to Britain by using our rich collections to tell inspirational stories about the UK's relationships with the world. Young people are at the heart of the project, working with curators to uncover objects that tell stories that resonate with their interests.
>
> *(MLA 2010)*

> Instead of the traditional curators' or historians' view, audiences will hear stories from the viewpoint of people from diverse cultures, now living in the UK. (...) Young people['s] involvement, creativity and innovation will reshape public perception of the word 'exhibition'.
>
> *(MLA 2009)*

Developed in partnership with the Museums, Libraries and Archives Council (MLA) and the London Organising Committee of the Olympic and Paralympic Games (LOCOG), *Stories of the World* reflects the wider cultural policy in the UK based on a discourse of diversity and access for all (DCMS 1999; Heritage Task Force 2009; ACE 2010). The key aim of the wider Cultural Olympiad was to provide young people of any background with opportunities to become involved in a range of cultural activities. The main requirements were 'young people', 'communities' and 'world collections'. The forms of these encounters, the focus of the reinterpretation of collections and which communities should be involved were left open to be shaped by local circumstances. Youth 'at the heart of the process' was explicit within the rhetoric, and implied that young people would give their own opinions on museums and collections. Participation was predicated on the 'rights' of young people to give their viewpoints and make decisions. 'Communities' was only vaguely defined, sometimes appearing to refer to local diaspora communities living in the UK, at other times referring to originating communities abroad. 'World cultures' further remained undefined, and was never explicitly politicised in relation to colonial legacies. The celebratory nature of the Olympics – young people as symbolic of the future, and joyous celebrations of cultures from around the world coming together – did not naturally suggest some of the more challenging aspects of the histories which were open to being examined, and the contemporary political landscape they might reveal was left unconsidered.

The overall purpose of the programme was for young people to 'coach' the museum to address its contested collections in creative and innovative ways that are relevant for contemporary audiences. The main tension in the rhetoric here is around the language of youth empowerment and creativity and the use of world cultures collections, without a direct acknowledgement of the politics of working with originating communities, or reference to museum practice in this area. It positioned youth as risk takers against a particular view of traditional museum practice. The language of national initiatives is necessarily lofty in its goals, however the gaps left by this framing clearly came into play in the development of the project as both we, the museum, and the young people we worked with reinterpreted the requirements for our own circumstances.

In our response to the national brief, some of the key aims were:

- The placing of young people at the centre of the curatorial process; they will take the decisions regarding all aspects of the exhibitions. Museums will learn to engage with young people in a more involved way.
- This process will see these important collections given new meaning (...) led by young people in dialogue with source communities supported, as appropriate, by specialist ethnographers and other subject specialists. This is a conscious move to develop a collaborative reflective dialogue with those outside of the existing structures of expertise to see where it takes our understanding.
- [The project will] create a focal point for the North East (...) which explores deeper themes of tolerance, understanding and contact between cultures in a way that is relevant to local communities.

(TWAM 2010)[2]

In considering how to structure the involvement of young people, the museum took an early decision that it would be unrealistic to expect participants to stay involved throughout a three-year period working towards the final exhibition from the start, as this would not offer opportunities to complete something meaningful in an appealing timescale, given the changes in life

circumstances and interests that young people could experience over such a long period. We therefore structured the programme to include digital projects of roughly six-month duration, followed by a final year working on the exhibition. The digital projects would take inspiration from different collections, involve contact with originating communities and result in a product defined by the young people's interests – this could be a film, a piece of music or an event.[3] The aim of this rolling structure was to introduce young people into conversations with originating communities, from which they could develop collective lines of enquiry over time, and a body of experience around dialogue and opening up authorship to others which would continue to grow with those who continued into the exhibition phase. Unfortunately, and because of a variety of practical problems, this strategy was not successful. Given the centrality of exhibitions as institution-led products (McLean 1999), the paper focuses on the processes involved in creating the exhibition rather than the earlier digital projects phase to consider how the dialogical approach was negotiated by participants and by the museum.

The approach to inviting young people to participate was inspired by a conversation with practitioners at the World Cultures Museum in Gothenburg, Sweden. There they approached people to be involved in programmes based not on their specific cultural or ethnic identity, assuming that a person's cultural heritage must be their primary interest, but by allowing participants to define the terms of their own involvement based on whether their experiences and/or interests resonated with the project. We therefore intended to develop a group of diverse participants who were motivated to get involved as a result of diverse interests and experiences, rather than a more tokenistic or targeted approach based on how the museum predefined participants. In an effort to maximise the decision-making opportunities for young people, we chose not to pre-select a theme, specific collections or culture.

In order to allow young people to make informed decisions, our strategy was to equip young people to engage with more difficult or contested issues and to feel that they could challenge staff and conventional ways of working. To engage with this 'tricky ground' (Tuhiwai Smith 1999), an external museum consultant delivered training with young people and staff, to consider how to initiate and participate in conversations with originating communities, and how this experience might translate to an exhibition. Sessions with the project staff further focused on thinking about cultural sensitivities, how to make the initial approach, formulating the right questions and using different media to communicate. Within the project timetable, two phases of developing conversations towards wider dialogue were planned: the first, a very open conversation where the young people would initiate contact, explain their aims and explore with community representatives how they felt about the proposed process, followed by a more detailed phase of discussion and research around the specific objects and collections. Supported by staff throughout, the intention was for the group to then become involved in taking the lead in all key aspects of practical museum activities: from curatorial to design, events, learning, digital technologies, marketing and communications.

The ethos of the whole project was grounded in a commitment to widening participation, informed by notions of civic dialogue as 'democratic exchange' (Bauman 2000; Bennett 1998). At the same time, the aims and strategies of the project can be seen as an ambition to create a 'contact zone' (Clifford 1997) – a space for discussion and contestation in the museum, and a practical exercise in developing partnership for the co-production of knowledge and exhibition. Notions of 'democratic exchange' and 'contact zone' have many commonalities, and although we do not go into a longer theoretical discussion here (see Dibley 2005; Witcomb 2003), it is worth noting their main point of departure: whether museum engagement processes are best conceived as relations of reciprocity or as relations of governmentality. This note is relevant to our reflections later.

The aim then was for the dialogic-democratic exchanges to produce new forms of participatory knowledge around collections; yet, in itself, the ethos of the project contained a number of problematic premises. From the onset, the approach implied asking participants to challenge established interpretive paradigms and practitioner discourses. It is clear that asking for the creation of new countervailing interpretations was an ambitious task to place on young people. Museum staff recognised that the ethnographic collection was under-used and little researched, with only limited engagement with non-UK-based originating communities.[4] The scope of the project was to produce new collaborative knowledge of collections through dialogic encounters between different groups. However, the approach assumed young people would be interested in other people's opinions and voices, especially ones that could challenge their own, and that youth voice, typically marginalised in museums and wider society, would find congruencies with another type of marginalised voice (originating communities). This would then lead to intercultural discussion and a co-produced outcome reflecting a deeper understanding and acceptance of different perspectives.

The project assumed a particular set of learning outcomes for museums – that young people's creativity and willingness to take risks would inform these forms of practice of participation. It further assumed that originating communities would be interested and willing to give their voice back to the young people and the museum. Indeed the very values of democratic exchange underpinning the project, like many such endeavours, were not necessarily compatible with all originating communities, for example around secret-sacred materials.[5] Although there was an awareness of the latter considerations within the museum, the three way nature of the collaboration complicated the issues of voice and participation; in particular, the issues of legitimacy and power (who has the right to exercise/display voice and on what basis) became central to the exercise. Most problematically, the form of the democratic exchange effectively deferred the responsibility for developing and leading conversations onto an external group without an explicit discussion within the museum of the levels of agency in the process, and the balance of authority between different agents.

Returning to the ambition of the contact zone, as Clifford (1997, 200) writes, '[t]he crucial issue of power often appears differently at different levels of interaction', and it is necessary to understand something of the intentionality of participants to comprehend the complexities of the contact zones. While we have acknowledged a lofty rhetoric (some of it inherited from the national initiative, some linked to our own aspirations), and set out some of the strategies put in place to respond to the national programme, in the rest of this paper we examine what happened as the project unfolded, in particular how the young people renegotiated their own interests through the process.

Process[6]

Throughout 2012, staff at TWAM worked with a group of 12 young people to develop the final exhibition. As the rolling programme of youth engagement through digital projects was not successful, a new group was engaged to develop and co-produce the exhibition. The participants joined the project for a variety of reasons; they stated they felt this was a unique volunteer experience – many were specifically interested in the opportunity to gain museum work experience as they had an interest in careers in the museum sector. The group was aged 17–23 years old, many with higher educational level qualifications or about to start their university studies. The group was not representative of cultural diversity locally: it was a mostly white, well-educated group of young aspirants to the museum profession.

Many of the early sessions were used to develop the confidence of the group and relationships between participants. It was important to the project, as we intended it, that the group take

ownership. We sought to move away from a didactic 'teacher-student' relation to provide open spaces for dialogue and participation, and where young people could freely express their opinions, and see them as valid and valuable. Later interviews with young people revealed the levels of control in decision-making were valued very highly, enabling participants to develop their confidence and their skills. Typical responses were:

> I thought we were going to be told what we would be doing and work to that brief, whereas we designed the pathway that we wanted to take with it, which is even now I'm still like 'wow' responsibility!
> I don't feel like I am a volunteer; I feel like I am a part of TWAM staff.

(Project participants)

The group of young people visited the museum stores with an ethnographic specialist of Pacific world cultures to get to know the collections. Although not planned by staff in this way, instead of looking at the collections thematically or as a whole, individuals chose two or three objects they were interested in and conducted independent research. The objects were chosen from a range of different cultures, including anthropological photography from late nineteenth-century Angola and Australia, a Dayak *Parang* (headhunting knife), and a Maori *Nguru* (nose flute), which amongst others made up the relatively small selection of 30 objects in the final exhibition.

The initial reaction of the group to the dearth of information about the collection was dismay, challenging their views of museums as repositories of quasi-encyclopaedic knowledge. One participant repeatedly asked: 'So seriously, when will you be giving us *the rest* of the information?' There was a sense from the young people that they wanted to be as knowledgeable as possible about their objects before going out and talking to people. The participants first focused their efforts on an academic style of research, which meant researching didactic and definite knowledge, 'facts' as fixed truths to be found in museum catalogues or books. Possibly because of their age, the group seemed reticent about initiating a conversation with adults from different cultures when the way in which such conversations might develop was unclear. Participants often chose to first contact other museums professionals and academic specialists in different countries.[7] These conversations often raised more questions for the group who were still looking for 'facts' and were confronted with divided opinions from specialists and some of the communities they talked to over the interpretation of objects. Many other participants felt somewhat demoralised when their queries remained unanswered. As time went by, and in order to realise their design ambitions, the group shifted their efforts to the more practical aspects of the exhibition's physical production rather than persevering with contacting originating communities.

Visiting the stores and uncovering objects in boxes and on shelves was repeatedly mentioned as one of the highlights of the project. This is perhaps best exemplified in the young people's choice of the exhibition title, 'The Curious Case Of ...'. The title connected with the young people's experience of the process, exploring objects 'forgotten' in museum stores. The choice of the title was first questioned by museum staff who were uncomfortable with the derogatory connotations of the word 'curious', replicating Western imperialist views of cultures as exotic (Peers and Brown 2003). The young people argued for a notion of curiosity reconnected with a more 'innocent' investigative attitude. The title was eventually agreed between staff and the young people after consulting with another group of mostly African diaspora young people working with the museum on a related Cultural Olympiad project.

The core idea of dialogue, although problematic and limited, always remained of key importance to the group in the planning of the exhibition. 'The Curious Case Of ...' opened in July 2012 for three months. The exhibition was conceptually divided into three spaces: objects in

Developing dialogue in co-produced exhibitions

cases, a discussion area and a contemporary cabinet of curiosity.[8] The interpretive panels, written by the young people, invited visitors to actively respond through comments cards and iPads connected to an online comments platform. Through the online platform, the group hoped to generate further dialogue with originating communities abroad around the objects on display.

Reflections

Having worked through this process, we consider whether the central *Stories of the World* concept was fatally flawed from the start, in that contact with originating communities for institutions which hold their heritage has to be a process based on longevity of contact (Kahn 2000; Peers and Brown 2003; Tuhiwai Smith 1999). However, the window of opportunity to achieve this was fixed and short term given that it involved working with young people. In attempting to seriously engage with meaningful dialogic practice we have raised a number of important questions for ourselves. First, about who participates and who takes the lead in making decisions, and fundamentally, whose participation is legitimate.

As a means of developing their exhibition process and plan, the young people drafted a manifesto:

We believe that:

- Anyone can be a curator and everyone's opinions have a value and should be shared.
- Young people have a place within museums and their ideas and input are vital to encourage meaningful engagement.
- Widening conversations around objects are the best ways of engaging young people/ everyone.
- Every object has multiple histories and layers of meaning that can be read in different ways in different contexts and these stories need to be shared.
- Originating communities should be involved in the interpretation of our objects to ensure we have an understanding of the originating community and the context in which an object was intended to be used before displaying it.
- No objects/subjects are out of bounds no matter how contentious, true understanding can only come from an open discussion.

('The Curious Case Of …', Young Curators Manifesto 2012)[9]

The manifesto can be read as the young people's recoding of the intentions of the project and how the group negotiated their relationship with museum. As mentioned, the young people reflected that they felt equal to staff, with similar levels of authority and decision-making, and so wanted to be seen as being 'professional'. The manifesto's first focus was on empowering young people *as curators* echoing the *Stories of the World* programme. At the same time, the group was aware that their role as 'young people' was to challenge the dominant paradigms of knowledge of the institution, and produce something innovative and new (as set up in the national framing of the project). As such, the manifesto 'reclaimed' the group's ownership of the project, even against the museum. Yet, as statement of intent, they had to do so on what they perceived as the museum's own terms: countering (museum) claims to rational knowledge with other claims to rational knowledge. In this way the group became co-opted into the institutional context and what they perceived as professional practice.

Despite the training and our best efforts to equip the group to make different choices and interrogate the institutional model, the museum itself had very limited practice of having wider conversations with non-UK-based originating communities (and it could be argued, given that

there is no ethnographic specialist employed by the museum service, it is not yet about to commit to initiating those conversations). In fact, the field of possibilities was always already structured by the national initiative aims and its requirement to 'produce' dialogue within the institutional museum frame.

It is clear that there were some mixed messages which were communicated to the young people by staff members in different parts of the organisation, but also through some of the external training, about whether this process was about the voices of originating communities or the voices of the young people. In fact, the preferred balance was never clear within the museum itself. Within the national framing of the initiative, the project was about 'young people at the heart of the process'. This explicitly required shared ownership of decision-making; however, it was unclear in the national objectives whether this was about young people giving their personal views on objects (whatever they chose); or about making collections relevant to a younger, contemporary audience; or about enabling young people to act as researchers in a museum setting. For the young people it became mostly about having an enjoyable experience and gaining work experience. For the museum, and the delivery staff, it was about developing 'a collaborative reflective dialogue with those outside of existing structures of expertise to see where it takes *our understanding*' (TWAM 2010, emphasis added). The actual ethics of balancing voices was not explicitly discussed within the museum, as it was assumed that these would emerge through the process of dialogic and democratic exchange itself.

Dialogue implies the need for a set of identifiable interlocutors. These interlocutors and their expected roles were imagined in specific ways by the museum: originating communities as knowledgeable and willing respondents, young people as mediators and the museum as facilitator through resources, expertise and advice. However, as our experience of the project describes, such conceptions of multiple and productive dialogue ignore the complexity of agency and intentions: many did not engage, whether by choice or happenstance. Reflecting on their attempts to contact originating communities, one participant stated: 'it was very difficult to get them to say what we would have liked them to say'. There was a sense throughout the process that no one was finding the expected interlocutor – and indeed that no one was saying, or doing, exactly what the museum had wanted. The museum was caught up with its own ambitions to provide open opportunities for people to participate based on interests and experience, and responding to a national programme that required a commitment to youth empowerment (and youth making decisions).

Youth empowerment, and indeed access for all in museums, is predicated on participation as a means to broaden horizons and life experiences. The fact that an individual does not have a particular position at the start of a process is not necessarily a reason for exclusion, but for nurturing their involvement. However, the issue of agency as it developed through the young people's interest in gaining career-oriented skills complicated this approach. In part, it reflects a more systemic problem within participation in arts and cultural activities, with a self-selection bias towards those interested in what cultural organisations already offer, which itself influences processes and their evaluation. At the same time, whereas much participatory practice is typically based in shared experiential knowledge (for example, youth projects on sex or violence), the institutional framing of the project did not explicitly ask for any specific experiential knowledge related to the collections or world cultures, or indeed wider (implied) issues of marginalisation. In fact, the ways in which the project was first communicated in the form of the advert for participation, focusing on opportunities to develop skills, and have fun (based on current practice for youth engagement), certainly impacted on the composition of the group.

The case reveals the tensions within different participatory practices in museums, and relates to the divide between individualist and universal understandings of participation that come into

Developing dialogue in co-produced exhibitions

play in an institutional attempt to 'produce' a top-down democratic exchange. This reflects the long-standing debate between cultural relativism and universalism in museums, expressed in the question 'which rights and for whom?' and its consequences for understandings of authority (see Karp and Lavine 1991). Museums are central in the history of modernity and its incipient enlightenment ideals of equality and freedom. The museum is caught up within these structures of modernity from which it was born and a (postmodern) desire to embrace the plurality of meanings (Bennett 1995). The point is how such a logical bind extends to notions of democratic participation in the formulation of museums as spaces of dialogue. This can be read onto the wider conception of 'participation for all', linked in part to a wider UK cultural policy that seeks to reclaim culture from an elite participation of the few to mass participation, creating opportunities for all to become active participants in museums and express their opinions and voices. Such a conception of participation is also implicated in wider neo-liberal agendas of consumer agency ('your choices matter, whatever you choose'). Another complexity within understandings of participatory practice is linked to the ladder approach to participation (Simon 2010). Implicit in this model is a hierarchy of social participation which equates the greatest level of relinquishing of power with the most valuable forms of participation work, for both individual participants and the institution. In this rhetoric, the ever-increasing demand for participation is thus defined as a goal and as an improvement. However, linear, progressive models of participation ladders discount the complexity of individual and group behaviour and motivation, as well as idealising some forms of participation over others. In the set up for *Stories of the World*, 'co-production' was posited at the top end of this ladder, and, through dialogue, all 'producers' were idealised as co-equal participants.

The choice of isolated, studious approach to research in some ways influenced the outcomes of the process, and placed much of the responsibility for developing dialogue onto individuals. Within the museum, we were not clear amongst ourselves, however, whether we could intervene against certain project developments. We should perhaps have made it much clearer to participants that if there were principles that they could not fully commit to, they could not be involved. However, we had no language or mechanism to determine the difference between complying with the values of the project as a way of accessing career experience, as opposed to our own determination to uphold the project submission's original values. This raises critical questions as to the role of museum staff in 'producing' dialogue. As the project developed, we wrestled with our implicit assumption that staff should contain their challenge to participants out of fear of being coercive, or risking having them walk out of a project with a deadline and outcome to achieve. The point is that by not taking an ethical stand, the museum was effectively divesting itself of its responsibilities. Considering how staff can take a stand is not an argument for maintaining control and withholding trust; rather it is about developing relationships wherein all participants' equality is underscored, and staff initiate conversations that are aimed, both and at the same time, to respect participants 'as they are' and cultivate respect for other cultures and world views. It is a dynamic practice that involves staff moving in and out of different roles of observer, facilitator, catalyser, teacher and listener to hold the context of dialogue. These interventions should never be obstructive, but staff will sometimes need to provoke and challenge, and be clear about where they draw the line.

In thinking about the role of staff as facilitators in such project we draw on Bauman's (1987) metaphor of the intellectual as interpreter. Interpreters do not decide on behalf of others; they seek, rather, to facilitate communication between different participants. Their role is to translate 'statements made within one communally based tradition so that they can be understood within the system of knowledge based on another tradition' (Bauman 1987, 5). As Bauman (1987, 5) insists 'the postmodern strategy does not imply the elimination of the modern one; on the

contrary, it cannot be conceived without the continuation of the latter' (hence the logical bind of the museum). Although the interpreter maintains power and influence, he/she is held accountable to her/his own agenda, and cannot defer responsibility. Without being open about agendas, and serious attention to the assumptions that guide participatory practice, museums will not be able to deliver on key values of openness and transparency (Marstine 2011). Perhaps in cases like *Stories of the World*, working with young people as mediators of the museum dialogue, we have to accept, as suggested by the governmentality logic presented in Bennett's 'democratic exchange', that we are 'cultural technicians' who facilitate intra-community exchange (Bennett 1998). At the same time, we are cautious of our own conclusions: how comfortable are we with the realisation that in order to achieve our intended aims, we needed to take more control of who was involved, on what grounds, and to what end? In reflecting where we should have intervened in the process by being clearer about the terms of involvement, we question how the museum can make judgements on participants' complex behaviours and motivations. We have considered whether the criteria for involvement could have been more specifically about attitudes, values and beliefs. However this places us in a questionable position as these would be *our* requirements that we place on participants, and *our* assessment of their suitability. Is our enterprise to socially engineer dialogue? Should it be the role of the museum to 'produce' dialogue? Do we fall again into the trap of the great self-regulating and civilising museum (Bennett 1998)? Does this undermine the democratic space of the museum, or its possibilities as a 'contact zone'? And furthermore, as museum professionals, how equipped are we, how visible are our intentions, and how much right do we have, if any, to dictate this process?

Conclusion

In our reflections it becomes clear that the field of possibilities of the project were limited from the onset with the museum attempting to 'produce' a (certain) dialogue within a certain timeframe and towards a certain end. Despite well meaning intentions to facilitate conversations between different groups, the effect of 'producing' dialogue in a top-down democratic project was misrecognition of the terms of participation. The attempt to produce to and fro engagement between different groups rested on a number of unexamined assumptions, around who might participate and why. What is interesting to draw from this case is the ways it reveals the problematic conflation of different participatory practice (dialogue, participation, co-production and youth empowerment) and the context it provides to examine the relations and ethics that arise from these processes. Museums are extensive places of relationships and responsibilities – they are open to everyone, accessible to all and belong to everyone – both present and future generations. They aim to represent all, and since monolithic authority can no longer be assumed, the extension of professional expertise draws legitimacy on processes that include public engagement and dialogue. Museums must address competing demands and rights, which are often ambivalent and inherently contradictory. It is the act of 'balance' that secures ethics.

Ethics of balance require a close consideration of the different terms and stakes of participation, and the contours of each participant's rights and responsibilities towards one and other. We have considered the issue of legitimacy of museum staff in sustaining balance. The danger is that museum practice simply takes its cues from the prevailing value system. As such, an ethics of balance cannot be a static set of professional rules; rather it is a discursive social practice. This begins with museum staff being open to wider participation and dialogue. This means being more upfront about the different aims of participation work, being honest about both the institution and different staff positionality, but remaining open to others, and admitting uncertainty

Developing dialogue in co-produced exhibitions

and risk. Accepting the uncertainty of engagement, a discursive practice of ethics enables all to take part and held to be responsible. In sharing authority, museums must fulfil their ethical responsibility to acknowledge not only the capabilities of all participants but also their structural positioning and unfinished knowledges. This will require preparedness to struggle with contradictions (between individualist, collectivist and institutional positions for example), and to accept these as inevitable yet productive.

We choose to close this paper with some suggestions for opening up, if only a little, the field of possibilities relating to participatory work.

In order for museums to deal with uncertainty, they will need to expand their strategies for how exhibitions developing out of dialogue can involve and inspire the wider public when it makes sense to present the emerging discussions, not simply when a pre-determined point in an exhibition calendar has been reached. This presents enormous challenges within current systems of operating and will require widespread experimentation, discussion, risk and publicly visible failures. It is not enough to assume that change will occur through engaging with a new approach to exhibition making through co-production. There is an imperative for a much longer term commitment to the process of developing relationships with communities than was ever possible within *Stories of the World*. Initial practical attempts might revolve around a 'family' of exhibitions in development, with groups of participants communicating with each other and negotiating their own exhibition timetable. The threat of empty exhibition space could perhaps be overcome by these groups of participants identifying interim digital content or events which could feature dynamic discussions in progress, or noteworthy moments and revelations for public display. It will require those involved to be clear about their personal and institutional beliefs. These suggestions are presented as some limited bridging strategies to extend an ethics of balance. They present a set of relations and skills that may begin to better accommodate dialogic practice and co-production by establishing visible and honest discussions about the assumptions and intentions of all interlocutors, and start a process of allowing the uncertainty of dialogue to find place in the certain world of museums.

Acknowledgements

The authors would like to thank the three anonymous reviewers for their helpful comments on earlier drafts. We are also especially grateful to Helen Graham (University of Leeds) and Adam Gutteridge (IPUP) who gave insightful advice on the text and argument. Nuala Morse was supported by the Economic and Social Research Council [ES/I902074/1] while writing this paper.

Notes

1 Harris' analysis focuses in particular on the East Side Tenement Museum in New York.
2 Extracts from unpublished HLF bid.
3 See the project website www.journeysofdiscovery.org.uk/
4 This is not uncommon in UK regional museums with large multidisciplinary collections and no ethnographic specialists.
5 As stated in the Tualip Tribe's submission to the Intangible Heritage/IP Commission: 'There is information that is restricted, that our children cannot learn about, there is information that is restricted even to adults, there is information that is of a secret or sacred nature, that many people have no knowledge of or access to. That knowledge is only there for certain people to have access to' (Galarrwuy Yunupingu 1986 cited in ATSILIRN Protocols).
6 This discussion reflects only *our own interpretations* of the events, from our roles as project manager, project coordinator and an associated researcher.

711

Nuala Morse *et al.*

7 For example, one participant had online conversations with members of the Ekpeye Kingdom through a Facebook group.
8 The contemporary cabinet encourages the public to rethink the idea of curiosities in terms of their own material culture and upload pictures of their 'curious' objects on a Flickr site (www.flickr.com/groups/thecuriouscaseof)
9 Extract from young curator's unpublished manifesto.

Bibliography

Aboriginal and Torres Strait Islander Library, Information and Resource Network (ATSILIRN). 2005. *ATSILIRN Protocols.* http://aiatsis.gov.au/atsilirn/protocols.php

Arts Council England (ACE). 2010. *Achieving Great Art for Everyone.* London: ACE.

Bauman, Z. 1987. *Legislators and Interpreters: On Modernity, Post-Modernity and Intellectuals.* Oxford: Polity Press.

Bauman, Z. 2000. *Liquid Modernity.* Cambridge: Polity.

Bellamy, K., and C. Oppenhiem. 2009. *Learning to Live: Museums, Young People and Education.* Institute for Public Policy and National Directors' Conference. www.nationalmuseums.org.uk/media/documents/publications/learning_to_live.pdf

Bennett, T. 1995. *The Birth of the Museum.* London and New York: Routledge.

Bennett, T. 1998. *Culture: A Reformer's Science.* London: Sage.

Bennett, T. 2006. "Exhibition, Difference and the Logic of Culture." In *Museum Frictions: Public Cultures / Global Transformations,* edited by I. Karp, L. S. Kratz, and T. Ybarra-Frausto, 46–69. Durham and London: Duke University Press.

Chakrabarty, D. 2002. *Habitations of Modernity: Essays in the Wake of Subaltern.* Chicago, IL: University of Chicago Press.

Clifford, J. 1997. *Routes: Travel and Translation in the Late Twentieth Century.* Cambridge, MA: Harvard University Press.

Collins, P. H. 1990. *Black Feminist Thought.* Boston: Unwin Hyman.

Crooke, E. 2007. *Museums and Community: Ideas, Issues, and Challenges.* New York: Routledge.

Department for Culture, Media and Sport (DCMS). 1999. *Museums for the Many.* London: DCMS.

Dibley, B. 2005. "The Museum's Redemption: Contact Zones, Government and the Limits of Reform." *International Journal of Cultural Studies* 8 (1): 5–27. doi:10.1177/1367877905050160.

Fouseki, K. 2010. ' "Community Voices, Curatorial Choices': Community Consultation for the 1807 Exhibitions." *Museum and Society* 8 (3): 180–192.

Hall, S. 2001. *Modernity and Difference.* London: Institute of International Visual Arts.

Harris, J. 2011. "Dialogism: The Ideal and Reality for Museum Visitors." *International Council of Museums Study Series ISS* 40: 87–97.

Harrison, J. 2005. "Shaping Collaboration: Considering Institutional Culture." *Museum Management and Curatorship* 20 (3): 195–212.

Heritage Task Force. 2009. *Embedding Shared Heritage: The Heritage Task Force Report.* London: The Mayor's Commission on African and Asian Heritage, Greater London Authority.

Kahn, M. 2000. "Not Really Pacific Voices: Politics of Representation in Collaborative Museum Exhibits." *Museum Anthropology* 24: 57–64. doi:10.1525/mua.2000.24.1.57.

Karp, I., and S. D. Lavine, eds. 1991. *Exhibiting Cultures: The Poetics and Politics of Museum Display.* Washington, DC: Smithsonian Institution Press.

Lynch, B. T. 2011a. "Collaboration, Contestation, and Creative Conflict: On the Efficacy of Museum/Community Partnerships." In *Redefining Museum Ethics,* edited by J. Marstine, 146–163. London: Routledge.

Lynch, B. T. 2011b. *Whose Cake is it Anyway?: A Collaborative Investigation into Engagement and Participation in Twelve Museums and Galleries in the UK.* London: The Paul Hamlyn Foundation. http://phf.org.uk

Lynch, B. T., and S. J. M. M. Alberti. 2010. "Legacies of Prejudice: Racism, Co-Production and Radical Trust in the Museum." *Museum Management and Curatorship* 25 (1): 13–35. doi:10.1080/0964 7770903529061.

Marstine, J. 2011. *Redefining Museum Ethics.* London: Routledge.

Mason, D. D. M., and C. McCarthy. 2006. " 'The Feeling of Exclusion': Young Peoples' Perceptions of Art Galleries." *Museum Management and Curatorship* 21: 20–31.

McLean, K. 1999. "Museums Exhibitions and the Dynamics of Dialogue." *Daedalus* 128 (4): 83–107.

McLean, K., and W. Pollock. 2007. *Visitor Voices in Museum Exhibitions*. Washington, D: Association of Science-Technology Centers, Inc.

MLA. 2009. *Stories of the World Prospectus*. www.artscouncil.org.uk/media/uploads/pdf/Stories_Prospectus_web.pdf

MLA. 2010. *Stories of the World*. www.mla.gov.uk/\what\programmes\2012_programme\stories_of_the_world.html

Nightingale, J. 2008. "People Power." *Museum Practice* 44: 50–51.

Peers, L., and A. Brown, eds. 2003. *Museums and Source Communities*. London: Routledge.

Phillips, R. B. 2003. "Community Collaborations in Exhibitions: Towards a Dialogic Paradigm." In *Museums and Source Communities*, edited by L. Peers and A. Brown, 155–170. London: Routledge.

Sandell, R. 2003. "Social Inclusion, the Museum and the Dynamics of Sectoral Change." *Museum and Society* 1 (1): 45–62.

Simon, N. 2010. *The Participatory Museum*. Santa Cruz, CA: Museum 2.0.

'The Curious Case Of …' Young Curators Manifesto. 2012. Unpublished Manifesto on File with TWAM.

Tuhiwai Smith, L. 1999. *Decolonising Methodologies: Research and Indigenous People*. London and New York: Zed Books.

TWAM (Tyne & Wear Archives & Museums). 2010. Heritage Lottery Fund Bid Submission for *Stories of the World*. Unpublished HLF Bid.

Watson, S. 2007. *Museums and Their Communities*. London: Routledge.

Witcomb, A. 2003. *Re-imagining the Museum: Beyond the Mausoleum*. London: Routledge.

Yuval-Davis, N. 1999. "Institutional Racism, Cultural Diversity and Citizenship: Some Reflections on Reading the Stephen Lawrence Inquiry Report." *Sociological Research Online* 4 (1), www.socresonline.org.uk/socresonline/4/lawrence/yuval-davis.html

48
Community engagement, curatorial practice, and museum ethos in Alberta, Canada

Bryony Onciul

Current museology presents community engagement as a positive, mutually beneficial way to improve and democratize representation. However, analyzing participation in practice reveals many forms of engagement, each with different advantages and challenges, none of which solve the problems associated with representing complex, multifaceted communities. Despite the positive assumptions, engagement has the potential to be both beneficial and detrimental. This chapter argues that while a worthy and honorable pursuit, engagement is limited as to what it can achieve within current museological practice, and engagement does not automatically grant integrity or validity to museum exhibits.

This chapter analyzes community engagement in theory and practice at three Canadian case study museum and heritage sites, each illustrating a different approach to collaboration with local Indigenous Blackfoot First Nations communities. The chapter proposes that, when museums work with communities, an *engagement zone* is created. This concept builds on James Clifford's (1997) theory of the museum as a contact zone and emphasizes the importance of inter- as well as cross-cultural relations, the sharing of on- and off-stage culture, and the potential risks, costs, and benefits for participants who enter into the complex and unpredictable space of engagement zones.

Engagement often produces results such as coproduced exhibits, museum programming, community employment, collection loans, repatriations, community participation on museum panels, and changes to museum practice and ethos. These products can be seen as the tangible manifestations of power negotiations between participants in engagement zones. What occurs in an engagement zone and what it produces depends upon the collaborative approach used, the participants involved, the way the process unfolds, and the context in which it occurs. This chapter introduces the concept of engagement zones and then focuses on two engagement zone products: indigenized curatorial practice and coproduced exhibits.

Methods and case studies

This chapter draws on original data I collected over twenty-four months in the field between 2006 and 2009, researching the case studies and conducting forty-eight-in-depth digitally recorded interviews with museum and community members supplemented with participant

observation, archival research, and exhibit analysis. Interviewees reflected upon their personal experiences of engagement, and while it must be acknowledged that they may have had vested interests and agendas for presenting a particular view (Hollway and Jefferson 2000: 26), interviewees were generally open, thoughtful, and reflective and invested time and energy in sharing their experiences.

The three case studies are located in southern Alberta, Canada, and each sought to work collaboratively with local Indigenous Blackfoot communities, in particular Blackfoot Elders,[1] to create coauthored exhibits on Blackfoot culture, and each adapted its curatorial practice and ethos to some extent to accommodate Blackfoot cultural protocol. The case studies were: Head-Smashed-In Buffalo Jump Interpretive Centre[2]; Glenbow Museum; and Blackfoot Crossing Historical Park (BCHP).

The first to embark on engagement was the Head-Smashed-In archaeological interpretive center. In the early 1980s, it opted to involve the Piikani and Kainai Blackfoot Nations in the development of a center for the interpretation of the buffalo kill site. Pre-NAGPRA (United States 1990) and pre-Task Force Report (Canada 1992), Head-Smashed-In was under no legal or professional obligation to engage. However, the proximity of the buffalo jump to the Piikani Reserve and the community's knowledge of and connection with the site influenced the archaeologists' decision to consult the community (Brink 2008: 272–275). Head-Smashed-In used a consultation model ranked as tokenism on Arnstein's Ladder of Participation (1969); however, it was a progressive step in museum–community relations at the time.

In the early 1990s, the ethnology team at Glenbow Museum began developing relationships with Elders from the four nations of the Blackfoot Confederacy. Through participation in community events and by cultivating personal relations with Blackfoot members, the museum developed culturally appropriate loan and repatriation practices. This relationship was formalized with the signing of a Memorandum of Understanding in 1998, which led to the establishment of a partnership to develop the Blackfoot gallery: Nitsitapiisinni: Our Way of Life. Glenbow sought to acknowledge the Task Force Report (1992), and the exhibition "embodies the spirit of those recommendations" (Conaty 2003: 237). As a result, "Nitsitapiisinni was one of the first permanent galleries in Canada to be built using a fully collaborative approach" (Krmpotich and Anderson 2005: 379).

Opening in 2007, the newest of the case studies is Blackfoot Crossing Historical Park (BCHP). It was developed by the Siksika Blackfoot community, for the community, with community money,[3] on community land, and is run and staffed by the community. As a facility of 37,000 square feet located on six square miles of park land (Bell 2007: 10–11), combining "a museum exhibition with recreational and other outdoor offerings [it] is an entirely new type of venture for the community and possibly unique in Canada" (Bell 2007: 5). BCHP's curators are both trained museum professionals and practicing community Elders. As such, they bring together professional and Blackfoot cultural approaches to heritage management and attempt to meet both museological standards and Blackfoot protocol. Despite being community controlled, BCHP faces problems common to any kind of representation and has to negotiate and balance competing stakeholder interests and differences of opinion within the community.

Unpacking the terms museum, community, and engagement

In this chapter, the term *museum* is used to refer to museums and interpretive centers, as the case studies reflect a combination of both. The term *museum* is often misleadingly associated with an idea of a neutral place where cultural and historical facts can be learned. Museums are political spaces where society frames its authorized culture, history, and identity. As Sharon Macdonald

states, "any museum or exhibition is, in effect, a statement or position. It is a theory: a suggested way of seeing the world" (1996: 14). Museums can influence the way people conceive and understand one another and the world they live in. They can help define who can claim certain cultures and identities; who are insiders and outsiders; and whose perspectives or versions of history should be recognized as valid. And yet museums are also reflections of the societies that create them. Consequently, museums are contested terrains and common focal points of cross-cultural political debates.

The *communities* this chapter specifically refers to are the four Blackfoot Nations within the Blackfoot Confederacy. They are known as Siksika (Blackfoot), Kainai (Blood), and Piikani (Peigan) in southern Alberta, Canada, and as Amsskaapipiikani (Southern Piikani or Blackfeet) in Montana, USA. However, *community* is a problematic term as it describes a myriad of complex relations and groupings of individuals. Despite the implication of being grouped under the term *community*, communities are not homogenous, well-defined, static entities. On the contrary, they are porous, multifaceted, ever-shifting, loosely connected groups of people. *Community* as a concept ceaselessly creates, struggles, renegotiates, transforms, destroys, and renews itself, constantly redefining what and who is and is not community. Communities' members may be knowingly or unknowingly involved, they may be insiders and outsiders, members of multiple communities, and self- and not self-identifying. Membership of a community may be fleeting, partial, or innate, lifelong, and unshakeable, often irrelevant of an individual's wishes. Thus, *community* is used as a poor substitute, or shorthand, for a complex, rich, and ever-changing interaction.

In addition to the problems surrounding the use of the term *community*, it must be remembered that when speaking of museum community engagement, it is neither the museum nor the community that is engaged, but individuals from each camp who come together to represent their source bodies and negotiate engagement. Consequently, every engagement zone is unique because of the individuals involved, as well as the context, time, place, and amount of power shared.

The term *engagement* has been used in academia and in practice to describe such a myriad of relationships that the label can often conceal more than it reveals about the realities of collaborative practice. There are as many approaches to engagement as there are museums, communities, and individuals to participate in them. Nevertheless, theorists have attempted to group engagement into categories based on the level of power sharing involved (Arnstein 1969; Farrington and Bebbington 1993; Galla 1997; Pretty 1995; White 1996). A dated and yet still relevant and frequently borrowed model is Sherry Arnstein's *Ladder of Participation* (1969). She groups participation under three main categories: non-participation; tokenism; and citizen power. Using the ladder format enables ranking of each form with manipulation at the bottom and citizen control at the top.

- Citizen power

 - Citizen control
 - Delegated power
 - Partnership

- Tokenism

 - Placation
 - Consultation
 - Informing

Engagement, practice and ethos in Alberta, Canada

- Non-participation

 - Therapy
 - Manipulation

Arnstein notes that each grouping is a simplification of participation in practice, yet useful because it shows the power dynamics between groups:

> The ladder juxtaposes powerless citizens with the powerful in order to highlight the fundamental divisions between them. In actuality, neither the have-nots nor the powerholders are homogeneous blocs. Each group encompasses a host of divergent points of view, significant cleavages, competing vested interests, and splintered subgroups. The justification for using such simplistic abstractions is that in most cases the have-nots really do perceive the powerful as a monolithic "system," and powerholders actually do view the have-nots as a sea of "those people," with little comprehension of the class and caste differences among them.
>
> *(Arnstein 1969: 219)*

The three case studies reflect three of the top five categories on Arnstein's ladder. Head-Smashed-In used consultation (tokenism); Glenbow used partnership (citizen power); and BCHP's community model represents the top of Arnstein's ladder as citizen control.

Despite echoing the model, the case studies do not completely reflect the hierarchy implied by their placement on Arnstein's ladder. Five factors can account for this: first, the realities of engagement are much more untidy and fluid than any model or category can account for. Second, during the process of engagement all the different kinds of participation listed in typologies such as Arnstein's may occur at different stages (Cornwall 2008a: 273–274). Third, museums and communities do not enter into engagement with a predetermined or fixed amount of power; it is always open to negotiation, theft, gifting, and change. Fourth, influences beyond the engagement zone such as logistics and institutional requirements limit what is made possible by engagement. Finally, the top rung of the ladder, citizen control, does not solve the problems of representation or relations between individuals within a community or an institution such as a museum. Community control still requires methods of power sharing and consensus forming, because every individual cannot make all the decisions, in fact the whole community may not be engaged or kept up to date. Some community members will be empowered at the top of the ladder, while others will be involved in tokenistic ways or may not participate at all. By not addressing internal group power relations among individuals, the model oversimplifies engagement in practice.

Engagement zones

Since current models and terminology do not fully encapsulate the complex realities of engagement in practice, I sought other ways of conceptualizing the process. James Clifford's (1997) use of Mary Pratt's (1992) term *contact zones* provided one such model, however it too underplays internal community collaboration.

Pratt used the term *contact zone* to describe "the space of imperial encounters, the space in which peoples geographically and historically separated come into contact with each other and establish ongoing relations" (1992: 8). Clifford applied the term to museums, explaining that "the organising structure of the museum-as-collection functions like Pratt's frontier" (1997:

192–193). From the beginning, Clifford acknowledged "the limits of the contact perspective" (1997: 193). Describing Portland Museum's consultation with Tlingit. Elders about the museum's Rasmussen Collection, Clifford notes that "some of what went on in Portland was certainly not primary contact zone work"; among the Tlingit, "interclan work" occurred that was "not directed to the museum and its cameras" (1997: 193). He adds:

> [I]t would be wrong to reduce the objects' traditional meanings, the deep feelings they still evoke, to "contact" responses. If a mask recalls a grandfather or an old story, this must include feelings of loss and struggle; but it must also include access to powerful continuity and connection. To say that (given a destructive colonial experience) all indigenous memories must be affected by contact histories is not to say that such histories determine or exhaust them.
>
> *(Clifford 1997: 193)*

Thus I propose the use of the term *engagement zones* to incorporate what *contact zones* cannot: the intercommunity work that occurs in cross-cultural engagement and is prominent in citizen-controlled grassroot community developments such as BCHP. Engagement zones emphasize the agency of participants and the potential for power fluctuations despite inequalities in power relations. They enable consideration and exploration of internal community engagement, culture, and heritage prior to and beyond the experience of colonialism and allow for indigenization of the process. The concept does not supersede the idea of contact zones, but is an overlapping and compatible notion. Contact zones can occur within engagement zones and engagement zones produce outputs such as public exhibits that often become contact zones, as Figure 48.1 illustrates.

The engagement zone is a physical and conceptual space in which participants interact. It is created when individuals from different groups enter into engagement and closed when those participants cease engaging. If participants change, so do the parameters of the zone and the interaction within it. It is a temporary, movable, flexible, living sphere of exchange that can occur spontaneously or be strategically planned. Engagement zones occur on frontiers, within groups, and as a result of border crossings. They are semiprivate, semipublic spaces where onstage and off-stage culture can be shared and discussed and knowledge can be interpreted and translated to enable understanding between those without the necessary cultural capital or to facilitate cross-cultural access. If required, offstage information may be disclosed to facilitate the process, although it is generally not intended to leave the engagement zone, nor is it for public dissemination in products such as exhibits.

Within the engagement zone, power ebbs and flows, continually being claimed, negotiated, and exchanged, not predetermined or innate, but situated within the context of the interaction, echoing Foucault's notion of power as "the name that one attributes to a complex strategical situation in a particular society … produced from one moment to the next, at every point, or rather in every relation from one point to another" (1976: 93). Conflict, compromise, and consensus can occur. Participants continually negotiate the rules of exchange, challenging and debating power and authority. Cultural concepts such as expertise, customary boundaries, and hierarchies come into question and negotiation and can change individuals' roles and status within the zone. Boundaries between insider and outsider blur, and temporary boundary crossings are enabled. For some participants, stepping out of traditional roles and crossing boundaries causes feelings of risk, along with the potential for individual participants to be judged by the action of the engagement zone group, irrespective of internal power relations or individual contributions.

Figure 48.1 Engagement Zone Diagram. The model shows the input of individuals from the museum and community into the engagement zone and potential products or results of engagement work in the form of adaptation to curatorial practice, community participation or influence on policy/advisory boards, coproduction of exhibits, program development (often connected with exhibits), and the employment of community members possibly in the form of guides. The model highlights the potential for contact zone work (Clifford 1997), but also for engagement zones to occur without necessarily being, or including, contact zones. Model created by B. Onciul 2011.

Despite the fluidity of power within engagement zones, structural inequalities weight interaction between museums and Indigenous communities. The Make First Nations Poverty History Expert Advisory Committee reported: "in 2009, First Nation communities are still, on average, the most disadvantaged social/cultural group in Canada on a host of measures including income, unemployment, health, education, child welfare, housing and other forms of infrastructure" (2009: 10). Museums generally hold the majority of the power as cultural authorities and the host of the "invited spaces" (Cornwall 2002; Fraser 1987, 1992) of engagement. Nevertheless, Indigenous communities still have power and agency to negotiate terms, particularly because they have the leverage of holding desperately sought after Indigenous knowledge that cannot be found beyond the private sphere of the community.

As spaces of power flux, engagement zones are an unmapped, unpredictable, and inconsistent terrain that has the capacity to produce unexpected outcomes. To borrow Lisa Chandler's expression, community engagement is a "journey without maps" (2009: 85), and what will be discovered, shared, and changed along the way can only be known through doing and experiencing the process. If temporary changes are carried beyond the engagement zone and incorporated into each group's work, or the products they coproduce, the results can be transformative. However these zones do not operate in isolation, but are influenced by the wider context in which they are situated.

Bryony Onciul

Adapting curatorial practice to cultural protocol

One of the potentially transformative products of the engagement zone is the indigenization of curatorial practice. According to Simpson, "To many Indigenous peoples, western-style museums are laden with associations of colonialism, cultural repression, loss of heritage, and death" (2006: 153). So much so that when the Kwakwaka'wakw developed U'Mista Cultural Society in Alert Bay, BC, the board of directors said, "We're not building a museum. Museums are for white people and are full of dead things" (Gloria Cranmer Webster quoted in Mithlo 2004: 754). Traditional museum practices of collecting and storing Blackfoot material had similar negative effects on Blackfoot life. It disrupted cultural practices by removing items from circulation and use. Sacred items, believed to be living beings by Blackfoot people, entered museums and were treated as inanimate objects, a practice that went against traditional protocol. Indigenizing the way sacred Blackfoot items are treated by museums can improve museum-community relations and support living Blackfoot culture.

Engaging with Indigenous communities can bring alternative concepts of cultural heritage management into museums and create museum practices sensitive to cultural protocol. Understanding and following cultural protocol can help museums become places that support living Indigenous cultural practice, rather than storehouses for disused relics considered dead or dominant by their source communities. To address these issues, some Indigenous groups have sought to work with mainstream museums to change the way they represent and treat Indigenous objects and culture. Many have created their own centers for the care and promotion of their cultural material, knowledge, and practices (Simpson 2007). The Blackfoot have done both, with Elders working with mainstream museums to change practice and the Siksika Blackfoot Nation opening its own center, BCHP, in 2007.

Both Blackfoot Elders and Western museum professionals have complex and intricate practices and procedures that determine the way they manage cultural heritage and materials. Both undergo extensive training with their respective educational authorities and both are valued by their communities as having particular knowledge and expertise that enables them to care for material culture and cultural knowledge on behalf of the wider community. While museum professionals tend to gain their qualifications through university courses, Blackfoot Elders train through apprenticeships in age-graded sacred societies and study for years before earning the right to become a keeper of an object, song, dance, story, or ceremony, which they must maintain and pass on according to strict cultural protocol. As such, it should come as little surprise that, when working with museums, Blackfoot Elders feel suitably qualified to question Western practices and suggest the adoption of Blackfoot protocols for the conservation and exhibition of Blackfoot materials in museum collections.

Museums can benefit from sharing and adapting to non-Western cultural curatorial practice, as Kreps explains: "Indigenous museum models and curatorial practices have much to contribute to our understanding of muscological behaviour cross-culturally, or rather, of how people in varying cultural contexts perceive, value, care for, and preserve cultural resources" (2003: 146). Engaging with communities and adapting museum practice in response demonstrates a museum's willingness to share power and to respect cultural practices, which can in turn strengthen relations between museums and the communities they represent. Simpson argues that: "Through the incorporation of indigenous concepts of cultural heritage, curation, and preservation, the idea of the museum is evolving to accommodate the needs of diverse cultural groups, both as audiences for museums and as presenters of culture and custodians of tangible and intangible heritage" (2006: 173). Such adaptation and indigenization can be seen in the case studies to differing extents.

720

At Head-Smashed-In, Piikani Elder Joe Crowshoe served as the main Blackfoot consultant during the development of the center. Through a combination of consultation with Elders and employment of community members as guides and interpretive staff, the non-Blackfoot management at Head-Smashed-In has learned about Blackfoot protocol and adapted practice to accommodate some cultural approaches. They created a space where smudging[4] and prayer can take place without disturbance, such as the triggering of fire alarms. They facilitate an annual renewal ceremony for a sacred skull they display and have acknowledged cultural restrictions about photographing this sacred item. However, they have not always acted on the community's advice, and images of the sacred skull continue to be used in marketing materials and products, causing controversy within the Blackfoot community. As Arnstein's model indicates, consultation favors the consulters over the consulted. In addition, the very presence of the sacred skull and two replica bundles in the display causes some upset as there is debate within the community as to the appropriateness of these displays (despite them being sanctioned by the original consultant). Thus Head-Smashed-In has made cultural adaptations, but not to the satisfaction of all members of the Blackfoot community; and it has institutionalized Blackfoot participation through employment, but power remains with the non-Blackfoot government employees who manage the site.

Like Head-Smashed-In, Glenbow made changes to allow space for prayers and smudging. But unlike Head-Smashed-In, Glenbow holds collections and has adapted its curatorial practice further to accommodate Blackfoot protocols that the ethnology team learned through participation in Blackfoot society, repatriation of sacred items, and the partnership they entered into with Blackfoot Elders to develop the Nitsitapiisinni: Our Way of Life gallery. Former CEO Robert Janes explained the learning process and the adaptations it inspired:

> We had a standard conservation practice of putting sacred bundles in a freezer so that they wouldn't contaminate the rest of Glenbow's collection when they came back from a loan. But then we found out that the Blackfoot view these bundles as living children. We had a choice: we could continue to uphold the museum's conservation standards; or, with our growing awareness and our evolving respect for Blackfoot traditions, we actually listened to the Blackfoot ceremonialists and no longer put the bundles in freezers.
>
> *(Robert Janes, personal communication, 2008)*

Traditionally, Blackfoot Elders keep sacred bundles in quiet, safe places; only those who have earned the appropriate sacred rights can handle them, as they are believed to be powerful living beings. Following Blackfoot protocol, Glenbow has removed sacred items from display, either repatriating them or keeping them in separate, designated areas in storage restricted from general access with clear labeling to avoid unintentional exposure. Glenbow follows traditional Blackfoot practice and restricts women accessing the sacred storage areas during their menstrual cycle or when pregnant, which has required Glenbow staff members to adapt their work schedules to accommodate these cultural protocols.

Glenbow recognizes that adaptation requires both granting and restricting access, and has opened up its collection to Blackfoot visitors, allowing object handling in response to Blackfoot traditions of using items to maintain the tie between the tangible object and the intangible knowledge it relates to. Some community members go into storage to see their ancestors' possessions and to reconnect with and renew culture, for example by studying traditional items of dress to inspire the creation of new regalia for cultural events.

Curatorial adaptation is an ongoing learning process informed by working with the community. The aim is to be sensitive to community beliefs and practices and to build relations that facilitate knowledge sharing between the museum and community. At Glenbow, partnership,

collaboration, and adaptation have helped to build a strong and respectful relationship between ethnology curators and Blackfoot Elders. This relationship has enabled the repatriation of sacred bundles; the participation of museum employees in cultural and ceremonial events; a Memorandum of Understanding with the Kainai Mookaakin Society; the development of the Nitsitapiisinni permanent gallery; Blackfoot employment at Glenbow; annual community exhibits; programs; and outreach. This co-operation has helped to maintain and renew tangible and intangible Blackfoot culture and enabled knowledge sharing across the network of engaged people, which has improved both the museum's and the community's understanding of Blackfoot culture (Conaty 2008: 255).

At BCHP, the situation is somewhat reversed. Its curators are Blackfoot Elders trained in Western museology and Blackfoot traditions. They hold the rights to handle and keep sacred objects and knowledge granted through their participation in sacred societies. As such, BCHP keeps sacred items in a separate storage area cared for by ceremonialists following traditional protocol, an area also environmentally controlled to meet museological standards. Photography is not allowed at all within the gallery, and the curators are conscious of noise levels within the museum to avoid disturbing the sacred items they house. BCHP has a tepee-shaped space for Elders to use for ceremonies and prayers, and it encourages its community to use the museum and archives to access and keep cultural items and information.

Limitations to indigenization

Some adaptations can be made relatively easily, such as removing sacred items from display, but some are more complicated and require new ways of thinking about collections, such as enabling communities to use certain collection items. For museums like Glenbow that hold collections from many communities and employ staff members from different social and ethnic backgrounds, it is worth considering how museums should balance rights and values across cultures as each adaptation has costs and benefits.

Glenbow has collections from around the world, and although it has worked closely with some communities such as the Blackfoot, it does not have the resources to engage with and embrace all cultural protocols relevant to the diverse communities represented within its collections. Incorporating Blackfoot protocol alone has created challenges. Restricting women's access to sacred material during their menstrual cycle or pregnancy, although done with good intentions, could prevent a member of staff from performing her duties in relation to that collection. This raises a dilemma, because it places additional demands upon staff that may be contrary to their own cultural values and societal rights.[5] Deciding whose values to respect and prioritize can be difficult because to work with Blackfoot Elders and then ignore their cultural protocol for their most sacred and powerful objects would make the process of engagement tokenistic and without validity or integrity. Currently, Glenbow ethnology staff willingly respect and accommodate these restrictions.

Interesting, it appears that adaptations that affect the institution as a whole, rather than individual employees or departments, are more strongly resisted. Miranda Brady (2009), in her analysis of the National Museum of the American Indian's collaborative approach to representation, identified five residual, naturalized practices that were maintained despite attempts to be a "museum different" (Rand 2009: 130). Brady identified these practices as: object-orientated museology (2009: 144–145); the commodification of Native culture for a mostly non-Native audience (2009: 136–137); failure to consider museum framing on self-representation (2009: 137); funding from sources that potentially contradict the community message (2009: 147); and the naturalization of the need for museums (2009: 148).

Engagement, practice and ethos in Alberta, Canada

These naturalized practices can be identified at Head-Smashed-In and Glenbow despite their engagement with communities and their cultural adaptations. Both present to a predominantly non-Blackfoot audience. Their sources of funding are bodies frequently in dispute with Black-foot communities: Head-Smashed-In is funded by government, and Glenbow often receives funding from major oil companies. Both frame the community voice in a non-community venue and naturalize the need for their existence.

BCHP has critically considered these residual practices and attempts to unsettle them by moving away from Western object fetishes and instead focusing on maintaining both tangible and intangible Siksika culture. While the dedicated museum area cares for its material collection, the center as a whole promotes intangible culture: interpreting sense of place in the river valley park area; providing language and cultural programs; and by hosting community events such as the Annual World Chicken Dance Competition and Siksika Has Talent. BCHP was created for the community as well as tourists, and provides interpretation in Blackfoot and hosts community-dedicated events, preventing it from being simply a commodification of Blackfoot culture for a non-native audience. Although Glenbow and Head-Smashed-In also give tours in Blackfoot and provide community-focused events, their overall primary responsibility is not to the Black-foot community. In contrast, BCHP is directly answerable to the Siksika community. The community was conscious of how to frame its message, and all aspects of the architectural and interior design of BCHP's building add to the interpretation and maintain Blackfoot voice and perspective. Plate 5.1 shows Blackfoot Crossing Historical Park, which as the architect company explains: "The building is intended to be a literal metaphor of traditional Blackfoot icono-graphy" (Fellow Architecture Ltd. n.d.).

Funding was and continues to be a key concern for the Siksika community, who self-funded the majority of the costs to minimize external pressures on how they represent themselves. The BCHP director explained that if they accepted government funding, they would become subject to funding agreements, policies, terminology, and medium requirements, which could under-mine and limit the community's freedom to tell its own story at BCHP (Royal, personal com-munication, 2008).

It is reasonable to ask why BCHP seeks to use Western practices at all, considering the Black-foot have maintained their culture and heritage for thousands of years. Why not follow tradi-tional practice alone? The answer can be found in the wider context in which BCHP operates. The Alberta Museums Association requires museums meet its definition of a museum (based on a modified version of the International Council of Museums definition, see ICOM 2007) for them to be formally recognized and designated by the association (AMA 2010; McLean 2007). If BCHP wishes to be considered for loans and repatriation of Siksika material from other museums, it has to meet certain museological standards. The apparent naturalized need for a museum on the Siksika reservation is partly due to the desire to have material repatriated and partly due to the status and recognition representing culture in a museum currently affords. As Barbara Kirshenblatt-Gimblett states, "Claims to the past lay the foundation for present and future claims. Having ... institutions to bolster these claims, is fundamental to the politics of culture" (1998: 65).

Thus restrictions dictate how far a museum can indigenize without stepping outside the professional community of practice. This illustrates that citizen control (Arnstein 1969) does not result in total empowerment or resolve all the challenges of representation, because there are limits to what can be done and recognized, as museums must operate within the context and power relations of their time. As such, combining Western and Blackfoot approaches to cura-tion is currently beneficial for BCHP.

723

Engagement and the integrity and validity of exhibits

Another common product of engagement zones is coproduced community exhibits. Through collaboration, museums can gain access to traditional community knowledge, deepening their current understandings and interpretation of collections; and communities can shape the representation of their culture in mainstream museums. This is commonly seen as a way to improve representation, increase the integrity and validity of exhibits, and signal community approval. However, in practice this is not an automatic consequence, but heavily dependent upon how the relationship and power negotiations unfold in the engagement zone. As Miltho astutely notes, the "incorporation of Native bodies does not necessarily indicate incorporation of Native thought" (2004: 744).

If museums, intentionally or unintentionally, fail to listen to the people they engage with, do not share power with them, or refuse to act on community advice (potentially due to unforeseen circumstances or institutional requirements), then the exhibitions they produce may have no more validity, integrity, or community approval than if the community had been excluded. In fact, tokenistic engagement can be significantly detrimental to community-museum relations and the museum's reputation within the source community. As Brown and Peers state, "Projects undertaken by museums and archives with source communities need to be more than just attempts to satisfy ideas of political correctness" (2006: 196).

The relationship Glenbow built with the Blackfoot has generally been viewed positively by those who participated (Conaty 2008: 255). Nevertheless, participants acknowledge there is still room for improvement. Not everything could be shown, included, or discussed in the exhibit, and they were limited by the collections available to them. As such the Nitsitapiisinni gallery still presents a simplified and essentialized narrative that only reflects a fraction of the complex and intricate Blackfoot culture, peoples, and history. Further still, the gallery does not fully represent the whole Blackfoot Confederacy, as community participants were not equally balanced from each Blackfoot Nation, nor was everyone involved. Curator Gerry Conaty noted that there was not an equal balance between men and women during consultation, and a different exhibit could be developed from a female perspective (Conaty, personal communication, 2007). The partnership received more involvement from the Kainai Blackfoot Nation than other nations, making the exhibit vulnerable to claims that the narrative favors a Kainai perspective, even though it was a collaborative project built on consensus across the representatives of the four nations.

Bridging the differences between the communities was achieved through traditional Blackfoot processes of consensus forming amongst the Elders, which often entailed long discussions in the Blackfoot language and excluding non-community participants from discussions until an agreement had been made. One example was the use of the Blackfoot language. With no official written language, the spelling of Blackfoot words in the exhibit had to be discussed and agreed upon. Differences in spellings are sometimes viewed as errors by community visitors, as former Glenbow curator Beth Carter explains:

> We've had some people who come into the gallery and question the content, saying: "well that's not right" and "where did you get that information?" So we say: "okay, these were the members on our committee." And they respond "Oh … well!" So they may disagree, but they knew at least where we got the information, that it's not just pulled from a book or from the stratosphere somewhere …
>
> *(Carter, personal communication, 2008)*

In the first instance, this quote highlights that community engagement can give validity and authority to exhibits, as participants can be cited as references for certain information. This was

done with the best intentions and is culturally appropriate as Blackfoot people cite their Elders to show that the information came from an authorized and knowledgeable source.

Nevertheless, it is worth considering the potential consequences for participants who are identified in coproduced exhibits, as they can be held personally accountable by the community they live in for the representation they helped produce in the museum. And yet to create a collaborative exhibit and not identify participants would potentially undermine the participants' agency in the process and be culturally inappropriate in a Blackfoot setting. A compromise would be to try to show that there was a balance of power between the community and museum by identifying the non-community members who also participated in the development of the exhibit. Glenbow and BCHP take this approach and name all participants, including the non-community members (although Glenbow only includes the community members in the photo display at the end of the exhibit). In doing so, visitors can see who the power was shared between and the balance between museum employees, community members, and external consultants. Although this does not reveal the nature of power sharing within the engagement zone, it does increase transparency and indicates the agency of both the museum and community members.

However, whether this message would be received and understood by visitors appears less likely, as Krmpotich and Anderson explored in their analysis of visitors' responses to the Nitsitapiisinni gallery: "Interviews conducted with visitors … demonstrate that museum visitors rarely recognized the extent of the collaboration, and thus rarely equated Niitsitapiisinni with concepts of self-representation or self-determination" (2005: 377). This can be explained in part by Elaine Fleumann Gurian's suggestion that: "While visitors expect to see the authors of works of art, music and fiction identified, they are not used to perceiving exhibitions as the personal work of identifiable individuals" (1991: 187). Krmpotich and Anderson go on to explain, "If visitors are not accustomed to thinking critically about who is creating exhibitions in the first place, they are unlikely to consider the processes of exhibition building and hence not fully appreciate the cultural representations embodied in collaborative exhibitions" (2005: 399).

The problematic nature of communicating power sharing to a public audience is unsurprising when considering the complexity of power relations found in engagement zones. Engagement is an ongoing process which may have peaks and troughs, and the integrity and validity of the relationship may vary at different points in the process. As Glenbow curator Gerry Conaty explains, "Institutions must realize that such-programs are very long term and that the returns on investment may be a long time in coming and may arrive in unanticipated ways" (2008: 256). Engagement relationships tend to experience periods of activity and commitment followed by periods of stagnation. Although resource heavy, museums can help to sustain the integrity of community engagement by planning how to maintain relations during and after the life of the exhibit, and, if necessary, how to end engagement in a mutually acceptable way. To keep an engagement zone open and active requires good communication to facilitate ongoing power sharing, decision making, and the exchange of information. This enables consent renewal and updates; helps to prevent representation from becoming dated or no longer appropriate; enables participants to be involved in the closure of exhibits; and helps to shape future engagements. Engagement relations need to be worked at, prioritized, and to some extent institutionalized into the ethos and daily workings of the museum. Maintaining relations ensures engagement is not just tokenism or a new form of collecting, but a genuine and potentially empowering and transformative experience for all involved.

Conclusion

Engagement has great potential to benefit museums and communities, to share knowledge, create new relationships, exhibits, programs, policies, and curatorial practices. It can give cultural representations greater integrity and validity and enable alternative narratives, new perspectives, and voices to be heard within museums. However, these are not automatic products of engagement, but depend upon the process and power sharing within the engagement zone and how relations are maintained after the initial process of engagement comes to an end.

Within the engagement zone, the lines between what is and is not possible and/or ethical can be blurred and complicated when cross-cultural dialogue identifies areas governed in different ways by different cultures, such as women's rights, or balancing current access with maintaining collections for future access. As such, curatorial adaptation and exhibit production are often tangible sites of power negotiation.

Engagement is an unpredictable process and even when levels of power sharing are apparently established at the outset, that is, in the form of a certain model of participation, power can still be negotiated within the engagement zone and participants may experience moments of empowerment and disempowerment over the course of the engagement. Engagement is complex and unpredictable and can be both beneficial and detrimental to those involved. As publicly acknowledged members of an engagement team, individual participants can be held accountable for the products of these processes, even if they were not (entirely) personally responsible for them. As such, participating in the unmapped territory of engagement zones is risky and has real consequences for the participants, museums, and communities involved.

Engagement can create new challenges that unsettle naturalized museum practices. For engagement to have validity and integrity, institutions need to share power, take on community concerns, and adapt. Otherwise engagement can become what Bernadette Lynch and Samuel Alberti term "participation-lite" (2010: 17), drawing on Andrea Cornwall's development studies concept of "empowerment-lite" (2008b). To engage simply to meet current expectations of political correctness, and to do so in a tokenistic way, undermines the spirit of engagement. Lynch and Alberti propose the idea of "radical trust" to overcome the problems of "participation-lite" (2010). "In practising radical trust," they argue, "the museum may control neither the product nor the process. The former—if there is one—will be genuinely co-produced, representing the shared authority of a new story … the process itself is the key issue. […] Consensus is not the aim; rather, projects may generate 'discensus'—multiple and contested perspectives that invite participants and visitors into further dialogue" (Lynch and Alberti 2010: 15–16).

Whilst admirable, "radical trust," like "citizen control," does not fully address the practical challenges of sharing power within a group through the unpredictable process of engagement. Nor does it address the outside factors that influence engagement zones and their products, such as institutional, professional, cultural, and societal pressures, requirements, and expectations. Even citizen-controlled community developed museums like BCHP must abide by certain standards to function within the professional field and be accepted as a museum by wider society. They also have to consult and negotiate with their own community, despite being community run. The challenge of how to empower a community and "genuinely coproduce" (especially when given a starting point of unequal power relations and institutionalized expectations) and still be recognized as a museum remains unsolved. As discussed earlier in this chapter, attempts to show collaborative working or "discensus" of views within a museum product such as an exhibit are often misread or unread by visitors who are not accustomed to thinking about museums in this way.

Current engagement is limited by the context in which it occurs and the extent to which a museum is willing to take on, adapt, and indigenize its practice, products, and ethos. As Lynch

Engagement, practice and ethos in Alberta, Canada

and Alberti note, "participation within a museum system that continues to disadvantage participants may give them some tools but, as Audre Lorde argued, 'the master's tools will never dismantle the master's house' " (2010; 18). Nevertheless, community engagement (however limited by context and power disparities) does still influence museums and the exhibits they produce, which in turn influences the audiences who come to view them, even when they are not read as works of coproduction or self-representation. Thus, community engagement with museums holds the potential to gradually change the society that frames current power relations, enable better cross-cultural understanding, and move towards wider empowerment of Indigenous Peoples. The development of genuine interpersonal relations, open, honest communication, and institutional commitment can develop models of engagement that will benefit both groups and give engagement the validity and integrity to improve current relations and approaches to representation.

Notes

I acknowledge the AHRC for funding the research outlined in this chapter.

1 The term *Elder* is capitalized because it is a title given to members of the Blackfoot in recognition of their status. An Elder is a member of one or more sacred societies, who has earned ceremonial rights and holds a certain level of traditional knowledge. The title does not refer to age, although Elders are often elderly because of the time taken to reach this level.

2 The name of the Jump is disputed. According to archaeologist Jack Brink, the name Head-Smashed-In comes from a traditional Blackfoot story about a young man who hid beside a cliff during a hunt and was crushed by falling buffalo, resulting in his head being smashed in (2008: 24–25). However, there is dispute as to the location of that buffalo jump, and Piikani Elder Allan Pard asserts that the center's cliff is called Ancient Jump (Allan Pard, personal communication, 2008). Brink acknowledges these discrepancies in his book, but notes that the name is now branded and unlikely to change (2008: 26).

3 Initial capital contributions prior to 2008 to fund the development of BCHP were $9,174,523 from the Siksika Nation, $6,000,000 from the federal government, and $4,500,000 from the Province of Alberta (Bell 2007: 19).

4 Blackfoot people use smudging (the burning of sweet grass, sage, tobacco, or sweet pine) to spiritually cleanse people and objects.

5 This could potentially be taken forward as a grievance against the employer under the Canada Fair Employment Act (1953).

Bibliography

Alberta Museums Association (AMA). 2010. *Recognized Museum Program*. AMA. Available at: www.museums.ab.ca/files/Recognized%20Museum%20Program%20Overview_2010.pdf. Accessed June 26, 2011.

Arnstein, S. R. 1969. "A Ladder of Citizen Participation." *JAIP* 35 (4): 216–224.

Bell, J.K. 2007. *Blackfoot Crossing Historical Park Business Plan July 2007*. Ontario: Bell and Bernard Limited.

Brady, M.J. 2009. "A Dialogic Response to the Problematized Past: The National Museum of the American Indian." In *Contesting Knowledge: Museums and Indigenous Perspective*, ed. S. Sleeper-Smith, 133–155. London: University of Nebraska Press.

Brink, J. W. 2008. *Imagining Head-Smashed-In. Aboriginal Buffalo Hunting on the Northern Plains*. Edmonton: AU Press.

Brown. A. K. and L. Peers, with Members of the Kainai Nation. 2006. *"Pictures Bring Us Messages"/ Sinaakssiiksi Aohtsimaahpihkookiyaawa: Photographs and Histories from the Kainai Nation*. Toronto: University of Toronto Press.

Chandler, L. 2009. " 'Journey Without Maps': Unsettling Curatorship in Cross-cultural Contexts." *Museum and Society* 7 (2): 74–91.

Clifford, J. 1997. *Routes: Travel and Translation in the Late Twentieth Century*. London: Harvard University Press.

Conaty, G.T. 2003. "Glenbow's Blackfoot Gallery: Working Towards Co-existence." In *Museums and Source Communities: A Routledge Reader*, eds. L. Peers and A. K. Brown, 277–241. London: Routledge.

Conaty, G. T. 2008. "The Effects of Repatriation on the relationship between the Glenbow Museum and the Blackfoot People." *Museum Management and Curatorship* 23 (3): 245–259.

Cornwall, A. 2002. "Locating Citizen Participation." *IDS Bulletin* 33 (2): 49–58.

Cornwall, A. 2008a. "Unpacking 'Participation': Models, Meanings and Practices." *Community Development Journal* 43 (3): 269–283.

Cornwall, A. 2008b. *Democratising Engagement: What the UK Can Learn from International Experience.* London: Demos.

Farrington, J. and A. Bebbington, with K. Wellard and D.J. Lewis. 1993. *Reluctant Partners: Non-governmental Organisations, the State and Sustainable Agricultural Development.* London: Routledge.

Fellow Architecture Ltd. n.d. *Blackfoot Crossing Historical Park—Interpretive Centre. Design Metaphors and Concepts* [unpublished]. Calgary: Fellow Architecture Ltd.

Foucault, M. 1976. *The History of Sexuality: Volume I: An Introduction.* London: Penguin Group.

Fraser, N. 1987. "Women, Welfare, and the Politics of Need Interpretation." *Hypatia: A Journal of Feminist Philosophy* (2): 103–121.

Fraser, N. 1992. "Rethinking the Public Sphere: A Contribution to the Critique of Actually Existing Democracy." In *Habermas and the Public Sphere*, ed. C. Calhoun, 109–142. Cambridge, MA: MIT Press.

Galla, A. 1997. "Indigenous Peoples, Museums, and Ethics." In *Museum Ethics*, ed. G. Edson, 142–155. London: Routledge.

Gurian, E.H. 1991. "Noodling around with Exhibition Opportunities." In *Exhibiting Cultures: The Poetics and Politics of Museum Display*, eds, I. Karp and S. D. Lavine, 176–190. Washington, DC: Smithsonian Institution Press.

Hollway, W. and T. Jefferson. 2000. *Doing Qualitative Research Differently: Free Association, Narrative and the Interview Method.* London: Sage Publications.

ICOM. 2007. *Museum Definition.* Available at: http://icom.museum/hist_def_eng.html. Accessed May 7, 2011.

Kirshenblatt-Gimblett, B. 1998. *Destination Culture: Tourism, Museums and Heritage.* London: University of California Press.

Kreps, C. F. 2003. *Liberating Culture: Cross-cultural Perspectives on Museums, Curation and Heritage Preservation.* New York: Routledge.

Krmpotich, C. and D. Anderson. 2005. "Collaborative Exhibitions and Visitor Reactions: The Case of Nitsitapiisinni: Our Way of Life." *Curator* 48 (4): 377–405.

Lorde, A. 1984. *Sister Outsider: Essays and Speeches.* Freedom, CA: Crossing Press.

Lynch, B. and S. J. M. M. Alberti. 2010. "Legacies of Prejudice: Racism, Co-production and Radical Trust in the Museum." *Museum Management and Curatorship* 25 (1): 13–35.

Macdonald, S. 1996. "Theorizing Museums: An Introduction." In *Theorizing Museums*, eds. S. Macdonald and G. Fyfe, 1–17. Oxford: Blackwell Publishers.

McLean, M. 2007. *Museum Affirmation Program: Findings & Analysis 2007.* Alberta Museums Association (AMA). Available at: www.museums.ab.ca/files/MuseumAffirmationProgramFinalReportSept11.pdf. Accessed June 26, 2011.

Make First Nations Poverty History Expert Advisory Committee. 2009. *The State of the First Nations Economy and the Struggles to Make Poverty History.* Available at: http://abde.be.ca/uploads/file/09%20 Harvest/State%20of%20the%20First%20 Nations%20Economy.pdf. Accessed March 2011.

Mithlo, N. M. 2004. " 'Red Man's Burden': The Politics of Inclusion in Museum Settings." *American Indian Quarterly* 28 (3/4): 743–763.

Pratt, M. L. 1992. *Imperial Eyes: Travel Writing and Transculturation.* London: Routledge.

Pretty, J. 1995. "Participatory Learning for Sustainable Agriculture." *World Development* 23 (8): 1247–1263.

Rand, J. T. 2009. "Museums and Indigenous Perspectives on Curatorial Practice." In *Contesting Knowledge: Museums and Indigenous Perspective*, ed. S. Sleeper-Smith, 129–131. London: University of Nebraska Press.

Simpson, M. G. 2006. "Revealing and Concealing: Museums, Objects, and the Transmission of Knowledge in Aboriginal Australia." In *New Museum Theory and Practice: An Introduction*, ed. J. Marstine, 153–177. Oxford: Blackwell Publishing.

Simpson, M. G. 2007. "Charting the Boundaries. Indigenous Models and Parallel Practices in the Development of the Post-museum." In *Museum Revolutions: How Museums Change and are Changed*, eds S. J. Knell, S. McLeod, and S. Watson, 235–249. London: Routledge.

Task Force on Museums and First Peoples. 1992. *Turning the Page: Forging new partnerships between museums and First Peoples*. 2nd ed. Ottawa: Assembly of First Nations and Canadian Museums Association.

White, S. C. 1996. "Depoliticising Development: The Uses and Abuses of Participation." *Development in Practice* 6 (1): 6–15.

Part VI
Contested histories and heritage

Introduction to Part VI

Sheila Watson

When we consider the subject of contested histories and heritage we probably think about those places fraught with centuries of strife and bloodshed with different sides and radically different interpretations of events. Alternatively, we might reflect on the disputed significance of some element of material culture where one group wishes to re-interpret an object in a way that makes more explicit the complex and difficult circumstances surrounding its acquisition and subsequent display. At the time of writing, some students at the University of Cambridge have asked that the Cockerel, a symbol of Jesus College, be repatriated to Nigeria. It was looted from the Kingdom of Benin, now in Southern Nigeria and later offered to the College, whose heraldic crest was composed of three cockerels. Despite the fact that Nigeria is not the same as Benin, there are demands that the bronze be sent back to Africa. Thus objects can be contested, their meanings changing over time, according to whoever owns them or who claims to own them.

However, what is difficult or contested may not always be something that happened in the past. As Creighton points out (2007: 394, this volume), the needs of living human beings can often clash with the desire to conserve heritage. What is contested here is whether or not it is ethical and/or economically desirable to destroy parts of a built heritage that contributes significantly to a sense of place and the uniqueness of a landscape now and in the future, in order to improve living and working conditions for those who live in the present. In the West there is much lamentation about the way in which slum clearances in the last hundred or so years have, in their wake, reduced to rubble buildings that would now enhance and grace the urban landscape and, perhaps, contribute to a tourism 'offer'. However, if we were living in those slums would we be so concerned with the loss of a heritage that caused us suffering?

Much heritage is less contested than deeply embarrassing to those who come after and may cause grief to some and fear and loathing to others. Macdonald (2009, this volume) has shown how decisions in Nuremburg, an ancient city with a Nazi past, where Hitler held his great rallies, about what to conserve and preserve and what to neglect or eradicate, were taken incrementally and after much discussion and soul searching by officials. For many, the parade ground and its surrounding buildings should act as a warning to future generations rather than as a commemoration of Nazi triumphs. However, such actions gave these places significance they otherwise would not have had, and it was only by linking this assemblage to a concept of

Sheila Watson

universal human rights that this problem of association could be partly resolved. This raises the interesting and difficult question as to whether or not we should actually destroy heritage that presents and thus preserves, in some way, aspects of the past that we abhor. If we do this, are we cultural vandals or, like Islamic extremists, intolerant of ideas and associations with which we disagree? In a thousand years' time, will the person who destroyed a Nazi interior in Nuremberg be seen to be any different from someone who destroyed a historic church in the areas of Syria controlled by Islamic State or those throughout Europe who pulled down pagan places of worship when they converted to Christianity in the third and fourth centuries AD? Who decides? Or should we conserve all heritage so we remember for the future the errors of the past, changing religious practices and the intolerances that led to violence and hatred? How do we prevent those who might hold unacceptable views from using such sites to commemorate the past in a way that ignores suffering and focuses on long discredited visions of the future? Are we morally obliged to use heritage, in general, for a better purpose than the one for which it was originally created? Lehrer (2010, this volume) looks at the ways in which conflicted versions of the Polish-Jewish past can be reconciled to allow room for a Jewish/Polish identity and heritage, often denied by Polish nationalists. She argues that the slums of areas where Jews once lived can become places for Polish/Jewish interaction, something that has been mostly absent for post-war Poland, as most Jews who survived the Holocaust fled to Israel. Here, new notions of identity are negotiated as young Poles immerse themselves in Jewish history and ritual to the occasional consternation of visiting Jews from outside Poland. Here we find that heritage is performed and can be found in the interactions between people who all connect in some way to a specifically difficult and contested past.

Beaumont's (2009, this volume) examination of the demolition of Changi Prison, the site of great suffering for Allied prisoners of war during the Second World War, illustrates the tensions that arise when a place has specific meanings for those not necessarily resident in the area, meanings that they wish to preserve and cherish. Here, local needs outweighed attempts by the Australian Government to preserve the original. In other places, the needs of locals is outweighed by the needs of visitors or pilgrims. In Elveden, Suffolk, there have been tensions between those who follow the Sikh religion and revere the burial site of the Maharaja Duleep Singh in the Churchyard, leaving tokens of their Sikh beliefs around his grave, and those who see it as a Christian burial site and who currently worship in the Church. The Maharaja was exiled to Britain by the British Government during the Victorian period and here he was accorded all the honours of his status with none of the power. He himself wished to return to India and reconverted from Christianity to the Sikh faith towards the end of his life. He was buried as a Christian gentleman near his country estate. Here, the actions of the past and a sense of grievance affect the ways in which his burial site is now regarded by different faith communities.

How can we articulate and understand what and how heritage is when it is so contested? Basu (2007, this volume) uses the metaphor of a 'memoryscape' and a palimpsest – a kapok tree, mass graves, banknotes, memorials and museums, as a means of deconstructing different 'regimes' or memory in post-civil war Sierra Leone, while Lankauskas (2006, this volume) looks at the difficult heritage of communism in Lithuania, where a café selling Soviet period food reminds us that smell, taste, touch and hearing all contribute to our sense of the past and to heritage in general. Heritage, as Ashworth and Graham point out (2005: 7, this volume), 'is that part of the past which we select in the present for contemporary purposes, whether they be economic or cultural (including political and social factors) and choose to bequeath to a future'. As such, it tells us not only about the way society understands itself but also what and why people feel the way they do about the past. It is integral to our sense of place, space and time. However, everything is politically and socially constructed, and Bender (2001, this volume) reminds us that even

734

a devastated landscape, deliberately cleared of human life, is a form of heritage, a type of remembering.

Community groups and nation states often mobilise heritage to support their political views. Crooke (2010, this volume) considers the synergies and disparities between the priorities of different stakeholder groups dealing with the contested past in Northern Ireland, where two sides battled for the political soul of the Northern Irish state, one side wanting a united Ireland, the other equally determined to remain part of the United Kingdom. At the time of writing, much of the violence has disappeared from the streets but communities remain divided, not only by current political aspirations but by different interpretations of a shared past and different heritages.

All heritage is political and some nations' ideas of heritage are very different from those of others. Barnes considers the ways in which modern China draws on certain types of communist heritage to promote the China Dream of a 'prosperous, democratic, civilized, harmonious, revitalized and happy China' (Chapter 53, this volume). A performative and immersive type of 'red tourism' that is carefully controlled and managed by the state, results in nostalgia rather than any attempt to confront the complex and contested communist past. Elsewhere in the world, as we have seen, much heritage is more openly questioning of past activities and events. What is certain in a changing world is that as meanings, values and ideas change in contemporary society, so will those attributed to the past and, as such, heritage is inherently contested and disputed over time.

Bibliography

Ashworth, G. J. and Graham, B. (2005). 'Senses of place, senses of time and heritage', in *Senses of Place: Senses of Time*. Aldershot: Ashgate Publishing Ltd, pp. 3–12 (this volume).

Basu, P. (2007). 'Palimpsest memoryscapes: materializing and mediating war and peace in Sierra Leone', in de Jong, F. and Rowlands, M. (eds) *Reclaiming Heritage: Alternative Imaginaries of Memory in West Africa*. Walnut Creek, CA: Left Coast Press, pp. 231–258 (this volume).

Beaumont, J. (2009). Contested trans-national heritage: the demolition of Changi Prison, Singapore. *International Journal of Heritage Studies*, 15 (4): 298–316 (this volume).

Bender, B. (2001). 'Introduction' in Bender, B. and Winer, M. (eds), *Contested Landscapes: Movement, Exile and Place*. Oxford and New York: Berg, pp. 1–18 (this volume).

Creighton, O. (2007). 'Contested townscapes: the walled city as world heritage', *World Archaeology*, 39 (3): 339–354 (this volume).

Crooke, E. (2010). 'The politics of community heritage: motivations, authority and control', *International Journal of Heritage Studies*, 16 (1–2): 16–29 (this volume).

Lankauskas, G. (2006). 'Sensuous (re)collections: the sight and taste of socialism at Grūtas Statue Park, Lithuania', *The Senses and Society*, 1 (1), March, pp. 27–52 (this volume).

Lehrer, E. (2010). 'Can there be a conciliatory heritage?', *International Journal of Heritage Studies*, 16 (4–5): 269–288 (this volume).

Macdonald, S. (2009). 'Reassembling Nuremberg, Reassembling Heritage', *Journal of Cultural Economy*, 2 (1–2): 117–134 (this volume).

49

Contested townscapes
The walled city as world heritage

Oliver Creighton

Introduction

Walled urban settlements represents a quintessential form of World Heritage Site (WHS): 'gem towns' such as Carcassonne, Toledo and Valetta feature prominently on a UNESCO list that is both dominated by 'tangible' heritage and displays an undeniable Eurocentric bias. This paper examines critically the concept of 'dissonant heritage' (that is tension and discord between populations and their heritage: Tunbridge and Ashworth 1996), using historic walled towns and cities on the WHS list as a case study. While a fundamental guiding principle of the UNESCO list is that sites are designated for the benefit of 'all' (although not interpreted literally), it is argued here that the particular physical and social characteristics of historic walled urban communities create unusually high potential for the past to become contested or disputed in the present in some way. Contestation can operate at various scales and between different interest groups – including host communities, tourists, archaeologists and heritage agendes – and creates ethical dilemmas that compound the considerable practical challenges of conserving, preserving and researching the multi-layered pasts of these places.

A growing body of literature is addressing the histories and archaeologies of historic walled communities, whether focused on particular countries (for the UK, see Creighton and Higham 2005), regions (for North Africa, see Slyomovics 2001), continents (for Europe, see Perbellini 2000), or the phenomenon viewed globally (Tracy 2000). The legacies for present populations and other stakeholders of having to engage with a walled heritage than can be divisive and contentious remain relatively little studied, however, and under-acknowledged in archaeological discourse (see Bruce and Creighton 2006). While case studies of the disputed heritages of individual walled WHS cities have been developed (e.g. for Quebec, see Evans 2002; for Jerusalem, Abu El-Haj 2002), this paper adopts a more broadly based and comparative approach that attempts to identify wider issues and draw out general lessons. Addressing an area of interface between archaeology and heritage studies, it also extends beyond the built heritage of city walls and the settlements they encircle to acknowledge more intangible dimensions to this heritage. Urban walls are also mental constructs and critical components to the multi-layered self-images of communities, and it is perfectly legitimate to consider some urban communities as psychologically walled even where the physical fabric of defences has been removed or compromised in some way.

Walled heritage as world heritage

The phenomenon of the walled heritage city is examined here with a particular focus on Europe, the Middle East and North Africa. It is also restricted to historic urban sites inscribed as UNESCO World Heritage Sites that persist as living communities. Globally, this distinctive group of sites – to which the most recent addition is the Ethiopian fortified desert city of Harar Jugol (2006) – comprises well over 100 of the 644 cultural properties on the UNESCO list. Moreover, for countries such as Albania, Morocco and Yemen, walled towns represent the only category of WHS site represented. Crucially, the monumentality of upstanding remains a stronger reason for the inclusion of a site on the list than archaeological potential or significance. It is difficult to envisage earthwork complexes gaining WHS status, for instance, while the list remains site-centric at the expense of wider landscapes and, significantly for the subject of this paper, the hinterlands and settings of settlements and monuments.

In terms of the criteria under which these walled towns are judged as having 'outstanding universal value', all have in common inscription under UNESCO's criteria (iv), meaning that each constitutes "an outstanding example of a type of building, architectural or technological ensemble or landscape which illustrates (a) significant stage(s) in human history" (UNESCO 2005: 20). Variations are apparent, however. A minority of sites has also been inscribed partly because of their 'intangible' heritage (and meet criteria (i): 'human creative genius', as with Valetta's link to the Order of the Knights of St John of Jerusalem). Other sites additionally meet criteria (iii) (and 'exhibit an important interchange of human values', where the walled ensemble demonstrate diverse cultural influences: e.g. Graz; L'viv) and/or (iv) ('exceptional testimony to a cultural tradition', where the town embodies a single social, ethnic or religious influence influence: e.g. Ávila; Shibam). Finally, the physical fabric of walls varies considerably in its importance to the inclusion of sites, from cases where walled heritage is integral to WHS status (e.g. 'Historic Walled Town of Cuenca', 'Old City of Jerusalem and its Walls') to places where walls are vestigial and incidental to inscription (e.g. Bath, Edinburgh, Salzburg).

If heritage is, in essence, a 'personal affair' (Tunbridge and Ashworth 1996: 70), then potential for dissonance is arguably greater in the case of the WHS given the variety of scales at which relationships between stakeholders and heritage operate, ranging from the local to the global. A critical point here is an underlying incongruity at the very core of the WHS inscription process. While properties are ostensibly inscribed for the benefit of humanity (regardless of where they are situated), they are nominated for inclusion not by UNESCO, but by the governments of sponsoring states, and it is consequently quite clear that the evolving WHS list is used as a tool for shaping national identities (see van der Aa 2005). Also potentially contestable is the principle that it is the governments currently controlling territories within which properties lie that have the dominant claim with regard to nomination, despite the fluid nature of state-making in the late twentieth and early twenty-first centuries. The exemplar is Jerusalem – the archetypal 'contested city' (Klein 2001). The city's political status being uncertain since 1967, Jerusalem is unique on the UNESCO list in not being listed under a 'host' country; it was inscribed along with its walls in 1981 following a (much disputed) proposal from Jordan, despite lying beyond the borders of the sponsoring state (UNESCO 1981: 6–15).

The processes through which walled towns and cities have been added to the UNESCO list also betray changing sensibilities regarding the perception and definition of 'World Heritage'. Many were designated relatively early in the history of the list and, in Europe at least, they have fallen out offavour as a 'brand' of WHS. The case of Carcassonne is instructive. The *Cité Médiéval* was denied inscription as a WHS in 1985 not only as European walled towns already featured heavily on the list, but because Viollet-le-Duc's internationally famous restorations of

Oliver Creighton

the nineteenth century were judged to have compromised the 'authenticity' of its historic fabric (ICOMOS 1996: 30). UNESCO's re-appraisal of the property eleven years later observed the 1994 Nara declaration's assertion that authenticity should not be judged on fixed criteria but within the cultural context that a site belongs (ICOMOS 1994). Accordingly, Carcassonne's inscription in 1997 portrayed the city's restoration (which played an iconic role in the emerging European heritage movement: see Ashworth and Howard 1999: 38) somewhat differently. Rather than compromising the site's historic integrity, the massive restorations were viewed as another distinctive layer to its cultural stratigraphy – a case of the heritage industry itself becoming heritage.

Inclusion and exclusion

The management of city walls as heritage sites poses particular challenges as they constitute uniquely 'civic' monuments, both in terms of their past histories and (very often) their present-day status. As much as walls originally encircled populations for reasons of defence, their roles as symbols of commercial advantage, individuality and separateness have been more enduring. The Renaissance scholar Leon Battista Alberti considered a city without a wall 'naked' (Alberti 1986: 72): city defences have always defined their communities in an Iconic as well as a physical sense. But, while historically city walls might be thought of as unambiguous markers of the urban limits, defining where the countryside stopped and the townscape started, this appearance can be illusory. City gates represent not simply barriers but transitional spaces between different spheres, within and without (for example, see Ratté 1999 on the gates of Florence and Siena). The urban edge was not a line marked rigidly in stone but a liminal zone of the townscape characterised by specific social or ethnic groups, activities and architecture (Creighton and Higham 2005: 32–50). The critical point here is that urban walls divided as well as united communities (and in many cases continue to do so), serving to create or exacerbate fractured identities. In these senses, while the image of the walled city might be outwardly be one of enclosure, cohesion and privilege, equally important but underestimated is the enduring role of walled heritage in excluding as well as embracing populations and in mediation with the world beyond the urban area.

The walls of Derry/Londonderry (not a WHS) are the very embodiment of the notion of city defences as an arena for contestation. In this case it is not the physical fabric of the walls that is disputed so much as rituals associated with the celebration of their martial past – in particular resistance to the siege of 1689 – as an expression of the heritage of Unionism (see MacGiolla Chriost 1996; Kelly 2001). In the late twentieth and early twenty-first century, this heritage is not only commemorated through the annual march around the (still London-owned) walls but also contestedthrough challenges to the route of the parade and ultimately in the courts of Northern Ireland over the name of the city.

The potentially divisive consequences of walled heritage as a symbol of partition are again exemplified by Jerusalem. In the wake of the city's occupation in the 1967 Arab-Israeli war, former Israeli Prime Minister David Ben-Gurion advocated the dismantling of the walls to eradicate the long-standing division they embodied (Abu El-Haj 2002: 178–9). Walls could be attacked as symbols of a squalid or unpopular antique heritage well into the twentieth century. For example, large sections of the monumental clay walls of the desert city of Sana'a were dismantled by the local population in the immediate aftermath of the 1962 Yemeni revolution. The destruction symbolised a break with the authority and isolation of the previous Imamic regime and, in the voice of one resident, served to break the 'handcuffs' of the past (Al-Sallal 2004: 99). Within a generation, UNESCO's development plan for the WHS included the

738

Contested townscapes

reconstitution of its walls (Lewcock 1986: 116). Yet a salutary lesson of the dangers of over-simplifying urban society's attitudes to walled heritage is provided by the complexity of local reactions after the dismantling of the Berlin Wall in 1989, which included 'wall nostalgia' (in East as well as West Berlin) in recognition of its lost benefits (Baker 1993: 730–1). Attitudes to walled heritage can also turn full circle in remarkably short periods of time. The WHS of Beijing's Forbidden City represents the focal point of the former walled Imperial City, which was until the 1950s the world's largest and best preserved historic walled community, comprising a hierarchical arrangement of vast inner and outer circuits around the imperial palace (ICOMOS 1986). But while virtually the entire walled ensemble wastorn down as a state-sponsored eradication of an evocative symbol of the 'Old China' within little more than a decade, the twenty-first century is witnessing the rebuilding and restoration of parts of the demolished circuits (and even their incorporation within branded heritage parks) in advance of the 2008 Olympic Games (see Shatzman Steinhardt 2000: 422; Chang and Halliday 2005: 542).

While the heritage industry might portray walled towns as unified celebrations of national heritage, the histories of these places frequently demonstrate division within society. Many circuits were built not as genuine communal enterprises but to control populations in some way. This is true, for instance, of many walled heritage towns planted as appendages to castles, as with Edward I's bastides in North Wales. In a very different cultural context, while in traditional Islamic history walled cities are frequently portrayed as lying on frontier zones – in particular between Islamic lands (*dār al-Islam*) and non-Islamic territories (*dār al-harb*) – the individual histories of these places frequently confirm walling against internal threats within society (Bloom 2000: 221). Indeed, in the case of many Islamic walled cities the notion of a historic single 'corporate identity' is often false. We might even question whether their portrayal by the heritage industry as unified entities is entirely appropriate considering that, historically, medieval Islamic urban places tended to lack the corporate institutions and self-identities of those in the Christian West, the major walled cities being rather collections of composite units (Lassner 2000: 123–30). The intramural gates and walls that defined these historic quarters were critical to a sense of place that may be lost through intervention and their removal in the face of development, as the cases of Tunis and Cairo exemplify (see Akbar 1988: 165–72).

Typically located on the edges of, or immediately beyond, enclosed zones, Jewish quarters represent another potentially contestable aspect of the heritage of walled cities (Ashworth 1997; see also Silberman 2005: 96–7). The Jewish heritage of a city such as Cordoba, where *La Juderia* quarter – clustered characteristically in the shadow of the city walls – symbolises a population dispossessed in the fifteenth century, is relatively uncontroversial (Cáceres, Évora and Provins are comparable cases of walled towns preserving tangible Jewish quarters), but other cases are less so. For example, a condition of the inscription of Sana'a as a WHS in 1986 was that the Jewish quarter tucked into the south-west part of the city walls and initially excluded from the proposal was encompassed within the designated zone, the city walls otherwise enclosing a sacred space with an exceptionally high density of mosques and recognised as a key centre for the spread of Islam from the seventh century (ICOMOS 1985b: 3). Bardejov was similarly inscribed with the recommendation that the designated area focused on the walled city was expanded to embrace the small Jewish district, including synagogue and baths (*mitve*), outside the fifteenth-century walls (ICOMOS 2000: 133). Issues of dissonance come into sharper focus in such Central and Eastern European WHS cities, due to the twentieth-century history of their Jewish communities and the incongruity of the near total absence of this social group from places that preserve a distinctive Jewish built heritage. The heritage of Cracow embodies dissonance of another level. Here, the Jewish Kazimierz district, located beyond the core and recognised from the fifteenth century as a legally separate entity with its own walls (now largely

Oliver Creighton

demolished), had by the end of the twentieth century transformed through 'Schindler Tourism' into a 'memorialised ghetto', the place's identity in the eyes of a massive transient tourist population having little resonance with the host community (Ashworth 2002: 366–7).

Notwithstanding their enduring symbolic significance, town walls also represent undeniably martial pasts. They have been characterised as representing a branch of 'atrocity' heritage (Tunbridge and Ashworth 1996: 115–6), where episodes of violence and bloodshed featuring prominently in local social memory can force populations (and tourists) to negotiate an uncomfortable past. Many walled cities on the WHS list are border towns and have changed political or national allegiance in the past: Caernarfon/Caernarvon and Mazagan/El Jadida are two of many examples where alternative names betray a colonial heritage that is contestable. Other WHS walled cities have been contested in the martial sense of the word since inscription, the most recent case being the medieval towers at Byblos damaged as an (indirect) result of Israeli aerial bombing in 2006. Other walled WHS cities have been targeted specifically because WHS status identifies them as perceived symbols of national heritage, as with the shelling of Dubrovnik in 1991–2. While the material and human damage wrought within the walled area was inconsequential relative to the suburbs, it was the plight of the iconic walled 'Old City' and WHS that caught the world's eye (Larkham 1994: 263–4). If the military targeting of the sixteenth-century walled city of Mostar in 1992–5 was a 'political act', then so too was its inscription as a WHS in 2005 as an emblem of reconciliation. The WHS was designated as an historic ensemble centred on the Ottoman *Stari Most* bridge, rebuilt almost in its entirety with UNESCO and World Bank funding, even if the focal monument could not meet any conventional criteria of authenticity (Grodach 2002; Jokilehto 2006: 10).

Delineation of walled heritage

The walled towns depicted on Figure 1 embrace an enormous range of origins, sizes and plan forms (for typology, see Hopkinson 2000: 55–62). At Siena, seven kilometres of extant walls originally pierced by 36 gates define the heart of a thriving modern city. In sharp contrast are small 'time-frozen' townscapes such as Caernarfon and Urbino, where stunted urban growth has preserved what are essentially fossilised urban ensembles, circled in stone. These communities have divergent histories in terms of their attitudes towards walled heritage through episodes of disrepair and disinterest through to conservation and sometimes reconstruction. What unites them, however, is that, as monuments, city walls have biographies that are cyclical in some way: originally constructed as iconic monuments to urban identity, most walls have undergone episodes of degradation, before re-emerging as cherished symbols of civic prestige and vitality in the context of the heritage industry. Frequently, the lines of walls – whether extant or fossilised in the townscape in some way – mark the boundaries of designated WHS zones, although variations are apparent (for instance, eighteenth-and nineteenth-century extra-mural settlements are encompassed at Riga). What is important here is that decisions regarding the delineation of walled cities as World Heritage Sites by definition embrace certain periods of the past and reject others. Prioritisation of the past can also be reflected in the 'branded' titles of inscribed sites – the 'Roman walls of Lugo' and 'Islamic Cairo' being clear cases in point, despite the multi-phase nature of the urban ensembles in question.

The concept of the 'buffer zone' (a protected envelope of surrounding space that is mandatory for WHS inscription: UNESCO 2005: 25–6) has particular importance in the case of walled towns. Effective conservation policies within buffer zones are essential to control the scale of extra-mural development and preserve the relationship between walled city and setting. Views of walled towns from outside can be important to the image of a city as heritage site:

at Gjirokastra, San Gimignano and Sana'a, for example, in sharply contrasting cultural contexts it is the intensity of historic towered development within a tightly constrained (walled) area that defines the urban image. Shibam's remarkable early Islamic townscape was inscribed with the recommendation that the zone of protection was extended into the surrounding valley of the Wadi Hadramawt, with its concentration of pre-Islamic archaeological sites (ICOMOS 1981: 2). Similarly, at Ávila the original proposal was amended so that the WHS extended to embrace Romanesque churches and their associated squares that formed a distinctive extra-mural setting characteristic of the region (ICOMOS 1985a). Elsewhere, sites such as Acre, Lyons, Jerusalem and Urbino were inscribed on condition that more effective extra-mural buffer zones were included. Designated WHS zones also need not remain static. The area of Rome initially included in the 1980 bid (coinciding with the Aurelian city wall) was rejected as it ignored the medieval urban enceinte, and was consequently extended to embrace the wall of Urban VIII, only to be expanded further in 1990 to include additional extra-mural properties (ICOMOS 1990). WHS zones can also be extended as knowledge of the archaeological potential of their Immediate environs increases, as at Dubrovnik and Butrint, where archaeological investigation revealed urban remains extending far beyond the walls, so that the area redesignated in 1999 included a substantial extra-mural area (Bowden *et al.* 2004).

Conservation and contestation

Effective management of this heritage of course recognises that town walls are indivisible from the townscapes within which they are embedded. Yet a long-standing tension exists between the restrictive qualities of walls and gates (and their conservation within the branded 'heritage city'), and the dynamic forces of urban change, which can exacerbate issues of dissonance (see Tunbridge and Ashworth 1996: 27–34). In certain contexts, uncontrolled development endangers the integrity of inscribed walled cities: at Shibam and Zabid, it is transforming living heritage into 'dying monuments' (Cernea 2001: 31), resulting in the inscription of the latter on to the list of World Heritage Sites in danger in 2000. Equally extreme is the clash with modernity experienced by many walled WHS medina towns in the Maghrib of North Africa (including Marrakesh, Sousse and Tétouan). Here 'traditional' settlements of narrow roads behind city walls can face massive challenges of deprivation and overcrowding, and tensions between the (potentially conflicting) imperatives of urban revitalisation and heritage conservation can be all too obvious. Many are 'polynuclear' cities (including the archetypal medina city of Fez), where the dichotomy between walled medinas and their accompanying colonial centres – between colonizer and colonized – highlights another dimension to this dissonance (Slyomovics 2001: 1–5; see also Rghei and Nelson 1994: 143). In a very different context, the time-frozen tendency of the classic European 'gem city' (see Ashworth and Tunbridge 1990: 2) carries the risk of a heritage that is dissonant in a contrasting way. The image of the walled town frozen in time is given official recognition in UNESCO's inscription of the 'Museum City of Gjirokastra', for example, and exemplified by places such as Quedlinburg and Urbino. At worst, the nurturing of walled enclaves as branded heritage quarters can transform local communities into incidental players on 'stage sets' where heritage is commodified for economic exchange – a criticism levelled at the World Heritage Sites of Brugge and Carcassonne, for example (see Graham 2002: 1007).

As physically massive forms of material culture comprising long, sinuous (and often discontinuous) monuments whose precise ownership is frequently debatable, issues of protection and conservation can be unusually complex for town walls. Moreover, as monuments closely connected to the self-images of communities and sometimes referencing contested periods of the

Oliver Creighton

past, so their presentation and interpretation throws up philosophical and ideological questions. This is particularly the case where the physical fabric of city walls exhibits a tangibly multi-layered history, and treatment can never be entirely neutral. For example, it has been contended that the selective preservation and presentation of defensive walls in Jerusalem's Jewish Quarter emphasises the Israelite past, as in the 'Israelite Tower', where heritage displays fashion a history of sieges and threatened national destruction (Abu El-Haj 1998: 178; 2002: 208–9). The city's extant ramparts essentially date to the sixteenth century, being attributable to Sultan Suleiman the Magnificent, but their intangible heritage is multi-layered and mutable (see Asali 1997: 201; Boas 1999: 13–21). The state-sanctioned destruction, by the Israeli military in 1967, of structures within the 'Maghariba Quarter' to create a plaza at the base of the Herodian blocks of the Western Wall shows how widely perspectives of 'host' communities can differ. While from one perspective these actions afforded a sacred monument 'breathing space' and a less cluttered physical setting, from another it removed not only an essential part of the Western Wall's sense of place but also a Muslim residential area whose social memory extended back to the twelfth century (Abu El-Haj 2002: 164–6; Dumper 2002: 78–80).

Populations need not always feel affinity with the walled heritage that surrounds them. While the present walls of the Old City of Acre represent an eighteenth-century Turkish construction (Pringle 1995: 81–4), the built environment of the Ottoman settlement overlies a walled Crusader-period city currently being investigated by the Israel Antiquities Authority (Boas 1999: 32–42; Stern 2000). Here, issues of dissonance are bought into sharp focus because of the 'placeless' nature of the present-day community, which comprises Palestinian migrants of the post-1948 period with little cultural attachment to the city. Continuous urban development frequently ensures that city walls become enmeshed in the living fabric of cities. At Zamość, inscription was conditional upon the adoption of a policy that would ensure demolition of 'unsympathetic' structures within the designated buffer zone (ICOMOS 1989: 2). But a blurred distinction exists between the judicious removal of structures encumbering or obscuring monumental remains to reveal and display the most historically valuable fabric, and a sanitisation of walled heritage that eradicates the contribution of communities themselves to the urban palimpsest. The epitome of the latter possibility is Carcassonne (Figure 3), where Viollet-le-Duc's restorations of the second half of the nineteenth century extended beyond the reconstruction of medieval fabric to remove over one hundred vernacular buildings and homes of textile workers clustered in the 'quartier des lices', between the inner and outer city walls (Amiel 200: 11–12). In a late twentieth-century context, the population of Old Bagan, Burma's 'city of pagodas' was transplanted beyond a newly designated heritage zone by the military junta in the early 1990s, ostensibly to facilitate archaeological excavation but undoubtedly for heritage tourism, and the site has been refused admission to the WHS list (Taylor and Altenburg 2006: 278–80).

It goes without saying that such actions can cause a long-term dislocation between communities and their historic environment. The late thirteenth-century town wall of Conwy is partly the product of mid twentieth-century 'conservation' that extended far beyond the treatment of masonry to include the reconstitution of part of a bank and ditch and the removal of structures built against it (Taylor 1995). While such actions might 'improve' the view of the site for external appreciation, they can also exacerbate the dissonant heritage of an unambiguously English monument in a present-day Welsh context, as the features removed arguably represented part of the community's own contribution to the town's identity, including industrial and nineteenth-century vernacular buildings (Austin 1997). In other cases, removal of structures built against city walls has continued after WHS inscription, as at Tarragona and Lugo, Spanish walled towns whose officially recognised historic 'value' relates primarily to their Roman heritage despite longer-term urban continuity. At the former archaeological research strategies

742

nurtured by the municipality have focused on Roman buildings at the expense of modern infrastructure and renovations have seen parts of the medieval inner city pulled down; at the latter, the Gallician government is pursuing a policy of the systematic clearance of houses built against the Roman wall (van der Aa 2005: 123–4). A more worrying case is that of Bosra where, until recently, the Classical period runs housed a 'squatter-type' community that – while ignored or written out of guidebooks – was a component of the site's sense of place since the eighteenth century. While the WHS inscription report noted that excavation and 'reclamation' was endangering the community's existence, 2001 saw the expulsion of the population (ICOMOS 1980: 2; Rowney 2004: 61–2).

Conclusions

Central to this paper have been the twin questions of how urban identities are shaped by walled heritage and how walled heritageis used, consciously or unconsciously, in the fashioning of identities. For the purposes of the international heritage industry city walls essentially define a product, and organisations such as the Organization of World Heritage Cities and the Walled Towns Friendship Circle are accordingly recognising the value of walled urban communities as among the world's foremost heritage tourism assets. But frequently, it seems, walls are a cloak concealing identities that are fractured rather than cohesive, and the arguments presented here can be equally applicable to walled communities not inscribed on the UNESCO list. The 'enclave heritage' of dispossessed groups, the layered identities of walls and their often very tangible references to disputed periods of the past, and their complex interrelationship with the built environment all create extraordinarily complex philosophical challenges for heritage management. The meanings of city walls and the identities they represent are not passive but active, and have inherent potential to be written and re-written through their treatment and presentation as heritage. No matter how sensitive the actions of agencies responsible for the fabric of monuments, neutral handling city walls which are the very embodiment of 'living' heritage is simply impossible, and many of the case studies examined here expose the difficulties of converting into practice the principle of the 1994 Nara Declaration that "The cultural heritage of each is the cultural heritage of all".

Bibliography

Abu El-Haj, N.L. 1998. Translating truths: nationalism, the practice of archaeology, and the remaking of past and present in contemporary Jerusalem. *American Ethnologist*, 25.2: 166–188.

Abu El-Haj, N.L. 2002. *Facts on the Ground: archaeological practice and territorial self-fashioning in Israeli society.* Chicago: University of Chicago Press.

Akbar, J. 1988. *Crisis in the Built Environment: The Case of the Muslim City.* London: Routledge.

Alberti, L.B. 1986. *Ten Books on Architecture, Translated into English by James Leoni.* New York: Dover Publications.

Al-Sallal, K.A. 2004. Sana'a: Transformation of the Old City and the Impacts of the Modern Era. In *Planning Middle Eastern Cities: An Urban Kaleidoscope in a Globalizing World* (ed. Y. Elsheshtawy). London: Routledge, pp. 85–113.

Amiel, C. 2000. *De la place forte au Monument. La restauration de la cité de Carcassonne au XIXe siècle.* Paris: Éditions du Patrimoine.

Asali, K.J. 1997. Jerusalem under the Ottomans, 1516–1831. In *Jerusalem in History: 3000BC to the present day.* London: Kegan Paul, 200–227.

Ashworth, G.J. 1997. Jewish culture and holocaust tourism. *Culture and Tourism* (ed. M. Robinson). Newcastle: Centre for Tourism Studies.

Ashworth, G.J. 2002. Holocaust tourism: the experience of Kraków-Kazimierz. *International Research in Geographical and Environmental Education*, 11.4: 363–367.

Oliver Creighton

Ashworth, G.J. and Howard, P. 1999. *European Heritage Planning and Management*. Exeter: Intellect.
Ashworth, G.J. & Tunbridge, J.E. 1990. *The Tourist-Historic City: Retrospect and Prospect of Managing the Heritage City*. London: Belhaven.
Austin, D. 1997. Devolution, castles and Welsh identity. *British Archaeology*, 29.
Baker, F. 1993. The Berlin Wall: production, preservation and consumption of a 20th-century monument. *Antiquity* 67: 709–733.
Bloom, J.M. 2000. Walled cities in Islamic North Africa and Egypt with particular reference to the Fatamids (909–1171). In *City Walls: the urban enceinte in global perspective* (ed. J.D. Tracy). Cambridge: Cambridge University Press, 219–246.
Boas, A.J. 1999. *Crusader Archaeology: The Material Culture of the Latin East*. London: Routledge.
Bowden, W., Hodges, R. & Lako, K. 2004. *Byzantine Butrint: Excavations and Surveys 1994–1999*. Oxford: Oxbow Books.
Bruce, D. and Creighton, O.H. 2006. Contested identities: the dissonant heritage of European town walls and walled towns. *International Journal of Heritage Studies*, 12.3: 234–254.
Cernea, M.M. 2001. *Cultural Heritage and Development: a framework for action in the Middle East and North Africa*. Washington: World Bank.
Chang, J. and Halliday, J. 2005. *Mao, The Unknown Story*. London: Jonathan Cape.
Creighton, O.H. and Higham, R.A. 2005. *Town Walls: a social history and archaeology of urban defence*. Stroud: Tempus.
Dumper, M.R.T. 2002. *The Politics of Sacred Space: the Old City of Jerusalem in the Middle East conflict*. London: Lynne Rienner.
Evans, G. 2002. Living in a world heritage city: stakeholders in the dialectic of the universal and particular. *International Journal of Heritage Studies*, 8.2: 117–135.
Graham, B. 2002. Heritage as knowledge: capital or culture. *Urban Studies* 39: 1003.
Grodach, C. 2002. Reconstituting identity and history in post-war Mostar, Bosnia-Herzegovina. *City: Analysis of Urban Trends, Culture, Theory, Policy, Action* 6.1: 61–82.
Hopkinson, M.F. 2000. Living in defended spaces: past structures and present landscapes. *Landscapes*, 1.2: 53–77.
ICOMOS 1980. *World Heritage Evaluation Report Number 22, The Old City of Bosra*. UNESCO.
ICOMOS 1981. *World Heritage Evaluation Report Number 192, The Old walled City of Shibam*. UNESCO.
ICOMOS 1985a. *World Heritage Evaluation Report Number 348 Rev., City of Ávila with its Extra Muros Churches*. UNESCO.
ICOMOS 1985b. *World Heritage Evaluation Report Number 385, Old City of Sana'a, Arab Republic of Yemen*. UNESCO.
ICOMOS 1986. *The Imperial Palace of the Ming and Qing Dynasties*. UNESCO.
ICOMOS 1989. *World Heritage Evaluation Report Number 564, The Old Town of Zamość*. UNESCO.
ICOMOS 1990. *World Heritage Evaluation Report Number 91bis, Rome*. UNESCO.
ICOMOS 1994. *The Nara Document on Authenticity*. UNESCO.
ICOMOS 1996 *World Heritage Evaluation Report Number 345 rev, Carcassonne, France*. UNESCO.
ICOMOS 2000. *World Heritage Evaluation Report Number 973, Bardejov, Slovakia*. UNESCO.
Jokilehto, J. 2006. Considerations on authenticity and integrity in World Heritage context. *City and Time* 2.1: 1–16.
Kelly, W. 2001. *The Sieges of Derry*. Dublin: Four Courts Press.
Klein, M. 2001. *The Contested City*. London: Hurst.
Larkham, P.J. 1994. A new heritage for a new Europe. In *Building a New Heritage: tourism, culture, and identity in the new Europe* (eds G.J. Ashworth and P.J. Larkham). London: Routledge, pp. 260–273.
Lassner, G. 2000. *The Middle East Remembered: forged identities, competing narratives, contested spaces*. Ann Arbor: University of Michigan Press.
Lewcock, R. 1986. *The Old Walled City of Sana'a*. Paris: UNESCO.
MacGiolla Chriost, D. 1996. Northern Ireland: culture clash and archaeology. In *Nationalism and Archaeology* (eds J.A. Atkinson, I. Banks and J. O'Sullivan). Glasgow: Cruithne Press, 128–134.
Perbellini, G. (ed.) 2000. *The Town Walls in the Middle Ages: les enceintes urbaines au moyen age*. The Hague: Europa Nostra IBI Bulletin No. 53.
Pringle, D. 1995. Town defences in the Crusader kingdom of Jerusalem. In *Fortification and Settlement in Crusader Palestine* (ed. D. Pringle). Ashgate: Variorum, pp. 69–121.
Ratté, F. 1999. Architectural invitations: images of city gates in medieval Italian painting. *Gesta*, 38.2: 142–153.

Rghei, A.S. and Nelson, J.G. 1994. The conservation and use of the walled city of Tripoli. *The Geographical Journal*, 160: 143–158.

Rowney, B. 2004. *Charters and the Ethics of Conservation: A Cross-Cultural Perspective*. Doctoral dissertation. University of Adelaide.

Shatzman Steinhardt, N. 2000. Representations of Chinese walled cities in the pictorial and graphical arts. In *City Walls: the urban enceinte in global perspective* (ed. J.D. Tracy). Cambridge: Cambridge University Press, 419–460.

Silberman, N. 2005. Jewish and Muslim Heritage in Europe: the role of archaeology in defending cultural diversity. *Museum International*, 57.3: 95–100.

Slyomovics, S. (ed.) 2001. *The Walled Arab City in Literature, Architecture and History: the city medina in the Magrhib*. London and Portland: Frank Cass.

Stern E. 2000. The center of the Hospitaller order in Akko. *Qadmoniot*, 119: 4–12.

Taylor, A.J. 1995. The town and castle of Conwy: preservation and interpretation. *Antiquaries Journal*, 75: 339–363.

Taylor, K. and Altenburg, K. 2006. Cultural landscapes in Asia-Pacific: potential for filling world heritage gaps. *International Journal of Heritage Studies*, 12.3: 267–282.

Tracy, J.D. (ed.) 2000. *City Walls: The Urban Enceinte in Global Perspective*. Cambridge: Cambridge University Press.

Tunbridge J.E. and Ashworth G. 1996. *Dissonant Heritage: managing the past as a resource in conflict*. Chichester John Wiley and Sons.

UNESCO 1981. *Convention Concerning The Protection Of The World Cultural And Natural Heritage, World Heritage Committee First Extraordinary Session, Paris, 10 and 11 September 1981*. UNESCO.

UNESCO 2005. *Operational Guidelines for the Implementation of the World Heritage Convention*. UNESCO.

van der Aa, B. 2005. *Preserving the Heritage of Humanity? Obtaining world heritage status and the impacts of listing*. Doctoral dissertation. University of Gronigen.

50
Reassembling Nuremberg, reassembling heritage

Sharon Macdonald

In 1945, Nuremberg's heritage and image lay in ruin. Most of its famous mediaeval Old Town had been destroyed by bombing and the city had come to be seen as a, or even *the*, Nazi city. The city faced the task of rebuilding itself, its present and future, and also, in a thoroughly entangled undertaking, its heritage.

This article looks at the reassembly of Nuremberg through its heritage – first through some of its pre-War architectural gems and, later, through its more recently acquired Nazi heritage. It is concerned, both for this specific case and also more widely, with what work the distinctive assemblage known as 'heritage' can perform, including assembling and reassembling other entities (such as place or particular temporalities). In this way, the article seeks to explore the contribution that an assemblage perspective might make to the understanding of heritage as well as to consider some of its limitations.

It has become commonplace in heritage research to highlight the ways in which heritage is defined and shaped to political ends. In such accounts, heritage is depicted as the outcome of particular political interests, and the past as manipulated to service the present.[1] While any contest involved in this may be acknowledged, or even made central, what is usually given less attention is the way in which heritage acts as what Bruno Latour calls a 'mediator'.[2] That is, rather than simply being the material worked upon, heritage plays a part in shaping the interactions in which it is enmeshed. It does so, as I explain further below, both as part of a wider 'heritage assemblage' as well as through specific material, symbolic and perhaps even legal features of the particular heritage involved.

In this article, then, I am concerned to show how heritage may act as a mediator even while it is being reassembled, and, in particular, how it may mediate, or shape, a city and its citizens, present and future. It does not do so alone but as part of a complex web of cultural materials, practices and interactions. Moreover, it does not necessarily do so in the same way as do other 'working surfaces on the social' (Bennett 2007) that are produced by interactions between such diverse cultural agents. Cities and citizens are assembled in multiple and sometimes untidy and even contradictory ways. The focus here is on how heritage – both in general and in its more specific forms – tends to perform that assembling, and the particular features it possesses that help it do so.

To explore this, I look at the reassembly of two different aspects of Nuremberg's heritage at two different 'moments' in the post-War period: the reassembly of the city's Old Town in the

immediate post-War period through to the 1950s; and the designation of the Nazi architecture at the grounds of the Nuremberg rallies as heritage in the 1970s and some of the subsequent negotiations over that designation, its implications and the material structures to which it was applied. Before doing so, however, I discuss further what might be entailed in an assemblage perspective on heritage.

Heritage as assemblage

Taking an assemblage perspective on heritage directs our attention less to finished 'heritage products' than to processes and entanglements involved in their coming into being and continuation. While a good deal of other heritage research in recent years has also been concerned with the 'construction' of heritage (rather than taking its existence and legitimacy as given), an assemblage perspective also tries to avoid imputing 'magical' notions such as, say, 'society' or 'ideology' as part of its explanations.[3] Instead, it focuses on tracing the courses of action, associations, practical and definitional procedures and techniques that are involved in particular cases. In so doing, it takes into account not only the human and social but also the material or technical. This typically has the following consequences. First, instead of reading a finished heritage product as an outcome of, say, a set of political interests, policy decisions or individual decision-making, the emphasis is on the multiple, heterogeneous and often highly specific actions and techniques that are involved in achieving and maintaining heritage. This does not mean that policy decisions and so forth are ignored – on the contrary – but they are not seen as a sufficient explanation. An assemblage perspective also asks what else helped to sustain their implementation, perhaps giving them a new inflection in the mediatory process. A usual consequence of this is that greater degrees of indeterminacy as well as, sometimes, of unintended courses of action, are made visible. Outcomes typically become more fragile and less inevitable.

Second, moments that previously may have seemed like clear punctuations – moments of novelty or invention – often become more blurred as we see how certain pre-existing elements are taken up into a reshaping assemblage. Although here I look at two different stretches of time which are often seen as belonging to distinct cultures of memory – sometimes defined as before and after 1968 – the detailed focus and attention to assemblage shows continuities alongside the more usually noted shifts.

Third, because of assemblage theory's commitment to trying to avoid imputing analytical divisions *a priori* and, more specifically because of its rejection of scalar models in which, say, the micro is seen as nestling inside the macro, or the local inside the global, an assemblage perspective potentially provides more nuanced accounts of complexes of interrelationships. This does not mean that categories such as 'global' and 'local' necessarily become irrelevant but rather than marking out the territory to be investigated at the outset, and being fixed points of reference within the analysis, the interest is instead in how such categories and divisions are themselves produced. Heritage is of particular interest here, for it is a supreme means of assembling and sustaining 'the local' but at the same time it assembles cosmopolitan and global elements and can itself be characterized as a 'global assemblage' in its capacity to 'move across and reconstitute' 'specific situations' (Collier & Ong 2005, p. 4).

This particular mode of spatializing – and its constitutive effects – is not the only characteristic feature of heritage that will be illustrated below. Another is its distinctive temporality. Heritage is always something from the past; yet its possession is equally 'a mark of modernity' (Kirshenblatt-Gimblett 2006, p. 180). It brings different temporal orders together, mediating the present and future; while at the same time 'heritage interventions attempt to slow the rate of change' (p. 180). A third feature of heritage that plays into its distinctive capacities is its

materiality. Even so-called 'intangible' heritage is typically materialized in some form, such as recordings, and arguments about its materialization are often central to policy debates about its maintenance as heritage. Both the fact of materialization and its interaction with temporality – its persistence or decay over time – and more specific material characteristics, such as the way in which, say, limestone crumbles, can have particular affordances and, thus, potentially, certain mediatory effects.

Heritage is, of course, also a linguistic term with particular connotations that do not necessarily map onto those in other languages. In German there is a constellation of terms that might be translated as 'heritage' and that refer broadly to the same kinds of entities but not in quite the same way. These include, for example, *das Erbe* and *die Erbschaft* (Macdonald 2006a; 2009, pp. 9–10) which also refer more widely to inheritance or legacy, and, although primarily carrying the positive evaluation that usually typifies heritage, can also refer to the negative, or what we might wish not to have had passed down from the past. The term *Erbe* has been taken up recently in relation to the idea of 'world heritage' – '*Weltkulturerbe*' (though note that the German term specifies that this is *cultural* heritage in order to differentiate it from other kinds of inheritance). More usually in relation to institutionalized heritage practices and products, however, terms related to *Denkmal* would be more likely to be used. While often more specifically translated as 'monument', *Denkmal* is also used more generically, especially in relation to heritage protection and conservation, which goes under the terms *Denkmalschutz* and *Denkmalpflege*. The root form is shared with that for 'to think' – *denken* – which suggests a different inflection from the English term 'heritage', giving emphasis to historical relics as prompts to reflection rather than as a more organic and even unconscious inheritance. These sometimes subtle varied conceptual constellations may be constitutive of the ways in which particular debates and arrangements play out, even while, at the same time, many heritage practices are assembled from elsewhere and there is, increasingly, a globally applied set of heritage practices and institutions. It is telling, for example, that a recent German edited academic collection employs the English-language term in its title, *Prädikat 'Heritage'* (Hemme *et al.* 2007). The selection of 'heritage' as the orienting concept for the volume is an indication of its valence internationally, both in scholarship and through institutions such as UNESCO with its world heritage listings. The title also acknowledges, similarly to an assemblage perspective, heritage not simply as a topic for investigation or management but as itself constitutive – and this brings us to a further characteristic mediatory effect of the heritage assemblage. A *Prädikat* is an evaluation or rating and to predicate is 'to assert or affirm as true or existent' (*OED*). Contributors to the book are concerned with what we might call the truth- or existence-effects of cultural products coming to be designated or treated as heritage. Heritage, as evident in the account that follows, can help make other entities with which it becomes entangled more 'real'.

Reassembling Nuremberg after the war

Following the War, a massive amount of clearing of rubble, demolition and building work was begun across Germany. This was a necessity in the aftermath of bombing – Nuremberg's Old Town, for example, was recorded as 90% destroyed (e.g. Bruckner 2002, p. 12). In addition to having a functional aim, building was also a moral project, involving the reassembling of cities and citizens both discursively and through the practices entailed in the work of building, reconstruction and preservation.

Post-War building was widely conceived as being of two types – *Aufbau* (construction) and *Wiederaufbau* (reconstruction) – and there were often conflicts between proponents of each (Koshar 1998; 2000; Whyte 1998). Those wanting *Aufbau* were concerned to get buildings up

quickly in order to return as soon as possible to functional daily living; though some also argued for new construction on grounds that to try to reconstruct was based on a misguided attempt to deny the War years. Proponents of reconstruction – returning as far as possible to a pre-War state – argued their case most strongly in relation to buildings that had been deemed to have historical or architectural significance. This was frequently expressed in terms of salvage from loss, of restoring that which had suffered a terrible onslaught – and the parallels between the physical fabric of the city and its population were often explicitly as well as more implicitly made. There were, however, differences in view of how restoration should be undertaken – some arguing for reconstruction to create replicas as true to the originals as possible, others for a 'modified historicist reconstruction' (Koshar 2000, p. 156) in which only aspects or just exteriors were reconstructed; some wanting whole areas to be reconstructed, others just specific significant buildings. These arguments were mobilized variously in relation to specific contexts and buildings, including how much damage they were calculated to have sustained; and all of these various positions were evident in Nuremberg as in so many other places. Alongside the apparently objective technical calculations about how practically feasible reconstruction was, cases were also sometimes couched in symbolic terms. In Nuremberg, for example, a monument to the renaissance painter Albrecht Dürer had withstood the bombing and this was taken by some as a sign that the city, and especially its Dürer heritage, was destined for restoration – and indeed the Dürer house was the first historic building to be restored in the city.[4] Nevertheless, although a considerable amount of reconstruction was carried out in Nuremberg and the city was generally regarded as one in which trying to preserve old buildings was a priority,[5] there was also extensive construction of new buildings, especially for homes and workplaces. This too could be given symbolic inflection. In 1948, for example, a sixteen-metre high letter A was erected in the city's centre by the Bavarian Social Democrats, as part of 'Aufbautag des Volkes' – 'People's Construction Day'. As well as standing for *Aufbau* – of clean new building work – the A was to stand for 'Anfang', beginning (Mittenhuber *et al.* 1995, p. 24). The fact that this event was presented in the name of 'the people' shows the alignment of physical construction with that of constituting a new post-War citizenry. The crowds who came to the city centre to celebrate the day, and surround the sculptural A, were a physical manifestation of a collectivity of Nuremberg citizens supporting this project; as too were the large crowds who came to the re-opening of the Dürer House.

Not only were citizens assembled by the building projects, so too were structures to organize the work of construction and reconstruction. After the War, governmental structures, procedures and personnel had to be rebuilt, a process in which the allies played a major role. Especially in Western zones this tended to entail a return to structures that had been in place before the Nazi seizure of power. While in some cases the allies were involved in detailed policy-making and also controlled certain buildings and finances, most matters to do with construction and reconstruction were the remit of the newly reconstituted local authorities.

In Nuremberg, shortly after the War, the Americans (who occupied this zone) set up a committee to conduct a detailed survey of the condition of individual buildings and art works; and they also put in place procedures to prevent building structures being either plundered or further damaged by members of the public (Wachter 1999, p. 316). The physical state of buildings – what possibilities they afforded – was central to debate about whether to build afresh or try to reconstruct. Several commentators argued that destruction was so great in Nuremberg's centre, the Old Town, that reconstruction was simply not physically possible (p. 315). Despite this, the city's mayor categorically ruled out the possibility of simply filling in the Old Town with rubble and building from scratch (p. 316). That Nuremberg would engage in the reconstruction of at least some buildings was also solidified into place by a set of planning documents, media

Sharon Macdonald

commentaries and two competitions for ideas – one for the public, one for architects. Although the competitions might have had the result of opposing *Wiederaufbau*, they were framed in ways that did not readily allow for this possibility. The architects' competition was worded in terms of a request for proposals that, while not trying to reconstruct the Old Town exactly, would 'be based on the same principles that had brought the city into being originally' (quoted in Wachter 1999, p. 319, my translation). The competition for the public was also framed in terms of *Wiederaufbau* – its title being 'A Thousand Ideas for Reconstruction' (Mittenhuber *et al.* 1995, p. 24). That this competition was conducted at all is perhaps surprising, for it was the architects' proposals that would be used to rebuild the city. But it was not so much a search for ideas as a means of trying to gauge public opinion and to assemble an engaged public – a citizenry of Nuremberg (*Nürnberger Bürger*). It received more than the 1000 responses anticipated.

Elsewhere in parts of Germany, there was opposition to reconstruction on moral grounds. In Frankfurt some argued that to rebuild the bombed Goethe House would be:

> an act of historical amnesia. A reconstruction, regardless of whether it reproduced the previous building or abstracted from it … would erase memories of wartime destruction. Even more seriously, it would obscure the intimate connection between the heritage of Goethe's thought and the rise of Nazism. Regardless of the great poet's intentions, argued the opponents, he had helped to create a German tradition of idealism that led many German Bürger to avoid their political and civic responsibilities in favor of 'inwardness' and individualism …
>
> *(Koshar 2000, pp. 156–157)*

In Nuremberg, where buildings – most notably the castle – had been appropriated into Nazi propaganda, there were good grounds for similar arguments. However, although the debate about the Goethe House was known in Nuremberg, no controversy on a similar scale occurred (Wachter 1999, pp. 324, 322). In part this was due to the processes just described, by which some form of *Wiederaufbau* became solidified as the route to be taken. In addition, a 1921 building plan (governing basic principles) for the city was adopted post-War and this had the effect of legitimizing decisions as following what had been laid down before the Nazi period (p. 319). Moreover, according to Wachter, in Nuremberg there was no 'dualism between an autonomous citizens' culture and the city government' (p. 324) as there was in Frankfurt. One reason for this, he argues, was that the council was careful to avoid bringing too much public notice to the reconstruction of historical buildings – especially ones that would not be put to immediate practical use – in order to avoid seeming to be dedicating too much resource to them (p. 323). Building and rebuilding were carefully intertwined, paying attention to the immediate needs of the city's inhabitants while also arguing for the symbolic importance of the reconstruction of the Old Town as what the Mayor called 'the beating heart of the city'; and citizens were more carefully enlisted through the means described above.

Even in Frankfurt, however, the opposition to the reconstruction of the Goethe House failed. It did so partly because, as Koshar explains, 'proponents of an exact historical copy … benefited from the fact that reconstruction had an international constituency that went well beyond the Germanophone world. Financial contributions came from all over North America and Europe, including the Soviet zone' (Koshar 2000, p. 157). In Nuremberg too, there was some wider financial support from the allies but the council's softly-softly and locally-oriented approach had the side-effect that buildings that might have most gained from external support – most notably the Dürer House – did not benefit to nearly the same extent (Wachter 1999, pp. 323–324); though it was reconstructed all the same.

The potential of heritage to pull in international support was not, however, entirely ignored in Nuremberg. In making an argument for reconstructing historic buildings the city archivist pointed out that, 'Otherwise no foreigner will ever come here any more – it is a money or currency question' (quoted in Wachter 1999, p. 325). This was perhaps best recognized and realized in the 'reconstruction' of apparently traditional 'little places' (*Örtlichkeiten*) – especially 'wine bars whose walls appeared to have been blackened by centuries of tobacco-smoke' – 'that had never in fact existed' (p. 325). In addition, buildings that had been made more mediaeval-looking by the Nazis were returned to this – rather than their earlier – appearance (Schmidt 1995).

The reassembling of Nuremberg's heritage in the decade following the War, then, was not all of a piece – this was not a complete reconstruction of the pre-War Old Town. Nevertheless it succeeded in reassembling Nuremberg as a city of significant heritage – as, in the title of one post-War guidebook, 'A Treasure Chest Once More'.[6] Here, the fact that reconstruction *in situ* seems to have been accepted as the reconstruction of an authentic original – as legitimately 'heritage' – rather than as a new building, enabled this work to be effective (Macdonald 2006a). This did not mean that reconstruction was forgotten. On the contrary, plaques were put up, giving dates of bombing alongside those of rebuilding – for Nuremberg as a victim of destruction was also another, related, and very significant, way in which the city was being assembled at this time (Gregor 2003a).

The reassemblage of heritage in post-War Nuremberg, then, was an uneven process of partial reconstruction in which pre-War elements were gathered together, some of which had never been there previously. Not only was heritage assembled, however, so too was Nuremberg as a potential heritage location once more, and so too was a heritage-supporting citizenry which would appreciate the restoration of the city as a moral project. This process did not come to an obvious end but has continued and been reshaped over the years as new buildings or adaptations to old ones have been proposed and as heritage has itself been reworked and reproduced. Prior to the 1970s, however, although there were plans, procedures and offices in place for managing such developments, there was no heritage legislation as such. This was introduced in 1973. In the following section I turn to this legislation and, in particular, its implications for another dimension of the city's post-War legacy: its Nazi buildings.

Legislating heritage

The 1973 Bavarian State Historic Preservation Law was Germany's first heritage conservation legislation, although there had been organizations dedicated to trying to preserve historic buildings for over a century. It was introduced primarily to try to regulate post-War building and became a model not only for other German states but also for heritage legislation in a number of other countries (Pickard 2002).

Its introduction was controversial in Nuremberg, not least because it meant that the Munich-based Bavarian Heritage Conservation Office (BHCO) officials could play a role in governing what occurred in the state's 'second city'. There was considerable dispute over the first list drawn up by the BHCO, especially over Nuremberg's Old Town, which the Munich officials wanted to be listed as 'an ensemble'. The consequence of listing in such a way was that all buildings would be covered by the new rules and any possible developments in the city centre would be restricted. Although there had been an emphasis on reconstruction in the Old Town, as described above, there had also been new developments, especially during the 1960s. After haggling and managing to considerably reduce the number of buildings in the overall listing, Nuremberg council finally accepted the listing of the whole of the Old Town as an ensemble.

Laws created primarily for one purpose can, however, have unanticipated application. In the case of the 1973 Bavarian State Historic Preservation Law, an initially unintended application was some Nazi architecture. As Gavriel Rosenfeld, in his detailed study of Munich, explains, the new legislation 'automatically', rather than intentionally, included Nazi buildings (2000, p. 260). The law was phrased in fairly general terms to potentially include any buildings of 'historical significance' of 'an already completed era of architectural history that no longer exists in the present' that had been erected before 1945.[7] Certainly, a judgment still had to be made about 'historic significance' – and it was not applied to all Nazi architecture – but the effect was that this judgment was largely evacuated of moral evaluation. That Nazi buildings fell under a definition and set of procedures that had been primarily devised for the kinds of buildings that were already largely accepted as heritage – such as those of the Old Town – was not a matter of concern to the officials in the conservation office. For they operated under what Rosenfeld calls a 'normalized perspective' in which they saw these buildings as just another historical form (2000, p. 261).

In Nuremberg, however, the city council was extremely concerned because the site of the former Nazi Party Rallies – the Nuremberg Rally Grounds – was listed by the BCHO as an 'ensemble' for its fascist style of architecture and significance as a 'witness of the past' (*Zeuge der Vergangenheit*). Consisting of a considerable area of former marching grounds (many of which had already been grassed over and some even built upon) and large monumental fascist buildings (some of which had been totally or partly destroyed or left to fall into decay), the site was not at that time marked as heritage in any official way. It did not feature in any tourist literature and there were no signs or other information provided on site. Instead, it was used for numerous everyday functions by the council and local people, including storage, sport and leisure events. The council was concerned primarily for the following reasons. First, the listing would potentially restrict further building on the site, sizeable portions of which had already been used for new developments such as housing and a concert hall. Second, it might mean that the council would have to dedicate funds for the buildings' upkeep and perhaps even for restoration. Third, as an outraged Nuremberg city councillor put it during the debate about the listing at the time, it would have the effect of 'cement[ing the buildings] into the catalogue of all those buildings ... deemed worthy of protection'.[8] That is, the legislation would make the Nazi buildings part of a 'heritage assemblage' with the risk that this would transmit the kind of positive evaluation that a heritage designation usually implies. Listed as heritage, the buildings would be fixed – or in the councillor's words, 'cemented' – to the city, its citizens and its future. Since the War, the rally grounds had mostly been viewed as a dirty mark, best ignored, on the city's image (Dietzfelbinger & Liedtke 2004). What heritage listing potentially did was to make the site – and its associated history – more visible and more indelibly part of Nuremberg. Despite these concerns – and, as with the debates about the Old Town, partly as a result of horse-trading over numerous cases and winning an overall reduction in listing – the council did not succeed in removing the rally grounds from the BCHO list. Nazi architecture was legislated into heritage.

Deleuze argues that an assemblage 'can have components working to stabilize its identity as well as components forcing it to change' – processes referred to as 'territorialization' and 'deterritorialization' respectively (DeLanda 2006, p. 12). Designating Nazi buildings as heritage might potentially have destabilized the heritage assemblage, perhaps by throwing into question the whole business of designating heritage and valuing certain kinds of buildings. There were hints of this in the challenge to the heritage listing but nothing emerged sufficiently strongly to destabilize an assemblage that was in the process of being increasingly stabilized through gaining legal powers and the apparatus of conservation officials and procedures. Alternatively, as some

in Nuremberg feared, Nazi buildings might become territorialized – stabilized not only as part of a heritage assemblage, with its capacities to ensure durability and confer worth, but also as part of the assemblage of Nuremberg and its citizens.

Destabilizing and recognizing Nazi heritage

The listing of the former Nazi site was not, however, followed by many of the other accoutrements of the heritage assemblage – at least, not immediately. No plaques were erected and it was still not included in tourist information. Moreover, in 1976, against the wishes of the BCHO, the city council removed some parts of one of the main buildings at the rally grounds site – the Zeppelin Building, which is familiar to many from photographs of Hitler giving speeches at its podium to rally crowds below. The council justified this partly with a claim that the listing had not yet come into full effect but also through arguments that preservation was too costly and that the physical structures had become dangerous due to decay.[9] The latter argument effectively blamed the buildings – their materiality – for the decision taken. While this was the last major physical destruction of buildings at the grounds, development around the site and proposals for major alteration of buildings continued over the years – such that in my longer account of this I have talked about a process of 'oscillation' in which moves towards turning the site into heritage are followed by encroachments on the area and vice versa (Macdonald 2009). The destruction at the Zeppelin Building, for example, was followed some years later by the restoration (with financial assistance from the BCHO) of its interior so-called 'Golden Hall', which was partly justified by the council by a claimed intention to use it for the hosting of exhibitions. It was followed in turn by the division of the old Zeppelin Field into football fields. And so on. To see the incursions into the site as a consequence of the preservation legislation would be to overstate the case but, nevertheless, following through the chains of associations involved suggests that they are not entirely disconnected. In some cases, explicit arguments were made in favour of destabilization of the possible heritage aura of the site. Culture minister Hermann Glaser's notion of 'banalization' – which argued that the site should be 'de-mythified' through ordinary trivial uses (such as storage or leisure) – was widely referred to in arguments about how the site should be treated (Macdonald 2006b; 2009). In effect it was an argument for continuing what was already – and had long been – happening anyway. And in effect it was a rejection of fully acknowledging and stabilizing the site as heritage, and the status of Nuremberg as a city of Nazi heritage. Other heritages – and other Nurembergs – were preferred. These included not only the mediaeval 'Treasure Chest' that had been reconstructed with the Old Town but also others, especially Nuremberg as an important centre of commerce, of industry, and of left-wing politics ('red Nuremberg') – all of which had historical legacies on which they could draw.

A telling playing out between some of these (further discussed in Macdonald 2006b; 2009), as well as a graphic indication of the continuing refusal to fully accept the heritage listing of the Nazi site, was a controversy in 1987 over another of the main Nazi buildings at the grounds – the Congress Hall, an enormous unfinished building modeled on the Roman Colosseum. A private company proposed that it be turned into a shopping and leisure centre, arguing that this would be important to Nuremberg as a leisure destination and major commercial centre. Many members of the city council supported the plans, partly because they were keen that Nuremberg further develop in this way and also because this would defray the costs for the upkeep of the decaying building from council coffers to the private company. The motion to go ahead with the plans was only narrowly defeated in a city council vote, despite opposition from both the BHCO – on grounds of the significance of the building as heritage – and a local citizens'

initiative, which argued that to allow the building to be used in this way would be the equivalent of a repression of the city's Nazi past.

A citizens' initiative is a legally enshrined right in Germany for ordinary citizens to oppose actions by governments. In a sense we might say that the Nazi heritage spurred the creation of this group of citizens; and the citizens who formed the initiative in turn assembled more people and arguments to their cause. What they argued in particular was that the Nazi buildings could perform an important civic function of informing the public about this history in order to help avert the possibility of it being repeated in future. In other words – in what was an important shift of language – the vast Nazi site should be recognized not so much as a *Denkmal* (a monument) but as a specific kind of heritage, a *Mahnmal*. With its root shared with the verb *mahnen*, meaning to warn, a *Mahnmal* is a kind of warning from the past. This was the first time that this term, which was in use in other parts of Germany at that time (Neumann 2000), had been used with reference to Nuremberg's Nazi buildings.

What followed this was an intensification of attempts to assemble the site as 'warning heritage', though these did not displace leisure activities and developments. Most of these activities were driven by either an organization called the Pedagogical Institute, which was a semi-independent branch of city government in which some of those involved in the citizens' initiative worked, or by Geschichte für Alle (History for All), an organization that was initially independent but later funded by the city council. There was also the more short-lived Congress Hall Initiative Group, assembled even more directly in association with the site. Over the following years, the initiatives included exhibitions, guided tours, information booklets and information panels. On the one hand, in their content, these destabilized the Nazi heritage as an assemblage deserving the kind of admiration that heritage is usually expected to command. On the other, however, they further stabilized it as heritage by making it into a recognizable site of history and providing it with the kinds of paraphernalia that accompany other visitor sites. Not least, the new tourist information made it easier for potential visitors to find the site. It also began the work of more fully assembling Nazi heritage to other aspects of Nuremberg's heritage, though it was not until the end of the century that organizing the site became part of the remit of the branch of city governance dealing with tourism.

None of this is to say, however, that the Nazi heritage could straightforwardly become a component of Nuremberg's existing heritage assemblage – that is, that it carried no risk of destabilization or deterritorialization. On the contrary, it called for special treatment, partly because of its tension with the worth-conferring capacities of heritage. This had to be unsettled and turned to educational purposes. So, for example, while the city council approved the building of one of the most visible and expensive accoutrements of heritage – an information centre – and while this was officially part of the museum service, it was not called a 'museum' because this might imply a positive evaluation of the worth of the subject matter. Instead, the new centre, opened in 2001, was called a Documentation Centre – 'documentation' being more associated with academia than tourist sites. In its materialization too, the Documentation Centre was designed to avoid being seen as conventional heritage or endorsement. The winning architectural proposal was for a glass and metal 'stake' through the Congress Hall – described as 'cutting through' the Nazi building. And while the Centre does contain a café and shop – other typical features of visitor attractions – these are low-key, the latter containing only books related to the subject-matter.

In developing its Nazi sites as warning heritage in this way, Nuremberg was not alone. In many other parts of Germany, and indeed in other countries too, there has been a considerable expansion since the 1980s in using former sites of atrocity in this way. And while sites such as the rally grounds, which were not directly sites of victims, were in many ways more problematic

– because of their potential endorsement effect – there were other instances of perpetrator-sites, such as the excavated remains of the SS and Gestapo headquarters in Berlin, whose display (resulting in an exhibition called The Topography of Terror) had been much discussed by the time that Nuremberg began to develop its Documentation Centre. Local activists (including those working in the Pedagogical Institute and Geschichte für Alle) incorporated such examples in their arguments about why Nuremberg and its citizens should publicly acknowledge their terrible heritage and take on the role of reminding for the sake of the future. Nuremberg's citizens were effectively positioned as moral guardians – safeguarding the heritage for the sake of safeguarding the future. They were so, moreover, not only in relation to the future of the city's own inhabitants but also citizens of (the new, post-unification) Germany, or Europe and even the world (see Macdonald 2009, pp. 116–120).

Nazi heritage and human rights

An important part of assembling Nurembergers, Nuremberg and Nazi heritage to this role of 'warning' and 'guarding' – and to elevating this beyond a local concern – was the global assemblage of Human Rights. There were historical components available for such a reassemblage, the Nuremberg trials being usually seen as the first international trials and the precursor of the Universal Declaration of Human Rights. Nevertheless, before the 1990s this was not an association that had been made explicit through the city's self-presentation. The trial courtroom, for example, was only opened for visitors in 2000, and then only at restricted times. (An information centre at the court is due to open in 2010.) The explicit articulation to Human Rights, however, linked the city into a network of international organizations and its scale-shifting had implications for how the city was seen and could operate.[10]

The way that Nuremberg became coupled to a global Human Rights assemblage highlights how international connections may work in practice as well as their contingency. In 1988 the city council put out a tender for a new architectural and art development for the refurbished Germanic National Museum. Israeli artist Dani Karavan won the commission primarily because he managed to solve an awkward architectural dilemma in a particularly elegant way. In the working up of his design he proposed that the street of pillars that he had drawn would be a Street of Human Rights, each pillar bearing one of the statements of the Universal Declaration. And although some in the city were initially nervous of the idea of Nuremberg daring to call itself a City of Human Rights, by the time of the unveiling of the sculpture in 1993, Karavan's proposal had taken hold and the unveiling was accompanied by a conference on Human Rights – bringing together numerous famous activists and commentators from around the world – and the announcement of a biannual Human Rights award to be funded by the city. Subsequently, the council also approved a biannual film festival on Human Rights and set up an office of Human Rights, directly accountable to the mayor; and in 2000, the city was awarded a prize by UNESCO for its Human Rights initiatives. Opening the new Documentation Centre at the former Nazi Party rally grounds was presented in official documents and speeches as a further important substantiation of the commitment to Human Rights.

Making Nuremberg's Nazi heritage a component of an assemblage of Human Rights education enabled those involved in Nuremberg's official self-presentation, especially various agencies of city governance, to draw attention to other atrocities and abuses beyond the locality and the nation. This does not necessarily lessen the crimes committed by the Nazis, especially where what is being emphasized is the continuing occurrence of Human Rights abuse. Nevertheless, following the empirical realization of the Human Rights assemblage in the Nuremberg case suggests that the shift of scale may lead to certain components falling out of the assemblage.

Sharon Macdonald

In particular, scaling to the global seemed to *displace* – or further stabilize an existing partial displacement of – some aspects of the local. Certainly, Nuremberg remained in the assemblage as a historical generator of, first, terror and then as the beginning of Human Rights (via the trials). What was not part of the assemblage, however, were some of the local and *placed* aspects of the Nazi past in Nuremberg and most of the continuities between past and present.

In particular, what was occluded by the shift of scale was attention to the particular social, political and especially business relations of the city – matters such as which firms had supported the Nazi regime and had used slave labour. Some of these firms are still in operation today and have either only recently settled compensation claims or are in the business of contesting or acceding to them. While these did not necessarily have to be ignored, or disassembled by the Human Rights assemblage, in practice this was what occurred. Moreover, in some cases the emphasis on Human Rights, and the claims of what the city was doing, were used instrumentally by politicians to enable this displacement. For example, in 1997 the new CSU (Christian Socialist Union) mayor made much of the city's human rights initiatives in countering objections to his proposal to confer honorary citizenship on a major industrialist whose company had manufactured armaments and used slave labour during the War (Gregor 2003b). The mayor's argument in effect was: how could a city that was being so evidently open and honest about its past, and was doing so much to highlight Human Rights abuses, possibly be accused of paying insufficient attention to that past and its political ramifications?

Reflections

In this article I have been concerned to explore some of the work that heritage – in various forms – has done in the reassembly of Nuremberg and its citizens post-War; and in the process to consider some of the particular capacities of the 'heritage-assemblage'. In these final paragraphs, I want to draw on some of that to add some reflections on the assemblage perspective itself. Because 'assemblage theory' is not a fully agreed-upon set of ideas, some and perhaps all of my comments on its possible limitations might be argued to be covered by parts of the work of some assemblage theorists (see note 3). I offer them here, nonetheless, as a stimulus to further debate and possible correction.

As I noted above, one much-noted feature of an assemblage perspective is its emphasis on the mediatory effects of materiality. In the Nuremberg case there are many examples of how buildings' materiality co-shapes the events that ensue – for example, whether a war-damaged building can be restored or not. Equally, however, it is clear that human decision-making and conceptual categories (e.g. heritage) can override this. For example, in the case of two equally war-damaged buildings, one may be judged 'restorable' – especially if 'heritage' – and the other not. This raises questions about how much agency an analyst should attribute to the buildings themselves, and how far analysis should seek to go beyond the claims of the human players involved. People, in Nuremberg and elsewhere, frequently attribute agency to materials. For example, some commentators in Nuremberg worried that restoring Nazi buildings might give them power to beguile their viewers into sympathy with the Nazi project; or, as described above, Nuremberg council claimed that it was the fault of the Zeppelin building (and indirectly of the Nazis for their earlier shoddy workmanship) that it needed to be partly destroyed. Making such attributions of agency can, however, also have the effect of demoting human agency, especially in morally-fraught contexts (Macdonald 2006b). Whether a social or cultural account should stick close to the actors and go along with this is a question which assemblage theory has not, perhaps, sufficiently addressed. Intentionality, even if inevitably mediated in practice, is important too – as Nazism shows us in particularly disturbing forms.

In addition to highlighting materiality as mediatory, the account above also frequently gives attention to linguistic and conceptual classifications, inflections and connotations, as constitutive parts of the course of events. For example, the distinction between *Aufbau* and *Wiederaufbau* and its application, or the shift from *Denkmal* to *Mahnmal*, motivates particular actions and has certain ramifications. While consideration of language, classification and meaning is not ruled out by an assemblage perspective, it is given relatively little emphasis.[11] Yet, it seems from the case explored, these are often crucial in the course that assembling takes.

Any account of assemblage is, of course, inevitably partial – it is never possible to follow all of the chains of connections that might be involved. In this short article I have only been able to give an indication of some of the connections between human and non-human players involved in heritage assemblage in post-War Nuremberg. Hopefully this has been sufficient to indicate something of the range and mix that might be involved, as well as the mix and range of what might be called 'local' or 'short-range' and 'longer-range' players. In so doing, this shows how these can co-exist without tension and without separating into different levels as parts of the assemblage. However, as I have suggested in the discussion of Nazi heritage as a heritage of Human Rights, associations made (in this case 'global') can be involved in the displacement of others (in this case, certain aspects of the 'local'). Following connections risks not attending to those severed or not made in the first place (see Strathern 1996) – and it might even deflect attention from them. Without a prior set of analytical concerns or some kind of framework that can alert us to the apparently unconnected, might an emphasis on assembling restrict perception of disassembling – and even of dissembling?

An assemblage perspective can productively open up questions for heritage research, not least about the capacities of heritage and its implication in the production of other entities, especially temporalities, place and citizens. At the same time, however, it tends not to push in certain directions that, here, have nevertheless seemed to have been particularly significant, at least in the post-War reassembling of Nuremberg. It is hoped that this article might contribute to more attention being paid to some of these areas and questions, and perhaps to some reassembling of assemblage perspectives themselves.

Acknowledgements

A first version of this article was presented at the Australian Cultural Researchers Network, CRESC, and Ian Potter Foundation workshop, *Assembling Culture*, University of Melbourne, December 2007. I thank the participants and especially Tony Bennett and Chris Healy for comments; and I also thank the anonymous referees. The research on which the paper is based has received financial support from the Alexander von Humboldt Foundation and the Arts and Humanties Research Council. A fuller list of acknowledgements and a fuller account of the research is presented in Macdonald (2009) from which some parts of this article draw.

Notes

1 For a useful account of directions in heritage research see, for example, Kockel and NicCraith 2007.
2 Latour distinguishes between the intermediaries, which 'transport … meaning or force without transformation' and 'mediators [which] transform, translate, distort, and modify the meaning or the elements they are supposed to carry' (2005a, p. 39).
3 What constitutes an 'assemblage perspective' has itself to be assembled from various sources and the introduction to this volume gives a fuller account. I draw on Latour (especially 2005a), Deleuze and Guattari (especially 1987), DeLanda's exposition (2006), and Bennett (2007). It might also be noted that Latour points out that anthropology often uses such an approach without naming it as such (2005a, p. 68).

4 E.g. *Nürnberg* c.1950, NCA ref: AV2708; Mittenhuber *et al.* 1995, p. 25.
5 It was categorized as such, for example, at the Great German Building Exhibition in 1949. See *Ausstellungszeitung* (exhibition newspaper) NCA AV Pe 10 2, 4.9.1949.
6 *Nürnberg: Wieder ein Schatzkästlein*, NCA 5070a8, n.d. See also Kosfeld (2001) and Hagen (2006).
7 Rosenfeld's translation (2000, p. 260), from Bayerisches Staatsministerium für Unterricht und Kultus (1974, p. 7). The reason for the 1945 cut-off was in order to exclude post-War redevelopment.
8 Quoted in 'Ein sündhaft teures Denkmal', *Nürnberger Nachrichten*, 13 November 1973.
9 See Macdonald (2009, pp. 60–61) for discussion of ways in which economic calculations could be made.
10 I have discussed this also in Macdonald (2009). The scaling to the global that articulation in terms of Human Rights allowed is in many respects similar to that involved in UNESCO World Heritage listing. Barbara Kirshenblatt-Gimblett's characterization of the way in which 'World heritage lists arise from operations that convert selected aspects of localized descent heritage into a translocal consent heritage – the heritage of humanity' (2006, p. 170) could apply equally well to the process of linking Nuremberg's Nazi heritage to a Human Rights assemblage. Moreover, a similar process of removing 'volition [and] intention' (p. 179) from those whose heritage is listed can be seen in the Nuremberg case, though to very different political effect.
11 It is evident, for example, in the attention to representation in Latour's discussion of 'Making Things Public' (2005b) – where there is also much authorial play with etymology. Yet it does not seem to be fully extended into any critique of the politics of attributions of agency or of the assemblage perspective itself, especially its emphasis on materiality.

Bibliography

Bayerisches Staatsministerium Für Unterricht Und Kultus (Ed.) (1974) *Bayerisches Denkmalschutzgesetz: Text und Einführung*, Munich.
Bennett, T. (2007) 'The work of culture', *Cultural Sociology*, Vol. 1, No. 1, pp. 33–47.
Bruckner, D. (2002) *Was war Los in Nürnberg 1950–2000*, Sutton Verlag, Erfurt.
Collier, S. J. & Ong, A. (2005) 'Global assemblages, anthropological problems', in *Global Assemblages. Technology, Politics, and Ethics as Anthropological Problems*, eds A. Ong & S. J. Collier, Blackwell, Oxford, pp. 3–21.
Delanda, M. (2006) *A New Philosophy of Society*, Continuum, London.
Deleuze, G. & Guattari, F. (1987) *A Thousand Plateaus*, University of Minnesota Press, Minneapolis.
Dietzfelbinger, E. & Liedtke, G. (2004) *Nürnberg – Ort der Massen. Das Reichsparteitagsgelände. Vorgeschichte und schwieriges Erbe*, Ch. Links, Berlin.
Gregor, N. (2003a) ' "Is he alive, or long since dead?": Loss, absence and remembrance in Nuremberg, 1945–1956', *German History*, Vol. 21, No. 2, pp. 183–203.
Gregor, N. (2003b) ' "The illusion of remembrance": the Karl Diehl affair and the memory of national socialism in Nuremberg, 1945–1999', *The Journal of Modern History*, Vol. 75, No. 3, pp. 590–633.
Hagen, J. (2006) *Preservation, Tourism and Nationalism: The Jewel of the German Past*, Ashgate, Burlington.
Hemme, E. Tauschek, M. & Bendix, R. (eds) (2007) *Prädikat "Heritage", Werschöpfungen aud kulturellen Ressourcen*, Lit, Berlin.
Kirshenblatt-Gimblett, B. (2006) 'World heritage and cultural economics', in *Museum Frictions. Public Culture/Global Transformations*, eds I. Karp, C. A. Kratz, L. Szwaja & T. Ybarra-Frausto, Chapel Hill: Duke University Press, pp. 161–202.
Kockel, U. & NicCraith, M. (eds) (2007) *Cultural Heritages as Reflexive Traditions*, Palgrave: Macmillan, Basingstoke.
Kosfeld, A. G. (2001) 'Nürnberg', in *Deutsche Erinnerungsorte I*, eds E. François & H. Schulze, C. H. Beck Verlag, Munich, pp. 68–85.
Koshar, R. (1998) *Germany's Transient Pasts. Preservation and National Memory in the Twentieth Century*, University of North Carolina Press, Chapel Hill.
Koshar, R. (2000) *From Monuments to Traces: Artifacts of German Memory, 1870–1990*, University of California Press, Berkeley.
Latour, B. (2005a) *Reassembling the Social*, Oxford University Press, Oxford.
Latour, B. (2005b) 'From Realpolitik to Dingpolitik or how to make things public', in *Making Things Public. Atmospheres of Democracy*, eds B. Latour & P. Weibel, MIT Press, Cambridge, MA and ZKM, Karlsruhe, pp. 14–41

Macdonald, S. (2006a) 'Undesirable heritage: fascist material culture and historical consciousness in Nuremberg', *International Journal of Heritage Studies*, Vol. 12, No. 1, pp. 9–28.

Macdonald, S. (2006b) 'Words in stone? agency and identity in a Nazi landscape', *Journal of Material Culture*, Vol. 11, nos 1/2, pp. 105–126.

Macdonald, S. (2009) *Difficult Heritage Negotiating the Nazi Past in Nuremberg and Beyond*, Routledge, London.

Mittenhuber, M., Schmidt, A. & Windsheimer, B. (1995) *Der Nürnbrger Weg*, Sandbag Verlag, Nuremberg.

Neumann, K. (2000) *Shifting Memories. The Nazi Past in the New Germany*, Michigan University Press, Ann Arbor.

Pickard, R. (2002) 'A comparative review of policy for the protection of architectural heritage of Europe', *International Journal of Heritage Studies*, Vol. 8, No. 4, pp. 349–363.

Rosenfeld, G. D. (2000) *Munich and Memory. Architecture, Monuments, and the Legacy of the Third Reich*, University of California Press, Berkeley.

Schmidt, A. (1995) 'Saubere Altstadt. "Entschandelung" und Zerstörung der Nürnberger Altstadt im Nationalsozialismus', in *Bauen in Nürnberg 1933–1945. Architektur und Bauformen im Nationalsozialismus*, eds H. Beer, T. Heyden, C. Koch, G.-D. Liedtke, W. Nerdinger & A. Schmidt, Tümmels Verlag, Nuremberg, pp. 130–151.

Strathern, M. (1996) 'Cutting the network', *JRAI*, 2, pp. 517–535.

Wachter, C. (1999) *Kultur in Nürnberg 1945–1950. Kulturpolitik, kulturelles Leben und Bild der Stadt zwischen dem Ende der NS-Diktatur und der Prosperität der fünfziger Jahre*, Stadtarchiv Nürnberg, Nuremberg.

Whyte, I. B. (1998) 'Modern German architecture', in *The Cambridge Companion to Modern German Culture*, eds E. Kolinsky & W. van der Will, Cambridge University Press, Cambridge, pp. 282–301.

51
Can there be a conciliatory heritage?

Erica Lehrer

[P]ublic spaces … can be sites of reconciliation between strangers who are wary of, but curious about, each other.

Elaine Gurian (2004, p. 89)

[C]ultural tourism becomes simply life-enhancing rather than life-consuming, not a spectacle but an experience, because real people still live it and share it with real people who interpret it. We are able to experience reciprocity and feel enriched by it.

Stuart Hannabuss (2000, pp. 363–364)

Remembering well requires reopening wounds in a particular way, one which people cannot do by themselves; remembering well requires a social structure in which people can address others across the boundaries of difference.

Richard Sennett (1998, p. 22)

'Why would a Pole open a Jewish bookstore?' Jewish visitors ask. A non-Jewish Jewish bookstore would be cause enough for suspicion. But a Polish one? This combination violates the basic order of a Jewish universe built from grandparents' stories of deceitful Poles turning over Jews to the Nazis for vodka.

Zdzislaw Les is the owner of the Jarden Jewish Bookshop in Cracow, Poland. He recalls his inspiration for opening the shop:

> I visited this normal bookshop, in this very building, in which sat two boring women selling crime stories and third-class literature. And there was one shelf, maybe two small shelves, on which was written 'Judaica.' Ten titles! And I asked them, '*Do you know where you are?*' I thought it was a scandal, and I told these women so. So I took it over, threw out the other 90 percent of the books, and began to increase the Judaica. And now I have about 150 titles – in practice, all of what is published in Poland. And it is the only Jewish bookshop in Poland.[1]

Zdzislaw used to direct Cracow's House of Culture, the omnipresent communistera centre for community arts and cultural ideology, where he introduced a series called 'Meetings with Jewish Culture'. There were gatherings with authors of books, concerts of Jewish songs, and other events. At university, Zdzislaw trained as a Slavicist. He attributes much of his sensitivity about Jewish influences on Polish culture to his familiarity with Polish literature. He pokes fun at Polish nationalism and says that many of Poland's cultural heroes were actually Jews. He always has an example up his sleeve:

> I don't know if you know that the best Polish poet of the twentieth century was Jewish. Boleslaw Lesmian. And the best master of Polish language. Many Polish poets in the twentieth century were Jews: Tuwim, Lesmian, Slonimski. And they created, I think, more variety in poetry than others. In *Polish* poetry … Isn't that a paradox? And some others fields, history for example, science. Maybe our stupid nationalists will finally understand that Polish folklore, which makes them have an orgasm, owes Jews a lot, and that their favourite potato pancakes are also a Jewish recipe, that our so-called folk art was also inspired by Jews and this dumb nation was only copying what they invented. So consider this: if so many Jews have done so much for Polish culture, why shouldn't two poor Poles like us do something for Jews?

Converging memory projects

The Jarden Jewish bookshop is located in Kazimierz, a rare medieval Jewish quarter that survived World War II intact. Until the early 1990s, however, it was a largely empty, dilapidated part of Cracow. The most obvious evidence of hundreds of years of Jewish habitation were the many dilapidated or re-purposed synagogues and entrance ways with visible impressions of *mezuzot* (small receptacles containing a biblical text traditionally affixed to door frames) that had been wrenched away in the wake of the brutal removal of the Jews by the Nazis. While Kazimierz is no longer a neighbourhood inhabited by Jews, fashionable Jewish-themed cafés and shops, run by ethnic Poles, now line the main square, beckoning customers with signs in Hebrew and Yiddish, and offering 'Jewish' food, decor, and music.

To extend Zdzislaw's rhetorical question: just what are these Poles doing for Jews, and why? Many foreign Jews have a ready answer. These 'poor Poles' are not doing anything for Jewish culture, quite the opposite. They are skimming what is fashionable and marketable from Jewishness while uninterested in and unconnected to actual Jews, who are conveniently absent. Simply put, the notion 'that preservation of the Jewish heritage of Poland lies partly in Christian hands … strike[s] some people as preposterous at best, and, at worst, in extremely bad taste' (Hoffman 1995, p. 276).

Yet contrary to the widespread view that interest in Jewish heritage in Poland today is merely a superficial fad, I suggest that its expression in Kazimierz is in important ways the result of two subaltern memory projects – a local Polish one and a foreign Jewish one, imported by tourism. The Polish project is meaningfully contiguous with activist projects rooted in Poland's struggle for democracy. In the 1970s and 1980s under late communism, grassroots interest in and activities on behalf of Jews represented a form of resistance against the government, which periodically wielded anti- (or occasionally philo-) Semitism as a political tool, but otherwise tightly censored Jewish themes.[2] This 'Jewish memory project' was also interconnected with Jewish de-assimilation and community revival in Poland. A highly dialogic project, non–Jewish Poles made crucial contributions to restoring Jewish heritage (Gebert 1994). As sociologist

Iwona Irwin-Zarecka notes, '[i]t would often be from these Catholic friends that a Jew brought up in silence learned some basics of Judaism and Jewish history' (Irwin-Zarecka 1989, pp. 90–91).

Since the early 1990s in post-communist Poland, non-Jewish 'heritage brokers' in Kazimierz have played key roles in cultivating conditions for the flowering and ferment of Polish-Jewish culture.[3] While not all were idealistically motivated, neither have most of their projects been singularly mercenary. Rather, as has been suggested of culture brokering projects elsewhere, they may be better understood as representing 'an honour, a responsibility, and something that can sometimes be turned to personal advantage and profit' (Kurin 1997, p. 39). In publicly affirming Jewish culture, key brokers took social risks that the few, mostly old, remaining local Jews were unable or unwilling to take. As international Jewish tourism and local Jewish confidence have grown, these brokers have been open to, and courted, Jewish involvement in their endeavours.

Conversely, while facing the Holocaust is a key component in most foreign Jewish travel to Poland, a growing minority seeks more than an experience of evil. A memory project developing among foreign Jews has drawn some to confront and re-consider their own community's refusal of Poland as a relevant part of Jewish heritage beyond the heritage of destruction. Thus, while a Polish urge to remember and reconcile with its Jewish heritage has been a prime mover in Kazimierz's development as a 'conciliatory heritage' site, individual Jewish quests to come to terms with Poland's broader Jewish heritage have played an integral complementary role. As Amos, a French Jew in his early 20s, told me while sitting in Café Ariel, one of Kazimierz's key Jewish-themed venues:

> People come here [to Poland] and say 'It is awful, it is awful.' I say, '*No*'. I don't come here to say it is awful. I just come to make peace with people. To *not* say, 'Okay, [see], it *is* anti-Semitic.' To try [instead] to make peace, and to make a place for that in my head … It was really nice to try to speak with Polish people without getting … I didn't want to go back to Poland to see anti-Semitism. I want to *stop* this.

While these emerging memory projects follow multiple pathways, Kazimierz is unique as a social catchment with an inherent *genius loci* that brings these projects into constant, meaningful contact. Over a 15-year span, I saw the Polish and Jewish projects not only converge, but intertwine, catalyse and refine each other in Kazimierz. The result is an evolving Polish-Jewish heritage site, a 'conciliatory' space that works against more conflictive notions of Poland's Jewish heritage – dominant in both Jewish and Polish society – that pit Jewishness and Polishness against one another.

Towards a conciliatory heritage

In theorising 'conciliatory heritage', I address gaps in three domains of scholarship. The first, overarching matter is to highlight and respond to the recurring preoccupation with themes of conflict and discord in recent heritage literature (see Tunbridge and Ashworth 1996, Kapralski 2001, Meskell 2002, Macdonald 2006 and 2009, Logan and Reeves 2009).

The second issue involves discussions of reconciliation. A central aspect of managing the past among members of aggrieved groups in the wake of massive political changes in transitional societies involves encounters of truth telling and listening, and much has been written on the successes – and increasingly the failures – of official, legal structures and processes put in place by transitional governments to facilitate such encounters (Minow 1999, Hayner and Garton Ash

2002, Bilbija *et al.* 2005). But 'reconciliation', if it is to be meaningful, is not achieved in one fell swoop; it is an organic process that unfolds in daily life, within and between aggrieved communities. Yet 'few authors have addressed the critical dimension of what must happen between people to lead to genuine rehumanization' (Halpern and Weinstein 2004, p. 305). Anthropologist John Borneman (2002, pp. 289, 293) has suggested that the courtroom is only one, highly formalised, site for such exchanges and that alternative sites and other 'potential listeners/practitioners of listening' should be considered. I take up his suggestion here by proposing, as one such alternative, heritage landscapes and the culture brokers who tend them. My observations in Kazimierz suggest this is a rich domain.[4]

The third discussion surrounds 'sites of memory'. Pierre Nora's notion of 'lieux de memoire' has inspired much writing on the cultural 'memory work' such sites do. But much of the scholarship seems to take for granted Nora's bifurcation of purely symbolic, historicised, alienated 'lieux' from 'milieux' – the more ancestral, living, embodied 'environments' of (supposedly pre-modern) memory, transmitted via 'gestures and habits, in skills passed down by unspoken traditions, in the body's inherent self-knowledge, in unstudied reflexes and ingrained memories' (Nora 1989, p. 13). Thus cultural studies of memory sites often limit themselves to a focus on representations or discursive identity constructions, overlooking more social, embodied practices of memory that sites may entail or inspire, through encounter, dialogue, network building, cultural activism and preservation, or even 'love' (Dominguez 2000).

Viewing Kazimierz at the intersection of these overlapping gaps, I argue that the quarter in its recent incarnation is more than an evocative site for the projection and reception of *representations* of Jewish heritage, which can then be read as texts – finished surfaces to deconstruct for hidden meanings, ideologies and assertions of power. Rather, I see Kazimierz as a unique *opening* in which Jews and Poles regularly cross paths, offering a rare opportunity for geographically dissociated groups to experience 'the face-to-face encounter that has traditionally grounded the ethical' (Rothberg 2000, p. 271).

The result is a unique arena in which Jewish and Polish collective memories and national identities can be confronted, questioned, and expanded. To be clear, my goal is not to suggest that Jewish heritage practice in Poland – or even in Kazimierz – *is* in some essential way conciliatory, only that it *can* be, both in its motivations and its reception. Because of the frequent, easy dismissal of Kazimierz as a 'Jewish Disneyland' – a type of site that social analysts have characterised as a totalising environment that reproduces normative identifications and constrains social interactions (e.g. Kuenz 1993) – central to my project is to show how this heritage site embodies counter-hegemonic political and moral concerns as well.

Jewish poland as conflictual heritage

The uniqueness and activist quality of the notion of a hybrid 'Polish-Jewish' heritage – as illustrated by Zdzislaw's statement above – must be understood in the context of the troubled symbolic landscape that Polish–Jewish relations were reduced to after the horrors of the Holocaust. This includes the immediate post-war years in which the few surviving Polish Jews were often seen and acted upon as unwanted foreigners, as well as the later communist-government-sponsored anti-Semitic campaigns that emptied Poland almost entirely of Jews and Jewish social and memorial infrastructure. Whether today there exists a *Polish-Jewish* heritage – and what that heritage consists of – is a matter of popular dispute.[5] In the post-war period a divorce of Polish and Jewish memory occurred – Polish national memory was re-articulated by Catholic Poles, Jewish memory of Poland by Jews now largely residing elsewhere. This split was perpetuated and reinforced by communist and ethno-national heritage practices within both the Polish and

foreign Jewish communities (Wrobel 1997, Polonsky and Michlic 2004). New scholarship, in publications tellingly titled *Contested Memories* (Zimmerman 2003) and *Imaginary Neighbors* (Glowacka and Zylinska 2007), illustrates contending frames of reference and charged symbolic engagements in which incommensurable Jewish and Polish national narratives of martyrology come head to head, particularly around the very sites of the Nazi genocide machinery (Kapralski 2002, Zubrzycki 2006).

On the Polish side, the priorities of the post-war communist state and the demands of Polish nationalism made the heritage of Poland's longstanding Jewish community invisible, unwanted, or irrelevant to what had become a mono-ethnic (Catholic) Polish nation.[6] While the Jewish past has become increasingly relevant in present-day, post-communist Poland, particularly in the international diplomatic arena, its grassroots significance is shifting, uneven and multivalent.[7] In the Jewish communal world outside of Poland the *hegemonic* answer to the corresponding question of whether the Jewish people have a Polish heritage that extends beyond their near-demise during the Holocaust remains a resounding 'No'. The majority of Jewish visitors to Poland visit primarily Holocaust-related sites, often continuing on (or returning) to Israel. These visits are frequently embedded in a form of state- and community-sponsored memory work that uses these countries as a stage to enact a Zionist-inflected pageant of national death and redemption, with an attendant either/or understanding of Polishness and Jewishness.[8]

The polarisation of Jewish and Polish national visions of Poland's Jewish heritage is highlighted by comparing two maps – one from an Israeli tourist agency specialising in youth tours to Poland and one from the Polish National Tourist Board.[9] Both maps show the contours of today's Polish state territory and are identically titled 'Jewish Heritage in Poland'. But the keys for each map – and the corresponding density of sites denoted – are strikingly different. While the Israeli map indicates *only* Nazi ghettos and extermination camps, the Polish map lists a range of historical Jewish locations, including key sites of Holocaust atrocity, but also synagogues, Hasidic centres and other sites of Jewish life.[10]

These fixed, divergent representations serve as a backdrop on which to view the rise of – and possibilities represented by – grassroots Jewish heritage initiatives, and the potential for new public formation in the dynamic social spaces these create. Discussions of Polish–Jewish relations focus overwhelmingly on the conflicting historical narratives of the Polish-Jewish past and the way in which those narratives frequently animate such relations. But sites of physical and intangible heritage, while often employed for exclusivist or bigoted national imaginings, can also become 'sites of conscience' (Sevcenko 2002). These facilitate interpersonal engagements and social risk-taking (telling/listening, expressing dissent, creating productive discomfort); the production of new social networks; reflexive learning, and identification experimentation. Such spaces provide a unique framework for working through the emotional, social and cultural detritus of the Holocaust in Poland.

Asymmetrical vectors of reconciliation

Jews and Poles were 'unequal victims' of Nazi crimes (Gutman and Krakowski 1986), and the Nazis also encouraged Poles to participate in Jewish persecution and profit from Jewish expropriation, which recent historical scholarship suggests they did to a greater extent than previously acknowledged, both during and after the war (Gross 2001, Engelking 2003, Grabowski 2004, Stola 2005). Compounding the injury, the communist-era Polish state generally declined to acknowledge the Holocaust – the disproportional persecution and uniquely motivated attempt to exterminate the Jews – as distinct from the more general,

Can there be a conciliatory heritage?

brutal occupation of Poland and attendant persecution of ethnic Poles. While Holocaust consciousness has been publicly cultivated in the post-communist era in new monument inscriptions, the popular media and school history textbooks, so too has Poland's national narrative of martyrology and resistance – in which Jews play an ambivalent role (perceived at turns as competitors for victim status, communism-embracing traitors and tarnishers of Polish heroism).

On the Jewish side, Holocaust consciousness (in which Poles play a role primarily as Nazi collaborators and Poland functions as the ground zero of Jewish extermination) has grown in significance with the communal battle against assimilation and waning identification with the Zionist project. Jewish Holocaust commemoration has tended to extract the Jewish experience from its larger wartime context, and from the fate and suffering of Poland in particular. Indeed, political scientist Claire Rosenson cites recent survey data suggesting that while Poles are very much aware of the victimisation of the Jews in World War II and believe it is necessary to remember the Holocaust, 'how many Jews can say anything at all about Polish losses during the war or even describe their situation under Nazi occupation? In my experience, many Jews are not even able to say whether Poland was an ally or opponent of the Nazis' (Rosenson 1997, p. 67).

Since shortly after World War II, Poles and Jews have not (in any significant numbers) shared a physical territory, let alone any sense of 'us'. Unlike, for example, black and white South Africans or conflicted citizens of Latin American countries, Polish–Jewish reconciliation has not been *necessary*, as the two groups no longer inhabit the same geographical space. In each side's narrative of victimhood, the other has served mostly to illustrate the first side's heroism or its own incomparable suffering. The resulting scenario is aptly captured by anthropologist Jack Kugelmass' statement that 'Jews see Poles as witnesses, if not outright accomplices, to murder; Poles see Jews as ingrates' (Kugelmass 1995, p. 295).

Hybrid physical and social space

Two generations of Poles and Jews have had almost no contact with each other. Most Jews come to Kazimierz because it is on the way to Auschwitz. Through the mid-1990s I knew many Jewish visitors who arrived in Cracow only to go directly by bus or taxi to the Holocaust's central symbol, returning the way they came. Those few particularly informed or with specific ancestral ties that brought them to Kazimierz would wander among crumbling facades bearing an occasional trace of flaking Hebrew lettering. Such visitors were struck primarily by the sense of Jewish *absence*, 'particularly visible, since in spite of the destructive force of the war, the cultural landscape and urban fabric had survived' (Murzyn 2006, p. 120). Decades of economic stagnation made it appear as if time had stopped in the near aftermath of destruction, leaving a monument to the apocalypse. For local Poles, even the Jewish identity of the quarter had been lost; Cracovians knew it only as a slum.

Today's gentrifying Kazimierz is strikingly different. Local heritage brokers have used the site to create *Jewish space* of a particular kind, beyond what Cracow's tiny 'official' local Jewish community has been able or willing to provide.[11] The venues that comprise this space – often advertised as 'Jewish sites' in guidebooks – have formed centres of gravity for Jewish travellers, and have been transformative for provincial and Cracovian Jews seeking places to assemble. But per historian Diana Pinto (2002, p. 251), just as such 'Jewish space',

> cannot exist without Jews … neither can it exist only with them, for the space is not the equivalent of a community. It is an open cultural and even political agora where Jews

765

intermingle with others qua Jews, and not just as citizens. It is a virtual space, present any-where Jews and non-Jews interact on Jewish themes or where a Jewish voice can make itself felt.

Pinto calls such space the 'the crown jewel' of a pluralist democracy (Pinto 2002, p. 251). Exceeding artifice or veneer – but also exceeding the bounds of Jewish community – Kazimierz venues have catalysed a range of encounters and reckonings around Jewish heritage.

Kazimierz is today perceived by local Jews as a *safe space*, free from widespread Polish suspi-cion and prejudice about Jews. Journalist Ruth Gruber noted that '[t]he district consciously forms a sort of "Jewish zone" where different rules from the rest of the city – or country – may apply' (Gruber 2003, p. 364). Further, Kazimierz possesses what Konstanty Gebert, a key figure in Poland's Jewish communal revival living in Warsaw, called *ruach* (Hebrew for 'spirit'), which makes it a favoured place for Jews from across Poland to come and 'be Jewish'. Not only do many Polish Jews feel it to be a rare place in Poland where one *can* wear a yarmulke [skullcap] openly, but as Stanislaw Krajewski (a prominent figure in the Polish-Jewish community) told me, it is a place 'where it feels *more* proper to wear one than not'.

Similarly, Kazimierz venues are perceived by many as a *living space* in what visiting foreign Jews otherwise encounter largely as a landscape of death. Wójciech Ornat, owner of the quar-ter's first and most locally beloved Jewish restaurant, told me he opened his Jewish café in Kaz-imierz to counteract what he saw as the quarter's emptiness and sadness.[12] 'One year ago, tourists saw only death. Now, with Café Ariel, they see life.' An American Jewish professor who asked me for help in arranging an educational trip echoed those sentiments, telling me her group's meal and concert at Ariel 'was a highlight of our trip – the first time after visiting concentration camps and cemeteries that the participants experienced Jewish life, not Jewish death'.

Indeed, Kazimierz's liveliness and popularity has led it to become a *space of social networking*. Foreign Jews (particularly Westerners) have been sources of information, resources, meaning, and even legitimisation of Jewish identity for many – especially young – Polish Jews. Michal, a Polish Jew in his early 20s, noted the importance of visiting Kazimierz for 'meet[ing] people with whom I have an emotional connection. Even if I've never talked to them. I see them each week [on Shabbat] and I know they're like me [*tacy jak ja*]. They have the same problems. I know that I'm not alone.'

Even older members of the tiny local community, who tend to mistrust much of the new Jewishness Kazimierz has suddenly sprouted, have nevertheless extended their social space to include some of these venues. Such old-timers developed the habit of visiting Café Ariel every Shabbat to enjoy the specially made challah and coffee that Ornat provides for them at no charge. Folklorist Eve Jochnowitz (1998, p. 226) noted, 'As soon as it opened, Ariel became the centre of all non-ceremonial Jewish activity in Cracow.'

Jonah Bookstein, a young American Jew from Detroit whom I met in Cracow in 1992 and who years later became the director of the Polish offices of the Ronald Lauder Foundation in Warsaw, was deeply involved in the early revival of Jewishness in Cracow. Together with late local Jew Henryk Halkowski – an institution in himself – Jonah organised many Jewish cultural and religious events at Café Ariel, like parties for Chanukah and Israeli independence day. 'There were lots of guests; it was really fun. Jewish and non-Jewish both. Probably half and half.' He maintains that,

> what Wojtek [Ornat, Ariel's owner] and Gosia [his wife] did contributed *so much* to the Jewish atmosphere in Kazimierz, and in a very positive way. Jewish people felt comfortable – whatever Jewish community is there – and it's *small* – felt comfortable going to Ariel.

Can there be a conciliatory heritage?

That was the first time in who knows how long that you got guys from shul – these old [guys] coming from the shul and going to sit at a café! I think that was a very significant thing.

Mateusz, a Polish-Catholic student also present at the dawn of Café Ariel shared the sense of excitement about the experience and the people he met:

I was selling books there. And I was very happy, I was just sitting there and reading the books, having some free cookies and Coca-Cola, and listening to the bands, every night, with Jewish music and there were a lot of American Jews, Israeli Jews [Jews from England, Holland, France], it was like, a lot of Jews! It was like, a *great place to be.*

Heritage brokers as an interface

Heritage brokers form a 'front line' of local contact for visiting Jews; indeed, they may be the only locals that Jewish visitors meet. Thus they act as hosts, forming a key 'interface' (Kirshenblatt-Gimblett 1995, p. 374) through which the symbolic meaning of heritage sites is produced, encountered, and understood – and one that has evolved in response to visitor input.

Jewish visitors often wander into the Jarden Jewish Bookshop with a vague air of confusion, blinking as they leave the brightness of the square for the cool dimness that lies beyond the metre-thick stone walls of the Landau Palace that houses it. Once inside, they gaze up at the shelves of Jewish books, wooden Jewish figurines, and political posters (*All different, All equal; 1 = 1, Intolerance = 0*) and then down at bearded Zdzislaw, or Lucyna with her menorah earrings. They often seem unsure of what to make of this unanticipated array. Zdzislaw calls the bookshop 'a kind of club'. He told me,

This isn't just a place where we sell books. Because tourists come and they ask us questions. Also inhabitants of Cracow come here and we talk with them. It was even shocking for us; people who write doctoral dissertations come here. They come here for scholarly consultations. Even if we don't have [a book] they ask us where in the world it exists. The tourists … don't just ask about the War, the Holocaust. They think we're some sort of information centre for Jews in Poland. They expect that of us.

Small daily gestures suggest a desire on the part of non-Jewish heritage brokers for Jewish input, belying accusations that Kazimierz promulgates a static portrait of an idealised, ahistorical culture. While nostalgia is certainly among the forces at play, its sources are multidirectional, coming as much from visiting Jews as local Poles (Lehrer 2003). The result is an active dialogue about the past. For example, while Café Ariel had been using recipes provided by Róza Jakubowicz, the late matriarch of Jewish Cracow (and mother of Tadeusz Jakubowicz, the president of Cracow's official Jewish community), 'Jewish grandmothers' from abroad critique these, telling Ornat in no uncertain terms how a kugel, cholent, or dish of chopped liver should be made (Jochnowitz 1998, p. 227). He welcomes their input, even seeking out visiting Jews for impromptu cooking sessions in the café's kitchen, and has tinkered with his dishes accordingly.

An example with broader impact is Cracow's annual Jewish Cultural Festival. The festival was started in 1988 by a couple of Poles with a few Jewish films and an intense curiosity about the culture they depicted. Today, it is an international event that draws 25,000 people over nine days to experience everything from Hassidic dancing and Jewish cooking to Yiddish and Hebrew

Erica Lehrer

language lessons, from lectures on religious and current political topics to world-class live music, culminating in a final outdoor concert in Kazimierz's main square that draws thousands of revellers and is broadcast nationwide on Polish television. It was through early encounters with Jewish musicians from abroad that Janusz Makuch, the festival's founding director, became 'aware that [Jewish] culture was alive, and important for many people ... that despite the Holocaust, there was a flow, a continuity of that culture', and that an entirely gentile Jewish cultural festival seemed inappropriate (Gruber 2003, pp. 365–366). Over the 20 years of the festival's development, Makuch has also moved away from 'nostalgic' themes of shtetl and klezmer to include avant-garde Jewish culture and current debates on Polish-Jewish history coming out of Europe, Israel and the United States.

Organic sites of truth-telling and listening

Many scholars have noted that audience is crucial in acts of storytelling or testimony, especially in the context of Holocaust survivor narratives (Young 1988, Plank 1989, Langer 1993, Greenspan 1998). 'Bearing witness to a trauma is, in fact, a process that includes the listener', and for the teller, the listener may be 'somebody they have been waiting for a long time' (Laub 1992, p. 70). While much of this work focuses on formal interview situations, I observed the same dynamics when survivors or their descendants told their stories impromptu in the informal setting of Kazimierz's 'Jewish' venues. This suggests the need to broaden our understanding of 'testimony' and where it can take place. Especially with the institutionalisation of survivor testimony collection projects, telling typically occurs in pre-arranged situations or official settings. But testimony may find more spontaneous outlets in less abstracted sites that evoke memory in vital, organic ways, in environments or landscapes whose sociality and physicality allows stories to 'stick', creating the conditions for new communities of listeners (Casey 1987).

One important category of listener for Jewish stories is other Jews with similar experiences. There is a kind of un-alienation, a collective ingathering and re-embrace of lost or suppressed memory and experience that represents an internal, intra-Jewish reconciliation with the Jewish-Polish past. Barry Spielman of Tel Aviv wrote of 'the very special attraction' that Kazimierz's main square held for him. He noted that people from all over the world 'gravitated to this spot because they needed something', to 'find some solace'. He called Café Ariel 'a sort of meeting place ... a magnet, attracting all sorts of people', and mentioned by name certain locals and perennial visitors:

> My uncle David, an Auschwitz survivor, immediately struck up a conversation with [another survivor who visits Kazimierz frequently]. Meanwhile my father was engaged in conversation with a white-haired gentleman from Israel who was also originally from Cracow. It turned out that they actually knew each other, and they went on reminiscing for quite a while. Could this be the reason people come back here?
>
> *(Spielman 2000, pp. 11–12)*

Kazimierz also attracts non-Jewish Poles eager for – although often anxious about – an encounter with Jewishness. Visiting Jews often seemed drawn to tell stories of their wartime experiences, or their inherited pain, to ethnic Poles – particularly stories of pain caused *by* Poles. Visiting Jews' desire to tell difficult stories may be read on some level as a test of Polish empathy, engagement, and willingness to listen. An American-Jewish woman complained to Zdzislaw

Can there be a conciliatory heritage?

after taking the Jarden bookshop's *Schindler's List* tour that the guide, when they stopped at the nearby Plaszow concentration camp site, had said that '*only* 20,000 Jews' had been imprisoned there.[13] The woman was very upset and argued with the guide. Later, Zdzislaw chastised the guide. 'You stupid man!' he said.

> Every half intelligent Pole knows that the situation of Jews and Poles was incomparable. For Jews, Plaszow was only a stopping place on the way to Auschwitz. It is not our job to argue this [numbers] question with our customers. This is a question for historians. We must provide a service for these very sensitive people.

Despite the fact that the guide may actually have erroneously inflated rather than down-played the number of Jews interned at the Plaszow camp (and that the Jewish visitor may have inflated it even more), Zdzislaw here highlights the distinct difference of *character* in the overall fates of Poles and Jews during the war – that Jews were singled out for extermination as a group. More significantly, whereas in Poland a narrative of ethnic Polish wartime martyrology is hegemonic, Zdzislaw sees his role as being sensitive to the primacy of the Holocaust framework for visiting Jews.

Intersubjectivity – uncomfortable encounters with difference[14]

Encounters between visitors and locals may prompt reconsideration of received understandings of Jewishness, Polishness and anti-Semitism, as well as epistemological reflection about the sources of one's own knowledge. The mere confrontation with Poles positively engaged with Jewish heritage can be a 'reality-rearranging' experience for Jewish visitors.[15] Visiting Jews are often taken aback – whether pleased, angry, or ambivalent – by non-Jewish tour guides or shop employees deeply involved with and educated in Jewish ritual, history and even languages (not infrequently to an extent greater than the visiting Jews to whom they cater). As Michael Traison, an American-Jewish lawyer involved with Jewish initiatives in Kazimierz told me, 'There, some Gentiles know so much about Jewish traditions that they're almost part of the community'.

An exchange between a visiting American-Jewish mother and daughter I interviewed in Kazimierz illustrates how the encounter with heritage brokers can provoke deep questions:

MOTHER: We definitely keep asking, and we keep saying to ourselves, 'Do you think she's Jewish? Do you think the proprietor of that place is Jewish?' Every time we go in anywhere – we've sort of learned now that the answer is No. But particularly our first few days here [we kept wondering], 'Is our guide Jewish? Can you tell if he's Jewish? Does he have a Jewish name? Would he have said something already?'

DAUGHTER: But then again, what does it mean to be Jewish? That he doesn't self-identify as a Jew? I still think he could have had a Jewish grandparent but just wasn't telling us. So it's clearly ... identity isn't very clear ... [W]e have a much more complex view as a result of this trip, wouldn't you say that? Of Polish history, of Polish–Jewish relations. Much more complex. And I think we found it stunning that a young woman like Janina [their non-Jewish tour guide] would be so interested.

Confronting Jewishness configured in unfamiliar ways prompted self-questioning about identity and identification, genealogy and participation.

Yet Jewish tourists are not passive recipients of narratives and information – however conciliatory – provided by Polish guides. In a 'personal seizure and appropriation of the narrative resources made available by tourism' (Hartman 2002, p. 769), visiting Jews often resist their Polish guides, challenging them openly, whispering disapprovingly to fellow travellers or silently doubting the guides' information. Sometimes Jewish visitors simply commandeer the tours. Malgorzata, a 21-year-old Polish guide from the Jarden Jewish Bookshop, was compelled to yield her prepared narrative to her client's recitation of her grandfather's memoir – and voiced enthusiasm about this development. 'I never thought I'd meet someone with such a story!' said Malgorzata, adding that she is always learning more about Kazimierz from Jewish tourists. Another guide, Marta, echoed appreciation of such 'teaching' by Jewish visitors, 'because sometimes they know more than I do, so sometimes they correct me. It's really good'. (Marta eventually converted to Judaism, and moved to Israel to marry).

Of course the interactions are not always pleasant. Jewish tourists at times make use of a 'captive' Polish audience to curse Polish ground. One man stood in the bookshop, loudly explaining the brevity of his visit. 'One day is more than enough among these *stinkende vilde chayes*' (Yiddish for 'stinking wild animals'). Many heritage brokers in Kazimierz have learned to allow space for this kind of reaction, rather than becoming defensive, which only exacerbates the conflict. But there are other approaches. Jarden co-owner Lucyna, whose Hebrew-studying shop assistant overheard an Israeli customer smearing Poles, reacted by quietly telling him as she rang up his purchases that she would be pleased to give him a 10% discount if he stopped saying such horrible things about Poles.

Two uncomfortable experiences of my own as a college student in the early 1990s shocked me into recognition of the limits of my own inherited view. First was my response to a Polish acquaintance, when he casually remarked that his father had been interned in Auschwitz, that I hadn't realised his family was Jewish. He replied – charitably revealing only a bit of the frustration he likely felt – that his family is *not* Jewish, and didn't I realise that ethnic Poles, too, were put in camps.

The second experience occurred when I began chatting with a young man selling small souvenir paintings of Cracow's historic sites. After a few minutes of pleasant banter, I asked him where he was from. He replied, 'Oswiecim', which I had recently learned was the Polish name for Auschwitz. That Oswiecim is an ordinary Polish town, and one that had been more than half Jewish before World War II, was still relatively new to me. In any case these realities did not make a dent in the much more significant fact that to my (American-Jewish) mind, this man had grown up in *Auschwitz*. I could not hide my consternation and said something along the lines of, 'Oh my gosh that must be a *horrible* place to live'. To condense an exchange whose details have blurred over the years, what I remember clearly is that I was informed that the town is not the camp, that his parents had been re-settled there after the war not by their own choosing, that he enjoyed a normal youth *thank-you-very-much*, and – most enduringly discomfiting for me – was I trying to *shame* him?

It is clear that cultural critique is not solely the domain of visiting Jews, nor is the direction of such critique aimed only at Poles. While Zdzislaw of the Jarden Bookshop sees his mandate as criticising Polish distortions and ignorance regarding Jewishness, he and Lucyna also work to dispel misconceptions about Poland that Jews bring with them. As Lucyna told me:

> I fight sometimes with Jews [too,] because [they need to] understand [that just] as on the Polish side, [on] the Jewish side there's a kind of mythology, you know, from the years of the Second World War time, and it's not exactly the truth, what they're telling about Poles. Of course it's possible, you know, to break this. But it's a very long process; it's for

generations. But somebody has to start something, anyway. In this way you can get what you want.

Zdzislaw often lamented the lack of basic historical knowledge of many visiting Jews, telling me stories like one about a Jewish group that called the bookshop wanting a guide for Auschwitz – a *Jewish* guide, they specified. Zdzislaw told them that there is only one 'half-Jewish' guide at Auschwitz, but that he could promise them a competent guide for Auschwitz and Birkenau. 'No, no' they responded, 'we only want to see Auschwitz.' Zdzislaw was furious, telling me, 'They demand a Jewish guide, but they don't even know that Birkenau is so much more important, where the vast majority of Jews died!' He said he had informed and chastised them, and that they had been surprised by the information.

Kazimierz's particular quality as a meeting ground also stimulates intersubjective reckonings of heritage among visiting Jews, at times within family groups or between generations. As I was walking out of Szeroka Street with two American-Jewish friends, an elderly man shouted excitedly across the square, 'Oh! Jews!' He hurried over, his two middle-aged daughters following. He was a Jewish Holocaust survivor, originally from Lvov and now American. As is the norm among Jewish tourists in Kazimierz, he told us his wartime story right then and there in the middle of the road. I told them about the research that brought me to Poland. The response came from one of his daughters: 'How can you bear to live here?' As I tried to formulate an answer, a local friend walked by and we exchanged a few words. The survivor's face lit up. 'You speak *Polish*!' he declared. 'My kids never learned Polish', he added, shaking his lowered head with apparent regret. The same daughter, looking away, said to the air, 'He never *taught* us Polish'. A moment later she turned back to me and snapped, 'Why do you speak *Polish*?'

Such encounters suggest the pain and ambivalence on both dangling ends of a broken cultural link between Jewishness and Polishness. Both child and parent struggle with a deeply felt locus of identity, at once intimate and volatile: Polish language. Something that could have bound them together in intimacy (as well as to other Poles), binds them instead to opposite sides of a cultural-historical chasm.[16]

Identification: expanding the collective self

Reconciliation consists, in part, in pursuing 'more inclusive principles of present day affiliation', or the expansion of group identity (Borneman 2002, p. 286). The popularity of a narrow, ethno-national understanding of Polishness (i.e. Pole = Catholic) has been a central problem for Polish–Jewish relations and notions of shared heritage. It can be argued that the naturalisation of this conception of Polishness constricted the 'universe of obligation' (Fein 1979) Christian Poles inhabited and in terms of which they acted towards their Jewish fellow citizens during the Nazi occupation.

But identity categories are malleable and Kazimierz is a place where broader conceptions of Polishness are promulgated. Rather than only providing a space *for* Jews as a significant 'other' in Poland (which they also do), Kazimierz heritage brokers actively call into question rigidly defined notions of Polishness and Jewishness altogether. As I have argued elsewhere, this makes the site conducive for Poles to explore a range of identifications with Jewishness, many of which are motivated by a progressive cultural politics (Lehrer 2007). It is a place where otherwise contradictory identities can be reconciled.

Kazimierz also accommodates visiting Jews who want to transcend the us/them binary promulgated by the hegemonic Jewish establishment by (re)claiming an embodied, *emplaced*

identification with Polish-Jewish heritage. 'My grandmother is from Poland', Adam, a 20-year-old Jewish Australian told me, sitting on a low stone wall along a Kazimierz alley, adding quickly that his grandmother hates it when he expresses feelings of connection to Poland, and had protested at his visit. 'She doesn't want me to think this way, but besides the atrocities, I know this is where [she] grew up. I see people on the street, going into fruit shops just like my grandmother did. I see their faces and think it's *amazing*, all these people who look just like my grandmother would've looked here'. Such a cultural politics of geographic affiliation functions in interestingly asymmetrical ways. While an embrace of Israel may be a progressive gesture among Poles, for foreign Jews a turn towards Poland as a site of ancestral rootedness suggests resistance to hegemonic identity categories and postures. Marisa Davidson, a doctoral student in Jewish history, told me that she went to Poland 'hoping to connect'. 'Israel wasn't doing it for me', she says. 'I wanted to find another way of thinking of myself as a historical Jew.'

Conclusion

Sociologist Slawomir Kapralski has characterised the landscape of memory work in post-communist Poland as a 'complicated, multi-centred space in which critical attempts to reclaim memory from national myths and ... silences, co-exist with the mythologisation of the past and ... conspiracy to expunge inconvenient memory' (Kapralski 2007, p. 98). The heritage brokers I met in Kazimierz are workers for the former cause, most particularly by calling into question one 'crucial feature' of Polish national identity, namely 'the belief that (ethnic) Poles have been the main victims of history in general and of WWII in particular' (Kapralski 2007, p. 98).

It may be that 'the desire to work through one's own traumatic memory does not necessarily emerge from the self' (Rosen 2008, p. 230). Encounters with the reality of 'the other' can seed recognition, empathy and new senses of 'we'. In this way heritage spaces are not just *lieux*, but *milieux de memoire*, where our abstracted, homogenising national stories are called into question through the daily telling and living of our unique and overlapping individual stories. Thus, the possibility of pluralistic publics may depend on nurturing public spaces that draw estranged groups together to do the hard work of practising conciliatory heritage. If one listens closely Kazimierz reveals two rare qualities. First, it is a space where people come because they can enact deeply felt truths about who they are and what they care about that may not find expression elsewhere. Second, it is a place where Poles and Jews can be heard listening to each other's truths.

One summer evening, a Jewish family – grandfather, son-in-law, grandson – stood in the Jarden Bookshop, leafing through books. The father, after ascertaining my Jewishness, pointed to the grandfather and said, 'He's from here. He didn't want to come back, but my wife wanted to see his town.' Zdzislaw asked if the grandfather could speak Polish. 'Sure he can. Pop, speak Polish to the man', said the son-in-law. The grandfather leaned over the counter and began to tell his story to Zdzislaw in a mix of Polish, Yiddish, and English. Zdzislaw listened intently. The grandfather described being tied up – 'like this', he said, pressing his wrists together as if bound – and turned over to the Nazis. 'By Poles', he said, leaning closer to Zdzislaw to make his point, '*Di Polyakn*', he repeated in Yiddish. Zdzislaw said nothing, only nodding, as if to encourage the grandfather to say more.[17]

Acknowledgements

Thanks to Susan Ashley, Carol Berger, Matti Bunzl, Avi Goldberg, Slawomir Kapralski, Carol Kidron, Cynthia Milton, Ellen Moodie, Monica Patterson, Doug Rogers, Roger Simon, Lucia Volk, and this journal's anonymous reviewers for thoughtful comments on drafts of this article. It is based on 18 months of ethnographic research during 1999–2000, and shorter visits from 1990 to the present. I am especially grateful to the mostly pseudonymous subjects whose voices appear in the text.

Notes

1 Zdzislaw told me this in a conversation in 1994. He has since expanded, and other Jewish bookshops have opened, two in Kazimierz, and at least one in Warsaw.
2 The anti-Semitic campaign of 1968 came as a wake-up call not only to 'Poles of Jewish origin', but also to young members of the opposition, who attacked anti-Semitism as a discredited tool of the state (Steinlauf 1997, p. 109). Censorship also stimulated interest in Jewish history, and '[r]e-inviting the Jew into Poland's collective memory stood … in opposition to the official efforts to make him disappear forever' (Irwin-Zarecka 1989, p. 127).
3 I use 'heritage brokers' following Kurin's 'culture brokers', which he uses to describe individuals who bring audiences together and represent, translate, negotiate, or exchange representations or definitions of culture or cultural goods among them.
4 The role of US Civil War battlefields in North–South reconciliation in the post-war period is discussed in Linenthal (1993) *Sacred Ground* and Kammen (1993) *Mystic Chords of Memory* (see esp. pp. 106–125).
5 I take heritage to be the meanings and representations ascribed in the present day to artefacts, landscapes, beliefs, memories and traditions understood as bearing traces of the (cultural or national) past.
6 Per historian Jan Gross, in this period 'the Holocaust became a nonsubject in Polish historiography' (2006, p. 30).
7 Steffen (2008) surveys how Jewish themes polarise Polish society. Gruber (2002) calls contemporary engagements with Jewish heritage 'virtual', while Waligorska (2008) argues that their most popular form – klezmer music – should be seen largely in instrumental terms, as a 'rhetorical device' and 'political correctness for all occasions'. Significant state-level initiatives have been undertaken on the Polish side. These include major interpretive changes at Nazi camp memorials, a formal apology in 2001 by the then-president Kwasniewski for the pogrom at Jedwabne, and former Warsaw Mayor and late Polish president Lech Kaczynski's donation of land and over 30% of the cost to create a world-class Museum of the History of Polish Jews in Warsaw, scheduled to open in 2012.
8 Scholarship by Kugelmass (1995, esp. the ideas of 'stage' and 'pageant') Feldman (2008), Sheramy (2007), and Stier (2003) characterises such travel broadly in these terms. Jewish individuals or family groups also seek personal heritage in specific towns, and other, comparatively marginal exceptions include Hasidic pilgrims to the tombs of dynastic Galician rabbis, genealogy enthusiasts who comb Polish archives, and fans of Yiddishkayt and klezmer who follow the festival circuit. But these groups are primarily interested in and hold in esteem pre-war *Jewish* heritage, understood as a discreet entity situated on a Polish backdrop, rather than a hybrid entity linked to Poles. An enduring example of the nostalgic view of East European Jewish culture as embodied in an idealised, hermetic shtetl is Zborowski and Herzog's (1995) *Life is with People*, especially as discussed in its 1995 introduction by Kirshenblatt-Gimblett. The fundamentally negative attitude towards Poland as a meaningful locus for Jewish memory is illustrated by the reserve among American Jews regarding the planned Warsaw museum, evidenced by difficulties in raising funds (see Ostow 2008, pp. 170–171). But change is afoot; it is worth noting Israeli ambassador to Poland David Peleg's categorical statement in a speech I heard him give at the Galicja Jewish Museum in Kazimierz during the Jewish Cultural Festival in June 2008 that 'Poland is not an anti-Semitic country'.
9 While the Israeli-Jewish and diasporic Jewish perspectives on Poland should not be conflated they have common roots and are structurally intertwined in a shared pedagogy of youth pilgrimage and thus can be meaningfully discussed together in this context. Their differences are also not particularly evident from the Polish point of view.

Erica Lehrer

10 The full key of the Polish map lists, in this order, 'Synagogues and houses of prayer open, Synagogues, Cemeteries, Ghettoes during World War II, Nazi death camps, Nazi concentration camps, Other important sites (Jewish history), Centres of Hasidism'.

11 Per local scholar Edyta Gawron, 'With respect to the material sphere, the Jewish Community [of Cracow] gained much. It was, however, unsuccessful in coordination of the activities aimed at rejuvenation and restoration of Jewish religious and cultural life. Thus, the present revival of Jewish culture has taken place in Cracow thanks to non-Jews with the help of the Jews from Israel and the Diaspora' (Gawron 2005, p. 209, cited in Murzyn 2006, p. 394). The Ronald Lauder Foundation Youth Club, long situated in the Izaak synagogue, was another significant site, but it publicised its Jewishness in orthodox religious terms – implicitly discouraging non-Jewish participation – and alienated many young Jews due to personality conflicts among its leadership. In spring 2008 a modern Jewish Community Centre (donated by Charles, Prince of Wales) opened in the centre of Kazimierz. While explicitly a space *for* Jews (rather than a 'Jewish space' in Pinto's sense), given its savvy, young, Polish-speaking American-Israeli director, it may nonetheless also contribute to the latter.

12 The restaurant, now called *Klezmer Hois*, has grown to include a hotel and klezmer cabaret, and an affiliated bookshop and publishing house, *Austeria*, a cutting-edge, bilingual (Polish/English) imprint for Jewish-themed works.

13 Until mid-1943, all the prisoners at the Plaszów forced labour camp were Jews. In July 1943, a separate section was created for Polish prisoners. Except for 'political prisoners', Poles served their sentences and were released. Jews remained in the camp indefinitely, or were sent on to nearby Auschwitz. For inmate population estimates see Offen and Jacobs (2008).

14 Borneman (2002, pp. 286, 302) stresses that preconditions for reconciliation must include 'an appreciation of the intersubjectivity of the present' with the uncomfortable encounters with difference this entails.

15 I thank Stephanie Rowden for this turn of phrase.

16 Such unanticipated encounters with cultural similarity or sharedness can be as provocative as confronting difference. Visiting Jews are often shocked by how familiar they find Polish food, habits, gestures or phenotypes.

17 Not infrequently when I have ended talks using this vignette, the first 'question' from the audience will be from an elderly Jew (or occasionally a Pole) who begins, 'I was born in Poland ...' and proceeds to tell their own story, which inevitably exceeds (and usually challenges) my own analytical framework. As Zdzislaw seems to, I also welcome such intrusions of the ongoing lived experience of these issues into the meagre spaces I have attempted to create for them. I thank Birgit Meyer for bringing this dynamic to my attention.

Bibliography

Bilbija, K., Fair, J.E., Milton, C.E., and Payne, L.A., 2005. *The art of truth-telling about authoritarian rule.* Madison: University of Wisconsin Press.

Borneman, J., 2002. Reconciliation after ethnic cleansing: listening, retribution, affiliation. *Public Culture,* 14 (2), 281–304.

Casey, E.S., 1987. Remembering: a phenomenological study. *In: Studies in phenomenology and existential philosophy.* Bloomington: Indiana University Press.

Dominguez, V.R., 2000. For a politics of love and rescue. *Cultural Anthropology,* 15 (3), 361–393.

Engelking, B., 2003. *'Dear Sir Gestapo': denunciation to the German authorities in Warsaw and its surroundings in the years 1940–1942.* Warsaw, Poland: IFiS PAN.

Fein, H., 1979. *Accounting for genocide: national responses and Jewish victimization during the Holocaust.* New York: Free Press.

Feldman, J., 2008. *Above the death pits, beneath the flag: youth voyages to Poland and the performance of Israeli national identity.* New York: Berghahn Books.

Gawron, E., 2005. *Spolecznosc zydowska w Krakowie w latach 1945–1995.* Thesis (PhD), Jagiellonian University.

Gebert, K., 1994. Jewish identities in Poland: new, old, imaginary. *In:* J. Webber, ed. *Jewish identities in the new Europe.* London: Littman Library of Jewish Civilization, 161–167.

Glowacka, Dorota and Joanna Zylinska, 2007. *Imaginary Neighbors: Mediating Polish-Jewish Relations after the Holocaust.* Lincoln: University of Nebraska Press.

Grabowski, J., 2004. *Ja Tego Zyda Znaml: Szanatazowanie Zydów w Warszawie, 1939–1943*. Warsaw, Poland: IFiS PAN.

Greenspan, Henry, 1998. *On listening to Holocaust survivors: recounting and life history*. Westport, CT: Praeger.

Gross, J.T., 2001. *Neighbors: the destruction of the Jewish community in Jedwabne, Poland*. Princeton, NJ: Princeton University Press.

Gross, J.T., 2006. *Fear: anti-Semitism in Poland after Auschwitz: an essay in historical interpretation*. Princeton, NJ: Princeton University Press.

Gruber, R., 2002. *Virtually Jewish: reinventing Jewish culture in Europe*. Berkeley: University of California Press.

Gruber, R., 2003. The Krakow Jewish Culture Festival. *In*: A. Polonsky and M. Steinlauf, eds. Focus on Jewish popular culture in Poland and its afterlife, Special issue, *Polin: Studies in Polish Jewry*, 16, 357–367.

Gurian, E.H., 2004. Singing and dancing at night. *In*: L.E. Sullivan and A. Edwards, eds. *Stewards of the sacred*. Washington DC: American Association of Museums and Harvard University, 89–96.

Gutman, Y. and Krakowski, S., 1986. *Unequal victims, Poles and Jews during World War Two*. New York: Holocaust Library.

Halpern, J. and Weinstein, H.M., 2004. Empathy and rehumanization after mass violence. *In*: E. Stover and H.M. Weinstein, eds. *My neighbor, my enemy: justice and community in the aftermath of mass atrocity*. Cambridge: Cambridge University Press, 303–322.

Hannabuss, S., 2000. How real is our past? Authenticity in heritage interpretation. *In*: J.M. Fladmark, ed. *Heritage and museums: shaping national identity*. Aberdeen: The Robert Gordon University, 351–365.

Hartman, S., 2002. The time of slavery. *The South Atlantic Quarterly*, 101 (4, Fall), 757–776.

Hayner, P.B. and Garton Ash, T., 2002. *Unspeakable truths: facing the challenges of truth commissions*. New York: Routledge.

Hoffman, C., 1995. *Gray dawn: the Jews of Eastern Europe in the post-communist era*. New York: Harper Collins.

Irwin-Zarecka, I., 1989. *Neutralizing memory: the Jew in contemporary Poland*. New Brunswick, NJ: Transaction Publishers.

Jochnowitz, E., 1998. Flavors of memory: Jewish food as culinary tourism in Poland. *Southern Folklore*, 55 (3), 224–237.

Kammen, M., 1993. *Mystic chords of memory: the transformation of tradition in American culture*. New York: Vintage Books.

Kapralski, S., 2001. Battlefields of memory: landscape and identity in Polish–Jewish relations. *History and Memory*, 13 (2), 35–58.

Kapralski, S., 2002. Auschwitz: site of memories. *Polin: Studies in Polish Jewry*, 15, 383–400.

Kapralski, S., 2007. The impact of post-1989 changes on Polish–Jewish relations and perceptions: memories and debates. *In*: L. Faltin and M.J. Wright, eds. *The religious roots of contemporary European identity*. London: Continuum, 89–104.

Kirshenblatt-Gimblett, B., 1995. Theorizing heritage. *Ethnomusicology*, 39 (3), 367–380.

Kuenz, J., 1993. It's a small world after all: Disney and the pleasures of identification. *The South Atlantic Quarterly*, 92 (1), 63–88.

Kugelmass, J., 1995. Bloody memories: encountering the past in contemporary Poland. *Cultural Anthropology*, 10 (3), 279–301.

Kurin, R., 1997. *Reflections of a culture broker: a view from the Smithsonian*. Washington, DC: Smithsonian Institution Press.

Langer, L.L., 1993 *Holocaust testimonies: the ruins of memory*. New Haven, CT: Yale University Press.

Laub, D., 1992. Bearing witness, or the vicissitudes of listening. *In*: S. Felman and D. Laub, eds, *Testimony: crises of witnessing in literature, psychoanalysis, and history*. New York: Routledge, 57–74.

Lehrer, E., 2003. Repopulating Jewish Poland – in wood. *Polin: Studies in Polish Jewry*. 16, 335–355.

Lehrer, E., 2007. Bearing false witness? Vicarious Jewish identity and the politics of affinity. *In*: D. Glowacka and J. Zylinska, eds. *Imaginary neighbors: mediating Polish–Jewish relations after the Holocaust*. Lincoln: University of Nebraska Press, 84–109.

Linenthal, E., 1993. *Sacred ground: Americans and their battlefields*. Chicago: University of Illinois Press.

Logan, W. and Reeves, K., 2009. *Places of pain and shame: dealing with 'difficult heritage'*. New York: Routledge.

Macdonald, S., 2009. *Difficult heritage: negotiating the Nazi past in Nuremberg and beyond*. New York: Routledge.

Macdonald, S., 2006. Undesirable heritage: Fascist material culture and historical consciousness in Nuremberg. *International Journal of Heritage Studies*. 12 (1), 9–28.

Meskell, L., 2002. Negative heritage and past mastering in archaeology. *Anthropological Quarterly*, 75 (3), 557–574.

Minow, M., 1999. *Between vengeance and forgiveness: facing history after genocide and mass violence*. Boston: Beacon Press.

Murzyn, M., 2006. *Kazimierz: the central European experience of urban regeneration*. Krakow, Poland: International Cultural Centre.

Nora, P., 1989. Between memory and history: les lieux de mémoire. *Representations*, 26 (Spring), 7–25.

Offen, B. and Jacobs, N., 2008. *My hometown concentration camp: a survivor's account of life in the Krakow ghetto and Plaszów concentration camp*. London: Vallentine Mitchell & Co. Ltd.

Ostow, R., 2008. Remusealizing Jewish history in Warsaw: the privatization and externalization of nation building. *In*: R. Ostow, *(Re)visualizing national history: museums and national identities in Europe in the new millennium*. Toronto: University of Toronto Press, 157–180.

Pinto, D., 2002. The Jewish challenges in the new Europe. *In*: D. Levy and Y. Weiss, eds. *Challenging ethnic citizenship: German and Israeli perspectives on immigration*. New York: Berghahn Books, 239–252.

Plank, K.A., 1989. The survivor's return: reflections on memory and place. *Judaism: A Quarterly Journal of Jewish Life and Thought*, 38 (3), 263–277.

Polonsky, A. and Michlic, J.B., 2004. Introduction. *In*: A. Polonsky and J.B. Michlic, eds. *The neighbors respond: the controversy over the Jedwabne massacre in Poland*. Princeton, NJ: Princeton University Press, 1–49.

Rosen, J., 2008. *Beyond memory: from historical violence to political alterity in contemporary space*. Thesis (PhD), Toronto: York University.

Rosenson, C., 1997. The ball is in the Jewish court. *East European Jewish Affairs*, 27 (1), 66–68.

Rothberg, M., 2000. *Traumatic realism: the demands of Holocaust representation*. Minneapolis: University of Minnesota Press.

Sennett, R., 1998. Disturbing memories. *In*: P. Fara and K. Patterson, eds. *Memory*. Cambridge: Cambridge University Press.

Sevcenko, L., 2002. Activating the past for civic action: the international coalition of historic site museums of conscience. *The George Wright Forum*, 19 (4), 55–64.

Sheramy, R., 2007. From Auschwitz to Jerusalem: re-enacting Jewish history on the march of the living. *Polin: Studies in Polish Jewry*, 19, 307–326.

Spielman, B., 2000. The streets of Kazimierz: a personal journey back to Poland and Jewish Kraków – a second generation perspective. Unpublished manuscript (given to me by the author shortly after it was written in 2000).

Steffen, K., 2008. Disputed memory: Jewish past, Polish remembrance. *Osteuropa* [online], 27 November. Available from: www.eurozine.com/articles/2008-u11-27-steffen-en.html (accessed 15 September 2009).

Steinlauf, M.C., 1997. *Bondage to the dead: Poland and the memory of the Holocaust*. New York: Syracuse University Press.

Stier, O.B., 2003. *Committed to memory: cultural mediations of the Holocaust*. Amherst: University of Massachusetts Press.

Stola, D., 2005. Fighting against the shadows: the anti-Zionist campaign of 1968. *In*: R. Blobaum, ed. *Antisemitism and its opponents in modern Poland*. Ithaca, NY: Cornell University Press, 284–300.

Tunbridge, J.E. and Ashworth, G.J., 1996. *Dissonant heritage: the management of the past as a resource in conflict*. New York: Wiley.

Waligorska, M., 2008. Fiddler as fig leaf: the politicisation of klezmer in Poland. *Osteuropa*, Impulses for Europe: Tradition and Modernity in East European Jewry, M. Sapper, V. Weichsel and A. Lipphardt, eds. 8–10, 227–238.

Wrobel, P., 1997. Double memory: Poles and Jews after the Holocaust. *East European Politics and Societies*, 11 (3), 560–574.

Young, J., 1988. Holocaust video and cinematographic testimony: documenting the witness. *In: Writing and rewriting the Holocaust*. Bloomington: Indiana University Press.

Zborowski, M. and Herzog, E., 1995. *Life is with people: the culture of the Shtetl.* New York: Shocken Books.

Zimmerman, Joshua, 2003. *Contested Memories: Poles and Jews during the Holocaust and its Aftermath.* New Jersey: Rutgers University Press.

Zubrzycki, G., 2006. *The crosses of Auschwitz: nationalism and religion in post communist Poland.* Chicago: University of Chicago Press.

52
Palimpsest memoryscapes
Materializing and mediating war and peace in Sierra Leone

Paul Basu

The anthropology of West Africa has recently benefited from two particularly nuanced Sierra Leonean ethnographies, both of which are concerned with the relationships among local memory practices, an often violent past, and landscapes in which material and immaterial traces of that past may be encountered (Ferme 2001; Shaw 2002). Working among Mende-speakers in the southeast of the country, Mariane Ferme explains that she is interested in exploring the modalities through which 'material objects, language, and social relations become sites where a sometimes violent historical memory is sedimented and critically reappropriated' (2001:5). In Sierra Leone, Ferme notes, 'collective memory and landscape are replete with evidence of military, political, and social advancement followed by reversals, and of crises turning into moments of opportunity' (ibid.:225). Relics of the colonial state and its modernizing project have thus been allowed to decay and be swallowed up by vegetation: paved roads have reverted to dirt tracks, commercial signs have rusted away, and buildings have fallen into ruin as such sites have been purposefully neglected by postcolonial authorities (ibid.:23). The forest environment, in contrast, although illegible to the uninitiated, continues to be a resonant and living memoryscape for those able to discern its secrets. A cluster of kola trees in second-growth forest or the appropriate undulations in the forest floor thus tell of a settlement abandoned by the living but perhaps not by memory, nor by the ancestral spirits. In this way, suggests Ferme, trees and other features of the 'natural' landscape 'can be read as ruins … as much as decaying, destroyed buildings' (ibid.:25).

Researching with Temne-speakers further north, Rosalind Shaw's concern is with the apparent absence of 'discursive memories' of slavery in the region – a curious silence given the huge significance of both the Atlantic and the domestic slave trade in Sierra Leonean history (2002). Following Bourdieu (1990) and Connerton (1989), Shaw thus searches for evidence of this ostensibly missing past in embodied, 'practical' memory and in ritual. She concludes that although 'the slave trade is forgotten as history', it is remembered 'as spirits, as a menacing landscape, as images in divination, as marriage, as witchcraft, and as postcolonial politicians' (2002:9). In contrast to early accounts of the Temne living securely under the protection of town-dwelling spirits, Shaw's informants warn of a landscape inhabited by roaming, predatory spirits who lurk along bush paths, ready to seize unlucky and unprotected victims (ibid.:55–56). Shaw's argument is that the Temne landscape has been metamorphosed into a sinister memoryscape, which

'condenses historical experiences of raiding and warfare, siege and ambush, death and capture, down the centuries and beyond recorded number' (ibid.:56).

Both ethnographies display a sensitivity to local 'regimes of memory' (Radstone and Hodgkin 2003) in which the 'realm of truth' is rarely manifest on the surface of verbal or facial expressions, or on the surface of the visible landscape, but rather remains implicit, waiting to be divined, often literally, in 'the underneath of things' (Ferme 2001:7; Shaw 2002:2). In a West African context that does not necessarily share Western 'ideals of transparency' (Ferme 2001:6), the past and the ambiguity of its material traces participate in a broader culture of dissimulation in which being adept in the 'arts of interpretation' confers power and prestige (ibid.:26–27). Here, then, stories of the past are both elusive and allusive, displaying a 'chronological heterogeneity' that challenges straightforward 'presentist' interpretations of the 'politics of the past in the present' (Shaw 2002:15; cf Halbwachs 1992) and, resisting any singular, definitive telling, provides the skilled narrator with an array of possibilities for the shaping of meaning (Ferme 2001:26).

Concerned primarily with rural contexts, these ethnographies present a mnemonic world that seems radically 'other' to the monuments, memorials, and museums associated with Western and urban modernity. Indeed, by stressing the alterity of Sierra Leonean memory practices, one can easily forget that, no matter how desperately underresourced, Sierra Leone also has its Monuments and Relics Commission, its National Museum, National Archive, and, in the aftermath of civil war, other modern 'technologies of memory', such as a Truth and Reconciliation Commission and a war crimes tribunal (the Special Court for Sierra Leone). On the one hand, such institutions are, of course, indicative of a colonial historical legacy – part of its modernizing project – and their neglect may therefore be as purposeful as that meted out on those other relics of the colonial state discussed by Ferme (ibid.:23). On the other hand, such technologies of memory are also locally appropriated and incorporated into a more profoundly 'creolised' (and 'creolising') culture, contributing to what Paul Richards describes as a 'heritage of cultural compromise forged over many centuries of social and economic flux' (1996:69–70).

It is not only Sierra Leone's Creole (locally, *Krio*) communities whose identity has been defined by this long history of flux: 'Everyone', suggests Richards, 'has complex cultural origins' here, and 'to be firmly flagged as having "age-old" roots simply makes for difficulties when it is time to adjust to new neighbours, or move on' (1996:69). Consequently, in Sierra Leone,

> there are many articulate ideas in local cultures about the importance of forgetting the past, the danger of over defining the present ... and the positive virtues of political compromise, religious syncretism, and hybridization of material culture.
>
> *(ibid.:70)*

For Richards, it is *this* cultural heritage that provides Sierra Leone with the greatest hope for the sustenance of a lasting peace.

Whilst it is tempting to employ an image of conflicting regimes of memory in Sierra Leone, drawing imaginary battle lines between 'indigenous' and 'colonizing' forms, it is this process of creolization – *mnemonic* creolization – that I am interested in exploring in this chapter. Thus, rather than characterizing and contrasting these regimes along such lines as social forgetting versus social remembering, immaterial versus material traces, unreflected upon everyday practices versus self-consciously iconic *lieux de mémoire* (memory versus history, tradition versus modernity, incorporation versus inscription – the list goes on), my interest is with how different mnemonic worlds articulate with and mediate one another. Such an approach recognises that, as with linguistic creolization, mnemonic creolization is a process 'invoked by endogenous as well as exogenous factors' (ibid.:74).

Paul Basu

And yet, the metaphor of creolization is not wholly satisfactory either insofar as it suggests that there is a *synthesis* of diverse influences, whereas it is perhaps more appropriate to think of these regimes of memory as coexistent, overlapping, and intersecting, whereby one form may sometimes obscure another but without completely erasing it. A more suitable metaphor might therefore be that of the palimpsest, in which the 'memory' of prior memory practices is retained and can even dominate. In this conceptualization, Pierre Nora's *milieux de mémoire* are not supplanted by *lieux de mémoire* with the ingress of modernity (1989:7); rather, as Ferme argues of the Mende memoryscape, 'new elements map onto older forces grounded in regional history and culture, and do so on the same terrain, so that modernity reinforces their magic and potentiality' (2001:5). In this respect 'memory' and 'history' are coincident: They share the same space.

Drawing on Jan Vansina's conception of 'palimpsest tradition' (1974:320), Shaw herself uses the phrase 'palimpsest memories' to describe how practical and discursive memories from different periods become intermeshed, such that one period is remembered through the lens of another (for example, so that experiences of the recent conflict are layered with memories of the Atlantic slave trade) (2002:15). In subsequent work, however, Shaw appears to resort to a more oppositional framework, arguing, for instance, that the effectiveness of Sierra Leone's Truth and Reconciliation Commission was compromised because it valorized a particular kind of Western memory practice that was 'at odds' with local practices predicated on 'social forgetting' (2005:2–3). This argument seems to essentialize both Sierra Leonean and Western memory practices, prioritizing the authenticity of local practices and consequently valorizing another particularly Western sensibility, this time concerned with purity and moral order.

In what follows, then, my intention is to explore the 'impure' mix of convergences, intersections, and interactions of different regimes of memory in Sierra Leone, and to do so by considering a number of sites associated with its recent conflict and ongoing peace process. As Young notes of Holocaust remembrance, so also are the 'sites of memory' of Sierra Leone's conflict 'many and diverse', and in this far-from-exhaustive discussion I shall be concerned with, among other things, species of trees, banknotes, and *noms de guerre*, as well as more obviously recognizable mnemonic forms such as murals, memorials, and gravesites (cf Young 1993:viii).[1]

Under the cotton tree

The interface between Sierra Leone's mnemonic worlds is manifest materially and spatially at the very centre of Freetown in the juxtaposition of the National Museum of Sierra Leone and one of the city's most famous landmarks, the 'Cotton Tree'. Established in 1957, the museum is housed in a low building – the former Cotton Tree Station – which is literally sheltered under the enormous boughs of the tree (indeed, the postal address of the National Museum is 'Cotton Tree, Freetown').[2] Freetown's Cotton Tree and the National Museum bookend a recent gazetteer of Sierra Leonean heritage sites compiled under the supervision of the Krio historian Akintola Wyse and funded by the U.S. Ambassador's Fund for Cultural Preservation (Wyse 2002). In this booklet, Freetown's 'majestic Cotton Tree' is described as standing,

> like a colossus, in the middle of the city keeping watch, and 'protecting', the capital, as it has done for over two hundred years. Its gnarled and spiky trunks, sturdy bole and massive shady branches also give it the look of a sentinel, 'standing in the centre of the oldest part of Freetown, surrounded by, yet dominating the principal buildings of Church, Law, and Government'.

(ibid.:10)

Palimpsest memoryscapes

According to legend (and there are many such legends), Freetown's Cotton Tree is said to have sheltered the first freed slaves who were sent to settle in the Sierra Leone Colony in 1787. Other stories state that, earlier, a slave market was held in the shade of the tree, and others still, that the tree was planted by freed slaves who had brought the seed with them from the Caribbean where the species is also found. Predating and dominating the structures of nation and state, Freetown's Cotton Tree is thus an important site of memory of Sierra Leone's slave heritage (a foundational narrative for Sierra Leone's Krio population). The tree both acts as a witness to the violent uprooting of people from their homeland in the image of the slave market and provides a symbol of sanctuary and protection for the freed slaves on their 'return' to Africa. Furthermore, in the story of the cotton tree being planted by exslaves, the tree itself shares in their experience and provides a literal motif for the rerooting of the slave diaspora in African soil.

Indeed, as JoAnn D'Alisera has recently observed, Freetown's Cotton Tree also features prominently as a resonant symbol of homeland and 'icon of longing' for a more recent Sierra Leonean diaspora in the United States, its photographic representation serving as a 'mediator' for a set of negotiations that emerge at the intersections of past and present, here and there, and indi-vidual and communal memory that, in part, define the diasporic experience (D'Alisera 2002). The iconic nature of the tree is similarly evident in the work of visual artists at home in Sierra Leone, not least in their responses to the conflict. Simeon Benedict Sesay's painting, *Handiwork of Child Combatanis* (2000), for example, depicts the January 1999 rebel invasion of Freetown. At the bottom right of Sesay's composite image, the rebels can be seen entering the city, leaving a trail of carnage in their wake; at the top right of the picture, those citizens fortunate enough to escape are shown making their way to a refugee camp. Meanwhile, depicted on the left half of the painting, Freetown's Cotton Tree stands as a lone witness, towering above streets emptied save for dogs and vultures picking over the corpses of victims, while the Law Courts Building (the 'Gran Kot') and the National Museum have been abandoned. Confronted by this image, one thinks of the words penned in 1947 by the British colonial administrator and ethnographer, E. F. Sayers:

> How many human joys and human sorrows has our Freetown Cotton Tree not seen, and how many tragedies and comedies must have been enacted within the sight of it and within its sight? … Freetown's Cotton Tree stands today for a sense of continuity in our corporate life, a symbolic link between our past and our future.
>
> *(Sayers 1961:133–34)*[3]

Colossal though Freetown's famous specimen may be, the cotton tree has much deeper roots in the Sierra Leonean memoryscape. Some of the earliest European accounts of Sierra Leone mention the special place of cotton trees in local cosmologies; as well as boundary markers, they are described as being regarded as 'idols', as 'symbols of power and might', and as sacred places under whose shade ceremonies are held and carved wooden statues set up (Alvares 1990:2, Chapter 1:7, Chapter 10:2, Chapter 12:2). Indeed, the silk cotton or kapok tree (*ceiba pentandra*) is a significant species throughout West Africa. Highly venerated, these trees frequently form the centre of village social life (Gottlieb 1992). Cotton trees were often planted to mark the establishment of new settlements and are associated with, and sometimes named after, founding ancestors (Fairhead and Leach 1996:89). The kapok tree is 'the beginning of all things in the village', one of Gottlieb's Beng informants explains to her; another adds that the tree itself is 'the head of the village' (1992:19). Referencing the earlier ethnographic work of E. F. Sayers in northeast Sierra Leone, Michael Jackson cites a standard Koranko lament sung at the funerals of

high-ranking elders, which explicitly links the greatness of the cotton tree with the greatness of the deceased:

> This year oh, a gold cotton tree has fallen, oh sorrow, a great cotton tree has fallen this year oh.
> A great cotton tree – that reached to heaven – has fallen. Where shall we find support and shade again?
> Lie down, lie down Mara [name of a ruling dau], the war chief has gone.
>
> *(Jackson 1989:70; see also Sayers 1925:22)*

As many commentators have described, fences of living cotton trees were also planted as part of the sometime elaborate fortifications erected around towns and villages at times of war in Sierra Leone (Alldridge 1901:56; Malcolm 1939). Although these 'war fences' were prohibited by the British colonial government after 1896, remnants nevertheless survive, and the sight of the much-matured rings of cotton trees rising above second-growth forest often indicates the location of long-deserted settlements: ruinlike 'inscriptions', suggests Ferme, telling 'of violent encounters or at least of abandonment of a once-inhabited site' (2001:25; see also DeCorse 1980:51).

The cotton tree, the dove and the Le10,000 note

Given the place of the cotton tree in both urban and rural mnemonic consciousness, and therefore its capacity to act as a unifying symbol, one is likely not surprised that it has been incorporated into Sierra Leone's national iconography. The Freetown tree appeared, for instance, on the first issue of Sierra Leone's own banknotes in 1964, only later to be joined and subsequently replaced by the head of the head of state. Banknotes are, of course, not only carriers of monetary value, they are also a particularly interesting medium for the expression of what Michael Billig (1995) terms 'banal nationalism': those unnoticed, everyday 'flaggings' of national identity and heritage. Unlike flags or anthems, however, banknotes have the peculiar characteristic of needing to be redesigned relatively frequently in order to counter the efforts of counter-feiters. As Jacques Hymans has recently observed, this fact 'forces states every decade or two to confront anew the question of how to portray the nation and its values' (Hymans 2005:317).

In 2004, two years after Sierra Leone's civil conflict had officially ended, the Bank of Sierra Leone introduced a new 10,000 Leone note. According to a speech made by J. D. Rogers, the Governor of the Bank, at the launch of the note, the theme of its design – 'National cohesion leading to peace and prosperity' (the words are printed on the note's obverse) – was proposed by President Kabbah himself (Rogers 2004). In addition to this inscription, the obverse of the banknote also features the Sierra Leonean national flag and a white dove with an olive branch in its beak flying over the territory of Sierra Leone as represented in the form of a map. After a fifteen-year absence from Sierra Leonean banknote designs, an image of the cotton tree returns to feature prominently on the reverse side of the bill, although it is interesting to note that it is no longer specifically identifiable as *Freetown's* Cotton Tree. In the background design of the reverse, framing the representation of the tree, is Sierra Leone's national coat of arms and the repeating motif of the dove with olive branch.

The values promoted in the iconography of this banknote seem unequivocal. For a bankrupt, so-called failed state emerging from over a decade of civil war and engaged in various transitional justice mechanisms, there is a clearly articulated aspiration to see the spirit of peace as a reunifying force reigning over the nation – a desire to see the dove of peace come to roost, as it

were, in the nation's cotton tree. But it is also interesting to observe how this aspiration is expressed on the banknote through the juxtaposition of the autochthonous symbol of the cotton tree – an emblem literally rooted in the soil of Sierra Leone – alongside a symbol of Judaeo-Christian origins, the olive-branch-bearing white dove, which was adopted as a symbol of the International Peace Congress held in Paris in 1949. Indeed, the inherently Eurocentric internationalism of this symbol of peace would seem to speak to a critique of truth and reconciliation commissions, pursued in a Sierra Leonean context by Shaw (2005), which challenges their universalist assumptions about trauma and recovery, their anthropomorphizations of the nation-state, and their foundations in Western psychotherapeutic practice (Hamber and Wilson 2002). As previously noted, Shaw's argument is framed through opposing a Western, globalizing concept of memory, which valorises the 'social remembering' of traumic events, with an indigenous Sierra Leonean memory culture 'based on the *social forgetting* of violence' (2005:3; italics in original).[4] Thus, although an explicit objective of Sierra Leone's TRC was to create 'an impartial historical record' of the conflict, Shaw maintains that its implicit mandate was 'to bring about an ideological or cultural transformation by turning a population who, for the most part, sought to forget, into truth-telling, nation-building subjects' (ibid.:8).

Although the report of the TRC may indeed be read as an exercise in nation-building myth-making, one doubts that this image of a dominant regime of memory effectively colonizing subaltern minds is born out in practice. Despite much rhetoric, there is little evidence to suggest that the TRC has effected anything like this kind of 'ideological or cultural transformation' in Sierra Leone's population. On the contrary, the activities of the TRC seem often to have been met with suspicion and indifference, and one suspects that ultimately the TRC will have little direct influence on whether peace will hold in Sierra Leone. Nevertheless, the '*Learn from Yesterday for a Better Tomorrow*' slogans of the TRC *are* graffitied onto the palimpsest of Sierra Leone's contemporary memoryscape, entering the consciousness of Sierra Leoneans through dis-trict hearings (Kelsall 2005) and popular radio programmes (Rashid 2006), as well as through the materializing practices that are the concern of this chapter. But in 'over-writing', such exogenous influences do not necessarily erase underlying practices so much as add another layer to their complexity – a process of incorporation that is apparent in the juxtaposition of the dove and the cotton tree on the Le10,000 note. The point is that just as the conflict localized in Sierra Leone throughout the 1990s had a 'global range of symbolic and dramaturgical references' (Richards 1996:xvii), so Sierra Leone's peace process is also bound up in the 'media flows and cultural hybridizations that make up globalized modernity' (ibid.).

In the name of Bai Bureh

Such global flows and hybridizations are evident, for example, in the *noms de guerre* assumed by fighters on all sides of Sierra Leone's conflict: the names of Hollywood heroes such as 'Superman', 'Rambo', 'Terminator', and 'Rocky', for instance, whose exceptional qualities are transferred, by association, to the bearer. But even pseudonyms taken from indigenous Sierra Leonean heroes have more complex global genealogies. Take 'Colonel Bai Bureh', for example: This was the *nom de guerre* adopted by, among others, Abubakar Jalloh, a commander of the Revolutionary United Front (RUF), the main rebel force during the conflict.

Bai Bureh of Kasseh (*c.* 1840–1908), Jalloh's namesake and another of the sites of memory I want to consider here, was a famous Temne warrior and leader who, in 1898, led an uprising against the British colonial power in what has become known as the 'Hut Tax War' (see Abraham 1974; Denzer 1971). Employing guerrilla tactics against British regiments inexperienced in bush warfare, Bai Bureh succeeded in evading capture for many months and was said

Paul Basu

to have supernatural powers, to be bulletproof and to have the ability to become invisible or stay under water for long periods (Kabba 1988:42).[5] Although a cultural memory of Bai Bureh no doubt survives locally (see Shaw 2002:64–66, for example), it is interesting to observe how this Temne chief has entered into the Sierra Leonean national iconography, not least through the agency of two American Peace Corps volunteers.

A life-sized representation of Bai Bureh is displayed in the National Museum of Sierra Leone. On an official tourism website, a caption explains that the statue 'is dressed in the … guerrilla leader's own clothes and holds the cutlass with which he fought in the Hut Tax War of 1898' (www.visitsierraleone. org/thingstodo.asp, accessed 20 July 2006). Significantly, however, it was an American secondary-school history teacher and Peace Corps volunteer named Gary Schulze who, as acting curator of the museum in 1962, argued that the story of Bai Bureh and the Hut Tax War ought to be included in the museum's displays (Gary Schulze pers. comm.). The earlier absence of what has become a key historical narrative celebrating Sierra Leone's resistance to colonial oppression is itself telling insofar as the museum hitherto presented a more 'Kriocentric' view of Sierra Leonean national heritage, and the Hut Tax War and subsequent Mende uprising of 1898 are ambiguous episodes in this heritage, not least because the majority of the victims of these insurrections were in fact Krios (Fyfe 1962:571–74; Hargreaves 1956:71).

Under Schulze's temporary management, however, the story was duly incorporated into the museum's exhibitions, and, indeed, it was Schulze who commissioned a Freetown-based sculptor to make the statue of Bai Bureh that would form the centrepiece of the display. Since there was no record of Bai Bureh's appearance other than a single drawing, made in profile, by a Lt H. E. Green of the 1st West Africa Regiment after he was captured, it was left to the sculptor's imagination to fashion the face; and although the *ronko* gown and cutlass were authentic to the region and period, they were merely samples taken from the museum's collections and did not belong to Bai Bureh himself as is popularly claimed (Gary Schulze pers. comm.). Indeed, whereas Green's drawing shows Bai Bureh wearing the conical white hat typical of West African Muslim elders of the late nineteenth century, Schulze dressed the museum statue in a red tricorn, which is associated with Mande hunters but, significantly, not with the Temne. Despite the improvised nature of the statue, Schulze explains that, in the months following the statue's installation, thousands of people visited the museum to see Bai Bureh, and, in subsequent years, photographs of the figure began to appear in Sierra Leonean history books (for example, Alie 1990:140). The statue has subsequently been paraded at agricultural shows and other events throughout the country and has come to define Bai Bureh's image in the popular imagination (Gary Schulze pers. comm.).

It was, however, another Peace Corps volunteer, the anthropologist Joseph Opala, who enshrined Bai Bureh, alongside other historical figures, such as Sengbe Pieh, the leader of the 1839 Amistad slave revolt, in what amounts to a national hagiography: a volume entitled *Sierra Leone Heroes* (Kabba 1988). As a Peace Corps volunteer, Opala was attached to the National Museum between 1974 and 1978; staying on in Sierra Leone, he later became a lecturer at Fourah Bay College in Freetown. In 1986, conscious of the absence of patriotic imagery in the country, Opala wrote a series of articles for the Freetown-based *Daily Mail* newspaper on what he termed Sierra Leone's 'neglected heroes' (Opala 1994:201). Around the same time he urged the Momoh government of the day to produce a book on these historical figures, which he hoped would be distributed freely to schools throughout the country. In 1987, the book was given the go ahead, and Opala was appointed to the editorial board. Opala notes that, when compiling and commissioning illustrations for the book, he was 'keenly aware' that he was involved in the creation of 'patriotic icons' and 'took pains to place the heroes in memorable

784

poses' (ibid.). *Sierra Leone Heroes* – the first edition of which features a more militant representation of Bai Bureh on its cover – was not distributed freely to schools, but sold commercially. Although sales were good, Opala explains that it was his use of it as a textbook for a course he taught on Art, Anthropology, and National Consciousness at Fourah Bay College that led to it being adopted by an increasingly politicised student body as a source book of emblems for Sierra Leonean cultural nationalism (ibid.). Indeed, the significance of Opala's role in promoting a more nationalistic mnemonic consciousness in Sierra Leone is evident when he describes how he would assign 'students the task of memorializing a hero in a painting, sculpture, song, poem, or play' (ibid.; see also Christensen 2005).[6]

Amid an escalating rebel war, the corrupt Momoh regime was deposed in a military coup in 1992, and it was the fabricated face and apparel of the museum statue of Bai Bureh that displaced Momoh's on the Le1,000 banknote introduced by the National Provisional Ruling Council (NPRC) government in 1993.[7] More recently, this same visage has been brought to life in the Sierra Leonean/Nigerian coproduction of a video film entitled *Bai Bureh Goes to War*. As the late Abu Noah, the writer and executive producer of the film, was keen to stress to me, although ostensibly about an historical leader and war, the film has much relevance for contemporary African politics: 'Today's leaders need to tap into the fountain of unsullied leadership qualities of our forebears', he explained.

> Contemporary world events buttress the foregoing … As we strive to make the African Union a viable one, the story of Bai Bureh couldn't have been more timely. It challenges both leadership and followership in the modern African society. The quality of leadership enjoyed by Africans before the advent of the colonial masters must be revisited.
>
> *(Noah 2004)*

Mediated by American ideas of patriotic iconography, the imagination of a Krio sculptor, the political ambitions of the NPRC regime, and idealizations of precolonial African polities – such is the nature of the making of an 'indigenous' Sierra Leonean hero (a malleable site of memory and ancestor capable of being claimed by all sides in a civil war).[8]

War memorials and peace monuments

Unlike previous regimes, the NPRC was conscious of the power of patriotic monuments and street art, and, in 1992 and 1993, statues and murals depicting Bai Bureh and Sengbe Pieh were erected and painted alongside those celebrating the heroic officers of the 1992 coup. In his 1994 article describing this popular movement and his own involvement in it through the *Sierra Leone Heroes* book, Opala notes that images of Captain Valentine Strasser and other leaders of the NPRC were intentionally associated with depictions of these historical figures, thereby incorporating them into an evolving national pantheon (1994:205). There are still a few decaying examples of the murals to be seen in Freetown – for instance, those on Howe Street depicting Captain Prince Ben-Hirsh and Lieutenant Samuel S. Sandy, two NPRC 'martyrs' who were killed during the coup. Lieutenant Sandy is shown dressed in camouflage jacket and beret under the inscription 'Even the Dead Lead Us Through', suggesting that, like Bai Bureh before him, he was claimed by the NPRC as an 'ancestor': not a figure of the past, but one who has gone on ahead and in whose footsteps others will follow – an active presence in contemporary events (Last 2000:380).

The initial popularity of the NPRC was largely due to its resolve to put an end to the rebel war that had been plaguing the country. One way in which this militancy was materialised and

made visible was in the installation of street side statues celebrating the new government's victories against rebel forces. One such statue was erected in 1994 to commemorate a skirmish in the town of Bo, in the Southern Province of Sierra Leone, at a road junction that became known as 'Soja Kill Rebel Corner'. The toppled remains of the statue survive, partially hidden behind advertising placards and under a tangle of tree branches that have been thrown over it. Although the statue now lies in a number of pieces, one can see that it graphically depicted a government soldier about to bayonet a cornered rebel. An inscription on its plinth reads:

> This monument … symbolizes the improved rebel war in Sierra Leone. It is dedicated to all our loyal and gallant soldiers of the NPRC Government.

It was not until 2002, six years after the NPRC itself was toppled from power, that the conflict was officially declared over and the process of reconstruction was begun in earnest. During the district hearings of the ensuing Truth and Reconciliation Commission, the Commission staged what it termed 'traditional reconciliation ceremonies' at sites where massacres or other atrocities had taken place. These ceremonies included the performance of cleansing rituals and pouring of libations, as well as prayers and religious ceremonies. According to the report of the TRC, such activities were regarded as being particularly important for local communities 'because they serve as recognition of the suffering of victims as well as the collective memory of the past' (TRC 2004a, Vol. 3b:475).

Such events were sometimes marked by the erection of memorials, thus leaving material traces of the peace process throughout the country in an attempt to counter the more abundant traces of the conflict. In Bo, for instance, on the closing day of the local TRC hearings, a ceremony was held at Soja Kill Rebel Corner in which the intersection was itself renamed 'Peace Junction' and a memorial sign board erected to signal the fact. Although this might seem like a classic enunciative act, which brings about the reality it announces and thus transforms the commemoration of war into a celebration of peace, the reality on the ground is, of course, that the junction is still remembered by its more vivid *nom de guerre*.

This attempt to overwrite conflict and leave an itinerary of peace monuments rather than war memorials in its wake was repeated by the TRC in other towns throughout Sierra Leone. Perhaps the most significant example is the renaming, in August 2003, of Freetown's Congo Cross Bridge as 'Peace Bridge'. This bridge marked the extent of the rebel incursion into Freetown in January 1999 and was the site of particularly fierce fighting. The bridge was renamed as part of a larger event marking the end of the TRC hearings, a National Reconciliation Procession, in which representatives of all the major factions marched together across the bridge on their way to the National Stadium, where speeches and formal apologies were delivered. A special 'child-friendly' version of the TRC report draws out some of the symbolic resonance intended in the act of renaming: 'The Peace Bridge reminds the people of Sierra Leone that the war was overcome. And it gives hope that peace will become the bridge to the future' (TRC 2004b:31).

With the support of President Kabbah, a National War Memorial Committee was established in 2002, and a competition was held to elicit designs for memorials in Freetown, Bo, Kenema, and Makeni. Despite an announcement in February 2006 that the President had also called for the erection of a commemorative monument in Bomaru, the town on the Sierra Leone/Liberia border where 'the first shots which started the long and protracted senseless war were fired' (www.statehouse-sl.org/archives/feb-2006.html, accessed 10 August 2006), to the best of my knowledge, none of these has yet been constructed, owing to lack of resources.

These government initiatives were encouraged by the TRC, and a section of one of the appendices to its report is devoted to the issue of 'Memorials and Transitional Justice'. This section of the report was compiled along with a series of recommendations for the establishment of 'successful memorials' in Sierra Leone by Artemis Christodulou, a graduate student from Yale University who was serving as an intern at the TRC at the time. Christodulou stresses the need to integrate 'traditional and cultural methods of memorialization' into any proposal and provides some suggestions made by various Sierra Leonean 'stakeholders' with whom she had consulted.

In the context of my earlier discussion regarding the cotton tree as a complex site of memory in Sierra Leone, it is interesting to note a suggestion for a memorial proposed by a group of excombatants, which involved leaving imprints of their hands in a cement wall encircling the Freetown tree. This was intended to signify 'a tacit agreement with themselves, with other perpetrators, and with the nation and the world that they will never use these hands again to pick up a weapon and strike a fellow human being' (TRC 2004a, app. 4, pt. 1:7). Given that the amputation of civilians' hands was one of the 'signature tactics' of the Sierra Leone conflict, this proposal had especial resonance, and, despite misgivings, some amputee groups were evidently supportive of the idea. Christodolou recommended that a forum be established so that perpetrators and victims could meet together to discuss the proposed memorial, suggesting that this would 'serve as a powerful space for healing and reconciliation' (ibid.).

No matter how well-meaning such interventions, it is significant that the report of the TRC fails to properly identify what form local 'methods of memorialization' might take or how such methods might be integrated with models imported from elsewhere. More fundamentally, as Shaw (2005) argues, the TRC does not consider the possibility that commemoration might be an inappropriate tool for reconciliation in the first place. It is not that war memorials are unknown in Sierra Leone, of course, but their connotative associations are ambiguous, to say the least. A prominent example is the memorial that lists the names of the Sierra Leoneans who were killed fighting for the British in the First and Second World Wars. Located in front of the old Secretariat Building in Freetown, the one-time hub of colonial government in Sierra Leone, this colonial relic, one suspects, brings to mind an altogether different, postcolonial narrative from that it was intended to commemorate. Indeed, the old Secretariat Building was attacked during the May 1997 coup staged by the Armed Forces Revolutionary Council (AFRC), and, although it is now being renovated, its gutted shell stood for several years as yet another kind of monument of warfare.

If the war memorial or peace monument remains a peripheral (and, in the case of the TRC's commemorative sign boards, an ephemeral) artefact in the Sierra Leonean memoryscape, there is one final category of site that I should like to consider at which 'indigenous' and 'non-indigenous' regimes of memory intersect more complexly: the site, that is, of mass graves associated with Sierra Leone's conflict.

Concerning the dead in mass graves

The mass grave occupies a particular place in the Western imagination as an emblem of atrocity. As well as having associations with appalling violence and the dangerous, polluting power of dead bodies (Hallam, Hockey, and Howarth 1999), mass graves, it is argued, inspire fear because they also involve the burial of social memory and identity (Ferrándiz 2006; Sanford 2003). Not only are mass graves often intentionally hidden and left unmarked by perpetrators – at once amplifying terror through secrecy, concealing evidence, and denying survivors a body to mourn – but in their carelessly cast jumbles of corpses is entailed an effacement of individual identity,

which is especially unsettling for societies used to commemorative practices that preserve an individual's identity to the grave (for instance, the indexical relationship between an inscribed headstone and the identity of the body below it).

As part of a wider interdisciplinary fascination with cultural trauma, violence, and memory, an increasing number of anthropologists have begun exploring the social and political significance of mass burials. In contexts ranging from Argentina (Crossland 2002; Robben 2000) and Guatemala (Sanford 2003) to Spain (Ferrándiz 2006), Cyprus (Sant Cassia 2005), and Eastern Europe (Verdery 1999), researchers have been considering the implications of exhuming both bodies and memories when such sites undergo forensic excavation as part of truth commissions or other investigations. As Crossland (2002) observes of the excavation of mass graves outside Buenos Aires, the physical uncovering of bodies at these sites constitutes a reappearance of the 'disappeared', which again makes visible the 'crimes of the juntas' and revivifies memories of state violence and oppression. Anthropologists have also explored the politics of preserving mass gravesites and their transformation into memorials of genocide (Cook 2005; Hughes 2005; Jarvis 2002; Williams 2004). Hughes, for example, contrasts the memorial activities of the Cambodian state at Choeung Ek with local-level memorial practices elsewhere in Cambodia; she observes how the memorialization of gravesites reflects contestations between multiple actors, meanings, and values, 'including Cambodian party-politics, Khmer Buddhist beliefs about death, and local and internationalised discourses of justice, education, and memory' (Hughes 2005:286). With advances in DNA identification techniques, the forensic examination of mass graves has now become a standard part of the toolkit of transitional justice mechanisms and human rights interventions across the world.

In 2001, human rights officers of the United Nations Mission in Sierra Leone began receiving information from local NGOs regarding discoveries of graves and other sites of atrocities related to Sierra Leone's conflict. The following year the Argentine Forensic Anthropology Team (EAAF) was funded by the UN Office of the High Commissioner for Human Rights to conduct a preliminary survey of these sites and to advise the TRC and other organisations regarding future investigations. In the course of a month, members of the EAAF team visited fifty-five sites located in five districts in the east and centre of the country. With permission from local authorities and chiefs, interviews with witnesses were conducted and the sites inspected, planned, and recorded. Although no exhumations were carried out, the EAAF made recommendations for the preservation of the sites so that evidence would remain intact should excavation be deemed of interest to the TRC or judicial inquiry (EAAF 2002). Details of the EAAF's activities and its discoveries of mass graves were reported widely in the Freetown press.

Following the EAAF's preliminary survey, the TRC embarked on its own programme of investigations of mass graves, extending its remit to include other sites 'that have a story to tell' – for example, 'mass killing sites, execution sites, torture sites, and amputation sites' (TRC 2004a, app. 4, pt. 2:1–2). TRC investigators were sent into the field with the following objectives:

a to identify as many 'mass graves' and 'other sites' as possible in all districts,
b to photograph the identified sites,
c to identify the number of victims,
d to reveal the identity of the victims,
e to identify the types of [human rights] violations committed at the site,
f to identify the perpetrators,
g to identify and locate the tools and instruments used in committing the violations,
h to identify the persons and institutions responsible for the management of the sites,

i to determine the current uses of the sites (if any),
j to advise the local community on the protection, preservation and security of the site. (ibid.:2)

It is clear from its report that the TRC encountered a number of difficulties in relation to these tasks, not least the lack of time and financial resources to properly conduct the research, which meant that coverage was rather patchy and the districts of Kambia, Western Area and Port Loko were not included at all. A more complex difficulty, which had far wider implications for the success of the TRC, is described in the TRC report as 'some confusion on the part of the local populace between the TRC and the Special Court' (ibid.). The problem of simultaneously conducting a truth commission, which promoted amnesty, and a war crimes tribunal, which sought to prosecute perpetrators of the more serious human rights violations, is discussed at some length in the TRC report itself (TRC 2004a, Vol. 3b:363–430). One result was that potential informants were reluctant to participate in TRC investigations because they were afraid that they would be called as witnesses or prosecuted by the Special Court: thus, detailed information relating to mass burials, even if known, was often not forthcoming.

Despite these limitations, the TRC compiled a database of some 99 mass gravesites, the majority containing fewer than 20 bodies, but a significant number reputedly containing in excess of 100 bodies each (two sites in Bonthe District were reported to contain 450 and 600 bodies, respectively). A table in an appendix of the TRC report provides details of the location of each of these sites, together with the number and the identity of victims (where known), the alleged cause of death (usually gunshot wounds), the date of the killings, date of burial, and the alleged perpetrators (usually RUF and AFRC, but instances of killings by the Sierra Leone Army [SLA] and Kamajor Civil Defence Force are also recorded). Graves were often dug hurriedly and without ceremony after an attack on a village; in other cases, bodies were not buried until a number of years after the killings took place (for instance, when a village that had been abandoned after an attack was later resettled). As the report states: 'Behind every mass grave there is a tragic story' (TRC 2004a, app. 4, pt. 2:1). An example of one such story, gathered by TRC investigators working in Pujehun District, follows:

> At Bumpeh Pejeh chiefdom two mass graves were discovered. As the burial took place three years following the killings in 1996, the remains could not be identified. According to eyewitnesses, Bumpeh Pejeh was the only chiefdom in the Pujehun district that had a heavy presence of SLA soldiers. As a result, many people from other areas came to this town for security. The RUF attacked the chiefdom causing heavy casualties and resulting in the dispersal of the population. When displaced persons returned after three years they discovered that many of the original inhabitants were missing. When the residents of the chiefdom returned the entire village had become overgrown. It was during the time when the bushes were being cleared ('under-brushing') that many of the remains were discovered, Most of the remains were collected from the township and some others were retrieved from the nearby bush. The first set of remains that was discovered was buried in a hole near a cotton tree at the southern end of the township. When the first site was full, the people dumped the remains at a second mass gravesite between the roots of the cotton tree.
>
> *(TRC 2004a, app. 4, pt. 2:19)*

In contrast to the ephemeral efforts of the TRC to displace the memory of war through the erection of peace monuments, this account – typical of similar descriptions recorded throughout the country – provides a vivid and disturbing illustration of how the landscape of Sierra Leone

continues to be transformed into a memoryscape of conflict, and not necessarily through intentionally commemorative practices.[9]

At the time of its investigations, the TRC found that, in most cases, the mass gravesites it visited were in a state of neglect, and their future preservation was in danger. The TRC recommended that, because they 'serve as powerful reminders of the abuses of the past and the need to ensure that they never occur again', steps must be taken to preserve and mark the most significant sites in all districts (ibid.:21). Whereas the TRC proposed the erection of 'shrines and monuments' over the graves, consultation with local people demonstrated that there was a preference for more ' "community oriented" ways of remembering and commemorating the dead' (ibid.:20) – for instance, the erection of hospitals, schools, and other community facilities that have a more immediate use value in the present and that 'remember' in another sense insofar as they call to mind a quality of life lost in the years of conflict. This preference calls to mind a debate that took place in Britain in the aftermath of the First World War between those who favoured commemorating the dead with schemes that served some utility for the living and those who felt 'a noble piece of sculpture' was a more fitting tribute (King 1998:86–105). In the Sierra Leonean context, the divergence between these approaches underlines the TRC's concern that the gravesites must remain *visible* reminders of past abuses and reveals its blindness to the fact that many of these sites were already 'marked' (or not) in locally meaningful ways – it is surely no coincidence, for example, that the mass graves in Bumpeh Pejeh chiefdom were located under a cotton tree.[10]

If the mass grave is a particularly terrifying spectre that haunts the Western (and international humanitarian) imagination, the question arises as to what other layers of meanings accrue at these sites. How, for instance, are they perceived according to local cosmologies in which different attitudes toward the dead may prevail? This is not the place to detail the mortuary customs of the various ethnolinguistic populations of Sierra Leone; however, as in other regions in West Africa, it is clear that the circumstances in which a person dies, as well as the person's status, affect the ceremonies performed, the location and nature of the burial, and the fate of the person's 'spirit' in the afterlife. Some sense of this may be discerned in an excerpt from a poem by Josaya Bangali entitled 'Elegy: For the Dead in Mass Graves':

> Ancestors of new death
> Take this message
> To ancestors of old death
> Among whom was Sengbe Pieh
> Not forgetting Mama Yoko and Bai Bureh
> Tell them that the children of Nyagua
> Have opened each others' stomachs
> And fought over their entrails.
> They've been laid to rest
> On top of each other,
> No side-bands are worn
> To pronounce them dead
> And the ceremonies of the spirit-house
> Cannot be looked after.

Although Bangali writes in English, he is a Mende-speaker, born in Tikonko Chiefdom, south of Bo. He was educated at Christ the King College, Bo, and at Njala University, where he studied Literature and Linguistics. The imagery Bangali uses in his 'Elegy' combines a nationalistic

sensibility with more traditional motifs in a manner that, as I have been arguing, is quite characteristic. Bangali explained to me that he wrote the poem as a response to the hopeless situation that Sierra Leoneans had, he thought, brought upon themselves because they no longer heeded the wisdom of their cultural heritage and traditions (a heritage mediated through the very processes I have been describing).

The following interpretation is based on Bangali's own comments. In the poem, Bangali contrasts those who have been killed fighting in Sierra Leone's recent civil conflict – the 'ancestors of new death' – with legendary figures from Sierra Leone's past who fought against slavery and oppression (Sengbe Pieh, Bai Bureh, Madam Yoko, Nyagua – the 'ancestors of old death'). Whereas Bangali argues that the ancestors of new death will soon be forgotten, he claims that the ancestors of old death 'are immortal and cannot be extinguished from memory' and that 'their deeds are worth emulating' (pers. comm.). The recent dead are thus told to carry a message to these ancestral heroes of old, that Sierra Leoneans – the 'children of Nyagua' – instead of uniting against common foes, are fighting one another in a most hideous manner. Those killed in the conflict are dumped into mass graves, their corpses piled on top of one another. Bangali explains that 'among the Mendes, the blood relatives of the deceased wear white side-bands to differentiate themselves from ordinary sympathizers; and it is by wearing side-bands that outsiders know that the wearer has lost a dear one' (pers. comm.). According to the poem (and, indeed, this is corroborated by the TRC investigations), the dead in the mass graves go unmourned, and the appropriate funeral ceremonies – the 'ceremonies of the spirit-house' – are not observed.

According to traditional Mende belief, this last point is of particular significance, for it is through the *tenjamɛi* ceremony, performed three days after the death of a woman, or four days after that of a man, that the dead are enabled to 'cross over the water' and properly join the community of the ancestors (Gittins 1987:57). If the *tenjamɛi* ceremony is not performed, then the dead person is destined to remain a liminal earth-bound spirit, or *ndoubla*, 'not properly integrated either with the living or with the ancestors' (ibid.:61, fn.33). Such spirits are thought to linger around their place of burial and are regarded as being discontented, capricious, and sometimes 'a threat to the living' (ibid.:57).

Rebirthing the nation?

The sites of memory, which have been the concern of this essay, are also sites of mediation. Not only are they the material mediators through which coexistent regimes of memory are brought into relation with one another, and through which multiple meanings of war and peace in Sierra Leone are shaped, but – as Sayers remarked of Freetown's Cotton Tree – they are also sites that mediate between the past and the future. The master trope articulated in the report of the Truth and Reconciliation Commission is, of course, that of 'rebirth'. By seeking to create 'an impartial historical record' of Sierra Leone's conflict (TRC 2004a, Vol. 1:10), the TRC hopes that the 'lessons of the past' can be learned, and out of the crisis of civil war can be born a new, peaceful, and just nation-state. Such an ambition is expressed in the many essays, poems, and paintings submitted by 'men and women of all ages, backgrounds, religions, and regions' in response to the TRC's invitation to Sierra Leoneans to contribute to the shaping of a 'National Vision' for the future of the country (TRC 2004a, Vol. 3b:i, 503). Examples of these submissions were reproduced in the final chapter of the report of the TRC, and they were also made into an exhibition that was displayed at Sierra Leone's National Museum between December 2003 and June 2004. Alongside images of reconciliation and hope painted in the colours of Sierra Leone's flag or superimposed on the cutout shape of the national territory, a contribution from Bishop

Joseph Humper, the chairman of the TRC, articulates this trope of rebirth most explicitly. Under the title of 'A Sierra Leonean Renaissance', Humper's message states that he envisions 'a revived Sierra Leone, born out of the ashes of a reckless and senseless civil conflict, [which] shall become active and committed to the establishment of genuine peace'.

Humper's words resonate with a broader vision of African Renaissance, associated in its most recent formulation with the pronouncements of Thabo Mbeki (Ajulu 2001). However, rebirth is not the only trope discernable in the palimpsest of Sierra Leone's memoryscape. If the desire of local communities to commemorate the victims of civil war with schools and hospitals, rather than with monuments and mausolea, suggests a future-oriented attitude that serves the living and not the dead, it is as well to remember the lingering discontent that haunts Sierra Leone's mass graves. Indeed, barely concealed beneath the optimistic rhetoric of the TRC is a more pessimistic observation: that many of the characteristics identified as antecedents to the conflict continue to persist in Sierra Leone, and, hence, there is considerable doubt as to whether the 'lessons of the past' will in fact be learned (TRC 2004a, Vol. 3a: 149). Thus, rather than prematurely celebrating the rebirth of a nation, we might heed the still-potent underlying layers of Sierra Leone's palimpsest memoryscape and, with some justification, fear that which is undead and which cannot yet be properly laid to rest (cf De Boeck 1998).

The authors of Sierra Leone's TRC report are not, of course, alone in seeking to construct a myth of the past that serves the perceived imperatives and aspirations of the present. This is, in part, my point: that there are multiple entities, each differently positioned in the social, cultural, and political landscape, each committed to a particular engagement with the past in the light of present needs, hopes, and future-oriented agendas. What is interesting to observe in this familiar, 'presentist' interpretation, is the way in which the same historical 'motifs' are, more or less strategically, reappropriated by differently positioned entities to serve very different ends (see my discussion of Bai Bureh, for instance). The past, no less than the present, thus becomes a contested ground. What this interpretation fails to capture, however, is the sense that it is not only the *use* of the past in the present that is contested but also the very nature of 'pastness' and its 'presence'.

Too often this contest is characterized as an opposition between competing regimes of memory, such that traditional mnemonic practices are regarded as being suppressed by modern historicizing ones, and local conceptualizations as being displaced by globalizing hegemonies. As this chapter has sought to argue in a Sierra Leonean context, the relationship between these regimes is more complex. Rather than reductive dichotomies, we need a more nuanced understanding of the 'synchronic heterogeneity' of diachronic processes in a given context (Cole 2001:289). Whereas the mnemonic practices of any one individual or social body might entail a synthesis of some of the diverse influences co-existent at a particular time and place, at a more general level these heterogeneous elements do not necessarily cohere into a new creolised form. Rather, the memoryscape is continually 'overwritten', resulting in an accretion of forms. But, unlike an ideal type of stratified archaeological contexts, whereby successive strata overlay one another neatly, this accretion occurs in an uneven manner and, to pursue the archaeological metaphor, is constantly being excavated and reburied, mixing up the layers, exposing unexpected juxtapositions, and generating unanticipated interactions. Such is the medium of the palimpsest memoryscape.

Acknowledgments

The fieldwork from which this essay is drawn was funded by a Nuffield Foundation grant for which I am extremely grateful. I should also like to thank Mike Rowlands and Ferdinand de Jong for their invitation to contribute to this book, James Fairhead for his comments on an earlier draft of the chapter, Josaya Bangali for permission to reproduce his poem 'Elegy: For the Dead in Mass Graves', and James Vincent for his invaluable research assistance.

Notes

1 No attempt is made to provide a history of Sierra Leone's conflict. For recent analyses, see Abdullah (2004) and Keen (2005).
2 A fuller history of Sierra Leone's National Museum and cultural heritage legislation is currently in preparation. In the present context, however, it is worth noting that the establishment of the Museum should be seen in the context of a broader movement across colonial British West Africa. In 1944, having visited the region as a member of the Commission on Higher Education in West Africa, Julian Huxley sent a detailed memorandum to the Colonial Office arguing that there was an urgent need to establish museums in each of Britain's four West African colonies. This memorandum was supported in a 1946 report commissioned by the Colonial Office and prepared by Hermann Braunholtz, then Keeper of Oriental Antiquities and Ethnography at the British Museum. Given the straitened conditions in the immediate aftermath of the Second World War, the colonial governments did not, however, consider this a high priority, and the recommendations were slow to be taken up. In Sierra Leone, it was not until 1954 that Governor Robert de Zouche Hall, who had a personal enthusiasm for cultural heritage matters, pushed for the creation of a museum under the management of the newly reconstituted Sierra Leone Society. M. C. F. Easmon, a retired Krio medical doctor and chairman of the Sierra Leone Monuments and Relics Commission, was appointed as its first curator.
3 In relation to his use of the possessive pronoun, '*our* Freetown Cotton Tree', it is interesting to note that Sayers was regarded by his peers in the colonial service as somewhat having 'gone native' (John Hargreaves pers. comm.). A Temne and Koranko speaker, Sayers was a frequent contributor to *Sierra Leone Studies* in the 1920s and 1930s on ethnographic topics, and he also served on the Monuments and Relics Commission from its inception, in 1947, until his death in 1954.
4 Shaw makes a distinction between 'social' and 'individual' forgetting, arguing that, although people still have personal memories of violence, it is the voicing of this memory in public that is avoided, since this is viewed as encouraging its return (2005:9).
5 In the context of the more recent conflict, Bai Bureh's supernatural powers resonate with those associated with the 'hunter-warrior' *kamajors* of the Civil Defence Force, who, through ' "contractual" associations with specific bush spirits' were believed to be able to make themselves 'invisible and impermeable to bullets' (Ferme 2001:27; Leach 2000:588).
6 Opala's involvement in Sierra Leonean cultural heritage issues continues in his support of a campaign to have the 'slave fort' of Bunce Island in the Sierra Leone River designated as a UNESCO World Heritage Site (see http://freetown.usembassy.gov/bunce_island_preservation.html, accessed 21 July 2006).
7 In addition to Bai Bureh, other historical Sierra Leonean 'heroes' to be represented on the new issue of Sierra Leonean banknotes during the NPRC rule included Sengbe Pieh (Le5,000) and Kai Londo (Le500). Each represents a different ethnic/language group within Sierra Leone (respectively, Temne, Mende, and Kissi); it was not until 2002 that a Krio national hero was added, with a portrait of Isaac T. A. Wallace appearing on a new Le 2,000 note. All of these figures feature in the *Sierra Leone Heroes* book.
8 As well as being Abubakar Jalloh's *nom de gnerre*, Bai Bureh lends his name to the 'Bai Bureh Star' (a medal awarded by the government 'for military gallantry of the highest degree'), the 'Bai Bureh Warriors' (Port Loko's main football team), and the 'indigenous political ideology' of 'Burchism' promoted by the People's Democratic League, which draws its principles from the 'teachings, preachings, ideas, beliefs, and practices' of the nineteenth-century chief. Citing an unpublished article by Joseph Opala. Christensen notes that, during Siaka Stevens' presidency, a group of actors was jailed for staging a play about Bai Burch on the grounds of 'inciting rebellion' (2005:17, fn.10).

Paul Basu

9 This account also resonates strikingly with Thomas Alldridge's late nineteenth-century descriptions of the devastated Sierra Leonean landscape in the aftermath of what he refers to as 'a long and serious tribal war', attesting to the palimpsest-like accretions of violent associations in place:

> We had not gone far into the Krim country before, as I went along, I saw many white objects on the ground which at first I hardly noticed, but which upon inspection I found to be bleached skulls.
> In the line of destruction extending over many miles, not a town was to be seen, the sites that they had occupied being then overgrown wildernesses; banana plants and kola trees alone testifying to the fact that here, not long since, had been human habitations.

> *(Alldridge 1901:166)*

The 'tribal war' to which Alldridge refers was actually provoked by the expansion of colonial trade in the region (see Caulker 1981).

10 See David Bunn's fascinating discussion of the politics of the changing visibility of Xhosa graves and the 'evolution of an intricate reciprocity between British monumentality and Xhosa grave practices' in the Colonial Eastern Cape (Bunn 2002).

Bibliography

Abdullah, I. (ed.). 2004. *Between Democracy and Terror: The Sierra Leone Civil War*. Dakar: Council for the Development of Social Science Research in Africa.

Abraham, A. 1974. 'Bai Bureh, the British, and the Hut Tax War', *The International Journal of African Historical Studies* 7(1):99–106.

Ajulu, R. 2001. 'Thabo Mbeki's African Renaissance in a Globalising World Economy: The Struggle for the Soul of the Continent', *Review of African Political Economy* 87:27–42.

Alie, J. A. 1990. *A New History of Sierra Leone*. Oxford: Macmillan.

Alldridge, T. J. 1901. *The Sherbro and Its Hinterland*. London: Macmillan.

Alvares, M. 1990 [c. 1615]. 'Ethiopia Minor and a Geographical Account of the Province of Sierra Leone', P. E. H. Hair (ed. and trans.). http://digicoll.library.wisc.edu/Africana/.

Billig, M. 1995. *Banal Nationalism*. London: Sage.

Bourdieu, P. 1990. *The Logic of Practice*. Palo Alto, CA: Stanford University Press.

Bunn, D. 2002. 'The Sleep of the Brave: Graves as Sites and Signs in the Colonial Eastern Cape'. In *Images and Empires: Visuality in Colonial and Postcolonial Africa*, P. S. Landau and D. D. Kaspin (eds.). Berkeley and Los Angeles: University of California Press.

Caulker, P. S. 1981. 'Legitimate Commerce and Statecraft: A Study of the Hinterland Adjacent to Nineteenth-Century Sierra Leone', *Journal of Black Studies* 11(4):397–419.

Christensen, M. J. 2005. 'Cannibals in the Postcolony: Sierra Leone's Intersecting Hegemonies in Charlie Haffner's Slave Revolt Drama Amistad Kata-Kata', *Research in African Literatures* 36(1):1–19.

Cole, J. 2001. *Forget Colonialism? Sacrifice and the Art of Memory in Madagascar*. Berkeley and Los Angeles: University of California Press.

Connerton, P. 1989. *How Societies Remember*. Cambridge: Cambridge University Press.

Cook, S. E. 2005. 'The Politics of Preservation in Rwanda'. In *Genocide in Cambodia and Rwanda: New Perspectives*, S. E. Cook (ed.). Piscataway. NJ: Transaction.

Crossland. Z. 2002. 'Violent Spaces: Conflict Over the Reappearance of Argentina's Disappeared'. In *Matériel Culture: The Archaeology of Twentieth-century Conflict*, J. Schofield, W. G. Johnson, and C. M. Beck (eds.). London: Routledge.

D'Alisera, J. 2002. 'Icons of Longing: Homeland and Memory in the Sierra Leonean Diaspora'. *Political and Legal Anthropology Review* 25(2):73–89.

De Boeck, F. 1998. 'Beyond the Grave: History, Memory and Death in Postcolonial Congo/Zaïre'. In *Memory and the Postcolony: African Anthropology and the Critique of Power*. R. Werbner (ed.). London: Zed Books.

DeCorse, C. R. 1980. 'An Archaeological Survey of Protohistoric Defensive Sites in Sierra Leone', *Nyame Akuma* 17:48–53.

Denzer, L. R. 1971. 'Sierra Leone – Bai Bureh'. In *West African Resistance: The Military Response to Colonial Occupation*. M. Crowder (ed.). London: Hutchinson.

EAAF (Equipo Argentino de Antropología Forense). 2002. Annual Report.

Fairhead, J., and M. Leach. 1996. *Misreading the African Landscape: Society and Ecology in a Forest-Savanna Mosaic*. Cambridge: Cambridge University Press.

Ferme, M. C. 2001. *The Underneath of Things: Violence, History, and the Everyday in Sierra Leone*. Berkeley and Los Angeles: University of California Press.

Ferrándiz, F. 2006. 'The Return of Civil War Ghosts: The Ethnography of Exhumations in Contemporary Spain', *Anthropology Today* 22(3):7–12.

Fyfe, C. 1962. *A History of Sierra Leone*. London: Oxford University Press.

Gittins, A. J. 1987. *Mende Religion: Aspects of Belief and Thought in Sierra Leone*. Studia Instituti Anthropos No. 41. Nettetal (Germany): Steyler Verlag-Vort und Werk.

Gottlieb, A. 1992. *Under the Kapok Tree: Identity and Difference in Beng Thought*. Bloomington: Indiana University Press.

Halbwachs, M. 1992. *On Collective Memory*, introduction by L. A. Coser (ed. and trans.). Chicago: Chicago University Press.

Hallam, E., J. Hockey, and G. Howarth. 1999. *Beyond the Body: Death and Social Identity*. London: Routledge.

Hamber, B., and R. A. Wilson. 2002 'Symbolic Closure Through Memory, Reparation and Revenge in Post-Conflict Societies', *Journal of Human Rights* 1(1):35–53.

Hargreaves, J. D. 1956. 'The Establishment of the Sierra Leone Protectorate and the Insurrection of 1898', *Cambridge Historical Journal* 12(1):56–80.

Hughes, R. 2005. 'Memory and Sovereignty in Post-1979 Cambodia: Choeung Ek and Local Genocide Memorials'. In *Genocide in Cambodia and Rwanda: New Perspectives*. S. E. Cook (ed.). Piscataway, NJ: Transaction.

Hymans, J. E. C. 2005. 'International Patterns in National Identity Content: The Case of Japanese Banknote Iconography', *Journal of East Asian Studies* 5:315–46.

Jackson, M. 1989. *Paths Toward a Clearing: Radical Empiricism and Ethnographic Enquiry*. Bloomington: Indiana University Press.

Jarvis, H. 2002. 'Mapping Cambodia's "Killing Fields" '. In *Matériel Culture: The Archaeology of Twentieth-century Conflict*, J. Schofield, W. G. Johnson, and C. M. Beck (eds.). London: Routledge.

Kabba, M. R. A. (ed.). 1988. *Sierra Leonean Heroes: Fifty Great Men and Women Who Helped to Build Our Nation*, 2nd ed. Freetown: Government of Sierra Leone.

Keen, D. 2005. *Conflict and Collusion in Sierra Leone*. Oxford: James Currey.

Kelsall, T. 2005. 'Truth, Lies, Ritual: Preliminary Reflections on the Truth and Reconciliation Commission in Sierra Leone', *Human Rights Quarterly* 27:361–91.

King, A. 1998. *Memorials of the Great War in Britain*. Oxford: Berg.

Last, M. 2000. 'Healing the Social Wounds of War', *Medicine, Conflict and Survival* 16:370–82.

Leach, M. 2000. 'New Shapes to Shift: War, Parks and the Hunting Person in Modern West Africa', *Journal of the Royal Anthropological Institute* (N.S.) 6:577–95.

Malcolm, J. M. 1939. 'Mende Warfare', *Sierra Leone Studies* (O.S.) 21:47–52.

Muana, P. K. and C. Corcoran (eds.). 2005. *Representations of Violence: Art about the Sierra Leone Civil War*. Madison, WI: 21st Century African Youth Movement.

Noah, A. 2004. 'Bai Bureh Goes to War: Movie Overview'.

Nora, P. 1989. 'Between Memory and History: *Les lieux de mémoire*', *Representations* 26:725.

Opala, J. A. 1994. ' "Ecstatic Renovation!": Street Art Celebrating Sierra Leone's 1992 Revolution', *African Affairs* 93:195–218.

Radstone, S. and K. Hodgkin. 2003. 'Regimes of Memory: An Introduction'. In *Regimes of Memory*, S. Radstone and K. Hodgkin (eds.). London: Routledge.

Rashid, I. 2006. 'Silent Guns and Talking Drums: War, Radio and Youth Social Healing in Sierra Leone'. In *Postconflict Reconstruction in Africa*, A. Sikainga and O. Alidou (eds.), Trenton, NJ: Africa World Press.

Richards, P. 1996. *Fighting for the Rain Forest: War, Youth and Resources in Sierra Leone*. London: The International African Institute, in association with James Currey and Heinemann.

Robben, A C. G. M. 2000. 'State Terror in the Netherworld: Disappearance and Reburial in Argentina'. In *Death Squad: The Anthropology of State Terror*, J. A. Sluka (ed.). Philadelphia: University of Pennsylvania Press.

Rogers, J. D. 2004. 'Launching of Le10,000 Note and Le500 Coin – The Governor's Address'.

Sanford, V. 2003. *Buried Secrets: Truth and Human Rights in Guatemala*. New York: Basingstoke.

Sant Cassia, P. 2005. *Bodies of Evidence: Burial, Memory and the Recovery of Missing Persons in Cyprus*. Oxford: Berghahn.

Sayers, E. F. 1925. 'The Funeral of a Koranko Chief', *Sierra Leone Studies* (O.S.) 7:19–29.

Sayers, E. F. 1961. 'Our Cotton Tree', *Sierra Leone Studies* (N.S.) 15:131–34.

Shaw, R. 2002. *Memories of the Slave Trade: Ritual and the Historical Imagination in Sierra Leone*. Chicago: Chicago University Press.

Shaw, R. 2005. 'Rethinking Truth and Reconciliation Commissions: Lessons from Sierra Leone', United States Institute of Peace, Special Report No. 130.

TRC (Truth and Reconciliation Commission). 2004a. 'Witness To Truth: Report of the Sierra Leone Truth and Reconciliation Commission'.

TRC (Truth and Reconciliation Commission). 2004b. 'Truth and Reconciliation Commission Report for the Children of Sierra Leone'.

Vansina, J. 1974. 'Comment: Traditions of Genesis', *Journal of African History* 15(2):317–22.

Verdery. K. 1999. *The Political Lives of Dead Bodies: Reburial and Postsocialist Change*. New York: Columbia University Press.

Williams, P. 2004. 'Witnessing Genocide: Vigilance and Remembrance at Tuol Sleg and Choeung Ek'. *Holocaust and Genocide Studies* 18(2):234–54.

Wyse, A. J. G. (ed.). 2002. *Vistas of the Heritage of Sierra Leone*. Freetown: Fourah Bay College and Sierra Leone National Museum.

Young, J. E. 1993. *The Texture of Memory: Holocaust Memorials and Meaning*. New Haven, CT: Yale University Press.

53

Representing the *China Dream*

A case study in revolutionary cultural heritage

Amy Jane Barnes

Introduction

President Xi Jinping's 'China Dream' (*Zhongguo meng*), sometimes translated into English as the 'Chinese Dream' was first announced by President Xi Jinping in November 2012. It is, in many respects, a continuum of the ideological legacy-forming campaigns of previous Chinese premiers (Zeng 2014). Described as 'a vision for the nation's future' (Anon. 2014), the campaign aims to have impact both at home and abroad. Says a correspondent for the English-language newspaper *China Daily*: 'The Chinese Dream integrates national and personal aspirations, with the twin goals of reclaiming national pride and achieving personal well-being. It requires sustained economic growth, expanded equality and an infusion of cultural values to balance materialism' (Anon. 2014). The 'China Dream' message, which exhorts the Chinese people to subscribe to national goals in order to achieve their dreams, has been interpreted as a manifestation of the widespread concern 'across the political spectrum' in China, that, 'after three decades of economic reform and opening up', a 'moral crisis' created by the 'new "money-worship" society' has emerged (Callahan 2015: 2). As some commentators have noted (see Griffiths 2013, for example), at first sight, the official billboard posters designed to support the campaign are reminiscent of Mao-era propaganda posters (*xuan chuan hua*), with their bold graphical style and prominent slogans.

In this chapter, I consider whether these visual representations of the China Dream can, therefore, be described as a manifestation of revolutionary cultural heritage. A cursory glance suggests this is an accurate assessment but a deeper analysis reveals a more nuanced story, in which revolutionary visual culture – and all its attendant connotations – are interwoven with 'folk-art traditions', forming a mesh of connected, but diverse cultural heritages, informed by different local and globalised heritage discourses. Why is it that certain forms of revolutionary heritage in contemporary China are tolerated, even encouraged and others remain taboo? And how do these internal manifestations of revolutionary cultural heritage contrast with representations of Chinese heritage promoted within the bounds of globalised heritage discourse?

To begin, I introduce and discuss the billboard poster campaign designed to promote the China Dream. I provide an analysis of its apparent relationships with visual antecedents. Next, in order to consider the extent to which the China Dream campaign may be described as a

product of revolutionary cultural heritage, I consider definitions of cultural heritage, the Chinese understanding of 'heritage', how European notions of official heritage have been applied to the Chinese context, with a particular emphasis on post-1949 period: the year in which the People's Republic of China (PRC) was founded. I then focus this discussion on the phenomenon of red tourism – the promotion of sites associated with revolutionary history – as a clear manifestation of revolutionary cultural heritage in China and its ideological role in Chinese society. This analysis is used as a means of situating the China Dream poster campaign within the contemporary concerns of the ruling Chinese Communist Party (CCP) and the PRC's turn towards nationalism in recent decades. Following this, I come to a conclusion as to whether these visual representations of the China Dream can, indeed, be described as expressions of revolutionary cultural heritage.

Visual representations of the *China Dream*

Well in excess of 50 different poster designs feature in the particular 'China Dream' campaign that I consider in this chapter,[1] which visually promote a set of guiding principles for the 'China Dream' as delineated by Xi Jinping in March 2013. These build on Deng Xiaoping's principle of 'socialism with Chinese characteristics' (see Deng 1984): a prosperous, democratic, civilised, harmonious, revitalised and happy China. These are national goals, which Barmé (2013) has inferred that the Chinese people are encouraged to accept in order to pursue their own dreams for the future. I intend to explore the broad themes and stylistic tropes used across the designs, and analyse the posters as visual texts for what they can reveal about revolution as cultural heritage in China.

The China Dream is, via the posters in their different formats and versions, disseminated in both the public and private spheres, on the streets and in people's homes. Like *xuan chuan hua* dating from the Great Proletarian Cultural Revolution (*wu chan jie ji wen hua da ge ming*) (1966–1976),[2] visual manifestations of the China Dream have become ubiquitous: 'In various forms such as print on billboards and electronic screens, the red dream appears in every corner of urban public space: streets, shopping malls, buses and subways' (Wang 2015: 177). Wang, via an analysis of the work of artist Ni Weihua, argues that the China Dream campaign is a manifestation of the dual methods of control exerted on the Chinese people: advertising and ideology. 'The government has adopted the [sophisticated] advertising strategies of the commercial world and is making use of popular technologies, materials, and styles in its efforts to occupy urban space' (Wang 2015: 179–180). But equally, the extent of the campaign is reminiscent of Mao-era ideological campaigns, which were 'successful', according to Mittler (2012: 24–25, 269–270, 304–305) exactly because they were 'continuous' and repetitious.

Produced by the state design agency – the Public Service Advertising Art Committee (Lee 2014) – to promote the China Dream, the posters seem, superficially at least, to reference their Mao-era antecedents – albeit with a degree of greater subtlety – with their graphical style, and the conspicuous use of red and dominant slogans. Some commentators, see Griffiths (2013) and Xuecun (2013) for example, have observed that these visual manifestations of the China Dream, are reminiscent of Maoist-era propaganda campaigns, which, I suspect, in most observers' minds, is signified by 'revolutionary romanticism' (*ge ming lang man zhu yi*), a uniquely Chinese, state-sanctioned genre that 'blended the romanticism of *guo hua* [brush and ink painting] with socialist realist principles' derived from the Soviet model (Barnes 2014: 28).[3] Such allusions to revolutionary visual culture seem curious, given the apparent ambivalence towards the popularised exploitation of revolutionary culture. Being an unashamed promulgator of Maoist nostalgia perhaps expedited Bo Xilai's spectacular fall from grace, for example (see Branigan 2011; Barnes 2014: 172).

Representing the *China Dream*

The China Dream poster campaign features objects and artwork created at 'well known folk art institutions' (Johnson 2013). The poster designs include works produced by: the Yangliuqing woodblock print workshops near Tianjin; Wuyang peasant painters from Henan; Shaanxi and Hebei papercutters; Taohuawu wood carvers from Suzhou; and the Nirenzhang clay sculpture workshop in Tianjian (Johnson 2013; Lee 2014). Of particular note are reproductions of paintings by Feng Zikai (Johnson 2013; Lee 2014) – a Shanghainese cartoonist (Sullivan 2006: 36). Feng was persecuted during the Cultural Revolution and died towards the end of the that tumultuous period in 1975, only to be rehabilitated just three years later in the post-Mao, post-'Gang-of-Four' period of reconciliation (see Barmé 2002: 346). This mix of different styles and artistic genres, Johnson (2013) notes, are

> … a sign of the Party's ability to mobilize pretty much any social organization it wants, and to appropriate symbols that it once condemned. Almost all of the art used in the posters, with its depictions of traditional dress and poses, used to be derided by the Party as belonging to China's backward, pre-Communist past; now, these aesthetic traditions are a bulwark used to legitimize the Party as a guardian and creator of the country's hopes and aspirations.
>
> *(Johnson 2013)*

Similarly, Benjamin Carlsen, writing for *Global Post* (2013) remarks: '[the campaign is] … drawing on patriotic imagery of the Great Wall, the Forbidden City, and statues from China's great ancient dynasties', in what, he notes, is a direct effort to engage with 'nationalists'.

When I first began to research the China Dream campaign I thought the designs were more stylistically reminiscent of new year prints (*nian hua*); mass-produced, posters designed to be pasted up in homes and businesses for the duration of the Spring Festival (Chinese New Year). These have generally depicted 'household icons to theatrical illustrations, historical tales and legends, harbingers of good fortune, calendars and floral decorations' (Flath 2004, 4), although, under Mao, *nian hua* on revolutionary themes were dominant particularly in the early years of the People's Republic (see Hung 2000: 776; Flath 2004: 146). Their typical themes – renewal, abundance and an optimistic perspective on the future – strongly resonate with the 'China Dream' and seem to be a direct influence. But I have since come to the conclusion that it is too simplistic to argue that these posters echo either *xuan chuan hua* or *nian hua*. There is something more nuanced at play here.

The quotes from Johnson and Carlsen above suggest an alternative to the view that the posters are directly inspired by revolutionary romanticism; the campaign harks back to genres that pre-date the communist revolution of 1949 – chubby babies, pre-revolutionary dress, brush and ink painting, the legacies of what Maoists might identify as 'feudal ideas'. However, to assert that the designs and the works they feature circumvent revolutionary visual culture would be equally erroneous. These 'old' genres and folk styles, when merged with European expressionism (in early incarnations) and Soviet social realism, were co-opted, reworked and infused with new ideological meanings. New uniquely Chinese revolutionary genres were developed: the previously mentioned so-called new or revolutionary *nian hua*, peasant painting, industrial landscapes and papercuts, as well as revolutionary romanticism: '…the culmination of which was a unique body of political art, manipulated to serve the specific propagandistic needs of the regime' (Barnes 2014: 41). To take *nian hua* as an example, '…the old "feudal", "superstitious", motifs of New Years' prints, were replaced with revolutionary themes' (Barnes 2014: 37; citing Sullivan 1996, 149–150). 'These quickly and directly conveyed the positive aspects of life in the People's Republic in a format with which people were familiar' (Johnston Laing 1986, 15–16;

799

Barnes 2014: 37). 'To be effective, Mao [Zedong] understood that art propaganda must take on "…the visual vocabulary and stylistic idiom of the masses"' (Barnes 2014: 37; citing Johnston Laing 1986, 16). 'After the foundation of the PRC, the Party continued to support the production of new *nianhua* through state-sponsored exhibitions and competitions' (Johnston Laing 1986, 15–16; Barnes 2014: 37), out of which developed (alongside other influences like commercial graphics of the nationalist era (see Mittler 2012: 17; Barnes 2014: 41;) the familiar *xuan chuan hua*, so closely identified with the Cultural Revolution.

A brief look at the aesthetic and iconographic aspects of a small selection of the designs, with consideration of their key influences, will help to situate these visual representations of the China Dream within the historical trajectory of Chinese visual culture under communism. Figure 53.1 features a painting of two young male children in pre-revolutionary, prosperous dress, placing coins into a jar marked 'compassion' (*ai xin*), with the main slogan 'Dedication to one's work, patriotism, integrity, friendship' (*jing ye ai guo, cheng xin, you shan*). In pre-revolutionary *nian hua* a similar image of boy children might symbolise prosperity (the coins) and great blessings (the boy children). Bartholomew (2002: 57) notes that children at play in a garden had become an established theme in art as early as the Song dynasty (960–1279) and, by the Ming dynasty (1368–1644), the preference was for representations of 'noble sons, who would excel in their studies … bringing wealth and the highest possible honors to their kin' (Bartholomew 2002: 59). These boys seem to represent such a sentiment, especially when the image is taken in tandem with the slogan, which in such a context becomes an entreaty to China's urban youth; the 'little emperors' of the one-child generation, oft criticised for their perceived self-interestedness, pessimism and consumerism (see Liu 2011: 141 and Cockain 2012: 2–3). It is also interesting to note that here the cash is being given in the spirit of charity, rather than representing a personal or familial wish for financial security (as such a motif on a similar *nian hua* print might). In Figure 53.2, a *guo hua* painting by Feng Zikai is accompanied by the slogan 'China: great virtue' (*Zhongguo da de*). Figure 53.3 features an elaborate and multi-coloured papercut featuring auspicious symbols such as a bat

Figure 53.1 'Dedication to one's work, patriotism, integrity, friendship' (jing ye ai guo, cheng xin, you shan). Beijing 2014.

Source: photograph courtesy of Qiao Dan.

Figure 53.2 'China: great virtue' (Zhongguo da de), Beijing 2014.
Source: photograph courtesy of Qiao Dan.

Figure 53.3 'China fulfils its dream and all families prosper' (Zhongguo yuan meng, jia jia you fu), Beijing 2014.
Source: photograph courtesy of Qiao Dan.

(happiness and joy), peonies (riches and honour) and interlocked rings (representing male and female) (Williams 2006 [1941]: 61, 310, 329) – visual imagery congruent with the typical themes of *nian hua*. The slogan reads 'China fulfils its dream and every household prospers' (*Zhongguo yuan meng, jia jia you fu*) (Wang 2015: 177).

And so, while it is true that, taken as a whole, the China Dream poster campaign consciously adopts the visual characteristics of *nian hua*, literati *guo hua* painting, 'minority' art,[4] papercuts, revolutionary romanticism,[5] and peasant painting,[6] there is also something very contemporary and quite chic about them, with their brightly coloured focal images set against a plain white background. As a shop clerk observed to the novelist Murong Xuecun (2013), they look expensive; they have a glossiness reminiscent not of an ideological campaign, but of an advertising drive for a deluxe brand. Lee (2014) notes, that while:

> The bold socialist-realism propaganda of Mao-era mass campaigns featured blue skies, waving red flags and muscular raised arms. The Chinese Dream posters typically feature a stark white background, a QR code, a red stamp seal adding a flourished imprimatur, and a subtle frame of red text designating the folk art style.

Versions of the posters are also available to download to mobile devices and share on social media, in a number of different formats.[7]

While the campaign somewhat belies Landsberger's (2008: 55) contention that the CCP has largely abandoned the poster as a means of disseminating policy in favour of new media, his observation that, since the reform period,[8] the Chinese propaganda machine has had to adapt, in order to compete with the multitude of messages with which citizens are bombarded by the media, can be detected here too. Many of the techniques of marketers have been adopted for propaganda campaigns, in an attempt to catch and hold viewers' attention. Landsberger notes that the Chinese people have been:

> … confronted with a new and subtle type of propaganda that often was very difficult to identify as such at first sight. Political messages seemed to be less crude than before and were embedded in the avalanche of commercials with which spectators were inundated … the state's messages are not limited to addressing social problems. They are also intended to engender a sense of pride and patriotism in China's people.

It could, therefore, be argued that the *Zhonguo meng* campaign posters combine several visual languages: i) typically Chinese art forms – as a means of asserting identity and promoting patriotic feelings; ii) the dynamism and immediacy of the propaganda poster (fostering some nostalgic sentiments in viewers of a certain age); and iii) commercial marketing techniques, to lend a sense of contemporary 'coolness' to the campaign. In respect of the sheer number and large range of designs used for the poster campaign (and the multiple formats in which they have been made available), the revolutionary propaganda poster model is directly relevant. Propaganda posters during the Mao era were ubiquitous. They brought 'colour to otherwise drab places where most people lived and work' and 'were able to penetrate every level of society' (Landsberger 2008: 54). But crucially:

> Most people liked the [*xuan chuan hua*] posters for their striking visual qualities and did not pay too much attention to the slogans printed underneath. This enabled political messages to be passed on in an *almost subconscious manner* [my italics].

> (Landsberger 2008: 54)

Conversely, the China Dream campaign posters have, anecdotally at least, been met with a certain jaded ambivalence. Carlson has noted incidences of Chinese netizens mocking the campaign online (Carlson 2013), and Johnson (2013) has documented several examples of slashed or graffiti-tagged posters, which he describes as 'a rare [and very public] attack on propaganda'. Murong Xuecun (2013) writes:

> My friend Wang Xiaoshan, a publisher, thinks that officials are wasting time with archaic slogans that seem irrelevant to ordinary people's struggles. 'Don't they know what era we're living in?' he asked.
>
> But my old schoolmate, the party member Mr. Lin, sees it differently. 'Of course it's stupid!' he told me. 'But who cares? We can stick that stupid stuff on all those walls. Can you?'

To conclude this section, it is important to acknowledge that the confines of a book chapter do not offer the scope for a comprehensive analysis of the 'China Dream' campaign. But I have identified, in broad strokes, the influence of pre- and revolutionary visual culture on the China Dream posters. I have been concerned with visual similarities and differences. I have not considered, for example, the commissioning of the images, the role of the cultural authorities in the design of the poster campaign, nor have I looked in depth at the prominent slogans featured on each poster and looked for Maoist equivalents.[9] However, it is possible to trace a range of revolutionary visual influences brought together with pre-revolutionary, identifiably Chinese genres, many of which had also been adapted for ideological purposes during the Maoist era. The poster format and bold slogans of the *Zhongguo meng* billboard poster campaign are, thus, reminiscent of propaganda posters. Like them, these posters serve a similar purpose – to widely disseminate policy and, most cogently, as Landsberger (2008: 54) notes, 'grandiose visions of the future', but also of contemporary advertising campaigns. As such, they are a continuation of a recent trend to incorporate the techniques of commercial design to maximise the reach and effectiveness of political campaigns (as identified by Landsberger 2008). But to what extent can the China Dream poster campaign be identified as a manifestation of revolutionary cultural heritage, if such a concept exists?

Revolutionary cultural heritage?

The UNESCO definition of cultural heritage encompasses several main categories, including examples which are 'movable' and 'immovable' (objects, paintings, sculptures versus monuments, archaeological sites, etc.), underwater sites (such as shipwrecks and inundated settlements), intangible heritage (song, dance, oral traditions, etc.); natural heritage (landscapes with cultural significance); and heritage in imminent threat of destruction or displacement in times of war and conflict (UNESCO n.d.). That definition provides an overview of the potential scope of 'cultural heritage', but does not consider what makes it culturally significant – something which remains open to interpretation.

Graham and Howard (2008: 2) argue that things that are designated as 'heritage' comprise 'very selective past material artefacts, natural landscapes, mythologies, memories and traditions … [which] become *cultural, political and economic resources for the present*' [my italics]: The past serving the present – a very familiar concept to anyone with knowledge of 'Mao Zedong Thought'.[10] 'Make the past serve the present' (*gu wei jin yong*), wrote Chairman Mao in 1964, just two years before the launch of the Cultural Revolution, meaning that 'history should be seen and used as a tool to advance the interest of the working class today' (King and Walls 2010:

14). Graham and Howard (2008: 2), following Laurajane Smith's conceptualisation of 'authorised heritage discourse' (2006), go on to assert that things 'selected' and 'classified' as heritage do so because of the meanings ascribed to them in the present by 'dominant political, social, religious or ethnic groups'. The visual identity of the China Dream poster campaign, with its emphasis on national revolutionary and pre-revolutionary genres of art suggests that it may be analysed according to this understanding of cultural heritage. The images and slogans, and the overall look and feel of the campaign, have been deliberately chosen for their value in meeting the present ideological needs of the CCP. The campaign is mediated through the lens of Mao Zedong Thought, which continues to drive the grand narrative of revolution: 'an officially advocated guideline ... [which] has again been embraced by the party leadership and has profound impacts on the state's relationship with cultural heritage throughout China' (Ai 2012: 130). As Long (2012: 215) notes, 'to abandon Mao is to call into question the Party's legitimacy and its continued right to rule'.

Harrell (2013: 287) asserts that the conceptualisation of heritage in the UNESCO sense 'is profoundly Eurocentric': '[T]he cult of the old', of authenticity, is rooted in Western civilisation. However, Zhang (2003: 11) writes that the Chinese conception of heritage (*wen wu*) is *not* 'in stones'. It is, instead, embodied in practice and people or, as Varutti (2014: 9) puts it, 'in their cultural-symbolic dimension'. Authenticity, as a Western concept, is not necessarily important in China: 'heritage preservation in China often means heritage reconstruction' (see Harrell 2013: 288 and Varutti 2014: 12–13), and the past is lodged not in buildings, but in writings and inscriptions – in the values and moral teachings of the ancient philosophers and, as Varutti notes, 'important personalities', such as past leaders of the PRC (Zhang 2003: 11; Varutti 2014: 15). '[T]he idea of keeping a tradition and a collective memory constitutes a key aspect of the Chinese approach to heritage, characterised by a concern to remember' (Varutti 2014: 9). That said, with the foundation of the Republic in 1912, China entered a period of Western-style 'modernisation'. Along with new ideas about art and culture, leisure and work, new infrastructural developments and opportunities to travel, came European conceptions of heritage, inherent in buildings, landscapes and monuments valued for their aesthetic, historic, scientific qualities or their status as the oldest, biggest or best example of their type (Harrison 2013: 14, 18; see also Varutti 2014: 9). The new middle classes emulated their Western counterparts, by visiting historical sites (see Wang 1999: 118–119 and Denton 2014: 218). Members of the left-leaning but fiercely-patriotic May Fourth Movement, rejected what they perceived to be the shackles of 'tradition' and promoted a 'new culture', written in the vernacular and incorporating aspects of Western critical discourse (see Wang 1999: 118–119 and Varutti 2014: 21). Alongside these developments an interest in the quotidian culture of the Chinese people emerged. In the 1920s, left wing historians began to document Chinese 'folk traditions' – music, dance, theatre, art – with a view to using them in anti-nationalist, socialist propaganda (Tan 2009: 158), similar to those genres so prominent in visual representations of the China Dream. This work continued into the 1950s after the foundation of the PRC in 1949. Although, as Tan points out, this was less an exercise in preservation as appropriation to new ends (see Tan 2009: 158). Silverman and Blumenfield (2013: 6) note that the first National Cultural Heritage Survey and Registration initiative took place as early as 1950, and some sites associated with the revolution were 'protected as historical sites right after 1949, but they were only for arranged visits, not open to the general public' (Lin 2015: 332). Denton (2014: 218) notes that this type of tourism was predominantly staged to offer leaders the opportunity to be seen at 'revolutionary sites ... demonstrating their loyalty to the revolution'.

Ai (2012: 130) argues that Mao had a complicated relationship to Chinese cultural heritage although the popular view of China under the leadership of Mao Zedong can be summed up

quite simply in his famous rallying cry at the start of the Cultural Revolution: 'Destroy the Four Olds!' (old ideas, old culture, old customs, old habits). On the one hand, it could 'be a guide to the revolutionary movement',[11] but he also advocated that the people 'reject its feudal dross' (Ai 2012: 130, citing Mao Zedong 1940: 282). It has been estimated that 4,922 of 6,843 officially designated places of cultural or historical interest, in Beijing alone were destroyed by 'red' factions, by far the greatest number in August and September 1966 (MacFarquhar and Schoenhals 2006: 118; Barnes 2014: 54–55). However, as a counterpoint to this, recent scholarship has documented attempts made by the Shanghainese cultural authorities to 'actively protect and preserve *wen wu* ("cultural relics") during the "Attack on the Four Olds"' (Ho 2011: 687–705; Barnes 2014: 55). By the early 1970s, after the initial 'manic' years of the Cultural Revolution had subsided (Harding 1991: 111), the state 'directed no small attention to archaeology and its results' (Loewe 1976: 8; Barnes 2014: 103). The famous Terracotta Warriors of Xi'an were first excavated in 1974.[12] An explanation for this turn towards the ancient cultural heritage of China is provided by Long (2012: 205) in his assertion that

> revolutionary regimes … have a powerful reliance of history as part on their claim to legitimacy … During the revolutionary period itself, this might entail a breach with the past – a rejection of the corrupted, illegitimate *ancien regime*. However, in the long term, efforts are made to establish links with a purer past, an uncorrupted proto-revolutionary tradition.

Although focused on an entirely different era, this analysis may help to cast light on the contemporary Chinese state's manipulation of certain pre and revolution-era artistic genres and conventions for the China Dream poster campaign. A discussion of a sanctioned form of revolutionary cultural heritage, so-called Red Tourism (*hong se lu you*), will explain this further.

Before looking at red tourism as a facet of domestic heritage promotion, I turn here to a brief consideration of the location and complex ideological implications of China in world heritage discourse. Silverman and Blumenfield (2013: 6) root the Chinese state's 'enthusiasm' for world heritage status in 'three aspects of cultural policy': an outward-looking policy of soft (cultural) power; the economic benefits of heritage tourism on a regional and local level; the facility to incorporate sites in minority ethnic regions (by way of world heritage status), thus bolstering China's self-image as 'a multi-cultural country whose traditions go back thousands of years in an unbroken history' (Silverman and Blumenfield 2013: 6). Drawing on the work of Breidenbach and Nyiri (2007), Long notes that World Heritage sites in China are 'heavily managed' by the state for economic ends in often under-developed areas of the country (Long 2012: 207), but also to fit the 'accepted national narrative … sometimes a difficult negotiation' (Long 2012: 208).

Ai (2012: 129–130) notes that from the 1990s, under Jiang Zemin (1989–2002), the attention given to Chinese cultural heritage internally increased, a trend that continued during the presidency of Hu Jintao (2002–2012), Xi Jinping's immediate predecessor. At the time of writing, China has 47 designated world heritage sites, including the world famous Mausoleum of the First Qin Emperor (1987), the Great Wall (1987) and the Sichuan Giant Panda Sanctuaries (2006), all of which are evocative symbols of China in popular Western imaginings.[13] China was also an early signatory to the UNESCO Convention for the Safeguarding of Intangible Heritage in 2004,[14] and its list includes wooden movable type (2010), Peking opera (2010), calligraphy and papercuts (2009), sericulture (silk production) (2009) and intangible heritage associated with China's 55 recognised ethnic minorities, including Mongolian singing (2009), Tibetan opera (2009) and Uyghur Muqam (2008),[15] an umbrella term encompassing singing, dancing, 'classical music' and instruments.[16] This globalised heritage is used by the CCP to present a very particular image of China abroad (see Ai 2012 and Kong 2015, the latter for a

discussion of how the Chinese state instrumentalises heritage through cultural diplomacy), but internally, heritage is officially classified into set categories by way of a hierarchical and bureaucratic system (see Silverman and Blumenfield 2013: 6–7): 'movable heritage' by four grades of 'value' and 'immovable heritage' by type: ancient cultural and archaeological sites, ancient tombs and architectural structures, cave temples, stone carvings and murals, and 'important modern and contemporary historic sites and memorable buildings' (Silverman and Blumenfield 2013: 7). It is the latter group into which revolutionary sites and landscapes – the subjects of red tourism – are categorised.

Red tourism is, beyond doubt, an ideological instrument of the CCP.[17] As a state-sanctioned phenomenon, it developed during the late 1990s and is 'Promoted in an explicitly nationalistic tone and guided by different patriotic themes' (Wang 2012: 218–9; see also Lin 2015: 332).[18] At these sites 'revolution is deliberately preserved, commercialised and marketised' (Wang 2012: 231), and is remarkably profitable, with red tourism sites attracting 540 million visitors in 2011 and predicted, by the *People's Daily*, to make 200 billion yuan (around $31 billion) by 2015 (Lin 2015: 328–329). It is focused almost exclusively on historical sites associated with 'wars and/or revolution' (Wang 2012: 220). These include: Yan'an, the seat of the communists during the Sino-Japanese and civil war and 'most sacred' revolutionary site in China (Wang 2012: 22; see also Lin 2015 for an in depth discussion of Yan'an's development as a red tourism destination); Chairman Mao's birthplace, Shaoshan in Hunan province; Nanchang, site of a communist uprising in 1927; Jinggang Mountain, the location of the first Red Army base; and Zunyi, a stop on the Long March, where Mao Zedong was first elected as a leader of the CCP in 1935 (Zhou 2014). At these sites, visitors – predominantly comprised of organised groups and work units on publicly-funded 'political learning' excursions (Wang 2012: 229; Denton 2014: 222) – have the opportunity to don Red Army uniforms, mimic revolutionary leaders, sing songs and eat food reminiscent of the era, watch plays based on 'real' events, buy souvenirs (Wang 2012: 226), and participate in commemoration events as well as visit museums and experience 'natural scenery' (Denton 2014: 220; 222–223).[19] 'Red tourism, as experienced by the vast majority of Chinese tourists, is a collective, participatory, performative, and ritualized affair' (Denton 2014: 221). 'By commodifying such "historical heritage" of war and revolution for consumption in the tourist market, the CCP is able to revive memories about the revolutionary past in older generations, while passing them onto the younger generations who have grown up in a relatively affluent society where such memories are fading away' (Wang 2012: 219). Wang observes that there is a significant element of nostalgia to these visits, with older tourists who experienced the revolutionary period first-hand being 'the most pious participants in what can be called "red pilgrimages"' (Wang 2012: 230; see also Denton 2014: 216–217). But Lin (2015: 338–339) notes that 'red tourists' are 'people of all ages' with a nostalgia for the past which is 'imagined' not necessarily 'experienced'. Guide books aimed at younger travellers emphasise 'that red tourism can offer an authentic experience to counter the materialism and blare of modern urban life' (Denton 2014: 224–225). 'The main gist of communist ideological values including collectivism and revolutionary spirit is explicitly promoted in this state-driven and officially sanctioned heritage tourism development … [It is] an interesting example of active, nation-state involvement in provoking collective nostalgia' (Park 2013: 103). In a time of rapid socio-economic and cultural change, red tourism puts people in touch with the political history of the CCP. It 'offers antidotes on the one hand to the feeling of loss residing in the nostalgic memories and imaginations of the socialist past, and on the other to social stress brought on by the postsocialist inequality' (Lin 2015: 338).

In addition to promoting these revolutionary ideals, there is a pragmatic motive for the official promotion of red tourism. Wang perceives it as a facet of the growing culture of

consumerism in China and 'the trend of commodification under the impact of the market economy' (2012: 219). Like their early republican counterparts before them, tourism in China is promoted to the burgeoning middle class, as a 'quintessentially modern activity' (Silverman and Blumenfield 2013: 9–10) and red tourism is promoted via the media to citizens as a suitable use of their holiday time (Wang 2012: 221–222; see also Denton 2014: 216). Leaving aside the problematic ramifications for local populations (see Silverman and Blumenfield 2013: 10–11 and Lin 2015: 337), red tourism has been instrumentalised in order to encourage economic development in poorer, less developed regions (Park 2013: 103). To improve access to often remote revolutionary sites, the Chinese state has sponsored a series of significant infrastructure projects. Wang (2012: 224) cites in particular the expansion of road and rail links between Yan'an and the city of Xi'an – designated world heritage site of the tomb of the First Emperor and his army of terracotta soldiers – and between Yan'an and Beijing (via the 'Red Tourism Express').

But the promotion of red tourism is also related to the turn towards nationalism and is intended to bolster support for the CCP. Writes Long, '[i]n China, heritage and tourism are explicitly engaged in the creation of a national ideology emphasising patriotism and socialist rectitude' (Long 2012: 214), and as a means of 'boost[ing] [the state's] legitimacy and to protect itself from internal and external criticism (Long 2012: 212). Indeed, the 'National Red Tourism Development Outline 2011–2015' (General Office of the CPC Central Committee and State Council, 2011), decrees that 'Red Tourism will help reinforce public trust in the CCP and in socialism with Chinese characteristics and thus consolidate the common ideological foundation for both the Party and people of all nationalities' (cited by Lin 2015: 331).[20] As '[r]ed tourism in China … performs the function of transforming the socialist past into a story of nationalism and nation building' (Long 2012: 215), so the China Dream poster campaign repurposes the uniquely and characteristically Chinese genres of art it presents – revolutionary romanticism, *guo hua*, papercuts, *nian hua*, peasant painting, ethnic minority art – into apparatus of nationalism. 'Cultural pride and national interests reinforce each other' (Harrell 2013: 289).

'[C]onsiderable efforts' are made to fix and standardise the ways in which early revolutionary history at red tourism sites is interpreted and represented to serve present needs (Wang 2012: 228, 231) and to justify the political legitimacy of the current regime (Long 2012: 206–207). Wang (2012: 229) notes that the state is unable to control the narrative presented externally or commercially, which might ultimately serve to undermine it (Wang 2012: 231). Citing the example of a set of videos on sale outside the Museum of Revolutionary History at Yan'an, on the subject of the Cultural Revolution, Wang asserts that '[t]he very act of selling materials related to the Cultural Revolution in these places is considered as not only a challenge to the official narrative of the nation, but also, in some extreme cases, a "blaspheme" to the sacredness of revolution' (Wang 2012: 229). This suggests a disjuncture between sanctioned revolutionary history, located in the struggle to establish communism in China, and the particularly problematic periods of Mao's leadership of the PRC, most notably the Cultural Revolution – the height of the type of populist red culture in China most exploited by the ill-fated Bo Xilai (see Dirlik 2012). Mittler, drawing on Barmé (1996), states that while the posthumous cult of Mao, which emerged in the 1980s and 1990s, was exploited by some CCP members, it had originated with and was driven by 'the people' (2012: 324). More recently, there has been a trend for Red-themed popular culture – like television programmes, propaganda songs and restaurants (Lin 2015: 342), but, much like the production and sale of videos as described above, this has been a predominantly commercially-motivated phenomenon (Mittler 2012: 325). However, according to Callahan (2015: 9–10), the New Left in China, in order to maintain the 'continued relevance

of socialism' and the predominance of the CCP, are seeking to 'rehabilitate Mao, the Great Leap Forward and the Cultural Revolution'. The 'imagined equality and order of the Maoist period' are promoted as a corrective for 'China's current money-worship society' (Callahan 2015: 10). While it would seem at present that the Cultural Revolution represents unsanctioned, undesirable revolutionary history from the perspective of the CCP, this may quickly alter, should these shifts in the intellectual field be mainstreamed, like the China Dream and 'Harmonious Society' – the ideological philosophy of Xi's predecessor, Hu Jintao – before it (see Callahan 2015).[21] Callahan (2015: 3) has observed that Chinese intellectuals, engaged in attempting to resolve China's 'moral crisis', are looking to traditional values, which in the Chinese context mean equally 'China's pre-modern civilization, but also … China's modern revolutionary and reformist ideology. In contemporary China, tradition is both "socialism" and the more familiar premodern "Chinese civilization"' (Callahan 2015: 3). He describes this as 'a 'nostalgic futurology' that looks back to key events like the Great Leap Forward in order to look ahead to Chinese success in the twenty-first century' (Callahan 2015: 3).[22] This sense of 'nostalgic futurology' encompasses and encapsulates the ideological value inherent in both red tourism *and* visual representations of the China Dream. And therein lies the problem, perhaps, for the state: revolutionary cultural heritage which harks back to the Mao period is only acceptable when it is filtered, ideologically expedient and controlled.

Conclusion

In the two examples I have looked at here, the China Dream posters and red tourism, the sense of heritage is inherent in the practice of artists and craftspeople and the objects they create. It is present in particular landscapes, buildings and monuments, and in the ideologies they represent: a kind of Western cultural heritage discourse with Chinese characteristics, perhaps? This point is noted by Harrell (2013: 287):

> China needs to live up to international standards in heritage preservation … but meeting these standards is awkward, given the fact that the Chinese intellectual, architectural, and artistic traditions have never made much of a distinction between what is old, preserved, and authentic, and what is new, reconstructed, and copied.

Long (2012: 201) argues that:

> To understand the role of heritage in communist states, it is necessary to acknowledge the deeply ideological nature of officially endorsed heritage in all societies – in the sense that official heritage expresses the cultural, social and political beliefs of the politically powerful.

Communists states have, he continues, 'particular approaches to the past and heritage as a way of interpreting and remembering the past for today's and future purposes' (Long 2012: 201). He further elucidates:

> The relationship between history/historiography and heritage is always complex, even more so in … China because historiography is officially constrained and there is an official version of history … In the Party-controlled state, nearly all heritage, as with most history, has a political significance beyond what it is expected to have in more pluralist societies.
>
> *(Long 2012: 206)*

Cultural heritage in China is, undoubtedly 'a political tool' (Silverman and Blumenfield 2013: 4) and a mass of contradictions, 'such as praise for Tibetan civilization but not Tibetan society and promotion of the Imperial palace of Beijing as a prime tourist destination while selectively representing the regimes that produced it' (Silverman and Blumenfield 2013: 4). While China institutes 'Cultural Heritage Days' and 'key cultural relics protection units', it also tacitly permits the 'destruction of wide swaths of historically significant [and even protected] buildings and even mountain landscapes' (Silverman and Blumenfield 2013: 3–5). And, so it is clear from the above discussion that China has a 'complicated relationship with … [its] cultural heritage' (Ai 2012: 129): '[T]he positioning of culture and heritage … is a highly politicised and strategic effort' (Ai 2012: 129). Internationally

> Cultural heritage has become one of the main vehicles through which the CCP is marketing and promoting itself … seeking to anchor itself onto the legitimacy of thousands of years of history, while both conveniently bringing the rich diversity of cultural heritage under the umbrella of 'Chinese' and white-washing the stain of the Cultural Revolution.
>
> *(Ai 2012: 137)*

While in

> the cultural imagination of contemporary China … the Chinese state seems simultaneously to be engaged in mining the past for its lucrative images and narrative resources as well as calculating a future linked to a kind of 'Red' economy where propaganda roots, morphs, and thrives.
>
> *(Lin 2015: 343)*

In this chapter I have considered the extent to which the China Dream poster campaign appropriates the stylistic conventions and themes of *xuan chuan hua*. To a point, the posters do echo their Maoist antecedents, but the real story is more nuanced than it might first appear. The poster designs assert particular visions of China and the character of the Chinese people generated by the nationalist agenda. They thusly make use of genres and techniques perceived to be uniquely or characteristically China, regardless of their origin in pre- or post-revolution visual culture (indeed, these genres are often a hybrid of both). However, the analysis of red tourism demonstrates that the CCP has a record of utilising and exploiting revolutionary cultural heritage in controlled and prescribed ways, in order to further a particular narrative of nationhood and to justify its own legitimacy to rule. It is not beyond the imagination, therefore, to state, with some confidence, that certain elements of the posters, with clear roots in revolutionary visual culture, have been consciously appropriated for the campaign; it seeks to promote the one-party political system during a period of social turmoil and economic instability.

Acknowledgements

Many thanks to Will Buckingham for his help with Chinese translations and to Qiao Dan (Jenny), who was kind enough to take photographs of China Dream posters *in situ* on my behalf.

Notes

1 It is possible to view all the posters in this particular set at the following link: www.wenming.cn/jwmsxf_294/zggygg/pml/zgmxl/ [in Chinese] (accessed 29 June 2015). Other types of images, often on militaristic themes and/or featuring the image of Premier Xi, have also been produced as part of the 'China Dream' campaign.

2 The decade now considered as the Cultural Revolution began with political purges and culminated with Chairman Mao Zedong's death in 1976 and the arrest of the notorious 'Gang of Four', blamed retrospectively for the worst excesses of the previous decade. The Cultural Revolution was conceived by Mao as an opportunity to reassert his power within the PRC, test the loyalty of officials, and to instil within the younger generation the revolutionary spirit of their parents and grandparents. For an in-depth study of the key policies and events of the Cultural Revolution, see MacFarquhar and Schoenhals (2006).

3 It is important to remember that while revolutionary romanticism is arguably the most recognisable genre of the period, it is not representative of the entire visual output of the Maoist period.

4 It is significant that minority art, i.e. that pertaining to China's 55 recognised national minorities, features so prominently in such an ideological campaign focused on developing national pride and confidence. Such an initiative reasserts the officially sanctioned narrative that 'China has been a united multi-ethnic country since ancient times' (Information Office of the State Council of the PRC, June 2000).As Silverman and Blumenfield (2013: 7–8) put it: 'This governmental approach pushes ethnic minorities to become members of the modern nation, participate in the process of modernization, and *cease being an obstacle to the state's goal of nation-building* [my italics]'.

5 Several posters feature clay figures in dynamic poses that are strongly reminiscent of the 'eight model works' (*yang ban xi*) and the life-size revolutionary tableaux the *Wrath of the Serfs* and the *Rent Collection Courtyard*. One example, in particular, directly references the revolutionary opera, *The White Haired Girl* (*Bai mao nu*); a clay figure of the protagonist Xi'er, accompanied by the slogan 'Shout dreams' www.wenming.cn/jwmsxf_294/zggygg/pml/zgmxl/201309/t20130930_1501209.shtml, accessed 18 July 2015.

6 Examples such as this, www.wenming.cn/jwmsxf_294/zggygg/pml/zgmxl/201309/t20130929_1500831.shtml, accessed 22 July 2015, consciously reference the celebrated style of the Huxian peasant painters in the 1970s. See the University of Westminster's China Poster Collection [online] for examples of the latter: http://chinaposters.westminster.ac.uk/zenphoto/page/search/tags/Huxian+peasant+painting (accessed 3 August 2015).

7 For example, different versions of Figure 53.2 are available to download from www.58pic.com/tupian/dadezhongguo.html [in Chinese], accessed 22 July 2015.

8 The economic reforms ushered in by Deng Xiaoping from the late 1970s onwards.

9 For more information on this aspect of the campaign see the *New York Times* article by Murong Xuecun (20 December 2013), which identifies and analyses three distinctive slogan themes used in the *Zhongguo meng* posters.

10 As Dirlik (2012: 17) states,

> official [Chinese] historiography has drawn a distinction between Mao the Cultural Revolutionary and Mao the architect of 'Chinese Marxism' – a Marxism that integrates theory with the circumstances of Chinese society. The essence of the latter is encapsulated in 'Mao Zedong Thought', which is viewed as an expression not just of Mao the individual but of the collective leadership of the Party.

> After the 1981 'Resolution on Party History', which recognised Mao's errors of judgement during the Great Leap Forward and Cultural Revolution, Mao Zedong Thought was 'invoked … as the crystallisation of the wisdom of the whole Party' (Weigelin-Schwiedrzik 1993: 170), which, as Weigelin-Schwiedrzik (1993: 170) notes, allowed for a certain level of flexibility – aspects of Mao Zedong Thought could be amended and added to – and transferred legitimacy to Deng Xiaoping's premiership. Even during the Cultural Revolution, writes Mittler (2012: 267) 'MaoSpeak' (his 'citations and phrases') was open to interpretation.

11 Ai (2012: 130) notes that in October 1938, Mao remarked that

> Contemporary China has grown out of the China of the past; we are Marxist in our historical approach and must not lop off our history. We should sum up our history from Confucius to Sun Yat-sen and take over this valuable legacy.
>
> *(Mao Zedong [1938] 1975a: 209)*

12 Incidentally, the Royal Academy hosted *Genius of China* in 1973–4 – an exhibition of recent archaeological finds which 'helped to challenge and salve Western concerns about the fate and protection of Chinese cultural heritage' (Barnes 2012:312; 2014: 104).

13 For the full list see http://whc.unesco.org/en/statesparties/cn, accessed 3 August 2015. China ratified the 1972 UNESCO World Heritage Convention in 1985.

14 See www.unesco.org/eri/la/convention.asp?KO=17116&language=E, for the full list of signatories, accessed 3 August 2015.

15 For the full list see www.unesco.org/culture/ich/index.php?lg=en&pg=00311&topic=mp&cp=cn, accessed 3 August 2015.

16 For a full description of Uyghur Muqam see www.unesco.org/culture/ich/index.php?lg=en&pg=00011&RL=00109, accessed 3 August 2015.

17 Issued during 2005, the officially designated 'year of red tourism' (Denton 2014: 220), the 'Outline of the National Plan for Developing Red Tourism', issued by the CCP and State Council, instrumentalised red tourism to promote patriotism and legitimise the ideological turn towards nationalism from 1990s, as well as kick-start the economic development of rural regions (Wang 2012: 220–221).

18 According to Lin (2015: 332) the official account of 'red tourism' traces its roots to the pre-Cultural Revolution era, with tourism during the Cultural Revolution and post-Cultural Revolution, the second and third phases of its development respectively. See Denton (2014: 219) for a discussion of red tourism during the Cultural Revolution.

19 While red tourism does attract some foreigners, it is predominantly a domestic phenomenon (see Wang 2012: 221; Denton 2014: 215).

20 Presumably 'people of all nationalities' refers here to the 55 recognised ethnic minorities within China, alongside the dominant Han.

21 Indeed, some commentators have compared Xi Jinping's leadership style to that of Mao Zedong's, noting recent crackdowns in the civil and cultural spheres, as well as attempts to foster a cult of personality (see Wasserstrom 2016). Xi even has his own 'Little Red Book' style collection of quotations, writings and speeches (*The Governance of China*), available in both book and digital app formats (see Phillips 2015; Anon., n.d.).

22 Callahan notes that this reference to the Great Leap is rooted in the renewed attention given to Mao's then prediction – before the resulting devastating famine and economic disaster which lead to his ousting as Chairman of the PRC – that the Chinese economy would surpass that of the United States within '50 or 60 years': 'For many, Mao's dream of a strong China that could beat America was coming true' (Callahan 2015: 2–5, citing Mao 1956).

Bibliography

Ai, Jiawen. 2012. ' "Selecting the Refined and Discarding the Dross": The Post-1990 Chinese Leadership's Attitude Towards Cultural Tradition'. In Daly, P. and Winter, T (eds) *Routledge Handbook of Heritage in Asia*. London and New York: Routledge, pp. 129–138.

Andrews, Julia F. 1995. *Painters and Politics in the People's Republic of China, 1949–1979.* Berkeley: University of California Press.

Anon. 2014. 'Potential of the Chinese Dream', *China Daily USA* [online], 26 March, http://usa.chinadaily.com.cn/epaper/2014-03/26/content_17380146.htm, accessed 29 June 2015.

Anon. n.d. 'Xi Jinping: The Governance of China' [online], www.china.org.cn/china/node_7214554.htm, accessed 12 February 2016.

Barmé, Geremie R. 2013. 'Chinese Dreams (Zhongguo meng 中国梦)'. *The China Story* [online], www.thechinastory.org/yearbooks/yearbook-2013/forum-dreams-and-power/chinese-dreams-zhongguo-meng %E4%B8%AD%E5%9B%BD%E6%A2%A6/, accessed 18 July 2015.

Barmé, Geremie R. 2002. *An Artistic Exile: A Life of Feng Zikai (1898–1975)*, Berkeley: University of California Press.

Barnes, Amy Jane. 2014. *Museum Representations of Maoist China: From Cultural Revolution to Commie Kitsch.* Farnham: Ashgate.

Bartholomew, Terese Tse. 2002. 'One Hundred Children: From Boys at Play to Icons of Good Fortune'. In Barrott Wicks, Ann Elizabeth (ed.) *Children in Chinese Art*. University of Hawaii Press, pp. 57–85.

Branigan, Tania. 2011. 'Red songs ring out in Chinese city's new cultural revolution', *Guardian*, 22 April. www.theguardian.com/world/2011/apr/22/red-songs-chinese-cultural-revolution, accessed 31 July 2015.

Breidenbach, Joana and P'al Ny'ıri (2007) '"Our Common Heritage". New Tourist Nations, Post-"Socialist" Pedagogy, and the Globalization of Nature', *Current Anthropology* 48 (2): 322–30.

Callahan, William, A. 2015. 'History, Tradition and the China Dream: socialist modernization in the World of Great Harmony'. *Journal of Contemporary China*, 24 (96): 1–19.

Carlson, Benjamin. 2013. 'How the Communist Party sells Xi Jingping's "Chinese Dream"'. *Global Post.* 18 August 2013, www.globalpost.com/dispatch/news/regions/asia-pacific/china/130815/communist-party-xi-jinping-chinese-dream, accessed 31 July 2015.

Cockain, Alex. 2012. *Young Chinese in Urban China*. London and New York: Routledge.

Deng, Xiaoping, 1984. 'Build Socialism with Chinese Characteristics' [speech], 30 June 1984, http://academics.wellesley.edu/Polisci/wj/China/Deng/Building.htm, accessed 18 July 2015.

Denton, Kirk A. 2014. *Exhibiting the Past: Historical Memory and the Politics of Museums in Postsocialist China.* Honolulu: University of Hawai'i Press.

Dirlik, Arif. 2012. 'Mao Zedong in Contemporary Chinese Official Discourse and History'. *China Perspectives* [online], 30 June 2015, http://chinaperspectives.revues.org/5852, accessed 3 August 2015.

Flath, James A. 2004. *The Cult of Happiness: Nianhua, Art and History in Rural North China*. University of British Columbia Press.

Graham, Brian J. and Peter Howard (eds). 2008. *The Ashgate Research Companion to Heritage and Identity.* Farnham: Ashgate.

Griffiths, James. 2013. 'New "China Dream" billboards hark back to the Cultural Revolution'. *Shanghaiist.* 8 August, http://shanghaiist.com/2013/08/08/china_dream_billboards_remind_many_of_cultural_revolution_propaganda.php, accessed 31 July 2015.

Harding, Harry. 1991. 'The Chinese State in Crisis, 1966-1969'. In MacFarquhar, Roderick (ed.) *The Cambridge History of China*. Cambridge: Cambridge University Press, pp. 105-217.

Harrell, Steven. 2013. 'China's Tangled Web of Heritage'. In Silverman, Helaine and Blumenfield, Tami (eds) *Cultural Heritage Politics in China*. New York, Heidelberg, Dordrecht and London: Springer, pp. 285–294.

Harrison, Rodney. 2013. *Heritage: Critical Approaches*. London and New York: Routledge.

Ho, Denise Y. 2011. 'Revolutionizing Antiquity: The Shanghai Cultural Bureaucracy in the Cultural Revolution, 1966–1968', *The China Quarterly*, 207: 687-705.

Hung, Chang-Tai. 2000. 'Repainting China: New Years Prints (Nianhua) and Peasant Resistance in the Early Years of the People's Republic'. *Comparative Studies in Society and History*. 42 (4): 770–810.

Information Office of the State Council of the People's Republic of China. 2000. 'National Minorities Policy and its Practice in China'. *Xinhua* [online], June. http://news.xinhuanet.com/employment/2002-11/18/content_633175.htm, accessed 23 July 2015.

Johnson, Ian. 2013. 'Old Dreams for a New China', *China File*, 15 October. www.chinafile.com/old-dreams-new-china, accessed 31 August 2014.

Johnston Laing, Ellen. 1986. *The Winking Owl: Art in the People's Republic of China*. Berkeley, Los Angeles and London.

King, Richard and Walls, Jan. 2010. 'Introduction: Vibrant Images of a Turbulent Decade'. In King, R., Croisier, R., Zheng, S. and Watson, S. (eds) *Art in Turmoil: The Chinese Cultural Revolution, 1966–76.* University of British Columbia Press.

Kong, Da. 2015. *Imaging China: China's Cultural Diplomacy through Loan Exhibitions to British Museums.* Unpublished doctoral thesis, University of Leicester.

Landsberger, Stefan. 2008. 'Designing Propaganda: The Business of Politics'. In Zhang, Hongxing and Parker, Lauren (eds) *China Design Now*. London: V&A Publishing, pp. 53–55.

Lee, Joyce. 2014. 'Expressing the Chinese Dream'. *The Diplomat.* 28 March, http://thediplomat.com/2014/03/expressing-the-chinese-dream/, accessed 25 April 2014.

Lim, Louisa. 2014. *The People's Republic of Amnesia: Tiananmen Revisited.* New York: Oxford University Press.

Lin, Chunfeng. 2015. 'Red Tourism: Rethinking Propaganda as a Social Space'. *Communication and Critical/Cultural Studies*, 12 (3): 328–346.

Liu, Fengshu. 2011. *Urban Youth in China*, London and New York: Routledge.

Loewe, Michael. 1976. 'Archaeology in the New China'. *The China Quarterly*, 65.

Long, Colin. 2012. 'Modernity, socialism and heritage in Asia'. In Daly, P. and Winter, T (eds) *Routledge Handbook of Heritage in Asia*. London and New York: Routledge: pp. 201–217.

MacFarquhar, Roderick and Schoenhals, Michael. 2006. *Mao's Last Revolution*. Cambridge, MA: Harvard University Press.

Mao, Zedong. 1975a [1965]. 'The Role of the Chinese Communist Party in the National War [October 1938], *Selected Works of Mao Tse-tung, Vol. II*. Peking: Foreign Languages Press, pp. 195–211.

Mao, Zedong. 1975b [1965]. 'On New Democracy [1940]'. In *Selected Works of Mao Tse-Tung, Vol. II*. Peking: Foreign Languages Press.

Mittler, Barbara. 2012. *A Continuous Revolution: Making Sense of Cultural Revolution Culture*. Cambridge (Massachusetts) and London: Harvard University Press.

Park, Hyung Yu. 2013. *Heritage Tourism*. London: Routledge.

Phillips, Tom. 2015. 'China's Xi Jinping launches his "Little Red App"'. *Telegraph* [online], 3 April, www.telegraph.co.uk/news/worldnews/asia/china/11513857/Chinas-Xi-Jinping-launches-his-Little-Red-App.html, accessed 12 February 2016.

Silverman, Helaine and Blumenfield, Tami. 2013. 'Cultural Heritage Politics in China: An Introduction'. In Silverman, Helaine and Blumenfield, Tami (eds) *Cultural Heritage Politics in China*. New York, Heidelberg, Dordrecht and London: Springer: 3–22.

Smith, Laurajane. 2006. *Uses of Heritage*. London and New York: Routledge.

Sullivan, Michael. 2006. *Modern Chinese Artists: A Biographical Dictionary*. Berkeley, Los Angeles and London: University of California Press.

Sullivan, Michael. 1996. *Art and Artists of Twentieth-Century China*. Berkeley, Los Angeles and London: University of California Press.

Tan, Hwee-San. 2009. 'Intangible Cultural Heritage with Chinese Characteristics'. In Lira, Sergio and Rogerio Amoeda (eds) *Constructing Intangible Heritage*. Barcelos: Green Lines Institute for Sustainable Development, pp. 155–166.

UNESCO. n.d. 'What is meant by "cultural heritage"? UNESCO [online] www.unesco.org/new/en/culture/themes/illicit-trafficking-of-cultural-property/unesco-database-of-national-cultural-heritage-laws/frequently-asked-questions/definition-of-the-cultural-heritage/, accessed 26 June 2015.

Varutti, Marzia. 2014. *Museums in China: The Politics of Representation after Mao*. Woodbridge: The Boydell Press.

Wang, Horng-luen. 2012. 'War and Revolution as National Heritage: "Red Tourism" in China'. In Daly, P. and Winter, T. (eds) *Routledge Handbook of Heritage in Asia*. London and New York: Routledge, pp. 218–233.

Wang, Liping. 1999. 'Tourism and Spatial Change in Hangzhou, 1911–1927'. In Esherick, Joseph (ed.) *Remaking the Chinese City: Modernity and National Identity, 1900–1950*. University of Hawaii Press, pp. 107–120.

Wang, Meiqin. 2015. 'Advertising the Chinese Dream: Urban billboards and Ni Weihua's documentary photography'. In *China Information*, 29 (2): 176–201.

Wasserstrom, Jeffrey. 2016. 'Hong Kong and the Disappearing Booksellers'. In *Foreign Affairs* [online]. 26 January. www.foreignaffairs.com/articles/china/2016-01-26/hong-kong-and-disappearing-booksellers, accessed 12 February 2016.

Weigelin-Schwiedrzik, Susanne. 1993. 'Party Historiography'. In Unger, J (ed.) *Using the Past to Serve the Present: Historiography and Politics in Contemporary China*. Armonk: M.E. Sharpe.

Williams, Charles Alfred Speed. 2006 [1941]. *Chinese Symbolism and Art Motifs: A Comprehensive Handbook on Symbolism in Chinese Art through the Ages*. Tuttle Publishing.

Xuecun, Murong. 2013. 'The New Face of Chinese Propaganda'. *New York Times* Sunday Review. 20 December, www.nytimes.com/2013/12/21/opinion/sunday/murong-the-new-face-of-chinese-propaganda.html?pagewanted=1&_r=1, accessed 15 September 2014.

Yi, Xing. 2015. 'Yangliuqing Woodblock Prints Captured Between Covers', *China Daily USA* [online], 20 May 2015, http://usa.chinadaily.com.cn/epaper/2015-05/20/content_20772376.htm, accessed 29 June 2015.

Zeng, Jinghan. 2014. 'Factional Politics behind China Dream: Displaying Loyalties through Ideological Campaigns in China' [conference paper], College Court, University of Leicester, *The 'China Dream': Passions, Policies and* Power, 24 September 2014.

Zhang, Liang. 2003. La naissance du concept de patrimoine en Chine, XIXe–XXe siècles [The Birth of the Heritage Concept in China, 19th–20th centuries]. Paris: Éditions Recherches.

Zhou, Ruru. 2014. 'The Five Most Popular Red Tourist Destinations', *China Highlights*, www.chinahighlights.com/travelguide/article/red-tourism.htm, accessed 29 July 2015.

54

Contested trans-national heritage
The demolition of Changi prison, Singapore

Joan Beaumont

Introduction

On 14 June 2003 the broadsheet daily newspaper in Melbourne, Australia, the *Age*, featured an article by its Asia editor, Mark Baker, which revealed that the Singapore government was facing an 'outcry' from war veteran groups and conservationists because it intended to demolish Changi prison. Used to incarcerate civilian internees and prisoners of war during the Japanese occupation of Singapore from 1942 to 1945, the prison was described as 'one of the island state's last architectural links to the war'. The historian of the major Australian veterans' organisation, the Returned and Services' League (RSL), Keith Rossi, was quoted in the article as saying Changi was 'a monument and a memorial to all those who suffered and died under the Japanese'. Most of the Australian servicemen captured by the Japanese after the fall of Singapore in 1942, he claimed, had been held in Changi or had 'passed through the prison on their way to the horrors of the Burma railway, the mines of Japan and the labour camps of Borneo'.

> Now the Anzacs[1] have gone the public will look for an icon of World War II and it will be Kokoda or the POWs of the Japanese ... and at the centre of it all is Changi, the prison and the camp. Changi is one of the few names that still strikes a chord with Australian children.

The national secretary of the Australian Ex-Prisoners of War Association, Cyril Gilbert, was also quoted as saying that: 'Thousands of POWs were in that jail and a lot died there. We've got to keep those memories alive as much as possible. It will be a sad day if the prison is lost. It is one of the few symbols of the war and of what happened in Singapore that are left'.

These concerns about the proposed demolition of Changi prison were shared by conservationists in Singapore. The *Age* quoted Dr Kevin Tan, then a member of Singapore's Preservation of Monuments Board (PMB) and president of the Singapore Heritage Society as saying, 'We shouldn't only be preserving the more glorious sites of our history. We also need the underbelly. Changi Prison is one of the great icons of Singapore that has international recognition.' The Director of the Changi Museum, which had been opened about one kilometre away from the prison in 2001, Jeyathurai Ayadurai, also argued that if Singapore's authorities were not

814

willing to save the prison for its historic value, they should at least recognise its potential as a tourist drawcard. Changi was 'already a place of pilgrimage for many people from around the world'.[2] In the *Sydney Morning Herald*, which carried the story the same day, Jeyathurai was also quoted as saying: 'We are desperately trying to make the authorities understand the heritage value of this site. The whole world knows the story of Changi, and it is a story that resonates with people of any nationality. If this is destroyed it will be a great loss for us all.'

These press articles triggered a public debate, not only in Australia but also in Singapore, which provides an intriguing case study of the complexity of heritage issues that involve sites of what might be called contested trans-national significance. In the 60 years since the Second World War, Changi prison had acquired far more significance for Australians than for Singaporeans. 'Changi' (to use the popular shorthand for the prison and the barracks nearby) had become emblematic of the suffering of over 22,000 Australian servicemen and women who were captured in the Asia Pacific region, almost a third of whom had died in captivity. In the postwar decades Changi prison had become the focus of regular 'pilgrimages' by Australians, who made up a large number of the tourists visiting the area. In the words of Jane Lydon, then, Changi had become a site in which 'configurations of meaning, memory and identity that define national heritage are reinscribed on an international stage'.[3]

However, as this article will argue, this inscription on the international stage was not matched by a resonance at the local level, even though the prison had played a significant role in Singaporean history. Rather, given its colonial associations and its contemporary use as place of internment for criminals, Changi prison embodied 'multiple and shifting identities' for Singaporeans.[4] The tourist potential of the precinct around the prison was recognised by government and heritage authorities, but Changi prison itself had such negative associations and such a tenuous place in the national narrative that there was little will to preserve the 1936 building. Hence, when the Australian government responded to the popular outcry described above, it was constrained not only by the fact that it was challenging the accepted right of a sovereign government to manage national heritage sites; but also by the lack of any sense of a shared history surrounding Changi prison. Nor could it invoke a strong sense of 'transnational' heritage, a concept which has little place in international heritage regimes. Heritage that is shared or contested between two or more nations sits awkwardly between the pillars of sovereign control of national heritage and world heritage, the latter of which envisages a world polity[5] rather than a bilateral or multilateral relationship.

Changi and its environs also illuminate another recurring issue in heritage conservation: the manner in which physical sites can acquire a significance beyond that which an objective analysis of their historic role suggests is appropriate. Significance is displaced from 'real' to 'un-real' (or substitute) sites that lack the authenticity attributed to them but nonetheless have a significant emotional power invested in them at the level of individual memory and popular culture. In the case of Changi prison this process occurred because the original sites of significance were destroyed or became inaccessible to those for whom the memory of captivity remained strong. Seeking sites with which to invest meaning, their agency inspired responses from official heritage agencies, whose intervention, in turn, reshaped individual memories and generated new rituals and sites of commemoration. In this Changi is, finally, a testimony to the way in which the construction of memory is a dynamic interactive process between individuals, organisational stakeholders and the state.

Changi prison was a colonial creation, built by the British in 1936 and located on the eastern tip of Singapore Island. During the Japanese occupation the prison was used initially to intern some 3,500 civilians (mostly British citizens and Eurasians, including women and children), although its capacity was only 600.[6] In May 1944, these internees were transferred to another

camp, at Sime Road in central Singapore. The prison was then used until August 1945 to house Allied prisoners of war, some of whom were returning from the Thai-Burma railway. In January 1945 it is estimated that around 10,000 prisoners were interned either in the cells of the prison (which contained three to four men each, though they were built for one), in the corridors and common areas of the gaol, or in huts erected in the prison grounds.

In the post-war period the prison reverted to British control. From 1946 to 1947 it was used to incarcerate perhaps 1,000 Japanese who were awaiting repatriation or trial for war crimes. In those years its scaffold was used to execute 137 Japanese war criminals.[7] Thereafter, the British colonial authorities detained both criminals and political opponents, including Devan Nair (later a president of Singapore) and the left-wing leader Lim Chin Siong.[8] After Singapore gained independence in 1965 Changi prison continued to be used as a criminal detention centre. It was still in use in 2003 when news of its planned demolition broke. The reasons for the proposed demolition were pragmatic: the Singapore government claimed to need a detention centre that met modern-day standards of a maximum security prison; and it wished to consolidate the Singapore prison population, then spread across several locations, on one site.

The passion generated in Australia by the news of the proposed demolition revealed the tension between 'history' and 'memory' that so often characterises heritage debates. Memory, particularly of war, is always contested and selective; and in Australia it is popularly believed that that Allied prisoners of war were interned in Changi prison throughout their period of captivity: that is, from February 1942 to September 1945. A prominent ex-prisoner of war, Bill Toon, urged Singapore to save 'at least the main gates through which 15,000 Diggers marched on their way to misery'.[9]

In fact, the main internment camp for Western prisoners of war was not Changi prison but the Changi barracks located close by. As part of their elaborate plans in the 1930s to make the Singapore naval base the hub of imperial defence in the Asia Pacific region, the British erected a complex of military installations on the eastern tip of the island: Kitchener Barracks, Roberts Barracks, Selerang Barracks and India barracks. It was to this precinct, not the prison, that Australian, British and other prisoners marched in the heat of the tropical sun after their surrender on 15 February 1942; and it was from this hub that many prisoners of war were despatched by their Japanese captors to Burma, Thailand, Japan and Borneo.

It was at Selerang barracks that one of the most famous incidents of Allied captivity occurred. In August 1942 the Japanese insisted that the Allied prisoners sign an oath not to escape. When the POWs refused to do so, on the grounds that this undertaking violated their honour and was inconsistent with international law, the Japanese herded over 15,000 prisoners into the barracks and parade ground at Selerang. They kept them there for four days until the Allied leadership, faced with a health crisis, agreed to sign the oath under duress. Given that these events were captured on a secret camera by an Australian prisoner, George Aspinall, it was this 'Selerang Barracks incident' which became an enduring image of captivity in Australian memory.

Over the years, however, Changi barracks has become conflated in popular memory with Changi prison. 'Changi' has also become coded for the much wider experience of captivity throughout the Asia Pacific region. The Changi museum, for example, sells souvenir badges, under the museum's name, which depict a Ray Parkin image from the Thai-Burma railway of emaciated malaria sufferers assisting a cholera victim to walk in July 1943.

This conflation of Changi barracks with Changi prison owes something to the importance of locality and space in the shaping of memory. In the past three decades, as Singapore has progressively become a hub of mass intercontinental travel, and war tourism has grown with the explosion of the 'memory industry' globally, Changi barracks have been inaccessible to war veterans. Used by the Singapore defence forces as a military base, the barracks are under restricted access.

Moreover, the visitor who manages to penetrate the barracks finds that almost all traces of the buildings and parade grounds on which the celebrated Selerang Barracks incident occurred have gone. Selerang Barracks were demolished in 1987 and the parade ground has been partly built over by unexceptional modern buildings. Only a few other buildings of the original British barracks remain. The cemetery created by prisoners within the barracks has also been relocated. The bodies were exhumed in 1946 and moved to the Common-wealth War Graves Commission cemetery at Kanji in the middle of Singapore Island. Changi gaol, in contrast, has remained more visible and accessible to tourists. Being a gloomy penitentiary, with high walls, steel-clad corridors and concrete cells, it has also lent itself to the mythologising of the hardships of captivity more naturally than the relatively open spaces of Changi barracks.

History and popular memory have also diverged on the question of the number of deaths suffered at Changi. Although 'Changi' is often used as a byword for horror, the barracks were relatively comfortable. They were a well-established military facility, where the Japanese delegated day-to-day administration to Allied officers, and the prisoners were able to maintain infrastructure, such as sewerage systems and gardens, that was critical to their health. Living conditions in Changi prison were worse than the barracks, but even there the number of deaths was not great compared to other prison camps in the region. In 1945 it was estimated that of 87,000 prisoners who passed through the prison only 850 died.[10] One prisoner of war, Stan Arneil recorded in his diary: 'This a tremendous gaol ... The huts are a good job ... we have plenty of room and I still have a bed so we are fairly comfortable.'[11] So while the national secretary of the Ex-Prisoners of War Association might say of Changi gaol, 'So many of the men who passed through those gates never came back',[12] the appalling loss of life of Allied prisoners occurred not in Changi goal, or even at Changi barracks, but on the Thai-Burma railway, and lesser known places such as Sandakan in North Borneo and Ambon in the Dutch East Indies. Less than 5% of Australian POW deaths occurred in Singapore; 35% were incurred on the railway. At Ambon meanwhile 77% of prisoners died, while at Sandakan, only 6 of about 2,500 Australian and British prisoners survived the war.[13]

Yet for all this, it was Changi gaol that, through a process of displaced significance, acquired iconic status for ex-prisoners of war from Australia particularly. A similar process of displaced significance has been evident in a related building that has become a focal point for commemorative practices in Singapore, the Changi chapel. The story of the chapel, or rather chapels, is a complex one. During the four-and-a-half years of captivity in Singapore, the Allied prisoners built many chapels.[14] One of these was erected in 1943 at the Sime Road camp by a group of prisoners who later relocated it to Changi prison.[15] Made from materials scrounged from around the camp, it was dismantled in 1946 and brought back to Australia by an officer of the Australian Army Graves Services Unit. It remained in storage at the Australian War Memorial for more than 40 years. It was then reassembled, with money raised through public subscription, in the grounds of the military academy, the Royal Military College, Duntroon, in the national capital of Australia, Canberra.[16] Through the instigation of the leading veterans' associations, including the RSL and the Ex-POWs Association, it was dedicated in 1988 as a national memorial to prisoners of war. Australians often believe that this was the only Changi chapel but its only claim to authenticity is that it was one of two wartime chapels to survive[17]—though even this 'authenticity' is qualified. When the Australian Heritage Commission placed the chapel on the National Estate Register it noted that 'the removal of the Chapel from its original location at Changi had reduced at least one aspect of its value'.[18]

In Singapore, meanwhile, another 'Changi chapel' was acquiring considerable significance. This chapel was not a wartime construction but had been developed within the confines of Changi prison in the 1950s by a chaplain to the prison, perhaps aided by inmates. Although this

converted hospital ward had no particular aesthetic value, and had never been located in a prisoner-of war camp, it nonetheless became a focus of visits by veterans and tourists who were granted access by prison authorities. Progressively the chapel began to be decorated with plaques in commemoration of those who died in the prison; and in 1957 it was formerly dedicated to the memory of POWs and civilian internees. The RSL donated twenty pews, a carpet and wall fittings and after this refurbishment the chapel was rededicated.[19]

However, the security problems associated with allowing visitors into what was a functioning gaol increased with growing tourism. By the mid-1980s as many as 200 tourists from coach tours could pass through Changi prison in a day. The prison authorities therefore decided to move the chapel to a small modern building outside the prison walls. When this proved to have had the effect of severing the emotional link of the chapel with the wartime experience, the Singapore Tourist Promotion Board (STPB) conceived the idea of building a new chapel. Opened in February 1988 and located outside the prison's north wall, where many of the POW chapels had been located in wartime, this chapel with gabled roof was modelled on one St George Chapel, which had been erected by prisoners in Changi gaol in 1944–45. The STPB involved ex-POW associations from Australia and Britain in creating this new chapel and a modest adjoining museum. Ex-POWs were enthusiastic about the initiative. George Aspinall, for example, donated his photographic collection on life as a POW to the Museum. The altar cross was provided by a British prisoner's son, and was in fact the cross used in an original Changi chapel. Thus rebuilt, the chapel succeeded in becoming the focal point for visitors, with veterans and their relatives continuing to place crosses and cards in it.[20]

In time the pressure from the prison for land increased and in 2001 this new chapel was painstakingly dismantled and relocated at a site some 800 metres to a kilometre away. It now forms the emotional centre of a relatively new Changi museum where it has become the site of multi-national commemorative activities, such as on the anniversary of the fall of Singapore on 15 February 1942.

This ambiguous history of the chapel and Changi prison perhaps explains why the Singapore authorities were taken by surprise when the latter became a cause célèbre in memory politics.[21] When in the late 1990s the officials in the Ministry for Home Affairs, which has responsibility for managing prisons, decided that they should demolish the 1936 building, they seemed unaware of its potential heritage or tourist value. Their planning continued without the statutory authorities responsible for heritage conservation, including the National Heritage Board and the Preservation of Monuments Board, being notified, though these bodies were aware, through informal contacts, of plans to at least renovate the prison. However, they were not aware of plans to completely demolish it until perhaps 2002 or 2003.

When the PMB and Jeyathurai Ayadurai learned of the proposed demolition, they were appalled. While they conceded that the pressure of land on Singapore Island meant that at least some proportion of the old gaol would need to be demolished in order to allow for renovation, they hoped that some parts of it might be retained. Several alternatives to complete demolition were mooted: firstly, preserving the 7.3 metre-high perimeter walls and watch towers, one prison block and the gates, which had acquired popular significance as the place where prisoners entered and gained freedom on leaving the gaol;[22] or, secondly, retaining a discrete block in which visitors could experience some of the claustrophobia and chill of the cells. This, after all, was what was known to appeal to tourists who were excited by going through an army of guards and the gates to the eerie interior of the gaol, a kind of chamber of horrors.[23] (The success in tourist terms of the Old Melbourne Gaol in Victoria, Australia, and Kilmainham Gaol in Dublin similarly owes much to their ambience of dank darkness; as well as, of course, to their association with folk and national heroes such as Ned Kelly, in the case of Australia, and the executed

leaders of the 1916 Easter uprising, in the Irish case.) Thirdly, it was suggested that the outside walls of Changi prison might be retained as a shell within which the interior space could be redeveloped. As one of the protagonists in the public debate in Singapore, senior legal counsel, (the late) R. Palakrishnan, argued, the modern trend was not to demolish structures which are unique and of historical value, but to build around them in such a way that the existing facades are retained. 'You do not pull down the Pyramids', Palakrishnan said, 'and then show your great-great-grandchildren how they looked by showing them photographs of it'.[24] Finally, and somewhat bizarrely, there was a proposal to turn the prison into a backpacker hostel.[25]

However, when conservationists began to protest against the planned demolition, it seemed that planning in the Ministry of Home Affairs (one of the more powerful players in the Singapore bureaucracy) was so well advanced that the bureaucratic momentum was impossible to resist. In arguing the case against the demolition conservationists found they could draw on only limited public support in Singapore. This was not for lack of an official and public interest in heritage and conservation per se. Although the pursuit of modernity and technological progress in the immediate post-independence period had resulted in much of Singapore's colonial heritage being demolished, by the 1980s this relentless 'demolish-and-rebuild philosophy' was generating considerable disquiet. It was recognised that the city was becoming troublingly antiseptic and soulless. Its bland modernity was a liability for tourism, an industry that Singapore needed to develop when, after years of rapid growth, it confronted a slowdown in manufacturing and an erosion of its international competitiveness in labour-intensive operations. The growing prosperity of Singapore also meant that heritage matters, relatively low in the hierarchy of human needs, could be addressed. In 1987 the Singapore Heritage Society was created in an effort by architects and other conservationists to slow the speed at which the heritage environment was being destroyed.

Moreover, the Singapore government authorities were increasingly conscious of the value of appropriating heritage preservation as part of nation building. In a multi-racial society which, more than many others, was an 'imagined community'— to use Benedict Anderson's now classic term—heritage conservation could help create a sense of a shared past: and, moreover, a past that could be constructed as 'Asian' and a bulwark against the Westernisation that was accompanying modernity. From the 1980s therefore there was a growing interest by the Singapore government in heritage conservation. However, it was an interest that tended to take the form of a state-sponsored repackaging and re-invention of the cultural landscape around 'narratives' and 'stories' intended to intrigue the visitor, and cultural themes, such as ethnicity, and 'conservation areas', such as Little India or China Town.[26]

The Second World War was taken up by tourist authorities as one such theme. Despite the fact that it pre-dated independence, it was inscribed as part of Singapore's nationhood in that it weakened the grip of British imperial rule and set the colony on the path to independence. In the years after 1990, a range of military sites and fortifications were restored, often in anticipation of the anniversaries of the Japanese conquest. The underground headquarters of the British Malay Command at Fort Canning in central Singapore, the place at which Lieutenant-General A. E. Percival decided to surrender in February 1942, were opened to the public in time for the 50th anniversary of that event. The 6-inch guns at Fort Pasir Panjang, Labrador Park were promoted to tourists, together with two tunnels discovered at the site in 2001. The Old Ford Motor Factory (dated 1941) on Bukit Timah Road, the site of the meeting between the Japanese commander Yamashita and Percival on 15 February 1942, was gazetted as a national monument in February 2006 and housed a display about the history of the war. Fort Siloso, the nineteenth century fortification on Sentosa Island, was re-invented as 'Singapore's largest military-themed site'[27] while a museum commemorating the role of the Malay Regiment in

Battle of Pasir Panjang Hill on 14 February 1942, Reflections at Bukit Chandu, was dedicated on 15 February 1942.[28] Pasir Panjang Hill itself was one of six key battles sites signposted as sites of significance.[29] All of this reinvention of the past combined memory, nation building and tourism in a seamless mix. The official website 'Visit Singapore' says chirpily:

> Behind the cosmopolitan modernity of bustling Singapore, lies a rich and poignant past. We invite you to venture back in time, to discover surprising sites and structures and unimaginable ruins and relics from the war years scattered across the island. Each one tells its own captivating story, yet weaved together, they form a colourful and intricate tapestry of what Singapore has become today.[30]

At the same time the STB has promoted 'cultural trails' or, as Lily Kong and Brenda Yeoh would call them, 'itineraries that organise history'.[31] Among these are 'Battlefield Tour' and 'Behind Barbed Wire: The Eastern Trail', the latter of which is focused on the Changi region: taking in the memorial plaque outside Selerang camp, Johore Battery (a 1939 labyrinth of tunnels used for storing ammunition in support of 15-inch guns), Changi beach where a massacre of Chinese civilians occurred,[32] Changi Museum and, finally, the Changi prison. It is revealing that this trail is promoted cheek-by-jowl with gastronomic and cultural tours such as 'Dhobis, Saris and a Spot of Curry' (Little India Walk), 'By the Belly of the Carp' (Singapore River walk), and 'Sultans of Spice' (Arab Street area).

This rediscovery of the heritage of war was not entirely synthetic. Many Singaporeans, particularly those of Chinese ethnicity, have ancestors who were victims of the Japanese occupation. The date of the surrender of Singapore to the Japanese, 15 February, also has continuing resonance with the local population in the form of Total Defence Day. The failure of the British to provide for the defence of the island is regularly invoked by the state to nurture a culture of national self-reliance and vigilance against external threats. A secondary school textbook reads: 'from the British defeat we learn [that] a country must always be well-prepared for any attacks from enemies … it must not depend on others to protect its people … The people must be trained to defend their own country'.[33] To reinforce this message schoolchildren are taken on tours of battle sites and the Changi Museum, thus being sensitised to the suffering of the population under Japanese occupation.

There has also been a conscious attempt by conservationists to create a sense of Singapore's 'ownership' of the history of the war, despite its obvious imperial associations. As Hamzah Muzaini and Brenda S. A. Yeoh have put it, they have sought to 'localise' the memories of the war by 'extracting the "local" out of what is essentially a global war'.[34] The displays at the Changi Museum, for example, are thematic, covering topics such as Hunger, Executions, Suffering under Japanese hands, Forced to be labourers, Living with fear. These include details not only about Allied prisoners but also local heroes, the Chinese and other civilians. They invoke universal experiences such as suffering and fortitude, thus 'de-centring' the foreign POW experience. The chapel at the museum also displays a box of sand from the nearby Changi beach at which Chinese civilians were massacred by the Japanese. For a donation visitors to the chapel can light a candle in memory of these local victims. Singaporeans are meanwhile encouraged to attend commemorative services held at the chapel. There is even an attempt to attract locals to the premises for weddings and other social purposes.

Yet for all this, Singaporean opinions about Changi appear to be ambivalent. Perhaps this is because of the strong Christian ambience of the chapel and the associated rituals commemorating captivity. More generally, there appears to be a considerable ambiguity about the memory of defeat and occupation. The experience of local internees who occupied Changi prison until

May 1944 has been largely forgotten, with the notable exception of a moving documentary, *Sayonara Changi*, made by the former CNN news anchor and correspondent, Lian Pek, just before Changi prison was demolished. These internees, after all, were often Western, Eurasian and servants of the former colonial regime.

Hence, for the Singapore public the heritage issues that resonate are not so much those associated with the war but those that are invested with significance in their personal life stories. The restoration of Chinatown in the 1980s, for example, provoked considerable controversy because it had the effect of driving out local traders and small business, while gentrifying the precinct and destroying the more organic elements of the community.[35] The Urban Redevelopment Authority (URA)'s proposal in 1999 to demolish the National Library, an unexceptional redbrick building in Stamford Road that was evocative of British architecture in the 1950s, also provoked a huge groundswell of public dissent because of the loss of social memory and an intimate public space. The fact that even the Library was demolished in 2004 to make way for the construction of the Fort Canning tunnel indicates the fragility of heritage claims when opposed to development priorities.

There was therefore little prospect of a locally grown 'Save Changi' protest movement. Eventually, after making limited headway with the customary behind-the-scenes lobbying, one of the main protagonists defending Changi from demolition sought the support of the Australian press. The furore of mid-2003, already described, had the desired effect. Australian veterans bombarded their Minister for Veterans' Affairs with enquiries and expressions of concern.[36] The issue of the gaol's demolition was taken up at the highest government-to-government level. Leading the campaign was Foreign Minister Alexander Downer, whose father had been a prisoner of the Japanese and later a Minister of Immigration and High Commissioner to London in the 1950s and 1960s. Downer believed that his father's imprisonment had been 'a defining moment in the history of my family' and he had already made a 'personal pilgrimage' to Changi in 1996.[37] In a classic instance of personal biographies converging with national memory, Downer raised the matter with the Singaporean Ministers for Foreign Affairs, Defence, and State, Trade and Industry (responsible for tourism) at the Singapore/Australia Joint Ministerial Committee on 28 July 2003.[38] In the next few months at least five other federal ministers, including the Deputy Prime Minister, John Anderson, also raised the issue with their counterparts when visiting Singapore.[39] The Australian High Commission went into battle locally. Singapore ministers were shamelessly lobbied, as were the Director of Prisons, the URA, STB,[40] the National Heritage Board, and the PMB.

Local activists added to the pressure in the local press. The *Straits Times* journalist, K. C. Vijayan published a series of articles in 2003 and 2004 arguing that the prison could be redeveloped within the existing walls in a way that was sympathetic to its architectural and historic value; that there were other sites that might be developed for a consolidated prison; that the supposed demand for more space might be a case of supply creating its own demand; and that Changi had local significance because People's Action Party leaders had been detained there by the British colonial authorities in the 1950s.[41]

The Australian lobbying was a remarkable example of intervention on the part of a foreign government in the decision-making processes of another country. But generally it was handled in a manner that was diplomatically sensitive. For example, the Minister for Veterans' Affairs, Dana Vale, stressed in the media that:

> No-one can question the commitment of the people and Government of Singapore to remembering their wartime history and those who fought and suffered in the defence of Singapore ... During [the] 60th anniversary commemorations of the Fall of Singapore,

I had the opportunity to visit a number of sites that have been preserved in memory of the experience of the people of Singapore and Australian and Allied personnel.[42]

Ultimately, the diplomatic intervention had an effect. Singapore authorities, perhaps in recognition of the long-standing defence relationship with Australia, began to consider a solution that might, in the words of the Director of Prisons, 'preserve the memory of the wartime Changi'.[43] While Melvin Wong, head of public affairs for the Singapore Prisons Department, had said originally that the Prison Department would take steps to preserve the prison's heritage only 'through documentation',[44] as the diplomatic campaign mounted he admitted that 'We know that the prison holds a special place in the collective memory of our people, as well as many Australians'.[45]

By late 2003 a compromise was agreed: the prison would be demolished but one section of the perimeter walls, 180 metres long, would be retained, complete with the turrets that had been used as Japanese guard posts.[46] This would be the most publicly visible wall, running along Upper Changi Road North, the road that takes tourists to the Changi museum and chapel. The emblematic prison gates would be transferred and affixed to that wall. In addition, fittings and artefacts from the prison would be sent to Australia and the United Kingdom for display in museums and other locations. (A cell door, for example, was later presented to the Australian War Memorial. The Victorian RSL, in recognition of Bill Toon's public advocacy, received an old cell door lock, by courtesy of the STB.[47] Other artefacts were sent to the Far East Prisoners of War Association in Britain,[48] while the Changi Museum inherited a cell door, a piece of wall and the original chapel pews.)

The Australian government seemed satisfied with this compromise solution. Although ex-POWs might say that their politicians had not done enough to preserve Changi,[49] the Australian High Commissioner, Gary Quinlan, publicly stated when the news of the compromise solution was announced: 'We're very pleased. This is what we've been asking for.' Calls to preserve the entire prison were never likely to succeed. 'It's a working prison. It has to be rebuilt, and we always recognised that.'[50] Foreign Minister Downer meanwhile declared that Singapore had shown a 'sympathetic—understanding of Australian interests' and that it had 'not been an easy decision in land-scarce Singapore'.[51]

There is unanimity among Singaporean conservationists that the Australian intervention was critical in preventing the complete demolition of Changi. However, there are a variety of views about the heritage and commemorative value of the compromise solution. The prison was demolished in 2004 and a stand-alone wall does not convey the discomfort of the overcrowding the prisoners endured and the harshness of their living conditions. In many ways the wall risks becoming nothing more than 'a marker'. The gates are now attached to the wall face and tourists cannot re-enact the POW experience by walking through them. Indeed, at the time of writing (February 2008) tourists cannot even see the wall easily. It is obscured from the road by a tall green fence. The space in front of it is not an open plaza but is cluttered with low-rise buildings and a car park. Nearly four years after the demolition of the prison, the vacant land behind the wall has not yet been redeveloped. Whether this is because the overheating of the construction industry in Singapore has delayed the building of the new prison, or because the demand for this facility that the authorities insisted in 2003 was so pressing has not materialised, remains a matter for debate.[52]

Possibly the remaining wall will evolve into a place of meditation and contemplation for war 'pilgrims' as they are now so popularly called. It may generate new commemorative practices, such as have sprung up spontaneously at the Vietnam Wall in Washington DC and in Hellfire Pass on the Thai–Burma railway, where visitors have wedged remembrance poppies and Australian flags into the walls of the cutting. There are aspirations to have an interpretative

centre at the wall; or alternatively have a shuttle bus operating between the wall and the Changi Museum, which arguably provides the focus for commemorative practice already. There is a further hope to enhance the wall by adding the names of all 130,000 plus prisoners held in Singapore during the Second World War. The latter, a massive undertaking and one that might be dependent upon private rather than public initiative, could invest the Changi wall with some new meaning and significance. Memorials that have the power to generate new meanings for successive generations of visitors are generally those that list the names of the dead and missing: *vide* the Menin Gate at Ypres; the Roll of Honour at the Australian War Memorial and, again, the Vietnam Wall in Washington.[53] Names invest collective monuments with personal meaning, providing visitors, even if they were not themselves participants in the events being commemorated, with a means of individuating the memory of war.

Conclusion

The demolition of Changi prison highlighted the intractable issue of 'ownership' of a heritage site when that site has a contested trans-national significance. Although the Second World War has some place in Singapore popular memory and official heritage planning, Changi prison itself meant far more to Australians than it did to any local authority or Singaporean.

Given that some 100,000 Australian defence personnel died outside Australian territory in the twentieth century, this is a recurring heritage issue for Australians. A consultancy conducted for the Department of the Environment and Heritage in 2005 concluded, on the basis of focus group discussions, that 35 of 97 sites of potential significance in Australia's history of war were located overseas.[54] The question as to how to protect these has been particularly acute in relation to Anzac Cove, the site of the landing on the Gallipoli peninsula on 25 April 1915, which has acquired an almost sacred status in Australian national memory. Some years ago the Australian government attempted to list the Anzac battlefield on the Australian National Heritage List. The then Prime Minister John Howard said in December 2003:

> It seems to me … entirely appropriate that the Anzac site at Gallipoli should represent the first nomination for inclusion on the National Heritage List.
>
> And, although it's not on Australian territory, anyone who has visited the place will know that once you go there you feel it as an Australian as the piece of land on which your home is built.[55]

Not surprisingly, Howard encountered Turkish resistance to this proposal on the grounds that it infringed Turkey's sovereign rights over the Gallipoli peninsula (which Australia itself has always recognised).[56] An amendment to the 1999 Australian Environment Protection and Biodiversity Conservation Act in 2007 therefore created a List of Overseas Places of Significance to Australia (LOPSA).[57] The listing of sites via this means has only moral authority and, unlike a listing of a site on the National List or World Heritage List, carries no penalties should the integrity of a site be compromised. As of 2008, there are only three places listed on LOPSA: Anzac Cove, the Kokoda Track in Papua New Guinea, a site of iconic significance in the memory of the defence of Australia during the Second World War, and (a very different site) the laboratory of Howard Florey, the medical scientist who discovered penicillin, in Oxford.

LOPSA did not exist at the time of the debate about Changi prison. But it is salient that the Australian government did not attempt to place Changi on the National List at the height of the public debate in 2003; nor has there been any attempt, by either an agency or individuals, since

January 2007 to list the remaining prison wall on LOPSA.[58] Moreover, there was no attempt on the part of the Australian government in 2003–04 to argue that Changi prison had the status of world heritage site and should be preserved in the interests of a wider world polity. Arguably the prison already had some informal status as such, in that international tourists had over some time asserted their 'right of a global accessibility' to the chapel and prison that they saw as part of 'their' heritage. But these tourists were largely Australian and British, not resembling a wider world polity with an interest in Changi.

Moreover, it is improbable that Changi could have met the criteria of 'outstanding universal value' as specified in the 1972 *World Heritage Convention*. Changi could hardly have claimed to be 'an outstanding example' of a colonial prison or even a prisoner-of-war and internment camp. Moreover, the progressive destruction of the nearby Changi barracks, and the lack of authenticity of the Changi chapel, would deny the Changi vicinity any claim to be part of a cultural landscape or a rich assemblage of world heritage status.

The future of Changi prison therefore could only be resolved, as it was, at the level of bilateral diplomacy. In such negotiations, where sovereignty is axiomatic, the Australian government willingly acknowledged Singapore's control of Changi. The Singapore government, in turn, took note of Australia's concerns but exercised its right to give priority to the demands of local development. In recognition of the long-standing defence and diplomatic relationship with Australia, and the value of POW tourism, it was willing to make the compromise of keeping the prison wall and gates. Had there been a stronger groundswell of support for the prison from within Singapore, the outcome might have been different. But it is clear that the memory of occupation and captivity in Singapore was sufficiently ambiguous to prevent such local support. The trans-national significance of the prison was asymmetrical; the past was not a single narrative shared by Singaporeans and Australians. In such circumstances then, perhaps inevitably, the priorities of the local custodians of the site took precedence over the claims of those outside the nation state. Presumably, however, the Singaporean state learned from the debate about Changi prison that 'a nation state no longer has free rein over how it recalls the [Second World] war and cannot be immune to how the international public may perceive it'.[59]

Notes

1 'Anzacs' is the term popularly used in Australia to describe its servicemen. Initially coined during the Gallipoli campaign of the First World War, the name has become deeply mythologised, and associated with the supposed national characteristics of mateship, resourcefulness, egalitarianism, and resilience during adversity and resourcefulness.
2 *Age*, 14 June 2003.
3 Lydon, 'Young and Free'.
4 Marstine, 'Introduction', 26.
5 Kirshenblatt-Gimblett, 'World Heritage and Cultural Economics', 189.
6 These statistics are taken from panels in the Changi Museum.
7 Information supplied by Dr Kevin Blackburn, Nanyang Technological University, Singapore, whose advice in the research for this article was invaluable, and whose extensive research on the Changi Museum and Changi murals as sites of pilgrimage inform this article.
8 *Straits Times*, 29 March 2003.
9 *Straits Times* Singapore, 4 July 2003.
10 Blackburn, 'Commemorating and Commodifying', 3.
11 Arneil, *One Man's War*, entries for 1 and 16 June 1944.
12 *Sydney Morning Herald*, 8 March 2004.
13 Nelson, 'Measuring the Railway', 20; Beaumont, *Gull Force*, 4.
14 Lewis Bryan (*The Churches of Captivity in Malaya*) lists 11 chapels in Changi barracks and gaol but does not include Catholic chapels. He does include one synagogue.

Contested trans-national heritage

15 The date is taken from Blackburn, 'Changi', 161. The date on various websites devoted to the memorial chapel at Duntroon vary slightly.

16 It is located next to the College's Anzac Memorial Chapel of St Paul's.

17 The other surviving chapel, St Luke's Chapel, originally in Block 151 of Roberts Barracks, containing the originals of five 'Changi murals' by prisoner of war, Stanley Warren, was converted into air force accommodation after the war. Even after the rediscovery of the murals in 1958, and their restoration in the 1960s, Block 151 has not been generally open to the public.

18 Quoted in Blackburn, 'Changi', 163.

19 Ibid., 164–6.

20 Ibid., 166–7.

21 The account which follows owes much to the information provided by conservation experts in Singapore, particularly Jeyathurai Ayadurai and Dr Kevin Tan.

22 As Bill Toon, Victorian Secretary of the Ex-Prisoners of War Association said: 'the facade of the entrance to the prison should at least be preserved in some way because that's where most of the boys were taken through' (*Age*, 10 October 2003).

23 Blackburn, 'Commemorating and Commodifying', 5.

24 *Straits Times*, 29 March 2003; *New Straits Times (Malaysia)*, 20 February 2004.

25 Interview with Jeyathurai Ayadurai, September 2006.

26 See Long and Yeoh, *Politics of Landscapes*, 131–8.

27 www.visitsingapore.com/WWII/sites.htm.

28 Brunero, 'Archives and Heritage', 427–39 provides the best accounts of the development of the Malay Regiment museum which was created partly in response to lobbying from the Malay community.

29 The others were Kranji Beach battle site, Jurong–Kranji defence line, Bukit Timah battle site, Sook Ching Centre and the Indian National Army site.

30 www.visitsingapore.com/WWII/sites.htm.

31 *Politics of Landscapes*, 138.

32 The Chinese community's suffering is marked on Changi beach by a very undistinguished and weatherworn memorial block.

33 Blackburn, 'Changi', 155–6.

34 See Muzaini and Yeoh, 'Contesting "Local" Commemoration', 2.

35 For a detailed discussion of the restoration of Chinatown and the use of heritage see Kong and Yeoh, *Politics of Landscapes*, 131–46.

36 Australian Defence Adviser, Australian High Commission, Singapore to Director of Prisons, 18 June 2003, documents gained from Australian Department of Foreign Affairs and Trade under special access.

37 Blackburn, 'Changi', 153.

38 Singapore High Commission to DFAT, 15 August 2003.

39 *Age*, 27 September 2003; *Straits Times*, 12 December 2003.

40 The Singapore Tourism Board replaced the Singapore Tourist Promotion Board 1997.

41 *Straits Times*, 29 March 2003; *New Straits Times* (Malaysia), 20 February 2004; *Sunday Times*, 11 July 2004.

42 Media release, 3 July 2003, Parliament of Australia, http://parlinfoweb.aph.gov.au/piweb/.

43 Singapore High Commission to Canberra, 15 August 2003.

44 *Straits Times*, 29 March 2003.

45 *Herald Sun*, 9 October 2003.

46 This was considerably more than was first offered to the PMB: only two turrets and no wall.

47 *Herald Sun*, 13 April 2005.

48 *Straits Times*, 29 October 2004.

49 *Age*, 10 October 2003,

50 *Age*, 8 March 2004; Singapore High Commission to Canberra, 30 October 2003.

51 *Morning Rush*, 8 March 2004.

52 It has been suggested that demand for prison space has declined as criminality has been defined, alternative forms of punishment have been adopted, and rates of recidivism have declined.

53 See Hass, *Carried to the Wall*, 20–33, 39–40.

54 Logan et al., Australians at War, 58–60.

55 Quoted on www.alp.org.au/media/1005/msenhwat130.php.

56 Lydon, 'Young and Free'.

57 www.environment.gov.au/epbc/publications/pubs/overseas-places.pdf.
58 There is no formal process for nominating a site for inclusion on LOPSA. Anyone, from the Minister down, can initiate this. If the Minister wishes, a nomination may be referred to the Australian Heritage Council for consideration.
59 Muzaini and Yeoh, 'Contesting "Local" Commemoration', 3.

Bibliography

Arneil Stan. *One Man's War*. Sydney: Alternative Publishing Co-operative, 1980.

Beaumont, Joan. *Gull Force: Survival and Leadership in Captivity, 1941–45*. Sydney: Allen & Unwin, 1988.

Blackburn, Kevin. 'Commemorating and Commodifying the Prisoner of War Experience in South-east Asia: The Creation of the Changi Prison Museum'. *Journal of the Australian War Memorial*, 33. Available from www.awm.gov,au/journal/j33/blackburn.htm.

Blackburn, Kevin. 'Changi: A Place of Personal Pilgrimages and Collective Histories'. *Australian Historical Studies* 112 (1999): 125–71.

Brunero, Donna. 'Archives and Heritage in Singapore: The Development of "Reflections at Bukit Chandu", a World War II Interpretive Centre'. *International Journal of Heritage Studies* 12, No. 5 (September 2004): 427–39.

Bryan, J. N. Lewis. *The Churches of Captivity in Malaya*. London: Society for Promoting Christian Knowledge, 1946.

Hass, Kristin Ann. *Carried to the Wall: American Memory and the Vietnam Veterans Memorial*. Los Angeles: University of California Press, 1998.

Kirshenblatt-Gimblett, Barbara. 'World Heritage and Cultural Economics'. In *Museum Frictions*, edited by Ivan Karp, Corinne A. Kratz, Lynn Szwaja and Tomas Ybarra-Frausto. Durham, NC and London: Duke University Press, 2006.

Kong, Lily and Brenda S.A. Yeoh. *The Politics of Landscapes in Singapore: Construction of 'Nation'*. New York: Syracuse University Press, 2003.

Logan, W. S., Joan Beaumont, Bart Ziino, Susan Balderstone and Anita Smith. *Australians at War: Report prepared for the Department of Heritage and Environment*. Cultural Heritage Centre for Asia and the Pacific, Deakin University, 2005, 2 vols.

Lydon, Jane. ' "Young and Free": The Australian Past in a Global Future'. In *Cosmopolitan Archaeologies*, edited by Lyn Meskell. Durham, NC: Duke University Press, forthcoming (MS draft supplied by author).

Marstine, Janet. 'Introduction'. In *New Museum Theory and Practice: An Introduction*, edited by Janet Marstine. Oxford: Blackwell Publishing, 2006.

Muzaini, Hamzah and Brenda S. A. Yeoh. 'Contesting "Local" Commemoration of the Second World War: The Case of Changi Chapel and Museum in Singapore'. *Australian Geographer* 36, No. 1 (2005): 1–17.

Nelson, Hank. 'Measuring the Railway'. In *The Burma-Thailand Railway: Memory and History*, edited by Gavan McCormack and Hank Nelson. Sydney: Allen & Unwin, 1993.

55

The politics of community heritage

Motivations, authority and control

Elizabeth Crooke

Introduction

Community is a multi-layered and politically charged concept that, with a change in context, alters in meaning and consequence. According to the situation, different priorities will come to the fore and the purpose of community-heritage engagement will differ. This paper emphasises the importance of understanding the diversity of that engagement, which varies according to social, cultural and political demands. When, for instance, community is associated with the museum, the museum space becomes a 'contact zone' (Clifford 1997), where different meanings of community, reflecting assorted assumptions and aspirations, are expressed. Different interest groups come into contact within the museum space and a new dynamic arises. It follows then that the community and museum relationship can be interrogated from multiple perspectives: that of government, the interests of the museum sector and the desires of grassroots initiatives. Each brings with them a different idea of community and a range of beliefs in the importance and contribution of heritage to their social, cultural or political project. As these enter the heritage sector, or the museum space, a new layer of meaning is introduced. By investigation of the synergies that arise when these various layers of meaning interact, this paper offers a deeper understanding of the significance of the relationship between community and heritage

Within this paper, diversity is explored through the analysis of examples of community engagement in the museum sector in Northern Ireland. As a divided society, the concept of community in Northern Ireland is politically charged – with questions concerning belonging, representation and agendas underpinning any engagement. Looking at the examples of community projects within museums, as well as those outside the official heritage sector engaging in their own community-heritage initiatives, this paper scrutinises the motivations underpinning the projects and the messages they convey. It draws upon the example of those in museums engaged in community-outreach; those in government departments forwarding museums as places for the promotion of 'good relations'; and those on the outside developing community-based collections relating to the often guarded experiences of local people. The connection between community and heritage will be revealed as a deeply meaningful process that is caught up in a host of contemporary concerns.

Elizabeth Crooke

Community, heritage and museums

The community and heritage connection is one that is considered so natural an affinity that it hardly needs justification or explanation. Community and heritage are both vague and elusive ideas, yet together they have gained popular currency and are used as the basis of multiple myths. Many understandings of community will refer to the building blocks of heritage as a means to define a community by its customs, language, landscape, history, artefacts and monuments. These representations of identity are thus selected to become the heritage of nations and communities. This is a heritage that is constructed and reconstructed according to time and place; on each occasion heritage is redefined according to what is most expedient. In these scenarios heritage becomes a flexible concept that is reconceptualised according to need (Harvey 2001). This is a characteristic that heritage shares with the concept of community because it too can be difficult to confirm or describe and will be renegotiated so that it fits the purpose for which it is being used. We then bring the two concepts together, one justifying the other. Their ambiguity is proved to be no handicap – in fact, that characteristic may well be their strength. Their malleability, twinned with their appeal, allows the associations to be remade in a myriad of situations. Both the community concept and the idea of heritage become intertwined with the lived experience and expression of community. The community group is defined and justified because of its heritage and that heritage is fostered and sustained by the creation of community.

Museums and heritage practitioners engaged in constructing, preserving and interpreting heritage experiences, and the historical or cultural record, are part of this process. Within the United Kingdom and elsewhere, increasing acknowledgement and integration of audiences within the museum, culture and arts sectors is now framed as involving local people in the creation of community collections, community exhibitions and community education programmes. Furthermore, if a local museum is not connected with its community the rationale for the museum may come into question. Moving from the position in UK museums where the creation of the post of community outreach officer was fairly innovative, the integration of the community agenda at every level within the museum is now essential. No longer considered the preserve of a single appointment, best practice recommends that consideration of community concerns is included in the brief of all staff. Such links have challenged museums to explore their mission statements, modes of practice and relations with the public. Community has become a way of thinking that is running through every level of a museum service shaping collecting, display and museum programming.

Not only is community the new way of thinking about museum audiences, museums are now directly linked to the social and economic agendas of public policy. In the UK, the plethora of community policies published in the late 1990s and 2000s demonstrate that the notion of sustainable, inclusive, cohesive and regenerated communities was a major strategic government approach. Museums took on the challenge and many were keen to contribute to realising such objectives. In response, museums developed social inclusion policies to guide collection, exhibition and audience development (Newman and McLean 2002). Despite community being for many a grass-roots concept, community policy, as it has developed in the UK, is largely a top-down approach. The community policy that has guided museum practice in recent years is that shaped by government priorities. Government agencies would, of course, argue that their policy is based on research within and amongst the identified groups, but still the agendas have been captured and packaged within the context of contemporary political agendas and has filtered through to the museum sector via the chain of cultural administration. In Australia, where the provision of community galleries is well established, the collaborations are also closely related to

828

government discourses of access and equality. Witcomb (2003, pp. 81–83), in her discussion of a number of examples, acknowledges the interplay of the production and representation of community but has found that in many instances the museum–community relationship is one that is co-operative, enabling a genuine dialogue between museums and community groups.

Few would doubt that the goals of a cohesive, integrated or regenerated society are worth pursuing. At each point, however, it is important to ask about the nature of the power relations and authority, and whether those are explored with equal vigour. Reflecting on examples of community collaboration in a museum in New Zealand and the United States, Message (2007) claims that the instrumentalisation of culture cannot be doubted and in her examples asks whether culture is being used as a resource for social management by the state or is actually a means to encourage open and inclusive debate, as well as active engagement between and within groups of people. For some within community development, and indeed working in museums, it is the renegotiation of these power relations that is the real concern. For those working at the grass roots of community development it is the idea of social action that is prevalent. This is when community becomes an issue of exploring democracy, accountability and relations of power. Within the established museum sector this is also relevant – with proponents advocating a rethinking of expertise and authority in the interpretation and presentation of histories and cultures. In the United Kingdom, for instance, the theme of democracy is currently explored by the think tank the Campaign for Learning through Museums and Galleries (CLMG). They challenge those in museums with the questions: Why should museum professionals dictate what goes into museums and what gets displayed? Who says that the public should just be consumers of culture? Why can't they be creators as well? Their proposal is that museums should be transformed so that the public can move from 'consumers to creators' and 'from readers to authors'. This will enable the formation of a two-way dialogue between visitors and institutions[1] and test curatorial practice, with the nature of authority and expertise within the museum now under interrogation.

Community: a political and social construct

The impact of community agendas in the museum and heritage sectors reveals the power of community both as a concept and a form of engagement. Thinking about community has challenged practice and dominated debate in both sectors for the past decade. This has resulted in the development and pursuit of an entire policy area based upon a concept that for many is impossible to define. The idea of community as a constructed concept is constantly shifting, continually challenged and difficult to grasp, with cultural markers, created and defined by socially engaged groups, used to define it. In some cases, as is often the case with the rise of nationalism and creation of national communities, these markers are themselves constructions, fabricated to suit the needs of the emerging national community. When the term 'community' is associated with a group of people, whether that is based on location, ethnicity, age or sexuality, it is a label that has been created for expediency and purpose. Many of us may go through our lives not giving a thought to the community to which we may belong – often we like to avoid such labelling and prefer to move freely amongst multiple situations. It is only when that freedom comes into question that we might step back and assess the value of group belonging. As a result, very often a community emerges as a community of action – the rural community may come together when there is a threat to rural businesses, high unemployment or depopulation. In such cases, claiming membership of a community is undertaken because it is expected that an advantage will be felt from association with others. We are seeking out a gain that will satisfy a need.

Elizabeth Crooke

It is the balance and interplay of need and gain that underpins the construction and experience of communities. At each level of engagement a trade-off is negotiated, which forms a relationship of exchange that brings rewards for participation. As they connect with each other, community members and community leaders occupy and interact within a framework of defined codes of behaviour marked by cultural symbols – be that language, landscape, dress, religion or the interpretation of history. Within the community there is a hierarchy of those who are most active, assume leadership, and defend cultural markers. These are the people that create and sustain community and draw the members together. This is not a purely altruistic process – there will always be some sense of personal gain. The lack of altruism is not to devalue participation – it may well be the case that community is a positive experience for leaders and members and an enriching and valuable process. Conversely, as experience and the literature reveals, community can be a negative experience. Feelings of exclusion, intimidation and insecurity can emerge for those who are on the outside, whether that is voluntary or forced (Bauman 2001).

The concept of community, the community group that is realised, and the nature of community engagement are interlinked. Engagement creates community by drawing upon notions of unity presented as pre-existing. The idea of community has truly succeeded when it is so embedded that it is rarely questioned. This occurs when the existence of the community is thought to be beyond doubt and indisputable. Community can then be used both as a galvanising force and a legitimising factor, which can justify actions and interests of the group. This is when the formation of community can have political force and the leaders can assume authority.

Community as a political construct in Northern Ireland

In Northern Ireland, the concept of community has particular political resonance – this is partly because the term is freely used but it is also because community is interwoven with issues of recognition, rights and representation. Dominic Bryan (2006, p. 605) observes that in Northern Ireland community is 'central to the political discourse of all the political parties and local activists, it is common parlance in much government policy and legislation and is continually quoted by those demanding peace and reconciliation'. It is also what he describes as a 'negotiated process' that very often arises from 'fear of "the other" ' (Bryan 2006, p. 608). He provides the example of paramilitary groups which legitimise their existence on the grounds of defending their community and their traditions. As a result, Bryan notes, in Northern Ireland, 'the phrase "community worker" or "community representative" is, at times, read as a euphemism for paramilitary or ex-paramilitary' (Bryan 2006, p. 614). This provides an entirely 'other' context for how community should be understood. Of course, wherever you interrogate the idea the political reality of the concept should be considered. In Northern Ireland, community contestation has been the basis of a conflict that has been sustained for three decades and is a legacy that is currently being dealt with. There is a political charge in Northern Ireland associated with community that is readily visible, one that may also exist in other locations but simmers further below the surface. Community could be just as contentious elsewhere, but the impression of calm may lure those engaged in community activity into a false sense of security.

In Northern Ireland, state engagement with community is most readily seen through support and development of community relations work. The administration of such work has altered with changing government structures but can be traced through the activity of the Central Community Relations Unit (1987–2000) and later the Community Relations Unit (CRU), now part of the Equality Unit of the Office of the First Minister and Deputy First Minister.[2]

830

The politics of community heritage

Early community relations work in the region has been criticised as a means to manage the conflict, a form of social engineering and as part of a pacification strategy (McVeigh 2002). Some, such as Bryan, would disagree with this particular perspective, but will concur that community, culture and identity have emerged in the region as mechanisms of control (Bryan 2006, p. 615). This is the case when culture or community is cited as a means to justify behaviour or manage responses. This sense of using community, culture and identity as a means of control extends beyond the politician. It can also be found within the community group and amongst the agencies that use community. They too recognise the power of the lure of community and how particular interpretations of culture, heritage and identity have influence.

Community heritage in a Northern Ireland museum

It is within the context of community as a politicised and contested concept that engagements between museums, heritage and community are encouraged and formed. The Mid-Antrim Museums Service, for instance, has developed a Community History Programme based around a principle of community engagement. They hope the project will enrich museum programmes, interpretation and collections. There is also a further underlying principle: 'it also, importantly, demonstrates the social value of museums and makes a significant contribution to the well-being of our society'.[3]

The Community History Programme at Mid-Antrim Museums Service (December 2006–2008) was mostly funded by the European Union Special Programme for Peace and Reconciliation (PEACE II) through Local Strategy Partnerships. Administered by the Special EU Programmes Body (SEUPB), whose aim is to enhance cross-border working between people and organisations in Northern Ireland and the Republic of Ireland,[4] this specific programme aims to promote economic and social benefit in areas most affected by the conflict. Community is at the core of the work of SEUPB with the request that projects should facilitate 'co-operation or joint action between different communities and parts of the community or build cohesion and confidence within a community with the perspective that this is a first step in breaking down community divisions'.[5] Target communities were those from disadvantaged areas that had experienced high levels of violence; victims of the conflict; ex-prisoners and their families; young people, women and older people who had been prevented from 'fulfilling their potential in society or the labour market'.[6]

The Community History Programme in mid-Antrim, which was part of the community outreach activity within the museums service, involved 20 community-based groups and focused upon the exploration of the histories associated with division in Northern Ireland. With direction and content determined by the group, the purpose was to consider shared histories and explore divisive periods with the aim to effect positive cultural and attitudinal change as well as building positive relationships within and between groups.[7] The initiatives were also aligned to the Good Relations and Community Development agendas of respective Borough Councils, approaches shaped by *A Shared Future – Policy and Strategic Framework for Northern Ireland* published in 2005 by the Office of the First Minister and Deputy First Minister.[8]

For community programmes to develop within the museum sector in Northern Ireland, they need finance and, more often than not, the larger projects are enabled by funding embedded in community relations and community development agendas. This link is almost impossible to escape – if a museum wishes to develop a high-profile service, with activity that can be accounted for as relevant to society, it must embed itself in current policy agendas. For Northern Ireland, the key agenda is that of peace and reconciliation. This is immersed in community policy approaches as understood and promoted by government both locally and nationally. A successful bid for

831

Elizabeth Crooke

funding for such projects will reflect government policy and be fully involved in the realisation of their objectives.

This provides a context for the community outreach work of the Northern Ireland museum sector, rather than a reason to rebuke the efforts of individuals in the museums working with local people and funded from such sources. The projects developed and realised by the Mid-Antrim Museums Service are impressive and show genuine commitment to exploring history in a life-enhancing manner. The museum team worked with groups in a thoughtful manner, exploring diverse interpretations of histories, places and collections. Community Groups, composed of mixed national and religious groups, senior citizens, ex-prisoners, women and young people, each participated in workshops, reminiscence, field trips and produced an exhibition that was displayed in local centres and later at The Braid, the flagship museum in Ballymena. The final exhibition included text panels depicting the histories they had investigated, objects donated by the groups that held significance for individual members, and video-testimonies of the impact of participation in the programme. In the same room experiences of members of the Inter-Ethnic Forum and women's groups were displayed alongside exhibitions developed by a group composed of ex-paramilitary prisoners and an exhibition developed by youths from a troubled estate that had a significant paramilitary presence.

Rather than causing tension, the well-curated and managed display enabled participants to move beyond past experiences and the stereotyping of histories to explore new avenues. The exhibitions were previously displayed individually in local community centres. This final display in The Braid provides an additional layer of meaning to the project. Prominent public display of local community stories and experiences in a professional museum introduces another set of values. Community histories were woven into the canon of national experiences, such as migration or the linen industry in Ireland, and significant historical events such as the 1801 Act of Union between Ireland and Great Britain and the First World War. This connects the local experience with national stories adding significance to both. Repeatedly, the participants referred to the enriching experiences and positive camaraderie fostered amongst the group and with museum staff. External evaluation concluded that the programme was responsible for 'reawakening civic pride', led to 'positive promotion of a community which had previously suffered from negative images', and had made a 'positive contribution to community cohesion' (Social Research Centre and Vision Management 2008).

Motivations amongst stakeholders

The Community History Programme was realised by the linking up of three very different stakeholder groups: the funding agency, the museum, and the participants. This is typical of many community projects in museums and the questions raised by the synergies arising from the diversity of such associations can equally be applied to other examples if, in each case, the aims and objectives of their engagement are considered. Each stakeholder has different priorities, varying understanding and experiences of community, and distinct expectations of their contributions to a project. This reflects the complexity of governance, management and authority within each stakeholder group – to expect motivations across such a range to be equal would risk naivety. We can however question what this brings to the engagement and how meaningful the associations are if the range of motivations and desired outcomes vary to such an extent.

Each stakeholder group will have its own line of authority and mode of governance. At each stage of funder, museum and community involvement, priorities will differ and the motivation to be involved will be far-ranging. The specific aim of the SEUPB PEACE II Programme, the principle funder, was to aid the creation of peaceful and stable society and to promote

The politics of community heritage

reconciliation. Significant to this was addressing the legacy of violence of the recent past and taking advantage of opportunities arising from the peace process.[9] The objective of the Mid-Antrim Museums Service is to collect, preserve and interpret the history of the region and provide accessible and enjoyable public services. Participants in the Community History Programme were described as motivated by an interest in local history and a wish to 'learn, grow and socialise'. The initiative was an opportunity to develop inter-community links and a chance to meet new people. In the case of the Community History Programme there would, at one level, have been a shared wish amongst the funder, museum and participant groups. Each are, for instance, interested in a less divided society and in increased understanding. Even if that is what is embedded in the work of SEUPB and their funding, it is not the core rationale of the museum or participants. This is not the key motivation of museum or individual participants. The outcomes that each stakeholder will be pursuing, in order to be satisfied that participation was worthwhile, will also differ. For SEUPB, it is the objectives of the funding, for the museum it is more innovative public programmes and, according to the programme evaluation report, for the individuals, the desired outcomes was getting to know their histories and people of their area better.

Common to each group is the idea of change or transformation. Underpinning funding agencies, the concept of change is general and wide-ranging, such as 'enabling greater social inclusion' or 'community cohesion'. In contrast, amongst participants the actual change may be more subtle and personal. These may be changes in perceptions, understandings, and relationships associated with people, places or histories. By providing the opportunity, the museum space becomes a location of interaction between groups of people, their histories and their agendas. It should also be a reactive space that needs to change with such encounters. In such context, the nature of change may not match the language of funding agencies – the particularities are more elusive. It is these indefinable, and maybe immeasurable, changes that are essential to enable the identifiable shifts at societal level. This complexity demonstrates that such engagement, with a range of stakeholders, is not fixed nor is it definite. Instead, it is a negotiated process, a highly creative journey with unpredictable consequences. It is almost futile to aspire to a project within which individuals in community groups, each with their range of individual experiences, interests and motivations, could be shaped to attain the predetermined objectives of an external funding agency. However, the skilled project applicant, who has to write the funding bids and final reports, can author an account that will satisfy the fixed criteria of a funding brief and will later fine-tune it to satisfy other audiences, such as the community group or the museum board. These are the pragmatics underpinning community engagement within the cultural sectors.

The way the community programmes have been set up in Mid-Antrim Museums Service is much like those in many museums in the UK. At the top level at least, first and foremost the concern is the operation of the museum and the development of the collection. Many in the profession would argue that for a museum that is where priorities ought to lie. Social value is a concern that is mentioned later; in other words it is secondary and eclipsed by fundamental museum concerns – collections and sustainability. Whether collections or public programmes is advocated as the core museum activity is dependent upon how the concept of a museum is understood. For the former the collection is the defining matter of museums, it is what makes a museum unique and should be the highest priority and consume the greatest proportion of museum resources. In favour of the latter, public programmes are the rationale underpinning the care and interpretation of collections and should take the lead. Bringing this even further, for some those public programmes should have a social agenda based upon the perceived needs of society. It is important that a museum's position in relation to priorities is established because,

833

Elizabeth Crooke

when engaging with community, where that priority is placed matters. In the worst cases community engagement is simply used as a means to tick a box or gain funding. The question remains, in a sensitive area like community work, should an institution for which community development is not the leading priority, and which is not fully trained in the area, be engaged in such activity? There are examples of when museum practice in community programmes has been exceptional; nevertheless, is the museum the most appropriate institution for it?

Heritage within politicised communities

As noted by Bryan (2006), community in Northern Ireland is a concept often tied up with the conflict and its legitimisation on the grounds of defending perceptions of rightful territory, histories and traditions. With the signing of the 1998 Belfast (Peace) Agreement a new power-sharing devolved administration was established in December 1999.[10] Since that time Northern Ireland is regarded by most as a post-conflict society. Even with the changing political context, community is still burdened with this past legacy. Not only is the legacy of the conflict still very much a lived experience with people and areas experiencing deprivation due to the impact of the conflict, the use of the term community has not lost the connotations of the earlier period.

So, when community groups engage in heritage projects, the contested nature of community, and issues in relation to political context of their work, are still relevant. It is still essential to ask whose history is represented, how identity and culture are interpreted, and what the purpose of such engagement is. These questions are pertinent to the many community-based heritage projects that have emerged across Northern Ireland, such as in areas that have experienced high levels of conflict. These heritage projects are valued by participants and serve a purpose identified by those involved. Belfast Falls Community Council, established in the 1970s, aims to develop community infrastructure and harness community activity in an area it describes as having experienced 'social injustice, economic discrimination and civic marginalisation'. The Council has developed a sound archive of oral histories of local experiences both as memorial and as a contribution to political and social transformation. This they hope will later become part of museum display (Crooke 2007, pp. 124–128). In Derry, the Museum of Free Derry, which opened in 2006 in the nationalist Bogside area of the city, aims to tell a community story and not, in the words of the curator, 'the distorted version parroted by the Government and the media'[11]

In these examples, community heritage, as a means to generate and share alternative histories, will find it impossible to escape the political context. In relation to the Derry example, the story told in the museum is the experiences of Bloody Sunday when on 30 January 1972, 26 people, who were part of a much larger civil rights march, were shot by British soldiers. Thirteen people died immediately and one a few months later.[12] The story told in the museum is an important one that is moving and powerful; it is also one that is heavily contested. For the moment, the account told in this museum is that espoused by the managing body, the Bloody Sunday Trust. The aim of the Trust is to commemorate the events of Bloody Sunday and to 'preserve the memory of those murdered that day', for the purposes of 'truth, justice, reconciliation and healing'.[13] In Northern Ireland, the very notions of truth and justice are contested – with challenges to what is presented as truth or considered justice. Nevertheless, a single narrative is presented for the public that provides an account of the events of the day according to that forwarded by the Trust. It is one that makes no attempt to gratify alternative viewpoints, interpretations or audiences. In the sparse environment of the museum highly sensitive material is displayed without reserve and with minimal interpretation.

834

The example of this display in the Museum of Free Derry raises questions about the definition of community and ownership of histories, as well as the uses or purposes of museums and public display. Regarding the presentation of community, the museum is very much targeted at the Bogside community, which is where the shootings took place. However, the story is also relevant to other nationalist communities in Derry and those belonging to other political persuasions within the city. Some hold the opinion the Trust and Museum have taken ownership of and assumed authority over a story that extends well beyond the Bogside.[14] Furthermore, the display is one of the public faces of the Trust and serves a purpose as a public contribution to its justice campaign. The sensitive material on display validates and adds depth to their pursuit. Museum display is a tool to achieve their goal. One of the important points from this example is that, in a region where the majority museums follow the established paths of engagement with audiences, guided by principles of embracing diversity, encouraging choice between stories and paths, as well as recognition of the role of multiple communities, this museum stands out for its singular narrative and overtly political purpose.

Conclusion: meaning and consequences of the associations between community and heritage

Community and heritage are not only malleable concepts; they are also highly emotive, closely guarded and are used to stake control and define authority. This paper has presented examples of community-heritage engagement that has been brought into museum spaces. Captured within the walls of museums and on the panels of exhibitions, the synergies between community and heritage are concentrated. Within individual projects, motivations change with stakeholder groups. Amongst them different conceptualisations of community exist, heritage has varying purposes, and the nature of gain will be different. The consequence of this is a form of engagement that can go in a number of directions. It has a range of meanings that can be interpreted and valued in different ways.

There remains a fundamental difference between the two community projects discussed in this paper. The Community History Programme is embedded in state structures and discourses of community and community relations. It is also aligned to contemporary thinking in relation to museums and access. The Bloody Sunday Trust project is independent of the state and has not evolved from a desire to renegotiate the traditional power structures of museums. Both can be regarded as community-heritage projects but the underpinning discourses are quite different. However, in each of the examples cited the museum space becomes the contact zone, enabling public display that adds impact and depth to project priorities. In the example of the Community History Programme the final exhibition provided the visitor with a glimpse of the community on display. The experience crossed a range of publics: the community group, interested friends and family who attended the opening and revisit later, and the chance visitor who views the exhibition in isolation from the project. Each will have a different experience and impression of the exhibition and the community on show; for each it will function differently. The crossing over of the experiences of these publics is also crucial – the visitor with little experience of the groups concerned learns a small amount of the experiences of the participants enabling new connections and familiarity.

In the community exhibitions, those involved have taken control of the public interpretation and presentation of their story. By controlling their own narratives the group is attempting to manage how others see them. This is not value-free; instead it is a selective process. In the case of the community museum developed by the Bloody Sunday Trust there is a sense of a heritage with a lot dependent on it. It is purposefully told in an overt manner with the aim to gain

Elizabeth Crooke

support and understanding for the broader campaign. In both examples of communities interpreting their history, public display adds charge to the story as it is told and retold to visitors ranging from those knowledgeable about the history to those who chance upon it. On each occasion the agenda of the group shapes the experience provided for the visitor. With every telling another person is drawn into the narrative and is invited to connect with it. Even if a visitor does not later come directly into contact with the community on display, a link is made, even if it is only in their imagination. Imagined communities, imagined stories and imagined experiences are enhanced in the minds of the visitor and may even become part of their personal story.

In both examples, community heritage has become a means to mould and communicate histories, understandings of identity, and definitions of culture and cultural relevance within groups and to others. By means of display contributors are drawing others into their project, disseminating the message further. By nature of its involvement the museum space is implicated in this process. The result of this is a socially and politically engaged heritage embedded in contemporary concerns and shared with consequence.

Notes

1 www.community-relations.org.uk (accessed 7 December 2009).
2 For background information see: www.ccruni.gov.uk/; www.ofmdfmni.gov.uk/communityrelation-sunit/index.htm; and www.nicrc.org.uk/.
3 William Blair, Museums Service Officer, preface of Mid-Antrim Museums Service (2008) *Making History in Mid Antrim*, published as a record of the project.
4 For further details of their work see: www.seupb.eu/ (accessed 7 December 2009).
5 EU Special Programme for Peace and Reconciliation *Operational Programme 2000–2004* (quote from p. 31). Available from: www.seupb.eu/documents/PEACE%20II%20Operational%20Programme/FINAL%20CLEAN.pdf (accessed 9 February 2009).
6 Ibid. (quote from p. 40).
7 As described in the Grant Application to the PEACE II programme for the Carrickfergus Community History Programme, November 2005.
8 For further information see: www.asharedfutureni.gov.uk/ (accessed 7 December 2009).
9 www.seupb.eu/aboutsus/about-us.aspx (accessed 7 December 2009).
10 Since December 1999, devolution and the Northern Ireland Assembly has been suspended for three periods regarding concerns about decommissioning of weapons and the ceasefire.
11 www.museumoffreederry.org (accessed 7 December 2009).
12 For more on the event see http://cain.ulst.ac.uk/events/bsunday/ (accessed 7 December 2009).
13 www.bloodysundaytrust.org/ (accessed 13 February 2009).
14 Points raised by local people in conversation with me.

Bibliography

Bauman, Z., 2001. *Community seeking safety in an insecure world*. London: Polity Press.
Bryan, D., 2006. The politics of community. *Critical Review of International Social and Political Philosophy*, 9 (4), 603–617.
Clifford, J., 1997. *Routes: travel and translation in the late twentieth century*. Cambridge, MA: Harvard University Press.
Crooke, E., 2007. *Museums and community: ideas, issues and challenges*. London: Routledge.
Harvey, D.C., 2001. Heritage pasts and heritage presents: temporality, meaning and the scope of heritage studies. *International Journal of Heritage Studies*, 7 (4), 319–338.
McVeigh, R., 2002. Between reconciliation and pacification: the British state and community relations in the north of Ireland. *Community Development Journal*, 37 (1), 47–59.
Message, K., 2007. Museums and the utility of culture: the politics of liberal democracy and cultural well-being. *Social Identities*, 13 (2), 235–256.

The politics of community heritage

Mid-Antrim Museums Service, 2008. *Making history in Mid Antrim, the Mid-Antrim Museums Service Community History Programme*. Ballymena: Mid-Antrim Museums Service.

Newman, A. and McLean, F., 2002. Presumption, policy and practice: the use of museums and galleries as agents of social inclusion in Great Britain. *International Journal of Cultural Policy*, 10 (2), 167–181.

Office of the First Minister and Deputy First Minister, 2005. *A shared future – policy and strategic framework for Northern Ireland*. Belfast: OFMDFM.

Social Research Centre and Vision Management Services, 2008. *Evaluation of the Community History Programme – final report*. Ballymena: Mid-Antrim Museums Service.

Witcomb, A., 2003. *Re-imagining the museum. Beyond the mausoleum*. London: Routledge.

56
"To make the dry bones live"
Amédée Forestier's Glastonbury Lake Village

James E. Phillips

Introduction

In December 1911 a series of artistic reconstructions of the recent discoveries made in the Somerset Levels, near Glastonbury in the West of England, appeared in *The Illustrated London News* (hereafter *ILN*).[1] Depicting scenes of everyday life in the Iron Age Lake Village, these eight pictures, created by the paper's Special Artist Amédée Forestier, have come to be some of the most widely reproduced archaeological reconstructions of all time, especially in works on British prehistory. However, discussion of the images does not usually go beyond a few brief comments that they represent a view of prehistory that many consider to be somewhat outdated. Dismissing such influential images so casually is to ignore what they can tell us about the role that archaeological reconstructions have played in creating the ideas that we have about life in the past. "Popular" presentations of archaeology, such as reconstruction drawings and journalistic articles, aimed at a general audience, are an important source in understanding the way that ideas about the past are created and consumed at different points in history, and constitute influential statements of archaeological knowledge.[2]

This chapter will explore how Forestier's reconstructions of the Glastonbury Lake Village created an image of prehistoric life, and will examine the wider associations the images have with the archaeology of Glastonbury, traditions of pictorial reconstruction, and the historical context of their production and consumption. Their story begins with the discovery of a prehistoric settlement at Glastonbury in the late nineteenth century.

The Glastonbury Lake Village

The discovery of the Glastonbury Lake Village is one of the great stories of British archaeology.[3] It is a tale of one man's persistence and dedication to the belief that, somewhere in the Somerset swamps, there were prehistoric lakeside dwellings similar to those found in other parts of Europe. In the 1850s the first lake villages had been discovered and excavated by Swiss archaeologist Dr. Ferdinand Keller, and an English translation of his book *The Lake Dwellings of Switzerland*, detailing the discoveries made in the wetlands outside of Zurich, was published in 1866, with an expanded second edition appearing in 1878.[4] In 1888, after reading of Keller's discoveries,

838

Arthur Bulleid, a resident of Glastonbury, noted the similarities between the environmental conditions of the Zurich region and the Somerset Levels, and commenced a search for similar settlement sites in his local area.[5]

For four years, whenever the opportunity arose, Bulleid wandered the Somerset swamps looking for signs of prehistoric occupation, particularly in the areas where peat cutting was taking place. He would often climb to the top of Glastonbury Tor, where he would scan the area below with his binoculars, looking for any sign of a settlement.[6] All this searching proved fruitless until the spring of 1892. As Bulleid writes:

> On a Wednesday afternoon in March 1892, when driving across the moor from Glaston-bury to Godney, a field was noticed to be covered with small mounds, an unusual feature in a neighbourhood where the conformation of the land is for miles at a dead level. On the following Sunday afternoon the field was visited, and anticipations were agreeably realized by picking from the numerous mole-hills a number of pottery fragments, a whetstone, and pieces of bone and charcoal. The same evening in course of conversation a valued friend and neighbour, Mr. Edward Bath, became interested in the matter, and having intimated that he believed that the field belonged to him, a note arrived the following morning to confirm this, with permission to dig, subject to making arrangements with the tenant. This was done, and a week or two later tentative excavations took place by digging trenches into two of the mounds.[7]

Soon after Bulleid's initial discovery a member of the Glastonbury Antiquarian Society, Mr. John Moreland, contacted Dr. Robert Munro, a specialist in lake settlements, who paid a visit to the site in September 1892.[8] The following month an article by Munro describing Bulleid's findings appeared in *The Times*.[9] It was with great anticipation that Professor Boyd Dawkins, author of the popular work *Cave Hunting* (1874), described Bulleid's presentation of his dis-covery, made to the Somerset Antiquarian Society, as "the most important he had heard made to a local society for many years."[10] As excavations proceeded and a wealth of well-preserved evidence of Iron Age life emerged, the truth of those words began to be realized and, a year after the discovery was made, two committees were established to oversee the excavations. The first included some of the most influential archaeologists of the day, including Dr. Munro, Sir Arthur J. Evans, Professor William Boyd Dawkins, and Lieutenant General Pitt-Rivers.[11] The second comprised members of the Glastonbury Antiquarian Society and other notable local residents.

The significance of the discoveries made at Glastonbury was soon well known within the archaeological community, with reports appearing in several learned journals.[12] Excavation took place at the site every summer from the time of discovery in 1892 up until 1898 under the direc-tion of Bulleid, and resumed six years later with Harold St. George Gray, former assistant to Pitt-Rivers, at the helm alongside Bulleid.[13] Work was concluded, and the first volume of the excavation monograph published, in 1911.[14] In the same year an article written by Bulleid, detailing the important discoveries made at Glastonbury, appeared in the *ILN*.

The Illustrated London News – purveyor of archaeological news

Founded in 1842 by newsagent and publisher Herbert Ingram, the *ILN* was Britain's first illus-trated weekly newspaper.[15] Its aim was to convey pictorially the news of the day, ranging from society gossip, to war correspondence and ethnography.[16] Covering all the important news stories, the *ILN* also had a major commitment to reporting the latest archaeological discoveries.[17] One of the features that readers of the *ILN* could expect in most editions was a full report of the

latest archaeological finds, fully illustrated, from all parts of the world. The focus was on the spectacular discoveries of the day, with Arthur Evans's work at Knossos, and the discoveries of Henry Layard, Heinrich Schliemann, and Flinders Petrie being some of the best-known examples. Almost as popular as the discovery of spectacular ancient treasures was speculation about the nature of our earliest ancestors, including accounts of Neanderthal remains from France, and the search for the "missing link" in Asia and Africa.[18] Earlier in 1911, two articles on Paleolithic finds, written by the archaeologist Arthur Keith and illustrated by Forestier, had appeared in the paper.[19]

The *ILN* was an extremely popular publication in the nineteenth century, with sales figures regularly in excess of 100,000 copies.[20] Although that figure had diminished somewhat by the beginning of the twentieth century, owing largely to competition from publications such as the *Daily Mail* (1896), Forestier's Glastonbury reconstructions would still have reached a substantial audience. An academic report (such as the Glastonbury Lake Village monograph) has a maximum audience of a few hundred people, composed primarily of the archaeological community, therefore its impact at a general level is fairly limited.[21] The importance of publications such as the *ILN* is the role that they play in the transmission of archaeology to a mass non-specialist audience.

The man who, more than any other, was responsible for bringing archaeology to the general public in the first half of the twentieth century was the editor of the *ILN*, Sir Bruce Ingram, great-grandson of the founder.[22] In a letter written to Cambridge prehistorian Glyn Daniel, later reproduced in Daniel's *A Hundred Years of Archaeology*, Ingram describes his commitment to reporting archaeology:

> As a boy at school, I was taken to Egypt by my father for an extended tour of most of the exploration sites, an experience which made a lasting impression on me. When the control of the paper fell to me in 1900, I made up my mind that there were a great many people who would have been equally interested if they were to be given an opportunity of seeing what was being done all over the world to throw light upon the civilisation of the past. The difficulty was to combine technical accuracy with an exposition simple enough for the comprehension of the layman, and by that means to stimulate his desire for further publication of a similar character.[23]

During his remarkable 63 years at the helm from the commencement of his editorship in 1900, over two thousand articles on archaeology were featured.[24] There was a noticeable decline in the coverage on his retirement, as Glyn Daniel lamented in an editorial of the archaeology journal *Antiquity* in the early 1970s: the *ILN* "is, alas, no longer the weekly purveyor of archaeological excitement that it was to those of us who grew up in the twenties and thirties."[25] The importance of the part played by the *ILN* in introducing a generation to archaeology should not be underestimated.

What set the *ILN* apart from other newspapers was its use of pictures as the primary medium to convey the news of the day.[26] In the nineteenth century the *ILN* had illustrated its archaeological articles with depictions of antiquities or of excavations in progress. A new feature of Ingram's editorship was the inclusion of imaginative reconstructions of life in ancient times, with most of these illustrations produced by their Special Artist Amédée Forestier.

840

Amédée Forestier and the creation of the reconstructions

Forestier was born in Paris in 1854 and studied under Lehmann at the Ecole des Beaux-Arts.[27] He began work for the *ILN* in 1882 and, for the remainder of the century, produced illustrations for royal events and general news items, as well as illustrations for the fictional stories that appeared in the paper. Forestier's work also accompanied fictional pieces in the *Windsor Magazine* and the popular novels of several prominent authors, including Walter Besant. However, it is for his imaginative reconstructions of archaeological finds that appeared in the first quarter of the twentieth century that Forestier will be best remembered.

In 1911 Forestier produced his reconstructions of the Glastonbury Lake Village, which have become his most enduring works. This series of eight illustrations, spread over six pages and accompanied by Bulleid's article, appeared in the first week in December. Earlier in the year the *ILN* had run several articles searching for the first Englishman (including the Galley Hill remains), and Bulleid's article appears to pick up on this theme.[28] Comparatively few articles on archaeological discoveries made in England found their way into the paper, with more exotic excavations being the preferred theme. That an article on British archaeology was given such a large amount of space, and high number of illustrations, attests to the importance of the discoveries made at Glastonbury.

Although working primarily on reconstructions for the *ILN*, Forestier also produced a series of illustrations of Roman life in London for the Museum of London, a continuation of earlier work produced for the Royal Ontario Museum in Canada, and an illustrated book entitled *The Roman Soldier*.[29] But it was to prehistoric discoveries that he devoted most of his efforts.[30] As a correspondent to *The Times*, almost certainly the architect, illustrator, and co-author of the best-selling *Everyday Life* series, C. H. B. Quennell, wrote on the occasion of Forestier's death in 1930:

> To my certain knowledge, for the last 25 years there was hardly any discovery of archaeological importance which was not illustrated by his drawings in the pages of the *Illustrated London News*. Forestier was especially interested in prehistoric man and loved to bring him to life, not by fictitious imaginings but by the most careful reconstructions based on scientific research. He did useful work also at the London Museum in the series of drawings which hang over and explain some of the exhibits there. Many will have seen and remembered these and be sorry to hear of the death of the kindly man who made them.[31]

Careful background research into the archaeology behind his reconstructions was a feature of Forestier's work, reflecting his wider interests in ancient history and prehistory. The article by Bulleid that accompanied the Glastonbury reconstructions provides some additional background details to the illustrations.

> Cases of exhibits may be seen in our public museums, showing the state of culture and progress of art during the succeeding Stone, Bronze, and early Iron Ages. To the casual observer, however, these relics lack interest, owing to his inability to visualise the everyday life of the people who made and used them. It is therefore the endeavour of the artist to make the dry bones live by depicting some views and scenes based on the relics found, and other information gained during the investigation of the Glastonbury Lake Village.[32]

The *ILN* article also included five photographic images of artifacts discovered at the site – a bronze bowl, a ladder, a jet ring alongside a sling stone, a decorated comb, and a wooden table

or anvil – many of which can be observed in Forestier's reconstructions; a link that was explicitly stated in the description of the roundhouse scene that appeared below the illustration.[33] The juxtaposition of imaginative reconstructions, that included artifacts discovered at Glastonbury, with photographs depicting the same objects is important, as it enhances the "reality" of Forestier's illustrations. The accompanying article, written by Bulleid, the accepted expert on the Lake Village, again reinforces Forestier's vision. "The occupations and amusements illustrated in this number are proved by the actual finds, and if anyone doubts this he may refer to the forthcoming monograph on the Lake Village now in press, and published by the Glastonbury Antiquarian Society."[34]

The authority of the reconstruction is further enhanced by the noticeable stylistic similarities between Forestier's reconstructions and the general illustrations that accompanied news items in the paper. In fact, it is likely that Forestier's depictions appeared less "alien" to readers of the *ILN* than a number of the ethnographic images that were frequently featured. If readers accepted the documentary nature of the news images, it is but a small step to accept the authenticity of Forestier's imaginative representations of life in the past. "I have made it my duty to secure accurate information on the many points involved to give my pictures a genuine documentary value," was how the artist described his work.[35] Who could doubt that this is what life was really like in Iron Age Glastonbury?

The aim of the reconstructions

All too often when we look at artistic reconstructions of life in the past we forget that such images were, in many cases, produced to convey a highly specific message about the period that they are representing. No records relating to Forestier's brief for the pictures survive, and no correspondence is known to exist between artist and excavator. However, we can still go some way toward establishing the aim behind the Glastonbury reconstructions and the messages they convey.[36]

Right from the start of the Glastonbury Lake Village article the quotation on the first page makes the aim explicit:

> Not the woad-daubed savage of the old history books: the civilised ancient Briton.[37]

The pictures were produced with a very specific purpose in mind: to challenge outdated representations of the Iron Age. As Bulleid says in the second paragraph of his article:

> The subject of prehistoric archaeology has made such rapid strides during the last fifty years or so that the views we held in our youth of the early inhabitants of the British Isles no longer hold good.[38]

The aim of Forestier's reconstructions is to replace the well-established depiction of the savage ancient Briton, which had been frequently reproduced, with an image that presents the Iron Age as civilized. This idea of challenging pictorial stereotypes is a theme that Forestier takes up again in his later work *The Roman Soldier*.[39] The evidence available from the Glastonbury Lake Village was ideal for this purpose, as such a wealth of evidence of craft production and "sophisticated" practices had been discovered. The headlines above all the pictures continue the theme of the first title by stressing how civilized the ancient Britons were. This message is further reinforced in Bulleid's text: "The relics discovered throw considerable light on the life and civilization of the people, whose artistic qualities were truly wonderful. They were skilled

carpenters; among the many remarkable wooden objects found were ladles, cups, bowls, a ladder, and several lathe-turned tubs."[40]

Art is often considered to be one of the most obvious markers of a civilized nature, so stressing the "artistic qualities" of the people is a powerful statement as to the status of the inhabitants of Glastonbury Lake Village. As Bulleid questions: "Can we now call the Briton of two thousand years ago prehistoric?"[41] But how was this impression of civilized life at Glastonbury achieved?

Creating Iron Age Glastonbury

Two of the most compelling images that we have of life in the Iron Age are the figure of the warrior chief, and the scene of life in the roundhouse. It is these two images that feature in the jetty scene and the roundhouse scene, the two Glastonbury reconstructions that have been most frequently reproduced. Both pictures depict scenes of everyday life in the Iron Age, and feature a wide range of activities brought together in a single illustration. The reconstructions are full of little cameos of Iron Age activities, representing a cross-section of the inhabitants of the village, from chiefs, to hunters, to slaves. It appears to be Forestier's aim to cram as much information as possible into a single scene, and wherever the eye travels a different facet of life can be observed. This is the basis of a successful reconstruction drawing, as the maximum quantity of information is conveyed in the smallest space. This was especially important in a publication such as the *ILN*, where column space allocated to each story was limited, and it was the paper's policy to subordinate text to image.

Warriors on the jetty

Perhaps the most famous image of the Iron Age is the figure of the warrior Celt, complete with helmet, sword, shield, and spear, and often seen staring heroically into the distance. It is this easily recognizable figure that dominates Forestier's scene on the jetty. The depiction of the Iron Age warrior has its origins in classical accounts of the ancient Britons, with Lucas de Heere's 1575 illustration of two ancient Britons about to go to battle being perhaps the earliest pictorial example.[42] Through time this original image was augmented with unfamiliar and exotic images from the New World, along with newly discovered archaeological evidence, to produce a powerful stereotype that has had a major influence in the way we represent the past.[43] The warrior image has frequently been drawn upon in portrayals of the earliest humans, but it has been employed with the greatest effect to represent the ancient Britons.[44] In its most familiar guise the depiction of the warrior conveys an impression of savagery and primitiveness, truly the woad-daubed savage of the old history books. Forestier, however, required an alternative source of inspiration.

The Glastonbury warriors appear to have their visual origins in French depictions of the ancient Gauls, which were closely linked to historical art of the 1860s.[45] The image of the heroic ancient Gaul became popular in France in the 1870s following its defeat in the Franco-Prussian War, and was to prove a powerful symbol of national pride. The image stresses the noble and civilized nature of the Gauls and it is significant that Forestier chose this depiction of the warrior. The wider connotations may have been familiar to him as a Frenchman, and in his reconstructions of the lake village the image is transported to Glastonbury ready-made to give an impression of civilization.[46] Bulleid makes the link to the Gauls explicit when he talks about the clothing of the inhabitants of Glastonbury: "It was an unfortunate circumstance that no actual article of dress or fragment of textile was found; therefore the artist has taken the responsibility

of clothing the inhabitants in the garbs of the contemporary people of Ireland and Northern Gaul, from the best possible evidence."[47]

The use of such a well-established visual image as the Celtic warrior is an extremely powerful way of conveying a sense of the period to a viewer, and Forestier uses the association with great effect. Both the jetty scene and the depiction of life in the roundhouse employ visual icons with a long historical association with the Iron Age to create an image of the past that is instantly recognizable to a viewer.

It is also apparent that Forestier's Glastonbury warriors closely resemble a number of his illustrations of Roman soldiers.[48] The contrast between the civilized nature of the Romans and the uncivilized ancient Britons, Gauls, and Germans is a well-known image from the accounts of Roman historians. By drawing on images of Romans in his depictions of ancient Britons, Forestier was making use of a well-established visual and textual association with civilization, another ready-made link that added to the image that Forestier wanted to portray. Making a link between Britain and the imperial power of Rome may have been especially important at this time, as 1911 was a year when international events caused a heightened sense of tension in Europe, and open conflict between France and Germany, which could have involved Britain, was only narrowly averted following a dispute over the balance of power in north Africa. Forestier's use of the civilized ancient Briton in the person of the warrior – civilized but with a harder edge – could perhaps be regarded as a reference to the international situation at the time. The village is described as being defended by a "pallisading of piles" and the chief standing at the jetty is heavily armed; a statement maybe that Britain was ready should the international situation deteriorate further, as indeed it did three years later. The warrior figure is usually depicted staring heroically into the distance, often toward the advancing Roman armies: a lone figure standing up to the aggressions of the invaders. It is a description that could accurately be applied to the Glastonbury chief, and is an image that would have struck the right patriotic note during a time of international uncertainty. The idea of a long civilized British nation also hints that others maybe do not have such a long civilized past: those who threaten war, perhaps?

The presence of a number of severed heads stuck on poles at the entrance to the village is a curiously incongruous image in an illustration that is designed to convey an impression of civilization. Set against an iconography that stresses the industry and civilized nature of the ancient inhabitants of the area, this somewhat gruesome depiction appears to be a marked contradiction to the otherwise harmonious message conveyed. Civilized maybe, but not quite there yet? Or is it just a case of the sensationalist illustrative style that is so characteristic of the *ILN*? Several other images of severed heads had appeared in news items in the paper in the same year in what appears to have been something of a fascination for decapitation in 1911. However, there is another explanation that is closely linked to the story of the excavation of the lake village itself.

A great area of dispute over the findings at Glastonbury, and a source of tension between Bulleid and Boyd Dawkins, was over the interpretation of the human bones.[49] In essence the conflict was whether they represented a violent end to the village through an attack, as proposed by Boyd Dawkins, or whether they did not, and the village fell out of use over a number of years with no catastrophic end, as Bulleid believed. As it was Bulleid who wrote the *ILN* article, emphasizing the civilized nature of the ancient Britons may have been his only counter to the views of a powerful professor, whose opinions were reproduced in the official excavation monograph.[50] Although we can never know the exact motivation behind a reconstruction unless the artist has left a record, it is certainly possible to make a number of different suggestions about how an image of the past creates a view of ancient life.

Everyday life inside the roundhouse

If the warrior is the most famous image of the Iron Age, the roundhouse follows only a short way behind. From classical times there has been an association of houses with civilization, the lack of a house being one of the most important signs of primitiveness.[51] It is therefore no coincidence that a roundhouse provides the setting for the second of Forestier's images that we will look at. The first impression of life that is given in this picture is the cozy familiarity of a family gathering. What is important here is that the scene would have appeared "familiar" to readers of the *ILN*, a scene that was distinctly different from their everyday experiences, but an image that was nonetheless recognizable, a combination of an Edwardian kitchen and parlor scene.

Women dominate this scene of everyday life, although the central figure, the returning hunter, is male.[52] As he enters the hut with a swan on a pole the women in the scene are turned toward him. A ray of light from the chimney highlights his face; the women's faces are almost without exception in shadow. The male is the active figure; the women are passive or engaged in domestic activities. This image provides a picture of a civilized Iron Age family group, and conveys this message by portraying men and women engaged in the sort of activities that would have been recognizable to the readers of *ILN*. Early twentieth-century gender roles are being projected back onto the Iron Age to make the people in the image appear "more like us," conveying their civilized nature through the use of a familiar image. It is a scene that could so easily be one of the depictions of everyday life shown to the readers in other stories that appeared in the paper.

But there is another important distinction that can be made within this picture. The women to the right of the central pillar are wearing more elaborate outfits and are looking outward. The dominant female figure is standing, offering a drink to the returning male, who is dressed in a similar manner to the chief's attendants on the jetty. The other female figures are crouching or kneeling and their faces are shadowed. This scene is making clear statements about social as well as gender roles in the past. These shadowed figures could so easily be the scullery maids, the lowest of the domestic servants, who carried out the tasks the ladies of the house, represented by the women on the right, would not dream of doing themselves. The man of the roundhouse can be observed entering through the door: the Edwardian gentleman returning home. Although such a scene is unlikely to have taken place in such a confined space in a fashionable Edwardian house, if we look at the individual elements of life above and below stairs and compress them into a single scene, the image we have is entirely plausible. A truly Edwardian Iron Age has been created that provides an impression of the past that is safe and familiar, an image that would have no doubt appealed to the generally educated middle- and upper-middle-class readership of the *ILN*. In providing an image of civilization, what better idea to draw on than the age-old traditions of English society? There are few images that would have so effectively conveyed an impression of civilization to anyone viewing the picture.

At a wider level this naturalization of Edwardian values can be seen as a statement on "the way things should be" by suggesting such social relations as natural and long term. There is an important link here to the wider political context of the times, as 1911 was a year of social unrest in Britain, with anarchist rioting in the capital and strikes and disputes in other regions. It was an uncomfortable time for many British people, who would have been very familiar with the political situation through the graphic portrayals and description provided by newspapers such as the *ILN*. When Forestier's reconstructions are set into the wider context of the times the message behind the reconstructions is clear. The traditional social roles and values of society are presented as natural and, in a wider sense, the illustrations are operating to neutralize the

James E. Phillips

perceived threat to the traditional order, presented by the social tensions of the times, by providing it with historical legitimacy.[53]

This impression is reinforced if we look at the description provided below the jetty scene:

> On the extreme left are seen men digging out a boat, one of those comparatively well-formed craft which were some eighteen feet long, and obviously sturdy. Next to these, and on the right looking at the picture, are fishermen hauling in their nets. Then there is a slave putting clay in baskets preparatory to conveying it into the village. In the centre is a chief, accompanied by two attendants, welcoming the return of a hunting expedition, the men on the left with fowl in the form of swans, the men on the right with meat.[54]

Everyone, from slaves, to hunters, to artisans, is working happily for the greater good of the village, each one in their natural place in society. The aristocratic chief stands aloof from the action, his power unquestioned. There is no hint of internal strife, and certainly no hint of strikes or riots against the traditional social order. Everyone is in their place, just like they had been since time indeterminate: such a civilized past, such an uncertain future.

Conclusions

This chapter has explored some of the ways that a detailed study of archaeological reconstructions can tell us how ideas about the past are created and disseminated. Forestier's images of the Glastonbury Lake Village are based on the excavated evidence from the site and are intended to convey an impression of the civilized nature of the inhabitants of the village. This aim is closely linked to the wider social and political situation of the time, which was one of uncertainty of what the future held, both in Britain and abroad. To create this image of civilization Forestier employed a number of well-established images that had a long history of association with the Iron Age, which were combined with familiar ideas about everyday life. By depicting contemporary social and gender roles the past was made to appear like the present, giving the impression that the people in the past were just like us. The projection of Edwardian social values onto the past also gave legitimacy to those roles in the present, by presenting them as long-lived and therefore natural.

Forestier's illustrations for the *ILN*, along with his work for the Museum of London, represented all periods of prehistory, from the earliest humans to the Iron Age, as well as many parts and periods of classical history. If we look at this work collectively we have a near-complete record of one man's vision of human history. Each one of these illustrations tells a complex story about how the past was considered at a different point in time, and how an image of that past was created for the consumption of the reading public. Archaeology provided Forestier with the dry bones, but it was his vision that brought them to life. As a final example of the influence of Forestier's work it is worth quoting the description of the Glastonbury Lake Village provided by Jacquetta and Christopher Hawkes in their *Prehistoric Britain*:

> The village would first appear to a visitor as a huddle of thatched roofs rising among the thickets of alders and willows; carts are bringing produce from the higher ground where the villagers keep their beasts and cultivate corn and vegetables, while dug-out canoes moored at the landing-stage are ready for fowling expeditions among the many waterways, or for longer trading excursions. Inside its protecting wall, the village itself is full of life and activity – a compact stronghold of humanity isolated among the swamps. Duck and coot can be

heard calling and splashing among reeds where herons and cranes stand motionless; occasionally a bittern sounds its uncanny booming call; and there, top-heavy, comical, and grotesquely beautiful, a family of pelicans is sailing down the open waterway.[55]

Reading this account, it is difficult to imagine that the source of inspiration could have been anything other than the *ILN* pictures of Glastonbury – a fascinating example of how a visual tradition of archaeological communication can so easily become a textual one, and a testament to the power of the vision of Iron Age life that Forestier created.

Notes

1 *The Illustrated London News*, December 11, 1911, pp. 928–33, 936.
 The illustrations that appeared were:

 - A full-page reconstruction of the outside of the lake village – "Defended by a pallisading of piles: the ancient British Lake Village near Glastonbury. With dwellings grouped like those of the settlements in the lakes of Switzerland and southern Europe."
 - A full-page illustration of the interior of a roundhouse.
 - A double-page spread of three warriors standing on the jetty outside the village.
 - A full-page illustration with five small scenes depicting weaving, bread making, playing dice, cockfighting, and metalworking.

 The original pictures are now housed in Taunton Castle Museum, Somerset, UK.

2 S. James, "Drawing Inferences: Visual Reconstructions in Theory and Practice," in B. L. Molyneaux, ed., *The Cultural Life of Images* (London: Routledge, 1997), pp. 22–48 and B. Davison, *Picturing the Past: Through the Eyes of Reconstruction Artists* (London: English Heritage/CADW, 1997) both describe the process of creating a reconstruction drawing. For accounts of the wider influence of reconstructions on academic thought, see also S. Moser, "The Visual Language of Archaeology: A Case Study of the Neanderthals," *Antiquity*, 66 (1992), pp. 831–44; and "Archaeological Representation: The Visual Conventions for Constructing Knowledge about the Past," in I. Hodder, ed., *Archaeological Theory Today* (Cambridge: Polity Press, 2001), pp. 261–83.

3 The story is recounted by R. Munro, *Ancient Scottish Lake-Dwellings or Crannogs. With a supplementary chapter on remains of lake dwellings in England* (Edinburgh: David Douglas, 1882), and again in R. Munro, "Introductory Chapter," in A. Bulleid and H. St. George Gray, eds., *The Glastonbury Lake Village*, Vol. 1 (Glastonbury; Glastonbury Antiquarian Society, 1911), pp. 1–35; see also A. Bulleid, *The Lake Villages of Somerset* (4th edn., Yeovil: Western Gazette Co., 1949) and J. Coles and S. Minnitt, *"Industrious and Fairly Civilised": The Glastonbury Lake Village* (Taunton: Somerset Levels Project and Somerset County Museums Service, 1995).

4 See F. Keller, *The Lake Villages of Switzerland and Other Parts of Europe*, trans. J. E. Lee (London: Longmans, Green & Co., 1866) and *The Lake Villages of Switzerland and Other Parts of Europe*, 2nd edn., trans. J. E. Lee, 2 vols. (London: Longmans, Green & Co., 1878).

5 For a brief biography of Arthur Bulleid see S. Dewar, *Arthur Bulleid and the Lake Villages of Somerset* (Beaminster: J. Stevens Cox/Toucan Press, 1966).

6 Ibid.

7 Bulleid, *The Lake Villages of Somerset*, pp. 14–15.

8 For the major early works on British lake settlements see Munro, *Ancient Scottish Lake-Dwellings or Crannogs* and R. Munro, *The Lake Dwellings of Europe. Being the Rhind Lectures in Archaeology in 1888* (London: Cassell & Co., 1890). Bulleid appears not to have been aware of Munro's researches at the time he first made his discovery.

9 *The Times* (October 24, 1892), p. 3. Reprinted as R. Munro, "The Discovery of an Ancient Lake-Village in Somersetshire," in *The British Lake Village near Glastonbury*, compiled by the Glastonbury Antiquarian Society (Taunton: Arnicott & Pearce, 1895), pp. 5–12.

10 Quoted in a letter from Moreland to Munro, reproduced in *The Times* and reprinted in Munro, "The Discovery of an Ancient Lake-Village in Somersetshire," p. 6.

11 For details of the members of the committee, see Munro, "Introductory Chapter," p. 7.

12 Annual reports of the findings from Glastonbury appeared in the proceedings of the Somerset Antiquarian Society. For a brief history of the publication of the site see Munro, "Introductory Chapter."

13 Details of the excavation of the Lake Village are described in detail by Coles and Minnitt, *"Industrious and Fairly Civilised."*

14 Bulleid and St. George Gray, *The Glastonbury Lake Village.*

15 For a useful introduction to the history of the *ILN*, see J. Bishop, "The Story of *The Illustrated London News,"* *ILN anniversary edition* (1992), pp. 29–34. On the origins of pictorial journalism see M. Jackson, *The Pictorial Press: its Origins and Progress* (London: Hurst & Blackett, 1885).

16 For a general idea of the style of coverage, see L. de Vries, *History as Hot News: The World of the Early Victorians Through the Eyes of the* Illustrated London News *1842–1865* (London: John Murray, 1967); for a more detailed examination of the earlier years see P. W. Sinnema, *Dynamics of the Pictured Page: Representing the Nation in the* Illustrated London News (Aldershot: Ashgate, 1998); for a history of illustrated publications before the *ILN* see P. Anderson, *The Printed Image and the Transformation of Popular Culture 1790–1860* (Oxford: Clarendon Press, 1991).

17 Edward Bacon, former archaeological editor of the *ILN*, reproduces some of the best-known archaeological finds featured in the paper in his compilation, *The Great Archaeologists* (New York: Bobbs-Merrill, 1976).

18 For a more detailed discussion see Moser, "The Visual Language of Archaeology," pp. 831–44, and S. Moser, *Ancestral Images: The Iconography of Human Origins* (Stroud: Sutton, 1998).

19 *ILN*, March 4, 1911, pp. 304–5; May 27, 1911, pp. 778–9.

20 See Bishop, "The Story of *The Illustrated London News,"* pp. 30–1; see also A. Ellegard, *The Readership of the Periodical Press in Mid-Victorian Britain* (Gothenburg: Göteborg Universitets Årsskrift Vol. LXIII, 1957).

21 283 subscribers are listed in the first excavation monograph.

22 Ingram was a Fellow of the Society of Antiquaries and received an Honorary D.Litt. from the University of Oxford in 1960.

23 Letter dated February 16, 1949, reproduced in G. Daniel, *A Hundred Years of Archaeology* (London: Duckworth, 1950), p. 311.

24 G. Daniel, "Editorial," *Antiquity*, 34 (1960), p. 4. See Bacon, *The Great Archaeologists*, p. 15 for a list of editors.

25 Daniel, "Editorial," *Antiquity*, 46 (1972), p. 94; see also G. Daniel, "Editorial," *Antiquity*, 35 (1961), p. 3; "Editorial," *Antiquity*, 40 (1966), p. 82.

26 The paper prided itself on the quality of its artwork and employed many talented illustrators through the course of its history. *ILN*, May 14, 1892, pp. 591–3 gives details of the artists employed in the nineteenth century.

27 See *ILN*, May 14, 1892, p. 593 for brief biographical details. As Stoczkowski notes, the artists who create archaeological reconstructions are rarely discussed. See W. Stoczkowski, "The Painter and Prehistoric People," in B. L. Molyneaux, ed., *The Cultural Life of Images* (London: Routledge, 1997), pp. 249–62.

28 *ILN*, March 1911, pp. 304–5.

29 See A. Forestier, *The Roman Soldier* (London: A. & C. Black, 1928).

30 See Moser, *Ancestral Images*, pp. 154–6. Forestier's reconstructions of prehistoric life also appeared in J. Baikie, *Men of the Old Stone Age* (London: A. & C. Black, 1928).

31 *The Times*, November 19, 1930, p. 19. Letter signed "C.H.B.Q."

32 A. Bulleid, "Not the Woad-Daubed Savage of the Old History Books: The Civilised Ancient Briton," *ILN*, December 2, 1911, p. 928.

33 Both the bowl (the excavation's most celebrated find) and the table feature prominently in the scene set inside a roundhouse.

34 Bulleid, "Not the Woad-Daubed Savage of the Old History Books," p. 928.

35 Forestier, *The Roman Soldier.*

36 The *ILN* archives were destroyed during World War II.

37 *ILN*, December 11, 1911, p. 928.

38 Bulleid, "Not the Woad-Daubed Savage of the Old History Books," p. 928.

39 Forestier, *The Roman Soldier*, p. 5.

40 Bulleid, "Not the Woad-Daubed Savage of the Old History Books," pp. 928, 936. Many of these activities feature in the small illustrations of craft production: *ILN*, December 11, 1911, p. 930.

41 Bulleid, "Not the Woad-Daubed Savage of the Old History Books," p. 933.

42 Reproduced in Moser, *Ancestral Images*, p. 69.

43 See especially ibid.

44 See especially S. Piggott, *Ancient Britons and the Antiquarian Imagination* (London: Thames & Hudson, 1989); S. Smiles, *The Image of Antiquity: Ancient Britain and the Romantic Imagination* (New Haven, CT and London: Yale University Press, 1994); Moser, *Ancestral Images*.

45 Tim Champion provides a detailed discussion of the origins and use of the warrior image in nineteenth-century France in T. C. Champion, "The Power of the Picture: The Image of the Ancient Gaul," in B. L. Molyneaux, ed., *The Cultural Life of Images* (London: Routledge, 1997), pp. 213–29.

46 Champion notes that the image of the warriors on the jetty most closely resembles Jules Didier's *Chef Gaulois à la Roche-Salvée*. See Champion, "The Power of the Picture," p. 228.

47 Bulleid, "Not the Woad-Daubed Savage of the Old History Books," p. 928.

48 See Forestier, *The Roman Soldier*, especially the illustration on p. 31.

49 Discussed in Dewar, *Arthur Bulleid and the Lake Villages of Somerset*.

50 W. Boyd Dawkins, "The Inhabitants of the Lake Village," in Bullcid and St. George Gray, *The Glastoubury Lake Village*, pp. 675–6.

51 See P. M. Vitruvius, *The Ten Books on Architecture*, trans. M. H. Morgan (New York: Dover Publications, 1960). S. Moser discusses the illustrations that accompanied early editions of Vitruvius in *Ancestral Images*, pp. 52–9.

52 For depictions of gender roles in illustrations of Paleolithic life, see D. Gifford-Gonzales, "You Can Hide, but You Can't Run: Representations of Women's Work in Illustrations of Palaeolithic Life," *Visual Anthropology Review*, 9 (1993), pp. 23–41 and S. Moser, "Gender Stereotyping in Pictorial Reconstructions of Human Origins," in H. du Cros and L. Smith, eds., *Women in Archaeology: A Feminist Critique* (Canberra: Department of Prehistory, Research School of Pacific Studies, 1993), pp. 75–92.

53 It is interesting to note how the roundhouse scene is altered in M. Quennell and C. H. B. Quennell, *Everyday Life in the New Stone, Bronze and Early Iron Ages* (London: W. T. Batsford, 1928), p. 85. This image depicts an Iron Age man and woman alone in the roundhouse, with the woman cooking while the man looks on. There is no evidence of any servants in the scene, which appears to reflect social changes that occurred after World War I.

54 Bulleid, "Not the Woad-Daubed Savage of the Old History Books," pp. 932–3.

55 J. Hawkes and C. F. C. Hawkes, *Prehistoric Britain* (London: Chatto & Windus, 1949), p. 116.

57

'Introduction' to *Contested Landscapes: Movement, Exile and Place*

Barbara Bender

… There are still those who would like to reserve the word 'landscape' for a particular, elitist way of seeing, an imposing/imposed 'viewpoint' that emerged alongside, and as part of, the development of mercantile capital in Western Europe. But this is just one sort of landscape which, even for those who enjoyed 'a fine prospect', was partaken of in very different ways depending on finely graded and gendered subtleties of class (Williams 1973; Daniels and Cosgrove 1993). Moreover, this class-driven 'view-point' suppresses the landscapes of those 'being viewed' or 'out of sight'. It ignores the labour that has gone into landscape and obscures the relationships *between* landscapes – the connections, for example, between factory or plantation landscapes and secluded English country houses and landscaped gardens (Said 1989). If, instead of this narrow definition, we broaden the idea of landscape and understand it to be the way in which people – all people – understand and engage with the material world around them, and if we recognize that people's being-in-the-world is always historically and spatially contingent, it becomes clear that landscapes are always in process, potentially conflicted, untidy and uneasy (Bender 1993; 1998: 25–38).

The Western-elitist-notion of landscape also creates a sense of things being 'in place'. The emphasis is on a visual 'scape in which the observer *stands back* from the thing observed. But, even within this limited understanding of landscape, stasis is an illusion. Whether painting or view, movement is required before the correct vantage point is achieved. And even when the body is stationary, the eye moves from foreground to background and back again. More importantly … 'static' landscapes are the precipitate of movement – of people, labour and capital – between town and country, between colony or factory and home county. Even in these formal landscapes, we can recognize the density and complexity of landscapes-in-movement.

Contested landscapes: landscapes of movement and exile

It is through our experience and understanding that we engage with the materiality of the world. These encounters are subjective, predicated on our *being in* and learning *how to go on* in the world. The process by which we make landscapes is never pre-ordained because our perceptions and reactions, though they are spatially and historically specific, are unpredictable,

'Introduction' to *Contested Landscapes*

contradictory, full of small resistances and renegotiations. We make time and place, just as we are made by them.

Depending on who we are (gender, status, ethnicity and so on) and the biographical moment, we understand and engage with the world (real and imagined) in different ways. Which bit of ourselves we bring to the encounter also depends upon the context. And as neither place nor context nor self stays put, things are always in movement, always becoming. So there are bound to be frictions and these are mediated in ways that range from well-worn daily practices and rituals that contain the friction, to covert or violent coercion in which certain 'viewpoints' are legitimated, while others are marginalized or criminalized. The political and economic playing fields are rarely level, and the goalposts move.

Attempts to enforce a particular viewpoint and to 'other' – and thereby contain – the other take many forms and deploy many different technologies. There will be laws that frame difference and exclusion (Stewart 1995; maps whose seeming neutrality mask the work of suppression and suggestion (Harley 1992; transport systems that spearhead colonization and policing, slicing through and bisecting the landscape; architecture that creates a hierarchy of places and strives to control; signposts that change direction, or renamings that usher in forgetfulness of earlier meanings and ways of doing things.

Landscapes contain the traces of past activities, and people select the stories they tell, the memories and histories they evoke, the interpretative narratives that they weave, to further their activities in the present-future.

> ... Memory is not the true record of past events but a kind of text which is worked upon in the creation of meaning. Identities are continually crafted and recrafted out of memory, rather than being fixed by the 'real' course of past events
>
> *(Thomas 1996)*

Some pasts are more audible than others:

> ... the names of propertied men overwrite the presence of unnamed others – not-male, not-white, or simply 'not-us' – in the landscape of memory.
>
> *(Steedly 1993: 28)*

Within nation states, history and heritage tell powerful stories, often ones that stress stability, roots, boundaries and belonging. We need to be alert to whose stories are being told, and to be aware that they naturalize particular sorts of social relations.

Silent voices can become more audible.[1] But again, we need to be wary of romanticizing these voices – of turning them into victims, dissenters, purveyors of radical alternatives (Massey 2000). There is as much variety, as much potential for good and evil, for suppression and omission, among those 'without history' as among those whose history is trumpeted.

Tensioned landscapes-in-movement occur at every scale, from the global to the most personal. From macro to micro and vice versa the different scales are indissolubly linked (Giddens 1985).

In this Introduction, I want to approach these landscapes-in-movement from two directions.[2] On the one hand, thinking about close-grained phenomenological studies of people in place and emphasizing the importance of movement; and, on the other, looking at the more sweeping studies of contemporary movement and emphasizing the importance of landscape. The first moves from micro to macro, the second reverses the order.

851

Barbara Bender

From micro to macro

Recent phenomenological approaches focus on a being-in-the-world attachment to place and landscape (Tilley 1994; Gow 1995; Ingold 1993). By moving along familiar paths, winding memories and stories around places, people create a sense of self and belonging. Sight, sound, smell and touch are all involved, mind and body inseparable. Often, in these studies, experience is conceived of as a sort of 'stock-taking' at points along the way, but it would be more accurate to think in terms of what Ingold (2000, citing Gibson) calls 'ambulatory vision' or, better still, 'ambulatory encounters'. As people go about their business, things unfold along the way, come in and out of focus, change shape and take on new meanings. 'Horizons, since they are relative to place and move as people move, do not cut the land into pieces. Hence they mark the limits of perception, but they do not enclose ...' (Ingold 1997).

These phenomenological accounts often focus on familiar places (Feld and Basso 1996). But even for people who live in the same place for generations and work 'within their knowledge', there are always other places (real, or encountered through hearsay, story and imagination). The familiar topography gives way to the unfamiliar, one landscape nests within another like Chinese boxes – except that the boxes are permeable. How do people deal with the part-familiar or the unknown? Walking along seasonal pathways, a person part-knows the way, part-knows that each time of return there will be change and unfamiliarity; part-fears, part-revels in the chance encounter, the possible adventure. Arriving is important but so are the stories woven around the travelling (Edmonds 1999). The Papua New Guineans embarking on sea-borne exchanges (Battaglia 1990); or prehistoric people from Stonehenge traversing unfamiliar landscapes as they search for and bring back the sacred stones from South Wales or North Wiltshire; or pilgrims walking – recreating – the Nazca lines: how do they deal with unfamiliar places and people? What real or fictive kinscapes and clanscapes are created to ease the journeys? What song-lines or sacred topographies woven to embrace the unknown? What webs of exchange (of people, things, information and ideas) spun? Who does the travelling? Who is left behind? Who encountered? Who tells the stories? Who gets to hear the tale?

People's sense of place and landscape thus extends out from the locale and from the present encounter and is contingent upon a larger temporal and spatial field of relationships. The explanation of what is happening moves backwards and forwards between the detail of everyday existence and these larger forces (Pred 1990; Sontag 1983: 385–401; Edholm 1993).

Take bell hooks walking to her grandmother's house:

> It was a movement away from the segregated blackness of our community into a white neighborhood. I remember the fear, being scared to walk to Baba's, our grandmother's house, because we would have to pass that terrifying whiteness – those white faces on the porches staring us down with hate ...

> Oh! That feeling of safety, of arrival, of homecoming, when we finally reached the edges of her yard, when we could see the soot black face of our grandfather, Daddy Gus, sitting in his chair on the porch, smell his cigar, and rest on his lap.

> *(hooks 1992)*

Or Jamaica Kincaid's Lucy, an Antiguan au pair in North America:

> Along the paths and underneath the trees were many, many yellow flowers, the shape of play teacups, or fairy skirts... . I did not know what these flowers were, and so it was a mystery to me why I wanted to kill them. Just like that. I wanted to kill them.

> *(Kincaid 1994: 29)*

The daffodils, for that is what they were, triggered memories of the poem by Wordsworth that she had had to recite as a child. She had never seen daffodils, they were just part of her colonial education. Part of the larger, gendered structure of endlessly unequal relations. For hooks, a trajectory of fear, for Kincaid one of oppression and anger, for both a present moment hung within a long coercive past.

By and large, there has been a tendency to assume that a rooted, familiar sense of place requires staying put. But as Humphrey (1995) has shown, for some nomadic communities in Mongolia it is quite possible to create an ego-centred world in which the 'centre' moves and the *axis mundi* – the joining of earth to sky – is recreated through the smoke that rises from the campfire at each resting point along the way.[3] For many contemporary Roma the landscape is ego-centred in a different way. Although the seasonal landscape may be familiar, the temporary campsite – grudgingly 'given' by authorities or claimed without permission – is treated as alien and polluted space. Whether on the move or within this alien space, 'home' and the centre of the world is the caravan.

There is also a tendency to create an opposition between a rooted sense of belonging and the alienating forces of modernity. Often it may be so, but sometimes, just as settled landscape can be both familiar *and* unfamiliar,[4] it may also be both rooted and undergoing rapid change. The forces of modernity may rework a landscape, but also be reworked in response to a local sense of place, a particular way of being-in-the-world …

So already the notion of small-scale, familiar, rooted landscapes needs to be questioned, and the phenomenological approach opened towards a stronger sense of movement within enlarged worlds.

On the other end of the scale, the contemporary anthropological focus on 'migration', 'diaspora', 'nomadology', and 'borderlands' needs not only to be set within longer histories of movement and displacement (Ghosh 1992; Eco 1980) but also to be grounded, to take on board an embodied, phenomenological approach.

From macro to micro

The current emphasis on global movement is about the reality of compressed time and space; of people 'being in touch' at first, third, tenth hand; of a global inequality which works to generate a leisured travelling world for some, a world of desperate economic deprivation for others, a thin wash of entrepreneurs travelling globally, and a wave of underpaid labour making its way from the 'peripheries' to (grudging) 'centres'; of civil wars and dispossession.[5] All of which interlock and work off each other and all of which have to be understood in terms of what went before:

> [A Third World poster:] WE ARE HERE BECAUSE YOU WERE THERE (Rich cited in Smith and Katz 1993)

The focus on global movements is also a repudiation of a Western reading of 'core'/'periphery', of victor and victim. Deleuze and Guattari react against rooted histories for good reason: 'We're tired of trees. We should stop believing in trees, roots and radicles. They've made us suffer too much' (Deleuze and Guattari 1981: 15). They offer instead the metaphor of rhizomes and the trope of Nomadology. But such tropes threaten to flatten out important differences. They make it seem as if ' "We" [are] all in fundamentally similar ways always-already travellers in the same postmodern universe' (Ang 1994 cited in Cresswell 1997).

But even writers who eschew such generalizations assume that movement creates a *dis-location* between people and landscape. Clifford, for example, offers a finely nuanced and

Barbara Bender

gendered approach to the 'specific, discrepant histories' involved in diasporic experiences, but emphasizes the historical and social, at the expense of spatial (Clifford 1997: 244; Smith and Katz 1993). Dislocation is also relocation. People are always in some relationship to the landscape they move through – they are never nowhere: 'Every movement between here and there bears with it a movement within here and within there' (Minh-ha 1994).

Augé (1995: 86) suggests that 'The traveller's space may ... be the archetype of *non-place*'. He talks of transit lounges, motels, airports. But are they non-places or are they just particular sorts of places? Are they not invested with many and fluctuating sorts of meaning dependent on experience? Thus, for example:

> Migrant workers, already living in the metropolis, have the habit of visiting the main railway station. To talk in groups there, to watch the trains come in, to receive first-hand news from their country, to anticipate the day when they will make the return journey.
>
> *(Berger and Mohr 1975: 64)*

Or:

> I like it here [in the airport]. I am a human maggot. I will build my nest here, in a place that belongs to nobody ... I will live in the artificial light of the airport as an example of the postmodern species, in a transit phase, in an ideal shelter, in purgatory, in an emotionally sterile room.
>
> *(Ugresic, a 'Yugoslavian' woman who, under the new dispensation, feels 'homeless', cited in Jansen 1998)*

This latter is, of course, a very 'knowing' account, but see how it creates, out of 'neutral' airport space, a sense of 'nest', 'transit', 'shelter', 'purgatory'. It is not a 'non-place', it is a place around which imagination weaves itself, a place that is pitched against other meaningful places in the author's biography.

Phenomenological approaches do not replace socio-political-economic analyses, they form part of them. Sometimes, they cut against the grain. There have, for example, been numerous attempts – by academics and by bureaucrats – to 'categorize' different types of movement. Clifford (1997), in his discussion of diasporic movement,[6] admits the categories blur. Experiential accounts demonstrate more forcibly the inadequacies of many of the designations, as well as the power of legal niceties to affect the attitudes and actions of reluctant host and desperate 'guest'.

These are male African 'economic migrants':

> [They] no longer recalled the stages or the place-names on the next leg of the journey ... So far as they know, and they were delirious for long periods, they crossed the Algerian Sahara in two months [Williams' companion] explained they had eaten leaves, sucked up the water from pools of sandy mud and drunk their own urine ... He spoke of 'trekking' to the point of death, of seeming to die on his feet, falling into an abyss of exhaustion, only to be resurrected by the furnace of the late afternoon.
>
> *(Harding 2000)*

These 'political refugees':

> They arrive at the huts [in the harbour of Otranto, Italy] drenched and chilled to the marrow. They are shivering, terrified, nearly ecstatic – a state induced by the journey and

854

the fact of having survived it… . After an hour or so, the men begin milling about, while the women sit with their heads bowed and the children sleep.

(Harding 2000 – note the different gendered experience)

This the experience of being categorized:

The migrants shuffle down the line with their hands extended. The abrupt introduction of the illegal alien to the grudging host state begins. In this parody of greeting, gloved hands reach out to bare hands, seize them, flatten them down on an ink block, lift them across the table-top and flatten them again onto a square of paper.

(Harding 2000)

We need to think about the experiences of place and landscape for those on the move, experiences that are always polysemic (they work at many different levels), contextual (the particularities of time and place matter) and biographical (different for different people and always in process, happening). How do people (variably) relate to unfamiliar and often hostile worlds? How create bridges between what is and what has gone before?

We need to work with the particular, and from the particular to the general. Take, for example, John Berger's account of (primarily) Turkish *gast-arbeiter* (Berger and Mohr 1975). A little out-of-date perhaps, but combining in rare measure empathy and trenchant analysis. The fearful journey gives way to the alienation of arrival:

One of the walls of the corner where his bed is, leads to a door, the door opens onto a passage, at the end of the passage are the taps to wash under and the place he can shit in, the wet floor of this place leads to the way out, down the stairs into the street, along the walls of the buildings on one side and the wall of the traffic on the other, past the railing, under the glass and the artificial light to the work he does …

But after work and on Sundays it is hellish …

(Berger and Mohr 1975: 87)

And yet a sort of 'dwelling' is created:

By turning in circles the displaced preserve their identity and improvise a shelter. Built of what? Of habits … the raw material of repetition turned into shelter … words, jokes, opinions, objects and places … photos, trophies, souvenirs … The roof and four walls … are invisible, intangible, and biographical.

(Berger 1984: 63)

From the old life, what gets brought, what left behind? What remembered, what erased? How does the old get eased into new and hostile landscapes?

In certain barracks the authorities have tried to forbid migrant workers keeping their suitcases in their sleeping rooms on the grounds that they make the room untidy. The workers have strongly resisted this … In these suitcases they keep personal possessions, not the clothes put in the wardrobes, not the photographs they pin to the wall, but articles which, for one reason or another, are their talismans. Each suitcase, locked or tied around with cord, is like a man's memory. They defend their right to keep the suitcases.

(Berger and Mohr 1975: 179)

Barbara Bender

Reminiscing, silently remembering, touched by the physicality of 'things' that matter, the migrant 'gets by'. John Berger talks us through the migrant worker's complex landscapes, and reiterates:

> To see the experience of another, one must do more than dismantle and reassemble the world with him at its centre. One must interrogate his situation to learn about that part of his experience which derives from the historical moment. What is being done to him, even with his won complicity, under the cover of normalcy?
>
> *(Berger and Mohr 1975: 104)*

Which is what Parkin does when he 'interrogates' how and why, in the worst of circumstances, when people are forced to flee their homes, they seize upon certain things:

> Personal mementoes provide the material markers ..., inscribed with narrative and senti-ment, which may later re-articulate the shifting boundaries of a socio-cultural identity ... But the objects are also ... archetypal possibilities for the commemoration of the death of those in flight and even of a community.
>
> *(Parkin 1999)*

Berger's account circles round a particular nexus of male migrant workers and tends to homogenize their experience. A recent account of Indian migrant workers employed in the Persian Gulf states suggests that, under different circumstances, they are 'less deracinated from the web of social relations' and more able to create 'a home away from home'. The authors stress, too, the variability of migrant experience and the effect of this on their status and identity on their return home (Osella and Osella 2000).

Most ethnographies on migrant workers focus on male migrant workers, as though women always stayed home. But this is often not the case,[7] and as Clifford suggests:

> Life for women in diasporic situations may be doubly painful – struggling with the material and spiritual insecurities of exile, with the demands of family and work, and with the claims of the old and new patriarchies.
>
> *(Clifford 1997: 259)*

Under different conditions, the relationships between 'here' and 'there' sometimes cast similar shadows, sometimes seem remarkably different ... A small Jewish boy flees Germany:

> ... In the customs hall in Dover ... they looked on with horror as Grandfather's pair of budgerigars, which had so far survived the journey unharmed, were impounded. It was the loss of the two pet birds ... and having to stand by powerless and see them vanish for ever behind some sort of screen, that brought [them] up against the whole monstrosity of chang-ing countries under such inauspicious circumstances.
>
> *(Hamberger cited in Sebald 1998: 176)*

A Polish Jew 'settled' in London, returns 'home' in memory:

> ... What would be left of me if by some ungodly edict I were to be stripped of all that is Polish in me? First of the language, which ... remains part of the furniture without which the inner space would be empty; of the poems and verses with which I lull myself to sleep;

'Introduction' to *Contested Landscapes*

of the recollection of landscape, its singular sights and smells … Were one to lose the link with that language and landscape … one would feel bereft, impoverished, incomplete.

(Felek Scharf cited in Lichtenstein and Sinclair 2000)

Another Jew refuses any such nostalgia and celebrates his 'rootlessness':

Some-one in a Cambridge common room [pestered] the self-designated 'non-Jewish Jew' and Marxist historian Isaac Deutscher … about his roots. 'Trees have roots,' he shot back, scornfully, 'Jews have legs.'

(Schama 1995: 29 cited in Olsen 2011)

But did Deutscher (and indeed the others) always feel the same sentiment, or just sometimes? Was it the context of interrogation that brought the sharp response?

The historical conditions matter, and the moment in time and place. Wardle (1999, citing Mintz) suggests that Caribbean people, transported into an alien geography, empty of indigenes, and individuated by the socio-economics of colonialism, were modern even before the Europeans. He suggests that for the migrant (male) Jamaican worker neither the 'here' nor 'there' take precedence, but rather the telling of an ego-centred 'adventure'. While this may be so in certain contexts – in the story-telling to an enraptured audience 'at home' – it is almost certainly less true for other moments along the way, as V.S. Naipaul's sharp insight, on his first journey from Trinidad to England, as the aeroplane stops down in North America, makes clear:

At home, among his fellows, just a few hours before, he was a man to be envied, his journey indescribably glamorous; now he was a Negro, in a straw-coloured jacket obviously not his own, too tight across his weight-lifter's shoulders … Now, in that jacket (at home, the badge of the traveller to the temperate North), he was bluffing it out, insisting on his respectability, on not being an American Negro, on not being fazed by the aeroplane and by the white people.

(Naipaul 1987: 101)

Naipaul himself rejects Trinidad as 'home', and turns rather to India, from where an earlier generation of indentured labour had come, or to England as promised and portrayed in his colonial education. And yet the landscapes of his 'non-home' haunt his English landscapes (Bender 1993).

Or take Gilroy (1991), memorably summarizing the landscapes of young Blacks in Britain: 'It's not where you're from, it's where you're at.' It says something about being both British and something else (Clifford 1997: 251), but doesn't necessarily say everything. Sometimes 'where you're from' does matter, and – depending on context – matters in different ways.[8]

Landscapes on the move: landscapes at home

So far, the focus is on the landscapes of those on the move. But that's not the end of it. Those on the move affect the landscapes of those being moved through. And they affect the landscapes of those being left behind.

Pheng Cheah recently took Homi Bhabha and Clifford to task, suggesting that they focus too much upon a metropolitan scenario of migrancy and mobility. Clifford's 'chronotope of travelling culture does not give equal time to the tenacity of national dwelling' (Cheah 1998). Some truth perhaps in this criticism, but 'the tenacity of national dwelling' is shaken up by, and

857

to some extent created out of the knowledge that somewhere – close at hand or at a distance – people are on the move, or by what Clifford (1992) describes as the 'forces that pass powerfully *through* – television, radio, tourists, commodities, armies'. Avtar Brah (1996: 242) uses the term 'diaspora space' to embrace ' *"the entanglement of the genealogies of dispersal"* with those of *"staying put"* '.

Landscapes of colonization

Recent anthropological literature on diaspora or migration has recognized the link to Empire and colonization.

> … It is one of the unhappiest characteristics of the age to have produced more refugees, migrants, displaced persons, and exiles than ever before in history, most of them as an accompaniment to, and ironically enough, as afterthoughts of great post-colonial and imperial conflicts.
>
> *(Said 1994: 402)*

But the process of colonization has tended to be analysed in terms of landscapes of power: the technology of control and the power of the Western Gaze to distance, objectify, attempt to control 'the other' – whether people or land (Pratt 1992; Mitchell 1989). Without dismissing the reality of this power, it is important to recognize that at the back of the unequal colonial encounter lurked the unequal encounter 'at home': the economic conditions, punitive laws, and downward social mobility that sent the young conscripts on their way. There is a terrible irony and:

> … a strange fate. The unemployed man from the slums of the cities, the superfluous landless worker, the dispossessed peasant: each of these found employment in killing and disciplining the rural poor of the subordinated countries.
>
> *(Williams 1973: 283)*

And it was not just conscripts, but felons and settlers. And not just men, but women and children.

We need to understand the experiences of the colonizing agents: the bitterness and misery – and, often, hope – of the leave-taking, the drear conditions of travel, and the fearfulness of arrival. Even for those better placed, the administrator or military man, (just as for the transcontinental entrepreneur today), the experiences of 'being in' and 'presiding over' work off each other and forge tensioned relationships with place and people (Blunt and Rose 1994; Foster 1998; Ong 1998).

Notes

1 In the 'great house' at Strokestown, Co. Roscommon, for example, the story of the assassination of the Anglo-Irish landowner during the Irish famine is told from seven different 'viewpoints' (Johnson 1996).
2 It will be clear by now that this text is littered with landscape and landscape-in-movement metaphors. Metaphors are an essential part of language; they are part of the way in which particular understandings of the world are naturalized and empowered (Salmond 1982). For this reason, they require close attention (Tilley 1994).
3 Humphrey also points out that for other Mongólian nomads a sense of belonging is created through a narrative of landscapes in which place names commemorate the mythical adventures of the shamanistic ancestors.

'Introduction' to *Contested Landscapes*

4 A familiar world may also become suddenly 'unfamiliar'. Thus a white Australian landscape and an unthinking sense of control may suddenly, with the MABO agreement and the (remote) possibility of successful Aboriginal claims to the land, feel threatened. The ground slips (Gelder and Jacobs 1995).

5 A recent estimate suggests that 25 million people have been forced to leave their country; 25 million people have been internally displaced; and another 75 million are on the move because of economic or environmental circumstances (Vidal 1999).

6 Clifford defines diaspora as: 'A history of dispersal, myths/memories of the homeland, alienation in the host (bad host?) country, desire for eventual return, ongoing support of the homeland, and a collective identity importantly defined by this relationship' (Clifford 1997: 247).

7 As Brah points out, women form the majority of Cape Verdian workers migrating to Italy. Filipinos to the Middle East, or Thais to Japan (Brah 1996: 179).

8 The tensions and ambivalences are clear in several recent novels by young black women writers (Melville 1990; Levy 1999).

Bibliography

Ang, I. 1994. On not speaking Chinese: postmodern ethnicity and the politics of diaspora. *New Formations* 24 4.

Augé, M. 1995. *Non-Places: Introduction to an Anthropology of Supermodernity*. London: Verso.

Battaglia, D. 1990. *On the Bones of the Serpent: Person, Memory and Mortality in Sabarl Island Society*. Chicago: University of Chicago Press.

Bender, B. 1993. Introduction: landscape – meaning and action, in B. Bender (ed.) *Landscape: Politics and Perspectives*. Oxford: Berg.

Bender, B. 1998. *Stonehenge: Making Space*. Oxford: Berg.

Berger, J. 1984. *And Our Faces, My Heart, Brief as Photos*. London: Granta.

Berger, J. and Mohr, J. 1975. *A Seventh Man*. Harmondsworth: Penguin Books Ltd.

Blunt, A. and Rose, G. 1994. *Writing Women and Space. Colonial and Postcolonial Geographies*. London: The Guildford Press.

Brah, A. 1996. *Cartographies of Diaspora*. London: Routledge.

Cheah, P. 1998. Given culture: rethinking cosmopolitical freedom in transnationalism, in P. Cheah and B. Robbins (eds) *Cosmopolitic: Thinking and Feeling beyond the Nation*. Minneapolis: University of Minnesota Press.

Clifford, J. 1992. Traveling cultures, in L. Grossberg, C. Nelson and P. Treichler (eds) *Cultural Studies*. New York: Routledge. 99–116.

Clifford, J. 1997. *Routes. Travel and Translation in the Late Twentieth Century*. Cambridge, Mass.: Harvard University Press.

Cresswell, T. 1992. Mobility as resistance: a geographical reading of Kerouac's *On the Road. Transaction of the Institute of British Geography* 18 249–62.

Daniels, S. and Cosgrove, D. 1993. Spectacle and text, in J. Duncan and D. Ley (eds) *Place/Culture/Representation*. London: Routledge.

Deleuze, G. and Guattari, F. 1981. *A Thousand Plateaus: Capitalism and Schizophrenia*. Minneapolis: University of Minnesota Press.

Eco, U. 1980. *The Name of the Rose*. London: Secker and Warburg.

Edholm, F. 1993. The view from below: Paris in the 1880s, in B. Bender (ed.) *Landscape: Politics and Perspectives*. Oxford: Berg. 139–68.

Edmonds, M. 1999. *Ancestral Geographies of the Neolithic: Landscapes, Monuments and Memory*. London: Routledge.

Feld, S. and Basso, K. 1996. *Senses of Place*. Santa Fe, NM: School of American Research Press.

Foster, J. 1998. John Buchan's 'Hesperides': landscape rhetoric and the aesthetics of bodily experience on the South African Highveld, 1901–1903. *Ecumene* 5 323–347.

Gelder, K. and Jacobs, J.M. 1998. Uncanny Australia. *Ecumeme* 2(2) 171–83.

Ghosh, A. 1992. *In an Antique Land*. London: Granta Books.

Giddens, A. 1985. Time, space and regionalisation, in D. Gregory and J. Urry (eds) *Social Relations and Spatial Structures*. London: Macmillan.

Gilroy, P. 1991. 'It ain't where you're from it's where you're at', the dialectics of diasporic identification. *Third Text* 13 3–16.

Goldsworthy, K. 1996. The voyage south: writing immigration, in K. Darian-Smith, L. Gunner and S. Nuttall (eds) *Text, Theory and Space: Land Literature and History in Southern Africa and Australia.* London and New York: Routledge.

Gow, P. 1995. Land, people and paper in western Amazonia, in E. Hirsch and M. O'Hanlon (eds) *The Anthropology of Landscape: Perspectives on Place and Space.* Oxford: Clarendon Press. 43–62

hooks, bell 1992. Representing whiteness in the Black imagination, in L. Grossberg et al. (eds) *Cultural Studies.* London: Routledge.

Harding, J. 2000. The uninvited. *London Review of Books* 3 February: 3–25.

Humphrey, C. 1995. Chiefly and shamanist landscapes in Mongolia, in E. Hirsch and M. O'Hanlon (eds) *The Anthropology of Landscape: Perspectives on Place and Space.* Oxford: Clarendon Press.

Ingold, T. 1993. The temporality of the landscape. *World Archaeology* 25(2) 152–74.

Ingold, T. 1997. The picture is not the terrain: Maps, paintings, and the dwelt-in world. *Archaeological Dialogues* 1 29–31.

Ingold, T. 2000. *The Perception of the Environment: Essays on Livelihood, Dwelling and Skill.* London: Routledge.

Jansen, S. 1998. Homeless at home: narrations of post-Yugoslav identities, in N. Rapport and A. Dawson (eds) *Migrants of Identity.* Oxford: Berg.

Johnson, N. 1996. Where geography and history meet: heritage tourism and the big house in Ireland. *Annales of the Association of American Geographers* 86(3) 551–66.

Levy, A. 1999. *Fruit of the Lemon.* London: Review.

Lichtenstein, R. and Sinclair, I. 2000. *Rodinsky's Room.* London: Granta Books.

Massey, D. 2000. Living in Wythenshawe, in I. Borden, J. Kerr, A. Pivaro and J. Rendell (eds) *The Unknown City.* London: Wiley.

Melville. P. 1990. *Shape-shifter.* London: Bloomsbury.

Minh-ha, T. 1994. Other than myself/my other self, in G. Robertson, M. Mash, L. Tickner, J. Bird, B. Curtis and T. Putnam (eds) *Travellers' Tales,* London: Routledge. 9–26.

Mitchell, T. 1989. The world as Exhibition. *Comparative Studies in Society and History* 31 217–36.

Naipaul, V.S. 1987. *The Enigma of Arrival.* London: Penguin.

Olsen, B. 2001. The end of history? Archaeology and the politics of identity in a globalized world, in R. Layton, P.G. Stone and J. Thomas (eds) *Destruction and Conservation of Cultural Property.* London and New York: Routledge. 42–54.

Ong, A. 1998. Flexible citizenship among Chinese cosmopolitans, in P. Cheah and B. Robbins (eds) *Cosmopolitics.* Minneapolis and London: University of Minnesota.

Osella, P. and Osella, C. 2000. Migration, money and masculinity in Kerala. *Journal of the Royal Anthropological Institute* 6 117–33.

Parkin, D. 1999. Mementos, reality and human displacement. *Journal of Material Culture* 4(3) 303–20.

Pratt, M. 1992. *Imperial Eyes: Travel Writing and Transculturation.* London and New York. Routledge.

Pred, A. 1990. *Making Histories and Constructing Human Geographies.* Boulder, CO: Westview Press.

Said, E. 1989. Jane Austen and empire, in T. Eagleton (ed.) *Raymond Williams: Critical Perspectives.* Oxford: Polity Press.

Said, E. 1994. *Culture and Imperialism.* London: Vintage.

Salmond, A. 1982. Theoretical Landscapes: on cross-cultural conceptions of knowledge, in D. Parkin (ed.) *Semantic Anthropology.* London: Academic Press.

Schama, S. 1996. *Landscape and Memory.* London: HarperCollins.

Sebald, W. 1998. *The Rings of Saturn.* London: the Harvill Press.

Smith, N. and Katz, C. 1993. Grounding metaphor, in M. Keith and S. Pile (eds) *Place and the Politics of Identity.* London: Routledge.

Sontag, S. 1983. *A Susan Sontag Reader.* Harmondsworth: Penguin.

Steedly, M. 1993. *Hanging Without a Rope.* Princeton: Princeton University Press.

Stewart, L. 1995. Louisiana subjects: power, space and the slave body. *Ecumene* 2(3) 227–45.

Thomas, J. 1996. A precis of *Time, Culture and Identity. Archaeological Dialogues* 1 6–21.

Tilley, C. 1994. *A Phenomenology of Landscape: Places, Paths and Monuments.* Oxford: Berg.

Vidal, J. 1999. The endless diaspora. *Guardian* April 2.

Wardle, H. 1999. Jamaican adventures: Simmel, subjectivity and extraterritoriality in the Caribbean. *The Journal of the Royal Anthropological Institute* 5(4) 523–39.

Williams, R. 1973. *The Country and the City.* London: Chatto & Windus.

58
Sensuous (re)collections
The sight and taste of socialism at Grūtas Statue Park, Lithuania

Gediminas Lankauskas

Who said we didn't live well?
Like everyone else we ate, slept, and drank,
Lamented, laughed, and loved …
Who said we didn't live well?

(Samuel Volkov, a Russian poet reminiscing about socialism)

These memories were not simple ones; each visual image was linked to muscular sensations, thermal sensations, etc… . He told me: "I alone have more memories than all mankind has probably had since the world has been the world."

(Jorge Luis Borges, Funes the Memorious)

Introduction

After the demise of the socialist Bloc in 1989 and the subsequent collapse of the Soviet Union in the early 1990s, erasing the communist past from collective memory became one of the most pressing preoccupations throughout Eastern Europe. In postsocialist Lithuania, forgetting the legacy of Soviet-Russian colonialism entailed very specific reconfigurations, or "reorderings," of the public realm (Verdery 1999). Reclaiming differing spaces from the state and cleansing them, as it were, of Marxist–Leninist imagery constituted one strategy of forgetting the era of communist rule that spanned almost five decades.

After the declaration of independence from the USSR, in Lithuania, as in many other Soviet republics, massive panels portraying robust workers and peasants were promptly taken down, red flags with images of hammers and sickles were folded, Lenin's voluminous writings disappeared from library shelves and statues of various distinguished comrades were removed from the nation's squares and parks.[1] By the mid-1990s, Lithuania's post-Soviet landscape was thoroughly cleansed of all referents to disvalued socialist history. At the time, this landscape became increasingly dominated by slick billboards advertising Coca-Cola and Calvin Klein, McDonald's and Mazda, SONY and Swatch among many other transnational brand names and their associated commodities.

While ideological insignia of the socialist past were out of public sight, socialism was not out of people's minds. Reordering immediate environments by erasing all referents to an undesirable past may aid forgetting, but it does not guarantee instant and complete amnesia. Letting go of the past is an inherently ambiguous and paradoxical process, one that hardly ever follows a straight trajectory toward a complete deletion of particular memories. Forgetting is often complicated and made problematic by recurrent moments of recollection. To put it another way, amnesia perpetually implicates memory and vice versa. These two features of consciousness coexist in a mutually constitutive and competing relationship – one is the dialectical partner of the other (Antze and Lambek 1996: xxviii–xxix; Davis and Starn 1989: 4; Terdiman 1993: 22).

In the late 1990s, after gathering dust for some time, the statues, busts and bas-reliefs of various renowned Party activists began to stir again. In 1998, a special parliamentary committee announced a nationwide competition for initiatives that would ensure careful recuperation and preservation of the "unduly forgotten" iconographic legacy of socialism. A former collective-farm administrator turned capitalist entrepreneur with a successful mushroom-pickling business, Mr. Viliumas Malinauskas, won the competition.

Over the next few years, socialist icons of every shape and size traveled from Vilnius and other cities and towns toward Grūtas, a sleepy village off a two-lane highway in south-eastern Lithuania. Executed in the style of imperial socialist realism, larger-than-life effigies of Marx, Lenin, Stalin, as well as countless other ideologues, activists, bards, heroes and heroines began to populate a wooded, swampy terrain of twenty hectares owned by the enterprising mushroom mogul. Behind the peaceful village where time seemed to stand still, Grūtas Park – "a museum of Soviet sculptures" (*sovietinų skulptūrų muziejus*) – was established in 2001.[2]

The park officially opened on April 1 – April Fool's Day – suggesting that it was a "joke" of sorts and as such should not be taken too seriously (see below). The opening ceremonies attracted a crowd of several hundred visitors who were entertained by a popular actor impersonating Lenin and by a group of "pioneers" (*pionieriai*) – invited guests masquerading as members of the defunct League of Communist Youth identifiable by the triangular red scarves tied around their necks.

Not everyone, however, found the idea of Grūtas amusing or entertaining. The park ignited a fierce national debate which polarized Lithuanians into those who applauded this commemorative initiative and those who saw it as a sacrilegious and "criminal" act.[3] Social memory hardly ever unfolds as a monologue. It is usually a heteroglossaic polemic animated by a multiplicity of remembering voices striving to be heard.

This paper is about Grūtas as a *lieu de mémoire* (Nora 1989) that recalls Lithuania's socialist past in the increasingly commodified and transnational milieu of the so-called transition to capitalist modernity. Remembering and its alter-ego forgetting interest me here as situated social practices, that is as phenomena that are shaped by processes of historical change and which in turn shape those processes. I suggest that memory as a practice and a generator of social knowledge (to remember is to know) affords a productive site in which to investigate and to better apprehend the ongoing postsocialist transformation with its many unintended and bewildering consequences.

Grūtas is also interesting as a site of commemoration where the period of Soviet rule is externalized, objectified and made meaningful by using predominantly non-verbal media of recollection. Specifically, this "museum of Soviet sculptures" is intriguing not only as a site of memory where the socialist past is made present through visual representations but also as a locus of commemoration that implicates the sense of taste. In other words, this museum makes it possible not only to see but also to savor Lithuania's communist past. Ethnographic in its approach,

Sensuous (re)collections

this paper attempts a "sensomemography" of Grūtas, one that insists on investigating sensuous recollections as "embodied within *persons*" who are "always part of dynamic living processes" (Howes 2003: 44; original emphasis).[4]

Using a broader temporal perspective, this paper begins with a discussion of the key features of public recall in Soviet Lithuania. Then it moves on to examine – empirically and theoretically – practices of remembering at the present postsocialist moment of unsettling systemic change. In the second half, I take the reader for a stroll through Grūtas – down the proverbial memory lane to the socialist past. The excursion concludes with a Soviet-style lunch at the museum's café (*kavinė*). I pay particular attention to the manners in which differing artifacts displayed at Grūtas, as well as dishes and drinks on offer at the *kavinė*, work to activate the sensoria of sight and taste as means for memorializing socialism. Finally, I reassemble the themes and arguments of this essay for a concluding discussion.[5]

(Un)making memory in socialism

According to the "scientific" reasoning of Party ideologues, socialism was an intermediary stage in humanity's progression toward equality, justice and material prosperity – a utopian social order known as communism. This socioeconomic evolution was theorized as a natural and inevitable outcome of historical development on the global scale. In other words, the future of all socialist nations and eventually of the entire world was envisioned as inevitably communist. Claiming that humankind had no other alternatives, paternalistic "people's" states used this unilinear conceptualization of time to reproduce and reinforce their legitimacy (Davis and Starn 1989: 4; Kaneff 2004: 8; Watson 1994: 1–2).

While there was little doubt as to what the future held, the past was more problematic and as such had to be reconfigured to conform to Moscow's ideological orthodoxies. Shortly after Lithuania lost its independence in 1940 its history was rewritten, many individual memories were silenced. As Edward Casey (2004: 25) has observed, "every revolution, no matter how radically it questions the official public memory of the ancien regime, immediately establishes … a new version of such memory."

In state-sanctioned historiography, for instance, one read that Lithuania, like the other Baltic republics of Latvia and Estonia, was not forcefully annexed to the USSR but joined it "voluntarily" after a popular referendum supposedly revealed the people's overwhelming endorsement of the geopolitical alliance with the Soviet Union. For another example, in "official" versions of history these nations were not occupied by the Red Army, but were "liberated" by it at the end of World War II, and so forth. Citizens who publicly questioned the socialist state's faulty memory and dared to remember differently were subjected to severe reprisals (Skultans 1997; Kiaupa 2002; Kaneff 2004).

Memory under socialism was by no means "monologic" (Watson 1994: 2). Contesting the official accounts of history were multiple voices of counter-memory that recalled various unsanctioned pasts either via remembrances of particular historical facts or through practices perceived to represent tradition. In Lithuania, clandestine commemorations of February 16th (the date on which, in 1918, independence was regained from Russia, now National Independence Day), memoirs of the "golden age" between the two World Wars (1918–1939), reminiscences of the KGB atrocities committed after the Soviet invasion in the 1940s, illegal celebrations of Christmas Eve (*Kūčios*) and Easter are but a few examples of resistive remembering that persisted under socialism. In Soviet Lithuania, as in other Baltic republics of the USSR, this underground or "shadow" memory was central to national identification which was reproduced in the intimate settings of family and home, a domain largely off-limits to the intrusive state.

863

During the socialist years, such domestic or "private" nationalism constituted a powerful counter-ideology directed against Moscow's colonial regime.

The appropriation and reordering of various public spaces was an important means used by the state to manipulate the nation's memory and history. Shortly after Lithuania's annexation to the Soviet Union, removing all indices of the presocialist "bourgeois" past from the public domain was one of the top priorities on the Party's ideological agenda. Marking "cleansed" public spaces with insignia of the new social order was an important tool for forgetting the "bourgeois" system that preceded it – statuary is an especially effective means in such endeavors. These strategies also helped establish and consolidate the regime's hegemony.[6]

Anthropologist Katherine Verdery (1996: 39ff) has written insightfully about the ways in which the socialist state appropriated and controlled people's time. Compelling socialist subjects into such activities as standing in long line-ups to obtain basic consumer goods, forcing them to participate in Party-sponsored mass celebrations, restricting employees' workday schedules, issuing curfews and the like exemplify what she calls the "etatization," or "statizing," of personal time.

Various strategies employed by communist regimes to usurp and manipulate public space, however, have received much less attention in research concerned with everyday life in socialism. It was not only the daily temporal routines of labor, consumption or leisure that were "etatized" by the authoritarian system as a means of domination. For the authoritarian state, being in control of space was equally, if not more, important. It was precisely in "etatized" public places that socialism's temporal hegemony was produced and sustained "for the good of the people," as the rhetoric relentlessly proclaimed. In more metaphoric terms, to make and reproduce socialist time, the state needed a great deal of socialist space. Both were closely implicated in the politics of memory and forgetting.

City streets and village roads, squares and subway stations, classrooms and factory floors, restaurants and even chronically barren state-run stores are some of the public loci in which Marxist–Leninist temporality was manufactured and reproduced (Kaneff 2004: 8–9). The Party's complete monopoly over the public realm played an important role in forgetting the "backward" past, in legitimizing the regime's existence in the present, and in envisioning a communist future. After the demise of socialism, for most Lithuanians, as for many other East Europeans, reclaiming "etatized" space and time from the occupying regime signified that that regime was finally vanquished and that its presence became irretrievably past.

"A feast of remembrance" after socialism

A salient feature of the ongoing "transition" from Marxist socialism to consumer capitalism in the European East is the emergence of a heightened historical and memorial consciousness. Throughout the region, multiple memories of differing national pasts – distant and recent – coexist with desires (and forebodings) of a "European, Western" future in an uneasy dialectic. In daily talk and political discourse, this future is usually envisioned *vis-à-vis* the continental alliance with the European Union as a supposed guarantor of prosperity and stability.[7]

An agent of the past, memory helps us create a sense of temporal continuity and interconnectedness between things gone by and things to be. But memory's principal concern is the present. To put it in grammatical terms, reminiscences are primarily about "what is," as opposed to "what was" or "what will be" (cf. Berdahl 1999: 206).

Anthropologist Rubie Watson (1994: 6) has written that "constructing the new is deeply embedded in reconstructing the old. There is … nothing particularly novel in the idea that new environments produce 'new pasts'." Perhaps the production of such pasts acquires added urgency

in social contexts where the present – "what is" – is perpetually unsettling and where the future is more disquieting than promising. The persistent preoccupation with the past in Lithuania, as in many other locales of Eastern Europe, might be construed as a response to the social upheaval and dislocation brought about by socialism's demise. As Davis and Starn (1989: 5) observe, memory "is … a substitute, surrogate, or consolation for something that is missing."

For most Lithuanians, as for many other East Europeans, the postsocialist present is one of disillusionment, doubt and existential uncertainty. Many of my informants described their daily lives as lacking in meaning and purpose, as well as devoid of order and solid ontological grounding (cf. Skultans 1997). The themes of rupture and loss figured prominently in my informants' accounts of their everyday lives in "modernizing" Lithuania. Typically sceptical and cynical, many spoke of the ongoing postsocialist "Westernization" as a process of economic destabilization and socio-moral breakdown.

Just like forgetting, remembering entails specific reconfigurations of the immediate social milieu. Memory is a hands-on practice that entails the use of very concrete mnemonic media and their associated symbolic repertoires. Newly erected monuments celebrating Lithuania's ancient rulers, ceremonies and exhibits commemorating "heroic" fifteenth-century battles, reconstruction of family genealogies reaching back to the Middle Ages, recuperation of "tradition" exemplify some of those media employed in contemporary Lithuania. Often incorporated into the public spaces reclaimed from the socialist state – such as squares, streets, museums and the like – today images, discourses, and practices memorializing the nation's pre-Soviet history permeate much of the postsocialist existence.

Memories that under the Kremlin's rule were cautiously voiced among trusted family members and friends assembled around the kitchen table figure prominently in postsocialism in many different loci of the public realm: "unapproved rememberings are now the stuff of which new histories and new states are being created" (Watson 1994: 4). What constituted counter-memory under socialism, typically sustained in "kitchen communities" (Boym 1996: 165), today is the stuff of very public remembering and a rich resource for radical revisions of national historiographies. Invoked in personal memoirs, autobiographies and oral narratives, or objectified through individual collections of photographs, letters, personal belongings and the like, "my past" has been marshalled to reevaluate and rewrite "our past." In such recall, biographical accounts of one's life story become constitutive of broader discourses of collective remembering. In mnemonic activity, the personal is usually inseparable from the social – "individual memories are inextricably part of a shared network" (James 2003: 101).

The unraveling of the socialist Bloc, in Watson's (1994: 6) words, unleashed a "feast of remembrance" throughout Eastern Europe. It is so refreshing to come across such a positive, indeed celebratory, approach to memory as the metaphor of feasting clearly implies. It seems that much scholarship concerned with mnemonic activity in social life has been governed by a paradigm that sees memory as a kind of disease. In history and sociology, in cultural and literary studies remembering is commonly conceptualized, implicitly or explicitly, as a disorder, dysfunction, deviation, pathology or a disabling burden (see Stewart 1984; Terdiman 1993). Simply put, this implies that those who remember too much are "sick." Afflicted with a debilitating condition of consciousness these "patients" naturally require treatment. Invoking the Freudian legacy of psychoanalysis, memories have been likened to nightmarish dreams that haunt those who cannot let go of their morbid past.[8]

Rather than "medicalizing" memory as an individual or collective malady, I suggest that we think of it in more constructive terms. Andreas Huyssen (1995: 35) has observed that the resurgence of memorial practices in many locales of the contemporary world is "a sign of contestation … and an expression of the basic human need to live in extended structures of temporality,

however they may be organized." While persistent reaching back into the past might be viewed as an indication of existential angst and uncertainty in the present, we should not overlook memory's potential to alleviate those states of disquiet. In other words, we should inquire into social remembering as both an indexical and instrumental practice. Memory is not only "a symptom of," often it is also "a remedy for."

Specifically with regard to postsocialist Eastern Europe, I suggest that we construe the ongoing accumulation and possession of memories as a strategy for generating a kind of symbolic capital. In this region of the world, where "hard" (or "real") economic capital, and indeed modernity itself, remain perpetually elusive, the pursuit of the symbolic kind acquires special importance (see Verdery 1999: 33). None of my informants talked about memory in the negative terms of burden, disfunction or illness. On the contrary, remembrances of differing valorized pasts were typically conceptualized as cherished objects of great value that enriched and empowered those who possessed them. One elderly woman, for instance, confided in me that her personal memories of "the good life" in prewar Lithuania was the only thing that sustained her in day-to-day existence as an impoverished pensioner after socialism. "Now I live by those memories only," she remarked pensively. My interlocutor did not want to remember the communist years.

Memory in postsocialism, as is true in many other contexts too, does not seem to follow strict sequential chronologies. While some pasts are retrieved and imbued with memorial significance, others are largely disvalued and forgotten. As do many other aspects of social life, remembering works in hierarchies of significance and value. Some reminiscences are more privileged than others; still others have little or no memorial status at all.

While it is true that the past "colonizes our present whether or not we realize its encroachment" (Terdiman 1993: 48), we are not exactly passive "colonial" subjects with no agency when it comes to remembering. More often than not, we choose, if unconsciously, which specific elements of the past to retrieve and which to leave in the wastebasket of biography or history. Drawing on her research in ex-communist Mongolia, Caroline Humphrey (1994: 22) concludes that memory in that nation "leapfrogs" selectively over vast stretches of time, providing us with "snapshots … rather than a consecutive film." We remember (or forget) – which is not necessarily a conscious process – what is advantageous to us at a given moment (Fentress and Wickham 1992). Social memory often becomes a project of incoherent bricolage that entails putting together differing pasts that are retrieved from temporally and sequentially unrelated moments in history.

The socialist past as a lived life

A notable trait in today's reminiscences of the socialist past is the invocation of the familiar, the mundane, the banal through various objects of daily use. Socialism is commonly recalled as a person, a biography, a lived life, rather than an anonymous authoritarian system.

To illustrate this, in the fall of 2002 a museum exhibit commemorating the 766th (!) anniversary of the founding of Šiauliai, a city of 150,000 in northern Lithuania, featured a recreation of the typical Soviet-style living room in an urban dwelling. The centerpiece of the display, titled *Soviet-Era Culture and Domesticity*, was a female mannequin wearing a high-school uniform and a red pioneer scarf, a symbol of allegiance to the Communist Youth organization and its Marxist-Leninist ideals. Big bows in her girly pigtails, the pioneer stood in the middle of the room surrounded by a Soviet-made radio called *Alpinist* (or *Mountaineer*), a television set *Temp-6*, a rotary-dial telephone, a mechanical clock, a metal baby stroller and other domestic objects reminiscent of the Soviet-style domestic modernity of the 1950s and 1960s. Some textbooks

and popular magazines were spread on the table, a Soviet movie poster and some prints on the wall constituted the room's spare decor.

Two Lithuanian museologists reviewing the exhibit noted that this socialist interior "reminds [one] of one's childhood and youth ...," and "no matter how difficult they [Soviet times] might have been, it is always pleasant to return to them in thoughts" (Baristaitė and Lukošiūtė 2002: 1). In a similar statement, an art critic writing about a recently launched exhibit of recuperated Soviet photography remarked that such displays "make one succumb to nostalgia – not for the system but for the erased personal time" (Narušytė 2003: 2).

Yet such pronouncements are not merely biographical. The nostalgia they are imbued with is not only personal or individual but also social; to put it another way, they are marked with "collective aspects, as well as cultural and public determinants" (Casey 2004: 21). I suggest that at a deeper level the above remarks speak to a longing for "the lost position of the Soviet subject," one that was grounded in "a clear understanding of the workings of Soviet society and its power relationships" (Krylova 1999: 249). More abstractly, such statements implicitly refer to the loss of a wealth of social knowledge that has been rendered largely irrelevant as a consequence of the profound systemic change that followed socialism's demise.

For many people knowing, navigating, and predicting the socialist daily life constituted a self-identifying and empowering experience. It conferred an identity on persons, that is it made them "Soviet," and at the same time enabled them to transcend, evade and conquer a system that perpetually controlled and circumscribed their lives. Socialism's collapse and the pursuit of capitalism has rendered this knowledge and the sense of identity it engendered largely obsolete and irrelevant. The Soviet way of life with its distinctive materiality and domesticity, quotidian routes and routines, social roles and sociability. notions of value and moral worth – all of which are the stuff of identity-making – is now irretrievably part of the past (cf. Krylova 1999: 248). It is this patterned and routinized knowing and doing – *savoir-faire* and *savoir-vivre* one might say – as well as a sense of well-defined self that is yearned for in the destabilizing and largely unknowable milieu of the current "transition" to capitalism. This yearning is nicely captured in the first opening quote above: "Who said we didn't live well?"

As museologists Baristaitė and Lukošiūtė (2002) point out, remembering the socialist era today is "a complex matter" (*sudėtinga*). Memories of socialism are "complex" because they operate at the intersection of the biographical and the ideological, of the individual and the collectivist, of longing with nostalgia and loathing with disdain. I now return to Grūtas, my principal ethnographic site, for a closer examination of these issues.

Spectacular memory of socialism

The late December day is grey and snowless. I stand at the entrance to Grūtas Park. Above me a billboard in red and white reads in Russian: "Happy New Year, Comrades!". The display window of the park's ticket office is cluttered with tourist brochures and postcards featuring colorful snapshots of Grūtas exhibits. A recently published anthology of Soviet Lithuanian poetry stands in the window amidst red paper flags sporting overlapping images of hammer and sickle. A row of four drinking glasses with miniature portraits of Lenin, Stalin, Khrushchev and Brezhnev runs along a shelf suspended at eye level. Complete with dates indicating the periods during which these leaders were in power, the set commemorates – in a chronological fashion – the history of Soviet socialism.

As I walk deeper into the swampy park, this history unfolds before me in a more detailed visual narrative. Effigies of Marx, Lenin and Stalin, as well as dozens of icons of various Lithuanian communist leaders and activists recount without words the nation's recent Soviet past.

Removed from the pedestals that once dominated "etatized" public spaces of the nation's cities and towns, these idols have been reduced to mnemonic curiosities at a sideshow of socialism. After decades of privilege and dominance, these monuments now stand relegated to the margins, both literally and metaphorically. To paraphrase Susan Stewart (1984: 89), no longer situated "above and over," they afford the viewer "the transcendent position." Lowered to ground level from superhuman heights they are now within easy reach by sight and touch. (I saw many visitors approaching the statues, touching them and often posing for photographs beside them.)

A number of my interlocutors conveyed a sense of victory and conquest, as they described to me their experiences at Grūtas. Indeed, while walking through the museum grounds and gazing at the immobile effigies of "great" socialist men and women one derives a feeling of momentary superiority in relation to them and the political regime they once served to sustain and legitimize. Overseeing the entire socialist history of Lithuania in a brief period of time (two hours or so is usually sufficient to explore the exposition) and within a circumscribed space makes for an empowering experience (cf. Grever and Waaldijk 2004: 18). At Grūtas the gazing visitor-voyeur assumes a position of power *vis-à-vis* a coercive authoritarian system that for decades kept him or her under close surveillance. The subject is now boldly staring back at the vanquished regime. Beholding a vast collection of communist icons, which stand dislodged from their original contexts and assembled in a single peripheral location, affirms that communism is conquered.

This victory is reaffirmed by an eclectic display of Soviet-era artifacts assembled in a nondescript one-story building located just off the park's main trail. Imitating the interior of a Soviet-style "house of culture" (*kultūros namai*) – public places designated by the socialist state for collectivist education and leisure – the single room in this structure is crammed with portraits of Lenin and Stalin, busts and figurines of war heroes, red flags and medals, copek coins and rouble bills, clippings from defunct Soviet dailies, boxes with Soviet-era newsreels and documentaries; the list goes on. A well-worn KGB uniform hangs displayed on the flimsy plywood wall. Another building located in the park's grounds and called *The Art Gallery* (*Meno galerija*) boasts an impressive collection of Soviet-era paintings and stained-glass works. Like their monumental counterparts displayed in the open air, these objects attest to the end of an era. Removed from their original settings, ideologically neutralized and "de-etatized," as it were, they are, today, mere mementoes of a deposed social order.

In her discussion of an analogous statue park-museum in Hungary, Anne-Marie Losonczy (1999) invokes the metaphor of cemetery, Szobor Park near Budapest, she proposes, is a place where socialism lies dead and buried. While the trope of interment is compelling, I suggest that we think of such expositions of socialism not so much as burial grounds but as places of imprisonment. They speak of the defeat, rather than execution, of the socialist system. After all, most Communist ideologues, or more precisely their bodily images, stand upright suggesting that they are "alive" – they are not laid out horizontally as dead corpses. At Grūtas, the sense of being at an institution of confinement, rather than a graveyard, is enhanced by several watch towers set up throughout the park's territory, making it into a kind of "penitentiary panopticon" (Foucault 1995). As well, its perimeter is circumscribed by a network of wire fences and drainage canals, as if to prevent the "inmates" from escaping.[9]

In some sense, Grūtas is a gulag upside down where the Marxist–Leninist state, visually objectified through museified Party propaganda, is held captive as a punishment for the many crimes it committed against its own people. One of those crimes – deportations of innocent Lithuanians to Siberian labor camps during the Stalin era – is memorialized at the park by a freight-train car on display at the main entrance. Exhibited outside the museum's territory, the rough-hewn wooden car stands attached to a locomotive on a stretch of rails. Its sliding doors

are flung wide open revealing a glum, austere interior: a single berth at the far end and a small barred window beside it. A sign attached to the car explains: "This is a Soviet relic, a horrific symbol that takes our memory back to the 1940s and 1950s. During this period the repressive Soviet regime was carrying out massive genocide of the Lithuanian nation." The train of deportees and the statues of communist ideologues on the other side of the park's fence are allegoric representations of contrasting yet complementing memories: one recalling the victim and the oppressed, the other – the victimizer and the oppressor.

Memory politics is often synonymous with identity politics. Remembering is often central to processes of self-conception and identification. As Richard Terdiman (1993: 7) puts it, "what precedes us seems to constitute the frame of our existence, the basis of our self-understanding." As we establish links with our individual or collective pasts through differing practices of memorialization, we assert who we are or who we are not. The past made present via memory often helps reconfigure and delineate the contours of persons and collectivities. In doing so, it binds and differentiates, includes and excludes. To put it simply, we remember in order to become and to be someone. When our sense of self is threatened or undermined, we often turn to the past (Gillis 1994; Antze and Lambek 1996).

Museums, which objectify the past and operate as preeminent loci of memory, are commonly implicated in the maintenance and assertion of identity, whether ethnic or national, pertaining to social class or to gender (Handler and Gable 1997; Grever and Waaldijk 2004). While Grūtas certainly is about identity, it suggests that memory may not always work constructively with regard to self-conception and identification. Rather than reproduce and reinforce identity through commemoration, most exhibits at this park-museum, I propose, seek to suppress it. More pointedly, the statuary and other recovered artifacts remind one to dissociate from the socialist past in order not to become Soviet or communist again. Marx, Lenin, Stalin, and their many followers are commemorated so as to "dis-identify" from them and their legacy. Kendall Phillips (2004: 5) has recently written that "publics have a responsibility to remember certain things. The most poignant instances of this responsibility lie in the almost universal urge to remember shameful events ..." Grūtas can be seen as a locus of such responsible and "dis-identifying" commemoration.

Savoring the Soviet

Much of Grūtas's success and popularity can be attributed to its effort to activate memories of socialism not only through visual means but also by implicating the sense of taste. The trail snaking through the museum's grounds takes the visitor to the park's café specializing in "Soviet cuisine" where his or her visual experience is complemented with a gustatory one.[10]

Passing a gigantic "Soviet soldier" at the door, a machine gun firmly in his grip, I enter the park's café (kavinė). Its interior is modest but welcoming. I sit down at one of the long, wooden tables and read the menu. Herring and onion rings "the Russian way," a beet soup called Nostalgija, meat patties (kotletai) called "Goodbye, Youth!", a thick cranberry drink (kisielius) "Remembrance" and "Vodka USSR" (CCCP) are among my choices. I order the kotletai and kislelius. At the end of my lunch the waiter, a red pioneer scarf around his neck, brings the bill with a complimentary chocolate in a red wrapper sporting assorted images of the Grūtas statuary. Dominating the visual collage is a diminutive Lenin staring pensively into the distance.

While both sight and taste are mobilized for "remembrance work" (Ten Dyke 2000) at Grūtas, these senses serve to evoke two distinct kinds of socialist memory. Writing about visual representations as media of recall, Barbie Zelizer (2004: 157) has argued that "different vehicles of memory offer different ways of making sense of the past" (see also Kuchler and Melion 1991).

Gediminas Lankauskas

Taking off from this claim, I propose that we think of ways in which different senses become implicated in recovering different, at times conflicting, dimensions of the same lived experience.

As argued above, to behold the demoted statues and other discarded material artifacts is to recall the Soviet state, as well as the suffering and injustice it inflicted on its citizens. The dejected effigies and smaller objects displayed at the Park are mementos of that state's demise. They activate memories of socialism as a system based on an untenable utopian ideology and simultaneously remind one that that system is no more.

To taste socialism, however, is to stir up more nostalgic memories of it. The dishes and drinks on offer at the Grūtas café are in many respects catalysts of what Debbora Battaglia (1995: 178) calls "practical nostalgia" with "a connective purpose." More specifically, this nostalgia "connects" the consumer to the daily life in the Soviet past, a great deal of which was sustained through quotidian commensality and sociability produced in networks of kinship and friendship.

When I inquired of Aldona, a retired teacher in her late sixties, what she thought of the food served at Grūtas, she told me that "after staring at those monsters [statues] for an hour ... it was so good to sit down for some lunch ... It just refreshed my body and soul [kūnas ir dvasia atsigavo]." Aldona, told me confidingly that she had also ordered some vodka to help her "wash down" and forget the unnerving experience of looking at the demoted socialist idols. My interlocutor also pointed out that the beet soup was "good ... very simple but good." After a long pause she added: "Beets! ... We ate beets often then and were so happy to get them!" These statements were followed by Aldona's other reminiscences of "then" – the long line-ups for basic consumer goods, rationed food packages at the school where she taught Lithuanian for thirty years, the monotony of the daily diet and so forth. "It was hard but we made do ... My husband, mother, even my children chipped in in the daily quest for food ... We were together in this."

As I listened to Aldona, I could not help but think of Marcel Proust. Not entirely unlike the oft-invoked French madeleines, the soup of Lithuanian beets – remember, it is called Nostalgija – slowly unleashed a stream of memories of a lost time. Edward Casey (2004: 21) has observed that when we remember "things" – they could be madeleines or beets – we often invoke "whole environmental complexes, auras, and worlds (and how these are given)."

Under socialist command economies of chronic shortage which "gave" little, networking among family members and friends often was the only way to obtain foodstuffs and consumer goods needed for daily use. Whatever was purchased was often shared with close relatives in anticipation that they would reciprocate with goods they bought through their forays into the barren state-owned stores. For essential produce or homemade vodka (samagonas), many urban Lithuanians frequently relied on their rural kin with "private" plots of land in the collectivized countryside. Such consumer practices constituted loci for (re)producing a sense of connectivity and camaraderie, which was typically experienced in the realm of the home and in opposition to the hostile regime.

As theorists tell us, consumption not only creates "community" but is often an effective marker of boundaries, be they defined in terms of social class, ethnicity, age, or, in the case of socialism, through the dualism of "people vs. state" (Verdery 1996). It is this communalism among kin and friends, produced inadvertently by the authoritarian system (it promised communism) that many of my interlocutors missed with a sense of nostalgia. The profound fragmentation of postsocialist societies along the lines of gender, generation and especially social class is one of the consequences of the ongoing "transition" (Hann 2002).

To eat thin beet soup and bland meat patties, to drink kisielius or vodka – all of which were part of the Soviet daily diet – is not so much to go back to socialism as a de-humanizing system,

but to return to the humanity of the home embodied by one's family and friends. For people who lived the better part of their lives under Communist rule, consuming such "foods past" (Sutton 2001: 7), as opposed to encroaching fast foods, is also deeply biographical. A comparison with the exhibit at the Šiauliai museum I described above seems apt here. Like the modest interior of that reconstructed room, the simple dishes served at the Grūtas café invoke memories of a person's childhood, adolescence or youth (the patties, remember, are called "Good-Bye, Youth!"). Reminiscences summoned by the "Soviet" dishes and drinks bring to the fore, as commemoration and consumption usually do, issues of identity. But the identity they speak to here has more to do with the personal and familial rather than with the collectivist, with sociability rather than socialism. The two, of course, are intimately intertwined.

Similarly to Aldona, an unemployed engineer in his late forties, when reminiscing about his visit to the Grūtas café, pointed out that the food there was "perhaps not very tasty, but not bad [*gal nelabai skanu, bet neblogai*]." Then he added emphatically: "Naturall" [*natūralus*] … not what we usually get these days at all kinds of *makdonaldas*." This remark alludes contrastively and sarcastically to various "Western" foodstuffs and drinks that have flooded Lithuania's free market after the fall of socialism. A great deal of such imports have been typically perceived as "full of preservatives, chemicals, contaminated," in other words, "unnatural" or "unreal" (*netikra*). I often heard these two qualifiers used in daily talk not only in relation to foreign consumer goods but also to the broader politico-economic and cultural changes brought about by the postsocialist "transition." To illustrate, referring to the daily life in today's Lithuania in a sweeping existential statement, one intellectual pessimistically concluded: "There's hardly anything *real* left here" [*Nieko tikro čia nebeliko*].

Through its commemorative dishes, Grūtas offers a riposte to the "unrealness" of postsocialism. Its café can be seen as a site of memorial counter-consumption, one that specializes, so to say, in the nation's Soviet history. The park commodifies that particular past and contrasts it with the present. During my fieldwork, I came across a number of other recuperated foodstuffs and drinks that were marketed as "Soviet," typically with a touch of humor and nostalgic irony.

While such consumer longing for socialist goods *vis-à-vis* current imports has been documented by ethnographers in other locales of Eastern Europe, nowhere is it as prominent as in the former German Democratic Republic. Over the past decade this ex-Communist nation has witnessed a virtual explosion of what is known as *(n)ostalgie* – "the birth and boom of a nostalgia industry that has entailed the … (re)production, marketing, and merchandising of GDR products …" (Berdahl 1999: 192). Polyester clothing and popular music, laundry soap and the infamous Trabant, soft drinks and champagne – consumer goods that some two decades ago were produced and consumed in the administered economy of the socialist GDR – are all the rage again.[11]

This nostalgic consumption has acquired such massive proportions for two principal reasons which contrast with its manifestation in other postsocialist locales. First, citizens of communist East Germany had more consumer choices than their comrades living in Moscow's other colonial peripheries. Simply put, as there was more to consume under socialism in Germany, there is more to remember today after its collapse. In the context of the so-called socialist Commonwealth, the GDR economy had a relatively productive industrial sector with a comparatively efficient distributive system. As a "more developed" socialist country, East Germany was usually held up by the Kremlin as a model of command economy. Second, in the unified Germany *(n)ostalgie* is booming also because various products are "remembered" and marketed not only by small local companies but also by large transnational manufacturers who have quickly transformed consumer memories of socialism into a lucrative capitalist business.[12]

Gediminas Lankauskas

A "funny" past

In their commentary on the socialist living room described above the reviewers also note that this particular display should be approached with some irony and good humor (Baristaitė and Lukošiūtė 2002). Similarly, many of the people with whom I spoke described their experiences at the Grūtas café – referring specifically to the food, the menu and the "pioneer" waiter – as "funny" or "fun" (*juokinga, smagu*). Also, recall that the park opened on April Fool's Day.

This suggests that socialism was also a kind of "joke" and could be commemorated as such. In the USSR and elsewhere in the Bloc, jokes (*anekdotai*) – many of which were political – were a powerful means of symbolic resistance *vis-à-vis* the authoritarian system (Krylova 1999). They circulated among trusted family members, friends and colleagues and were constitutive of what might be seen as a kind of "civil society." Joke-telling pertained to the unofficial culture of laughter which defined itself in opposition to the official state-sponsored culture of seriousness, to borrow Mikhail Bakhtin's (1988) terminology. As *anekdotai* challenged and deconstructed, albeit symbolically, the dominance of the alienating state, they at once operated as means for constructing and reproducing networks of more intimate daily interaction and sociability. While after the demise of socialism the political joke has inevitably lost its power and all but withered away as a genre, humor and irony live on in people's reminiscences of the now defunct system.[13]

Soviet citizens mocked socialism as they lived it. Today they often snicker, smirk or laugh out loud when they remember it. Perhaps this humorous-ironizing disposition toward the socialist era is a means with which to diffuse the "complexity" and unease that recuperations of this recent past entail and to simply make them more "pleasant" too. Freud (1976: 238) once remarked that we commonly resort to jokes "to gain a small yield of pleasure" (see also Douglas 1991). The "pleasure" of laughing at socialism today, just like gazing at it, might be construed as constitutive of the same empowering (or "conquering") experience I discussed in the foregoing pages.

"Funny" memories of socialism in post-Soviet Lithuania and the other locales of Eastern Europe, might be seen as representative of marginal, indeed "carnivalesque" remembering, to invoke Bakhtin again. Whether objectified in ritual, discourse or imagery, carnival with its distinct aesthetic of incongruity, ambiguity and paradox is always an instance of liminality. Commemorations of socialism, then, can also be theorized as liminal recall.[14] In many respects, recollections of socialism constitute a kind of alternative remembering, a counter-memory that coexists today with multiple reminiscences of the nation's other, more distant historical pasts in an uneasy, contentious relationship.

By way of conclusion

This paper has attempted to examine one form of memory in today's Lithuania – reminiscences of socialism. Among its objectives has been to foreground the paradox and ambiguity that inform recollections of this particular national past. Liminal and "complex," memories of socialism illicit anger and shame, provoke laughter and derision; they activate feelings of rupture, trauma and loss, and conjure up images of injustice and victimhood. At the same time, more positively, they give those who remember a sense of victory, triumph, closure.

Grūtas Park is an apt *lieu de mémoire* in which to examine these multiple and seemingly contradictory dimensions of socialist memory which operates between empathy and estrangement (Boym 1999). This "museum of Soviet sculptures" is especially interesting as a public locus wherein reminiscences of the recent communist era are activated predominantly by

872

Sensuous (re)collections

non-articulated or non-discursive means, notably via the "bodily ways" of sight and taste (Guerts 2002). But seeing socialism at Grūtas is not the same as savoring it. While for most of my informants beholding the dejected socialist icons constituted a distancing and hence dis-identifying experience, partaking of the recuperated "Soviet" dishes and drinks at the café typically invoked sentiments of nostalgic longing and yearning – not for socialism as an oppressive system but for the quotidian sociability centered around kin and friends that that system inadvertently produced and perpetuated.

Grūtas is not only about the recent Soviet past of Lithuania. It is also a visual and gustatory critique of the nation's increasingly commodified and "Westernized" present, a present that many Lithuanians construe as baffling, disorienting, or "unreal." In many respects, this "prison" of socialism is an evocative counterpoint to the imagery of capitalist display which is becoming increasingly prominent in many reordered and "de-etatized" public spaces of the nation.[15]

Rather than an instance of morbid or pathological recall, Grūtas exemplifies "constructive" remembering. Memories of socialism conjured up by the park might be seen as constitutive of Lithuania's symbolic capital in a milieu where real economic wealth and social well-being remain perpetually elusive. A kind of social knowledge, those memories work not only as strategies of "enrichment," but also as a resource for constructing cognitive frameworks in which to anchor oneself existentially at a profoundly disorienting moment of liminal transformation.

While offering an alternative reality to capitalist commodification and consumerism, Grūtas at the same time, of course, is a preeminently capitalist enterprise, one that commodifies, packages, markets and sells the socialist past. Its business is both memory and money.

Finally and more abstractly, Grūtas is an apt ethnographic locus in which to critique simplistic unilinear approaches to the ongoing postsocialist change or "transition," approaches that remain remarkably enduring in the study of contemporary Eastern Europe. This park suggests that "modernization" in Lithuania is not exactly a straightforward progression from socialism to capitalism. Rather, the pursuit of Western-style "modernity" in this nation, as in many other locales of the ex-Soviet Bloc, is a multidirectional process which is perpetually complicated by practices of remembering and forgetting, by preoccupation with multiple pasts and visions of an uncertain future.

Acknowledgments

I thank members of the Concordia Sensoria Research Team (CONSERT) for their thoughtful comments and suggestions on earlier drafts of this paper. My thanks also go to the anonymous reviewers of *The Senses and Society*. As well, words of gratitude are due to Michael Bull, Ian Critchley, Felicity Marsh, and Jill Sweet for their cooperation and good will. Finally, a big thank you to my informants in Lithuania. Funding for ethnographic fieldwork and writing was provided by the Social Sciences and Humanities Research Foundation of Canada (SSHRC Postdoctoral Fellowship).

Notes

1 The "lift-off" – on August 23, 1991 – of Lenin's twelve-foot statue from its granite pedestal, where it had stood across from the KGB headquarters in the capital of Vilnius for many years, is one instance of such removal. As legless Lenin (his lower limbs remained stubbornly stuck to the bronze base) dangled in the air suspended on a crane cable, thousands of jubilant participants applauded and cheered on. This iconoclastic event was picked up by the media around the world as an evocative symbol of the end of Moscow's rule in the Baltic states and in Eastern Europe in general (cf. the toppling of Saddam Hussein's statue in downtown Baghdad in April 2003, a representation that appeared countless times on various

873

TV newscasts covering the Iraq War). Once taken out of the public domain, Lenin, the principal ideologue of Soviet socialism, and dozens of his followers ended up in municipal basements and garages or were deposited in sites of industrial waste on the city outskirts.

Ritualized acts of disposal of a despised ruler's body, be it in image or in flesh and blood, are an especially powerful means of indexing the end of a social order. Imagery of Nicolae Ceauşescu's dead body, beamed by the broadcast media across the world immediately after his public execution in 1989 Romania, is another example.

2 A private enterprise, Grūtas is run by Mr. Malinauskas and his family members who live in a three-storey mansion sprawled out just several hundred meters from the park's entrance. All exhibits at Grūtas, however, remain state property.

3 See, for instance, *Grūto Parko Tiesa*, April 1, 2002, p.2; cf. endnote 5 below.

4 Ethnographies of memory produced since the mid-1980s or so have focused predominantly on the contents of remembering rather than on the media through which it is objectified. What groups and individuals retrieve through memory is of paramount importance of course. Obviously there is no memory if nothing is remembered. But the various ways in which social actors differentiate, conceptualize and display their memories to themselves and to others as they negotiate their past, present and future should not escape our attention. In other words, we need to document and understand better not only *what* but also *how* people reminisce. To quote David Sutton (1998: 3), "the past comes in many different containers bearing different labels." Those multiple "containers" are often as significant as the mnemonic messages they carry.

In explorations of memory, oral narrative and text have been the most privileged objects of analysis. Indeed, it is through these verbal media that a great deal of remembering is externalized (see Humphrey 1994; Skultans 1997). Yet we also need to record and explain how the past is made present via various performative, representational, and sensorial – that is, non-verbal or non-articulated – means of memorialization. This can be accomplished only by shifting away from the logocentric methodologies that dominate much of memory research (but see Abercrombie 1998; Sutton 2001; Lambek 2002).

5 This paper draws on ethnographic research undertaken in Lithuania in 2003 and 2004. My first visit to Grūtas in the fall of 2003 consisted of a guided tour given by the staff and included an extended interview with the owner of the museum, Mr. Malinauskas. I returned to Grūtas on two other occasions for more "phenomenological" and sensory experiences of it.

Furnished with big, wooden tables that seat up to twelve people at a time, the café proved to be an effective ethnographic site not only for tasting "Soviet" dishes but also for participant observation, informal interviewing and simply for casual talk with its employees and customers. One of the waiters, a group of high-school students and their teachers, a young family with two children and a German tourist with his young son were among my interlocutors at the *kavinė*.

I also interviewed individuals of different generations in Vilnius and Kaunas, Lithuania's second-largest city, who had visited Grūtas on one or more occasions. As well, I talked to several people in their sixties and seventies who claimed they had no desire to travel to "that place of crime" (*nusikaltimo vieta*) as one of them referred to the park with disdain. For these interlocutors, Grūtas, paradoxically, was an evocative reminder of what should be forgotten; they seemed to want no memories of socialism. While some of my informants strove consciously to suppress the park's memorial effect, for others, especially the younger generations of Lithuanians born in the late 1980s or early 1990s, Grūtas was hardly more than a theme park featuring quaint memorabilia that referred to a past of little value, relevance, or interest.

Print, broadcast, and electronic media were also used in this project as valuable data sources (see, for instance, the park's official website at www.grutoparkas.lt). All translations from Lithuanian and Russian are mine.

6 Such practices in post-revolutionary, and more recently, post-socialist Russia are discussed by Susan Buck-Morss (2002:80–5); Sergei Eisenstein's classic film *Oktyabr* ("October"), released in 1927, is rich in vivid images portraying the demolition of the statue of Tsar Alexander III in "people's" Petrograd in 1921. Produced by Laura Mulvey and Mark Lewis, the documentary *Disgraced Monuments* (1994) thoughtfully examines the ways in which the life of various monuments was shaped by changing regimes in the ex-USSR.

7 The resurgence of memory is, of course, not exclusive to the former Soviet bloc. Recuperation of the past, one can safely conclude, has become a transnational phenomenon *par excellence*. Ethnographers have provided a wealth of evidence attesting to the vitality and heterogeneity of mnemonic practices in differing local contexts. More specifically, researchers have documented various ways in which social

actors recall, reproduce, or "invent" the past, as well as how they mobilize memory to identify, to accuse, to demand accountability, to dispute state-sanctioned master narratives of history and so forth (Antze and Lambek 1996; Sutton 1998). As well, today's mass media are replete with discourses and representations that invoke differing pasts. Closely implicated in the politics of identity, memory is certainly not losing its social value and relevance in the face of advancing capitalist modernity and its associated visions of the future. "Modern societies" are not becoming "hopelessly forgetful," as Nora (1989: 8) pessimistically concludes. Memory is constantly on our minds not because there is so little of it left, as he claims, but precisely because there is so much of it.

8 Sigmund Freud once concluded that "hysterics suffer mainly from reminiscences" (cited in Terdiman 1993: 3). James Joyce, Freud's contemporary, wrote: "History is the 'nightmare' from which Western man must awaken if humanity is to be served and saved" (cited in Sutton 1998: 13); and Karl Marx famously proclaimed that "the tradition of all generations weighs like a nightmare upon the brain of the living" (in Terdiman 1993: 48–9). These, of course, are preeminently evolutionist pronouncements that valorize futuristic ideas and ideals and denigrate the past, often subsumed under the concept of backward "tradition," as crippling ballast to be cast off in the name of "modern" social progress.

9 In postapartheid South Africa, the idea that all statues representing white male supremacy should be "jailed," rather than "executed," was voiced by satirist Pieter Dirk Uys who wrote: "All Afrikaner [Boer] monuments [should] be removed from the mainland and placed in cells in the prison on Robben Island. It could then be called "Boerassic Park" (cited in Coombes 2003: 19). A cartoon depicting such a "park" appeared some time later in the South African *Mail and Guardian* February 1, 1996.

10 "Multisensory" exhibits, fairs, museums, and other sites of public display are certainly nothing particularly new; see Grever and Waaldijk 2002: 117–23; Handler and Gable 1997. For an interesting discussion of how sight and taste operate as complementary and mutually reinforcing memory media in a museum setting, see Joy and Sherry (2003: 275ff).

11 An excellent cinematic illustration of *(n)ostalgie* is a German feature film entitled *Good Bye, Lenin!* (2003). In many ways, this film is also about remembering and "sensing" socialism. It examines, explicitly and implicitly, the nostalgic longing to see, touch, hear, smell, and taste socialist quotidian life. To illustrate, one of the main characters of the film, a woman in her fifties, has a nagging craving for a specific brand of "socialist" pickles (*Spreewald Gurken*) that have been displaced by their "capitalist" counterparts.

12 See Blum 2000; food as a commodified nostalgic past is examined in Duruz 1999; Sutton 2001; Kugelmass 1990; remembrances of "tastier" pasts in modernizing Greece is discussed in Seremetakis 1994.

13 Writing about contemporary Russia, Anna Krylova (1999: 260) notes that the Soviet joke, while now devoid of its political clout, has become a significant site of socialist memory. She reports that over the past several years many thousands of jokes have been sent by individual citizens to Russian publishing houses, newspapers, and magazines as "an aggregate attempt to (re)write Soviet history within a public forum."

14 The marginality of Grūtas Park as a locus of liminal counter-remembering is spatially indexed by its location – a forested terrain removed from major urban centers. Similarly, Szobor Park in postsocialist Hungary is spread out in a semirural area at the edge of Budapest; see Losonczy (1999: 446).

15 Such displays, or perhaps more precisely performances, are not only visual but also increasingly aural, olfactory, haptic and gustatory, as exemplified, for instance, in ritualized launches and presentations of various "Western" products at the new, glitzy supermarkets of Vilnius and sometimes in the city's squares and parks. These interactive marketing events might be seen as pertaining to the so-called experience economy, which seeks to activate and exploit different senses in an attempt to make consumption more engaging, satisfying, and – significantly for this project – memorable (see Pine and Gilmore 1998; Schmitt 1999).

Bibliography

Abercrombie, Thomas. 1998. *Pathways of Memory and Power: Ethnography and History among an Andean People*. Madison: University of Wisconsin Press.

Antze, Paul and Lambek, Michael (eds). 1996. *Tense Past: Cultural Essays in Trauma and Memory*. New York: Routledge.

Bakhtin, Mikhail. 1988. *The Dialogic Imagination*. Austin: University of Texas Press.

Baristaitė, R. and Lukošiūtė, B. 2002. "Paroda apie miestiečio buitį ir kultūrą" [An Exhibit about the City-Dwellers Domesticity and Culture]. In *Muziejininkystės biuletenis* [Bulletin of Museology], Nos. 5–6. Available online: www.muziejai.lt/Informacija/miestiecio_buitis.htm.

Battaglia, Debbora. 1995. "On Practical Nostalgia: Self-Prospecting among Urban Trobrianders." In D. Battaglia (ed.) *Rhetoric of Self-Making*. Berkeley: University of California Press.

Berdahl, Daphne. 1999. " '(N)ostalgie' for the Present: Memory, Longing, and East German Things." *Ethnos* 64(2):192–3.

Blum, Martin. 2000. "Remaking the East German Past: *Ostalgie*, Identity, and Material Culture." *Journal of Popular Culture* 34(3): 229–53.

Boym, Svetlana. 1996. "Soviet Everyday Culture: An Oxymoron?" In D. Shalin (ed.) *Russian Culture at the Crossroads: Paradoxes of Postcommunist Consciousness*. Boulder: Westview Press.

Boym, Svetlana. 1999. "From the Toilet to the Museum: Memory and Metamorphosis of Soviet Trash." In A.M. Barker (ed.) *Consuming Russia: Popular Culture, Sex, and Society since Gorbachev*. Durham: Duke University Press.

Buck-Morss, Susan. 2002. *Dreamworld and Catastrophe: The Passing of Mass Utopia in East and West*. Cambridge, MA: MIT Press.

Casey, Edward. 2004. "Public Memory in Place and Time." In P. Kendall (ed.) *Framing Public Memory*. Tuscaloosa: University of Alabama Press.

Coombes, Annie. 2003. *Visual Culture and Public Memory in a Democratic South Africa: History after Apartheid*. Durham: Duke University Press.

Davis, Natalie and Starn, Randolph. 1989. "Introduction." *Representations* 26:3–25, special issue on Memory and Counter-Memory.

Douglas, Mary. 1991. "Jokes." *Rethinking Popular Culture*. C. Mukerji and M. Schudson (eds). Berkeley: University of California Press.

Duruz, Jean. 1999. "Food as Nostalgia: Eating the Fifties and the Sixties." *Australian Historical Studies* 113:231–50.

Fentress, James and Wickham, Chris. 1992. *Social Memory*. Oxford: Blackwell.

Foucault, Michel. 1995. *Discipline and Punish: The Birth of the Prison*. New York: Vintage Books.

Freud, Sigmund. [1903] 1976. *Jokes and their Relation to the Unconscious*. New York: Penguin Books.

Gillis, John. 1994. "Memory and Identity: The History of a Relationship." In J. Gillis (ed.) *Commemorations: The Politics of National Identity*. Princeton: Princeton University Press.

Grever, M. and Waaldijk, B. 2004. *Transforming the Public Sphere: The Dutch National Exhibition of Women's Labor in 1989*. Durham: Duke University Press.

Guerts, Kathryn Linn. 2002. *Culture and the Senses: Bodily Ways of Knowing in an African Community*. Berkeley: University of California Press.

Handler, Richard and Gable, Eric. 1997. *The New History in an Old Museum: Creating the Past at Colonial Williamsburg*. Durham: Duke University Press.

Hann, Chris, (ed.). 2002. *Postsocialism: Ideals, Ideologies and Practices in Eurasia*. New York: Routledge.

Howes, David. 2003. *Sensual Relations: Engaging the Senses in Culture and Social Theory*. Ann Arbor: University of Michigan Press.

Humphrey, Caroline. 1994. "Remembering an 'Enemy': The Bogd Khaan in the Twentieth-Century Mongolia." In R. Watson (ed.) *Memory, History, and Opposition under State Socialism*. Santa Fe: School of American Research Press.

Huyssen, Andreas. 1995. *Twilight Memory*. New York: Routledge.

James, Wendy. 2003. *The Ceremonial Animal: A New Portrait of Anthropology*. Oxford: Oxford University Press.

Joy, A. and Sherry, F. 2003. "Speaking of Art as Embodied Imagination: A Multisensory Approach to Understanding Aesthetic Experience." *Journal of Consumer Research* 30: 259–82.

Kaneff, Deema. 2004. *Who Owns the Past? The Politics of Time in a "Model" Bulgarian Village*. New York: Berghahn Books.

Kiaupa, Zigmas. 2002. *The History of Lithuania*. Vilnius: Baltos Lankos.

Krylova, Anna. 1999. "Saying 'Lenin' and Meaning 'Party': Subversion and Laughter in Soviet and Post-Soviet Society." In A.M. Barker (ed.) *Consuming Russia: Popular Culture, Sex, and Society since Gorbachev*. Durham: Duke University Press.

Kuchler, Susanne and Melion, Walter (eds). 1991. *Images of Memory: On Remembering and Representation*. Washington and London: Smithsonian Institution Press.

Kugelmass, Jack. 1990. "Green Bagels: An Essay on Food, Nostalgia, and the Carnivalesque." *YIVO Annual* 19:57–80.

Lambek, Michael. 2002. *The Weight of the Past: Living with History in Mahajanga, Madagascar*. Basingstoke: Palgrave Macmillan.

Losonczy, Anne-Marie. 1999. "La patrimoine de l'oubli: Le 'parc-musée des statues' de Budapest. In *Ethnologie française* 3:445–52.

Narušytė, Agne. 2003. "Post-Soviet Scriptum." *Šiaurės Atėnai* [*Athens of the North*], 367 (January 25). Available online: http://services.tvk.1t/culture/satenai.

Nora, Pierre. 1989. "Between Memory and History: *Les Lieux de Mémoire.*" *Representations* 26: 7–25, special issue on Memory and Counter-Memory.

Phillips, Kendall. 2004." Introduction" In P. Kendall (ed.) *Framing Public Memory*. Tuscaloosa: University of Alabama Press.

Pine, J. II and Gilmore, J. 1998. *The Experience Economy*. Boston: Harvard Business School Press.

Schmitt, Bernd. 1999. *Experiential Marketing: How to Get Customers to Sense, Feel, Think, Act, and Relate to Your Company and Your Brands*. New York: Free Press.

Seremetakis, Nadia. 1994. *The Senses Still: Perception and Memory as Material Culture in Modernity*. Boulder: Westview Press.

Skultans, Vieda. 1997. *The Testimony of Lives: Narrative and Memory in Post-Soviet Latvia*. London: Routledge.

Skultans, Vieda. 2001. "Arguing with the KGB Archives. Archival and Narrative Memory in Post-Soviet Latvia." *Ethnos* 66(3):320–43.

Stewart, Susan. 1984. *On Longing: Narratives of the Miniature, the Gigantic, the Souvenir, the Collection*. Baltimore: Johns Hopkins University Press.

Sutton, David. 1998 *Memories Cast in Stone: The Relevance of the Past in Everyday Life*. Oxford: Berg.

Sutton, David. 2001. *Remembrance of Repasts: An Anthropology of Food and Memory*. Oxford: Berg.

Ten Dyke, Elizabeth. 2000. "Memory, History, and Remembrance Work in Dresden." In D. Berdahl, et al. (eds) *Altering States: Ethnographies of Transition in Eastern Europe and the Former Soviet Union*. Ann Arbor: University of Michigan Press.

Terdiman, Richard. 1993. *Present Past: Modernity and the Memory Crisis*. Ithaca: Cornell University Press.

Verdery, Katherine. 1996. *What Was Socialism, and What Comes Next?* Princeton: Princeton University Press.

Verdery, Katherine. 1999. *The Political Lives of Dead Bodies. Reburial and Postsocialist Change*. New York: Columbia University Press.

Watson, Rubie. 1994. "Memory, History, and Opposition under State Socialism: An Introduction." In R. Watson (ed.) *Memory, History, and Opposition under State Socialism*. Santa Fe: School of American Research Press.

Zelizer, Barble. 2004. "The Voice of the Visual Memory." In K. Phillips (ed.) *Framing Public Memory*. Tuscaloosa: University of Alabama Press.

Index

Ablett, P.G. 588, 592, 595

Aborigines 116, 533; myths, songs and story-telling 533; and Native Americans 364

abuses 74, 113, 179, 475, 755, 790; human rights 389, 756; past 790; sexual 365, 690

academics 61, 64, 78, 91, 136, 170, 447, 450, 599, 602, 625, 628, 632, 634–635, 637; cross-disciplinary 632; Icelandic 156; museum 3, 537; non-Communist 574

ACE *see* Arts Council England

Aceh 466–467

Acosta, Pablo 482

activism 469, 572–573, 581, 587, 763; conservative nationalist 469; contemporary 581; cultural 763; post-colonial 572

activists 10, 56, 70, 581, 628, 755, 862; community-based 625; identity-focused 629; indigenous 566; local 755, 821, 830

Adams, Henry 115, 259, 261–262, 396, 573–576, 772

adaptations 12, 88, 719–722, 751; contemporary 12; cultural 721, 723; of curatorial practices to cultural protocol 720; museum's 702

Adorno, T.W. 284–285, 501

adults 324, 362, 657–658, 706

advertisements 147–150, 156, 159, 161, 433–434, 438; food 149; Icelandair's inflight 154; large 502; local 149; and news articles 163

Aegina marbles (restoration) 224

aesthetics 69, 113, 117, 119, 123, 125–126, 208, 238–239, 368, 419, 492, 534–536; cultural 11; traditional 231; transcendental 140; values of 125, 137, 224, 818

affective responses 186, 300, 307–308, 321, 329, 333–334, 340, 443; initial 422; instinctive 321

affiliations 74, 350, 435, 771; academic 272; ethnic 547; Irish-American links and 350; multinational 545; religious 436

AFRC *see* Armed Forces Revolutionary Council

Africa 90–91, 180–181, 189–190, 192, 194–195, 197–198, 200–201, 381, 384, 388–392, 461–463, 465, 479–480, 605, 607; historic role in slave trading 202; and the influence on Spain

from northern 548, 657; pre-colonial 462; and school examinations controlled by British examination boards 457

African American Art Museums 574, 579

African American Institutional Study Advisory Board 576–577

African-Americans 189–192, 194–197, 199–200, 246, 250, 347, 570, 573, 576–580, 582; civil rights 463; culture 582; kids 349; scholars 463; visitors 186

Africans 169–173, 180, 189, 192–195, 198, 384, 387, 389–390, 395, 461, 463, 465, 481, 534, 607; antecedents (quest for) 463; architectural experience 173; building traditions 172; civilizations 391, 461; descendants 170, 172, 463, 574; diaspora 171, 605, 706; enslaved 190–191, 193–195, 200; heritage 12, 170, 388, 605; identities 386, 393–394; immigrant 171; influence on Puerto Rican architecture 170; nationalists 462; oral histories 461; polities 785; slaves 192–194, 348; society 387, 462

Afrikaners 394–395

Afro-Brazilians 547; history and culture 547; identity 547

Agadja, King 193–194, 200

Ahmed, Sara 308, 330, 340

AHRC *see* Arts and Humanities Research Council

Ahrens, J. 600, 602

Akagawa, N. 114–116

Alberta 714–715, 717, 719, 721, 725, 727

Alberta Museums Association 723

Algeria 436, 457–459

Alisera, J. 781

Alivizatou, M. 115, 117–118

Alldridge, T.J. 782

Allied prisoners 734, 816–817, 820

allies 363, 749–750, 765; involved in the rebuilding and policy-making 749; western 358–359

AMA *see* Alberta Museums Association

Ambos, Eva 543, 543–558

American flags 346, 443

American Immigrant Wall of Honour 346–347

Index

Americans 67, 247, 250, 254, 256, 344, 350, 354, 358, 367, 562–563, 570, 574, 579, 582; and Indian activism 573, 575, 722; and their culture 254–255, 574; and their heritage sites 244–245, 247, 249, 251, 253, 255; and their identities 254, 347, 349; and their immigrant heritage 346

ancient monuments 21

Anderson, Benedict 58, 158, 379, 387, 436, 688, 715, 725, 819

Anderson, John 821

anthropologists 65, 286, 385, 395, 446, 534, 551, 587, 589, 688, 788; cultural 254; inspired 281; professional 255, 534; social 534

anthropology 3, 5, 57–58, 71, 134, 189, 275–276, 418, 520, 655–657, 660, 778, 785; history of 275–276; museums 540, 656–657, 660

anti-globalization 391

antiquities 1, 12, 83, 87, 138–140, 185, 187, 209, 222, 228, 268, 270, 378, 391, 406; classical 84, 223; festival's 280; great 22; Mexican 138

Anzac Cove 823

apartheid 381, 383, 385, 387, 392–394, 396–397, 514, 548–549; administrators 384; governments 388, 391, 393–394; laws 385; repression 388; rule 383, 386; state 384, 548, 551; tribes 384

Arab heritage 476

Arab nationalists 464

Arab nations 407

Aram, Eugene 88

archaeological 140, 686, 688, 698, 838; heritage 164; monuments 134, 138; projects 399, 686; reconstructions 838, 846; research strategies 742

archaeologists 69–70, 84, 138, 163, 385, 394, 398, 446, 450, 534, 643, 686, 689–690, 693, 697–698

archaeology 32, 37, 138, 140, 390–391, 393–394, 446, 450, 631, 643, 686–689, 696–697, 736, 838, 840–841; contemporary 687; prehistoric 842

Archer, Jeffrey 45

architects 83, 138, 264, 444, 559, 750, 819, 841

architecture 124, 170–171, 174–175, 235, 237–238, 264, 444, 446, 738, 752, 851

archivists 625–627

Arendt, H. 57, 59

Arleen Pabón 12, 164, 169–170, 172, 174–175

Armed Forces Revolutionary Council (Sierra Leone) 787, 789

Armstrong, John 409, 451

Armstrong Fumero, A. 140–141

Arneil, Stan 817

Arnheim, Rudolf 232

Arnold, J. 15

Arnoux, Alexandre 231

Arnstein, S. 628, 632, 716–717, 723

Arnstein's Ladder 717

art 124–125, 205–207, 210–211, 223–224, 226–231, 233, 235–239, 265–268, 270–272, 451, 530–531, 533, 656–658, 799–800, 804; folk 245, 424, 761; forms 125, 228, 235–237, 444; galleries 211, 424, 451; historical 453, 843; history 37, 58, 63, 275, 298, 575, 656; work of 224, 226–230, 232–234, 237, 265–266, 536

art museums 265, 270, 442, 655–656; contemporary 657, 661; public 180

artefacts 57, 171, 266–268, 282, 334, 356, 361, 368, 377–378, 421, 423, 425–426, 532–533, 535–536, 822; cultural 202, 356; historical 208; identifiable 170; popular memorial 21; religious 268

Arthur, King 84

artists 206–208, 211, 213–215, 217, 223–225, 337, 339, 494–496, 520, 522, 530, 533, 559, 561, 841–844; drag queen 666; professional 211; Steampunk 186, 205–207, 209–210, 213, 217; visual 660, 781

Arts and Humanities Research Council 625, 629–631, 633–634, 637, 664, 667

artworks 31, 125, 207–209, 214, 216–217, 503, 523, 533, 560, 566, 799; contemporary 533; finished 125; intermingling Steampunk 211; public 559, 567

Ascherson, N. 34

Ashmolean Museum 205, 419–420

Ashton, P. 96, 98, 101, 105–106

Asian communities 435, 514, 600, 602–604, 609, 611; in Leicester 600, 604; transnational 611

Aspinall, George 816, 818

Atkinson, Jeanette 205, 205–218, 601

audiences 96–97, 102–104, 106–108, 205–206, 210–211, 232, 253–254, 524, 537–538, 610, 621–622, 641–642, 657–658, 680, 833–835; contemporary 703, 708; international 191, 388; national 461; non-Native 722–723

Aulenti, Gay 272

Auschwitz 47, 267, 358–359, 362–364, 368, 765, 769–771

Austen, Jane 437

Australia 2–3, 115–116, 383, 421, 457, 460, 544, 548, 553–554, 622, 626, 640–641, 643, 814–818, 822–824; flags 822; government of 359, 642, 734, 815, 822–824; history of involvement in war 823; national identity 296, 533; national memories 823; servicemen 814–815; territory 823

authenticity 3, 114, 119–120, 185–187, 195, 197–201, 224, 227–229, 244–249, 251–255, 274–286, 406–407, 446, 534, 738; absolute 254; changing 286; claim to 198, 817; cultural 275, 278, 285; dreams of 245, 255; existential 119, 285; folkloristic 280, 282; hidden 274; identifiable 274; as impression management 254–255; institutional 248; issues of 34; jargon

879

Index

authenticity *continued*
of 284–285; lost 244; 'ludic' 119; moral 283;
nature of 276–277; objectivist 249; religious
281; removing 277–278; rhetoric of 276, 285;
twentieth-century 284
Authorised Heritage Discourse 1, 102, 441, 451,
453, 804
authority 9–10, 56–57, 59, 66–74, 198, 200–202,
244–245, 249–250, 552, 636–637, 642, 701,
829–830, 832, 835; institutional 622; invisible
528–529; scientific 199, 296; shared 626, 642,
726
Avoncroft Museum 35
Ayeni, Y. 216, 218
Azuela, Antonio 133–135, 138–139

Baines, Edward 392
Baker, Arthur 739
Baker, Charles 87
Bal, Mieke 330–331, 340
Baldwin, Stanley 441, 497
Balkan culture 429–430
Baltic republics 863
Barcelona 550
Bardgett, Suzanne 361
Barker, Nicolas 222
Barmé, Geremie R. 798–799, 807
Barnes, Amy Jane 1–5, 9–12, 598–612, 797–809
Barratt, John 87
Barry, James 677
Barthes, Roland 85
Basadre, Jorge 465
Basque nationalist historiography 465
Basu, Paul 5, 97, 734, 778, 778–792
Bateman, Mary 88
Bath, Edward 839
Battaglia, D. 852
Battle of Britain 497–498
battlefields 175, 363, 496, 591; historic 175; sites
820
Bauman, Z. 59–61, 68–69, 704, 709, 830
Bavarian Heritage Conservation Office 751, 753
BBC 158, 556
BCHO 752–753
BCHP *see* Blackfoot Crossing Historical Park
Beaumont, Joan 734, 814, 814–824
Bede's Ecclesiastical History of the English People 83, 86
Beer, Gillian 503
Beijing 469, 553, 800–801, 805, 807, 809
Belfast 52, 834
Belsen 355, 357–360, 363–364, 366, 368
Bender, Barbara 850, 850–858
Bendigo 622, 640, 643–650, 652; engagement
project 648; experience of local heritage 640,
651; groups with an interest and identity based
in local heritage 648; heritage project 647, 649;
project showing signs of success 647

Bendigo and District Cornish Association 645–646
Bendigo Art Gallery 640, 644–646, 648, 650, 652
Bendigo Cemeteries 645–646
Bendigo Heritage Representative Group 644, 650
Bendigo Historical Society 645–647
Bendix, Regina 187, 274, 274–286, 446
Bénin 186, 189–192, 195–197, 199–202, 733;
government of 191, 194, 197, 199–200; and the
indigenous religion found in Vodun 190; Slave
Route 186, 192–193; social and religious
landscape 199; tourism industry 194
Béninois 191–192, 201; contemporary 190;
officials 190; people 193; politics 190; tour
guides 189, 195; university students 198
Benjamin, Walter 236–239
Bennett, Alan 10, 44, 46, 48, 50, 52, 54–55, 58,
60–62, 66–67, 205, 209–210, 441, 641–642,
709–710
Bennett, Jane 447
Bennett, Jim 207, 209–211
Bennett, Oliver 66
Bennett, Tony 58, 61–62, 64, 540, 546
Bennison, Geoffrey 46
Béraud, Jean 272
Berenbaum, Michael 361
Berger, Carol 99, 854–856
Berger, John 855–856
Berlin 543, 755
Berlin Jewish Museum 549
Berlin Wall 739
Berman, Marshall 284
Besant, Walter 841
Best, Joel 56
Bharatiya Janata Party 459–460
BHCO *see* Bavarian Heritage Conservation Office
Bicentenary of the Abolition of the Slave Trade
2007 103–104
Biddle, Jennifer 307–308
Billig, Michael 346, 411, 782
biodiversity conservation 398–399
Birkenau 361, 771
Biven, Lucy 295, 313, 313–325
black communities 383, 385, 465
black veterans 361
black waiters 251
Blackfoot 715–716, 720–725; community 721,
723; culture 715, 722–724; elders 720–722;
language 724; people 720, 725; protocols 715,
720–721; traditions 721–722
Blackfoot Crossing Historical Park 715, 718, 720,
722–723, 725–726
Blériot, Louis 496, 501
Bloch, C. 450
Bloggs, Joe 689
Bloody Sunday 834–835
Boardman, Stan 355
bodies 63–64, 135, 295, 298–303, 307–310,

880

321–323, 330–332, 357, 359, 363–365, 368–369, 448, 478–481, 670, 787–789; independent 30; institutional 62; national 134, 356; patient's 234; sexual 479–480

Bodin, Jean 89

Bodnar, John 346–347

Bodo, Simona 97, 105, 514, 517, 517–524, 655, 657, 667

Bohemia 267–268, 410

Bolivia 460

Bonaparte, Napoleon 87

bones 158, 270, 307, 333, 839

Bonfil Batalla, G. 137, 139–140

Bonfire Night 18–20

Bookstein, Jonah 766

borders 91, 266, 344–345, 348, 351, 404, 465, 483, 537, 539, 548, 551, 594, 737; cultural 539; member-state's 594; monitored 404; national 344, 465, 503; Scottish 91

Borneman, J. 771

Bortolotto, C. 114–115, 117

Boston 360

Boston National Historical Park 348

Bourdieu, Pierre 59, 63, 189, 198, 200, 285, 375, 438, 441, 450

Brace, Catherine 491

Bradford Industrial Museum 205, 210, 212

Brady, Miranda 722

brain 295, 313–322, 325, 442–443, 452; evolution of 318–319; functions 315–316, 319; higher 319; mammalian 313, 320; process 314, 321; regions 313, 322; research 315; sciences 665; systems 313–314, 316

BrainMind 314–317

Brandon, Laura 337, 339

Brazil 191–192, 547

Brazilian history 547

Brazilian Museums Association 552

Brcuilly, John 412

Breckenridge, Carol A. 64, 547

Breen, J. 123

Briggs, Charles 286

Brink, Cornelia 357, 388, 715

Britain 19, 58, 354–358, 360, 362–365, 367–368, 435, 437, 490, 492–495, 497–499, 501–505, 602–603, 606–607, 844–846; and British identities 490; history of resistance 500; maritime identity 491, 497; museum world in 354–355, 357, 359, 361, 363, 365, 367, 369; nineteenth-century 90; place in Europe 495; relationship with the sea 491

British: cultural policy 59; domination of Ireland 22; examination boards 457; heritage conservation movement 16; historical understanding of the relationship between place and national identities 491; identities 490, 495, 501, 503; imperial claims 562; museum

professionals 63; people 355, 443, 501, 505, 600, 845; society 10, 78, 355

British Museum 69, 72, 221, 462, 658

Brown, Alison 65

Brown, Claudine 576

Brown, Kyle 337

Brown, Michael 581

Brown, Wendy 382

Browne, Kyle 338

Brumann, C. 120

Bruner, Edward 190, 194, 198–200, 244, 248, 250, 253–256, 396

Bryan, Dominic 830–831, 834

Buchan, John 355

Buchenwald 355, 358, 367

buildings 31, 113–115, 159, 185–186, 237–238, 250, 259, 261, 449, 547–548, 693, 748–754, 756, 804, 817–818; historical 750; memorable 806; new 749, 751; old Secretariat 787; synagogue 267; war-damaged 756

Bulleid, Arthur 839, 841–844

Bumpeh Pejeh 789–790

Bunning, Katy 1, 1–5, 513–515, 570–583, 621–623

Burchill, Julie 355

Burgh Castle 446–448, 450

Burke, Peter 100–101

Burnett, Andrew 222

Burns, Arthur 570, 573

business 32, 174, 246–247, 251, 263, 389, 398, 470, 550, 603, 752, 756, 799, 852, 873; history 628; links 598; relations 756; sari shop 604; tourist-related 162

Butler, Beverley 303–304, 330–334, 337–340, 627, 681

Butler, Judith 302

Bybee, Sally 503

Caesar, Julius 83, 87, 495

Café Ariel 762, 766–768

cafés 31, 154, 734, 754, 767, 871, 873; museum's 863; in the park specializing in "Soviet cuisine" 869

Calais 497–498, 504; surrender to France in 1558 494; and travelers on the route to Dover 498

Callahan, William A. 797, 807–808

Cambodia 359, 369, 590, 788; and the memorial activities of the Cambodian state at Choeung Ek 788; party-politics 788

Camden, William 493–494

cameras 196, 231–233, 236, 336, 355, 530, 646, 691, 695–696, 718

Cameron, F. 104, 642

Campaign for Learning through Museums and Galleries 829

campaigners 56, 65, 67, 69–70, 72, 154; animal rights 90; for the repatriation of human remains 64

881

Index

campaigns 70, 90, 280, 296, 350, 386, 581, 591, 797–799, 802–805, 809, 821, 829; advertising 803; communist-government-sponsored anti-Semitic 763; contemporary 627; culture-focused public-relations 114; nationalist 338; online 803; political 803; women's rights 391

camps 267, 280, 357–358, 360, 364, 716, 770, 814, 816–817; concentration 268–269, 355–356, 358–360, 366, 369, 422, 766; eastern 359; extermination 358, 764; labour 814; prison 349, 817; refugee 627, 781; Reinhard 358; slave labour 358; western 358–359, 364

Canada 47, 115, 383, 460, 544, 553, 626, 714–717, 719, 721, 723, 725, 727, 841; military past of 334; three case study museum and heritage sites 714

Canadia: government of 338; troops 47, 337

Canadian Forces Artists Program 337

Canadian War Museum 296, 329–330, 333–335, 337, 339–340

Canales, Pedro 477

Candlin, F. 29–30, 32–33, 35, 37–38

Canute, King 86

capacity 23, 200–201, 271, 298–300, 302–303, 306–309, 319, 321–322, 474, 480, 521, 642–643, 747, 753, 757; affective 318, 320; ancient prelinguistic 322; artwork's 272; assimilative 378; building 381, 396, 644; distinctive 747; individual's 310; innate neural 320; official 561; organisation's 643; possessor's 535; reduced 567; reproductive 321; sense-making 98; sexual 480; sustained 633; transformative 299; unique 303; worth-conferring 754

capital 62, 90, 92, 151, 201, 377, 388, 435, 460–461, 527, 603, 780, 845, 850; cities 140, 163; national 817; nation's 337, 571; regional 379; social 199–200

capitalism 16, 78–79, 392, 435, 471, 554, 867, 873

capitalist societies 59, 376

Captain's Tree 194

captivity 815–817, 824; Allied 816; in Changi Prison 820

Carcassonne 736–737, 741–742

Caribbean 12, 169–171, 173, 175, 191–192, 491, 781, 857; cultural memory 175; images 192; islanders 171; native houses 170; people 857

Carlsen, Benjamin 799

Carman, John 33, 37–38

Carnap, Rudolf 284–285

Casaubon, Isaac 222

Casey, Edward 768, 863, 867, 870

Castells, M. 376–377

Castle Park 691–692

castles 186, 494–495, 498, 739; historic slave 194; in Nuremberg 750

castration 478, 483

Catalans, and Basques 590

Catholic Spain 476, 482

Catholics 645–646, 762, 764, 771

Cavani, Liliana 366

Cavarero, Adriana 299

CCTV cameras 692, 695–696

cells 52, 816, 818, 822; concrete 817; old 822; small 531; surviving 52

cement 276, 418, 652, 657, 752; sculpture 194; walls 195, 787

Central Africa 114

Central America 460

Central Community Relations Unit, Northern Ireland 830

Central Europe 406

Central Jewish Museum 268

ceremonies 159, 192, 198, 200, 263, 410, 459, 561, 589, 720, 722, 786, 789–790, 862, 865; tenjamᵢ 791; wedding 263

CFAP see Canadian Forces Artists Program

Chaney, Sarah 668

Changi 814–817, 820–822, 824; barracks 816–817, 824; beach 820; gaol 817–818

Changi Museum 814, 816, 818, 820, 822–823

Changi prison 814–821, 823–824; and the Australian government's shared history of 815; demolishing of 734, 814, 823; living conditions in 817; occupation of 820

Chapman, Jake 362

CHCAP see Cultural Heritage Centre for Asia and the Pacific

Cheyette, Bryan 355

'China Dream' 735, 797–800, 802–805, 807–809

Chinese 468–469, 544, 551, 553, 798, 800, 804–805, 808–809, 820; approach to history 469, 804; civilians 820; collections in Europe 424; concept of heritage 804; history 468; people 797–798, 802, 804, 809; society 798; state instrumentalises heritage through cultural diplomacy 806

Chinese Communist Party 469, 798, 802, 804–809

Christian 159, 263, 405, 761; culture 481; monastic culture of early medieval Ireland 409

churches 20–21, 57, 86, 89, 235, 259–261, 263, 281, 392, 410, 529, 686, 691–692, 734, 780; derelict 694; early 20; fourteenth-century 264; of Harlem 274; historic 734; medieval Christian 21; original 261; Romanesque 741

Cicalo, André 543–558

Cimoli, Anna Chiara 655–661

civilization 58, 136, 282, 396, 458–459, 461, 463, 478, 536, 660, 842, 844–845; and barbarism 396; commercial 90; destroyed 361; human 57; impressions of 843–845; pre-Hispanic 140; pre-modern 808; protecting Western 483; religious 411

882

Clark, William 559
Classen, Constance 419–420
Clifford, James 64, 275, 581, 667, 693, 704–705, 714, 717–719, 827, 853–854, 856–858
CLMG *see* Campaign for Learning through Museums and Galleries
co-produced exhibitions 623, 700–711
Cobbett, William 90, 496
Coca-Cola 269, 767
collaboration 210, 628–630, 640, 643, 650, 655–656, 660, 664–667, 669, 674–675, 698, 701–702, 705, 722, 724–725; community-based participatory heritage research 629, 666, 669, 676, 679–680, 717, 829; structured 636; three-way 701–702
collaborative practices 637, 656, 664–667, 669, 680, 716
collaborative projects 623, 664, 667, 676–677, 680, 724
collections 30–32, 63–65, 69–71, 269–271, 519–523, 606, 608–612, 643–644, 650–652, 668–671, 675–677, 701–706, 721–722, 831–833, 867–869; anthropological 362, 368; city's 44; contested 703; historical 106, 217; individual 865; interpretation of 519, 724, 833; manuscript 156, 264; medical 665, 675; museums 31, 207, 521, 656, 668–670, 718, 784; new 70, 675; permanent 205, 209, 211, 217, 339, 523, 606; public 57, 225
collective identity 133, 139–140, 367, 374, 408, 411, 433, 592
collective memory 179–180, 189–190, 202, 354, 366, 374, 593–594, 643, 763, 778, 786, 804, 822, 861; official 375; postcolonial studies on 179
Colley, Linda 355
colonial 15, 140, 354, 358, 384, 460–461, 603, 779; control 562–563; domination 279; heritage 740; past 399; period 462, 554; place names 463; powers 457–458
Columbia River 515, 559–565, 567–568
Columbus, Christopher 170
Comaroff, Jean 181, 383, 390, 395, 601
commemorating 103–104, 124, 187, 193, 267, 345, 350, 476, 550, 559, 734, 786–787, 790, 792, 865–866; captivity in Changi 820; centenaries 297; European arrival in South Africa 386
commemorations 137, 181, 192, 297, 469, 474–475, 497, 559, 786–787, 815, 818, 856, 862, 869, 871; clandestine 863; "dis-identifying" 869; new multicultural independence 179; of socialism 872; state-led 394
commemorative practices 441, 788, 790, 817, 822–823
communication, personal 604–607, 668–672, 674, 676–677, 679–681, 721, 723–724

Communist China 470
communist ideologues 868–869
communist past 735, 861–862
communist states 808
communists 118, 280, 466, 468, 471, 763, 806, 863–864, 869
communities 206–211, 408–412, 545–546, 549–551, 588–591, 593–595, 626–637, 640–644, 648–652, 665–667, 714–717, 719–726, 740–742, 827–832, 834–836; academic 33, 159; aggrieved 515, 763; ancient Israelite 410; archaeological 839–840; associated 197, 592, 594; autonomous 412; best preserved historic walled 739; citizen-controlled 726; contemporary African 532; diverse 435, 519, 600, 722; historical 407, 413; homeless 686, 693, 697; imagined 58, 379, 387, 436, 611, 819, 836; international 190, 197–198; living 533, 737; middle-class 478; non-ethnic Norwegian 529, 538; religious 408, 531–532
community archaeology 625, 628–629, 697
community engagement 524, 578–579, 621–622, 625, 640–642, 652–653, 674, 714, 719, 724–725, 727, 827, 830–831; and institutions undertaking 641; internal 718; and museums 641, 716; pragmatics underpinning 833; projects 640, 643–644; rhetoric 643, 653; strategies 642; work 642; worst cases of 834
community groups 67, 206, 594, 630–631, 633–636, 640, 642, 648–649, 651–652, 675, 679–680, 828–835; employing 680; established 634; local 652; and nation states 735; racially-defined 570
community heritage 4, 210, 625, 627, 629–631, 633–635, 637, 667, 831, 834, 836; groups 634, 643, 648; initiatives 827; organisations 621–622, 648; politics of 827, 829, 831, 833, 835; programmes 630; projects 625, 647; research activities 631; research on 625, 627, 629, 631, 633, 635, 637
community members 622, 644, 674, 676, 714, 717, 719, 721, 725, 830; employment of 719, 721; individual 645; marginalised 677
community museums 550, 552, 570, 643, 835
community projects 600, 632, 634–635, 637, 648, 676–677, 679, 697, 827, 832, 835; effective 643; initiating 665
Community Relations Unit 830
competition 54, 115, 158, 563, 750, 786, 800, 840, 862; international 819; nationwide 862
complexities 99, 303, 306, 314–315, 319, 435, 439, 465, 468, 530, 532, 554, 705, 708–709, 832–833; cultural 534, 538; political 306, 470
concentration camps 268–269, 355–356, 358–360, 366, 369, 422, 766
conciliatory heritage 760–763, 765, 767, 769, 771–773

883

Index

condoms 691–692

'Confluence Project' (Maya Lin) 515, 559–561, 563–568

Connor, Walker 405

consciousness 81, 315, 317–319, 321, 324, 330, 385, 783, 862, 865; affective 313, 317–318; false 33, 254, 393; global heritage 113; nationalistic mnemonic 785; secondary-process 318

conservation 100, 136–138, 140, 180–181, 186, 390–391, 398, 448, 450, 521, 524, 588, 592, 740–742, 748; biodiversity 398–399; and exhibitions 720; people-centered 399

conservationists 82, 814, 819–820

construction 56–57, 65, 67, 174, 260, 336, 338, 503, 505, 547, 599, 601, 611, 747–749, 829–830; cultural 256, 437; discursive identity 763; materials 172; national 574; workers 657

contested landscapes 850–851, 853, 855, 857

contested townscapes 736–737, 739, 741, 743

Cook-Lynn, Elizabeth 515, 567

Cosgrove, Denis 34, 491, 850

'cotton tree' 780–783, 787, 789–790

country houses 44–47, 49–52

Cousins, Julia 385

Cox, Laverne 666

Cox, Rupert 120

crack cocaine 689, 691, 696

Cracow 739, 760–761, 765–768, 770

Creasy, Edward 88

Creighton, Oliver 186, 733, 736, 736–743

critics 34–35, 38, 118, 123, 126, 232, 244–245, 247, 300, 303, 306, 308, 310, 577–579, 581; cultural 244, 298, 300, 308–309, 388, 570; museum's 247

critiques 61, 244–245, 247, 250, 252, 302–303, 306, 333–334, 471–472, 573–574, 577, 579–580, 582–583, 767, 770; anthropological 140–141; archaeological 686; cultural 244, 770; representational 572

Croatian nationalists 430–431, 465

Croats 429–430, 432, 436

Cromwell, Oliver 44

Crooke, Elizabeth 206, 629, 640, 667, 701, 735, 827, 827–836

Crosland, Tony 494

CRU *see* Community Relations Unit

Cuba 169, 533, 549–550

cultural authority 10, 56–58, 63, 200, 664, 672, 719, 803, 805; crisis of 56–57, 59, 61, 63, 65, 67, 69, 71, 73; involves the construction of reality through definitions of fact and value 57; and Max Weber 56

cultural contexts 448, 523, 536, 607, 623, 630, 720, 738–739; contemporary 67; contrasting 741

cultural difference 383, 388, 517, 528, 535,

538–540; depiction of 529, 540; negotiation of 527

cultural diversity 64, 97, 175, 393, 395, 397, 517, 528, 533, 537, 540, 575–577, 582, 588, 590; agenda 575; approach 590; global human 591; issues of 574–575; principle of 587, 590; priorities 575; programming 575

cultural groups 384, 386, 518, 578, 648; discrete 397; diverse 720; particular 573–574, 577; under-represented 66

cultural heritage 156, 189–190, 197, 200–201, 388–392, 397, 587–588, 590–592, 599–600, 607, 687, 743, 797–798, 803–805, 808–809; definition of 31, 798; diverse 383, 797; global 587; management 643, 720; managing 687; planning 592; preservation 644; rights 595; self-identified 598; treasures 152; understandings of 609, 804; unique 153

Cultural Heritage Centre for Asia and the Pacific 543

cultural identities 4, 12, 383, 386, 438, 481, 495, 515, 521, 529, 540, 587, 593–594, 601; collective 407, 411–412; complex 577; and the diaspora 438

cultural institutions 66, 149, 159, 246, 345, 641, 665, 670, 679; and artistic networks 61; state-sponsored 59

cultural policies 62, 135, 149, 543, 551–552, 709; three aspects of 805; wider and based on a discourse of diversity and access for all 703

cultural power 18, 20, 22; large-scale 271; relationships 22

cultural practices 97, 99, 114, 267, 383, 552, 655, 720; disrupted 720; present-centred 22

cultural property 114, 132, 134–135, 137, 139, 197, 737

cultural relativism 60–61, 66, 709

cultural representations 534, 725–726; diverse 513; updated 534

Cultural Revolution (China 1960s) 468–469, 799–800, 803, 805, 807–809

cultural studies 5, 37, 61–62, 64, 295–296, 298–299, 309, 434, 484, 763; early 61; scholars 64

cultural theorists 300, 302, 306; contemporary 306; hardened 300; shy 302

cultural theory 60–62, 65, 298–302, 304–305, 308, 310; contemporary 300; development of 61–62

cultural traditions 159, 393, 411, 518–519, 594, 609, 737

cultural villages 382, 395–397, 549; critiqued 398; high-end 397

culture 59–64, 254–255, 275–276, 278–281, 331, 383–390, 392–395, 433–437, 518–520, 527–528, 532–534, 536–540, 551–552, 588–590, 592; black African 463; civic 279,

405; common 140, 433; consultancy 390, 398; consumer 118; devaluing community 592; diversity of 519, 551, 573, 702; dominant 354, 518; drug 698; elite 1; emotional 450; ethnic 278, 409; expressive 278, 280, 285–286; foreign 539; hegemonic 180; human 375, 419, 492; and identity 159, 831; identity-based 590; immigrant 538; Jewish 362, 761; mainstream 519, 600; middle class 58; migrant 538; military 337–338; minority 519; national 278–279, 346, 407, 436, 505, 547, 571; non-conformist 698; non-ethnic Norwegian 527, 530, 539; Polish 761; politics of 275, 723; shared 432, 592; and society 146; Soviet-Era 866; superior Babylonian 410; visual 4, 334, 797–800, 803, 809; wars 63, 255, 571–572; working class 35
Cunningham, Hugh 490
curators 65, 68–71, 73–74, 211, 213–214, 335, 337, 421, 539, 545–546, 655–656, 677, 679–681, 707, 722; guest 207; the role of the 575; senior 69, 74; traditional 702; volunteer 603; work of 528–529
Cuthill, M. 642–643
CWM *see* Canadian War Museum

Dabin, Katie 671, 674–677, 679–680
DAC *see* Department of Arts and Culture
Daehnke, Jon 515, 559, 559–568
Dahlhaus, Carl 274
Daniel, Glyn 840
Daniels, Stephen 491
Darnton, Robert 86
David, Samuel T. 405
Davidson, Marisa 772
Davies, Samuel T. 99, 325
Davis, Peter 64, 156, 862–863, 865
Dawkins, Boyd 839, 844
de Blunes, Miguel Ángel 474
De Botton, A. 451
de Ruiz, Lombardo 136, 138, 140–141
DEAT *see* Department of Environment and Tourism
deaths 181, 194, 304, 337, 339, 359, 362, 364–366, 482–483, 766, 788–789, 791, 817, 854, 856; Australian POW 817; camp 363; heritage is rooted in 12; Jewish 766; rates of 563
defence 66, 120, 464, 491, 495, 497, 500, 736, 738, 820–821, 823; imperial 501, 816; long-standing 824; national 338, 490, 495, 497, 505; natural 495; policies 497
Defoe, Daniel 493
Deleuze, Gilles 301, 309–310, 752, 853
Deloney, Thomas 88
Department for Culture, Media and Sport 72–74, 703
Department of Arts and Culture 383, 389

Department of Environment and Tourism 389
Derrida, Jacques 174
Descartes, Rene 295, 315
Desgues, Patrick 264
Deutsch, Karl 405
Deutscher, Isaac 857
development 2, 14–18, 20–21, 57–59, 138–139, 190–191, 222–223, 383–384, 393–395, 520–523, 574–575, 628–631, 633, 640–644, 650–652; cultural 151; economic 377, 389, 393, 472, 642, 807; heritage tourism 806; historical 2, 90, 170, 453, 481, 608, 863
Dhanjal, Sarah 629
dialogic, process 701, 708
dialogical 514, 520–521, 523, 655; dimensions 522; paradigm 518; programming 622
diaspora communities 603–604, 606, 611–612
diaspora cultures 603, 611
Dibdin, Charles 494
Dickens, Charles 207
Dig Where We Stand 625, 630–633, 635–638
disciplines 1–3, 5, 9–11, 14, 57–58, 62, 82, 275–277, 279–281, 296, 301, 442–443, 587, 631, 636; of archaeology and history 446, 450; cultural 275–276, 279; historiographical 588
discoveries 23, 86, 106, 275, 280, 283, 302, 409, 480, 559, 690, 696, 700, 788, 838–841; archaeological 839, 841; important 163, 839; Keller's 838; native cultural 277; nineteenth-century 90; prehistoric 841; recent 838
discrimination 98, 106, 385, 574, 666; aesthetic 267; alleged 465; economic 834; new 393; reverse 576
Disneyland 34, 246–247
displacement 66, 140, 266, 307, 481, 528, 563–564, 567, 756–757, 803, 853; affective 308; bodily 301; cultural 594; existing partial 756; forced 545; mass 514; physical 592
display 65–66, 213–215, 268–270, 329, 334, 336–337, 340, 357–358, 419, 527–536, 539, 667–670, 672–675, 721–722, 835–836; cases 266, 268, 665, 672; cultures on 64, 534, 536, 573; museum's window 156; objects on 205, 214, 216, 531, 533, 536, 707; public 333, 365, 588, 711, 832, 835–836; techniques 528, 530, 532, 536–537
diversity 30, 32, 213, 386, 436–437, 513–515, 543–546, 548, 550, 574–575, 581–582, 591–592, 598–599, 648, 827; of cultural expressions 587, 590; historical 644; and identity 511, 577
Dodd, Philip 104–107, 664, 667
Dodd, Thomas 358
Douglas, Lawrence 358, 872
Douglas, Norman 659
Dover: town 493, 499, 502; white cliffs of 490–499, 501–502, 504–505

885

Index

Drew, Arthur 32
Dubin, Steven 65, 67, 572
Dubuffe, Guillaume 272
Dudley, Sandra H. 3, 418, 418–426
Duhamel, Georges 237
Duncan, Carol 58, 63–64
Dunn, Richard 214–215, 217
Durie, Robin 636–637
dwellings 175, 274, 530, 632, 855; Caribbean 170; lake 838; national 857; prehistoric 838; rural 530; urban 866

Eagleton, Terry 59–60, 62
Early, James 574
East Africa 457, 602–603, 605, 607
East African Asians 514, 598, 600, 602–604, 606
East Europeans 864–865
Eastern Europe 81, 280, 358, 361, 409, 435–436, 656, 788, 861, 865, 871–872
Edgar, Percy 499–500
Eide, Elisabeth 538
Einarsson, Niels 159
El-Haj, Abu 736, 738, 742
Elders of Zion 222, 715, 718, 720, 722, 724–725
elites 2, 17, 22, 61, 63, 67, 139, 410–411, 441, 460; colonial 246; cultural 66, 354; educated 500, 642; Western 1; white 385
Elizabeth, Ann 133, 448
Ellis Island 343–351
Ellis Island Immigration Museum 344–346, 350–351
Ellis Island National Monument 344
emigration 545, 550, 658–659
emotional connections 297, 299, 766
emotional expressions 443
emotional feelings 314–315, 317, 319, 322, 325
emotional responses 187, 295, 315, 422, 424, 441, 443, 450–451, 453, 627; intense behavioral 317; personal 442; strong 186
emotions 3, 102–104, 293, 295–296, 300–301, 308, 310, 317–320, 323, 325, 441–444, 446, 448, 450–451, 453; basic 314, 316, 320, 443; negative 104, 323; primary-process 315–316, 321
employees 248–250, 254, 260, 450, 562
engagement 210–211, 213, 330–331, 333, 418–419, 423–424, 622–623, 630, 637, 640–644, 647–648, 714–719, 723–727, 827, 829–835; community 524, 578–579, 621–622, 625, 640–642, 652–653, 674, 714, 719, 724–725, 727, 827, 830–831; cycles of 636–637; emotional 209, 297, 420, 426, 441, 443, 446–447, 449, 451, 453; heritage 827, 835; museum 206, 218, 704; object-person 420; process of 424, 717; projects 640, 644, 648–650, 652–653, 679, 681; relationships 725; work 643–644, 648–649, 652, 719; zones 623, 714, 716–720, 724–726

English Heritage 19, 450
environment 90–91, 117, 235, 245, 254, 318, 378, 395, 559, 566, 591, 595, 742–743, 763, 768; commitment to the 391; forest 778; free-choice 641; historic 441, 742; immersive 659; physical 98; social 478; sustainable community 630
environmental: catastrophe 391; issues 566, 642; losses 565; pollution 153, 536; stewardship 567; sustainability 376, 391, 560, 567
ethnic communities 409, 412, 540, 579, 594
ethnic groups 35, 349, 431, 437, 463, 538, 574, 578–579, 581, 738, 804
ethnic heritage 570–571, 573, 575, 577, 579, 581, 583
ethnic museums 570, 573, 577–581, 583; developments 580, 582; federally supported 579; new 573
ethnographic 405, 531, 533–535, 537, 656, 862; approach 532–533, 608; galleries 527, 532, 534; museums 572; regimes of representation 536
ethnography museums 622, 656
European 170–174, 191–194, 280–281, 356–357, 429–430, 435–436, 460–464, 470–471, 475–484, 499–502, 517–518, 545–546, 560–562, 737–739, 864–865; buyers 192; cities 379, 435; colonization 461; cultures 63, 354, 356, 430, 463; ethnology 280; identities 436; museums 34, 553, 656; nations 356, 475, 484; societies 354, 501, 546
European Commission Directorate General for Education and Culture 518
European Institute for Comparative Cultural Research 518
European Union 150, 260, 436, 470–471, 475–476, 478, 518, 545, 864
Evans, Jessica 736, 839
excavations 45, 359, 364, 693–694, 696, 698, 743, 788, 839–840, 844
exhibition: space 58, 207, 521, 531; strategies 335, 524; style 533; value 230
exhibitions 65, 103–104, 205–211, 213–215, 217, 360–364, 366–368, 421, 444, 531–536, 599–600, 603–604, 608–612, 700–706, 832; collaborative 520, 644, 656, 666, 725; controversial 65–66; cultural history of 531; multi-vocal 520–521; programmes 645–646; temporary 103, 156, 533, 537, 650, 667, 674
experience 97–99, 119–121, 270–274, 320–323, 418–420, 424–425, 433–434, 446–447, 657–660, 676–677, 702, 704, 767–768, 835–836, 856; affective 317, 322, 325, 329; disabled people 106; emotional 195, 450; intangible 124–125; museum visitor's 426; national 573, 582–583; subjective 119, 123, 317; tourist 199; visitors 1, 447, 529; young people's 706
extermination camps 358, 764

886

Faguais-Ridel, Geraldine 263
Fairhead, James 781
Farred, G. 385–387, 398
fascism 238–239, 300, 470
Felix, Francisco 192
Ferry, E. 133
fieldwork 253, 280, 286, 688–689, 691, 693, 695, 871
Fiennes, Celia 419–420
filming 46, 48
films 46, 206–208, 210, 217, 227–228, 230–238, 348, 357, 359–361, 366, 368, 499, 503, 556–557, 785; and actors 231–232; great historical 228; sound 227, 232, 234
Finch-Boyer, Heloise 215
First World War 18, 82, 88, 355, 458, 496, 563, 790, 832
flags 394, 443, 561, 782; American 346, 443; Australian 822; Icelandic 149–150; national 432, 658, 782
Flamsteed, John 214
Fleischmann, Karel 267
Flinn, Andrew 621–622, 625, 625–638
Florescano, Enrique 134, 136–140
Florey, Howard 823
folk art 245, 424, 761
folklore 113, 154, 187, 275, 277–281, 286, 385, 409; museums 47, 120; studies 274–275, 286
Fontana, Lucio 657
food 156, 260, 263, 321, 323, 535, 658–659, 806, 870–872; advertisements 149; fast 871
Forestier, A. 838, 840–847
Fortmann, Tracy 561
Foucault, Michel 200, 381, 441, 718, 868
framework 4–5, 103, 107, 277, 281, 302, 324, 422–423, 431–432, 435, 591–592, 622, 627, 631, 635–636; broader socio-historical 632; historical 187
France 57–58, 63–64, 90, 259, 262–263, 410, 413, 462, 464, 492, 494–495, 497, 502–504, 840, 843–844; cultural history 272; resurgent 496; revolution-ravaged 499
Frank, Adam 299
Fraser, Mat 106
Fraser, N. 303, 719
Fraser, Nancy 302
Freetown 780–781, 784–787
Friedman, David 366
Fuller, Nancy 64
functions 96, 99, 308, 313, 315, 356, 363, 375–376, 492, 498, 500–502, 517, 521, 523–524, 701; anthropological 363; artistic 227, 230; central 62; civic 754; fundamental 524; geographic affiliation 772; linguistic 588; mechanical 521; museum-as-collection 717; social 229; socio-political 377–378
funding 30, 60, 388, 575, 579, 625, 629–631, 633,

641, 647–649, 651–652, 667, 679–680, 722–723, 831–834; central government 38; external 629; federal 345; private sector 346; public 629, 667; sources of 723
Furedi, Frank 61–62, 67

Gable, Eric 3, 102, 187, 244, 244–256, 869
Gaither, Barry 65, 571
Gakpa, Beatrice 605
Gala, Antonio 474–475, 478, 484
galleries 59, 63, 216–217, 452–453, 527, 529–530, 532–533, 641–642, 648, 650, 652–653, 668–669, 673–674, 722, 724; community 828; ethnographic 527, 532, 534; great national 490; historical 339; and museums 106, 641–642, 652, 657; permanent 530, 533–534, 536, 665, 667, 674, 715, 722
Gance, Abel 228, 231
Gapta, Beatrice 605
Garret, Jim 362–363, 365
Gay, Enola 65, 573
GEACPS see Greater East Asia Co-Prosperity Sphere
Geertz, Clifford 199, 201, 275
Gell, Alfred 528
Gellner, Ernest 405
gender 64, 106, 278, 307, 411, 438–439, 471, 594, 664–665, 667–672, 674–675, 677, 679, 681, 869–870; boundaries 483; changing 676; differences 432; dilemmas 676; discrete 598; diversity 664; issues 668, 670, 672; roles 845–846
gender identity 433, 623, 665, 668, 670, 672, 674–675
Germany 99, 186–187, 281, 355–356, 358, 363, 493, 503, 543, 545–546, 748, 750–751, 754–755, 844, 871; reality and law 284; unified 871
Gezo, King 192
Ghana 189–190, 194, 199, 201, 387, 470, 605
ghosts 50, 87, 90, 441, 446–448, 453
Gibbs, Kirsten 667
Gibson, Lisanne 641, 852
Gibson, William 206
Giddens, Anthony 277, 435, 851
Gilbert, Cyril 814
Gilmour, Nicola 296, 474, 474–484
Gilroy, Paul 189, 351, 857
globalization 139, 435, 471–472, 544, 547–548, 551–552, 554, 557; contemporary 376; involving an interaction between economic and cultural factors 435
Glomdal Museum 527, 537–539
Gluck, Carol 118
Goldberg, Avi 581
Golden Dragon Museum 645
Goldhagen, Daniel 360

Index

Goldstein, Helen 360
Gonzalez, Pablo Alonso 543–558
Goodman, Cynthia 587
Gordon, Colin 211, 385
Gottlieb, Alma 781
governments 33, 36, 47–48, 190, 388–389, 392, 395, 398, 459–460, 462, 465, 629, 640–641, 737, 831; apartheid 388, 391, 393–394; Chinese 468; colonial 787; Dutch 149–150; policies of 36, 563, 641, 830, 832
Goytisolo, Juan 476, 483
Graham, Brian 15, 103, 134, 296, 303, 374, 374–379, 599–602, 734, 741, 803–804
Graham, Helen 476
Gransden, Antonia 83
graves 359, 447, 734, 788–790; ancestor's 382; common 193; mass 195, 357, 359, 364, 734, 787–791; open 366; shallow 369
Graves-Brown, Paul 419
gravesites 780, 788, 790
Greater East Asia Co-Prosperity Sphere 115
Green, Sam 561, 564
Greenblatt, Stephen 187, 265, 265–273, 420, 449, 451
Greene, Thomas 266
Gregoire, Christine 180, 561
Gregoire, Mike 561
groups 71–72, 432, 519, 521–523, 537–538, 547, 578–579, 630–631, 633–637, 642–652, 657–658, 671–672, 704–708, 717–718, 828–833; bounded identity 545; of buildings 31, 114; civic 559, 561; disadvantaged social/cultural 719; external 66, 679–680, 705; governing 459–460; immigrant 348, 350, 545, 577; interest 675–676, 736, 827; local 141, 650, 667; mixed 520–521; stakeholder 735, 832, 835; tour 196; vulnerable 667
Guatelli Museum 521–522
Guggenheim, Charles 348
Guinevere, Queen 84
Gujarati communities in Leicester 600, 603, 606–608, 610
Gujarati textile collection 609–610
Gunnell, Terry 154
Gurian, Elaine 218, 760

Hall, Stuart 61, 438
Halley, Edmond 214
Halperin, David 299
Handler, Richard 3, 102, 187, 244, 244–256, 869
Hannabuss, Stuart 760
Hannas, Linda 82
Hantman, Jeffrey 563
Hardacre, H. 115–116, 121, 123
Hardt, Michael 299
Hardy, Thomas 16, 53
Harewood, David 45

Hargreaves, John 784
Harper, Charles G. 504
Harrison, Rodney 2, 9, 33, 95, 97, 105, 116–117, 333, 441, 514, 571, 590, 599, 601, 700
Hartog, Francois 180, 536
Hartog, François 536
Harvey, David C. 9, 14, 14–24, 38, 95, 97–98, 828
Haskell, Francis 84
Hastings, Adrian 409–410
Hawkes, Christopher 846
Healy, Chris 544
Heidegger, Martin 174, 284–285
Helgerson, Richard 88
Hemmings, Clare 295–296, 298, 298–310
Hemon, Audrey 264
heritage 1–5, 9–12, 14–23, 33–38, 95–105, 132–134, 179–181, 374–379, 381–395, 517–520, 598–603, 610–612, 733–739, 746–748, 750–757; age of 179, 181; agendas 22, 687; "ambivalent" 180; architectural 170; celebration of 12, 179, 396; commercialized 119; common 590; conceptualising 116, 612; construction of 611; contested 195; definition of 16, 18, 97; difficult 101; dissonant 376, 736, 742; education 606, 655; encounters 95–96, 101, 103–105; engagement 450, 644, 647–648; global 612; history of 14, 17–18, 23, 96–101, 107, 181, 386, 623, 851; and identity 4, 162, 515, 599, 831; images of 12, 151, 179–180; industry 1, 9, 16–17, 19, 33–34, 118, 437, 738–740; interpretation 21–22, 106, 375, 588, 591–593, 668; landscapes 22, 97, 345, 351, 389, 763; legislation 388, 751; management 376, 378, 715, 743; memorials 2; museums 33–34, 244, 828; narratives 4, 17; organisations 96, 611, 621–622, 625, 640, 643, 648, 650; practices 3, 12, 14, 17–18, 20, 23, 37, 132, 513–515, 555, 591, 594, 687, 748; processes 4, 15–16, 18–23, 621, 687; professionals 4, 99, 105, 107, 343–344, 377, 515, 600, 629, 697; projects 397, 552, 622, 834; resources 377–378, 623; rights-based 587, 593, 595; sector 117, 389, 391, 393, 396, 513, 552, 623, 626, 643, 827, 829; studies 33, 37; transnational 601, 611, 815
heritage groups 644, 647–650, 667, 697; local 640, 644, 650–652; representative 644; work of 644, 647
Heritage Lottery Fund 625, 629–631, 633, 637, 667
heritage practices 16, 513–514; changing 2; collaborative 680; ethno-national 763; institutionalized 748; international 587
heritage projects 394, 515, 622; community-based 834; independent community 667, 669; large 631, 648; sustaining innovative community 630

888

heritage research 631, 667, 680, 746–747, 757;
 co-produced community 630; community-
 based 628–629, 631; innovative community-
 based 631; techniques 631
heritage sites 29–31, 33–35, 95–97, 101–108,
 197–198, 245, 295–296, 344–346, 441–443,
 447, 449–451, 588, 592, 664–665, 676;
 conciliatory 762; cultural 197, 592; deliberately
 aged 120; designated world 805, 807; living
 102; management of 396, 643; national 815;
 rural 34
heritage studies 2–3, 9–10, 14–19, 22, 29–30, 33,
 36–38, 97, 571–572, 601, 605, 736
heritage theme parks 19–20
heritage tourism 119, 190, 378, 742, 805
heritage work 14, 97, 515, 621–622, 647
Hersveinn, Gunnar 158
Hewison, Robert 9, 14, 16–18, 21, 33–35, 61, 95,
 118, 379
Heywood, Paul M. 36, 73
Hill, Rick 576
Hird, William 504
Hiroshima Peace Memorial Museum 107
historians 38, 78–79, 81–86, 90, 92, 98–99, 193,
 198, 246–247, 249, 345, 348–349, 394, 491,
 546–547; academic 631; ancient Greek 223;
 architectural 126, 249; county 89; cultural 474,
 554; economic 85, 89; foundation's 250; left
 wing 804; literary 89; medieval 406, 409;
 nationalist 459; new 246; professional 34, 81,
 118, 245, 249; socialist 78; traditional 17;
 trained 66; white Western 463; working 79–80
historic buildings 186, 691, 749, 751
historic preservation 170; activities 174; dwindling
 345; methdologies 174; standards 170
historic sites 96, 103, 253–254, 261, 345, 382,
 446, 448, 450, 770; contemporary 806; global
 network of 102, 838
historical analysis 15, 395, 536; embedded 16;
 longer 14
historical consciousness 11, 95–105, 107–108, 461,
 463, 468; changing 91; exemplary types of 100,
 108; genetic type of 100, 103, 105; positioned
 as a universal process familiar to all human
 societies 99
historical context 348, 408, 413, 444, 446, 451,
 477, 536, 563, 571, 838; longer 548; particular
 382; singular 421
historical events 100, 156, 214, 217, 492, 530;
 important 146, 162; significant 832
historical facts 249, 715; objective 119; particular
 863
historical interpretations 351, 368; best 248; formal
 346
historical knowledge 83–84, 771
historical legacy 56, 459, 470, 753, 779
historical narratives 60, 105, 386, 388, 764

historical research 10, 81–82, 119, 180, 335, 460,
 572, 593, 628
historical sites 12, 190, 346, 441–442, 448, 804, 806
historiography 245, 279–280, 461, 470–472, 549,
 808; anti-colonial 459; constructivist 252, 255;
 contrasting 469; entrenched objectivist 246; and
 historical methods 461; national 865; new 252,
 460; pre-modern Islamic 470; state-sanctioned
 863; traditional Western 461
history 17–18, 78–79, 81–92, 95–99, 216–218,
 249–254, 343–345, 431–433, 437–438,
 457–462, 465–470, 549–552, 577–580,
 831–836, 863–867; academic 99, 101;
 architectural 170, 752; of art 37, 58, 63, 275,
 298, 575, 656; boundaries of 10, 78; collections
 572; cultural 98, 276; discipline of 296, 552;
 diverse 360, 642–643; economic 85, 469, 471;
 and heritage 17–18, 96–101, 107, 386, 623,
 851; human 343, 391, 501, 737, 846; of
 immigration 347, 349, 519; individual 191,
 306, 739; interpretation of 89, 206, 830;
 legendary 87–88; military 385; museums 105,
 250, 451, 550; personal 194, 459, 521, 656;
 politics of 91, 305, 310, 648, 806; post-colonial
 460, 462, 464; presentation of 462, 467; racial
 572, 577, 582; recent 45, 298, 459, 465; sacred
 87, 91; scientific 11, 90; of slavery 547, 555
history museums 245, 248, 261, 346, 531, 540,
 574; often constructed by members of
 dominant classes 346
Hitler, Adolf 296, 329–330, 335–337, 733, 753;
 parade car 331–333, 340; parades 330
HLF see Heritage Lottery Fund
Hobsbawm, Eric 18, 95, 118, 280
Hodgkin, Thomas 779
Hogarth, William 216
Hoggart, Richard 61, 355
Holloway, Joseph 447
Holocaust 47, 335, 354–357, 359–363, 365–367,
 369, 464, 734, 762–765, 767–768;
 commemoration 354, 363; consciousness 765;
 memorials 464; museums 361–362, 369
Holocaust Exhibition 296, 356, 361–363,
 367–368; national 363; permanent 354, 356
Holtorf, Cornelius 120
homeland 194, 200, 384, 393–394, 407, 491,
 497–499, 501–502, 505, 545–546, 548, 602–603,
 605, 610–612, 781; British 499, 502–503; historic
 408; imperial 504; legislation 385; nations
 claiming 490; perceived 611; tribal 384
homeless people 118, 623, 688–691, 693–698
homeless places 690–691, 694
homeless sites 696
homelessness 12, 146–147, 149–152, 154,
 156–159, 162–163, 623, 686–688, 690–691,
 696, 698; contemporary 686, 688, 690; culture
 of 688, 698; heritage and local history 694

889

Index

Hood, Robin 88
Horka village collection 608–609
house museums 102–103, 422, 591
houses 31, 44–54, 114, 120, 170–174, 193, 211, 214–216, 227, 252, 262, 356, 443, 449, 845; grandmother's 852; historic 247, 453; turf 150–152
Howard, Leslie 33, 35, 38, 499, 599, 601–602, 738, 803–804, 823
Howard, Peter 37
Howes, David 419–420, 863
Hughes, Kathryn 47, 283, 389, 396, 788
Hugo, Victor 207, 260
human community 285, 407, 411, 413; forms of 408; historical 410; types of 407
human rights 97, 102, 469, 587–589, 591–593, 595, 626, 755–756, 788; cultural 591; and education 755; heritage of 592, 757; initiatives 755–756; interventions 788; issues 588; primary 592; principles 588; universal 734; values 588, 595; violations 789
Hume, David 461
Humper, Joseph 792
Humphrey, Caroline 853, 866
Hutchinson, John 413
Huyssen, Andreas 95–96, 98, 865
Hymans, Jacques 782

Iacocca, Lee 347
Iceland 12, 146–147, 149–154, 156–159, 161–164
Icelandic 147, 149–150, 152–153, 156, 159, 162; culture and heritage 147, 149; government 147, 149–150; heritage 146–147, 149–151, 156, 159, 162–163; history 149, 156; identity 152, 158–159; museums 147
Icelandic manuscripts 146, 156, 163
ICOM *see* International Council of Museums
ICOMOS *see* International Council of Monuments and Sites
identification 33, 62, 232, 307, 322, 336, 374, 377, 408, 434, 589, 594, 769, 771–772, 869; cultural 528; national 436, 863; processes 610
identity 95–98, 100, 104–107, 139–141, 374–376, 378–379, 411–412, 429–439, 461–462, 546–548, 550–551, 557–558, 580–583, 598–603, 787–789; assertion of 431, 869; building 550; categories 439, 771; collective 133, 139–140, 367, 374, 408, 411, 433, 592; contemporary 103, 591; contested 435; crisis of 431, 433–435, 437, 439, 478–479; and diversity 511, 577; essentialising 514, 579; ethnic 384–385, 409, 433, 435–437, 468, 547–548, 570, 578, 580, 602, 704; formation 64, 438; gender 433, 623, 665, 668, 670, 672, 674–675; individual 374, 787; issues of 162, 383, 465, 871; local 102, 187, 435, 502, 514, 545, 650, 696; museums 570–571, 580–581; politics 4,

394, 439, 515, 549–550, 554, 571–573, 575, 577, 579, 583, 591, 601, 680, 869; and representation 433, 601
Iervolino, Serena 622–623, 664, 664–681
Iggers, George C. 101
Ignatieff, Michael 407, 429–432
IKM *see* Intercultural Museum
Il-Sung, Kim 459
Ilie, Paul 479
Illustrated London News 838–839, 841
images 152, 179–181, 198–200, 215–216, 266–267, 336–337, 358–360, 365–368, 434, 497–499, 563–564, 659, 781–783, 838, 842–846; atrocity 338, 367; cultural 558; new 180; photographic 230, 338–339, 841
imagination 62, 81, 96, 98, 104–105, 199–201, 209, 254, 264, 441, 446, 785, 790, 806, 809; collective 201, 539; cultural 809; historical 103; popular 497, 784
immigrant communities 519–521, 538, 552, 660
immigrant histories 343–344, 351
immigrants 344–348, 350, 477, 520, 527, 538, 549, 553, 591, 661; contemporary 347; inclusion of 656; Italian 346; Jewish 464; young 522
immigration 343–348, 367, 477, 514, 519, 545–546, 550, 552–553, 557, 658–659, 821; experiences 346–347; history 347, 349, 519; museums 344, 546, 553
Immigration and Naturalisation Service 344
Imperial War Museum 354, 356–357, 360–363, 365, 367–368
Inauen, Ronald 281
independent museums 9–10, 29–38; association of 29, 32; growth of 29–32; heritage orientated 29; large-scale 35; new 32–34; small 30; surrounding 38; *see also* museums
inheritance 11–12, 17, 20, 81, 133–134, 181, 382, 457, 592, 601, 748; historical 437; unconscious 748
INS *see* Immigration and Naturalisation Service
institutional change 664–665, 667, 669, 671, 674–675, 677, 679, 681
institutions 30–31, 37–38, 56–60, 62–72, 74, 246–248, 250–252, 552–553, 555–556, 573–577, 641–643, 656–658, 667–669, 679, 701–702; international 201, 552; national 72, 411, 572
Intercultural Museum 514, 527, 531–532, 537–538
International Council of Monuments and Sites 119, 185, 197, 201, 738–739, 741–743
International Council of Museums 31, 137, 147, 185, 552, 723
international tourists 190–192, 194, 197, 200, 202, 389, 824; and Béninois 191, 194; envision and consume the past 191

890

Ireland 21–22, 84, 222, 350, 458, 464, 495, 831–832, 844; early medieval 409; united 735
Islamic heritage 475, 477, 484; contested 474; vision of Spain's contested 474–484
Islamic past 475, 477, 481, 483
Israel 87, 405, 410, 464, 590, 734, 764, 768, 770, 772
Italian migration museums 520, 522, 656, 658, 661
Italy 132, 462, 493, 517, 544, 546, 549, 622, 655–659, 854

Jackson, Michael 105, 302, 600, 602, 604, 781–782
Jacobsen, Jane 561
James, Henry 53, 573, 621, 865
Jane, Amy 688, 692–693, 696
Japan 11, 65, 113–115, 125–126, 197, 221, 263, 459, 469–470, 532, 604, 606, 814, 816; and General MacArthur's 'Shinto Directive' 115; made in 599, 604–605; open-air architecture and folklore museums 120
Japanese 113–115, 117–118, 120, 123–126, 263, 458–459, 468–470, 599, 601, 603–606, 611, 621, 806, 814–817, 819–822; aesthetics 125–126; captors 816; client force 458; clothing items 533; commander Yamashita 819; conquest of China 468, 819; government 114; guard posts 822; internment 349; left–wing scholars 470; made synthetic saris 604; mills 604; nationals 333; occupation of Singapore 814–815, 820; textile production 604, 611; tourists 263; traditional paintings 125; tsunami 447; war criminals 816; weddings 263
Japanese American National Museum 621
Jefferson, Thomas 247, 715
Jenkins, Philip 10, 68, 98, 394, 513, 580–581
Jenner, Caitlyn 666
Jewish 268–269, 362–364, 464, 761, 763–766, 768–770; communities 267–268, 739, 764, 766; culture 362, 761; de-assimilation and community revival in Poland 761; heritage 739, 761–763, 766, 769; history 734, 762, 772; identities 765–766; memories of Poland by Jews now living elsewhere 763; tourists 770; victims 267, 364; visitors 760, 764–765, 767, 769–770
Jews 268, 348, 354–356, 358–363, 369, 405, 464, 476, 734, 760–772, 857; historical 772; orthodox 364–365
Jingu History Museum 123
Jones, Ceri 11, 95–108, 185–187, 213, 599–601
Jones, Mark 221–225
Judah, Kingdom of 410
Julius Caesar 83, 87, 495

Kamajor Civil Defence Force 789
Kaplan, Louise 478, 481

Karp, I. 35, 58, 64, 246, 571–572, 664, 667, 669, 709
Karpf, Anne 361
Katan, Alphons 365
Kaufmann, Thomas 271
Kearns, Gertrude 329–330, 337
Keller, Ferdinand 838
Kelley, Donald R. 91
Kennicott, P. 577–580, 583
Kiddey, Rachael 623, 686, 686–698
King Adandozan 192
King Agadja 193–194, 200
King Arthur 84
King Canute 86
King Gezo 192
Kirshenblatt-Gimblett, Barbara 117, 125, 180, 285, 346–347, 396, 608, 747, 767
Klein, Calvin 737, 861
Knell, S. 34, 101
knowledge 57–60, 64–67, 279, 284–286, 304–305, 313, 319–321, 376–378, 441, 446, 520–521, 641–642, 670–672, 676–677, 720–722; authoritative 275, 573; cultural 138, 276, 279, 608, 720; environmental 566–567; objective 60, 102; rational 707
Kon-Tiki Museum 527, 535
Kong, Lily 820
Kopper, Philip 247, 253
Kraamer, Malika 514, 598, 598–612
Kraut, Alan 58, 246, 349, 664
Kruger National Park 382, 385, 395–396, 398–399
Kuper, Adam 283, 384, 394–395
Kurin, Richard 116–117, 762
Kushner, Tony 354, 354–369

labor camps 814, 868
labour 79, 233, 376, 425, 435, 540, 603, 627–628, 850; conditions 149; indentured 857; markets 435, 439, 598, 831; slave 358, 756; underpaid 853
labourers 345, 603, 820
Laclau, Ernesto 438
LAMS see Leicester Arts and Museum Service
Landry, Timothy R. 186, 189, 189–202
landscapes 22, 31, 139, 141, 152, 490–495, 497–501, 503–505, 530, 564, 566–567, 778–779, 803–804, 850–855, 857–858; associational value of 492, 494, 504–505; and the connections with human nature 492; historical 103, 501; national 379, 501–502
languages 84–85, 135–136, 200–201, 266, 282–285, 302–303, 318, 375–376, 385–386, 410–411, 457, 464–465, 661, 703, 723–724; contemporary art 520, 522; European 356, 464; foreign 356; Romance 133
Lankauskas, Gediminas 861–873
L'Arbre des Capitaines (The Captain's Tree) 194

891

Index

lateral geniculate nucleus 316

Latour, B. 179–180

law 57, 71, 74, 114, 134–136, 139, 150, 190–194, 198–199, 201, 237, 284, 410, 567, 752; apartheid 385; common 408; customary 384; existing 138; international 333, 816; military 469; national conservation 587; punitive 858

Law, Robin 192

leadership 190, 573–574, 576, 622, 652, 785, 804, 830; Allied 816; ANC 386; of Chairman Mao 807; military 461; party 804

Lehrer, Erica 760, 760–772

Leicester Arts and Museum Service 600, 609

Lenin 233, 862, 867–869

Lesbian, Gay, Bisexual, Transgender and Intersex 664, 666

LGBTI *see* Lesbian, Gay, Bisexual, Transgender and Intersex

LGN *see* lateral geniculate nucleus

List of Overseas Places of Significance to Australia 823–824

Lithuania 734, 861, 863, 865, 868, 871–873

Littler, J. 572, 642

living museums 102, 397

local government 147, 197, 199–200, 202, 345, 643, 651

Logan, W.S. 96–97, 589, 762

London Science Museum 665, 680

LOPSA *see* List of Overseas Places of Significance to Australia

Lorde, Audre 307, 310, 439, 727

Lowenthal, D. 14–15, 18, 20, 23, 33–34, 98, 103, 378–379, 600

Lynch, B.T. 513, 664, 667, 701–702, 726

Macdonald, Sharon 37, 66–67, 97–99, 101, 104, 108, 385, 392, 572, 577, 599, 601, 746, 746–757, 762

MacKinnon, Catherine 366

Macpherson, Morag 623, 700–711

Maddern, Joanne 343, 343–352

Mailer, Norman 284

Manchester Jewish Museum 362

Mandela, Nelson 381, 386–387, 389, 391, 394, 398, 463

manifestos 10–11, 14, 37, 213, 238–239, 707; defining heritage 14; government 118

Mann, Michael 19, 405, 412

mannequins 263, 335, 419, 530–532, 536

Manpower Services Commission 629

manuscripts 156–157, 159, 267, 270, 389, 462; copied 262; Icelandic 146, 156, 163; saga 12, 156; thirteenth century Landnáma 158

maps 87, 214–215, 266–267, 302, 309, 493, 556, 658, 688–690, 748, 764, 782, 851; embroidered 421; engraved 493; homophobic 305; paper 215; stable 302

Mapungubwe National Park 389–390

Marketing and Media Research 159

marketplaces 16, 272, 278

Maropeng complex 389–392

Marroni, Cintia Velázquez 132–141

Martin, P. 627–628

Marx, A. 90, 862, 867, 869

Marxist historians 11, 857

Mary Queen of Scots 449

Mascheroni, Silvia 655

Maskelyne, Margaret 215

Mason, Rhiannon 543–558

mass graves 195, 357, 359, 364, 734, 787–791

mass murder 358–360, 366, 369

Massumi, Brain 298–300, 302–306, 308–310

material 69, 71, 73, 124–125, 138–140, 170–173, 418–420, 423–426, 462–463, 518–519, 575, 604–607, 657, 689, 746–747; artefacts 803; cultural 720, 746; evidence 221, 354, 689; form in academic and institutional contexts 303, 528; heritage 599, 611; historical photographic 536; objects 419, 422–423, 606, 778; possessions 133; relics 209; sensitive 834–835; synthetic 604; valued 56; wealth 62; world 133, 374, 418–419, 850

material culture 1–4, 393, 395, 399, 441, 448, 528, 531, 533, 599, 606, 610–611, 686–687, 733, 741; conserving 185; heritage 601; religious 449; scholarship 419; studies in anthropology 418

Matless, David 491

Matthews, Sara 329, 329–340

Mauthausen camp museum 365

McCarthy, Conal 543–558

McCrone, D. 15–16

McLoughlin, John 562

McSweeney, K. 674–676

mechanical reproduction 226, 228, 232, 276; age of 226–229, 231, 233, 235, 237, 239, 276, 284; of art changes 235; emancipates the work of art from its parasitical dependence on ritual 229

mediators 179, 181, 520–521, 566, 642, 708, 710, 746, 781; cultural 520; material 791; museum 622, 655–656

medieval historians 406, 409

Melly, George 46

memorials 18, 47, 97, 195, 267, 332, 334, 350, 459, 469, 695, 779–780, 786–788, 814, 823; ageless 17; heritage 2; Holocaust 464; national 817; slave 547; successful 787; war 15, 459, 785–787

memory 98–99, 180–181, 189–191, 446–448, 500–502, 601–602, 610–612, 778–781, 787–788, 814–816, 820, 822–824, 851–852, 861–867, 869–873; ancestral 317, 321; communal 18, 448, 781; cultural 447, 563, 600, 784; discursive 778, 780; folk 19, 102; and

identity 815; living 89, 98, 384, 593, 606; local
179, 201, 369; national 20; nation's 864;
nostalgic 806, 870; objectified 254; personal
448, 866; politics 818, 864, 869; regimes of
779–780; role of 4–5; sites of 193, 334, 763,
780, 783, 791, 862; technologies of 779;
traditional 17; true 19
Mental Fight Club 631, 635
Merseyside Maritime Museum, Liverpool 368
Meskell, Lynn 381, 381–399, 567, 587, 599, 762
metacultural productions 117
methodologies 5, 38, 95, 331, 523, 593, 627, 657,
688; common 657; inter-cultural 657, 661;
mediation 520; new 544; relational 520
México 35, 132–134, 136–141, 459–460, 533,
550
MFC *see* Mental Fight Club
MGC *see* Museums and Galleries Commission
MHS *see* Museum of the History of Science
Michael, F. 688
micromuseums 30
middle classes 2, 33–34, 46, 246, 807
migrant communities 518, 523, 529, 538, 557
migrant labor 549
migrants 344, 347–348, 387, 517, 523, 545–547,
554–555, 557, 600, 602–603, 611, 622, 643,
655–660, 856–858; inclusion of 655, 658;
multiple 598–600, 602, 604, 611; workers 854,
856
migration 343, 345, 347–349, 351, 435, 513–514,
544–548, 554–557, 599, 602–603, 611–612,
622, 655, 658, 661; histories of 345, 554, 599,
602, 612; international 435; multiple 599–600,
611–612; museums 555, 557, 622, 658–661;
routes 600, 602, 611; and transnationalism 3,
34, 513
mind 46–48, 54, 85, 87, 125, 151–152, 295, 300,
309, 313–319, 321–325, 333–334, 410–411,
492, 790; human 99, 314–316, 446; origins of
the 313–314; people's 377, 862
Ministry of Aboriginal Affairs (Taiwan) 469
Mirzoeff, Nicholas 333–334, 336
MMR *see* Marketing and Media Research
modernism 60–61, 180, 407
modernists 17, 404–406, 408, 412
modernity 23, 58, 60, 150, 153, 277, 283–284,
405–407, 539, 545, 553–555, 779–780, 819,
853, 866; bland 819; capitalist 862;
cosmopolitan 820; domestic 866; globalized
783; history of 61, 709; new national 397;
twentieth-century 501; urban-industrial 501
Møller, Bente 531
Mont-Saint-Michel 187, 259–264
Monteux, Pierre 57, 477
Montrose, Louis 265
monuments 18–19, 22, 88, 132–135, 137–139,
141, 190–191, 193, 196–198, 332, 740–741,

743, 748–749, 786–787, 803–804; ancient 21;
civic 738; collective 823; constructed 195;
dying 741; focal 740; high 19; iconic 740;
impressive 194, 199; literary 461; new 594;
official 194, 200, 261; peace 785–787, 789;
protected 114, 594; public 2, 394; reimagined
185; repatriate 462; representative 658; sacred
742; seized 463
Monuments and Relics Commission (Sierra
Leone) 779
Moore, Annie 210, 349–350, 384
Moreland, John 839
Moreno, Barry 345, 351
Morris, William 14–16, 23, 491–492, 513
Morsea, Nuala 700–711
MSC *see* Manpower Services Commission
Mugabe, Robert 458
Muir, Edwin 82
multicultural 386, 527, 540, 575, 578, 582;
countries 540; liberal 572
multiculturalism 278, 386, 436, 513, 544, 547,
549–551, 572, 659; commemorative activities
818; knowledge-oriented 518
Munro, Robert 295–296, 839
Munt, Sally 299
Murray, M. 97–98, 103
museum 245, 250, 296, 531, 706, 833; academics
3, 537; and archives 464, 722; audiences 206,
520, 828; buildings 31, 163, 207, 553;
communities 68, 209; curators 70, 527, 537,
659; employees 722, 725; engagement with
members of the Steampunk community 206;
environment 217, 425; heritage 655; and
heritage sectors 30–31, 38, 72–73, 524, 548,
552, 555, 622, 705, 827–829, 831; institutions
1, 64–65, 67, 73, 553, 558, 621; learning 642,
700; mediators 622, 655–656; objects 213–214,
217, 419–420, 423, 425, 453, 520–521, 528,
532, 700; professionals 10, 66–67, 72, 186, 253,
345, 517, 523, 540, 574, 641, 667–668, 680,
710, 720; programming 714, 828; projects 58,
558, 576; representations 529, 538, 540, 557;
services 32, 708, 754; spaces 419, 518, 554,
579, 827, 833, 835–836; staff 10, 32, 205, 451,
664, 672, 705–706, 709–710, 832; strategies
578, 702; teams 363, 606, 832; visitors 63,
208–211, 329–331, 336, 340, 357, 419–420,
423, 725; workers 419
museum collections 31, 66, 74, 106, 205, 357,
720; highlighting the negative historical legacy
of colonialism 56; reinterpreting to tell
alternative stories 206
museum developments 63, 515, 570–572, 577,
582; national ethnic 583; new 571
museum displays 368, 529, 558, 609, 670,
834–835; objects 610; poetics and politics of 64
Museum of Agriculture 123

Index

Museum of American History 579
Museum of Anthropology and Ethnography 520, 656
Museum of Cultural History 527, 532–537
Museum of Free Derry 834–835
Museum of London 205, 841, 846
Museum of Revolutionary History 807
Museum of the History of Science 205–211, 213, 217
museum practice 66, 423–424, 515, 608, 611, 623, 665–666, 702–703, 710, 714, 720, 834; adapting 644, 720; naturalized 726
museum studies 1, 10, 16, 29–31, 33, 36–38, 65, 106, 354, 424, 548, 553, 556, 572, 631; and heritage 9, 29, 31, 33, 35–37; scope of 29
museums 29–38, 56–74, 345–351, 418–426, 517–521, 543–559, 570–583, 608–612, 655–661, 664–672, 674–677, 700–711, 714–727, 827–829, 831–835; abbey 47; accessible 426; accredited 147; analysis of 63, 527, 537; anthropology 540, 656–657, 660; art 265, 270, 442, 655–656; balkanized 578; centralised 648, 650; and communities 64, 623, 717; community-focused 570, 573, 621; cultural 570; elitist 426; ethnic-specific 578; ethnographical 356, 572; ethnography 622, 656; existing Jewish 268; existing Smithsonian 576; flagship 390, 832; folklore 47, 120; and galleries 106, 641–642, 652, 657; and heritage 544; heritage 33–34, 244, 828; Holocaust 361–362, 369; house 102–103, 422, 591; Icelandic 147; identity 570–571, 580–581; immigration 344, 546, 553; Italian migration 520, 522, 656, 658, 661; living 102, 397; local 71, 120, 549, 557, 828; mainstream 720, 724; migrant labor 549; migration 555, 557, 622, 658–661; new Smithsonian 578; Norwegian Museum of Cultural History 527, 529–531, 536–539; political role of 580, 583; post-colonial 554; private family 555; purposes of 33, 835; role of 64, 538, 581; self-reflective 556; study of 29, 58, 63, 540; western-style 720; working-class movement 627
Museums and Galleries Commission 31, 35
'Mythistoricus' (F.M. Cornford) 90
myths 90–91, 99, 228, 253, 255–256, 266, 357, 379, 408, 471, 574, 792; historical 464; national 90, 772

Napoleon, Louis 496
Napoleon Bonaparte 87
narratives 64, 66, 96, 99, 101, 103, 105, 377–379, 514–515, 521–522, 528, 534–537, 576–577, 627–628, 670; cultural 520, 571; official 106, 120, 623
Nash, Paul 347, 497
nation states 18, 22, 58, 116, 376, 430, 436, 547, 552, 555, 589, 591, 783, 791, 824

National African American Museum 571, 574, 576
National Black Museum 574
national communities 409–410, 413, 829
national consciousness 18, 406, 785
National Gallery, London 48, 451
national heritage 4, 33, 297, 390, 493, 499–500, 551, 561, 570–571, 577, 581–582, 739–740, 784, 815
national history 11, 65, 86–87, 296, 458, 464–466, 470, 499–501
national identity 18, 20–21, 139–141, 408–409, 411–413, 430–433, 435–436, 474–475, 490–492, 495, 497, 500–505, 538–539, 544, 546–547; assertion of 431–432; construction of 430, 490, 505, 547; creation 572; discourses of 490; modern British 503; new 4, 296; understandings of 141, 436; unique 474
National Mall 570, 573, 578, 582
national memory 351, 763, 821
national minorities 468, 538
National Museum and Asian Civilization Museum 553
National Museum in Mexico City 550
National Museum of African American History and Culture 570–571, 582
National Museum of American History 576
National Museum of Australia 421
National Museum of Natural History 576
National Museum of Sierra Leone 780, 784
National Museum of the American Indian 571, 573, 576, 580, 722
National Museum of the American Latino 571, 578–579
national museums 70, 105, 107, 544, 552, 557, 570–571, 573, 576, 578–579, 581–583, 667, 669, 779–781, 784; large 674; main 140; modern 58; new 578; refurbished Germanic 755; reopened 553; unique American 574
National Park Service 344–345, 348–350, 560
National Railway Museum 668
National Reconciliation Procession 786
National Theatre 45
National Trust 10, 16, 44–45, 48–49, 449–450, 503, 645
national unity 140, 159, 285, 385–386, 394, 580
nationalism 134, 190, 296, 375, 378, 404–407, 409, 411–413, 458, 462, 465–466, 491, 550–551, 553–554, 807; banal 346, 782; cultural 465, 785; ideology of 159, 404, 406; movement of 406, 409
nationalistic associations 503, 505
nationalists 118, 135, 280, 329, 406, 409, 458–460, 468, 470, 761, 799; ideologies 374, 406; movements 433, 436, 458
nationhood 3–4, 59, 387, 404–405, 407, 410, 412, 471, 491–492, 503, 513, 550–551, 553, 809

894

nations 132–134, 152, 156, 161–164, 381–384, 386, 388–393, 404–413, 498–502, 513–515, 543–550, 552–553, 570–571, 581–583, 872–873; community of 404, 587; historic 408, 411, 413; independent 140, 161; and nationalism 404, 491; new 253, 381–383, 399; persistence of 404, 408–409; western 113, 115

Native Americans 364, 515, 559–562, 564, 566–567, 576

natives 170, 172, 253–254, 256, 280, 523, 563, 724; anxious 244; Caribbean 170

natural heritage 37, 97, 382, 384, 388–389, 399, 529, 687, 803; and cultural heritages 383; designations 391

nature 14–15, 89–91, 146–147, 150–153, 162–164, 227–228, 230–231, 235–236, 274, 284, 564, 566–567, 582–583, 829–830, 835–836; civilized 843–846; contested 65, 368, 466, 834; emotional 314, 316; inter-cultural 657

Naylor, John 206, 209–211

Nazi 268, 358–360, 363–366, 368, 734, 751, 755–756, 760–761, 764–765, 772; Germany 79; heritage 753–755, 757; Party Rallies 752; past 733; sites 753–754

Ndwandwe, Reuben 395

Nefertiti, Queen 463

NEPAD see New Partnership for Africa's Development

Netanyahu, Binyamin 464

neuroscience 3, 314, 321, 324, 442

new nationalisms 469

New Partnership for Africa's Development 388–389

Newstead, Keith 212

NGOs see Non-Governmental Organizations

Nicholson, Julia 606–607

Nkomo, Joshua 458

NMAAHC see National Museum of African American History and Culture

NMAI see National Museum of the American Indian

NMAL see National Museum of the American Latino

Nolan, James 62, 67, 207

non-Governmental organizations 118, 135, 382, 389, 395

Nora, Pierre 17–18, 98, 763, 780, 862

Norman Conquest 83, 222

North Africa 382, 412, 436, 457, 736–737, 741, 844

Northern Ireland 436, 499, 544, 735, 738, 827, 830–832, 834; policy framework for 831; Protestantism in 436; Roman Catholicism in 436; strategic framework for 831

Norwegian 146, 529–531, 538–540; history 539; museums 540; nation 539–540; society 527, 537–540

Norwegian Museum of Cultural History 527, 529–531, 536–539

Nuremberg 101, 186, 358, 734, 746–757; citizens 749; and Nazi heritage and image 746, 751, 754–755; Nazi past in 101, 756; post-War 751, 757; rallies 335, 747, 752; trials 755

OAU see Organization of African Unity

Old Town (Nuremberg) 746, 749–753

Oldbuck-like, Jonathan 89

Olive, Julio 135–138

Onciul, Bryony 714–727

Opala, J.A. 784–785

oral histories 193, 346, 628–629, 631, 634–635, 659, 834; collections 348; contemporary 192

Organization of African Unity 388, 465

Orientalism 355, 436, 472

O'Sullivan, Simon 298

Ouidah (slave beach) 190–194, 196, 198, 200–202

Paine, James 47

painters 224, 234, 272, 452

paintings 330–333, 338–340; ink 798–799; Kearns 331–332; peasant 799, 802, 807; Picasso 235; religious scroll 468; Renaissance 266; Soviet-era 868

Palestinian refugees 464

Palimpsest memoryscapes 778–779, 781, 783, 785, 787, 789, 791–793

Panksepp, Jaak 313–325

Parby, Jakob Ingemann 543–558

Parkin, Ray 816, 856

partner organisations 640, 648–652, 674; developed collaboratively by all involved 649; larger 649–652; provides professional advice and guidance to groups 649

partnerships 628, 630–632, 640, 642–643, 651–652, 655, 657, 659–660, 676, 679, 698, 703, 715–717, 721, 724; community 398; development of 648

Patel, Anisha 607, 610

patrimony 12, 132–141; management 135; national 133–134, 139, 141

patriotism 187, 252–253, 348, 443, 490, 505, 800, 802, 807; local 502; national 502

peace 88, 107, 151, 332, 386, 388, 574, 762, 778–779, 782–783, 786, 791, 830–831, 834; genuine 792; monuments 785–787, 789; process 780, 786, 833

'Peace Bridge' 786

Peace Corps 784

Pearce, Susan 96, 101, 213

Pears, Charles 497

peasant paintings 799, 802, 807

Peers, Laura 65

Pek, Lian 821

895

Index

people 14–17, 19–23, 47–49, 95–99, 105–106, 193–199, 245–250, 344–346, 418–420, 544–557, 598–601, 607–612, 686–694, 766–768, 850–856; black 396; contemporary 844; decent 452–453; local 114, 191, 193, 195, 446, 450, 453, 644, 752, 790, 827–828, 832; marginalized 688, 698; movements of 421, 598; ordinary 10, 17, 19–20, 79, 118, 365, 692; prehistoric 852; real 760; transnational 598; vulnerable 686, 690; white 720, 857

People's Republic of China 469, 553, 798–800, 804, 807

Perkin, Corinne 217, 622, 629, 640, 640–653

personal communication 604–607, 668–672, 674, 676–677, 679–681, 721, 723–724

perspectives 99, 101, 103, 198, 201, 334–336, 338, 521, 528–529, 571, 574, 641, 644, 688–689, 742; academic 470; audience's 103; cognitive 315, 325; contested 726; culturally-diverse 574; disciplinary 9; dualistic 314–315; female 724; ideological 467; intercultural 523–524; international 4, 514; local 606; neuro-evolutionary 314; neuroscience-based 325; non-essentialist 431; regional 472; scholarly 338, 553; sociological 548; theoretical 600

Petrov, Julia 155

Phillips, James E. 701, 838, 838–847

Phillips, Kendall 869

philosophers 59–60, 255, 309, 314–316, 474; ancient 804; eighteenth-century 86; Liberal 384; social 587

photographs 212–213, 215, 230, 333, 335–338, 340, 357–359, 361, 363, 365, 367–368, 442, 444–445, 522–523, 563; early 230; fabricated 222; featured 366; iconic 335; large 156; newspaper 358, 367; old 170, 174, 418; original 339; small 335; trophy 332, 338; vintage 346

photography 89, 153–155, 161, 227, 229–231, 235–236, 333, 503, 523, 661, 722; anthropological 706; early 230; exhibits of recuperated Soviet 867; foreshadowing the sound film 227; World War II combat 338

Pilgrim, Richard 125

pilgrimages 20, 115, 121, 123, 190, 200, 283, 350, 498, 815; mass thanksgiving 123; personal 821; "red" 806

pilgrims 88, 121, 123–125, 259–260, 262, 264, 505, 734, 822, 852

Pinto, Diana 765

Pitt Rivers Museum 65, 356–358, 362, 368

Plamenatz, John 232–233, 407

PMB *see* Preservation of Monuments Board

Poland 221, 358, 369, 734, 760–767, 769–772; culture of 761; Jewish book-shops in 760; Jewish heritage in 358, 761, 763; and Jewish people 734, 763–766, 769, 772, 856;

nationalism 761, 764; post-communist 762, 764, 772; post-war 734

political 56–67, 275–280, 302–303, 377–379, 383–389, 404–413, 433–439, 469–472, 528–530, 555–557, 570–575, 734–735, 806–809, 827–830, 834–836; authority 57, 462, 528–529; community 118, 404, 412–413; contexts 302, 834; correctness 476, 574, 724, 726; culture 285, 412; demands 642, 827; goals 147, 672; identities 408–411, 413, 439, 465; power 190, 259, 275, 406; situations 845–846; sovereignty 413

political refugees 854

politics 3–4, 135, 137, 238–239, 272, 275–277, 279, 281, 283, 295–296, 572, 580, 640–641, 647–649, 652–653; identitarian 383, 390; local 550; of recognition 62, 64, 383, 545, 555, 580

Pollard, Royce 561

Polynesian people 548, 553

Pool, Stanley 499

pop culture 535

population 381, 383, 405–406, 408–409, 411, 466, 468–469, 527, 529, 544, 550, 553, 736, 739, 742–743; aboriginal 469; civilian 497; diasporic 349; enslaved 172, 175; ethnolinguistic 790; free African-Puerto Rican 174; immigrant 348; migrant 598; non-white 383, 544; settler 563; transient tourist 740; tribal 567; urban 384

pornography 45, 366–367

post-apartheid 385–386; era 385, 393–394; fetishizations of tribal culture 394; heritage 381–382, 385; reconciliation 460; shifts in the cultural productions of history and heritage, museums and tourist locales 386; state 548

post-modernity 16–17, 61

postmodernism 60, 63, 65

power 3, 135–136, 198–199, 264–266, 270–272, 298–299, 375–377, 421–425, 434, 458–460, 480–481, 651–652, 716–721, 724–726, 858; citizen 716–717; and culture 392; imbalances 632, 642, 650–651; national 113; social 199–200

Powers, Tim 206

Pownall, Thomas 22

POWs 814, 816, 818

practices 16–17, 97, 113–114, 116–119, 265, 267, 441, 530–532, 551–552, 621–622, 655–656, 679–681, 720–723, 748, 778–780; activist 582; ancestral 385; barbaric 357; historical 553; naturalized 722–723; professional 37, 666, 707; representational 265, 267, 527; working 439, 520, 523, 634, 676

Pratt, Mary 717, 858

PRC *see* People's Republic of China

prehistoric 171, 368, 841, 843; life 838; occupations 839

prejudice 63, 106, 349, 354–357, 513, 515, 582,

658, 766; dangerous 393; ethnic 381; institutional 114

Preservation of Monuments Board 814, 818, 821

Pride, Gay 12

Prior, Nick 58, 66

prison 4, 45, 260–263, 338, 531, 698, 814–819, 821–822, 824, 873; authorities 818; camps 349, 817; walls 818, 824

prisoners 260, 262–263, 365, 814, 816–818, 821–823; British 817; condemned 45; ex-paramilitary 832; former 499

Probst, Peter 12, 179, 179–181

processes 14–16, 64–68, 96–98, 138–141, 227–229, 276–277, 431–435, 527–529, 550–554, 575–577, 625–628, 679–680, 701–711, 725–726, 749–753; creative 201, 626; historical 79, 548; learning 87, 721; social 15, 253, 404, 408–409; unpredictable 726

projects 264, 520–524, 623, 630–637, 643–644, 647–653, 659–660, 664–665, 667–672, 674–677, 679–680, 686–691, 696–698, 700–710, 831–833; community-heritage 835; contemporary political 347; context of museums and heritage 622; culture brokering 762; digital 704–705; emerging memory 762; historical 460; individual 637, 835; intercultural 656–657; working 514, 523, 651, 701

properties 45, 52, 83, 133–134, 138, 140, 181, 233, 250, 274, 345, 594, 696, 737–738; acquired 45; ancestral 133; common 79, 233; extra-mural 741; intellectual 118; personal 268; preserving 238; prestigious 270; public 134; royal 133; social 137

Proust, Marcel 266, 870

psychoanalysis 235–236, 299–300, 434, 865

public culture 64, 404, 524

public museums 38, 57–58, 641, 841; *see also* museums

Puerto Rican 12, 169–171, 173–175; culture 170, 175; domestic architecture 12

Puerto Rico 12, 169, 171–173

Queen, Mary 449

Queen Guinevere 84

Queen Nefertiti 463

Quinlan, Gary 822

Rackham, Oliver 90

Rahtz, Philip 691

Rainbow Nation 381–383, 385–387, 389, 391, 393, 395, 397, 399

rallies 335, 733, 747, 752; Hitler's great 733; Nuremberg 335, 747, 752

Ranger, Terence 280, 385

Rankin, Robert 214, 216

Rapoport, Nathan 360

Rassool, Ciraj 543–558

RCMG *see* Research Centre for Museums and Galleries

RCUK *see* Research Councils

Readman, Paul 490, 490–505

Reagan, Ronald 346, 348

realise community 652

recognition 62, 64, 67, 73–74, 138, 140, 331–333, 383, 436, 438, 476, 545, 547, 701–702, 822; belated 378; collective 674; direct 627; heightened 538; increasing 141, 643; international 814; shared 627; therapeutic 67; transformative 447

'red tourism' 735, 798, 805–809

Redler, Hannah 671

refugee camps 627, 781

refugees 364, 464, 538, 545, 591, 657, 858; first Jewish 598; Palestinian 464; political 854

regimes 459, 466, 528, 536, 681, 734, 779, 785, 792, 799, 807, 809, 864; aesthetic 535; army-based 466; coexistent 791; competing 792; dominant 783; established 540; former colonial 821; historical 536; hostile 870; left-wing Mengistu 467; legal property 133; non-indigenous 787; political 868; repressive Soviet 869; vanquished 868; of visibility 528–529

Reiner, N. 579

Reinhard camps 358

Rekdal, Bjorn 537, 540

relativism 60, 63, 66; cultural 60–61, 66, 709; historical 250

relics 84, 223–224, 281, 778–779, 820, 841–842; disused 720; historical 748; physical 21; preserved 22; religious 223; sacred 47

repatriation 56, 64–65, 365, 591, 714, 721–723, 816; practices 715; programmes 573

representation 12, 61–62, 64–67, 330–332, 354–355, 357–358, 362–365, 367–368, 375, 433–434, 535–536, 544–546, 601, 665–666, 722–725; historical regimes of 536; hybrid regimes of 535, 537–538; military heritage 363; politics of 97, 273, 572–573; processes of 274, 583; regimes of 527–529, 531, 536–540; visual 199, 365, 797–798, 800, 804, 808, 862, 869; working grassroots 116

reproduction 59, 185, 226–229, 236, 249, 253, 270, 276, 321, 367, 431, 530, 533, 602, 611; mechanical 226, 228, 232, 276; partial 335; perfect 227; photographic 227; pictorial 227; social 59, 300; technical 227, 230

research 78–80, 91, 95–97, 102–108, 132–134, 136–139, 280–281, 547–551, 602–604, 621–623, 627–631, 641–643, 650, 667–669, 679–680; activities 627; animal 315–316, 318; approaches 636, 665; archival 635, 715; community-based 627–628, 630, 636; cultural 281; historiographic 282; process 630, 632, 668, 677; projects 106, 630–631; scientific 73, 201, 841

897

Index

Research Centre for Museums and Galleries 106
Research Councils 629–630
researchers 104, 543, 632–633
resistance 3, 23, 36, 61, 66, 394, 451, 458, 460,
462–463, 500, 578, 761, 765, 772; historical
narrative celebrating Sierra Leone's 784;
historiography of 462
resources 134, 139, 375, 377–378, 383, 388,
409–410, 627–628, 633, 636–637, 641,
643–644, 649, 722, 725; cultural 404, 410–411,
560, 720; historic 174; political 377–378;
subsoil 133–134; symbolic 408–409, 438
Returned and Services' League 814, 817–818
Revolutionary United Front 783, 789
Richards, Paul 115, 123, 779
Riefenstahl, Leni 335
Ripley, Dillon 573
Robertson, Jennifer 118
Robins, Kevin 393, 396, 435
Robinson, Sophie 451, 623, 700–711
Rockefeller Jr, John D. 245
Romanesque churches 741
Rossi, Keith 463, 782, 814
Routledge, Bruce 409
Roux, Naomi 543, 543–558
Rowlands, M. 179
Rozental, Sandra 133–134, 137, 139–140
RSL *see* Returned and Services' League
Rubinstein, J.L. 316
RUF *see* Revolutionary United Front
ruins 138, 163, 174–175, 251, 269, 368, 446–447,
467, 691, 746, 778; disappearing 170; industrial
447; longhouse 163; unimaginable 820
Rüsen, Jörn 11, 96, 99–101
Ruskin, John 78, 85, 496
Russell, James 314, 316
Rutherford, Jonathan 434
Rynhart, Jeanne 350

sacred items 720–722
sacred space 195, 527, 531–532, 739
SADC *see* Southern African Development
Community
SADF *see* South African Defence Force
saga manuscripts 12, 156
Saga Museum 157–159
Said, Edward 355, 436
Sami communities 530
Sami culture 530, 539
Samuel, Raphael 11, 17, 34, 78–92, 118–119, 581,
628
San Salvario 657
Sánchez, Antonio 476
Sandell, R. 102, 108, 517, 523, 622, 640–642,
656, 666–667, 679, 701
Sandy, Lieutenant Samuel S. 785
Sapir, Edward 274

Sarro, Ramon 180
Scheermeyer, C. 382–383, 394, 399
Schmitt, Thomas 117
Schneider, Cliff 561
Schofield, John 117, 623, 686, 686–698
scholarship 4, 34, 60, 91, 195, 252, 276, 286,
418–419, 553–554, 572–573, 575, 579–581,
590, 762–763; academic 459; cultural 276,
278–279; democratic 79; foundational 275;
humanistic 278; new 570, 575, 764; reflexive
276; tourism 283; unbiased 573
Schorch, Philipp 543–558
Schulze, Gary 784
science 62, 65–66, 71, 73, 201, 205–206,
209–211, 213, 217, 236, 275, 278, 665, 668,
672; cognitive 3, 314, 325; history of 205–206,
208–209; medical 667, 672; modern 86, 399;
planetary 23
science fiction literature 91, 205–206
Scotland 495, 502–503, 544
Sear, Martha 421, 425
Second World War 280, 333, 335, 355, 357, 361,
363, 379, 458, 535, 765, 770, 772, 814–815,
823
Sedgwick, Eve 299–310
Sennett, Richard 57, 760
Sérusier, Paul 272
Seton-Watson, Hugh 407
SEUPB *see* Special EU Programmes Body
Sexton, Anna 621–622, 625, 625–638
sexuality 161, 307, 438–439, 478, 664–666, 829;
associated with non-European cultures 479;
female 366
Shakespeare, William 19, 88, 228, 297, 494,
499–500
Shaw, Rosalind 53, 778–780, 783–784, 787
Sherman, Daniel 64
Shrine, Ise 113–115, 121
Siberian labor camps 814, 868
Sicily 259, 658
Siegenthaller, Peter 120
Sierra Leone 778–792; and the Creole
communities 779; and the Krio population 781;
and the mass graves 792; post-civil war 734;
and Western memory practices 780
Sierra Leone National Museum 791
Silberman, Neil 515, 587, 587–595, 739
Simpson, Moira 64–65, 354
Singapore 553, 814–824
Singapore Heritage Society 814, 819
Singapore Island 815, 817–818
Singapore Tourist Promotion Board 818
sites 20–22, 33–35, 102, 253–256, 442–444,
446–448, 590–592, 690–693, 736–738,
752–754, 763–765, 786–791, 804–806,
815–816, 818–824; burial 193, 364, 734;
complex 358, 787; of conscience 102–103, 591,

898

764; of contestation 65–67, 571; of controversy 65–66; historic urban 737; important 781; irreplaceable 378; local 364, 623; museums and heritage 29, 31, 295, 441, 447, 519, 665; national 359; original 152, 205, 815; particular 245, 249; prehistoric 391; sacred 192, 394; significant 20, 790; visitor 754
Skounti, Ahmed 120
Slade, Joseph 366
slave labour camps 358
Slave Route 189–202; of Ouidah 192, 198; Project 191, 194, 201
slave trade 103–104, 190–194, 199, 201, 778; trans-Atlantic 189–190, 192–195, 199, 201
slaves 45, 50, 104, 149, 171–175, 190–193, 463, 547, 843, 846
Smith, Anthony D. 1, 11, 96–97, 102–104, 106, 115, 117, 133, 140, 404, 404–413, 499, 501, 686, 853–854
Smith, Joan 366
Smithsonian 65, 247, 571–577, 579, 582, 658
Smithsonian Centre for Folklife and Cultural Heritage 116
Smithsonian Council 574–575
Smithsonian Institution 133, 515, 570–573, 582
Smithsonian National Air and Space Museum 65
Snow, Susan 173
social activism 587
social historians 252
social history 37, 65, 90, 187, 246, 252, 255, 344, 348, 351, 549, 599
socialism 79, 229, 490, 798, 807–808, 861–868, 870–873; memorializing 863; memories of 867, 869–870, 872–873; state 472; taste of 861
socialist 867–868, 872; Bloc 861, 865; 'Commonwealth' 871; economies 870; GDR 871; historians 78; history 861; icons 862, 873; memories 869, 872; past 806–807, 862–863, 866, 869, 873; propaganda 804; realist principles 798; state 863–865, 868
society 14–16, 61–65, 106, 146–147, 282, 285–286, 374–375, 377–379, 435–436, 536, 546–548, 552–554, 580–581, 687, 831; contemporary 70, 95–96, 99, 174, 554, 735; human 73, 99–100; multicultural 105, 108, 376, 386, 517, 540, 556; national 140; people-centered 381; post-conflict 180, 834; transnational 602
Society for the Protection of Ancient Buildings 16, 23
soldiers 52, 87, 115, 330, 332–339, 430, 443, 496, 499; American 335, 358, 535; British 357, 363, 496, 834; dead 333; fighting overseas 498; gallant 786; nation's 338; Serbian 429–430; terracotta 807
Solicari, Sonia 211, 213
Somalia 337–339

Somalia Without Conscience (painting) 102–103, 329–332, 337–339, 591
South Africa 102, 381–384, 386–393, 395–398, 457, 460, 543, 548–549, 552, 558, 603; culture 392, 396; identity categories 383; past 388
South African Defence Force 385
South African National Parks 389
South Africans 382–387, 389, 391–392, 394, 396–398, 463, 550–551; majority of 382–383; white 384, 765
South America 49, 457, 550
South Asia 457, 471, 598–600, 602–607, 609–611
Southern African Development Community 388
Soviets 358, 799, 867, 869–871; history 871; past 867, 873
SPAB *see* Society for the Protection of Ancient Buildings
space 81, 194–195, 236, 334, 336, 351, 418, 424, 442–444, 446–447, 523–524, 599–602, 632–633, 764–766, 770–772; contested 351; cultural 117; heritage gallery 644; inter-cultural 519; memorial 329, 334; museum's 522; national 351; political 556, 715; purpose-designed heritage gallery 650; religious 531–532; transnational 600, 603–606, 611–612
Spain 133, 140, 413, 453, 465, 474–484, 549–550, 557, 590, 788; Catalans and Basques 590; history of 474–475; identity 483; Islamic past 475, 478; modern 475–477, 481; vision of identity 483
Spanish culture 474, 481
Special EU Programmes Body 831, 833
speeches 36, 50, 83, 85, 227, 255, 387, 391–392, 477, 497, 543, 753, 755, 782, 786; centenary 398; historic 83; impassioned political 392
Spielman, Barry 768
St. George Gray, Harold 839
Stacey, J. 303
staff 35, 66, 207, 253, 296, 345, 575, 649, 665, 668, 671, 680, 704–707, 709, 722; interpretive 248, 721; members 246, 680, 708, 721–722; museum's 246, 520–521, 671; professional 253, 574; scientific 524
stakeholders 197, 201, 349, 351, 621, 632, 648–649, 651, 736–737, 787, 832–833; community-based 652; international 350; local 593; multiple 197; organisational 815; transnational 5
Stanley, Henry 302, 394, 499
Starn, Ralph 64
Starn, Randolph 64, 119, 862–863, 865
state heritage 394
Steampunk 205–211, 213–218; art 205–207, 211–212, 217–218; communities 206, 208, 211, 217; heritage 205, 207, 211, 213, 215, 217; objects 205, 208, 210–211, 213
Steampunk and Victoriana Exhibition 210

899

Index

Steichen, Edward 338
Steward, Jay 668
Stewart, Jay 276, 671–672, 851, 865
Stewart, Susan 535
Stille, Alexander 187, 259, 259–264
Stocking, George 158, 275–276, 279
STPB *see* Singapore Tourist Promotion Board
Stuart England 499
Stukeley, William 21
Sturgeon, Noel 566
Styron, William 366
Subirats, Eduardo 474
symbols 58, 150, 152, 322, 408, 410, 412, 491,
498, 553, 580, 582, 738, 781, 783; cultural 385,
830; historic 503; national 58, 492
synagogues 267, 269, 739, 764
Szeman, Sherri 366

Tan, Kevin 804, 814
Tap, Tony 688
Tapestry, Penelope 448–449
Taylor, John 10, 62, 222, 283, 364–365, 367, 448,
742
technologies 23, 95–96, 205, 208–209, 211, 214,
234, 239, 356, 493, 496–497, 548, 668, 672,
676; digital 98, 420, 631, 704; modern 23, 100,
102, 599; political 59, 384; popular 798; steam
205–206, 211; web 522
Tell, William 90
Terdiman, Richard 862, 865–866, 869
Thatcher, Margaret 34, 48
Thomas, Keith 90, 208, 366, 396, 687, 851
Tilley, Christopher 105, 423, 528, 852
Toon, Bill 816, 822
tour groups 196
tourism 3–4, 117, 120, 123, 126, 150–152,
162–163, 377, 389, 398–399, 549, 551, 557,
807, 819–821; international 190, 196–197, 377;
producers 377
tourists 150–152, 162, 164, 186, 192, 196, 198,
200–201, 260–261, 391–392, 396–397,
766–767, 815, 817–819, 822; destinations 159,
493, 558, 809; industry 147, 152, 159;
marketing 147, 151; monies 190, 192, 196–197;
sites 196, 199, 349–350, 754
Traison, Michael 769
trans-Atlantic slave trade 189–190, 192–195, 199,
201
trans-national heritage 814–824
transformations 23, 172, 254, 259, 268, 271,
278–279, 283, 381, 389, 391, 398, 600–601,
680, 687; cultural 171, 783; historical 231
transgender 664–665, 670, 675–676; heritage 667;
histories 666; people 666; stories 666
Trump, Donald J. 570, 582
Tudor England 499
Turci, Mario 521–522

Turkey 296, 471, 475, 479–481
Turner, J.M.W. 494–496

UK *see* United Kingdom
UNESCO *see* United Nations Educational,
Scientific and Cultural Organisation
United Kingdom 10, 29–34, 36–37, 101–102,
186, 207–208, 436, 543–544, 606, 625,
627–630, 641, 665–668, 700–703, 828–829;
and the emergent 'heritage industry" 9; and the
precarious position of independent museums 9,
29–30, 106, 700, 828
United Kingdom Museums Association 30–31
United Nations Educational, Scientific and
Cultural Organisation 9, 113–119, 126, 132,
135, 137–138, 186, 191, 197–202, 343–344,
587–588, 590–591, 593, 737–738, 803–804
United Nations General Assembly 589
United Nations High Commissioner for Human
Rights 588
United States 3, 172–173, 275, 281, 346, 348,
383, 561, 563–564, 570, 572, 574, 577, 581,
583
United States Holocaust Memorial Museum 354,
358, 365, 367
Universal Declaration of Human Rights 587, 589,
594, 755

Vale, Dana 821
Valéry, Paul 226–227
values 1–2, 59–62, 73, 95–99, 107–108, 139–140,
185–187, 197–201, 217–218, 407–408,
418–420, 425, 450–451, 492, 528; authentic
199–200, 202; cultural 62, 73, 101, 104, 119,
146, 501, 534, 589, 722, 797; historic 192, 194,
815, 819, 821; national 574; timeless 379
Vannier, Eric 260–261, 263
Varutti, Marzia 514, 527–540
Vergo, Peter 63, 666
Vermeer, Johannes 224
Verne, Jules 207
Victorian Steampunk Society 206, 209, 211
Viking heritage 147
Vikings 147, 151, 154, 156–157, 161
violence 302, 329–330, 332, 337, 339, 391, 394,
563, 567, 734–735, 740, 783, 788, 831, 833;
hypermasculine 338; military 340; police 581;
racial 363; sexual 339, 366–367; social 330,
338; symbolic 66
visitors 101–108, 156–157, 193–196, 199–201,
209–211, 248–254, 334, 348–349, 421–426,
451, 529–534, 608–610, 725–726, 817–819,
835–836; black 389; donation 820; heritage
sites influencing 106; individual 35, 423;
international 190–191, 195, 199; museum's 674
Vlastos, Stephen 118
Volkov, Samuel 861

900

VSS *see* Victorian Steampunk Society
Vuitton, Louis 223

Wagner, Roy 280
Walker, William 133, 573
Walklate, Jennifer 543
walled cities 736, 738–740
walled communities, historic 736
walled towns 737, 739–741
Walsh, John 34, 104, 350
war 107, 238–239, 329–334, 337–340, 356–359,
 364–365, 367–369, 429–430, 496–499, 748–749,
 764–765, 785–786, 814, 816–817, 819–824;
 memorials 15, 459, 785–787; memories of 789,
 823; museums 330, 335, 337, 356; prisoners of
 816–817; subjects of 329–330, 332–334, 338–339;
 trophies of 329, 331, 333, 335, 337, 339
Watson, Sheila 1, 1–5, 97–98, 102, 108, 185,
 185–187, 295, 295–297, 441, 441–453, 733,
 733–735, 863, 865
Waugh, Evelyn 47
Weber, Max 56–57, 412
Wehner, Kirsten 421
Weiss, David 362, 382, 395–396
Weiz-mann, Luc 264
Wells, H.G. 207, 496
West, Bob 34
West, Cornell 576
West Berlin 739
western camps 358–359, 364
Western Europe 233–234, 409, 545–546, 850
Wheeler, Sarah 635
white cliffs 492–495, 497–504
Whitehead, Christopher 12, 146, 150, 152–154,
 156, 158, 161–162, 164, 514, 543–558
Whittington, Dick 88
Whitworth, S. 339
WHS *see* World Heritage Site
Williams, Raymond 59, 61, 259, 261, 450, 501,
 697, 788, 802, 850, 858
Williams, Stephen 697
Witcomb, Andrea 37, 102–103, 105, 108, 422,
 544, 640, 704, 829
Witz, Leslie 382, 386, 397–398, 514, 543,
 543–558
women 213, 359–360, 394–395, 397, 430,
 492–493, 498–499, 504–505, 522, 532, 760,
 815, 831–832, 845, 855–856; with beading

jewelry 395; fashion-forward 599; migrant 522,
 603; young urban 607
Wong, Melvin 822
Wood, Marcus 368
Woodham, Anna 10, 29, 29–38
Woodward, Kathryn 429, 429–439
workers 263, 278, 397, 436, 438–439, 598, 628,
 772, 855; agricultural 659; professional heritage
 628
workplaces 628, 648, 749
workshops 31, 78–79, 250, 389, 491, 550, 631,
 635, 657–658, 670–672, 799, 832; collaborative
 670–671; creative 664; delivered 631; in-the-
 field 660; language teaching 657; training 633
world cultures 700, 703, 708
world heritage 113, 189, 344, 588, 736–737, 748,
 815
World Heritage Convention 9, 31, 113–114, 116,
 587–589, 593–594, 824
World Heritage Sites 114, 132, 135, 179, 197,
 261, 344, 350–351, 389–390, 392, 587–588,
 591, 594–595, 736–741, 748, 805, 807
World War I 18, 82, 88, 355, 458, 496, 563, 790,
 832
World War II 280, 333, 335, 355, 357, 361, 363,
 379, 458, 535, 765, 770, 772, 814–815, 823
Wright, Frances 33–34, 105, 222, 359
Wright, Patrick 33
Wright, Richard 359, 364
Wright, Thomas 89
Wyatt, Katrina 636

Yamin, Muhammad 466
Yeoh, Brenda 820
Young, Edward 274
Young, James 360–362, 367–368
young people 96, 101, 105, 606, 610, 659,
 664–665, 668, 670–671, 674–675, 677, 681,
 700–708, 710, 831–832; empowerment of 701,
 703, 708, 710; identifying 670; interests of 704,
 708; vulnerable 671

Zane, Stuart 296
Zedong, Mao 468, 804–806
Zen Buddhists 124
Zimbabwe 458, 460, 463, 549
Zimmerman, George 581, 688, 764
Zittel, Andrea (Californian artist) 523

Taylor & Francis eBooks

www.taylorfrancis.com

A single destination for eBooks from Taylor & Francis with increased functionality and an improved user experience to meet the needs of our customers.

90,000+ eBooks of award-winning academic content in Humanities, Social Science, Science, Technology, Engineering, and Medical written by a global network of editors and authors.

TAYLOR & FRANCIS EBOOKS OFFERS:

- A streamlined experience for our library customers
- A single point of discovery for all of our eBook content
- Improved search and discovery of content at both book and chapter level

REQUEST A FREE TRIAL
support@taylorfrancis.com